REMEMBERING
Torn-Down BALLPARKS

REMEMBERING Torn-Down BALLPARKS

OVER A COLD BEER

A BEER TABLE BOOK CELEBRATING LOST BALLPARKS

KEN FINNIGAN

SPORTS
PUBLISHING

Sports Publishing books may be purchased in bulk at special discounts for sales promotion, corporate gifts, fund-raising, or educational purposes. Special editions can also be created to specifications. For details, contact the Special Sales Department, Sports Publishing, 307 West 36th Street, 11th Floor, New York, NY 10018 or sportspubbooks@skyhorsepublishing.com.

Sports Publishing® is a registered trademark of Skyhorse Publishing, Inc.®, a Delaware corporation.

Visit our website at www.sportspubbooks.com.

10 9 8 7 6 5 4 3 2 1

Library of Congress Cataloging-in-Publication Data is available on file.

Cover design by Kathy Johnson
Cover coasters by Ken Finnigan

ISBN: 978-1-68358-487-2
Ebook ISBN 978-1-68358-488-9

Printed in China

Dedicated to both my mother Sandra Finnigan (nee Del Guidice),
who self-sacrificed throughout life, and my oldest brother, Tom,
who passed away at the end of the manuscript completion.
He inspired this book.
I just wish he was here now.

Contents

AUTHOR'S NOTE

From an early age, I started noticing demolished venerable stadiums and the void left at their ground zero. This seemed both compelling and appalling. Ballparks were a sanctuary, and the demolished ones were a far-off, elusive ideal where I wished I could be. When I was in grade school, my high school-aged brother Tom set out with his baseball-crazed friend on a quest to haul any remaining artifacts from the gutted old Yankee Stadium carcass, while the entire ballpark was being remodeled in 1974-75. This rooted me early on for recognition and reverence of old stadiums. As a ten-year-old in the mid 1970s, I read a magazine classified section advertising old Ebbets Field bricks. I knew the venue must have been a unique attraction for its rubble to be sold a decade and a half beyond its shelf life. After becoming a young adult, I walked through the former ballpark's neighborhood and squarely in front of the apartment complex that replaced the baseball shrine. There was a noticeable aura in the surroundings, and although it was leveled twenty-five years earlier, the subtle atmosphere of the ballpark pervaded, with older adjacent construction hanging on by a thread. Two years later, I visited the Polo Grounds apartments and came away with the same familiar traces of atmosphere surrounding this former landmark. The ambience of these old ballparks seemed to faintly live on, even in their absence.

As an apprentice bricklayer in younger days, I used masonry blocks to build. To hear of ballparks dismantled in piles of brick shards seemed like an ironic twist of fate. Later, trying home brewing, I was inspired by a unique branding idea that combined passions for torn-down ballparks and the blossoming craft beer industry. The name Classic Park Brew® was conceived. If the release of a full line of beers proved too costly, I would commemorate the lost ballparks with a beer coaster, by showing color photos, artifact remnants, and history, similar to a sports card presentation. Each coaster would represent a word-association style of beer that matches the ballpark. With a nostalgic memory of being inside an old stadium while enjoying a cool ale during a hot summer's day baseball game, I designed the concept to help you develop a spark for a ballpark you may never have experienced in person.

ACKNOWLEDGMENTS

To all the people who have helped me pursue this dream of absorbing and explaining razed ballparks, I must show my gratitude. It may have all started with that day of opening my very first pack of baseball cards and then looking at my oldest brother's baseball book collection. He was the original baseball fan in my family, and without him, I likely would have missed this calling. Growing up involved trips to the ballpark with said brother, my father, parents of friends, and my other older brother, even if I "lost" my sunglasses under a seat. A day at the baseball field was expected to be enjoyable, no matter the style of the venue, but the only stadiums that transported me back in time seemed to be the ancient ones. Within twenty years of that first baseball card, my oldest brother and I took regional trips to see other now-defunct stadiums and even former ballpark sites. On one of those trips, we linked up with my sister and brother-in-law at the fortunately still existing Fenway Park. My mother attended games with me, too, on the West Coast. The friends who have joined me for games are too many to name here. One late friend, who was a soda vendor at Wrigley Field in the 1970s, had told me that my pursuit of this topic was putting me "on to something." Salute to my ex-girlfriend, who never poked fun at my ballpark brick collection in the garage. Professional contacts have been instrumental and propelled the ballparks and beer concept. Trademarking expertise came from Dave Branfman, with a later assist from Mark Reichenthal. Website design expertise came from Randy Hernandez. Lori Varaich provided sage advice. Johann Ammerlahn jump-started a direction for public domain photo implementation. John Schleppi and his wife, Carroll, were generous, specifically regarding their experience at Griffith Stadium. The curator of the National Ballpark Museum, Bruce Hellerstein, was an encouragement and may exceed me on reverence for classic ballparks. Writer Paul Ferrante and his editor of *Sports Collectors Digest*, Jeff Owens, granted me the opportunity to tell some of my story and fuel this endeavor. Linda Wilson's conversations on baseball and her writing example were much appreciated and led to book preparation details provided by Kathy Johnson, who was immensely helpful. Jay Paris, AP/*Coast News*/*Forbes* journalist, wrote my story and has been a lynchpin in getting me to this point and connecting me to Julie Ganz. Thank you to all.

INTRODUCTION

Old baseball stadiums have a multi-generational link, as they persist for long periods. Throughout the twentieth century, billions made visits to their team's home ballpark to enjoy a baseball game while forgetting their daily routines. Stadium visitors came from all surrounding areas. In any given city, the neighborhood ballpark brought people together. They convened to witness the drama that would unfold on the playing field.

Classic urban neighborhood ballparks were located within a network of community city streets, an unexpected spot for a large swath of natural grass. From the outside, the ballparks resembled old warehouses, museums, theaters, factories, and schoolyards. As visitors walked from local sidewalks through the stadium gates, they were greeted by green landscape with reddish-brown infield pathways. Above the field were columns, seats, and views of the local neighborhood, which impressively contrasted with the natural, green turf. The aroma of hotdogs, cigars, mowed ballfield, and beer filled the air.

Gradually, as over a half century elapsed, these monuments showed deterioration. The ballparks and their surrounding neighborhoods became old, obsolete for travel, limited for parking, and costly to provide safety with adequate maintenance. From about the 1970s onward, the opportunities to drive through neighborhood streets to watch a game at these historic venues rapidly dwindled, with stadium after stadium falling to the wrecking ball.

Today, just about all of the old twentieth-century ballparks are torn down, a collection of vanished antiquities. While this loss deprived some fans of the distinctness and joy that these venues generated, a handful of vivid but gradually fading memories remain for those lucky enough to have witnessed the ballparks in person.

Baseball and ice-cold beer are linked together. To represent the combination of the beer and the long-gone stadiums of yesteryear, a descriptive, commemorative beer coaster for each of these famous demolished ballparks is presented as part of the illustrations herein, with the coasters displaying like a baseball card collectible.

The coasters have details about the ballparks, such as years of opening, closing, and demolition, as well as the current use of the site. They also include color photos of the ballparks in their heyday or after they were knocked down. The flip sides present color photos of remaining artifacts and the aftermath of demolition, such as bricks, and other pieces from stadiums, like seats or site grass and dirt. They represent the remaining vestige of the ballparks.

REMEMBERING
Torn-Down BALLPARKS

Arlington Stadium

Starting as Turnpike Stadium for Minor League baseball in 1965, it was upgraded for MLB in 1972, when the Washington Senators became the Texas Rangers and moved to the suburb of Arlington, Texas, just north of the former Arlington Downs racetrack. Simple in construction, it featured one level, sparse shade, and vast outfield bleachers. It had a very hard infield, likely caused by extreme Texas heat. Scorching weather influenced the scheduling of many night games, with sporadic attendance during the heat spells. The stadium, primarily a baseball venue, was symmetrical with average capacity. The field had natural grass surface and small foul territory. An ample parking lot surrounded the ballpark, as little neighboring land-use existed around the stadium, especially in its earlier lifespan. The venue became the first to serve ballpark nachos, starting in the mid-1970s. It added an upper deck behind home plate in 1978 and replaced the Texas-shaped scoreboard in left-centerfield with a higher elevated, wraparound scoreboard in 1984, which covered the top of the outfield bleachers. This scoreboard included multiple billboards attached to it from foul pole to foul pole.

Other Historic Highlights: From this stadium, Nolan Ryan's last no-hitter took place in 1991. The last game played there was October 3, 1993, which also happened to be Kansas City rival George Brett's last game of his career. No MLB World Series, All-Star, or playoff games ever took place during the ballpark's twenty-two seasons as a Major League stadium.

Tombstone Facts:

Location: Arlington, Texas, between Dallas and Fort Worth
Opened: 1965
Closed: 1993
Demolition: 1994
Current use: Part of the site was paved over, with some undeveloped ground, as well as an access road extending through the center of the site. A portion of the land is now set aside for redevelopment, to include a national museum, expected by 2024.

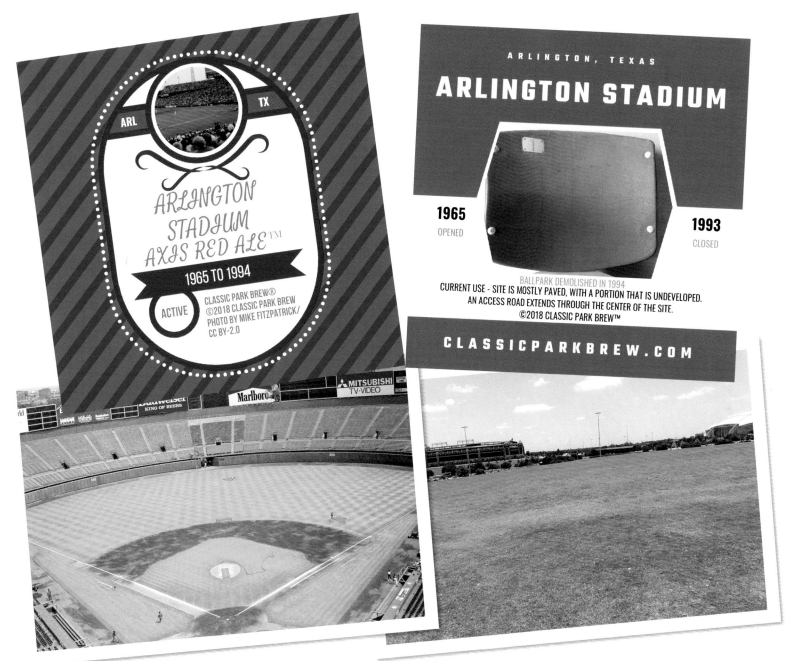

ARL · TX

Arlington Stadium Axis Red Ale™

1965 TO 1994

ACTIVE

CLASSIC PARK BREW®
©2018 CLASSIC PARK BREW
PHOTO BY MIKE FITZPATRICK/
CC BY-2.0

ARLINGTON, TEXAS

ARLINGTON STADIUM

1965
OPENED

1993
CLOSED

BALLPARK DEMOLISHED IN 1994
CURRENT USE - SITE IS MOSTLY PAVED, WITH A PORTION THAT IS UNDEVELOPED.
AN ACCESS ROAD EXTENDS THROUGH THE CENTER OF THE SITE.
©2018 CLASSIC PARK BREW™

CLASSICPARKBREW.COM

Baker Bowl

From the late nineteenth century, the Phillies called this small ballpark their home, located a few blocks from Shibe Park, in Philadelphia's north section, tight against streets and buildings. Built initially with wood, the park caught fire and was rebuilt in 1895, as baseball's first majority steel and brick venue. "Baker Bowl" was never an official name but became a nickname given by a sportswriter circa 1923, to ridicule Phillies owner William Baker. The original name was Philadelphia Baseball Park. In 1913, it changed to National League Park.

With amazingly short right-field dimensions but a very high wall (height was used to offset the puny distance), home run clearance needed sufficient arc. The wall was covered with a huge soap billboard and tin exterior. Requiring constant repairs, the stadium had structural collapses, such as the deadly bleacher failure in 1903. In 1927 a section of stands gave way, causing a few weeks of park closure. A double-decked grandstand extended around the infield. The upper deck vibrated often. Spectators from the lower deck received falling rust, debris, and dirt that was jarred from the overhang when fans above stomped the wood flooring. Upper-deck patrons that sat below the corroded metal roof could endure falling rust when foul balls banged it. During rain, wet soot with rust sometimes seeped through the leaking roof on fans.

An underground train ran below the field. Heckling and gambling existed, but a PA system, permanent lights, and an affiliated car lot did not. Burk's hot dogs and peanuts were staples there.

Other Historic Highlights: The 1915 MLB World Series was played in Baker Bowl, during which Babe Ruth's first World Series appearance occurred. He also played his last game there, in 1935. The first ever Negro League World Series game took place there on October 3, 1924, with other series games in 1925 and 1926. No MLB All-Star games were played inside the ballpark.

Tombstone Facts:

Location: North Philadelphia, Pennsylvania
Opened: 1887
Closed: 1938
Demolition: 1950
Current use: After interim use as racetrack and rink in the 1930s to '40s, the remaining ballpark structure was razed in 1950. Today, the site is occupied by a gas station, with store and car wash venues. In 2000, a marker was placed on Broad Street between Lehigh Avenue and Huntingdon Street—site of the former ballpark's location, in recognition of its important role in state history.

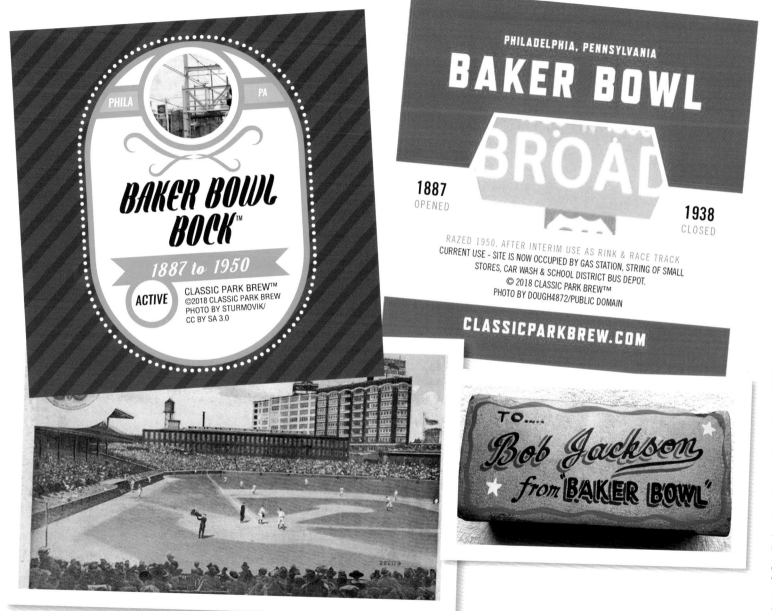

PHILA PA

BAKER BOWL BOCK™

1887 to 1950

ACTIVE — CLASSIC PARK BREW™
©2018 CLASSIC PARK BREW
PHOTO BY STURMOVIK/
CC BY SA 3.0

PHILADELPHIA, PENNSYLVANIA

BAKER BOWL

BROAD

1887
OPENED

1938
CLOSED

RAZED 1950, AFTER INTERIM USE AS RINK & RACE TRACK
CURRENT USE - SITE IS NOW OCCUPIED BY GAS STATION, STRING OF SMALL
STORES, CAR WASH & SCHOOL DISTRICT BUS DEPOT.
© 2018 CLASSIC PARK BREW™
PHOTO BY DOUGH4872/PUBLIC DOMAIN

CLASSICPARKBREW.COM

TO....
Bob Jackson
from "BAKER BOWL"

Boston Beehive

With the Charles River just beyond its outfield and located in the Allston neighborhood, three miles west of Boston Common (a public park in downtown), the Beehive was an unofficial name given to the Boston venue that was mainly known as Braves Field starting with its inaugural year of 1915. The name Beehive became an interim nickname from 1936 through 1940, when the Braves changed their name to the Bees. In 1941 the ballpark resumed as Braves Field, until its closure in 1952.

In its early prime, the ballpark, which was near Fenway Park and across the river from Harvard, had a large playing field, and very deep center field. Then, the lengthy outfield dimensions and large foul territory made it a pitchers park. In the midst of its lifespan, fences were pulled closer in, but river wind often blew directly from the outfield to affect fly balls. Capacity started at forty thousand, dipping slightly below that in its last decade. Seating was on a vast single level, with a grandstand roof covering infield seats. A steep section of stands in right field was given the name "jury box" by a sportswriter.

The Beehive was known to have vocal fans, who had a propensity for beer drinking and gambling. Railroad tracks beyond left field were close enough for home runs to land inside rail cars, and smoke from trains was visible from the stands. In 1946 the ballpark hosted its first night game. Boston fans watched their last hometown National League team play in the 1948 World Series. The fan-favorite food was fried clams.

Tombstone Facts:

Location: West of central Boston, Massachusetts
Opened: 1915
Closed: 1952
Demolition: Jury box, left field pavilion, and scoreboard sections were razed in 1955. Grandstand was demolished in 1959, soon after a Boston College vs. Boston University baseball game.
Current use: After last MLB game in 1952, the ballpark was purchased by Boston University. It was redesigned to all-purpose usage in 1955, which included baseball through 1950s. After grandstand razing in 1959, the site had revised seating, a more rectangular college field for multiple athletics, and pro sports, such as football. Today, it continues as a college stadium for various field sports. The stadium contains a portion of old right field concourse section from the original ballpark, and an old ticket office at the main entrance still stands, serving the Boston University Police Department.

Other Historic Highlights: The 1915, 1916, and 1948 MLB World Series were played there by the Red Sox (1915 and '16, due to larger capacity than Fenway Park) and Braves (1948). The longest game in MLB history took place at the field in 1920, with Brooklyn and Boston taking a 1-1 tie over 26 innings and the game halted due to darkness. The 1936 All-Star Game was played during the first year of the stadium's nickname of Beehive.

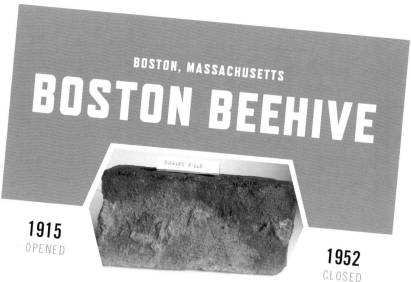

BOSTON, MASSACHUSETTS
BOSTON BEEHIVE

BRAVES FIELD

1915
OPENED

1952
CLOSED

MODIFIED TO MULTI-USE COLLEGE STADIUM IN 1955. GRANDSTAND RAZED 1959
CURRENT USE - SITE IS A BOSTON UNIVERSITY STADIUM, HOSTING COLLEGE &
PRO SPORTS. ORIGINAL STRUCTURE IS RAZED EXCEPT A PORTION OF OLD CONCOURSE.
© 2018 CLASSIC PARK BREW™

CLASSICPARKBREW.COM

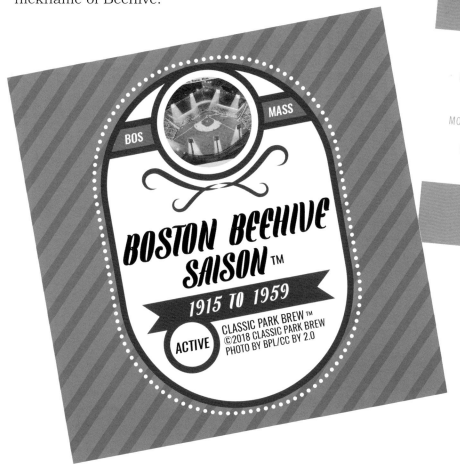

BOS MASS

BOSTON BEEHIVE
SAISON ™
1915 TO 1959

ACTIVE CLASSIC PARK BREW ™
©2018 CLASSIC PARK BREW
PHOTO BY BPL/CC BY 2.0

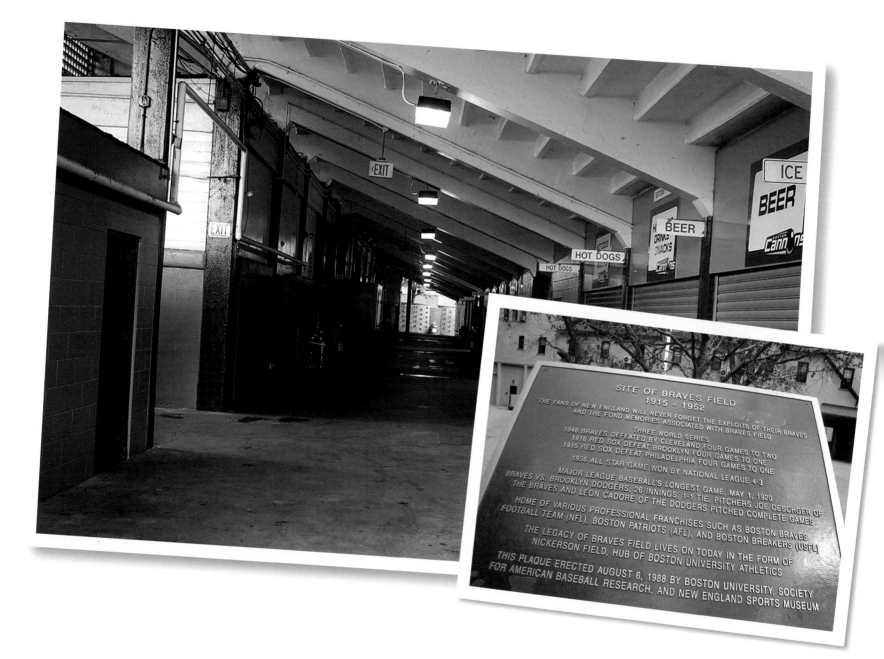

The plaque in the image reads:

SITE OF BRAVES FIELD
1915 - 1952

THE FANS OF NEW ENGLAND WILL NEVER FORGET THE EXPLOITS OF THEIR BRAVES
AND THE FOND MEMORIES ASSOCIATED WITH BRAVES FIELD

THREE WORLD SERIES
1948 BRAVES DEFEATED BY CLEVELAND FOUR GAMES TO TWO
1916 RED SOX DEFEAT BROOKLYN FOUR GAMES TO ONE
1915 RED SOX DEFEAT PHILADELPHIA FOUR GAMES TO ONE

1936 ALL STAR GAME WON BY NATIONAL LEAGUE 4-3

MAJOR LEAGUE BASEBALL'S LONGEST GAME
BRAVES VS. BROOKLYN DODGERS, 26 INNINGS, 1-1 TIE, MAY 1, 1920
THE BRAVES AND LEON CADORE OF THE DODGERS PITCHED COMPLETE GAMES
PITCHERS JOE OESCHGER OF

HOME OF VARIOUS PROFESSIONAL FRANCHISES SUCH AS BOSTON BRAVES
FOOTBALL TEAM (NFL), BOSTON PATRIOTS (AFL), AND BOSTON BREAKERS (USFL)

THE LEGACY OF BRAVES FIELD LIVES ON TODAY IN THE FORM OF
NICKERSON FIELD, HUB OF BOSTON UNIVERSITY ATHLETICS

THIS PLAQUE ERECTED AUGUST 6, 1988 BY BOSTON UNIVERSITY, SOCIETY
FOR AMERICAN BASEBALL RESEARCH, AND NEW ENGLAND SPORTS MUSEUM

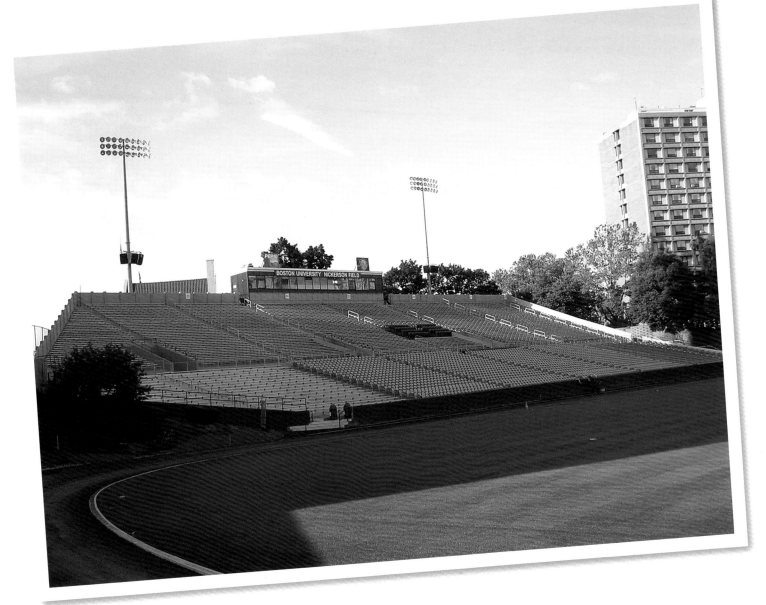

Briggs Stadium

Located in Detroit's Corktown neighborhood since 1912, Briggs Stadium had its name changed to Tiger Stadium in 1961. The building's exterior was white, with blue trim at the top and blue metal doorways at the bottom, resembling a meat-packing plant. At Michigan and Trumbull Avenue, a marquee-style billboard displayed the ballpark name.

Parking was unpredictable. Adjacent spaces were scattered against the stadium. As an alternative, you could park within a nearby front yard by negotiating a fee with neighborhood residents.

In its early days, the park had an open end beyond the outfield. Added second deck outfield seats enclosed the venue in the 1930s. Center-field, upper-deck seats could get filled with thousands of fans within the batter's view, and, at times, spectators shone sunlit pocket mirrors to distract opposing batters. The scoreboard was above these seats.

In its last decades, the interior color scheme was blue, matching the blue (and orange) plastic seats. Prior to that, the wooden seats, roof, interior, and supports were green. Columns, located throughout the stadium, obstructed nearby fans.

The park catered to hitters due to its short dimensions but had a deep center field, where a flagpole was located. The right-field upper deck hung over the lower fence by about ten feet, so home runs could sail a shorter distance there than did those just clearing the fence below. Seats were close to field action.

Even in the stadium's last decade, hot dog vendors applied mustard an old-fashioned way: with a jabbing stick inserted into a mustard jug. The mustard seemed to taste better this way, compared to the plastic mustard packets of today.

Tombstone Facts:

Location: West Detroit, Michigan
Opened: 1912
Closed: 2001
Demolition: 2008
Current use: For a few years after demolition, the site was undeveloped and retained a makeshift baseball field in its original location. Currently, the lot has a commemorative, scaled-down sports venue, as well as onsite buildings. The original diamond location is used as an amateur baseball field by youth, high school, and college teams.

Other Historic Highlights: The 1934, 1935, 1940, 1945, 1968, and 1984 MLB World Series were played there. Game 7 of the 1934 Series was famously delayed at the venue after a melee resulted in opposing player Joe Medwick getting pelted with trash. MLB All-Star games were played there in 1941, 1951, and 1971. Reggie Jackson's 1971 All-Star Game home run is one of the longest and most memorable in the park. It cleared the roof and hit the light tower during the telecast.

DETROIT, MICHIGAN

BRIGGS STADIUM

1912
OPENED

2001
CLOSED

DEMOLITION BEGAN IN 2008 AND WAS COMPLETED IN 2009
CURRENT USE - SITE IS NOW OCCUPIED BY AN AMATEUR BASEBALL FIELD USED
BY YOUTH, HIGH SCHOOL, AND COLLEGE TEAMS.
© 2018 CLASSIC PARK BREW™

DET MICH

BRIGGS STADIUM BROWN ALE™

1912 TO 2008

ACTIVE

CLASSIC PARK BREW™
©2018 CLASSIC PARK BREW
PHOTO BY RICK DIKEMAN/
CC BY SA 3.0

CLASSICPARKBREW.COM

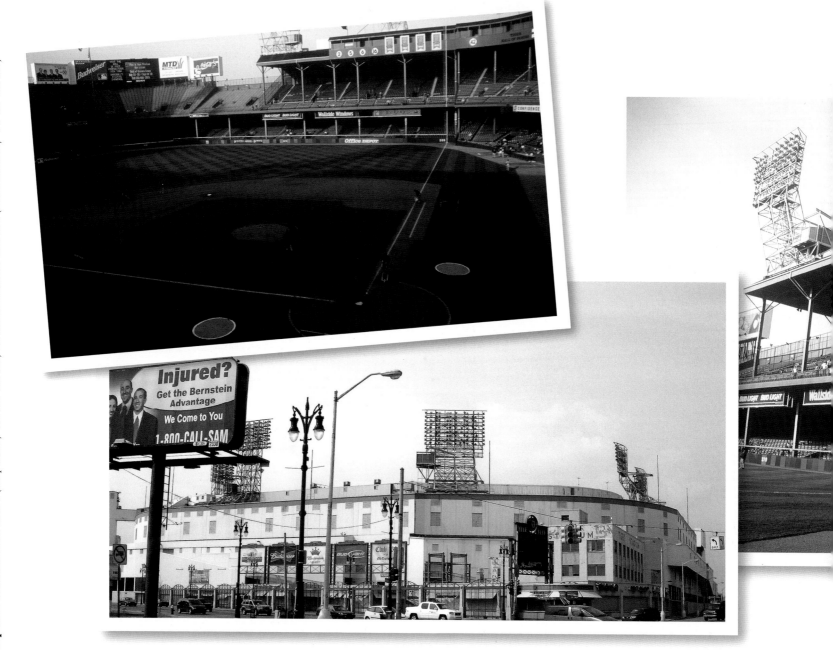

Buffalo War Memorial Stadium

Buffalo War Memorial Stadium, built in 1937 on the east edge of downtown Buffalo, featured a football stadium–sized layout. The baseball field was oddly fit within this oval-shaped edifice, leaving much space between the center-field fence and curved stands behind it.

The park initially housed college football and then minor-level pro football. It was also used by the NFL's Bills, up to 1972. The Triple-A Bisons were the highest-level baseball team to call the stadium home, through the 1960s, and again in the 1980s. Between that time, it was strongly considered for MLB expansion. An MLB exhibition was played in April 1987 between Cleveland and Toronto, with hope that the game would make Buffalo a strong candidate when MLB expanded.

The stadium had a vast single level and long columns supporting a grandstand roof along the third base side. Infield seats were tight against the playing field. Outfield fencing was placed for symmetry, with the shortest distance at the right-field foul line 310 feet away. Seating capacity was about forty-five thousand in its prime. Football fans sat close to the field, especially by the sidelines. They also had very close access to a player entrance called the "Dodge Street" tunnel, where empty beer cans were known to rain down on the opposition. The baseball diamond would sometimes conflict with the football field layout when the two sports had overlapping seasons, and sometimes the pitcher's mound would cause backpedaling football players to trip over the hump. The stadium was called the "Rockpile" in later years, for its eventual ragged condition. Seats were painted gray for the last years of minor league baseball in the 1980s.

Other Historic Highlights: In the stadium on August 19, 1963, an All-Star team from the triple-A minor league defeated the New York Yankees, 5–0. The 1964 and 1966 American Football League title games were played there, with the Buffalo Bills winning the first one against the San Diego Chargers and losing the second one to the Kansas City Chiefs. In 1967, future Reds star Johnny Bench was with the Buffalo Bisons as a home player in the ballpark. The stadium was featured in the 1984 film *The Natural*, capturing the vintage look of the pre–World War II era.

Tombstone Facts:

Location: Near East Side of Buffalo, New York
Opened: 1937
Closed: 1989
Demolition: 1989
Current use: The stadium was razed in 1989, except for two preserved entrances. A high school athletic field is located at the site. The original home plate location is on the playing turf.

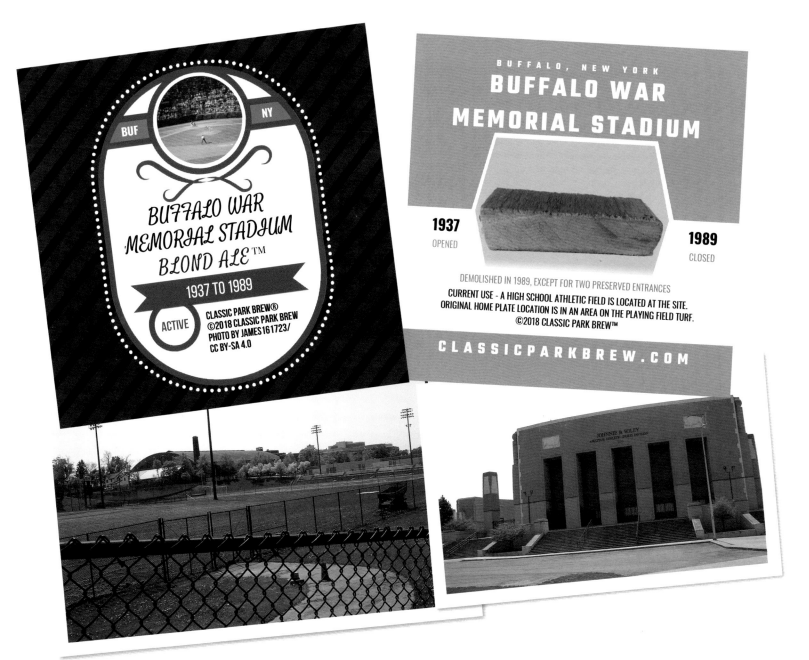

BUF NY

BUFFALO WAR MEMORIAL STADIUM BLOND ALE™

1937 TO 1989

ACTIVE

CLASSIC PARK BREW®
©2018 CLASSIC PARK BREW
PHOTO BY JAMES161723/
CC BY-SA 4.0

BUFFALO, NEW YORK
BUFFALO WAR MEMORIAL STADIUM

1937
OPENED

1989
CLOSED

DEMOLISHED IN 1989, EXCEPT FOR TWO PRESERVED ENTRANCES

CURRENT USE - A HIGH SCHOOL ATHLETIC FIELD IS LOCATED AT THE SITE.
ORIGINAL HOME PLATE LOCATION IS IN AN AREA ON THE PLAYING FIELD TURF.
©2018 CLASSIC PARK BREW™

CLASSICPARKBREW.COM

Bottom left: Current site (Fortunate4now/ Public Domain) **Bottom right:** Restored entrance (Fortunate4now/ Public Domain)

Candlestick Park

Amid wind, fog, cold, and blustery weather, this stadium was located by Candlestick Point, overlooking San Francisco Bay. The exterior had a protruding concrete rim. The ballpark started with an open outfield and lower bleachers in 1960 but was enclosed with the addition of an outfield upper deck in the early 1970s. At about the same time, the park started using synthetic turf but discontinued its use by the end of the decade. The outfield seat expansion gave the stadium more of an enclosed bowl appearance and raised capacity from the low–forty thousands to mid–fifty thousands. Features included a large foul territory and dimensional symmetry.

It was not a hitter's park, and chilling winds hindered home-run output. For most of the ballpark's history, the home-run fence was wire chain-link with attached distance signage. Highlight reels often showed fans retrieving home runs by bolting in the open space between the bleachers and fence.

The park had a mix of styles. While it had a curved seating bowl, like late-twentieth-century stadiums, it also had older-style pole supports. The poles were positioned behind most of the seating underneath the second deck, however, which avoided the early-twentieth-century obstruction issues. The damp salt air and gusty winds also gave the interior concrete and hardware a weathered look.

Parking was simple with the large lots, but when exits were crowded, bottlenecks formed. A slight incline went from the parking lot to the ballpark, which was accentuated by the double escalators at the park entrance. From its middle years forward, Candlestick Park featured the color red on the trim and plastic seats.

Occasionally, the park lived up to a rowdy image, as skirmishes sometimes flared, likelier in the outfield bleachers when the rival Dodgers came to town. It was also common to see discarded hot dog wrappers blown in all directions from swirling winds.

Tombstone Facts:

Location: Western shore of San Francisco Bay, California
Opened: 1960
Closed: 2014
Demolition: 2015
Current use: After seat removal began in late 2014 and full demolition started a year later, the site was cleared for development. Earliest plans were for a town square full of shops, entertainment, and a living center.

Other Historic Highlights: The 1962 and 1989 MLB World Series were played at Candlestick. One of the most dramatic endings in World Series history occurred there in 1962, when the Giants' Willie McCovey hit a two-out, screaming line drive directly at the second baseman, with a winning runner in scoring position, to end the game and season. The 1989 Bay Area World Series between the Giants and Oakland A's endured an earthquake that postponed Game Three at the ballpark, just before it started. The 1961 and 1984 All-Star Games took place in the stadium.

SAN FRANCISCO, CALIFORNIA

CANDLESTICK PARK

1960
OPENED

2014
CLOSED

SEAT REMOVAL BEGAN LATE 2014. FULL DEMOLITION 2015
CURRENT USE - SITE IS NOW CLEARED FOR DEVELOPMENT OF TOWN SQUARE
RETAIL, SHOPPING, ENTERTAINMENT AND LIVING CENTER.
© 2018 CLASSIC PARK BREW™

CLASSICPARKBREW.COM

SF CA

CANDLESTICK PARK CHILLY ALE™

1960 TO 2015

ACTIVE CLASSIC PARK BREW™
©2018 CLASSIC PARK BREW
PHOTO BY DAVID PRASAD/CC
SA-2.0

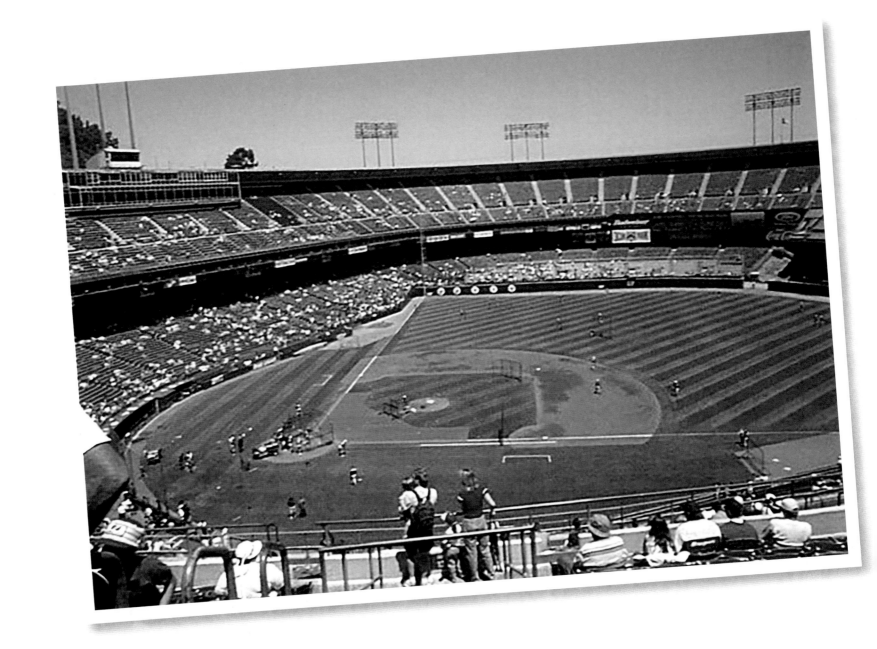

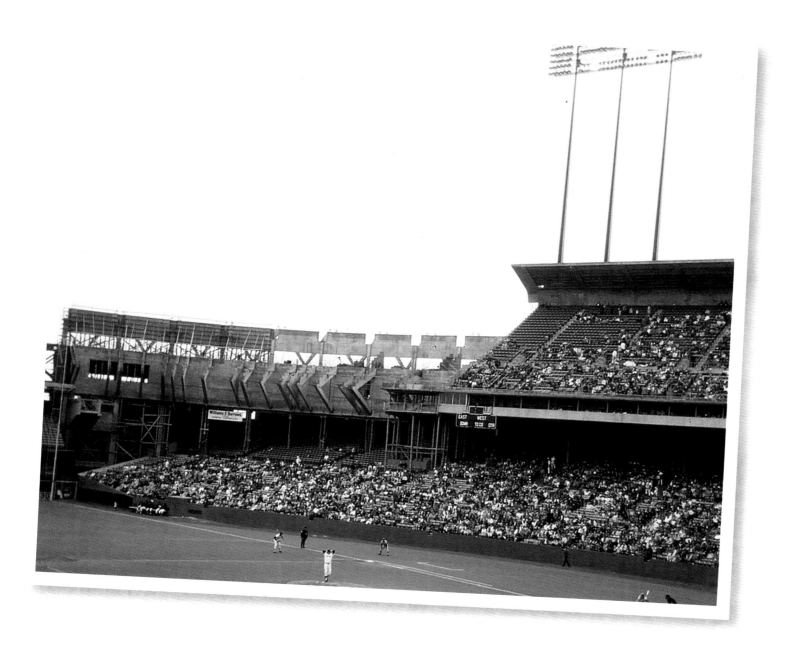

Cleveland Municipal Stadium

The stadium was located off the banks of Lake Erie, with early spring cold winds causing frigid conditions for this Rust Belt ballpark. Built in the early 1930s, it initially was one of two Cleveland ballparks, until 1947, when it became the sole home field. It was large in size and capacity, unlike the vacated League Park, which still functions as a restored amateur baseball park. Built to attract the Olympics, it was an early pioneer of the multisport stadium design. By the 1990s, it had the look of an earlier era, with its old brick veneer that created the weathered brown/tan color, the myriad outdated windows on the exterior, and the previous team logo caricature of Chief Wahoo affixed on the building, as a cartoonish Native American representation for a team called the Indians.

Not many attractions or activities were in the immediate surroundings. Parking lots were readily available, and crowds were often smaller, which gave fans a chance to move from seat to seat. Green and blue wooden seats in the pre-1970s eventually became red and yellow plastic seats. The outfield was vast with symmetry. Sitting high in the upper deck gave one a hazy panorama outside the park, with nothing distinct to focus on beyond the center-field bleachers and scoreboard, though a few seats had a glimpse of the lake on a clear day. Over decades, the center-field distance was shortened to a more hitter-friendly 400 feet. There were columns in this double-decked stadium, with very long ones supporting the wraparound grandstand roof. When crowds were minimal, the supports were less obstructive, as most spectators sat in front of them. In the last few years, the facility seemed rustic or simply dated. Food vendors were kept busy by some fans, who demanded free-flowing beer and hot dogs on constant call.

Tombstone Facts:

Location: Downtown lakefront, Cleveland, Ohio
Opened: 1931
Closed: 1995
Demolition: 1996
Current use: Demolition started in 1996 and completed in 1997. The site has been occupied by a professional football stadium since 1999. Old stadium debris was submerged in Lake Erie.

Other Historic Highlights: The 1920, 1948, and 1954 MLB World Series were played there, and it was where Joe DiMaggio's 56-game hitting streak ended in July 1941. Games for the Negro League World Series took place there in 1945 and 1947. On June 4, 1974, ten-cent beer night became a forfeit after fans mobbed the field. On April 8, 1975, Frank Robinson became the first African American manager at the park and hit a home run as player-manager. The 1935, 1954, 1963, and 1981 MLB All-Star Games were played there.

CLEVELAND, OHIO
CLEVELAND MUNICIPAL STADIUM

1931 OPENED

1995 CLOSED

DEMOLITION STARTED IN 1996, AND COMPLETED IN 1997
CURRENT USE - SITE IS OCCUPIED BY NEW FOOTBALL STADIUM SINCE 1999.
OLD STADIUM DEBRIS WAS SUBMERGED IN LAKE ERIE.
© 2018 CLASSIC PARK BREW™

CLASSICPARKBREW.COM

CLEVE — OHIO

Cleveland Municipal Stadium Crisp Ale™

1931 TO 1996

ACTIVE

CLASSIC PARK BREW™
©2018 CLASSIC PARK BREW
PHOTO-WASTED TIME R/
CC BY-3.0

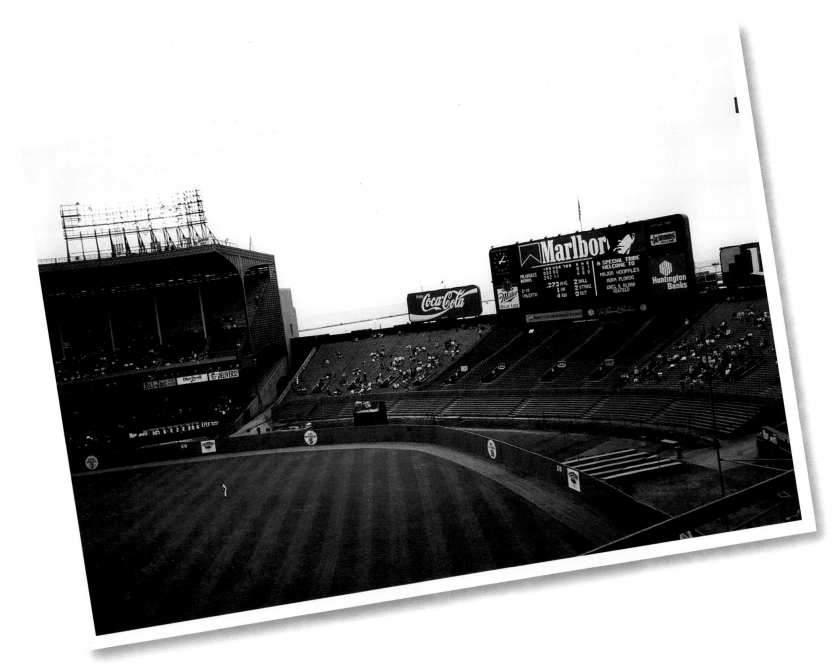

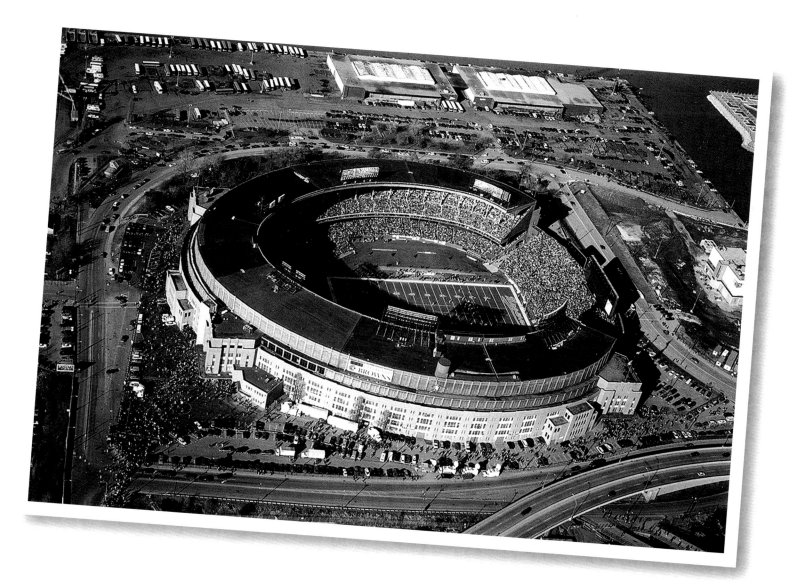

Colt Stadium

This interim Houston venue was built quickly in 1962, for the Colt 45s expansion team, just prior to rebranding as the Astros and moving to the nearby Astrodome in 1965. It was built with a single uncovered level, exposing fans to heat, especially during summer. The stadium was so hot that the Major League commissioner curbed a rule and allowed the team to play its Sunday home games at night. Mosquitos often invaded the stands, as a result of the humid climate and pooling water at the Astrodome construction site. The ballpark had a no-frills, baseball-only feel, with some newer attributes of the era. For example, seating had a colorful mix of flamingo red, burnt orange, yellow, pink, turquoise, purple, and chartreuse. The bright color scheme even spread to the dugout, outfield fencing, and exterior. Commercial billboards were affixed to outfield fences. A basic field-level scoreboard in center field had a large black section in the middle. Dimensions were vast and more helpful to pitchers. Some players complained of poor lighting. Capacity was in the low–thirty thousands, with parking lots adjacent to the stadium.

After its last season in 1964, the stadium was occasionally used by the Astros as a training site. Later, in the early 1970s, it was abandoned, with just a few stadium parts remaining and contained junk storage from the nearby AstroWorld amusement park.

Other Historic Highlights: No postseason or All-Star games were played there, but two no-hitters were thrown at the ballpark. The Houston Colt 45s won their last game at Colt Stadium on September 27, 1964, with a 1–0 win over the Dodgers in 12 innings.

Tombstone Facts:

Location: South Houston, Texas
Opened: 1962
Closed: 1964
Demolition: Dismantling began in 1970, following seat and banner removal. New ownership by a Mexican team (Union Laguna) took over the stadium in 1971 and accelerated the demolition and shipping of stadium parts to Torreón, Mexico. This continued up to the mid-1970s, and the parts were used for another ballpark in 1975.
Current use: Throughout the 1980s and '90s, the site was a blacktop parking area for the nearby Astrodome. It is now within a massively developed area that replaced the old blacktop and its surroundings, with a large complex that includes a sports stadium, arena, and convention center. The former ballpark's footprint is in the northwest section of that land parcel, nearest to the convention center.

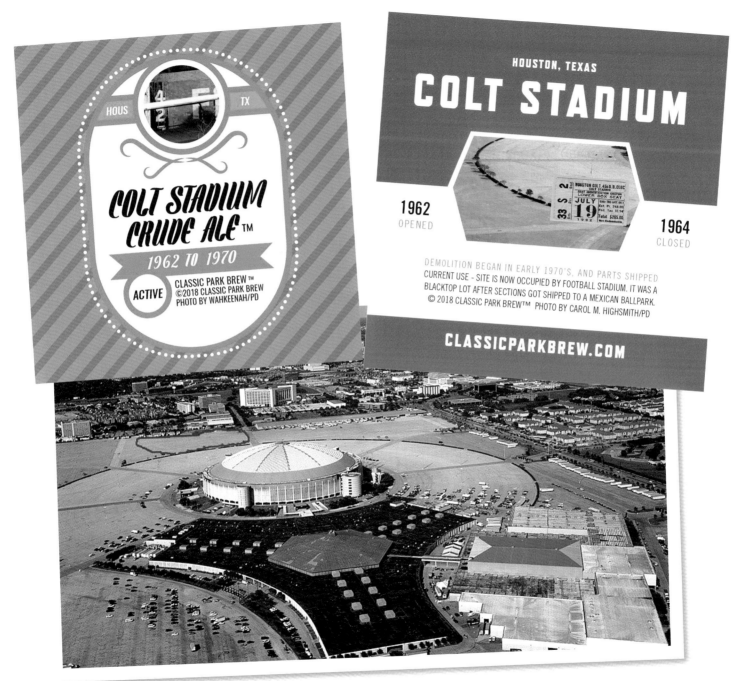

HOUS · 42 · TX

COLT STADIUM CRUDE ALE™

1962 TO 1970

ACTIVE · CLASSIC PARK BREW™
©2018 CLASSIC PARK BREW
PHOTO BY WAHKEENAH/PD

HOUSTON, TEXAS

COLT STADIUM

1962
OPENED

1964
CLOSED

HOUSTON COLT 45s B. B. CLUB
COLT STADIUM
SEAT IDENTIFICATION COUPON
LOWER BOX SEAT
33 S 2
JULY 19
1962

DEMOLITION BEGAN IN EARLY 1970'S, AND PARTS SHIPPED
CURRENT USE - SITE IS NOW OCCUPIED BY FOOTBALL STADIUM. IT WAS A
BLACKTOP LOT AFTER SECTIONS GOT SHIPPED TO A MEXICAN BALLPARK.
© 2018 CLASSIC PARK BREW™ PHOTO BY CAROL M. HIGHSMITH/PD

CLASSICPARKBREW.COM

Former Colt Stadium site near Astrodome, as shown in red marking (Carol M. Highsmith / Public Domain)

Comiskey Park

Legend has it that Babe Ruth would stop at a tavern across the street from this South Side Chicago venue, between doubleheader games. From outside, this structure, built in 1910, looked like a warehouse, with white painted brick, glass block, and arched window openings. Inside, these openings were a familiar feature bisecting the two decks throughout the park.

Access was near the expressway. The vicinity was urban, but the ballpark was slightly apart from residential and commercial activity, with a buffer of surrounding parking lots dating to its very early era. By extending upper deck grandstands in 1927, the outfield was enclosed, except for center field. When a scoreboard was added to this gap in 1951, it filled most of the opening. While this enclosed the stadium further, the grandstand's low roof, small crevice space around the scoreboard, and arched window openings still gave a subtle line-of-vision to the outside.

Columns obstructed some unlucky patrons. Prime capacity was about forty thousand. In the early 1960s, the park was painted white, and exploding pinwheel fireworks were introduced as a scoreboard perk to celebrate White Sox home runs. It was striking to approach the park from behind, as the board appeared blank white, with familiar pinwheel outline. The infield had artificial turf from 1969 to 1975.

For late afternoon or night games, areas under the stands were dimly lit, such as where one might buy a scorecard near concessions. Its old wood seats along foul lines were not positioned toward the plate. In batting practice, the ball echoed after ricocheting from the bat, especially when crowd noise was sparse. The seats, interior walls, fences, and other portions were green, blending well with the grass. Yellow rails separated seat sections. Large foul territory and deep foul lines gave pitchers a benefit.

The stadium was kept in its original state while dismantling was planned. As the longest continuing ballpark without major refurbishing, the park had worn concrete, peeling paint, and ancient troughs in the men's restroom that were extremely rusted. In its last season, the adjacent replacement stadium was visible from inside the old ballpark.

Tombstone Facts:

Location: South Side Chicago, Illinois
Opened: 1910
Closed: 1990
Demolition: 1991
Current use: The site is a parking lot next to the replacement stadium. A marker locates the original home-plate location.

Other Historic Highlights: MLB World Series were played there in 1917, 1919, and 1959. The 1919 Series had members of the White Sox accused of game-fixing. Games for the Negro League World Series took place there in 1943, 1946, and 1947. The park hosted the first MLB All-Star Game in 1933, and then again in 1950 and 1983. The star-filled 1934 Negro League All-Star Game that took place there was among the most riveting.

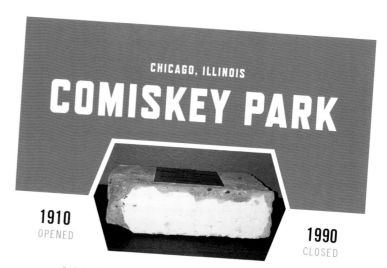

CHICAGO, ILLINOIS

COMISKEY PARK

1910
OPENED

1990
CLOSED

RAZED 1991, WHEN NEW PARK OPENED ACROSS THE STREET
CURRENT USE - SITE IS NOW A PARKING LOT FOR THE NEW BALLPARK OPPOSITE
FROM THE OLD LOCATION. THE OLD HOME PLATE AREA HAS A MARKER.
© 2018 CLASSIC PARK BREW™

CLASSICPARKBREW.COM

CHI IL

COMISKEY PARK CREAM ALE™

1910 TO 1991

ACTIVE CLASSIC PARK BREW™
©2018 CLASSIC PARK BREW
PHOTO BY RICK DIKEMAN/
CC BY SA 3.0

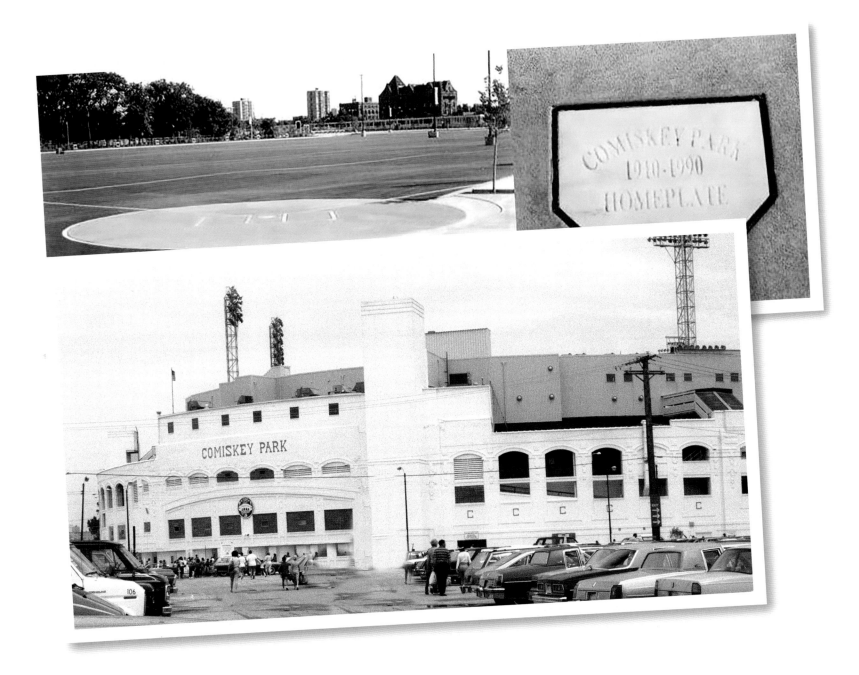

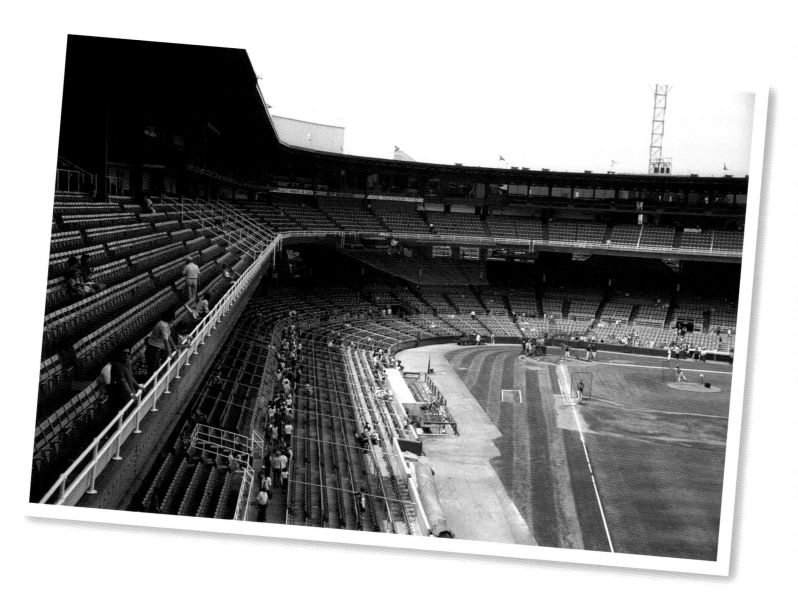

County Stadium

Located near the Story Hill neighborhood in Milwaukee, this ballpark saw large crowds and immediate MLB success upon the Braves' relocation from Boston in the early 1950s. After the Braves left Milwaukee, a new team, the Brewers, called this ballpark home from 1970 on. Built in 1953 with symmetrical middle-sized dimensions, it had two seating levels. The exterior was a combination of brick below and gray siding above, with a simple ballpark name identifier high up on the surface. The park was a mix of an older column-support style and a slightly rounded later-twentieth-century bowl. Between the 1950s and 1970s, more seating was added down each foul line. Nearby turnpikes gave cars a route to the stadium, which had ample parking around it. The far-removed neighboring area was dense suburbia.

Even with its peak capacity in the low–fifty thousands, the ballpark had a cozy atmosphere, with seats close to the field. The outfield was open and allowed views of some trees and the neighborhood outskirts beyond the bleachers and parking lot. Wood seats were faded blue-green and red-orange. An original red railing separated the front row from the field. In later years, the park had an older, vintage appeal. One noted feature was an oversized mock beer barrel and mug of brew, just below a dwelling perch in the outfield. When home runs were hit by the Brewers, a character named "Bernie Brewer" would slide down a chute aimed into the stein. A basic scoreboard stood behind the right field bullpen. The stadium was also known for tasty bratwurst, and fresh beer was abundant, with hardworking vendors pouring refills. The smell of grilling and brew permeated the air.

Tombstone Facts:

Location: West side of Milwaukee, Wisconsin
Opened: 1953
Closed: 2000
Demolition: 2001
Current use: Part of the site is a large parking lot next to the replacement stadium, with a marker identifying the original home-plate area; another part is a miniature baseball park that was designed for Little League use.

Other Historic Highlights: The 1957, 1958, and 1982 MLB World Series were played there, as were the 1955 and 1975 MLB All-Star games. While playing in County Stadium on July 20, 1976, Hank Aaron hit his last home run, number 755.

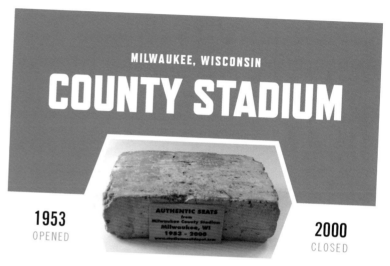

MILWAUKEE, WISCONSIN
COUNTY STADIUM

1953 OPENED

AUTHENTIC SEATS from Milwaukee County Stadium Milwaukee, WI 1953 - 2000

2000 CLOSED

RAZED 2001, WHEN NEW PARK OPENED ACROSS THE STREET
CURRENT USE - SITE IS NOW OCCUPIED BY A LITTLE LEAGUE BASEBALL PARK.
© 2018 CLASSIC PARK BREW™

CLASSICPARKBREW.COM

MIL WI

COUNTY STADIUM CLASSIC ALE™

1953 TO 2001

ACTIVE

CLASSIC PARK BREW™
©2018 CLASSIC PARK BREW
PHOTO BARREL MAN
SAMMY/CC SA-2.0

Crosley Field

This modest-sized ball yard was located in Cincinnati's western section starting in 1912. Arriving spectators could watch and smell peanuts roasted by a noted vendor outside. As a two-level, lower capacity park, it seated fans close to the field. The left-field foul line was much shorter than right-field line and made the venue a better hitting park for right-handed pull hitters. The ballpark's brick exterior was painted white in the 1960s, and the interior and seats were red and green. A high in-play tilt-up scoreboard was located in left field and had advertisement signs attached to the top and bottom. It could knock down hard line drives that didn't arc high enough. Less-powerful, higher-looping fly balls could land over it for a home run. The park did not have an outfield dirt warning track; instead, the area near the fence slanted upward. A slanted terrace in left field was the steepest of the inclines. A right-field bleacher, called the "sun deck" or "moon deck" depending on the time, accounted for the only outfield seating in fair territory. Spectators looking behind outfield fences had great open views of nearby hillsides, rooftops, and neighboring scenery.

For most of its lifespan, the area just beyond outfield fences was crowded with various commercial dwellings, such as for laundry and engineering. These structures nearly touched the back of the home-run fence. By the mid-1960s, this area became more desolate when surrounding buildings were cleared for parking lots around the venue. A huge interstate project also began directly behind the fences, which were slightly elevated to obscure the construction. The ballpark retained its authentic original look in its last years, although the immediate area around the park had become more vacant because of the parking lots and turnpike.

Other Historic Highlights: It had the first official MLB night game, played on May 24, 1935. The MLB World Series was played there in 1919, 1939, 1940, and 1961, and the venue hosted the 1938 and 1953 All-Star Games. The Houston Astros' Jimmy Wynn hit a Crosley Field home run so far in 1967 that it landed on the interstate.

Tombstone Facts:

Location: West end of Cincinnati, Ohio
Opened: 1912
Closed: 1970
Demolition: 1972
Current use: After serving as a car impound location just prior to demolition in 1972, the site had commercial buildings and also an extensive historic display with murals and commemorative markers of home plate and bases. A continuation of an existing street also extends through the old site.

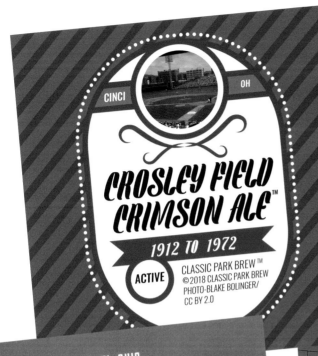

CINCI OH

CROSLEY FIELD CRIMSON ALE™

1912 TO 1972

ACTIVE CLASSIC PARK BREW™
© 2018 CLASSIC PARK BREW
PHOTO-BLAKE BOLINGER/
CC BY 2.0

CINCINNATI, OHIO

CROSLEY FIELD

Crosley Field

1912
OPENED

1970
CLOSED

DEMOLITION IN 1972, AFTER SERVING AS CAR IMPOUND
CURRENT USE - SITE IS NOW OCCUPIED BY COMMERCIAL BUILDINGS AND HAS A
HISTORIC DISPLAY WITH MURAL. A NEW STREET ALSO EXTENDS THROUGH SITE.
© 2018 CLASSIC PARK BREW™

CLASSICPARKBREW.COM

Top: Home plate marker (w_lemay/Public Domain) **Bottom:** Crosley's old light post (w_lemay/Public Domain)

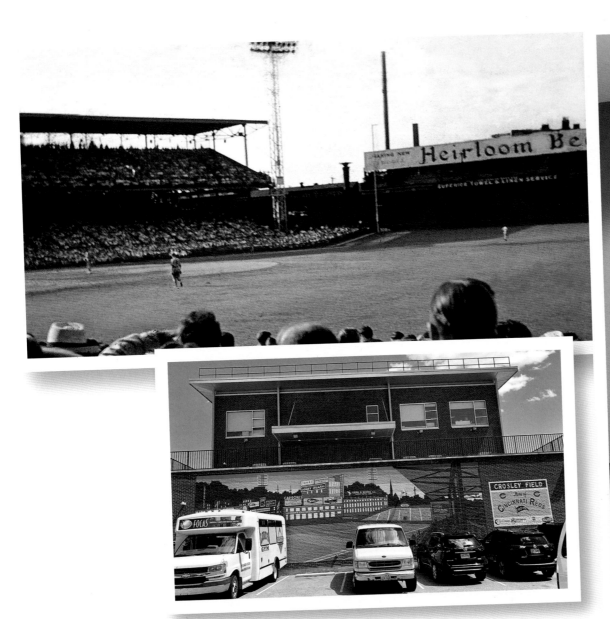

SITE OF THE
CINCINNATI REDS
HISTORIC

CROSLEY
FIELD

Ebbets Field

Built in 1913, this small ballpark was located in one of New York City's five boroughs, Brooklyn, in a central section called Flatbush, on a city block between neighborhood streets. A mix of apartments and businesses were next to the park. It had distinct red bricks at the front facade, patterned with arched windows, and the ballpark name marquee at the top. A section of tan brick was on the exterior behind the left-field stands.

For those who did not use public transit, parking was limited to a small lot of a few hundred spaces next to the field or hit-or-miss curbside parking. A tall rotunda with a marble interior stood as the main entrance; fans continued underneath the stands before taking a portal to the aisles. The stadium was double-decked except for right field, which had a tall, concave wall and no stands beyond it. The wall contributed to odd baseball ricochets, as did the black scoreboard in the middle of the wall. Dimensions and capacity were compact.

Seats were blue, and a red railing ran throughout. Colorful billboards lined the outfield walls, except the black center-field wall that served as a batter's eye. At the base of the scoreboard, a sign had an offer for free suits to any hitter who struck it on a fly. Fans sat close to the action and were known to be animated. A ragtag band called the Sym-Phony burst into song to mock umpires or players. Hilda Chester, a lady with a cowbell and booming voice, was a renowned character.

Some fans watched games from apartment rooftops beyond right field, just across the street from the ballpark. Home runs often sailed over the right-field wall onto Bedford Avenue, where cars travelled, and souvenir hunters clustered in the street, by a nearby gas station, to find the ball.

> ## Tombstone Facts:
>
> **Location:** Flatbush section of Brooklyn, New York. The current city boundaries place the site in Crown Heights.
> **Opened:** 1913
> **Closed:** 1957
> **Demolition:** 1960
> **Current use:** By 1960 the new property owner had planned to build apartments, along with a Little League stadium, but the amateur field was never built. The site is occupied by high-rise apartments that comprised the largest state-subsidized housing complex in New York City when constructed in 1962. The city defines it as public housing, even though privately owned, due to the subsidy, with affordability criteria to inhabit. Ironically, a sign posted in the complex reads, NO BALL PLAYING ALLOWED.

Other Historic Highlights: The 1916, 1920, 1941, 1947, 1949, 1952, 1953, 1955, and 1956 MLB World Series were played there. It was the site of Jackie Robinson's season-opening game on April 15, 1947, when he became the first African American to enter MLB. The 1949 All-Star Game was played there. After ballpark closure, Satchell Paige pitched in an exhibition game there in August 1959. A youth league game followed in September, in what is considered to be its last organized baseball contest.

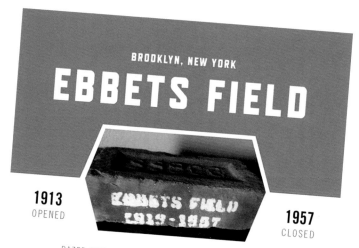

BROOKLYN, NEW YORK

EBBETS FIELD

1913 OPENED

EBBETS FIELD 1913-1957

1957 CLOSED

RAZED 1960. LAST BASEBALL GAME(EXHIBITION) SEP 59
CURRENT USE - SITE IS NOW OCCUPIED BY HIGH RISE APARTMENTS IN A PUBLIC HOUSING COMPLEX. A SIGN IN THE COMPLEX STATES THAT NO BALL PLAYING IS ALLOWED.
© 2018 CLASSIC PARK BREW™

CLASSICPARKBREW.COM

BKLYN NYC

EBBETS DODGY IPA™

1913 TO 1960

ACTIVE

CLASSIC PARK BREW™
©2018 CLASSIC PARK BREW
PHOTO BY ACACIA CARD
CO./DEFUNCT

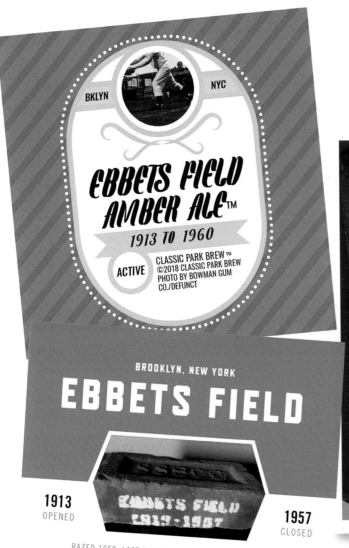

BKLYN NYC

EBBETS FIELD AMBER ALE™

1913 TO 1960

ACTIVE CLASSIC PARK BREW™
©2018 CLASSIC PARK BREW
PHOTO BY BOWMAN GUM
CO./DEFUNCT

BROOKLYN, NEW YORK

EBBETS FIELD

1913
OPENED

EBBETS FIELD
1913-1957

1957
CLOSED

RAZED 1960. LAST BASEBALL GAME(EXHIBITION) SEP 59
CURRENT USE - SITE IS NOW OCCUPIED BY HIGH RISE APARTMENTS IN A PUBLIC
HOUSING COMPLEX. A LITTLE LEAGUE STADIUM ORIGINALLY PLANNED AS PART
OF THE SITE WAS NEVER BUILT.
© 2018 CLASSIC PARK BREW™

CLASSICPARKBREW.COM

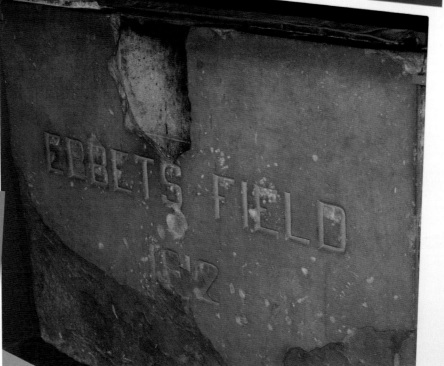

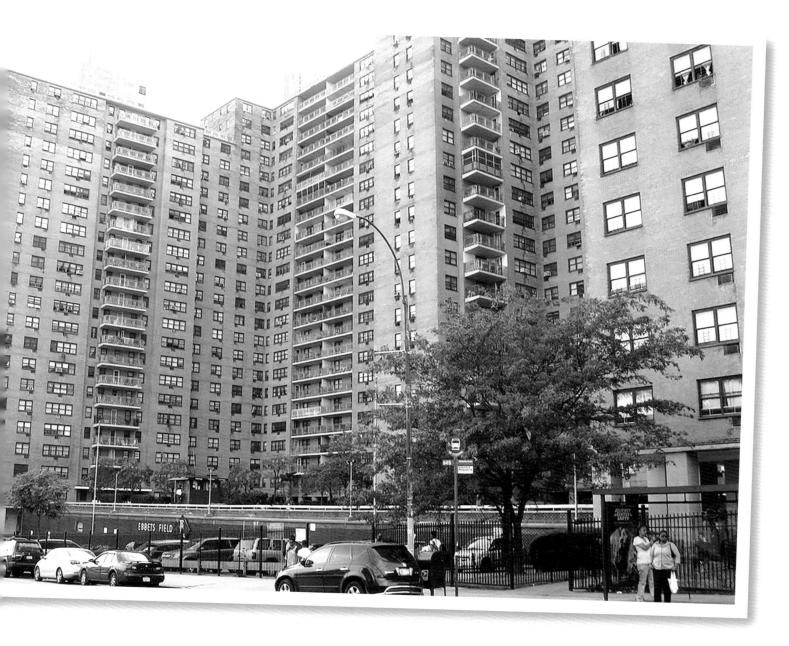

Exhibition Stadium

Located by Lake Ontario's shoreline in Toronto, this venue started in 1959 as a natural-grass football stadium and eventually served three sports (football, baseball, and soccer). It had already installed artificial turf about five years before MLB awarded 1977 expansion to Toronto. With its synthetic turf, the stadium, on the surface, resembled most circular multipurpose stadiums, but its hodgepodge seating was geared more for football. From the outside, it looked like an enlarged medical center.

Cold weather affected games played early and late in the season, and one level of seats near the infield and foul lines were unprotected from the elements. Seats were blue plastic and became weather-faded in later years, as did the green artificial grass. During baseball games, some infield seats were closer to the field, but an extended section of roof-covered bleachers towered behind left field and continued far away, toward center field, with the furthest seats about eight hundred feet from home plate. These seats were rarely occupied, but, overall, the park had good baseball attendance. Capacity was in the low–forty thousands. A parking lot was near the stadium, but it was difficult to avoid bottleneck exits, and many used public transit. A scoreboard was located beyond the open-ended right field, and another behind home plate. The stadium was somewhat favorable to hitters, with basic symmetry and hard turf that sped up groundballs. Gusty wind blew wrappers inside, and the green carpet was frequented by lake-dwelling seagulls that fed on discarded snacks. Unfortunately, beer was not as plentiful, until it was finally sold by 1982.

Other Historic Highlights: The first MLB game ever played with snow covering the entire field took place there on April 7, 1977, which also was the first AL game ever played in Canada. No MLB World Series or All-Star games were played there, but four playoff games took place in the 1985 ALCS during a close series that reached Game Seven.

Tombstone Facts:

Location: Just west of downtown Toronto, Ontario Canada
Opened: 1959
Closed: 1989
Demolition: 1999
Current use: After a decade of spare use from 1989 to 1999 and then demolition in 1999, the site was converted to an outdoor stadium for multiple professional sports in 2007. The adjacent parking lot has the marked bases of the old stadium.

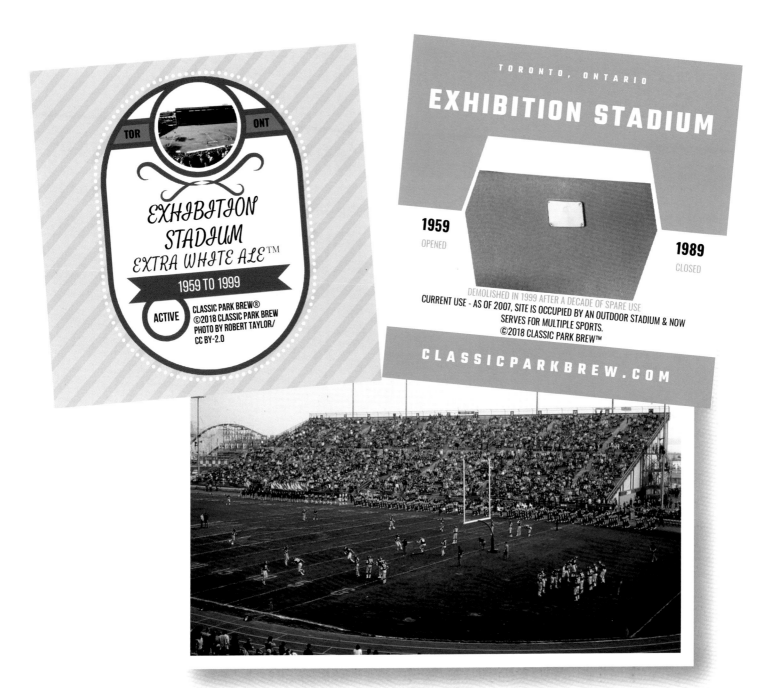

TOR **ONT**

EXHIBITION
STADIUM
EXTRA WHITE ALE™

1959 TO 1999

ACTIVE CLASSIC PARK BREW®
©2018 CLASSIC PARK BREW
PHOTO BY ROBERT TAYLOR/
CC BY-2.0

TORONTO, ONTARIO

EXHIBITION STADIUM

1959
OPENED

1989
CLOSED

DEMOLISHED IN 1999 AFTER A DECADE OF SPARE USE
CURRENT USE - AS OF 2007, SITE IS OCCUPIED BY AN OUTDOOR STADIUM & NOW
SERVES FOR MULTIPLE SPORTS.
©2018 CLASSIC PARK BREW™

C L A S S I C P A R K B R E W . C O M

Exhibition Stadium in 1971 (TorontoGuy79/ CC BY-SA 4.0)

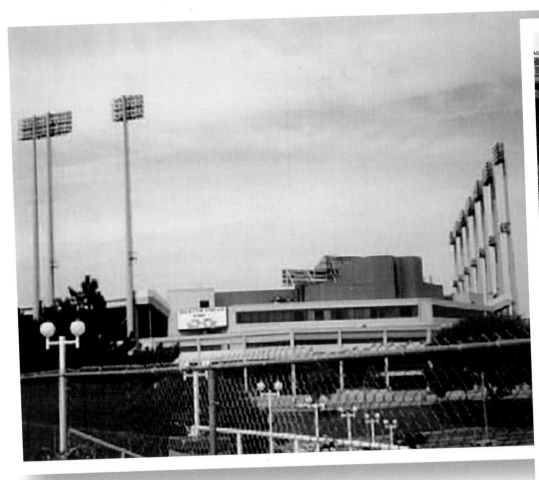

Forbes Field

In Pittsburgh's Oakland section, Forbes was the first full concrete and steel ballpark for the NL in 1909. It had a tan and green exterior, with gold-colored masonry arches and veneer. On the front of the building, large windows were positioned high above, with lime-colored framing, arch inserts, and exposed metal support stanchions on the surface. The ballpark was bordered by streets, except for the outfield area, adjacent to Schenley Park, which afforded views of many trees. Green foliage; wooded, rolling hillsides; structures; and smokestacks were also part of the vista. The left- and center-field walls were brick, with ivy clung to it. The right-field wall was green, with diminished-arch indentations lining the surface. Extended above that wall was an in-play wire screen that long drives caromed against. A high scoreboard in fair territory was positioned at the back of left field's warning track, serving as the home run fence for that location near the foul line.

It was a pitchers' park, as outfield dimensions were deep. Distances were sometimes altered to assist hitters. So deep was center field that a batting cage was placed there during games, and light tower bases were at the wall, along with a flagpole. There were three levels of decking, but the third deck was smaller and placed only behind the infield. Enough separation was between the two lower level sections to see the outside neighborhood. Around the right-field foul pole was an upper deck. There were no seats located beyond the center- or left-field fences. Red rails lined the seating, and many seats were blue. Advertising was virtually non-existent inside. Until 1959 the ballpark allowed fans to enter with beer, but it was never sold. Capacity was in the mid–thirty thousands. The night lights were considered dim. Few parking spaces were available next to the venue. At the end, modern buildings near the ballpark contrasted with its older look. Fans could be boisterous, such as during the last game, when they swarmed the field for ballpark items.

Tombstone Facts:

Location: Just east of downtown Pittsburgh, Pennsylvania
Opened: 1909
Closed: 1970
Demolition: 1971
Current use: The University of Pittsburgh had purchased the lot a few years before the ballpark was razed. The site is mostly occupied by a complex of buildings for the campus. A home-plate marker is located inside a building, and a portion of the outfield wall remains in its original spot next to Schenley Park.

Other Historic Highlights: The 1909, 1925, 1927, and 1960 MLB World Series were played there. Negro League World Series games were also played there in 1942 and 1944. MLB All-Star games took place inside in 1944 and 1959. Babe Ruth hit his last career home run at Forbes Field on May 25, 1935, a tremendous drive that completely left the ballpark. Arguably the most exciting World Series ending happened there in 1960, when Bill Mazeroski of the Pirates hit the game-winning, walk-off home run to end the season.

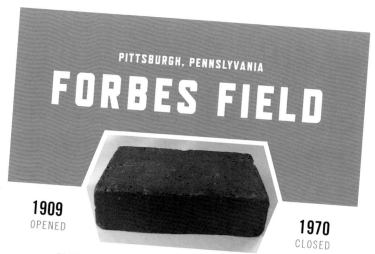

PITTSBURGH, PENNSLYVANIA

FORBES FIELD

1909
OPENED

1970
CLOSED

RAZED 1971. UNIVERSITY OF PITTSBURGH PURCHASED LOT
CURRENT USE - SITE IS NOW A BUILDING COMPLEX OF UNIVERSITY OF
PITTSBURGH CAMPUS. A HOME PLATE MARKER IS LOCATED INSIDE AND A
PORTION OF OUTFIELD WALL REMAINS.
© 2018 CLASSIC PARK BREW™

CLASSICPARKBREW.COM

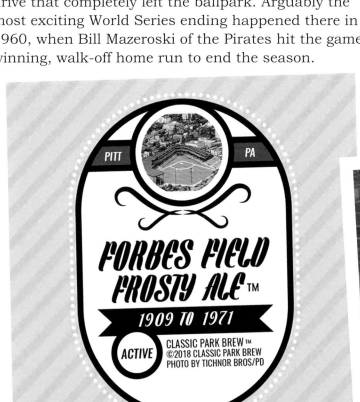

PITT PA

FORBES FIELD FROSTY ALE™

1909 TO 1971

ACTIVE CLASSIC PARK BREW™
©2018 CLASSIC PARK BREW
PHOTO BY TICHNOR BROS/PD

406 FT

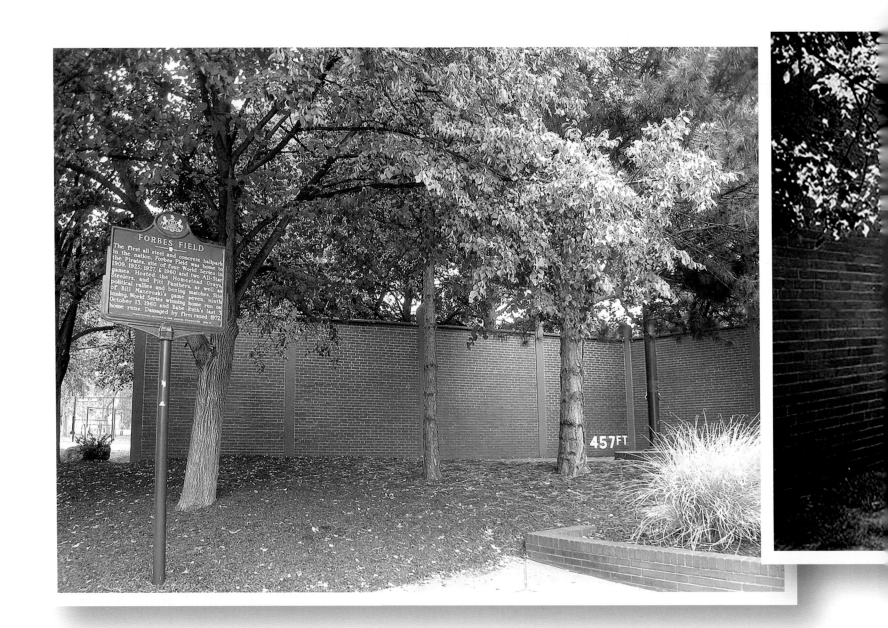

On the sign:

FORBES FIELD

The first all steel and concrete ballpark in the nation, Forbes Field was home to the Pirates, site of four World Series, 1909, 1925, 1927, & 1960 and two All-Star games. Hosted the Homestead Grays, Steelers, and Pitt Panthers, as well as political rallies and boxing matches. Site of Bill Mazeroski's game seven, ninth inning, World Series winning home run on October, 13, 1960 and Babe Ruth's last 3 home runs. Damaged by fire; razed 1972.

457FT

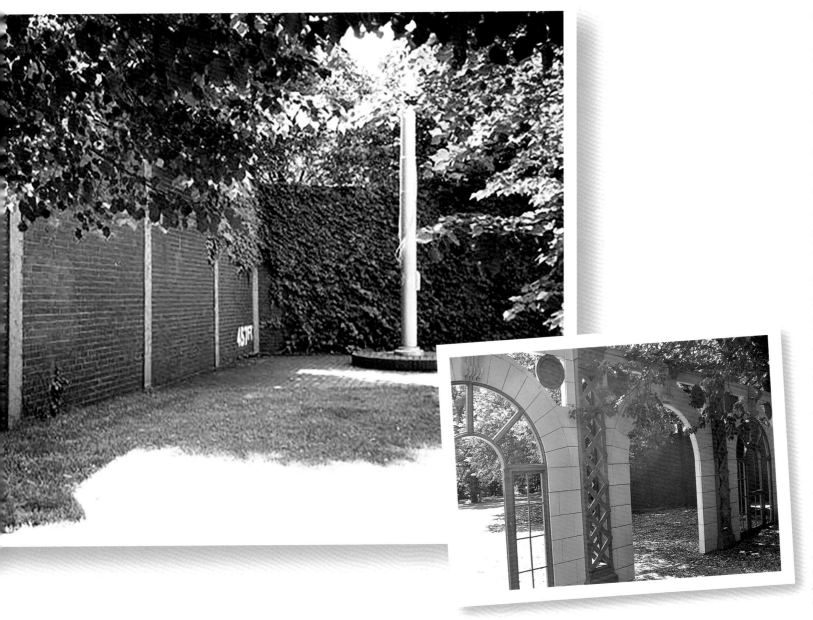

Left: Forbes site marker and remaining wall (Daderot/Public Domain) **Center:** Forbes flagpole and remaining wall (Wahkeenah/Public Domain) **Right:** Forbes recreated entrance (Crazypaco/ CC BY-SA 3.0)

Fulton County Stadium

South of downtown Atlanta, Fulton County Stadium was one of the first circular multipurpose stadiums. Unlike its successors of that type, it did not have artificial turf or replace a previous classic MLB park. In 1966, it became the first MLB venue to operate in the city of Atlanta, and it held a large capacity, in the mid–fifty thousands. With major interstates nearby, the outside had a skeletal look and carried the 1960s trend of parking lots next to the stadium. Given that it had high altitude coupled with common, non-expansive symmetry, the high altitude and the parade of long ball hitters that played there lent it to having the name "launching pad" as many home-team, long-ball hitters struck home runs within the ballpark. Outfield fences initially had a wire-style transparency, and the stands behind it were positioned high atop a back wall, leaving a gap where home runs could land between the fencing and the elevated back seats. In later years, the warning-track dirt took on a white-sand hue, and outfield fences became blue-padded. Seats were blue wood in early years; by the time plastic replaced them, they were blue on the bottom deck and red on top. A small middle section was recessed in between the two larger decks.

The stadium had an enclosed feel, but the authentic grass gave a hint of more tradition than the other round-bowl, synthetic-surface versions. Fans sitting in the highest level, such as above the first base side, could glimpse Atlanta's skyline. Modest advertising signage appeared on outfield fencing and back walls, though larger billboards sat alongside the wraparound scoreboard, which attached to the top curvature of the upper-deck overhang in the highest reaches of center field.

Other Historic Highlights: The 1991, 1992, 1995, and 1996 MLB World Series were played there. The stadium hosted the All-Star Game in 1972. Hank Aaron hit his record 715th home run over its left-field wall on April 8, 1974. The last game played there was Game Five of 1996 World Series.

Tombstone Facts:

Location: Just south of downtown Atlanta, Georgia
Opened: 1965
Closed: 1996
Demolition: 1997
Current use: Inside demolition started in 1996, and the stadium was imploded in 1997. The site is next to an outdoor stadium and has served as a parking lot, with further plans for a sports or recreation field.

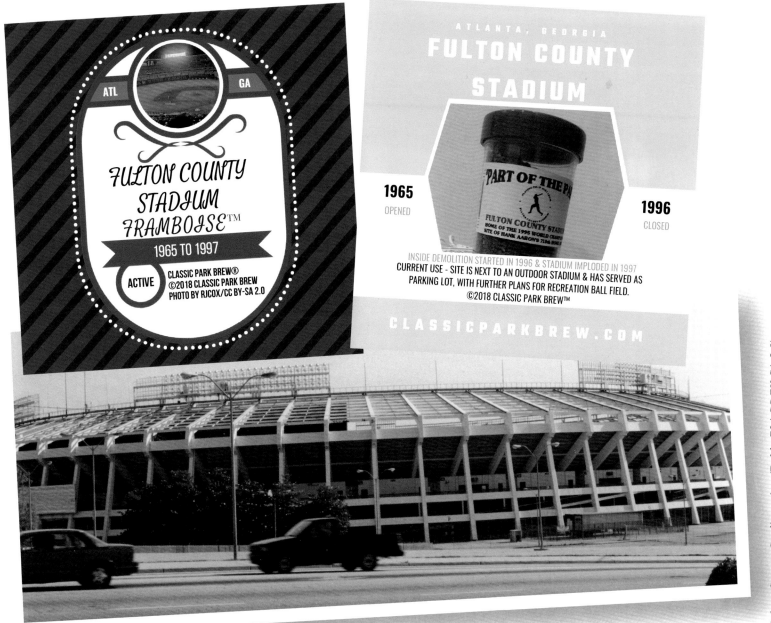

ATL GA

FULTON COUNTY STADIUM FRAMBOISE™

1965 TO 1997

ACTIVE CLASSIC PARK BREW®
©2018 CLASSIC PARK BREW
PHOTO BY RJCOX/CC BY-SA 2.0

FULTON COUNTY STADIUM

1965
OPENED

PART OF THE PA
FULTON COUNTY STADI
HOME OF THE 1995 WORLD CHAMP
SITE OF HANK AARON'S 715th HOME

1996
CLOSED

INSIDE DEMOLITION STARTED IN 1996 & STADIUM IMPLODED IN 1997
CURRENT USE - SITE IS NEXT TO AN OUTDOOR STADIUM & HAS SERVED AS
PARKING LOT, WITH FURTHER PLANS FOR RECREATION BALL FIELD.
©2018 CLASSIC PARK BREW™

CLASSICPARKBREW.COM

Fulton County Stadium view (Bubba73/ CC BY-SA 3.0)

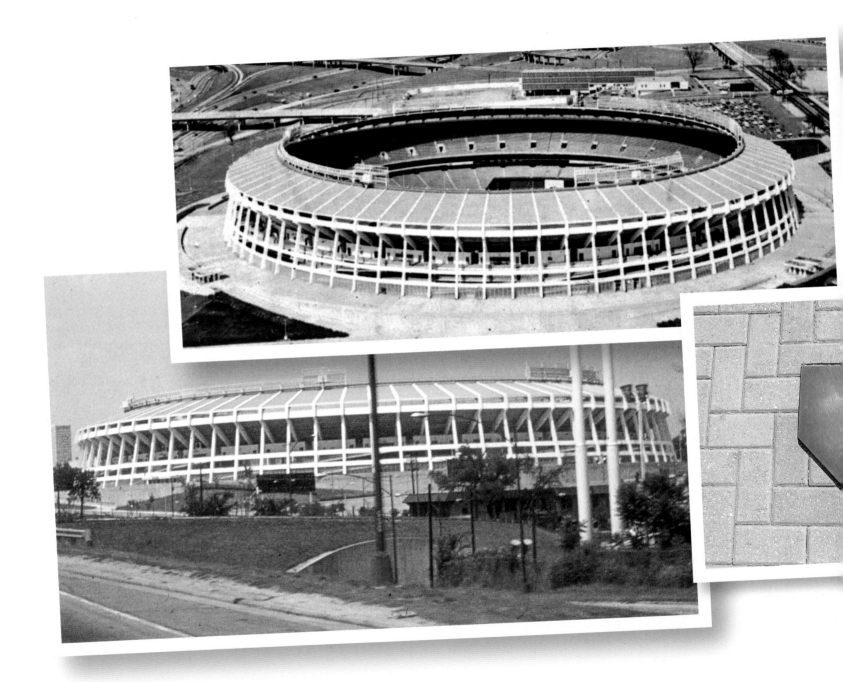

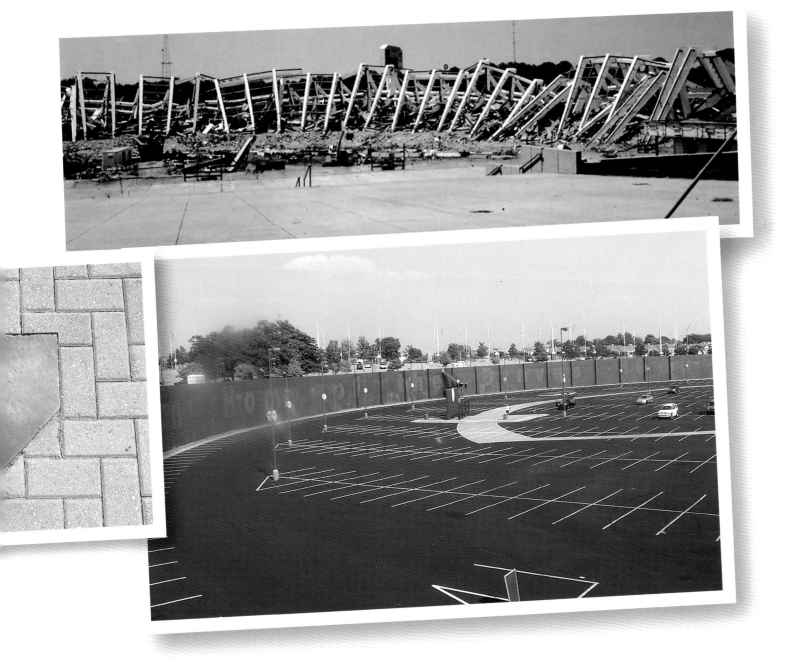

Greenlee Field

Starting in 1932 on slopes above downtown Pittsburgh, this ballpark served seven seasons in the Negro Leagues. It was the first major brick-and-mortar ballpark built by an African American owner, Gus Greenlee of the Pittsburgh Crawfords. Construction was an example of depression-era basics, with high-quality brick masonry. The outside and inside featured red brick. There was a brick facade and arch-style entrances. Interior lower-brick walls separated the first row from the field. Lumber was used for seats, railings, and dugouts. The capacity was about 7,500, and while limited in size, the ballpark provided player locker rooms and showers. It had one level, with a pole-supported covering above seats on the left-field foul line. Dimensions were spacious at the foul lines, and left field sported a notable scoreboard. Beyond the right-field fence stood about ten rows of bleachers. Behind it was a steep incline leading to a property-line wood fence at the top. Stands along the right-field line were roofless, and a gap interrupted the infield seats and right-field-corner seats, perhaps for vehicle access to the playing field. In an era of obtrusive power lines, two above-ground utility poles tucked against the right-field corner stands, with draping wires.

Telephone poles and cables also appeared around the ballpark. A flagpole was in deep center field, and the park enjoyed night lights prior to MLB's evening baseball. PA speakers were used. Attendance grew, especially after the first few years.

Other Historic Highlights: Hall of Fame battery Satchell Paige and Josh Gibson played home games there. Paige pitched a 1932 no-hitter at the park and had two hits. Home to the Pittsburgh Crawfords throughout its time, the Homestead Grays used it as their own during parts of the 1930s as well. Other ballpark events included boxing, football, and soccer.

Tombstone Facts:

Location: Hill District east of downtown Pittsburgh, Pennsylvania
Opened: 1932
Closed: 1938
Demolition: 1938
Current use: The demolition began in December 1938 for a housing project. A housing development still exists on the site today.

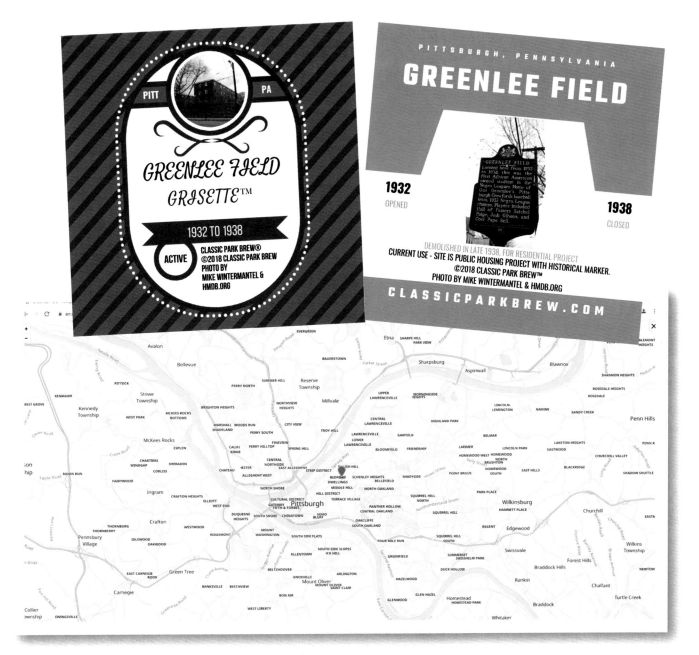

PITT PA

GREENLEE FIELD

GRISETTE™

1932 TO 1938

ACTIVE CLASSIC PARK BREW®
©2018 CLASSIC PARK BREW
PHOTO BY
MIKE WINTERMANTEL &
HMDB.ORG

PITTSBURGH, PENNSYLVANIA

GREENLEE FIELD

1932
OPENED

1938
CLOSED

DEMOLISHED IN LATE 1938, FOR RESIDENTIAL PROJECT
CURRENT USE - SITE IS PUBLIC HOUSING PROJECT WITH HISTORICAL MARKER.
©2018 CLASSIC PARK BREW™
PHOTO BY MIKE WINTERMANTEL & HMDB.ORG

CLASSICPARKBREW.COM

Griffith Stadium

Reconstructed in 1911 after a fire, Griffith Stadium was in a downtown area of Washington, DC. Exterior white color with green panels combined with auburn-hued brick to offer a nonuniform appearance. Behind the home-plate grandstands were disjointed ticket booths and offices, like a string of bungalows and garages springing up next to an old factory building. A series of passages led to a ramp for inside access. The area often had the aroma of baking dough from a nearby bread factory. Nonsymetrical deep dimensions limited home runs, although shortened distances in the last half decade increased home-run output. When balls did travel over fences, they could roll into nearby yards. It had a large field yet small capacity, typically below thirty thousand.

The column-supported double decks down each foul line allowed for views of the surrounding cityscape between levels; surroundings included Howard University, besides the local residences and streets. Most seats were close to the field. Fans in lower seats were treated to treelined views beyond the outfield; spectators in higher levels looked upon neighboring structures. The top infield roof on both sides of the diamond terminated along the foul lines, with a sudden gap, until a more elevated grandstand roof continued after that, exemplifying the park's mismatched features. No seating was beyond the right-field wall. The right-field fence, once filled with signs, was solid green for later decades, the stadium's version of the Green Monster. The seats and walls were also green. The right-field fence sported an attached scoreboard, and large bleachers stood behind the left-field wall. A center-field wall had a sharp angle, formed around a tree with houses that an owner refused to raze.

Beer was not sold until 1956, when the stadium supplied drinking tables in the left-field bleacher area. Oddly, the pre-1956 dry period did feature beer billboards. Briggs hot dogs were sold there. The last decades had sparse crowds. A small car lot was behind the first-base side; otherwise, parking was a challenge on the busy nearby streets.

Tombstone Facts:

Location: Northwest Washington, DC
Opened: 1911
Closed: 1961
Demolition: 1965
Current use: After brief use as a parking lot, several years of abandonment, and then demolition in early 1965, Howard University Hospital has since occupied the site, with a historical marker inside to commemorate the original home-plate location.

Other Historic Highlights: The 1924, 1925, and 1933 MLB World Series were played there, and the stadium hosted the 1937 and 1956 All-Star Games. From 1942 to 1945, the Negro League World Series was played at Griffith Stadium. From there in 1953, one of the all-time longest home runs was hit by Mickey Mantle—an estimated 565 feet—clipping a left-field advertising billboard. Two teams that no longer exist used it as their home–the Washington Senators from opening until early 1960s, and the Homestead Grays in the 1940s.

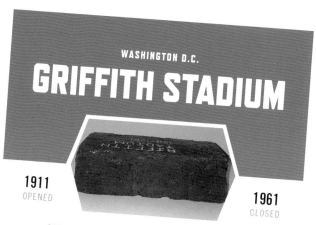

WASHINGTON D.C.
GRIFFITH STADIUM

1911
OPENED

1961
CLOSED

DEMOLISHED IN 1965, AFTER BRIEF USE AS PARKING LOT
CURRENT USE - SITE IS NOW OCCUPIED BY HOWARD UNIVERSITY HOSPITAL, WITH A MARKER INSIDE TO IDENTIFY HOME PLATE.
© 2018 CLASSIC PARK BREW™

CLASSICPARKBREW.COM

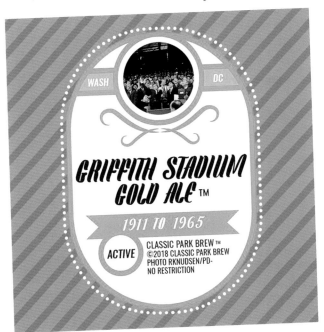

WASH DC

GRIFFITH STADIUM
GOLD ALE™

1911 TO 1965

ACTIVE

CLASSIC PARK BREW™
©2018 CLASSIC PARK BREW
PHOTO RKNUDSEN/PD-
NO RESTRICTION

Plate marker (Michael J/ CC BY-SA 4.0)

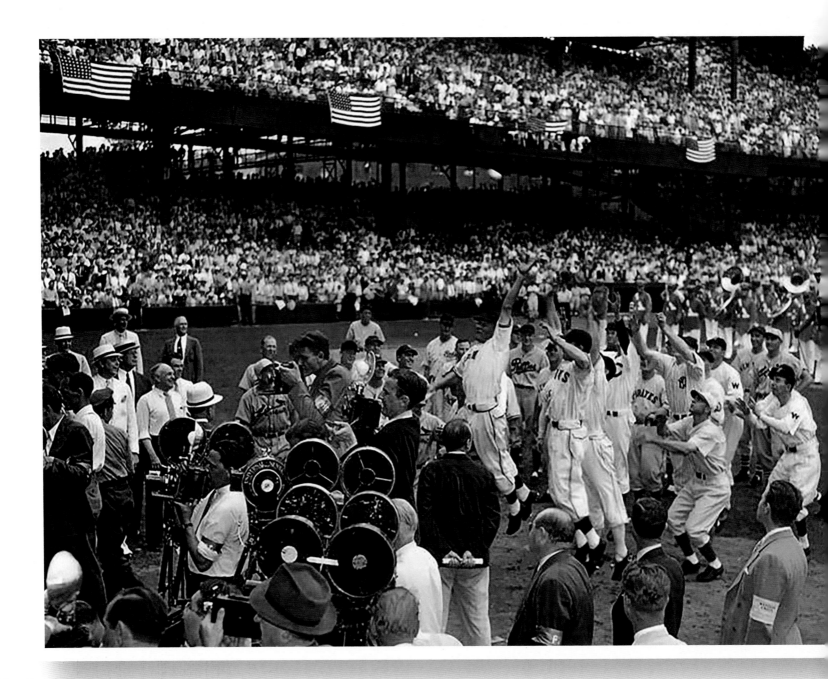

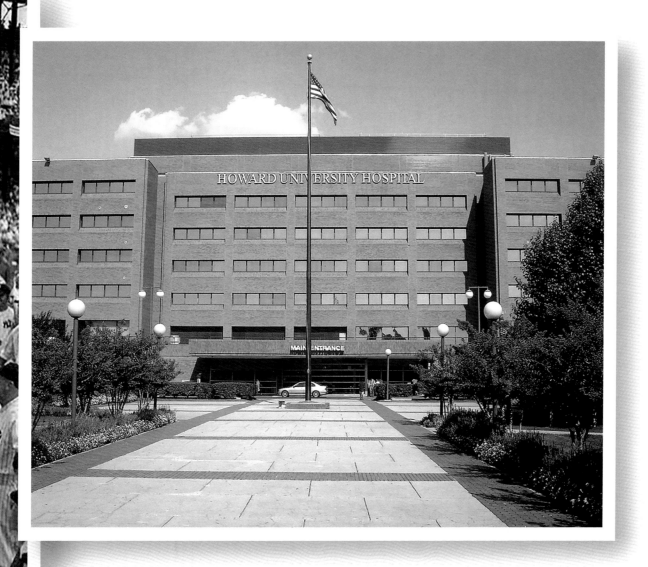

Left: 1937 All-Star Game (Public Domain) **Right:** Griffith site now (Agnostic Preacherskid/ CC BY-SA 3.0)

Griffith Stadium ★ 59

Jarry Park

This Montreal venue was within a large public park area and was built in 1960 as a baseball field to attract a Minor League team. By 1969 it was upgraded to MLB standards for the expansion Expos. Its appearance resembled a curved ship with a protruding section and small cabin-style windows. Being in a public park, the ballpark had adjacent car spaces nearby. The stadium had one flat unroofed level, exposing spectators to sun, rain, or snow, depending on the month, except for the enclosed press box on top of the grandstand. Seats went down each line and were light blue, silver, and light red; the park's exterior was white behind the infield grandstand. The seats were metal to withstand the weather but of course were cold during frigid games. Left field had a long bleacher. No seats were behind the center or right fielders.

Jarry Park had deeper and slightly angled symmetrical dimensions, but wind-currents helped drive balls, and home runs averaged out. A city park swimming pool beyond right field was a splash landing for long home runs. Scoreboards stood behind the center and right-field chain-link fences.

Grassland and distant trees were beyond the outfield, in addition to the pool. Those features made the ballpark seem ensconced within the community park atmosphere, like a recreational league venue, but larger. However, the grass field, smaller capacity (high–twenty thousands), and open outfield gave the venue some old-world ballpark qualities. Nevertheless, it was an interim ballpark befitting a stripped-down status. At a time when large capacity, circular-doughnut stadiums were the rage, it was a more baseball-friendly alternative, but not quite a throwback to early-twentieth-century classic ballparks.

Other Historic Highlights: The first MLB game ever played in Canada took place inside the park on April 14, 1969. No MLB World Series or All-Star Games were played there. In 1969 Willie Stargell's 495-foot blast was another home run that hit the swimming pool behind right field, but this one is recalled as one of the longest round-trippers hit there.

Tombstone Facts:

Location: North end of Montreal, Quebec Canada
Opened: 1960
Closed: 1976
Demolition: 1995
Current use: The stadium had multiple uses after 1976. Gradually, it was modified to a full tennis stadium, even using the old seating bowl up to the summer of 1995. Later that year, removal of the inside seats took place. Today, few remnants of the old ballpark remain in the tennis stadium, but the updated version of the grandstand continues to function there.

JARRY PARK
SPLASH PALE ALE™

1960 TO 1995

MTL QUE

ACTIVE CLASSIC PARK BREW®
©2018 CLASSIC PARK BREW
PHOTO BY JEFF FROM USA/
CC BY-2.0

JARRY PARK

1960
OPENED

1976
CLOSED

STADIUM HAD MULTI USES AFTER 1976
CURRENT USE - GRADUALLY MODIFIED TO FULL TIME TENNIS STADIUM BY MID 90'S.
©2018 CLASSIC PARK BREW™

Ron Fairly in Jarry Park, 1969 (Public Domain)

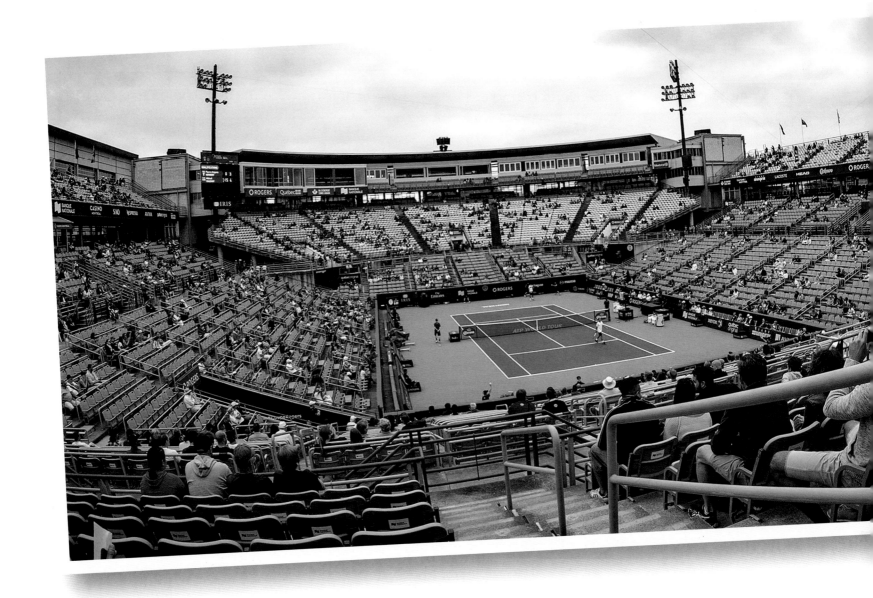

Left: Current tennis venue (Francis Bourgouin / CC BY-SA 2.0) **Top right:** Tennis venue in 2006 (Public Domain) **Bottom right:** Scoreboard at night (Public Domain)

KC Municipal Stadium

This stadium, east of downtown Kansas City, was built in 1923 by the Blues Minor League team and was also home to the Monarchs of the Negro Leagues. When the Athletics relocated from Philadelphia, major upgrades, including a second deck, were made in 1955. The simple exterior had a white base and an exposed structural shell above that. By the right-field corner was a white, two-story building with garage-like openings—for ticket windows—and roll-up doors. A lot behind left field, a few minilots nearby, and streets or front yards provided parking space. Dimensions were deep and nonsymetrical. A light tower stood in left-center field, and beyond right-center field was a big scoreboard. No seating was behind fences, except bleachers in right field. Sometimes, fence heights got raised with added screens.

Fans looking toward the outfield could easily see trees and houses. Both decks had columns, which obstructed view for some fans. The decking continued down each line, and the grandstand top deck went further on the right field side.

Interior and fence walls were green. The last years witnessed light blue and gray seats with red railing and columns. The stadium was prone to wind gusts, even during sunny games. During the 1960s, the owner put a small zoo and picnic area behind right field and sometimes entered the diamond on a mule. The stadium had a rickety but traditional feel toward the end.

Other Historic Highlights: No MLB World Series took place there. Negro League World Series games were played there in 1924, 1925, 1946, and 1948. KC Municipal Stadium was home to the 1960 All-Star Game. Lou Gehrig, the ailing legendary player, appeared in his last game there, an exhibition on June 12, 1939. After the Athletics left for Oakland in 1968, the Royals expansion team played there from 1969 to 1972.

Tombstone Facts:

Location: City section east of downtown Kansas City, Missouri
Opened: 1923
Closed: 1972
Demolition: 1976
Current use: After closure, the site was an open field and garden area that had a commemorative display board. It is now a home-development area with a historical marker.

KC
MO

KC MUNICIPAL STADIUM KOLSCH™

1923 TO 1976

ACTIVE

CLASSIC PARK BREW™
©2018 CLASSIC PARK BREW
PHOTO BY DELAYWAVES/CC
BY-3.0

KANSAS CITY, MISSOURI

KC MUNICIPAL STADIUM

1923
OPENED

1972
CLOSED

DEMOLISHED IN 1976. ONCE HAD MAJOR REBUILD IN 1955
CURRENT USE - SITE WAS AN OPEN FIELD & GARDEN.
IT IS NOW A HOME DEVELOPMENT WITH HISTORICAL MARKER.
© 2018 CLASSIC PARK BREW™

CLASSICPARKBREW.COM

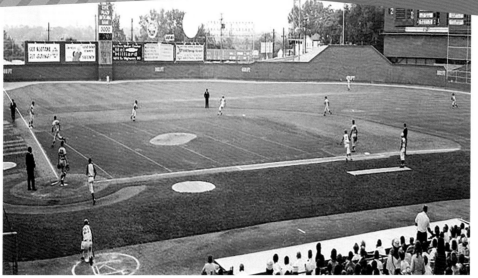

1966 (Public Domain)

Kingdome

This indoor multipurpose stadium was located in Seattle. Constructed in 1976, the Mariners opened their tenancy in 1977. The exterior was very concrete-centric and gray, with exposed outside ramps that looked like wavy horizontal sections. The temperature-controlled conditions, devoid of effects from the elements, contributed to an interior drabness. The Kingdome had typical 1970s accessories, including a main scoreboard elevated beyond the outfield, capacity in the high–fifty thousands, and a three-level seating bowl with no obstructing columns. Some seats were maroon or red, and others in the highest deck were orange. Fences were green. Parking was situated next to the dome.

Unlike the Astrodome before it, this dome was hitter-friendly. Offense was produced quickly by odd bounces that careened off the artificial turf and walls. Fly balls might even hit the high suspended speakers and be in play. Home runs were frequent. Dimensions were modest and symmetrical until the left-field fence was later pushed back, resulting in slight asymmetry. A taller right-field wall was installed, and all fences were then changed to blue. A black elongated scoreboard was placed atop the right-field wall. This high wall and scoreboard seemed more of a throwback, becoming a target for Ken Griffey Jr.

Other Historic Highlights: No MLB World Series ever took place inside. The 1979 All-Star Game was played there in a tightly contested 7–6 game won in the last inning by the NL. The 1995 ALDS final game had an iconic extra-inning walk-off win there. The subsequent 1995 ALCS was played there as well. The Kingdome had the distinction of hosting the highest professional level of four major pro sports—baseball, football, basketball, and soccer.

Tombstone Facts:

Location: Southern edge of downtown Seattle, Washington
Opened: 1976
Closed: 2000
Demolition: 2000
Current use: The stadium was imploded in 2000, setting a record for the largest building or dome implosion. The site is now occupied by a multisport stadium, completed two years after the implosion.

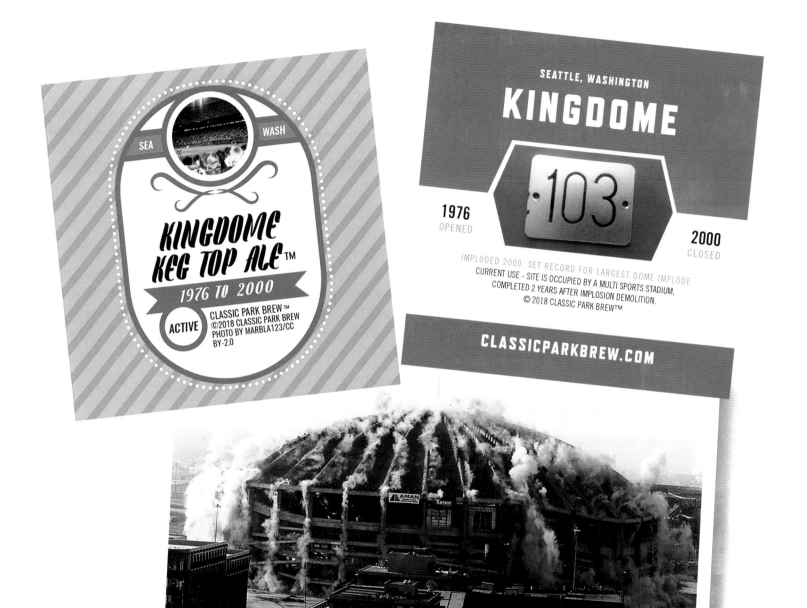

SEA WASH

KINGDOME KEG TOP ALE™

1976 TO 2000

ACTIVE

CLASSIC PARK BREW ™
©2018 CLASSIC PARK BREW
PHOTO BY MARBLA123/CC
BY-2.0

SEATTLE, WASHINGTON

KINGDOME

103

1976 OPENED

2000 CLOSED

IMPLODED 2000. SET RECORD FOR LARGEST DOME IMPLODE
CURRENT USE - SITE IS OCCUPIED BY A MULTI SPORTS STADIUM,
COMPLETED 2 YEARS AFTER IMPLOSION DEMOLITION.
© 2018 CLASSIC PARK BREW™

CLASSICPARKBREW.COM

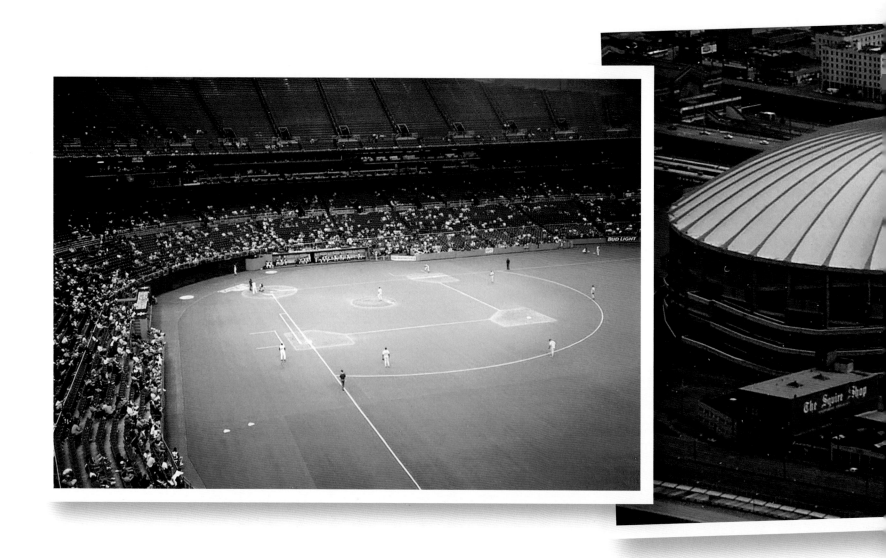

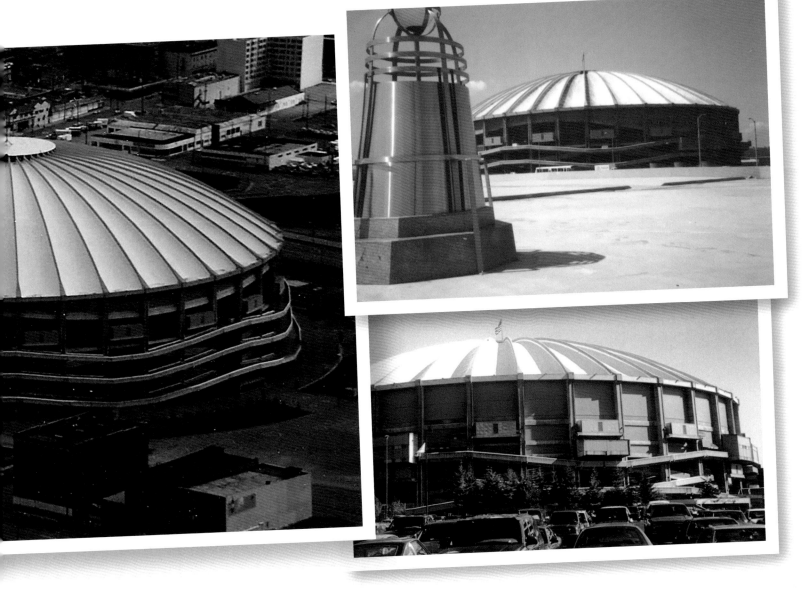

LA Wrigley Field

In the south area of Los Angeles, a few miles from the Coliseum, this compact ballpark was built and given its name in 1925, prior to the Chicago Cubs park being renamed Wrigley Field in 1926. It was home for Minor League baseball up to the late 1950s, but the MLB expansion Angels played there in 1961. Along the exterior behind home rose a high clock and office tower. The venue was white, with Spanish design, red-tile roof, and windows.

The venue was a hitter's park with very short power-alley distances. A home-run record (since broken) was set in that lone MLB season. Sitting on a square lot snugly within city streets, the park was double-decked with columns from home plate down each line. Seats were green, and capacity was slightly over twenty thousand. Besides right center-field bleachers, no seats were beyond home run fences. The left-field brick wall had occasional ivy. The bleacher wall was concrete with wire and continued as the right-field wall. A brick perimeter wall was behind that. From their seats, fans could fully view nearby homes and palm trees, and home-run balls would bombard close houses. A fair ball was capable of hitting the light pole on the playing field within deep left-center field. Venue parking was against the third base side, and a small lot was located behind right field; otherwise, curbside parking was an option. A scoreboard was at the top of the bleachers and operated electronically in its later years.

Other Historic Highlights: No MLB World Series or All-Star Games were ever played there. MLB stars participated in a home-run derby television show that aired inside in early 1960. The last MLB game played there was on October 1, 1961.

> ## Tombstone Facts:
>
> **Location:** South central Los Angeles, California
> **Opened:** 1925
> **Closed:** 1969
> **Demolition:** 1969
> **Current use:** The site is now used as a community health facility, adjacent to a park and recreation center, where a historic marker was placed.

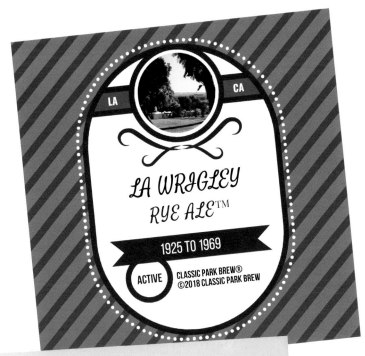

LA WRIGLEY
RYE ALE™

1925 TO 1969

ACTIVE CLASSIC PARK BREW®
©2018 CLASSIC PARK BREW

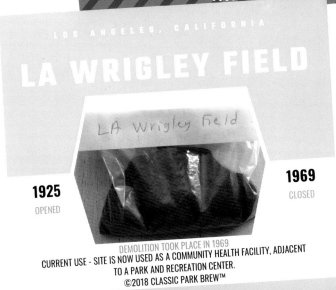

LA WRIGLEY FIELD

LA Wrigley Field

1925
OPENED

1969
CLOSED

DEMOLITION TOOK PLACE IN 1969
CURRENT USE - SITE IS NOW USED AS A COMMUNITY HEALTH FACILITY, ADJACENT
TO A PARK AND RECREATION CENTER.
©2018 CLASSIC PARK BREW™

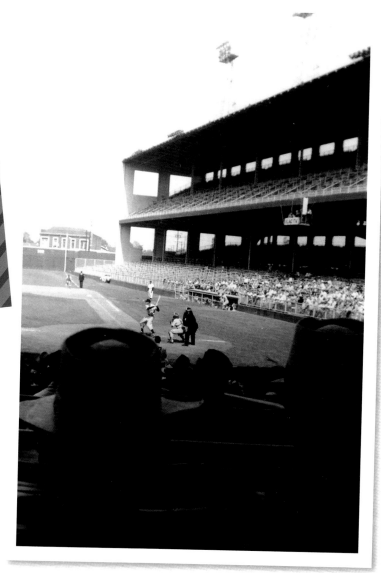

1952 (Marlcal/ CC BY-SA 2.0)

Lane Field

This smaller, single-level ballpark was constructed in 1936 at the edge of San Diego Harbor, with the site originally serving as an athletic field from 1925. Lane Field provided tenancy for the minor-league Padres, which was part of the Pacific Coast League (PCL), the highest pro level of West Coast baseball at the time. Capacity totaled eight thousand. On the exterior along the first-base side was a white arched mission-style entrance and a nearby billboard marquee with the ballpark name. Palm trees were planted around this area. A grandstand roof with column supports covered the infield's seating. The distance between the home plate and backstop was very short, but the center field was very deep. Bleachers were in left field, and the Pacific Highway and Santa Fe Depot railroad tracks were just beyond the wall in right field. Parking was sporadically available in an area along the third-base harbor side of the field, at angled spaces against the first-base side, and by the depot. The grandstand exterior and interior, roof, seats, and columns had a dark green hue. The park eventually installed night lights. The combination of wood construction and being near the waterfront likely contributed to the venue's recurring maintenance issues. Termites plagued the ballpark at its end.

Other Historic Highlights: No MLB games were ever played there. The minor-league Padres won the PCL pennant in a one-game playoff there in 1954. Ted Williams played in the late 1930s for the Padres of Lane Field. It is rumored that he hit a home run into a boxcar of a passing train beyond the fence, and the ball continued on to Los Angeles.

Tombstone Facts:

Location: Downtown harbor, San Diego, California
Opened: 1936
Closed: 1957
Demolition: 1958
Current use: After serving as a parking lot since the 1960s, the site is now occupied by a historical area marking the plate location and bases. A hotel complex is just beyond the old infield.

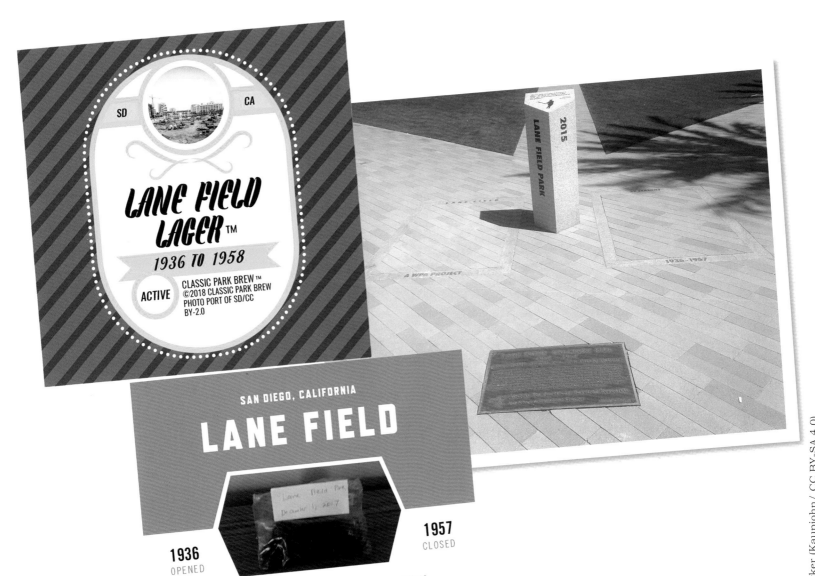

SD | CA

LANE FIELD LAGER™

1936 TO 1958

ACTIVE · CLASSIC PARK BREW™
©2018 CLASSIC PARK BREW
PHOTO PORT OF SD/CC
BY-2.0

2015

LANE FIELD PARK

A WPA PROJECT

1936 - 1957

SAN DIEGO, CALIFORNIA

LANE FIELD

1936
OPENED

1957
CLOSED

DEMOLISHED IN 1958. BECAME A PARKING LOT IN 1960'S
CURRENT USE - SITE IS OCCUPIED BY A HISTORICAL AREA MARKING THE PLATE & BATTERS BOX,
MOUND, AND BASES. HOTEL COMPLEX IS LOCATED BEYOND THE OLD INFIELD & OUTFIELD.
© 2018 CLASSIC PARK BREW™

CLASSICPARKBREW.COM

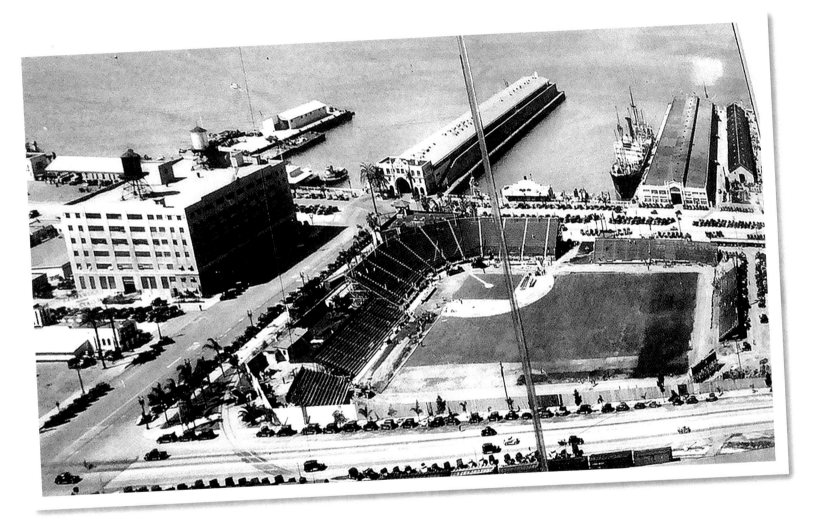

Memorial Stadium

Built in 1954 near residences, this Baltimore ballpark staged historic baseball and football championship games. Many signs on neighborhood tree-lined streets directed travelers to the venue, which had a large parking area along its perimeter. The exterior featured pink brick and concrete, with a bowl-like gray portion situated on top. Stadium lettering on the exterior memorial wall behind home plate welcomed fans. Capacity approximated fifty thousand. The multisport structure featured some aspects reminiscent of the earlier twentieth century, such as some exposed stand supports. Two circling deck levels wrapped to each foul line, with the lower level continuing uncovered to outfield corners. The top deck hindered the vision of high fly balls for fans seated back many rows underneath.

When first built, the stadium's dimensions were deep, although fences were moved in during the 1950s. The shorter distances converted a pitcher's park to a neutral one, but large foul areas helped pitchers. At the end of the stadium's lifespan, a second scoreboard was added beyond the fence.

Green abounded in and around the stadium, from the walls and grass to the green embankment and trees outside. White-painted houses dotted the distant landscape.

Other Historic Highlights: The MLB World Series was played there in 1966, 1969, 1970, 1971, 1979, and 1983, as was the 1958 All-Star Game. Only one home-run ball was completely hit out of this stadium, by Frank Robinson over the left field, single-deck level, on May 8, 1966.

Tombstone Facts:

Location: Just northeast of downtown Baltimore, Maryland
Opened: 1954
Closed: 1997
Demolition: 2002
Current use: The site is occupied by a youth baseball field and senior-housing complex.

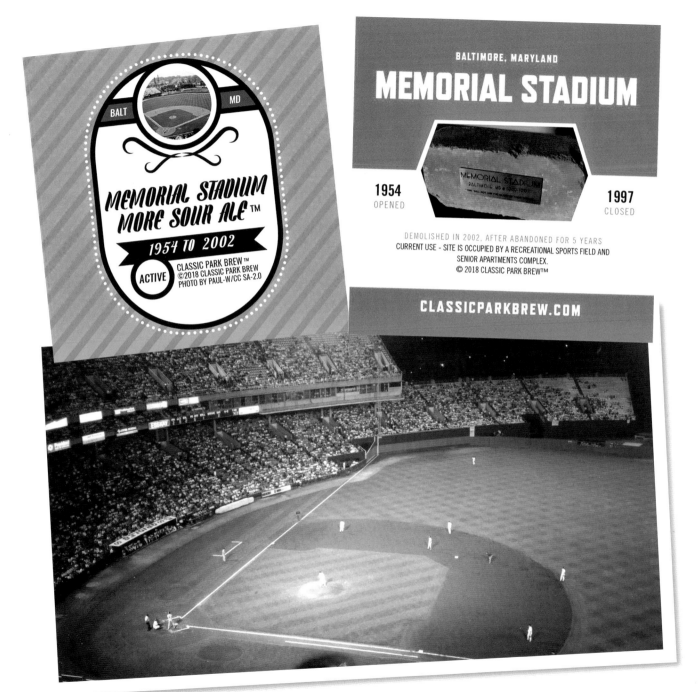

BALT MD

MEMORIAL STADIUM
MORE SOUR ALE™

1954 TO 2002

ACTIVE

CLASSIC PARK BREW™
©2018 CLASSIC PARK BREW
PHOTO BY PAUL-W/CC SA-2.0

BALTIMORE, MARYLAND

MEMORIAL STADIUM

1954
OPENED

1997
CLOSED

DEMOLISHED IN 2002, AFTER ABANDONED FOR 5 YEARS
CURRENT USE - SITE IS OCCUPIED BY A RECREATIONAL SPORTS FIELD AND
SENIOR APARTMENTS COMPLEX.
© 2018 CLASSIC PARK BREW™

CLASSICPARKBREW.COM

1991 (Wasted Time R/ CC BY 3.0)

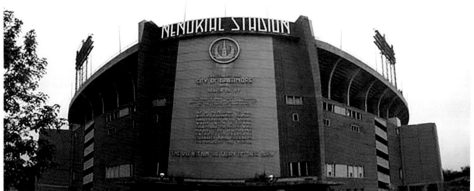

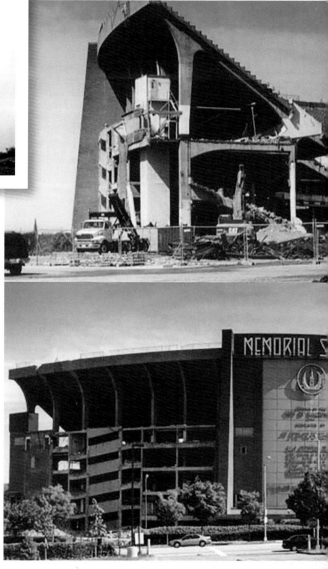

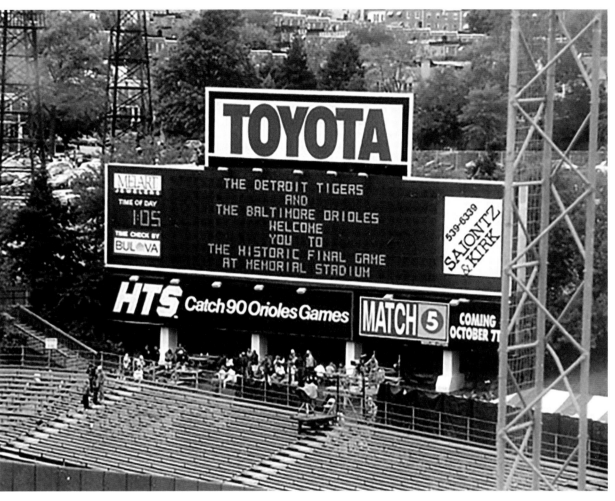

On the scoreboard:

TOYOTA

THE DETROIT TIGERS
AND
THE BALTIMORE ORIOLES
WELCOME
YOU TO
THE HISTORIC FINAL GAME
AT MEMORIAL STADIUM

TIME OF DAY
1:05
THE CHECK BY
BULOVA

SAIONTZ & KIRK
539-6339

HTS Catch 90 Orioles Games

MATCH 5

COMING
OCTOBER 7T

Top left: Memorial outside (Paul-W / CC BY-SA 2.0) **Bottom left:** Current site (Public Domain) **Center right:** Demolition (Public Domain) **Right:** 1991 for final game (Public Domain)

Metropolitan Stadium

Located in Bloomington, Minnesota, this stadium was built along a cornfield, for minor-league play in 1956. When the Senators moved to Minnesota to become the Twins in 1961, the stadium had three levels, with the smallest top level by the infield. The middle and lower levels extended further to the right field pole. No column supports were used. Single-level bleachers were in right field, left field, and down the third-base foul line; however, left-field bleacher seating later expanded to a double deck.

The main exterior had multi colored decorative brick sections in the outer structural shell, giving it an exposition-like appearance. No seats were beyond the center-field wall, but a large black batter's eye was. A big scoreboard hung beyond the right-center-field fence.

Metropolitan Stadium was considered a hitter's park; it started with symmetrical dimensions, but later adjustments introduced some asymmetry. Like many venues of the era, pro baseball and football shared tenancy.

Parking spaces ringed the stadium; near the edge of the parking stood a marquee with the stadium name.

Cold weather could have escalated deterioration, leading to the venue's reputation as being poorly maintained.

Other Historic Highlights: The MLB World Series and All-Star Game both took place there in 1965. The longest home run ever hit at this ballpark was by Harmon Killebrew on June 3, 1967, estimated at 520 feet.

Tombstone Facts:

Location: Fifteen miles south of downtown Minneapolis in Bloomington, Minnesota
Opened: 1956
Closed: 1981
Demolition: 1985
Current use: After demolition in 1985, the site was vacant for several years, until ground broke on a mall project in the late 1980s. The land is now occupied by an extremely large mall, which has been listed as one of the biggest in the world.

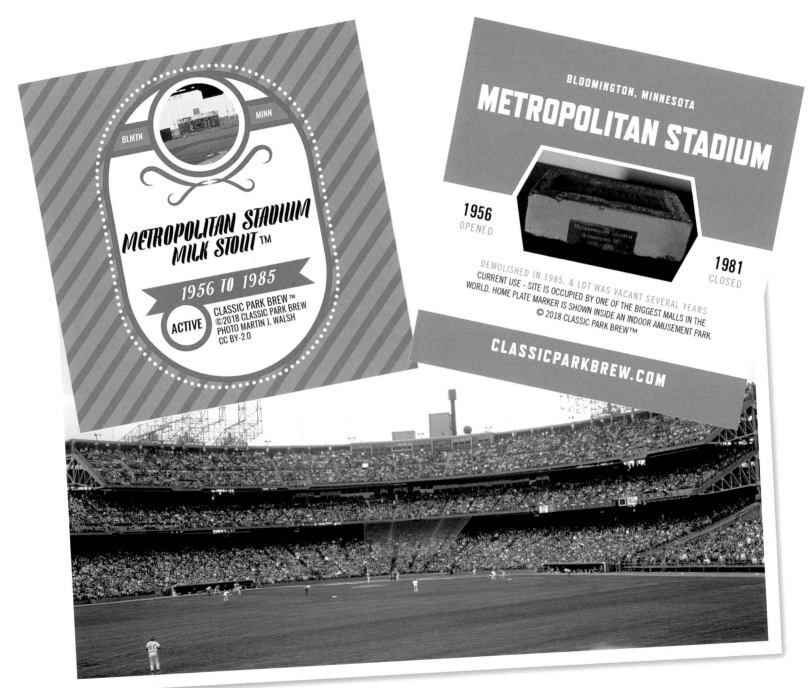

BLMTN · MINN

METROPOLITAN STADIUM MILK STOUT™

1956 TO 1985

ACTIVE

CLASSIC PARK BREW™
©2018 CLASSIC PARK BREW
PHOTO MARTIN J. WALSH
CC BY-2.0

BLOOMINGTON, MINNESOTA

METROPOLITAN STADIUM

1956
OPENED

1981
CLOSED

DEMOLISHED IN 1985, & LOT WAS VACANT SEVERAL YEARS
CURRENT USE - SITE IS OCCUPIED BY ONE OF THE BIGGEST MALLS IN THE
WORLD. HOME PLATE MARKER IS SHOWN INSIDE AN INDOOR AMUSEMENT PARK.
© 2018 CLASSIC PARK BREW™

CLASSICPARKBREW.COM

1981 (snaebyllej2/ CC BY 2.0)

Miami Stadium

This ballpark was built in the Allapattah neighborhood of Miami in 1949 and had a small capacity of about thirteen thousand. It displayed classic, tropical features but also modernistic architecture for its time. The exterior was white, with neon lettering of the stadium name behind the home-plate grandstand outside, ticket window booths at the bottom, a squared mini tower extending just above the roof, and some stadium windows. The park had a half-moon-shaped seating grid, night lights, and a smaller horizontal right-field scoreboard. One level of seats continued down each foul line, with a cantilevered, curved-roof that was futuristic for the era. The stadium provided new amenities, such as no post obstructions. Seats were close to the field. Center field had a higher fence than right and left field, and dimensions were symmetrical and of average distances. Miami Stadium hosted minor-league teams, including the Miami Sun Sox and the old Miami Marlins. MLB teams used it for spring training, starting with the Dodgers in the 1950s, and the Orioles played spring-training games in the stadium from 1959 to 1990. The venue also held boxing matches and concerts. There were some lot spaces next to the ballpark.

Other Historic Highlights: No MLB regular-season games were played there. The Dodgers held their first game representing Los Angeles there in 1958, in an exhibition. Satchell Paige played for the Minor League Marlins at the stadium from 1956 to 1958. The final spring-training game ever played there was between the Orioles and Braves on April 5, 1990. It hosted the 1991 Caribbean Series, with past and newly rising MLB players.

Tombstone Facts:

Location: Northwest of downtown Miami, Florida
Opened: 1949
Closed: 1996
Demolition: 2001
Current use: After several years of inactivity starting in 1996, demolition took place in 2001, followed by the construction of apartments at the site.

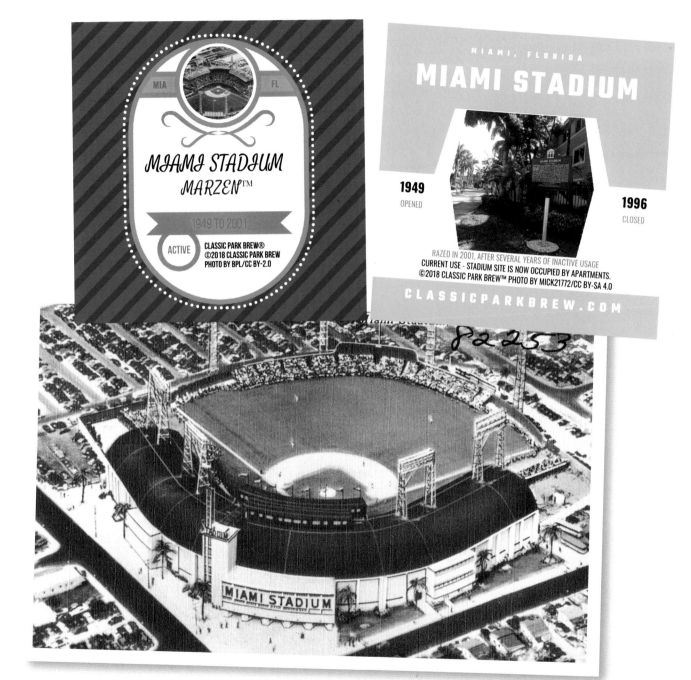

MIA FL

MIAMI STADIUM
MARZEN™

1949 TO 2001

ACTIVE CLASSIC PARK BREW®
©2018 CLASSIC PARK BREW
PHOTO BY BPL/CC BY-2.0

MIAMI, FLORIDA

MIAMI STADIUM

1949
OPENED

1996
CLOSED

RAZED IN 2001, AFTER SEVERAL YEARS OF INACTIVE USAGE
CURRENT USE - STADIUM SITE IS NOW OCCUPIED BY APARTMENTS.
©2018 CLASSIC PARK BREW™ PHOTO BY MICK21772/CC BY-SA 4.0

CLASSICPARKBREW.COM

82253

MIAMI STADIUM

Mile High Stadium

This Denver ballpark was constructed in 1948 as the minor-league Bears Stadium. Gradually expanded over time to be a multipurpose stadium, it had frequent football contests and a large capacity of up to the mid–seventy thousands. A plain series of horizontal and vertical slabs gave the exterior a skeletal look. The MLB expansion Rockies opened tenancy in 1993, with a last baseball game played there in 1994.

The stadium was hitter-friendly, as thin air provided great ball liftoff. To compensate, center- and right-field distances were quite deep. Three decks partially encircled the field from the infield to right- and left-field corners, and a separate left-field stand section, comprised of three decks, enclosed half the outfield. The furthest section in center field was a small collection of seats called the "rockpile," which could be removed, leaving even more open views beyond the center-field wall. (The "rockpile" description was again used at the next Rockies ballpark.) Right field had a single-level seating deck that was steeply slanted and had the scoreboard above it. On the outside behind this deck was the stadium name in a large orange, blue, and red ribbon-style design, with a rearing bronco statue on top. Many seats were blue and orange. The stadium's easier access from the interstate and plentiful parking matched the multipurpose template, although the stadium was not fully enclosed like bowl-shaped stadiums. Due to the large seating, it had a cavernous aesthetic, along with the mixed styles of traditional and multipurpose.

Other Historic Highlights: No MLB World Series or All-Star Games were played there. In a minor league game there, Joey Meyer hit a home run measured at 582 feet, on June 3, 1987. The stadium drew nearly 4.5 million fans for its first year of MLB in 1993.

Tombstone Facts:

Location: Just west of downtown Denver, Colorado
Opened: 1948
Closed: 2001
Demolition: 2002
Current use: The site is now a parking lot for a replacement football stadium, with a marker locating the old home-plate area.

MILE HIGH STADIUM MALT ALE™

1948 TO 2002

ACTIVE

CLASSIC PARK BREW™
©2018 CLASSIC PARK BREW
PHOTO BY
ABDULMAKESFONTS/PD

DEN · COLO

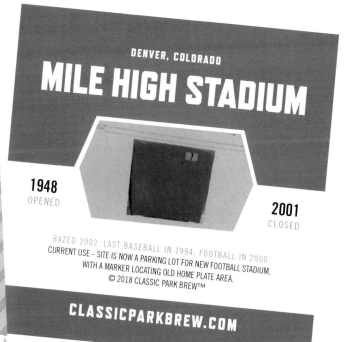

DENVER, COLORADO

MILE HIGH STADIUM

1948
OPENED

2001
CLOSED

RAZED 2002. LAST BASEBALL IN 1994; FOOTBALL IN 2000
CURRENT USE - SITE IS NOW A PARKING LOT FOR NEW FOOTBALL STADIUM,
WITH A MARKER LOCATING OLD HOME PLATE AREA.
© 2018 CLASSIC PARK BREW™

CLASSICPARKBREW.COM

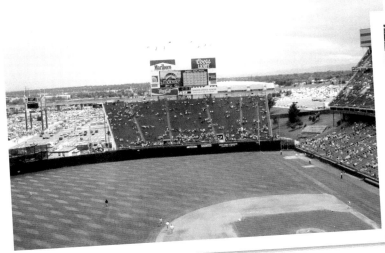

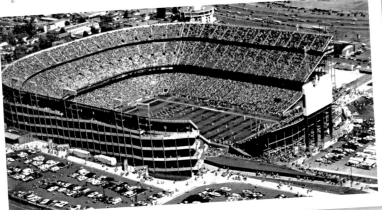

Polo Grounds

Reconstructed in 1911 and located in New York City's Manhattan borough under a rocky bluff and near subway stations, the park was oddly bathtub-shaped, with very short foul lines and a tremendously deep center field. The exterior was a white and gray mosaic of finishes with flat masonry, etched finish, arch designs above, rails, and exposed ramps. Column-supported double-deck infield grandstands extended down each line and curled to the outfield, terminating next to single-level bleachers on either side of a prominent clubhouse beyond center field. Capacity reached the mid–fifty thousands. Urban surroundings, such as apartments, were visible between the two seating levels. Seats, walls, decks, columns, and dugouts were green. The power alleys were so deep that bullpens with benches were placed at the fences; players there used a pull-down canopy for shade. Foul territory was also vast. Horizontal scoreboards were attached to the second deck front panel at each foul line, and in its last two years, another board was at the top of the center-field clubhouse. Parking was challenging, with a meager lot on the right-field side of the venue. The Harlem River flowed in the distance beyond center field, and Eighth Avenue was next to the ballpark. A simple door separated that street from center field. Assuming access was granted, walking through the door would place one inside the playing area in seconds. Such simplicity emphasized the venue's old service life.

Other Historic Highlights: 1911 to 1913, 1917, 1921 to 1924, 1933, 1936, 1937, 1951, and 1954 MLB World Series were played there, as were the 1934 and 1942 All-Star Games. Negro League World Series games were played there in 1946 and 1947. It was the stage for one of the most famous walk-off home runs, on October 3, 1951, when the Giants' Bobby Thomson hit a two-out, game-ending home run in the tie-breaker series, to complete a comeback for the National League pennant. Its last professional baseball game was an exhibition featuring Latino stars, with a few on their way to the Hall of Fame, on October 13, 1963.

Tombstone Facts:

Location: Harlem section of Manhattan (bordering Washington Heights) in New York City, New York
Opened: 1911
Closed: 1963
Demolition: 1964
Current use: The site is now occupied by high-rise apartments in a public housing complex. A wall plaque approximates home-plate location.

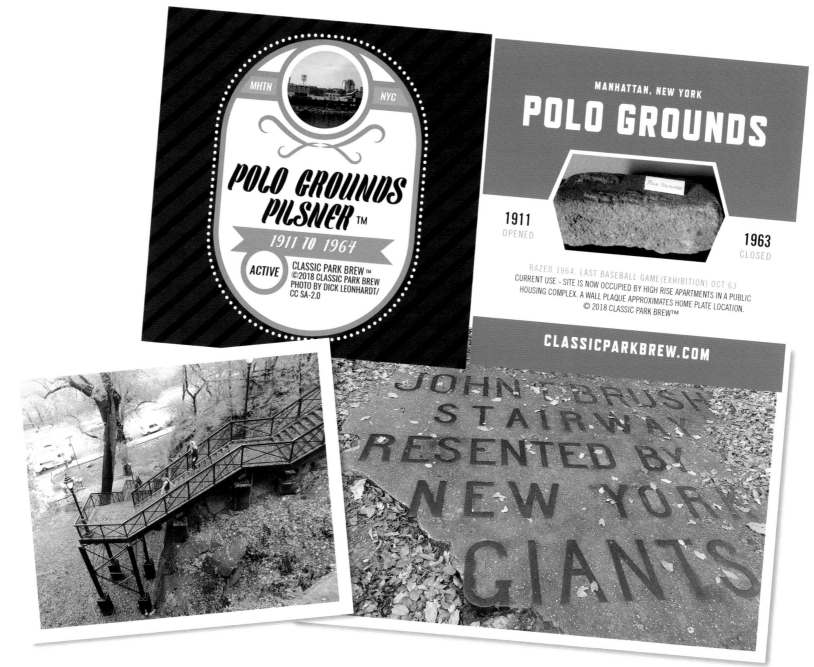

MHTN NYC

POLO GROUNDS PILSNER ™

1911 TO 1964

ACTIVE CLASSIC PARK BREW ™
©2018 CLASSIC PARK BREW
PHOTO BY DICK LEONHARDT/
CC SA-2.0

MANHATTAN, NEW YORK

POLO GROUNDS

1911
OPENED

1963
CLOSED

RAZED 1964. LAST BASEBALL GAME (EXHIBITION) OCT 63
CURRENT USE - SITE IS NOW OCCUPIED BY HIGH RISE APARTMENTS IN A PUBLIC
HOUSING COMPLEX. A WALL PLAQUE APPROXIMATES HOME PLATE LOCATION.
© 2018 CLASSIC PARK BREW™

CLASSICPARKBREW.COM

JOHN T. BRUSH
STAIRWAY
RESENTED BY
NEW YORK
GIANTS

Roosevelt Stadium

This Jersey City ballpark, built in 1937 close to Newark Bay, could fit mid–twenty thousand attendance. Used almost exclusively for minor-league baseball, it featured art-deco styling and a brick exterior. The outfield had average, symetrical dimensions. An extended marquee emblazoned with the park's name protruded from the front entrance, which sported brick veneer in columns and multiple windows throughout. Circular in design, the stadium had one level with a column-supported grandstand roof over the infield seats. The single level continued uncovered as it extended down the foul lines. The area beyond the outfield was void of seating, although scoreboards existed behind the left-center and right-center walls. An outside perimeter wall was set even further back. Open space bordered the park, with looping pathways. Looking past the outfield, fans could see greenery beyond the baseball field, including vegetation on the outskirt wall and a far-off, tree-lined neighboring region with structures. A lot on the third-base side accommodated parking.

Sandy Koufax described conditions in the stadium as windy, and Rickey Henderson called the venue big with dim lighting. At the end, much of the interior (seats, columns) had a light blue or even gray color. Other sports that took place inside were football, boxing, and soccer. Roosevelt Stadium had an active musical concert schedule in the 1970s; some concertgoers described it as dusty and worn.

Other Historic Highlights: No MLB World Series or All-Star Games were played here. The longest tenant was the Jersey City Giants of the International League (IL), a minor-league team winning league titles in 1939 and 1947. Jackie Robinson made his IL baseball debut in the minors there on April 18, 1946. The Brooklyn Dodgers played fifteen regular-season games within the confines, in 1956 and 1957, briefly introducing the stadium to MLB. In one of those games in 1956, Willie Mays hit the only ball completely out of the ballpark.

Tombstone Facts:

Location: Southwestern Jersey City, New Jersey
Opened: 1937
Closed: 1980
Demolition: 1985
Current use: The last event was in 1980, for a contest of marching bands. The site was cleared by the mid-1980s, and a gated housing development replaced the old stadium.

JC NJ

ROOSEVELT
STADIUM
ROASTED ALE™

1937 TO 1985

ACTIVE

CLASSIC PARK BREW®
©2018 CLASSIC PARK BREW
PHOTO BY SKYLINER72/
CC BY-2.0

JERSEY CITY, NEW JERSEY

ROOSEVELT STADIUM

Nº 10862
Adult GRANDSTAND
ROOSEVELT STADIUM
JERSEY CITY, N. J. 1958
SUN., SEPT. 7th
In event of rain, contest will be held
Wednesday, Sept. 10, 1958, 7:30 P.M.
ADULT TICKET $1.50

1937
OPENED

1980
CLOSED

LAST EVENT (1980) WAS A CONTEST FOR MARCHING BANDS. DEMOLISHED IN 1985
CURRENT USE - SITE WAS CLEARED BY MID 1980'S & GATED HOUSING
DEVELOPMENT COMPLEX REPLACED THE STADIUM.
©2018 CLASSIC PARK BREW™

CLASSICPARKBREW.COM

San Diego Stadium

Opened in San Diego's Mission Valley in 1967, this stadium was utilized for pro football and baseball. In 1969 it became an MLB venue for the Padres. Built in the "brutalist" style, it was familiar to freeway travelers who saw the gray skeletal, concrete exterior and large, spiral ramps. With a combined square and round seating bowl, it was considered modern and roomy at its grand opening. The design had three predominant decks (with a smaller tier tucked below the top deck). The third-base side had multiple levels all the way to left-center field. The first-base side had those levels through the infield, but seats continued from there as a single deck to center field. Eventually, the right field single-deck seats extended slightly higher with an added section. Spectators still kept their hillside view, until a multiple-level outfield seat expansion completely enclosed the stadium in 1997, which made the park more of a cookie-cutter venue. Capacity in its prime was in the mid–fifty thousands, although the last seating upgrade increased that by about ten thousand. Dimensions were symmetrical and of average distances. A parking lot encircled the stadium, which allowed massive tailgating parties but also bottlenecked exiting cars. The scoreboard was wedged among the right-field seats and was considered modern during its early period, but by the last few years, it seemed older and dated. The ballpark had several names after San Diego Stadium, most notably Jack Murphy Stadium.

Other Historic Highlights: The 1984 and 1998 MLB World Series were played there, as were the 1978 and 1992 All-Star Games. The stadium hosted the 1988, 1998, and 2003 Super Bowls. The park witnessed one no-hitter, by Dock Ellis, who walked eight batters on June 12, 1970, and claimed to have ingested hallucinogenic substances prior to the game. The story was made into a documentary.

Tombstone Facts:

Location: Mission Valley area of San Diego, California
Opened: 1967
Closed: 2020
Demolition: 2021
Current use: The site is just east of the college football and multisport stadium built in 2022. A roadway now extends through a portion of the old site.

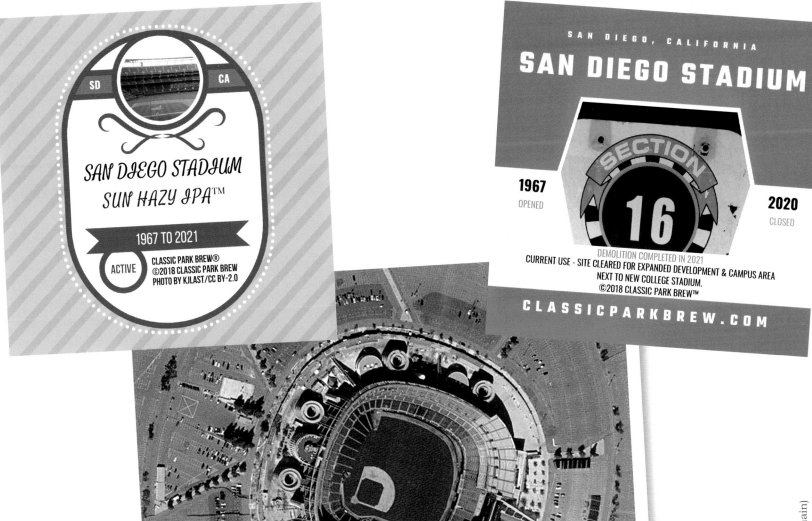

SAN DIEGO STADIUM
SUN HAZY IPA™

1967 TO 2021

ACTIVE

CLASSIC PARK BREW®
©2018 CLASSIC PARK BREW
PHOTO BY KJLAST/CC BY-2.0

SD CA

SAN DIEGO STADIUM

SECTION
16

1967
OPENED

2020
CLOSED

DEMOLITION COMPLETED IN 2021
CURRENT USE - SITE CLEARED FOR EXPANDED DEVELOPMENT & CAMPUS AREA
NEXT TO NEW COLLEGE STADIUM.
©2018 CLASSIC PARK BREW™

CLASSICPARKBREW.COM

Top aerial (Public Domain)

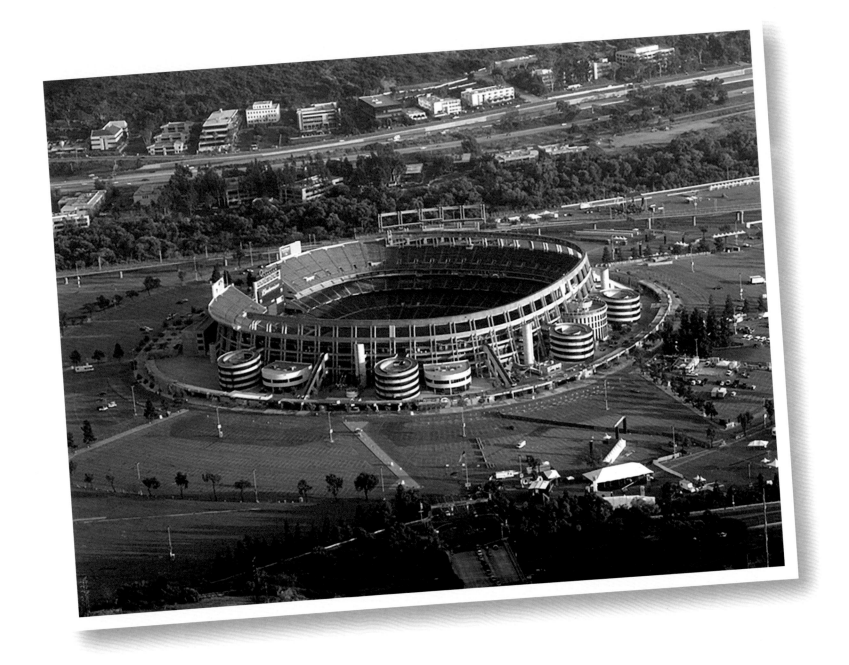

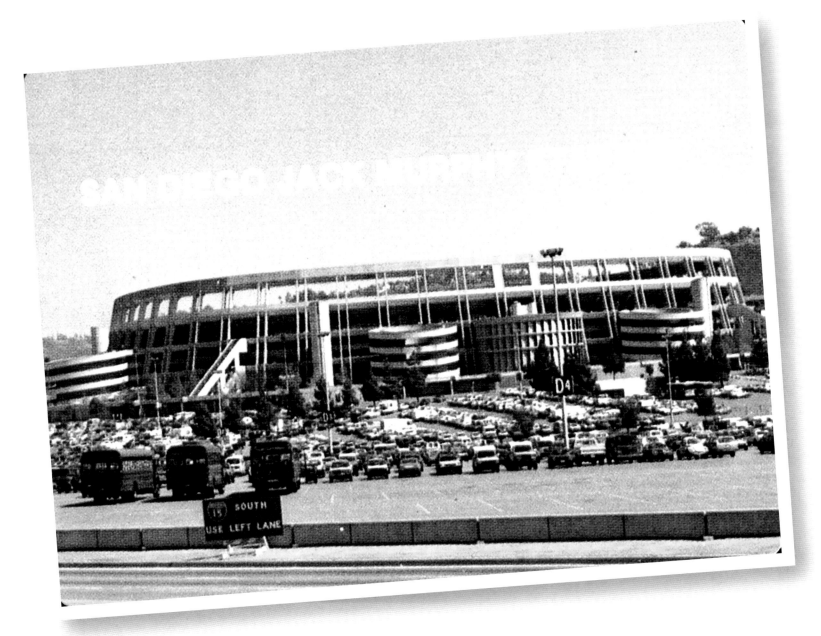

Seals Stadium

This San Francisco ballpark, of white exterior mission-style design, was built in 1931 as a minor-league ballpark. It had a modest capacity of the low–twenty thousands at its peak. The outfield fencing had some angles, so dimensions were asymmetrical. This single-level ballpark had deep foul lines and seats that extended to them, but no grandstand roof covered those seats. The outfield had right-field bleachers and, by 1958, left-field bleachers. A well-known brewery with a large beer sign overlooked the baseball field from behind the stands between home plate and first base. The horizontal scoreboard was simple and black, positioned behind the center-field fence. On a stadium building outside the right-field corner, a marquee announced the venue name and game schedule for fans. Seats were green with red railings. Beyond the outfield, attendees could see trees, San Francisco hills, and surrounding homes. Some bold tree-climbers were even able to get a free peek of the game. Parking areas were behind the outfield and on the third-base side, plus curbside parking was available on the local streets.

Other Historic Highlights: Championship boxing took place inside. No MLB World Series or All-Star Games were played there. While playing at this stadium, the minor-league Seals won fifteen Pacific Coast League titles. Once the Giants moved to San Francisco, the first-ever official Major League Baseball game played on the West Coast was at Seals Stadium, April 15, 1958. Two Hall of Famers stood out, as Orlando Cepeda hit a home run, and Willie Mays drove in two runs.

Tombstone Facts:

Location: Northeastern edge of Mission District in San Francisco, California
Opened: 1931
Closed: 1959
Demolition: 1959
Current use: Demolished just weeks after the last pitch, the site has housed a department store, supermarket, and auto dealership. It is now occupied by a strip mall. A plaque is located at the former ballpark's corner location of 16th and Bryant Streets.

SEALS STADIUM
STRONG ALE™
1931 TO 1959

ACTIVE

CLASSIC PARK BREW™
©2018 CLASSIC PARK BREW
PHOTO BY DELAYWAVES/
CC BY-3.0

SAN FRANCISCO, CALIFORNIA
SEALS STADIUM

1931
OPENED

1959
CLOSED

DEMOLISHED IN 1959, JUST WEEKS AFTER LAST PITCH
CURRENT USE - SITE IS NOW OCCUPIED BY A STRIP MALL SHOPPING CENTER. IT
WAS USED EARLIER FOR A DEPARTMENT STORE & THEN, AN AUTO DEALERSHIP.
© 2018 CLASSIC PARK BREW™

CLASSICPARKBREW.COM

1933 (Public Domain)

Shea Stadium

The stadium was located in Queens, one of the five boroughs of New York City. Built in 1964, it stood adjacent to the World's Fair and the noise of LaGuardia Airport. With a four-level wrap around configuration to the foul poles, it had a large capacity, in the mid–fifty thousands, and was a multiplc-sport stadium. Dimensions were symmetrical and distances on par with contemporaries of the era. It started with no seats beyond the fences but added left-field bleachers starting in 1980. Ornamental metal panels flecked with blue and orange confetti-like disks were affixed to the circular exterior until 1980; after that, the ramps were visible. The unenclosed round seating grid allowed views of stadium parking and urban periphery, which, combined with its natural grass surface, differentiated Shea Stadium from the ashtray-style multipurpose stadiums prevalent at the time. Parking lots on the outside perimeter were abundant, but so was traffic congestion at the game's end. Inside, colors were organized according to level (blue, red, orange, and turquoise and, in the earlier days, yellow and burnt red). The stadium's upper deck was markedly high, and box-seat entrances were tightly secured with a gate that prohibited seat-hopping on field level, unless someone on the inside was convinced to pass his or her ticket through the gate. (This was before the era of swiped ticket barcodes.) Long home runs sometimes hit the large scoreboard beyond right field. In its last season, a replacement ballpark emerged behind the outfield.

Shea Stadium was known for wild celebrations, as when the Mets won the 1969 World Series and 1973 pennant. Fans poured onto the field, stampeding the grass.

Other Historic Highlights: The 1969, 1973, 1986, and 2000 MLB World Series were played there, as was the 1964 All-Star Game. Shea hosted baseball, football, boxing, and concerts. Facing elimination, the Mets were down to their last strike during Game Six of the 1986 World Series at the stadium, but they came back to win and then won the final Game Seven.

Tombstone Facts:

Location: Flushing section of Queens, New York
Opened: 1964
Closed: 2008
Demolition: 2008
Current use: Demolition started in 2008 and finished in 2009. The site is now a parking lot serving the replacement ballpark. The old home-plate area is marked in the lot's pavement.

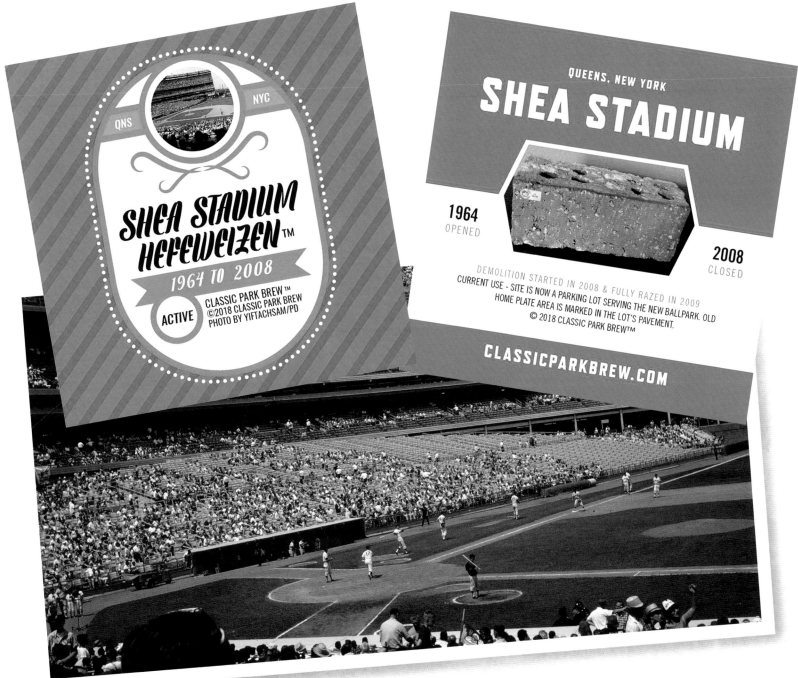

QNS · NYC

SHEA STADIUM HEFEWEIZEN™

1964 TO 2008

ACTIVE

CLASSIC PARK BREW™
©2018 CLASSIC PARK BREW
PHOTO BY YIFTACHSAM/PD

QUEENS, NEW YORK

SHEA STADIUM

1964
OPENED

2008
CLOSED

DEMOLITION STARTED IN 2008 & FULLY RAZED IN 2009
CURRENT USE - SITE IS NOW A PARKING LOT SERVING THE NEW BALLPARK. OLD
HOME PLATE AREA IS MARKED IN THE LOT'S PAVEMENT.
© 2018 CLASSIC PARK BREW™

CLASSICPARKBREW.COM

Late sixties (Dada1960/ CC BY-SA 4.0)

Shea Stadium ★ 99

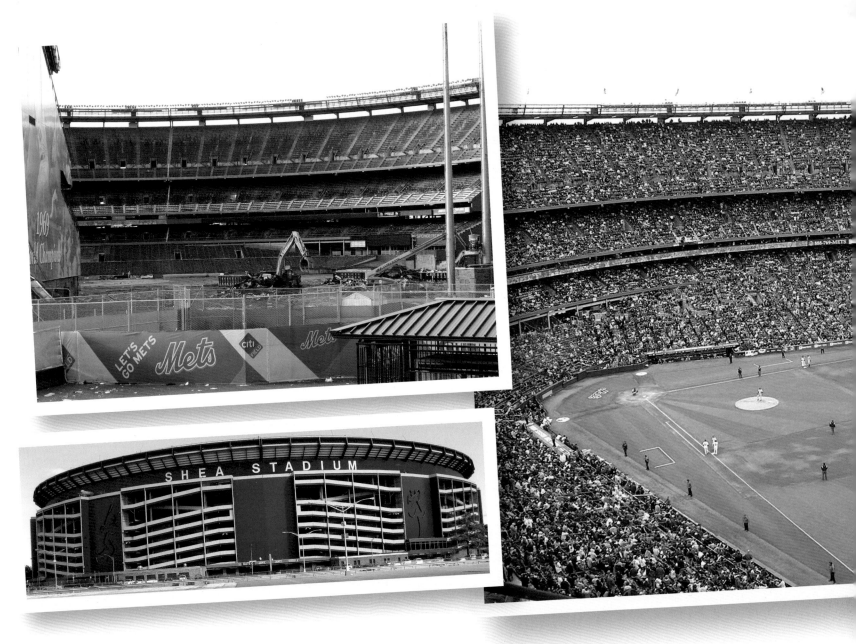

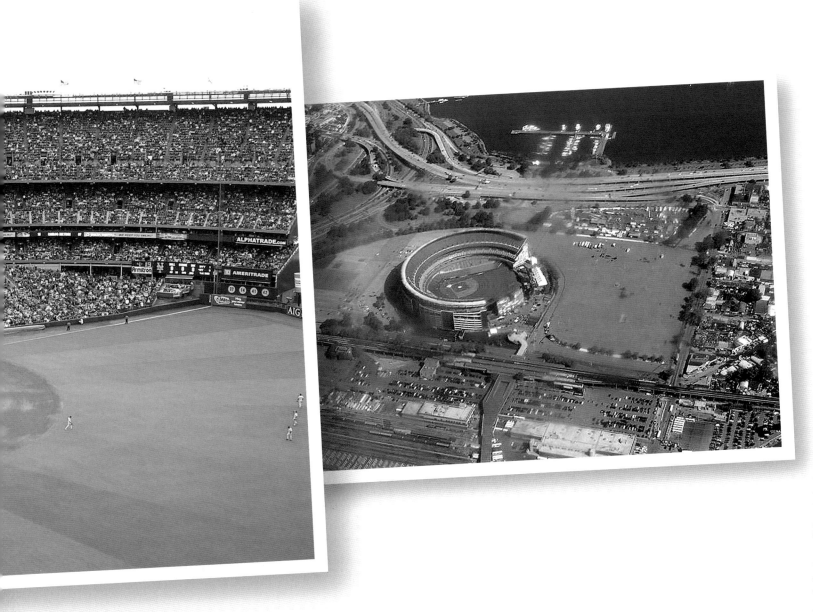

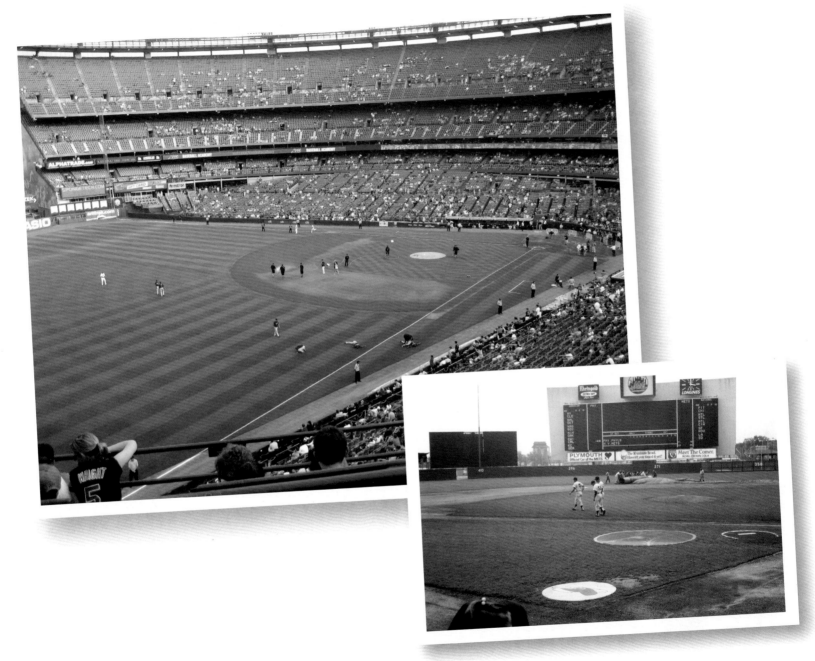

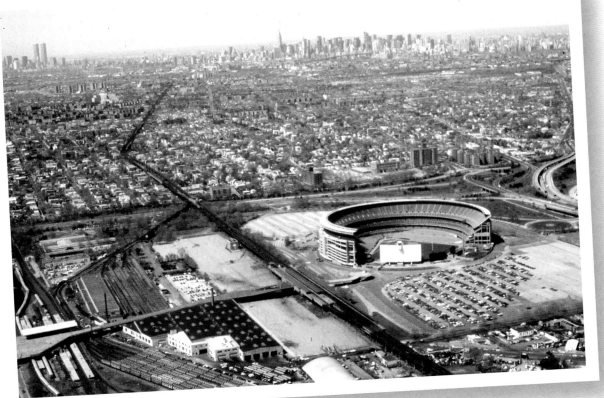

Shibe Park

Built in 1909 on a city block, Shibe Park was tightly bordered by north Philadelphia residential homes. Regal design was used at the front facade of this first full concrete and steel stadium in MLB. A mini tower with a domed roof fronted the exterior, which included red brick, windows, doors, and arches. Other areas had white masonry. The brick called to mind an old secondary school, while the sectioned white areas resembled a factory. Capacity was in the low–thirty thousands. Many seats were red, and the right-field wall, decking, panels, and columns were gray. Outfield dimensions were non-circular. In the vicinity of center-field, there were nooks at the wall. The center-field distance was far but got reduced to normal depth in its last years. The advertisement-filled, large in-play scoreboard in right field was a high barrier. Column-supported double decking reached both foul pole areas. Left field had its own double-decked grandstand with a roof low enough that home runs could clear, but only if hit very solidly. Initially, rowhouse residents viewed games from the tops of their homes beyond right field, but by the 1930s, a high corrugated, gray, metal fence was installed to prevent viewing. The stadium was thereby more enclosed, but fans sitting higher up could still look upon the neighborhood. Parking at the venue was challenging, as lots were in short supply and street spaces were the only other option. Maintenance issues worsened at the end, with rust and peeling paint the least of them. Hot dogs had a reputation for tastiness. Before 1961, no beer was sold due to state restrictions. Fans had a raucous reputation; they removed bolted-down items at the last game.

Other Historic Highlights: The 1910, 1911, 1913, 1914, 1929 to 1931, and 1950 MLB World Series were played there, as were the 1943 and 1952 All-Star Games. Negro League World Series games took place there in 1942, 1945, and 1947. The Athletics opened the venue in 1909, and the Phillies became permanent tenants in 1938. Just prior to the Athletics' departure for Kansas City, the ballpark's name changed to Connie Mack Stadium in 1953.

Tombstone Facts:

Location: North Philadelphia, Pennsylvania
Opened: 1909
Closed: 1970
Demolition: 1976
Current use: After closure, the abandoned park had a fire in 1971. The park did not get razed until five years later. Then, the site stayed vacant for two decades. It is now occupied by a church.

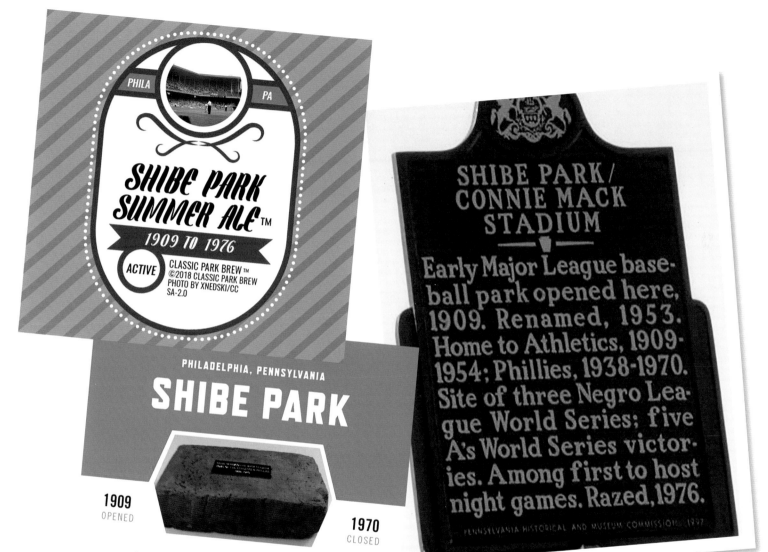

PHILA PA

SHIBE PARK SUMMER ALE™

1909 TO 1976

ACTIVE CLASSIC PARK BREW ™
©2018 CLASSIC PARK BREW
PHOTO BY XNEDSKI/CC
SA-2.0

PHILADELPHIA, PENNSYLVANIA

SHIBE PARK

1909
OPENED

1970
CLOSED

RAZED IN 1976. ABANDONED PARK HAD FIRE IN 1971
CURRENT USE - SITE WAS VACANT LOT FOR TWO DECADES & IS NOW OCCUPIED BY A CHURCH.
© 2018 CLASSIC PARK BREW™

CLASSICPARKBREW.COM

SHIBE PARK/ CONNIE MACK STADIUM

Early Major League base-ball park opened here, 1909. Renamed, 1953. Home to Athletics, 1909-1954; Phillies, 1938-1970. Site of three Negro League World Series; five A's World Series victor-ies. Among first to host night games. Razed, 1976.

PENNSYLVANIA HISTORICAL AND MUSEUM COMMISSION 1997

Shibe historical marker (Bob Brophy/CC BY-SA 4.0)

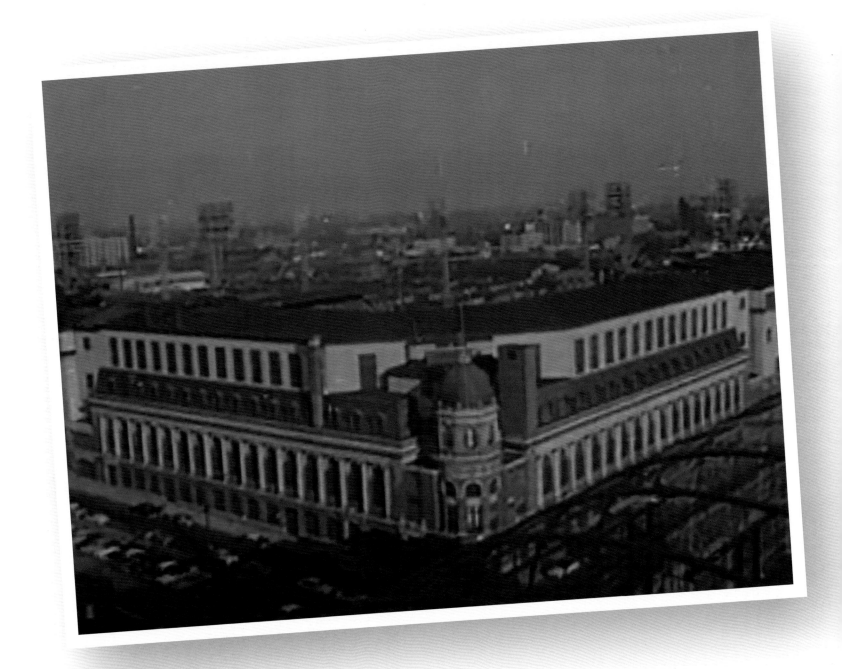

CONCESSION PRICES

OSCAR MAYER RED HOTS .. 25c
FORMOST KOSHER RED HOTS 30c
FISH CAKES SERVED ON A VIRNELSON'S ROLL 20c
(MEE'S) .. 15c
COCA-COLA ... 15c
HIRES' ROOT BEER .. 15c
ORANGE
COCA-COLA AND ROOT BEER WITH ICE 25c
(VENDERS ONLY) LARGE SIZE 15c
PEANUTS .. 25c
POPCORN AND MEGAPHONE 20c
HOT CHOCOLATE .. 10c
COFFEE (SNACK BAR ONLY) 25c
CAMEL CIGARETTES ... 25c
OLD GOLD CIGARETTES ... 25c
LUCKY STRIKE CIGARETTES 25c
PHILIP MORRIS CIGARETTES 15c
PHILLIE CIGARS .. 20c
EL PRODUCTO CIGARS ... 05c
BEECHNUT GUM

THE FOLLOWING SANDWICHES SOLD
AT SNACK BAR ONLY:

HAMBERGERS ... 25c
BAR-B-QUE PORK .. 35c
HAM SANDWICHES .. 40c
CHEESE SANDWICHES .. 25c
HAM AND CHEESE SANDWICHES 50c
HOT DOGS WITH ERNST'S SAUERKRAUT
(SNACK BAR ONLY)

PLEASE NOTE:

All Vendors and Stand Employees have uniform numbers. Any complaint can only be rectified when having EXACT UNIFORM NUMBERS.

LOGAN PARKER
Gen'l Mgr., Concessions and Advertising

Sicks Stadium

Constructed in 1938 and located in southeast Seattle, this stadium was a minor-league ballpark for multiple decades, with one MLB season in 1969, for the short-lived Seattle Pilots. The exterior was white, with the name identifier on the facade's top portion. A game-schedule display sign was located next to the venue. It was mounted on a pillar-like stand that included an ornamental simulated large baseball bat and ball.

Compact in size, the stadium was single-decked, with a roof covering the infield grandstand seats, short outfield dimensions, and lower seating capacity, which maximized to the mid–twenty thousands. It had a modest-sized, plain scoreboard beyond center field. A large right-field bleacher accompanied smaller left- and center-field bleachers for outfield seating. The venue had its third-base side against an incline of a hillside and first-base side next to a roadway. With just one level of seats, the views to the outside of the ballpark were open, showing hills, trees, and structures. Seats were blue and yellow. Parking lots were available behind the frontage and at the outfield exterior.

This short-term MLB stadium continued as a minor-league and amateur facility for the decade following its lone 1969 Major League Baseball season. Some dwellings beyond the outfield hillside overlooked the field and allowed a view of the game for free.

Other Historic Highlights: No MLB World Series or All-Star Game took place at Sicks Stadium. The first MLB game played in the Northwest region happened there on April 11, 1969. Pilots pitcher Jim Bouton kept a diary of the 1969 season, as part of his *Ball Four* book project. Boxing events featuring well-known prize fighters and concerts featuring famous musicians came to pass at the venue.

Tombstone Facts:

Location: Southeast Seattle, Washington
Opened: 1938
Closed: 1976
Demolition: 1979
Current use: Demolished and stripped for parts, the site is now occupied by a retail store. A plaque near the store exit identifies the former stadium.

DEC • 65

SICKS' SEATTLE STADIUM

Historic Site of
Sick's Stadium
1938-1979
Home of the Seattle Rainiers
Baseball Club

SEA · WASH

SICKS STADIUM
SMOKED PORTER™

1938 TO 1979

ACTIVE

CLASSIC PARK BREW®
©2018 CLASSIC PARK BREW
PHOTO BY SEATTLE MUNICIPAL
ARCHIVES/ITEM #193022

SEATTLE, WASHINGTON

SICKS STADIUM

1938
OPENED

1976
CLOSED

DEMOLISHED IN 1979 AND STRIPPED FOR PARTS
CURRENT USE - SITE IS OCCUPIED BY RETAIL STORE. A PLAQUE NEAR STORE EXIT
IDENTIFIES THE FORMER STADIUM.
©2018 CLASSIC PARK BREW™

CLASSICPARKBREW.COM

Sportsmans Park

Reconstructed in 1902 and updated from wood to concrete and steel in 1909, this classic northwest St. Louis ballpark had column-supported double-deck stands from the infield to each foul pole. Columns presented fan obstruction, as did so many stadiums of the era. Outfield bleachers consisted of an uncovered, left-field pavilion and a roofed, right-field pavilion. The right-field dimensions were shorter than that of the left field, although a high screen stood in front of the right-field pavilion seats. Left-handed pull hitters attempted to hit lofty fly balls to clear the right-field fence. Center field was quite deep, which made the outfield asymmetrical.

Columns were red at the bottom and green above, and the outfield fences were green. Parts of the exterior at the base wall, sides, and outfield pavilions were reminiscent of an erector set. Columns, white walls, and glass block also formed the exterior. Outside near the home-plate area stood white base supports, a white minitower, and a green support grid for the upper deck.

The seat levels inside the venue had separation to allow outside visibility between the two decks. Fans setting their gaze above the single-level outfield stands were treated to a neighborhood panorama.

During the park's prime, capacity stood at the low–thirty thousands. Sportsmans Park, which was renamed Busch Stadium in the early 1950s, boasted enthusiastic fans and good attendance.

Other Historic Highlights: The 1926, 1928, 1930, 1931, 1934, 1942 to 1944, 1946, and 1964 MLB World Series were played there. The 1940, 1948, and 1957 All-Star Games happened here too. While two tenants shared the stadium, the Cardinals eventually stayed longer than their cotenant, the Browns, which left in 1954. The cotenants played one another at this venue in the 1944 World Series.

Tombstone Facts:

Location: Northwest St. Louis, Missouri
Opened: 1902
Closed: 1966
Demolition: 1966
Current use: Demolished almost immediately after the last baseball game in May 1966, the site is now occupied by a youth athletic facility with amateur sports fields. A sign on an exterior wall identifies the former stadium site.

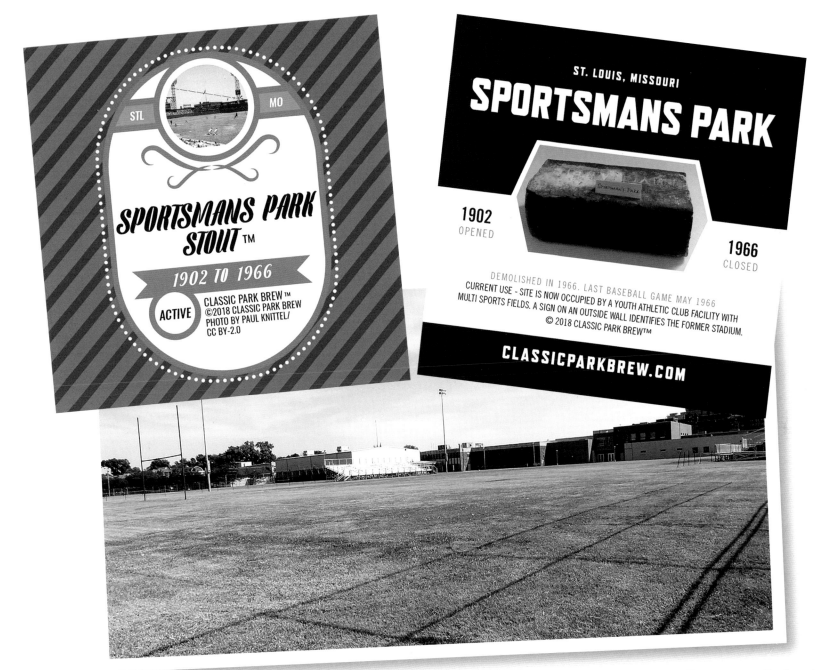

STL · MO

SPORTSMANS PARK STOUT ™

1902 TO 1966

ACTIVE

CLASSIC PARK BREW ™
©2018 CLASSIC PARK BREW
PHOTO BY PAUL KNITTEL/
CC BY-2.0

ST. LOUIS, MISSOURI

SPORTSMANS PARK

1902
OPENED

1966
CLOSED

DEMOLISHED IN 1966. LAST BASEBALL GAME MAY 1966
CURRENT USE - SITE IS NOW OCCUPIED BY A YOUTH ATHLETIC CLUB FACILITY WITH
MULTI SPORTS FIELDS. A SIGN ON AN OUTSIDE WALL IDENTIFIES THE FORMER STADIUM.
© 2018 CLASSIC PARK BREW™

CLASSICPARKBREW.COM

Site in 2012 (Delaywaves / CC BY 3.0)

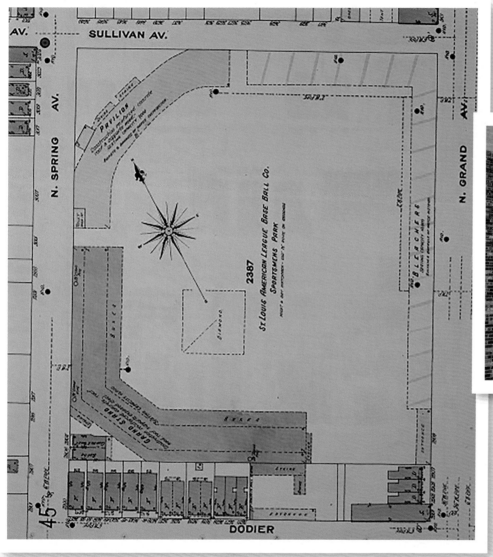

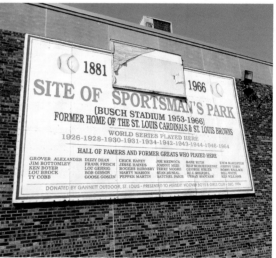

GENERAL PREFACE

Dov Gabbay, Paul Thagard, and John Woods

Whenever science operates at the cutting edge of what is known, it invariably runs into philosophical issues about the nature of knowledge and reality. Scientific controversies raise such questions as the relation of theory and experiment, the nature of explanation, and the extent to which science can approximate to the truth. Within particular sciences, special concerns arise about what exists and how it can be known, for example in physics about the nature of space and time, and in psychology about the nature of consciousness. Hence the philosophy of science is an essential part of the scientific investigation of the world.

In recent decades, philosophy of science has become an increasingly central part of philosophy in general. Although there are still philosophers who think that theories of knowledge and reality can be developed by pure reflection, much current philosophical work finds it necessary and valuable to take into account relevant scientific findings. For example, the philosophy of mind is now closely tied to empirical psychology, and political theory often intersects with economics. Thus philosophy of science provides a valuable bridge between philosophical and scientific inquiry.

More and more, the philosophy of science concerns itself not just with general issues about the nature and validity of science, but especially with particular issues that arise in specific sciences. Accordingly, we have organized this Handbook into many volumes reflecting the full range of current research in the philosophy of science. We invited volume editors who are fully involved in the specific sciences, and are delighted that they have solicited contributions by scientifically-informed philosophers and (in a few cases) philosophically-informed scientists. The result is the most comprehensive review ever provided of the philosophy of science.

Here are the volumes in the Handbook:

Philosophy of Science: Focal Issues, edited by Theo Kuipers.

Philosophy of Physics, edited by Jeremy Butterfield and John Earman.

Philosophy of Biology, edited by Mohan Matthen and Christopher Stephens.

Philosophy of Mathematics, edited by Andrew Irvine.

Philosophy of Logic, edited by Dale Jacquette.

Philosophy of Chemistry and Pharmacology, edited by Andrea Woody, Robin Hendry and Paul Needham.

Philosophy of Statistics, edited by Prasanta S. Bandyopadhyay and Malcolm Forster.

Philosophy of Information, edited by Pieter Adriaans and Johan van Benthem.

Philosophy of Technology and Engineering Sciences, edited by Anthonie Meijers.

Philosophy of Complex Systems, edited by Cliff Hooker.

Philosophy of Ecology, edited by Bryson Brown, Kent Peacock and Kevin de Laplante.

Philosophy of Psychology and Cognitive Science, edited by Paul Thagard.

Philosophy of Economics, edited by Uskali Mki.

Philosophy of Linguistics, edited by Ruth Kempson, Tim Fernando and Nicholas Asher.

Philosophy of Anthropology and Sociology, edited by Stephen Turner and Mark Risjord.

Philosophy of Medicine, edited by Fred Gifford.

Details about the contents and publishing schedule of the volumes can be found at http://www.elsevier.com/wps/find/bookseriesdescription.cws_ home/BS_ HPHS/ description

As general editors, we are extremely grateful to the volume editors for arranging such a distinguished array of contributors and for managing their contributions. Production of these volumes has been a huge enterprise, and our warmest thanks go to Jane Spurr and Carol Woods for putting them together. Thanks also to Lauren Schulz and Gavin Becker at Elsevier for their support and direction.

Handbook of Philosophy of Science
Volume 16
Philosophy of Medicine

Edited by

Fred Gifford

AMSTERDAM • BOSTON • HEIDELBERG • LONDON • NEW YORK • OXFORD
PARIS • SAN DIEGO • SAN FRANCISCO • SINGAPORE • SYDNEY • TOKYO
North Holland is an imprint of Elsevier

ELSEVIER

North Holland is an imprint of Elsevier
The Boulevard, Langford lane, Kidlington, Oxford, OX5 1GB, UK
Radarweg 29, PO Box 211, 1000 AE Amsterdam, The Netherlands
30 Corporate Drive, Suite 400, Burlington, MA 01803, USA

First edition 2011

British Library Cataloguing in Publication Data
A catalogue record for this book is available from the British Library

Library of Congress Cataloging-in-Publication Data
A catalog record for this book is available from the Library of Congress

ISBN: 978-0-444-51787-6

For information on all North Holland publications
visit our web site at elsevierdirect.com

Transferred to Digital Printing in 2011

Working together to grow
libraries in developing countries
www.elsevier.com | www.bookaid.org | www.sabre.org

ELSEVIER BOOK AID
 International Sabre Foundation

CONTRIBUTORS

Robyn Bluhm
Old Dominion University, USA.
rbluhm@odu.edu

Christopher Boorse
University of Delaware, USA.
cboorse@udel.edu

Kirstin Borgerson
Dalhousie University, Canada.
kirstin.borgerson@dal.ca

Benjamin Djulbegovic
University of South Florida, USA.
bdjulbeg@health.usf.edu

Fred Gifford
Michigan State University, USA.
gifford@msu.edu

Sander Greenland
University of California, USA.
lesdomes@ucla.edu

Iztok Hozo
Indiana University Northwest, USA.
ihozo@iun.edu

John Lizza
Kutztown University of Pennsylvania, USA.
lizza@kutztown.edu

Dominic Murphy
University of Sydney, Australia.
dominic.murphy@sydney.edu.au

Dean Rickles
University of Sydney, Australia.
dean.rickles@sydney.edu.au

Mark Risjord
Emory University, USA.
mark.risjord@emory.edu

Kazem Sadegh-Zadeh
University of Münster Clinicum, Germany.
ksz-3@medizintheorie.de

Kenneth F. Schaffner
University of Pittsburgh, USA.
kfs@pitt.edu

Jeremy R. Simon
Columbia University: College of Physicians and Surgeons, USA.
js1115@columbia.edu

Miriam Solomon
Temple University, USA.
msolomon@temple.edu

Daniel Steel
Michigan State University, USA.
steel@msu.edu

David Teira
Universidad Nacional de Educación a Distancia, Spain.
dteira@fsof.uned.es

Paul Thagard
University of Waterloo, Canada.
pthagard@uwaterloo.ca

R. Paul Thompson
University of Toronto, Canada.
p.thompson@utoronto.ca

CONTENTS

x

PHILOSOPHY OF MEDICINE: INTRODUCTION

Fred Gifford

The philosophy of medicine, as conceived of here, encompasses the topics connected to the philosophy of science that arise in reflection upon medical science and practice. The chapters in this volume span a broad range of such topics.

Considering medicine in the context of science, one obvious question is that of the comparison of medicine with the other sciences: is medicine distinctive, and if so, in what way? And insofar as it is seen as distinctive, is it in some way second rate, such that we should find its explanations less compelling than those in the physical sciences, or recommend to those pursuing medical science that they emulate — or give way to — the physical sciences?

Whether the question is distinctiveness or inferiority, this line of thought urges us to reflect further on just what our domain here is. On the one hand, these comparisons come up for *biological science in general*: it is sometimes asked whether biology lives up to the other sciences, or whether its forms of explanation are unique, etc. Here the worry — or insight — might not be something specific to medicine, but something about biology more generally. But we can also ask these questions about *medical* science more specifically. Is something distinctive about *medical* science *vis-à-vis biological* science, and if so, how does this reflect on medical science, and what does it mean for the kind of endeavor it is? Finally, there is also a distinction between medical *science* and the *practice* of medicine, so perhaps at least some of the distinctive aspects of medicine (and hence of the philosophy of medicine) come from its being a practice, where the goal is the improvement of health rather than the achievement of theoretical understanding.

In any case, while it may be useful to distinguish medical science and medical practice, this volume deals with both, as both raise epistemological, conceptual, and methodological issues that belong to the philosophy of science.

There are, represented here, a variety of topics and a variety of *kinds* of topics. In some cases, some well-known meta-scientific concept that applies across all of science is considered in relation to medicine or medical science in particular. This is true, for instance, in the cases of discovery, reduction, theories and models, and causal inference. Other chapters focus on some particular *domain* (psychiatry, public health, nursing). Some discuss some *key concept* that comes up specifically in medicine (diagnosis, health and disease, brain death).

Medical science and medical practice are, of course, activities in the real world, and hence they are often connected with a number of ethical and policy issues.

Handbook of the Philosophy of Science. Volume 16: Philosophy of Medicine.
Volume editor: Fred Gifford. General editors: Dov M. Gabbay, Paul Thagard and John Woods.

Such normative considerations or implications can almost always be discerned in the background in the following chapters, and in some cases they are more directly in view. Indeed, these normative issues can quite often be a significant motivation for addressing the conceptual, epistemological, and methodological questions constitutive of the philosophy of science. But it is the philosophy of science issues, not the ethical and policy questions, that constitute the central purpose and content of the diverse chapters in this collection.

The collection begins with "Concepts of Health and Disease", where Christopher Boorse takes up what is sometimes thought of as the central conceptual question for medicine. What is health? What does it mean to say that something is a disease? Can we give a general account that captures all of our usage here? Do we or can we make such assessments in an objective way? Or does asserting that some condition is pathological necessarily involve the making of a value judgment, and relatedly, is it necessarily relative to a particular culture? Are "mental" diseases of a different sort than "physiological" diseases, or will one account fit both? (Note that this question of the distinction between health and disease, or normality and abnormality, is distinct from the nosological question of how conditions are to be categorized into particular diseases (and whether *that* is objective).)

Further, what are the criteria for judging whether an analysis of the term 'health' or the term 'disease' is adequate? Is it a matter of what fits with the language of medical textbooks? The linguistic intuitions of lay people? The normative decisions we need to make (concerning treatment or insurance coverage, for instance) based on whether something is determined to be a disease?

The concepts of health and disease appear to be quite fundamental for medicine, as we take medicine to have the goals of diagnosis, prevention and cure of diseases or the advancement of health. And yet there has been a great deal of disagreement in the literature in philosophy of medicine on this topic.

Boorse presents and evaluates his own non-normative, "biostatistical" theory, according to which health is normal functioning, a matter of one's biological organs and systems functioning at or above species-typical efficiency; and he also presents and evaluates Wakefield's "harmful dysfunction" analysis, which asserts that a normative element enters in the judgment that some state is harmful, but which also requires the presence of dysfunction, something determined by the biological facts. He then goes on to deal with two important "action-theoretic" accounts, those of Fulford and Nordenfeld, which understand health and illness in terms of the ability or inability to act, and relatedly in terms of ordinary concepts applied to the person as a whole, rather than more medical concepts that could apply to component organs. Finally, Boorse provides a detailed treatment of the approach of Lawrie Resnek, and then briefer treatments of several other views.

Jeremy Simon's chapter, "Medical Ontology", takes on a different set of questions about this central concept of disease. Here the question is not (as in the previous chapter) how to draw a line between healthy and diseased states, or the normal and the pathological. Simon is concerned instead with how we should understand the nature, ontologically speaking, of diseases — the individual entities

or processes as well as the disease categories. The question is whether disease entities and categories pick out something objective or real, or whether, for example, the categories are just conventional labels used for grouping certain patients together. Thus the question is how the realism/anti-realism debate — a long and rich one in the philosophy of science — plays out concerning diseases.

'Realism' and 'anti-realism' have denoted a wide range of positions in the philosophy of science, and there are various arguments for and against each of these. Simon surveys a number of such positions and evaluates them in light of their implications for realism about disease. Disease and disease categories play a somewhat different role in medicine than do entities and categories in other sciences, and so the application of these positions and arguments are not always straightforward.

In the case of the realist positions, Simon discusses arguments such as that concerning inference to the best explanation, as well as the counterarguments concerning causal complexity, the lack of law-like regularity in medicine, and the pessimistic meta-induction from the history of science. Amongst the anti-realist positions, Simon focuses especially on constructivism as the most promising form of anti-realism about disease. He distinguishes a number of subtypes of this view and outlines the arguments for and against it.

The problem of "extremal diseases" (such as hypertension), where the difference from the normal state is only quantitative and the exact cut-off seems so clearly conventional, is worth special mention. Not only is this quite common phenomenon interesting and challenging, it is an example that raises questions simultaneously about the reality of the categories and about the distinction between health and disease.

In his chapter, "Theories and Models in Medicine", Paul Thompson describes and analyzes the construction and use, in medical science, of models (which provide descriptions, sometimes mathematical ones, of systems) and theories (large, general models that integrate submodels). In so doing, he illustrates both their importance in medical science and how this is quite in line with such construction and use in the natural sciences (and, interestingly, in engineering). He utilizes as his examples some models of different levels of generality — Bolie's insulin-glucose model, the menstrual cycle, and the mathematical modeling of epidemics — to illustrate the role of theories and models in various scientific endeavors. In particular, he shows their ability to integrate large bodies of knowledge and support counterfactuals, leading to predictions and explanations, and their ability to manipulate nature and interpret and correct empirical observations.

Concerning the mathematical modeling of epidemics, he shows how this has been used in explanation and testing. In particular, a sub-model called the Reed-Frost chain binomial model has yielded very important insights concerning the Black Death, narrowing the range of possible causes and providing evidence against the widely held Bubonic plague hypothesis. Relatedly but more immediately important, such modeling is relevant to critical practical questions concerning present-day epidemics about what interventions are likely to be effective.

Thompson also distinguishes the sort of explanatory power of models and theo-

ries from the kind of narrow information obtained from randomized clinical trials, since, without an account of the dynamics provided by an appeal to theory, a randomized clinical trial yields evidence for an isolated causal claim at best.

Another important philosophical topic for the biomedical sciences is reductionism, and the set of issues that arise from considering the relationship between fields, questions, theories and entities at different "levels" of organization, such as those of molecules, cells, organs, organisms, etc. The philosophical questions that arise here span ontological ones concerning what items should be said to exist and methodological ones concerning whether biology and medicine ought to take up the methods of physics and chemistry. Ken Schaffner's chapter, "Reduction in Biology and Medicine", addresses the fact that there do appear to be reductive explanations taking place in biomedicine in terms of underlying phenomena, and yet there is controversy about this and about how it should be conceptualized. Much of the debate has been on the question of whether the account of inter-theoretic reduction inherited from the logical empiricist tradition, with its emphasis on theories in the physical sciences, should be seen as the appropriate model for other sciences, and how to respond if the complexity of the biomedical cases seems to prohibit reduction in those terms.

Schaffner is interested in how this will play out for the scientific investigation of complex and higher level traits of organisms like humans. But he starts small. He reviews in detail the underlying explanations of some specific behaviors of the roundworm, *C. elegans*, and shows that even in such a simple case, the reduction that is carried out is very partial and incomplete, and that we cannot expect to fill it in. Obviously this sort of patchiness and incompleteness will be much more pronounced once we consider the higher level and more complex phenomena of human biomedicine and psychiatry.

But first, it must be borne in mind that the robust sort of reduction referred to here very rarely occurs in physics either, so the above-mentioned patchiness and incompleteness is not a function of their having to do with biology or medicine *per se*. And second, Schaffner also insists that these fragmentary patchy explanations stand as important scientific achievements, not as scientific failures. But we gain a better understanding of them if we think of them and their success in terms of explanation, not inter-theoretic reduction. So Schaffner goes on to give an analysis of what such micro-explanation involves and why it is explanatory and worthwhile, connecting it to other ideas about explanation. One of those ideas involves the fact that these explanations are in terms of interlevel mechanisms, so one line of investigation would be to clarify the role of "mechanism" in explanation.

Dan Steel's chapter, "Causal Inference in Medical Experiments", discusses causal inference in medicine, focusing on the context of medical experiments (as opposed, for instance, to observational studies). Steel first reviews the various general philosophical accounts of causation (probabilistic, counterfactual, mechanistic and manipulation) and what virtues they have in relation to medicine. He shows in some detail how facets of medical experimentation can be illuminated by appeal to a "Bayesian networks approach" to causal inference, which involves utilization of

a set of nodes connected by arrows for representing causal claims. Such an account enables the derivation of statistically testable predictions and helps us to determine what to conclude from a given test and thus to make recommendations about what tests to perform. With this as background, he addresses a number of methodological issues — including issues of internal and external validity — concerning medical experiments, and concerning randomized clinical trials in particular. These include methodological aspects of some of the ethical issues associated with such clinical trials. His discussion of the external validity of experiments focuses on animal research aimed at drawing conclusions about humans, and he evaluates the challenges for making and assessing such extrapolations.

Discovery in the biomedical sciences is addressed by Paul Thagard's chapter, "Patterns of Medical Discovery". The topic of discovery has received substantial attention in recent years, though it was for a long time left aside by philosophers. From the perspective of logical empiricism, it was alleged that normative philosophical analysis could be provided only for questions concerning the evaluation or justification of theories once they were created, whereas questions of discovery and generation of new concepts and theories involved an unanalyzable creative process that could only be given a descriptive analysis by the psychologist, for there was no "logic of discovery". This sharp distinction between the context of discovery and the context of justification has now long been challenged, and Thagard's writings constitute part of the work generated by this.

Thagard offers a taxonomy for classifying medical breakthroughs, including both the generation of new hypotheses (about basic biological processes, about the causes of diseases, about treatments of diseases, and about the utility of new diagnostic instruments) and new methods (such as Koch's postulates or controlled clinical trials). Focusing especially on a detailed case analysis of the discovery that stomach ulcers are caused by a bacterial infection, Thagard then shows how a number of psychological patterns of discovery in the medical sciences can indeed be discerned, and how these patterns can be made sense of in a naturalistic account conceived in terms of cognitive neuroscience. Further, he argues that the study of patterns at this level — as well as of the role of computers in the discovery process (as used in the Human Genome Project and in the use of robotics in drug discovery) — should be studied by philosophers of science interested in developing an account of scientific discovery and the growth of knowledge.

"Evidence-based medicine" (EBM) can be seen as part of an effort to make medicine more "scientific" in its method of evaluation. It is a practice and movement that arose in the 1990's in response to the significant problem of unwarranted variation in medical practice and the need to work out systematically how we should assess the appropriateness of various therapies in a way that both is warranted and will convince practitioners to act according to the evidence rather than hide behind clinical judgment. Analysis of EBM and the debate surrounding it is both very practically important for addressing the problems of medical policy, and also philosophically rich, as it links with the theoretical understanding of medical evidence, reasoning and judgment, and how we should in fact assess

diverse evidence.

In "Evidence-Based Medicine", Robyn Bluhm and Kirstin Borgerson present an analysis of this practice and movement of EBM. They provide a history of how it came to be, a description of the specific components of EBM, and an account of the controversies that exist within it (including the contentiousness of different definitions and conceptions of EBM). They argue that following this program as it has come to be practiced is not warranted. They are especially critical of the "hierarchy of evidence" that exists within it, which privileges randomized clinical trials on large populations over all else. While there are methodological advantages to the use of such trials when they can be done, the arguments for their overall superiority are far from determinative (as noted in the chapters by Steel and by Teira), and the conclusion that we can be dismissive of all non-randomized evidence is farther still. There are in addition ethical costs to the performance of RCTs, a topic that Bluhm and Borgerson also discuss. This sort of connection between ethics and epistemology in medicine is suggested, along with theories of evidence and social epistemology, as an important direction for future research connected to EBM.

In "Group Judgment and the Medical Consensus Conference", Miriam Solomon also analyses an important social practice or institution related to medical knowledge — namely, the NIH Consensus Development Conferences, begun in the late 1970's.

Like the creation of Cochrane reviews and guidelines tied to the project of evidence-based medicine, this is a social enterprise justified by the goal of improving medical practice. In this case, the objective is to take particular questions of practice and subject them to a systematic process of evaluation — one in which the best, most recent evidence is presented to a number of experts, during a period of two to three days, and they are asked to come to an agreement about what the most reasonable position is.

Solomon analyses these consensus conferences from the point of view of social epistemology, demonstrating that in fact they do not yield objective decisions about these matters. This is in part because of the various ways that bias will arise in such a context, despite the claim that this is controlled for, and in part because of the timing of such conferences: Given that there is so much at stake in coming to agreement, and given the time necessary to arrange the conference, this ends up being late enough for there already to be a consensus in the community. Instead of their playing an epistemic role, it is more plausible to see consensus conferences as playing a rhetorical and political role, making results well-known and convincing the community to change their practice. These things are obviously important for us to understand if we want to consider whether such institutional mechanisms ought to be reformed or eliminated. Exploration of these matters is also significant because of their ties to important theoretical issues concerning the nature of (group) judgment and concerning social epistemology.

In "Frequentist vs. Bayesian Clinical Trials", David Teira discusses a central debate concerning the proper methodology of clinical trials — that between the

frequentist and Bayesian approaches to trial design and interpretation. (The focus of this chapter is drug trials, but the analysis is of more general relevance.) This is a debate that connects both to deep questions concerning the proper interpretation of probability and the debate about what counts as evidence in general, and also to practical and ethical dilemmas that arise concerning the performance of clinical trials. Teira describes each of these methodologies and their interpretations in detail, in part via a detailed recounting of certain important trials that have occurred.

Teira also argues that while the philosophical debate concerning Bayesianism and frequentism has been played out in terms of epistemological and ethical criteria, in fact there is another dimension that ought to be considered. This is the regulatory dimension: how does each approach fare with respect to how adequately the goals of regulation are achieved? While the Bayesian approach has much to recommend it, taking seriously this regulatory dimension, and in particular the desideratum of impartiality, makes this judgment much more complicated. This is explored in part via an examination of the decision process of certain regulatory bodies involved in the adoption of the frequentist standard.

"Uncertainty in Clinical Medicine", by Djulbegovic, Hozo and Greenland, addresses another topic concerning which there is a great deal of theoretical unclarity and yet at the same time a great deal of practical importance. Physicians find themselves in contexts where the data are incomplete, and from various sources, and where it can be said of each source that there are epistemological difficulties in inferring something about the medical case before them at the moment. Yet those physicians need to act. Further, as mentioned above in the discussion of EBM, there is a great deal of (presumably unwarranted) variation in clinical practice as a result. A clear understanding of this uncertainty would be welcome, but there are diverse meanings of uncertainty and diverse theoretical accounts of how it should be understood.

Djulbegovic, Hozo and Greenland provide an overview and analysis of this idea of uncertainty in medicine and the theories that have been put forward to understand it. They provide a taxonomy of the many ways this term is used and defined, its types and sources, and its connections to other concepts, such as (various conceptions of) probability. They describe a variety of theories, means of measurement, and areas of empirical work (e.g., psychological studies on judgments under uncertainty) which have been appealed to in what has been written about this topic, and in each case they provide one or more medical cases which illustrate how the ideas can be or have been applied to medical reasoning or medical problems. Finally, they consider some of the implications of this discussion for how uncertainties need to be managed, how they need to be communicated to patients, and what sort of training is appropriate for health care professionals who will be dealing with these phenomena of uncertainty.

In "The Logic of Diagnosis", Kazem Sadegh-Zadeh uses the tools of logic and analytic philosophy to provide a reconstruction of the concept of medical diagnosis, with the goal of clarifying and improving this concept and improving the quality

of medical decision-making, research and clinical practice. The discussion provides insight concerning both how to conceptualize the diagnostic activity and what to think of the prospects for improvement in diagnostic ability.

Sadegh-Zadeh begins by examining the syntax and semantics of diagnosis and then explores various methods that have been proposed for generating those diagnoses (such as hypothetico-deductive, Bayesian, similaristic and fuzzy logic reasoning). He also examines the pragmatics of diagnosis, ultimately arguing for an account that makes diagnosis relative to a complex context — the patient, the person doing the diagnosis, and the knowledge and method of reasoning utilized. He is also concerned to show that diagnosis is a social act. (For instance, it brings about a social fact by imposing the sick role.) Further, while the process of diagnosis is *computable*, it should be conceived as a *deontic act*, with the implication that it is to be understood as part of practical ethics.

Sadegh-Zadeh argues that there is no "logic of diagnostics", yet it must also be said that the process of medical diagnostics will include a number of logics. While in principle these various logics can be used, normatively, to improve the diagnostic process, for various reasons this will not be a matter of helping human physicians to perform this reasoning themselves, but rather will involve the increasing use of engineered medical knowledge-based systems. One reason for this is the fact of the continued and increasing explosion of medical knowledge, such that the logical operations which must be carried out will be ever-more complex. Another is the fact that medical language is inherently fuzzy (one of the sources of uncertainty identified by Djulbegovic, Hozo and Greenland), necessitating the use of fuzzy logic. Yet another is the fact that any sizable knowledge base, constructed from different domain experts, will not be consistent, necessitating paraconsistent logic. Hence, even if physicians were skilled in classical logic (which they are not) this would not be sufficient. All this means that the doctor will become less and less involved in the process of diagnosis, something that will surely have important social consequences.

The motivation behind Dominic Murphy's discussion of philosophy of psychiatry in "Conceptual Foundations of Biological Psychiatry" is the trend in modern psychiatry to become more biological. He addresses the question of whether (or to what extent or in what ways) the "medical model" appropriately captures psychiatry, and the implications of this for how we conceptualize psychiatric explanation and for the way in which mental illnesses are to be classified.

Of course, one of the tasks is to clarify what is meant by the "medical model". Murphy endorses what he calls the strong version of the medical model of psychiatry, according to which mental illnesses are caused by particular pathophysiological processes in the brain (so mental illness is disease of the brain). But, even though he argues that classification of psychiatric diseases should be based on causal hypotheses, he does not endorse the common view that their explanation must be given in terms of some specific level, such as that of molecular biology or genetics. On the one hand he doesn't want the endorsement of this version of the medical model to entail anything about what processes must be appealed to in these expla-

nations. In fact, Murphy does have a view here about the appropriate approach for conceptualizing psychiatry and mental illness: psychiatry is to be viewed as an "applied branch of the cognitive neurosciences."

The task he sets for himself of course ties to several other chapters from this volume; it deals with the nature of (mental) illness, the question of realism about disease categories, the nature of explanation, the levels of explanation and the temptations of reductionism. His examination of the nature of explanation in psychiatry, involving models which explain exemplars, utilizes the work of Giere and others on models, and Thagard's work on diseases as causal networks.

John Lizza's chapter, "Brain Death", addresses the philosophical debate generated by controversy over conceptual and definitional questions about death. Controversy arose once medical advances made it possible to keep people alive, but only ambiguously so (for instance, someone without discernable neurological activity, having spontaneous heartbeat but with respiration continuing only because of a mechanical respirator). This sort of case challenged the traditional definition of death, especially in the face of practical, ethical and legal questions such as those concerning when one could remove organs for transplantation. This challenge forces upon us a whole range of questions — epistemological, conceptual and ethical. Indeed part of the philosophical task concerns how to tease apart different questions, such as those concerning the concept, the definition, and the criteria for the determination of death.

Lizza begins by describing these discoveries, practices and legal cases, and then proposals that were made, such as those of the Ad Hoc Committee of the Harvard Medical School to Examine the Definition of Brain Death in 1968 and the President's Commission for the Study of Ethical Problems in Medicine and Biomedical and Behavioral Research in 1981. The latter concluded that death could be established by showing "irreversible cessation of all functions of the entire brain, including the brainstem." These proposals had a substantial impact, but they left certain questions unresolved; for some, it was still difficult to accept, and it was terminologically quite complicated and confusing.

The philosophical debate that Lizza recounts concerns why, exactly, we should accept such a change. And why shouldn't we go further and take persons in persistent vegetative state (who lack function of the "higher brain", exclusive of the brain stem) to be dead? We are further led to consider: To what extent, and in what ways, is this a biomedical matter? What is meant by, and how do we assess: integration of the functioning of the organism as a whole, mere artificial support, the claim that a certain part of the brain supports consciousness? Must all brain function cease in order to say that brain function has ceased in the relevant sense? And how are all these connected to what death is?

The debate shares with that concerning the concepts of health and disease that different ways of conceptualizing these things have different practical – ethical and legal — implications. This is surely an important part of why they are controversial, why some might say that the judgments are ineliminably normative, or that there is worry about whether one's normative position is inappropriately driving

one's conceptual choice.

Health care is the concern and activity of a wide variety of health and health care practitioners — not only physicians. The term 'medicine', whether in 'philosophy of medicine' or in 'medical intervention', can obscure this; note the term 'medical school'. This is relevant to the next chapter, "Nursing Science". This topic has not been given much attention by philosophers of medicine, and yet, as Mark Risjord shows, nursing and nursing science present a rich set of important issues, ones with direct connection to the philosophy of science. These arise in part because of the kind of field that nursing is (practical, interdisciplinary, and in a very specific institutional role in the health care system), and in part because those involved in the new nursing research have been self-conscious in their attempts to create a new discipline.

The questions raised and debated have included: How should we deal with the fact that a wide range of phenomena are investigated, via a wide range of methods? To what extent does there need to be some unique or overarching theory for nursing? How are the various theories related to one another? For a practical discipline like nursing, how is the relationship between theory and practice, and between science and values, to be conceived? What is to be the relationship between quantitative and qualitative research? Those involved in the debates concerning nursing research and trying to establish the legitimacy of nursing science have been mindful of the complex goal of demonstrating the scientific credibility of nursing science, while at the same time making it maximally relevant to nursing practice.

Risjord describes how these matters have been dealt with over the history of debate about nursing research, and how these have interacted with positions in the philosophy of science of the time, whether that of the logical empiricists or of Kuhn and the post-postivists. Important developments in the thinking which Risjord discusses include methodological triangulation, middle-range theory and evidence-based practice.

Finally, Risjord argues that understanding nursing science from the perspective of "standpoint epistemology", as developed by feminists in recent years, can help us better address the philosophical issues that have arisen for nursing science.

It might be said that in the final chapter, "Public Health", Dean Rickles takes on a particular branch or field of medicine (or, better, of the health sciences), but it is of course somewhat different from and broader than taking on a branch of medical science like genetics, immunology, or even psychiatry, and this for a number of reasons. First, it's said that public health is not so much a scientific domain as a *practice* — defined in terms of certain practical problems — but of course this is could be said to be true of medicine as well. Moreover, rather than constituting some unique science, it utilizes a number of other sciences (such as epidemiology, demography, statistics, and various social sciences). Further, it tends not to be recognized as medicine when the latter is conceptualized as tied to individual doctors treating individual patients. For public health is concerned with the health of *populations*, as well as population-level interventions. So public

health would appear to be about *health*, but not (at least not always) about health *care*.

A wide range of philosophical questions are raised by public health. One was just raised: what is meant by population health? Even the definition of public health is controversial (what counts as public, what counts as health, and what connection should there be to social issues?), and it has been so historically. And of course most of the "standard" issues arise, concerning, for instance, the statistical nature of its subject matter, the nature of its evidence, and the use and interpretation of a variety of kinds of study designs.

One especially important question is that of how health is to be *measured*. For instance, we want to measure the impact of disease on populations, in order to address various matters related to policy decisions: we want to compare populations, to track changes over time, to measure "health inequalities", and to determine where intervention would be most appropriate. But what "summary measures" can most appropriately be used for these things is a complicated and controversial topic. This is one place Rickles puts forth a pragmatic position, that there won't be some one answer to the question, but rather it will vary depending on the theoretical or practical purposes at hand.

Finally I would like to say just a few more words about this particular collection of articles, and about the range of approaches and the range of medical examples. Of course, not all topics of importance have been provided a chapter here. Some topics are examined by multiple authors, without having their own chapters. Explanation, for example, is taken up in several places, such as in the chapters on models and theories, reductionism, and psychiatry. Randomized clinical trials are discussed by several authors. Even the more specific topic of ethical issues concerning RCTs (that is, the methodological issues underlying them) is dealt with briefly by each of Teira, Steel and Bluhm and Borgerson. It is also worth noting other examples of connections between chapters. Obviously the concepts of health and disease are discussed by a number of the authors. Meta-analysis comes up in discussions of evidence-based medicine and of public health. Clearly medical inference and judgment are brought up by the majority of the contributions.

These chapters come at the subject of philosophy of medicine from quite different angles. Obviously they take up different topics, but also they use different approaches and have different sorts of emphasis or means of analysis. Some attempt to provide a philosophical analysis of certain terms, concepts, or practices, such as health and disease, diagnosis, or medical experiment. All utilize reference to substantive cases from the science or practice of medicine, but they do this to different degrees and in different ways, sometimes more as illustration, sometimes more as evidence. It is also worth noting the range of biomedical cases that are utilized across the chapters, indicating the breadth of the field. In some ways, it is noteworthy the extent to which the same features or issues apply across such a wide variety of cases; of course, it is also true that there are sometimes differences, such that one has to keep in mind that certain claims really only apply well to a certain sub-domain of medicine or medical science.

Some, like Thagard, pull together and categorize a wide variety of scientific examples. Some (actually *including* Thagard) analyze a particular case in some detail. Schaffner, for instance, provides a quite detailed description of the line of argument given in certain scientific papers.

Several chapters provide substantial historical detail in order to make their case: in particular, those on Bayesianism and frequentism, evidence-based medicine, consensus conferences, nursing, psychiatry and public health. Finally, as mentioned at the outset, all to varying degrees connect with or at least have some of their motivation in value questions of some sort, but, again, it is the philosophy of science issues that constitute the focus.

CONCEPTS OF HEALTH AND DISEASE

Christopher Boorse

1 SIGNIFICANCE

Basic to many clinical disciplines are the concepts of health and of its various defects — illness, disease, disorder, pathology, injury, disability, and so on. Philosophical analysis of these ideas can clarify many issues, both in the health professions and in their relations to society. Such *internal* or *external* issues may be either *specific* to a particular disorder or *general*, touching a class of them.

As to specific internal issues, both ordinary medicine and psychiatry need a clear view of normality to decide whether some disputed diagnoses are disorders, or, for those that are, to fix their boundaries. Many such debates concern controversial treatments, such as giving children growth hormone for shortness [White, 1993; Tauer, 1995] or Ritalin for ADHD (*cf.* [Hawthorne, 2007]), or inducing pregnancy in postmenopausal women (*cf.* [Cutas, 2007]). Many people assume that if a child's shortness is due to normal variation, not disease, then drug treatment is medically inappropriate. Similarly, if ADHD diagnosis is, as some say, often based on behavior normal for boys, its control by drugs is widely viewed as unethical. Moreover, even such well-established disorders as deafness are now sometimes denied to be such. Some disability advocates call deafness a normal variant on which a separate deaf culture is based, and so they oppose cochlear implants in children to cure it (*cf.* [Sparrow, 2005; Broesterhuizen, 2008; Shaw, 2008]).

The most famous controversies over normality involve sexual psychopathology. The best-known recent example is the 1973 decision [Bayer, 1981] by the American Psychiatric Association (APA) to delete homosexuality from the third edition of its official *Diagnostic and Statistical Manual of Mental Disorders* (DSM). This decision, by vote of APA members, was influenced by explicit definitions of mental disorder (*see* section 5.5) offered by Robert Spitzer and his coworkers on the APA nomenclature committee. The change dramatically affected clinical practice, as well as society at large. Before it, some doctors used treatments as radical as electric shock to try to prod homosexual men into heterosexuality [Reznek, 1987, 8]. Now, professional organizations condemn even psychotherapy for homosexuals who wish to change [Cooper, 2005, 34]. In a transitional period, for such patients, DSM included the category 'ego-dystonic homosexuality', consisting not in homosexuality itself but in conflict over it. This category was later dropped — not, however, on the grounds that a patient's or society's attitudes to a condition should not determine its normality. Indeed, the rest of the classic perversion list

Handbook of the Philosophy of Science. Volume 16: Philosophy of Medicine.
Volume editor: Fred Gifford. General editors: Dov M. Gabbay, Paul Thagard and John Woods.

remained in DSM, but only, as of DSM-IV [APA, 1994], for people whose sexual desires caused them problems. Critics claimed that, say, pedophilia is a perversion however a pedophile feels about it. The APA replied that moral judgments should not be confused with psychiatric classification [Cooper, 2005, 28]. But can they be separated? In any event, DSM-IV-TR [APA, 2000] changed the rules again: acting on one's urges, with a child or other nonconsenting partner, now suffices for a diagnosis of pedophilia, voyeurism, exhibitionism, or frotteurism.

An earlier parallel to contemporary sex debates was medical views about, and therapy for, masturbation. Much of mainstream 19th-century medicine viewed masturbation as not only a cause of many diseases, but also a disease in itself [Comfort, 1967; Engelhardt, 1974]. Some physicians took it to justify a long list of gruesome and painful treatments, including clitoridectomy for many women and castration for a few men. In the 20th century, the medical consensus reversed to count masturbation normal. Many writers use this change to argue that disease categories rest on social value judgments. Interestingly, however, the change was independent of the practice's most influential moral critics, conservative Christian churches, whose views were unaltered.

Outside the realm of sex, the existence of many other specific mental disorders, or their boundaries, are also controversial. The long-standing debate over the 'disease concept of alcoholism' (cf. [Fingarette, 1988]) reveals much uncertainty about what it means to call alcoholism a disease. Even if we grant the category, to separate alcoholism from normal drinking raises definitional issues about normality. Wakefield [1997a, 640] criticizes the current DSM definition for letting a wife's reaction to her husband's drinking determine whether he has a mental disorder. Another line-drawing problem is to distinguish depression from normal sorrow. Again, Horwitz and Wakefield [2007] accuse DSM of nearly obliterating the latter category — a timely issue in an era when millions of people take daily antidepressants. Interestingly, these writers assume that, e.g., a typical grief reaction after the death of a loved one is normal, not pathological. Yet some psychiatrists argue that grief, a reaction to an emotional wound, is transient pathology, like the body's reaction to a physical wound (cf. [Kopelman, 1994]). At the opposite emotional pole, some writers ask how the energy and euphoria of hypomania — as opposed to full-blown mania — can be pathological. Did Handel need a psychiatric drug, as a pharmaceutical ad once suggested, to guard him from the excitement of composing Messiah in 24 days?

As for general internal issues about health, some arise in ordinary somatic medicine. Is 'normal aging', with its countless functional deficits, really normal — and, if so, does that make it wrong to prevent or treat it if we can? Is whatever raises the risk of disease itself a disease, as seems to be assumed in current diagnoses, such as hypercholesterolemia or hypertension, based solely on risk factors [Schwartz, 2008]? Regarding gene therapy, should we accept the popular bioethical view that it should be aimed only at diseases, not at 'enhancement' — and, if so, how do we draw this distinction (cf. [Daniels, 2000; Malmqvist, 2006])? Very generally, is health a purely negative concept, the absence of disease, or can there be

'positive health'? The World Health Organization (WHO) constitution endorses a positive view: 'Health is a state of complete physical, mental, and social well-being and not merely the absence of disease or infirmity'. Some people use positive health to help distinguish other health professions, such as nursing or dietetics, from medicine. Conceivably, though, the WHO definition means that medicine itself should move beyond its 19$^{\text{th}}$-century model, of local pathophysiology causing manifestations of disease, to more ambitious 'holistic' goals of human flourishing. But is the definition plausible? Or does it falsely merge all possible values into health?

The greatest professional debates are, again, over mental health. Over several decades, a large literature grew on the 'medical model' of mental illness [Macklin, 1973]. Many writers, in disciplines such as clinical psychology, found nonmedical models a better fit to various kinds of psychotherapy. But this literature shows scant agreement about what a 'medical model' is. For each of the following theses, at least some writers took it to be part of the medical model: that individual, not group, therapy is the best mode of treatment; that all treatment should be done by physicians; that drugs are better than psychotherapy; that there are classical disease entities in psychology; and that all mental diseases are physical diseases. Yet these theses all seem independent [Boorse, 1976b, 62]. Most famous of all is the attack on the very idea of mental health by 'antipsychiatrists' such as Thomas Szasz. Szasz [1960; 1961; 1970; 1987] argued that mental illness is a myth, because genuine disease, in ordinary medicine, is identifiable by objective science, whereas the boundaries of psychopathology are set by value judgments. Hence, psychiatry is an illegitimate medical specialty — a mode of medical oppression of society's troublesome members. A great deal of later analysis of concepts of health and disease aims to answer Szasz's arguments, which also led to reforms in the DSM. Other critics of psychiatry, such as Laing [1967], portrayed mental illness as a sane adaptation to an insane environment. But cannot adaptations to stressful environments be genuine disorders? Perhaps the most complete survey of, and rebuttal to, psychiatry's critics is Reznek [1991].

Extraprofessional issues about health and disease begin with payment for health care. Private health insurance is usually limited to abnormal conditions, excluding such medical treatments as cosmetic surgery and abortion. Any such exclusion presupposes a general concept of health and disease. Similar questions arise more urgently for those who believe publicly funded health care an important right in a just society (*cf.* [Daniels, 2008]). Should government restrict such coverage to genuine diseases, as defined by some test, or extend it further — perhaps to all biomedical enhancements of people's lives? Reznek [1987, 2-3] mentions stuttering and nicotine addiction as specific conditions raising controversy over government funding of their treatment. In the private sector, anti-impotence drugs are a recent example.

Health, quite apart from its funding, also has legal significance in various contexts. Several times, the U.S. Supreme Court has ruled whether specific conditions are disorders. In *Robinson v. California*, 370 U.S. 660 (1962), it held that heroin

addiction was a disease and its punishment therefore unconstitutionally cruel and unusual. In *Powell v. California*, 392 U.S. 514 (1968), four dissenting justices said the same of alcoholism, with an apparent majority taking *Robinson* to bar conviction for acts 'irresistibly compelled' by disease. In *General Electric v. Gilbert*, 429 U.S. 125 (1976), the Court examined the issue whether pregnancy is a disease for purposes of private employee-disability benefits. Among reasons to say no, the majority noted that pregnancy is often a voluntary and desired condition. More recently, in *Bragdon v. Abbott*, 524 U.S. 624 (1998), the Court ruled, with no dissent on this issue, that HIV infection is, at every stage, an 'impairment' for purposes of the 1990 Americans with Disabilities Act (ADA).

These examples illustrate some general ways in which health has legal importance. The basic kind of disability defined in the ADA is an impairment that substantially limits a major life activity, and 'impairment' may be best taken to mean nearly the same as 'pathological condition' [Boorse, 2010]. In constitutional abortion law, from *Roe v. Wade*, 410 U.S. 113 (1973), through *Gonzales v. Carhart*, 550 U.S. 124 (2007), the Court has held that states must allow therapeutic abortions — those necessary to the woman's health. And in *Roe*'s companion case, *Doe v. Bolton*, 410 U.S. 179 (1973), it said that 'all factors — physical, emotional, psychological, familial, and the woman's age — relevant to the well-being of the patient' may relate to health. This inclusion of emotional well-being under health recalls the expansive WHO definition. Significantly, in the pre-*Roe* period, 92% of all California abortions were justified under state law on mental-health grounds [Wardle and Wood, 1982, 35].

More familiar legal applications of psychiatry are judgments of civil incompetence or criminal insanity. All current insanity tests in Anglo-American law make psychopathology a necessary condition. For example, by the M'Naghten rule, a defendant is insane if his mental disease kept him from knowing what he was doing or that it was wrong; control tests excuse him if mental disease kept him from controlling his actions; and the ALI test is essentially a disjunction of these two [LaFave, 2003, ch. 7; Reznek, 1997]. Interestingly, a solely health-based rule, the simple 'product test' — that any act caused by psychopathology is excused — is now in general disrepute. On the most extreme views, such as Menninger's [1968], that rule would excuse nearly all crime whatsoever.

Enough has been said to illustrate the important issues that health judgments may be assumed to decide. But one result of philosophical analysis is to show how complexly these issues truly connect with disease status. Summarizing the importance of analyzing disease, Reznek writes:

> The classification of a condition as a disease carries many important consequences. We inform medical scientists that they should try to discover a cure for the condition. We inform benefactors that they should support such research. We direct medical care towards the condition, making it appropriate to treat the condition by medical means such as drug therapy, surgery, and so on. We inform our courts that it is inappropriate to hold people responsible for the manifestations of

the condition. We set up early warning detection services aimed at detecting the condition in its early stages when it is still amenable to successful treatment. We serve notice to health insurance companies and national health services that they are liable to pay for the treatment of such a condition. Classifying a condition as a disease is no idle matter. [1987, 1]

But some or all of these relations are far from simple. In a later book [1991], Reznek himself offers a theory of criminal insanity much more complex than the simple product rule above. And recent medical practice hardly fits his ringing declaration on disease and treatment: 'Judging that some condition is a disease commits one to stamping it out. And judging that a condition is not a disease commits one to preventing its medical treatment' [1987, 171]. As to the latter point, current medicine accepts cosmetic surgery and contraceptive drugs, but it does not call the conditions so treated disorders. Conversely, are there not also diseases that we should not treat? Perhaps it is at least as important to know what disease judgments do not imply as what they do. So let us consider analytic issues about health in more detail.

2 CONCEPTUAL ISSUES

One might hope, at least, for an analysis of health concepts to answer the following questions.

- **interrelations of health concepts** How do the concepts health, disease, disorder, illness, injury, disability, abnormality, pathology, and so on relate to each other? Are some primary, with others defined in their terms?

- **scientific vs. lay concepts** Which of these health concepts are purely medical? Which lay? Which, if any, are the same in both medical and lay usage?

- **vagueness** What are health concepts' limits of precision? Are there conditions, such as sickle trait, that cannot be clearly labeled as normal or pathological? If so, how does this matter?

- **normality vs. positive health** To what degree is health a kind of normality? Insofar as disease is abnormality, can there also be positive health beyond the absence of disease — *e.g.*, unusual fitness, happiness, or achievement?

- **reference class** What fixes the reference class for medical normality? Is whether a condition is normal relative to species? To age? Race? Environment? Other factors? Is it relative to a particular population? *E.g.*, why are, or are not, pygmies [Reznek, 1987, 85], homosexuals [Kingma, 2007, 132], or

elderly female Masai mountain bikers [Cooper, 2005, 14] appropriate reference classes for judging normality? Might normality, indeed, be different for each person, based on his or her typical performance?

- **protodiseases** Is whatever makes illness more likely a disease? *E.g.*, which of the following should be considered pathological: early localized cancer; precancerous tissue changes, *e.g.*, cervical dysplasia; a latent virus infection, *e.g.*, HIV; an abnormal gene, *e.g.*, BRCA; a clinical risk factor, *e.g.*, high cholesterol?

- **nosology and natural kinds** Is the demarcation problem — to divide the normal from the pathological — independent of nosology, the taxonomy of individual diseases? As for nosology, how should diseases be defined and classified — by clinical features, etiology, pathology, or some combination? What is the best model of disease causation? Are health and disease natural kinds? Are individual disease entities?

- **organisms besides adult humans** Is the concept of health the same for babies as for adults? More generally, do health and disease exist for all organisms, including lower animals and plants — or, perhaps, only for those we care about? Is health the same for human beings, badgers, sparrows, salmon, cicadas, sycamores, lawn grass, and bacteria?

- **disease and treatment** What is the relation between disease judgments and medical treatment? Does calling X a disease mean medical treatment (i) must, or (ii) may, or (iii) *prima facie* should or may be given? Does calling X a non-disease mean treatment (i) need not, (ii) must not, or (iii) *prima facie* may or should not be given? Should medicine actually discard the concept of disease — or even health as well [Hesslow, 1993]? Also, what makes a treatment medical — its nature, or who gives it? If a condition is a disease, does that mean physicians are best qualified to treat it?

- **values** If we assume a fact/value distinction, are health judgments pure value judgments, pure factual judgments, or a mixture? If they involve values, what kind — *i.e.*, how do health evaluations relate to other sorts? Should value judgments about health be made by patient, physician, or society? Must a disease be bad for its bearer, or can it suffice that, like psychopathy, it is bad for others?

- **mental vs. physical health** Can there literally be such a thing as mental health, and mental disease or illness? Or are these dangerous metaphors [Szasz, 1960]? Must mental health be a species of the same genus as physical health? Or can mental health be conceptually independent of physical health, or at least of medicine? What makes a disorder mental rather than physical — *e.g.*, signs and symptoms, etiology, pathology, treatment, or some mixture? Are the two classes mutually exclusive, or can a disorder be both? Does it matter whether we call a disorder mental or physical?

- **cultural relativism about health** How significant is it that disease judgments vary with culture? Some diseases in current Western medicine have been seen as normal elsewhere: measles in rural China [Topley, 1970], intestinal worms in Africa [Reznek, 1987, 93], dyschromic spirochetosis in a South American tribe [Dubos, 1965, 251]. Some of our most serious disorders were highly valued by other cultures: epilepsy in classical Greece, hallucinations among Plains Indians. Countless societies inflict wounds during rites of passage. Conversely, what we view as normal, such as lefthandedness or the female orgasm, our own ancestors called pathological. Given cultural variation in disease judgments, is there any fact of the matter? Or must we accept cultural relativism? Can we say only that masturbation was a disease in 19th-century America and homosexuality in 20th-, but neither is today, and a clitoris is normal or abnormal for a woman depending on where in Africa she lives?

3 SOME ASPECTS OF HEALTH ANALYSES

3.1 Methodology

3.1.1 Target

Some writers, such as Boorse [1977, 543], aim to capture a concept of health — freedom from pathological conditions — in theoretical scientific medicine. Other writers adopt a similar goal, but believe that this concept of disease is shared by medicine and common sense [Wakefield, 1999a, 375-6; Reznek, 1987, 67]. Both Wakefield [1999b, 470] and Reznek [1987, 67] cite empirical research on what conditions clinicians and laymen count as diseases or disorders. Boorse, by contrast, finds lay concepts of disease of no interest [1997, 62]. Other writers aim at an ordinary concept of health broader than medicine's. Thus, for Nordenfelt [1987, 110-1], freedom from medical disorder is only one aspect of health; besides medical illnesses, there are also nonmedical ones.

Also important is whether a writer has one target concept or several. Wakefield sticks almost exclusively to the term 'disorder'. Reznek's first book [1987] distinguishes 'disease' from 'pathological condition', but has no separate category 'illness'; in his second and third books [1991; 1997], he freely interchanges 'disease' and 'illness'. By contrast, Fulford, Nordenfelt, and Boorse all distinguish 'disease' from 'illness', though Boorse changed his mind about the difference [1975; 1987]. Both Fulford [1989, 62-9] and Nordenfelt [1987, 110-11] describe multiple concepts even within medical theory, while, in the practical sphere, Boorse [1997, 100] proposes an array of 'disease-plus' concepts for pathological conditions meeting various criteria of importance.

3.1.2 Method

Some writers pursue conceptual analysis, based on current usage of key terms. Boorse claims merely to seek a lexical definition of 'pathological condition' in physiological biomedicine; thus, he stresses, definitions wider or narrower than the set of recognized somatic disorders are wrong [1987, 366]. Yet he himself ends up disqualifying some members of this set: purely structural disorders and universal diseases [1977, 565-8]. Thus, as Nordenfelt [2001, 26] notes, Boorse's view may be best described as a rational reconstruction of a scientific concept in the style of Carnap, Hempel, or Quine, with stipulative precisifications and exclusions.

Likewise, Wakefield [1999a, 376-7] claims to be doing philosophical analysis of an existing concept. Like most writers, he makes considerable use of hypothetical cases, or 'thought experiments', about what we would or would not call a disorder. He also has a strong reformative aim: to correct the existing psychiatric classification's infidelity to the notion of disorder in ordinary medicine. By contrast, Boorse says little about DSM, except to express skepticism about its value [1987, 382], and he avoids using mental disorders as examples.

Clouser, Culver, and Gert [1997] set out to analyze a common concept ('malady') unifying a group of medical terms. However, they end up with some great divergences from usage in ordinary nonpsychiatric medicine. Another highly reformative analyst is Reznek, who seems to conclude [1991, 12, 157] that medicine misunderstands its own concept of the pathological.

Other writers, notably Worhall and Worhall [2001], Murphy [2006], and Nordby [2006], reject conceptual analysis altogether. Worhall and Worhall call the attempt to define disease 'a degenerative project' [2001, p. 55]. To Murphy, the best characterization of mental disorder must emerge from scientific theorizing, not analysis of usage. Boorse and Wakefield, he charges [2006, 51-3], illegitimately limit psychiatric science by folk psychology. This methodological contrast between Murphy and Boorse, Wakefield, or Reznek resembles the one between Millikan [1984] and Neander [1991a] on biological functions.

3.2 Common Ideas in Health Analyses

3.2.1 Medical treatment

Kräupl Taylor [1971] defined disease as any statistical abnormality that doctors treat. Though Reznek's analysis [1987] is more complex, he holds that a condition merits medical treatment if and only if it is pathological. Yet, for some time, the realm of medical treatment has been both wider and narrower than disease. It has been narrower throughout medical history in that many diseases were wholly untreatable, except by palliative measures to reduce suffering. Doctors before 1900 had no beneficial treatments for most serious diseases, such as cancer, diabetes, and coronary atherosclerosis, or even for infections like syphilis and smallpox. Even until very recently, nothing effective could be done against symptomatic rabies, metastatic melanoma, muscular dystrophy, or congenital blindness or deafness, to

name only a few. As for palliation, what is distinctively medical about it, given that many painkillers are sold today without prescription — as is alcohol, and as were morphine and heroin in the past?

Conversely, only an ultraconservative medical ethics rejects treatment by physicians for all nondiseases. That view would condemn contraceptive pills, obstetrical anesthesia, and all cosmetic surgery, including circumcision. Interestingly, even in 19th-century America, when nearly all baby boys were circumcised, not even the operation's most enthusiastic advocates called the male foreskin pathological (cf. [Darby, 2005]). And, today, when many doctors endorse nontherapeutic abortion, a merely unwanted pregnancy is still not classified as a disorder. Anyway, much of obstetricians' work involves normal pregnancy, delivery, and 'well-baby' care. The fact is that medicine distinguishes, among conditions it treats, between some it considers pathological and others it does not.

There is also no doubt that genuine diseases can be effectively treated by nonphysicians — e.g., nurses, dentists, podiatrists, and dieticians — not to mention the corrective measures of optometrists or physical therapists.

3.2.2 Pain, discomfort, disability

Many diseases are painful or cause other kinds of physical discomfort, such as nausea, dizziness, shortness of breath, coughing, sneezing, itching, or general 'malaise'. Yet many pathological conditions cause no uncomfortable sensations at all — e.g., hypertension, blindness, deafness, aphasia, mental retardation. Inability to feel pain is a symptom of some diseases, such as leprosy and syringomyelia, and total unconsciousness is a feature of comas. At the same time, many normal conditions are painful or uncomfortable, such as teething, pregnancy, labor, adolescence, and living with the opposite sex.

Since pain and discomfort interfere with one's activities, one might think the most general element in disease, embracing the above counterexamples, to be disability. Among other objections, this runs into a major problem for many analyses: most diseases are asymptomatic in early stages. Even if asymptomatic disease is clinically detectable, it may not reduce any of a person's gross abilities, as with dental caries or early cancers. Is what makes purely local pathology disease that it will cause gross disability or death later? This is often false for diseases of old age, and probably not even true for all disease types. Most prostate cancers are subclinical, discovered, before the PSA-screening era, only after death, if at all. Even in life's prime, a small infection, of skin or an internal organ, quickly cured by the immune system, is self-limiting pathology that may never have gross effects. Possibly any infection raises the risk of systemic illness; but so does pregnancy, or having an appendix.

3.2.3 Statistical abnormality

Since the antonym of 'pathological' is 'normal', one might suppose health to be normality of some kind. Yet many statistically abnormal conditions are not dis-

orders. Unusual physical strength, endurance, intelligence, or creativity is not pathological. It is not a physical disorder to be lefthanded, red-haired, or green-eyed, nor a mental disorder to speak Navajo, enjoy morris dancing, or play the accordion.

Conversely, it seems that a disease or disorder can be typical, or even universal, in the human population. There may be actual examples. Pathology books say that atherosclerosis begins in childhood, thus affecting nearly all human beings' arteries. It is also said that most human lungs suffer minor irritation by atmospheric pollutants, and that most human mouths have gum disease or tooth decay. Certainly most people, at any time, have a cut, bruise, or other skin lesion. Also, many writers offer hypothetical cases of universal disease. After a nuclear war, all surviving human beings might be blind [Neander, 1983, 86-7] or have Huntington's chorea [Reznek, 1987, 93]; yet, it is claimed, these conditions would remain disorders. If we discovered that we all suffer slight copper poisoning that reduces average human IQ by 30 points, we would consider that an environmental injury [Reznek, 1987, 93]. Or, if we found a drug that gives us a lifespan of 200 years, we would call it vitamin F and view normal aging, though previously universal, as a vitamin-deficiency disease [Reznek, 1987, 97; Margolis, 1976, 247].

Considering such scenarios, many writers take medical normality to be an ideal state, not a statistically average one. Nevertheless, medicine does often relativize normality to a reference group, indeed to a fraction of our species. A five-year-old child who cannot walk or talk is abnormal, but not a one-year-old — and it is hard to see how this judgment rests on any ideal. Likewise, a 25-year-old woman who fails to menstruate is abnormal, but not a man of the same age. To age and sex, some writers add race: Reznek [1987, 85] says that insensitivity to growth hormone is normal for pygmies, but not for Masai. Is normality relative to yet other classifications?

3.2.4 Disvalue

Nearly all writers make health judgments value judgments, in whole or in part. This thesis is called *normativism* about health, and its denial *descriptivism*, *objectivism*, or (most commonly) *naturalism*. Normativism is at least a widespread and confident intuition. Some writers support it by the false claim that the English prefix 'dis' always has evaluative meaning, and so does in 'disease'. However, it is true that the 'ill' in 'illness' usually does. At any rate, *pure* or *strong normativism* holds that a disease is just a condition bad for a person, whether physical or mental. On this view, 'disease' is a bit like 'weed'. A weed is merely an unwanted plant; no botanical characteristics are necessary or sufficient. In fact, the same plant — daisy, dandelion — can be a weed in one garden and a valued flower in another [Cooper, 2005, 26]. According to *mixed* or *weak normativism*, a disease is a bad condition satisfying further descriptive properties. On this view, 'disease' is more like 'mutt' or 'nag', pejorative terms restricted to dogs and horses, respectively. For a more fine-grained classification of views about health and values, see [Simon, 2007].

Apparently espousing strong normativism is Sedgwick, who writes:

> Outside the significances that man voluntarily attaches to certain con
> ditions, *there are no illnesses or diseases in nature.* ... Are there not
> infectious and contagious bacilli? Are there not definite and objective
> lesions in the cellular structures of the human body? Are there not
> fractures of bones, the fatal ruptures of tissues, the malignant multi
> plications of tumorous growths? ... Yet these, as natural events, do not
> — prior to the human social meanings we attach to them — constitute
> illnesses, sicknesses, or diseases. The fracture of a septuagenarian's
> femur has, within the world of nature, no more significance than the
> snapping of an autumn leaf from its twig.... Out of his anthropocen
> tric self-interest, man has chosen to consider as 'illnesses' or 'diseases'
> those natural circumstances which precipitate the death (or the failure
> to function according to certain values) of a limited number of biolog
> ical species: man himself, his pets and other cherished livestock, and
> the plant-varieties he cultivates for gain or pleasure. ... Children and
> cattle may fall ill, have diseases, and seem as sick; but who has ever
> imagined that spiders and lizards can be sick or diseased? [1973, 30-1]

Weak normativism is more plausible, since so many bad physical conditions,
even among human beings, are not medical disorders. It is disadvantageous, but
not pathological, to be fairly short, stupid, or ugly, and especially to be all three.
For that matter, it is bad to need regular food, water, and sleep, and bad to be
unable to fly, breathe underwater, or smell carbon monoxide, but these are normal
conditions. African ancestry was a huge disadvantage in the prewar American
South, but medicine, then or now, never classified it as a disorder. Note that these
normal conditions can be far worse for a person than minor disorders like myopia,
ringworm, or baldness.

A converse challenge to normativism, weak or strong, is that disorders are sometimes helpful. In war, flat feet may save a young man's life by exempting him from
a military draft. Oviduct blockage is a blessing to a young woman who wants no
more children. Cowpox, a mild disease, once conferred immunity to smallpox, a
lethal one. For virtually any disease not instantly fatal, one can imagine a scenario where it protects someone from something worse. Still, one can defend weak
normativism — at the cost of possible departure from medical usage — by saying
that beneficial cases of a disease type are not disease. Cooper [2005, 26] says that
an artist who adapts to his loss of color vision, and comes to prefer seeing in black
and white, then has no visual disorder. Similarly, Reznek [1987, 161] denies that
cowpox was a disease in the smallpox era, because it caused no net harm.

Worth special mention is a sometimes value-laden type of definition that one
may call '3-D', since it defines diseases as conditions tending to cause a specific
list of evils, such as death, disability, discomfort, or deformity. For example, one
psychiatry text defined disease as

any condition associated with discomfort, pain, disability, death, or an
increased liability to these states, regarded by physicians and the public
as properly the responsibility of the medical profession. [Goodwin and
Guze, 1979, 68]

Another example is by Engelhardt:

[A]ny physiological or psychological processes or states not under the
immediate control of a person which (1) preclude the goals chosen as
integral to the general life of humans (inability to engage in the range
of physical activity held integral to human life); (2) cause pain (if that
pain is not integral to a process leading to goals held to be integral
to human life); (3) preclude a physical form that other humans would
hold to be normal (not deformed) — will count as diseases. [1976a,
136]

Whenever any of the 'D' concepts is value-laden, so, too, one might think, will
the 3-D definition be. In Engelhardt's definition, the disability and discomfort
clauses rest on a value judgment of what is 'integral' to human life. The deformity
clause refers to social value judgments about appearance. For that very reason,
however, it is descriptive. To say that X is bad is a value judgment. To say that
X is considered bad by some group is descriptive, not normative, if we assume,
as most philosophers do, that cultural relativism is a false metaethical view. (For
this reason, it is inaccurate to describe normativism about health — even pure
normativism — as 'social constructivism.') Even on a nonrelativist view, of course,
whose value judgments doctors should rely on — their own, their patients', or their
societies' — is an important issue of medical ethics.

3.2.5 Specific biological ideas: homeostasis, fitness, adaptation

Some writers equate health to some idea of theoretical biology. Such a view allows
disease judgments about many, or even all, species of organism. By contrast,
on many other analyses, health makes sense only for a fairly narrow range of
organisms. *E.g.*, medical treatment is given only to a few species, and it is unclear
what value or disvalue can be for nonsentient beings like bacteria, protozoa, or
plants.

Homeostasis Much of any organism's physiology aims at homeostasis, or con-
stancy in its 'internal environment' (Bernard's *milieu intérieur*), as to variables
like temperature, blood pressure, and blood acidity, osmolarity, nutrient content,
and so on. Still, many functions are not directly homeostatic (vision, locomotion),
while others are not so at all (growth, reproduction). The latter aim to upset an
equilibrium, not to preserve one. Not surprisingly, then, while many disorders do
disrupt internal equilibrium, others, such as deafness, quadriplegia, or sterility, do
not mark homeostatic failures.

Fitness A more adequate general account of physiological goals than homeostasis is what we might call fitness, *viz.*, individual survival and reproduction. (This is a loose usage of a term which, in evolutionary theory, refers to reproduction only, *i.e.*, to the expected number of offspring.) Writers tying health directly to fitness include Scadding, who defines disease as

> the sum of the abnormal phenomena displayed by a group of living organisms in association with a specified common characteristic or set of characteristics by which they differ from the norm of their species in such a way as to place them at a biological disadvantage. [1988, 121]

Likewise, Kendell [1975] argues that psychiatric conditions such as schizophrenia, manic-depressive psychosis, and homosexuality are genuine diseases simply because they reduce life-expectancy or fertility.

Critics complain that no similar evidence exists for many disorders. Kendell himself admits [1975, 451] that shingles or psoriasis does not make people die sooner or have fewer children. In current human environments, even total anosmia (inability to smell) may not reduce longevity or fertility. Conversely, many forms of behavior which raise the risk of early death — mountaineering, race-car driving [Fulford, 1989, 44], joining the Marines in wartime — do not count as mental disorders, nor do the personality traits typically underlying them. Also, do we really wish to say that there cannot be a healthy mule or seedless-grape plant [Cooper, 2005, 37], or that parents become healthier with each successive child?

Adaptation Many writers see health as environmentally relative — as a matter of fitness in, or adaptedness to, a specific environment. The basic idea is that a trait healthy in one environment is unhealthy in another. We find a version of this idea in Ryle:

> The small stocky Durham miner — poor though his general physique may appear to be from the combined effects of heredity, malnutrition in childhood, and occupational stress in adolescence — is probably better adapted to underground work and life than would be the more favoured and robust candidate for the Metropolitan police force.
>
> ...what we call normal or (better) normal variability in biology and medicine must always be related to the work required of the organism or of its parts and to the medium in which they have their being. [1947, 3-4]

But this quotation contains the seeds of its own criticism, by suggesting that some of the Durham miner's adaptations to his work are effects of disease. Indeed, much pathology in environmental disease is an organism's desperate adaptations to physically extreme conditions.

Nevertheless, many writers offer examples like these: a light-skinned Norwegian travels to sub-Saharan Africa, where intense sun gives him a skin disease he would

never have gotten at home [Engelhardt, 1986, 169]; lactase deficiency is a disorder
in Sweden, where milk is an important part of the diet, but not in North Africa,
where it isn't [Nordenfelt, 1987, 107]; sickle trait is a disease in the mountains,
where it can cause a sickling crisis, but not in the lowlands, where it protects one
from malaria [Reznek, 1987, 85]. If X is a type of condition, these authors hold
that the basic concept is not *X is a disease*, but *X is a disease in environment E*.
A problem for this thesis is that even a serious disease — *e.g.*, severe combined
immune deficiency — may be harmless in a special environment, like a sterile
plastic bubble. In general, medical books do not call controlled or compensated
cases of diseases, like diabetes or hemophilia, normal.

4 FIVE MAJOR ANALYSES

4.1 Dysfunction-Requiring Accounts

Another biological idea, part-dysfunction, is crucial to analyses of disorder by sev-
eral writers, including Boorse and Wakefield. For both, it is a necessary element.
To Boorse it is also sufficient: he defines a pathological condition simply as one in-
volving statistically subnormal part-function as compared with a certain reference
class. To this, Wakefield adds a harm requirement: disorder is harmful biological
dysfunction. Thus, Boorse takes theoretical health to be value-free, while Wake-
field makes it a mix of biological facts and social values. They differ, as well, in
their analyses of biological function and on a few other minor points.

4.1.1 Boorse's biostatistical theory (BST)

The best-known philosopher espousing naturalism about health is Christopher
Boorse [1975; 1976a; 1976b; 1977; 1987; 1997; 2002]. A similar position was later
taken by Ross [1979; 1980]. In medicine, naturalist writers include Scadding [1967;
1988; 1990], Kendell [1975; 1976], Klein [1978], and, of course, Szasz [1960; 1961;
1970; 1987]. Writers inspired by, but modifying, Boorse's views include Schramme
[2000], Schwartz [2007], and Ananth [2008].

Analysis Because Boorse's analysis rests on statistical normality of biological
part-function, Nordenfelt [1987, 16] calls it the 'biostatistical theory'. Boorse
takes Western scientific medicine to rest on one basic theoretical concept: the
normal/pathological distinction. Initially, his contrast was health/disease, with
the term 'disease' used very broadly for any sort of condition violating perfect
health, including injuries, poisonings, growth disorders, static defects, environ-
mental stresses, and so on [1977, 550-1]. Later, he switched to 'pathological con-
dition', conceding the broad usage of 'disease' to be atypical of medical writing,
though found in some reference books and presupposed by the slogan 'Health is
the absence of disease' [1987, 364].

What unifies all pathological conditions, says Boorse, is (potential) biological dysfunction of some part or process in an organism. In most disease states, parts at some organizational level — organs, tissues, cells, organelles, genes — totally fail to perform at least one of their species-typical biological functions. But Boorse also allows for mere statistical subnormality of function, under some arbitrarily chosen minimum level below the mean. In either case, the reference class for statistical normality is a fraction of a species — specifically, an age group of a sex of a species (*e.g.*, 7-9-year-old girls), perhaps further subdivided by race. Finally, since many functions, like sweating or blood clotting, are performed only on suitable occasions, what health requires is functional readiness of every part to perform all its normal functions if such occasions arise. Boorse's original definition [1977, 567] had a special clause to cope with universal environmental injuries. Later, however, he expressed doubt about it [1997, 86], so it is best to stick to his simpler account:

> *Health* in a member of the reference class is *normal functional ability*: the readiness of each internal part to perform all its normal functions on typical occasions with at least typical efficiency.

> A *disease* [later, *pathological condition*] is a type of internal state which impairs health, *i.e.*, reduces one or more functional abilities below typical efficiency. [1977, 562]

Boorse bases this statistical-functional view of health on a view of biological function sometimes called the cybernetic analysis [1976, 77-80]. It views functions as causal contributions to goals of a goal-directed system, as described by Sommerhoff [1950; 1969] and Nagel [1961]. A physical system has the purely physical, nonintensional, property of being directed to goal G when disposed to adjust its behavior, through some range of environmental variation, in ways needed to achieve G. On this account, the physiology of any organism is a hierarchy of goal-directed systems, the goals at each level contributing to those of the next. Boorse suggests that, for physiology, the highest-level goals, of the organism as a whole, are individual survival and reproduction. But physiological function statements are typically made not about individual organisms, but about a class of them. So the physiological functions of a part-type are its typical causal contributions to individual survival and reproduction in a whole species, or fraction thereof in the case of functions limited to one age (bone growth) or sex (lactation). Collectively, all such functions constitute the 'species design', against which part-tokens are judged normal or abnormal.

> [T]he subject matter of comparative physiology is a series of ideal types of organisms: the frog, the hydra, the earthworm, the starfish, the crocodile, the shark, the rhesus monkey, and so on. The idealization is of course statistical, not moral or esthetic or normative in any other way. For each type a textbook provides a composite portrait of what I will call the *species design*, i.e. the typical hierarchy of interlocking functional systems that supports the life of organisms of that type.

Each detail of this composite portrait is statistically normal within
the species, though the portrait may not exactly resemble any species
member. Possibly no individual frog is a perfect specimen of *Rana
pipiens*, since any frog is bound to be atypical in some respect and to
have suffered the ravages of injury or disease. But the field naturalist
abstracts from individual differences and from disease by averaging
over a sufficiently large sample of the population. [1977, 557]

Regarding individual differences, the discrete, equally functional variants of a poly-
morphism — blood type, eye color — are equally normal alternatives in the species
design. Likewise, statistical variation in any part's performance is also normal if
not too far below the population mean.

Cybernetic analyses of function are only one of at least four main types in
the literature. Others are *etiological* accounts [Wright, 1973], especially, as to
biology, *selected-effects* theories [Neander, 1991a; 1991b; Millikan, 1984; 1989];
value-centered views [Bedau, 1991; 1992a; 1992b]; and *causal-role* accounts [Cum-
mins, 1975]. For surveys of the function debate, see [Melander, 1997; Nissen, 1997;
Wouters, 2005]. Boorse's biostatistical analysis of health could instead be based on
alternate function analyses, with varying success in fitting medical judgments of
pathology. Note that a causal-role account choosing individual survival and repro-
duction as system outputs — sometimes called an 'S&R analysis' — is equivalent,
for biological functions, to Boorse's function analysis.

At least on cybernetic, etiological, or S&R accounts of function, the species
design is a biological fact, making theoretical health judgments as value-free as
biological science itself is. Theoretical health, on this view, belongs to the life-
death family of biological concepts, not to the welfare-harm family of evaluative
ones. But medicine is a clinical as well as a theoretical science, and its therapeutic
decisions do depend on values. Originally, Boorse used the concept of *illness* to
contrast value-laden clinical judgments with value-free theoretical ones. A disease
is an illness, he said, 'only if it is serious enough to be incapacitating, and there-
fore is (i) undesirable for its bearer; (ii) a title to special treatment; and (iii) a
valid excuse for normally criticizable behavior' [1975, 61]. Shortly thereafter, he
withdrew this analysis of illness, replacing it by a vague but value-free concept
of illness as systemic disease, affecting the organism as a whole. Still, he stresses
the existence of a wide range of 'disease-plus' concepts [1997, 100]: disease with
specific normative features important in medical or social contexts. In medicine,
such value-laden concepts include *diagnostic abnormality* (a clinically apparent
pathological state) and *therapeutic abnormality* (a diagnostic abnormality merit-
ing treatment) [1987, 365]. Value-laden social concepts include *criminal insanity*
(mental disorder that negates criminal guilt), *civil incompetence* (mental disorder
that invalidates civil decision-making), and, in many contexts, *disability* [2010].
The key point remains: a bare disease judgment *per se* entails no value judg-
ments, either about medical treatment or about social status. And since 'positive
health' is often indeterminate without an evaluative choice among incompatible
excellences, Boorse suggests that this concept has only limited application [1977,

572].

Boorse's basic analysis of normality vs. pathology applies unaltered to mental health on one condition: that physiology have a parallel in psychology [1976, 63-4]. Mental health exists if, and only if, the human mind can be divided into psychological part-functions with species-typical contributions to survival or reproduction. Since mind-body materialism — an ontological thesis — does not require psychological concepts to be physiologically definable, on Boorse's view mental disorders need not be physical disorders. Nonetheless, species-atypical mental dysfunctions are literally disorders, contrary to Szasz and other critics, and their status as such is value-free. Examples of psychological theories that sufficiently anatomize the mind into part-functions to support a concept of mental health are classical psychoanalysis [Waelder, 1960; Brenner, 1973] and, more recently, evolutionary psychology [Stevens and Price, 1996; Baron-Cohen, 1997; McGuire and Troisi, 1998; Buss, 2005] . Both disciplines are controversial in philosophy of science [Grünbaum, 1984; Kitcher, 1992; Buller, 2005]. An example of a theory that does not do so is Skinnerian behaviorism. In any case, without assuming some, possibly future, theory of mental part-functions, one cannot, on Boorse's view, speak of mental health. In an early article, he also suggested ways in which, even if mental disorder exists, it could be misleading to speak of mental illness [1975, 62-66]. But it is unclear which of these ideas survive his change of view on illness.

Criticisms Boorse [1997] is a nearly complete reply to his prior critics on health; a less complete one to critics on function is his [2002]. For a lengthy critique of Boorse's rebuttal on health, as well as a detailed analysis of his position, see Ananth [2008]. Other recent critiques as yet unanswered are DeVito [2000], Amundson [2000], Stempsey [2000], Nordenfelt [2001, ch. 2], Cooper [2005, 12-18], Schwartz [2007], Kingma [2007], and Giroux [2009].

Attacks on the biostatistical theory (BST) fall into several categories. First are technical objections to the definition. Scadding [1988] charges that on it, a disease cannot explain its symptoms. Hare [1986] and several other writers attack the BST for vagueness in its component concepts, quite apart from the admitted vagueness of the notion of statistical subnormality. Very popular are charges of covert normativism: that the BST account of disease is not, either in theory or in practice, value-free. Fulford [1989, 37-8] cites Boorse's use of terms like 'hostile', 'deficient', 'interference', and 'incompetent' to show that he constantly slips from descriptive to normative terms. Engelhardt [1976b, 263-66] argues that the choice of survival and reproduction as the goals in relation to which function is defined rests on a value judgment — indeed, one contrary to medical values. Recently, critics argue that the BST's choice of reference class for normality — an age group of a sex of a species, with or without race — is either too large for correct judgments of normality [Cooper, 2005, 14-5] or scientifically arbitrary, so that its disease judgments fail to be objective and value-free [Kingma, 2007]. DeVito [2000] argues that the BST is value-laden in other ways as well. Boorse has not yet answered these criticisms, nor Schwartz's [2007, 375-6] points: that, on the

BST, necessarily some members of every age group are unhealthy, and the same statistical threshold for dysfunction seems to apply at any age — both implausible views of youth vs. old age.

A second line of criticism alleges that the BST uses bad biology [Engelhardt, 1976b; 1986; van der Steen and Thung, 1988]. Specifically, critics charge that Boorse's notion of 'species design' rests on an outdated Aristotelian view of species, ignoring the ubiquity and normality of intraspecific variation, as well as the environmental relativity of adaptation. Boorse [1997, 28-41] replies, first, that if the BST well fits the medical notion of disorder, then these criticisms show, at most, that medicine rests on bad biology. That would be an objection to medicine, perhaps suggesting that we should abandon the concept of disease [Engelhardt, 1984; Hesslow, 1993], but to have shown this would be a success for the BST. In reality, Boorse argues, the BST — designed as an 'aseptic substitute' [1977, 554] for ancient notions — is not essentialist in any objectionable sense, but fully consistent with modern populationist biology. Quoting a leading anti-essentialist, Ernst Mayr, Boorse notes that the BST is explicitly an empirical statistical model of normality, with none of the features of essentialism described by Sober [1984]. It assumes no single species design, since it accepts polymorphic traits as normal variants. Lastly, the BST, like medicine, distinguishes health from adaptation: both judge Engelhardt's Scandinavian in Africa and Nordenfelt's African in Scandinavia to be wholly normal, though at greater risk of disease [1997, 41]. Here Boorse uses his triple distinction [1987, 387 n. 14] among the pathological (constituting disease), the pathogenic (causing disease), and the pathodictic (indicating disease). Despite these replies, Amundson [2000] argues that normal function is a biological myth, comparable to race, which serves to ground disability discrimination.

A third line of criticism alleges that the BST is bad medicine, either in some general feature or by failing to match specific medical judgments of normality. Among general features, many writers reject Boorse's very broad usage of 'disease' to cover any pathological condition, including injuries, deformities, static abnormalities, poisonings, environmental effects, etc. Boorse reacted by changing terminology from 'disease' to 'pathological condition', while noting [1977; 1997] that a broad usage of disease is required by the slogan 'Health is the absence of disease', and also that conditions called diseases lack any uniform nature, as Reznek [1987, 73] agrees. Other critics deny that pathological conditions form a theoretical category. Some say that there is no such thing as medical theory, since medicine is not a science. Hesslow [1993] argues that 'disease' is a theoretically useless concept. Margolis [1976], Brown [1985], Agich [1982], and Engelhardt [1986], among others, insist that the essence of medicine is clinical practice, not scientific theory. Accordingly, they define disease by its relation to illness, the 'reverse view' [Fulford, 1989, 67] to the BST. Given the contrast between pathology and clinical disease, several authors claim that the BST's view of health as complete freedom from pathological conditions is too demanding. Wulff *et al.* [1986, 48] complain that, by the BST, anyone given enough lab tests will be proved abnormal; Nor-

denfelt [1987, 28] notes that the BST makes one dead cell pathological. Boorse embraces these conclusions. He says that, to a pathologist, essentially everyone is diseased, but there is no paradox here. One dead neuron is 'a trivial piece of pathology': '[T]o call a condition pathological implies nothing about its importance. To think otherwise is to confuse theoretical and clinical normality' [Boorse, 1997, 51]. Finally, many writers hold that, even given the BST, disease remains an evaluative concept, either because science in general is value-laden [Agich, 1982, 39], or biology is [Toulmin, 1975, 62], or biological function [Schaffner, 1993; Bedau, 1991; 1992a; 1992b].

Critics also claim that the BST misclassifies many specific conditions, actual or hypothetical. Hare [1986, 175] uses such examples as skin diseases and lice to criticize the BST's view of disease as an 'internal state.' But his main argument (178) is that disease must be an evaluative concept because baldness in men counts as disease, but naturally hairless legs in women would not. Following Engelhardt [1974], many writers take the 19th-century examples of masturbation or drapetomania (the running-away disorder of slaves) to show that disease judgments rest on social values. By the BST, however, these were simply false disease judgments — as false, in the former case, as the associated causal claims about masturbation's effects. Writers such as van der Steen and Thung [1988] and Nordenfelt [1987, 29-30] criticize the BST for ignoring the way normal levels of function continually vary with the organism's activities and environment. Boorse replies [1997, 83-4] that the BST fully accommodates all such variation, with, at most, one added reference to statistically normal environments. Nordenfelt [1987, 30] says that the BST mishandles defense mechanisms, e.g., inflammation and the immune response to infection. Boorse answers [1997, 85-6] that the defense mechanisms are normal functions, though triggered by the cellular dysfunctions caused by infection, and the infection would be more abnormal without them. Nordenfelt [2001, 17] replies that since this is not exactly the standard medical view, the BST is, again, a revisionist account, not a purely analytic one. A harsher judgment by a pathologist is Stempsey's, who argues that pathology is itself a value-laden science making "no sharp division between theoretical and practical aspects of disease" [2000, 329]. Many authors claim that the BST cannot handle cases of heterozygote superiority, such as sickle trait. Boorse replies [1997, 89] that it classifies sickle trait as a disease, just as do medical references.

Last are criticisms relating to aging and to goal conflict. Writers like Margolis [1976, 247] and Reznek [1987, 97] say that if we found out how to treat normal aging, it would be proper to do so, and we would count it as disease. Boorse replies [1997, 92] that there is no need to classify aging as disease in order to treat it, since medicine does, and should, treat many nondiseases. Authors like Goosens and Reznek also stress cases where the goals of survival and reproduction conflict. The female octopus dies of starvation while guarding her eggs, because she has an endocrine organ that functions to suppress her appetite; the male praying mantis must lose his head to ejaculate [Reznek, 1987, 103, 111]. Similarly, Goosens imagines scenarios in which, by evolved mechanisms, an intelligent and

reflective species must endure horrible pain and early death, or metamorphose into a 'sluglike creature' [1980, 112-3], in order to reproduce. Boorse answers [1997, 93-4] that it is impossible for a species-typical stage of development, or reproductive mechanism, to be pathological. Such cases show only that to reproduce may be deeply damaging to parents, who might wish medical treatment to avoid doing so. That would parallel contraceptive pills, tubal ligation, or vasectomy today, all of which destroy normal functional ability in the patient's best interests.

4.1.2 Wakefield's harmful-dysfunction analysis (HDA)

From 1992 onward, Jerome Wakefield added to the BST's element of biological dysfunction the element of harm, found in analyses by writers like Robert Brown [1977] and Reznek [1987]. Many other writers, without using the specific term 'harm', hold that diseases are bad things to have. Wakefield's 'harmful-dysfunction' analysis has had a powerful influence on American mental-health professions, as a result of his prolific applications of it to the DSM classification.

Analysis Wakefield aims to analyze 'the general concept of disorder used in physical medicine' [1992b, 233], which he sees as shared by physicians, mental-health professionals, and, 'largely', the general public [1992a, 374]. This category is to cover 'every pathological condition', whether or not it is 'currently an object of professional attention' [1992b, 234]. Also, 'disorder' is 'the generic medical term of art for all medical conditions, including diseases and traumatic injuries' [2000b, 20]. At first sight, then, Wakefield seems to have the same target concept, pathological condition, as Boorse and Reznek. But his arguments for the harm clause, as will be seen, raise some doubt about this. His view of disorder as a 'practical concept' that is 'supposed to pick out only conditions that are undesirable and grounds for social concern' [1992b, 237] suggests that he has a partly clinical — not purely pathological — idea of medical disorder.

Why must dysfunctions, to be disorders, be harmful? Originally, Wakefield argued for the harm clause via cases of nonharmful dysfunctions that, he said, were not disorders. If one of a person's kidneys is diseased or missing due to organ donation, his overall renal function may be intact. Likewise, albinism, dextrocardia, and fused toes may not adversely affect a person's life [1992a, 383-4]. More recently, Wakefield uses the example of a redundant immune receptor, the absence of which supposedly protects one against AIDS [2001, 352]. As to what harm is, Wakefield, unlike Reznek [1987, 134-53], offers no lengthy analysis. But he takes harm to be a normative category determined by social values. It is part of the 'constructed social world,' not the 'given natural world' of biology, and so disorder lies 'on the boundary' of the two [1992a, 373]. He summarizes his view:

> A condition is a disorder if and only if (a) the condition causes some harm or deprivation of benefit to the person as judged by the standards of the person's culture (the value criterion), and (b) the condition results from the inability of some internal mechanism to perform its

natural function, wherein a natural function is an effect that is part
of the evolutionary explanation of the existence and structure of the
mechanism (the explanatory criterion). [1992a, 384]

As this quotation shows, Wakefield uses an etiological analysis of function, of
the type introduced by Wright [1973] and popularized, for biology in particular, by
theorists like Neander [1991a; b] and Millikan [1984; 1989]. Wakefield elaborates
his specific view by taking biological function to be a natural kind of the Kripke-
Putnam type, the explanatory essence of which is an empirical discovery.

> Organisms are unique in the way their functions are complexly related,
> hierarchically organized, remarkably beneficial, and produce a viable
> overall pattern of life and reproduction. There is no other natural con-
> text where recursive causal processes are so puzzlingly miraculous. ...
> ...A natural function of a biological mechanism is an effect of the
> mechanism that explains the existence, maintenance, or nature of the
> mechanism via the same essential process (whatever it is) by which pro-
> totypical nonaccidental beneficial effects — such as eyes seeing, hands
> grasping, feet walking, teeth chewing, fearing danger, and thirsting for
> water — explain the mechanisms that cause them. ...
> ...It turns out that the process that explains the prototypical non-
> accidental benefits is natural selection acting to increase inclusive fit-
> ness of the organism. Therefore, a function of a biological mechanism
> is any naturally selected effect of the mechanism. [1999b, 471-2]

Besides the harm clause, this etiological analysis of function is a second contrast
with the BST. A third is that Wakefield, like Clouser, Culver, and Gert (see section
5.1), requires a disorder not to have an 'environmental maintaining cause' [1992b,
240, 242]. A fourth apparent divergence is over statistically subnormal function.
In most of Wakefield's examples, a part or process exhibits total failure of an
evolved function. Where dysfunction is less than total, he suggests that natural
selection determines a normal range. Prior [1985, 320] and Boorse [2002, 101-2]
argue against Neander [1991b, 454] that this is not so. Likewise, Schwartz [2007,
370] raises two new problems for Wakefield's solution: most disease states are not
produced in the first place by genetic variants subject to differential selection, and,
for those that are, evolutionary theory offers no way to divide variants into selected-
for and selected-against. In reply to Lilienfeld and Marino [1999], Wakefield agrees
with the BST that a disorder like diabetes has 'fuzzy boundaries' [1999b, 467]. But
he rejects purely statistical criteria, as in his complaint that DSM-IV 'allows the
top third, say, of the normal distribution of reactivity to stress to be diagnosed as
disordered' [1997a, 638]. A normal range can be determined by selection pressures,
Wakefield thinks, and still have fuzzy boundaries.

In any event, Wakefield deploys the HDA to mount a devastating critique of
DSM's diagnostic criteria for specific disorders [1992b; 1997a]. In case after case,
he proves them to be overinclusive, counting all sorts of normal conditions as dis-
ordered. Major Depressive Disorder fails to state an exclusion for normal reactive

depressions to losses other than death of a loved one [1997a, 637]. Worse yet, anyone who has a crush for more than four days, but, after rejection, is intensely sad for at least two weeks, suffers from Bipolar II Disorder (641). Antisocial Personality Disorder includes as much as 80% of career criminals (638). Personality Disorder, defined as a culturally unexpected personality trait causing distress or impairment, 'covers a vast range of normal personality variation,' including 'foolish, selfish, nonconformist, or irreverent' people, as well as political activists like Alexander Solzhenitsyn or Martin Luther King, Jr. (639). Child and Adolescent Disorders embrace 'normal but rambunctious children,' and even those with very bad handwriting (639). Adolescents 'who are responding with antisocial behavior to peer pressure, to the dangers of a deprived or threatening environment, or to abuses at home' have a Conduct Disorder (639). Whether a pot smoker has a Substance Abuse Disorder can depend simply on his wife's attitude to it, or on local police behavior (641). For a comparable book-length attack on current psychiatric views of depression, see Horwitz and Wakefield [2007].

Wakefield's diagnosis of the cause of this and other DSM defects is its failure to apply its own definition of mental disorder. This definition, he believes, is essentially editor Robert Spitzer's 'sophisticated analysis' [1997a, 643; *see* section 5.5], which, in turn, Wakefield sees as a version of his own later HDA (*ibid.*; [1992b]). But Spitzer also believed that specific disorders must be operationally defined in purely symptomatic terms, so as to make DSM a reliable, theory-neutral tool for therapy and research. Unfortunately, operational definition is incompatible with dysfunction-based mental disorders: ''Dysfunction' is a theoretical concept that refers to internal processes that explain surface, descriptive features' [1997a, 645]. As a result, DSM's diagnostic criteria end up systematically sacrificing validity to reliability and theory-neutrality. Wakefield thinks this problem can be somewhat ameliorated 'by giving up purely symptomatic criteria, and contextualizing diagnosis' (633). Ultimately, however, 'theory-guided psychological research into normal mental mechanisms is critical to an understanding of pathology' [1992b, 245] — a thesis common to the HDA and the BST.

Criticisms

1. Harm All but one of Wakefield's original examples of harmless dysfunctions are, in fact, disorders in ICD-10 [WHO 1994]: albinism (E70.3), dextrocardia (Q24.0 or 89.3), fused toes (Q70.3), and unilateral kidney disease under its appropriate number. Only surgically produced absence of a kidney is placed in a nondisease Z-category — a judgment open to obvious criticism. People with such conditions, have, perhaps, no abnormality on clinical tests and need no treatment; yet their conditions are classified as pathological. As for the missing immune receptor, this dysfunction could be a disease that protects you against another, like cowpox and smallpox. From these examples, one might hypothesize that Wakefield's target concept is really not disorder, but disorder significant in some way, perhaps resembling Boorse's categories of clinical or therapeutic abnormality.

Wakefield calls it 'an important truth' that 'disorders are negative conditions that justify social concern' [1992a, 376]. Yet he agrees with the BST that judgments of pathology entail no therapeutic or social ones: 'the status of a condition as *disordered* or *nondisordered* from the HD or any other perspective has no necessary implication for the priority the condition deserves with respect to treatment, prevention, or policy' [1999a, 374]. Still, this may just mean that disorders, though always *prima facie* worthy of treatment, need not be so on balance. Why a dysfunction, to be a disorder, must be harmful at all remains unclear. DeBlock [2008], for his part, argues that the harm clause is redundant given dysfunction.

A further difficulty is that Wakefield, like Boorse, applies the disorder concept literally to all organisms, across the whole biological realm. Two of his examples of true disorder, as opposed to environmental maladaptation, are a mutant white moth in a sooty environment and a mutant bacterium oriented toward the wrong geomagnetic pole [1999a, 385-6]. There is little 'social concern' and no cultural standards for moths and bacteria. In these examples, Wakefield either ignores the harm requirement (374) or assumes a concept of harm independent of social values. Since Reznek offers such a theory of harm, the issue of how lower organisms and plants can be harmed is more fully discussed below, along with the problems of essential and contrasentient pathology. In general, Wakefield's harm clause faces the same difficulties as Reznek's, plus any extra ones arising from Wakefield's appeal to social values. Note that what values a given society has, though not a biological fact, is a fact nonetheless. Thus, Wakefield is no normativist about health, except on a cultural-relativist metaethics. Rather, his HDA makes disorder status a mixture of two kinds of facts, biological and social.

2. Dysfunction As Wakefield notes [1999a, 374], HDA critics attack almost exclusively the dysfunction clause, not the harm clause. To such objections he replies at length. First, several writers attack Wakefield's evolutionary analysis of function. Sadler and Agich [1995], Fulford [1999], Murphy and Woolfolk [2000a], and Houts [2001] argue that this analysis is value-laden in various ways. Moreover, Murphy and Woolfolk [2000b] charge that Wakefield ignores an alternative Cummins-type analysis that some philosophers claim to be commonly used in biology as well. Wakefield replies to these critics in his [1995; 1999b; 2000b; 2003], respectively.

A host of writers deny that evolutionary dysfunction is a necessary condition of disorder, and only some of their reasons can be mentioned here. Lilienfeld and Marino [1995] argue that where evolution yields a continuously distributed function, no clear boundary defines dysfunction; that many disorders are of nonselected functions, such as biological or cultural exaptations; and that many other disorders, such as emotional disorders, are themselves naturally selected. In the same vein, Murphy and Woolfolk [2000a] argue that failed spandrels, inflamed vestigial organs, design mismatches, and learned responses to abnormal environments all illustrate disorder without malfunction. Wakefield argues that all these examples tend to confirm, not refute, the HDA. For example, failures of cultural

exaptations are not usually considered disorders, and when they are, as in amusia, acalculia, or reading disorders, it is because of a hypothesized malfunction of some evolved mental system [1999a, 382-3]. Likewise, he says, when an evolved function — *e.g.*, male aggression or the fight-or-flight response — is maladaptive in a new environment, it does not count as a disorder (384-5). As to Murphy and Woolfolk, Wakefield says that appendicitis involves tissue, not organ, dysfunction; that mechanism-environment mismatches are not, in fact, viewed as disorders; and that 'conditions acquired through normal learning processes can involve dysfunctions and are considered disordered only when they do' [2000b, 253]. As one more objection, both Lilienfeld and Marino and Spitzer charge that the HDA classifies many medical symptoms, such as coughing, pain, inflammation, and the immune response, as normal — an objection Nordenfelt made to the BST. Wakefield replies [1999a, 393] that, insofar as they are selected defense mechanisms against disease or injury, these phenomena are, in fact, normal, and when medicine has judged the opposite, as with fever, it has been confusedindexamusia

A common claim in the clinical literature is that disorder is indefinable because it is a Roschian prototype concept, attributed to new objects on the basis of their overall similarity to paradigm cases, much as in Wittgenstein's example of games. Wakefield argues that only the dysfunction clause correctly predicts actual and hypothetical disorder judgments, while mere resemblance makes incorrect predictions. For example, summarizing the HDA's verdict on 'designed responses to threat,' he writes:

> ...(a) designed reactions to threat (*e.g.*, fever, anxiety) are not in themselves considered disorders; (b) designed reactions to threat that occur in response to underlying dysfunctions (e.g., fever in response to infection, swelling in response to a sprain) are considered symptoms of disorder but not disorders; (c) designed reactions to threat that are not responses to dysfunctions (e.g., sneezing due to dust, uncomplicated grief, fear in the face of danger) are considered neither disorders nor symptoms of disorder; (d) designed reactions to threat that do not operate as designed (e.g., when they occur without the appropriate triggering threat or at undesigned levels of intensity) are dysfunctions of the relevant mechanisms and, if harmful, are disorders (e.g., panic disorder, generalized anxiety disorder, pathologically high fever); (e) designed disruptions in the functioning of one mechanism by another mechanism are not disorders (e.g., muscular inhibition during sleep; inability to concentrate due to a normal fear response; and (f) inappropriate responses are not considered disorders when they are due to design rather than to dysfunction (e.g., fear at harmless snakes, startle response to a shadow). The HD analysis explains this very complex web of shared beliefs about disorder and nondisorder [1999a, 397]

In the end, Wakefield draws much the same conclusion from his critics as Boorse [1997, 2] drew from his:

> critics' proposed counterexamples fail to disconfirm the HDA and in
> fact provide more nuanced evidence for it. The critics' alternative
> accounts of *disorder* confuse disorder with social deviance, personal
> unhappiness, maladaptiveness, treatability, and problems in living —
> all the errors that have been the targets of professional and lay crit-
> ics from the 1960s antipsychiatrists to current opponents of insurance
> parity for mental health care. [1999b, 472]

For critiques of Wakefield by authors in section 4.2, see Fulford [1999] and Nor-
denfelt [2003].

We turn now to non-dysfunction-requiring accounts. Since most criticisms below
have not been published before, there are usually no authors' replies to report.

4.2 Action-Theoretic Accounts

Both K.W.M. Fulford and Lennart Nordenfelt ground their accounts of health in
philosophical action theory. Thus, both offer what Fulford [1989, xix, 260] calls
'reverse views,' defining disease or other kinds of malady via ordinary holistic
concepts of health or illness, rather than the other way around, which he sees as
the conventional medical approach. Fulford begins with illness, Nordenfelt with
health. But Nordenfelt [2001, 72-3] finds the following common theses, among
others:

1. Health is a kind of ability to act; illness is a kind of disability or
 failure of action. The basic notion of action, at least, is intentional
 action as analyzed by action theory.

2. Physical and psychiatric medicine share the same basic health
 concepts.

3. Health and illness are primarily holistic concepts: a human being
 as a whole is healthy or ill, with component organs healthy only
 in a derivative sense.

4. Health and illness are the primary concepts; disease, injury, and
 defect are derivative concepts.

5. A good analysis of health concepts should be a practically useful
 conceptual basis for medical science and practice.

Another common thesis — endorsed by all writers in section 4 except Boorse —
is:

6. Professionals and laypeople share the core medical concepts of
 health and illness.

Let us survey Fulford's and Nordenfelt's individual accounts and objections specific
to each, then consider four objections affecting both.

4.2.1 Fulford

Analysis Fulford, like all other writers in this section except Boorse, aims to
analyze an 'everyday usage' [1989, 27] of medical concepts largely common to
physicians and the lay public. Unlike other writers, he identifies his method as
the 'linguistic analysis' (22) practiced by such figures as Wittgenstein, Austin,
Urmson, and Hare (xv, 22-3, 54, 121-22). One major goal is to illuminate con-
ceptual problems in, specifically, psychiatry. Hence, Fulford begins by relating his
project to the controversy over Szasz's claim that mental illness, as a conceptual
impossibility, is a myth. In his first chapter, he argues that we need to recast
that controversy by rejecting two assumptions and a form of argument shared by
both sides in this dispute, antipsychiatrists and psychiatrists. The assumptions
are that mental illness is conceptually problematic, but that physical illness is not.
The form of argument is to test alleged mental illnesses against properties thought
essential to physical ones (5).

Fulford next seeks to undermine the 'conventional' view of medical concepts, as
represented by Boorse. A brief chapter 2 identifies features of common medical
usage that the BST allegedly fails to capture. Then chapter 3 offers a debate
between a metaethical descriptivist and a nondescriptivist over 'Boorse's version
of the medical model' (37). One of the main conclusions of this debate is that
'dysfunction' is a 'value term,' *i.e.*, has evaluative as well as descriptive content.
The main argument for this thesis, in chapter 6, proceeds by comparing functions
in artifacts and organisms. In artifacts, functioning is doing something in a special
sense, 'functional doing' (92 *ff*). Fulford argues by a rich array of examples that
the function of an artifact depends on its designer's purposes in two ways, both
as to end and as to means: 'for a functional object to be functioning, not only
must it be serving its particular 'designed-for' purpose, it must be serving that
purpose by its particular 'designed-for' means' (98). Moreover, 'purpose' is 'an
evaluative concept,' *i.e.*, 'evaluation is ... part of the very meaning of the term'
(106). From this Fulford concludes that claims of biological function also rest on
value judgments.

Fulford's own positive account can be summarized as follows. Not only are
'illness' and the various 'malady' terms such as 'disease' negative value terms, but
they express a specifically medical kind of negative value involving action failure.
As the 'reverse-view' strategy requires, 'illness' is the primary concept, from which
all the others are definable. To motivate his account of illness, Fulford uses the
point that bodies are dysfunctional, yet persons ill. To what, he asks, does illness
of a person stand in the same relation as bodily, or artifact, dysfunction stands to
functional doing? Since artifacts and their parts function by moving or not moving,
Fulford considers illnesses consisting of movement or lack of movement. Using
action theory's standard example of arm-raising, he suggests that the concept of
illness has 'its origins in the experience of a particular kind of action failure': failure
of ordinary action 'in the apparent absence of obstruction and/or opposition' (109).
By ordinary action, he means the 'everyday' kind of action which, as Austin said,

we 'just get on and do' (116). He next suggests that this analysis also suits illnesses consisting in sensations or lack of sensations. Pain and other unpleasant sensations, when symptoms of illness, also involve action failure. That is because 'pain-as-illness,' unlike normal pain, is 'pain from which one is unable to withdraw in the (perceived) absence of obstruction and/or opposition' (138). Finally, the analysis covers mental illness as naturally as physical illness. As physical illness involves failure of ordinary physical actions, like arm-raising, so mental illness involves failure of ordinary mental actions, like thinking and remembering.

From this basic illness concept, Fulford suggests, all the more technical medical concepts are defined, and in particular a family of concepts of disease. He begins by separating, within the set I of conditions that 'may' be viewed as illness, a subset Id of conditions 'widely' viewed as such (59). 'Disease', he thinks, has various possible meanings in relation to Id. In its narrowest meaning (HDv), 'disease' may merely express the same value judgment as 'illness', but in relation only to the subset Id, not to all of I (61). A variant of this idea is a descriptive meaning of 'disease' (HDf1) as 'condition widely viewed as illness,' which, of course, is not an evaluation, as is HDv, but a description of one (63). Two other broader descriptive senses of 'disease' are then derivable from HDf1: condition causally [HDf2] or statistically [HDf3] associated with an HDf1 disease (65, 69). Fulford provides no comparable analyses for other 'malady' terms such as 'wound' and 'disability', nor for 'dysfunction'. Nevertheless, he seems to hold that their meaning depends on the concept of illness in some fashion.

Fulford judges his account of illness a success by two outcome criteria. The first is that it find, if possible, a neutral general concept of illness, then explain the similarities and differences of 'physical illness' and 'mental illness' in ordinary usage (24). The main difference is that people disagree much more in evaluating mental features, *e.g.*, anxiety compared with pain. Using the example of alcoholism, he tries to show how clinical difficulty in diagnosing mental illness results from the nature of the phenomena, which the concept, far from being defective, faithfully reflects (85,153).

Fulford's account succeeds equally, he thinks, by his second criterion, clinical usefulness. In psychiatric nosology, it suggests several improvements: (1) to make explicit the evaluative, as well as the factual, elements defining any disease for which the former are clinically important; (2) to make psychiatric use of nondisease categories of physical medicine, such as wound and disability; and to be open to the possibilities that (3) mental-disease theory will look quite different from physical-disease theory and (4) in psychiatry, a second taxonomy of kinds of illness will also be required (182-3). Fulford claims three specific advantages for his view over conventional psychiatry. By revealing the essence of delusions, it vindicates the category of psychosis and explains the ethics of involuntary medical treatment. First, delusions can be seen as defective 'reasons for action,' whether cognitive or evaluative (215). Second, since this defect is structural, psychosis is the most radical and paradigmatic type of illness (239) — 'not a difficulty in doing something, but a failure in the very definition of what is done' (238). Third,

that is what explains, as rival views cannot, both why psychotics escape criminal responsibility and why only mental, not physical, illness justifies involuntary medical treatment (240-3). Finally, Fulford thinks his theory promotes improvement in primary health care, as well as closer relations both between somatic and psychological medicine and between medicine and philosophy (244-54). He pursues the themes of "values-based" medicine in his [2004] and in Woodbridge and Fulford [2004].

Criticisms One possible criticism of Fulford's book is methodological. Half a century after the heyday of English ordinary-language philosophy, its theories of meaning, on which he relies, now seem undisciplined — the product of an era largely innocent of formal semantics or the semantics-pragmatics distinction. Likewise, it is unclear how Wittgenstein's idea of family resemblance (121-2) can answer attacks like Szasz's on the concept of mental illness. How could an 'everyday' (27) term ever be ruled illegitimate by ordinary-language philosophy, the basic assumption of which is that all such terms are legitimate, philosophical problems being mere symptoms of our 'distorted view' (23) of their meaning? But *cf.* Fulford [2001].

Substantively, some difficulties arise in applying Fulford's account to psychosis. Even if the essence of delusion is practical irrationality, why is irrational intentional action any the less intentional action? That the criminally insane lack intent (242) is an old account of the insanity defense exhaustively criticized by Fingarette [1972] and others. The more recent consensus seems to be that most insane killers fully intend to kill their victims, and fully act in doing so. In that case, as Nordenfelt says [2001, 91], far from Fulford's account's revealing the essence of psychosis, it is unclear that it covers psychosis at all. There is no 'failure of ordinary doing' if psychotics can do all the ordinary actions they decide to do. In fact, manics may do them even more effectively. It is unclear how Fulford can simultaneously hold (i) that the 'logical origin' of the concept of illness is 'in the experience of failure of 'ordinary' doing' ' (121) 'in the (perceived) absence of obstruction and/or opposition' (138) and (ii) that psychosis is the most paradigmatic form of illness (239), yet grant (iii) that psychotics usually do not see themselves as ill (194). Assuming psychotics have the ordinary concept of illness, if they do not see themselves as ill, then they do not experience action failure without external obstruction, and so are at best atypical examples of illness. In any event, experience of action failure — or of anything at all — is not necessary for illness, as Nordenfelt's example [2001, 83] of coma shows.

Cooper [2007, 34-5] charges that Fulford's view of disease is too narrow, excluding, *e.g.*, disfiguring conditions and such 'pathological sensations' as distortion of the visual field. That is because diseases must be linked to illness, which in turn is failure of normal action, including actions to remove unpleasant sensations. But disfigurement fits neither category, and there is no normal way to stop sensations that are not normally experienced at all.

Further objections touching both Fulford's and Nordenfelt's analyses are discussed in section 4.2.3.

4.2.2 Nordenfelt

Analysis Lennart Nordenfelt's action-based theory of health is a descendant of earlier ones by Caroline Whitbeck [1978; 1981] and Ingmar Pörn [1984]. As we saw, Nordenfelt shares with Fulford six important theses about medical concepts. Nordenfelt [2001, 73-4] also names key differences, including the following. Where Fulford uses English ordinary-language philosophy, Nordenfelt's style of conceptual analysis is the rational reconstruction of theory typical of logical empiricism. He is less centered than Fulford on psychiatry; and he begins with health rather than illness. Finally, as to result, the ability that Nordenfelt takes to constitute health is defined not via ordinary action, but in terms of vital goals.

Like Fulford's, Nordenfelt's is a 'holistic' account at the level of the whole person — not the 'analytic' [1987, xiii] level of part-function. He begins with an 'everyday' idea of health: 'a person is healthy if he feels well and can function in his social context' (35). But he immediately replaces feelings by abilities, assuming that major pain or suffering conceptually entails disability, but not conversely. Consequently, his task is to describe that kind and level of ability which constitute health. Moreover, his target is 'complete' or 'absolute' health (97-8) — that perfect health which is the total absence of illness, as opposed to some idea of minimal health, or health adequate for some practical purpose like hospital discharge.

Nordenfelt [1987] begins with concepts of action theory, here omitted but for one point. Ability is the set of internal factors required for doing something. For the practical possibility of action, one also requires opportunity, or favorable external circumstances. All talk of ability, therefore, presupposes some background environment. For health judgments, Nordenfelt calls this environment 'standard' — more recently, 'accepted' [2000, 72-3] — circumstances, and he usually takes it to be relative to a particular time, place, and society.

Given the standard background of one's society, what abilities constitute health? Nordenfelt reformulates this as a question about goals, in the (noncybernetic) sense of ends chosen by a conscious being [1987, 53]. What goals must a healthy person be able to achieve? He first considers two unsatisfactory answers. One is that health is a person's ability to fulfill his basic human needs (57-65). A serious problem here is that a need, as opposed to a want, must be necessary for some special goal. Unfortunately, writers on human needs usually define them in relation to not just survival, but also health, making the first theory circular. The second view, adopted by Whitbeck [1981] and Pörn [1984], is that health is a person's ability to attain his own chosen goals (65-76). To this view Nordenfelt sees three fatal objections. A person with very low ambitions — e.g., one who has accepted death from terminal cancer — will be perfectly healthy. So will a person, like an alcoholic, with irrational, self-damaging goals. And, since plants, lower animals, and even babies cannot choose goals at all, only adult higher animals can be healthy.

Nordenfelt now proposes his own theory, the 'welfare theory,' combining some elements of the other two. His basic intuition is that to be healthy is to have the

abilities required for a certain level of welfare, which, for human beings, is happiness. Thus, to be healthy is to be able to fulfill all one's 'vital goals': 'those goals which are necessary and jointly sufficient for a minimal degree of happiness' (78). A person's vital goals are partly objective, partly subjective. They are subjective in that people vary greatly in the goals they find crucial to their happiness. Still, we evaluate the fulfillment of very low or primitive goals as not 'minimal *human* welfare' (79), hence not real happiness (78). So vital goals have an objective side as well. Nordenfelt notes that his account

> implies neither that health is sufficient for minimal happiness, nor that it is necessary. Health is not sufficient, since the ability to fulfill one's vital goals does not imply that one actually fulfills them. (78)

For example, one might be in nonstandard circumstances — locked up by kidnappers. Or one might simply choose not to be minimally happy, in sacrificing for others. And 'health is not necessary, since the vital goals can be fulfilled by other means, for instance by the actions of someone else' (78).

Finally, the abilities at issue are second-order, not first-order, ones. Nordenfelt adopts this view to handle the case of a healthy person moved to a new environment. For example, an uneducated African farmer moves to Sweden as a political refugee. Initially, he can no longer support himself and his family (49). To avoid counting this first-order disability as illness, Nordenfelt appeals to a second-order ability: the ability to acquire the first-order abilities, such as reading and speaking Swedish, needed for a happy life in Sweden. Thus, in a sense, the essence of health is not so much ability as adaptability. Nordenfelt's final formulation is as follows:

> A is healthy if, and only if, A has the second-order ability, given standard circumstances, to realize all the goals necessary [and jointly sufficient] for his minimal happiness. [1987, 79, 148]

Any deficiency in health so defined — any second-order disability in realizing one's vital goals — is illness (109). Thus, illness can be medical or non-medical. It is medical when it results from one of the types of conditions discussed in medical books, for which Nordenfelt adopts Culver and Gert's [1982, 66] umbrella term 'malady'. Maladies include diseases, impairments, injuries, and defects [1987, 105]. In each case, a malady is essentially a type, not a token. Thus, a disease is a type of internal process instances of which, in a given environment, 'with high probability' cause illness (108). The various kinds of maladies differ ontologically: disease is a process, impairment an endstate of disease, injury an externally caused event or state, and defect a congenital state (149). A family of technical medical concepts of health can now be defined via maladies. For example, one could define three different medical concepts of health as follows: lack of disease; lack of malady; lack of in-principle curable malady (110-1). Still, there is a whole realm of nonmedical illness. This seems to be one of two things: an impairment of universal vital goals by a process that does not usually impair them, or an impairment of idiosyncratic vital goals not shared by most people. An example of the latter might be muscle

weakness in an Olympic weightlifter who has his heart set on a medal (*cf.* 122). Another example is unwanted pregnancy (114).

Pregnancy is one of four disputed cases that Nordenfelt uses his analysis to clarify. Despite involving discomfort and physical disability, pregnancy is not a disease because most cases of it are chosen to satisfy the woman's vital goal of motherhood. At worst, its negative aspects involve the common phenomenon of goal conflict. But pregnancy with a baby that will never make its mother happy is illness (113-4). In somewhat parallel fashion, grief, and most other negative emotions, are not illness, since the disability caused by grief is a nearly inevitable effect of the emotional sensitivity required for a happy life (116). There are two possible ways, Nordenfelt suggests, to view old age. If senile degeneration is incurable in principle, one might again call it nonmedical illness in the sense just defined. Alternatively, insofar as the aged adjust their vital goals to their diminished abilities, it is not illness at all (113). Finally, homosexuality is not a disease or pathological condition, but it may be an illness in some cases. The reasons it is no malady are as follows. First, the evidence that most homosexuals are unhappy and disabled is weak; moreover, those who are unhappy may be so because of the 'severe circumstances' of social condemnation (136). Second, reproduction and family life are not universal vital goals, nor are homosexuals, in general, unable to pursue them. Still, those homosexuals who do have these goals, but cannot pursue them, have nonmedical illness (139). Nordenfelt applies his account to other psychiatric conditions in [2007b].

Criticisms Nordenfelt relativizes disease to environment, and, as noted below regarding Reznek, it is questionable whether medicine does the same. In any case, Nordenfelt's treatment of the African in Stockholm will not apply to irreversible disabilities. But not all of these seem to be defects of health. Suppose Sweden were a less tolerant country, and the new African were forever socially handicapped by his accent, which, like most adults, he could not easily lose. Then he might be forever unable to earn a good living. Yet it seems no more plausible to call him ill in this scenario than in Nordenfelt's own.

Arguably, Nordenfelt's theory also diverges sharply from medical judgments, by allowing a person with a systemic disease not to be ill, while a person frustrated by a normal physical condition may be seriously ill. Illustrating the first possibility is Albert, a mathematician, whose overriding vital goal is to prove the Riemann conjecture. After years of rich, exciting work, he finally does so. During this period, he also suffers from malaria, or progressive diabetes, or cystic fibrosis. In both lay and medical usage, Albert is ill. Yet he may be happier than he would have been with neither the disease nor the creative success. It seems Nordenfelt must deny that Albert is ill, because his particular set of vital goals, unlike most people's, allows minimal — indeed, great — happiness despite crippling disease. There are, in fact, real cases of the necessity of medical illness to a goal. For example, early microbiologists deliberately gave themselves infectious diseases in their search for a cure. On Nordenfelt's theory, it seems impossible to sacrifice one's health to achieve goals one prefers to it, at least if the need for such a tradeoff is a

standard feature of one's environment. Clearly, in any case, on Nordenfelt's view a person with a dangerous disease, like early cancer, may be perfectly healthy [Nordenfelt, 2004, 151]. This reflects his choice to make health the absence of illness, not of disease.

About the second possibility, nonmedical illness, Nordenfelt is frank. An example might be Lily, an athlete, one of whose vital goals is to win a Olympic medal in high jump [Nordenfelt, 1987, 122; Schramme, 2007, 14]. Despite struggling her whole adult life to reach this level, she cannot do so even with the finest training, and ends up sad and angry. It seems that Nordenfelt must say that Lily is ill, at least to some degree, though no English speakers, even laymen, would call her so. In such cases, it is as though Nordenfelt's 'welfare theory of health' treats illness as 'illfare' — a considerably broader usage than normal. Schramme concludes that Nordenfelt has a stipulative definition of health which, lacking the bulwark of a dysfunction requirement, invites the 'medicalization of all kinds of problems in life' (15). Nordenfelt [2007c, 30] replies that, though Lily's health is 'somewhat reduced,' it may well be high enough still to need no medical treatment.

4.2.3 Objections to both Fulford and Nordenfelt

Illness too narrow a holistic concept to define disease In modern English, the gross effects of many diseases or other 'maladies,' even when full-blown, are not called illness or sickness. Cataract and macular degeneration are diseases that cause partial or total blindness; but blindness is not illness. Nor is deafness, due to degeneration of the hair cells of the inner ear. A sprained ankle or a snapped Achilles tendon is an injury or disability, but not illness. Even purely local inflammatory or infectious disease is not illness: laryngitis, athlete's foot, conjunctivitis, cystitis, gum disease. Probably most conditions treated by some whole medical specialties — ophthalmology, otolaryngology, dermatology — are not illness. Examples like these suggest that what Nordenfelt calls maladies cannot be, as he says, conditions that usually cause illness. Likewise, none of Fulford's three disease concepts — conditions widely viewed as illness, or causes of them, or statistical correlates of them — seems able to cover all medical diseases. Ringworm or myopia is not widely viewed as illness, and it neither causes nor is associated with any condition that is.

Can any holistic concept define disease except via part-dysfunction? Perhaps the previous point is a linguistic quibble, and we need only start with a broader holistic concept. Certainly both Fulford's and Nordenfelt's notions of disability are intended to cover examples like those above. More important is that it is false that most cases of every disease have gross effects. There are diseases the vast majority of cases of which are, and remain, subclinical. Most carcinoids are discovered as incidental findings at autopsy. So were most prostate cancers, at least of the slow-growing type, before PSA screening. Most diverticula do not cause diverticulitis, yet diverticulosis remains a disease. The obvious weaker criterion —

some cases cause gross effects — is not proposed by Fulford or Nordenfelt, and is far too weak anyway. Many normal conditions sometimes cause illness, but are not diseases. Pregnancy can lead to eclampsia and heart failure, or death in childbirth. Having an appendix can lead to appendicitis. And to search for some probabilistic test of intermediate strength is not promising. Is the average diverticulum, or even diverticulous colon, more likely to become infected than an average appendix? It is also hard to imagine how a holistic notion can distinguish the ill effects of local pathology from those of normal variation. Many men would rather have Harrison Ford's face with a small scar, and many women Cindy Crawford's with a small mole, than their own without one. What makes a skin lesion pathological is only local dysfunction of skin cells, not gross effects. Any dermatology atlas raises doubt that what makes the listed conditions pathological, but unlisted ones not, is any holistic effects.

At the same time, nearly all major accounts of biological part-function have their holistic side. Nearly all, that is, define the functions of a part or process in terms of some effect on the whole organism. Perhaps, then, Nordenfelt's contrast between holistic and analytic views of health should be between accounts that are (i) only holistic and (ii) both holistic and analytic. What Boorse and Wakefield claim is that a specific kind of relation to holistic effects — biological part-dysfunction — is essential to any accurate account of such basic concepts of scientific medicine as disease or pathological condition.

Relativity to, or relativism about, social values As both Fulford and Nordenfelt explicitly note, to describe values is not to evaluate. Both hold, however, that medical concepts span both possibilities. The resulting issues are too complex for quick summary. Fulford's view seems to be that to call a condition illness is always to evaluate it yourself, while to call it a disease is to report an evaluation by others or some relation to such an evaluation [1989, 62-4]. At least two independent elements in Nordenfelt's analysis of health, minimal happiness and reasonable circumstances, require evaluation. He apparently holds (2001, 107-8) that either a first-person statement ('I am healthy') or a third-person statement ('A is healthy') can be either evaluative or descriptive, depending on whether the speaker is expressing his own evaluation or describing his own, A's, or society's evaluation.

This ambiguity thesis of Nordenfelt's seems implausible, for reasons familiar from the metaethics of cultural relativism. Even if speaker X and patient A belong to the same society S, there is a gulf between X's saying that patient A's happiness is subminimal and saying that it is considered subminimal by S. X may be a harsh critic of his society's values. If X belongs to a different society, S', from A, the contrast between these two statements is more obvious still. Logically, X might judge A's minimal happiness either by the values of S' or by those of S. But, in either case, whether medicine ever properly makes health judgments in this way is debatable.

How can health concepts apply to babies, lower animals, and plants?
Fulford admits that, on his account, with lower organisms there is 'often ... a
distinct element of 'as if' in our use of the medical concepts in respect of them'
[1989, 122]. But to be as if diseased is not a way of being diseased; it is a way of
not being diseased. In Fulford's example, if leaf-mold on a plant is a disease (122),
yet plants cannot be ill (123), then 'disease' is not, in fact, definable via 'illness'
in any of the ways he says it is.

Nordenfelt says that his own analysis cannot literally apply to plants and lower
animals (for short, PLA), or even to human babies, without 'reconstruction' [1987,
104]. First, as to babies: they have no abilities, he says, and cannot realize their
vital goals without adult aid. Hence, he suggests calling a baby healthy when its
internal state is suitable for its minimal happiness 'given standard adult support'
(104). But why is need for other people's care consistent with babies' health,
but not with adults'? As Nordenfelt emphasized, ill adults can reach minimal
happiness with others' support (78). Moreover, his account is based on action
theory. It seems, therefore, that to deny that babies have abilities means that
babies cannot, in fact, be healthy or ill, except in a fundamentally different sense
from adults.

As for adult higher animals, Nordenfelt thinks that his welfare theory of health
applies to them 'in all its essentials' (141). But lower animals and plants, which are
incapable of happiness (141), can be healthy or diseased only in some 'parasitic'
sense based on 'incomplete analogies' to human beings (143). He suggests two such
analogical health concepts for PLA. One is that the same biological processes,
such as 'steady growth, reproduction and development of potentialities,' which
support human happiness also occur in PLA and so can be taken as 'criteria' for
their 'welfare' (142). Another possibility is to use the benefit of PLA to man
to define their health. Milk cows, beef cattle, hunting dogs, wheat crops, berry
bushes, medicinal plants, and ornamental flowers will be 'ill' if they cannot, in
standard circumstances, 'fulfill the goals for which they have been cultivated and
trained' (142-3). These two concepts of PLA health are, of course, different and
can conflict. Farm animals, even pets, are often treated in ways, like castration
and other mutilations, that make them more useful to us, but would impair the
health of a human being. A perfect example of such conflict is medical research.
An 'animal model' of disease D is useful to humans precisely by having disease
D, so here health in the one sense is disease in the other. Health writers disagree
whether the two disciplines concerned with PLA health — veterinary medicine
and plant pathology — employ the human-centered conception, or not. In any
case, it is not an attractive line for Nordenfelt, since a view that defines health in
terms of the healthy organism's welfare is hardly analogous to one that defines it
in terms of the welfare of other entities.

In later writing on nonhuman health [2007a], Nordenfelt downplays the human-
centered view. Instead, he expands his previous remarks on how PLA show ana-
logues to the biological basis of human abilities. Besides the capacity of higher
animals for suffering, emotion, and even intentional action, he says that all animals

have goals and engage in goal-directed behavior. We may use these 'factual' goals [1987, 17] as the vital goals defining their minimal welfare, and say that internal obstacles to achieving these goals are illness. For plants as well as animals, we can define their quality of life, or welfare, by the notion of vitality or flourishing. By this move, Nordenfelt's view approaches more closely to Boorse's or Wakefield's. Nordenfelt uses this framework to develop a systematic account of animal welfare in his [2006].

4.3 Reznek

The last of our five writers, Lawrie Reznek, is, like Fulford, both a psychiatrist and a philosopher. His work, which has not received the critical attention it deserves, combines sophisticated philosophical analysis with an unmatched array of provocative examples. His first two books [1987; 1991] compose one sustained argument, applied by his third [1997] to the insanity defense.

4.3.1 Analysis

In his first book, although Reznek begins with the term 'disease', he soon notes that the most general term for 'negative medical conditions' (65) is 'pathological.' Pathological conditions include not just diseases, with their associated signs, symptoms, and pathologies, but also injuries, poisonings, and miscellaneous states like heat stroke and starvation (65-7). After a general discussion of taxonomic realism in and out of science, he concludes that, unlike many other scientific categories, diseases share neither a real nor a nominal essence. That is, 'disease' does not refer to a natural kind. Nor, in fact, can one even find qualities separating pathological conditions called 'diseases' from those that are not. Likewise, pathological conditions in general fail to be a natural kind. But one can analyze the meaning of 'pathological'. One hundred pages later, Reznek concludes:

> A has a pathological condition C if and only if C is an abnormal bodily/mental condition which requires medical intervention and for which medical intervention is appropriate, and which harms standard members of A's species in standard circumstances. (167)

In his second book, Reznek states one further requirement on disease, which he would presumably also apply to pathological conditions in general: that one cannot acquire or remove the condition by a direct act of will [1991, 92]. In addition, in both [1991] and [1997], Reznek adopts Culver and Gert's requirement [1982, 74-5] that a disease not have a distinct sustaining cause. But this seems to be a requirement only on diseases, not on pathological conditions in general.

How does Reznek arrive at this analysis? In broad outline, he first concludes that a condition is 'pathological if and only if it has an explanatory nature that is of a type that is abnormal and that causes harm or malfunctioning' [1987, 91]. The normality in question is ideal rather than empirical. The norms of health 'cannot

be theoretical,' since, as he has already argued, 'there *is* no natural boundary to be discovered between normal and pathological conditions' (95). Nor can they be merely statistical. Whole populations already suffer from diseases — dental caries in the West, dyschromic spirochetosis or intestinal worms in Africa. And our whole species might be judged abnormal. For example, we might discover that we all have a slight copper poisoning that lowers our IQ by 30 points, or a nuclear war might kill everyone lacking Huntington's chorea. Instead, we choose norms of health by their 'practical consequences' (97).

> [W]e wish to create certain priorities in dealing with all those conditions that we would be better off without. We would all be better off if we did not age, if we did not suffer from a need to sleep for 8 hours a day, if we did not synthesize uric acid and thereby be liable to gout, etc. But we are not diseased because of this — we are not diseased because we are not supermen! ... [W]e regard [dental caries] as an abnormal process because we choose to give its cure the same priority as we give to the cure of TB and multiple sclerosis. ... We regard the process of ageing as normal, because we consider that it is more important first to rid ourselves of those processes we take to be abnormal. ...

> An important factor that will influence whether to regard some process as normal is the ability we have to treat the condition medically. We are unlikely to regard ageing as a disease, even though we would be better off without it, because we are at present unable to do anything about it. However, if we discovered a drug that enabled us to live healthy lives to 200-years-old, would we not come to view the drug as vitamin F, and regard our present ageing process as abnormal and as a vitamin-deficiency disease? [1987, 94, 97]

Reznek next finds harm, not dysfunction, to be the second element of a pathological condition. Endorsing an etiological account of function (ch. 6), he argues that dysfunction is neither necessary nor sufficient for pathology. It is not necessary because lack of a trait with no biological function — the female orgasm, perhaps, or life itself after one's last reproductive contribution — could still be pathological, since harmful (131). It is not sufficient because functions can be harmful, in which case their lack is not pathological. Here Reznek's examples are functions that harm, even kill, the individual to serve reproduction or group survival. Adults of many species must die to reproduce, such as the male praying mantis, who loses his head to ejaculate (111), or the female gall-midge, whose young eat her alive (121). Hypothetically, we could imagine equally painful and lethal self-destruct mechanisms favored by group selection. Lack of any of these functions would benefit the individual, and would not, Reznek thinks, be pathological. What makes an abnormality pathological is not dysfunction, but harm (133, 170). After surveying various 'theories of human good,' he settles on a 'normativist' account of harm: 'X does A some harm if and only if X makes A less able to lead a good or worthwhile life' (153). For human beings, good or welfare

'consists in the satisfaction of worthwhile desires and the enjoyment of worthwhile pleasures' (151). But all organisms, even those with no desires or pleasures, have some sort of good or welfare defined by their flourishing (135).

To a first approximation, then, pathological conditions are harmful abnormalities. But Reznek's final analysis includes several amendments. First, reference is made to species because 'one species' disease [is] another species' adaptation' (160). Malformed wings harm mainland flies, but, on a windy island, a different fly species may be better off flightless. Second, standard circumstances are included because diseases can be harmless to individuals in special environments. A victim of hemophilia or immune deficiency may be lucky enough never to encounter the danger against which he is defenseless (160). And, third, pathological conditions harm only standard species members, not necessarily all of them. A man set on being a jockey may welcome pituitary dwarfism; a woman who wishes no children may be glad to be infertile (161-2). Finally, for pathological conditions, medical treatment is both necessary and appropriate. It must be necessary because various harmful abnormal conditions, such as starvation or being very cold, are not considered pathological, presumably because they can be treated by nonmedical means. By contrast, hypothermia, which requires medical intervention, counts as pathological (163). And medical treatment must be appropriate. If we discovered that all criminals have a specific neurologic abnormality treatable by frontal lobotomy, we might still reject such surgery, because we regarded criminal behavior as freely chosen. Then we would not consider the neurologic state pathological, medical treatment being inappropriate for it (167). Reznek reasserts this strong semantic link between the pathological and medical treatment in the last two sentences of his chapter: 'Judging that some condition is a disease commits one to stamping it out. And judging that a condition is not a disease commits one to preventing its medical treatment' (171).

In sum, Reznek's analysis, at least in his first two books, is that condition C in a member A of species S is pathological iff it satisfies five requirements:

1. C is abnormal

2. C is harmful to standard members of S in standard circumstances

3. Medical treatment of C is necessary

4. Medical treatment of C is appropriate

5. A cannot acquire or remove C by direct act of will.

Moreover, all five conditions, even the last, turn out to be value judgments, on Reznek's view. A final feature of his account is his thesis that, within a species, a condition can be a disease in one environment but not another (85).

In his second book [1991], Reznek uses this analysis to defend the concept of mental disease against all its leading critics, such as Eysenck, Laing, Szasz, Sedgwick, Scheff, and Foucault. At the outset, the book describes 'the medical paradigm,' consisting of eleven theses:

T1. The *Causal Thesis*: A sub-class of abnormal behaviour is caused by disease.

T2. The *Conceptual Thesis*: A disease is a process causing a biological malfunction.

T3. The *Demarcation Thesis*: A mental illness is a process causing a malfunction predominantly of some higher mental function.

T4. The *Universality Thesis*: Diseases are not culture- or time-bound.

T5. The *Identification Thesis*: Scientific methodology enables us to identify diseases.

T6. The *Epistemological Thesis*: Scientific methodology enables us to discover the causes and cures for these diseases.

T7. The *Teleological Thesis*: Psychiatry's goal is the prevention and treatment of mental disease.

T8. The *Entitlement Thesis*: Having a disease entitles a patient to enter the sick role.

T9. The *Neutrality Thesis*: Besides the values implicit in the goal of preventing and treating disease, psychiatry is neutral between any ethical or political position.

T10. The *Responsibility Thesis*: Having one's behaviour caused by a mental illness in a certain way excuses one from responsibility.

T11. The *Guardianship Thesis*: Having a serious mental illness entitles the psychiatrist to act against the patient's will. (12)

But not all these theses, he finds, fit his own analysis. T2 and T9 are false, and T7 needs revision.

4.3.2 Criticisms

Normality As Nordenfelt notes [2001, 40], the abnormality clause in Reznek's analysis of pathological condition looks redundant. It cannot mean statistical abnormality, since Reznek is clear that disease can be typical and that the atypical — *e.g.*, Einstein's brain — need not be disease [1987, 89]; but *cf.* [1997, 203, 212]. Nor can 'abnormal' have its special medical meaning of 'pathological,' since that would make the other elements of the analysis superfluous. 'Abnormal' is also redundant if it means the 'prescriptive content' (95) of disease judgments, since that content is just elements (2)-(4). That leaves only the political dimension of disease judgments, discussed below.

Environmental relativity Reznek embraces the environmental relativity of disease: "whether a process is pathological or not depends not just on its nature, but on the relation of the organism to the environment in which it lives — 'one environment's adaptation is another's disease'" [1987, 85]. As with similar claims by Engelhardt and Nordenfelt, some critics say this confuses disease with what causes disease. In medical thought, does a Masai's black skin become pathological if he moves to a region of low sunlight, where it causes rickets [1987, 86]? Would a pygmy's size be pathological if he began living with the Masai? Reznek embraces the converse point that genuine diseases — *e.g.*, hemophilia or immunodeficiency [1987, 160] — can be harmless in special environments. That is why he requires a disease to be harmful 'in standard circumstances.' But if nonstandard circumstances are just a different environment, this point seems to contradict the environmental relativity of disease.

A special case of this issue is Reznek's claim that pathology depends on social values. Patterned scars in African culture, or European noblemen's dueling scars, are not pathological, he says, because the African scars are considered attractive and the European ones enhanced a nobleman's status [1987, 158]. On this view, it would seem that the effects of African clitoridectomy are likewise not pathological, at least if they make the girls better off within their own societies.

Medical treatment Reznek holds that we should define disease not, like Kräupl Taylor, 'as what doctors treat,' but 'in terms of what doctors *ought* to treat' [1991, 165]. Specifically, a condition is pathological only if medical treatment of it is necessary, appropriate, and fits our priorities. As to priority, are we really giving tooth decay a higher priority than normal aging? Of course, we have better treatment for it; but it is unclear that we are more likely to find a cure for cancer, or genetic diseases, than for aging. That medical treatment must be necessary for a genuine disease ill fits disorders like heat exhaustion or altitude sickness, which are treated by moving the patient to a friendlier environment, or nutritional disorders, which are treated by dietary change. This, of course, invites the question: what treatments are medical? In his first book, Reznek said medical treatment can be defined enumeratively, as drugs, surgery, 'and so on' [1987, 1, 163]. In his second book, his thesis that rival views of mental illness all fit the medical paradigm forces him to a broader view of medical treatment, encompassing psychoanalysis, behavior therapy, cognitive therapy, and even education [1991, 49]. Moreover, Reznek stresses that organisms human beings do not care about can still be diseased: 'Desert grass and pestilent [Australian] rabbits can have infectious diseases (even though we have no interest in their survival) because the infection does *them* harm' [1991, 100]. So nothing about medical treatment is, in fact, necessary for wild grass and rabbits to be diseased. Thus, Reznek sometimes ignores clauses (3) and (4) in his later work.

Harm If to be harmed is to be made worse off, any analysis requiring harm faces at least two problems: diseases of lower organisms and essential pathology. First,

many philosophers, including all utilitarians, agree with Singer [1994, 200] that nonsentient beings have no interests. Beings without interests cannot suffer harm or benefit. Yet biologists freely attribute diseases to plants and lower animals. Even harm-requiring writers like Wakefield and Reznek discuss disorders of bacteria or grass. Presumably, lower organisms can in some sense be damaged, as by mutilation, or destroyed. But that is equally true of artifacts like cameras, cars, or robots, to none of which health or disease is attributed. Unlike artifacts, lower organisms can be killed; but this is of little aid, since not all diseases are lethal. To explain harm and benefit for plants and lower animals, Reznek [1987, 135], like other writers, appeals to von Wright's doctrine [1963, 45] that every living organism has a good of its own. But a further worry about univocality is raised by Reznek's account of human good in terms of 'the satisfaction of worthwhile desires and the enjoyment of worthwhile pleasures' [1987, 151]. Can the lives of viburnums, slime molds, or bacteria fail to be worthwhile?

Second, given what Feinberg [1986] called 'the counterfactual element' in harm, no essential property can be harmful. On some views, such as Kripke's [1980], one's genotype, or aspects thereof, are essential to one's identity. Then genetic diseases such as phenylketonuria — especially those involving gross genetic abnormality, like Down's or Turner's syndrome — cannot make their bearers worse off. Without them, their bearers would not have existed at all (*cf.* [Kahn, 1991; Zohar, 1991]). An interesting issue combining both problems is raised by Roy Sorensen: contrasentient pathology. Not only does, say, anencephaly prevent all consciousness, but one even wonders if there is a definite human being who would have been sentient without it. If not, then, again, anencephaly is not harmful, since it has no victim. To accommodate essential pathology, writers could, of course, try replacing harm with another disvalue category missing the counterfactual element.

'Political dimension' of disease judgments In all three books, Reznek says that what conditions we call pathological should be affected by the social effects of so doing. In choosing what is normal, we choose not only 'what sort of people' we ought to be, but also 'what sort of society we ought to create' [1991, 169]. Illustrating the former choice is our decision to call grief normal. To illustrate the latter, Reznek uses examples of male baldness, black skin, and homosexuality. Suppose that homosexuality is intrinsically harmful, and medical treatment for it appropriate; in other words, suppose that homosexuality fits all elements (2)-(5) of Reznek's analysis. Still, he says, it should not be called pathological, since to do so would create a social 'stigma,' perpetuating prejudice (169). To Nordenfelt, this pragmatic view of nosology 'undermines all the sharp theoretical analysis that Reznek performs at other places' [2001, 41].

5 SOME OTHER ACCOUNTS

Other philosophers who have written at length on health concepts, are often cited, or both, are as follows. The list is far from complete.

5.1 Clouser, Culver, and Gert

K. Danner Clouser, Charles M. Culver, and Bernard Gert [1981; 1997; see also Culver and Gert, 1982] define 'malady'. They wish this term to have the common content of all the 'disease words,' such as 'injury', 'illness', 'sickness', 'disease', 'trauma', 'wound', 'disorder', 'lesion', 'allergy', 'syndrome', and so on [1997, 177].

> Individuals have a malady if and only if they have a condition, other than their rational beliefs or desires, such that they are incurring, or are at a significantly increased risk of incurring, a harm or evil (death, pain, disability, loss of freedom, or loss of pleasure) in the absence of a distinct sustaining cause. [1997, 190]

On this analysis, the authors say, malady is a normative concept because harm is. But since only 'basic harms' are at stake — death, pain, disability, loss of freedom, and loss of pleasure — and on these there is general agreement, the disvalue of malady is universal and objective (184). Only increased risk of such a harm is required, since many conditions, such as HIV infection or hypertension, are maladies before they have ill effects. A malady must be an internal condition of the individual — not, for example, being in jail or falling off a high building — and also not sustained by an external cause, like a wrestling hold or a hot sun (186-90). Finally, a rational belief (*e.g.*, that one has lost a fortune in the stock market) or rational desire (*e.g.*, to climb mountains) is not a malady.

Abnormality is neither necessary nor sufficient for malady (190). Its nonnecessity is illustrated by several of the authors' 'troublesome borderline cases.' Pregnancy, menopause, and teething are definite maladies; still, the authors say, 'plausible changes' (205) in their definition would exclude them. For medicine, of course, as for biology, nothing is more normal than an uncomplicated pregnancy. Menstruation, moderate shortness, and old age are already nonmaladies on the current definition (205-210).

5.2 Whitbeck

Caroline Whitbeck [1978; 1981] defines health as 'the psychophysiological capacity to act or respond appropriately in a wide variety of situations,' meaning 'in a way that is supportive of, or at least minimally destructive to, the agent's goals, projects, aspirations, and so forth' [1981, 611]. One thing that can reduce health is diseases, *i.e.*,

(i) psychophysiological processes which

(ii) compromise the ability to do what people commonly want and
 expect to be able to do,

(iii) are not necessary in order to do what people commonly want to
 be able to do, and

(iv) are either statistically abnormal in those at risk or there is some
 other basis for reasonable hope of finding means to effectively treat
 or prevent them. (615)

But the concepts of health and disease are 'concepts of different orders.' Health is
'much more than the absence of disease,' and 'a high level of health is compatible
with having some disease' (624). Moreover, besides medical conditions, there is
another class of conditions that often reduce health: 'self-alienation conditions'
(625), such as weakness of will, self-deception, and self-hatred.

5.3 Pörn

Ingmar Pörn [1984; 1993] calls his theory of health 'the equilibrium theory.' A
person is healthy when his repertoire, the sum of all his abilities, is adequate to
his personal profile of goals [1984, 5]. That is, he has the right internal resources
to reach his goals; of course, the right external opportunities for action may not
exist. A person who is not healthy is ill. Diseases are processes with a 'causal
tendency to restrict repertoires and thereby compromise health' (6).

5.4 Richman

Kenneth Richman [2004], extending Richman and Budson [2000], offers a theory
of health of the same kind as Whitbeck, Pörn, and Nordenfelt, but with at least
two novel features. One is to distinguish, for human beings, between health of
the person and health of the organism (28), as some writers do for death in the
literature on defining death. A second new idea is to use a person's "objectified
subjective interest" (45), as judged by an epistemically idealized version of himself,
to fix the goals that define his health.

5.5 Spitzer and DSM

In response to 1970's gay activists' challenge to the pathological status of homosex-
uality, the American Psychiatric Association's Task Force on Nomenclature and
Statistics asked Robert L. Spitzer to study the concept of mental disorder [Spitzer
and Williams, 1982, 16-7]. Ultimately, Spitzer and Jean Endicott proposed a gen-
eral definition of medical disorder, which, in a 'highly abbreviated form' omitting
many interesting provisos, is as follows:

 A medical disorder is a relatively distinct condition resulting from an
 organismic dysfunction which in its fully developed or extreme form is
 directly and intrinsically associated with distress, disability, or certain

other types of disadvantage. The disadvantage may be of a physical, perceptual, sexual, or interpersonal nature. Implicitly there is a call for action on the part of the person who has the condition, the medical or its allied professions, and society.

A mental disorder is a medical disorder whose manifestations are primarily signs or symptoms of a psychological (behavioral) nature, or if physical, can be understood only using psychological concepts. [1978, 18]

The authors go on to offer detailed 'operational criteria' to apply this definition, with many examples of disorders and nondisorders, including the sexual orientations that prompted the exercise.

Notable in the short version are (i) a dysfunction requirement and (ii) a disadvantage requirement, which together are very like Wakefield's later harmful-dysfunction analysis. In one way the definition looks weaker than the HDA, since the dysfunction need only be harmful in fully-developed or extreme form. In another way, it looks stronger, since a disorder 'calls for action' by patient, doctor, and society. This feature seems similar to DSM's restriction (see below) to 'clinically significant' conditions.

Neither the Task Force's original proposal nor Spitzer and Endicott's analysis was incorporated into DSM. But, beginning with DSM-III, which Spitzer edited, each edition has stated some version of a closely related analysis. Here is the DSM-IV version:

In DSM-IV, each of the mental disorders is conceptualized as a clinically significant behavioral or psychological syndrome or pattern that occurs in an individual and that is associated with present distress (e.g., a painful symptom) or disability (i.e., impairment in one or more important areas of functioning) or with a significantly increased risk of suffering death, pain, disability, or an important loss of freedom. In addition, this syndrome or pattern must not be merely an expectable and culturally sanctioned response to a particular event, for example, the death of a loved one. Whatever its original cause, it must currently be considered a manifestation of a behavioral, psychological, or biological dysfunction in the individual. Neither deviant behavior (e.g., political, religious, or sexual) nor conflicts that are primarily between the individual and society are mental disorders unless the deviance or conflict is a symptom of a dysfunction in the individual, as described above. [APA 1994, xxi-xxii]

We lack space for detailed discussion of this analysis, except to note that to require clinical significance means that DSM's target concept may be, not pathological condition, but pathological condition of a certain severity. Spitzer and Williams write:

> The phrase 'clinically significant' acknowledges that there are many
> behavioral or psychological conditions that can be considered 'patho-
> logical' but the clinical manifestations of which are so mild that clinical
> attention is not indicated. For this reason, such conditions are not in-
> cluded in a classification of mental disorders. ... [The] syndrome of
> caffeine withdrawal never leads to seeking professional help. There-
> fore, it is not included in DSM-III as a mental disorder [1982,
> 19-20]

If so, DSM may differ from, say, ICD's concept of nonmental disorder [WHO,
1994]. To mention only skin disorders, there is no need for cellulitis (L03), freck-
les (L81.2), sunburn (L55), male-pattern baldness (L64), prematurely gray hair
(L67.1), acne (L70.0), or scars (L90.5) to be severe, or to be a 'call to action' by
anyone. For further discussion of the DSM classification, see, among many other
sources, Wakefield [1992b; 1997a; b], Sadler, Wiggins, and Schwartz [1994], Sadler
[2002], Horwitz [2002], Cooper [2005], Sadler [2005], and Bolton [2008].

5.6 Cooper

Rachel Cooper holds that 'a condition is a disease if and only if it is a bad thing
to have, sufferers are unlucky, and it is potentially medically treatable' [2005, 41].
First, mere abnormalities, such as ginger hair or genius, are not diseases since they
are not bad. Moreover, being bad for society cannot make a condition a disease;
it must be bad for the individual who has it (23). Cooper finds it irrelevant
whether or not most cases of a condition are bad. If sterility were advantageous to
most sterile people, it would still be a disease for the rest. Conversely, recognized
disease-types are not diseases in individuals for whom they are a net benefit; *e.g.*,
if a schizophrenic enjoys his hallucinations, or an artist his color-blindness, their
conditions may not be pathological for them (26).

To be diseased, a person must also be unlucky, in that he 'could reasonably
have hoped to have been otherwise' (29). That is, there must be a 'good number
of possible worlds consistent with the laws of human biology where people like
[him] are in a better state' (30). Since human biology requires teething, it is
not a disease; but human biology does not require blindness. Nor does it require
conditions that may be universal, such as tooth decay now, or leprosy after a
nuclear holocaust (30, 32). To the problem of essential pathology, Cooper replies
as follows. Even if Fred, who has Huntington's chorea, has it in all possible worlds,
he is still unlucky in that '[t]here are many possible people like him who are better
off' (31).

Thirdly, diseases must be potentially medically treatable. If no cure is available
now, there must be reasonable hope for a future one. Sometimes, when a *medical*
cure becomes available, a condition becomes a disease, as when shyness became
treatable by paroxetine (32). But bad, unlucky conditions easily treatable by
nonmedical methods, like fatness or a poor haircut, are not diseases. Cooper
suggests defining medical treatment not enumeratively, like Reznek [1987, 163],

but sociologically, by stating who are 'doctors and other medical personnel' (33). Finally, what is medically treatable is not only a technical question, but also a social one. Thus, homosexuality 'ceased to be considered a disease as it became socially unacceptable to treat it' (34).

Cooper notes that insofar as each of her three criteria is vague, her account is too (35). Answering other objections, she holds that unwanted pregnancy due to contraceptive failure is, in fact, a disease. She believes that her account applies unchanged to higher animals; but, for plant diseases and some animal diseases, the badness requirement needs reinterpretation along the lines of Nordenfelt's human-centered account. A condition is bad for a plant if it makes the plant deviate from the 'ideal standards' of its breeders. Similarly, a female dwarf rabbit, who has more problems giving birth, does not have a genetic disease, since 'she is as the rabbit breeder wants her to be' (37).

6 AFTERWORD

Three final points about our summary of health literature are worth making. First, we can see clear differences among writers' target concepts. Among those taking health to be the absence of disease or disorder, Boorse claims to analyze a pathologist's concept, whereby many pathological conditions are wholly local and trivial. By contrast, Spitzer says that not all pathological states are disorders, and Wakefield excludes from medical disorder various conditions listed as such in ICD-10, because they do not harm the person as a whole 'in the practical sense relevant to disorder' [1992a, 384]. This suggests some tension between pathological and clinical views of disease in ordinary medicine. Other writers, such as Nordenfelt, make health the absence of illness, so that a person with early cancer can be in perfect health.

Second, our summary wholly omits the topic of nosology, the division of the field of pathological conditions into individual entities. Though Reznek has two chapters on nosology [1987, ch. 10, 11], writers discussed above have less to say about how disease entities should be identified and distinguished than about what makes a condition pathological in the first place.

Third, the authors we have surveyed mostly lack any systematic treatment of the crucial topic of health comparisons. In most practical contexts, one needs to know not just whether a condition is pathological, but how severe it is. Doctors must judge not only whether a patient has a disease, but whether it needs treatment, and, if so, when its treatment is making the patient healthier absent a full cure. Given limited resources and the constraints of liberty, social policy on diseases, mental or physical, always requires an estimate of how important specific conditions are to patient or society. One may hope that, years hence, a survey article like this one will be able to discuss a wide range of theories, not just of pathology and health, but of their degrees as well.

7 FOR FURTHER READING

The easiest entry points to the writings of the authors in section 4 are as follows. Boorse's most concise summary of his view is [1987], covering roughly the same material as [1976b] and [1977]. Wakefield states his basic position on disorder in [1992a], elaborating on function in [1999b]; he applies these ideas to DSM in [1992b] and [1997a; b] and replies to manifold critics in [1999a; b]. The basic source for Nordenfelt's account is his book [1987; rev. ed. 1995]; for Fulford, [1989]; for Reznek, [1987; 1991].

Among various works not discussed above, book-length treatments of the topic of mental health include Svensson [1995], Tengland [2001], Pickering [2006], and Bolton [2008]. An influential older classic on health and disease by a physician is Canguilhem [1966/1978]. Wachbroit [1994] argues that a unique kind of normality, neither statistical nor evaluative, is central to biology. Nesse [2001], drawing on Nesse and Williams [1994], presents an evolutionary perspective on defining disease. And Vácha [1985; 2004] offers stimulating essays on the pitfalls of normality in biology and medicine.

Finally, two interesting anthologies on health and disease are Caplan, Engelhardt, and McCartney [1981] and Caplan, McCartney, and Sisti [2004].

BIBLIOGRAPHY

[Agich, 1982] G. J. Agich. Disease and value: a rejection of the value-neutrality thesis. *Theoretical Medicine* 4:27-41, 1982.

[American Psychiatric Association, 1980] American Psychiatric Association. *Diagnostic and Statistical Manual of Mental Disorders* (3rd ed.). Washington, DC: APA. [*DSM-III*], 1980.

[American Psychiatric Association, 1994] American Psychiatric Association. *DSM-IV*. Washington, DC: APA, 1994.

[American Psychiatric Association, 2000] American Psychiatric Association. *DSM-IV-TR*. Washington, DC: APA, 2000.

[Amundson, 2000] R. Amundson. Against normal function. *Studies in History and Philosophy of Biological and Biomedical Sciences* 31:33-53, 2000.

[Ananth, 2008] M. Ananth. *In Defense of an Evolutionary Concept of Health*. Aldershot: Ashgate, 2008.

[Baron-Cohen, 1997] S. Baron-Cohen, ed. *The Maladapted Mind: Classic Readings in Evolutionary Psychopathology*. Hove: Psychology Press, 1997.

[Bayer, 1981] R. Bayer. *Homosexuality and American Psychiatry*. NY: Basic Books, 1981.

[Bedau, 1991] M. Bedau. Can biological teleology be naturalized? *Journal of Philosophy* 88:647-55, 1991.

[Bedau, 1992a] M. Bedau. Goal-directed systems and the good. *Monist* 75:34-51, 1992.

[Bedau, 1992b] M. Bedau. Where's the good in teleology? *Philosophy and Phenomenological Research* 52:781-806, 1992.

[Bolton, 2008] D. Bolton. *What is Mental Disorder?* NY: Oxford University Press, 2008.

[Boorse, 1975] C. Boorse. On the distinction between disease and illness. *Philosophy and Public Affairs* 5:49-68, 1975.

[Boorse, 1976a] C. Boorse. Wright on functions. *Philosophical Review* 85:70-86, 1976.

[Boorse, 1976b] C. Boorse. What a theory of mental health should be. *Journal for the Theory of Social Behaviour* 6:61-84, 1976.

[Boorse, 1977] C. Boorse. Health as a theoretical concept. *Philosophy of Science* 44:542-573, 1977.

[Boorse, 1987] C. Boorse. Concepts of health. In D. VanDeVeer and T. Regan, ed., *Health Care Ethics: An Introduction* (Philadelphia, PA: Temple University Press), 359-393, 1987.

[Boorse, 1997] C. Boorse. A rebuttal on health. In J.M. Humber and R.F. Almeder, ed., *What is Disease?* (Totowa, NJ: Humana Press), 1-134, 1997.

[Boorse, 2002] C. Boorse. A rebuttal on functions. In A. Ariew, R. Cummins, and M. Perlman, ed., *Functions: New Essays in the Philosophy of Psychology and Biology* (NY: Oxford), 63-112, 2002.

[Boorse, 2010] C. Boorse. Disability and medical theory. In D. C. Ralston and J. Ho (eds.), *Philosophical Reflections on Disability.* Dordrecht: Springer, pp. 55-88, 2010.

[Brenner, 1973] C. Brenner. *An Elementary Textbook of Psychoanalysis.* Garden City, NY: Anchor, 1973.

[Broesterhuizen, 2008] M. Broesterhuizen. Worlds of difference: an ethical analysis of choices in the field of deafness. *Ethical Perspectives: Journal of the European Ethics Network* 15:103-31, 2008.

[Brown, 1977] R. Brown. Physical illness and mental health. *Philosophy and Public Affairs* 7:17-38, 1977.

[Brown, 1985] W. M. Brown. On defining 'disease'. *Journal of Medicine and Philosophy* 10:311-28, 1985.

[Buller, 2005] D. J. Buller. *Adapting Minds.* Cambridge, MA: MIT Press, 2005.

[Buss, 2005] D. M. Buss, ed. *The Handbook of Evolutionary Psychology.* Hoboken, NJ: John Wiley & Sons, 2005.

[Canguilhem, 1966/1978] G. Canguilhem (trans. C.R. Fawcett 1978). *On the Normal and the Pathological.* Dordrecht: Reidel, 1978.

[Caplan et al., 1981] A. L. Caplan, H.T. Engelhardt, Jr., and J.J. McCartney, eds. *Concepts of Health and Disease: Interdisciplinary Perspectives.* Reading, MA: Addison-Wesley, 1981.

[Caplan et al., 2004] A. L. Caplan, J.J. McCartney, and D.A. Sisti, eds. *Health, Disease, and Illness.* Washington, DC: Georgetown University Press, 2004.

[Clouser et al., 1981] K. D. Clouser, C.M. Culver, and B. Gert. Malady: a new treatment of disease. *The Hastings Center Report* 11:29-37, 1981.

[Clouser et al., 1997] K. D. Clouser, C.M. Culver, and B. Gert. Malady. In J.M. Humber and R.F. Almeder, ed., *What is Disease?* (Totowa, NJ: Humana Press), 175-217, 1997.

[Comfort, 1967] A. Comfort. *The Anxiety Makers.* London: Nelson, 1967.

[Cooper, 2005] R. Cooper. *Classifying Madness.* Dordrecht: Springer, 2005.

[Cooper, 2007] R. Cooper. *Psychiatry and Philosophy of Science.* Montreal: McGill-Queen's University Press, 2007.

[Culver and Gert, 1982] C. M. Culver and B. Gert. *Philosophy in Medicine: Conceptual and Ethical Issues in Medicine and Psychiatry.* NY: Oxford, 1982.

[Cummins, 1975] R. Cummins. Functional analysis. *Journal of Philosophy* 72:741-65, 1975.

[Cutas, 2007] D. Cutas. Postmenopausal motherhood: immoral, illegal? A case study. *Bioethics* 21:458-63, 2007.

[Daniels, 2000] N. Daniels. Normal functioning and the treatment-enhancement distinction. *Cambridge Quarterly of Health Care Ethics* 9:309-22, 2000.

[Daniels, 2008] N. Daniels. *Just Health: Meeting Health Needs Fairly.* NY: Cambridge, 2008.

[Darby, 2005] R. Darby. *A Surgical Temptation.* Chicago, IL: University of Chicago Press, 2005.

[De Block, 2008] A. De Block. Why mental disorders are just mental dysfunctions (and nothing more): some Darwinian arguments. *Studies in History and Philosophy of Biological and Biomedical Sciences* 39:338-46, 2008.

[DeVito, 2000] S. DeVito. On the value-neutrality of the concepts of health and disease: unto the breach again. *Journal of Medicine and Philosophy* 25:539-67, 2000.

[Dubos, 1965] R. Dubos. *Man Adapting.* New Haven, CT: Yale. 1965.

[Engelhardt, 1974] H. T. Engelhardt, Jr. The disease of masturbation: values and the concept of disease. *Bulletin of the History of Medicine* 48:234-48, 1974.

[Engelhardt, 1975] H. T. Engelhardt, Jr. The concepts of health and disease. In Engelhardt and S.F. Spicker, ed., *Evaluation and Explanation in the Biomedical Sciences* (Dordrecht: Reidel), 125-141, 1975.

[Engelhardt, 1976a] H. T. Engelhardt, Jr. Human well-being and medicine: some basic value judgments in the biomedical sciences. In Engelhardt and D. Callahan, ed., *Science, Ethics and Medicine* (Hastings-on-Hudson, NY: Hastings Center), 120-39, 1976.

[Engelhardt, 1976b] H. T. Engelhardt, Jr. Ideology and etiology. *Journal of Medicine and Philosophy* 1:256-268, 1976.
[Engelhardt, 1984] H. T. Engelhardt, Jr. Clinical problems and the concept of disease. In L. Nordenfelt and B.I.B. Lindahl, ed., *Health, Disease, and Causal Explanations in Medicine* (Dordrecht: Reidel), 27-41, 1984.
[Engelhardt, 1986] H. T. Engelhardt, Jr. *The Foundations of Bioethics.* NY: Oxford, 1986.
[Feinberg, 1986] J. Feinberg. Wrongful life and the counterfactual element in harming. *Social Philosophy and Policy* 4:145-178, 1986.
[Fingarette, 1972] H. Fingarette. *The Meaning of Criminal Insanity.* Berkeley, CA: University of California, 1972.
[Fingarette, 1988] H. Fingarette. *Heavy Drinking.* Berkeley, CA: University of California, 1988.
[Fulford, 1989] K. W. M. Fulford. *Moral Theory and Medical Practice.* NY: Cambridge University Press, 1989.
[Fulford, 1999] K. W. M. Fulford. Nine variations and a coda on the theme of an evolutionary definition of dysfunction. *Journal of Abnormal Psychology* 108:412-20, 1999.
[Fulford, 2001] K. W. M. Fulford. Philosophy into practice: the case for ordinary-language philosophy. In Nordenfelt (2001), pp. 171-208, 2001.
[Fulford, 2004] K. W. M. Fulford. Facts/Values: Ten principles of value-based medicine. In J.Radden (ed.), *The Philosophy of Psychiatry: A Companion* (NY: Oxford), pp. 205-34, 2004.
[Giroux, 2009] E. Giroux. Définir objectivement la santé: une analyse critique du concept biostatistique de Boorse à partir de l'épidémiologie moderne. *Revue Philosophique de la France et de l'Etranger* 199:35-58, 2009.
[Goodwin and Guze, 1979] D. W. Goodwin and S. B. Guze. *Psychiatric Diagnosis,* 2^{nd} ed. NY: Oxford, 1979.
[Goosens, 1980] W. K. Goosens. Values, health, and medicine. *Philosophy of Science* 47:100-15, 1980.
[Grünbaum, 1984] A. Grünbaum. *The Foundations of Psychoanalysis: A Philosophical Critique.* Berkeley: University of California Press, 1984.
[Hare, 1986] R. M. Hare. Health. *Journal of Medical Ethics* 12:174-81, 1986.
[Hawthorne, 2007] S. Hawthorne. ADHD drugs: values that drive the debates and decisions. *Medicine, Health Care and Philosophy* 10:129-40, 2007.
[Hesslow, 1993] G. Hesslow. Do we need a concept of disease? *Theoretical Medicine* 14:1-14, 1993.
[Horwitz, 2002] A. V. Horwitz. *Creating Mental Illness.* Chicago: University of Chicago, 2002.
[Horwitz and Wakefield, 2007] A. V. Horwitz and J. C. Wakefield. *The Loss of Sadness.* NY: Oxford, 2007.
[Houts, 2001] A. C. Houts. Harmful dysfunction and the search for value neutrality in the definition of mental disorder: response to Wakefield, part 2. *Behaviour Research and Therapy* 39:1099-1132, 2001.
[Kahn, 1991] J. P. Kahn. Genetic harm: bitten by the body that keeps you? *Bioethics* 5:289-308, 1991.
[Kendell, 1975] R. E. Kendell. The concept of disease and its implications for psychiatry. *British Journal of Psychiatry* 127:305-315, 1975. Reprinted in Caplan, Engelhardt, and McCartney (1981), pp. 443-58.
[Kendell, 1976] R. E. Kendell. The concept of disease. *British Journal of Psychiatry* 128:508-9, 1976.
[Kingma, 2007] E. Kingma. What is it to be healthy? *Analysis* 67:128-33, 2007.
[Kitcher, 1992] P. Kitcher. *Freud's Dream.* Cambridge, MA: MIT Press, 1992.
[Klein, 1978] D. F. Klein. A proposed definition of mental illness. In Spitzer and Klein, eds. (1978), pp. 41-71, 1978.
[Kopelman, 1994] L. M. Kopelman. Normal grief: Good or bad? Health or disease? *Philosophy, Psychiatry and Psychology* 1:209-20, 1994.
[Kripke, 1980] S. A. Kripke. *Naming and Necessity.* Cambridge, MA: Harvard University Press, 1980.
[LaFave, 2003] W. R. LaFave. *Criminal Law,* 4^{th} ed. St.Paul, MN: Thomson West, 2003.
[Laing, 1967] R. Laing. *The Politics of Experience.* Harmondsworth: Penguin, 1967.

[Lilienfeld ad Marino, 1995] S. O. Lilienfeld and L. Marino. Mental disorder as a Roschian concept: a critique of Wakefield's 'harmful dysfunction' analysis. *Journal of Abnormal Psychology* 104:411-20, 1995.
[Macklin, 1973] R. Macklin. The medical model in psychoanalysis and psychiatry. *Comprehensive Psychiatry* 14:49-69, 1973.
[Malmqvist, 2006] E. Malmqvist. The notion of health and the morality of genetic intervention. *Medicine, Health Care and Philosophy* 9:181-92, 2006.
[Margolis, 1976] J. Margolis. The concept of disease. *Journal of Medicine and Philosophy* 1:238-55, 1976.
[McGuire and Troisi, 1998] M. T. McGuire and A. Troisi. *Darwinian Psychiatry.* NY: Oxford, 1998.
[Melander, 1997] P. Melander. *Analyzing Functions: An Essay on a Fundamental Notion in Biology.* Stockholm: Almqvist and Wiksell, 1997.
[Menninger, 1968] K. Menninger. *The Crime of Punishment.* NY: Viking, 1968.
[Millikan, 1984] R. G. Millikan. *Language, Thought, and Other Biological Categories.* Cambridge, MA: MIT Press, 1984.
[Millikan, 1989] R. G. Millikan. In defense of proper functions. *Philosophy of Science* 56:288-302, 1989.
[Murphy and Woolfolk, 2000a] D. Murphy and R. L. Woolfolk. The harmful dysfunction analysis of mental disorder. *Philosophy, Psychiatry and Psychology* 7:241-252, 2000.
[Murphy and Woolfolk, 2000b] D. Murphy and R. L. Woolfolk. Conceptual analysis versus scientific understanding: an assessment of Wakefield's folk psychiatry. *Philosophy, Psychiatry and Psychology* 7:271-93, 2000.
[Murphy, 2006] D. Murphy. *Psychiatry in the Scientific Image.* Cambridge, MA: MIT Press, 2006.
[Nagel, 1961] E. Nagel. *The Structure of Science.* NY: Harcourt, Brace & World, 1961.
[Neander, 1983] K. Neander. Abnormal psychobiology. Ph.D. dissertation, La Trobe University, 1983.
[Neander, 1991a] K. Neander. Functions as selected effects: the conceptual analyst's defense. *Philosophy of Science* 58:168-84, 1991.
[Neander, 1991b] K. Neander. The teleological notion of 'function'. *Australasian Journal of Philosophy* 69:454-68, 1991.
[Nesse and Williams, 1994] R. M. Nesse and G. C. Williams. *Why We Get Sick: The New Science of Darwinian Medicine.* NY: Vintage, 1994.
[Nesse, 2001] R. M. Nesse. On the difficulty of defining disease: a Darwinian perspective. *Medicine, Health Care and Philosophy* 4:37-46, 2001.
[Nissen, 1997] L. Nissen. *Teleological Language in the Life Sciences.* Lanham, MD: Rowman and Littlefield, 1997.
[Nordby, 2006] H. Nordby. The analytic-synthetic distinction and conceptual analyses of basic health concepts. *Medicine, Health Care and Philosophy* 9:169-80, 2006.
[Nordenfelt, 1987/1995] L. Nordenfelt. *On the Nature of Health: An Action-Theoretic Approach.* Dordrecht: Reidel, 1987. Revised edition Dordrecht: Kluwer, 1995.
[Nordenfelt, 2000] L. Nordenfelt. *Action, Ability, and Health: Essays in the Philosophy of Action and Welfare.* Dordrecht: Kluwer, 2000.
[Nordenfelt, 2001] L. Nordenfelt. *Health, Science, and Ordinary Language.* NY: Rodopi, 2001.
[Nordenfelt, 2003] L. Nordenfelt. On the evolutionary concept of health: health as natural function. In L. Nordenfelt and P.-E. Liss, eds. *Dimensions of Health and Health Promotion* (NY: Rodopi), pp. 37-54, 2003.
[Nordenfelt, 2004] L. Nordenfelt. On holism and normality. *Medicine, Health Care and Philosophy* 7:149-52, 2004.
[Nordenfelt, 2006] L. Nordenfelt. *Animal and Human Health and Welfare: A Comparative Philosophical Analysis.* Wallingford: CABI, 2006.
[Nordenfelt, 2007a] L. Nordenfelt. Holistic theories of health as applicable to non-human living beings. In H. Kincaid and J. McKitrick, eds., *Establishing Medical Reality* (NY: Springer), 2007.
[Nordenfelt, 2007b] L. Nordenfelt. *Rationality and Compulsion.* NY: Oxford, 2007.
[Nordenfelt, 2007c] L. Nordenfelt. Establishing a middle-range position in the theory of health: a reply to my critics. *Medicine, Health Care and Philosophy* 10:29-32, 2007.
[Pickering, 2006] N. Pickering. *The Metaphor of Mental Illness.* NY: Oxford, 2006.

[Pörn, 1984] I. Pörn. An equilibrium model of health. In L. Nordenfelt and B.I.B. Lindahl, eds., *Health, Disease, and Causal Explanations in Medicine* (Dordrecht: Reidel), pp. 3-9, 1984.

[Pörn, 1993] I. Pörn. Health and adaptedness. *Theoretical Medicine* 14:295-303, 1993.

[Prior, 1985] E. W. Prior. What is wrong with etiological accounts of biological function? *Pacific Philosophical Quarterly* 66:310-28, 1985.

[Reznek, 1987] L. Reznek. *The Nature of Disease.* London: Routledge and Kegan Paul, 1987.

[Reznek, 1991] L. Reznek. *The Philosophical Defence of Psychiatry.* London: Routledge, 1991.

[Reznek, 1997] L. Reznek. *Evil or Ill?* London: Routledge, 1997.

[Richman and Budson, 2000] K. A. Richman and A. E. Budson. Health of organisms and health of persons: an embedded instrumentalist approach. *Theoretical Medicine* 21:339-54, 2000.

[Richman, 2004] K. A. Richman. *Ethics and the Metaphysics of Medicine.* Cambridge, MA: MIT, 2004.

[Ross, 1979] A. Ross. Sygdomsbegrebet. *Bibliotek for Laeger* 171:111-129, 1979.

[Ross, 1980] A. Ross. Det psykopathologiska sygdomsbegreb. *Bibliotek for Laeger*, 1980.

[Ryle, 1947] J. A. Ryle. The meaning of normal. *Lancet* 252:1-5, 1947.

[Sadler *et al.*, 1994] J. Z. Sadler, O.P. Wiggins, and M.A. Schwartz, eds. *Philosophical Perspectives on Psychiatric Diagnostic Classification.* Baltimore: Johns Hopkins, 1994.

[Sadler and Agich, 1995] J. Z. Sadler and G.J. Agich. Diseases, functions, values, and psychiatric classification. *Philosophy, Psychiatry, and Psychology* 2:219-31, 1995.

[Sadler, 2002] J. Z. Sadler, ed. *Descriptions and Prescriptions: Values, Mental Disorders, and the DSMs.* Baltimore: Johns Hopkins, 2002.

[Sadler, 2005] J. Z. Sadler. *Values and Psychiatric Diagnosis.* NY: Oxford, 2005.

[Scadding, 1967] J. G. Scadding. Diagnosis: the clinician and the computer. *Lancet* 2:877-82, 1967.

[Scadding, 1988] J. G. Scadding. Health and disease: what can medicine do for philosophy? *Journal of Medical Ethics* 14:118-24, 1988.

[Scadding, 1990] J. G. Scadding. The semantic problem of psychiatry. *Psychological Medicine* 20:243-48, 1990.

[Schaffner, 1993] K. F. Schaffner. *Discovery and Explanation in Biology and Medicine.* Chicago: University of Chicago Press, 1993.

[Schramme, 2000] T. Schramme. *Patienten und Personen: Zum Begriff der psychischen Krankheit.* Frankfurt: Fischer, 2000.

[Schramme, 2007] T. Schramme. A qualified defence of a naturalist theory of health. *Medicine, Health Care and Philosophy* 10:11-17, 2007.

[Schwartz, 2007] P. Schwartz. Defining dysfunction: natural selection, design, and drawing a line. *Philosophy of Science* 74:364-85, 2007.

[Schwartz, 2008] P. Schwartz. Risk and disease. *Perspectives in Biology and Medicine* 51:320-34, 2008.

[Sedgwick, 1973] P. Sedgwick. Illness — mental and otherwise. *Hastings Center Studies* 1:19-40, 1973.

[Shaw, 2008] D. Shaw. Deaf by design: disability and impartiality. *Bioethics* 22:407-13, 2008.

[Simon, 2007] J. Simon. Beyond naturalism and normativism: reconceiving the 'disease' debate. *Philosophical Papers* 36:343-70, 2007.

[Singer, 1994] P. Singer. *Rethinking Life and Death.* NY: St. Martin's Griffin, 1994.

[Sober, 1980] E. Sober. Evolution, population thinking, and essentialism. *Philosophy of Science* 47:350-83, 1980.

[Sommerhoff, 1950] G. Sommerhoff. *Analytical Biology.* London: Oxford University Press, 1950.

[Sommerhoff, 1969] G. Sommerhoff. The abstract characteristics of living organisms. In F.E. Emery, ed., *Systems Thinking* (Harmondsworth: Penguin), pp. 147-202, 1969.

[Sparrow, 2005] R. Sparrow. Defending deaf culture: the case of cochlear implants. *Journal of Political Philosophy* 13:135-52, 2005.

[Spitzer and Klein, 1978] R. L. Spitzer and D. F. Klein, eds. *Critical Issues in Psychiatric Diagnosis.* NY: Raven Press, 1978.

[Spitzer and Endicott, 1978] R. L. Spitzer and J. Endicott. Medical and mental disorder: proposed definition and criteria. In Spitzer and Klein, eds. (1978), pp. 15-39.

[Spitzer and Williams, 1982] R. L. Spitzer and J.B.W. Williams. The definition and diagnosis of mental disorder. In W.R. Gove, ed., *Deviance and Mental Illness* (Beverly Hills, CA: Sage), pp. 15-31, 1982.

[Stempsey, 2000] W. E. Stempsey. A pathological view of disease. *Theoretical Medicine* 21:321-30, 2000.

[Stevens and Price, 1996] A. Stevens and J. Price. *Evolutionary Psychiatry: A New Beginning.* London: Routledge, 1996.

[Svensson, 1995] T. Svensson. *On the Notion of Mental Illness.* Aldershot: Avebury. 1995.

[Szasz, 1960] T. S. Szasz. The myth of mental illness. *American Psychologist* 15:113-18, 1960.

[Szasz, 1961] T. S. Szasz. *The Myth of Mental Illness.* NY: Hoeber–Harper, 1961.

[Szasz, 1970] T. S. Szasz. *Ideology and Insanity.* Garden City, NY: Anchor, 1970.

[Szasz, 1987] T. S. Szasz. *Insanity.* NY: John Wiley and Sons, 1987.

[Tauer, 1995] C. A. Tauer. Human growth hormone: a case study in treatment priorities. *The Hastings Center Report* 25:18-20, 1995.

[Taylor, 1971] F. K. Taylor. A logical analysis of the medico-psychological concept of disease. *Psychological Medicine* 1:356-64, 1971.

[Tengland, 2001] P.-A. Tengland. *Mental Health: A Philosophical Analysis.* Dordrecht: Kluwer, 2001.

[Topley, 1970] M. Topley. Chinese traditional ideas and the treatment of disease: two examples from Hong Kong. *Man* 5:421-37, 1970.

[Toulmin, 1975] S. Toulmin. Concepts of function and mechanism in medicine and medical science. In H.T. Engelhardt, Jr., and S.F. Spicker, eds., *Evaluation and Explanation in the Biomedical Sciences* (Dordrecht: Reidel), 1975.

[Vácha, 1985] J. Vácha. German constitutional doctrine in the 1920s and 1930s and pitfalls of the contemporary conception of normality in biology and medicine. *Journal of Medicine and Philosophy* 10:339-67, 1985.

[Vácha, 2004] J. Vácha. *Health, Disease, Normality.* Brno: Faculty of Medicine, Masaryk University, 2004.

[van der Steen and Thung, 1988] W. J. van der Steen and P.J. Thung. *Faces of Medicine.* Dordrecht: Kluwer, 1988.

[von Wright, 1963] G. H. von Wright. *The Varieties of Goodness.* London: Routledge and Kegan Paul, 1963.

[Wachbroit, 1994] R. Wachbroit. Normality as a biological concept. *Philosophy of Science* 61:579-91, 1994.

[Waelder, 1960] R. Waelder. *Basic Theory of Psychoanalysis.* NY: International Universities Press, 1960.

[Wakefield, 1992a] J. C. Wakefield. The concept of mental disorder: on the boundary between biological facts and social values. *American Psychologist* 47:373-388, 1992.

[Wakefield, 1992b] J. C. Wakefield. Disorder as harmful dysfunction: a conceptual critique of DSM-III-R's definition of mental disorder. *Psychological Review* 99:232-247, 1992.

[Wakefield, 1993] J. C. Wakefield. Limits of operationalization: a critique of Spitzer and Endicott's (1978) proposed operational criteria for mental disorder. *Journal of Abnormal Psychology* 102:160-172, 1993.

[Wakefield, 1995] J. C. Wakefield. Dysfunction as a value-free concept: a reply to Sadler and Agich. *Philosophy, Psychiatry and Psychology* 2:233-46, 1995.

[Wakefield, 1997a] J. C. Wakefield. Diagnosing *DSM-IV*, Part 1: *DSM-IV* and the concept of mental disorder. *Behaviour Research and Therapy* 35:633-49, 1997.

[Wakefield, 1997b] J. C. Wakefield. Diagnosing *DSM-IV*, Part 2: Eysenck (1986) and the essentialist fallacy. *Behaviour Research and Therapy* 35:651-665, 1997.

[Wakefield, 1999a] J. C. Wakefield. Evolutionary versus prototype analyses of the concept of disorder. *Journal of Abnormal Psychology* 108:374-399, 1999.

[Wakefield, 1999b] J. C. Wakefield. Mental disorder as a black box essentialist concept. *Journal of Abnormal Psychology* 108:465-472, 1999.

[Wakefield, 2000a] J. C. Wakefield. Aristotle as sociobiologist: The 'function of a human being' argument, black box essentialism, and the concept of mental disorder. *Philosophy, Psychiatry, and Psychology* 7:17-44, 2000.

[Wakefield, 2000b] J. C. Wakefield. Spandrels, vestigial organs, and such: reply to Murphy and Woolfolk's 'The harmful dysfunction analysis of mental disorder'. *Philosophy, Psychiatry, and Psychology* 7:253-269, 2000.

[Wakefield, 2001] J. C. Wakefield. Evolutionary history versus current causal role in the definition of disorder: reply to McNally. *Behaviour Research and Therapy* 39:347-366, 2001.

[Wakefield, 2003] J. C. Wakefield. Dysfunction as a factual component of disorder. *Behaviour Research and Therapy* 41:969-90, 2003.

[Wardle and Wood, 1982] L. D. Wardle and M.A.Q. Wood. *A Lawyer Looks at Abortion.* Provo, UT: Brigham Young University Press, 1982.

[Whitbeck, 1978] C. Whitbeck. Four basic concepts of medical science. In P.D. Asquith and I. Hacking, eds., *PSA 1978* (East Lansing, MI: Philosophy of Science Association), pp. 210–222, 1987.

[Whitbeck, 1981] C. Whitbeck. A theory of health. In Caplan, Engelhardt, and McCartney, eds. (1981), pp. 611-26, 1981.

[White, 1993] G. B. White. Human growth hormone: the dilemma of expanded use in children. *Kennedy Institute of Ethics Journal* 3:401-9, 1993.

[Woodbridge and Fulford, 2004] K. Woodbridge and K.W.M. Fulford. *Whose Values? A Workbook for Values-based Practice in Mental Health Care.* London: Sainsbury Centre for Mental Health, 2004.

[Worhall and Worhall, 2001] J. Worhall and J. Worhall. Defining disease: much ado about nothing? *Analecta Husserliana* 72:33-55, 2001.

[World Health Organization, 1994] World Health Organization. *International Statistical Classification of Diseases and Related Health Problems.* Tenth revision [*ICD-10*]. Geneva: WHO, 1994.

[Wouters, 2005] A. Wouters. The function debate in philosophy. *Acta Biotheoretica* 53:123-51, 2005.

[Wright, 1973] L. Wright. Functions. *Philosophical Review* 82:139-68, 1973.

[Wulff *et al.*, 1986] H. R. Wulff, S.A. Pedersen, and R. Rosenberg. *Philosophy of Medicine: An Introduction.* Oxford: Blackwell Scientific Publications, 1986.

[Zohar, 1991] N. J. Zohar. Prospects for 'genetic therapy': can a person benefit from being altered? *Bioethics* 5:275-288, 1991.

MEDICAL ONTOLOGY

Jeremy R. Simon

A prime desideratum in any field of philosophy is a clear understanding of the entities under consideration. (I use "entity" in the most general sense. Entities may be real, constructed, mind-dependent or even non-existent, or at least fictional.) In philosophy of medicine, this calls for an understanding of the nature of individual diseases. By "disease" here, I mean, very roughly, the diagnoses physicians apply to their patients: melanoma, tuberculosis, cystic fibrosis, etc. Posing the question using the standard realist/anti-realist dichotomy, are these real entities or not, and, whether real or not, what exactly are they?

We shall return soon to these questions and spend the bulk of this chapter considering the various responses to them. Before we do this, however, we must spend some time clarifying two ambiguous usages in the last paragraph. First, what do we mean by "disease"? What is the relationship, if any, between this topic and the question of distinguishing disease from health? Second, we should be clear on what we mean by realism and anti-realism, which are hardly univocal terms in philosophy.

1 PRELIMINARIES

1.1 Disease, Diseases, or Conditions?

It might appear that before we can address the primary question of this chapter we must first settle the difficult problem of distinguishing between disease and health. (See chapter by Christopher Boorse in this volume for a discussion of this issue.) After all, how can we consider the nature of diseases without being able to properly identify them, and how can we do that without knowing what "disease" means — that is, without having an account that picks all and only diseases? Fortunately, this appearance is deceptive, and we can indeed consider the nature of individual diseases without first knowing how to distinguish disease and health. Instead of beginning with diseases as such, we can begin simply with those entities actually of interest to medicine, i.e., the various diagnoses that are made. Our question will then be, to what do these diagnosis names refer and what is the nature of these referents? When a doctor says that a patient has X, where X is lung cancer or cystic fibrosis, etc., what is the nature of that X? The word "disease" does not enter in at all.

Even once we clarify that we can talk about diseases without a clear sense of how disease differs from health, using "disease" to refer to the entities we are discussing

Handbook of the Philosophy of Science. Volume 16: Philosophy of Medicine.
Volume editor: Fred Gifford. General editors: Dov M. Gabbay, Paul Thagard and John Woods.

in this chapter may still be problematic. First, there are many conditions whose ontological status we might be interested in, such as broken bones (or, better, particular types of broken bones, such as Laforte II or Colles' fractures), that we would not ordinarily think of as diseases. We should not preemptively exclude such diagnostic entities from our analysis. Second, use of "disease" would obscure the fact that the entities we are interested in here need not necessarily be diseases under *any* account of the distinction between disease and health or even be of interest to therapeutic medicine. Therefore, a more neutral term might be desirable to denote the entities in question here — those entities which are either themselves disease entities or have the same ontological nature as disease entities. One term that might do is "medical conditions."

On the other hand, virtually all of the writers who have discussed the ontology of what we might now call "medical conditions" have used "disease" to denote the entities they are considering. Changing the terminology makes it difficult to enter into dialogue with these writers. Therefore, despite the above complications, I too will use "disease" to denote the subjects of our inquiry. I ask the reader to keep in mind, however, the various caveats that must implicitly be raised each time I use this term.

1.2 Realism and Anti-realism

We are now ready to shift to our primary focus. But before addressing the ontology of diseases in particular, with its emphasis on realism and anti-realism, we should make clear how we will understand these terms, which can be used in so many different philosophical contexts.

When people feel ill, they go to the doctor for a diagnosis or diagnoses. We can describe this interaction as follows. After hearing about what troubles the patient, the doctor determines which of the patient's particular complaints can be joined together into a single diagnosis, or disease token (perhaps identifying more than one such token, if not all of the patients complaints seem to be related to the same problem) and then identifies the type or types to which the patient's disease token or tokens belong. In this setting there are then two questions on which realists and anti-realists about diseases disagree. First, is there a correct answer, independent of any classificatory decisions by the physicians or others, as to which of a patient's complaints, findings, etc., belong to an individual token? According to the realist, if the doctor is correct when she says that her patient's cough and abdominal pain are part of the same disease (token), then there is some underlying physical entity that unites these symptoms. The anti-realist, however, believes that even at this level the doctor has made a subjective, perhaps pragmatic, choice.

The second question that distinguishes medical realists from anti-realists is, are the types into which we organize disease tokens real? Do they represent features of the underlying structure of the world, essentially, natural kinds, or do we arrange tokens and choose means of identifying the types to which they belong based on various subjective criteria? As a slogan, we can say that the realist believes

that diseases are discovered, the anti-realist, that they are invented. To be more concrete, for our purposes, the realist about diseases answers yes to both of the above questions and the anti-realist answers no to both.[1] This dichotomy, of course, leaves open space in the middle. It is possible, at least in principle, to have a mixed theory, realist about disease tokens but not about types. The relevant disease token may be given to us by the outside world without there necessarily being a real type to which it belongs. This would be analogous to acknowledging the reality of individual organisms, that is, saying that individual creatures can be distinguished from their surroundings in a way which we would call realist, and not based on pragmatic or other anti-realist criteria, but denying that any collection of these real individuals form real species. (It is much more difficult to see how one could be a realist about types without being one also about tokens. One would have to hold that the tokens do not exist until we create them, but that, once we do so, Mother Nature swings into action and creates objective types to cover these tokens.) For most of this chapter, we will restrict the term realist to those who are realists about both types and tokens and anti-realist to those who are anti-realist about both. Mixed theories will be considered separately, after we have understood realism and anti-realism as defined here.

The preceding two paragraphs provide only the most basic sketch of what it means to be a realist, anti-realist, or mixed theorist about disease. The remainder of this chapter will be devoted to elaborating and evaluating these positions. However, before proceeding to the body of our analysis, we must note some questions that we will *not* discuss in this chapter. First, we will not engage the epistemological problems of metaphysical realism as we have defined it. Even assuming that disease types and/or tokens are objective features of the real world, and even assuming that we grant that we can have epistemic access to the external world in general, can we have the epistemic access to diseases necessary to justify the statements we make about them, and if so, how? This is certainly an important question for metaphysical realists about diseases, for, as we will discuss in the next section, diseases differ metaphysically in significant ways from simple objects even for realists about both. However, answering this question requires a detailed consideration of medical epistemology and methodology, an inquiry which is beyond our scope here. For our present purposes, we will simply grant the realist that if there are real diseases we can have access to them.

Second, what follows is written with somatic medicine, as opposed to psychiatry, in mind. This is not because the analysis is necessarily inapplicable to psychiatry, but because there are many relevant issues in the philosophy of psychiatry that are still unsettled. At some point, we may be able to see whether our current analysis

[1]It will not be necessary, however, for a realist to claim that disease tokens are material, causally efficacious, entities that impinge on bodies, which are then said to "have" the disease in question. There is a sense in which such an account of diseases might be called realist, and any other, anti-realist. We shall consider this question briefly when we examine realist accounts of diseases, as there are some such accounts which are best understood in this way, but ultimately, we will conclude that there is no serious question in this regard. Whatever a disease is, you cannot capture it in a box and display it.

applies to psychiatric diseases as well. If it can, then no further work will need to be done. If not, it will be clear that psychiatric diseases are not ontologically similar to somatic diseases, and require a chapter (or book) of their own.

2 REALISM

We shall begin our consideration of medical ontology with realist accounts of diseases. First, we will enumerate various positions and identify their defenders. This will be followed by a consideration of arguments for and against these accounts. Of course, arguments for realism are often also arguments against anti-realism, and vice versa, so that a given argument is often relevant to our discussion of both positions, albeit for the prosecution in one place and the defense in the other. To avoid needless redundancy, I have distributed the material as follows. Any point that can be fully understood within the context of the discussion of realism I have placed in this section, with a reference to it later at the appropriate place in the discussion of anti-realism. Any point that could be best understood only after considering some issues specific to anti-realism I have deferred to that section.

2.1 The Positions

A survey of various realist theories that have been proposed is complicated by two factors. First, even those who explicitly identify themselves as realists about diseases often fail to specify what they mean by "realist," although sometimes a partial explication is implicit in their writings. Second, we have ourselves combined two questions — those of type and token realism — that are not necessarily dealt with by any single author. This failure to deal with both issues is usually due to a lack of clarity, and not an excess of focus, on the part of these authors. However, this lack of clarity can make it difficult to unambiguously identify most writers as realists in our sense of the term (i.e., about both types and tokens). Therefore, most of the positions below must be seen as reconstructions of possible positions suggested by the literature, rather than as definitively attributable to specific authors. I will nonetheless indicate which authors appear to be advocating, or at least suggesting, the various positions.

The best place to begin our discussion is with realist accounts of disease tokens. A realist about disease tokens holds that, in at least some people, there are diseases present and these individual diseases are real parts of the external world. For the moment, this statement will not be at issue. But, granting that these individuals exist, the question remains, what is their nature? What do disease tokens consist of for the realist?

Probably the most venerable form of disease token realism might be called concrete realism. For the concrete realist a disease is a (non-abstract) entity that can exist separate from a host. When a host encounters and acquires such an entity, he then has the disease in question. Thus, when we say "Charlie has a cold" we mean this in the most concrete sense of the word "has," just as we do

when we say "Charlie has a dog." The disease is entirely separate from the patient and not even partially a state the patient enters into. The earliest examples of this type of account would probably be ancient theories that diseases were evil spirits invading the body. More recently, early adherents to the germ theory of disease, who thought that one had a disease if and only if one was infected with the relevant bacterium, may well have held such views. More recently still, it seems safe to say, this position has been discarded. It requires the postulation of ghost-like disease entities, separate from the causes commonly identified for diseases. While there is no proof that such ghosts do not exist, their material and causal natures are so mysterious as to take us back to the days of evil spirits. Nothing in our current scientific worldview would lead us to believe that such entities exist.

Leaving such ontologically extravagant accounts of disease tokens aside, then, we can examine instead accounts of disease tokens which, while granting diseases reality, do not grant them independence from the body of the patient. In giving such an account of the nature of disease tokens, realists seek not to grab hold of some mysterious entity that explains and indeed constitutes the presence of a disease, but rather to identify those features of a patient in which a disease consists. Such accounts could allow us to admit diseases into our ontology without expanding it in a fundamental way. There are, as far as I can tell, six variations on this position. The first identifies a disease with a bundle of signs and symptoms; to have a disease is to have the relevant signs and symptoms. The second identifies a disease with the underlying physiological state of the body in question. The third identifies a disease with a process the body is undergoing. Finally, these three can be turned into six by creating compound positions by saying that a disease is a bundle of signs and symptoms, a state or a process *plus* a cause, that is, by requiring that the given signs and symptoms, state or process be brought about by a specific cause.

1) Concrete realism — diseases are entities wholly separable from the person bearing them.

2) Diseases as a bundle of signs and symptoms.

3) Diseases as a bundle of signs and symptoms plus a cause.

4) Diseases as an underlying physical state of the body in question.

5) Diseases as an underlying physical state of the body in question plus a cause.

6) Diseases as a bodily process.

7) Diseases as a bodily process plus a cause.

Figure 1. The varieties of disease token realism

We noted earlier the difficulty in interpreting realist writers — their failure to clearly indicate what they mean by realism. However, citations from a few authors who at least appear to hold these views may help flesh them out a bit.

Keeping this in mind, we can examine examples of at least the three primary positions we identified. Let us start with the view that signs and symptoms play the essential role, to which L. J. Rather appears to adhere. Rather's disease-entity "is a discrete, orderly pattern of [clinical] events" [1959, p. 366]. In explicating the type of events he means he quotes at length Sydenham's classic description of gout, a description that consists for the most part of signs and symptoms, along with a few epidemiological observations, and summarizes Sydenham's description as containing "everything which ... has] any bearing on the [clinical] problem" [p. 367]. In sum, what we have been calling a signs-and-symptoms view identifies diseases with a constellation of observations which can be made by and about the patient — complaints the patient makes, such as pain, nausea, etc., and observations the physician makes, such as swelling, rashes, pulse, temperature, etc. These are the observations ordinarily made in the clinical course of events, at least at the current time, and thus the signs-and-symptoms view ties diseases to the notice we take of them. For example, the entity (untreated)-type-1-diabetes might be the combination of low insulin production, elevated blood glucose, excessive thirst and urination and perhaps generalized fatigue.[2]

The next class of positions, the disease-as-state view, is exemplified by Rudolph Virchow, who wrote that "the disease entity is an altered body part, or ... an altered cell or aggregate of cells, whether tissue or organ" [1895/1958, p. 192]. The disease, for Virchow, does not consist in a particular set of observable manifestations or in the functional state they represent. Rather, it is the underlying disordered state of the body. The disease is whatever has altered, or gone wrong. Ultimately, this is to be assessed at the lowest possible level, which, for Virchow, was the cell. More generally, the disease-as-state view holds that the underlying state of the body is the disease, however it is manifested and however we measure it. The description is secondary; what matters is the state of the patient, which, given our current understanding of the world, can only truly be given at

[2]Note that although this example refers to a disease type, we are here concerned with disease tokens. At this point in the discussion, we have taken no position on the nature of the types into which these diseases are grouped, that is, whether they are real or not. The only realist assertions we are now considering is that the disease tokens of individual patients are real parts of our ontology. It is, however, extremely difficult to talk about a disease token that has no name, i.e., type. Therefore, here, and for the rest of this section dealing with disease tokens, reference to particular disease types in examples should be understood only as a way to more easily identify a particular token which is ordinarily considered to belong to the named type, without making any assertion about the nature of the type itself. In other words, the last sentence of the text may be read as shorthand for: "For example, the disease of a hypothetical patient (one who, were he to be seen by a contemporary physician would probably be diagnosed) with (untreated)-type-1-diabetes, might comprise the combination of low insulin production, elevated blood glucose, excessive thirst and urination and perhaps generalized fatigue," and *mutatis mutandis* elsewhere. The reference to type 1 diabetes here only serves to focus the reader on certain common knowledge to make the example more readily understandable. It is not necessary, however, for stating the position or giving an instance of it.

the elementary particle level. Thus, for the state view, one way of describing the entity (untreated)-type-1-diabetes is to refer to altered structural or biochemical features of the insulin producing parts of the pancreas and the overall state of glucose metabolism in the patient. However, this description is at best a partial substitute for the true description of the disease, which would describe the changes in the patient at the lowest level without reference to higher levels of organization, which may or may not truly reflect the underlying states; whatever has changed in the patient is the disease.

The final view, disease-as-process, is proposed by Whitbeck [1977]. She explicitly refuses to identify a disease either with its cause or with a static state of the individual. Diseases, unlike abnormal conditions (hare-lip is her example) are characterized, at least in part, by following a specific course. Therefore, to ignore the temporal aspect of a disease is to mischaracterize it. Rather, we must acknowledge disease as consisting of a *sequence* of signs and symptoms and of pathological changes. Thus, for her, type 1 diabetes is not merely decreased insulin production, increased thirst, and structural and biochemical alteration of the pancreas. Rather, it essentially includes diachronic features such as the process leading up to the change in pancreatic insulin production as well as the effects the change in glucose metabolism has on the patient, such as, perhaps, blindness and vascular disease. It is not just the state of the patients, but their course, that matters.

In addition to deciding which of these three views, diseases as signs-and-symptoms, as states or as processes, to accept, realists about disease tokens have one more decision to make. Any of the three positions sketched above can be modified by adding the specification of a particular cause to the account of diseases. Thus, to a signs-and-symptoms account we would add to our account of the nature of the disease in question the fact that these signs and symptoms were brought about by a particular cause. For example, to move away from diabetes for the moment, sickle-cell anemia may be anemia and painful crises caused by a particular genetic mutation.

We have seen now seven total positions among which a realist about diseases may choose in describing the nature of tokens of these real diseases. To be a realist in the full sense we identified, however, it is not enough to choose one of these accounts of disease tokens and maintain that they describe the nature of real tokens. One must further hold that that in addition to real tokens, there are also real disease kinds. That is, the external world imposes a correct sorting of disease tokens into kinds, although we will say no more here about what those kinds consist in. Any one of a variety of realist accounts of natural kinds could potentially serve, especially essentialist ones of the Kripke-Putnam variety [Kripke, 1980; Putnam, 1975], or even of the sort championed by Ellis [2001; 2002].

2.2 Arguments for Realism

Now that we understand within a range of options what it is to be a disease realist, we can examine various arguments for and against these positions. In

general, arguments for realism tend to run downhill from types (higher-level) to tokens (lower-level), but not all the way. That is, they generally make a case for the reality of disease types, thus implying the reality of the tokens. They do not, however, provide differential support for any particular account of tokens.

The first argument, with which any account of realist arguments must begin, is a version of Putnam's "no-miracles" argument [1979, originally due to Smart [1963]. Temkin [1961, pp. 646-7] appears to have something like this in mind. The general form of this argument is that unless the terms of scientific theories refer, and the theories themselves are at least approximately true, there is no explanation for the fact that our theories succeed in describing the world we see around us. In the absence of realism, we would have to consider it a miracle that our scientific theories accurately describe and predict what we see.

In the case of medicine, this might be explicated as follows. Medicine is clearly successful, at least in the twenty-first century, in treating certain diseases and in developing therapies for others that we were previously unable to treat. If diseases are real entities, we can easily explain this success. By identifying a real disease, we identify an entity whose features are fixed by nature and therefore repeat each time it is instantiated. We can then study these features, learn how they fit into the causal structure of the world, and thus predictably manipulate them in research, diagnosis and treatment. The anti-realist, it seems, can tell no such story. If the types of diseases we identify are not given to us by the natural world but rather are selected by us, e.g., to meet certain pragmatic goals, why should we expect that they would obey any set of predictable rules that would allow us to reliably control them? In the absence of an underlying structure tying the various tokens together into a type, what could explain the predictable response to stimuli by the various tokens? Another way of understanding the realist's claim is as follows. If our disease terms do not, for the most part at least, successfully refer to natural law-abiding kinds, how can a practice based on the use of these terms allow us to make accurate predictions of the type that underlie our successful medical research, diagnoses and therapies? What else other than these kinds could explain our success?

Related to the no-miracles argument are appeals to inference to the best explanation (IBE), such as that of Reznek [1987]. Reznek states that "possession of a distinct cluster of properties is *evidence* that objects [such as diseases] belong to a natural kind — most objects that share a significant cluster of properties will also be members of the same natural kind" [p. 175, emphasis in the original]. However, although related to no-miracles arguments, IBE is much easier to dismiss as an argument for realism. For, it is not truly an argument for realism so much as a statement of realist methodology. The appropriateness of IBE is precisely what is at stake between realists and anti-realists generally. What the realist sees as onto-logical conclusions based on evidence, the anti-realist sees as merely ungrounded metaphysical speculation. The fact that an explanation is *good*, or even the best, does not make it *true* for the anti-realist; more direct evidence is needed for that.

Returning to a consideration of Temkin's work, we find that he brings a second argument for the existence of real disease types as well. He notes that many who work at combating specific diseases never see a patient, and do not think in terms of individuals. For example, Pasteur, who developed a vaccine to protect against rabies, never saw a patient with rabies prior to the vaccine's first, successful, use. Pasteur was a chemist, working in a laboratory. How could he have created a treatment for sick individuals (as opposed to a particular disease), as Temkin's anti-realist claims he did, without ever seeing a sick individual or knowing anything about them? Rather, argues Temkin, there must be a disease type, separable, at least in some sense, from the patient, which Pasteur could study in the laboratory without any patients being present.

Although related to the no-miracles argument, this version of the argument seems to suffer from some unique weaknesses. Pasteur may have worked in a lab, but he did not work in a social vacuum. The anti-realist could well argue that even though Pasteur himself did not encounter or consider any patients in his studies, the notion of rabies he used was not arrived at in complete isolation from, and with no relationship to, individual patients. Rather, it developed out of others' experience with many particular patients and then entered general medical use, whence Pasteur clearly had access to it. Thus, the anti-realist may claim that Pasteur's rabies concept was ultimately, if indirectly, derived from actual patient contact, even if he had none. His success against rabies could just as well be described as success regarding a pragmatic grouping of patients as it could be described as success regarding a real grouping. Furthermore, in claiming that the ability to study a disease separate from any patient argues for realism, Temkin seems to be relying on a concrete realist account of disease ontology, whereby the disease can be physically separated from the patient. We noted above many problems with this view. Finally, we have the much less abstract objection that although Pasteur may not have treated humans, he certainly had access to sick animals. Placing the burden of the argument on his separation from human patients assumes that human and animal diseases, at least in cases like rabies, do not belong to the same type. Although this may be true, the claim certainly needs further argument.

Turning again from Temkin to Reznek, we will find another argument from medical practice. Reznek believes that our criteria for differentiating diseases show that it is analytically true that diseases form natural kinds, and he cites the case of gout vs. pseudogout as an example [p. 178]. Both gout and pseudogout are inflammatory reactions to the deposition of microscopic crystals in joints. Until recently, all patients with the symptoms characteristic of these depositions (particularly, joint pain, tenderness and swelling) were considered to have gout. It was then discovered that in some cases the crystals were made of urate and in other cases calcium pyrophosphate.

Reznek argues that at this point, having discovered that either one of two different explanatory natures (which is Reznek's term for what distinguish natural kinds one from another), the presence of urate or calcium pyrophosphate crystals, could account for a given case of gout, medicine had two options. Either it could

decide that the disease gout, having two different explanatory natures, was not after all a natural kind, but could nonetheless continue to be counted as a single disease, or it could conclude that there are two diseases with different explanatory natures here — gout, with inflammation due to urate crystals, and pseudogout, a reaction to calcium pyrophosphate crystals. Since the latter course was chosen, and according to Reznek "whenever a syndrome does not have a single nature, it is concluded that it consists of more than one disease entity" [p. 178], Reznek concludes that diseases are natural kinds. In other words, if diseases are not real kinds, why break up a perfectly useful one just because it was found to have more than one explanatory nature. Only the fact that diseases must be real kinds, argues Reznek, could motivate the abandonment of the old gout.

Beyond the ambiguity of what Reznek means by "explanatory nature," there are two further problems with this argument. First, he provides no evidence that the decision to distinguish gout from pseudogout was made on realist grounds as opposed to pragmatic ones. Perhaps medicine suspected that patients falling into these two groups may be susceptible to different therapies and should therefore be considered separately. This would certainly seem to be adequate reason to distinguish between gout and pseudogout even if one did not think that diseases must be real kinds with only one explanatory nature. If this were the case historically, the example would not show that realism is analytically true, as Reznek claims it does, since gout and pseudogout would be artificially constructed, and not natural, kinds. Rather, it would provide an example of *anti*-realist construction. Reznek does not provide enough information to distinguish these two possibilities. However, even if we grant that those who separated gout from pseudogout did so on realist grounds, attempting to distinguish distinct real kinds with distinct explanatory natures, we cannot draw any ontological conclusions from this fact. At best, we could conclude that the medical community *believes* that diseases form natural kinds and that the discovery of multiple natures necessitates the division of diseases. They may, however, be mistaken. Distinctions between individual diseases may not in fact reflect, or even attempt to reflect, distinctions in the underlying nature of reality but rather (unrecognized) pragmatic choices. A racist's belief that whites have a different nature from other races does not make it so, and the medical community is no more ontologically powerful. Belief does not generate reality. Ontology does not recapitulate psychology.

The next argument for realism, which we might call the consilience argument, comes from Rather [1959, p. 368]. Over the course of history, through any number of changes in scientific theories, therapeutic tools and goals, and diagnostic methods, certain diseases have remained persistently identifiable and identified. Thus, for example, we may note the Hippocratic descriptions of epilepsy and mumps, both of which are clearly recognizable today, as well as Sydenham's account of gout. If disease types are only recognized as a result of various pragmatic concerns, what explains this historical persistence?

Although this argument for realism is plausible, it ultimately relies on inference to the best explanation. The real existence of diseases is cited as the best expla-

nation for the observed consilience. However, as we noted above, the anti-realist denies that this is a legitimate mode of argumentation. Even though it may indeed be true that real existence is the best explanation of the phenomenon, the anti-realist does not allow that this fact is evidence for such existence. The point here is not that there is a specific objection to the argument; disease realism may indeed provide the best explanation for consilience. However, since the argument ultimately relies on the discredited (according to the anti-realist) mode of argument (IBE), they will not gain the realist further traction against the anti-realist, who has already rejected out-of-hand such forms of evidence for realism.

Rather [1959, p. 369] presents a second argument as well, one which prefigures Fodor's [1974] account of the special sciences and which applies not to realism generally, but specifically to Rather's preferred state-and-symptom view. Here, Rather is responding to the argument against realism, to which we will return at the end of the next section, that it is impossible to say that two people have the same disease given that there will always be countless similarities and differences between any two people, even those who supposedly have "the same" disease, and that it is impossible to non-arbitrarily identify the similarities in virtue of which they "really" have the same disease. Whereas it may be true, Rather responds, that at the deepest micro-level no two people, even sufferers from the same disease, are ever identical, reduction to this level may not be appropriate for medical science, and therefore, these differences cannot be held against the claim that two patients have the same disease. At the more appropriate macro-level there are relevant similarities/identities that make the identification of disease types non-arbitrary. As it stands this "argument" is more of a statement of one realist's faith than a proof for the existence of diseases; Rather gives no evidence of these higher level identities. However, it does provide the framework for a more complete argument supplemented with an identification of such similarities or identities.

2.3 Arguments against Realism

Having seen the arguments in favor of realism, let us now turn to arguments against realism. Unlike arguments for realism, which, as we noted, tend to support realism generally, the arguments we will present here often militate against accepting only a particular account or type of account within realism. Thus, we must pay attention not only to the quality of the arguments, but also to their particular targets.

The first few objections we will consider only apply to causal realisms, accounts that identify diseases at least partially with their causes, that is, those types of concrete realism, such as nineteenth century germ theory, which identify diseases entirely with their causes, as well as those versions of the disease-as-state, -process and -signs-and-symptoms views which included causes in their disease specifications.

The most obvious objection to causal realism comes from the complexity of the causal tree and is raised by Whitbeck [1977, p. 635]. No diseases are the result

of one-to-one interaction between a host and a pathogen. As with any effect, the causal network behind a disease is more complicated than that. We know that for any putative disease cause there are genetic and environmental factors affecting host susceptibility. To take a contemporary example, HIV is *not* the cause of AIDS. Infection with HIV and the presence (or absence) of as yet unidentified host factors causes AIDS. Witness such long-term non-progressors as the novelist and critic Edmund White, who was found to be infected with HIV twenty-five years ago but has not developed full-blown AIDS, despite beginning anti-retrovirals only four years ago [Teeman, 2006]. Likewise, the amino-acid phenylalanine is toxic only to those with a specific genetic mutation, causing severe mental retardation. Conversely, this genetic mutation causes mental retardation only if the host ingests phenylalanine (whence the warnings on aspartame-flavored drinks). Vaccination may be the simplest case in point. Infection with the variola virus only results in smallpox in patients who have not previously been exposed to the vaccine. Certainly, HIV, variola or a certain genetic mutation may often be the most explanatorily salient causal feature in the patient's history. But explanatory salience, being interest-relative, is not metaphysically significant, at least not for a realist. Since no part of the causal tree can be picked out as metaphysically significant by itself, no part can be included in the disease. (The option of including the entire causal tree is clearly not plausible, as the disease would then extend temporally and spatially far away from the current patient.)

We must note that, rhetoric aside, the problem here is not that there is no way to identify HIV as causally responsible for AIDS. On a probabilistic account of causality, such as that advanced by Suppes [1970] and Cartwright [1983], it is enough that the presence of HIV increases the probability that a person will have AIDS. This is indisputable; the chance of having AIDS without HIV is zero. However, since some people with HIV never develop AIDS, there must be some other factor involved. A plausible theory, and one which will do for our current purposes, is that non-progressors lack a certain protein, present in those who progress to full-blown AIDS, that gives the virus access to the parts of the body it must reach for AIDS to develop. In that case, the extra protein is also a cause of AIDS; no protein, no AIDS. But, Whitbeck would argue, from among the causes they might consider, causal realists mean to include only HIV in the essence of AIDS. They do not mean, and no reasonable person could want, to include this proposed protein, which has been present in the patient from birth, as part of the essence of AIDS. Whitbeck's objection is that there is no ontologically salient difference between the virus and the protein. Since the latter is not part of the disease, neither is the former. We can strengthen the objection by noting that it is unlikely in general that there is only one additional factor ("the protein") beyond the conventional cause ("the virus") involved in most diseases. The number of factors is vast, and including all of them in the cause would blur beyond reason the distinction between the disease and the causal history of the person who has it.

When we consider the objection in this light, one possible response for the causal realist presents itself. Although the causal tree is vast, there are ontologi-

cally significant distinctions. One could consider as part of the disease only those causally relevant factors which actually enter the body of the patient, or, if one wants to include the protein, which are present in the body of the patient at the time that the disease is present. Spatially (and temporally) limiting the disease is not ontologically arbitrary and would presumably limit the number of causes that must be considered.

Engelhardt [1985] and Severinsen [2001] also argue against realism by considering the problems of identifying causes. They note that we recognize diseases, such as rheumatoid arthritis, with unknown etiologies and which we are not even sure have a single etiology in all cases. This implies that we have a means other than the cause of identifying the disease, and therefore we cannot define a disease based on its etiology. Likewise, they, as well as Whitbeck [1977] and Temkin [1961], cite diseases with multiple possible etiologies against (causal) realism. Temkin's example, appendicitis, is merely the infectious inflammation of the appendix. Any number of different types of bacteria can lead to this inflammation, which is nevertheless generally acknowledged to constitute a single disease-entity.

The causal realist could plausibly respond to many of these arguments. Some of the arguments presented above beg the question against the realist who identifies diseases with, or at least partially in terms of, their causes. Part of the point of considering the nature of diseases, at least for the realist, is to determine which of them are real. Perhaps appendicitis, if not all cases have the same cause, is not a single real disease. As for the complaint that there is no objective way of identifying *the* cause of a disease, a causal realist might respond that if we could find a single causal feature common to all and only cases of a single disease, we might be justified in calling this the unique ontologically salient cause, even if it is not *the* cause, full stop. For example, if (apparently contrary to fact) all and only those exposed to HIV developed AIDS, then perhaps we could (at least partially) ontologically identify AIDS with the HIV virus. Finally, the causal realist could respond to Engelhardt and Severinsen's objection from rheumatoid arthritis by saying that until its cause is identified, its status as a real disease is only tentative, and if no cause is found in common to all cases, it will be stricken from the roll of diseases, all appearance that it may belong there notwithstanding.

Despite the room for these responses by the causal realist, it might seem wiser for realists in general to avoid these problems altogether by renouncing causal versions of their positions, as it is not clear why a realist should feel constrained to adopt causal realism. Let us therefore consider now objections that apply to realism more generally, regardless of the place of causal factors in their accounts.

The first of these, which may be called "the problem of extremal diseases," comes from Reznek [1987]. "Extremal disease" is Reznek's term for those diseases, such as essential hypertension or anemia, which differ from a state of health quantitatively, but not qualitatively [p. 179]. Thus, everyone has a blood pressure, but some people's is too high; everyone has red blood cells, but some people have too few. If we accept that if there are any natural kinds there ought to be joints between them at which we can carve nature, how can hypertension, which is es-

sentially continuous with normotension, form a natural kind? On the other hand, if realists admit that extremal diseases do not form natural kinds and are therefore not diseases, we may ultimately find that there are no diseases, as it is possible that all diseases, even those that appear to be discontinuous with health, could turn out to be extremal, with the appearance of discontinuity, where it arises, being the result of threshold phenomena or other such illusions.

Reznek does not intend this to be a general attack on realism; he himself is basically a realist. He simply intends to show that some diseases are not natural kinds. However, the argument seems to apply to realism in general, for if, as he acknowledges is possible, all diseases are extremal, there would then turn out to be no real diseases.

The solution to this problem, for the realist, seems to be to acknowledge that extremal diseases are not diseases without agreeing that the risk that there will be no realistically acceptable diseases is a problem. The fact that it *could* turn out that, on a realist account, there were no real diseases is not an adequate argument against the realist. The acceptance of any sort of natural kind is always an empirical claim. The fact that a theory does not logically imply that there are at least some natural kinds is neither a problem nor surprising. Empirical claims cannot support that type of burden, nor are they designed to.

The next problem to consider is a version of Laudan's [1981] "pessimistic meta-induction." As we saw above, the realist, in the no-miracles argument, claims that the success of our medical practices provides evidence for the assertion that our disease terms refer to real, natural, kinds. For, if our practice was not based on an understanding of the underlying nature of the world, how could we successfully predict and manipulate the future in medical contexts, i.e., research, diagnose and treat diseases? The response to this claim, according to the meta-induction, is to point out the many disease types that we now dismiss as spurious, but which, in their time, played a role in apparently successful medical practices. Thus, fever was, for many physicians for many years, a disease. Likewise, at least for John Hunter, syphilis comprised both the disease we now recognize as syphilis as well as the one now known as gonorrhea. As a third exhibit we may note that before Sydenham, gout covered many arthritic inflammations and not just hyperuricemic ones. We would not grant that Sydenham's successful treatment of gout (as he understood it) and fever warranted the conclusion that they were real entities, since we now know that they are not. Yet if Sydenham would have been wrong in his success-to-reality inference, why are we more justified in the twenty-first century?

We should note that although this argument is based on Laudan's, there is one significant difference. The traditional meta-induction, most commonly applied to various physical sciences, concerns the reality not just of the entities the theory posits, but also the truth of the theory itself. Thus, quantum physics not only implies the existence of electrons, but it also purports to describe the laws of the universe in which these electrons are embedded. In the medical case, however, we have only the entities in question — disease types. With only a few exceptions,

such as Brunonian medicine of the eighteenth century, medical theories do not themselves provide laws the entities they recognize are subject to. Even such quasi-scientific approaches to medicine as seventeenth century iatrophysics and iatrochemistry pointed more to the types of laws they believed were relevant than to specific laws. At any rate, modern medicine seems to have no place for unified theoretical structures like those of physics, and so can only be judged on the failure of past nosographies and not on past theorizing.

This distinction between medicine and the usual targets of the meta-induction closes off some realist responses to it while freeing medical realists of other apparent difficulties. Thus Worrall's [1989; 1994] structural realism, with its allegiance to the structure of past successful theories but not the entities they posit, will have no relevance to theory-free, and entity-rich, medicine. Likewise, it is difficult to see how to apply Kitcher's distinction between presuppositional and working posits (see [1993, pp. 143-9]). Kitcher's response to Laudan is to distinguish between entities that were critical to a theory's success (working posits) and those that served a merely heuristic purpose but could have been eliminated from the theory without reducing its success (presuppositional posits). In medicine, the absence of an overall structure (or theory) in which reference to logically unnecessary but heuristically helpful entities can be embedded makes this distinction highly problematic.

If Kitcher's and Worrall's approaches do not seem relevant to defending medicine from the meta-induction, Psillos's [1996] "*divide et impera*" strategy takes on new strength when applied to a theory-free domain. Psillos suggests that we rescue realism from the meta-induction by granting the realist imprimatur only to those constituents of a theory that were responsible for past sciences' empirical successes. If these and only these features of past sciences have been retained in our current science, we can then block the meta-induction. For, in that case, the success of past sciences did not in fact rely on false claims. The empirically productive parts of science will have remained constant and realistically viable. The historical embarrassments to realism which Laudan relies on, such as ether and phlogiston, can be safely ignored. They never really were part of the theory in the first place.

Clearly, the success of Psillos's defense of realism relies on the truth of the empirical claim that the essential features of past sciences have been retained in our current practices. Prior to assessing this claim, however, we must have a criterion for distinguishing between essential and idle constituents of a theory. Furthermore, this criterion must be applicable in real-time and not only in hindsight. Otherwise, in assessing current science, we will have no way to reliably bestow the status "real" only on the real constituents that our science correctly identifies and thus no reason in general to believe in the constituents of our current accounts. Psillos claims that such a criterion is readily available. We have but to ask the leading scientists of the day. Thus, according to Psillos, the leading physicists of the early eighteenth century, such as Laplace, Lavoisier and Carnot, themselves withheld full belief from the notion of caloric, viewing it as too unsupported to fully accept. This is in contrast to their attitude towards, e.g., the adiabatic propagation of sound in air,

to which they committed fully. Of course, the division between caloric heat and adiabatic sound propagation is precisely the distinction we would, in hindsight, want them to make, since we still accept the latter, and Psillos claims that at least prominent scientists reliably and more or less explicitly withhold (full) belief from all, or almost all, of the idle constituents of their theories while bestowing it on those constituents that are indeed essential to the theories' empirical successes. Thus, to avoid believing in unreal entities (and laws), we have only to pay more attention to the scientists themselves.

Psillos's response to the meta-induction has recently been attacked by Stanford [Stanford, 2003a; 2003b]. Stanford argues that in finding the scientists of the past to be reliable judges of essentiality, Psillos relies on a selective reading of history. Thus, although it is true that in the nineteenth century many scientists expressed skepticism about the ether, as Psillos asserts, this in general was confined to the specifics of various mechanical models of the ether. This limited skepticism, how- ever, is not enough for Psillos's purposes. He needs there to be skepticism about the very notion of any sort of mechanical medium being necessary for the propagation of electromagnetic waves, since this is what was dropped with the abandonment of the ether, not particular models like Green's elastic solid or Stokes's elastic jelly. Unfortunately, we find that even Maxwell himself was committed to the idea that a material medium was necessary for the propagation of electromagnetic waves:

> In fact, whenever energy is transmitted from one body to another in time, there must be a medium or substance in which the energy exists after it leaves one body and before it reaches the other, for energy, as Torricelli remarked, "is a quintessence of so subtile a nature that it cannot be contained in any vessel except the inmost substance of material things." [Maxwell, 1955, vol. 2, p. 493, quoted in Stanford, 2003a, p. 560]

If Maxwell himself did not see that the ether was problematic, it would appear that scientists are not reliable judges of which constituents of their own contem- poraneous theories are idle. No useful distinction can be drawn by considering the views of scientists themselves, who were often fully committed to the theoretical constituents we now know to be false, or unreal. Thus, according to Stanford, Psillos's criterion fails the real-time test.

At this point we see medicine's strength in opposing the meta-induction. For, rather than relying on the perhaps implausible, and according to Stanford, false, claim that leading scientists have a reliable nose for reality, we can, in the case of medicine, make use of a much simpler, and less tendentious, criterion for distin- guishing in real-time between those theoretical constituents, i.e., diseases, which are essential for medicine's success and hence real, and those which are not. That criterion is success. In order to determine, at any point in history, which of our disease entities we ought to believe are real, we have but to ask ourselves, which of them do we use successfully? Which of them are we able to diagnose and treat

effectively?[3] This criterion can be used at any time, in real-time, to determine which disease entities then in use ought to be believed in and retained. If past generations failed to do this, it is not because the criterion is only applicable in retrospect, but because they lacked the requisite epidemiological concepts. If they had more closely examined the clinical utility of their disease entities, they would have known which entities to withhold belief from. Conversely, by examining these past utilities ourselves, we could identify which, if any, historically discarded diagnoses we ought to reintroduce into our nosology. Of course, it may emerge that *no* disease entities of the past meet this criterion for essentiality. In that case, however, the meta-induction has been completely neutralized, as there would then be no past successes with which to challenge current medicine. However, even assuming the ancients did know a true thing or two about medicine, the meta-induction would simply prod us to enlarge our current ontology, not abandon it.

If such a simple argument from success is available to counter the meta-induction here, why can the realist not use it to diffuse the general meta-induction? The reason, again, lies in the theoryless-ness of medicine. In medicine, each individual entity can be used on its own, independent of other specifically medical beliefs (as opposed to biological or physiological ones). If the entity malaria meets our success criteria, no other constituents (i.e., diseases) are even apparently implicated in this success. Malaria's success is not used to support belief in skin cancer. In theoretical sciences, however, this is not the case. On the surface, at least, any successes the caloric theory had must be imputed to the theory as a whole, caloric substance and all. It is possible that certain parts of a theory may be otiose, but there is no reason for anyone who has adopted the theory as successful to believe that. A simple argument from success would affirm the reality of the caloric fluid. Teasing out the otiose elements in real time, therefore, requires more subtle tools, such as those suggested by Psillos. Unfortunately, as we saw, these tools are neither easy to come by nor particularly resistant to the elements.

If medical realists are particularly well equipped to deal with the meta-induction, let us see how they fare against other general anti-realist attacks. The next objection to disease realism we will consider can be called "the strangeness objection." This is the claim that diseases are simply not, ontologically, the sort of things that can be considered real either as tokens or in being subject to laws of nature/able to form natural kinds. The prototypical law-obeying entities, elementary particles, are all strictly identical, and this is at least part of what makes them susceptible to being covered by unchanging universal laws of nature. Members of biological species, which are neither identical with each other nor evidently subject to their own particular laws, are at least bound together materially, through biological descent, and thus have a naturalistically understandable means of being connected as a kind. Although neither of these conditions is clearly necessary for forming a natural kind, and their applicability may be arguable even in the cases we just raised,

[3]Although I do not intend to propose a formal account of medical success here, as a rough approximation, we may apply the standards now applied in clinical research for deciding what therapies and diagnostic tests to use.

they at least provide a way of understanding the connection between members of
these sorts of kinds. Disease tokens of a given type, however, are neither identical
with one another nor connected in a historical-material manner. It is thus unclear
what binds them together as kinds. Related to this argument is the claim that
disease tokens are not even the sort of entity which can be considered real. For,
unlike all other real entities, they are not physically contiguous and independently
existing objects. They may be embedded in such an object, a human body, but,
be they processes, states or sets of signs and symptoms, disease tokens cannot be
separated from a body and displayed on their own. It is not clear wherein their
reality lies. This argument that diseases are not real tokens incidentally provides
a further argument that they cannot form natural kinds given our argument above
that one cannot be anti-realist about tokens and realist about types. Diseases are
thus too strange to form natural kinds or even to be granted reality as individuals.
(Note that this objection is most specifically not applicable to causal realism, since
such accounts can identify and connect diseases based on their causes, which may
be legitimate candidates for belonging to natural kinds.)

The obvious response to this objection is that it merely restates the conclusion
of the disease anti-realist (but scientific realist). If we *can* identify patterns in
human bodies which repeat themselves in different times and places, and which
respond in predictable ways to outside influences, why shouldn't these count as
real entities? To restrict in this way the kinds one might admit to one's ontology
is to prejudge the issue.

The final set of arguments against realism is perhaps the most traditional and
general. First, if diseases are real parts of the natural world, we would expect them
to behave with the (law-like) regularity we expect from the rest of the natural
world. If this is the case, why do different people with the "same" disease respond
differently to the same "effective" treatment? The regularity expected of nature is
difficult to discern in medical practice and research. The medical generalizations
that doctors use to guide their practice appear to be mere rules of thumb next
to what we know of physiology, let alone physics. Furthermore, how could we
possibly identify diseases based on the similarity between cases? There will always
be countless similarities and differences between any two disease tokens, be they
of the same type according to the realist or different. (This second question is
raised by Severinsen [2001].)

These two objections highlight the difficulty realists have in identifying the rel-
evant similarities and differences among cases. Treatment failures, for a realist,
have three realistically acceptable causes. The first possibility is that heteroge-
neous cases have incorrectly been included under a single disease type. That is,
what appeared to be cases of the same disease were in fact instances of different
disease types. The second explanation the realist can avail herself of is that the
failure is due to our missing relevant differences in the "experimental situation"
of two different cases of the same disease. Although we were correct to identify
both cases as representing the same disease type, we did not take into account
differences in the diseases' environment, i.e., in the patients' physiology or envi-

ronment, that alter the diseases' responses to the intervention in question. The relevant laws may be more complicated than "Disease X + Therapy A = cure." The third possibility, which is really a version of the second, is that the relevant regularities are probabilistic generalizations and not strict laws. Of course, some realists may balk at the notion of a universe governed to this extent by probabilistic laws (even if quantum weirdness is acceptable, medical weirdness may not be). Nevertheless, the route is available to them as realists.

Despite these potential responses, the anti-realist surely has a serious challenge to the realist here. Even if the realist is right that the underlying structure of the universe sets out disease kinds, how could we ever know this? What sort of objective findings could lead us to the knowledge that such complicated entities as diseases form kinds and how they do so? How could we ever come to the conclusion that diseases are real entities? Certainly the realist needs to provide an epistemology to answer this question, and this will be no trivial task. As we noted at the outset, however, it is not the task we face here. At this point we are only trying to *describe* the world according to the realist, however it is that we come to know about it. Furthermore, even without an epistemology, realists, at least by their own lights, do have some evidence that the challenge can be met. The no-miracles argument we encountered before indicates that somehow or another we in fact *are* successful at sorting these tokens into diagnostically and therapeutically effective groups (which are real, or natural, kinds). The problem the last two anti-realist objections pose for the realist is thus not whether we can do this, but how. The anti-realist's epistemic challenge only works if one does not believe that one has evidence that the task can in fact be done. Realists believe they have this evidence.

3 ANTI-REALISM

3.1 Preliminaries

In the preceding section, we examined, under the heading "Realism," accounts of the nature of disease entities that grant existence to both disease types and tokens. With this criterion for being realist, it should be enough for a position to refuse real status to either disease types or tokens to be classified anti-realist. However, as we indicated above, we will only consider accounts that are anti-realist about both types and tokens as anti-realist. In addition to providing a "purer" form of anti-realism for initial consideration, this restricted anti-realism describes most of the non-realist positions in the literature, and thus seems to be a reasonable category for consideration. Mixed theories, realist about tokens and anti-realist about types, will receive separate treatment later. (We saw above that the converse of this, realist about types and anti-realist about tokens, is not a plausible position.)

The structure of this section is somewhat more complicated than that of the last. We will begin with a very brief and general statement of what anti-realism

about diseases amounts to. This will be followed by a consideration of the various types of anti-realism current in philosophy of science (constructivism, empiricism, instrumentalism and reductionism) leading to the conclusion that of these, constructivism is best, if not uniquely, suited to the case of diseases. Next we will develop a taxonomy of potential constructivisms regarding diseases, identifying a total of fifteen different positions along two primary axes, as well as some other secondary distinctions between positions. We will then survey the literature to consider where various anti-realists about medicine fall in this taxonomy. At that point we will be prepared to assess disease anti-realism.

3.2 Disease Anti-realism Generally

What, then, do disease anti-realists claim? In the terms laid out in the first part of this chapter, anti-realists deny that the diseases — types or tokens — that we identify are either part of, or given to us by, the underlying structure of our world. That is, at least roughly, the types do not form natural kinds and the tokens are in no way wholly picked out by mind-independent features of the world. Rather, diseases are structures whose existence consists ultimately in certain peoples' decision, whether conscious or not, to acknowledge them. Note that the anti-realist is not claiming merely that disease concepts, like "pneumonia," are the result of human decisions. This would be platitudinous. Even those we have called disease realists can, and probably would, agree that had there never been any people there never would have been the concept "pneumonia." Rather, whereas the realist claims that there are underlying natural structures that these concepts try, ideally successfully, to reflect, for the anti-realist, disease concepts neither aim to nor can refer to anything other than disease tokens or patient substates which have been recognized by certain authoritative individuals or groups. It may be possible to critique these recognitions as better or worse, but the grounds for this critique, for an anti-realist, cannot be extent of the correspondence of the recognized structures with structures that are given to us by the world. What the grounds for assessment *can* be is what is at issue between various anti-realist positions.

Before investigating this variety of anti-realist accounts, we must first understand what it is that unites all anti-realists regardless of their particular account. This unifying feature is their claim that diseases — both types and tokens — are constructs devised and chosen by the human mind, not underlying features of the world as the realist claims. For example, it may be that diseases are constructed by physicians to maximize the usefulness of the therapies currently at hand. Alternatively, it may be patients who construct diseases in an effort to maximize their political clout.

The use of the word "construct" in the last paragraph is not meant to be a contentious reference to social constructivism. Rather, it serves merely to acknowledge that anyone who denies that the world imposes disease categories on us but claims that there are indeed such categories, i.e., an anti-realist, *eo ipso* claims that we

impose our own categories. However, the usefulness of the word here implies that constructivism may indeed be amenable to application to medical anti-realism. Are the two positions, medical constructivism and medical anti-realism, actually equivalent?

Anti-realists as a group may be understood as being united in the claim that theoretical statements within their chosen domain have a defective relationship with truth as compared with simple observational statements and thus cannot be understood to be true in the same way that such observational statements are. Anti-realists differ only in their assessment of this defect. Constructivists claim that the defect is in the nature of the truth-makers for the relevant statements — human choices rather than the nature of the mind-independent world, but this is only one possible account of the defect. What of the other possibilities?

Within scientific anti-realism, at least, there seem to be three other generally recognized accounts of the defect. First, we may claim, *a la* van Fraassen, that theoretical claims may have truth-values, but that if so they are epistemically inaccessible to us. (See, e.g., [van Fraassen, 1980].) Second, we may deny that theoretical claims have any truth-value at all, understanding them as "merely linguistic, uninterpreted tools for systematizing observations and making predictions" [Niiniluoto, 1991, p. 145]. Finally, the relevant statements may be understood as reducible to other, non-disfavored, statements. Are any of these positions, which we will refer to, respectively, as empiricism, instrumentalism and reductionism, applicable in the case of diseases, at least given our definition of anti-realism?

First, empiricism. I want to start with this merely to set it aside. The problem with it in our context is that while it is often considered an anti-realist position in the general dialectic, it does not pass our test for anti-realism. Empiricism about diseases does not claim that real diseases do not exist, but only that, if they do, we lack epistemic access to them. So for now, we will exclude empiricism from consideration and turn to instrumentalism.

What would instrumentalism about diseases amount to? The claim would seem to be that any statements about disease types or tokens, such as "bacterial meningitis can be cured with the antibiotic ceftriaxone" (a gross, but I think harmless, simplification) or "this patient has bacterial meningitis, so if we do not administer ceftriaxone she will die," are not in fact making statements about a particular disease but are merely "uninterpreted tools," in Niiniluoto's words, helping us to make predictions, based on past experiences, about the future of a certain patient or group of patients we encounter. What does it mean, however, for the apparent references to diseases to be uninterpreted? In standard scientific anti-realism about, say, elementary particles, what this lack of reference means is more or less clear. When we say that after powering up the collider and sending a beam of protons against a beam of antiprotons we got a stream of muons, what we are really saying, according to instrumentalists, is that in the past, when we have turned on the collider with such-and-such settings ("streams of protons and antiprotons"), we have observed certain tracks in the cloud chamber photographs ("muons"), and we saw them again this time. Similarly, regarding types, when we

say that proton-antiproton collisions create muons, what we are really saying is that in the past, when we have turned on the collider with such-and-such settings, we have observed certain tracks in the cloud chamber, and we expect to see them again under similar circumstances. Apparent references to elementary particles are merely a shorthand way of collating and relating the details of different observations and predictions. What we are really talking about, however, are colliders and photographs, not any microentities.

This works relatively well when talking about unobservable entities. In the absence of any direct sightings of protons and muons themselves, there is no inherent problem in interpreting away references to them. We are not left with any unexplained perceptions; we have no intuition that the track is, in any sense, the actual muon. We realize that our references, even if we believe them to be real and not merely apparent, are to things that we do not directly see and that hence *may* not be there; it could be the case that there is nothing more to this part of the world than colliders and cloud-chamber tracks. The same cannot so easily be said in the case of diseases. Diseases do not appear only in our attempts to explain certain observations, but, on a naïve level at least, seem to be present in the observations themselves. Pneumonia *is*, again roughly and naïvely, the fever, cough, shortness of breath, etc., we see in the patient. At least, we may feel that we are directly observing the disease under these circumstances in a way we are not observing electrons in a cloud-chamber. Symptoms *are*, or at least are part of, the disease in a way that a cloud-chamber track is not, or is not part of, a muon. The question we are asking is, what is the nature of these diseases we seem to directly perceive? Apparent references to diseases cannot be dissolved inside a black box. The question would remain for the instrumentalist, what is wrong with the patient, what does the patient *have*?

There would appear to be one response here for the potential instrumentalist about diseases. It is, as we implied above, rather naïve to say that we directly perceive a disease, in this case pneumonia, in a patient's fever, cough, shortness of breath, etc. Indeed, such claims are precisely what anti-realists deny. Instead of seeing a disease in the symptoms, they see symptoms in the disease. That is, they eliminate, at least formally, all talk of diseases and replace it with descriptions of the relevant symptoms. Or, for those who are somewhat differently inclined, we can talk of culture results, x-ray findings, biopsy results or biochemical states of the patient instead of symptoms. If we thus do not directly perceive them, perhaps diseases really are like elementary particles.

The problem is that the position just described is not instrumentalist. Our references to diseases are not uninterpreted; they are reduced to statements about the patient. We thus appear to have switched from our second sort of anti-realism, instrumentalism, to our third, reductionism. Instrumentalism remains inapplicable to diseases. But even if this reductive account is applicable to medicine, is it anti-realist by our criteria? Clearly not. Many of the realist positions we identified in the last section performed precisely this type of reduction. What distinguishes realist from anti-realist reductionism in our terms is the means used to identify

the proper reduction for the disease term in question. If the set of symptoms, lab findings, biopsy results, etc., are determined by the underlying structure of the world, then the position is realist. Only if it comes from elsewhere do we have anti-realism. Once we have reached this point, however, we seem to have returned to constructivism. For, if our categories, at least in this domain, are not imposed by nature, where else could they come from but within? This self-imposition of categories is the essence of constructivism.

3.3 Constructivism in Medicine — Overview

We see then that forms of anti-realism other than constructivism have serious difficulties if applied to diseases. The impression that constructivism is the best interpretation of disease anti-realism is strengthened by the fact that, as we will see, all of the positions currently in the literature are constructivist. We will, therefore, be restricting our further discussion to constructivism, and will often use "constructivism" and "anti-realism" (in the medical context) interchangeably. Even once we confine ourselves to constructivism, however, there are several questions we need to answer to understand what constructivism in medicine amounts to. Granted, it is the human mind, and no (other) part of nature which imposes order on our experience of diseases. But who constructs the diseases we accept, and why do they get to choose? What criteria do they use, and is choice really the best term, or is the selection made subconsciously, without the freedom choice seems to imply?

Before addressing these various questions, let us see, in a general way, what it is to construct diseases — types and tokens — as anti-realists claim we do. Tokens first. For an anti-realist, there is no fact of the matter as to which of a patient's features constitute his disease. Rather, we are free, in principle at least, to identify any set of components of the patient's overall state as constituting that patient's disease (although further consideration of the details of constructivist accounts will yield some limits on this freedom, as we shall soon see). These components need not even be ontologically similar. Thus, we may choose to say that a particular patient's disease at a given time comprises a particular derangement of cellular metabolism, the presence of a certain microbe in her brain and her headache. However, we could also say, instead, that her disease at this time comprises her blood-pressure, white blood cell count and weight, and even deny that the factors listed in the last sentence have any place in our medical practice or discourse. (Although we could also, instead of banishing these factors from medicine, reserve the option to recognize them as features of other diseases.) Or we could choose any other set of symptoms and features, some of which may not even be nameable with our current physiological vocabulary. Of course, being anti-realists and not anarchists, this freedom to pick out whatever disease we want from a patient's current state is not absolute. The disease token we identify must serve some predetermined purpose. This purpose, however, will not be the realist's purpose of revealing the underlying truth and structure of the world, but one which uses man as the measure.

Similarly with disease types. For anti-realists, the decision of which disease tokens or patients should be brought together as members of a particular disease type is not driven by a desire to match our grouping to nature's. Rather, the goal is to create types which will best further the non-realist goals of medicine. In short (although this may not follow directly from what we have just said) for an anti-realist, a disease — type or token — is constituted by the agreement of the relevant parties that it should be adopted.

A rough analogy with race may help clarify this point. Let us assume, as is generally done today, that even if species are real (say, natural kinds), the races of humanity are not. The natural world does not simply present us with three types of humans, which, to avoid offensive terminology, we may call European, African and Asian. (The standard terminology, of course, refers to skin color rather than presumed geographic origin.) Rather, it was the decision of certain people, primarily European, to use cosmetic features to divide humanity into three groups which created the three races. This is not to say that there is no biology underlying these classifications. Clearly, there is a genetic basis to such features as skin color. Nor is race necessarily explanatorily useless. High levels of melanin may correlate well with a higher density of fast-twitch muscle fibers in the quadriceps muscles, thus explaining why white men can't jump, and it certainly correlates well, at the current time, with lower socio-economic status, allowing us to predict future income. Despite our ability to make these generalizations, we still take it that humanity does not come in three essential kinds. For the anti-realist, the disease type tuberculosis is analogous to whiteness.

If we may find an analogy to disease types in races, disease tokens may perhaps be represented, again, roughly, by a Rorschach test. The number of different figures we can identify in an inkblot, and their boundaries, are no more than roughly defined by the inkblot itself. There are a virtually limitless number of figures that can be identified in a sufficiently complicated blot. This does not mean that we could not come to an agreement as to how we will describe the blot and which figures we will identify. Such an agreement, however, would be no more than that, an agreement. It would neither create nor reveal any true structure that underlies the appearance of the blot. For the anti-realist, patients are the inkblots and diseases are the monsters hiding within them.

With these analogies in mind, let us explore the different kinds of constructivism available in medicine. In truth, although there are several questions that in principle must be answered to characterize a constructivist position in medicine, only two of them — who constructs disease types and what criteria do they use — will really be relevant to our discussion here. Answers to other questions, such as those regarding the construction of disease tokens, are necessary for a full description of a given position, but not to discussing the underlying issues of anti-realism.

Let us then start this analysis with the two major axes regarding the construction of disease types. In establishing a position, a disease constructivist must specify two things regarding the construction of types. First, what criteria guide the constructions? What purpose do they serve? Medicine is an organized, not

anarchic, practice, so there must be some rules regarding what diseases are acceptable. Second, who selects and applies these criteria, constructing the disease types and deciding which diseases are recognized? The possible answers to these two questions define the two major axes along which constructivist positions can be placed.

Turning to the first question, what criteria should be used to identify the diseases to be acknowledged by medicine? Anarchy is unacceptable. Even the least scientifically-minded anti-realist must have some account of how the cases and terms of our medical discourse arise. We shall see that there are five different sets of criteria among which medical constructivists can choose on this first axis.

It will perhaps be simplest, after having examined realism, to begin our examination of anti-realism with more scientifically inclined accounts. One criterion we could use to identify diseases would treat medicine as a science, albeit an instrumentalist anti-realistic one. On this account, the goal of medicine, as of science, is the understanding of the world through the development of an ability to explain past events and predict future ones.[4] Disease types are those categories which best account for our previous observations of patients and best allow us to predict/alter the course of future patients. Thus, on this account, which we may call "medical instrumentalism,"[5] rabies is a disease because it allows us to predict who will die if not given certain medications. (Even before Pasteur it allowed us to predict, although at that time the prediction was merely one of imminent death.) By contrast fever, with its extremely limited explanatory and predictive power, is not considered a disease, although it seems to have enjoyed this distinction in the eighteenth century, when it was, or appeared to be, more useful in this regard. Similarly, for a medical instrumentalist, the decision as to whether a suspect disease such as chronic-fatigue syndrome should be accepted depends on whether we are able to make prognostic or therapeutic use of the category.

A position apparently similar to this medical instrumentalism but ultimately quite different is one we may call "patient-centered pragmatism." Pragmatists see the purpose of medicine not as understanding and predicting nature's ways, but as helping patients. Diseases are then chosen to maximize benefit to patients,

[4]I am speaking here in only the roughest terms. I do not mean to imply that "understanding of the world through the development of an ability to explain past events and predict future ones" identifies *the*, or even an, unequivocal goal of science. I do not even want to argue that science as such has any univocal goal. But however one understands the goal(s) of science, the explanatory/predictive uses of science play an important part. It is to this part of the goal of science to which I refer. The modifications to this goal that a more nuanced understanding of science might provide (e.g., [Kitcher, 2001]) occur at a higher level than that at which diseases are identified. They would affect rather the attitudes we take to various diseases and the ways we chose to interact with them, much the same way the scientificity of research into nuclear power does not affect the ontological status of electrons for instrumentalists.

[5]This repetition of "instrumentalism," in the first instance naming an alternative to constructivism and in the second instance naming a variety of constructivism, is admittedly somewhat unfortunate. However, given that we disposed of the first use of the term earlier in this chapter, never to return to it, and also given that the current use of the word is modified by "medical," I have chosen to recycle the term that is, for slightly different reasons, by far the best in both contexts.

however one measures that. A highly scientistic view of the effects of medicine would consider this pragmatic goal best served by the instrumental considerations discussed in the last paragraph. This understanding of medicine is too narrow according to patient-centered pragmatists. We must consider the full range of medicine's social, political and economic effects in determining which diseases to recognize. Among other "nonscientific" effects, identifying diseases can generate political movements (e.g., ACT-UP, the AIDS Coalition to Unleash Power), create massive expenditures (e.g., President Nixon's War on Cancer) and stigmatize those to whom it is applied (e.g., leprosy and, again, AIDS). Thus, for a medical pragmatist, the question of whether AIDS is a disease is not determined, as it is for the medical instrumentalist, solely by how well it facilitates our research into the prognosis and treatment of the group of people so designated. Rather, we must balance the prolonged life of certain patients against their international stigmatization (including, if not especially, in countries in which they have no hope of securing treatment), the economic drain research into AIDS causes, the cost of treating AIDS and the political upheaval (to date minor) it causes. Not an easy calculation, but for the pragmatist, an essential one if we are to determine whether "AIDS" belongs in our medical lexicon.

Note that this patient-centered approach really comprises two variants. In determining diseases we can focus either on the benefit to the individual who will be receiving the diagnosis in question or on the benefit to patients in general, i.e., all those whom the practice of medicine serves. I will reserve the name "patient-centered pragmatism" for the former, individualist approach. The latter, which may come to radically different conclusions, we can call "utilitarianism." Utilitarians focus on the benefit to society as a whole; diseases types are acceptable if they tend to benefit society as a whole. The calculations required here are similar in kind and complexity to those called for in utilitarian ethics; accepting such criteria for medicine, however, does not imply acceptance of a utilitarian ethic. The natures of medicine and ethics may be entirely separate.

Accounts of diseases can also be given in pragmatic, but not patient-centered, terms. Thus, the criteria for recognizing diseases may be strictly economic. Disease types are then recognized as they tend to increase economic welfare of a particular group (patients given the diagnosis, society in general, etc.). Perhaps this should be called a Marxist account, because of its focus on economic matters. I do not mean to imply as an historical matter that any Marxists have endorsed it; in fact, as far as I know, no one has embraced a purely economic account of medicine. Another, perhaps more plausible, variant on medical pragmatism might be called "totalitarianism." Totalitarians see the role of medicine as supporting the authority of those in power. A disease type is thus appropriately recognized by medicine if it supports those in power, usually by subjecting a disfavored social group to economic hardship and social ostracism, but possibly also by benefiting certain people by bestowing such benefits as freedom from various obligations. (Cf. the sick role as described by Parsons, [1951] and elsewhere.) Such a position has been described, if not endorsed, by Illich [1976, esp. chapter 4], and we may see

at least an echo of it in the Nazis' pathologizing of Jewishness [Lifton, 1986, esp. chapter 1]. Similarly, some might claim that AIDS was recognized as a disease only because it provided a means for stigmatizing, and perhaps quarantining, certain disfavored groups such as gays, drug users and/or blacks.

Let us consider now the second axis. Who is it that decides which disease types these criteria license? Who speaks, as it were, for medicine? Here we have three options. The first is that physicians, or medical scientists, or however we want to name the group considered expert in medicine, identify acceptable diseases. Certainly, this is how on the surface it appears to happen, even for an anti-realist, with physician-scientists trying to track down the latest scourge of mankind or subtly distinguishing between two types of cancer. Such a position need not be associated only with a medical instrumentalist or patient-centered pragmatist view, although it may lend itself most easily to them. It may be that although physicians are properly placed *vis a vis* the practice of medicine to be the ones who generate the acceptable disease types and tokens, they are motivated purely by a desire to promote the power and influence of their profession. Although such a critique is not frequently launched at physicians as a group, they are often considered the modern, secular, priesthood, and such accusations have been leveled at priesthoods in the past. Medicine is not, in principle, immune.

Another group that may drive the creation of diseases is what we may call for want of a better term the ruling party. Diseases may be imposed from above, through the political hierarchy. Again, we need not associate this position with the most obvious set of criteria. Certainly, political leaders may be interested in increasing their power. However, it is also possible for them to be moved by a desire to help their subjects, either through economic, medical (i.e., as defined by purely by patient-centered pragmatism) or generally utilitarian means, and thus apply one of those criteria instead.

The final group to consider is patients. Perhaps those who themselves feel the need for a diagnosis generate the diseases. Individual patients are not well placed to generate disease types, but groups of patients are. Perhaps disease types are created by groups of patients in particular states finding others like themselves and joining together to enhance their medical clout. Chronic-fatigue syndrome, a disease that receives much more attention from its sufferers and their supporters than from the medical community, may be an example of this phenomenon (with its legitimacy as a diagnosis from this perspective hinging on whether patients have the requisite authority to construct diseases).

What criteria might patients as a group apply in constructing disease types? Although patients as a group (i.e., all those with the same (potential) disease) are deeply enough involved in the practice of medicine to have the influence to generate diseases types, they seem to lack many of the relevant interests. They are poorly placed to introduce instrumentally useful diseases. They are unlikely to (consciously) favor the ruling class as such. Even utilitarianism, although an option, is problematic. Patients as a group might take into account the good of society as whole in deciding whether to enshrine their problem as a disease, but it is

not clear why they would; this would require a high degree of coordinated altruism. It seems likely, then, that patients as a group would only implement patient-centered pragmatic criteria for generating diseases, keeping their own interests in mind as they decide whether to ratify their disease.

Groups / Criteria	Physician-scientists	The ruling party	Patients as a group
Medical instrumentalism	▓		
Patient-centered pragmatism	▓	▓	▓
Utilitarianism	▓	▓	
Marxism		▓	
Totalitarianism	▓	▓	

Figure 2. The varieties of type constructivism.

The rows of this table represent the different criteria that can be used to construct disease types, and the columns represent the various groups that can be empowered to apply these criteria in constructing disease types. Each box in the grid represents one of our possible positions. The shaded boxes represent those we identified in the text as being plausibly occupied.

As I said at the beginning of this section, the two axes illustrated in fig. 2 provide all the distinctions among anti-realists necessary for further discussion. I would note here, however, that there are in fact several other distinctions that can be made among anti-realist positions. First, one can pose the same questions, "who?" and "how?", about the construction of disease tokens. This would yield a four dimensional grid taking into account positions on both types and tokens. Furthermore, for any given cell on such a grid, we can distinguish between strong and weak versions of such a constructivism. A strong constructivism says that a patient cannot have a given disease, regardless of how it is constructed, unless she has that diagnosis officially bestowed upon her by a medical professional. Weak constructivism allows that even undiagnosed patients who meet the requirements have the disease. Finally, the exact structure of one's account of disease anti-realism may vary depending on whether one takes a top-down or bottom-up approach; that is, whether one considers types or tokens to be logically prior. Beyond pointing out these further distinctions here, however, we will not address them.

3.4 Positions in the Literature

We have now completed our overview of constructivist positions and can turn to specific accounts. Note that what follows is not an exhaustive review of the literature, but rather a discussion of writers who are clearly anti-realists by our criteria and can help illustrate the positions staked out in the last section. Other writers, such as Stempsey [1999], give strong indications of being anti-realist in our sense without making clear what specifically they intend, and thus are not dealt with here.

Perhaps the earliest, as well as most completely presented, modern anti-realist is Lester S. King. In discussing disease types he describes the position he endorses in explicitly constructivist terms. "[A] disease is created by the inquiring intellect, carved out by the very process of classification, in the same way that a statue is carved out of a block of marble by the chisel strokes of the sculptor" [1954, p. 200]. Nothing could be clearer. Similarly, one page later he says that "we carve out whatever disease patterns we wish, in whatever way we desire" [p. 201]. We may even be able to clearly identify King as an anti-realist about tokens. One of his primary arguments for anti-realism is the downgrading of some former "diseases" to the status of symptom. Thus, fever, pleurisy and jaundice, once considered independent diseases, are now considered symptoms only. According to King, this shift occurred through reconstruction of the relevant diseases, or rather, the deconstruction of some diseases, such as jaundice, and the construction anew of others, such as cholangitis and the various forms of hepatitis. If at some points in history jaundice, or the various states underlying it, could be a disease and at other points not, with the shift occurring on pragmatic (as we shall soon see) and not realist, grounds, then the choice in a token patient to identify yellow skin and elevated blood bilirubin as a disease (jaundice) is itself pragmatic. The choice could just as well have been made to identify elevated bilirubin, liver inflammation, and biliary tree infection as the disease (cholangitis).

Next we move to the criteria used to construct diseases for King. Here again he is reasonably explicit. "A disease ... is a complex pattern ... which ... usefully organize[s] experience" [p. 202]. And, "'[u]sefulness' means not only the practical taking-care of patients, but also the intellectual facility with which we can assimilate new discoveries and observation" [p. 201]. This seems to be what we have called medical instrumentalism, especially if we assume that one of the side-effects of being able to "assimilate new discoveries and observations" will be the ability to take care of patients.

The only question King does not explicitly address is that of which group applies this criterion. However, as we saw above, only the group of physician-scientists is well-placed to apply medical instrumental criteria, so, although he is not explicit about it, we can reasonably identify this as King's group. We can thus fully identify King as a constructivist who holds that physician-scientists apply medical instrumental criteria in creating diseases.

The most persistent anti-realist is H. T. Engelhardt. In a series of papers [1980; 1984; 1985] he presents a consistent anti-realist position. Any number of quotations can be adduced to demonstrate his anti-realism, at least regarding disease types. Consider the following quotations: "I hold [that nosologies, and particular disease phenomena, have their boundaries invented, not discovered] because of the impossibility of designating certain physiological phenomena as pathological without invoking evaluations" [1985, p. 58]. (The bracketed phrase is a quotation from the same page.) Furthermore,

> [c]linical medicine is not developed in order to catalogue disease *sub specie aeternitatis*, but in order for physicians to be able to make more cost-effective decisions with respect to considerations of morbidity, financial issues, and mortality risks, so as to achieve various goals of physiologically and psychologically based well-being. [1984, p. 36]

Finally, "[o]ne should develop classifications of diseases with a view to maximizing the achievement of the goals of treatment and prevention" [1985, p. 67], and, similarly, "[d]iagnostic reality is then a pragmatic construct in the sense that a diagnosis is selected ... on the basis of the likely consequences of holding it to be true, which consequences include ... goods and harms to the lives of patients" [1980, p. 45].

These quotations, with their frequent references to the invention of nosologies and the pragmatic nature of medical diagnoses, clearly show that Engelhardt is an anti-realist about diseases. In particular, he appears to be a patient-centered pragmatist, concerned as he is with "physiologically and psychologically based well-being" as well as "goods and harms to the lives of patients." It is, however, also possible that he is a utilitarian, since he says that the consequences to be considered in selecting diagnoses "include" effects on the patient, and also makes reference to "cost-effective decisions." However, given that the cost-effectiveness citation ends with the focus on "physiologically and psychologically based well-being," I think that "patient-centered pragmatist" is the best designation for Engelhardt. Regarding our other primary question regarding anti-realists, namely, who determines the criteria, I find no indication in Engelhardt as to which position he takes. Engelhardt also does not explicitly consider disease tokens.

Another explicit anti-realist is Ralph Gräsbeck. For him "[t]he diagnosis of pulmonary tuberculosis is ... a pragmatic choice" [1984, p. 57]. He is here talking about a token diagnosis, but he is equally explicit regarding types:

> [E]verybody has his own disease ... The categorization of diseases into diagnoses is based on practical considerations: We need standard patterns of dealing with our patients to put them through an established machinery of investigations, treatments and perhaps social and legislative arrangements. Laboratory medicine has to help the clinician in this classification work. [p. 57]

This passage also makes clear where Gräsbeck fits into our taxonomy of constructivists. Here again we have physician-scientists as the constructors of diseases,

but using a different criterion. Gräsbeck is a utilitarian, concerned not only with diagnosis and treatment but also, potentially at least, with "social and legislative arrangements."

Morten Severinsen, whose critiques of realism we saw in the last section, responds to these critiques with his own version of anti-realism. Regarding disease types he approvingly quotes Engelhardt's pragmatism: "disease categories ... [and] ... typologies are not *true or false* in any straightforward fashion but rather are more or less useful in the conduct of clinical medicine." [Engelhardt, 1985, p. 67, quoted in Severinsen, 2001, p. 327, emphasis in Engelhardt's original, where "useful" is also emphasized.] With regard to disease tokens his position is less clear, for, although of all the writers we are considering he is the one who most clearly distinguishes types and tokens, he does not say enough about the nature of these tokens to definitely describe his position on them. He is, however, clear about both the criteria used to construct types and the proper judges of their satisfaction. To be acceptable according to Severinsen, a disease type must provide us with successful treatments as well as other factors:

> Disease entities should be defined so as to secure a reasonably high correlation between ... the disease entity and ... certain severe consequences and complications of diseases, certain success rates of various treatments or — if the disease is undesired in itself — certain causes that are relevant to its prevention. [p. 328]

Furthermore, consequences and complications (i.e., "premature death, pain, impairment or disabilities" [p. 328]) are included here because this helps diagnoses assist us in such tasks as "preparing for a life with a disability or an impairment, or in the case of a premature death in a family, arranging matters with regard to children. In addition, it may be relevant to take the cost of treatment into account" [p. 328]. Finally, we must we able to reach a diagnosis of this disease not only reliably, but also "within reasonable economic limits, and with limited discomfort to patients" [p. 327]. If, in light of all the patient-centeredness of all of his other criteria, we understand Severinsen's economic concerns as being with a patient's ability to pay, and not macroeconomic impact, we have here a statement of patient-centered medical pragmatism. As for the "who," Severinsen is again clear. "It is the responsibility of medical research to determine which disease definitions are best." It again falls to the physician-scientist to set the rules.

To find an anti-realist who does not rely on physician-scientists we must turn to Ivan Illich. First, his anti-realism: "All disease is a socially created reality ... we are prisoners of the medical ideology in which we were brought up" [1976, p. 166]. Although Illich here is probably referring to disease types, his anti-realism appears to extend to tokens as well. For, he describes the patient confronting a physician who is armed with this socially created reality thus: "His sickness is taken from him and turned into the raw material for an institutional enterprise. His disease is interpreted according to a set of abstract rules in a language he cannot understand" [p. 170]. We have here really two disease tokens. The first is

the token the patient identifies, which he had picked out from among his sufferings and experiences as the problem he feels needs attention. The second is the token as seen by the physician, who uses the predetermined disease types to interpret and label the patient's experiences, although the experiences so interpreted may not be quite the same ones the patient himself was concerned with. Both of these token kinds are clearly anti-realist, so whichever we consider, Illich is an anti-realist. However, according to Illich it is the latter physician identified token that wins out and is relevant to the enterprise of clinical medicine. And what is the goal of this "institutional enterprise"? How does it construct its diseases? For Illich "disease [is] an instrument of class domination" [p. 171]. Whichever diseases will best "put the worker in his place" [p. 171] are the diseases to be used by medicine. As for who generates the diseases that are used by medicine, here Illich is less clear. He claims that "one branch of the elite [physicians] was entrusted by the dominant class with autonomy in [disease's] control and elimination" [p. 159]. What he does not tell us is whether this autonomy extends also to creating diseases. Certainly physicians seem best placed to do this, but perhaps their colleagues in the elite, "the university-trained and the bureaucrat[s]" [p. 171] did not trust them with so much power. Perhaps the elite as a whole create the medical diseases best suited to maintaining their dominance. If this is Illich's position, he does not explain how they do this. However, even if he leaves this power in the hands of physicians, it is still not the physician-scientist, i.e., the physician *qua* scientist and in association with scientists, but the physician *qua* elite, who is in control of diseases.

It is impossible to end this list of anti-realists without citing the most famous anti-realist of all, albeit one to whom we will not return in our analysis. In *War and Peace*, Tolstoy, describing Natasha's illness, presents the clearest, and most well-written, statement of the anti-realist creed:

> [T]he simple idea never occurred to any of [the doctors] that they could not know the disease Natasha was suffering from, as no disease suffered by a live man can be known, for every living person has his own peculiarities and always has his own peculiar, personal, novel, complicated disease, unknown to medicine — not a disease of the lungs, liver, skin, heart, nerves, and so on mentioned in medical books, but a disease consisting of one of the innumerable combinations of the maladies of those organs. [1942, pp. 726-7]

3.5 Arguments for Anti-realism

Now that we have seen the range of positions which may be and are endorsed by anti-realists, let us assess them. What arguments can be mustered for and against anti-realism in medicine? We will start, as before, with the pro arguments. Why be an anti-realist? Interestingly, those anti-realists who argue in favor of their position (as opposed to those, like Severinsen [2001] who only argue *against* realism) do so in a relatively limited, focused, manner. None gives their overriding rationale for being anti-realist about diseases. Nonetheless, I take it that they

all share more or less the same motivations. While talk of disease entities works well on paper (or in PowerPoint), it is difficult to maintain this abstraction when confronting actual patients. Although in straightforward cases it may be easy to assign a diagnosis and consider the issue closed, in most cases that require any thought or investigation one is struck by the feeling that one is confronting an unbelievably complex system (the patient) with a derangement that is all its own and requires, ideally, a specially tailored therapy, which will properly mesh with all of the variables in question and not only those that are most obviously similar to some large group of other patients. Gräsbeck perhaps comes closest to presenting this argument when he notes that "no two persons (except perhaps identical twins) really have the same disease" [1984, p. 57]. The argument here, which he does not make (he identifies the above quotation as his "thesis") is that to have the same disease, two patients must be the same in every regard. This is not quite the same as the motivation we started with. Gräsbeck requires an argument that identity of patients in all respects is a prerequisite for identity of their diseases. We simply require the sense that the variety of ways in which a patient can present is so large that there is no reason to believe that it is ever repeated, even in identical twins. In short, when confronted with the variety presented by actual patients, one may come to doubt, medical texts notwithstanding, whether there are any real disease types, whether any two patients are joined in this way. Anti-realism thus takes seriously the individuality of each patient. This, of course, is not an argument for anti-realism. It is, however, a motivation, and a powerful one.

The specific arguments actually raised in favor of anti-realism can be divided into two types: those based on the goals or practice of medicine, and those based on more general philosophical considerations. Gräsbeck provides an example of the former type just prior to the above quotation. He points out that the reason we diagnose a patient as having tuberculosis (his example), as opposed to immune deficiency (which allowed the tuberculosis bacillus to overrun the patient's lungs) or poverty and starvation (which caused the immune deficiency) is that of these potential diagnoses, only tuberculosis lends itself to specific medical therapy. This evidence from actual medical practice shows, according to Gräsbeck, that the choice of diagnostic categories, not only which one we will use in this case, but also which ones we will recognize as legitimate, is purely pragmatic.

Although this appears to be Gräsbeck's main argument for his pragmatism, there is no reason for the realist to accept it. First, we do not identify diseases only based on their need for, or response to, particular medical interventions. Tuberculosis itself, like any other infectious disease, shows a wide variety of responses to different antibiotics, with some patients being cured only by one, and some patients only by another, therapeutic regimen. They are all, however, considered to have the same disease, tuberculosis, even, certainly, by pragmatists like Gräsbeck. The realist however, has an even more powerful response to Gräsbeck. For every tuberculosis, which appears to form a therapeutically pragmatic type, the realist can display diseases that appear to have, or have had at the beginning, no therapeutic value. Many diseases are identified before any form of therapy is available.

In fact, this is probably the rule, as the identification of a new disease is usually the impetus to search for an effective treatment (assuming that the disease is thought to require treatment). SARS, AIDS and lupus are all recognized diseases that were identified and accepted without any therapies being available or in the offing. Even the cause and mode of transmission was not initially known in at least some of these cases, so that even such interventions as quarantine, which Gräsbeck indicates would be a sufficient therapy for his pragmatic purposes, would not be available. In the face of so many apparent counterexamples, the realist has no reason to read the case of tuberculosis as Gräsbeck does. The point here is not that there is no way to understand AIDS, SARS, etc., as pragmatically constructed categories, but rather that the simple realist reading of these cases more than balances Gräsbeck's pragmatic reading of the case of tuberculosis and that therefore they cannot provide the proof that he wants. Nor can Gräsbeck argue that before therapies are identified, any disease-designation is merely tentative, for this would imply that such uncontroversial diseases as Huntington's disease, Tay-Sachs, many cancers and genetic diseases are only tentative. Tuberculosis itself was identified before any effective treatments were available, when, furthermore, we could do more about nutrition than about bacteria. Indeed, it would imply that there are no untreatable fully accepted diseases. Therapy will work no better as a pragmatic criterion for disease identity than cause will for a realist.

Engelhardt provides two more arguments from the goals and practice of medicine. The first one argues from the goal of medicine. Consider this passage, part of which we saw above:

> Clinical medicine is not developed in order to catalogue disease *sub specie aeternitatis*, but in order for physicians to be able to make more cost-effective decisions with respect to considerations of morbidity, financial issues, and mortality risks, so as to achieve various goals of physiologically and psychologically based well-being. Thus, clinical categories, which are characterized in terms of various warrants or indications for making a diagnosis, are at once tied to the likely possibilities of useful treatments and the severity of the conditions suspected. The employment of a particular taxon in a classification of clinical problems presupposes, as a result, a prudential judgment with respect to the consequences of being right or wrong in the circumstances. [1984, p. 36]

The goal of medicine is pragmatic; therefore, its tools, including its nosology, must share in this pragmatism. As it stands, of course, this is not an argument against disease realism. It could be that whereas clinical medicine (as Engelhardt understands it) does not categorize diseases *sub specie aeternitatis*, some other science in the vicinity of medicine does or could. That Engelhardt takes his claim to be stronger than this, to be a denial of the possibility of real diseases, we can see from the statement of his we quoted above (which appears almost verbatim in both his [1980] and [1985], thus temporally bracketing the argument quoted

above) to the effect that "disease categories ... [and] ... typologies" are neither true nor false in any straightforward sense, but more or less useful. No allowance is made for a parallel realist concept of diseases.

Unfortunately, although merging these two claims makes the assertion stronger, it does not make the argument stronger. The disease realist is here in the position of a theoretical physicist confronted by a civil engineer. The fact that the engineer does not now, and perhaps never will, have any use in his bridge building for quarks is not an argument against the existence of elementary particles.

One way such an argument from the goals of medicine might appear to be useful is if it were specifically used as a reply to the no-miracles argument we discussed earlier. To a realist who argues for the reality of diseases from the success modern medicine has had while using disease concepts, an anti-realist following Engelhardt might retort that modern medicine is a pragmatic practice, and therefore the diseases it has had so much success with are themselves pragmatic, and not realist, entities. Since the realist has argued for her position based on the success medicine has had with the diseases clinically used, it is not open to her to appeal to another domain (i.e., a realist, scientific but not clinical, practice) in search of real diseases.

This response to the no-miracles argument, however, will not work. For, it amounts to no more than a restatement of the anti-realist's credo; it is not an independent argument. The anti-realist claims that the success of modern medicine is the result of selecting pragmatically useful categorizations. The realist responds that our ability to make such repeatedly useful categorizations is a miracle unless the world really is the way these "pragmatic models" suggest. That the no-miracles argument has problems we saw above. This, however, is not one of them.

The prime example of Engelhardt's second argument is rheumatic fever. Rheumatic fever is diagnosed based on the Jones Criteria, with what might be called the "Chinese-menu" method. One has rheumatic fever if one has two of five major manifestations of the disease (such as arthritis and a rash), or one major manifestation and two of five minor manifestations (such as fever and electrocardiographic changes). Why precisely this number of signs or symptoms and not more or fewer? Engelhardt [1985, p. 66] claims that it is because at this point treating such patients becomes pragmatically prudent. Similarly, Engelhardt claims, the recognition of appendicitis as a disease type, despite its varying etiologies, is also a pragmatic decision. Diagnosing appendicitis allows us to determine an effective course of action, surgery, which does not vary based on the etiology of the appendiceal infection.

We met with the appendicitis case earlier as an objection to realism, so here it will suffice to remind ourselves that its force relies on the assumption that the only proper criterion for a realist to use in distinguishing diseases is cause. Since we already noted that realists are best off avoiding causal versions, we see that the strongest versions of realism can account for the disease called "appendicitis" just as well as Engelhardt's pragmatism can; the relevant parts of the patient's state can be the same even if the cause is not. The rheumatic fever example requires a somewhat different response. Only if the presence of the req-

uisite number of manifestations is constitutive of rheumatic fever do we have a truly pragmatic entity under Engelhardt's account. The realist, however, may understand the manifestations merely as a pragmatic guide to the presence of a real disease, rheumatic fever, which we are unable at the current time to directly detect through a straightforward diagnostic test but for which the realist can adduce many of the same arguments, from success, etc., as he can for any other (real) disease. Indeed, this appears to be how the American Medical Association and the American Heart Association understand the criteria: "The [Jones] criteria were established to guide physicians in the diagnosis of acute rheumatic fever and to minimize its overdiagnosis" [Anonymous, 1992, p. 2069], and not, apparently, to define rheumatic fever. The use of the Jones Criteria thus does reflect a pragmatic streak in medical practice, but not necessarily in its ontology.

Engelhardt also provides an argument of the second, more philosophically based, kind. To understand this argument we must note that in the debate between normativists and naturalists about the meaning of "disease" in general, Engelhardt is a normativist, in particular, one who ascribes significant evaluative meaning to the word "disease." Based on this assumption, that the overall notion of disease is itself evaluative, Engelhardt asks, how could its component parts not be as well? "[N]osologies, and particular disease phenomena, have their boundaries invented, not discovered] because of the impossibility of designating certain physiological phenomena as pathological without invoking evaluations" [1985, p. 58]. (Again, the bracketed phrase is a quotation from the same page.) The problem with this argument is obvious. It is, at best, only open to one who agrees with Engelhardt's particular understanding of "disease." Furthermore, as we discussed in the beginning of this chapter, the entities in question in any ontological study of medicine are not parts of an antecedently defined domain of disease. Rather, they are ontologically independent entities which might or might not meet the criteria (whatever they may be) for being diseases in the sense that Engelhardt is discussing here. That these criteria may be evaluative is irrelevant to our current ontological concerns.

Two further "philosophical" arguments for anti-realism were covered in our discussion of realism and so I will just mention them here. First, the anti-realist may say that diseases, perhaps because they are not material, are not even potentially real entities. Second, the anti-realist may point to the different responses to therapy of two patients with the "same" disease. If the diseases in question belong to the same natural kind, why do they react differently to the same therapy?

Although it may seem that there should be more, and more forceful, arguments for disease anti-realism, their relative paucity is not surprising. The most convincing argument, to anti-realists, at least, is cumulative and implicit. Anti-realists take the absence of an acceptable argument for/account of realism to be adequate support for their position. They place the burden of proof on the realists, and I suspect that realists, on some level, accept this. For this reason, although they certainly provide some positive arguments, most of the anti-realist effort goes into attacking realist arguments. Placing the burden of proof on one's opponents is

not without its risks, even if they accept it. Although it relieves one of having to produce a demonstration of one's position's correctness, one must constantly be alert to, and respond to, new arguments from the other camp. Passing on the burden of proof leaves one's victory always tentative.

This assumes, however, that this balance of forensic trade is reasonable. Should anti-realists be allowed to avoid providing strong positive arguments for their case? Ultimately, locating the burden of proof is a matter of intuition. If the debate were a draw, which candidate would win the election? Only if there is agreement on both sides can the burden of proof be placed on one side or the other. It seems that in our case such an accord may be reasonable. We saw in our consideration of realist accounts that even for those inclined to realism, a description of their ontology was difficult to articulate. Disease tokens were radically different from anything else in the world, and, although we deferred the issue at the time, our epistemic access to them was problematic. Nor was it clear, whatever their nature, that diseases could form natural kinds. In the absence of strong reasons to believe in disease entities, naïve metaphysics would seem to rule them out, even for those of generally realist inclinations. Nor, again in the absence of realist proofs such as the no-miracles argument, does anything in our experience of the world force a belief in these queer entities upon us. Thus, the argument from ontological strangeness emerges as one of the primary supports of anti-realism.

3.6 Arguments against Anti-realism

Having considered pro-anti-realist arguments, both explicit and implicit, we can now turn to the arguments against anti-realism. I take these to be four in number, three of which can be found in at least some form in the literature. The first argument, which, again, we will only mention at this point, is the no-miracles argument we discussed in the section on realism, and again briefly in this one. The second argument against anti-realism is one Temkin raises based on what he calls "the danger of ... *aeipatheia*, perpetual illness" [1961, p. 641]. If, as Temkin takes anti-realists to be saying, disease tokens can be and are freely constructed by taking a subset of the state of the person in question and identifying that as her disease, then everyone, at every time, is at least potentially ill; if some constructivist identifies some part of the patient's state as being a disease, then suddenly she has a disease. Since, Temkin says, being in a physiological state is the only prerequisite for part of that state being identified as a disease, everyone is perpetually at risk for contracting such an "instant disease." Temkin finds this idea of perpetual, universal illness, the impossibility in principle of perfect, unquestionable, health, to be highly implausible.

There are several potential responses to this objection. The first is that it relies on a questionable intuition. It is not at all obvious that perfect health *is* a possibility. Even the healthiest person is subject to occasional aches and pains, which may be signs of underlying, albeit possibly minor, disease. Why should mortals be able to achieve perfection in health when they cannot achieve it in any

other domain? Some people may appear to be in "perfect" health, but this is not the same as perfect health.

Second, the objection ignores the fact that anti-realists cannot identify diseases in patients arbitrarily. Whoever identifies a disease in the patient is bound by certain interests in claiming that a disease is present — the patient's personal concerns in the one case and the various criteria for types in the second case. Merely being a physiological state is not adequate for that state's being a disease. The substates of those in "perfect" health may not be susceptible to being identified as anti-realist disease.

Third, as an objection directed at anti-realists, it is particularly weak. Many anti-realists (though not necessarily all) will likely believe that the distinction between the relevant senses of disease and health is likewise constructed and that there is no a priori reason that the distinction cannot in fact be drawn to encompass any given person.

Finally, and from our perspective most importantly, the objection does not take into account the distinction between medical conditions and diseases that we made earlier. This is because the objection could not work if phrased in terms of medical conditions as we described them at the beginning of this chapter, and which are the true subject of our investigations here. For, what objection could it be to anti-realism that it implies that everyone, at least potentially, has a medical condition? Medical conditions are neutral to the distinction between disease and health, however it is drawn. There is no reason to think that everyone does not have at least one medical condition. From this, however, it does not follow that everyone has a disease and that indisputably perfect health is therefore unobtainable. Temkin's objection relies on the assumption that every anti-realist construction is a disease, thus falling into one of the traps we explicitly avoided by changing our terminology (albeit temporarily) to "medical condition," when we noted that although medical conditions did not necessarily outstrip the diseases, they might. Thus, if Temkin finds an anti-realist medical condition in every person, this is no threat to good health.

The next argument against anti-realism we will look at here is one which apparently lies behind objections raised by Nordenfelt and Grene. Nordenfelt, arguing against what he calls the physiological account, by which he means a nominalist refusal to accept disease types, says that communication is essential to medical practice, and that this communication could not take place without recourse to disease species (i.e., disease types). This presupposes, he says, that there are disease concepts about which we can ask, what is the ontological nature of their tokens [1987, p. 158]? Grene, after citing a prototypical statement from a medical text, concludes that "a nominalist would never have world enough or time to produce such statements." Medicine, she concludes, "presuppose[s] a belief in natural kinds" [1977, p. 79].

Both of these arguments appear to be a version of the indispensability argument, a general realist argument best known from the philosophy of mathematics. Bluntly stated, it maintains that realism, about mathematical entities or, in our

case, diseases, is indispensable to the practice of (some part of) science. Thus, Nordenfelt claims that unless there are real disease types, we could not coherently refer to these diseases. Without the ability to refer to these diseases, no medical communication between professionals could take place. Without this communication, the practice of medicine, i.e., the gain and spread of relevant information, would be impossible. But medicine is possible, so clearly we ought to be disease realists.

Grene's argument is related, but somewhat different. Although she takes an instance of medical communication, a quotation from a textbook, as her example, her concerns seem to lie at an even deeper level. Never mind communication, says Grene. We do not need a second interlocutor to raise problems for anti-realism. A nominalist could never even process the relevant data necessary for thinking about and discussing medicine.

Let us elaborate the argument here a bit more. Field describes indispensability arguments in general as "an argument that we should believe a certain claim ... because doing so is indispensable for certain purposes" [1989, p. 14]. The claim in question here is clearly that disease types exist. What is the purpose in question? "The practice of medicine" is too vague an answer, as it subsumes many different purposes — e.g., public health, medical therapy of individual patients, clinical research and basic research. As we have been concerned throughout this chapter with the philosophy of (clinically relevant) medical science, we might identify the clinical research as the purpose in question. However, even this is too general. A full account of the purpose of clinical research would involve us not only in metaphysics and epistemology, but ethics and public policy as well, and whatever answer was arrived at would undoubtedly be controversial. Let us settle for a somewhat imprecise answer that should be adequate for us here but not overly tendentious, an answer we have assumed more or less explicitly at various points in this chapter. Let us accept that the purpose of medicine (i.e., clinical research) is to learn how to predict and affect the future physical disease of people. The argument then is that it would be impossible to learn how to predict and affect the future disease of people unless there were real disease types. We can, and do, do this. Therefore, there must be real disease types.

Anti-realists have several possible replies to this argument. First, they may deny that any progress occurs of the sort real diseases are said to be needed for. While there is indeed a practice of medicine, they may say, it is not of the progressive sort realists seem to assume. Change may occur in medical practice, but this is not a result of a better understanding of nature but rather of changing needs and goals. If there is no medical progress, nothing can be indispensable to this progress.

A second anti-realist response, at least for medical instrumentalists, is to accept that medical progress of a sort occurs, but to deny that real diseases are necessary for this progress. We certainly seem to succeed in treating more patients with Legionnaire's disease now than we did twenty-five years ago. This does not, however, prove that there is any such entity as Legionnaire's disease. Rather, it shows that we are learning to make certain generalizations about the group of people we have

chosen to classify as having Legionnaire's disease. However we organize people, we will be able to make certain true generalizations about them, whether or not they form a real kind. Medicine seeks to make the *optimal* groupings for making these sorts of generalizations, not the *true* groupings, which do not exist. As support for this claim, the anti-realist may make a sort of pessimistic meta-induction. If, as the realists claim, we are currently making progress of the sort for which a handle on real kinds is necessary, then we must currently be working with real kinds. But no one claims that our current classifications are necessarily, or even probably, the ultimately correct ones. Therefore, real kinds cannot be necessary for the type of progress medicine is now making. Optimal groups, of the kind provided by medical instrumentalists and patient-centered pragmatists at least, will serve just as well.

Perhaps, to be fair to Nordenfelt and Grene, we should return to their original arguments rather than analyzing the reconstructed amalgamated argument from progress we have been considering for the last several paragraphs. Perhaps something was lost in the conversion. Let us consider Nordenfelt first. He claims that real diseases are needed for medical communication to be successfully carried out, for without real diseases, what would terms refer to? Clearly, however, Nordenfelt cannot be referring to simple communication in general, for we routinely and successfully refer to such kinds as brunettes, paperback books, and candy bars without drawing any ontological conclusions from this. Rather, he must have a particular type of communication in mind, one which apparently relies on reference to real kinds. The most plausible candidate for this type of communication is that which results in scientific progress, returning us to the generic argument we just considered.

Grene's argument likewise is inadequate under other readings. If we read her as making an argument different from the one we already considered, it would have to be as follows. Nominalistically considering only individual patients and not natural medical kinds would make it impossible to make the observations and statements medical science comprises, as there would never be enough time to list each individual case every time a kind was apparently referred to or thought of. This argument, however, will not work either. The limitation is purely human. Were our brains vastly more powerful, perhaps we could process cases individually. Our capacities place no bounds on the structure of the universe. If, however, her point is that we in fact succeed in accomplishing something with our limited capacities which we could not unless the universe comprised real medical kinds, then we have again returned to our earlier, reconstructed, argument.

The final argument against constructivism, and perhaps the most serious one, focuses on the historical plausibility of the position. The power of the various groups — physicians, patients, the ruling class — to create and impose disease constructs on the rest of the world has varied greatly over time, and even, synchronically, across societies. It is not enough to extrapolate from twentieth century Western society to the rest of history. Either one must provide detailed historical analysis to show that the constructivists' preferred group has always had the

requisite power and relationship to medicine to impose its categories on medical practice and language or one must explain how the ability to construct diseases gets shifted from one group, say physicians, to another, say patients, as societies change. It is not obvious that neither of these tasks can be met (although the first seems to me to be a particularly unpromising angle), and there can certainly be no *a priori* argument to this effect. However, it is also not obvious that one of the requisite accounts can be provided. I am skeptical, but at any rate, an essential part of a well supported constructivism would be such an account. I have been unable to find one. Yet, if the diseases recognized were constant across cultures at a time where the governing classes were weak and locally confined, for example, it is hard to see how the ruling class could be responsible for the construction of diseases then or now. How could they have done it then, and if they did not do it then, how did they acquire the means to do so now, especially without disrupting medicine? More detailed socio-historical analysis is needed, and it is not clear that it can be provided.

4 OTHER ACCOUNTS

Although the various forms of realism and anti-realism discussed above represent the vast majority of approaches to medical ontology, we will conclude this chapter with a consideration of two other approaches: mixed theories and Reznek's account.

4.1 Mixed Theories

Our discussion of realism and anti-realism considered only accounts that are realist or anti-realist about both disease types and tokens. There is, however, at least potentially, a third, mixed, position, which would be realist about disease tokens but not about disease types. On its face this seems to be a plausible position. As per the realists, there are real disease tokens in the world. These individual entities, however, do not form natural kinds, and thus must be assembled by people into constructed kinds.

I should note that I am not aware of anyone's adopting such a mixed theory (although a close reading of Engelhardt's various writings may reveal that this is ultimately the best way to understand him). However, given the gap that remains between realism and anti-realism as we have been understanding them, it is important to see whether mixed theories provide a happy medium.

What then can we say for and against mixed theories? Given that mixed theories are constructed out of components that we explicitly considered when discussing realism and anti-realism, it seems reasonable to suppose that most potential arguments for and against mixed theories were raised in the preceding two sections. It does not follow, however, that all of these arguments apply to mixed theories; the hybrid may be hardier or weaker than its pure-bred parents. Let us therefore

review the most salient arguments presented above and see how they relate to the current case.

From amont the pro arguments, mixed theories really cannot draw much support from those raised in favor of strict realism, as these tended to focus on supporting disease type-realism, leaving token-realism to draw implicit support from the truth of type-realism. Denying real types, as the mixed theorist does, thus vitiates the support straight realists were able to generate. Most significantly, the no-miracles argument is unavailable to the mixed theorist. The crux of the no-miracles argument is that without real types, we cannot account for the success of (medical) science, because only the existence of real types reflecting the underlying causal order can explain how, by identifying tokens, we can predict how they will react to various interventions. In denying real types, the mixed theorist has cut himself off from what we found was one of the strongest supports of the disease realist. Reznek's argument that it is analytically true that diseases form natural kinds is likewise useless to the mixed theorist who denies natural kinds. Similarly, Rather's consilience argument is also non-starter without real types. Indeed, not only do these arguments not support mixed theories, they are not neutral towards them either. To the extent that they are arguments that real disease types are needed to explain certain observed phenomena, they are arguments against mixed theories.

Inference to the best explanation produces a different problem for the mixed theorist. On the one hand, his adoption of real tokens implies approval for IBE, since this ultimately is what allows him to accept the existence of real disease tokens he cannot directly point to — real tokens are the best explanation for the patient's experiences and observed changes according to the mixed theorist. However, at the same time, he refuses to use IBE to generate real types to explain our observations on that level. The mixed theorist must explain why he feels that IBE is acceptable in principle, even in the realm of medicine, but specifically not in the case of disease types. Such an argument is not logically impossible, but the need to adduce it places an extra burden on the mixed theorist, one which even an anti-realist, who can simply deny the legitimacy of IBE, does not bear.

The mixed theorist does somewhat better in deriving support from the arguments for anti-realism we canvassed, since we find the same focus on supporting (constructed) types there. One class of arguments maintained that medical practice in some way or another showed that its diagnoses, its assignments of disease tokens to types, are arrived at pragmatically. Regardless of one's approach to disease tokens, as long as one accepts that disease types are constructed, as the mixed theorist does, one can adopt these arguments. Likewise, given her commitment to constructed disease types, the mixed theorist can adopt arguments for anti-realism that argued that patients' manifest individuality show that they do not fall into any real types.

The one exception to this pattern, and the one anti-realist defense the mixed theorist cannot use, is the anti-realist strategy of shifting the burden of proof, claiming that, at least in the case of diseases, the burden of proof lies with the realist. It is forensically more difficult, albeit not incoherent, for one who professes

realism within one domain under debate to claim that, in the area in which he repudiates it, it is not even a position worthy of direct confrontation.

On the con side, the situation is less sharply defined. The mixed theorist is vulnerable to some, but not all, of the arguments against both anti-realism and realism, although again, its position is closer to that of anti-realism. Thus, looking at the arguments against realism, just as we saw that the mixed theorist is unable to avail herself of the no-miracles argument, she is also not open to attack by the pessimistic meta-induction. Since the mixed theorist does not claim that there are real disease types, past "mistakes" in recognizing particular disease types cannot be brought up against her.

The mixed theorist is also not vulnerable to the problem of extremal diseases. The realist had to explain why crossing otherwise unremarkable thresholds is significant at the level of the underlying structure of the world. However, since the division of diseases into types for the mixed theorist, like the anti-realist, is constructed and not based on natural factors, there is no reason to assume that the distinction between hypertension and normotension would be apparent based solely on a consideration of physiology.

There is, however, one argument against the realist which applies at least in part to a mixed theorist as well. Although for obvious reasons, the strangeness objection to disease types does not concern mixed theories, the objection, when applied to tokens, applies to the disease tokens of mixed theories just as to those of strict realism, since they are ultimately the same. In response to this, the mixed theorist may respond, as the strict realist did, that the strangeness objection is not an argument, but only a statement of anti-realist conviction.

Switching now to the arguments raised against anti-realists, the mixed theorist shares the problem of indispensability with strict anti-realists. If real disease types are needed in order to carry out any sort of medical science because without them scientific thought and communication are impossible, mixed theories are lacking in this essential just as much as anti-realists. Mixed theories are also as vulnerable as anti-realists to the question whether any of the proposed groups with authority to construct diseases were consistently powerful enough throughout history to impose their constructs on the rest of society. The mixed theorist must provide the same answers we demanded from the anti-realist to demonstrate that their type-constructivism is plausible.

In addition to all these points derived from mixed theories' relationship to realism and anti-realism, there is a further problem with mixed theories specifically — the tension between the realist and anti-realist commitments of these theories. One who is anti-realist about types is an unlikely candidate for accepting real token entities like diseases.

Where does this leave us? Besides not solving any pressing problems for the anti-realist and drawing little of the support available to realists, mixed theories add to the burden of the anti-realist by being open to a charge of strangeness. Furthermore, there is the internal tension that develops from their inconsistency regarding IBE as well as, more generally, the oddity of both accepting and refuting

realism. Against this, we can only place the motivation for mixed theories we noted above, that one is impressed both by the real presence of a disease in individual patients and by the variability between patients. This motivation, however, seems inadequate to make up for the mixed theorist's failure to resolve any of the most pressing difficulties either realism or anti-realism faces. Mixed theories are anti-realist enough to be almost as vulnerable as anti-realists to realist attacks, while the realism they adopt weakens, rather than strengthens, their overall position.

4.2 Reznek's Blended Account

As we have noted before, most accounts of medical ontology are at best really just sketches. One exception to this is Reznek [1987]. Although we earlier identified him as an example of a process realist, this is accurate only up to a point. Reznek's fully developed theory is in fact a blend of realism and anti-realism, realist about some diseases and anti-realist about others. Let us see how this blend is accomplished and whether it in fact works.

Before we see how Reznek is not truly a realist, we must understand something about how he views the difference between health and disease. For Reznek, P has disease (or what Reznek calls "pathological condition") C iff C is an abnormal condition that requires medical intervention and that, in standard circumstances, causes P to be less able to live a good or worthwhile life [pp. 163-4].

This understanding of the nature of disease and health affects Reznek's realism by leading him to conclude that not all diseases are natural kinds. We saw earlier that Reznek takes note of extremal diseases, diseases that, like hypertension, form a continuum with normal, healthy states. Whatever the boundary between hypertension and normal blood-pressure is, there are, or at least may be, people with blood-pressures immediately to either side of the boundary. Given 1) his understanding of what it is to be a disease, 2) his apparent belief that diseases are all natural kinds and 3) his claim, which we have not seen before, that natural kinds must be discontinuous from one another either qualitatively or quantitatively, Reznek asks how we can say that hypertension, which violates #3, could be a disease. Hypertension violates #3 because it is distinct from normotension neither qualitatively or quantitatively, the decision of what blood-pressure constitutes a disease rather than a healthy state being based on an ultimately subjective judgment of what level of blood-pressure generally interferes with the ability to live a worthwhile life (according to Reznek). Rejecting the possibility we accepted for the realist, that hypertension is not a disease, as well as the possibility that the natural kind comprising both hyper- and normo- tension is a disease that everyone has to a greater or lesser degree, Reznek concludes that extremal diseases like hypertension are diseases but not natural kinds.

According to Reznek, then, what blood-pressure constitutes hypertension depends ultimately on subjective decisions about what it takes to live a worthwhile life. Indeed, were we to decide that no level of blood-pressure interferes with the ability to live a good life, the disease type hypertension would disappear. This is a decidedly anti-realist conclusion; the existence of a type, hypertension, depends

on choices we make, not on the world. Reznek is thus not a true realist, but one who accepts both real and non-real diseases. Extremal diseases are constructed, whereas all others are real. It is for this reason that I describe Reznek's theory as "blended."

Although by our criteria for distinguishing realists from anti-realists Reznek certainly blends the two, the internal tension within Reznek's position between realism and anti-realism is somewhat mitigated by his claim that although it is not a natural kind, hypertension does have an explanatory nature and thus a place in the real world. It simply does not have a nature distinct from normotension. Thus, the explanatory nature of anyone's blood-pressure is (perhaps) the kidneys' retention of sodium. Some people, namely, hypertensives, merely retain too much sodium, with the definition of "too much" being arrived at through the above described subjective process. Because hypertension has this explanatory nature, it shares certain features with diseases that are natural kinds. Thus, although for Reznek natural-kind diseases are discovered whereas extremal diseases like hypertension are constructed by deciding, for example, that a certain blood-pressure interferes with the subjective notion of a good life, the distinction between hypertension, once constructed, and other diseases is discovered. This is because although hypertension's nature is not distinct from that of normotension, it is distinct from that of tuberculosis. The natural distinction between these two explanatory natures means that the distinction between hypertension, a constructed disease, and tuberculosis, a discovered one, is itself discovered.

Regardless of the exact degree of blending Reznek engages in, any attempt to combine extreme approaches to a problem in order to arrive at an Aristotelian mean runs the risk of producing a position that inherits the weaknesses of the extremes rather than, or at least to a greater degree than, the strength of the extremes, as we saw above with mixed theories. To see how Reznek fares in this regard, we must again review the arguments pro and con as we did in the last section, although the results here are somewhat different.

Starting again with the pro-realism arguments, we note that Reznek cannot appeal to no-miracles as a full realist can. For, according to Reznek, with regard to some diseases (extremal diseases) we indeed have success despite the absence of real entities on which to base this success. Even if we accept Reznek's claim that hypertension has an explanatory nature, our ability to make correct predictions about hypertensives as opposed to normotensives is not based on a natural division, but on a constructed separation. Reznek is apparently unperturbed by the miracle that this represents to realists and therefore cannot claim that a realist account of (other) diseases is necessary to avoid invoking such miracles.

Rather's consilience argument is also problematic for Reznek for similar reasons. If any of our extremal diseases have been persistent across history, Reznek cannot claim that consilience implies realism. He would have to show that no extremal disease exhibits this consilience, a difficult task that he does not even attempt. Only then could he say that the persistence of non-extremal diseases shows that non-extremal diseases are real.

Even Reznek's own argument for realism, that it is analytically true that our diseases form real entities, is problematic for the position he ultimately adopts. Beyond the problems we noted earlier about this argument, Reznek's blended theory creates a further problem. For, in support of realism, we extrapolated from the apparently realistically motivated distinction between gout and pseudogout (and perhaps some other similar cases) to the reality of diseases in general. As we have seen, however, Reznek holds that diseases can not be said to be real in general, and therefore this extrapolation is unacceptable, since it contradicts Reznek's overall position. Unless Reznek can provide a reason why the realist conclusions we reach about gout and pseudogout should be extrapolated to all and only non-extremal diseases, the argument at best can show only that some diseases, namely those for which a direct argument of the type Reznek made regarding gout and pseudogout can be given, are real. It will not, however, support any general conclusions for Reznek.

One way in which Reznek fares better than the mixed theorists of the last section is regarding IBE. Like the mixed theorist, Reznek both accepts and rejects the application of IBE here. In the case of non-extremal diseases, Reznek, like any realist, will appeal to IBE in taking his evidence and concluding from there that there is an underlying, but not directly observable, entity. However, when it comes to extremal diseases he will deny that we need to or should use IBE. We should not take the evidence about hypertension and conclude that there is a real, underlying but unobservable, entity. Rather, we should conclude that the entity is merely constructed. However, because Reznek splits his use of IBE differently from the mixed theorist (who applied it to tokens and not to types), he avoids the problem this splitting caused for the mixed theorist. There is no conflict in his applying IBE to some diseases and not to others. After all, all realists agree that some sorts of entities are constructed and not subject to analysis via IBE, and hypertension need not be any more problematic than the U. S. Army. However, the support that IBE can offer is vitiated somewhat by Reznek's willingness to admit that for some diseases (again, extremal diseases) we can proceed without invoking IBE. Why can we not extend this methodology to other diseases? It is not clear what the relevant distinction would be.

Reznek fares even worse than the mixed theorist, however, when it comes to deriving support from arguments for anti-realism. Recall that there were three such classes of arguments. The first was Engelhardt's and Gräsbeck's arguments that medical practice shows that diagnosis is essentially an anti-realist practice. Since for Reznek, the majority of diagnostic practice is realist (indeed, tuberculosis is one of his paradigm real diseases, whose explanatory nature we understand), he can hardly argue that medical practice shows the pragmatic nature of diseases. At best, he could try to show that medical practice shows that the process of assigning a diagnosis of an extremal disease in particular is pragmatic, but again, it is not clear what the argument would be, since medical practice in assigning a diagnosis of tuberculosis does not seem to differ from that in assigning a diagnosis of hypertension; if this practice does not show that tuberculosis is a constructed

entity (since, according to Reznek it is not), it does not show that hypertension is either. Reznek's analysis may show that hypertension is a constructed entity, but medical practice itself does not seem to.

The second type of argument for anti-realism was that the individuality of patients even with the same diagnosis shows that they do not jointly form a natural kind. Since this individuality (in prognosis, response to therapy, etc.) is just as visible in non-extremal disease as in extremal diseases, Reznek clearly cannot claim that it makes an argument for his position.

Reznek cannot even gain succor from the anti-realist strategy of shifting the burden of proof to the realists. Clearly, this could not support his entire position, but only at best the anti-realist part of it. Furthermore, Reznek attempts to give arguments for both sides of his account, indicating that he does not think that one side or the other bears the primary burden of proof.

Let us now turn to the con arguments we have seen, starting with those against realism. Although Reznek is not able to use all of the realists' arguments for realism, he seems vulnerable to most of the arguments against realism, despite his transitional position. Thus, even though, like the mixed theorist, he cannot rely on the no-miracles argument, he is, this time in contrast with the mixed theorist, still vulnerable to the pessimistic meta-induction. For, just as he was deprived of the support of no-miracles because he was anti-realist about some diseases, he is open to the charges of the meta-induction because he is realist about other diseases. Any of his real diseases is as vulnerable to the meta-induction as realism generally is — the anti-realist asks, what reason would we have to believe that we are correct about *those* diseases?

Again, the realist part of Reznek's account is open to the strangeness objection just as strict realists are. If diseases are not the kinds of things which can be real in the sense we need, either as tokens or types, Reznek's realism has a problem. (Although it may be that a clear understanding of explanatory natures would make it clear that under that account of what it is to be a natural kind, diseases are eligible, thus leaving only the strangeness objection to real *tokens* standing against Reznek.)

One set of arguments against realism that Reznek is proof against are those against causal forms of realism, since there is no evidence that Reznek is a causal realist. However, this was not of primary concern to realist, since the strongest realist positions were not causal either. Reznek also does not need to worry about his own argument from extremal diseases. At the most, that argument shows that not all diseases are natural kinds, which is precisely his position.

Let us now turn to the three primary arguments against anti-realism. Reznek remains vulnerable to the charge of *aeipatheia* to the same extent as the anti-realist. According to Reznek, construction, at least to the extent of choosing what point along a continuum constitutes the division between disease and health, is a legitimate way of generating some diseases (i.e., extremal diseases), and he puts no limits, in principle, on the number of types that can be thus generated. Therefore, even under Reznek's account, any person is susceptible to being saddled with a

disease by someone's arbitrary, or at least idiosyncratic, selection of a cut-off point for an extremal disease.

To the extent that there are constructed, that is, extremal, disease, for Reznek, he is also vulnerable to the question of whether the group that defines these diseases has consistently held enough power across history and geography to maintain these constructions. At least as regards these constructed diseases, Reznek must explain how they remained constant across time. Reznek does have one avenue of response here open that is difficult for a strict anti-realist to pursue. Given the limited number of extremal diseases Reznek actually acknowledges, he can argue that none of these diseases, in fact, have remained constant over time. Perhaps anemia, hypertension, etc., were all identified after the rise of modern medicine with its authoritative physician-scientists. In that case, there is no paradox for Reznek to explain. (It would be difficult for the anti-realist to argue that *no* diseases have persisted across at least some of history.) However, even in this case, Reznek has to provide a historical argument to support this response, which he does not do.

The only argument against anti-realism from which Reznek may be shielded is that of indispensability. On the one hand, he appears vulnerable to this, because if real diseases are necessary for medical practice, how could that part of the practice that deals with extremal diseases occur? However, Reznek does claim that even extremal diseases have explanatory natures, just not such as to make these diseases natural kinds. Reznek may be able to claim that this explanatory nature allows us to communicate just as well about extremal as about non-extremal diseases, since the information about where the quantitative cut-off occurs is easy to add to the scientifically useful and available explanatory natures.

Where does this assessment leave Reznek? Most of the arguments for and against realism were designed to show that real diseases are (or are not) plausible or at least possible. Reznek needs to show that real diseases are possible just as much as any other realist does. By losing the support of the no-miracles argument, and by being vulnerable to the meta-induction and strangeness objection, he finds himself in a weaker position than (other) realists to defend the possibility of real diseases. On the other hand, even to the extent that Reznek retreats to anti-realism, we see that he has none of the motivating arguments available to him that the straight anti-realist has, while he remains open to most, if not all, of the primary arguments against anti-realism.

We may ask whether there are any arguments, either for or against, which apply specifically to Reznek's account but not to either realism or anti-realism, and thus should be unique to this section. Reznek himself does not raise any pro arguments specifically for his account except for the need to deal with the problem of extremal diseases. On the other side, we can raise against him a similar charge to that which we raised against the mixed theorist, one which is really a summation of all that we have just said. One who is open to both real and constructed diseases will find it difficult to press the various arguments each side individually uses to support its case. Only if the division Reznek strikes between real and constructed

diseases exactly matches that which separates those diseases that motivate realist arguments such as no-miracles from those that motivate anti-realist ones such as variability between patients will he be free of this problem. As we saw, however, he will still have several other problems. If a safe path to medical metaphysical truth lies between Scylla and Charybdis, Reznek has failed to find it.

BIBLIOGRAPHY

[Anonymous, 1992] Anonymous. Guidelines for the Diagnosis of Rheumatic Fever: Jones Criteria, 1992 Update, *JAMA* 268: 2069-2073, 1992.

[Cartwright, 1983] N. Cartwright. *How the Laws of Physics Lie*. Oxford: Clarendon Press, 1983.

[Ellis, 2001] B. D. Ellis. *Scientific Essentialism*. Cambridge: Cambridge University Press, 2001.

[Ellis, 2002] B. D. Ellis. *The Philosophy of Nature*. Montreal & Kingston: McGill-Queen's University Press, 2002.

[Engelhardt, 1980] H. T. Engelhardt, Jr. Ethical Issues in Diagnosis, *Metamedicine* 1: 39-50, 1980.

[Engelhardt, 1984] H. T. Engelhardt, Jr. Clinical Problems and the Concept of Disease, in Nordenfelt and Lindhal (eds.), *Health, Disease, and Causal Explanation*. Dordrecht: D. Reidel, pp. 27-41, 1984.

[Engelhardt, 1985] H. T. Engelhardt, Jr. Typologies of Disease: Nosologies Revisited, in Schaffner (ed.), *Logic of Discovery and Diagnosis in Medicine*. Berkeley, CA: University of California Press, pp. 56-71, 1985.

[Field, 1989] H. Field. *Realism, Mathematics and Modality*. Oxford: Blackwell, 1989.

[Fodor, 1974] J. Fodor. Special Sciences, *Synthese*, 28: 97-115, 1974.

[Gräsbeck, 1984] R. Gräsbeck. Health and Disease from the Point of View of the Clinical Laboratory, in Nordenfelt and Lindhal (eds.), *Health, Disease, and Causal Explanation*. Dordrecht: D. Reidel, pp. 27-41, 1984.

[Grene, 1977] M. Grene. Philosophy of Medicine: Prolegomena to a Philosophy of Science, *PSA 1976*, vol. 2, pp. 77-93, 1977.

[Illich, 1976] I. Illich. *Medical Nemesis: The Expropriation of Health*. New York: Pantheon, 1976.

[King, 1954] L. S. King. What is Disease, *Philosophy of Science*, 21: 193-203, 1954.

[Kitcher, 1993] P. Kitcher. *The Advancement of Science*. New York: Oxford University Press, 1993.

[Kitcher, 2001] P. Kitcher. *Science, Truth, and Democracy*. New York: Oxford University Press, 2001.

[Kripke, 1980] *Naming and Necessity*. Cambridge, MA: Harvard University Press, 1980.

[Laudan, 1981] L. Laudan. A Confutation of Convergent Realism, *Philosophy of Science*, 48: 19-48, 1981.

[Lifton, 1986] R. J. Lifton. *The Nazi Doctors: Medical Killing and the Psychology of Genocide*. New York: Basics Books, 1986.

[Maxwell, 1955] J. C. Maxwell. *A Treatise on Electricity and Magnetism*, 3^{rd} edition. London: Oxford University Press, 1955.

[Niiniluoto, 1991] I. Niiniluoto. Realism, Relativism, and Constructivism, *Synthese*, 89: 135-62, 1991.

[Nordenfelt, 1987] L. Nordenfelt. *On the Nature of Health*. Dordrecht: Reidel, 1987.

[Parsons, 1951] T. Parsons. *The Social System*. New York: Free Press, 1951.

[Psillos, 1996] S. Psillos. Scientific Realism and the "Pessimistic Induction", *Philosophy of Science*, 63: S306-14, 1996.

[Putnam, 1975] H. Putnam. The Meaning of "Meaning", in *Mind, Language and Reality: Philosophical Papers, Volume 2*. Cambridge: Cambridge University Press, pp. 215-71, 1975.

[Putnam, 1979] H. Putnam. "What is Mathematical Truth," in *Mathematics, Matter and Method: Philosophical Papers, Volume 1*, 2^{nd} edition. Cambridge: Cambridge University Press, pp. 60-78, 1979.

[Rather, 1959] L. J. Rather. Towards a Philosophical Study of the Idea of Disease, in Brooks and
 Cranefield (eds.), *The Historical Development of Physiological Thought.* New York: Hafner,
 pp. 353-73, 1959.
[Reznek, 1987] L. Reznek. *The Nature of Disease.* London: Routledge & Kegan Paul, 1987.
[Severinsen, 2001] M. Severinsen. Principles Behind Definitions of Diseases – A Criticism of the
 Principle of Disease Mechanism and the Development of a Pragmatic Alternative, *Theoretical
 Medicine*, 22: 319-36, 2001.
[Smart, 1963] J. J. C. Smart. *Philosophy and Scientific Realism.* New York: Humanities Press,
 1963.
[Stanford, 2003a] P. K. Stanford. Pyrrhic Victories for Scientific Realism, *Journal of Philosophy*,
 100: 553-72, 2003.
[Stanford, 2003b] P. K. Stanford. No Refuge for Realism: Selective Confirmation and the History
 of Science, *Philosophy of Science*, 70: 913-25, 2003.
[Stempsey, 1999] W. E. Stempsey. *Disease and Diagnosis: Value Dependent Realism.* Dor-
 drecht: Kluwer, 1999.
[Suppes, 1970] P. Suppes. *A Probabilistic Theory of Causality*, Amsterdam: North Holland
 Publishing Company, 1970.
[Teeman, 2006] T. Teeman. Inside a Mind Set to Explode, *The Times.* July 29, Features, 18,
 2006.
[Temkin, 1961] O. Temkin. The Scientific Approach to Disease, in Crombie (ed.), *Scientific
 Change.* London: Heinemann, pp. 629-47, 1961.
[Tolstoy, 1942] *War and Peace*, Tr. L. and A. Maude. New York: Simon and Schuster, 1942.
[van Fraassen, 1980] B. C. van Fraassen. *The Scientific Image.* Oxford: Clarendon Press, 1980.
[Virchow, 1895/1958] One Hundred Years of General Pathology, in *Disease, Life, and Man,
 Selected Essays. Translated and with an Introduction by Lelland J. Rather.* Stanford, CA:
 Stanford University Press, 1895/1958.
[Whitbeck, 1977] C. Whitbeck. Causation in Medicine: The Disease Entity Model, *Philosophy
 of Science*, 44: 619-37, 1977.
[Worrall, 1989] J. Worrall. Structural Realism: The Best of Both Worlds?, *Dialectica*, 43: 99-
 124, 1989.
[Worrall, 1994] J. Worrall. How to Remain (Reasonably) Optimistic: Scientific Realism and the
 "Luminiferous Ether", *PSA 1994*, vol. 1, pp. 334-42, 1994.

THEORIES AND MODELS IN MEDICINE

R. Paul Thompson

1 PRELIMINARIES

The terms, "theory" and "model" have multiple meanings in everyday discourse, so some clarification at the outset is in order. In this chapter, "model" means a description of the ontology[1] and dynamics of a physical system; this can be achieved using ordinary language but is most often achieved by identifying variables and specifying, mathematically, the relations among the variables and how the variables change over time. Mathematical models have many advantages over ordinary language models. Mathematical models are precise (i.e., the ambiguities and vagaries of ordinary language are removed), there are a large number of mathematical domains on which one can draw (topology, probability, infinitesimal calculus, set theory and the like) and powerful deductive machinery can be harnessed.

Some models describe a large system; these involve a large number of variables and equations. Usually, such models can be decomposed into sub-models which describe sub-systems. Some models describe a single aspect of a system such as Bolie's insulin-glucose model (see below) which describes one endocrine system among many. Ideally, a collection of these single aspect models can be aggregated into a larger unifying model, at which point they are best described as sub-models of the integrating model. Theories[2], as understood in this chapter, are large models with a level of generality that integrates many sub-models, guides hypothesis formation, underpins explanation and prediction, supports counterfactual claims, and determines the relevance of evidence. Broad integrative models such as are found in endocrinology, immunology and neuroscience have the requisite level of generality to be deemed theories; although useful, Bolie's insulin-glucose model does not.

In this chapter, I use the term "medical science" as a contrast with "clinical medicine". There, of course, is no sharp division between these aspects of medicine;

[1]The ontology of a system is the collection of entities believed to exist (e.g., DNA, proteins, amino acids and the like) and their properties and their physical relationships to each other (e.g., proteins are strings of amino acids). Dynamical relationships are expressed by a set of equations.

[2]There are two broad conceptions of the structure of scientific theories: a syntactical conception and a model-theoretic (semantic) conception. I am an advocate of the model-theoretic conception, see [Thompson, 1983; 2007]. Nothing in this chapter hangs on which conception one adopts.

Handbook of the Philosophy of Science. Volume 16: Philosophy of Medicine.
Volume editor: Fred Gifford. General editors: Dov M. Gabbay, Paul Thagard and John Woods.

interactions between them occur frequently. In some respects, the interactions mirror those between chemistry and physics on the one hand and the application of chemical and physical knowledge and theorising in engineering on the other. For example, medical sciences are more focused on underlying mechanisms, as is chemistry and physics, while clinical medicine is more focused on applications; that is, improvements in diagnosis, and determining safety and efficacy of prophylactic and therapeutic interventions dominate research in clinical medicine; discovering and describing underlying mechanisms dominates research in medical sciences. At different periods in medicine's long history the pendulum has swung between an emphasis on the clinical and the emphasis on the theoretical/mechanistic (see [Duffin, 1999; Pomata, 2005; Siraisi, 2007; Rawcliffe, 1995; Wartman, 1961; Estes, 1989]. Today, under the umbrella of medicine, areas as diverse as microbiology and family practice co-exist; the worlds inhabited by researchers and clinicians in the disparate fields, however, are very different in goals, methods, practices, motivations and conceptual assumptions. The focus in this chapter is on medical science.

Models and theories — expressed mathematically — are ubiquitous in medical sciences. Three examples are provided here; they have been chosen to illustrate important aspects of models and theories in medicine. The first is an example of a simple model. The second is an example of a more general and complex model. Both these models can be subsumed under a more general dynamical model. The third is an example of the transition from a model of a single phenomenon to an incipient theory; also, a sub-model is described and its value sketched. After setting out these examples, I draw out, by reference to them, the salient features of models and theories in medicine. The precision allowed by such mathematical models is important to scientific research but the main philosophical points about models and theories that these examples underscore can be grasped without a detailed grasp of the mathematics.

These examples illustrate, in part, the four central philosophical theses expounded in this chapter. First, theories, in medicine and other sciences, integrate a large body of knowledge by describing mathematically a dynamical system. Second, in part because of the first, models and theories support counterfactual claims (predictions in medicine are instances of counterfactual claims; at the point the prediction is made the circumstances described have not occurred). This feature has two corollaries: that exploring the dynamics of models and theories can lead to new knowledge, and that models and theories enable us to manipulate nature — a central role of engineering and of clinical medicine. Third, models and theories are essential to providing robust explanations (answers to "why-questions"); the results of randomised controlled trials cannot underwrite explanations, notwithstanding the current emphasis on them in clinical medicine. Fourth, models and theories are the basis for any interpretation or correction of empirical observations. That models and theories in medicine have these roles, as they do in the natural and biological sciences, makes clear that a significant amount of medical research is deeply connected to the rest of science and shares the theoretical depth,

sophistication and explanatory power of those sciences.

As a final preliminary comment, I note that exploring the history of medicine (which is beyond the scope of this chapter) underscores the value of models and theories in medicine. The evolution of scientific knowledge and the methods, conceptual tools and reasoning that science (including medical science) employs is inextricably connected to the increasing use and refinement of models and theories. The dawn of the use of models and theories reaches back to at least the period of Greek science and medicine, see [Clagett,1966]. From Hippocrates, through Galen, Harvey and a host of others, to the present, theory and model construction has been pivotal to the evolution of modern medicine. Today, as in the past, theories and models are integral to medicine and its advancement; they provide, in a way randomised controlled trials (RCTs) do not[3], the mechanistic dynamics1 that we currently accept as accounting for observed medical phenomena.

2 MODELS IN MEDICAL SCIENCE: THREE EXAMPLES

2.1 Bolie Model of Insulin-Glucose Regulation

Understanding insulin-glucose regulation is essential to the clinical management of regulatory failure such as diabetes. In 1960 Bolie [1960] provided a simple but powerful model of the regulatory dynamics. The chief role of insulin is to mediate the uptake of glucose into cells. A deficiency of, or a decreased sensitivity of cells to, insulin results in an imbalance of glucose uptake, resulting in severe physiological problems, which if untreated lead to kidney, eye and nervous system deterioration and ultimately to death. In the case of juvenile-onset *diabetes mellitus*, one way of maintaining a glucose balance is a long-term schedule of daily doses of insulin. Understanding the dynamics of the regulatory system has allowed considerable refinement to this therapeutic regime.

Bolie's model assumes only three entities (glucose, insulin and extracellular fluid) and identifies nine variables:

[3]RCTs may reveal connections among events but they do not answer the question, "why are these events connected?", see [Cartwright, 2007; Thompson, 2009]. RCTs have some value in determining safety, efficacy and secondary effects of pharmaceuticals and of lifestyle choices (diet, exercise and the like) but only models and theories provide the dynamical underpinnings that allow us to understand **why** the pharmaceutical or lifestyle choice is safe, efficacious and **why** certain secondary effects occur. RCTs, as currently employed, have come under considerable criticism of late, see [Ashcroft, 2002; Bluhm, 2005; Borgerson, 2005; Cartwright, 2007; Howson and Urbach, 1989; Kravitz, 2004; Salsburg, 1993; Schaffner, 1993; Upshur, 2005; Worrall, 2002].

Extracellular fluid volume V
Rate of insulin injection I
Rate of glucose injection G
Extracellular insulin concentration $X(t)$
Extracellular glucose concentration $Y(t)$
Rate of degradation of insulin $F_1(X)$
Rate of production of insulin $F_2(Y)$
Rate of liver accumulation of glucose $F_3(X,Y)$
Rate of tissue utilization of glucose $F_4(X,Y)$

The last four rates are functions on X and Y at specific times. Bolie developed two dynamical equations: one expressing the rate of change in insulin over time assuming a specific rate of insulin injection, the other the rate of change in glucose.

Insulin: $dX/dt = (I - F_1(X) + F_2(Y))/V$

That is, the change in extracellular insulin concentration with respect to time equals the rate of insulin injection minus the natural rate of its production minus the rate of its degradation, all divided by the volume of extracellular fluid. The division by the volume of extracellular fluid means the change in insulin is express as a change per unit volume of extracellular fluid.

Glucose: $(dY/dt) = (G - F_3(X, Y) - F_4(X, Y))/V$

That is, the change in extracellular glucose concentration with respect to time equals the rate of glucose injection minus the rate of liver accumulation of glucose minus the rate of tissue utilization of glucose, all divided by the volume of extracellular fluid.

This is an excellent example of a model of a single phenomenon. Useful though it is, it describes a single regulatory system in isolation from other such systems. Today, this system is embedded in our understanding of homeostatic (self-regulating) endocrine systems more generally. Another much more complicated self-regulating system is provided in example 2 below. The more general and more abstract model of self-regulating systems of which these are instances is a low level theory. When the interactions among many of these systems is described using a model, as it is in modern endocrinology, that model is best understood as a robust general theory from which sub-models (and sub-systems such a Bolie's) can be extracted.

2.2 Example 2: The Menstrual Cycle

The menstrual cycle is not restricted to humans but medical science has provided the most in-depth and physiologically embedded advances in understanding the cycle — its hormonal, biochemical, physiological and evolutionary dynamics. Cycles that are more or less coincident with the day (circadian), the month (circalunal) and the year (circannual) began to be studied vigorously in the 1960s. Indeed, it is appropriate to date its inception at 1960, when the Coldspring Harbour Symposium on circadian rhythms was held.

Any standard textbook on internal medicine, physiology or endocrinology will contain a description of the dynamics of the menstrual cycle. For those interested in a medical textbook account, *Harrison's Principles of Internal Medicine* [Braunwald, 2001] provides a clear and succinct account. The normal menstrual cycle is an activator-inhibitor system with a feedback complex. The cycle is divided into two phases: a follicular phase and a luteal phase. The cycle — the onset of one menstrual bleed to the onset of the next — is 28 days ± 3. A normal bleeding period is 4 days ± 2.

The entities of this system are chemicals (e.g., gonadotropins, ovarian steroids and many others as set out below), cells (e.g., granulosa lutein cells, theca leutin cells) and organs (e.g., the hypothalamus, the pituitary, the ovaries). The key chemicals are:

Progesterone as its name suggests, it acts principally to prepare the uterus for zygote (fertilised ovum) implantation and gestatation. It is a 21-carbon steroid secreted by the corpus luteum.

Androgens a variety of 19-carbon steroids synthesised in the ovaries. The major one is androstenedione, of which some portion of the production is converted to oestrogen in the granulosa cells and testosterone in the interstitium.

Oestrogen a steroid produced by developing follicles in the ovaries as well as the corpus luteum, the placenta and, although of less importance in menstruating women, other organs. Both follicle-stimulating hormone (FSH) and luteinizing hormone (LH) stimulate the production of oestrogen. Oestrogens are synthesised in the theca cells in the ovaries. **Estradiol** is the major oestrogen in humans.

Follicle Stimulating Hormone (FSH) and **Lutenising Hormone** (LH) glycoprotein hormones synthesised in the gonadotrope cells of the anterior pituitary.

Inhibin a hormone secreted by the dominant (maturing) follicle. It inhibits the release of Follicle Stimulating Hormone (FSH) by the hypothalamic-pituitary complex.

Gonadotropin-releasing Hormone (GnRH): a hormone that regulates the synthesis and secretion of FSH and LH.

There are numerous other chemicals but focusing on these permits a sketch of the normal menstrual cycle to be given.

> ... At the end of a cycle plasma levels of estrogen and progesterone fall, and circulating levels of FSH increase. Under the influence of FSH, follicular recruitment results in development of the follicle that will be dominant during the next cycle.

After the onset of menses, follicular development continues, but FSH levels decrease. Approximately 8-10 days prior to the midcycle LH surge, plasma estradiol levels begin to rise as the result of estradiol formation in the granulosa cells of the dominant follicle. During the second half of the follicular phase, LH levels also begin to rise (owing to positive feedback). Just before ovulation, estradiol secretion reaches a peak and then falls. Immediately thereafter, a further rise in the plasma level of LH mediates the final maturation of the follicle, followed by a follicular rupture and ovulation 16-23 hours after the LH peak. The rise in LH is accompanied by a smaller increase in the level of plasma FSH, the physiological significance of which is unclear. The plasma progesterone level also begins to rise just prior to midcycle and facilitates the positive feedback action of estradiol on LH secretion.

At the onset of the luteal phase, plasma gonadotropins decrease and plasma progesterone increases. A secondary rise in estrogen causes a further gonadotropine suppression. Near the end of the luteal phase, progesterone and estrogen levels fall, and FSH levels begin to rise to initiate the development of the next follicle ... [Braunwald, 2001, p. 2157]

This succinct description of the process makes clear the feedback and activation-inhibition processes involved. A more direct description of some of these is given earlier in *Harrison*.

The secretion of FSH and LH is fundamentally under negative feedback control by ovarian steroids (particularly estradiol) and by inhibin (which selectively suppresses FSH), but the response of gonadotropins to different levels of estradiol varies. FSH secretion is inhibited progressively as estrogen levels increase — typical negative feedback. In contrast LH secretion is suppressed maximally by sustained low levels of estrogen and is enhanced by a rising level of estradiol — positive feedback. Feedback of estrogen involves both the hypothalamus and pituitary. Negative feedback suppresses GnRH and inhibits gonadotropin production. Positive feedback is associated with an increased frequency of GnRH secretion and enhanced pituitary sensitivity to GNRH. [Braunwald, 2001 p.2157]

The mathematical description of this activation-inhibition and feedback system draws on complicated mathematical domains and techniques that render a complete account in the context of this chapter inappropriate; readers with a strong mathematical background should consult [Edelstein-Keshet, 1988; or Murray, 1993]. Here I provide a sketch of the mathematical description. In essence, as already indicated, the entities (the ontology) of the system are chemicals, cells and organs. Their properties are imported from biochemistry, cell biology and physiology.

The fundamental dynamics are expressed as rate equations where x and y are chemicals in interaction; and, they are continuously rising and falling:

$$dx/dt = f_1(x, y)$$
$$dy/dt = f_2(x, y)$$

A non-trivial steady state of the system is (x, y). In a two dimensional phase plane xy, the nullclines for x and y will be:

$$f_1(x, y) = 0$$
$$f_2(x, y) = 0$$

The steady state (x, y) is the intersection point of the curves.

Differentiating both sides of these equations with respect to x yields the slope of the nullcline $f_1 = 0$ at some point P, and the slope of the nullcline $f_2 = 0$ at some point P. It is the point of intersection of these two nullclines that defines the steady state in the phase space. In a couple of deductive steps one can derive four partial derivatives evaluated at (x, y). These can be arranged in a Jacobian[4] square matrix. The signs for the partial derivatives in this Jacobian are determined by the mutual effects that interacting chemicals have on each other. Since, in most cases in the menstrual cycle the chemicals have pairwise interactions, the interactions can be modelled as a two chemical system. Hence, the sign patterns of the partial derivatives in the Jacobian can be specified as:

Activator-inhibitor system

$$\mathbf{J}_1 = \begin{pmatrix} + & - \\ + & - \end{pmatrix}$$

This pattern of signs indicates that chemical 1 has a positive effect (an activation effect) on its own synthesis and that of chemical 2; whereas, chemical 2 has a negative effect (an inhibitory effect) on its own synthesis and that of chemical 1. Using the same meaning of the matrix of signs:

Positive Feedback system

$$\mathbf{J}_2 = \begin{pmatrix} - & - \\ + & + \end{pmatrix}$$

Negative feedback system

$$\mathbf{J}_3 = \begin{pmatrix} + & + \\ - & - \end{pmatrix}$$

The systems with their signs can be expressed graphically. For example, the positive feedback system is graphically represented in an xy phase plane as:

[4]A Jacobian determinant (or Jacobian for short) is named after the Prussian mathematician Carl Gustav Jacobi (1804-1851). A Jacobian is a matrix of partial derivatives.

Chemical x

Chemical y

This modelling allows a clear understanding of the steady state of the system as well as the rates of change driven by the interaction of the chemicals. It also makes possible predictions about how external interventions will affect the behaviour of the system (for example, a prediction about what will happen if plasma levels of oestrogen and progesterone at specific points in the process are artificially increased by a human external intervention such as taking birth control pills). As a result, this mathematical model of the menstrual cycle has enabled a significant refinement of the dosage and timing of external interventions to alter oestrogen and progesterone levels during the menstrual cycle to achieve control of ovulation.

2.3 Example 3: Epidemics (Plagues)

Mathematical modelling of epidemics can be traced back to three papers [Ross and Hudson, 1916; 1917a; 1917b]. They begin with an expression of surprise:

> It is somewhat surprising that so little mathematical work should have been done on the subject of epidemics, and, indeed, on the distribution of diseases in general. Not only is the theme of immediate importance to humanity, but it is one which is fundamentally connected with numbers, while vast masses of statistics have long been awaiting proper examination. But, more than this, many and indeed the principal problems of epidemiology on which preventive measures largely depend, such as the rate of infection, the frequency of outbreaks, and the loss of immunity, can scarcely ever be resolved by any other methods than those of analysis. [Ross and Hudson, 1916, pp. 204-05]

These are seminal papers which were drawn upon by Kermack and McKendrick in two foundational papers [1927; 1932]. Some of the key elements of models of epidemics were identified in these early papers — for example, partitioning the population into those susceptible, those infected and those immune. An epidemic results from a high rate of change in the numbers of those moving from susceptible to infected.

As contemporary researchers have shown (see, for example, [Halloran, 1998; Anderson and May, 1979; May and Anderson, 1979]), using this partitioning of

the population, the dynamics of the system can be described by three differential equations:

$$dX/dt = -IX = -cp(Y/N)X$$
$$dY/dt = cp(Y/N)X - vY$$
$$dZ/dt = vY$$

X is number of susceptible people

Y is number of infected people

Z is number of immune (non-susceptible)

I is the incidence rate

N is the size of the population

v is the recovery rate

c is the rate of contact

p is the transmission probability

This model takes all the essential factors into account (in a closed population) but substantial sophistication can still be added. For example, "c" can be refined. Within a population, groups do not exhibit random contact; sub-populations tend to have higher intra-group interactions than inter-group interactions. This can be formulated by indexing c, such that c_{ij} denotes contact rate of members of group j with members of group i. Contact among members with a group (intra-group) is assumed to be random. Contact of sub-group members between two groups (inter-group) is not. The intra-group and inter-group contacts can be represented by a matrix:

$$C = \begin{pmatrix} c_{ii} & c_{ji} \\ c_{ji} & c_{jj} \end{pmatrix}$$

Intra-contacts are c_{ii} and c_{jj}, and c_{ij} and c_{ji} are inter-group contacts.

Additional factors can be added such as the number of new cases an infectious person is expected to generate (R_0). The more variables and parameters included the more robust and realistic the model will be. R_0 depends on contact rate, probability of transmission and duration of infectiveness (d): hence, $R_0 = cpd$. R_0 equals the cases expected to be produced but usually one also needs to know the symmetrical value, namely, the probability that some susceptibles will be infected: that is, the incidence rate I. The differential equations describing the dynamics require that this value be determined. The incidence rate I will be a function of contact, probability of transmission and prevalence at a particular time:

$$I(t) = cpP(t)$$

At this point, the entities of the system (people) have been specified, as have the characteristics of the entities: infected people, susceptible people and immune people. Also the dynamics of the system have been expressed in the three differential

equations, and we have a way to determine the values of the key variables such as I.

Although there are no criteria for when a model is robust enough to satisfy all the roles of a theory, at some point that will happen. By adding R_0, to this model based on the partitioning of the population, the various roles of a theory come into play. With an additional partitioning of X, those susceptible, into vaccinated (hence with reduced susceptibility) and non-vaccinated[5], the *desiderata* of a theory will have been met. Further additions will increase the robustness and utility of the model/theory. What is also obvious is that this model can be applied to systems with entities other than people, such as closed populations of other mammals.

Realistic model construction has to take into account that, increasingly, populations fail to be closed with respect to disease transmission; for one thing, globalisation is accelerating the contact rate between populations. There are two ways to recognise this. The simpler, from the point of developing a model and applying it, is to regard what was once a single relatively closed population as a sub-population of a much larger closed population. This, however, will not adequately handle entries into a population through births and departures through deaths. The other is to remove the constraint of closure and add to the dynamics of the systems. In this way, mobility into and out of a particular population — and each of three partitioned groups within it — through immigration, emigration, tourism and the like as well as births and deaths can be taken into account. This requires a level of complexity in describing the dynamics that that adds no value to this exposition of theories and models in medicine.

One feature of note, however, is the utility of an equilibrium equation in describing the dynamics of open systems; an equilibrium equation could be added to the dynamics of closed populations but is unnecessary and has significantly diminished utility. The equilibrium equation plays the same role in descriptions of the dynamics of open populations as the Hardy-Weinberg equilibrium in population genetics, where migration in and out of population, births, deaths, etc. also have a fundamental effect on the behaviour of the system over time. Amplifying this briefly to draw attention to the conceptual importance of equilibrium equations, in population genetics, locations on a chromosome (loci) are occupied by alleles. At any specific location, different allelic forms can occur. With paired chromosomes, as are found in the nuclei of somatic cells of almost all animals, alleles are paired and their joint influence determines, in whole or part, a characteristic of the adult organism. What Hardy and Weinberg demonstrated mathematically was that the proportion of alleles remains constant after the first generation **unless** a factor like selection occurs. In effect the principle means, "if nothing happens, nothing will happen — nothing will change." Newton's first law is also an equilibrium principle: everything remains in a state of rest or rectilinear uniform motion **unless** acted upon by an external unbalanced force. In other words, if nothing happens,

[5]Where a vaccine is 100% effective, this partition, of course, is unnecessary. However, few vaccines are 100% effective and even those that are, depend on proper administration, timing of the vaccination with respect to contact with infected persons or other vectors, and so on.

then nothing will happen.

The above is a complex (although, compared to the empirical phenomena it is modelling, it is relatively simple and idealised) mathematical model that has sufficient richness to fulfil all the desired roles of a theory. This level of complexity is not necessary, however, for a model to be an important tool within medicine as consideration of the often used Reed-Frost chain (or serial generation time) binomial model shows it is a sub-model of the more general and complex model just described. What an examination of this model demonstrates is that one is not constrained to using the most general model available; a sub-model derivable from it that encompasses all the relevant features of a particular aspect of epidemics is sufficient. Moreover, because it can be derived from the more general, more robust model, it is imbued with the same robustness, and hence the same degree of confidence. This is a crucial point to note about theories: sub-models of greater specificity than the theory are often all one needs to generate or defend an explanation of a phenomenon. The recourse made to the Reed-Frost model by researchers studying the Black Death illustrates this point well — as well as illustrating the role of theories in explanation (a role to which I return again later).

As one would expect of a simpler, less general, model derivable from the more general model, the Reed-Frost model also assumes a closed population and assumes the same partitioning of the population into three groups: susceptible (X), infected (Y) and immune (Z). Serial generation time (t) equals:

$$L + ((I + S)/2)$$

Where:

L is the duration of any latent period (expressed usually in days but it could be hours or weeks)

A is the duration of the infectious period but where there are no symptoms (a-symptomatic)

S is the duration of the infectious period where there are symptoms

The total infectious period is the a-symptomatic period and the symptomatic period ($A+S$). $L + ((I+S)/2)$ assumes that the mean point of transmission is the mid-point of the infection: $(I + S)/2$. Hence, $L + ((I + S)/2)$ expresses the mean time for transmission. In this model, transmission depends on the number of contacts; sometimes an infectious agent is so virulent and the method of transmission so effective that only one contact is required but frequently numerous contacts are required. This is a density function such that as the number of contacts increases so does the probability of transmission:

$$p = K/(N - 1)$$

where:

p is probability of transmission,

K is average number of contacts,

N is total population size.

A number of other relationships can be derived easily from these, for example, probability of avoiding transmission. Since probability ranges from 0 to 1, the probability of avoiding transmission is 1 - p (i.e., $q = 1 - p$, where q is the probability of avoiding transmission).

Although the Reed-Frost model is highly idealised and far less general than the theory from which it is derived, it is nonetheless an extremely useful explanatory model. Consider, for example, the quest for the causal agent(s) in the Black Death. Reliable first-hand accounts of the *cause* are, for obvious reasons, absent. Hence, most examinations have relied on contemporary epidemiological models and contemporary knowledge of the causes of diseases today that are similar in symptoms, spread, mortality and so on to the first-hand descriptions given of the Black Death. Examining the first-hand accounts and using current microbiological knowledge, it has long been a majority view that this was an outbreak of bubonic plague (causative agent: *Yersinia pestis*[6]). Some scholars have questioned the use of current microbiological knowledge because viruses and bacteria change characteristics over time (see [Gottfried, 1978]). Others have defended the majority view, pointing out that there is still only one serotype of *Y. pestis* (see [Twigg, 1993]. The development of the above theory of epidemics, and specifically in this case the Reed-Frost sub-model derived from it, calls the majority hypothesis into question; indeed, it provides a compelling basis for rejecting it and sidesteps the entire issue about inferences from current microbiological knowledge to epidemics in the past — even the recent past. As what follows illustrates, a model can provide substantial additional support for accepting or, as in this case, rejecting a hypothesis or explanation.'indexbubonic plague

The crux of the argument rests on the fact that based on first-hand accounts of the characteristics of the epidemic — high rates of infection, high mortality, average length of an outbreak in a region (about 8 months), increasing cases to a single peak before decaying, the rate and nature of spread, and so on - the Black Death conforms to the Reed-Frost dynamics, something bubonic plague would not have done. Susan Scott and Christopher Duncan [2001, see especially pp. 107-109] have provided an excellent account of this challenge using the Reed-Frost model. Their account (which demonstrates the crucial role models can play in understanding medical phenomena — even those in the distant past) can be sketched briefly.

Features of the Black Death are:

- It is a highly infectious lethal disease,

- Transmission was direct, person to person,

[6]For a detailed and comprehensive description of current knowledge of this disease, see [Christie, 1969].

- The mortality curve rose to a single peak and then decayed,

- The average outbreak in a geographic region (each sub-population) was 8 months,

- The long average outbreak suggests a long incubation period,

- Time between appearance of symptoms and death was short (3-5 days),

- It struck cities, towns and rural areas equally,

- With a slight favouring of summer the disease was not seasonal.

These features are all consistent with what the Reed-Frost model predicts. The same is not true of bubonic plague, some of whose features are:

- It is far less lethal than the Black Death,

- Rodents and the fleas that feed on them are a required vectors of transmission,

- It moves slowly and erratically (especially in a period before modern transport),

- Outbreaks rapidly disappear,

- It is not capable of spreading rapidly in winter (especially not over alpine passes and in cold sub-northern climates).

It is the second point — intermediate vectors (rats and fleas) and disease reservoirs (rats) — that mostly account for its lack of conformity to the Reed-Frost model.

This example makes clear how a specific sub-model derived from a more general theory can be used to narrow the range of potential causative agents, especially in the early stages when rates of transmission and geographical dispersion are all that is known. The example focuses on an epidemic in the past but the analytical and methodological features are exactly the same when a current epidemic is being examined and explanations and predictions are being sought. That is, sub-models of the general theory are equally useful in segregating potential pathogenic causes of contemporary epidemics into those that are unlikely or impossible and those that are likely, and in yielding information about when an intervention that restricts person-to-person contact is likely to be the most effective prophylactic measure (as is the case with current — 2009 — analysis of the potential H1N1 viral flu epidemic– commonly called swine flu).

This entire arena of theorising and modelling is deep and explanatory. The above provides a glimpse into the domain, a glimpse that requires a modest mathematical background. A more mathematically sophisticated and in depth analysis of deterministic communicable disease models, with epidemiological interpretations has been provided [Hethcote, 1976]. Although a considerable amount of important work has been done since then, this is an excellent point of departure for anyone interested in the field.

3 MODELS AND THEORIES IN MEDICINE: FEATURES AND FUNCTIONS

A fundamental goal of the sciences (including medical science) is to understand how nature works, often with an eye to controlling nature. To understand how things work, one must uncover the dynamics underlying observable phenomena. At the most elementary level, the task begins by probing nature and observing the response. Where one observes regularities, these can be codified and an elementary single-aspect model can be developed. Bolie's insulin-glucose model is an example of this. There is a vast amount that such models do not tell us about the dynamics of specific phenomenon. In Bolie's model, for example, we do not find answers to questions about how the rate of insulin production is controlled or why the glucose accumulates in the liver and what factors determine and/or affect the rate of accumulation. Models at this level of generality, however, do answer a few important questions. Bolie's model does answer questions about how insulin and glucose levels are related and how a change in certain other rates will cause changes in insulin and glucose levels.indexhomeostatic systms

Sometimes the move to a higher level of generality comes by expanding the scope of the model through further empirical investigation. More variables and equations are added to the model to describe additional regularities. Bolie's model might be expanded, for example, to include entities and relationships involved in insulin production in the islet of Langerhans in the pancreas. This process of model expansion is exemplified by the gradual expansion of the model of epidemic spread. As in that case, this process can lead to a model that is sufficiently general that it fulfils all the conditions required for a model to be deemed a theory — conditions I will discuss more fully below. This transition to a theory can be considered evolutionary.

Sometimes many elementary models of specific phenomena are constructed somewhat independently. At some point, a person or persons constructs a model that subsumes all these models; they become instances of higher-level dynamical processes and all the previously disparate domains are unified in a single revolutionary step. In the limit, someone constructs a model with a few very high-level generalities such that all other models in that domain are derivable from it — i.e., are sub-models of it. Newton's and Darwin's theories are considered instances of this; their respective domains were all of physical mechanics and all of evolutionary dynamics.

Examples in medicine are not of the all-encompassing character assumed to be the case with Newton's theory until the twentieth-century. An example of a unifying model in medicine is the construction of models of self-regulating systems (homeostatic systems) which, in endocrinology for example, subsumes the insulin-glucose system as well as the menstrual cycle and many other hormonal systems such as the TSH-thyroxin system. These all become instances of a more general dynamical process. What distinguishes them is not the dynamics of the processes but the specific elements involved and the complexity of the interactions; as seen

above the menstrual cycle is more complex than Bolie's model (for one thing, the menstrual cycle case involves several self regulating sub-systems).

Whether a theory arises through an evolutionary or a revolutionary path, one of its key functions is to unify (integrate) a large body of knowledge about the dynamics underlying phenomena. The integration of a large body of knowledge about the dynamics underlying phenomena is a function only a theory-level model can perform. Clearly the pivotal phrase here is "large body of knowledge". It can be grounded in two complementary ways. First, the body of knowledge that has been integrated is deemed "large enough" if it allows all the functions of a theory (discussed below) to be satisfied. Second, it must encompass all the knowledge of the dynamics of a broad domain of inquiry — e.g., immunology, endocrinology and neurobiology. If the domain of inquiry is hormones, a theory-level model must provide the dynamical basis for all hormonal systems. This sets a generality-floor for theory-level models. Obviously, if someone constructed a model that integrated knowledge in immunology and endocrinology, this would be a theory-level model; indeed, it would be one that brought into existence a fundamentally new domain of medical science.

Unification and integration of a large body of knowledge is the hallmark of theories but they, along with less general models, play many other roles in science. I now turn to a detailed examination of these other roles of theories. For the most part, these other roles can be also be played by models with a level of generality below that of a theory. The greater the level of generality, however, the more robust will be the use of the model.

Theories are used to support counterfactual claims. Counterfactual claims are common; "if you jump off this 200 metre cliff, you'll be dead" is an example. Since you have not made the jump and are still very much alive, the claim is "counter to the facts" of the situation. Some counterfactual claims, like the one just given, are often accepted on simple inductive grounds; in **all** the **previous cases** of people jumping from such a height, they have died on impact. Induction, however, is fraught with logical difficulties, difficulties it would be best to avoid where possible. Well-confirmed theories allow one to avoid simple induction in assessing a counterfactual claim. In the current example, Newtonian Mechanics (determining speed on impact, vector forces on the body, etc.) coupled with a sub-model of physiological theory related to blood circulation, bone plasticity limits, cell membrane elasticity limits and the like deductively entails death under normal circumstances. Moreover, if the circumstances are not normal — the person is wearing a parachute for example — the theory can include that and entail a different outcome.

Consider the model of the menstrual cycle given above. Based on the model, one can claim, "If the frequency of secretion of gonadotropin-releasing hormone (GnRH) is artificially increased in a female, the sensitivity of the pituitary gland to GnRH will be enhanced, gonadotropin production will be increased and follicle stimulating hormone will increase." Because the menstrual cycle model is well confirmed, this claim can be declared true even if such an intervention never oc-

curred. The value of this is obvious; physicians do not need to engage in trial and error experiments — with all the ethical issues that involves — in order to know the claim is true.

One corollary of this role of theories is that theories can be used to gain new knowledge. Often, a well-confirmed theory will allow one to derive new knowledge in the absence of observation or experiment. If one has confidence in the goodness of fit between a theory and the empirical domain to which it is intended to apply (i.e., the model is well confirmed), then exploring the dynamics of the model can reveal things not yet observed or discovered by experiment. This is especially useful when the direct observation of a phenomenon is impossible (even with a technological extension of our senses such as a computerized axial tomography (CAT) scan), or when an observation or experiment is too expensive or bafflingly complex or too dangerous to warrant doing it.

The use of the Reed-Frost model and the Black Death is an example of this. As indicated above, it is possible to discover that the Black Death was not an outbreak of bubonic plague because the Black Death conforms to the Reed-Frost model of transmission whereas bubonic plague does not. The larger model of the dynamics of epidemics set out above — of which the Reed-Frost dynamics are a sub-model — allows one to explore novel situations. For example, the rate, scope and path of geographic spread can be determined for a not-yet-encountered infectious agent arising in a location not hitherto known as a source-point. One can also determine which interventions (designed to change one or more variables) will reduce the impact of the epidemic. These cannot be determined empirically because no such event has occurred or is occurring. The immediately obvious value of using a well-confirmed theory in this way is for preparing for epidemics and determining how best to mitigate the impact of an epidemic.

A second and obvious corollary of the fact that theories support counterfactuals is that theories can be used to make predictions and, thereby, to manipulate nature. The counterfactual, "If the frequency of secretion of gonadotropin-releasing hormone (GnRH) is artificially increased in a female, the sensitivity of the pituitary gland to GnRH will be enhanced, gonadotropin production will be increased and follicle stimulating hormone will increase." is also a prediction. That prediction can be used to manipulate nature in order to achieve a goal.

The obverse of prediction is explanation. Explanations are answers to "why-questions". Only scientific theories provide the machinery for giving scientific answers to why-questions about empirical phenomena. Why-questions are requests for an account of the behaviour of a system in certain circumstances. Because a theory (or a relevant sub-model of the theory) is a description of the ontology and dynamics of a system, connecting (deductively or probabilistically) the phenomenon to be explained to a theory provides quite naturally the requested account. The stronger the confidence in the theory, the more robust the account provided. By contrast, for example, the results of randomised controlled trials (RCTs) do not answer "why" questions. An RCT might establish that pharmaceutical P results in physiological change X — that is, it establishes an association.

It, however, does not provide an answer to the question, "**why** does P result in X?" because it provides no account of the dynamics; for that, one needs to appeal to some combination of physiological theory, cell and systems theories and the like. Even if, under exceptionally constrained circumstances such as Ronald A. Fisher's agricultural trials [Fisher 1935], one can be convinced that the association the RCT uncovered is a causal association (and this would be a stretch in the case of medical RCTs), it would provide the weakest possible explanation because, in the absence of a theory, it would be an **isolated** causal claim. The robustness of explanations based on connecting phenomena to a theory comes precisely because a theory interconnects a large body of knowledge, creating a whole that is vastly more robust than any one of the knowledge claims it encompasses.

Another fundamental role of theories is interpreting and correcting observations. The overworked but clear example is the observation, on a hot day, that a stretch of asphalt pavement in the distance is wet. Thermodynamic and optical theories explain why it appears wet but actually is not. Optical theory accounts for chromatic aberrations — for example, the appearance, when using a light microscope, of colours that do not correspond to the actual colour of the object being observed. In this case optical theory allows us to correct the problem by providing a clear understanding of its causes — properties of the lenses. A simple medical example is referred pain; for example, the sensation of pain in the back when the actual physiological location of the trauma is intestinal. Neurological and physiological theories enable this phenomenon to be explained and, critical to clinical diagnosis, those theories in part ground a differential diagnosis — a diagnosis of an intestinal disorder rather than a back disorder — and they guide choices in investigative imaging. "Raw" observations — the way things appear — are frequently deceptive; this is why crude empiricism is flawed.

Consider a more complicated case, a case that also serves to reinforce the point made above about the use of theories in explanation. Some individuals manifest impaired growth and development, increased susceptibility to infection, severe abdominal pain with normal bowel sounds and no rebound tenderness, paleness and physical weakness. These symptoms are suggestive of haemolytic anaemia resulting from the sickling of red blood cells (i.e., the red blood cells are curved, like a sickle blade) — a disease commonly known as sickle-cell anaemia. In individuals with sickle-cell anaemia, the nucleotide sequence (gene), which determines the structure of the protein 'haemoglobin', codes for the amino acid 'valine' in the sixth position on the β-chain instead of 'glutamic acid' as is normally the case. This substitution, under reduced oxygen tension, results in the valines at positions 6 and 1 forming a hydrophobic association which leads to a conformation that stacks in such a way as to distort the erythrocyte and thus cause the sickle shape.

The physical symptoms described above are the result of reduced oxygen transport in the blood stream due to the conformation of the haemoglobin and deformed structure of the cells. This explanation employs (1) the theory of molecular genetics which describes, among numerous other things, how the nucleotide sequences of DNA determine the structure of proteins, (2) biochemical theory which describes

the behaviour of biochemical structures and (3) physiological models which describe the effects on the organism of reduced oxygen transport.

This disorder is endemic in certain African populations. Since a segment of DNA codes for this disorder and since those with it have a very high mortality rate and reproductive rates near zero, one would expect that individuals with the segment of DNA would fail to reproduce. Consequently, over time (a very few generations in fact), the segment should be eliminated from the population. However, the disorder persists in these African populations at about 8-11%. This persistence is contrary to expectations; given the disease profile, selection pressure against the trait is exceptionally high and as indicated, in only a few generations, its percentage representation in the population should be at or close to zero. As a result, it **appears** on the surface that some factor is overriding selection and spontaneously generating the genetic sequences underlying the trait. Contrary to appearance, however, selection is not being thwarted.

The theory of population genetics allows this appearance to be properly interpreted (corrected). This is a case of heterozygote fitness. Chromosomes in human somatic cells exist as pairs. These complementary pairs, as a unit, determine in whole or in part[7] the characteristics (traits) of the organism. Specific locations on a chromosome are called loci; at each locus there is an allele. Consequently, alleles are also paired and it is the joint action of the pair that in whole or in part determines the characteristic. There are three different forms of the allele responsible for haemoglobin production: an allele that codes for normal haemoglobin (N), a form that codes for sickle-cell haemoglobin (S) and a form that confers resistance to malaria (C)[8]. In individuals with two N alleles at that locus, the haemoglobin is normal. In individuals with two S alleles, the haemoglobin is sickle-cell and the disease will be manifested. In individuals with one N and one S allele (a heterozygote), there is a mild, non-debilitating, anaemia. These individuals have another characteristic — a significant immunity to malaria. Hence, in areas of where both the *Plasmodium falciparum* parasite[9] and the anopheles mosquito[10] are prevalent, the heterozygote NS or SN (order doesn't matter) is fitter than NN or SS; only CC is fitter than NS.

The NN has a high risk of being compromised by, and dying from, malaria; the SS will be compromised and die of sickle-cell anaemia. The NS has significant protection from both. Cavalli-Sforza and Bodmer (1971) (see also, Livinstone, 1967) have estimated the fitnesses as: NN = 0.9, NC = 0.9, CC = 1.3, NS = 1.0, CS = 0.7, SS = 0.2. Individuals with NN or NC are susceptible to malaria, but do have sickling red cells. CC and NS individuals are resistant to malaria and have little (CC) to mild (NS) sickling. CS individuals have significant sickling with

[7]In many cases more than one locus is involved in the production of a trait and there are a number of developmental factors at work as well. In this case, haemoglobin is the product of one locus and development factors do not seem significant.

[8]The C allele is recessive to both N and S. Hence, a CS individual will manifest sickle cell anaemia.

[9]The species of the *Plasmodium* parasite that is most often responsible for severe malaria.

[10]The anopheles mosquito is the specific mosquito that transmits the *Plasmodium* parasite.

anaemia. SS individuals have severe sickling and severe anaemia. As a result, the breeding population in each generation will consist of a high proportion of the heterozygous individuals (i.e., NS and CS individuals, with considerably more NS than CS).

In reproduction, each parent will contribute one allele to the offspring. The sub-population of individuals that are NS will, on average, produce 25% NN offspring, 50% NS and 25% SS:

Male sperm

		S	N
	S	SS	SN
N	NS	NN	

Female ova

offspring allelic combinations

Since, SN/NS individuals will fare better in malarial environments, they will constitute a high percentage of the reproducing individuals. Also, 25% of their offspring will be SS individuals. Contrary to appearances, in this medical disease, selection is active and the theory of population genetics can be employed to demonstrate that it is.

CONCLUDING REMARKS

As should be clear at this point, I consider the construction and employment of models and theories essential to medical science in the way they are widely recognised to be in the natural and biological sciences. They provide an essential unification of knowledge. They underwrite prediction and explanation. They make possible in medicine the manipulation of nature, which is a *raison d'etre* of clinical medicine, one that parallels that of engineering in the manipulation of physical nature. Given this, it is not surprising that theories and models are ubiquitous in medical science. What is somewhat surprising is the lack of attention given to this fact in medicine. The explanation of this lack of attention is multifaceted.

The explanation, in part, lies in differences in the historical development between medicine, and the physical and biological sciences. The founding revolutionary moments in the natural and biological sciences were importantly theoretical (Galileo, Newton, Einstein, Heisenberg, Priestley, Lavoisier, Prigogine, Darwin, Fisher, Haldane, Wright, and Watson and Crick to point to just a few examples). As a result, in physics, chemistry, astronomy and biology, theorising and model building are part of the fabric of the science; almost all departments have a theory group. Medicine's origins are more empirical and applied. Today and throughout its history, clinical practice and medical research have been inextricably amalgamated. Physics and its engineering applications complement each other but the

research endeavours remain largely separate, and the motivations and methodologies in each area differ in clear and important ways; the same is true of biology and its biotechnological applications. In medicine, this separation is largely absent and clinical applications dominate, resulting in tensions of motivation, swings of methodological commitments and relegation of theorising to the sidelines.

Another part of the explanation lies with philosophers. Even though there is a wealth of interesting epistemological, metaphysical, logical and methodological issues to explore, philosophy of medicine has been underserved by philosophers. In my view, two factors have contributed to this neglect. First, epistemological, metaphysical and logical aspects of medicine have been swamped over the last 40 years by a fascination with ethical issues. Second, the rapport between philosophers and medical professionals has been minimal. For the most part neither has taken much interest in the work of the other. In ethics, that has changed as a result of social, political and legal changes that thrust ethics onto the medical stage, amid strong resistance from some quarters of the medical profession. But, even here, philosophers are one among many "experts" to enter the fray. Lawyers, theologians, physicians, sociologists, criminologists and the like have entered as well; the "bioethics" tent is a very large and diverse tent indeed.

Yet another part of the explanation rests on the disproportionate amount of public, political, sociological and economic interest that is focused on clinical medicine, which has increasingly been dominated by pharmacological intervention and lifestyle modification. Although the theories and models of biochemistry, physiology, endocrinology and the like are employed in the development of a pharmaceutical product, the public, regulatory and marketing emphasis is on randomised controlled trials. Contrary, however, to the impression to which this disproportionate interest in RCT-based medical research and practice gives rise, it is, in fact, a small corner of medicine; high-quality clinical medical research itself encompasses substantially more. More importantly to the focus of this chapter, the vast majority of medical science is deeply connected to the rest of science and shares the theoretical depth, sophistication and explanatory power of those sciences.

BIBLIOGRAPHY

[Anderson and May, 1979] R. M. Anderson and R. M. May. Population Biology of Infectious Disease: Part I, *Nature* 280: 361-367, 1979.

[Ashcroft, 2002] R. Ashcroft. What is Clincal Effectiveness? *Studies in History and Philosophy of Biological and Biomedical Sciences* 33:219-233, 2002.

[Bluhm, 2005] R. Bluhm. From Hierarchy to Network: A Richer View of Evidence for Evidence-Based Medicine, *Perspectives* 48: 535-547, 2005.

[Bolie, 1960] V. W. Bolie. Coefficients of Normal Blood Glucose Regulation, *Journal of Applied Physiology* 16: 783-788, 1960.

[Borgerson, 2005] K. Borgerson. Evidence-Based Alternative Medicine, *Perspectives in Biology and Medicine* 48: 502-515, 2005.

[Braunwald, 2001] E. Braunwald *et al* (eds.). *Harrison's Principles of Internal Medicine*, 15^{th} edition. New York: McGraw-Hill, 2001.

[Cartwright, 2007] N. Cartwright. *Hunting Causes and Using Them*. Cambridge: Cambridge University Press, 2007.

[Cavelli-Sforza and Bodmer, 1971] L. L. Cavelli-Sforza and W.F. Bodmer. *The Genetics of Human Populations*. San Francisco: W.H. Freedman and Co., 1971.

[Christie, 1969] A. B. Christie. *Infectious Diseases: Epidemiology and Clinical Practice*, 3^{rd} edition. Edinburgh: Churchill Livingstone, 1969.

[Clagett, 1966] M. Clagett. *Greek Science in Antiquity.*, 2^{nd} edition. New York: Collier Books, 1966.

[Duffin, 1999] J. Duffin. *History of Medicine: A Scandalously Short Introduction*. Toronto: University of Toronto Press,1999.

[Edelstein-Keshet, 1988] L. Edelstein-Keshet. *Mathematical Models in Biology*. New York: Random House, 1988.

[Estes, 1993] J. W. Estes. *The Medical Skills of Ancient Egypt*, revised edition. Canton, MA: Watson Publishing International, 1993.

[Fisher, 1935] R.A. Fisher. *The Design of Experiments*. Edinburgh: Oliver & Boyd, 1935.

[Gibson, 1917] J. Gibson. *Locke's Theory of Knowledge and Its Historical Relations*. Cambridge: Cambridge University Press, 1917.

[Halloran, 1998] M. E. Halloran. Concepts of Infectious Disease Epidemiology, in K. J. Rothman and S. Greenland (eds.) *Modern Epidemiology*, 2^{nd} edition. Philadelphia, PA: Lippincott-Raven Publishers, pp. 529-554, 1998.

[Hethcote, 1976] H. W. Hethcote. Qualitative Analyses of Communicable Disease Models, *Mathematical Biosciences* 28: 335-356, 1976.

[Howson and Urbach, 1989] C. Howson and P. Urbach. *Scientific Reasoning: The Bayesian Approach*. La Salle, Illinois: Open Court, 1989.

[Kermack, and McKendrick, 1927] W.O. Kermack and A.G. McKendrick. A Contribution to the Mathematical Theory of Epidemics II. The Problem of Endemicity, *Proceedings of the Royal Society of London, Series A.* 138 (832): 55-83, 1927.

[Kermack and McKendrick, 1932] W. O. Kermack and A.G. McKendrick. Contributions to the Mathematical Theory of Epidemics," *Proceedings of the Royal Society of London, Series A.* 115 (772): 700-721, 1932.

[Kravitz, 2004] R. L. *et al.* Evidence-Based Medicine, Heterogeneity of Treatment Effects, and the Trouble with Averages, *The Milbank Quarterly* 82:661-687, 2004.

[Livingstone, 1967] F.B. Livingstone. *Abnormal Hemoglobins in Human Populations*. Chicago: Aldine, 1967.

[May, 1979] R. M. May and R. M. Anderson. Population Biology of Infectious Disease: Part II, *Nature* 280: 455-461, 1979.

[Pomata, 2005] G. Pomata and N.G. Siraisi (eds.). *Historia: Empiricism and Erudition in Early modern Europe*. Cambridge, MA: MIT Press, 2005.

[Rawcliffe, 1995] C. Rawcliffe. *Medicine and Society in Later Medieval England*. Phoenix Mill, Stroud, Gloucestershire, UK: Sutton Publishing Limited, 1995.

[Ross and Hudson, 1916] R. Ross and H. P. Hudson. An Application of the Theory of Probabilities to the Study of a priori Pathometry. Part II, *Proceedings of the Royal Society of London Series A* Vol. 92, No. 638, pp. 204-230, 1916.

[Ross and Hudson, 1917a] R. Ross and H. P. Hudson. An Application of the Theory of Probabilities to the Study of a priori Pathometry. Part II, *Proceedings of the Royal Society of London Series A* Vol. 93, No. 650, pp. 212-225, 1917.

[Ross and Hudson, 1917b] R. Ross and H. P. Hudson. An Application of the Theory of Probabilities to the Study of a priori Pathometry. Part II, *Proceedings of the Royal Society of London Series A* Vol. 93, No. 650, pp. 225-240, 1917.

[Scott, 2001] S. Scott and J. C. J. Duncan. *Biology of Plagues: Evidence from Historical Populations*. Cambridge: Cambridge University Press,2001.

[Segel, 1987] L. A. Segel. *Modeling Dynamical Phenomena in Molecular and Cellular Biology*. Cambridge: Cambridge University Press 1987.

[Siraisi, 2007] N. G. Siraisi. *History, Medicine, and the Traditions of Renaissance Learning*. Ann Arbor, MI:The University of Michigan Press, 2007.

[Thompson, 1996] M. W. Thompson *et al. Genetics in Medicine*, 5^{th} edition. Philadelphia: W.B. Saunders Company, 1996.

[Thompson, 1983] P. Thompson. *The Structure of Biological Theories*. Albany, NY: State University of New York Press, 1983.

[Thompson, 2007] P. Thompson. Formalisations of Evolutionary Biology, in *Philosophy of Biology*, M. Matthen and C. Stevens (eds.) Amsterdam: Elsever, 2007.
[Thompson, 2010] P. Thompson. Causality, Mathematical Models and Statistical Association: Dismantling Evidence-based Medicine, *Journal of Evaluation in Clinical Practice*, 16: 1-9 2010.
[Twigg, 1993] G. Twigg. Plague in London: Spatial and Temporal Aspects of Mortality, in J. A. I. Champion (ed.), *Epidemic Disease in London*. London: University of London Centre for Metropolitan History, 1-17, 1993.
[Wartman, 1961] W. B. Wartman. *Medical Teaching in Western Civilization*. Chicago: Year Book Medical Publisher Inc, 1961.

REDUCTION IN BIOLOGY AND MEDICINE

Kenneth F. Schaffner

'Well! I've often seen a cat without a grin,' thought Alice;
'but a grin without a cat! It's the most curious thing
I ever saw in all my life!'
Lewis Carroll, Alice in Wonderland

1 INTRODUCTION AND TWO THESES ABOUT REDUCTION

A number of biological and medical scientists and philosophers have argued that biology (and *a fortiori* medicine) involves types of concepts and forms of explanation which are *distinct* from those employed in the physical sciences. The reductionistic alternative is to view these concepts and modes of explanation as only *prima facie* distinct and really definable in terms of (or fully explainable and perhaps replaceable by) concepts and modes of explanation drawn only from the physical and chemical sciences. The issue of reduction (and reductionism) in the biomedical sciences often provokes vigorous debate. Reduction, to a number of medical and biological scientists, often has the connotation that biological entities are "nothing but" aggregates of physicochemical entities. This can be termed "*ontological* reductionism" of a strong form. A closely related but more *methodological* position is that sound scientific generalizations are available only at the level of physics and chemistry. In philosophy of science, a major extended debate about the concept of reduction has revolved around what has been termed *intertheoretic* reduction, though I think the term is somewhat misleading. Essentially intertheoretic reduction is the *explanation* of a theory initially formulated in one branch of science by a theory from another discipline. This approach was pioneered by Ernest Nagel in a formal reduction model [Nagel, 1961], and I shall address this notion in the text below, if only to put it aside as more suitable for the philosophy of physics than for philosophy of medicine and its closely related biological sciences. (As we shall see later, the Nagel intertheoretic reduction model is a generalization of the Hempel covering law deductive explanation model [Hempel, 1948].)

This article on reduction ultimately has a focus on a high level property of an organism — here the organism's "behavior" — since if this feature of an organism can be treated reductively, which I believe it can, then lower-level features likely can be so treated as well. We shall see however, even in quite simple examples from model organisms which have been extensively characterized at the cellular and molecular level, "reductions" are virtually always partial and incomplete. If

Handbook of the Philosophy of Science. Volume 16: Philosophy of Medicine.
Volume editor: Fred Gifford. General editors: Dov M. Gabbay, Paul Thagard and John Woods.

there is a take-home lesson in this article, it is this view that reductions in biology and medicine will be partial, and essentially "interlevel", accomplishments. And though the point will be made using a simple model organism, the lesson holds, even more so, for human features that are treated in medicine, and still more so, behavioral features that are treated in psychiatry.

I will begin this article by first clearing away some potential distractions by making some distinctions. One distinction is between two kinds of reductionism. The first is what I call "sweeping reductionism," where we have a sort of "Theory of Everything" and there is *nothing but* those basic elements — for example, a very powerful biological theory that explains all of psychology and psychiatry. The second kind is "creeping reductionism," where bit by bit we get fragmentary explanations using interlevel mechanisms. In neuroscience, this might involve calcium ions, dopamine molecules, and neuronal cell activity, among other things, of the sort we will encounter in the worm example later on. Sweeping reductionism, I think, is probably nonexistent except as a metaphysical claim. There is, however, some scientific bite in trying to do something like this in terms, say, of reducing thermodynamics to statistical mechanics, or, as I will describe below, reducing optics to electrodynamics, but even these sweeping reductions tend to fail somewhat at the margins. In any event, I don't think that sweeping reductionism really has much in the way of cash value in the biological, psychological or social sciences. It's a scientific dream for some, and for others, a scientific nightmare.

Creeping reductionism, on the other hand, can be thought of as involving partial reductions — reductions that work on a patch of science. Creeping reductionism is what, for example, neuroscientists do when they make models for and propose mechanisms of particular cognitive functions. Creeping reductions do not typically commit to a nothing-but approach as part of an explanatory process. Rather, they seem to tolerate a kind of pragmatic parallelism, or emergence, working at several levels of aggregation and discourse at once. And creeping reductions are consistent with a co-evolutionary approach that works on many levels simultaneously, with cross-fertilization.

Clearing away another distraction requires distinguishing between two kinds of determinism. "Sweeping determinism," regarding a powerful theory we think might be fundamental and universal, states that given a set of initial conditions for any system, all subsequent states of the system are predictable and determined. This is what some Newtonians believed. And quantum mechanics, though it's indeterministic in the small, is essentially deterministic for bodies, like cells and organisms, that are medium-sized and larger. In the genetics area, where we focus on the presence of powerful genes (alleles) related to disorders and traits, this kind of determinism is called genetic determinism.

But sweeping genetic determinism has so far failed to be the case empirically, and sweeping neuroscientific determinisms are not yet even close for humans. And, as we shall see later in this article, there is incomplete reduction even in narrowly focused worm behaviors. What we have seen then, is "creeping," or partial, neuroscience, with determinism that may be coming. As mechanisms get elaborated,

neuroscientists will get roughly deterministic explanations for some types of behavior even in some people. And I say "roughly" because here too there will be some problems at the margins, because of both biological variation and stochasticity. Claims of sweeping determinism worry philosophers and the philosophically inclined, but a mechanical determinism of a sweeping sort has never had any ethical or especially legal relevance, so far as I know. Nobody ever brought somebody into court and said that they were mechanically determined by Newton's theory of motion.

In this article I want to elaborate on these distinctions, especially the first, and propose two theses, and then examine what the consequences of those theses might be for discussions of reduction and emergence as philosophers have discussed these notions. The first thesis is that what have traditionally been seen as robust reductions of one theory or one branch of science by another more fundamental one are largely a myth outside of some examples in the physical sciences. In the biological sciences, these prima facie sweeping reductions tend to fade away, like the body of the famous Cheshire cat, leaving only a grin, whence the epigraph to this article. The second thesis is that the grins, maybe better to say "smiles," that remain are fragmentary patchy explanations, and though patchy and fragmentary, they are *very important*, potentially Nobel-prize winning advances. To get the best grasp of them, I want to argue that we need to return to the roots of discussions and analyses of scientific explanation more generally, and not focus mainly on reduction models such as are found in the intertheoretic reduction literature.

I did not always think that the first thesis was true. Particularly in the physical sciences, it appeared that we had strong reductions that were constituent parts of actual science — and not mere philosophical quests for unified science. When I studied physics in the 1950s and 60s, thermodynamics was taught as a separate course in physics departments, but everyone knew that statistical mechanics was the science underlying thermodynamics. Similarly, there were separate courses offered in optics, but the nature of light was known to be an electromagnetic wave (at least to a good first approximation), and Maxwell's equations could be mathematically manipulated to generate a wave equation, which in turn could be used to explain various laws of optics, such as Snell's law of refraction.

Closer inspection of the explanatory process, however, revealed difficulties.[1] Though one can get Snell's law by derivation from Maxwell's electromagnetic theory, one does not obtain the entire range of Fresnel's theory of physical optics (actually theor<u>ies</u> is more accurate, since there were several models employed by Fresnel to cover all of optics — see [Schaffner, 1972]). Furthermore, to get an explanation of optical dispersion, one has to go beyond Maxwell's theory *per se* to Lorentz's electron theory. But even Lorentz's theory was not enough to account for all of physical optics, since to get an explanation of the photoelectric effect, one has to go beyond it to Einsteinian elementary quantum mechanics, and an explanation of the optics of moving bodies requires special relativity. To an extent, what we

[1]These difficulties were systematically developed in the writings of Feyerabend and Kuhn about this time, in the 1960s and 70s, and will be discussed later in this article.

see in these theory shifts from Maxwell to Lorentz to Einstein represents a partial
– a creeping rather than sweeping — approach to reduction of optics, but these
shifts can be overemphasized. In fact, Feyerabend, and especially Kuhn, seized
on these shifts and interpreted them as representing not reduction but rather
replacement of the earlier higher level theory of physical optics. That strikes me
as too extreme a view, since optics can by and large be preserved at its level,
and a very powerful general reduction accomplished by an amalgam of Maxwell,
Lorentz, and Einstein, suitably corrected. This view of theory corrections, later
termed theory co-evolution by Churchland, was sketched in my [Schaffner, 1967;
1968] essays.

These sweeping types of reductions are, as noted, rare. But they can be ex-
traordinarily powerful, as in the explication of optics by electromagnetic theory.
The logical features and explanatory strategies of that example come quite close to
fulfilling classical Nagelian reduction conditions (more about these later). Skeptics
of this kind of powerful general reduction need to examine a detailed account of
exactly how that reduction works, and also consider where departures from clas-
sical theory are needed. This can be found in two, back-to-back books by the
distinguished physicist Arnold Sommerfeld. Sommerfeld published six advanced
textbooks in the 1940s covering all of physics, which were based on his extensive
lectures on the topics delivered in the 1930s. Volume III was entitled *Electrody-
namics*, and volume IV, *Optics* [Sommerfeld, 1950a; 1950b]. The optics in volume
IV is developed reductionistically from Maxwell's theory as delineated in volume
III, and the two texts represent an in-depth extended exemplar of a sweeping
reduction. This is written in the Euclidean-Newtonian mode of entire fields be-
ing mathematically derived from a small number of integrated universal physical
laws supplemented with simple connections between the fundamental terms in the
reduced and reducing theories.

But such a comprehensive, sweeping, deductively elaboratable account seems to
be dependent on some rather stringent requirements. Both reduced and reducing
fields need to be representable in terms of a small number of principles or laws.
Also, the connections between the two fields need to be straightforward and rela-
tively simple, though far from obvious. (It is a simple and general statement that
that the electric vector *is* the light vector but it is *not obvious* — it turned out
that the identification required both experimental and theoretical arguments. Nor
it is at all obvious that light is an electromagnetic wave — Hertz's magnificent
experiments wonderfully recounted in his Introduction to his collected papers in
Electric Waves tell this clearly [Hertz, 1962/1893].) Both of these stringent condi-
tions, simple axiomatizablity and simple connectability, fail in significant ways in
more complex sciences such as molecular genetics and neuroscience, though that
they do fail, or would fail, was not necessarily foreseeable at the beginning of the
Watson-Crick era of molecular biology in the 1950s and 60s.

That one encounters creeping rather than sweeping reductions in biology, how-
ever, can be illustrated by Kandel's classical explanations of learning in the sea
snail *Aplysia* in neuroscience. The standard accounts by Kandel provide expla-

nations of some simple learning behaviors in *Aplysia*, but not *all* of *Aplysia*'s behaviors are explained. (For example, *Aplysia californicum* engages in a kind of California-style sex involving multiple partners, but I have not seen any molecular "cartoon" — a term that biologists use to describe a graphical depiction of one or more causal mechanisms in one or more pathways — describing and explaining this complex behavior). Additionally, those Kandel models are only partial neural nets and partial molecular cartoons that describe what happens to strengthen synapse connection [Kandel *et al.*, 2000]. And the Kandel cartoons (and text explanations) use interlevel language (mixing organs, cells, receptors, second messengers, and ions, among other types of entities at different levels of aggregation) — not a language involving purely chemical entities interacting with other chemical signals. So this is no robust unilevel explanation of learning — even just in A*plysia* — based solely on molecular mechanisms and chemical entities. The reasons for this have been suggested above, and include lack of any broad scope simple theories, plus the aggregated complexity of the parts of the mechanisms or models involved. Both of these reasons reflect the manner in which evolution has "designed" living organisms — by opportunistically utilizing whatever bits and pieces of mechanisms may be available and pulling them together in a Rube Goldberg assemblage — not pretty, but satisfactory if it wins in the fitness sweepstakes.

However, though we do not get sweeping reductions in the biological sciences, we do get extremely valuable potentially Nobel-prize winning progress in our explanations in terms of parts, albeit of a creeping sort. Thus, it is important to know at a general philosophical level what is occurring when we obtain these important results. The results are *like* reductions, but I think they are better described as *micro-explanations*, using that term as an alternative to reduction because the e-word does not carry the conceptual freight of various reduction models and is a more appropriate general context within which to analyze what is actually occurring in the biomedical sciences. Such explanatory reductions are in a sense *complementary* to the sweeping theoretical reductions we can find in rare instances in the physical sciences.[2] Neither impugns the character of the other, and which type of reduction one finds will depend on the structure of the disciplines and empirical results. The present paper focuses primarily on these explanatory reductions, but does so with the model of theoretical reduction as a backdrop. In point of fact, a revisiting of the well-spring of the major reduction model — that of Ernest Nagel — suggests it was a generalization or extension (but more accurately a specification) of an ancient Aristotelian model of deductive-nomological explanation — an explanation model also rediscovered by Hempel [Nagel, 1961, p. 21; Hempel, 1948]. And Nagel did write in 1961 that "reduction, in the sense in which the word is here employed, is the *explanation* of a theory or a set of experimental laws established in one area of inquiry, by a theory usually though not invariably formulated for some other domain" (p. 338); my italics.

[2]Compare Ernst Mayr on the distinction between explanatory and theory reduction in his [Mayr, 1982],esp pp. 60-63; and also [Sarkar, 1998].

2 EXPLANATION AND EMERGENCE

Discussions of reduction are typically co-paired with an account of emergence —
an almost Janus-faced philosophical topic (see [Schaffner, 1993, pp 411-422]). In
terms of explanation, one way to approach emergence is to define it as failure of
any possible explanation of a whole *in terms of its parts and their relations* (and
expressed only in the parts' language). To situate a discussion of emergence and
its relations to reduction, I want to distinguish three types of emergence:

> *Innocuous* — The parts, without a specification of the interrelations,
> do not tell you what the whole will do. Example: the parts of an
> oscillator are a resistance, a capacitor, and a coil, plus a power source,
> but the system will not oscillate unless the connections are right, i.e.,
> the connections must be specified for the parts to be an oscillator.
> This is uncontroversial. *Strong* — All the information about the parts
> and the connections will *never* allow an explanation of the whole, and
> the behavior of the whole must be observed as the whole acts as a
> whole. This view is *very* controversial; I suspect it is tantamount
> to substance pluralism. (For examples of such claims by Mayr and
> Weiss, see [Schaffner, 1993, pp. 415-417], though probably neither
> would have accepted substance pluralism as the natural implication of
> this position.)[3] This notion of emergence also seems to have been C.D.
> Broad's view — see [Broad, 1925]. *Pragmatic* — For the immediately
> foreseeable future (\sim10 years), and maybe for many years (\sim50 years),
> we do not have the analytical tools that allow us to infer the behaviors
> of the wholes (or sometimes even the next level up) from the parts and
> their connections. It is this pragmatic sense that runs through this
> article. (For related views see [Wimsatt, 1976a; Simon, 1981].)

Research into a wide range of examples in the biological and medical sciences
was summarized in an overly long (115 page) reduction chapter in my [1993] book.
The gist of this was as follows. First, in biology most purported reductions are at
best partial reductions in which corrected or slightly modified fragments or parts
of the reduced science are reduced (explained) by parts of the reducing science.
Second, in partial reductions a causal/mechanical approach (CM) is better at
describing the results than is a developed formal reduction model.

The latter model had first appeared in [Schaffner, 1967] as a general reduc-
tion model modifying some of Nagel's schema, and had then evolved into an
account which could tolerate some replacement — what I called the "General
Reduction/Replacement Model" (GRR) [Schaffner, 1977]. This GRR model, in
my [1993], however, is still seen as a good executive summary and regulative ideal
for unilevel clarified — and essentially static — science; and it also pinpoints

[3]By substance pluralism, I mean the existence of two independent substances, such as mind
and matter were for Descartes, or matter and field seemed to be for Einstein — see his comments
on Maxwell in his Autobiographical Notes, [Schilpp and Einstein, 1949, pp. 1-95].

where identities operate in reductions, and emphasizes the causal generalizations inherent in and sometimes explicitly found in mechanisms. As noted earlier, some such virtually complete reductions can in point of fact be found in the history of physics. The more common partial *reductions,* though usually termed "reduction," are, paradoxically typically *multi-level* in both the reduced and reducing sciences, mixing relatively higher entities (and predicates); with relatively lower-level entities (and predicates); it is extremely rare that there are only two levels. What happens in these "reductions" is a kind of "integration" — to use Sterelny and Griffith's term — in the sense that there is a mixing and intermingling of entities and strategies from higher level and more micro domains in a consistent way [Sterelny and Griffiths, 1999]. In some ways this integration is reminiscent of what Kitcher and Culp [Culp, 1989] termed an "explanatory extension," though I have disagreed with much of the unificatory and anti-causal baggage that such a view seems to take [Schaffner, 1993, pp. 499-500].

3 THE CONDITIONS FOR A PARTIAL REDUCTION

In attempting to return to the explanatory roots of reductions, I will begin with what distinguishes a non-reductive explanation from one that is (at least partially) reductive. One way to work toward a minimalist set of distinguishing conditions is to look at strong candidates for reductive explanations in a science of interest, for which a general reduction account is desired. The following conditions were suggested by a review of the Kandel models for *Alpysia* learning that were mentioned above. These were discussed in my 1993 book (Chapter 6), and are available in an updated and accessible form in many standard neuroscience texts, including [Kandel *et al.*, 2000]. Thus, the scientific details of those examples will not be re-presented in the current article. The general conclusion of my recent review is that successful (though partial) *reductions are* causal mechanical *explanations, if,* in addition to whatever we call adequate causal mechanical explanations (this will come later), the following three conditions hold. The first two of these are informal and the third is a formal condition that retains an important formal condition of the Nagel (and GRR model) regarding connectability assumptions:[4]

1. the explainers (or *explanans*) (more on what these are later) are parts of the organism/process; i.e., they are (partially) decomposable microstructures in the organism/process of interest.[5]

2. the *explanandum* or event to be explained is a grosser (macro) typically aggregate property or end state.

3. Connectability assumptions (CAs) need to be specified, (sometimes these CAs are called bridge laws or reduction functions), which permit the relation

[4]I will state these in the material mode, though they can be rephrased so that they refer to sentences which describe the referents.

[5]Partial decomposability has been discussed by [Simon, 1981] and by [Wimsatt, 1976a]

of macrodescriptions to microdescriptions. Sometimes these CAs are causal consequences, but in critical cases they will be identities (such as gene? = DNA sequence ?, or aversive stimulus = bacterial odor).[6]

So far I have said little about what these three conditions are conditions of, or to what account of causal mechanical explanation they need to be added, to reflect what we find in partial and patchy reductions. Before I sketch the explanation model, however, it is important to underscore a prima facie somewhat paradoxical aspect of partial reductions. This is their *dual* interlevel character.

Though possibly under appreciated, I think it fair to say that it is reasonably broadly recognized that typical reducing/explaining models are interlevel (mixing together, e.g., ions, molecules, cells, and cell networks, and not infrequently, even organs and organisms). Less appreciated, I think, is that the *reduced* theory/model is *also interlevel*, but not as fundamental or fine-structured as is the reducing model. In a long-running debate about reduction of Mendelian genetics by molecular genetics by myself, David Hull, and others, and offshoot debates among a number of others in the philosophy of biology throughout the 1970s and 1980s (see my [1993, pp. 432-487], for a summary), I do not think it was fully recognized, by me or others, that Mendel's theory of heredity was *itself* vigorously interlevel. Mendel had not only summarized his discoveries in genetics in terms of laws, but in the same article he also proposed an explanation in terms of underlying factors that segregated randomly, thus mixing in his theory phenotypes and what were later called genes.

A reduction of Mendel's laws and his process of factor segregation typically involves an appeal to entities intertwined from several levels of aggregation: cells, chromosomes, DNA strands and loci, and enzymes, so even this paradigm of reduction is also interlevel at the present time. The reduction is also partial because it is impossible (so far as I know) to account for *all* of the pea plant's phenotypes strictly in terms of molecular features and mechanisms, even in 2009.

For this article, I am going to restrict an account of my model of explanation to what might be called "local" explanations. This notion of "local" is intended to indicate that I am referring to explanations within a time slice of a field that use a currently accepted theory or class of mechanisms. I distinguish this type of explanation from "global" explanations that capture explanations across successive historical periods of scientific change — of the sort that Kuhn described as revolutions involving major paradigm change.[7]

[6]One possibility that retains what Nagel called a correspondence rule interpretation of these connectability assumptions is to use a causal sequence interpretation of the logical empiricists' correspondence rules. For how this might be further analyzed see my [Schaffner, 1969] paper on correspondence rules and also Suppe's discussion of this view in his [Suppe, 1977, pp. 104-106].

[7]This second type of (global) explanation involves what I call in chapter 5 of my 1993 book "temporally extended theories" that allow for replacement in some circumstances. Using such temporally extend theories is too complex for a first cut at getting back to the explanatory roots of reductions. This global type of explanation also involves issues of "global evaluation" (transtheoretical criteria) that need to bracketed here, though a list of those criteria and a Bayesian analysis of how they work can be found in chapter 5 of my [1993].

4 A REPRESENTATIVE PARTIAL "REDUCTIVE" ACCOUNT — WORM FEEDING[8]

What might a successful partial reduction that met these requirements look like? In this article I would liked to have presented a successful reduction of an interesting behavioral trait that would also be relevant to psychiatry as the medical science of the mind. However neither behavioral genetics nor psychiatry is currently sufficiently advanced to provide any such example. Thus we might profitably consider work on the behavior of simple organisms, especially the worm, as the simplest organism with a functioning nervous system. It is to this example that I now turn.

The anatomy, genetics, and neurology of C. elegans. This model organism, which has attracted more than 1000 fulltime researchers worldwide, received additional recognition in 2002 when the Nobel Prize in biology and medicine went to the worm: i.e., to Brenner, Horvitz and Sulston for cell death work in *C. elegans.* The animal (yes, researchers do use that term) has been called "the reductionist's delight" [Cooke-Deegan, 1994], but a review of the *C. elegans* literature indicates that its behavior is much more complex than originally thought: most behavior types relate to genes influencing them in a *many-many relation* (for details see my 1998a). Nevertheless, a recent essay in *Nature Neuroscience* commented on the use of the worm in the following terms:

> With a circuitry of 302 invariant neurons, a quick generation time, and a plethora of genetic tools, *Caenorhabditis elegans* is an ideal model system for studying the interplay among genes, neurons, circuits, and behavior. [Potter and Luo, 2003]

Some features of the worm's anatomy are presented in the following diagram:

Figure 1. Original source `http://wormatlas.psc.edu/handbook/bodyshape.htm`. Current diagram has since been modified slightly on the WormAtlas website and is available at `http://www.wormatlas.org/hermaphrodite/introduction/IMAGES/introfig1leg.htm`. Last revision: April 28, 2010. Altun, Z.F. and Hall, D.H. 2009. Introduction. In WormAtlas. doi:10.3908/wormatlas.1.1.

This 1 mm long adult hermaphrodite has 959 somatic nuclei and the male (not pictured) 1,031 nuclei; there are about 2,000 germ cell nuclei [Hodgkin *et al.,*

[8]This section partially borrows from my recent account of reduction and etiological explanations in [Schaffner, 2008a].

1995] . The haploid genome contains 1 x 10^8 nucleotide pairs, organized into
five autosomal and one sex chromosome (hermaphrodites are XX, males XO),
comprising about 19,000 genes. The genes have all been sequenced. The organism
can move itself forward and backward by graceful undulatory movements, and
it responds to touch and a number of chemical stimuli, of both attractive and
repulsive or aversive forms, with simple reflexes. More complex behaviors include
egg laying and mating between hermaphrodites and males [Wood, 1988, 14]. The
worm also learns, as studied by Cathy Rankin and others [Rankin, 2002].

The nervous system is the worm's largest organ, being comprised, in the
hermaphrodite, of 302 neurons, subdividable into 118 subclasses, along with 56
glial and associated support cells; there are 95 muscle cells on which the neurons
can synapse. The neurons have been fully described in terms of their location and
synaptic connections.

These neurons are essentially identical from one individual in a strain to another
[Sulston *et al.*, 1983; White, 1986] and form approximately 5,000 synapses, 700
gap junctions, and 2,000 neuromuscular junctions [White, 1986]. The synapses are
typically "highly reproducible" (~85% the same) from one animal to another, but
are not identical, due to "developmental noise". (For further details about this
concept see [Schaffner 1998a])[9].

An interesting "exception" to the many-many genes behavior relation? A re-
view of *C. elegans* behaviors by the author [Schaffner 1998a] suggested eight "rules
that characterized the relationship between genes and behaviors in the worm, and
a table summarizing those rules is presented below.

The bottom line from the study is that the relations between genes and be-
haviors are not one-one but rather many-many. However in their 1998 essay in
the prestigious scientific journal *Cell*, de Bono and Bargmann investigated the
feeding behavior of two different strains of the worm, one of which engaged in
solitary feeding, and the other in social feeding (aggregated in a crowd) [de Bono
and Bargmann, 1998], and appeared to discover a remarkable one-one relationship
between a genetic mutation and two forms of feeding behavior.

De Bono and Bargmann summarized their 1998 results in an abstract in *Cell*
[de Bono and Bargmann, 1998, 679], which I closely paraphrase here, interpolating
just enough in the way of additional information that nonspecialists can follow the
nearly original abstract text:

> Natural subpopulations of *C. elegans* exhibit solitary or social feed-
> ing behavior. Solitary eaters move slowly across a surface rich in the
> bacteria (a bacterial "lawn") on which they feed and also disperse on
> that surface. Social eaters on the other hand move rapidly on the bac-
> teria and bunch up together, often near the edge of a bacterial lawn.
> A knock-out ("loss of function") mutation in a gene known as *npr-1*
> causes a solitary strain to take on social behavior. This gene is known

[9]de Bono (personal communication) indicates that "There may also be more plasticity in
synapse number/size than indicated in the mind of the worm — difficult to say as only 2-3
worms were sectioned in the John White's em [electron micrograph] studies."

Table 1. Some Rules Relating Genes (Through Neurons) to Behavior in *C. elegans*

1.	*many genes → one neuron*
2.	*many neurons (acting as a circuit) → one type of behavior* (also there may be overlapping circuits)
3.	*one gene → many neurons (pleiotropy)*
4.	*one neuron → many behaviors (multifunctional neurons)*
5.	*stochastic [embryogenetic] development → different neural connections**
6.	*different environments/histories → different behaviors* (learning/plasticity) (Short-term environmental influence.)*
7.	*one gene → another gene ... → behavior (gene interactions, including epistasis and combinatorial effects)*
8.	*Environment → gene expression → behavior (Long-term environmental influence.)*
*	in prima facie genetically identical (mature) organisms

The → can be read as "affect(s), cause(s), or lead(s) to."

to encode a type of protein, here it is NPR-1, known as a G-protein coupled receptor, a protein that acts like a switch to open or close ion channels in nerve cells. This NPR-1 protein is similar to a family of proteins called Y receptors that are widely present in the nervous system of other organisms and relate to feeding and foraging behavior in other species. Two variants of the NPR-1 protein that differ only in a single amino acid (phenylalanine versus valine) occur naturally in the wild. One variant, termed NPR-1 215F (with phenylalanine, abbreviated as F) is found exclusively in social strains, while the other variant, NPR-1 215V (with valine) is found only in solitary strains. The difference between the F and V variants are due to a single nucleotide difference in the gene's DNA sequence (T versus G). Inserting a gene that produces the V form of the protein can transform wild social strains into solitary ones. Thus these only slightly different proteins generate the two natural variants in *C. elegans'* feeding behavior.

This remarkable paper by de Bono and Bargmann made strong claims involving a genetic explanation of behavior. At the end of the introduction to this 1998 essay, the authors wrote that "we show that variation in responses to food and other animals in wild strains of *C. elegans is due to* natural variation in *npr-1*" (my emphasis) [1998, 679]. The phenotype difference is actually somewhat more complex, and not just related to social or solitary feeding in the presence of a sufficient amount of bacterial food supply. As already indicated, the social and solitary strains also differ in their speed of locomotion. Also, the two types differ in burrowing behavior in the agar jell surface on which the worms are studied in the

laboratory. But de Bono and Bargmann contended that "a single gene mutation can give rise to all of the behavioral differences characteristic of wild and solitary strains" [1998, 680].

de Bono and Bargmann offered several "different models that could explain the diverse behavioral phenotypes of *npr-1* mutants" [1998, 686], but added that "resolution of these models awaits identification of the cells in which *npr-1* acts, and the cells that are the source of the *npr-1* [sic] ligands [those molecules that bind to and regulate this receptor]" [1998, 686].

Complications and an example of a PCMS. This wonderfully "simple" story of one gene that influences one type of behavior in the worm was told in 1998 as just described. Since then, further work by de Bono and Bargmann, who did search for the cells in which *npr-1* acts and for the source of the NPR-1 ligands, has indicated that the story is more complex. In follow-up work in 2002 to determine how such feeding behavior is regulated, de Bono and Bargmann proposed what were, at least initially, two separate pathways [de Bono *et al.*, 2002; Coates and de Bono, 2002]. One pathway suggests that there are modifying genes that restore social feeding to solitary feeders under conditions of external environmental stress. The other pathway is internal to the organism, and will be very briefly described at the conclusion of this section. (An accessible overview of the two initial pathways, and some possible very interesting connections with fly and honeybee foraging and feeding behaviors, can be found in Sokolowski's editorial [Sokolowski, 2002] accompanying the publication of the two de Bono *et al.*, 2002 papers.)

The first 2002 paper by de Bono and Bargmann, also writing with Tobin, Davis and Avery, indicates how a partially reductive explanation works, and also nicely illustrates the features of how general field knowledge and specific causal models systems work in tandem. The *explanandum* (Latin for the event to be explained) is the difference between social and solitary feeding patterns, as depicted in figure #2 below. The explanation (at a very abstract level) is contained in the title of the 2002 paper "Social feeding in *C. elegans* is induced by neurons that detect aversive stimuli." The specifics of the explanation appeal to the 1998 study as background, and look at *npr-1* mutants, examining what *other* genes might prevent social feeding, thus restoring solitary feeding in *npr-1* mutants. A search among various *npr-1 mutants* (these would be social feeders) indicated that mutations in the *osm-9* and *ocr-2* genes resulted in significantly more *solitary* feeding in those mutant animals. (Both of these genes code for *components* of a sensory transduction ion channel known as TRPV (transient receptor potential channel that in vertebrates responds to the "vanilloid" (V) compound capsaicin found in hot peppers). Both the *osm-9* and *ocr-2* genes are required for chemoattraction as well as aversive stimuli avoidance.) Additionally, it was found that *odr-4* and *odr-8* gene mutations could disrupt social feeding in *npr-1* mutants. The *odr-4* and *odr-8* genes are required to localize a group of olfactory receptors to olfactory cilia. Interestingly, a mutation in the *osm-3* gene, which is required for the development of 26 ciliated sensory neurons, *restores social* feeding in the *odr-4* and *ocr-2* mutants.

de Bono *et al.* present extensive data supporting these findings in the arti-

cle. Typically the evidential reasoning involves an examination of the effects of screening for single, double, and even triple mutations that affect the phenotype of interest (feeding behaviors), as well as looking at the results of gene insertion or gene deletion. This reasoning essentially follows Mill's methods of difference and concomitant variation (the latter because graded rather than all-or-none results are often obtained), and is prototypical causal reasoning. Also of interest are the results of the laser ablation of two neurons that were suggested to be involved in the feeding behaviors. These two neurons, known as ASH and ADL, are implicated in the avoidance of noxious stimuli and toxic chemicals. Identification of the genes noted above (*osm-9, ocr-2, odr-4* and *odr-8*) allowed the investigators to look at where those genes were expressed (by using Green Florescent Protein (GFP) tags). It turned out that ASH and ADL neurons were the expression sites. The investigators could then test the effects of laser beam ablation of those neurons, and showed that ablation of both of them restored a solitary feeding phenotype, but that the presence of either neuron would support social feeding.

The net result of the analysis is summarized in a "model for social feeding in C. elegans" just below [fig 5 in de Bono *et al.*; my figure 2].

Figure 2. Adapted by permission from Macmillan Publishers Ltd: *Nature* de Bono, M., D. M. Tobin, *et al.* (2002). "Social feeding in Caenorhabditis elegans is induced by neurons that detect aversive stimuli." *Nature* 419(6910): 899-903.), copyright 2002.

The legend for the model quoted from [de Bono et al., 2002] reads as follows:

> Figure 5 c, A model for social feeding in C. elegans. The ASH and ADL
> nociceptive neurons are proposed to respond to aversive stimuli from
> food to promote social feeding. This function requires the putative
> OCR-2/OSM-9 ion channel. The ODR-4 protein may act in ADL to
> localize seven transmembrane domain chemoreceptors that respond to
> noxious stimuli. In the absence of ASH and ADL activity, an unidenti-
> fied neuron (XXX) [involving osm-3] represses social feeding, perhaps
> in response to a different set of food stimuli. The photograph shows
> social feeding of a group of > 30 npr-1 mutant animals on a lawn of E.
> coli.

This model is what I like to call a preferred causal model system (PCMS) for this
Nature article. The model is what does the partial reduction — more on this in
a few pages. The model is simplified and idealized, and uses causal language such
as "respond to" and "represses." (The causal verbs also contain the word "act,"
about which much has been made in recent years in the philosophy of biology and
neuroscience literature about "activities," as opposed to causation, which may be
present in "mechanisms"; more about this below.) The *PCMS* is clearly interlevel.
I think it is best to approach such models keeping in mind the scientific field(s)
on which they are based, and the specific "field elements" that a scientific article
proposing the model needs to refer to in order to make the model intelligible
to readers. Here, the fields on which the model draws are molecular genetics
and neuroscience. Scattered throughout the article are occasional alternative but
possible causal pathways (I call these "field elements") which are evaluated as not
as good an explanation as those provided in the preferred model system presented.
(One example is the *dauer* pheromone explanation, discussed on p. 899 of [de Bono
et al., 2002]; another is the "reducing stimuli production" versus "reducing stimuli
detection" hypotheses on p. 900 of that article.) I will not say more about how
fields and field elements are characterized here, but interested readers can see
[Schaffner, 2006] for additional details.

The preparation or *experimental system* investigated in the laboratory (this
may include several data runs of the "same" experimental system) is identified
in its relevant aspects with the preferred causal model system. At the abstract
or "philosophical" level, the explanation proceeds by identifying the laboratory
experimental system with the theoretical system — the preferred model system
(*PCMS*) — and exhibiting the event or process to be explained (called the *ex-
planandum*) as the causal consequence of the system's behavior. The *explanans*
(or set of explaining elements) here uses molecular biology and is mainly compar-
ative rather than involving quantitative derivational reasoning, in the sense that
in this paper two qualitatively different end states — the solitary and the social
states of the worms — are compared and contrasted.[10] The theoretical system
(the *PCMS*) utilizes generalizations of varying scope, often having to appeal to

[10] A quantitative derivation of a path of *C. elegans* motion that agrees with the experimentally

similarity analyses among like systems (e.g., the use of TRPV channel *family*) to achieve the scope, as well as make the investigation of interest and relevance to other biologists (e.g., via analogies of the NPR-1 receptor to Y receptors and the internal worm circuit to cyclic GMP signaling pathways found in flies and bees that control foraging and feeding behavior — see [Sokolowski, 2002]. For those concerned with philosophical rigor, the preferred model system and its relations to model-theoretic explanation can be made more philosophically precise (and technical), along the lines suggested in the footnote below.[11]

The discussion sections of scientific papers are the usual place where larger issues are raised, and where extrapolations are frequently found. This is also the case in this [de Bono *et al.*, 2002] paper, where the discussion section states that "food, food acquisition, and population density are important regulators of aggregation in a variety of species." (902). The paper concludes on an evolutionary note, tying the proximate cause model to a distal causal (i.e., evolutionary) advantage, where the authors write:

> The data in this paper and in the accompanying paper suggest that the regulation of social feeding behaviour in *C. elegans* is complex, involving several layers of positive and negative inputs. Such complexity may have evolved as a result of the tension between cooperation and competition that underlies social behaviour, and may be important to ensure that social behaviour is induced only when it offers a selective advantage.

observed path can be computed based on neural theory, though the explanation quickly becomes extraordinarily complicated — see my summary of Lockery's results using this type of approach in my [Schaffner, 2000].

[11] The following philosophically general account parallels the discussion in my 1993 book. It assumes an analysis of biological explainers as involving models representable as a collection of generalizations of variable scope instantiated in a series of overlapping mechanisms as developed in chapter 3 of the 1993 book. We can, as described in that chapter, employ a generalization of Suppes' set-theoretic approach and also follow Giere [1984] in introducing the notion of a "theoretical model" as "a kind of system whose characteristics are specified by an explicit definition" [1984, 80]. Here entities $\eta_1...\eta_n$ will designate neurobiological objects such as neuropeptide receptors, the Φ's such *causal* properties as "ligand binding" and "neurotransmitter secretion," and the scientific generalizations $\Sigma_1...\Sigma_n$ will be of the type "This odorant activates a G-protein cascade opening an ion channel". Then $\Sigma_i(\Phi(\eta_1...\eta_n))$ will represent the *i*th generalization, and

$$\Pi[\sum_{i=1}^{n} {}_i(\Phi(\eta_1 \ldots \eta_n))]$$

will be the conjunction of the assumptions (which we will call Π) constituting the preferred model system or PCMS. Any given system which is being investigated or appealed to as explanatory of some explanandum is such a PCMS if and only if it satisfies Π. We understand Π, then, as implicitly defining a kind of natural system, though there may not be any actual system that is a realization of the complex expression Π. To claim that some particular system satisfies Π is a theoretical hypothesis, which may or may not be true. If it is true, then the PCMS can serve as an explanandum of phenomena such as "social feeding." (If the *PCMS* is potentially true and well-confirmed, then it is a "potential and well-confirmed explanation" of the phenomena it entails or supports.)

5 THIS EXPLANATION IS BOTH REDUCTIVE AND NON-REDUCTIVE

The above example is typical of molecular biological explanations of behavior. Behavior is an organismic property, and in the example is actually a populational property (of aggregation), and the explanation appeals to entities that are *parts* of the organism, including molecularly characterized genes and molecular interactions such as ligand-receptor bindings and G-protein coupled receptor mechanisms — thus this is generally characterized as a *reductive* explanation. But it represents *partial* reduction — what I termed reduction of the *creeping* sort — and it differs from *sweeping* or comprehensive reductive explanations because of several important features.

1. The first model does not explain *all* cases of social versus solitary feeding; a different though somewhat related model (that of [Coates and de Bono, 2002]) is needed for the internal triggering of solitary behavior in *npr-1* mutants; the 2005 model does more, but is still incomplete (see below).

2. Some of the key entities, such as the signal from bacteria that is noxious to the worms and the neuron represented by XXX in figure 2, have not yet been identified.

3. It utilizes what might be termed "middle-level" entities, such as neuronal cells, in addition to molecular entities. Further work that is even more reductionistic can address ion channels in the neurons, but this research is yet to come. (I discuss some of this ion channel work in connection with worm touch sensitivity in [Schaffner, 2011].)

4. It is not a quantitative model that derives behavioral descriptions from rigorous general equations of state, but is causally qualitative and only roughly comparative.

5. Interventions to set up, manipulate, and test the model are at higher aggregative levels than the molecular, such as selection of the worms by their organismic properties (feeding behaviors), distributing the worms on an agar plate, and ablating the neurons with a laser.

The explanation does meet the three conditions that seem reasonable for a reductive explanation, namely:

1. the explainers (here the preferred model system shown in figure 2) are a partially decomposable microstructure in the organism/process of interest.

2. the explanandum (the social or solitary feeding behavior) is a grosser (macro) typically aggregate property or end state.

3. Connectability assumptions (CAs), sometimes called bridge laws or reduction functions, are involved, which permit the relation of macrodescriptions

to microdescriptions. Sometimes these CAs are causal sequences as depicted in the model figure where the output of the neurons under one set of conditions causes clumping, but in critical cases the CAs are identities (such as social feeding = clumping, and aversive stimulus = (probably) bacterial odor).

Though etiological and reductive, the preferred model system explanation is not "ruthlessly reductive," to use Bickle's phrase, even though a classical organismic biologist would most likely term it strongly reductionistic in contrast to their favored nonreductive or even antireductionist cellular or organismic points of view. It is a *partial* reduction.

This partial reduction for a very simple model organism does have some lessons for reductions related to far more complex human behavior, including psychiatric genetics [Craver, 2007].

6 WILL "MECHANISM LANGUAGE" SUFFICE?

One recent philosophical alternative to classical models of theory reduction can be found in what [Bickle ,2006] calls "the recently revived *mechanistic* philosophy of science." This revival dates to the seminal article by Machamer, Darden, and Craver [Machamer, 2000] that stressed the importance of the "mechanism" concept as an alternative to law-based approaches to explanation and to reduction. In this approach, a mechanism is "a collection of entities and activities organized in the production of regular changes from start or set up conditions to finish or termination conditions" [Machamer, 2000, 3]. The analysis has been applied to examples in the neurosciences and molecular biology, and even more broadly and recognizes that mechanisms need not be molecular, but can be multi-level (see [Craver, 2004; 2007]). In some of its variants, the approach wishes to eschew causal language, causal generalizations, and any appeals to standard counterfactual analyses, that are typically developed as elucidations of causation (compare [Schaffner, 1993, pp. 296-312; 1993b; Glennan, 1996; Woodward, 2003] with [Tabery, 2004; Bogen, 2004b]).

An appeal to mechanisms, as a contrast with an emphasis on high-level general theories, is an eminently sensible approach. In biology and in medicine, there are few such general theories (with component laws) that are broadly accepted, though population genetics is a notable exception. An early commitment to theories such as population genetics as representing the best examples of biological theory (see [Ruse, 1973]) skewed, as I argued, in my [1980] and again [1993, chapter 3], the appreciation of philosophers of biology away from better or more representative alternative approaches to theory structure and explanation. And in that 1980 article and in [1993] chapter 3 as well as in chapters 6 and 9, I frequently utilized references to "mechanisms" as another way to describe the "models" that are so widely found in biology, and which function broadly as surrogates for theories in the biomedical sciences.

But the *strong* form of appeals to mechanisms, as in early arguments by [Wimsatt, 1976b] seemed to aim at avoiding any discussion of generalizations and laws of working of a mechanism, an avoidance which appeared both philosophically incomplete (see my [1993, pp. 494-495] for specifics), as well as contradicted by the way biologists present their own models. A paradigm case of how generalizations are articulated to form a model can be found in Jacob and Monod's classic paper on the operon model.[12] In their concluding section they write that "a convenient way of summarizing the conclusions derived in the preceding sections of this paper will be to organize them into a model designed to embody the main elements which we were led to recognize as playing a specific role in the control of protein synthesis; namely the structural, regulator and operator genes, the operon, and the cytoplasmic repressor." Jacob and Monod then state the generalizations which constitued the model.[13] Similar generalizations can be found in the figure legend from [de Bono *et al.*, 2002] quoted above on p. 151. And also see my discussion of Ohm's law and the Nernst equation as "laws of working" in the Hodgkin-Huxley model of the action potential [Schaffner, 2008b].indexHodgkin

This avoidance of generalizations by the revived mechanistic tradition is even more evident in the recent essays by [Tabery, 2004] and also in [Darden, 2005] and especially in [Bogen, 2004b], which also seem to me to try to replace the admittedly still problematic concept of causation with appeals to "activities" — a notion that I find much more opaque than causation. (In those places in scientific articles where terms like "acts" appear, I think a good case can be made that what is being referred to is plain old-fashioned causal action.)

Finally, a word may be in order about stretching the term "mechanism" to cover more in the way of partially reductive explanations than is warranted. A review of much of the literature in biology and medicine, spanning work on *E. coli* through to humans, suggests that "mechanisms" function as parts of larger schema, typically referred to by the term "pathway." Pathways seem to be where causal explanations and interventions (both experimental and therapeutic) take place. Mechanisms appear to be parts of pathways, and often modifiable parts of pathways as science progresses. The pathway-mechanism-model debate is not for this article, but worth considering as better characterizations of partially reductive explanations are developed.

But in a weaker form, such as in [Glennan, 1996] and in most of [Machamer, 2000], the revived mechanistic philosophy of science, perhaps to be supplemented by an account of pathway analysis, appears to me to be an important complement to the account of explanation developed in the present article, as well as to my [1993] and [2000] essays. I had noted in my [1993] that appeals to mechanisms

[12]Another paradigmatic example of how generalizations, and even simplified "laws" are involved in the articulation of a model or mechanism can be found in Hodgkin and Huxley's classic article on the action potential in the giant squid axon [Hodgkin, 1952]. Bogen [2004a] analyzes Hodgkin and Huxley's model construction as not supporting a typical generalization account, but I read their paper differently.

[13]A full quotation of the statement of the operon model from [Jacob, 1961] can be found on pp. 158-159 of my [1993].

that eschewed generalizations (such as [Wimsatt 1976b]) were problematic for a number of reasons, a chief one of which was that earlier writers in this tradition appeared to take "mechanism" as a largely unanalyzed term and place a very heavy burden on that term. The new mechanistic philosophy of science remedies that problem by articulating a complex analysis of the terminology involved in appeals to mechanisms, but some of the stronger theses, such as those replacing causation by activities, seem to me to move in a less promising direction.

7 SUMMARY AND CONCLUSION

In this article I began by proposing two theses, and then examined what the consequences of those theses were for reduction and emergence. The first thesis was that what have traditionally been seen as robust reductions of one theory or one branch of science by another more fundamental one are largely a myth in biology, though some rare, but extraordinarily important, instances of them can be found in physics. On closer inspection, and particularly in biology, these reductions seem to fade away, like the body of the famous Cheshire cat, leaving only a grin, or a smile. The second thesis was that these "smiles" are fragmentary patchy explanations, and often partial reductions, and though patchy and fragmentary, they are very important, potentially Nobel-prize winning advances.

To get the best grasp of them, I argued that we needed to return to the roots of discussions and analyses of scientific explanation more generally, and not focus mainly on reduction models, though three conditions based on earlier reduction models are retained in the present analysis. This led us through a very brief history of explanation and its relation to reduction models, such as Nagel's, and through a brief account of my own evolving views in this area. Though the account of scientific explanation I presented above is one I have discussed before, in this article I tried to simplify it, and characterized it as involving a preferred causal model system *(PCMS)*. This *PCMS* account was then applied to a recent set of neurogenetic papers on two kinds of worm foraging behaviors: solitary and social feeding. One of the preferred model systems from a 2002 *Nature* paper was used to illustrate the *PCMS* analysis in detail, and was characterized as a partial reduction.

The article closed with a brief discussion of how this approach in this article partially differed from and partially was congruent with Bickle's "ruthless reductionism" [Bickle, 2003] and with the recently revived mechanistic philosophy of science of [Machamer, 2000]. In that section I could only very briefly indicate some parallels of these approaches with the one developed in the present essay. Clearly further discussion will continue on these topics for some time to come, and should deepen our appreciation of both the power and the limits of reductive explanations.

BIBLIOGRAPHY

[Bickle, 2003] J. Bickle. *Philosophy and Neuroscience: A Ruthlessly Reductive Account.* Dordrecht, Kluwer, 2003.

[Bickle, 2006] J. Bickle. Reducing Mind to Molecular Pathways: Explicating the Reductionism Implicit in Current Mainstream Neuroscience. *Synthese* **152**: 411-434, 2006.

[Bogen, 2004b] J. Bogen. Analyzing Causality: The Opposite of Counterfactual is Factual, 2004.

[Broad, 1925] C. D. Broad. *The mind and its place in nature.* New York, Harcourt, Brace & company, inc, 1925.

[Coates de Bono, 2002] J. C. Coates and M. de Bono. Antagonistic pathways in neurons exposed to body fluid regulate social feeding in Caenorhabditis elegans. *Nature* **419**(6910): 925-9, 2002.

[Craver, 2004] C. Craver. Beyond Reduction: Mechanisms, Multifield Integration and the Unity of Neuroscience (submitted). *Studies in History and Philosophy of Biological and Biomedical Sciences*, 2002.

[Craver, 2007] C. F. Craver. *Explaining the brain: mechanisms and the mosaic unity of neuroscience.* New York, Oxford University Press (Clarendon Press), 2007.

[Culp and Kitcher, 1989] S. Culp and P. Kitcher. Theory Structure and Theory Change in Molecular Biology. *British Journal for the Philosophy of Science* **40**: 459-483, 1989.

[Darden, 2005] L. Darden. Relations Among Fields: Mendelian, Cytological and Molecular Mechanisms. *Philosophy across the Life Sciences.* R. Skipper, with C. Allen, R. Ankeny, C. Craver, L. Darden, G. Mikkelson, and R. Richardson, (book ms. in preparation), 2005.

[de Bono and Bargmann, 1998] M. de Bono and C. I. Bargmann. Natural variation in a neuropeptide Y receptor homolog modifies social behavior and food response in C. elegans. *Cell* **94**(5): 679-89. 1998.

[de Bono et al., 2002] M. de Bono, D. M. Tobin, *et al.* Social feeding in Caenorhabditis elegans is induced by neurons that detect aversive stimuli. *Nature* **419**(6910): 899-903, 2002.

[Glennan, 1996] S. Glennan. Mechanisms and the Nature of Causation. *Erkenntis* **44**: 49-71, 1996.

[Hempel, 1948] C. G. Hempel. Studies in the Logic of Explanation. *Philosophy of Science* **15**: 135-175, 1948.

[Hertz, 1962/1893] H. Hertz. *Electric waves, being researches on the propagation of electric action with finite velocity through space.* New York, Dover Publications, 1962/1983.

[Hodgkin and Hodgkin, 1952] A. L. Hodgkin and A. F. Hodgkin. A Quantitative Description of Membrane Current and its Application to Conduction and Excitation in Nerve. *Journal of Physiology* **117**: 500-544, 1952.

[Hodgkin et al., 1995] J. Hodgkin, R. H. Plasterk, *et al.* The nematode Caenorhabditis elegans and its genome. *Science* **270**(5235): 410-4, 1995.

[Jacob, 1961] F. a. M. Jacob. Genetic Regulatory Mechanisms in the Synthesis of Proteins. *Journal of Molecular Biology* **3**: 318-356, 1961.

[Kandel et al., 2000] E. R. Kandel, J. H. Schwartz *et al. Principles of neural science.* New York, McGraw-Hill, Health Professions Division, 2000.

[Machamer et al., 2000] P. Machamer, L. Darden, and C. Craver. Thinking About Mechanisms. *Philosophy of Science* **67**: 1-25, 2000.

[Nagel, 1961] E. Nagel. *The structure of science; problems in the logic of scientific explanation.* New York,, Harcourt, 1961.

[Potter and Luo, 2003] C. J. Potter and L. Luo. Food for thought: a receptor finds its ligand. *Nat Neurosci* **6**(11): 1119-20, 2003.

[Rankin, 2002] C. H. Rankin. From gene to identified neuron to behaviour in Caenorhabditis elegans. *Nat Rev Genet* **3**(8): 622-30, 2002.

[Ruse, 1973] M. Ruse. *Philosophy of Biology.* London, Hutchinson, 1973.

[Sarkar, 1998] S. Sarkar. *Genetics and reductionism.* Cambridge, UK ; New York, NY, Cambridge University Press, 1998.

[Schaffner, 1967] K. F. Schaffner. Approaches to Reduction. *Philosophy of Science* **34**: 137-147, 1967.

[Schaffner, 1968] K. F. Schaffner. The Watson-Crick Model and Reductionism. *British Journal for the Philosophy of Science* **20**: 325-348, 1968.

[Schaffner, 1969] K. F. Schaffner. Correspondence Rules. *Philosophy of Science* **36**: 280-290, 1969.

[Schaffner, 1972] K. F. Schaffner. *Nineteenth Century Aether Theories.* Oxford, Pergamon Press, 1972.
[Schaffner, 1977] K. F. Schaffner. Reduction, Reductionism, Values, and Progress in the Biomedical Sciences. *Logic, Laws, and Life.* R. Colodny. Pittsburgh, University of Pittsburgh Press. **6**: 143-171, 1977.
[Schaffner, 1993] K. F. Schaffner. *Discovery and Explanation in Biology and Medicine.* Chicago, University of Chicago Press, 1993.
[Schaffner, 1993] K. F. Schaffner. *Discovery and Explanation in Biology and Medicine.* Chicago, University of Chicago Press, 1993.
[Schaffner, 1998] K. F. Schaffner. Genes, Behavior, and Developmental Emergentism: One Process, Indivisible? *Philosophy of Science* **65**(June): 209-252, 1998.
[Schaffner, 2000] K. F. Schaffner. Behavior at the Organismal and Molecular Levels: The Case of C. elegans. *Philosophy of Science* **67**: s273-s278, 2000.
[Schaffner, 2006] K. F. Schaffner. Reduction: the Cheshire cat problem and a return to roots. *Synthese* **151**(3): 377-402, 2006.
[Schaffner, 2008a] K. F. Schaffner. Etiological Models in Psychiatry: Reductive and Nonreductive. *Philosophical Issues in Psychiatry.* K. S. a. P. Kendler, J. Baltimore, Johns Hopkins University Press: 48-90, 2008.
[Schaffner, 2008b] K. F. Schaffner. Theories, Models, and Equations in Biology: The Heuristic Search for Emergent Simplifications in Neurobiology. *Philosophy of Science* **75**: 1008-1021, 2008.
[Schaffner, 2011] K. F. Schaffner. *Behaving: What's genetic and what's not, and why should we care,* Oxford University Press, 2011.
[Schilpp and Einstein, 1949] P. A. Schilpp and A. Einstein. *Albert Einstein, philosopher-scientist.* Evanston, Ill., Library of Living Philosophers, 1949.
[Simon, 1981] H. Simon. *The Sciences of the Artificial.* Cambridge, MA, MIT Press, 1981.
[Sokolowski, 2002] M. B. Sokolowski. Neurobiology: social eating for stress. *Nature* **419**(6910): 893-4, 2002.
[Sommerfeld, 1950a] A. Sommerfeld. *Lectures on theoretical physics: Electrodynamics.* New York, Academic Press, 1950.
[Sommerfeld, A. 1950b] A. Sommerfeld. *Lectures on theoretical physics: Optics.* New York,, Academic Press, 1950.
[Sterelny and Griffiths, 1999] K. Sterelny and P. E. Griffiths. *Sex and death : an introduction to philosophy of biology.* Chicago, Ill., University of Chicago Press, 1999.
[Sulston et al., 1983] J. E. Sulston, E. Schierenberg, *et al.* The embryonic cell lineage of the nematode Caenorhabditis elegans. *Dev Biol* **100**(1): 64-119, 1983.
[Suppe, 1977] F. Suppe. *The Structure of Scientific Theories.* Urbana, University of Illinois Press, 1977.
[Tabery, 2004] J. Tabery. Activities and Interactions. *Philosophy of Science* **71**: 1-15, 2004.
[White et al., 1986] J. G. White, E. Southgate, J. N. Thomson, and S. Brenner. The structure of the nervous system of the nematode Caenorhabditis elegans. *Phil. Trans. Roy. Soc. London Ser. B* **314**: 1-340, 1986.
[Wimsatt, 1976a] W. Wimsatt. Reductionism, Levels of Organization, and the Mind-Body Problem. *Consciousness and the Brain.* G. G. e. al. New York, Plenum Press: 205-267, 1976.
[Wimsatt, 1976b] W. Wimsatt. Reductive Explanation: A Functional Account. *Proceedings of the 1974 Philosophy of Science Association.* R. S. C. e. al. Dordrecht, Reidel: 671-710, 1976.
[Wood, 1988] W. B. Wood. *The Nematode Caenorhabditis elegans.* Cold Spring Harbor, N.Y., Cold Spring Harbor Laboratory, 1988.
[Woodward, 2003] J. Woodward. *Making things happen: a theory of causal explanation.* New York, Oxford University Press, 2003.

CAUSAL INFERENCE AND MEDICAL EXPERIMENTS

Daniel Steel

Causal inference plays a fundamental role in medical science: it is what any researcher is doing when she attempts to discover the underlying mechanisms of a disease or to estimate the effectiveness of a treatment. This article focuses on causal inference within the context of medical experiments, and does not address causal inference in non-experimental or observational studies. The ensuing discussion is organized as follows. First, several accounts of causation from the current philosophy of science literature will be discussed. Secondly, a general theory of causal inference based upon Bayesian networks will be described. Given this background, the third section of the article discusses problems relating to the internal validity of an experiment. Questions about internal validity have to do with whether the causal relationships *in the experimental context* — whether that be a collection of human subjects in a clinical trial or animal models in a laboratory — have been correctly inferred. In contrast, external validity or extrapolation has to do with the extent to which causal conclusions drawn with regard to the experimental context can be extended to *other* contexts or populations. External validity and extrapolation are discussed in the final section of this article.

1 THEORIES OF CAUSATION

In order to think clearly about causal inference, it is helpful to have a sense of what claims about cause and effect assert. The leading accounts of causation in the current philosophical literature can be grouped into four main categories: probabilistic [Suppes, 1970; Eells, 1991], counterfactual [Lewis, 1973], mechanistic [Salmon, 1984; Dowe, 2000; Machamer *et al.*, 2000], and manipulation [Menzies and Price, 1993; Mellor, 1995; Woodward, 2003]. Probabilistic theories of causation are modern descendants of David Hume's regularity theory [1978/1740], according to which A causes B just in case occurrences of A are regularly followed by occurrences of B. Probabilistic theories of causation attempt to avoid a well-known shortcoming of Hume's theory, namely, that an association between A and B might be due to a common cause of both rather than to one causing the other. For instance, the rooster's crowing is regularly followed by but does not cause the sunrise; instead, both are effects of the daily rotation of the earth. Probabilistic theories of causation attempt to avoid this problem by requiring that a cause raise the probability of its effect even when relevant prior factors are taken

Handbook of the Philosophy of Science. Volume 16: Philosophy of Medicine.
Volume editor: Fred Gifford. General editors: Dov M. Gabbay, Paul Thagard and John Woods.

into account. For instance, given the relative positions and motions of the earth and sun, information about the rooster's crowing no longer makes any difference to the probability of the sunrise.

Counterfactual theories are based on the thought that A is a cause of B when it is the case that, had A not occurred, then B would not have occurred either. There are many cases in which A is regularly followed by B but in which B would have occurred anyway even if A had not occurred, as the example of the rooster and the sunrise illustrates. Hence, the counterfactual theory seems to provide a straightforward answer to the difficulty confronting Hume's regularity theory. But upon closer inspection it is not clear that this is indeed the case. For suppose that A and B are associated due to being effects of the common cause C. Then one might reason that, had A not occurred, then neither would have C and thus B would not have occurred either. For instance, imagine that little Tommy runs into a table, knocking over both a lamp and a vase which smash on the floor. One might reason that if the vase had not smashed, that would have meant that Tommy had not run into the table, in which case the lamp wouldn't have smashed either. Such counterfactuals are called "backtracking". So, the counterfactual theory of causation requires that the counterfactuals in question be interpreted in a non-backtracking manner. David Lewis [1979] provides a list of guidelines for interpreting counterfactuals so that backtracking is avoided. For events that occur at clearly defined points in time,[1] the idea is roughly that one should consider a scenario in which the alleged cause is changed at the last possible moment and in the most localized way. For example, in the case of little Tommy running into the table, one might suppose that the vase is prevented from smashing thanks to an adept saving catch by Tommy's sister. In this scenario, the lamp would still smash on the floor. However, one concern with this modification of the counterfactual approach is that it seems to have no motivation besides the desire to make the theory agree with intuitive judgments about causation. One would like a theory of causation that provides some insight into why certain types of counterfactual scenarios rather than others are deemed relevant to assessments of cause and effect.

Mechanistic approaches to causation take their cue from the observation that causal relationships generally depend upon interactions among physically contiguous objects between which some type of influence is transmitted or exchanged. One of the best known theories of this kind focuses on exchanges of conserved quantities, such as energy or momentum [Salmon, 1998; Dowe, 2000]. For instance, an exchange of momentum occurs between little Tommy and the table when he collides with it, and also between the floor and the vase when the vase smashes. But there appears to be no exchange of a conserved quantity between the vase and the lamp. So, the conserved quantity theory would seem to agree with judgments about causation in simple examples like this. But upon closer inspection, that is not so clear. Suppose that the vase hits the floor before the lamp does. Then after the impact of the vase, vibrations propagate through the floor, resulting in

[1]The contrast here would be with standing conditions (e.g. the mass of the earth, or the level of popular dissatisfaction with the ruling party).

an indirect exchange of momentum between the vase and the lamp when the latter comes crashing down. In short, while an exchange of conserved quantities may be a necessary condition for causation in many circumstances, it is rarely sufficient [Hitchcock, 1995; Hausman, 1998; Dowe, 2000, pp. 147–8; Woodward, 2003]. One solution to this difficulty would be to combine the mechanistic account of causation with either a probabilistic or counterfactual approach. For example, according to Phil Dowe's definition A causes B if and only if these events are connected by a sequence of interactions involving exchanges of conserved quantities in virtue of which A raises the chance of B [2001, p. 167]. Given Dowe's definition, the smashing of the vase does not cause the lamp to smash, since the sequence of exchanges of conserved quantities between them is not one that increases the chance that the lamp smashes. In contrast, little Tommy's collision with the table would be a cause of the smashing of both the vase and the lamp according to Dowe's definition.

While the conserved quantity theory was devised with simple physical examples in mind, there are discussions of mechanisms that focus specifically on how that concept is employed in the biological sciences. According to what is probably the most commonly cited definition of a mechanism, "Mechanisms are entities and activities organized such that they are productive of regular changes from start or set-up to finish or termination conditions" [Machamer *et al.*, 2000, p. 3].[2] Examples of mechanisms in the sense of this definition include protein synthesis, the HIV replication mechanism, and carcinogenic mechanisms. In protein synthesis, the entities would include such things as DNA, RNA polymerase, mRNA, and so on. Examples of activities would include such things as RNA polymerase binding to a strand of DNA, mRNA nucleotide bases attaching to the DNA nucleotide bases, and so forth. As this example illustrates, the activities referred to in the above definition of a mechanism are often interactions that involve exchanges of conserved quantities.

Finally, manipulation theories of causation are inspired by the insight that causes are often means to bring about their effects. According to Jim Woodward's [2003] version of this idea, the difference between causation and mere correlation is that a causal generalization is invariant under interventions that target the cause. To take a stock example, consider the correlation between the readings of a barometer and the occurrence of storms. An example of an intervention on the barometer readings would be to place the barometer in a chamber in which the air pressure can be set at will. If the barometer readings are set in this way, the correlation between the barometer readings and storms will no longer obtain. In short, the correlation between barometer readings and storms is *not* invariant under intervention, and hence not a causal generalization according to Woodward's account. In contrast, a correlation between smoking and emphysema, for instance, would be invariant under an intervention that targeted smoking. In this case, an

[2]See Glennan [1996, p. 52] for a definition that is similar to Machamer, Darden, and Craver's except that it requires that the interactions among the components of the mechanism are governed by "direct causal laws."

example of an intervention would be a randomized controlled experiment in which some are required to smoke and others are not allowed to do so. Under such circumstances, smoking would still be correlated with emphysema. According to this account, then, the distinctive feature of causal generalizations is that they indicate effective means for altering one's surroundings in specific ways. In contrast, mere correlations only provide a basis for prediction.

One of the most appealing features of manipulation theories of causation is that, unlike the other approaches described so far, they provide a straightforward explanation of why the notion of causation would be so important to human beings. Humans care about causation because of the immense practical importance of being able to alter one's surroundings to achieve desired ends. In contrast, it is not very clear why humans should find it so important to know that A raises the probability of B even when all prior factors are taken into account. Nor it is clear why humans ought to be concerned with non-backtracking counterfactual dependences, nor why it matters to know about interactions involving exchanges of conserved quantities. From the perspective of a manipulation theory, these things are relevant to causation only because they have some indirect connection to control. For instance, that A occurs prior to B and raises its probability even when prior factors are taken into account is often evidence that A can be used as a means for controlling B. Similarly, knowledge of a mechanism underlying a disease is often a basis for developing effective therapies.

An objection to manipulation theories of causation is that causal claims often appear pertinent in contexts in which manipulation and control are clearly not possible. For instance, according to modern astronomy, the tilt in the earth's axis was caused by a collision between the earth and a large asteroid (the debris kicked up by this collision then coalesced to form the moon). An advocate of a manipulation approach to causation would respond that situations involving actual human intervention are the basis for our concept of causation, which is then extended and abstracted to other situations — including ones in which human intervention is not possible. Indeed, the concept of an intervention can be defined in a way that makes no reference to human agency, as will be discussed in Section 3.

It is unlikely that there will be a consensus any time soon among philosophers as to the one true theory of causation. Nevertheless, an appreciation of the several theories of causation can be useful. First, some theories are especially relevant in particular contexts. For example, manipulation approaches to causation are directly relevant to medical science, which aims to discover effective treatments for disease. Moreover, a great deal of medical research aims to discover mechanisms. Secondly, despite disagreement about whether probability, manipulation, or mechanism is the defining characteristic of causation, everyone will agree that these things are linked to causation in important ways. In particular, the following propositions seem very plausible with regard to medical science: the relationship between probability and causation is important for providing evidence for causal claims; interest in causation is often motivated by a desire to find effective means for achieving ends, and causal relationships are based on underlying mechanisms.

2 BAYESIAN NETWORKS

This section describes an approach to causal inference based upon Bayesian networks [Spirtes *et al.*, 2000; Pearl, 2000; Neopolitan, 2004]. At the heart of this approach is an intuitive format for representing claims about cause and effect that facilitates general formulations of some commonly assumed principles linking causation and probability. This framework allows for algorithms that, as it were, squeeze as much causal information as possible out of statistical data. Bayesian networks have been and continue to be used for a number of medical applications, particularly diagnosis (cf. [Neopolitan, 2004, pp. 641–2]). This section presents some of the basics of Bayesian networks, which ground the discussion of experimentation in the subsequent section.

Bayesian networks consist of directed acyclic graphs (DAGs) associated with probability distributions that satisfy certain requirements. A DAG is composed of a collection of nodes some of which are connected by arrows (as in Figure 1).

Figure 1. A directed acyclic graph

The graph is directed, since every edge linking the nodes has one arrowhead — a graph with edges without arrow heads or with double-headed arrows would not be a DAG. It is acyclic because there are no cycles, that is, no sequence of arrows aligned head to tail that begins and ends with the same node. DAGs are an intuitive means by which to represent causal claims: the nodes represent random variables, while the arrows represent the relationship of direct causation. For instance, the DAG in Figure 1 could represent the causal relationships in the barometer-storm example discussed above: B indicates the barometer reading, A the atmospheric pressure, and S the occurrence or non-occurrence of a storm. Since DAGs may include arbitrarily many nodes, the DAG in Figure 1 is a particularly simple example, as can be appreciated by considering the DAG in Figure 2.

Figure 2. A bushier DAG

The node X is said to be a *parent* of the node Y if there is an arrow pointing directly from X to Y. For example, C is a parent of B and D in the DAG in Figure 2. A node X is said to be a descendant of Y if a sequence of arrows leads from Y to X.[3] For example, in Figure 2, C is a descendant of H as well as of A, G, and E. Notice that in Figure 1, S is neither a parent nor a descendant of B.

A Bayesian network is a DAG with a probability distribution over the variables represented by the nodes in the graph, where that probability distribution is assumed to satisfy some conditions. The first and most fundamental is known as the Markov condition.

> Let G be a DAG with a set \mathbf{V} of variables and P be a probability distribution over \mathbf{V}. P satisfies the Markov condition with regard to G if and only if for every X in \mathbf{V}, X is independent of its non-descendants conditional on its parents (cf. [Sprites *et al.*, 2000, p. 11]).

For example, in Figure 1, A is the sole parent of B, and S is not a descendant of B. Hence, if the probability distribution over the variables $\{B, A, S\}$ satisfies the Markov condition with regard to the graph in Figure 1, then B and S are independent conditional on A. In other words, once one knows the value of A, learning the value of B provides no additional information about the value of S.[4]

A closely related consequence of the Markov condition can be illustrated by means of the DAG in Figure 3.

Figure 3. A and C related only through the mediator B

In the DAG in Figure 3, A is a non-descendant of C, while B is the sole parent of C. Hence, if the probability distribution over $\{A, B, C\}$ satisfies the Markov condition with regard to this DAG, then A and C are independent conditional on B. Finally, consider the DAG in Figure 4.

In the DAG in Figure 4, there are no parents of A, and C is a non-descendant of A. Hence, if the probability distribution satisfies the Markov condition with regard to the DAG in Figure 4, A and C are independent. However, the Markov condition does *not* entail that A and C are independent conditional on B.

Note that the Markov condition only makes claims about independence and conditional independence relationships. Yet it is typically assumed that causal

[3]The sequence of arrows can be zero arrows long, which means that every node is technically a descendant of itself. This terminological oddity simplifies the formulation of the Markov condition, since it entails that X is not a member of the non-descendants of X.

[4]More formally, variables X and Y are independent when $P(x|y) = P(x)$, for every value x of X and y of Y. $P(x|y)$ is a conditional probability, read as the probability of X given Y. X and Y are independent conditional on Z when $P(x|y, z) = P(x|z)$; in other words, once the value of Z is known, learning the value of Y makes no difference to the probability of X taking one value rather than another.

Figure 4. No connection between A and C

connections generate probabilistic dependences as well. A second assumption, known as the faithfulness condition, addresses this issue. The faithfulness condition requires that the *only* probabilistic independence and conditional independence relationships are those entailed by the Markov condition (cf. [Spirtes *et al.*, pp. 13–14]). For example, in Figure 1, although the Markov condition entails that B and S are independent conditional on C, it does not entail that B and S are unconditionally independent. Thus, the faithfulness condition requires that they are not independent. Of course, that is precisely what one would expect in this case: the barometer readings and occurrence of storms are correlated as a result of the common cause, atmospheric pressure. Similarly, the faithfulness condition requires that A and C are probabilistically dependent in the DAG in Figure 3.

Although it is fairly easy to apply the Markov and faithfulness conditions directly to simple DAGs like those in Figures 1, 3, and 4, the same is not true for more complex DAGs like the one in Figure 2. Fortunately, there is a graphical concept known as d-separation that allows one to easily read off the implications of the Markov condition for any DAG, no matter how complex. In particular, for any disjoint sets of nodes in a DAG, \mathbf{X}, \mathbf{Y}, and \mathbf{Z}, the Markov condition entails that \mathbf{X} and \mathbf{Y} are independent conditional on \mathbf{Z} if and only if \mathbf{Z} d-separates \mathbf{X} and \mathbf{Y} [Pearl, 2000, p. 18; Neopolitan, 2004, pp. 74–79]. D-separation is defined as follows:

> A path p is said to be *d-separated* (or *blocked*) by a set of nodes \mathbf{Z} if and only if
>
> 1. p contains a chain $i \rightarrow m \rightarrow j$ or a fork $i \leftarrow m \rightarrow j$ such that the middle node m is in \mathbf{Z}, or
>
> 2. p contains and inverted fork (or *collider*) $i \rightarrow m \leftarrow j$ such that the middle node m is not in \mathbf{Z} and such that no descendant of m is in \mathbf{Z}.
>
> A set \mathbf{Z} is said to *d-separate* \mathbf{X} from \mathbf{Y} if and only if \mathbf{Z} blocks every path from a node in \mathbf{X} to a node in \mathbf{Y}. (Pearl 2000: 16-17)

For example, in Figure 2, $\{E, G\}$ d-separates H and C. Hence, if the probability distribution associated with that DAG satisfies the Markov condition, then H and C are independent conditional on $\{E, G\}$. In addition, E and A are d-separated by the empty set, since there is a collider on every path between these two nodes. However, E and A are not d-separated by $\{B\}$, since B is a collider on

the path $A \rightarrow B \leftarrow C \leftarrow E$. Note that boldfaced capital letters in the definition of d-separation represent sets rather than individual nodes or variables. Thus, d-separation can be used to derive conclusions about the independence of groups of variables in addition to single pairs. For instance, in Figure 2, $\{E, G\}$ d-separates $\{A, B, C, D\}$ and $\{F, H\}$. So, the Markov condition entails that $\{A, B, C, D\}$ and $\{F, H\}$ are independent conditional on $\{E, G\}$ in this DAG.

In all of the applications discussed here, DAGs will be interpreted as representing causal structures, so that "parents" in a DAG represent direct causes while "descendants" represent effects. What is often called the "causal Markov condition" is simply the Markov condition stated above with that causal interpretation of DAGs made explicit (cf. [Spirtes *et al.*, 2000, p. 29; Neopolitan, 2004, p. 59]). It will be helpful to reformulate some of the consequences of the Markov condition in explicitly causal terms.

> Common Causes Screen-off their Effects: If X and Y are related solely as effects of the common cause Z, then X and Z are independent conditional on Z.

In Figure 1, the common cause is A, the atmospheric pressure. Figure 3 illustrates a closely related principle:

> Mediating Causes Screen-off Distal Causes: If X and Y are related solely by a causal chain mediated by Z, then X and Y are independent conditional on Z.

Notice that these two rules are encapsulated in item 1 of the definition of d-separation. The notion of a causal connection will be helpful for stating the next useful consequence of the Markov condition. Let us say that two variables are causally connected just in case one is a cause (direct or indirect) of the other or there is a common cause of both. For instance, B and S are causally connected in Figure 1, as are A and C in Figure 3. In contrast, in Figure 4, A and C are not causally connected.

> Probabilistic Dependence entails Causal Connection: If X and Y are probabilistically dependent, then there is a causal connection between X and Y.

For instance, this rule entails that A and C are independent in the DAG in Figure 4. Notice that this rule concerns only *unconditional* probabilistic dependence, a point which is important for understanding the next rule.

Finally, a somewhat surprising but important consequence of the faithfulness condition:

> Conditioning on Common Effects Creates Dependence: If Z is a common effect of X and Y (that is, $X \rightarrow Z \leftarrow Y$), then conditioning on Z creates probabilistic dependence between X and Y.

Although perhaps counterintuitive, this last principle is in fact is easy to grasp once one considers some examples. For instance, the presence of gasoline in the tank and the battery being charged are causes of the car starting. So, the car starting is a common effect of there being gasoline in the tank and the battery being charged. Suppose that I know that the car does not start. Then learning the state of the battery provides information about whether there is gas in the tank and vice versa. Conditional on knowing that the car won't start, learning that there is gasoline in the tank is full makes me think it more probable that the battery is dead. Consider another example. Both patriotism and having one's draft number called were causes of serving in the US military in Vietnam. Yet since draft numbers were selected randomly, there was no *unconditional* dependence between patriotism and having one's draft number called. However, among those who did serve in Vietnam, one would expect an inverse correlation between patriotism and having one's draft number called. That is, those who served in Vietnam despite not having their draft number called were more likely to have been patriotic, while those who served despite not being patriotic are more likely to have been people whose draft numbers were called.

Bayesian networks, then, provide a general format for representing hypotheses about what causes what and for systematically deriving statistically testable predictions from these hypotheses. Clearly, that is a very useful thing for causal inference. Indeed, given Bayesian networks, it is possible to devise algorithms that, when provided a set of statistical data, will output all of the DAGs capable of accounting for those data [Spirtes *et al.*, 2000; Pearl, 2000; Neopolitan, 2004]. Without experiment, there are usually several DAGs that can account for the available data, which is a way of putting the old slogan that correlation is not the same as causation. However, controlled experiments tend to restrict the set of possible causal explanations — ideally, to just one. How that is so, and what to do when experiments are less perfect than one would like, is the topic of the next section.

An important question about causal inference based on Bayesian networks concerns the grounds for assuming that DAGs representing real world causal relationships satisfy the Markov and faithfulness conditions. There is an active philosophical literature that addresses this issue [Pearl, 1998; Woodward, 1998; Hausman and Woodward, 1999, 2004; Cartwright, 1999; 2002; 2006; Glymour, 1999; Sober, 2001; Hoover, 2003; Steel, 2003; 2005; 2006a; 2006b]. For the present purposes, it will suffice to point out that the Markov and faithfulness conditions are commonly assumed in scientific practice. For instance, the rule that conditioning on common causes screens off effects is implicit in studies that attempt to statistically control for potential common causes by means of regression analysis. It is also implicit in attempts to draw causal inferences from comparisons of carefully matched groups (cf. [Rosenbaum, 2002]). Likewise, it is typically expected that probabilistic dependencies are indicators of causal connections — either one factor is a cause of the other or there is some common cause of the two. Conversely, absence of probabilistic dependence is generally taken to indicate an absence of causal connection,

as the faithfulness condition asserts. Of course, that the Markov and faithfulness conditions are implicit in a great deal of scientific research dealing with questions of cause and effect does not show that these principles are always true. But it does make it worthwhile to carefully explore the causal inferences that would be possible when they do obtain.

Finally, Bayesian networks illustrate a number of the conceptual connections highlighted by theories of causation discussed in the previous section. Most obviously, the connection between probability and causation is central to the use of Bayesian networks for drawing causal inferences. Moreover, Bayesian networks have been proposed as a basis for explicating counterfactuals [Pearl, 2000, chapter 7]. And as will be explained in the next section, Bayesian networks are very helpful for clarifying the connection between causation and manipulation. In fact, the notion of causation involved in Bayesian networks is sometimes explicitly defined in terms of manipulation [Neopolitan, 2004, p. 49].

3 INTERNAL VALIDITY

Questions about internal validity ask whether the causal relationships in the experimental context have been correctly inferred. Bayesian networks approach the topic of causal inference in controlled experiments by providing an explication of the concept of an intervention or manipulation. This is best presented by reference to a concrete example.

Suppose that there is observational data that those who follow a vegetarian diet tend to score better on several measurements related to overall health, such as blood pressure, body mass index, and so forth. The question is whether this correlation between a vegetarian diet and better health is present because a vegetarian diet is a cause of better health or because of the presence of a common cause. For example, perhaps vegetarians are more health-conscious and therefore are more likely to engage in other health-promoting activities such as regular exercise. Given the discussion in the previous section, it is easily seen that the correlation can be explained by each of the hypotheses in Figure 5.

In the DAGs in Figure 5, V is a variable indicating whether the person is a vegetarian, while H is a variable indicating a pertinent measure of health. The DAG in Figure 5(a), then, represents the hypothesis that a vegetarian diet is a cause of health, while 5(b) is the alternative that one's state of health is a cause of whether one is a vegetarian. Finally, 5(c) asserts that there is an unmeasured common cause of V and H (the circle rather than the square around the variable indicates that it is unmeasured). That there are common causes of V and H is quite probable. For example, a general concern about one's health is a likely cause of being a vegetarian, and it is also likely to cause other behaviors that make one healthy. The point is that outside of the context of a controlled experiment, a correlation between V and H cannot distinguish between these three alternatives.

In contrast, a controlled experiment is an attempt to devise a situation in which only 5(a) could account for a correlation between V and H. A controlled exper-

Figure 5. Three possible explanations of a correlation between V and H

iment works by introducing variation in the alleged cause (V in this case) that comes from "outside" the causal system. In the present example, this might work as follows. A group of subjects are randomly divided into two groups, one of which is required to follow a vegetarian diet, while the other is required to eat meat. If the subjects in each group follow the prescribed diet, randomization would seem to ensure that there are no unmeasured common causes of V and H, and that H does not cause V. Thus, in this experimental set up a correlation between V and H could apparently not be explained by either 5(b) or 5(c). So, it would seem that in a randomized controlled experiment, the only possible explanation of a correlation between V and H is that V is a cause of H. Such observations have inspired some to maintain that randomization makes inferences "from probabilities to causes ... quite infallible" [Papineau, 1994:, p. 447]. Although Bayesian networks pinpoint a definite virtue of randomization, they also help to explain precisely in which ways a controlled experiment can go awry even when treatment is assigned at random and probabilities have been correctly estimated.

From the perspective of Bayesian networks, a randomized controlled experiment is an effort to implement an *ideal intervention*. An ideal intervention can be defined as follows. Let **V** be a set of variables of interest.

Definition of Ideal Intervention:[5] I is an ideal intervention on $X \in$ **V** if and only if it is a direct cause of X that satisfies these three conditions:

1. I eliminates other influences upon X but otherwise does not alter the causal relations among **V**,

2. I is a direct cause of no variable in **V** other than X, and

3. I is exogenous with respect to **V**.

[5]See [Woodward, 2003, p. 98] for a similar definition.

One variable is exogenous with respect to a collection of others just in case it neither is an effect of nor shares a common cause with any of them. Thus, item (3) means that I does not share a common cause with any variable in \mathbf{V} and is not an effect of any variable in \mathbf{V}. This is the formal analogue to the intuitive idea that interventions come from "outside."

The usefulness of an ideal intervention for drawing causal conclusions from correlations is illustrated by the example concerning vegetarianism. Any of the three DAGs in Figure 5 represents a possible explanation of a correlation from non-experimental data. However, things are different if the value of V is set by an ideal intervention.

Figure 6. Ideal interventions

In each case, the intervention (represented by I) satisfies the three conditions of the definition given above. First, it eliminates all other influences upon the targeted variable V, but otherwise makes no changes to the causal relationships. The elimination of other influences upon V is represented by erasing arrows pointing into it. Since there were no arrows pointing into V in 5(a), no arrows have been erased from that DAG in 6(a). Secondly, the intervention directly targets only one variable, in this case V. Finally, the intervention is exogenous: it is not an effect of V or H, nor does it share a common cause with any of these variables. Suppose then that the experiment finds a correlation between V and H. By the "probabilistic dependence entails causal connection" rule, this correlation must be explained by a causal connection. However, of the three DAGs in Figure 6, only the one in 6(a) has a causal connection between V and H. Thus, if the experiment is an ideal intervention, it is possible to distinguish the hypothesis that V is a cause of H from the other two hypotheses represented in Figure 5.

Of course, many actual interventions are not ideal, and considerable ingenuity and hard work are often needed to ensure that the conditions (1) through (3) are satisfied in an experiment. Moreover, a randomized controlled experiment might fail to be an ideal intervention. For example, a common difficulty in clinical trials is that some subjects do not follow the experimental protocol. In the example above, some of those assigned to be vegetarians might surreptitiously eat meat,

while some assigned to the meat-eating group might follow a strict vegetarian diet. In such cases, item (1) in the definition of an ideal intervention is not fulfilled. This is problematic, since it allows for the possibility that there is a common cause of the variable being manipulated and the outcome. For instance, those who are more health conscious might follow a vegetarian diet, regardless of which group they are assigned to. In such circumstances, there may be a correlation between the treatment and outcome, even if the treatment is entirely ineffective. The point is illustrated by the DAG in Figure 7.

Figure 7. An intervention that fails (1)

In short, randomized treatment assignment does not guarantee that all subjects will follow the experimental protocol as directed.

Likewise, randomization does not ensure that the second item in the definition of an ideal intervention obtains. Item (2) fails to obtain when the intervention directly affects more than one variable in the system. In well designed clinical trials, for example, great care is taken to ensure that both the test and control groups are treated identically except that former receives the treatment and the latter does not. Placebos and double-blinds are, of course, standard tactics for achieving this end. Yet there are many clinical trials in which it is not possible to conceal from subjects which treatment they receive. For instance, this would be the case in any study that compares noticeably distinct types of treatment, such as surgery versus a pharmacological therapy. Likewise, in the vegetarian example, the subjects would know which diet they were assigned to follow. In such cases, the intervention might have a direct effect on more than one variable in the system, as is illustrated in Figure 8.

Figure 8. An intervention that fails (2)

In such cases, the treatment and outcome might be correlated even if the treatment has no effect whatever.

Although randomization does not ensure that (1) and (2) of the definition of an ideal intervention are fulfilled, it does guarantee that (3) is satisfied. For if

treatment assignment is random, then it is exogenous, that is, it neither is an effect of nor shares a common cause with any variable in the system. However, (3) can easily fail in the absence of randomization. In the vegetarian example, suppose that which diet is assigned is influenced by factors related to how health conscious the individual is. This situation can be represented in the DAG in Figure 9.

Figure 9. An intervention that fails (3)

In such a case, treatment may be correlated with the outcome even if it is entirely ineffective.

There is some dispute in the philosophical literature concerning the necessity and desirability of randomization in clinical experiments [Urbach, 1985; 1991; 1994; Mayo, 1987; Papineau, 1994; Kadane and Seidenfeld, 1999]. Although not referred to in this dispute, Bayesian networks are helpful for clarifying the arguments at play. The above analysis allows for a concise reformulation of two legitimate points made by skeptics of randomization: first that randomization alone does not ensure that the experiment is an ideal intervention, and secondly that there is no reason in principle why randomization is the only possible way to ensure that item (3) in the definition of an ideal intervention is satisfied — treatment could be assigned on the basis of *any* variable exogenous factor. The first point is not really an objection to randomization so much as a correction to exaggerated claims sometimes made on its behalf. The second point does challenge the position that randomization is a *necessary* feature of controlled experiments. But even if randomization is not the only possible way to ensure that treatment assignment is exogenous, it may be an especially convenient and effective means for achieving that end. In particular, randomization is a source of obviously exogenous variation, is applicable in almost any setting, and it is easy to carry out.

Randomization is sometimes thought to be ethically problematic since it may infringe upon the freedom of a physician to recommend what she judges to be best given the specific characteristics of her patient. But if treatment is determined by the judgment of the physician (or the patient), then it is no longer clear that treatment assignment is exogenous. For instance, the physician might recommend treatment on the basis of a feature that affects the outcome. Moreover, if the physician is not consciously aware of all of the characteristics of the patient that influence her treatment recommendation, some of these common causes may be unmeasured, thereby resulting in a causal structure like that in Figure 9. The

question, then, is whether there is some method of treatment assignment that gives the patient what relevant experts judge to be the best for her particular needs while ensuring that treatment assignment is exogenous. Such an approach has been proposed and developed by Joseph Kadane [1986; 1996]. In Kadane's proposal, experts are consulted prior to the assignment of treatment, and several predictor variables are agreed upon that are thought to be relevant to deciding which treatment assignment would be best for the patient. The expert opinions concerning the relationship between the predictor variables and appropriate treatment assignment are carefully elicited and represented in a computer program. Treatment assignment, then, must obey the following rule: *"unless at least one expert (as modeled on the computer) finds a treatment to be the best for someone with the predictor variable values of the patient, it will not be assigned"* [Kadane, 1986, p. 393; italics in original]). Among patients for whom more than one treatment is admissible according to this rule, treatment may be assigned in several ways, including at random [1986, p. 394]. In estimating the effectiveness of the treatment it is, of course, necessary to condition on the predictor variables, since they are causes of treatment assignment in this set up and are believed to be indicators of the outcome as well. That is, if the predictor variables were *not* conditioned on, then one could have an unmeasured common cause of treatment assignment and outcome, as in Figure 9.[6]

Bayesian networks are helpful for understanding a variety of other issues relating to causal inference in the context of medical experiments. Consider again the problem that subjects may not follow the experimental protocol, a situation sometimes referred to as "non-compliance." Non-compliance opens the door to potential unmeasured common causes of treatment and outcome, as in Figure 7. A common approach to this problem is known as the *intent-to-treat methodology*. In the intent-to-treat methodology, one asks — not whether the treatment and outcome are correlated — but whether treatment *assignment* and outcome are. In terms of the DAGs in Figures 5 through 9, this means that one asks not whether V and H are probabilistically dependent, but whether I and H are. An experiment performed in this manner, therefore, does not estimate the effect of treatment upon the outcome, but instead estimates the effect of *treatment assignment* upon the outcome. If treatment assignment is randomized, then it is exogenous, and hence there can be no concern about a common cause of I and H. Thus, the intent-to-treat methodology is appealing in that it avoids the problem of unmeasured common causes. Nevertheless, there are several reasons for dissatisfaction with the intent-to-treat methodology. The most obvious objection is that an experiment performed in this manner does not answer the question originally asked, namely, what is the effect of the *treatment*? Indeed, as the DAG in Figure 8 illustrates, treatment *assignment* may have an effect on the outcome even when the treatment itself is utterly inefficacious. One response to this objection is that since treatment assignment is all that a physician can directly control, it

[6]For further discussion of alternatives to randomization in clinical trials, see [Spiegelhalter *et al.*, 2004].

is worthwhile to estimate its impact. The difficulty with this reply is that patient response to treatment recommendation in the context of an experiment may differ systematically from that in clinical practice. For example, a patient may be more willing to follow a treatment recommendation if she believes that the effectiveness of that treatment has been definitively established. That, however, is a problem of external rather than internal validity.

A different approach to non-compliance is based on the thought that although treatment assignment may not be an ideal intervention, it may nevertheless be an *instrumental variable*. An instrumental variable resembles an ideal intervention except that is not required to satisfy item (1) of the definition given above. That is, an instrumental variable is not required to eliminate the influence of other causes upon its target. To see how an instrumental variable can be useful for causal inference, consider the two DAGs in Figure 10.

(a) (b)

Figure 10. An instrumental variable

The variable U represents unmeasured common causes of X and Y (squares indicate measured variables, circles unmeasured ones). Both graphs predict a probabilistic dependence between X and Y, but the presence of I makes it possible to distinguish between these two alternatives by means of statistical data. If graph 10(a) is correct, then it follows from the causal Markov assumption that I and Y are independent. In contrast, if graph 10(b) is right, then the faithfulness condition entails that I and Y are probabilistically dependent. Indeed, under appropriate conditions, the covariance between I and Y divided by the covariance between I and X is a consistent estimator of the impact of X upon Y.[7]

In the above example, I is an instrumental variable with respect to X and Y. The concept of an instrumental variable can be defined as follows. Let us say that I is *exogenous with respect* to X and Y just in case I is neither an effect of nor shares a common cause with either of these two variables. Then I is an instrumental variable with respect to X and Y exactly if (i) I is a cause of X, (ii) I is exogenous with respect to X and Y, and (iii) any causal path from I to Y passes through X. Condition (iii) is sometimes called the *exclusion restriction* [Angrist *et al.*, 1996, p. 447; Rosenbaum, 2002, p. 181]. The DAGs in Figure 11 illustrate cases in which I fails conditions (ii) and (iii), respectively.

In 11(a), there is a common cause of I and Y, and hence I is not exogenous. In 11(b), there is a directed path from I to Y that does not pass through X(namely,

[7]See [Angrist *et al.*, 1996; Rosenbaum, 2002, pp. 180–88] for discussion of details.

(a) (b)

Figure 11. Not an instrumental variable

$I \to U \to Y$), so I fails the exclusion restriction. Given the faithfulness condition, both graphs predict that I and Y are probabilistically dependent, despite the fact that X is a cause of Y in neither. Consequently, a probabilistic dependence between I and Y does not show that X is a cause of Y if either condition (ii) or (iii) fails.

One common application of the method of instrumental variables occurs in randomized controlled experiments with non-compliance. For example, in experiments designed to evaluate welfare-to-work programs, not all those assigned to participate in the program actually did so, while some of those not assigned found comparable programs elsewhere [Friedlander and Burtless, 1995]. Nevertheless, assignment might be an instrumental variable with respect to program participation and income. Assignment to the program is clearly a cause of participation in it, and assignment is exogenous thanks to randomization. However, the exclusion restriction is more problematic. For example, welfare recipients might interpret assignment to the job training program as indication that their benefits will soon be terminated, and this perception might stimulate them to search more actively for employment.

In a double-blinded randomized experiment, the exclusion restriction is on much firmer ground. For instance, a placebo ensures that any psychological impact resulting directly from treatment assignment is distributed equally among control and experimental groups. But when double-blinds are absent, as is the case in welfare-to-work experiments, the exclusion restriction is often uncertain. Concerns about the exclusion restriction are also prominent in examples of putative instrumental variables outside of randomized experiments. One well-known alleged instrumental variable is draft number with respect to military service in Vietnam and subsequent income. Since Vietnam era draft numbers were assigned randomly, they satisfy items (i) and (ii) of the definition of an instrumental variable, but the exclusion restriction is again uncertain (cf. [Angrist *et al.*, 1996, p. 452]). For instance, since draft deferments could be gained by attending university, it is plausible that draft number might influence the choice to attend college and hence earnings (cf. [Angrist, 1990, p. 330]).

Is there, then, any statistical test for whether a putative instrumental variable I satisfies the exclusion restriction with regard to a pair of variables X and Y? One

approach is to provide data against particular hypotheses about how the alleged instrumental variable might fail the exclusion restriction (cf. ibid; [Angrist and Krueger, 1992, pp. 334–5]). The problem with this strategy is that it is difficult to know whether all of the ways the exclusion restriction could fail have been considered. A different suggestion is that if I is a genuine instrumental variable, then it should be independent of Y conditional on X and measured causes of Y (cf. [Heckman, 1996, p. 460]). To see the idea, consider the DAGs in Figure 12.

(a) (b)

Figure 12. Testing the exclusion restriction

In 12(b), I is an instrumental variable with respect to X and Y, but it is not in 12(a), owing to the arrow from I to Y, which violates the exclusion restriction. However, given the causal Markov and faithfulness conditions, these two graphs make differing predictions about conditional probabilities. Since X is a cause of Y, both graphs predict that I and Y are probabilistically dependent. Moreover, both predict that I and Y are dependent conditional on X. This is because X is a collider on the path $I \rightarrow X \leftarrow C \rightarrow Y$, and hence conditioning on it induces probabilistic dependence, as noted in the previous section. However, conditional on *both* X *and* C, the DAG in 12(a) predicts that I and Y are probabilistically *dependent*, while the one in 12(b) predicts the opposite. Thus, it seems that the exclusion restriction should be accepted if I and Y are independent conditional on X and C and rejected otherwise.

Unfortunately, there is a serious flaw with this test. In particular, a genuine instrumental variable would be expected to fail the test whenever there is an unmeasured common cause of X and Y. To see why, consider the DAG in Figure 13.

Owing to the path $I \rightarrow X \leftarrow U \rightarrow Y$, this graph predicts that I and Y are probabilistically dependent conditional on X and C. Nevertheless, I is an instrumental variable with regard to X and Y. In sum, the exclusion restriction may be a difficult assumption to establish, although it is often reasonable when experiments are double-blinded. In such cases, the method of instrumental variables can enable one to draw inferences about the effect of treatment despite non-compliance.

There are several other topics relevant to medical experiments that are illuminated by Bayesian networks, and interested readers are encouraged to consult the

Figure 13. An instrumental variable that fails the test

texts cited above for further discussion and references.

4 EXTERNAL VALIDITY AND EXTRAPOLATION

Experiments typically aim to draw conclusions that extend beyond the immediate context in which they are performed. For instance, a clinical trial of a new treatment for breast cancer will aim to draw some conclusion about the effectiveness of the treatment among a large population of women, and not merely about its effectiveness among those who participated in the study. Similarly, a study of the carcinogenic effects of a compound on mice usually aims to provide some indication of its effects in humans. External validity has to do with whether the causal relationships learned about in the experimental context can be generalized in this manner. External validity is an especially obvious challenge in research involving animal models, wherein it is referred to as "animal extrapolation" (cf. [Calabrese, 1991; Steel, 2008]). This section will focus on external validity as it concerns animal research, since there is a more extensive literature on that topic.

Any extrapolation is an inference by analogy from a base to a target population. In animal extrapolation, the base is an animal model (say, laboratory mice) while humans are usually the target population. In the cases of concern here, the claim at issue in the extrapolation is a causal generalization, for instance, that a particular substance is carcinogenic or that a new vaccine is effective. The most straightforward approach to extrapolation is what can be called "simple induction." Simple induction proposes the following rule:

> Assume that the causal generalization true in the base population also holds approximately in related populations, unless there is some specific reason to think otherwise.

In other words, simple induction proposes that extrapolation be treated as a default inference among populations that are related in some appropriate sense. There are, however, three aspects of the above characterization of simple induction that stand in obvious need of further clarification. In particular, to apply the above rule in any concrete case, one needs to decide what it is for a causal generalization to hold approximately, to distinguish related from unrelated populations, and to know what counts as a reason to think that the extrapolation would not be appropriate. It seems doubtful that a great deal can be said about these three issues in the abstract — the indicators of related populations, for instance, can be expected to be rather domain specific. But it is possible to give examples of the sorts of considerations that may come into play.

Simple induction does not enjoin one to infer that a causal relationship in one population is a precise guide to that in another — it only licenses the conclusion that the relationship in the related target population is "approximately" the same as that in the base population. It is easy to see that some qualification of this sort is needed if simple induction is to be reasonable. Controlled experiments generally attempt to estimate a *causal effect*, that is, the probability distribution of an effect variable given interventions that manipulate the cause (cf. [Pearl, 2000, p. 70]). In biology and social science, it is rare that a causal effect in one population is

exactly replicated even in very closely related populations, since the probabilities in question are sensitive to changes in background conditions. Nevertheless, it is not rare that various qualitative features of a causal effect, such as positive relevance, are shared across a wide range of populations. For example, tobacco smoke is a carcinogen among many human and non-human mammal populations. Other qualitative features of a causal effect may also be widely shared; for instance, a drug therapy may promote an outcome in moderate dosages but inhibit it in large ones across a variety of species even though the precise effect differs from one species to the next. In other cases, the approximate similarity may also refer to quantitative features of the causal effect — the quantitative increase in the chance of lung cancer resulting from smoking in one population may be a reasonably good indicator of that in other closely related populations. In the case of extrapolation from animal models, it is common to take into account scaling effects due to differences in body size, since one would expect that a larger dose would be required to achieve the same effect in a larger organism (cf. [Watanabe *et al.*, 1992]). Thus, in such cases, the scaling adjustment would constitute part of what is covered by the "approximately." Depending on the context, the term "approximate" could refer to similarity with regard to any one of the aspects of the causal effect mentioned above, or other aspects, or any combination of them.

Simple induction is also restricted in allowing extrapolations only among related populations, a qualification without which the rule would obviously be unreasonable: no population can serve as a guide for every other. In biology, phylogenetic relationships are often used as a guide to relatedness for purposes of extrapolation: the more recent the last common ancestor, the more closely related the two species are (cf. [Calabrese, 1991, pp. 203–4]). A phylogenetic standard of relatedness also suggests some examples of what might count as a specific reason to think that the base population is not a reliable guide for the target population. If the causal relationship depends upon a feature of the model not shared by its most recently shared common ancestor with the target, then that is a reason to suspect that the extrapolation may be ill founded.

In many biological examples, the simple induction requires only some relatively minimal background knowledge concerning the phylogenetic relationships among the base and target populations, and its chief advantage lies in this frugality of information demanded for extrapolation. Yet the weakness of the simple inductive strategy also lies in exactly this frugality: given the rough criteria of relatedness, the strategy will inevitably produce many mistaken extrapolations. According to one review of results concerning interspecies comparisons of carcinogenic effects:

> Based on the experimental evidence from the CPDB [Carcinogenic Potency Database] involving prediction from rats to mice, from mice to rats, from rats or mice to hamsters, and from humans to rats and humans to mice, ... one cannot assume that if a chemical induces tumors at a given site in one species it will also be positive and induce tumors at the same site in a second species; the likelihood is at most 49% [Gold *et al.*, 1992, p. 583].

A related challenge for the simple induction is that it is not rare that there are significant differences across distinct model organisms or strains. For instance, aflatoxin B_1 causes liver cancer in rats but has little carcinogenic effect in mice [Gold et al., 1992, pp. 581–2; Hengstler et al., 2003, p. 491]. One would expect that extrapolation by simple induction is more frequently justified when the inference is from human to human than when it is from animal to human. But the difference here is likely one of degree rather than kind, since a variety of factors (e.g. gender, race, genetics, diet, environment, etc.) can induce distinct responses to the same cause among human populations. Thus, it is of interest to ask what grounds there are, if any, for extrapolation other than simple induction.

As one might expect, there are more and less optimistic answers to this question in the literature on animal extrapolation. On the more optimistic side, there are discussions of some circumstances that facilitate and some that hinder extrapolation, often presented in connection with detailed case studies. For instance, it has been observed that extrapolation is on firmer ground with respect to basic, highly conserved biological mechanisms [Wimsatt, 1998; Schaffner, 2001; Weber, 2005, pp. 180–4]. Others have observed that a close phylogenetic relationship is not necessary for extrapolation and that the use of a particular animal model for extrapolation must be supported by empirical evidence [Burian, 1993]).[8] These suggestions are quite sensible. The belief that some fundamental biological mechanisms are very widely conserved is no doubt a motivating premise underlying work on such simple model organisms as the nematode worm. And it is certainly correct that the appropriateness of a model organism for its intended purpose is not something that may merely be assumed but a claim that requires empirical support.

Yet the above suggestions are not likely to satisfy those who take a more pessimistic view of animal extrapolation. Objections to animal extrapolation focus on causal processes that do not fall into the category of fundamental, conserved biological mechanisms. For example, Marcel Weber suggests that mechanisms be conceived of as embodying a hierarchical structure, wherein the components of a higher-level mechanism consist of lower-level mechanisms, and that while lower-level mechanisms are often highly conserved, the same is not true of the higher-level mechanisms formed from them [2001, pp. 242–3; 2005, pp. 184–6]. So, even if one agreed that basic mechanisms are highly conserved, this would do little to justify extrapolations from mice, rats, and monkeys to humans regarding such matters as the safety of a new drug or the effectiveness of a vaccine. Since critiques of animal extrapolation are often motivated by ethical concerns about experimentation on animals capable of suffering (cf. [LaFollette and Shanks, 1996]), they primarily concern animal research regarding less fundamental mechanisms that cannot be studied in such simpler organisms as nematode worms or slime molds. Moreover, noting that the appropriateness of an animal model for a particular extrapolation is an empirical hypothesis does not explain how such a hypothesis can be

[8]Guala [2005] also emphasizes the importance in experimental economics of providing empirical evidence to support the claim that the model is relevantly similar to the target.

established without already knowing what one wishes to extrapolate.

The most sustained methodological critique of animal extrapolation is developed in a book and series of articles by Hugh LaFollette and Niall Shanks [1993a; 1993b; 1995; 1996]. They use the term *causal analogue model* (CAM) to refer to models that can ground extrapolation and *hypothetical analogue model* (HAM) to refer to those that function only as sources of new hypotheses to be tested by clinical studies. According to LaFollette and Shanks, animal models can be HAMs but not CAMs. A similar, though perhaps more moderate thesis is advanced by Marcel Weber, who maintains that, except for studies of highly conserved mechanisms, animal models primarily support only "preparative experimentation" and not extrapolation [2005, pp. 185–6]. Weber's "preparative experimentation" is similar to LaFollette and Shanks' notion of a HAM, except that it emphasizes the useful research materials and procedures derived from the animal model in addition to hypotheses [2005, pp. 174–6, 182–3].

LaFollette and Shanks' primary argument for the conclusion that model organisms can function only as HAMs and not as CAMs rests on the proposition that if a model is a CAM, then *"there must be no causally relevant disanalogies between the model and the thing being modeled"* [1995, p. 147; italics in original]. It is not difficult to show that animal models rarely if ever meet this stringent requirement. A second argument advanced by LaFollette and Shanks rests on the plausible claim that the appropriateness of a model organism for extrapolation must be demonstrated by empirical evidence [1993a, p. 120]. LaFollette and Shanks argue that this appropriateness cannot be established without already knowing what one hopes to learn from the extrapolation.

> We have reason to believe that they [animal model and human] are causally similar only to the extent that we have detailed knowledge of the condition in *both* humans and animals. However, once we have enough information to be confident that the non-human animals are causally similar (and thus, that inferences from one to the other are probable), we likely know most of what the CAM is supposed to reveal [1995, p. 157].

LaFollette and Shanks presumably mean to refer to their strict CAM criterion when they write "causally similar," but the above argument can be stated independently of that criterion. Whatever the criterion of a good model, the problem is to show that the model satisfies that criterion without already knowing what we hoped to learn from the extrapolation.

Those who are more optimistic about the potential for animal extrapolation to generate informative conclusions about humans are not likely to be persuaded by these arguments. Most obviously, LaFollette and Shanks' criterion for a CAM is so stringent that it is doubtful that it is could even be satisfied by two human populations. Nevertheless, LaFollette and Shanks' arguments are valuable in that they focus attention on two challenges that any adequate positive account of extrapolation must address. First, such an account must explain how it can be possible to

extrapolate even when some causally relevant disanalogies are present. Secondly, an account must be given of how the suitability of the model for extrapolation can be established without already knowing what one hoped to extrapolate.

One intuitively appealing suggestion is that knowledge of the mechanisms underlying the cause and effect relationship can help to guide extrapolation. For example, imagine two machines A and B. Suppose that a specific input-output relationship in machine A has been discovered by experiment, and the question is whether the same causal relationship is also true of machine B. But unfortunately, it is not possible to perform the same experiment on B to answer this question. Suppose, however, that it is possible to examine the mechanisms of the two machines — if these mechanisms were similar, then that would support extrapolating the causal relationship from one machine to the other. Thus, the mechanisms approach to extrapolation suggests that knowledge of mechanisms and factors capable of interfering with them can provide a basis for extrapolation. This thought is second nature among molecular biologists, and some authors concerned with the role of mechanisms in science have suggested it in passing (cf. [Wimsatt, 1976, p. 691]). Although appealing, the mechanisms proposal stands in need of further elaboration before it can answer the two challenges described above. First, since there inevitably will be some causally relevant differences between the mechanisms of the model and target, it needs to be explained how extrapolation can be justified even when some relevant differences are present. Secondly, comparing mechanisms would involve examining the mechanism in the target — but if the mechanism can be studied directly in the target, it is not clear why one needs to extrapolate from the model. In other words, it needs to be explained how the suitability of the model as a basis for extrapolation could be established given only partial knowledge of the mechanism in the target. Further elaboration of the mechanisms approach to extrapolation that addresses these issues can be found in [Steel, 2008].

BIBLIOGRAPHY

[Angrist, 1990] J. Angrist. Lifetime Earnings and the Vietnam Era Draft Lottery: Evidence from Social Security Administrative Records, *American Economic Review* 80: 313-35, 1990.

[angrist et al., 1996] J. Angrist, W. Imbens, and D. Rubin. Identification of Causal Effects Using Instrumental Variables, *Journal of the American Statistical Association* 91: 444-55, 1996.

[Angrist and Krueger, 1991] J. Angrist and A. Krueger. Does Compulsory School Attendance Affect Schooling and Earnings?, *Quarterly Journal of Economics* 106: 979-1014, 1991.

[Burian, 1993] R. Burian. How the Choice of Experimental Organism Matters: Epistemological Reflections on an Aspect of Biological Practice, *Journal of the History of Biology* 26: 351-367, 1993.

[Calabrese, 1991] E. Calabrese. *Principles of Animal Extrapolation.* Chelsea, MI: Lewis Publishers, 1991.

[Cartwright, 1999] N. Cartwright. Causal Diversity and the Markov Condition, *Synthese* 121: 3-27, 1999.

[Cartwright, 2002] N. Cartwright. Against Modularity, the Causal Markov Condition and any Link Between the Two: Comments on Hausman and Woodward, *British Journal for the Philosophy of Science* 53: 411-453, 2002.

[Cartwright, 2006] N. Cartwright. From Metaphysics to Method: Comments on Manipulability and the Causal Markov Condition, *British Journal for the Philosophy of Science* 57: 197-218, 2006.

[Dowe, 2000] P. Dowe. *Physical Causation.* Cambridge: Cambridge University Press, 2000.

[Eells, 1991] E. Eells. *Probabilistic Causality.* Cambridge: Cambridge University Press, 1991.

[Friedlander and Burtless, 1995] D. Friedlander and G. Burtless. *Five Years After: The Long-Term Effects of Welfare-to-Work Programs.* New York: Russell Sage Foundation, 1995.

[Glennan, 1996] S. Glennan. Mechanisms and the Nature of Causation, *Erkenntnis* 44: 49-71, 1996.

[Glymour, 1999] C. Glymour. Rabbit Hunting, *Synthese* 121: 55-78, 1999.

[Gold et al., 1992] L. Gold, N. Manley, and B. Ames. Extrapolation of Carcinogenicity between Species: Qualitative and Quantitative Factors, *Risk Analysis* 12: 579-88, 1992.

[Guala, 2005] F. Guala. *The Methodology of Experimental Economics.* Cambridge: Cambridge University Press, 2005.

[Hausman, 1998] D. Hausman. *Causal Asymmetries.* Cambridge: Cambridge University Press, 1998.

[Hausman and Woodward, 1999] D. Hausman and J. Woodward. Independence, Invariance and the Causal Markov Condition, *British Journal for the Philosophy of Science* 50: 521-83, 1999.

[Hausman and Woodward, 2004] D. Hausman and J. Woodward. Modularity and the Causal Markov Condition: A Restatement, British Journal for the Philosophy of Science 55: 147-161, 2004.

[Heckman, 1996] J. Heckman. Identification of Causal Effects Using Instrumental Variables: Comment, *Journal of the American Statistical Association* 91 (434): 459-62, 1996.

[Hengstler et al., 2003] J. G. Hengstler, M. S. Bogdanffy, H. M. Bolt, and R. Oesch. Challenging Dogma: Thresholds for Genotoxic Carcinogens? The Case of Vinyl Acetate, *Annual Review of Pharmocological Toxicology* 43: 485-520, 2003.

[Hitchcock, 1995] C. Hitchcock. Salmon on Explanatory Relevance, *Philosophy of Science* 62: 602-620, 1995.

[Hoover, 2003] K. Hoover. Nonstationary Time Series, Cointegration, and the Principle of the Common Cause, *British Journal for the Philosophy of Science* 54: 527-551, 2003.

[Hume, 1740/1978] D. Hume. *A Treatise of Human Nature.* Oxford: Oxford University Press, 1740/1978.

[Kadane, 1986] J. Kadane. Progress Toward a more Ethical Method for Clinical Trials, Journal of Medicine and Philosophy 11: 305-404, 1986.

[Kadane, 1996] J. Kadane, ed. *Bayesian Methods and Ethics in a Clinical Trial Design.* New York: J. Wiley and Sons, 1996.

[Kadane and Seidenfeld, 1999] J. Kadane and T. Seidenfeld. Randomization in a Bayesian Perspective, in Kadane, Schervish, and Seidenfeld (eds.), *Rethinking the Foundations of Statistics.* Cambridge: Cambridge University Press, pp. 292-313, 1999.

[LaFollette and Shanks, 1993a] H. LaFollette and N. Shanks. Animal Models in Biomedical Research: Some Epistemological Worries, *Public Affairs Quarterly* 7: 113-30, 1993.

[LaFollette and Shanks, 1993b] H. LaFollette and N. Shanks. The Intact Systems Argument: Problems with the Standard Defense of Animal Extrapolation, *Southern Journal of Philosophy* 31: 323-33, 1993.

[LaFollette and Shanks, 1995] H. LaFollette and N. Shanks. Two Models of Models in Biomedical Research, *Philosophical Quarterly* 45: 141-60, 1995.

[LaFollette and Shanks, 1996] H. LaFollette and N. Shanks. *Brute Science: Dilemmas of Animal Extrapolation.* New York, NY: Routledge, 1996.

[Lewis, 1973] D. Lewis. Causation, *Journal of Philosophy* 70: 556-567.

[Lewis, 1979] D. Lewis. Counterfactual Dependence and Time's Arrow, *Noûs* 13: 455-476, 1979.

[Machamer et al., 2000] P. Machamer, L. Darden, and C. Craver. Thinking about Mechanisms, *Philosophy of Science* 67: 1-25, 2000.

[Mayo, 1987] O. Mayo. Comments on 'Randomization and the Design of Experiments' by P. Urbach, *Philosophy of Science* 54: 592-596, 1987.

[Mellor, 1995] D. H. Mellor. *The Facts of Causation.* London: Routledge, 1995.

[Menzies and Price, 1993] P. Menzies and H. Price. Causation as a Secondary Quality, *British Journal for the Philosophy of Science* 44: 187-203, 1993.

[Neopolitan, 2004] R. Neopolitan. *Learning Bayesian Networks.* Upper Saddle River, NJ: Prentice Hall, 2004.

[Papinau, 1994] D. Papineau. The Virtues of Randomization, *British Journal for the Philosophy of Science* 45: 437-450, 1994.

[Pearl, 1998] J. Pearl. TETRAD and SEM, *Multivariate Behavioral Research* 33: 119-128, 1998.

[Pearl, 2000] J. Pearl. *Causality: Models, Reasoning, and Inference.* Cambridge: Cambridge University Press, 2000.

[Rosenbaum, 2002] P. Rosenbaum. *Observational Studies,* 2^{nd} edition. New York: Springer-Verlag, 2002.

[Salmon, 1984] W. Salmon. *Scientific Explanation and the Causal Structure of the World.* Princeton, NJ: Princeton University Press, 1984.

[Salmon, 1998] W. Salmon. *Causality and Explanation.* Oxford: Oxford University Press, 1998.

[Schaffner, 2001] K. Schaffner. Extrapolation from Animal Models: Social Life, Sex, and Super Models, in P. Machamer, R. Grush, and P. McLaughlin (eds.), *Theory and Method in the Neurosciences.* Pittsburgh: Pittsburgh University Press, pp. 200-30, 2001.

[Sober, 2001] E. Sober. Venetian Sea Levels, British Bread Prices, and the Principle of the Common Cause, *British Journal for the Philosophy of Science* 52: 331-46, 2001.

[Spirts et al., 2000] P. Spirtes, C. Glymour, and R. Scheines. *Causation, Prediction, and Search,* 2^{nd} edition. Cambridge, MA: MIT Press, 2000.

[Spiegelhalter et al., 2004] D. Spiegelhalter, K. Abrams, and J. Myles. *Bayesian Approaches to Clinical Trials and Health-Care Evaluation.* New York: J. Wiley and Sons, 2004.

[Steel, 2003] D. Steel. Making Time Stand Still: A Response to Sober's Counter-example to the Principle of the Common Cause, *British Journal for the Philosophy of Science* 54: 309-17, 2003.

[Steel, 2005] D. Steel. Indeterminism and the Causal Markov Condition, *British Journal for the Philosophy of Science* 56: 3-26, 2005.

[Steel, 2006a] D. Steel. Comment on Hausman & Woodward on the Causal Markov Condition, *British Journal for the Philosophy of Science* 57: 219-231, 2006.

[Steel, 2006b] D. Steel. Homogeneity, Selection, and the Faithfulness Condition, *Minds and Machines* 16, 2006.

[Steel, 2008] D. Steel. *Across the Boundaries: Extrapolation in Biology and Social Science.* New York: Oxford University Press, 2008.

[Suppes, 1970] P. Suppes. *A Probabilistic Theory of Causality.* Amsterdam: North-Holland, 1970.

[Urbach, 1985] P. Urbach. Randomization and the Design of Experiments, *Philosophy of Science* 52: 256-273, 1985.

[Urbach, 1991] P. Urbach. A Reply to Mayo's Criticisms of Urbach's 'Randomization and the Design of Experiments', *Philosophy of Science* 58: 125-128, 1991.

[Urbach, 1994] P. Urbach. Reply to David Papineau, *British Journal for the Philosophy of Science* 45: 712-715, 1994.

[Watanabe *et al.*, 1992] K. Watanabe, F. Dois, and L. Zeise. Interspecies Extrapolation: A Reexamination of Acute Toxicity Data, *Risk Analysis* 12: 301-10, 1992.

[Weber, 2001] M. Weber. Under the Lamppost: Commentary on Schaffner, in P. Machamer, R. Grush, and P. McLaughlin (eds.), *Theory and Method in the Neurosciences*. Pittsburgh: Pittsburgh University Press, 231-49, 2001.

[Weber, 2005] M. Weber. *Philosophy of Experimental Biology*. Cambridge: Cambridge University Press 2005.

[Wimsatt, 1976] W. Wimsatt. Reductive Explanation: A Functionalist Account, in R. S. Cohen et al. (eds.), *PSA 1974*. Dordrecht-Holland: D. Reidel Publishing Company, 671-710, 1976.

[Wimsatt, 1998] W. Wimsatt. Simple Systems and Phylogenetic Diversity, *Philosophy of Science* 65: 267-75, 1998.

[Woodward, 1998] J. Woodward. Causal Independence and Faithfulness, *Multivariate Behavioral Research* 33: 129-148, 1998.

[Woodward, 2003] J. Woodward. *Making Things Happen: A Causal Theory of Explanation*. Oxford, UK: Oxford University Press, 2003.

PATTERNS OF MEDICAL DISCOVERY

Paul Thagard

1 INTRODUCTION

Here are some of the most important discoveries in the history of medicine: blood circulation (1620s), vaccination, (1790s), anesthesia (1840s), germ theory (1860s), X-rays (1895), vitamins (early 1900s), antibiotics (1920s-1930s), insulin (1920s), and oncogenes (1970s). This list is highly varied, as it includes basic medical knowledge such has Harvey's account of how the heart pumps blood, hypotheses about the causes of disease such as the germ theory, ideas about the treatments of diseases such as antibiotics, and medical instruments such as X-ray machines. The philosophy of medicine should be able to contribute to understanding of the nature of discoveries such as these.

The great originators of the field of philosophy of science were all concerned with the nature of scientific discovery, including Francis Bacon [1960], William Whewell [1967], John Stuart Mill [1974], and Charles Peirce [1931–1958]. The rise of logical positivism in the 1930s pushed discovery off the philosophical agenda, but the topic was revived through the work of philosophers such as Norwood Russell Hanson [1958], Thomas Nickles [1980], Lindley Darden [1991; 2006], and Nancy Nersessian [1984]. Scientific discovery has also become an object of investigations for researchers in the fields of cognitive psychology and artificial intelligence, as seen in the work of Herbert Simon, Pat Langley, and others [Langley *et al.*, 1987; Klahr, 2000]. Today, scientific discovery is an interdisciplinary topic at the intersection of the philosophy, history, and psychology of science.

The aim of this chapter is to identify patterns of discovery that illuminate some of the most important developments in the history of medicine. I have used a variety of sources to identify forty great medical discoveries [Adler, 2004; Friedman and Friedland, 1998; Science Channel, 2006; Strauss and Strauss, 2006]. After providing a taxonomy of medical breakthroughs, I discuss whether there is a logic of discovery, and argue that the patterns of medical discovery do not belong to formal logic. In contrast, it is possible to identify important psychological patterns of medical discovery by which new hypotheses and concepts originate. In accord with recent developments in cognitive science, I also investigate the possibility of identifying neural patterns of discovery. Finally, I discuss the role that computers are currently playing in medical discovery.

Handbook of the Philosophy of Science. Volume 16: Philosophy of Medicine.
Volume editor: Fred Gifford. General editors: Dov M. Gabbay, Paul Thagard and John Woods.

2 MEDICAL HYPOTHESES

There are at least four different kinds of hypotheses employed in medical discovery: hypotheses about basic biological processes relevant to health; hypotheses about the causes of disease; hypotheses about the treatment of disease; and hypotheses about how physical instruments can contribute to the diagnosis and treatment of disease. Generation of new hypotheses about health and disease often involves the creation of new concepts such as *virus, vitamin C,* and *X-ray.* I will now give examples of the different kinds of medical hypotheses and concepts.

Although medicine is largely concerned with the diagnosis, causes, and treatment of disease, a great deal of medical knowledge concerns the basic biological processes that support healthy functioning of the body. The first reliable account of human anatomy was Vesalius's *On the Fabric of the Human Body*, published in 1543, which provided detailed illustrations of the structure of bones, muscles, organs, and blood vessels. His careful dissections produced discoveries about the structure of human bones that contradicted the accepted account of Galen, who had only dissected non-humans. The first major discovery in physiology was William Harvey's recognition in his 1628 book that blood circulates through the body as the result of the pumping action of the heart. Although cells were first observed in the seventeenth century, it took 200 years before the discovery and acceptance of the hypotheses that all living things are made of cells and that all cells arise from preexisting cells. During the twentieth century, many hypotheses about the functioning of the human body were generated and confirmed, establishing the fields of genetics and molecular biology that provided the basis for modern molecular understanding of the causes of health and disease. Table 1 summarizes some of the most important medical discoveries concerned with basic biological processes. All of these discoveries eventually contributed to discovery of the causes and treatments of disease, with a delay of decades or even centuries. For example, van Leeuwenhoek's discovery of "little animals" such as bacteria only became medically important 200 years later with the development of the germ theory of disease. All of these basic medical discoveries involved hypotheses about biological structure or function, and some required the introduction of new concepts such as *cell, gene,* and *hormone.*

Discoveries that are more specifically medical concern the causes of diseases. Until modern Western medicine emerged in the nineteenth century, the predominant world theories attributed disease to bodily imbalances, involving the humors of Hippocratic medicine, the *yin, yang* and *chi* of traditional Chinese medicine, and the *doshas* of traditional Indian Ayurvedic medicine. Pasteur revolutionized the explanation of disease in the 1860s with the hypothesis that many diseases such as cholera are caused by bacteria. In the twentieth century, other diseases were connected with infectious agents, including viruses and prions. The nutritional causes of some diseases were identified in the early twentieth century, for example how vitamin C deficiency produces scurvy. Autoimmune diseases require explanation in terms of malfunction of the body's immune system, as when mul-

DECADE	DISCOVERY	DISCOVERER	HYPOTHESES
1540s	anatomy	Vesalius	bone structure, etc.
1620s	circulation	Harvey	blood circulates
1670s	bacteria	Leeuwenhoek	animalcules exist
1830s	cell theory	Schleiden,etc.	organs have cells
1860s	genetics	Mendel	inheritance
1900s	hormones	Bayliss, etc.	messaging
1950s	DNA	Watson, Crick	DNA structure
1950s	immune system	Lederberg,etc.	clonal deletion

Table 1. Some major discoveries concerning medically important biological processes.

tiple sclerosis arises from damage to myelin in the central nervous system. Some diseases such as cystic fibrosis have a simple genetic basis arising from inherited mutated genes, while in other diseases such as cancer the molecular/genetic causes are more complex. The general form of a hypothesis about disease causation is: disease D is caused by factor F, where F can be an external agent such as a microbe or an internal malfunction. Table 2 displays some of the most important discoveries about the causes of diseases.

DECADE	DISCOVERY	DISCOVERER	HYPOTHESES
1840s	cholera	Snow	cholera is water-borne
1840s	antisepsis	Semmelweiss	contamination causes fever
1870s	germ theory	Pasteur, Koch	bacteria cause disease
1890s	tobacco disease	Ivanofsky, Beijerinck	viruses cause disease
1910s	cholesterol	Anichkov	cause of artherosclerosis
1960s	oncogenes	Varmus	cancer
1980s	prions	Prusiner	prions cause kuru
1980s	HIV	Gallo, Montagnier	HIV causes AIDS
1980s	H. pylori	Marshall, Warren	H. pylori causes ulcers

Table 2. Some major discoveries concerning the causes of diseases.

The third kind of medical hypothesis, and potentially the most useful, concerns the treatment and prevention of disease. Hypotheses about treatment of disease based on traditional imbalance theories, for example the use in Hippocratic medicine of bloodletting to balance humors, have been popular but unsubstantiated. In contrast, Edward Jenner's discovery in the 1790s that inoculation provides immunity to smallpox has saved millions of lives, as has the twentieth-century discoveries of drugs to counter the infectious properties of bacteria and viruses. The discovery of insulin in the 1920s provided an effective means of treating type 1

diabetes, which had previouisly been fatal. Treatments need not actually cure a disease to be useful: consider the contribution of steroids to diminishing the symptoms of autoimmune diseases, and the use of painkillers such as aspirin to treat various afflictions. Surgical treatments have often proved useful for treating heart disease and cancer.

It might seem that the most rational way for medicine to progress would be from basic biological understanding to knowledge of the causes of a disease to treatments for the disease. Often, however, effective treatments have been found long before deep understanding of the biological processes they affect. For example, aspirin was used as a painkiller for most of a century before its effect on prostaglandins was discovered, and antibiotics such as penicillin were in use for decades before it became known how they kill bacteria. Lithium provided a helpful treatment for bipolar (manic-depressive) disorder long before its mechanism of action on the brain was understood. On the other hand, some of the discoveries about causes listed in table 2 led quickly to therapeutic treatments, as when the theory that ulcers are caused by bacterial infection was immediately tested by treating ulcer patients with antibiotics [Thagard, 1999].

Table 3 lists some of the most important discoveries about medical treatments. These fall into several disparate subcategories, including prevention, surgical techniques, and drug treatments. Vaccination, antisepsis, and birth control pills serve to prevent unwanted conditions. Anesthesia, blood transfusions, organ transplants, and in vitro fertilization all involve the practice of surgery. Drug treatments include aspirin, antibiotics, and insulin. All of the treatments in table 3 are based on hypotheses about how an intervention can bring about improvements in a medical situation. A few involve new concepts, such as the concept of a blood type which was essential for making blood transfusions medically feasible.

My fourth kind of medical discovery involves hypotheses about the usefulness of various instruments. I listed X-rays among the most important medical discoveries because of the enormous contribution that X-ray machines have made to diagnosis of many ailments, from bone fractures to cancers. Other instruments of great medical importance are the stethoscope, invented in 1816, and techniques of testing blood for blood type, infection, and other medically relevant contents such as cholesterol levels. More recent instruments of medical significance include ultrasound scanners developed in the 1960s, computed tomography (CT) scanners invented in the 1970s, and magnetic resonance imaging (MRI) adopted in the 1980s. All of these instruments required invention of a physical device, which involved hypotheses about the potential usefulness of the device for identifying diseases and their causes. Table 4 lists some of the major medical discoveries involving physical instruments useful for the diagnosis of diseases. The origination of such instruments is perhaps better characterized as *invention* rather than discovery, but it still requires the generation of new hypotheses about the effectiveness of the instrument for identifying normal and diseased states of the body. For example, when Laennec invented the stethoscope, he did so because he hypothesized that a tube could help him better hear the operation of his patients' hearts.

DECADE	DISCOVERY	DISCOVERER	HYPOTHESES
1790s	vaccination	Jenner	prevent smallpox
1840s	anesthesia	Long	reduce pain
1860s	antiseptic surgery	Lister	prevent infection
1890s	aspirin	Hoffman	treat pain
1890s	radiation treatment	Freund	remove cancer
1900s	Salvarsan	Ehrlich	cure syphilis
1900s	blood transfusion	Landsteiner	transfusion works
1920s	antibiotics	Fleming	mold kills bacteria
1920s	insulin	Banting	treat diabetes
1930s	sulfa drugs	Domagk	cure infection
1950s	birth control pill	Pincus, etc.	prevent pregnancy
1950s	transplants	Murray	kidney, lung
1950s	polio vaccination	Salk	prevent polio
1960s	IVF	Edwards	treat infertility
1980s	anti-retrovirals	various	slow HIV infection

Table 3. Some major discoveries about treatments of diseases.

DECADE	DISCOVERY	DISCOVERER	HYPOTHESIS
1810s	stethoscope	Laennec	measure heart
1890s	x-rays	Reontgen	reveal bone
1900s	EKG	Einthoven	measure heart
1900s	tissue culture	Harrison	detect infections
1920s	cardiace catheterization	Forssman	inspect heart
1950s	radioimmunoassay	Yalow	analyze blood
1970s	CAT scans	Hounsfield	observe tisseu
1970s	MRI scans	Lauterbur	observe tissue

Table 4. Some major discoveries of diagnostic instruments.

The discovery of new hypotheses always requires the novel juxtaposition of concepts not previously connected. For example, the hypotheses that comprise the germ theory of disease connect a specific disease such as peptic ulcer with a specific kind of bacteria such as Helicobacter pylori. Construction of hypotheses requires the application and sometimes the generation of concepts. In the early stage of the bacterial theory of ulcers, Barry Marshall and Robin Warren associated the concepts *ulcer, cause,* and *bacteria,* and later their hypothesis was refined by specification of the bacteria via the concept of *H. pylori.* Other concepts of great importance in the history of discovery of the causes of disease include *vitamin, virus, autoimmune, gene,* and *oncogene.* Hence a theory of medical discovery will have to include an account of concept formation as well as an account of the generation of hypotheses. How this might work is discussed in the section below on psychological patterns.

All the medical discoveries so far discussed have involved the generation of specific new hypotheses. But there is another kind of more general medical breakthrough that might be counted as a discovery, namely the development of new methods for investigating the causes and treatments of disease. Perhaps the first great methodological advance in the history of medicine was the Hippocratic move toward natural rather than magical or theological explanations of disease. The theory of humors was not, as it turned out millennia later, a very good account of the causes and treatments of disease, but at least it suggested how medicine could be viewed as akin to science rather than religion. In modern medicine, one of the great methodological advances was Koch's postulates for identifying the causes of infectious diseases [Brock 1988, p. 180]:

1. The parasitic organism must be shown to be constantly present in characteristic form and arrangement in the diseased tissue.

2. The organism which, from its behavior appears to be responsible for the disease, must be isolated and grown in pure culture.

3. The pure culture must be shown to induce the disease experimentally.

It turned out that these requirements, identified by Koch in the 1870s as part of his investigation of tuberculosis, are sometimes too stringent a requirement for inferring causes of infectious diseases, because some infectious agents are extremely difficult to culture and/or transmit. But the postulates have been useful for setting a high standard for identifying infectious agents. A third methodological breakthrough was the use, beginning only in the late 1940s, of controlled clinical trials in the investigation of the efficacy of medical treatments. Only decades later was it widely recognized that medical practices should ideally be determined by the results of randomized, double-blind, placebo-controlled trials, with the emergence of the movement for evidence-based medicine in the 1990s. None of these three methodological breakthroughs involve the discovery of particular medical hypotheses, but they have been crucial to development of well-founded medical views about the causes and treatments of diseases.

3 LOGICAL PATTERNS

Karl Popper published the English translation of his *Logik der Forschung* with the title *The Logic of Scientific Discovery.* The title is odd, for in the text he sharply distinguishes between the process of conceiving a new idea, and the methods and results of examining it logically [Popper, 1959, p. 21]. The book is concerned with logic, not discovery. Like Reichenbach [1938] and many other philosophers of science influenced by formal logic, Popper thought philosophy should not concern itself with psychological processes of discovery. The term "logic" had come to mean "formal logic" in the tradition of Frege and Russell, in contrast to the broader earlier conception of logic as the science and art of reasoning. In John Stuart Mill's [1970/1843] *System of Logic,* for example, logic is in part concerned with the mental processes of reasoning, which include inferences involved in scientific discovery.

If logic means just "formal deductive logic", then there is no logic of discovery. But N. R. Hanson (1958, 1965) argued for a broader conception of logic, which could be concerned not only with reasons for accepting an hypothesis but also with reasons for entertaining a hypothesis in the first place. He borrowed from Charles Peirce the idea of a kind of reasoning called *abduction* or *retroduction,* which involves the introduction of hypotheses to explain puzzling facts. By abduction Peirce meant "the first starting of a hypothesis and the entertaining of it, whether as a simple interrogation or with any degree of confidence" [Peirce, 1931–1958, vol. 6, p. 358]. Unfortunately, Peirce was never able to say what the first starting of a hypothesis amounted to, aside from speculating that people have an instinct for guessing right. In multiple publications, Hanson only managed to say that a logic of discovery would include a study of the inferential moves from the recognition of an anomaly to the determination of which types of hypothesis might serve to explain the anomaly [Hanson, 1965, p. 65]. Researchers in artificial intelligence have attempted to use formal logic to model abductive reasoning, but Thagard and Shelley [1997] describe numerous representational and computational shortcomings of these approaches, such as that explanation is often not a deductive relation.

The closest we could get to a logical pattern of hypothesis generation for medical discovery, in the case of disease, would be something like:

> Anomaly: People have disease D with symptoms S.
> Hypothesis: Cause C can produce S.
> Inference: So maybe C is the explanation of D.

For Pasteur, this would be something like:

> Anomaly: People have cholera with symptoms of diarrhea, etc.
> Hypothesis: Infection by a bacterium might cause such symptoms.
> Inference: So maybe bacterial infection is the explanation of cholera.

Unfortunately, this patterns leaves unanswered the most interesting question about the discovery: how did Pasteur first come to think that infection by a bacterium

might cause cholera? Answering this question requires seeing abduction as not merely a kind of deformed logic, but rather as a rich psychological process.

For Popper, Reichenbach, and even Hanson and Peirce, there is a sharp distinction between logic and psychology. This division is the result of the schism between philosophy and psychology that occurred because of the rejection by Frege and Husserl of psychologism in philosophy, as inimical to the objectivity of knowledge (see [Thagard, 2000, ch. 1] for a historical review). Contemporary naturalistic epistemology in the tradition of Quine [1968] and Goldman [1986] rejects the expulsion of psychology from philosophical method. I will now try to show how richer patterns in medical discovery can be identified from the perspective of modern cognitive psychology.

4 PSYCHOLOGICAL PATTERNS

We saw in the last section that little can be said about discovery from the perspective of a philosophy of science that emphasizes logical structure and inference patterns. In contrast, a more naturalistic perspective that takes into account the psychological processes of practicing scientists has the theoretical resources to explain in much detail how discoveries come about. These resources derive from the development since the 1960s of the field of cognitive psychology, which studies the representations and procedures that enable people to accomplish a wide range of inferential tasks, from problem solving to language understanding. Starting in the 1980s, some philosophers of science have drawn on cognitive science to enrich accounts of the structure and growth of science knowledge (see e.g. [Carruthers *et al.*, 2002; Darden, 1991; 2006; Giere, 1988; Nersessian, 1992; Thagard, 1988; 1992; 1999]). On this view, we should think of a scientific theory as a kind of mental representation that scientists can employ for many purposes such as explanation and discovery. Then scientific discovery is the generation of mental representations such as concepts and hypotheses.

I will not attempt a comprehensive account of all the cognitive processes relevant to discovery, nor attempt to apply them to explain the large number of discoveries listed in tables 1–4. Instead I will review a cognitive account of a single major medical discovery, the realization by Barry Marshall and Robin Warren that most stomach ulcers are caused by bacterial infection, for which they were awarded the 2005 Nobel Prize in Physiology or Medicine. Figure 1 depicts a general model of scientific discovery developed as part of my account of the research of Marshall and Warren [Thagard, 1999]. Discovery results from two psychological processes, questioning and search, and from serendipity. Warren's initial discovery of spiral gastric bacteria was entirely serendipitous, happening accidentally in the course of his everyday work as a pathologist. Warren reacted to his observation of these bacteria with surprise, as it was generally believed that bacteria could not long survive the acidic environment of the stomach. This surprise, along with general curiosity, led him to generate questions concerning the nature and possible medical significance of the bacteria.

Figure 1. Psychological model of discovery. From Thagard [1999, p. 47].

Warren enlisted a young gastroenterologist, Barry Marshall, to help him search for answers about the nature and medical significance of the spiral bacteria. After an extensive examination of the literature on bacteriology, they concluded that the bacteria were members of a new species and genus, eventually dubbed *Helicobacter pylori*. Here we see the origin of a new concept, that is a mental representation of the bacteria that Warren observed through a microscope. Marshall's questioning about the medical significance of these bacteria was driven, not only by curiosity, but also by medical needs, as he was aware that available medical treatments for stomach ulcers using antacids were not very effective, diminishing symptoms but not preventing recurrences.

Warren had observed that the bacteria were associated with inflammation of the stomach (gastritis), and Marshall knew that gastritis is associated with peptic ulcer, so they naturally formed the hypothesis that the bacteria might be associated with ulcers. A 1982 study using endoscopy and biopsies found that patients with ulcers were far more likely to have *H. pylori* infections than patients without ulcers. They accordingly generated the hypothesis that the bacteria cause ulcers, by analogy with the many infectious diseases that had been identified since Pasteur. The natural psychological heuristic used here is something like: if A and B are associated, then A may cause B or vice versa. In order to show that A actually does cause B, it is desirable to manipulate A in a way that produces a change in B. Marshall and Warren were initially stymied, however, because of difficulties in carrying out the obvious experiments of giving animals *H. pylori* to induce ulcers and of giving people with ulcers antibiotics to try to kill the bacteria and cure the ulcers. Within a few years, however, they had discovered a regime involving multiple antibiotics that was effective at eradicating the bacteria, and by the early 1990s there were multiple international studies that showed that such eradication often cured ulcers.

The discoveries of Marshall and Warren involve two main kinds of conceptual change. The first kind was introduction of the new concept of *Helicobacter pylori*, which was the result of both perceptual processes of observing the bacteria and of cognitive processes of conceptual combination. Originally they thought that the bacteria might belong to a known species, *Campylobacter*, hence the original name *Campylobacter pylori*, signifying that the new species inhabited the pylorus, the part of the stomach that connects to the duodenum. However, morpholog-

ical and RNA analysis revealed that the new bacteria were very different from *Campylobacter,* so that they were reclassified as members of a new genus. Such reclassification is a second major kind of conceptual change, in that the discovery that bacteria cause ulcers produced a dramatic reclassification of the peptic ulcer disease. Previously, ulcers were viewed as metabolic diseases involving acid imbalance, or even, in older views as being psychosomatic diseases resulting from stress. Through the work of Marshall and Warren, peptic ulcers (except for some caused by non-steroidal anti-inflammatory drugs such as aspirin) were reclassified as infectious diseases, just like tuberculosis and cholera.

Thus the discovery of the bacterial theory of ulcers involved the generation and revision of mental representations. New concepts such as *H. pylori* were formed, and conceptual systems for bacteria and diseases were reorganized. Also generated were hypotheses, such as that bacteria cause ulcers and that ulcers can be treated with antibiotics. Both these sorts of representations can be produced by psychological processes of questioning, search, conceptual combination, and causal reasoning.

Analogy is a psychological process that often contributes to scientific discovery [Holyoak and Thagard, 1995]. Marshall and Warren reasoned analogically when they thought that ulcers might be like more familiar infectious diseases. Other analogies have contributed to medical discoveries, such as Semmelweiss' mental leap from how a colleague became sick as the result of a cut during an autopsy to the hypothesis that childbed fever was being spread by medical students. Thagard [1999, ch. 9] describes other analogies that have contributed to medical discoveries, such as Pasteur's realization that disease is like fermentation in being caused by germs, and Funk's argument that scurvy is like beriberi in being caused by a vitamin deficiency. Thus analogy, like questioning, search, concept formation, and causal reasoning is an identifiable psychological pattern of discovery applicable to medical innovations.

5 NEURAL PATTERNS

The field of cognitive psychology is currently undergoing a major transformation in which the study of brain processes is becoming more and more central. Psychologists have long assumed that mental processing was fundamentally carried out by the brain, but the early decades of cognitive psychology operated independently of the study of the brain. This independence began to evaporate in the 1980s with the development of brain scanning technologies such as fMRI machines that enabled psychologists to observe brain activities in people performing cognitive tasks. Another major development in that decade was the development of connectionist computational models that used artificial neural networks to simulate psychological processes. (For a review of approaches to cognitive science, see [Thagard, 2005].) As illustrated by many journal articles and even the title of a recent textbook, *Cognitive Psychology: Mind and Brain* [Smith and Kosslyn, 2007], the field of cognitive science has become increasingly connected with neuroscience.

This development should eventually yield new understanding of scientific discovery. The psychological patterns of discovery described in the last section saw it as resulting from computational procedures operating on mental representations. From the perspective of cognitive neuroscience, representations are processes rather than things: they are patterns of activity in groups of neurons that fire as the result of inputs from other neurons. The procedures that operate on such mental representations are not much like the algorithms in traditional computer programs that inspired the early computational view of mind. Rather, if mental representations are patterns of neural activity, then procedures that operate on them are neural mechanisms that transform the firing activities of neural groups.

Accordingly, we ought to be able to generate new patterns of medical discovery construed in terms of neural activity. To my knowledge, the only neural network model of discovery is a highly distributed model of abductive inference described by Thagard and Litt [2008]. They showed how to implement in a system of thousands of artificial neurons the simple pattern of inference from the occurrence of puzzling occurrence A and the knowledge that B can cause A to the hypothesis that B might have occurred. Representation of A, B, and B *causes A*, is accomplished, not by a simple expression or neuron, but by the firing activity of neural groups consisting of hundreds or thousand of neurons. The inference that B might have occurred is the result of systematic transformations of neural activity that take place in the whole system of neurons. This simple kind of abductive inference is not sufficient to model major medical discoveries, but it does appear appropriate for diagnostic reasoning of the following sort common in medical practice: this patient has ulcers, ulcers can be caused by bacterial infection, so maybe this patient has a bacterial infection. Much work remains to be done to figure out how neural systems can perform more complex kinds of inference, such as those that gave rise in the first place to the bacterial theory of ulcers.

On the neuroscience view of mental representation, a concept is a pattern of neural activity, so concept formation and reorganization are neural processes. In the development of the bacterial theory of ulcers, initial formation by Warren of the concept of spiral gastric bacteria seems to have been both perceptual and cognitive. The perceptual part began with the stimulation of Warren's retina by light rays reflected from his slides of stomach biopsies that revealed the presence of bacteria. At that point his perceptual representation of the bacteria was presumably a visual image constituted by neural activity in the brain's visual cortex. Warren's brain was able to integrate that visual representation with verbal representations consisting of other neural activities, thus linking the visual image to the verbal concepts *spiral, gastric,* and *bacteria.* But these concepts are not simply verbal, since they also involve representations that are partly visual, as is particularly obvious with the concept *spiral.* It is likely that for an experienced pathologist such as Warren the concepts *gastric* and *bacteria* are also partially visual: he had often seen pictures and diagrams of organs and microorganisms.

So how does the brain form concepts such as *spiral gastric bacteria of the kind*

observed through the microscope in Warren's samples? I have previously described generation of new concepts as a kind of verbal conceptual combination, such as production of *sound wave* by combining the concepts of *sound* and *wave* [Thagard, 1988]. But the neural process for Warren's new concept is considerably more complicated, as it requires integrating multiple representations including both verbal and nonverbal aspects. Here is a sketch of how this neural process might operate.

A crucial theoretical construct in cognitive psychology and neuroscience is *working memory* [Smith and Kosslyn, 2007; Fuster, 2004]. Long term memory in the brain consists of neurons and their synaptic connections. Working memory is a high level of activity in those groups of neurons that have been stimulated to fire more frequently by the current perceptual and inferential context that a person encounters. Then conceptual combination is the co-occurrence and coordination in working memory of a number of perceptual and verbal representations, each of which consists of patterns of neural activity. It is not yet well understood how this coordination occurs, but plausible hypotheses include neural synchronization (the patterns of neural activity become temporally related) and higher-level representations (patterns of neural activity in other neural groups represent patterns in the neural groups whose activity represents the original concepts). These two hypotheses may be compatible, since something like temporal coordination may contribute to the neural activity of the higher-order concept that ties everything together. Thus concept formation by perceptual-conceptual combination is a neural process involving the simultaneous activation and integration of previously unconnected patterns of neural activity.

This new account of multimodal conceptual combination goes well beyond the symbolic theory that I have applied to scientific discovery (Thagard, 1988). As Barsalou, *et al.* [2003] argue, conceptual representations are often grounded in specific sensory modalities. For example, the concept *brown* is obviously connected with visual representation, as are more apparently verbal concepts like *automobile,* which may involve auditory and olfactory representations as well as visual ones. One advantage of theorizing at the neural level is that all of these kinds of verbal and sensory representations have the same underlying form: patterns of activity in neural groups. Hence newly generated concepts such as *brown automobile* and, more creatively, *gastric spiral bacteria,* can consist of neural activities that integrate verbal and sensory representations.

6 TECHNOLOGICAL PATTERNS

My discussion of logical, psychological, and neural patterns of medical discovery has so far concerned the contributions of human beings to medical advances. But medical research is increasingly relying on computers, not only to store information about biological systems but also to help generate new hypotheses about the causes and cures of disease. This section briefly sketches some emerging patterns of discovery that involve interactions between people and computers.

Computers have been essential contributors to projects involving basic biological processes, such as the Human Genome Project completed in 2003. This project succeeded in identifying all the 20,000–25,000 genes in human DNA, determining the sequences of the 3 billion base pairs that make up human DNA, and storing the information in computer databases [Human Genome Project, 2006]. All diseases have a genetic component, whether they are inherited or the result of an organism's response to its environment. Hence the information collected by the Human Genome Project should be of great importance for future investigations into the causes and treatments of a wide range of diseases. Such investigations would not be possible without the role of computers in sequencing, storing, and analyzing DNA information.

GenBank, the genetic sequence database compiled by the U.S. National Institutes of Health, contains over 50 million sequence records. These records include descriptions of many viruses, which proved useful in identifying the cause of the disease SARS that suddenly emerged in 2003. Within a few months, scientists were able to use the GenBank information and other technologies such as microarrays to determine that the virus responsible for SARS is a previously unidentified coronavirus [Wang, et al., 2003]. Without computational methods for identifying the DNA structure of the virus associated with SARS and for comparing it with known structures, knowledge of the cause of SARS would have been greatly limited. Thus computers are beginning to contribute to understanding of the causes of human diseases.

New technologies are also being developed to help find treatments for disease. Robots are increasingly used in automated drug discovery as part of the attempt to find effective new treatments, for example new antibiotics that are not resistant to existing treatments. Lamb et al. [2006] describe their production of a "connectivity map", a computer-based reference collection of gene-expression profiles from cultured human cells treated with bioactive small molecules, along with pattern-matching software. This collection has the potential to reveal new connections among genes, diseases, and drug treatments. Thus recent decades have seen the emergence of a new class of patterns of medical discovery in which human researchers cooperate with computers. Scientific cognition is increasingly distributed, not only among different researchers, but also among researchers and computers with which they interact [Thagard, 1993; 2006; Giere, 2002]. Because medical discovery is increasingly a matter of distributed cognition, the philosophy of medicine needs to investigate the epistemological implications of the collaborative, techological nature of medical research.

7 CONCLUSION

Although not much can be said about the *formal* logic of medical discovery, I hope to have shown that discovery is a live topic in the philosophy of medicine. We have seen that there are four kinds of discovery that require investigation, concerning basic biological processes, the causes of disease, the treatment of dis-

ease, and the development of new instruments for diagnosing and treating diseases. Psychological patterns of discovery include the development of new hypotheses by questioning, search, and causal reasoning, and the development of new concepts by combining old ones. Research in the burgeoning field of cognitive neuroscience is making it possible to raise, and begin to answer, questions about the neural processes that enable scientists to form hypotheses and generate concepts. In addition, philosophers can investigate how computers are increasingly contributing to new medical discoveries involving basic biological processes and the causes of disease. A major aim of the philosophy of medicine is to explain the growth of medical knowledge. Developing a rich, interdisciplinary account of the patterns of medical discovery should be a central part of that explanation.

BIBLIOGRAPHY

[Adler, 2004] R. E. Adler. *Medical firsts: From Hippocrates to the human genome.* Hoboken, N.J.: John Wiley & Sons, 2004.

[Bacon, 1960] F. Bacon. *The New Organon and related writings.* Indianapolis: Bobbs-Merrill, 1960.

[Barsalou et al., 2003] L. W. Barsalou, W. K. Simmons, A. K. Barbey, and C. D. Wilson. Grounding conceptual knowledge in modality-specific systems. *Trends in Cognitive Sciences, 7,* 84-91, 2003.

[Brock, 1988] T. D. Brock. *Robert Koch: A life in medicine and bacteriology.* Madison, WI: Science Tech Publishers. 1988.

[Carruthers et al., 2002] P. Carruthers, S. Stich, and M. Siegal, eds. *The cognitive basis of science.* Cambridge: Cambridge University Press, 2002.

[Darden, 1991] L. Darden. *Theory change in science: Strategies from Mendelian genetics.* Oxford: Oxford University Press, 1991.

[Darden, 2006] L. Darden. *Reasoning in biological discoveries.* Cambridge: Cambridge University Press, 2006.

[Friedman and Friedland, 1998] M. Friedman and G. W. Friedland. *Medicine's 10 greatest discoveries.* New Haven: Yale University Press, 1998.

[Fuster, 2002] J. M. Fuster. *Cortex and mind: Unifying cognition.* Oxford: Oxford University Press, 2002.

[Giere, 1988] R. Giere. *Explaining science: A cognitive approach.* Chicago: University of Chicago Press, 1988.

[Giere, 2002] R. Giere. Scientific cognition as distributed cognition. In P. Carruthers, S. Stich & M. Seigal (Eds.), *The cognitive basis of science* (pp. 285-299). Cambridge: Cambridge University Press, 2002.

[Goldman, 1986] A. Goldman. *Epistemology and cognition.* Cambridge, MA: Harvard University Press, 1986.

[Hanson, 1958] N. R. Hanson. *Patterns of discovery.* Cambridge: Cambridge University Press, 1958.

[Hanson, 1965] N. R. Hanson. Notes toward a logic of discovery. In R. J. Bernstein (Ed.), *Perspectives on peirce* (pp. 42-65). New Haven: Yale University Press, 1965.

[Holyoak and Thagard, 1997] K. J. Holyoak and P. Thagard. The analogical mind. *American Psychologist, 52,* 35-44, 1997.

[Human-Genome-Project, 2006] Human-Genome-Project. *Human genome project information,* from http://www.ornl.gov/sci/techresources/Human_Genome/home.shtml, 2006.

[Klahr, 2000] D. Klahr. *Exploring science: The cognition and development of discovery processes.* Cambridge, MA: MIT Press, 2000.

[Lamb et al., 2006] J. Lamb, E. D. Crawford, D. Peck, J. W. Modell, I. C. Blat, M. J. Wrobel, et al. The Connectivity Map: Using gene-expression signatures to connect small molecules, genes, and disease. *Science, 313*(5795), 1929-1935, 2006.

[Langley et al., 1987] P. Langley, H. Simon, G. Bradshaw, and J. Zytkow. *Scientific discovery.* Cambridge, MA: MIT Press/Bradford Books, 1987.

[Mill, 1974] J. S. Mill. *A system of logic ratiocinative and inductive.* Toronto: University of Toronto Press. 1974.

[Nersessian, 1984] N. Nersessian. *Faraday to Einstein: Constructing meaning in scientific theories.* Dordrecht: Martinus Nijhoff, 1984.

[Nersessian, 1992] N. Nersessian. How do scientists think? Capturing the dynamics of conceptual change in science. In R. Giere (Ed.), *Cognitive Models of Science* (Vol. vol. 15, pp. 3-44). Minneapolis: University of Minnesota Press 1992.

[Nickles, 1980] T. Nickles, ed. *Scientific discovery, logic, and rationality.* Dordrecht: Reidel, 1980.

[Peirce, 1931–1958] C. S. Peirce. *Collected papers.* Cambridge, MA: Harvard University Press, 1931–1958.

[Popper, 1959] K. Popper. *The logic of scientific discovery.* London: Hutchinson, 1959.

[Quine, 1968] W. V. O. Quine. Epistemology naturalized. In W. V. O. Quine (Ed.), *Ontological relativity and other essays* (pp. 69-90). New York: Columbia University Press, 1968.

[Reichenbach, 1938] H. Reichenbach. *Experience and prediction.* Chicago: University of Chicago Press, 1938.

[Science-Channel, 2006] Science-Channel. *100 greatest discoveries: Medicine.* Retrieved Oct. 4, 2006, 2006, from `http://science.discovery.com/convergence/100discoveries/big100/medicine.html`, 2006

[Smith and Kosslyn, 2007] E. E. Smith and S. M. Kosslyn. *Cognitive Psychology: Mind and Brain.* Upper Saddle River, NJ: Pearson Prentice Hall, 2007.

[Straus and Straus, 2006] E. W. Straus and A. Straus. *Medical marvels: The 100 greatest advances in medicine.* Buffalo: Prometheus Books, 2006.

[Thagard, 1988] P. Thagard. *Computational philosophy of science.* Cambridge, MA: MIT Press/Bradford Books, 1988.

[Thagard, 1992] P. Thagard. *Conceptual revolutions.* Princeton: Princeton University Press, 1992.

[Thagard, 1993] P. Thagard. Societies of minds: Science as distributed computing. *Studies in History and Philosophy of Science, 24,* 49-67, 1993.

[Thagard, 1999] P. Thagard. *How scientists explain disease.* Princeton: Princeton University Press, 1999.

[Thagard, 2000] P. Thagard. *Coherence in thought and action.* Cambridge, MA: MIT Press 2000.

[Thagard, 2003] P. Thagard. Pathways to biomedical discovery. *Philosophy of Science, 70,* 235-254 2003.

[Thagard, 2005] P. Thagard. *Mind: Introduction to cognitive science* (2nd ed.). Cambridge, MA: MIT Press, 2005.

[Thagard, 2006] P. Thagard. What is a medical theory? In R. Paton & L. A. McNamara (Eds.), *Multidisciplinary approaches to theory in medicine* (pp. 47-62). Amsterdam: Elsevier, 2006.

[Thagard and Litt, 2008] P. Thagard and A. Litt. Models of scientific explanation. In R. Sun (Ed.), *The Cambridge handbook of computational cognitive modeling* (pp. 549-564). Cambridge: Cambridge University Press, 2008.

[Thagard and SHelley, 1997] P. Thagard and C. P. Shelley. Abductive reasoning: Logic, visual thinking, and coherence. In M. L. Dalla Chiara, K. Doets, D. Mundici & J. van Benthem (Eds.), *Logic and Scientific Methods* (pp. 413-427). Dordrecht: Kluwer, 1997.

[Wang et al., 2003] D. Wang, A. Urisman, Y. T. Liu, M. Springer, T. G. Ksiazek, D. D. Erdman, et al. Viral discovery and sequence recovery using DNA microarrays. *PLoS Biology, 1*(2), E2, 2003.

[Whewell, 1967] W. Whewell. *The philosophy of the inductive sciences.* New York: Johnson Reprint Corp, 1967.

EVIDENCE-BASED MEDICINE

Robyn Bluhm and Kirstin Borgerson

1 INTRODUCTION

Since its introduction in the early 1990s, evidence-based medicine (EBM) has been extremely influential, but it has also generated considerable controversy. This controversy may be puzzling to some. After all, if medicine is to be based on something, evidence would seem to be a good choice. It is certainly better than "vehemence-based medicine" or "eminence-based medicine", as some of the more sarcastic defenders of EBM point out [Isaacs and Fitzgerald, 1999, p.1618]. In fact, the ubiquitous EBM movement relies heavily on this initial impression. EBM has gained at least some of its popularity from the intuitively obvious nature of its name as well as its apparently innocent and widely accepted goals. A closer look at the details of the movement makes the controversy more understandable. As the EBM ideology is rapidly and often uncritically adopted in medical settings around the world, as well as integrated into new domains ("evidence-based practice" is now common in nursing, physiotherapy, occupational therapy, dentistry, veterinary science, health management, library science, public policy, social work and economics, just to name a few areas), reasonable concerns about the assumptions, implications and epistemological limitations of such an approach are mounting.

Although EBM has not received much attention from philosophers, the nature of the controversies over EBM suggest that it would benefit from closer philosophical attention, particularly since it raises issues about evidence, causation, induction, justification and the production of scientific knowledge. Brian Haynes, one of the leading proponents of EBM, has issued a challenge:

> One hopes that the attention of philosophers will be drawn to... the continuing debate about whether EBM is a new paradigm and whether applied health care research findings are more valid for reaching practical decisions about health care than basic pathophysiological mechanisms and the unsystematic observations of practitioners. [2002, p.3]

The demand for philosophical attention to EBM comes not only from the medical field. In a recent paper, philosopher of science John Worrall makes a strong case for philosophical attention to topics raised by EBM:

> [The logic of evidence as it is applied to medicine is] a new area where philosophers of science could have enormous impact — both intellectual

Handbook of the Philosophy of Science. Volume 16: Philosophy of Medicine.
Volume editor: Fred Gifford. General editors: Dov M. Gabbay, Paul Thagard and John Woods.

and (very unusually) practical — but have so far largely not done so. [2007a, p.981.]

We share Worrall's optimism regarding the value of philosophy, and agree with Haynes and other EBM proponents when they suggest that a philosophical perspective is needed in current debates over standards of evidence in medicine. In this chapter, we begin with a historical overview in order to contextualize the EBM movement. We then describe the unique features of EBM, the most common criticisms of the movement, and the most fruitful areas for further philosophical investigation. We aim to provide a comprehensive overview of EBM in the hopes that more philosophers will be enticed to turn their attention to the epistemological and ethical issues it raises.

2 HISTORY OF EBM

2.1 Two Traditions in Medicine

Modern medicine has inherited two competing approaches to the care of patients, rationalism and empiricism. These terms, taken from the medical literature, are not used in the standard philosophical senses. *Rationalists* in medicine, for instance, do not only reason from first principles. Rather, they emphasize the importance of empirical investigation into basic mechanisms of disease. (The designation "rationalist" was likely picked to highlight the role of reason in this approach.) *Empiricists* in medicine are thought to be interested in whether something works, regardless of causes or mechanisms. Again, the use of the terminology does not correspond to classic philosophical accounts of empiricism. The rationalist/empiricist debate in medicine is, in philosophical terms, better described as a debate between empiricist approaches to medicine at different levels. While empiricism (in the philosophical sense) prevails in medicine, there are vigorous ongoing debates about whether it is more appropriate to ask questions about basic mechanisms of disease at the micro-level (pathophysiology) or whether it would be better simply to investigate what works at the level of the average patient (as in RCTs).

Both rationalism and empiricism in medicine are present as early as Ancient Greece. Rationalism in ancient Greek medicine, which can be traced back to Hippocrates, emphasized the importance of uncovering the mechanisms of disease. Medical doctors could, on the basis of their understanding of physiology, anatomy and other basic sciences, identify problems and reason through to the effects of various treatments on patients. This rationalist approach was advanced by Hippocratic physicians for many centuries and posited single causes as the source of illness and disease. At the time, this meant a diagnosis of imbalance in the four humours (blood, phlegm, yellow bile and black bile) and treatment designed to restore the body's ideal balance [Newton, 2001]. The later empiricists, in contrast, developed an approach to medical practice that eschewed theoretical reasoning in favour of observations of patients. They developed their practices through careful observation of cases and cumulative expertise about a number of cases. The

primary interest of empiricists was in choosing the best treatment for a condition, rather than understanding the "first causes" of disease [Newton, 2001].

Using different terminology, Wulff *et al.* [1990] describe early modern medicine as being dominated by "speculative realism," so that physicians, rather than examining their patients, listened to them describe their symptoms and then made their diagnosis on the basis of their preferred medical philosophy (most commonly based on Hippocratic doctrines). Empiricism began to regain importance during the 17^{th} century, for example in the work of Thomas Sydenham, whose "description of a disease like gout could be used in any modern textbook of medicine" [Wulff *et al.*, p. 33]. During the course of the 19^{th} century, a new form of empiricism arose in the work of the French physicians Jules Gavaret and P.C.A. Louis. Wulff and colleagues focus on Gavaret's *Principes Generaux de Statistique Médicale*, which argued that judgments of the efficacy of a treatment could be made only on the basis of observation of its effect in large numbers of individuals (the Law of Large Numbers); only by using these methods could a Therapeutic Law describing efficacy be obtained. The work of Louis, in particular, developed into the science of epidemiology, and it is this strain of medical empiricism that has had a strong influence on EBM.

For the vast majority of the 20^{th} century, however, the practice of medicine in North America (and concurrent devaluation of otherwise popular alternative medicines) was shaped by the rise of another period of rationalism in medicine. The highly influential Flexner Report in the United States in 1910 argued for an increased focus on the basic sciences as a vital part of medical education. The tremendous influence of the report in the West led to additional attention to physiology, anatomy, pathology and microbiology in medical schools. In effect the report challenged physicians to understand basic mechanisms of disease. As a result of the changes in medical schools over the 20^{th} century, the situation circa 1980 was described as follows: "the orthodoxy of modern medicine is rationalist; a large majority of physicians within academic medical centers and in practice are subspecialists who are experts in a particular set of diseases and focus on particular organ systems or diseases" [Newton, 2001, p. 304]. Speaking of the historical dominance of laboratory science in hospitals, Kerr White has described the dominant mentality colourfully as follows, "[D]iseases have single causes, and they are mostly 'bugs'. What I call the Big Bug Hunt was under way: we have got to look for bugs everywhere. Meanwhile, the hygienists who looked at the environment, including the social scene, poverty, economic conditions, and occupational hazards, were cast aside by the biomedical establishment" [Daly, 2005, p.42]. Also cast aside were epidemiologists and medical researchers conducting trials on large groups of patients. The return to an empiricist approach to medicine, however, came about relatively quickly and with great force. As Warren Newton puts it, "for all its rhetoric of novelty, Evidence Based Medicine represents a counter-revolution of traditional empiricism, draped in modern clothes of statistics and multi-variate analysis" [2001, p. 314].

2.2 Clinical Epidemiology

From approximately the late 1960s to the 1990s, (with significant growth in the late 1980s) physicians in Canada, the United States and Europe began to shift their attention to a new approach to medicine that was based on the increasingly popular methods of clinical epidemiology. The new movement aimed to remedy a perceived over-reliance on basic science research as a resource for clinical decision-making. Epidemiological methods were traditionally within the purview of public health but work by a number of scholars, notably Alvan Feinstein at Yale University, sought to adapt these methods for clinical practice — hence, *clinical* epidemiology. Feinstein's book *Clinical Judgment* (1967) provided much of the groundwork for the movement by outlining the need for greater systematization, classification and consistency in medical diagnosis and treatment. The first comprehensive textbook of the new field, *Clinical Epidemiology: The Essentials*, emerged in 1982 (Fletcher, Fletcher and Wagner). Finally, Feinstein's *Clinical Epidemiology: The Architecture of Clinical Research*, in 1985, had a significant impact on many practicing physicians who were attracted by his desire to define, classify and quantify the various elements of clinical practice. Many of Feinstein's original suggestions were ignored, but the commitment to using data obtained from populations of patients to guide decisions at the bedside remains the core of clinical epidemiology today.[1] Clinical epidemiology was touted as the replacement for an outdated Flexnerian reliance on the laboratory sciences in medicine [Sackett *et al.*, 1991].

Clinical epidemiologists upheld a commitment to studying populations and using the knowledge gained to guide decisions in the care of individual patients. The first department of Clinical Epidemiology and Biostatistics was established at McMaster University in Canada, under the leadership of David Sackett. It was the members of this department, including, among others, Brian Haynes and Gordon Guyatt, who formed the Evidence-based Medicine Working Group. In fact, members of this group published a clinical epidemiology textbook shortly before EBM was launched. The subtitle of this book described clinical epidemiology as "a basic science for clinical medicine" [Sackett *et al.*, 1991]. If clinical epidemiology is a basic science, then EBM is the application of the techniques of this science to the problems encountered at the bedside.

The EBM movement arose for a number of reasons, each of which is grounded in the social, historical, economic and political contexts of modern health care. Three particularly influential factors that led to the development of EBM were the growth in laboratory research in medicine, the growth in clinical research in

[1]Contributions by Danish scholar Henrik Wulff are also worth noting. Wulff's book *Rational Diagnosis and Treatment*, first published in 1973, echoed many of the sentiments raised by Feinstein, and he later developed a philosophical analysis of clinical medicine in *Philosophy of Medicine: An Introduction*. Particularly in the latter book, Wulff offers some useful insights into the motivations, and also the shortcomings of approaches to clinical decision-making (such as clinical epidemiology) that neglect the humanistic elements of health care. These sentiments are echoed by Jeanne Daly in her book *Evidence-based Medicine and the Search for a Science of Clinical Care*.

medicine, and the realization that, despite the increase in scientific knowledge, medical practice was not uniformly influenced by the results of research. In what follows, we will describe these factors in greater detail.

Although it is useful to view the rationalist and the empiricist strains of medicine as being in tension, and although EBM itself is a particularly strong form of medical empiricism, the development of EBM was also due in large part to the success of rationalist medicine. Throughout the 20^{th} century, there was an incredible growth in laboratory research in the biomedical sciences, which resulted in a better base of knowledge about the causes of disease and also, for the first time in history, the development of treatments that targeted specific diseases. Jacalyn Duffin describes early attempts to develop "magic bullets" that could "kill germ invaders yet leave a living, healthy human being" [1999, p. 103]. The earliest of these, she notes, were both developed by Paul Ehrlich. Trypan red, for experimental trypanosomiasis, was developed in 1903 and Salvarsan, an arsenic-containing treatment for human syphilis, in 1910. By the 1930s and 40s, therapeutic agents had been developed that could cure a number of infectious diseases. These therapies had a revolutionary effect on medicine. Lewis Thomas writes:

> I was a medical student at the time of sulfanilamide and penicillin, and I remember the earliest reaction of flat disbelief concerning such things. We had given up on therapy, a century earlier. With a few exceptions which we regarded as anomalies, such as vitamin B for pellagra, liver extract for pernicious anemia, and insulin for diabetes, we were educated to be skeptical about the treatment of disease. Miliary tuberculosis and subacute bacterial endocarditis were fatal in 100 percent of cases, and we were convinced that the course of master diseases like these could never be changed, not in our lifetime or in any other.

> Overnight we became optimists, enthusiasts. The realization that disease could be turned around by treatment, provided that one knew enough about the underlying mechanism, was a totally new idea just forty years ago. [1994, p. 4]

The success of laboratory research in both elucidating the causes of disease and developing new treatments contributed to both the Flexnerian emphasis on biomedicine in medical education and the growth of clinical research more generally. This latter development, which was informed by developments in statistics in the early part of the 20^{th} century, was a significant influence on EBM. The increase in clinical research led to the creation of thousands of new medical journals. Physicians, who were trained mainly in basic sciences, appeared ill-equipped and often, as a result, ill-motivated to stay on top of the massive quantity of research (of highly varied quality) published every day [Sackett et al., 1996, p. 71]. They lacked the statistical knowledge and the critical attitude necessary to tackle the evaluation of such research. The advent of the technological age only exacerbated this problem, as it allowed greater and more efficient access to these journals,

through a variety of databases (MEDLINE, for instance) and, more recently, electronic journals.

Finally, there was a perceived need to make sure that clinical practice reflected the results of this growing body of research. A number of surveys suggested that patients with similar symptoms were receiving different treatments depending on the particular physician they visited (Tanenbaum 1996, p. 518). This was true even in the case of illnesses where fairly conclusive evidence was present to indicate a particular treatment choice. This "troubling" lack of consistency amongst physicians reflected two important facts. Physicians were continuing to provide treatments (for example anti-arrhythmic agents such as flecainide and encainide, penicillin for the flu, or shaving and enemas for childbirth) long after they had been proven unnecessary, or even harmful, and physicians were failing to prescribe treatments even when such treatments had been subjected to considerable testing and were widely regarded as the best available treatment for a particular condition [Laupacis, 2001, p. 6A-7A].

2.3 Introduction of EBM

All of these factors — the development of clinical epidemiology, the growth in both laboratory and clinical research, and the inconsistency of clinical practice — contributed to the belief that medicine could, and should, become "evidence-based." The term "evidence-based medicine" is often used to cover a number of developments in the attitude of clinicians to medical research, including increased attention to the quality of reporting of clinical trials, various attempts to rank or grade the evidence for treatments, and the development of summaries of research evidence by such groups as the Cochrane Collaboration. (These other aspects of EBM will be discussed further below.) The term was created by the "Evidence-Based Medicine Working Group" at McMaster University. The McMaster University group can reasonably be viewed as representative of the core of EBM, as it has shaped the discussion on the relationship between clinical research and clinical practice, in addition to coining the phrase "evidence-based medicine."

While the earliest published use of the phrase "evidence-based medicine" occurred in the title of an editorial in the summer 1991 issue of *ACP Journal Club*, the EBM "manifesto" appeared in the *Journal of the American Medical Association* (JAMA) in November of 1992 (Evidence-Based Medicine Working Group, 1992). In structure, this latter article mirrors the earlier editorial; both present a hypothetical clinical scenario and offer two possible ways to proceed. The 1992 scenario describes a previously well man who experienced a grand mal seizure and who asks the resident who admits him to hospital about his risk of seizure recurrence. How should the resident go about finding an answer to her patient's question? The "Way of the Past" involves an appeal to authorities higher in the medical hierarchy: the resident checks with her senior resident whose view is supported by the attending physician, and then conveys their (vague) response to the

patient. The "Way of the Future" sees the resident searching the medical literature online for articles pertaining to "epilepsy," "prognosis," and "recurrence," then discussing with the patient his risk over the next few years and her recommendations for treatment. The outcome here is that the patient "leaves with a clear idea of his likely prognosis," compared with his state of "vague trepidation about his risk of subsequent seizures" resulting from the appeal to authority (p. 2420).

The authors of this article describe evidence-based medicine as a "new paradigm" resulting from "developments in clinical research over the last 30 years" (p. 2420). In 1960, they claim, the randomized controlled trial (RCT) was "an oddity." By the early 1990s, however, the RCT had become the standard methodology for showing the efficacy of new drugs, and was increasingly being used to determine the effects of surgery and the accuracy of diagnostic tests. Not only were there more trials conducted and published in the medical literature, the results of multiple trials of the same intervention could be combined in a systematic review or meta-analysis. Further research had also led to methodological advances in the assessment of diagnostic tests and prognosis, though these advances were "less dramatic" than those arising from the use of RCTs.

The authors go on to distinguish between the "former paradigm" and the "new paradigm" by making explicit the assumptions that they saw as underlying each approach. In the former paradigm, clinical practice (whether related to diagnosis, prognosis or treatment) was based on (1) unsystematic observations from clinical experience; (2) knowledge of the basic science describing disease mechanisms and pathophysiology; and (3) evaluation of new tests and treatments using "a combination of thorough traditional medical training and common sense" (p. 2421). On this view, "[c]ontent expertise and clinical experience are a sufficient base from which to generate guidelines for clinical practice" (p. 2421).

By contrast, while the new evidence-based paradigm acknowledges that "clinical experience and the development of clinical instincts" (p. 2421) and knowledge of disease mechanisms are both necessary to the competent practice of medicine, it denies that they are sufficient. A third set of skills is required in order to interpret the literature, namely the understanding of certain "rules of evidence" (p. 2421). These rules of evidence had previously been described in detail in Sackett *et al.*'s textbook, *Clinical Epidemiology*, (1991), but they were summarized in the *JAMA* article as the ability to do the following: precisely define a patient problem and determine what information would be required to resolve it; efficiently search the literature and determine the relevance and validity of the studies retrieved; succinctly summarize and present the content, strength and weaknesses of the papers; and finally extract the "clinical message" and apply it to the patient's problem (p. 2421). It is this set of skills with which EBM has been primarily concerned.

2.4 The Hierarchy of Evidence

According to a recent paper by long-time EBM proponents Montori and Guyatt, the "first fundamental principle" of EBM is the hierarchy of research evidence [2008, p.1815]. The difficulty of achieving consensus among medical experts led to the creation of the first hierarchy of evidence. David Sackett originally proposed the idea of ranking evidence on a scale as an objective method for resolving disputes amongst physicians at consensus conferences [Daly, 2005, p.77]. Consensus conferences had a tendency to stall once various experts had presented the evidence for their preferred position. What Sackett did was aid the members in developing a method for comparatively assessing evidence. Case reports were graded lower on the ranking, while randomized controlled trials held the top spot. Later developments added meta-analyses of RCTs at the very top and the details of the middle levels were worked out in greater detail.

Recall that according to EBM, "understanding certain rules of evidence is necessary to correctly interpret literature on causation, prognosis, diagnostic tests, and treatment strategy" [Evidence-Based Medicine Working Group, 1992, p. 2421]. Proponents of EBM assume that physicians need rules in order to correctly evaluate current medical evidence. Rules of evidence, according to this assumption, should be designed by experts (clinical epidemiologists and statisticians, for instance) and then followed and applied by physicians. The practice of ranking different types of evidence (as in an evidence hierarchy) is one that is thought to follow from scientific standards. This is not just the claim that it is helpful to be able to distinguish, for instance, good RCTs from bad RCTs. This is an assumption about the necessity of ranking research methods against one another in order to allow for a more straightforward critical evaluation of the evidence.

Although it is common to talk about "the" hierarchy of evidence, there are actually multiple hierarchies. First, there are different hierarchies corresponding to the type of clinical question being asked: for example, for treatment studies, studies of prognosis, or studies testing the utility of clinical decision rules. All of the hierarchies follow the same basic structure; in particular, the hierarchy for studies of prognosis is the same as that for treatment, except that it includes only nonrandomized designs (since there is no treatment, or control, to which patients could be assigned). There are also multiple hierarchies in the sense that different groups have developed different versions of, for example, the treatment hierarchy. Although different versions of the hierarchy are quite similar, the details vary. For example, some hierarchies explicitly say that RCTs included in a meta-analysis must have similar characteristics (e.g. medication dosages, inclusion and exclusion criteria), and some subdivide the level of "observational" studies into cohort and case-control designs.

The evidence hierarchy for medical treatments was designed to reflect the methodological strength of scientific studies. It is assumed that better evidence on this scale is less likely to be infected by bias, more likely to correctly attribute causal powers to a particular treatment and more likely to accurately generalize beyond

the study group to the broader patient population. Clinical confidence comes from the assumption that "the randomised trial, and especially the systematic review of several randomised trials, is so much more likely to inform us and so much less likely to mislead us" [Sackett *et al.*, 1996, p. 72].

The version of the treatment hierarchy found in *The Users' Guides to the Medical Literature* is representative, and is simple enough to allow us to focus on the reasons for the main distinctions drawn between different study designs. *The Users' Guides* is the textbook version of a series of articles published by members of the Evidence-based Medicine Working Group that taught clinicians how to appraise the quality of clinical research. It presents the following as "a hierarchy of strength of evidence for treatment decisions" [Guyatt and Rennie, 2001, p.7]:

- N-of-1 randomized controlled trial

- Systematic reviews of randomized trials

- Single randomized trial

- Systematic review of observational studies addressing patient-important outcomes

- Single observational study addressing patient-important outcomes

- Physiologic studies (studies of blood pressure, cardiac output, exercise capacity, bone density, and so forth)

- Unsystematic clinical observations

Although EBM operates with a broad definition of evidence, on which "any empirical observation about the apparent relation between events constitutes potential evidence" (p. 6), *The Users' Guides* also claim that the hierarchy "implies a clear course of action for physicians addressing patient problems: they should look for the highest available evidence from the hierarchy" [Guyatt and Rennie, 2001, p. 8]. This is because the hierarchy is ostensibly constructed to ensure that the best available evidence is at the top.

The top five levels of evidence (which in practice are those that are usually considered in EBM) consist of study designs that provide systematic clinical observation and that are borrowed from the scientific methods of epidemiology. Of these, the lowest levels are a single "observational" (nonrandomized) study that addresses patient-important outcomes and, next up the list, a systematic review of a number of such studies. These studies tend to follow large groups of patients, for varying lengths of time. However, observational studies are considered to provide a biased assessment of treatment effects (see, e.g. [Laupacis and Mandani, 2004]) as compared to nonrandomized studies. Because it is thought to reduce bias, randomization is generally held to be the best method of allocating subjects to groups. Thus, randomized trials rank higher on the hierarchy of evidence and systematic reviews of randomized trials rank higher still. In these studies, patients can be

randomly allocated to treatment groups (thus minimizing the effects of unknown confounding factors by making it more likely that that there are equal numbers of patients in each group to which these factors apply) and "blinding" both participants and researchers to the treatment being received by each patient (in order to minimize the effects of expectation on assessment of outcomes). The randomized controlled trial is the ideal form of evidence in evidence-based medicine, with the top three levels of the hierarchy devoted to randomized studies.[2]

Variations of the hierarchy offered by other agencies and institutions tend to follow this same basic pattern. That pattern is:

<div align="center">

Randomized Studies

Nonrandomized Studies

Anecdotal Evidence, Bench Research, Physiologic Principles

</div>

Systematic reviews are preferred over single trials (of whatever design) and randomized studies are preferred over nonrandomized studies. The two lowest levels of the hierarchy are occupied by "physiologic studies" and by "unsystematic (anecdotal) clinical observations." The former are the types of laboratory research popular post-Flexner, and, while systematic, are not held to be clinically relevant. The latter, while clinically relevant, do not have the scope or systematicity necessary to ensure that this type of evidence is generalizable to other patients. EBM was developed in part because it was believed that these two types of evidence carried too much weight in medical practice. Before turning to a critical evaluation of the EBM hierarchy of evidence, we will first outline some of the more general concerns with EBM that have been raised consistently in the medical literature, and the responses provided to these concerns by the proponents of EBM.

2.5 Initial Criticisms

Despite the revolutionary aspect of evidence-based medicine implied in the use of Kuhnian terminology, the *JAMA* "manifesto" is careful to point out that "[e]vidence-based medicine also involves applying traditional skills of medical training" (p. 2421), such as an understanding of pathophysiology, the development of clinical judgment and the sensitivity to patients' emotional needs. Even the appeal to authority has a place, albeit a small one, in the new paradigm, although physicians are also expected to "gain the skills to make independent assessments of evidence and thus evaluate the credibility of opinions being offered by experts" (p. 2421). Thus, the skills of "critical appraisal" are meant to be added to traditional medical skills, not to replace them. However, it is clear that the new skills are meant

[2]The top level of the Users' Guides' treatment hierarchy is held by the "n-of-1" randomized controlled trial. This is an unusual feature of this particular hierarchy (most hierarchies don't mention the n-of-1 design). In this type of trial, a patient and physician conduct their own experiment to see which of two (or more) treatment options is best for that patient. The results of this type of study, however, are not meant to be generalized to the care of other patients, and in practice, the top levels of the hierarchy are occupied by meta-analyses (or systematic reviews) and single RCTs.

to play a major role in clinical practice, to form, as the name "evidence-*based* medicine" suggests, the basis upon which medical decisions are made.

While the 1992 *JAMA* article is careful to maintain a place for traditional medical knowledge, critics of EBM felt that this place was not big enough. A number of authors [Naylor, 1995; Tanenbaum, 1993; Feinstein, 1994; Malturud, 1995; Charlton, 1997; Horwitz, 1996; Maynard, 1997] argued that EBM as originally formulated was deeply problematic, for a variety of reasons. Many note that the evidence provided by clinical research can never replace the tacit knowledge and practical expertise that can come only through clinical experience. Some took this criticism even further, charging that EBM was just "cookbook" medicine. Miles and Charlton [1998] argued that this trend threatened the autonomy of physicians by putting clinical decision-making in the hands of "Infostat technicians" such as epidemiologists, statisticians and health economists, who thereby "acquire substantive influence over millions of clinical consultations, but without any responsibility for the clinical consequences" (p. 372).[3]

2.6 Response to Criticisms

In 1996, several members of the EBM Working Group published an article entitled, "Evidence-based Medicine: what it is and what it isn't," which was designed to clarify (and tone down) some of the more contentious claims of the initial formulation. In this oft-quoted article, Sackett and colleagues offer a more thoughtful and carefully worded description of their approach to medicine:

> Evidence-based medicine is the conscientious, explicit and judicious use of current best evidence in making decisions about the care of individual patients. The practice of evidence-based medicine means integrating individual clinical expertise with the best available external clinical evidence from systematic research. [1996, p. 71]

This latest definition reflects an attempt on the part of EBM advocates to honor the art as well as the science of good medical practice. The new, more integrative EBM explicitly recognizes the importance of clinical expertise, judgment, intuition, and patient values:

> External clinical evidence can inform, but can never replace, individual clinical expertise, and it is this expertise that decides whether the external evidence applies to the individual patient at all and, if so, how it should be integrated into a clinical decision. [1996, p. 72]

The change in tone here is palpable. Instead of calling for a revolution, EBM proponents are looking to reconcile the "former" and "new" paradigms of medicine. Or, at least, that is how this statement appears on the surface.

[3]It should be noted that this last criticism is only indirectly applicable to the version of EBM articulated in 1992, but has become more relevant as the influence of EBM and the number of systematic reviews, meta-analyses and practice guidelines — based largely on the critical appraisal skills taught as EBM — has increased.

Tonelli [1998] describes the shift in language used in the EBM literature from the original article's statement that EBM was meant to "de-emphasize" unsystematic clinical judgment, to a later focus on "integrating clinical expertise, pathophysiologic knowledge, and patient preferences" (p. 1235) in medical decision-making. Similarly, a central EBM textbook, *Evidence-based Medicine: How to Practice and Teach EBM*, reflects these changes in its introductory outline of the steps involved in the practice of EBM. In the first edition [Sackett *et al.*, 1997], a clinician who has completed a critical appraisal of the evidence bearing on a clinical question is told that the next step is "using the evidence in clinical practice." In the second edition, published in 2000 [Sackett *et al.*, 2000], this step has been changed to "integrating the critical appraisal with our clinical expertise and with our patient's unique biology, values and circumstances" (p. 4). The new emphasis on integration is also reflected in the structure of the text. The first edition consisted of five chapters, one for each step. By contrast, the second edition has separate chapters for diagnosis and screening, prognosis, treatment, harm, and clinical guidelines. Within each of these chapters, both the "application" and "integration" steps are covered.

3 PERSISTENT CONCERNS

Response to EBM, since 1996, has been mixed. Some physicians find the idea of basing medical practice on the best available evidence to be beyond reproach - even "obvious" [Laupacis, 2001]. Others direct their attention to the precise meaning and interpretation of the terms "conscientious" and "judicious" in the EBM definition [Zarkovich and Upshur, 2002]. Still others continue to write in to medical journals with concerns about the shortcomings of the new approach, including: the persistent "grey zones" of clinical practice, the absence of discussion on the role of values in medical decision-making, and the tendency to downplay the individual and complex nature of the patient-physician interaction [Greenhalgh, 1999; Naylor, 1995; Schattner and Fletcher, 2003]. Defenders of EBM maintain that these criticisms are "misguided", "misunderstandings", or even "clearly invalid" [Laupacis, 2001]. They maintain that there is no reason for physicians to fear the newer, more inclusive version of EBM.

As noted above, the original proponents of EBM — and its increasing number of supporters — have both defended EBM against its critics and altered their message in response to criticism. In an article responding to criticisms of evidence-based medicine, Straus and McAlister [2000] argue that many of the criticisms that have been offered are actually "misperceptions of evidence-based medicine" (p. 837). Often, these criticisms are made by those who fear the erosion of medical autonomy and who see the recommendation to make evidence from clinical research the basis of medical practice as a threat to clinicians, rather than a tool to be used by them. While this assertion by Strauss and McAlister may be partly true, it should be acknowledged that these criticisms do in fact raise legitimate fears about the way in which evidence-based medicine may be practiced by individual clinicians (or

mandated by policy); the "authority" of expert opinion can simply be replaced by the authority of an RCT or systematic review, crowding other considerations out of the clinical picture.

Moreover, it is understandable that the EBM movement, particularly in some of its early articulations, might be misunderstood. The proponents of EBM are not known for the precision of their explanations of their position. In a letter published in the March 1993 issue of JAMA, La Vera Crawley criticized the original article for its use of Kuhn's term "paradigm" to describe EBM. Crawley acknowledged that "evidence-based medicine might be poised to herald a paradigm shift" in medicine [1993, p. 1253], but denied that it actually qualified as one. In response, Gordon Guyatt, who authored the original article on behalf of the Evidence-Based Medicine Working Group, defended the article's terminological laxity on the grounds that the authors had elsewhere [Sackett et al., 1991] made explicit that they were "nominalists" about the meanings of words and, as such, did not intend "the narrow, essentialist definition of paradigm shift insisted on by Dr. Crawley" [Guyatt, 1993, p. 1254]. Yet presumably even "nominalists" (perhaps especially them) are required to clarify their terminology if they expect to be understood. If not, they certainly bear a large share of the responsibility for any subsequent "misperceptions" of their position.

We turn now to some of the more persistent concerns raised about EBM.

3.1 New Forms of Authority

The growth in the number of research trials being conducted in recent years has led to a dramatic increase in the number of journal articles published in all areas of medicine. While EBM was originally intended to be an approach to clinical decision-making carried out by individual physicians (hence the emphasis on training in critical appraisal), the movement has been forced to adapt to deal with a variety of practical constraints. The need for such changes is reflected in the following statements:

> "Busy doctors have never had time to read all the journals in their disciplines. There are, for example, about 20 clinical journals in adult internal medicine that report studies of direct importance to clinical practice, and in 1992 these journals included over 6000 articles with abstracts: to keep up the dedicated doctor would need to read about 17 articles a day every day of the year". [Davidoff et al., 1995, p. 1085]

> "The difficulties that clinicians face in keeping abreast of all the medical advances reported in primary journals are obvious from a comparison of the time required for reading (for general medicine, enough to examine 19 articles per day, 365 days per year with the time available (well under an hour a week by British medical consultants, even on self reports)". [Sackett et al., 1996, p.71]

In spite of a stated desire to diminish the reliance of physicians on the authority of others, the EBM movement has resulted in the creation of a number of new authorities in order to deal with this overload of information. The Cochrane Collaboration, founded in 1993, is a volunteer-driven organization whose members perform systematic analyses of the literature and disseminate the results to fellow health care professionals. The main products of the collaboration are systematic reviews – primarily of RCTs — which are updated and added to the Cochrane Database of Systematic Reviews every three months. Various organizations have followed the Cochrane model, such as the National Guideline Clearinghouse in the U.S. and, according to the Canadian Medical Association Infobase, over 40 guideline-producing organizations in Canada. These developments prompt further clarification of the appropriate "guidelines for guidelines" and conferences on methods of systematic review. The production of reviews and guidelines has led to a new type of evidence-based practitioner in recent years. It is not uncommon to find physicians claiming to practice EBM who rely entirely on reviews and guidelines produced by others. EBM *users*, as they have been called, contract out the 'critical evaluation' step originally outlined by EBM proponents [Upshur, 2002; Brody *et al.*, 2005]. This version of EBM (known more recently as the '4S' or '5S' approach) advises physicians to rely on summaries of the research evidence produced by experts, rather than attempt critical evaluation themselves. It has been endorsed by an authoritative handbook of EBM [Straus *et al.*, 2005], and is gaining in popularity despite concerns raised by physicians and philosophers [Upshur, 2002; Borgerson, 2009b].

This approach to EBM is efficient, but in cutting out the critical evaluation physicians once again put themselves in a position of subservience to authority. In this case it is the authority of those who produce systematic reviews and guidelines, but given that there will always be social and political pressures on those producing the reviews and guidelines, this seems to be a risky endeavor. A recent article by David Cundiff [2007] on the financial interests influencing members of the Cochrane Collaboration makes this point persuasively. In establishing pre-digested reviews and guidelines as the new authority, EBM users once again drift away from the demands of critical thinking. Whenever this occurs, there is reason for concern. These new authorities, draped in claims to scientific objectivity, serve a similar function to that traditionally occupied by older, more-experienced clinicians in the "old paradigm". The authority of the past has been replaced not by a new democratic spirit in medicine, but by new forms of authority. Analysis of why this has occurred may best be done by social scientists, rather than philosophers, though the potential epistemological implications of this trend should be recognized by philosophers of science interested in EBM. For now, it will suffice to note that, as EBM becomes the new authority in medicine, it no longer fulfills its own claims to anti-authoritarianism.

3.2 General Evidence and Individualized Care

The roots of medical practice are captured in the famous saying attributed to Hippocrates, "It is more important to know what kind of person has the disease than what kind of disease the person has." In contrast with this highly personalized philosophy of medicine, EBM suggests that medical practice should be based on the generalized results of clinical research. According to the hierarchy, for instance, meta-analyses of RCTs provide excellent evidence, and case-studies provide the worst. In other words, the larger, more abstract general studies provide better evidence and thus guides to practice than do carefully developed, detailed individual studies. The hierarchy is oriented from the general to the specific. As it turns out, however, 1) it isn't easy to defend the claim that certain research designs are more generalizable than others, and 2) this generalizability, if achieved, may actually be a liability in practice.

Let's start with the standard argument for the generalizability of the highest ranked research methods. Because the RCT is performed on a group of individuals (often quite a large group) and collects average patient data across that group, the average patient data obtained from an RCT is more likely to be generalizable to members of the general population than the data obtained from one particular individual in a case study. For all we know, the individual described in a case study may have been an exception to the norm. (In fact, case studies are usually published to illustrate an unusual case or approach to treatment.) This generalizability is thought to extend even further in the case of meta-analyses of RCTs. In an RCT, the exceptional and the usual are averaged to produce one result: the average efficacy of a particular therapeutic intervention.[4] And in a meta-analysis, the results of a variety of RCTs are averaged again. Proponents of EBM offer the following advice about applying the results of such research to practice,

> [A]sk whether there is some compelling reason why the results should not be applied to the patient. A compelling reason usually won't be found, and most often you can generalize the results to your patient with confidence. [Guyatt and Rennie, 2001, p. 71]

There is a great deal of confidence in the strength of the connection between the results of research and the demands of clinical practice. However, these claims to generalizabilty are not as straightforward as they seem.

Subjects in RCTs are not randomly sampled from the general population. In fact, the subjects enrolled into clinical trials are often quite unrepresentative of the members of the general population or even the target population for a treatment. While it is sometimes possible to design a trial in which the trial population is purposely matched to the target population for the treatment (at least, as closely as possible), it is uncommon for a number of reasons. First, members of the tar-

[4]In other cases, exceptional cases may be dismissed as 'outliers' or attributed to errors in the design of the trial.

get population often have a number of comorbidities (concurrent conditions).[5] It is more difficult to isolate a cause-effect relationship when many other variables (including other medications) are added into the equation. These sorts of comorbidities are, accordingly, seen as a liability for the trial. Researchers often include in their studies only participants who have no other conditions and who are taking no other medications.

Second, members of the target population are often elderly and likely to be put on a treatment for long periods of time or even indefinitely. So the target population would be long-time users of the treatment. However RCTs are usually quite short in duration (ranging from a few weeks to a few months long). There is a gap between the short-term data produced by RCTs and the long-term use by the target population. The data from RCTs, then, are not easily generalized to the standard patient.

Third, it is common for researchers to select their study population in a way that allows them to test the healthiest people. The selection of younger subjects means that, because in general these subjects are healthier than older people, they are less likely to have adverse reactions to the drug. The healthier a person is, the less pronounced the adverse reaction (in general) and more positive the overall reaction. Again, this means the trial population is different from the target population.

Fourth, research trials are often conducted in contexts that differ in significant ways from the contexts of general practice. As a result, therapy may be administered and monitored in a way that cannot be easily replicated. Research is often conducted at facilities with more resources than is standard, and implementation of treatments in contexts where resources are scarce is not straightforward. This contributes to a gap between individual patients and the promises of benefit attributed to particular treatments.

Even if we were to set aside these concerns about the generalizability of research from RCTs, we would still be left with concerns about the gap between generalized results and individual patients. This gap between the results of generalized clinical research evidence and complex individual patient care has been raised time and again in medical literature. Feinstein and Horwitz remind us that, "When transferred to clinical medicine from an origin in agricultural research, randomized trials were not intended to answer questions about the treatment of individual patients" [Feinstein and Horwitz, 1997, p.531]. Patients are idiosyncratic individuals dealing with multiple complex problems. The most scientific medical research, by EBM standards, produces average generalizations across homogenous populations that, as discussed, often fail to resemble the patient because of inclusion and exclusion criteria. The highest ranked clinical research focuses on large-scale studies designed to determine simple causal relationships between treatments and their effects. In many cases, a particular patient would never have qualified for the study because he or she has comorbidities, or does not meet certain age or gender specifications [Van Spall et al., 2007]. As Tonelli points out:

[5]For instance, people who are mentally ill often have problems with drug addiction and this can make it difficult to isolate new treatments for mental illnesses.

> Clinical research, as currently envisioned, must inevitably ignore what
> may be important, yet non-quantifiable, differences between individ-
> uals. Defining medical knowledge solely on the basis of such studies,
> then, would necessarily eliminate the importance of individual varia-
> tion from the practice of medicine. [1998, p.1237]

If we pay attention to average outcomes, we may lose sight of significant vari-
ation within the trial population. It may be that some subjects responded well,
while others responded poorly. Though on average a drug may be more effective
than the comparison intervention used in an RCT, this isn't a full characterization
of what has occurred. In fact, important subgroup data will likely be missed. The
applicability of scientific evidence, especially large-scale, single-factor studies, "de-
pends on the individual being conformable to the group in all relevant aspects,"
which is rarely the case [Black, 1998, p.1]. On the basis of these concerns, we
suggest that simply binding medical practice to medical research fails to capture
the importance, difficulty, and skills required for re-contextualizing and individu-
alizing medical knowledge. This is not to say that medical practice won't benefit
from thoughtful and critical use of a wide variety of results from medical research,
but that is not what has been proposed. The concern raised here is directed not
at a general claim that medical practice should pay attention to medical research
(which critics of EBM support), but at the specific rules tying medical practice
to medical research in EBM, which fail to capture important distinct elements of
medical practice.

3.3 Patient Values and Shared Decision-making

The move toward a more inclusive decision-making process that has been occur-
ring in medicine over the last half century has forced physicians to become more
aware of the inherent limits and uncertainty of medical decision-making. Recent
attention to the bioethical principle of autonomy has pushed the medical model
away from doctor-knows-best paternalism and raised new questions about the role
of patients in medical decision-making. The more we recognize the role of patients'
values in medical decision-making, the further the original EBM project is from
the reality of practice. Even if there are biological similarities between several dif-
ferent cases of a disease, the values and other non-quantifiable factors introduced
by each of the individual patients could and should radically shift the medical
decision being made. No matter how strong the evidence is, without patient input
there is no clear best decision. Furthermore, the patient's subjective experience of
illness is an important part of the clinical encounter (and the source of his or her
desire for treatment) and so should form the basis for discussion about treatment
and for the evaluation of objectives and desired outcomes of treatment. These el-
ements of medical decisions require the careful development of listening skills and
compassion on the part of the physician and indicate the importance of elements
besides scientific evidence to the successful practice of medicine.

It is unclear how the sort of medical practice advocated by EBM fits with exist-
ing standards of shared decision-making and patient-centered care. Some authors
see the fit between these concepts as unproblematic. Tony Hope, for example,
suggests that EBM and patient-centered care have "a natural affinity" and that
providing patients with evidence about the effectiveness of treatments enhances
their autonomy and promotes patient-centred health care [Hope, 1996, p.1]. Yet
this assessment may be overly optimistic. Shared decision-making implies a shift
in the burden of health care work. Patients become part-time (unpaid) health care
workers as they search out evidence online, solicit advice from friends, and devote
time to careful consideration of their values. Shared decision-making is often jus-
tified on the basis of the principle of autonomy. But how are the results of the
patient's work integrated within evidence-based practice? It is clear that patients
often highly value anecdotal evidence. If something happened to a patient's friend,
sister or grandfather, he or she will be much more likely to attach significant weight
to that piece of evidence. Should the anecdotes and intuitions of patients carry
any greater weight than those of physicians, which have been explicitly condemned
under the EBM model? This seems unlikely, particularly since these anecdotes and
intuitions are supremely unscientific by EBM standards. Should the values of pa-
tients be permitted to override best research evidence?[6] In these situations, it
will be tempting for physicians to strongly guide patients to the correct evidence
from clinical trials and meta-analyses (indeed, this may be required by EBM).
There appears to be, at the very least, a tension between commitments to shared
decision-making and the rules of EBM. Moreover, according to EBM, it is still up
to the *physician* to "integrate" patients' values and preferences with the evidence
obtained from clinical trials and thus to determine the best treatment, suggesting
that EBM's contribution to *patient* autonomy is minimal [Bluhm, 2009].

The initial formulation of EBM seemed to require an almost algorithmic ap-
proach to decision-making according to which an individual physician assesses the
evidence and then applies it to the particular case. The later versions of EBM
arguably deal with the need for individualized care, as well as the importance
of incorporating patient values, by suggesting that medical research should be
conscientiously and judiciously applied to patients. While this appeal to clinical
judgment tempers the claim that clinical decision-making should be based on re-
search evidence, it does not retract it. Medical practice is still assumed to be best
when it is based on medical research. The integrative concessions were meant to
leave some room in the medical decision-making process for patient values, but
patient-centered care and shared decision-making require more than this. If we
take patient-centered care seriously, best evidence will vary depending on the val-
ues of the patient and the nature and context of illness. This appears to call into
question the 'basic' nature of best evidence. Physicians who emphasize the pa-
tient's role in the decision-making process are likely to resist the standardization

[6]It is worth keeping in mind that these values may have already been influenced by direct-to-
consumer advertising of pharmaceuticals (particularly in the U.S.) and by self-diagnosis on the
basis of on-line questionnaires provided by the makers of various medical treatments.

implicit in the more scientific approach advocated by EBM.

As described above, "best evidence" for EBM is evidence that ranks high on the hierarchy of evidence. Shared decision-making challenges the hierarchy, but it is not the only grounds on which the hierarchy has been criticized. In the next section, we will examine the assumptions that support the view that evidence should be ranked hierarchically, and will critically assess the justifications offered for these assumptions. We believe that this is one way in which philosophers can make a contribution to the debate over EBM, since "even if scientists are not concerned in their daily practice with directly justifying the assumptions that structure their reasoning, philosophers concerned with the nature of scientific knowledge must be" [Longino, 2002, p.127]. The hierarchy of evidence has come under attack from a number of different perspectives and we will provide an overview of these arguments in what follows.

4 THE CENTRAL CONCERN: THE HIERARCHY OF EVIDENCE

Proponents of EBM have declared the evidence hierarchy the fundamental first principle of EBM. However, the evidence hierarchy proposed by EBM is just one of many possible hierarchies, and so is in need of justification against the alternatives [Upshur, 2003; Borgerson, 2009a]. The literature on EBM has not yet yielded a clear defense of the current hierarchy. Because of this, we have attempted to reconstruct the most defensible justifications based on comments in the original *JAMA* and *BMJ* articles on EBM (1992, 1996), the EBM handbook *Evidence-based Medicine: How to Practice and Teach EBM* [Straus *et al.*, 2005] and the *Users' Guides to the Medical Literature* [Guyatt and Rennie, 2001]. According to this analysis, the evidence hierarchy for medical treatments organizes research methods according to their ability to produce evidence that is: randomized, clinically relevant, and unbiased. In this section we outline arguments that have been made by various philosophers that challenge each of these justifications for the current evidence hierarchy. We also consider whether the idea of a hierarchy of evidence is coherent.

4.1 Randomization

Despite its name, the hierarchy of evidence is actually *not* a hierarchy of evidence, but a hierarchy of study designs. That is, it focuses not on the actual results of a particular study or group of studies, i.e. on the evidence they provide for the efficacy of a treatment, but on how that evidence was obtained. The proponents of EBM often claim that they are misunderstood as saying that RCTs are the *only* source of good evidence; however, as we shall show below, this misunderstanding is not surprising given their discussion of the benefits of randomized trials. It may also be that the term "hierarchy of evidence" obscures the difference between the evidence for a particular treatment and the methods used to obtain that evidence.

Randomized trials are consistently ranked higher than non-randomized trials (of any type) within the evidence hierarchy.[7] So what epistemic benefits are attributed to randomization? The value placed on randomization can be studied if we pay closer attention to the division, in the hierarchy, between the RCT and the lower-ranked cohort study. Given that, like RCTs, cohort studies have treatment and control groups, can usually be double-blinded, can be analyzed according to a variety of statistical protocols, and draw conclusions on the basis of principles of eliminative induction, the only feature distinctive of RCTs is the random allocation of participants into different groups. This critique of the EBM hierarchy, then, will focus on justifications of the RCT as the gold standard of medical research. A number of philosophers, statisticians and physicians have argued that randomization does not secure the epistemic benefits it is thought to secure.

Randomized trials are consistently placed at the top of various versions of the evidence hierarchy. The following quotes are representative of the attitude toward randomization by proponents of EBM:

> [W]e owe it to our patients to minimize our application of useless and harmful therapy by basing our treatments, wherever possible, on the results of proper randomized controlled trials. [Sackett *et al*, 1991, p.195]

> To ensure that, at least on your first pass, you identify only the highest quality studies, you include the methodological term 'randomized controlled trial (PT)' (PT stands for publication type). [Guyatt *et al.*, 1994, p.59]

> If the study wasn't randomized, we'd suggest that you stop reading it and go on to the next article in your search. (Note: We can begin to rapidly critically appraise articles by scanning the abstract to determine if the study is randomized; if it isn't, we can bin it.) Only if you can't find any randomized trials should you go back to it. [Straus *et al.*, 2005, p.118]

The first two statements were made by prominent members of the EBM working group, and the advice proffered in the third appears in the 2005 edition of the official EBM handbook. Claims that EBM does not privilege RCTs and that advocates do not tell physicians to ignore other sources of evidence seem misleading

[7]Discussions of randomization in clinical research refer to the random allocation of subjects to some number of treatment and control groups (usually one of each). They do not refer to the selection of a random sample of the general population for the study (in fact, clinical trials are often notoriously unrepresentative of the general population because of inclusion and exclusion criteria). Random sampling is arguably related to our ability to generalize from the results obtained on the particular subjects under investigation to the population as a whole, while random allocation is thought to balance treatment and control groups and isolate a cause and effect relationship between treatment and outcome. The following discussion addresses random allocation. Random allocation is achieved by tossing a die, flipping a coin, drawing a card from a deck, or through more complicated measures such as random number tables. There are problems with all attempts to create 'randomness', but we will not get into them here.

in light of these recent statements. In addition, evidence gathered by Grossman and Mackenzie [2005], using the example of the MERGE guidelines, has exposed a persistent tendency to set aside non-randomized trials.

John Worrall [2002] provides an overview and criticisms of the arguments for randomization, which include an appeal to the assumptions that govern frequentist statistics and the belief that randomization "guarantees" equivalence of the treatment and control groups with regard to factors that may influence the outcome of the study. He concludes that the only argument for randomization that is not flawed is that randomization prevents the "selection bias" that occurs when study clinicians systematically (whether consciously or unconsciously) assign patients to the treatment or to the control group. Yet he points out here that while randomization may be sufficient to eliminate this bias, it is not necessary. Alternative methods for preventing selection bias are equally effective. Similarly, Grossman and Mackenzie [2005] criticize EBM's emphasis on randomized studies, noting that there are many research questions for which randomization is either impractical or unhelpful. For example, if there is a chance that the effects of the treatment will "bleed" into the control group (as in the case of discussion between participants in different groups in a study of an educational program, or sharing of drugs between participants in the treatment and the control group, which occurred in clinical trials subverted by AIDS activists), randomization is useless. Grossman and Mackenzie also criticize "empirical" arguments for the superiority of randomization, which point to differences in the outcomes of randomized and nonrandomized trials as evidence that randomization results in more accurate assessments of a treatment's effect. They note that this is actually a circular argument, since the inference from different results to more accurate results (with the RCT) can only be made if RCTs are assumed to give the most accurate outcomes in general.

Despite these arguments, the RCT is central to evidence-based medicine. As noted above, some people believe that if both nonrandomized and randomized studies have been conducted for a given intervention, only the latter should be considered in summaries of the literature. Even less drastic views tend to overemphasize the importance of randomization at the expense of a more nuanced discussion of the methodological merits of clinical studies. EBM advocates do not often discuss how to weight studies of different qualities or what sort of trade-off exists between the quality of a study and its effect size. Should a large nonrandomized trial that is well-conducted be considered to be inferior to a small RCT with methodological flaws? And how major must these flaws be before the nonrandomized trial is considered to be more trustworthy? The more thoughtful formulations of EBM acknowledge that there are no simple rules that can guide this decision (the less thoughtful formulations simply ignore these problems), but have not made much headway in providing more complicated guidelines, or in tempering the "randophilia" common in medicine today.[8]

[8]The term 'randophilia' comes from noted EBM critic, Alvan Feinstein.

4.2 Clinical Applications

We suggested earlier that EBM is a manifestation of the empiricist stream in medicine. The emphasis on randomized controlled trials and on systematic reviews and meta-analyses of such trials echoes Gavaret's Law of Large Numbers, which states that the effect of a treatment can only be estimated on the basis of observation of its effect in a large number of cases. Gavaret further says that this Law could be expressed only as a range, the width of which depended on the number of cases observed, echoing the concern for precision and narrow confidence intervals that places systematic reviews and meta-analyses at the top of the hierarchy of evidence. But EBM's empiricism is more thoroughgoing than that of Gavaret, who also acknowledges that:

> In investigations of aetiological problems, the Law of Large Numbers only serves to prove the presence or absence of an assumed specific cause, regardless of its nature. One must seek to determine the cause itself by means of considerations of a different order. This last question is outside the domain of statistics. [Wulff et al., 1990, p. 36; their translation of Gavaret]

In the words of Wulff et al., this statement marks a "retreat from radical empiricism" — the causes of a disease cannot be explained without reference to information from the basic sciences. Gavaret's empiricism, then, recognizes the importance of the "rationalist" concern with disease mechanisms, though it does not espouse the speculative aspect of earlier forms of rationalism. EBM's empiricism, by contrast, appears to reject the appeal to causal mechanisms, not just in evaluating the efficacy of a treatment, but also in its approach to the etiology of disease. As was mentioned earlier, the hierarchy of evidence for treatment studies and that for prognosis differ only in that the latter does not include RCTs. Physiological studies, which reflect the "realist" concern with disease mechanisms, rank well below observational studies in both hierarchies. Instead, EBM emphasizes the importance of population-level (epidemiological) studies in elucidating the causes of disease (or at least factors that are statistically associated with disease).

Further evidence of EBM's tendency towards empiricism can be found in some of the writings of David Sackett [1999; 2000]. The original EBM manifesto positioned the "new paradigm" against the traditional appeal to authority in making treatment decisions (on the grounds that unstructured individual experience, no matter how much of it, was both too narrow and too biased to provide adequate grounds for judgment). Sackett [2000] also emphasizes the differences between EBM and the type of "bottom up" laboratory research that informed medicine during the first half of the 20th century. He describes the increase in the number of epidemiological studies performed by physicians as a shift from "clinical research" to "clinical-practice research." Since the 1960s and 70s, he suggests, the skills required for medical practice in a clinical setting have become increasingly remote from those required to conduct laboratory research. At the same time,

fewer medical students have chosen careers that incorporate both laboratory re-
search and clinical medicine. Instead, laboratory research in biomedicine is now
carried out primarily by Ph.D. researchers.

Sackett further argues that the increase in the number of physicians involved in
what he calls "clinical-practice research" — primarily, judging from his examples,
randomized controlled trials, but also encompassing small, qualitative studies —
has occurred largely because (unlike bench research) it is easily integrated with
clinical practice and its results are immediately transferable to clinical practice.
In another editorial, Sackett [1999] contrasts bench research with clinical-practice
research — to the benefit of the latter:

> "Millions of dollars' worth of bench research that appeared to show
> a reduction in atherosclerosis-related oxidative stress with vitamin E
> therapy was recently tested in an RCT that asked the vital question:
> Does the vitamin E therapy endorsed by this research really help pre-
> vent heart disease? The answer was a resounding 'No'". (p. 1414)

Yet a look at the study he cites suggests that the "no" is actually less than re-
sounding. The authors of this study point out that previous observational studies
had shown some benefit with vitamin E therapy, and they describe the results
of previous RCTs as "controversial." Moreover, there was no agreement on the
appropriate dose of vitamin E, or on the specific population for which it might be
beneficial. In addition, although there was no significant difference in this study in
the total number of deaths (the primary endpoint for the study) in the vitamin E
and the control group, an analysis of a secondary endpoint in each group suggested
that there were significantly fewer cardiovascular deaths in the vitamin E group.
The authors note in their discussion of the study's results that "[r]esults of contin-
uing large randomised trials with other doses of vitamin E supplements will better
elucidate the efficacy profile of this antioxidant substance in lowering cardiovas-
cular risk in patients with myocardial infarction and in other patients, possibly
in different clinical settings" [Gruppo Italiano per lo Studio della Sopravvivenza
nell'Infarto miocardiaco, 1999. p. 453]. In summary, the study investigated the
question of whether a specific dose of vitamin E, in a specific population (patients
who had previously had myocardial infarctions) that was studied for a specific
(relatively short) time, would benefit from taking the supplement. Sackett seems
to want to conclude that the results of that study can be generalized beyond the
specific population and dosage. This case highlights some of the problems with
the attitude of advocates of EBM toward randomized controlled trials. First, de-
spite the evidence of a large body of laboratory research, it is assumed that the
results of an RCT should trump evidence from "physiological studies." Second, it
is assumed that a single RCT, if it is large enough and well conducted, can provide
a definitive answer to a scientific question. Third, there does not seem to be any
recognition of how difficult it can be to generalize from the results of a study to
predict the effects of changes in the medication regimen or in the population be-
ing treated (see [Bluhm, 2007] for further discussion of this point). Yet it is only

on the basis of these unsubstantiated assumptions that Sackett can claim that "clinical-practice" research, unlike bench research, is directly applicable to clinical care.

While the clinical research that Sackett advocates is important and does hold promise to improve health care, his argument ignores the fact that bench research and clinical (epidemiological) research are intimately related. Epidemiology seeks to explain disease in terms of various factors or characteristics possessed by individuals with and without the disease and to give statistical links between these factors and the occurrence of disease. Laboratory research aims to give physiological explanations for disease etiology in terms of normal and pathological functioning of biological mechanisms. Epidemiologists, but not clinical researchers influenced by EBM and its hierarchy of evidence, recognize this relationship when they draw on research in laboratory-based disciplines to distinguish between causal and merely statistical relationships between risk factors and disease. Epidemiological studies are designed to ensure that these latter types of factor, designated "confounding factors", can be identified and removed from explanations of the development of a disease. The epidemiologist Kenneth Rothman is explicit about the relationship between epidemiological research and the understanding of disease mechanisms: "[a]s the layers of confounding are left behind, we gradually approach a deeper causal understanding of the underlying biology" [2002, p. 105]. By contrast, the *Users' Guides* cautions that "the human mind is sufficiently fertile that there is no shortage of biological explanations, or indirect evidence, in support of almost any observation" [Guyatt and Rennie, 2001, p. 562]. Although they recognize that some biological explanations may be better founded than others, the proponents of EBM ultimately give the impression that all such explanations remain suspect. While it is true that what is learned from laboratory research is always open to revision or rejection in light of further evidence, it is no less true of clinical research. Moreover, there is no reason to accept that evidence from clinical research should count against evidence from laboratory research, but to deny that laboratory research can count against clinical evidence.[9]

4.3 Bias

One of the justifications of the evidence hierarchy is that it ranks research methods according to their ability to eliminate bias. However, it has been argued that evidence ranked highest in the hierarchy is not necessarily less biased than that below [Borgerson, 2009a]. According to the Oxford English Dictionary, in statistical terminology bias is, "a systematic distortion of an expected statistical result due to a factor not allowed for in its derivation; also, a tendency to produce such distortion." The narrow concern of statistical methodology is with confounding

[9]Mita Giacomini has recently argued that EBM needs to pay more attention to theoretical (causal) reasoning. She describes the case of remote intercessory prayer, which has been shown to be effective in a number of clinical trials despite the lack of a plausible mechanism of action. By EBM's own hierarchy, prayer should be accepted as an effective therapy [Giacomini, 2009].

factors as possible sources of bias. The EBM working group identifies the systematic attempts to record observations in an "unbiased" fashion as one of the key features distinguishing clinical research from clinical practice [EBM Working Group, 1992, p.2421]. Of all of the available methods, the RCT is thought to be least subject to bias.

As noted earlier, the (causal) inferential structure of the RCT is identical to that of the cohort study, yet the cohort study is consistently ranked below the RCT in various versions of the EBM hierarchy. The superiority of RCTs is often illustrated with reference to selection bias. Authors of a recent guide to RCTs, Alejandro Jadad and Murray Enkin, suggest that this is the primary bias RCTs can truly claim to control better than other trial designs [Jadad and Enkin, 2007]. This is thought to partly justify their higher status in the evidence hierarchy. The authoritative CONSORT statement defines selection bias as: "systematic error in creating intervention groups, such that they differ with respect to prognosis. That is, the groups differ in measured or unmeasured baseline characteristics because of the way participants were selected or assigned" [CONSORT statement]. Even philosophers who are otherwise very critical of RCTs are willing to concede that they have some special epistemic powers with respect to selection bias [Urbach, 1993; Worrall, 2007b]. This form of bias can occur when selecting participants from the general public.

In order to deal with selection bias, it is important that researchers institute some form of allocation concealment. By concealing the allocation of enrolled patients from the physicians doing the intake for the study, this form of bias can be minimized. As it turns out, however, allocation concealment is secured independently of randomization [Borgerson, 2009a]. In fact, a study can be randomized and yet fail to have allocation concealment. Just imagine a case in which a physician steams open the envelope containing the randomization sequence. If the physician conducting the trial is aware of the randomization sequence, then there is no allocation concealment. And a non-randomized cohort study can have concealed allocation as long as the allocation criteria are successfully hidden during intake). When allocation concealment is achieved, it is not because the allocation was randomized, but rather because it was successfully concealed. RCTs aren't unique in controlling for selection bias because randomization is not the mechanism by which allocation concealment is guaranteed. RCTs cannot guarantee freedom from bias, and have no special powers to secure freedom from selection bias.

4.4 Is a Hierarchy Necessary?

It will always be useful to have clear, explicit criteria that demarcate a good RCT from a bad RCT, a good-quality cohort study from a poor-quality cohort study, and a well-conducted qualitative study from a poorly conducted qualitative study. This is not what is at issue when we ask whether the evidence hierarchy of EBM is justified. What is at issue is whether it is possible to categorically rank

an RCT against, for instance, a cohort study, or a case-control study against a qualitative study. We have identified arguments against three of the most common justifications offered for the hierarchy advanced by EBM. We turn now to the question of whether any hierarchy of evidence could be justified in medicine.

The proponents of EBM claim that they are not trying to say that the *best* way to answer *every* question is to conduct an RCT; in fact, they point out that different types of questions (diagnosis, treatment, prognosis) have different hierarchies. They note, though, that in the case of treatment studies, RCTs should be performed wherever possible. Only random allocation can ensure that the purported effects of an intervention are due to that intervention, rather than to confounding factors that also affect whether patients end up in the treatment versus the control group (and therefore which intervention they receive). Our worry here is that the hierarchy (or any hierarchy) focuses attention on methods, rather than on the goals of a study. Even if it is true that a nonrandomized study cannot tell us whether smoking *really* causes lung cancer, or whether instead both the propensity to smoke and the susceptibility to lung cancer are caused by the same underlying (possibly genetic) factor, we would be much better served by encouraging people to quit smoking and then comparing health outcomes (in another nonrandomized study) between these ex-smokers and those who continue to smoke. The goal in investigating the link between smoking and lung cancer is, after all, not to eliminate all possible alternative explanations, but to prevent people dying of lung cancer. Similarly, qualitative research is valuable because it answers questions that could not be answered by RCTs. If we are interested in asking *why* questions, such as, for instance, 'why was compliance so low for this treatment?' we require research methods such as surveys, interviews and focus groups.

Given the doubts about the superiority of RCTs discussed earlier, it may be that the hierarchy ultimately does more harm than good, since any hierarchy that attempts to rank research methods against each other will end up prioritizing certain research questions over others, thus restricting the scope of investigation. This restriction is detrimental to medical knowledge and, by extension, to medical practice. Grossman and Mackenzie [2005] point out that the prevailing belief that randomized studies are best may have implications for the kinds of studies that get conducted (in part by influencing funding practices). This would mean that a study investigating the effects of exercise on rates of heart disease in elderly women would be more likely to be funded if participants were randomly assigned to the exercise/no exercise groups. But such an approach cannot account for the fact that motivation to exercise will affect whether participants comply completely with their assigned regimen. Thus the best design for answering this question is a nonrandomized prospective study.

4.4.1 *Methodological Pluralism as an Alternative to a Hierarchy*

In light of a lack of justifications for the current evidence hierarchy, and for evidence hierarchies generally, it is worth discussing possible alternative ways of organizing

evidence. Henrik Wulff, for instance, advocates viewing EBM "not [as] a new discipline but [as] one ingredient in the production of good clinical care" [Daly, 2005, p.36]. Petticrew and Roberts [2003] have suggested the importance of "horses for courses" with respect to research methods, and proposed a "matrix" of evidence. Muir Gray [2001] has developed a "typology" in order to schematically indicate the different strengths of each of the research methods. Bluhm [2005] has proposed a "network" of evidence that pays closer attention to the interdependence of evidence at each level of the traditional hierarchy. There is no shortage of different names for what amounts to a renewed appreciation for methodological pluralism in medical research. Recognition of pluralism forces physicians to become more aware of the strengths and weaknesses of different research methods, and though more challenging in practice, at least discourages the false complacency that comes with rigid hierarchies.

Ross Upshur and colleagues have provided a model of evidence that aims to capture the variety of meaningful types of evidence in medicine as well as their interrelationships, without imposing any comparative ranking. The four distinct but related concepts of evidence are: "qualitative/personal", in which evidence is narrative in nature, socially and historically context-specific and individualized; "qualitative/general" in which evidence is social, historical and general; "quantitative/general" in which evidence is statistical, general, impersonal and quantitative; and "quantitative/personal" in which evidence is quantitative, yet individualized. Of these, the emphasis of EBM has been on quantitative/general evidence, often at the expense of other types of evidence. Exclusive focus on this one type of evidence is unjustified. This model acknowledges the value of each type of evidence and provides a general framework for understanding how each type of evidence can complement the others. This does away with hierarchies altogether and embraces a more complicated — yet more accurate — description of the plurality of useful research methods [Upshur *et al.*, 2001].

5 FUTURE RESEARCH RELATED TO EBM

In this section, we briefly review several areas in which philosophers of science have begun to contribute to discussions about EBM, or where discussions in philosophy of science seem to have something to add to the debates over EBM. Given that philosophy of science has a vast body of literature on issues like the nature of evidence, the concept of causation, the relationship between different fields of scientific research, the relationship between hypotheses, theories, models and evidence, and the nature of various forms of induction, we believe that research in each of these areas has the potential to contribute to the betterment of both medicine and philosophy of medicine.

5.1 Theories of Evidence

Nancy Cartwright has recently, and provocatively, described the function of evidence-based standards as follows:

> Grading schemes [such as the evidence hierarchy] don't combine evidence at all — they go with what's on top. But it seems to me to be daft to throw away evidence. Why are we urged to do it? Because we don't have a good theory of exactly why and how different types of evidence are evidence and we don't have a good account of how to make an assessment on the basis of a total body of evidence. Since we don't have a prescription for how to do it properly, we are urged not to do it at all. That seems daft too. But I think it is the chief reason that operates. That is why the philosophical task is so important. [Cartwright *et al.*, np]

The philosophical task Cartwright refers to is that of developing a theory of evidence that is both philosophical and practicable. Traditional philosophical theories of evidence have tended to focus on how to determine whether something is evidence (usually in terms of the probabilistic relationship between evidence and hypothesis or of a further account of explanation).[10] These accounts, while useful for clarifying the relevant epistemological issues, are impractical for use. Practical accounts of evidence implicit in current standards of evidence proposed by, for instance, the evidence-based medicine movement, have focused on ranking different types of evidence as better or worse than others, but have neglected the more basic question: what makes something evidence in the first place?[11] Further, such practical accounts are often inconsistent or incoherent. They are thus not comprehensive (or, in Cartwright's terms, 'philosophical'). This no doubt leads to confusion over the place of expert judgment, patient values and anecdotes as evidence. A theory of evidence should guide us in determining whether anecdotes and expert judgments are evidence at all rather than assuming they are not because they fail to meet arbitrary standards of *good* evidence captured by the assumptions underlying the evidence hierarchy. Cartwright's proposal is ambitious. We believe such a theory is impossible on the grand scale, but we are in agreement that a context-specific account of evidence would be a significant addition to the medical debate. Cartwright's discussion reiterates the "daftness" of proposals to rank research methods against each other and the need for a less restrictive and non-hierarchical description of medical evidence.

5.2 Social Epistemology

Social epistemology appears to be a fruitful area of research for those interested in pursuing constructive projects related to standards of evidence in medicine. In what follows we will outline a few of these more specific projects.

[10]See for instance [Achinstein, 2001].

[11]In Cartwright's terms, what makes something candidate evidence?

5.2.1 Experience, Expertise and Testimony as Knowledge

There are a number of social epistemologists working on justifications for testimonial evidence, including Elizabeth Fricker, Tyler Burge, Alvin Goldman and Jennifer Lackey. Extension of these discussions to the medical context would be a fruitful line of research. EBM, as a movement, aims to decrease physicians' reliance on testimonial knowledge — particularly that passed down from older physicians with decades of practical experience. Whether this is a good move or not will depend in part on the legitimacy of testimony as a source of knowledge. In addition, the epistemic status not only of physician expertise, but of the special expertise attributed to patients (particularly patients with chronic illnesses) is under-theorized and, as a result, often neglected in discussions of evidence-based medicine. While proponents of EBM call for 'integration' of expertise, patient values, and clinical research evidence, little guidance is given on how to do this, or on what the status of each of these elements as 'evidence' might be. Those in the medical community would no doubt welcome further philosophical attention to these issues.

5.2.2 Consensus Conferences and Dissent

Miriam Solomon [2007] has analysed the social epistemology of NIH Consensus Conferences, which involve a panel of clinicians, researchers, statisticians and the general public, who develop a consensus statement on the basis of testimony from 20 to 30 experts on the issue being judged. Solomon notes that the conferences are designed to develop a consensus on controversial topics in health and medicine when there is enough evidence available to give rise to a consensus, and/or when there is a perceived gap between theory and practice. Like meta-analyses, consensus conferences are supposed to be designed to overcome bias in the assessment of evidence. Solomon points out that meta-analytic techniques are increasingly being incorporated into the consensus program, raising the question of what the traditional format for these conferences adds to the results of such analyses. She further suggests that we should distinguish between two functions of these conferences: first, the development of a consensus on a scientific question, and second, "knowledge transfer" to health care providers and the public. She concludes that, for the most part, the consensus statements produced "have reflected an already existing consensus in the research community, and have been re-appropriated as educational resources for the health care community" (p. 176). Solomon's analysis gives rise to a number of interesting questions, including a more detailed analysis of the influence of the techniques of EBM on these conferences, and an investigation into the parallels between the epistemological problems faced by consensus conferences and those facing EBM. In light of the development of various guideline-producing groups, many of which claim to be evidence-based, this is an important area for further philosophical attention.

5.2.3 Social Norms in Science

Social epistemologists analyze the social structures relevant to the knowledge-productive capabilities of particular communities. Helen Longino, for instance, stresses the importance of *recognized avenues for criticism* within knowledge-productive communities. In scientific communities, this typically includes peer-reviewed journals, conferences, workshops, and so on. What has been called the "open science" movement of recent years provides a number of specific recommendations for ensuring the transparency and publicity of scientific research, and thus for upholding this social epistemological criterion. These include: rejection of non-disclosure clauses in research contracts, disclosure of competing interests in publications, prohibitions on ghost authorships, a mandatory clinical trials registry, open peer-review, open access journals, open submission processes, public funding for research, an emphasis on original research, greater awareness of the collective nature of medical decision-making, and more comprehensive analytic training for health professionals [Borgerson, 2008; 2009b]. Whereas EBM focuses on rules of evidence as a mechanism for controlling bias and improving the accuracy of research, social epistemologists point out the limitations of this fixation on rules of evidence. However necessary such rules may be, they are certainly not suf-

ficient for the production of knowledge. Greater attention to the social dimensions of knowledge-production would allow advocates of EBM to address some of the concerns raised by critics. In particular it would encourage proponents of EBM to acknowledge the less-than-definitive nature of even 'best evidence' in clinical decision-making. Further philosophical work in this area is warranted.

5.3 Ethics and Epistemology in Medicine

Although the claim that medicine should be based on research evidence clearly has ethical implications,[12] of perhaps greater interest to philosophers of science than a straightforward ethical analysis is work that examines the relationship between epistemological and ethical issues in EBM. Although EBM has clear standards for "best" evidence, and although it is claimed that EBM will result in *improved* patient outcomes, it is by no means clear that the epistemological standards of EBM are conducive to the *best* patient outcomes. While this point is implicit in the discussion above of the tension between general evidence and individual data (section 4.2.2), shared decision-making (4.2.3) and methodological pluralism (5.4.1), we think it is worth making explicit that EBM's evidence hierarchy has ethical implications. Kenneth Goodman has suggested that one point in favour of EBM is that it is "an honest attempt to come to terms with the great and embarrassing fact that much of what has passed for clinical expertise and knowledge was custom, tradition, intuition, and luck" [2003, p. 132]. He further suggests that because uncertainty is an unavoidable part of medical practice, it is deceptive for a clinician not to acknowledge this uncertainty when talking with patients. On the other hand, Howard Brody and his colleagues point out that "it has always been difficult to get physicians to understand and embrace uncertainty whenever they are offered pseudo-certainty as an alternative" [2005, p. 578]. We have suggested that the hierarchy of evidence, which says that the best evidence is provided by systematic reviews or meta-analyses (with narrow confidence intervals) offers pseudo-certainty: it gives a precise estimate of average outcomes, but at the expense of ignoring the uncertainty that arises from variability between patients. Further exploration of the implications of certainty and uncertainty in research and practice is warranted, as are comparisons between medicine and other sciences on this topic. There is a small but growing literature that examines the relationship between epistemology and ethics, and the implications of this relationship for clinical care (e.g. [Goldenberg, 2006; Zarkovich and Upshur, 2002]). We believe that this area of research is of particular importance and warrants further exploration.

Further, bioethicists and medical researchers alike draw on equipoise as part of the ethical justification of RCTs. Although the concept of equipoise is open to different interpretations and may be epistemologically troublesome [Gifford, 2007], it is most often interpreted to mean that we are only justified in randomizing

[12]These ethical implications have been examined in work by a few scholars, including Kenneth Goodman [2003], Howard Brody *et al.* [2005] and Mona Gupta [2003].

patients to a control group (and, thus, putting them at risk of receiving sub-standard treatment) when there is genuine community-wide uncertainty about the efficacy of a proposed new treatment or intervention. Because equipoise is generally taken to be a measure of the uncertainty within a community, concerns about equipoise are intimately caught up with questions about the evidential power of various knowledge claims in medicine. After all, if we only 'really know' a treatment works when we have an RCT, then our threshold for performing RCTs will be very low (after all, if we have not done an RCT yet, then we will always be justified in pursuing research to settle the question). But this is likely to lead to RCTs where convincing historical evidence already exists for a particular treatment, as well as to RCTs for "absurd" treatments [Ernst, 2009]. The ethical and epistemological concerns are intertwined in this discussion, and this appears to be a fruitful and pressing area for further philosophical attention.

6 CONCLUSION

In summary, EBM has become highly influential in guiding clinical decision-making, in developing discipline-specific guidelines and in setting health policy. Yet, as suggested by persistent criticisms, the epistemological basis of EBM is not as solid as its proponents seem to think. Given both the inherent interest and the practical importance of the epistemological issues raised by EBM, it promises to be a fruitful area of research for philosophers of science.

BIBLIOGRAPHY

[Achinstein, 2001] P. Achinstein. *The Book of Evidence.* Oxford: Oxford University Press, 2001.

[Black, 1998] D. Black D. The Limitations of Evidence, *Perspectives in Biology and Medicine* 42: 1-7, 1998.

[Bluhm, 2005] R. Bluhm. From Hierarchy to Network: A Richer View of Evidence for Evidence-Based Medicine, *Perspectives in Biology and Medicine* 48: 535-47, 2005.

[Bluhm, 2007] R. Bluhm. Clinical Trials as Nomological Machines: Implications for Evidence-Based Medicine, in Kincaid and McKitrick (eds.), *Establishing Medical Reality: Essays in the Metaphysics and Epistemology of Biomedical Science.* Dordrecht: Springer, pp. 149-166, 2007.

[Bluhm, 2009] R. Bluhm. Evidence-Based Medicine and Patient Autonomy, *International Journal for Feminist Approaches to Bioethics* 2: 134-151, 2009.

[Borgerson, 2008] K. Borgerson. Valuing and Evaluating Evidence in Medicine, Unpublished Doctoral Dissertation. University of Toronto, 2008.

[Borgerson, 2009a] K. Borgerson. Valuing Evidence: Bias and the Evidence Hierarchy of Evidence-based Medicine, *Perspectives in Biology and Medicine* 52: 218-233, 2009.

[Borgerson, 2009b] K. Borgerson. Why Reading the Title Isn't Good Enough: An evaluation of the 4S approach of evidence-based medicine, *International Journal for Feminist Approaches to Bioethics* 2: 152-175, 2009.

[Brody *et al.*, 2005] H. Brody, F.G. Miller, and E. Bogdan-Lovis. Evidence-Based Medicine: Watching out for its Friends, *Perspectives in Biology and Medicine* 48: 570-84, 2005.

[Brody, 2005] H. Brody. Patient Ethics and Evidence-Based Medicine–The Good Healthcare Citizen, *Cambridge Quarterly Healthcare Ethics* 14: 141-6, 2005.

[Canadian Medical Association Infobase,] Canadian Medical Association Infobase. Guidelines for Canadian Clinical Practice Guidelines, `http://mdm.ca/cpgsnew/cpgs/gccpg-e.htm`.

[Cartwright *et al.*, 2007] N. Cartwright, A. Goldfinch, and J. Howick. Evidence-based policy: Where is our Theory of Evidence? *Centre for Philosophy of Natural and Social Science (CPNSS/LSE) Contingency and Dissent in Science Technical Report* 02/07, 2007.

[Charlton, 1997] B.G. Charlton. Restoring the Balance: Evidence-Based Medicine put in its Place, *Journal of Evaluation in Clinical Practice* 13: 87-98, 1997.

[Charlton and Miles, 1998] B.G. Charlton and A. Miles. The Rise and Fall of EBM, *Quarterly Journal of Medicine* 91: 371-4, 1998.

[CONSORT statement,] CONSORT (Consolidated Standards of Reporting Trials) Group. "CONSORT Statement. `http://www.consort-statement.org/`.

[Crawley, 1993] L. Crawley. Evidence-Based Medicine: A New Paradigm for the Patient, *JAMA: Journal of the American Medical Association* 269: 1253, 1993.

[Cundiff, 2007] D. K. Cundiff. Evidence-Based Medicine and the Cochrane Collaboration on Trial, *Medscape General Medicine* 9: 56, 2007. `http://www.medscape.com/viewarticle/557263`.

[Daly, 2005] J. Daly. *Evidence-Based Medicine and the Search for a Science of Clinical Care.* Los Angeles: University of California Press, 2005.

[Davidoff *et al.*, 1005] F. Davidoff, B. Haynes, D. Sackett, and R. Smith. Evidence Based Medicine, *BMJ* 310: 1085-1086, 1995.

[Duffin, 1999] J. Duffin. *History of Medicine: A Scandalously Short Introduction.* Toronto: University of Toronto Press, 1999.

[Ernst, 2009] E. Ernst. Complementary and Alternative Medicine: Between Evidence and Absurdity, *Perspectives in Biology and Medicine* 52: 289-303, 2009.

[Evidence-Based Medicine Working Group, 1992] The Evidence-based Medicine Working Group. Evidence-based Medicine: A new approach to teaching the practice of medicine, *The Journal of the American Medical Association* 268: 2420-2425, 1992.

[Feinstein and Horwitz, 1997] A. R. Feinstein and R. Horwitz. Problems in the 'Evidence' of Evidence-Based Medicine, *American Journal of Medicine* 103: 529-535, 1997.

[Feinstein, 1967] A.R. Feinstein. *Clinical Judgment.* Baltimore MD: Williams and Wilkins, 1967.

[Feinstein, 1985] A.R. Feinstein. *Clinical Epidemiology: The Architecture of Clinical Research.* Philadelphia: W.B. Saunders Co., 1985.

[Feinstein, 1994] A.R. Feinstein. *Clinical Judgment* Revisited: The Distraction of Quantitative Methods, *Annals of Internal Medicine* 120: 799-805, 1994.

[Fletcher et al., 1982] R.H. Fletcher, S.W. Fletcher, and E.H. Wagner. *Clinical Epidemiology: The Essentials.* Baltimore: Williams and Wilkins, 1982.

[Giacomini, 2009] M. Giacomini. Theory-Based Medicine and the Role of Evidence: Why the Emperor Needs New Clothes, Again, *Perspectives in Biology and Medicine* 52: 234-251, 2009.

[Gifford, 2007] F. Gifford. Taking Equipoise Seriously: The Failure of Clinical or Community Equipoise to Resolve the Ethical Dilemmas in Randomized Controlled Trials, in Kincaid and McKitrick (eds.), *Establishing Medical Reality: Essays in the Metaphysics and Epistemology of Biomedical Science.* Dordrecht: Springer, pp. 215 - 233, 2007.

[Goldenberg, 2006] M. Goldenberg. On Evidence and Evidence Based Medicine: Lessons from the Philosophy of Science. *Social Science & Medicine*, 62: 2621-2632, 2006.

[Goodman, 2005] K.E. Goodman. *Ethics and Evidence-Based Medicine: Fallibility and Responsibility in Clinical Science.* New York: Cambridge University Press, 2003.

[Greenhalgh, 1999] T. Greenhalgh. Narrative Based Medicine in an Evidence Based World. *British Medical Journal* 318: 323-325, 1999.

[Grossman and MacKenzie, 2005] J. Grossman and F. J. MacKenzie. The Randomized Controlled Trial: Gold Standard, or Merely Standard? *Perspectives in Biology and Medicine* 48: 516-34, 2005.

[Gruppo Italiano per lo Studio della Sopravvivenza nell'Infarto miocardiaco, 1999] Gruppo Italiano per lo Studio della Sopravvivenza nell'Infarto miocardiaco. Dietary Supplementation with n-3 Polyunsaturated Fatty acids and Vitamin E After Myocardial Infarction: Results of the GISSI-Prevenzione Trial, *Lancet* 354:447-55, 1999.

[Guyatt and Rennie, 2001] G. Guyatt and D. Rennie, eds. *Users' Guide to the Medical Literature.* Chicago: AMA Press, 2001.

[Guyatt et al., 1994] G.H. Guyatt, D.L. Sackett, and D.J. Cook. How to Use an Article About Therapy or Prevention: What Were the Results and Will They Help Me in Caring for My Patients? *The Journal of the American Medical Association* 271: 59-66, 1994.

[Guyatt, 1993] G. Guyatt. Evidence-Based Medicine: A New Paradigm for the Patient, *JAMA: Journal of the American Medical Association* 269:1254, 1993.

[Gupta, 2003] M. Gupta. A Critical Appraisal of Evidence-Based Medicine: Some Ethical Considerations. *Journal of Evaluation in Clinical Practice.* 9: 111-21, 2003.

[Haynes, 2002] R.B. Haynes. What Kind of Evidence is it that Evidence-Based Medicine Advocates want Health Care Providers and Consumers to Pay Attention to? *BMC Health Services Research* (2002) 2: 3.

[Hope, 1996] T. Hope. *Evidence-based Patient Choice.* London: The King's Fund, 1996.

[Horwitz, 1996] R.I. Horwitz. The Dark Side of Evidence-Based Medicine, *Cleveland Clinical Journal of Medicine* 63: 320-3, 1996.

[Isaacs and Fitzgerald, 1999] D. Isaacs and D. Fitzgerald. Seven Alternatives to Evidence-based Medicine, *British Medical Journal* 319: 1618, 1999.

[Jadad and Enkin, 2007] A.R. Jadad and M.W. Enkin. *Randomized Controlled Trials: Questions, Answers and Musings.* Malden, MA: Blackwell Publishing, 2007.

[Laupacis, 2001] A. Laupacis. The Future of Evidence-based Medicine, *Canadian Journal of Clinical Pharmacology* Supp A: 6A-9A, 2001.

[Longino, 2002] H. Longino. *The Fate of Knowledge.* Princeton: Princeton University Press, 2002.

[Maynard, 1997] A. Maynard. Evidence-Based Medicine: An Incomplete Method for Informing Treatment Choices. *Lancet.* 349: 126-128, 1997.

[Montori and Guyatt, 2008] V.M. Montori and G. H. Guyatt. Progress in Evidence Based Medicine, *JAMA* 300: 1814-1816, 2008.

[Muir Gray, 2001] J.A. Muir Gray. *Evidence-based Healthcare: How to Make Health Policy and Management Decisions.* Second Edition. London: Churchill Livingstone, 2001.

[Naylor, 1995] C.D. Naylor. Grey Zones of Clinical Practice: Some Limits to Evidence-Based Medicine, *The Lancet* 345: 840-2, 1995.

[Newton, 2001] W. Newton. Rationalism and Empiricism in Modern Medicine, *Law and Contemporary Problems:* Causation in Law and Science 64: 299-316, 2001.

[Parker, 2002] M. Parker. Whither our Art? Clinical Wisdom and Evidence-based Medicine, *Medicine, Health Care and Philosophy* 5: 273-280, 2002.

[Petticrew and Roberts, 2003] M. Petticrew and H. Roberts. Evidence, Hierarchies and Typologies: Horses for Courses, *Journal of Epidemiology and Community Health* 57: 527-529, 2003.

[Rothman, 2002] K. Rothman. *Epidemiology: An Introduction.* New York: Oxford University Press, 2002.

[Sackett, 1999] D.L. Sackett. Time to Put the Canadian Institutes of Health Research on Trial, *Canadian Medical Association Journal* 161:1414-1415, 1999.

[Sackett, 2000] D.L. Sackett. The Fall of 'Clinical Research' and the Rise of 'Clinical-Practice Research', *Clinical and Investigative Medicine* 23:379-81, 2000.

[Sackett et al., 1996] D.L. Sackett, W.M. Rosenberg, J.A. Gray, R.B. Haynes and W.S. Richardson. Evidence-Based Medicine: What it Is and What it Isn't, *British Medical Journal* 312: 71-72, 1996.

[Sackett et al., 1991] D.L. Sackett, R.B. Haynes, G.H. Guyatt, and P. Tugwell. *Clinical Epidemiology: A Basic Science for Clinical Medicine.* Second Edition. Toronto: Little, Brown and Company, 1991.

[Sackett et al., 1997] D.L. Sackett, W.S. Richardson, W. Rosenberg, and R.B. Haynes. *Evidence-Based Medicine: How to Practice and Teach EBM.* 1st Edition. New York: Churchill Livingstone, 1997.

[Sackett et al.,, 2000] D.L. Sackett, S.E. Straus, W.S. Richardson, W. Rosenberg, and R.B. Haynes. *Evidence-Based Medicine: How to Practice and Teach EBM.* 2nd Edition. New York: Churchill Livingstone, 2000.

[Schattner and Fletcher, 2003] A. Schattner and R.H. Fletcher. Research Evidence and the Individual Patient, *Quarterly Journal of Medicine* 96: 1-5, 2003.

[Straus and McAlister, 2000] S.E. Straus, F.A. McAlister. Evidence-Based Medicine: A Commentary on Common Criticisms, *Canadian Medical Association Journal* 163:837-841, 2000.

[Straus et al., 2005] S.E. Straus, W.S. Richardson, P. Glasziou, and R.B. Haynes. *Evidence-based Medicine: How to Practice and Teach EBM.* Toronto: Elsevier, 2005.

[Solomon, 2007] M. Solomon. The Social Epistemology of NIH Consensus Conferences, in Kincaid and McKitrick (eds.), *Establishing Medical Reality: Essays in the Metaphysics and Epistemology of Biomedical Science.* Dordrecht: Springer, pp.167-178, 2007.

[Tanenbaum, 1996] S. Tanenbaum. 'Medical Effectiveness' in Canadian and U.S. Health Policy: the Comparative Politics of Inferential Ambiguity, *Health Services Research* 31: 517-532, 1996.

[Tanenbaum, 1993] S. Tanenbaum. What Physicians Know, *NEJM* 329: 1268-1271, 1993.

[Thomas, 1994] L. Thomas. Medical Lessons from History, in Kornblum and Smith (eds.), *The Healing Experience: Readings on the Social Context of Health Care.* Englewood Cliffs, NJ: Prentice Hall, pp. 1-10, 1994

[Tonelli, 1998] M. Tonelli. The Philosophical Limits of Evidence-Based Medicine, *Academic Medicine* 73: 1234-1240, 1998.

[Upshur, 2003] R. Upshur. Are all Evidence-Based Practices Slike? Problems in the Ranking of Evidence, *CMAJ* 169: 672-3, 2003.

[Upshur, 2002] R. Upshur. If Not Evidence, Then What? Or Does Medicine Really Need a Base? *Journal of Evaluation in Clinical Practice* 8: 113-119, 2002.

[Upshur et al., 2001] R.E.G. Upshur, E.G. VanDenKerkof, and V. Goel. Meaning and Measurement: A new model of evidence in health care, *Journal of Evaluation in Clinical Practice* 7: 91-96, 2001.

[Urbach, 1993] P. Urbach. The Role of Randomization and Control in Clinical Trials, *Statistics in Medicine* 12: 1421-31, 1993.

[Van Spall et al., 2007] J.G.C. Van Spall, A. Toren, A. Kiss, and R. A. Fowler. Eligibility Criteria of Randomized Controlled Trials Published in High-Impact General Medical Journals: A Systematic Sampling Review, *JAMA* 297: 1233-40, 2007.

[Worrall, 2002] J. Worrall. What evidence in evidence-based medicine? *Philosophy of Science,* 69: S316-30, 2002.

[Worrall, 2007a] J. Worrall. Evidence in Medicine and Evidence-based Medicine, *Philosophy Compass* 2: 981-1022, 2007.

[Worrall, 2007b] J. Worrall. Why There's No Cause to Randomize, *British Journal for the Philosophy of Science* 58: 451-488, 2007.

[Worrall, 2000] J. Worrall. Controlling Clinical Trials: Some Reactions to Peter Urbach's Views on Randomization, *LSE Centre for Philosophy of Natural and Social Science Discussion Paper Series* DP 51/00. Edited by M. Steuer. `http://www.lse.ac.uk/collections/CPNSS/pdf/DP{_}withCoverPages/DP51/DP51F-00-C.pdf`, 2000.

[Wulff et al., 1990] H.R. Wulff, S. Andur Pederson, and R. Rosenberg. *Philosophy of Medicine: an Introduction*, 2nd Ed. London: Blackwell Scientific Publications, 1990.
[Zarkovich and Upshur, 2002] E. Zarkovich. and R.E.G. Upshur. The Virtues of Evidence, *Theoretical Medicine and Bioethics* 23: 397-402, 2002.

GROUP JUDGMENT AND THE MEDICAL CONSENSUS CONFERENCE

Miriam Solomon

Since the 1970s, medical consensus conferences have become a standard means of assessment of medical technologies. Such conferences are typically two to three days long, and bring together ten to twenty medical experts with the stated intention of coming to consensus on a controversial matter. Medical consensus conferences may seem like a reasonable practice, but they are intrinsically puzzling. If the scientific matter is controversial, why push for a consensus? Why not leave things in a state of dissent, go with the majority, or aggregate opinions in some formal way? Why not return to the laboratory or the clinic and do further investigations? Even if consensus is desirable, why expect that a conference of two to three days will produce an epistemically desirable consensus rather than a hurried and perhaps biased accord? Why are consensus conferences so widely used in medicine, but hardly used at all in other areas of science and technology? This paper explores and gives an answer to these questions, beginning with a general discussion of the social epistemics of group judgment and continuing with an examination of the NIH Consensus Development Conference Program (the first and paradigmatic medical consensus conference program) and its development over time. I finish with an exploration of other consensus conferences in the USA and internationally. My conclusion is that medical consensus conferences do not, in fact, do epistemic work, in that they do not process information. Rather, they do rhetorical and political work, with varying success. Recommendations for improvement and change of the conduct of consensus conferences should take these actual achievements into account.

1 THE APPEAL OF GROUP JUDGMENT

Group judgment is familiar in some everyday settings, such as department meetings and family negotiations. It is also familiar in some scientific contexts, such as panel review of grant applications. Group judgment involves discussion of the details of the matter at hand by members of the group and an attempt to come to a decision. Consensus is usually viewed as the most desirable conclusion, and majority/minority opinions as second best but still valuable. There is some debate about the best procedures to use for reaching group judgment, specifically, how to avoid biasing phenomena such as groupthink, peer pressure and so forth. Group judgment should be distinguished from *aggregated* judgments, in which members

Handbook of the Philosophy of Science. Volume 16: Philosophy of Medicine.
Volume editor: Fred Gifford. General editors: Dov M. Gabbay, Paul Thagard and John Woods.

of a group typically do not deliberate with each other, but instead cast their votes independently. Financial markets such as the Iowa Electronic Market make such aggregated judgments.

Those who advocate group judgment see it as superior to individual judgment(s), especially if it results in consensus. This is partly because there are no formal losers but also because all considerations have been shared and considered by members of the group, which seems more thorough than the limited considerations one individual can bring to a question. Often, the desired group discussion is described as "rational deliberation" in which criticisms and responses to criticism are thought of as transparent to each reflective individual. Deliberation corrects errors, uncovers presuppositions, and sometimes transmits additional evidence. Each individual in the community is thought of as capable of recognizing their own errors and presuppositions when they are pointed out by others, and of accepting evidence discovered by others.

Philosophers from Plato to Mill to Popper to Rawls and Longino have made critical discussion and deliberation central to their social epistemologies. The claim is that rational dialogue between two or more individuals improves reasoning over what can be accomplished by individuals working alone. Longino [1990; 2002] even goes so far as to claim that objectivity is constituted by such critical discourse, provided that the discourse satisfies constraints such as tempered equality of intellectual authority, public forums for criticism, responsiveness to criticism, and some shared standards of evaluation.

Contemporary moral and political philosophers make use of group judgment more prominently than epistemologists and philosophers of science, often writing of "deliberative democracy" or "discursive democracy". Characteristically, the Kantian focus on *individual* reason has been replaced by various ideals of *group* reason. For example, in Rawls's "original position" a community of individuals rationally deliberates in order to select shared principles of justice [Rawls, 1971]. And in Habermas's "discourse ethics," participants rationally deliberate with one another from their actual social positions, attempting to reach consensus [Habermas, 1972].

Group judgment is thought of as satisfying two important constraints: *rationality* and *democracy (or fairness)*. Group deliberation, on this account, is the proper response to both intellectual controversy and political conflict. "Closure" is the desired outcome for both.

2 IMPETUS FOR MEDICAL CONSENSUS CONFERENCES

During the post World War II years, the United States increased public investment in medical research at the National Institutes of Health. In the years 1945 to 1975, the number of full time employees at NIH went up from 1000 to almost 14,000[1]. Concern was expressed in Congress that the new medical technologies

[1]In contrast, from 1975 to the present, the number of employees has only risen by 4,500. My source for this information is the NIH website http://www.nih.gov/about/almanac/staff/

developed at the NIH at taxpayer expense were not being put into appropriate use. Senator Edward Kennedy chaired the Senate Subcommittee on Health that in 1976 called for accelerating "technology transfer" between researchers and health care providers [Kalberer, 1985].

In response, the then Director of NIH, Donald Fredrickson, created the new Office of Medical Applications of Research (OMAR) in 1978. The primary responsibility of OMAR was (and still is) *to close the gap between research and practice.* The model that Fredrickson chose, interestingly, was a conflict resolution model suggested in 1967 by Arthur Kantrowitz in the journal *Science* [Kantrowitz, 1967]. With this model, Fredrickson chose to emphasize a possible epistemic reason for the gap: if researchers do not agree about the results of a new technology, then technology transfer will probably not take place. Kantrowitz's idea was to create an institution called a "science court" for situations in which collective action (such as the implementation of a particular technology) needs to be taken before a scientific issue is definitively settled. The idea is that a panel of unbiased scientists listens to the evidence from experts on both sides of a controversy and comes to an impartial, if only temporary, conclusion about the scientific issue. This, Kantrowitz thought, will keep the political issues out of the scientific arena. Kantrowitz had in mind that a "science court" would convene over controversial matters such as "Do fluorocarbons damage the ozone layer?" and "Is it safe to use Yucca mountain as a nuclear waste facility?" Kantrowitz hoped that this procedure would keep scientific issues free of political bias. A general "science court" was never implemented, but the idea was adapted by Fredrickson for the NIH Consensus Development Conference Program.

An important difference between Kantrowitz's idea and the NIH's is that Kantrowitz intended to use the consensus conference for cases when the science is not (yet) conclusive and intended the consensus to form on the most plausible option; NIH, on the other hand, has hoped for a more definitive, evidence-based conclusion. In fact, NIH CDCs are intended "to target the moment when the science is there but the practice is not" [Leshner *et al.*, 1999]. The idea is that when evidence is looked at as a whole, by a neutral group of experts, it will be possible to come to a firm conclusion about the science. Another difference is that Kantrowitz was not concerned with communication and dissemination of scientific results. However, "closing the gap between research and practice" requires effective knowledge transfer from researchers to clinicians.

So it should be noted at the outset that Kantrowitz's "science court" is not, in fact, much of a model for the "gap between research and practice" situation. Rather, it is a model for scientifically controversial research. While there may be occasions when the gap between research and practice is at least partly due to ongoing research controversies, this will not be the case in general. Frequently there is no research controversy, but still a gap between research and practice. For example, use of antibiotics to treat gastric ulcer disease took several years after the research was uncontroversial to be effectively communicated to clinicians treating

`index.htm`, accessed February 25, 2009.

the disease [Thagard, 1999, Chapter 6]. So the first notable finding in this paper is that the original model for medical consensus conferences does not, in fact, model the epistemic situation of the NIH CDC Program. So far as I know, this was not noticed or commented on at the time.

The basic design of an NIH Consensus Development Conference from the beginning in 1977 through the 1990s, summarized briefly, is as follows. The planning process, which takes about a year, consists of topic selection, question selection, chair selection and panel selection. The Planning Committee is composed of NIH staff and outside experts, including the designated panel chair. Chair and panelists are mostly experts (physicians, scientists) in scientific areas other than the one under discussion, hence considered free of "intellectual bias." Chair and panelists should also be free of financial conflicts of interest (a condition that has become more difficult to satisfy). Before the conference, the panel receives copies of important papers on the topic. Over the first two days of the consensus conference, the panel listens to the evidence presented by experts on both sides of a medical controversy. The panel then secludes itself and aims to produce a consensus statement by the third morning of the conference. In the rare cases when the evidence is deemed insufficient to come to a conclusion, they produce a "State of the Science"[2] rather than a Consensus statement. In even rarer cases the Consensus statement includes majority and minority statements. Most of the time, a univocal Consensus Statement is produced. After comments from the audience and one more round of revisions, the consensus statement is presented to the media the same day and published shortly afterwards.

The NIH CDC Program has asserted almost from the beginning that its purview is scientific, and not political, ethical or economic. It is supposed to address only questions of safety and effectiveness and not, for example, questions of cost effectiveness or distributive justice. In that way it agrees with the Science Court model. However, this means that the NIH CDC Program cannot address a number of important questions about application of a health care technology and cannot provide concrete guidelines for practice. (Other, non-NIH consensus conference programs have not limited themselves in this way, as we shall see below.)

Since 1977, NIH has held 148 Consensus Conferences, of which 26 became State-of-the-Science conferences. Representative topics are Breast Cancer Screening (1977), Intraocular Lens Implantation (1979), Drugs and Insomnia (1983), Prevention and Treatment of Kidney Stones (1988), Helicobacter Pylori in Peptic Ulcer Disease (1994), Management of Hepatitis C (1997). The number of conferences has gone down over time, see Figure 1.

3 EPISTEMIC CONCERNS ABOUT THE NIH CDC PROGRAM

The NIH CDC Program is a particular institutionalized form of group judgment, designed, through adaptation of the Kantrowitz model, to resolve scientific con-

[2]Before 1999 they were called "Technology Assessment Statements."

Figure 1. Number of Consensus Conferences from 1977 to 2007

troversy. One epistemic concern about the Program was stated above: resolution of scientific controversy is neither necessary nor sufficient to close the gap between research and practice. Another epistemic concern is that of timing: to resolve scientific controversy, consensus conferences need to take place in that window of time when the evidence is sufficient to reach a conclusion but the researchers don't yet realize it, perhaps because of delays in communication of results or reluctance to give up preferred but incorrect ideas. An NIH CDC takes about a year of planning, and during this time any scientific controversy may resolve. In fact, NIH CDCs tend to miss the intended window of epistemic opportunity: they typically take place *after* the experts reach consensus. John Ferguson, a longtime director of the Program, writes frankly, "Often the planners of any given consensus conference are aware of a likely outcome and use the conference as a mechanism to inform the health care community" [Ferguson, 1993]. This acknowledgement shows an official lack of distress about the fact that consensus conferences typically take place too late to bring about consensus. The dissemination of knowledge goal seems to suffice. A third epistemic concern is whether the particular group process devised for the NIH CDC Program in fact generates objective (or worthwhile or true) results. Some well known sources of error in group decision making are controlled for, for example, panel members are independent of commercial, governmental or professional interests. Other sources of error such as group dynamics in the panel, partial weighting of the evidence, time pressure and style of the chair are not addressed.

How can the results of the NIH CDC Program be assessed? One way might be to test the replicability of results: i.e. show through repeated and preferably simultaneous consensus conferences on the same matter that *any* panel composed of neutral experts will come to the same conclusion. No-one has attempted this interesting and expensive (in terms of both money and personnel) experiment.

Nor has anyone attempted to compare the results of NIH CDCs with "scientific truth," as though we had a God's eye point of view. In any case, what is realistic to hope for in a consensus conference is the best answer for the time, not truth for all ages. Assessment of the NIH CDC Program has, for the most part, been through reflection on the process by those who have been on panels or been close to them. So we see particular concerns about "objectivity" of panel members, fairness of chairs, time pressure and late night sessions, balanced assessment of the evidence, and so forth. The NIH CDC Program has been evaluated on a number of occasions: internal review in 1980, a University of Michigan Study in 1982, a Rand Corporation review in 1989 an IOM study in 1990, and most recently by a NIH working group in 1999 [Perry and Kalberer, 1980; Wortman *et al.*, 1982; Kanouse *et al.*, 1989; IOM, 1990a; Leshner *et al.*, 1999] Concerns have regularly been expressed about panel selection to ensure 'balance and objectivity,' speaker selection that represents the range of work on the topic, representation of patient perspectives and more careful and systematic assessment of the quality and quantity of scientific evidence. Concerns have also been expressed about the time pressure to produce a statement in less than three days, and especially the lack of time for reflection or gathering of further information. Such concerns have in fact been behind some changes over time in the NIH CDC Program, and also behind the creation of different procedures at other kinds of consensus conferences, in both the national and the international scene.

In [Solomon, 2007], I argued that if the actual goal of NIH CDCs is to "close the gap between current knowledge and practice," the *appearance* of objectivity is more important than a reality of freedom from bias. Scientific knowledge is communicated on trust, and trust is all about the *perception* of reliability. Trust, in our culture, is transmitted primarily through particular kinds of human relationships (see e.g. [Shapin, 1994]). The appearance of objectivity, the professional qualifications of the panel and the imprimatur of NIH go a long way to create epistemic trust. If this is correct, then a prior consensus by researchers is a plus rather than a disqualification for an effective consensus conference — a good outcome is assured by what the researchers say and a good dissemination is assured by what the consensus conference panel does to maintain the appearance of objectivity. This led me to the conclusion in that paper that the role of consensus conferences is rhetorical (persuasive) rather than productive of knowledge.

In this earlier paper, I went on to mention that outcome studies have shown that NIH consensus conferences have had little direct effect on medical practice at least up through 1993 [Ferguson, 1993]. So now there are even more reasons for epistemic concern: NIH consensus conferences have not succeed at either the production of consensus or at the dissemination of it.[3]

[3]The situation is different with European and Canadian consensus conferences. They are much more successful at bringing about changes in medical practice. This is probably because the health care organization in these countries, and especially the economics of health care, is more centrally organized. See further remarks below.

4 NON-NIH CONSENSUS CONFERENCES

Despite these reasons for epistemic concern, the NIH CDC Program was widely copied and adapted by professional and government groups, both national and international, from the late 1970s through the early 1990s. Indeed, the situation around 1990, as stated in an Institute of Medicine report of that year, was that "Group judgment methods are perhaps the most widely used means of assessment of medical technologies in many countries."[4]

This widespread adoption of the NIH consensus conference model is not, therefore, a result of positive outcome evaluations. I suggest that it is the result of the intrinsic appeal of its group process of judgment, and the lack of an alternative process for assessing complex evidence at that time (systematic evidence review was not invented until the 1990s). The NIH CDC Program was not, however, adopted completely unreflectively. Criticisms made of the NIH program were often addressed in the newly created consensus programs.

For example, NIH Consensus Conferences were criticized for working under time pressure and going into late night sessions, which favors the opinions of those hardy enough to function under such conditions.[5] NIH Consensus Conferences were also criticized for trying to avoid "intellectual bias" by barring from the panel anyone with published work in the area of the conference. The loss of domain expertise may be more significant than the gain in neutrality obtained by excluding scientists with published work in the area of the conference. NIH Consensus Conference panels are composed of medical professionals, and experts in fields close to the area of the conference, and the occasional community representative, but the exclusion of those with "intellectual bias" excludes those with the most knowledge of the topic. Concerns have been raised about the role of the panel chair and the need for a careful and documented group process. Concerns have also been raised about how the panel considers the available evidence, which may be extensive, complex and even contrary. Panelists do not have the time to read every relevant study, and typically they have focused on some and neglected others.

Other consensus conference programs took some of these criticisms to heart, modifying their procedures to better correspond with their conception(s) of objectivity as well as to fit with their particular needs. For example, the Institute of Medicine (established 1970) does not aim for the elimination of "intellectual bias," instead aiming for a "balance" of expertise on panels. The Medicare Coverage Advisory Committee (established in 1998, renamed in 2007 as the Medicare Evidence Development Coverage Advisory Committee or MedCAC) takes a vote,

[4]Note that the epistemic situation has changed since that time. Now (2008) the IOM would say that the techniques of "evidence-based medicine" are the most widely used means of assessment of medical technologies.

[5]This is one of the recurrent criticisms of the NIH CDC Program. See e.g. the Institute of Medicine [1990] report and the working group report chaired by Alan Leschner [1999]. Some other consensus conference programs provide much more time for consensus formation and final review. The NIH CDC Program has not been willing to give up the drama and/or satisfaction of having an immediate statement.

after discussion, from each member of the panel on each of a large number of questions and does not require the panel to debate to unanimity (which is usually what consensus means). Note that MedCAC still values part of the group process, viz. group discussion. The Canadian Task force on Preventative Health Care (established 1979) uses external peer review to evaluate the recommendations of the Task Force. Guidelines produced by the American College of Physicians Clinical Efficacy Assessment Project (begun 1981) undergo multiple levels of review: outside review, review by an education committee, review by the Board of Regents and the Board of Governors. Most of the American consensus conference programs (other than NIH, of course) provide ample time for reflection and make no public announcements at the end of the conference.indexconsensus conferne program

In Europe, and especially in Scandinavian countries, the focus of medical consensus conferences tends to be much more applied in that they encourage discussion of economic, ethical and political factors. Also, the aim is to inform the public, rather than just clinicians. Probably correspondingly, the panels have much higher representation from the public and from non-medical professionals. For example, the Danish Medical Research Council, which established consensus conferences in 1983, includes journalists, politicians and patient representatives on the panel. The Norwegian National Research Council began a consensus development program in 1989. It only takes on topics with significant ethical or social consequences [Backer, 1990, p. 120]. The Swedish consensus development program (established late 1981) took on questions about cost implications from the beginning [Jacoby, 1990, p. 12]. All the European medical consensus conference programs are modeled to a greater or lesser extent on the NIH CDC Program and preserve some of its controversial features such as requiring a neutral (rather than a balanced) panel, one and a half days of expert presentations with questions and a public statement on the third day (with overnight work by the panel if necessary). Perhaps the European programs were constructed less carefully because Europeans did not gain early experience from involvement with the NIH CDC Program. Those who have to stay up all night writing a consensus statement are more aware of the possibility of a biased outcome than those who have not had that experience. Consensus conferences on non-medical issues e.g. environmental action and international aid priorities are also popular in Europe, again especially in Scandinavian countries. The method of consensus conferences with public participation coheres with the style of participatory democracy that is politically established in these countries.

European and Canadian consensus conferences have, in general, been much more successful than United States consensus conferences at the dissemination of their conclusions. Consensus conferences tend to be organized by governmental bodies (or organizations that report directly to them) and the results of the consensus conferences are directly fed into a centralized bureaucracy for health care provision and reimbursement. Not so in the United States, where health care is more decentralized and physicians have more autonomy.

At the height of the consensus conference era — in the mid to late 1980s — there were many consensus conference programs, some public (such as the NIH

CDC Program), some professional (such as the Eastern Association for the Surgery of Trauma consensus conference), some private (such as the Blue Cross and Blue Shield Technology Evaluation Centers), some international (such as the Norwegian National Research Council Consensus Conferences). They differ in some of their goals and in some details of their procedures, but all have in common a reliance on the rationality of properly conducted "group process." The epistemic appeal is in the idea of an expert panel coming together, face to face, to sort out the issues. When the issues are economic, political or ethical as well as scientific, experts from different fields are included. And the addition of lay persons provides a check on the perspective of experts, as well as a transparency to the whole process: addressing any concerns about secrecy which would impinge on objectivity. The addition of patient representatives (sometimes in addition to, sometimes the same as, laypersons) often provides important input about patient preferences, for example patient preferences for surgery in early breast cancer.

5 MORE EPISTEMIC CONCERNS ABOUT CONSENSUS CONFERENCES

Are these other consensus conferences concerned with consensus building on controversial scientific matters, or are they, like NIH CDCs, concerned more with the dissemination of knowledge and change of practice than with the production of knowledge?

There is something epistemically odd about the use of consensus conferences in a scientific arena such as medicine (rather than in, say, diplomacy). To put it plainly, why should a bunch of eminent doctors sitting in a hotel conference room be able to resolve a controversy between medical researchers? When physicists or geologists disagree, they do not convene a consensus conference to hash things out. Nor would they find the suggestion of holding a consensus conference to be helpful. Rather, they go back to the lab or back to the field in search of additional evidence, devising experiments and observations around points of controversy.

Perhaps climate change scientists are an exception to this claim? The Nobel Peace Prize in 2007 was awarded to the Intergovernmental Panel on Climate Change (IPCC) which regularly produces consensus reports authored by hundreds of scientists. The IPCC does not construct these reports for the benefit of scientists, however. In fact, climate scientists contain their differences in order to present a united front to the public and to governments. Sometimes, for example, they assent to a statement that is *less* alarming about climate change than their own research suggests, because even this milder conclusion is sufficient as a basis for aggressive and immediate action. The report of the IPCC is not a resolution of a scientific controversy but a professional effort to communicate to non-scientists the best of scientific thinking on a topic.

If the topic is not a scientific topic but is, instead, a matter of policy, the use of a consensus conference can be appropriate. The scientific community can tolerate

— even celebrate[6] — research disagreements. Policy decisions usually require the
joint action of individuals, groups and nations. A well-negotiated consensus is
widely thought of as the ideal foundation for joint action. So those European
Consensus Conferences which consider questions of policy are more appropriately
designed to attain their goals than, for example, the NIH CDC Program. For
example, the Swedish conference on hip replacement in 1982 discussed the costs
and availability of the technology as well as the safety and efficacy [Schersten,
1990].

The NIH CDC Program is, of course, not designed for policy decisions. Not
only is its official position that it is concerned with scientific matters only, but
also its design, in which panelists are "neutral," does not bring the key players to
the table. Negotiation of a policy or plan for action will be much more successful
when representatives of all the interested parties are seen to be at the table. Then,
for example, a surgeon cannot object to a recommendation to treat ulcers with
antibiotics on the grounds that there was no surgeon at the table: conference
planners will be sure to have an eminent surgeon at the table. The European
Consensus Conferences have this in mind when they have patient representatives,
politicians, economists, scientists, ethicists and clinicians on their panels. I will
say more about this in due course.

The role that consensus conferences can play in making policy explains why
different countries hold consensus conferences on the same topics. For example,
recommendations for mammograms to screen for breast cancer may be different
in countries with different resources or different values. For instance, in the UK,
mammograms are not routinely offered to elderly women because they are not cost-
effective at that age; in the USA cost effectiveness is not valued so highly. More-
over, national barriers are significant enough that representatives from a group
in one country are often not seen as negotiating for representatives of the cor-
responding group in another country (e.g. participation of obstetricians in the
United States in a United States consensus conference on Cesarean delivery would
probably not reassure obstetricians in the Netherlands that their perspective had
been represented on the panel).

6 THE CHALLENGE OF "EVIDENCE-BASED MEDICINE"

After the early 1990s there was, generally speaking, a drop off in the number of con-
sensus conferences held, and a change in the rhetoric of the consensus conferences
that are held. Group judgment is still a pervasive feature of medical technology
evaluation, but it is framed in a different way. For example, the Canadian Task
Force on Preventative Health Care — one of the earliest consensus programs and
started in 1979 — has been completely revamped to emphasize "Evidence-Based
Prevention" which are the words with the largest font on their brochure. Group
judgment is still part of the process, which uses a "National scientific panel of

[6]In *Social Empiricism* (2001) I argue at length for pluralism in scientific research.

clinician-methodologists.[7]" The Medicare Coverage Advisory Committee, established in 1998, was renamed "Medicare Evidence Development Coverage Advisory Committee" in 2007. It still works through conducting meetings at which panelists vote, but the meetings are preceded by an evidence report.

The rise of "evidence-based medicine"[8] in the 1990s lies behind these changes. The roots of evidence-based medicine lie in the earlier work of Archibald Cochrane in the UK and its maturation in the work of Iain Chalmers of the United Kingdom, David Sackett and Gordon Guyatt in Canada. "Evidence-based medicine" is a set of formal techniques for producing and assessing multiple and complex kinds of evidence. It involves use of an evidence hierarchy, where some kinds of evidence (e.g. prospective double blind randomized trials) are viewed as qualitatively better than some other kinds of evidence (e.g. observational studies). It also involves formal techniques of combining the results from more than one clinical trial — meta-analysis — in order to aggregate evidence and produce an overall result. At first, "evidence-based medicine" was viewed with suspicion, but as the techniques became accepted it made little sense to expect panelists on a consensus conference to read and aggregate and deliberate about all the evidence in their own informal individual and group ways. There had always been concern that panelists in consensus conferences evaluate complex evidence in a biased manner, weighting more heavily those studies that are more salient or available to them.

The 1999 evaluation of the NIH CDC Program concluded that "The scientific rigor of CDCs should be improved by including systematic reviews of evidence" [Leshner et al., 1999]. Producing "evidence reports" on particular topics requires bibliographic, statistical and domain expertise. In the United States, twelve[9] "Evidence-Based Practice Centers," established in 1997 and funded by the Agency for Healthcare Research and Quality (AHRQ) provide evidence reports that are widely used, particularly by government organizations. Since 2001, the NIH CDC Program has commissioned such evidence reports, which are distributed to the panel in advance of the meeting.

If a panel gets an evidence report on the topic of the consensus conference, what is left for them to do? Why not just publish the evidence report? Consensus conferences claim to make decisions based on the evidence, yet evidence-based medicine offers to formally determine the conclusions that can be drawn from the evidence, obviating the need for the more informal processes of expert deliberation. Above, I mentioned that consensus conferences do not, in fact, tend to resolve controversy, but usually take place after the controversy is resolved among researchers. Here is a further reason for concluding that the current purpose of the NIH CDC Program is not the resolution of controversy: any controversy should be resolved by the evidence report, and if it cannot be resolved by the evidence report it should not be resolved by any other means, on pain of making the process

[7]Note the new importance of "methodologists" — people with the skills to produce systematic evidence reports. The traditional importance of "clinicians" is not given up, however.

[8]The term "evidence-based medicine" was first used in a 1992 paper by Gordon Guyatt et al.

[9]Now (2008) there are fourteen.

non-evidence based.[10]

One thing that is left for consensus conferences to do is "to close the gap between research and practice" by communicating results to clinicians and persuading them to alter their practice. This rhetorical (rather than strictly epistemic) function of consensus conferences remains. One way in which this is facilitated is that consensus statements designed for clinicians and for the public are much more readable than the statistically sophisticated evidence reports on which they are based. I'll say more about the (several) rhetorical functions of consensus conferences below.

But first, it is important to ask the question: are there any strictly epistemic — information processing — functions that consensus conferences can perform in the age of evidence-based medicine? After all, evidence-based medicine is not a complete epistemology of medicine. It does not, for example, take the place of scientific theorizing about causal relations. Evidence-based medicine produces epidemiological results about correlations rather than scientifically plausible accounts of mechanisms. This latter kind of theorizing, however, is typically done by research scientists and not by a group consensus process.

Officials at the NIH CDC Program maintain that consensus conferences do epistemic work — the work of "extrapolating" experimental studies to ordinary clinical contexts and "comparing risks and benefits."[11] For example, in recommending against universal screening for celiac disease, the Consensus Statement took into account the base rate occurrence of celiac disease in the USA population, and a comparison of risks (unnecessary surgery and unnecessary diet for those testing positive to antibodies but without organic disease) with benefits (avoidance of malabsorption syndromes and bowel lymphomas).[12] Other consensus programs consider local circumstances such as the cost of particular treatments and patterns of follow-up and referral. Some medical consensus conferences, particularly the European ones, do political work of deciding health care policy and, as I suggested above, group deliberation may be an appropriate democratic and participatory way in which to do so.

Application to local circumstances and comparison of risks and benefits are both necessary, but are they tasks that need the whole apparatus of expert consensus conferences, with in-person meetings and, sometimes (for non-NIH panels) layers of peer review checking the final statement? It seems like overkill to me, especially since the basic risk-benefit analysis can be done by more formal procedures (of course, particular patient preferences are considered when the risk-benefit analysis is applied). It is also an incongruous claim for the NIH CDC Program to make, since that program has explicitly claimed to avoid questions of costs and benefits and application to local circumstances from the beginning, restricting itself to the scientific questions only. Furthermore, the panel is not composed of domain

[10]A few consensus statements and guidelines permit "expert opinion" to fill in the blanks where evidence cannot. This would be a valid use of panel consensus, provided that the panel consists of experts or the expert opinion does not come from the (non-expert) panel.

[11]Telephone conversation, Susan Rossi (deputy director of OMAR), 9/23/02

[12]Interestingly, the comparison was made informally; perhaps formal methods would be an improvement.

experts, who would be needed for the application to local circumstances. Perhaps other consensus conference programs, which are composed of domain experts, do epistemic work here. Is it enough epistemic work to justify the whole apparatus of a consensus conference? Or, as I just suggested, can the risk-benefit calculations and applications to local circumstances be done more simply and cheaply? I suspect there are some other reasons why consensus conferences have not disappeared as evidence-based medicine has gained in influence.

We can get a hint of this if we look at the criticisms that are often made of evidence-based medicine.[13] It is frequently said that Evidence-Based Medicine is "cookbook medicine" which does not allow for tailoring to meet the conditions or the preferences of individual patients. It is also said that Evidence-Based Medicine denigrates clinical expertise and threatens the autonomy of the doctor-patient relationship. There does not have to be truth to these criticisms for them to resonate with interested parties. Medicine as a profession is still attached to nineteenth century ideals of the autonomy of individual physicians and the "art" of clinical expertise, despite studies showing that, in many domains, good algorithms and guidelines perform better than expert physicians. Physicians often regard challenges to their autonomy and clinical experience as a threat to their professional identity and integrity.

One of the functions of consensus conferences is, surely, to put some particular human faces onto formal results and, moreover, to support the importance of the individual clinician by pointing out classes of judgments that should be made on a "case by case" basis. Whether or not "case by case" judgments are a good idea (and there is evidence to suggest that they are not: physicians make more errors than they avoid when they depart from best practice algorithms[14]), it is common for consensus statements to support the need for them in explicitly defined circumstances. Hence also the frequent use of the term "guideline" rather than "algorithm," denoting something that will guide the expert rather than reduce the expert to a functionary. The "art" of the physician is thus contained but not dismissed, making the conclusions of Evidence-Based Medicine more palatable. It is a rhetorical strategy. The fact that it may be nothing more than a rhetorical strategy is best not noticed by those involved. If physicians become more comfortable with evidence-based medicine, there will be less need for the humanizing reassurance of consensus conferences.

Rhetorical strategies have epistemic importance, at least for naturalized epistemologists. Epistemic factors include both causes and reasons for belief. Norms of belief change cannot depart too far from actual processes of belief change, at the risk of global skepticism. And if we reflect on such broad epistemic considerations (i.e. not just the information processing), there is a good deal achieved by consensus conferences.

Knowledge dissemination (the goal of both the NIH and other Consensus Con-

[13]I draw on [Ashcroft, 2004; Cohen *et al*, 2004; Sackett *et al.*, 1996; Straus and McAlister, 2000].

[14]Bishop and Trout [2004] is a place to start for an extensive literature on this claim.

ferences) depends in part on a variety of rhetorical factors. The idea of an objectively achieved consensus of experts is rhetorically powerful — as was noted at the beginning of the paper — whatever the reality of the epistemics of group deliberation. The authority of the experts and the institution organizing the conference are also important. The appearance of objectivity is crucial — hence the care taken to avoid conflicts of interest and to conduct the proceedings of the conference in what is perceived as a fair manner. Different consensus conferences aim to achieve this in different ways. NIH Consensus Development Conferences, for example, forbid both financial and "intellectual" conflicts of interest — by the latter they mean an established record of answers to the questions of the conference. Other consensus conferences, such as the Institute of Medicine conferences and the Medicare Coverage Advisory Committee, aim for diversity of intellectual commitments rather than elimination of them. And, for example, some consensus conferences (e.g. NIH) aim to talk the matters through to consensus; others (e.g. MCAC, now MedCAC) take a vote and go with the majority.

Dissemination of knowledge also depends on making the knowledge intelligible to those to whom it is communicated. Sometimes that means translation into a more familiar technical genre. It is often pointed out that evidence reports are unintelligible to "the average clinician" who is not trained in the relevant statistical concepts. Consensus statements are typically much more readable to the clinician than are the evidence reports that they are based upon.

Trust of the source is a requirement for the dissemination of knowledge. Trust of the source comes more naturally when the source is human beings, especially humans in professions with high social status. Evidence reports are, currently, faceless and nameless (at least, the names are buried in the small print), associated with an organization that does evidence reports, and a profession that is not particularly trusted (statisticians) rather than a particular group of known, named and trusted medical professionals. The human touch, which consensus conferences provide with a prominent list of participants and their credentials (usually including an M.D.), facilitates trust.

Historians and sociologists of medicine have noticed other important epistemic and political features of consensus conferences. For example, Harry Marks [1997] argues that it is important to "negotiate compromises in private," because "Concessions are easier to make when they are not acknowledged as such." When panelists are selected from as many constituencies as possible, there is the most likelihood of "buy in" to the conclusions of the conference. Someone (or some constituency) left out of the panel deliberations is more likely to find fault with them. I would add that even when compromises are not necessary, wide representation on panels facilitates communication and trust of the results to as many constituencies as are represented. Negotiation is especially relevant for those consensus conferences that have a policy agenda, rather than a purely information producing agenda.

Stefan Timmermans and Marc Berg [2003] have noticed another feature of consensus conferences, which is that they often lead to standardization of medical

procedures. Timmermans and Berg see this standardization as politically important because it is an indicator of professionalization. Those professions with their own standards which they enforce are less likely to be interfered with by other organizations with their own preferences and priorities — in this case, insurance companies and other regulatory bodies. Perhaps the loss in individual physician autonomy is balanced by the overall preservation of physician authority.

7 CONCLUSION

Medical consensus conferences are not what they are named and often claimed to be. They do not resolve medical controversy and bring about consensus on scientific matters. Sometimes, especially in the European context, they make policy. Most of the time, especially in the United States, medical consensus conferences are rhetorical devices, designed (with more or less success) to close the gap between research and practice. The appearance of objectivity (whatever the reality is) and the presence of trust are essential for consensus conferences to do this work. Consensus conferences may decrease in importance if and when clinicians and the public become more trusting of the results of evidence-based medicine and, perhaps also, more suspicious of the results of group deliberation. We are a long way from that point.

ACKNOWLEDGEMENTS

Brief portions of this paper are taken from [Solomon, 2007]. I include them here so as to make a self-contained paper. I thank Fred Gifford for his comments on an earlier draft of this paper.

BIBLIOGRAPHY

[Ashcroft, 2004] R. E. Ashcroft. Current Epistemological Problems in Evidence Based Medicine, *Journal of Medical Ethics 30*, pp. 131-135, 2004.

[Backer, 1990] B. Backer. Profile of the Consensus Development Program in Norway: The Norwegian Institute for Hospital Research and the National Research Council. In Clifford Goodman and Sharon Baratz eds. *Improving Consensus Development for Health Technology Assessment: An International Perspective*, pp. 118-124. Washington DC: National Academy Press, 1990.

[Bishop and Trout, 2004] M. A. Bishop and J. D. Trout. *Epistemology and the Psychology of Human Judgment*. Oxford University Press, 2004.

[Cohen et al., 2004] A. M. Cohen, S. P. Stavri, and W. R. Hersh. A Categorization and Analysis of the Criticisms of Evidence-Based Medicine, *International Journal of Medical Informatics 73*, pp. 35-43, 2004.

[Ferguson, 1993] J. Ferguson. NIH Consensus Conferences: Dissemination and Impact, in *Annals of the New York Academy of Sciences 703*, pp. 180-198, 1993.

[Guyatt et al., 1992] G. Guyatt, J. Cairns, D. Churchill et al. [Evidence-Based Medicine Working Group]. Evidence-based medicine. A new approach to teaching the practice of medicine. *JAMA* 1992;268:2420-5, 1992.

[Habermas, 1972] J. Habermas. *Knowledge and Human Interests*. Beacon Press, 1972.

[Institute of Medicine, 1990a] Institute of Medicine. *Consensus Development at NIH: Improving the Program*. Report of a Study by a Committee of the Institute of Medicine Council on Health Care Technology. National Academy Press, 1990.

[Institute of Medicine, 1990b] Institute of Medicine, Council on Health Care Technology. *Improving Consensus Development for Health Technology Assessment: An International Perspective*. National Academy Press, 1990.

[Jacoby, 1990] I. Jacoby. Sponsorship and Role of Consensus Development Programs within National Health Care Systems. In Clifford Goodman and Sharon Baratz eds. *Improving Consensus Development for Health Technology Assessment: An International Perspective*, pp. 7-17. Washington DC: National Academy Press, 1990.

[Kalberer, 1985] J. T. Kalberer. Peer Review and the Consensus Development Process. *Science, Technology & Human Values 10:3*, pp. 63-72, 1990.

[Kanose et al., 1989] D. E. Kanouse, R. H. Brook, and J. D. Winkler. Changing Medical Practice Through Technology Assessment: An Evaluation of the National Institutes of Health Consensus Development Program. Santa Monica, CA: The Rand Corporation, 1989.

[Kantrowitz, 1967] A. Kantrowitz. Proposal for an institution for scientific judgment. *Science 156*, pp. 763-764, 1967.

[Leshner et al., 1999] A. Leshner et al. Report of the Working Group of the Advisory Committee to the Director to review the Office of Medical Applications of Research. At `http://www.nih.gov/about/director/060399a.htm` accessed 08/06/2008.

[Longino, 1990] H. Longino. *Science as Social Knowledge: Values and Objectivity in Scientific Inquiry*. Princeton, NJ: Prineton University Press, 1990.

[Longino, 2002] H. Longino. *The Fate of Knowledge*. Princeton, NJ: Princeton University Press, 2002.

[Marks, 1997] H. M. Marks. *The Progress of Experiment: Science and Therapeutic Reform in the United States, 1900-1990*. Cambridge University Press, 1997.

[Perry and Kalberer, 1980] S. Perry and J. T. Kalberer. The NIH Consensus-Development Program and the Assessment of Health-Care Technologies: The first two years. *NEJM 303:169-172*, 1980.

[Rawls, 1971] J. Rawls. *A Theory of Justice*. Cambridge, MA: Harvard University Press, 1971.

[Sackett et al., 1996] D. L. Sackett, W. M. C. Rosenberg, J. A. Muir Gray, R. B. Haynes, and W. S. Richardson. Evidence-Based Medicine: What it is and what it isn't , *British Medical Journal 312*, pp. 71-72, 1996.

[Schersten, 1990] T. Schersten. Topic and Scope of Consensus Development Conferences: Criteria and Approach for Selection of Topics and Properties for Assessment, in Clifford Goodman and Sharon Baratz eds. *Improving Consensus Development for Health Technology Assessment: An International Perspective*, pp. 18-22 Washington DC: National Academy Press, 1990.

[Shapin, 1994] S. Shapin. *A Social History of Truth: Civility and Science in Seventeenth-Century England*. Chicago, IL: University of Chicago Press, 1994.

[Solomon, 2001] M. Solomon. *Social Empiricism*. Cambridge, MA: MIT Press, 2001.

[Solomon, 2007] M. Solomon. The social epistemology of medical consensus conferences. In *Establishing Medical reality*, eds. Harold Kincaid and Jennifer McKitrick, pp 167–177. Springer, 2007.

[Straus and McAlister, 2000] S. E. Straus and F. A. McAlister. Evidence-based medicine: a commentary on common criticisms, *Canadian Medical Association Journal 163:7*, pp. 837-841, 2000.

[Thagard, 1999] P. Thagard. *How Scientists Treat Disease*. Princeton, NJ: Princeton University Press, 1999.

[Timmermans and Berg, 2003] S. Timmermans and M. Berg. *The Gold Standard: The Challenge of Evidence-Based Medicine and Standardization in Health Care*. Temple University Press, 2003.

[Wortman et al., 1982] P. M. Wortman, A. Vinokur, and L. Schrest. Evaluation of NIH Consensus Development Process. Ann Arbor: University of Michigan. Publication No. NIH-80-301, 1982.

FREQUENTIST VERSUS BAYESIAN CLINICAL TRIALS

David Teira

1 INTRODUCTION

Stuart Pocock [1983] defined clinical trials as any planned experiments, involving patients with a given medical condition, which are designed to elucidate the most appropriate treatment for future cases. The canonical example of experiments of this sort is the drug trial, which is usually divided into four phases.[1] Phase I focuses on finding the appropriate dosage in a small group of healthy subjects (20-80); thus such trials examine the toxicity and other pharmacological properties of the drug. In phase II, between 100 and 200 patients are closely monitored to verify the treatment effects. If the results are positive, a third phase, involving a substantial number of patients, begins, in which the drug is compared to the standard treatment. If the new drug constitutes an improvement over the existing therapies and the pharmaceutical authorities approve its commercial use, phase IV trials are begun, wherein adverse effects are monitored and morbidity and mortality studies are undertaken.

This paper focuses on phase III drug trials. The standard experimental design for these trials currently involves a randomised allocation of treatments to patients. Hence the acronym RCTs, standing for randomised clinical (or sometimes controlled) trials.[2] The statistical methodology for planning and interpreting the results of RCTs is grounded in the principles established by Ronald Fisher, Jerzy Neyman and Egon Pearson in the 1920s and 1930s. A hypothesis is made about the value of a given parameter (e.g., the survival rate) in a population of eligible patients taking part in the trial. The hypothesis is tested against an alternative hypothesis; this requires administering the drug and the control treatment to two groups of patients. Once the end point for the evaluation of the treatment is reached, the interpretation of the collected data determines whether or not we should accept our hypothesis about the effectiveness of the drug, assigning a certain probability to this judgment.

[1]Clinical trials can be set to analyse many different types of treatment: not only drugs, but also medical devices, surgery, alternative medicine therapies, etc. The characteristics of these types of trials are quite different; so, for the sake of simplicity, I will only deal here with drug testing.

[2]In this paper, for the sake of simplicity, 'RCTs' will refer to standard frequentist trials. Notice though that randomization may well feature in the design of a Bayesian clinical trial.

Handbook of the Philosophy of Science. Volume 16: Philosophy of Medicine.
Volume editor: Fred Gifford. General editors: Dov M. Gabbay, Paul Thagard and John Woods.

This statistical methodology is based on a specific view of probability – called the frequestist approach – according to which probabilities are (finite or infinite) relative frequencies of empirical events: here these are treatment effects in a given experimental setting. However, there are alternative interpretations of the axiomatic definition of probability and it is possible to construct clinical trials from at least one of these: Bayesianism. In the Bayesian approach, probabilities are conceived as degrees of belief. Hence, for instance, these probabilities can be calculated on the basis of whatever information is available and are not tied to a particular trial design [Berry, 2005]. Unlike in the case of standard RCTs, we can calculate these probabilities with or without randomisation and with any number of treated patients. Hence, depending on the conception of probability we adopt, clinical trials can be designed and their results interpreted in different manners, not always convergent.

The first clinical trial planned and performed following a frequentist standard was the test of an anti-tuberculosis treatment, streptomycin. It was conducted in Britain and published in 1948. Over the following decades, RCTs would be adopted as a testing standard by the international medical community and by pharmaceutical regulatory agencies all over the world. Today, RCTs constitute the mainstream approach to drug testing and, through evidence-based medicine, they even ground standards of medical care. The 1980s brought a boom in Bayesian statistics, with many practical implementations in medicine, as well as in other disciplines. As soon as the computing power required by Bayesian calculations became available, increasingly sophisticated Bayesian trials were designed and implemented. It has been argued that these trials may be more efficient and more ethical than a frequentist RCT: e.g., reaching a cogent conclusion about the efficacy of a treatment may require fewer participants, minimising the number of patients exposed to the risks of the experiment. Today, there is debate about whether regulatory agencies, and in particular the FDA, should accept evidence from Bayesian trials as proof of the safety and efficacy of a drug. If (or, rather, *when*) this happens, frequentism may lose its commanding position in the field of medical experiments. The question is whether the grounds for this change are in fact sound.

The aim of this paper is to provide an overview of the philosophical debate on frequentist versus Bayesian clinical trials. This has been an ongoing discussion over the last thirty years and it is certainly not closed. The comparison between these approaches has focused on two main dimensions: the epistemology of the statistical tools (e.g., p-values vs. prior and posterior probabilities) and the ethics of the different features in each experimental design (e.g., randomisation). As of today, the mainstream view among philosophers (certainly not among biostatisticians) is that RCTs are epistemically and ethically problematic and a Bayesian alternative would be welcome. I would like to add a third dimension of comparison, so far neglected in this debate: the advantages of each approach as a regulatory yardstick. I contend that a fair comparison between these two approaches should simultaneously consider three dimensions: epistemological, ethical and regulatory.

Philosophers and statisticians care deeply about the epistemological issues. Physicians and patients are equally concerned about the ethical issues. But we all care, as citizens, about the regulatory issues. There is a trade-off between these three different dimensions and the perfect trial that would satisfy all the concerned parties may well not exist.

Most of the conflicts created by RCTs derive from the regulatory constraints imposed on medical experimentation. In a world where clinicians and patients were free to negotiate which testing standard was more mutually suitable for their goals in research and care, it is likely that the frequentist and Bayesian trials would both flourish. Yet for the last 100 years we have lived in a regulated world in which we want state agencies to conduct trials in order to determine whether treatments are safe and effective enough to warrant authorisation of their commercial distribution. RCTs were adopted as a testing standard by many of these regulatory agencies and, despite their epistemic and ethical flaws, they seem to have done a good job in keeping harmful compounds off pharmaceutical markets. As long as we want this type of regulatory supervision, we should be willing to accept certain constraints on our testing methodologies (be these frequentist or Bayesian) whenever we conduct experiments in order to gain regulatory approval.

I will open the first part of this paper by trying to elucidate the frequentist foundations of RCTs. I will then present a number of methodological objections against the viability of these inferential principles in the conduct of actual clinical trials. In the following section, I will explore the main ethical issues in frequentist trials, namely those related to randomisation and the use of stopping rules. In the final section of the first part, I will analyse why RCTs were accepted for regulatory purposes. I contend that their main virtue, from a regulatory viewpoint, is their impartiality, which is grounded in randomisation and fixed rules for the interpretation of the experiment.

Thus the question will be whether Bayesian trials can match or exceed the achievements of frequentist RCTs in all these respects. In the second part of the paper, I will first present a quick glimpse of the introduction of Bayesianism in the field of medical experiments, followed by a summary presentation of the basic tenets of a Bayesian trial. The point here is to show that there is no such thing as "a" Bayesian trial. Bayesianism can ground many different approaches to medical experiments and we should assess their respective virtues separately. Thus I present two actual trials, planned with different goals in mind, and assess their respective epistemic, ethical and regulatory merits. In a tentative conclusion, I contend that, given the constraints imposed by our current regulatory framework, impartiality should preside over the design of clinical trials, even at the expense of many of their inferential and ethical virtues.

1.1 In what sense are RCTs grounded in frequentism?

Running a phase III clinical trial is a manifold task, which goes far beyond its statistical underpinnings. The credibility (and feasibility) of a trial is conditional

on a complete preplanning of every aspect of the experiment. This plan is formally stated in the study protocol. The following items should feature in the protocol, according again to Pocock [1983, p. 30]:

Background and general aims	Patient consent
Specific objectives	Required size of study
Patient selection criteria	Monitoring of trial progress
Treatment schedules	Forms and data handling
Methods of patient evaluation	Protocol deviations
Trial design	Plans for statistical analysis
Registration and randomisation of patients	Administrative responsibilities

The aim of a trial is to test a hypothesis about the comparative efficacy of an experimental treatment (be it with the standard alternative or a placebo). Leaving aside for a moment the statistical design of the test, first it is necessary to define which patients are eligible for the study (e.g., they should be representative of the disease under investigation); how to create an experimental group and a control group; how to administer treatment to each of them; and what the endpoints for the evaluation of their responses are. During the course of the trial, an *interim analysis* is usually performed in order to monitor the accumulating results, since reaching the number of patients specified in the design may take months or years and because the information gleaned from such an interim analysis may in fact warrant some action such as terminating the trial early. Once the trial is completed, the hypothesis about the comparative efficacy of the treatment will be either accepted or rejected and the results published. Depending on the disease and the planned sample size, this may add several years to the time taken up by the two previous trial phases. Thus the development of a new drug may well take a decade before it is approved for public use by the pharmaceutical regulatory agency.[3]

In this section, we will focus only on those aspects of the trial more directly connected to the frequentist view that have been more broadly discussed in the medical literature: namely, randomisation as a treatment allocation mechanism, on the one hand, and the use of significance testing and confidence intervals in the analysis of the results of the trial, on the other. The goal of this section will be limited to showing how these concepts are related to the frequentist interpretation of probability. It is important to clarify them in order to show the real scope of the Bayesian alternative: paradoxically, p-values and confidence intervals are often understood as if they measured some kind of posterior probability – i.e., as if they were measuring Bayesian degrees of belief for certain events rather than

[3]For an updated account of the practical arrangements involved in a trial, including compliance with the current regulatory constraints, see [Hackshaw, 2009, pp. 157-201]. The book provides a concise overview of every dimension of a clinical trial today. For a thorough overview, see [Piantadosi, 2005].

frequencies.

Let us start with randomisation. Once a patient is deemed eligible (according to the trial's protocol) and recruited, the informed consent form signed and the log sheet with her identification details filled out, the treatment is assigned at random. Depending on the arrangement of the trial (number of treatments, whether or not it is double blinded, whether or not it is multi-centre), randomisation may be implemented in different ways. The general principle is that each patient should have an equal probability of receiving each treatment. If it is convenient to control the allocation of treatments according to patient characteristics, in order to prevent imbalances, randomisation can be *stratified*. What is the statistical rationale of this procedure?

Let us informally sketch Fisher's original argument for randomisation (as reconstructed in [Basu, 1980]). In order to study the response differences between the two treatments in trial patients, we need a test statistic with a known distribution: for instance, $T = \Sigma d_i$, where d_i is the response difference. Assuming the hypothesis that there is no difference between treatments, suppose we observe a positive difference d_i between treatments in a given pair of patients who received them at random. Assuming that our hypothesis is true, this difference must have been caused by a nuisance factor. If we kept this factor (and all other factors) constant and repeated the experiment, the absolute value of $|d_i|$ would be the same with the same sign, if the treatments were identically allocated; it will be reversed if the allocation had been different. The sample space of T will be the set of 2^n vectors $R = \{(\pm d_1, \pm d_2, \ldots, \pm d_n)\}$

Randomisation warrants that all these vectors will have an equal probability. If d_i is positive for all i, we will observe another n response differences d_i' equal or bigger than d_i if and only if $d_i' = d_i$. The probability of observing this response is $(1/2)^n$, the significance level of the observed differences, as we will see below. This probability was, for Fisher, the frequency of observing this difference in an infinite series of repetitions of the experiment. And we will need it in order to calculate how exceptional the results of our experiment have been.

This statistical rationale for randomisation is usually skipped in medical textbooks, where random allocations are usually justified through the following two arguments. First, randomisation prevents selection bias: it prevents investigators from assigning (consciously or unconsciously) patients with, say, a given prognosis to any one of the treatments. For instance, an investigator might allocate the experimental treatment to the healthier patients, if she wants the trial to be positive, or to the patients with a worse prognosis, if she thinks they will benefit more. This is an argument that never fails to appear in medical textbooks and, as we will see below, it was extremely influential in the acceptance of clinical trials by the medical profession, at least in the United Kingdom and the United States. A second argument that is often cited in medical textbooks to justify randomisation can be traced back to Fisher's famous *tea tasting* experiment. In clinical trials, randomisation would allow control over unknown prognostic factors, since, over time, their effect would be distributed in balance between the two groups. Bayesians

and frequentists usually accept the first argument –we will see more about this in the second part of this paper. But, as we will see in the following section, there is more disagreement about the second argument within both approaches. However, neither of these two arguments presuppose a particular conception of probability, so we will not develop them at more length here.

Let us focus instead on the statistical interpretation of test results. The aim is to evaluate how *significant* they are under a number of probabilistic assumptions. Again, it is often the case that their statistical rationale is only partially explained in medical textbooks, giving rise to great confusion about what clinical trials actually mean. So let us revisit once more the original rationales for significance levels, because, as we will see, the medical community (as it is often the case in many social sciences) uses a combination of them.

The use of significance tests certainly predates Fisher. Leaving aside previous uses in astronomy, Karl Pearson was already using them to measure the discrepancy between a theoretical distribution of probability and a curve of empirical frequencies, using χ^2 as a test of the "goodness of fit" [Cowles and Davis, 1982]. If the probability of observing a given value of χ^2 was below 0.1, Pearson considered the goodness of fit "a little improbable". But this implied nothing about the truth or falsity of any hypothesis –being a committed positivist, Pearson viewed curves just as summaries of observations. W. S. Gosset made a more precise estimate of significance levels, arguing they should be "three times the *probable error* in the normal curve": the odds of such an observation were approximately 30 to 1, which was usually rounded to 0.5. In the 1920s Fisher restated the concept within his own statistical framework. He was a frequentist for whom any probability judgment should be theoretically verifiable to any chosen degree of approximation by sampling its reference set. However, Fisher admitted various ways to represent our uncertainty depending on the extent of our prior knowledge.[4]

Significance tests will better assess the plausibility of a given hypothesis (the *null hypothesis*) about which not much is previously known. It should allow us to specify a unique distribution function for the *statistic* that we will use to test it. But there may be many different such statistics available. With this function, we can calculate the probability of each possible value of the statistic on the assumption that the hypothesis is true. Once the experiment is run and actual data provide the observed value of the statistic, we can also calculate how likely it is, assuming the truth of the hypothesis, to obtain a result with less or equal probability than the observed one: this is the *p-value*. In other words, the p-value is the proportion of an infinite series of repetitions of an experiment, all conducted assuming the truth of the null hypothesis, that would yield data contradicting it as strongly as or more so than the observed result. Therefore, the p-value is a probability of observed and unobserved results which is tied to the design of the experiment and cannot be properly interpreted without it.

Suppose the probability of observing a result within this tail area is less than

[4]Fisher's positions is certainly simplified here. For a brief comparative discussion see [Lehmann, 1993].

0.5: if one such result occurs in the experiment, Fisher would interpret it as a serious deviation from what we would have expected, were the hypothesis true. Such a result would make the hypothesis "implausible": either an exceptionally rare chance has occurred or the hypothesis is not true. But the data alone cannot establish whether the former or the latter is the case (or whether both are).

Fisher was careful (usually, but not always) to remark that a single experiment did not provide solid enough grounds to demonstrate any natural phenomenon. Only when an experiment is repeated and delivers results that systematically deviate from the hypotheses tested can we judge the latter to be implausible. However, the truth of the hypothesis can never be established with significance testing: it is just assumed. Neyman and Pearson developed a different rationale for the testing of hypotheses: instead of assessing the plausibility of a single (null) hypothesis, we should have a criterion for choosing between alternative exclusive hypotheses, with a known probability of making the wrong choice in the long run. Errors could be of two kinds: rejecting the null hypothesis when it is true or accepting it when it is false.

Using the probability distribution of the statistic, we define a rejection region R: if the observed value of the statistic falls within R, the null hypothesis (H_0) should be rejected and the alternative hypothesis (H_1) accepted; if the observed value falls outside R, H_0 should be accepted and H_1 rejected. The probability α of making an error of the first kind (accepting H_1 when it is false) is called the *size* of the test; given the probability β of making an error of the second kind (rejecting H_1 when it is true), the *power* of the test amounts to 1-β. In order to construct the test, we should decide which hypothesis would be the null, in order to minimize the probability α of an erroneous rejection. We then choose a rejection region with the desired probability α that maximises the power of the test. Achieving this power implies a certain sample size (a given number of patients in a trial).

In the Neyman-Pearson approach, instead of measuring how implausible the observed result makes H_0 (without any actual probability value), α gives us the probability of incorrectly rejecting H_0 in a hypothetical long run of repeated experiments. Again, nothing is concluded about the truth of H_0: accepting a hypothesis implies, at most, acting as if it were true. Whereas Fisher wanted significance to ground an inductive inference (repeated experiments would make H_0 implausible), Neyman calculated probabilities (size and power) for a test, trying to minimize their epistemic import. For Neyman, we cannot know that H_0 will be incorrectly rejected in only a given number of instances: we can only *decide* to believe it.[5]

In its more widespread interpretation, the Fisherian p-value would somehow express the inductive support that a hypothesis receives from certain experimental data: given a certain observation, and assuming the hypothesis is true, it is the probability of observing it or a more extreme result.[6] The Neymanite significance

[5] In Neyman's [1957, p. 12] own words, this is "an act of will to behave in the future (perhaps until new experiments are performed) in a particular manner, conforming with the outcome of the experiment". From a Bayesian perspective, this inductive behaviour is just decision-making without loss functions.

[6] As Donald Gillies made me notice, after 1930 Fisher himself would have preferred the fiducial

level α is a deductively established probability of making type I errors in a series of experiments, before observing any particular result.

Fisher was extremely unhappy with the approach advanced by Neyman and Pearson. Leaving aside technical objections, Fisher considered Neyman's behaviouristic tests as an industrial procedure aimed at cutting experimental costs, not at solving inferential problems. However, as Gigerenzer et al. [1989] put it, their respective views were merged in a sort of "hybrid theory" that textbooks popularised over the second half of the 20^{th} century. Neyman's behaviourism was dropped and error probabilities were given an epistemic interpretation: the $p-$value became an observed α, a post trial error rate that measured the inductive evidence for a hypothesis. This is what Steve Goodman [1999a] calls the *p-value fallacy*. In a similar vein, a confidence interval is often simply understood as a range within which the true outcome measure is likely to lie, without any mention of error probabilities in the long run. As we will see in the second part of this paper, such misinterpretations would correspond more to Bayesian posterior probabilities than to the original frequentist definition.

It is an open question to what extent these sorts of misconceptions have actual consequences on the assessment of the safety and efficacy of drugs. Perhaps a better understanding of the scope of *p*-values and confidence intervals would contribute to reducing the confusion generated by so many trials with apparently mutually contradictory results.[7] However, this confusion may well have other sources, such as, for instance, the publishing practices inspired by pharmaceutical companies [Sismondo, 2009]. For the time being, I hope the previous clarification is enough to clarify in what sense RCTs are conceptually grounded in the frequentist paradigm. In the following section we will examine a number of objections concerning the possibility of implementing RCTs according to this very demanding standard.

1.2 *Methodological issues*

The controversy over the foundations of statistics between frequentists and Bayesians is too long and deep to be summarised here. Equally beyond the scope of this paper is a discussion of the technical objections addressed by each party against their respective approaches to clinical trials.[8] I will focus instead on the philosophical debate on the flaws of frequentist RCTs, presenting a number of arguments that hold independently of any conception of probability.[9] These objections, listed below, have been developed over the last thirty years, mainly by Peter Urbach and

argument by way of inductive measure: see [Gillies, 1973; Seidenfeld, 1979] for an analysis.

[7]Statistical mistakes of this sort were soon denounced in the medical literature: see, for instance, [Mainland, 1960]. For an update, see, e.g., [Sterne and Smith, 2001].

[8]The interested reader can catch a glimpse of this debate in the special issue on this topic of the journal *Statistics in Medicine* 12: 1373-1533, 1993.

[9]A connected but separate issue that I will not address here either is the scope of RCTs in causal inference, which has also received some philosophical attention: see, e.g., [Cartwright, 2007; Papineau, 1994] and also Dan Steel's paper in this volume.

John Worrall, without much response so far. The reader may now judge to what extent they are conclusive.

Objection #1: which population?

In a clinical trial there is no real random sampling of patients, since the population random samples should be drawn from remains usually undefined: there is no reference population, just criteria of patient eligibility in the trial protocol. Generalizing from the individuals entered into the study to any broader group of people seems ungrounded [Urbach, 1993].

Objection #2: significant events may not be that rare.

A positive result in a significance test is interpreted as an index that H_0 is false. Were it true, such result would be an "exceptionally rare chance". It would be exceptional because a randomised allocation of treatments would ideally exclude any alternative explanation: uncontrolled factors would be evenly distributed between groups in a series of random allocations. However, it would not be "exceptionally rare" that the treatment was effective in the case where it had been allocated to the healthier patients alone, to those with best prognoses or to any group of patients that for whatever reason could differentially benefit from the treatment.

Colin Howson, among others, has argued that randomisation as such does not guarantee that the occurrence of such unbalanced allocation *in a particular trial* is rare: it may be produced by uncontrolled factors. As Worrall [2007, pp. 1000-01] puts it, "randomisation does not free us from having to think about alternative explanations for particular trial outcomes and from assessing the plausibility of these in the light of 'background knowledge'". This further assessment cannot be formally incorporated, as it should be, into the methodology of significance testing. Hence, we cannot ground our conclusions on this methodology alone.

Objection #3: post randomisation selection.

By sheer chance, a random allocation may yield an unbalanced distribution of the two treatments, i.e., the test groups may differ substantially in their relevant prognostic factors (these are called *baseline imbalances*). This difference may bias the comparison between treatments and spoil the experiment. If one such distribution is observed, the customary solution is to randomise again seeking a more balanced allocation. However, argues Urbach [1985], the methodology of significance testing forbids any choice between random allocations: if they are adequately generated, any allocation should be as good as any other. Hypotheses should be accepted or rejected on the basis of the experiment alone, without incorporating our personal assessment of the generated data (justified though it may be).

It is usually assumed that with a high number of enrolled patients, it is very unlikely that randomisation generates unbalanced groups. Urbach argues that we cannot quantify this probability and much less discard it. At best, a clinical trial provides an estimation of the efficacy of a treatment, but there is no direct connection between this result and the balance of the two groups. The conclusions of the trial can be spoiled by the following two objections.

Objection #4: unknown nuisance variables after randomisation.

Even after randomising, uncontrolled factors may differentially influence the performance of a treatment in one of the groups. Further randomisations at each step in the administration of the treatment (e.g., which nurse should administer it today?) may avoid such interferences, but this is quite an impractical solution. Declaring such disturbances negligible, as many experimenters do, lacks any internal justification in the statistical methodology assumed [Urbach, 1985; Worrall, 2007].

Objection #5: known nuisance variables.

It has been argued that randomisation can at least solve the problem created by known perturbing factors that are difficult to control for. These could be at least randomised out. Following Levi [1982], Urbach [1985, p. 267] argues that since we know of no phenomena correlated to these confounding factors, "there is no reason to think that they would balance out more effectively between groups by using a physical randomising device rather than employing any other method".

Objection #6: RCTs do not necessarily perform better than observational studies.

Despite all these objections, it is often claimed that RCTs are more reliable than non-randomised "observational" studies such as, for instance, case-control studies, where retrospective samples of cases and controls matched for known risk factors are compared. Cohort studies or registry databases may also provide information about comparative interventions. In the 1970s and 1980s analyses of randomised and non-randomised trials of a given treatment showed that the estimated effects were higher in the latter than in the former.[10] If we assume that RCTs provide the more reliable estimation of the true effect of a treatment, we can conclude that the observational studies indeed "exaggerated" the effects. However, a recent wave of analyses concerning the quantitative bias of observational studies shows that there might not be such overestimation. In view of all these, Worrall [2007, p. 1013] concludes that there is "no solid independent reason for thinking that randomisation has automatic extra epistemic weight": if we do not commit *ex ante* to RCTs as the gold standard to provide the estimation of the effects of a treatment, the comparison is not necessarily unfavourable to observational studies.

These six objections are sound, in my view. Even if, over the last 50 years, RCTs have certainly succeeded in identifying effective and ineffective treatments, their *a priori* epistemic grounds are not as flawless as you might think if you just relied on the standard biomedical literature. There is certainly room for competing alternatives, as we will have the occasion to discuss in the second part of this paper. However, let me close this section now noting that there is quite a general agreement, even among Bayesian critics, about one argument *for* randomisation:

[10]See [Worrall, 2007, pp. 1009-1013] for a discussion.

it offers protection against selection biases. As I already mentioned, the medical profession has always appreciated this epistemic virtue of randomisation, perhaps because there has been a clear awareness of biases of this sort in the medical literature for at least a hundred years if not more. Allocating treatments at random prevents any manipulation and guarantees a fair comparison. This argument for randomisation is also independent of any particular view of probability[11] and, as we will see below, played a central role in the acceptance of RCTs as regulatory standards, as I will discuss in section 1.5 below. But let us now examine a different source of objections against frequentism in clinical trials: the ethical dilemmas it leads to.

1.3 Ethical issues

Randomised clinical trials are, obviously, experiments with human subjects. As such, they are usually conducted under external supervision according to the ethical principles approved in the Nuremberg code, the Helsinki declaration, and other national and international guidelines.[12] Trials are conducted for research purposes, and the design of the experiment often imposes constraints on the standards of care that patients may receive. Many ethical dilemmas arise therein. In this section I will only focus on the conflicts more directly related to the frequentist foundations of RCTs: namely, the ethical issues involved in randomisation (as a treatment allocation procedure) and in the stopping rules that may close a trial before it reaches the targeted sample size.[13]

There is a common stance regarding the ethics of randomisation: it is only acceptable when there is genuine uncertainty in the medical community about which one among the allocated treatment is most beneficial for a patient (in the population determined by the study's eligibility criteria).[14] This is often referred to as *clinical equipoise*. Ideally, this would be reflected in the null hypothesis adopted (no difference between treatments) and the trial should eliminate this uncertainty. It is open to discussion whether there is a sound ethical justification for random assignment rather than patient or doctor choice whenever clinical equipoise obtains, or whether this is just an *ad hoc* ethical principle to justify the random allocation of treatments required by significance testing. There has long been evidence that individual clinicians have preferences about the best treatment for their patients, in particular when the illness is serious and the risks and possible benefits are not negligible.[15] This could be interpreted as resistance to treat them as the indeter-

[11]See [Berry and Kadane, 1997] for a nice decision-theoretic argument for randomisation developed from a Bayesian perspective. See also how the impossibility of manipulation provides a very good defence for observational studies in [Vandenbroucke, 2004].

[12]However, in developing countries the regulation of clinical trials is significantly softer and this creates a clear incentive for the industry to conduct their tests there: for an overview and discussion see [Macklin, 2004].

[13]For a general overview of bioethics with particular attention to clinical trials, see [Beauchamp and Childress, 2001] and [Levine, 1998].

[14]For a critique, see, for instance, [Gifford, 1986; 1995].

[15]E.g., [Taylor *et al.*, 1984].

minate members of a statistical population, as required in the statistical design of the experiment.

But even if there were genuine equipoise, why would it be ethical to allocate treatments at random? The standard argument for justifying the participation of patients in clinical trials draws on the general normative principles usually applied in bioethics after the Belmont Report: autonomy, beneficence or non-maleficence, and justice. Autonomy is granted if the patients consent to receive their treatment at random after being properly informed about the clinical equipoise of both treatments and the research design of the trial. If the equipoise is genuine, then random allocation is consistent with the *expected* effect being as good as possible. As for justice, if there finally were a difference between treatments despite the initial equipoise, those who received the less effective one did so at random, which doesn't seem intuitively unfair. The principles of autonomy and justice bear a more direct connection to the statistical assumptions of the trial, so let us discuss them in more detail.

For all practical purposes, the autonomy of every patient in a trial is grounded in the informed consent she gives to participate in the experiment, signing a formal agreement before it starts. This is a legal requirement in many countries and, in addition, an Institutional Review Board usually oversees the process. There are different standards concerning the information that the patient should receive before giving consent, but it should certainly include the fact that the trial is for research purposes, the fact that participation is voluntary, and an explanation of the procedures to be followed. In RCTs, there is at least a paragraph about the random allocation of treatments, stated in a non-technical language.[16] However, there is qualitative evidence that patients often misunderstand these paragraphs, making their informed consent to randomisation dubious. Moreover, there is also evidence that clarifying this confusion is often difficult, if not expensive.[17]

Various surveys of the patients' motivation to take part in trials (e.g., [Edwards *et al.*, 1998]) point out that a randomised allocation of treatments is at odds with their goals: they are expecting to benefit personally from the treatment and the more information there is about the different effects of each drug, the more reluctant they are to a random assignment. It is often cited in this context how AIDS activists subverted research protocols in the early 1980s trials: among other things, they exchanged treatments after randomisation in order to increase their probabilities of receiving the experimental drug [Epstein, 1996]. They vindicated their autonomy to bear the risks of receiving untested treatments and succeeded in gaining access to the first antiretroviral drug, AZT, before any trial was completed. If patients perceive any difference in the treatments that they can benefit from, they

[16]E.g., "You will be randomised into one of the study groups described below. Randomisation means that you are put into a group by chance. It is like flipping a coin. Which group you are put in is done by a computer. Neither you nor the researcher will choose what group you will be in. You will have an EQUAL/ONE IN THREE/ETC. chance of being placed in any group" (From the informed consent template developed by the American national Cancer Institute in 1998, included as an appendix in [Hartnett, 2000]).

[17]See, e.g., [Featherstone and Donovan, 1998; Flory and Emanuel, 2004].

may well prefer to dispense with randomisation. Such differences exist: equality among treatments may refer just to the single quantified outcome measured in the trial, but the quality of life that each treatment yields may significantly differ.

The question of the benefits that a patient can expect from a trial is also relevant for the discussion of the justice of randomisation. Intuitively, patients can perceive randomisation as a fair lottery. However, lotteries are considered fair procedures when the good allocated is scarce. This was sometimes the case in clinical trials, but usually there are doses of the experimental treatment for every patient in the experiment, even if only half of them receive it. What should be distributed are the potential benefits and burdens of the test, which are a priori unknown. The fairness of such a distribution does not rely on the outcome (some may win and some may lose, none of them deserving it), but rather on the impartiality of the allocation. No patient can claim that the allocation was intended to favour one person over another.

The best formulation for the view of justice intuitively captured in the idea of a fair lottery is probably a contractarian one [Stone, 2007]. If the participants in a trial acknowledge that, all of them being equally eligible, all of them have equally strong claims to receive the potential benefits and burdens of the trial and, on the other hand, no other consideration is taken into account, then it seems plausible that they would agree to use an equiprobable lottery in order to distribute whatever comes out of the treatments. However, if we adopt a different approach to justice, the fairness of randomisation can be questioned. In a utilitarian perspective, for instance, the allocation of treatments would be fair if it maximised the social utility of the participants in the trial (or, perhaps, society as a whole). There is no a priori reason to presume that a randomised allocation would achieve this. E.g., if equipoise fails concerning the comparison of these treatments, there may be differences in the expected utility that each treatment may yield to each participant. Hence certain non-random allocations may yield a superior average expected utility superior and be ethically preferable from a purely utilitarian perspective.

To sum up, from an ethical perspective, randomisation is quite controversial, and it seems clear that if it were possible to avoid it, this would bring ethical gains. Alternative approaches to randomisation may fare better in some respects, as we will see in more detail in the second part of the paper. Yet if we want to interpret the results of the trial through significance tests, some sort of randomisation is necessary.

The second ethically contentious topic regarding frequentism in clinical trials is that concerning stopping rules.[18] It may happen that before completing the trial, a larger than expected treatment effect, either beneficial or harmful to the patients, is observed in the experimental arm. Or, alternatively, it may appear that the experimental therapy is having no effect. Hence the trial might be terminated early due to the very bleak prospect of demonstrating any effect, at the risk of

[18]See [Baum et al., 1994; Cannistra, 2004] for a general discussion. See also [Mueller et al., 2007; Goodman, 2007] for a discussion incorporating the Bayesian perspective.

not reaching the statistical power initially envisaged in the protocol, which is tied to the sample size (i.e., the number of patients treated in the trial). In order to justify this decision, certain factors should be considered. Namely, the plausibility of the observed effect, the number of patients already recruited, the number of interim analyses performed, and the monitoring method applied. If the trial takes a long time to be completed, the protocol will specify a number of *interim analyses* (e.g., according to certain clinical endpoints). At each stage, there will be a stopping rule providing a criterion for whether or not to continue the trial. The patients' interests are usually considered in the choice of the interim endpoints. As mentioned above, a common view about the ethics of trial interruption nowadays is that this should happen as soon as the evidence accumulated contradicts the initial assumption of clinical equipoise. However, if the effect of the experimental drug is, at that point, positive, should we stop the trial and use it on other patients without conducting an additional trial in full?[19]

Our views on this question will depend on the epistemic standard we adopt. We might choose the standard view in evidence-based medicine, namely that only accomplished RCTs with a given statistical power count as proper evidence of the safety and efficacy of a treatment. In this view, it is unethical to administer the experimental drug to a patient without completing a trial.[20] Cases in which patients have been injured after receiving an improperly tested drug are cited for this position: thalidomide provides a good example. In the late 1950s and early 1960s, a million West Germans consumed thalidomide (under the trade name *Contergan*) as a sedative; many more people around the world took the drug as well. Reports were soon published in medical journals showing an association between the drug and peripheral neuropathy and, later, between the drug serious birth defects when consumed by pregnant women. Only then did the manufacturer withdraw the drug from European markets, but eight thousand babies had been already born with severe deformities. At that point, there was no clear regulatory standard about the safety of a compound, neither in the United States nor in Europe. As we will see in the following section, the thalidomide scandal prompted the approval of more strict regulations, leading to the current prevalence of RCTs. However, there are cases in which lives were lost in additional trials for a treatment whose efficacy was seemingly clearly evident, but not statistically grounded in a proper RCT: e.g. the ECMO trials, as analysed by John Worrall [2008].

A recent systematic review shows that the number of trials that are being stopped early for apparent benefit is gradually increasing [Montori *et al.*, 2005]. This decision is usually not well justified in the ensuing reports: the treatment effects are often too large to be plausible, given the number of events recorded. Again, this is open to various interpretations: trials may have been stopped out of

[19]This is what Gifford [2000, p. 400] calls the RCT dilemma: if trials are stopped as soon as clinical equipoise vanishes, but before we reach their predefined statistical endpoints, there would be no point in designing the experiment in search of a certain level or significance or power.

[20]Therefore stopping rules should be calibrated depending on the trade-off between benefits for the participants in a trial and benefits for future patients in order to minimize the loss of information if the trial has to be interrupted. See [Buchanan and Muller, 2005] for a discussion.

genuine concern for the patients' welfare, but less altruistic motivations could have also played a role (e.g., pressure from the funding body or the urgency of an impact publication). Yet, this review [Montori *et al.*, 2005] depends on the evidentiary standard we adopt: if we only consider credible the evidence originating from properly powered RCTs, we should be sceptical about the results of early stopping trials. However, if we accept alternative sources of evidence, as Worrall suggests, we may accept some of the results from these trials as legitimate.

Just as it happened with randomisation, the problem is whether there is any alternative standard for judging clinical evidence which is at least as epistemically strong as RCTs, but causes less ethical trouble. Part of the strength of the Bayesian approaches we will discuss in the second part of this paper is that, in principle, they can solve these problems. On the one hand, randomisation is not strictly necessary for inference (even if it can be defended on other grounds); hence perhaps following a Bayesian approach will allow us to avoid it. On the other hand, a trial may be stopped at any point without disturbing the statistical validity of the results: the conclusions will be as strong as the evidence gathered so far.

But before we get to examine this alternative, we should first consider just what the original alternatives to RCTs were and why the latter succeeded so quickly. Relatedly, it is worth noticing here that the ethical dilemmas we have just discussed are not created by RCTs as such, but rather by our current regulatory framework, in which RCTs feature prominently as a testing standard. As I anticipated in the introduction, a fair comparison between RCTs and any alternative approach to clinical trials should take into account not only the inferential and ethical merits of each option, but also their respective soundness as a regulatory standard.

To this end, I will now present in some detail the different approaches to drug testing implemented over the 20^{th} century, considering also their regulatory impact. This will show that we demand from clinical trials not only certain inferential virtues and ethical foundations, but also certain warrants of impartiality that vary according to each social context.

1.4 Regulatory issues

From the 1950s on, RCTs have been adopted in many countries as a regulatory standard to decide whether a drug is suitable for commercial distribution: a properly conducted phase III trial would decide about its safety and efficacy. As I mentioned in the introduction, this regulatory dimension of RCTs is not usually considered in their philosophical discussion, despite the attention it receives from sociologists and historians. However, the epistemic merits of RCTs as a regulatory yardstick should be considered together with their methodological and ethical foundations, if only because these merits were certainly considered by the agencies that adopted them as their testing standard. This adoption poses an interesting philosophical problem: assuming that the civil officers at these agencies were statistical novices, what sort of arguments convinced them of the superiority of

RCTs as opposed to other testing methods? Were they justified in accepting these arguments, or did they blindly follow the advice of the statistical experts who recommended RCTs?

The standard sociological account of statistical expertise provides the following picture of how, in modern democracies, it came to replace non-mathematical forms of expert advice. [Porter, 1995] An increasing pressure for public accountability made politicians choose statistical advisors. Statistical figures were perceived as the outcome of impersonal rules and calculations that exclude bias and personal preferences. Hence weak professional groups adopted statistical methods in order to strengthen their credentials as experts. In this account, trust in numbers is somehow blind: if there is no external check, the mere appearance of impartiality makes quite a poor epistemic justification. This approach grounds nowadays the best historical accounts of the introduction of RCTs for regulatory purposes.

In this section, I will provide an overview of the regulatory uses of RCTs, discussing the main alternatives considered for drug testing in different countries. In choosing between these alternatives it seems as if the regulatory bodies were driven by an epistemic concern: they wanted their testing standard to be impartial, i.e., the result of the test should be independent of the interests of any of the concerned parties (patients, clinicians, the pharmaceutical industry, and the regulator itself). Historians and sociologists claimed that the adoption of RCTs as an impartial testing standard was blind, because their frequentist foundations were never well understood either by the medical profession or by the regulators. This claim may be true, but I contend that they understood quite well in what sense randomisation and significance testing provided insurance against testing biases, independently of their statistical underpinnings. In this respect, their adoption was clearly justified. By way of conclusion, I will briefly consider what our regulatory dilemmas are today and to what extent this impartiality request is still valid today.

Between 1900 and 1950 expert clinical judgment was the main criterion in the assessment of the properties of pharmaceutical compounds, both in Britain and the United States. An experienced clinician would administer the drug to a series of patients he considered more apt to benefit from it. His conclusions would be presented as a case report, informing of the details of each patient's reaction to the treatment. The alternatives were first laboratory experiments and then controlled clinical trials (from which RCTs would later emerge). Laboratory experiments would proceed either *in vitro* or *in vivo* (on animals and patients) and they were considered superior by clinicians with a scientific background. Yet their scope was usually restricted to safety considerations. It soon gave way to comparative trials, in which two treatments were alternated on the same patient or administered in two groups of patients (simultaneously or not). The arrangements to secure the comparability of the two treatments were the *controls,* and these adopted different forms: among the most prominent features were a clear statement of eligibility criteria to enter the trial, alternation and then randomisation in the allocation of treatments, uniformity in their administration and *blinding* (concealing the admin-

istered treatment from the patients and sometimes the doctors). These controls were not necessarily used all at once. Descriptive statistical reports from these trials conveyed their results with different degrees of sophistication. Significance testing features only occasionally in the medical literature before 1950.[21]

The regulatory authorities in Britain and the United States arranged official drug testing depending on the standards adopted by the research community within their respective medical professions. In both cases, and all throughout the 20th century, regulators were concerned about *impartiality*, here understood as independence from the financial interests of the pharmaceutical industry. Tests sponsored by manufacturers for advertising purposes were considered suspicious by consumers in both countries and this prompted, in different ways, the development of public pharmaceutical agencies to conduct or supervise the tests. However, most clinical researchers considered themselves impervious to biases from non-financial sources and impartial enough to conduct clinical tests without bias-proof mechanisms. Until the 1960s, regulatory decisions were fundamentally based on expert judgments of this sort. Expert judgment came only to be discredited in the United States because in the late 1950s a group of methodologically-minded pharmacologists imposed their views on the superiority of RCTs at the Food and Drug Administration.[22] However, as Iain Chalmers and Harry Marks have often argued, even for this enlightened minority the inferential power of RCTs and its statistical foundations were not the primary reason to adopt them: randomisation and significance testing were understood as impersonal rules for allocating treatments and interpreting trial results which warranted the impartiality of the assessment.

During the 1960s and 1970s, RCTs became mandatory for regulatory decisions in different degrees. In the United States, before the 1960s, the Food and Drug Administration was only entitled to test the safety but not the efficacy of pharmaceutical compounds. In the late 1950s there were voices in the FDA demanding stricter testing standards linking safety and efficacy, under increasing public mistrust in the pharmaceutical industry. The thalidomide scandal gave them the opportunity to project their views on the 1962 Drug efficacy amendment to the Food, Drug and Cosmetics Act. It required from the applicant "adequate and well-controlled clinical studies" for proof of efficacy and safety (although the definition of a well-controlled investigation would not be clarified until 1969, when it was formally quantified as two well-controlled clinical trials plus one previous or posterior confirmatory trial). Carpenter and Moore [2007] are correct, in my view, when they claim that this set of regulations created the modern clinical trial industry. In the following three decades, pharmaceutical funding would boost the conduct of RCTs in the United States and abroad.

In the United Kingdom, the Medical Research Council (MRC) acted as a consulting body to the Ministry of Health in pharmaceutical issues from the 1920s on. Unlike the FDA, the MRC did not supervise *ex officio* the British drug market:

[21] For excellent overviews see [Edwards, 2007; Marks, 1997; Toth, 1997].

[22] For an illustration of these points see [Marks, 2000, Carpenter and Moore, 2007].

when its Therapeutic Trials Committee started testing compounds in the 1930s, it was always at the request of the manufacturer. The MRC trials were undertaken in support of the British pharmaceutical industry, with a view to foster its international competitiveness and domestic reputation. Until the thalidomide scandal in the 1960s, the commercialisation of a drug in the UK did not formally require any sort of clinical test for either safety or efficacy. The thalidomide scandal prompted the creation of the Committee on Safety of Drugs (CSD) within the Ministry of Health, with a subcommittee in charge of clinical trials and therapeutic evidence. However, neither the Ministry of Health nor the CSD could legally prevent the commercialisation of new drugs. The industry informally agreed to get CSD approval for their trials and inform them about the toxicity of their products: it was a non-compulsory licensing system established on the basis of safety alone, not efficacy. This voluntary arrangement operated smoothly for almost a decade (1964-1971). A statutory system came to replace it as a result of the 1968 Medicines Act, which gave to the Ministry of Health the licensing authority, with a Medicines Commission acting as advisory body. The industry was now required to present evidence regarding safety and efficacy, but clinical trials were defined in the 1968 Act in a way general enough to encompass all the testing procedures mentioned above (from expert clinical judgment to statistical tests). Even if RCTs were at this point the testing standard in clinical research in Britain, the regulator did not officially adopt them as a yardstick. Provided that the regulatory body established its independence from the industry (hence, its financial impartiality), it was possible to submit evidence gathered from different sources and the decision would be made on a case by case basis.[23]

Impartiality in clinical trials is therefore the more socially desirable the bigger the public concern about biases, and this seems to depend entirely on the context in which trials take place. In Germany, for instance, the Drug Law was also revised in the aftermath of the thalidomide catastrophe. Yet this did not bring centralised control over clinical trials, which was considered costly and inefficient. Instead, it was agreed that the Federal Chamber of Physicians (BÄK) Drug Commission and the German Society for Internal Medicine issue guidelines for drug testing that the manufacturers should follow. Unlike Britain or the United States, in Germany therapeutic reformers did not form a coalition with statisticians after the II World War. Arthur Daemmrich's [2004, pp. 53-54] hypothesis is that, as a reaction against the terrible experiments conducted by the Nazi doctors during the war, the German medical profession strongly defended the necessity to treat patients individually, beyond any research protocol reducing them to standardised cases. In consequence, placebos and double blind experiments were often avoided, even if their virtues against biases were known and praised. The BÄK's reputation was based on the defence of patients' rights and not even the thalidomide scandal could shatter it throughout the 1960s and 1970s. While RCTs became more and more widely used, the 1976 Drug Law still granted the medical profession the right to

[23]On the creation and early trials of the MRC see [Cox-Maksimov, 1997]. The regulatory dimensions are discussed in [Abraham, 1995; Ceccoli, 1998].

set testing standards, even if the BÄK had been already accused of pro-industry bias and the socialist party had demanded a "neutral" examination of drugs by a central agency.

The political demands and expectations placed on clinical trials were different in all these countries. However, for regulatory purposes, the testing standard adopted was always justified on the grounds of its purported impartiality, no matter if whether was clinical expert judgment, laboratory tests, or RCTs. Historians and sociologists are probably right in explaining this regulatory concern for impartiality as the result of external public pressure. However, it is open to discussion whether the adoption of a testing standard was always epistemically blind. It may be true that the statistical foundations of RCTs were never well understood by the medical profession as a regulatory yardstick either in the United States or in Britain at the time of their adoption, or even later. However, in both cases, the medical profession, and even the public, seemed to understand quite well in what sense RCTs offered real protection against biases in the conduct and interpretation of medical experiments. RCTs provided proper impartial grounds for regulatory decisions. As I pointed out in the previous sections, randomisation certainly helps in preventing selection bias independently of its statistical grounds. Significance testing was understood less as discretionary interpretation rule than mere clinical expert judgment. On these grounds, the adoption of RCTs as a testing standard for regulatory purposes seems epistemically justified.[24]

All in all, the social process that led to the adoption of frequentist RCTs as a regulatory standard may have been interest-driven, but it was not epistemically blind. If we still adhere to the principle that regulatory clinical trials should be independent of the particular interests of the manufacturers, any alternative testing methodology should be at least as impartial as our current RCTs are. However, the situation is today far more complicated than in the 1950s.

As we saw in the previous sections, as patients we may prefer to avoid randomisation, but as consumers of pharmaceutical compounds we may want them to be fairly tested by an independent authority. For the pharmaceutical consumer, the situation is today paradoxical in this respect. On the one hand, tight regulatory standards generate *lags*: it takes more time for a new drug to reach its targeted consumers, with significant economic costs for the producer. On the other hand, consumers are, more than ever, wary of potential fraud in the testing process, if the industry is entirely free to conduct them.[25] In the United States, for-profit private contractors conduct about 75 percent of all clinical trials, in which the pharmaceutical industry invests billions of dollars annually. There is growing evidence of

[24]Of course, RCTs are not the only means to implement a fair test, but just part of a larger set of tools: see [Evans *et al.*, 2006] for an overview. The interested reader can visit the James Lind Library for a general view of the evolution of fair tests over the world: http://www.jameslindlibrary.org/ See also the Project Impact site: http://www.projectimpact.info/ [both accessed in July 2009]

[25]For an overview of the literature on the *drug lag* and related topics, see [Comanor, 1986]. [Carpenter, 2004] provides an analysis of patients' influence on FDA decisions. The risks of pharmaceutical fraud are discussed in [Krimsky, 2003].

bad testing and reporting practices biasing the results, such as: enrolling patients with a milder disease or healthier than the population who will actually receive the drug, using a dose of a comparable drug that is outside of the standard clinical range, using misleading measurement scales, etc.[26] In this context, randomisation and significance testing alone do not guarantee an unbiased clinical trial: various surveys have found significant degrees of association between private sponsorship and positive conclusions for the experimental drug in published trials.[27] Of course, these results are open to interpretation (it may simply be the case that the industry only funds and publishes trials of products that are considered better than the standard therapy), but caution about bias is advisable.

In sum, frequentist clinical trials are controversial from a methodological and ethical perspective, but have worked reasonably well so far as an impartial regulatory standard. However, there is a clear need for improvement on this front as well: we want regulatory trials to be both more impartial and more efficient (and, in particular, quicker). The *prima facie* strength of the Bayesian approach to clinical trials is that they promise improvement along these three dimensions (methodological, ethical and regulatory). Let us present how they work.

2.1 Bayesian trials: a 25 years history

Let me begin this second part of the paper with a brief summary of the development of the Bayesian approach to clinical trials during the last thirty years. I follow here Deborah Ashby's [2006] review, where she distinguishes three main periods. In the first one, ranging from 1982 to 1986, several experimental designs were launched and some were even implemented [Kadane, 1996]. But the computational power needed to implement more ambitious trials was still lacking. This became gradually available between 1987 and 1991, when the BUGS computer simulation package was created. Then came a period of consolidation (1992-1996), with a regular flow of publications on Bayesian trials and the first hints of regulatory attention to this approach. In the following ten years the variety of ideas and experiences accumulated deserved a first textbook [Spiegelhalter, Abrams and Miles, 2004]. Over the last ten years many phase I and II trials have been conducted following Bayesian principles, since these are allowed by the regulations. Phase III trials for drugs are still rare, due to regulatory restrictions, but they are already accepted by the FDA for medical devices.[28] And a Bayesian meta-analysis has been accepted as evidence in 2003 in the approval of a therapeutic compound.[29] Bayesianism has not yet reached the mainstream medical literature: according to Ashby, it will be the next frontier. But there is growing debate on whether the FDA should approve Bayesian designs for regulatory purposes, and if this occurs, this last boundary will soon be crossed, just as it happened with

[26]For a quick general overview of these practices see [Jain, 2007].

[27]E.g., [Lexchin, *et al.*, 2003; Yank *et al.*, 2007].

[28]I will not consider here the case of medical devices: see [Campbell, 2005] for a discussion.

[29]See [Berry, 2006, p. 29] for a quick review. The published source is [Hennekens *et al.*, 2004].

standard RCTs.

I will first introduce the more elementary concepts in the Bayesian approach to clinical trials, together with an attempt to classify the different methodologies in their design and analysis. The point of this section is to show that Bayesian clinical trials are constitutively diverse and can be tailored to multiple purposes, so no straightforward overall comparison with standard RCTs is possible. In order to illustrate this diversity, in the following two sections I will briefly review two different Bayesian trials. The first one, conducted during the 1980s, exemplifies how very elaborate ethical considerations can be incorporated into the design of a trial through a statistical representation of expert judgment. The second one, designed and conducted at the beginning of this decade, illustrates instead the potential efficiency of Bayesian trials and their impact on the regulatory process.

The following three sections will thus cover the basic items considered in the first part of the paper: epistemic, ethical, and regulatory issues. On these grounds I will provide a final discussion of the relative merits of each approach, frequentist and Bayesian, in the concluding section.

2.2 Bayesian approaches: a quick introduction

> The basic paradigm of Bayesian statistics is straightforward. Initial beliefs concerning a parameter of interest, which could be based on objective evidence or subjective judgment or a combination, are expressed as a prior distribution. Evidence from further data is summarized by a likelihood function for the parameter, and the normalized product of the prior and the likelihood form the posterior distribution on the basis of which conclusions should be drawn [Spiegelhalter, Freedman and Parmar, 1994, p. 360].[30]

Suppose we are interested in finding out the true mean difference (δ) between the effects of two treatments. The statistic x_m would capture the difference observed in the sample of participants in a comparative trial. The statistic x_m would here be normally distributed as expressed in the following density function:

$$p(x_m) = \phi(x_m | \delta, \sigma^2/m)$$

where m would be the number of observations of the mean response recorded so far in the trial and δ and σ^2/m would stand for the mean and variance of the distribution. This first equation provides the *likelihood function*: it shows the support lent by the trial data to the possible values of the mean difference between treatments.

Our initial beliefs about the true mean difference (δ), excluding all evidence from the trial, could be expressed thus by this density function:

$$p_0(\delta) = \phi(\delta | \delta_0, \sigma^2/n_0)$$

[30]In this section, I will follow two standard introductions: [Spiegelhalter, Freedman and Parmar, 1994] and [Spiegelhalter, Abrams and Miles, 2004]. Donald Berry has produced very concise overviews of the Bayesian approach to clinical trials: e.g., [Berry, 1993 and 2006].

Bayes theorem would allow us to weight our prior by the likelihood function[31], obtaining the posterior distribution of δ:

$$p_m(\delta) \propto p(x_m | \delta) p_0(\delta)$$

$$= \phi\left(\delta \Big| \frac{n_0 \delta_0 + m x_m}{n_0 + m}, \frac{\sigma^2}{n_0 + m}\right)$$

This is the expression of our beliefs about δ after m observations. The posterior mean would provide a point estimate of the true mean difference (δ) between treatments. The posterior mean \pm 1.96 posterior standard deviations would provide a 95% credible interval estimate of δ.

By way of example, Spiegelhalter, Freedman and Parmar [1994] provide the following Bayesian analysis of a conventional RCT. This trial studied the effects of levamisole (LEV) in combination with 5-fluorouracil (5-FU) for patients with resected cancer of the colon or rectum: that is, LEV+5-FU *versus* control. The main outcome measure in this trial was the duration of patients' survival.

Two prior distributions were constructed for the analysis. The first one was a *sceptical* prior formalizing the belief that large treatment differences are not likely. For instance, we may initially believe that the mean difference δ_0 will be 0. The prior should be spread to encompass a range of treatment differences considered plausible by the experts who designed the experiment. The probability of observing a mean difference equal or superior to the minimal clinically worthwhile benefit was set to 0.05 (the type I error α of the original trial). Assuming a value for σ, we can calculate n_0 and specify the sceptical prior distribution $p_0(\delta)$. An enthusiastic prior would concordantly represent the beliefs of those "individuals who are reluctant to stop when results supporting the null hypothesis are observed". They would expect the mean difference δ_0 to be the minimal clinically worthwhile benefit. This second distribution would be spread with the same σ and n_0 than the sceptical prior.

In fig.1 we can see the sceptical (continuous line) and the enthusiast prior (intermittent line), with the probabilities of falling below, within and above the range of equivalence between treatments (dotted vertical lines) in the right hand corner.[32]

With the data from the m patients gathered in the original trial, we can calculate the observed sample difference x_m and the corresponding likelihood for LEV+5 *versus* control, as shown in fig.2. The probability that LEV+5-FU is an inferior treatment seems low (0.003), though the probability of it being superior is just moderate (0.777)

Weighting the priors with the likelihood, we obtain their posterior distributions (fig.3)

Should anyone holding the sceptical prior (continuous line) accept the efficacy of LEV+5-FU? Even if the posterior mean is now closer to the upper limit of

[31]In the usual expression of Bayes theorem, the product of the prior and the likelihood function is divided by the normalising factor $p(x_m)$.

[32]The range of equivalence is the space between the null hypothesis and the minimal clinically important difference, measured as an increase in average survival of a given number of months.

Figure 1. (from [Spiegelhalter, Freedman and Parmar, 1994])

Figure 2. (from [Spiegelhalter, Freedman and Parmar, 1994])

Figure 3. (from [Spiegelhalter, Freedman and Parmar, 1994])

the range of equivalence than the prior mean (fig.1), it is still within this range. The sceptic can reasonably refuse to accept the superiority of LEV+5-FU over the control treatment on the basis of the trial data.

Despite this straightforward illustration, *there is no such thing as a single Bayesian approach*, not only to clinical trials, but generally. But for concreteness, let us just focus here on the general approaches to clinical trials classified by Spiegelhalter, Abrams and Miles in their textbook [2004, pp. 112-13].

One classificatory criterion is the type of prior used in each approach. In the *empirical Bayes* approach, hyperparameters for the distribution of an array of studies assumed exchangeable can be estimated directly from these studies through a meta-analysis. In the *proper Bayes* approach the priors are constructed with either empirical data or subjective opinions (obtained through elicitation methods). *Objective* or *reference* prior distributions are used in the *reference Bayes* approach. These priors summarise a minimal amount of information: for instance, a uniform (e.g., flat) probability distribution over the range of interest; or the sceptical and enthusiastic priors of the previous example.

We can also differentiate these approaches according to their methods of analysis and reporting. In the *empirical Bayes* approach, a frequentist meta-analysis of several studies is reinterpreted, under certain assumptions, as an approximation of a Bayesian estimate. In the *reference Bayes* and *proper Bayes* approaches, the analysis is a direct application of Bayes's theorem. However, in the former, depending on the priors, the posterior distribution would approximate the conclusions of a frequentist likelihood analysis. Spiegelhalter, Abrams and Miles distinguish a fourth Bayesian approach to clinical trials: the *full Bayes* approach, in which decision theory is incorporated into the analysis so that judgments about treatments depend on the maximization of an expected utility function (with subjective

probabilities).

Hence, depending on the approach implemented, a Bayesian clinical trial will yield results that will diverge more or less from the conventional RCT. By way of example, we can compare the strength of a p-value for or against a given hypothesis with the corresponding *Bayes factor*. This latter is, in its simplest form, the ratio between the likelihoods of two alternative hypotheses, i.e., the probability of the data, assuming their truth:

$$\text{BF} = p(data|H_0)/p(data|H_1)$$

The p-value is precisely the probability of observing a certain range of values (observed and unobserved), assuming the truth of a hypothesis. The BF is independent of the priors on the hypothesis[33]: it just compares how probable the observed data are assuming the truth of each hypothesis. If H_0 states that there is no difference between treatments regarding a certain parameter ($\theta = 0$) and H_1 encompasses a range of alternative values of θ, the *minimum Bayes Factor* proposed by Steve Goodman takes, among these alternative values, the one that provides the "smallest amount of evidence that can be claimed for the null hypothesis (or the strongest evidence against it) on the basis of the data".

Of all possible $\theta \neq 0$ (H_1), we take the one which makes higher the probability of obtaining the observed data, assuming the truth of H_1. For this value of θ, the BF will be minimum: a small BF implies that the observed data will be much more probable under H_1 than under H_0, just as a small p-value implies that there is a small probability of obtaining data as extreme or more than the one observed if H_0 is true, which is why we should reject it.

Table 1 provides a comparison between one particular minimum BF[34] and the corresponding one-sided p-value (for a fixed sample size), for a range of values of the test statistic Z. For the conventional p-value threshold, 0.05, the BF is 0.15, meaning that the null hypothesis gets 15% as much support as the best supported alternative value of θ. As Goodman observes, this is a moderate strength of evidence against H_0. If the prior probability of H_0 is 0.75, the impact of the corresponding likelihood will yield a posterior of just 0.44. Only with a very low initial probability (0.26) will we obtain a posterior of 0.05.

This illustration just shows that, for BF of a certain form, a Bayesian analysis can be as demanding as a conventional hypotheses testing or even more so. However, as Spiegelhalter, Abrams and Miles [2004, p. 132] point out, there is no simple monotonic relationship between Bayes factors and p-values. If we choose a different form for the BF, they can diverge from the p-values. In other words,

[33]Yet, it does depend on the prior distribution within hypothesis. The BF impinges on the prior probabilities through Bayes theorem, which for the comparison between these two hypotheses takes the form:
$$\frac{p(H_0|y)}{p(H_1|y)} = \frac{p(y|H_0)}{p(y|H_1)} \times \frac{p(H_0)}{p(H_1)}$$
[34]Assuming a normal distribution and H_1 ? 0, the minimum Bayes Factor would be:
$$\text{BF}_{\min} = \exp(-z_m^2/2)$$
where z_m is the standardised test statistic for H_0. For further details see [Goodman, 1999b].

P Value (Z Score)	Minimum Bayes Factor	Decrease in Probability of the Null Hypothesis, %		Strength of Evidence
		From	To No Less Than	
0.10 (1.64)	0.26 (1/3.8)	75 50 17	44 21 5	Weak
0.05 (1.96)	0.15 (1/6.8)	75 50 26	31 13 5	Moderate
0.03 (2.17)	0.095 (1/11)	75 50 33	22 9 5	Moderate
0.01 (2.58)	0.036 (1/28)	75 50 60	10 3.5 5	Moderate to strong
0.001 (3.28)	0.005 (1/216)	75 50 92	1 0.5 5	Strong to very strong

Figure 4. (from [Goodman 1999b])

the traditional frequentist approach to clinical trials and a possible Bayesian alternative will depend on a combination of principled and practical considerations that can justify this choice in case of discrepancy. Since this justification depends entirely on the type of Bayesian approach we choose, it is better to examine a couple of well-articulated examples to see how strong the Bayesian case can be.

2.3 The veramapil vs nitroprusside trial

Our first example is a clinical trial aimed at determining the relative efficacy of two drugs, veramapil and nitroprusside, in controlling hypertension immediately after open-heart surgery. The trial was conducted over 30 months, from September 1984 to March 1987 in Baltimore, at Johns Hopkins Hospital, by a team led by E. Heitmiller and T. Blanck. The statistical advisors were led by J. Kadane at Carnegie Mellon University in Pittsburgh. Both drugs were already available, though verapamil was used for different heart conditions and counted as the experimental treatment in the comparison. A conventional RCT had already been attempted unsuccessfully at John Hopkins in the early 1980s, and in 1984 the idea arose of conducting instead a pilot Bayesian study. The trial implemented for the first time an approach developed by Kadane, N. Sedransk and T. Seidenfeld (hereafter KSS), in the early 1980s. Following the classification outlined above, the KSS approach, as implemented in the trial, would count as a *proper Bayes* approach: priors are elicited from a group of experts to be updated through Bayes theorem.

However, Kadane and his coauthors show a clear sympathy for the *full Bayes* approach: decision theory plays a certain role in the conceptual foundations of the KSS methodology (e.g. [Sedransk, 1996]), even if in this particular trial utility functions were not elicited or postulated to account for any of the choices made.

The main goal of the KSS approach is ethical: it is aimed at improving the allocation of treatments in a trial, so that patients receive a treatment that at least one expert would recommend in view of his personal characteristics. This way, they are protected against treatments that are unanimously considered inferior at the point they enter the trial. The elicited prior for the variable measuring the effect of each treatment probabilistically depends on a set of covariates (diagnostic indicators) and treatment. Depending on the values of these covariates in each patient, a computer will calculate which of the two treatments each expert would recommend for him, according to the expert's updated prior.

Whereas the implementation of the clinical equipoise principle in a frequentist RCT presupposes that the medical community has no statistical grounds to judge one treatment as superior until a significant conclusion is reached, in a Bayesian approach at least some actionable evidence can be attained earlier, depending on one's prior and the data accumulated throughout the trial. The KSS approach uses this evidence in the following manner: a patient will only receive a treatment if at least one expert judges it *admissible,* given his characteristics, at the point at which he enters the trial. From then on, the patient will never receive a treatment that the panel of experts in the trial agree to consider inferior at that point.

Sedransk [1996] provides an excellent formal analysis of the notion of *admissibility* as implemented in the KSS design. It hinges on the following basic principles (for which Sedransk provides an axiomatic statement as well)[35]:

P1: The outcome following treatment with any admissible treatment must be scientifically interpretable

P2: Admissibility must be determined based on current information including data already gathered in the course of the clinical trial

P3: A set of K experts is sufficient when the addition of any other expert (i.e., any other relevant scientific opinion) cannot change the admissibility or inadmissibility of any treatment.

For a treatment to be admissible P1 requires that its effects can be traced to clearly defined factors (excluding therefore those "alternative" therapies without clear causal mechanisms to back up the experts' opinion). P2 differentiates the KSS approach from standard RCTs since the evidence accumulated throughout the trial impinges on the definition of an admissible treatment. P3 is also crucial for the design of the study, since the trial will terminate only when the data gathered bring to an agreement the panel of experts whose priors are elicited for

[35]Sedransk actually presents eight principles, but in order to simplify the discussion I will just consider three, those that she deems the "basic premises" for the KSS designs [Sedransk, 1996, p. 109]

the study. The cogency of the results of the trial will therefore depend on the range of opinions represented in the panel. P3 establishes a sufficiency criterion to assess the diversity of this range.

Several admissibility criteria can potentially satisfy this set of principles, of which the simplest one defines an admissible therapy "as a treatment considered superior or equivalent (to the proper comparison treatment(s)) by at least one expert in the panel".[36] However, this criterion presents no particular difficulty for P1 and P2, but it will only comply with P3 if the views about each treatment in the scientific community are just a few and are fully represented in the panel. Otherwise, the admissibility criterion may not secure that patients do not receive an inferior treatment.

A variety of allocation rules based on admissibility criteria are possible within the KSS approach, sometimes departing from standard randomisation. The "statistical price" to pay for the ethical constraint imposed on allocation rules is that the likelihood function should explicitly condition on the patients' characteristics that are considered in the allocation of a treatment. As Kadane and Seidenfeld [1996] show, the likelihood function would then be of the general form:

$$f_\theta(P_j) \propto \prod_j^J f_\theta(O_j|T_j, X_j)$$

Where X_j is the vector of relevant characteristics of jth patient, T_j is the treatment assigned to the jth patient and O_j the corresponding outcome. The past evidence up to and including the jth patient is expressed by $P_j = (O_j, T_j, X_j, O_{j-1}, T_{j-1}, X_{j-1}, \ldots O_1, T_1, X_1)$. θ is a vector of the parameters that determine the probability of an outcome O_j for a patient j given characteristics X_j and treatment T_j.

This is the likelihood function that will be used in the allocation of treatments during the trial; conditioning on X_j, the set of diagnostic indicators used in the allocation of the treatment, makes explicit all the information on the outcome O_j carried by the assigned treatment. If the computer assigns treatments according to this information alone, all other sources of bias in the allocation will be excluded. Even if randomisation is acceptable in a Bayesian perspective in order to prevent selection biases, the KSS approach achieves this by virtue of its own design.[37] However, the allocation algorithm designed by Sedransk will make use of it in order to balance the independent variables.

Let us now briefly review how the KSS methodology was implemented in the veramapil vs. nitroprusside trial conducted at Johns Hopkins Hospital.[38] Five experts representing a range of medical opinions about the treated condition were identified. Once the criteria of eligibility for the trial were set, the anaesthesiologist in charge of the study independently chose the four most important variables for

[36] More formally, as Kadane puts it, "if at least one (updated) expert would consider it (in the computer) to have lower expected deviation from target than the other treatment" [Kadane, 1994, p. 223].

[37] See [Kadane and Seidenfeld, 1990] for the details of this argument and a wonderful discussion of randomisation from a Bayesian perspective.

[38] This summary draws from the papers compiled in [Kadane, 1996, pp. 129-219].

predicting a prognosis for each of the participant patients. Then the prior opinion of each expert on the outcome (the effects on arterial pressure) was elicited as a function of these covariates and the treatment administered.[39]

The elicitation method designed by Kadane and his coauthors required an hour-long telephone interview. The prior was estimated assuming that the treatment outcome depended on the four predictor variables according to a normal linear model. There were 16 possible combinations of these variables and, therefore, 16 possible patient types. For each of these, each expert's prior would allow us to estimate the effect of each treatment and therefore the expert's preference for either veramapil or nitroprusside.

Once the trial started, whenever a suitable patient was recruited, the values of each of the four predictor variables were measured and entered into a computer, which yielded the mean arterial pressure predicted by each expert for a patient with such values according to each treatment. The computer also implemented an allocation rule as follows: if all the experts predicted a higher (better) mean arterial pressure with the same treatment, this one was assigned to the patient; otherwise, the computer would assign one at random with the constraint of maximising balance among treatments regarding the predicting variables. After a treatment was administered to a patient, the lowest mean arterial pressure recorded was also entered into the computer and the experts' priors were updated. The updated priors were then used to deliver predictions for new patients entering the trial.[40]

All in all, 29 patients completed the trial, 17 in the verapamil arm and 12 receiving nitroprusside. Even if the allocation rule made more likely that certain types of patients received one of the treatments more often, no statistically appreciable effect was detected. The results can be summarised in a table showing the treatment each expert would recommended for each type of patient before and after the treatment, using for this end the priors elicited for LADEV, once updated with the data collected in the trial. This table shows "an overall trend towards preferring verapamil over nitroprusside" [Kadane and Sedransk, 1996, p. 177]. The prior and posterior distributions of each expert for the effects of each treatment in each type of patient are also presented. Kadane and Sedransk do not provide an aggregate of these opinions showing the degree of consensus attained and suggest instead

[39]E.g.: "For patients on beta blockers and calcium antagonists who have no previous history of hypertension and no wall motion abnormality, what is your median for the average deviation of mean arterial pressure from 80mmHg?" [Kadane, 1996, p. 171]. The methodology of this elicitation procedure was exposed in full in [Kadane et al., 1980].

[40]Due to a "gap in communication" between the medical team and the statistical advisors about how to measure the more beneficial outcome for patients, two different endpoints were used in the trial (each one with its own set of elicited priors): the lowest value of the mean arterial pressure and the average deviation from a target pressure, both over 30 minutes after the patient received the treatment (LADEV). An additional measure was used in the transition between these two. Also, due to a bug in the computed program, the treatments were not assigned according to the original allocation rule. However it was always a function of the patients' characteristics alone and therefore the results were not biased by this change. For a discussion of these complications see Kadane's section on "Operational History and Procedural Feasibility" [Kadane, 1996, pp. 171-176].

a more general assessment, using standard indexes in cardiology to evaluate the effects of each treatment [Heitmiller *et al.*, 1996].

Given the difficulties that hindered this particular implementation of the KSS approach, it is understandable that the trial yielded no strong conclusion. Actually, this study is not defended on the basis of the statistical strength of its results, but rather for its ethical superiority in terms of the standard of care provided to the participants. Let us then briefly examine this Bayesian methodology in the light of the ethical issues that arise in frequentist trials. It has already been mentioned that in the KSS framework it is possible to incorporate the actual beliefs of the medical community about a treatment: clinical equipoise can therefore be measured rather than merely postulated as in conventional RCTs. On the patients' side, regarding their autonomy, it is open to discussion whether there is real understanding of the informed consent form regarding the allocation procedure. The participants in the verapamil trial had to deal with the following paragraph:

> The drug to be used in your case would be chosen with a recently developed statistical technique which incorporates the opinions of experts in the field concerning which drug is best for you, based on a variety of characteristics of the disease process, such as any history of high blood pressure or abnormal heart movements, rather than on an actual consideration of your case. If these opinions lead to the conclusion that only one of the drugs is allowable for you, that drug will be used. If both are found to be allowable, the assignment will be based on the need for balance in the characteristics of participants receiving each drug. [Kadane, 1996, p. 141]

Whether patients can understand this paragraph better than the usual sentence about flipping coins is a purely empirical question. A priori, it does not seem very plausible that they do.The autonomy of the participant in KSS trials seems to be grounded more on their desires than on their beliefs. If patients expect to benefit personally from their participation in a trial, it can be argued a priori that a KSS trial gives them a better expected utility to do so under very reasonable assumptions [Emrich and Sedransk, 1996]. Notice that this does not amount to straightforward choice of treatment by the patient [Kadane and Seidenfeld, 1996, pp. 118-119], but the KSS allocation rule probably does more to meet the demand for the personal recommendation of the physician than standard randomisation.

This is also relevant to the justice of the allocation procedure. If the distribution of costs and benefits in a KSS trial admits a utilitarian justification from the patient's point of view, *a fortiori* it will be equally justifiable from a contractarian perspective: if the treatment assigned is conditional on just the set of covariates capturing the relevant diagnostic indicators, no patient can claim that the allocation was intended to favour one person over another.[41] Hence, the KSS allocation

[41] Assuming, of course, that nobody can decide at what point a patient enters a trial: the later he does, the more accumulated information he will benefit from.

rule admits a broader justification than randomisation, as far as the principle of justice is concerned.

Lastly, the admissibility rule implemented in the verapamil trial provides a very strong implementation of the principles of beneficence and non-maleficence: patients will not receive a treatment that no expert recommends, and they have a better chance of receiving one they can personally benefit from than with randomisation. This is also relevant for the discussion of the trial-stopping rules, the other ethical contentious issue raised by frequentist trials. Let me quote Kadane again:

> Whether to stop is a different kind of decision in a design of this sort than it is in a classically randomised design. In the latter, there can be agonizing decisions about whether to suspend operations when it is fairly clear which treatment is best (either overall or for a subclass of patients), but the results are not yet "significant". By contrast, in the trial suggested above, patients are protected from clearly bad treatments, so the decision of whether to continue has no ethical component. Rather, it is merely a question of whether the cost of continued data collection is repaid by the information gained. [Kadane, 1994, p. 223]

All in all, the KSS approach seems to comply better with the principles of autonomy, justice, and beneficence than do standard RCTs. However, its scope is somewhat more restricted: as Kadane [1994, p. 222] points out as well, the KSS approach will only offer protection to patients against inferior treatments if the results are gathered at a pace quick enough to update the experts' priors before new patients enter the trial. In the verapamil trial the relevant data were ready for collection from each patient an hour after the surgical procedure. "In slower, more chronic diseases, there might be little or no information to capture at this step, and consequently little or no advantage to patients (or anyone else) in using these ideas" [Kadane, 1994, p. 222]. Not much was said about the advantages of the KSS approach from a regulatory perspective, but I will discuss this further in the final conclusion.

2.4 The ASTIN trial

Our second example is ASTIN (Acute Stroke Therapy by Inhibition of Neutrophils), a phase II clinical trial conducted between 2000 and 2001 in order to test a neuroprotective therapy to stop or slow the death of brain cells in acute ischemic stroke.[42] Very few treatments are available for this condition, despite the tens of thousands of patients randomised into clinical trials over the last four decades. The ASTIN design was intended to provide a more *efficient* approach to clinical trials, improving the use of scarce patient resources and accelerating the development of promising therapeutic agents. ASTIN was described as follows:

[42]The neutrophil inhibitory factor UK-279,276.

A Bayesian sequential design with real-time efficacy data capture and continuous reassessment of the dose response allowed double-blind, randomised, adaptive allocation to 1 of 15 doses (dose range, 10 to 120 mg) or placebo and early termination for efficacy or futility. The primary end point was change from baseline to day 90 on the Scandinavian Stroke Scale (SSS), adjusted for baseline SSS. [Krams *et al.*, 2003, p. 2543]

This is an instance of so-called *adaptive designs*: in trials of this sort, the design can be periodically modified depending on the evidence about certain hypotheses provided by the accumulated data. In ASTIN both treatment allocation and stopping rules were adaptive in a sense we will discuss in detail below.

ASTIN was a multi-centre international trial, sponsored by a pharmaceutical company (Pfizer). The trial was designed by Donald Berry and Peter Mueller, from the University of Texas M.D. Anderson Cancer Center. Under the leadership of Berry, over the last decade the centre became an international reference in the conduct of Bayesian clinical trials.[43] Of the 964 trial protocols registered at M.D. Anderson between 2000 and early 2005, 178 used both a Bayesian design and a Bayesian analysis, namely for monitoring efficacy and toxicity. Some trials implemented Bayesian adaptive randomisation and dose finding techniques and, to a lesser degree, hierarchical models and predictive probabilities were also incorporated. For the last thirty years, Berry has advocated a *full Bayes* approach to clinical trials, grounding his arguments both on statistical and ethical considerations. However, Berry and his team at M.D. Anderson work under a strict regulatory system which requires approval from various internal panels and, sometimes, the FDA and other national bodies. Due to these regulatory constraints, most of trials at M.D. Anderson were phase I/II or phase II, supported by extensive simulations of their operating characteristics showing their degree of equivalence with standard frequentist trials. As Berry [2004, p. 186] puts it,

At least for the near future they will be used as tools, with justifications following a more or less traditional frequentist course. As time passes and as researchers and regulatory folk become more accustomed to Bayesian ideas, they will be increasingly accepted on their own terms.

The ASTIN trial is no exception in this respect, and its original design was described by their own authors as a "frequentist cake with Bayesian icing" [Berry *et al.*, 2002, p. 154]. This is why the efficiency of these constrained Bayesian designs is so prominently emphasised. Even if the "playing field" is not levelled, Bayesian trials can provide a more efficient solution to one of the main regulatory issues of our time: scientific innovation goes much faster than the development of new therapies and this delay is partly caused by the time constraints imposed by the current regulatory regime of RCTs.

[43]See Berry's profile in [Couzin, 2004]. For an overview of the trials conducted at M.D. Anderson, see [Biswas *et al.*, 2009].

Bayesian phase II trials such as the one we will discuss here can be more efficient in the following ways [Krams *et al.*, 2005, p. 1341]: the participant patients will be treated more effectively thanks to an adaptive allocation procedure that incorporates the available information about the more efficient dosage; their design allows a quicker and more reliable choice of the dose to be used later in the phase III trial; if the regulatory authority permits, it is possible to make a seamless (and therefore quicker) transition from the dose finding to this confirmatory phase of the trial.[44]

The aim of the ASTIN trial was to identify the *minimum dose with satisfactory effects*, defined as the ED_{95}: this dose would deliver 95% of the maximum efficacy, minimizing unacceptable adverse reactions. ASTIN sought a point estimate of ED_{95} with minimal variance. In order to achieve this goal, a standard phase II design may use between three and five doses and placebo. Each dose will be tested on an equal number of patients, usually fixed, independently of their comparative efficacy that will only be revealed at the end of the trial. The patients' reactions will provide the basis to estimate the *dose-response curve*. However, part of the observations may be wasted depending on the adjustment between the true range of efficacy of the drug and the dosage tested in the trial. The separation between the doses tested will constrain the accuracy of the ED_{95} estimate. Ideally, it would be better to test many different doses, but the number of patients that this would require to ground the power of a standard design is prohibitive.

The ASTIN trial tested 15 doses and placebo. In order to learn quickly and make the sample size as small as possible an adaptive treatment allocation rule was implemented. The rule was grounded on a formal decision model that calculated, at each point in the trial, the expected utility of choosing a given dose with a view to minimise the expected variance of the response at the ED_{95}. Once the optimal dose Z_j was chosen, the next patient could receive either placebo (with a fixed probability p_0) or a dose in the neighbourhood of Z_j (the remaining probability $1-p_0$ was split uniformly over all of them).[45]

Another adaptive feature of the ASTIN trial was an optimal stopping rule. Once a week, in view of the available data, it had to be decided whether to end the trial abandoning the drug (futility), continue with the dose-finding phase or finish it switching to a phase III trial. A stopping rule grounded on another formal decision model was initially constructed, but the trial implemented a simpler approach, based on bounds of posterior probability, that the authors summarised as follows:

> The stopping rule in ASTIN continuously asked the following questions: (1) Does our estimate of the dose–response suggest that there is <10% chance of success for any dose (success was defined as a >3-point

[44]The original design of ASTIN [Berry *et al.*, 2002] envisaged the possibility of this seamless transition between phase II and phase III, but it was not finally implemented. Inoue *et al.*, 2002 provide another sequential design for a seamless phase II/III trial.

[45]This fixed lower bound p_0 for placebo granted that there would be a group of patients (at least 15% of the total) providing a "comparison benchmark" in the study, as expected by the regulator: see [Walton, 1995, p. 352].

recovery over and above placebo as measured by a stroke scale)? If so, then stop for futility. (2) For the best dose, is the response good enough to conclude that there is >90% chance of success? If so, then stop for efficacy and switch to a confirmatory trial, comparing the "best dose" against placebo. [Krams *et al.*, 2005, p. 1343]

The effects of this sort of therapy are measured around 90 days after the stroke, assessing the patient's neurological deficit with a standardised scale. In order to update the dose allocation system before this three-month deadline, a predictive longitudinal model was built to estimate the score for eligible patients in the Scandinavian Stroke Scale (SSS). Once measured, the true day 90 score replaced the estimate. The model was built on the evidence gathered in the Copenhagen Stroke Database[46] and was updated with the periodical responses obtained from patients in ASTIN .

Finally, in ASTIN the probability model for the dose-response curve was a normal dynamic linear model.[47] In the initial week of the trial, the prior estimate was flat, with a placebo effect of 10 points change from the SSS baseline (calculated from the Copenhagen Database). Such prior would not influence much the final results of the analysis and therefore its validity was never a concern for the regulators, who could rely entirely upon the study data [Walton *et al.*, 2005, p. 352]. Updating this model with the study data yielded posterior estimates and 95% posterior credible intervals of the dose-response curve, ED_{95} and the effect over placebo at the ED_{95}.

The successful conduct of this trial depended on a computer system that recorded and processed the information entered by the investigators, ran the software implementing all the statistical models, delivered the dose for each patient to the investigators, and assessed the stopping rules, helping to monitor the progress of the study [Berry *et al.*, 2002, pp. 127-134]. In the actual trial, the computer system was run by a private company independently of the sponsor.

The trial process could therefore be charted as follows[48]:

[1] A patient enters the trial. Baseline data are entered into the system;

[2] Patient is randomised in blinded fashion to placebo or "optimal" dose to learn about research question;

[3] Dose assigned is converted to particular vial numbers, allowing for blinded administration of study drug;

[4] Patient's response data are entered into the system as they progress through the study;

[46]A compilation of data gathered over two years in a Copenhagen facility from 1351 pharmacologically untreated stroke patients.
[47]See [Berry *et al.*, 2002] for details.
[48]I quote from [Krams *et al.*, 2005, p. 1343].

[5] Patient's final outcome is predicted using a longitudinal model (the prediction is substituted by the final response, as soon as it becomes available)

[6] Based on the currently available data, the system updates the "estimate" of the dose response curve and its uncertainty;

[7] Each day the algorithm implements a decision rule and recommends to either:

[8] A0: stop the study because of futility (based on the posterior probability that the treatment has an effect smaller than a minimum clinically relevant size) or

[9] A2: stop dose finding and moves to a large confirmatory study (based on the posterior probability that the treatment has an effect larger than some clinically relevant size);

[10] A1: continue dose finding study (the recommendation of the system is reviewed by the IDMC, which incorporates clinical judgment and factors in safety issues);

[11] The dose allocator chooses a dose from a list of possible doses that will optimise learning about the ED_{95} or some aspect of the dose-response curve. The database used to determine the dose is continually updated as outcome data from patients are gathered.

Before the trial was started ASTIN was simulated under a wide range of assumptions in order to convince both the sponsors and the regulatory authorities of its soundness [Berry et al., 2002, pp. 135-154]. Simulations provided both optimal parameters for the algorithm and the operating characteristics of the design, allowing a comparison with a standard RCT. The following table compares, for instance, the sample size required in each [Grieve and Krams, 2005, p. 345]

Benefit over placebo	Power of traditional design		Adaptive design (max. 1000 pts)	
	80%	90%	% Stopped for efficacy	Median number of patients
0	—	—	0.02	501
2	2432	3220	0.56	644
3	1080	432	0.90	416
4	608	808	0.95	280

Figure 5.

For a dose-response curve that reached a plateau at 2, 3 or 4 points benefit over placebo, on the left side there is the number of patients needed for a 80% and

90% power. On the right side, for an adaptive design with a maximum of 1000 patients, you can see the percentage of trials that would stop for the same benefit over placebo and the median number of patients required in each. The trial was designed to detect a 3 point benefit over placebo.[49]

In the actual trial, 966 patients were randomised, 26% of them to placebo. 40% of the patients were allocated to the top three doses. Quoting from the published results, "UK-279,276 did not produce any statistically significant effect on any of the efficacy variables at any dose or dose category for any of the analysed populations" [Krams *et al.*, 2003, p. 2545]. After 48 weeks, the Independent Data Monitoring Committee that oversaw the trial decided that it could be stopped for futility and no more patients were admitted. The algorithm allowed a conclusion of futility at week 40, so the number of patients recruited might have been smaller. However, the trial protocol required at least 500 assessable patients before stopping. Those already in the trial were monitored for 13 additional weeks without a positive-dose response.

A less conservative protocol could have stopped the trial much earlier: apparently, similar conclusions could have been reached with half of the recruited patients [Walton *et al.*, 2005, p. 356]. However, with sequential stopping rules, a frequentist design could have been effective with fewer patients than those estimated in table 2. As William du Mouchel observed, the inflexibility of standard RCTs is more a consequence of the regulatory framework than of the frequentist approach itself [Walton *et al.*, 2005, p. 354]. The panel discussion of the ASTIN trial organized in 2005 in a FDA-sponsored symposium revealed a general appreciation of the simplicity of implementing, e.g., the stopping rule in a Bayesian approach. Yet it remains an open question to what extent it is necessary to become a fully committed Bayesian in order to benefit from the ASTIN techniques. I will return to this point in the final discussion.

Finally, notice that, from an ethical perspective, the ASTIN trial is at least as defensible as a standard frequentist trial, and perhaps more so. Going again through the principles we examined in the KSS trial, the autonomy of the patient is certainly respected. When adaptive randomisation schemes are implemented in a M.D. Anderson trial, the informed consent form incorporates clauses along these lines:

> If you are ... eligible to take part in the study, you will be randomly assigned (as in the toss of a coin) to one of two treatment groups. Participants in one group will receive [regimen 1]. Participants in the other group will receive [regimen 2]. At first, there will be an equal chance of being assigned to either group. As the study goes along, however, the chance of being assigned to the treatment that worked better so far will increase. [Biswal *et al.*, 2009, p. 214]

[49]For a more extensive comparative discussion of sample sizes in both approaches, see the contribution of Land and Wieand in [Berry *et al.*, 2002, pp. 169-174] and the rejoinder in pp. 176-180.

Again, this seems no more difficult to understand than standard randomisation techniques in a conventional RCT, and plausibly the patients will be happy that their chances of being assigned to the better treatment are gradually increased. Beneficence and non-maleficence are equally well observed. From the point of view of justice, the stopping rule originally designed for the trial is particularly interesting. This rule allowed maximisation of the value of each stroke patient entering the trial in order to optimise treatment for the overall population and the individual patients [Berry *et al.*, 2002, pp. 119-124]. From a utilitarian perspective, the sacrifices of the trial participants will be minimised and justified by the welfare the tested treatment would bring to this bigger collective [Krams *et al.*, 2005, p. 1343].[50] However, the contractarian argument to justify the distribution of costs and benefits among trial participants would also apply here.

3 CONCLUDING DISCUSSION: FREQUENTIST VS BAYESIAN TRIALS

The examples discussed in the previous section show that, on the one hand, we have highly standardised frequentist RCTs, the design of which evolved under increasing regulatory pressure over the last 50 years. On the other hand, we have a plurality of Bayesian approaches to clinical trials: depending on which principles we want to implement, there is a wide range of designs available and more will certainly come in the future. What would a fair comparison under these circumstances be? Let us examine this question considering the three dimensions discussed in this paper: epistemological, ethical, and regulatory.

Starting with the first one, we saw that p—values and confidence intervals are often misinterpreted in the medical literature as if they provided direct probabilities for particular events in clinical trials (§1.1). If this is not just a misunderstanding, but rather the expression of the sort of probability assignment the medical profession is interested in, this is an argument for the Bayesian approach, in which these probabilities can be correctly calculated. The objections against randomisation we examined in section 1.2 do not apply, in principle, to its use in Bayesian trials, since it does not provide any inferential grounds: randomisation can be defended in a Bayesian perspective as a device against allocation biases [Berry and Kadane, 1997]. Even in this respect, there are alternatives to randomisation in a Bayesian approach, like conditioning on the allocation mechanism (and implementing it in a computer in order to assign treatments): the KSS approach provided a nice illustration of this possibility. We saw in section 1.4 that RCTs were mainly adopted in Britain and the United States for the warrant they provided against biases. Bayesian trials can provide such warrants, using randomisation if necessary.

Hence, in principle, Bayesianism is a suitable alternative for the potential epistemic demands of the medical profession. From a pure research perspective, any kind of Bayesian trial provides an excellent tool to conduct experiments to learn

[50]From this perspective, it is really worth considering the procedure to calculate sample sizes developed in [Inoue *et al.*, 2005].

about therapies, and in non-regulatory contexts their use is growing fast [Biswas *et al.*, 2009]. The thorny question is what kind of Bayesian approach should be preferred for the design and analysis of clinical trials in a regulatory context, where experiments should prove the efficacy and safety of a compound. It is at present dubious whether there is a purely epistemic response to this issue.

As I briefly mentioned in the discussion of the ASTIN trial, from a purely pragmatic perspective it may seem possible to use the more suitable technique for the goals of each trial, be it frequentist or Bayesian, without paying much attention to coherence (e.g. [Walton *et al.*, 2005, p. 354]). However, the main epistemic argument for Bayesianism is that it makes it possible to carry out the entire design and analysis of a trial within a coherent framework (e.g., [Walton *et al.*, 2005, p. 356]). In this respect, the apex of coherence would be provided by a *full Bayes* approach, in which every decision to be made in a trial could be explicitly formalised. This may not be very attractive for many practitioners: as it was observed in the discussion of the ASTIN design, the utility functions that feature in decision models are often simplistic in order to facilitate computations [Berry *et al.*, 2002, p. 167]. Yet, as Berry often notes, the decisions will be made anyway and the formalisation contributes to clarify our choices and make them more transparent to every stakeholder in the trial. The verapamil and the ASTIN trials are both supported by expected utility calculations that are certainly relevant from the patient's perspective.

The open question here is whether it is possible to incorporate in a unified decision model all the interests at stake. John Whitehead [1993, p. 1410] presented this problem as follows. Three different goals are usually pursued in phase III clinical trials: regulatory agencies (acting on behalf of patients and consumers) want to keep out of the market ineffective and harmful compounds; pharmaceutical companies want to introduce into the market effective and safe compounds; finally, clinicians are interested in acquiring information on the relative characteristics of the experimental and control treatments. This is certainly a simplification, since all parties are interested in all aspects of the trial, but, it shows nonetheless that there is no single decision maker in clinical trials. But from a Bayesian perspective, this multiplicity of agents is difficult to encompass in a unified model.[51] There may be limits to the implementation of a full Bayes approach in a regulatory context.

As Whitehead points out, in standard RCTs all these interests are somehow represented in the different elements of the analysis: small $p-$values express the concerns of the regulator; high-powered trials give a better chance of showing the efficacy of a compound and thus are in the producer's interest; and the estimates of the comparative difference between treatments will serve the clinician's interests. Of course, as we saw, it is easy to approximate all these aspects of standard RCTs from a Bayesian perspective, even without a full-fledged decision model. But, again, there are too many ways of approximating these characteristics in a

[51]This is too technical an issue to discuss here, but it is certainly not neglected by the authors we are considering here: see, for instance, the compilation of essays in [Kadane, Schervish and Seidenfeld, 1999].

Bayesian trial. In the current epistemology of science, this is more a virtue than an obstacle: as the methodological debate on evidence-based medicine illustrates (e.g., [Worrall, 2007]), scientific data serve different practical purposes and it is good to have different approaches to assess them (e.g., [Cartwright, 2006]). However, in a regulatory context, this plurality of standards may complicate the final decision: whether to authorise or not the commercial distribution of a drug. As Robert Temple, an FDA officer put it in an informal debate on the incorporation of Bayesian approaches to regulatory decisions:

> Of course, everybody knows that "$p < 0.05$" is sort of stupid. Why should it always be the same? Why shouldn't it be adjusted to the situation, to the risks of being wrong in each direction? The alternative to adopting a standard is to actually determine a criterion for success on the spot for each new case. That is my idea of a nightmare. So, we use a foolish, if you like, simplification. Maybe we adjust it sometimes when we feel we have to but you simplify the process a little bit so you can get done. I don't want to have to have a symposium for every new trial to decide on an acceptable level of evidence. [Berry *et al.*, 2005, p. 303]

The FDA has been revising their views on acceptable evidence for regulatory purposes over the last decade. Two landmarks in this process are the so-called *Evidence Document* and the *Critical Path Initiative* report[52]: both texts acknowledge that quicker phase III trials drawing on broader data sources are necessary in order to accelerate the approval of new drugs. The current regulatory process is costly for pharmaceutical companies and deprives patients of access to potentially life-saving drugs for years. Complaints about this *drug lag* date back to the late 1960s and early 1970s, when the FDA enforced the current regulatory regime requiring two trials. However, nowadays the Bayesian approach provides a viable alternative to RCTs in order to meet this demand for faster trials and it has been defended precisely along these lines: patients want quick access to a better standard of care from the early testing stages just as much as the industry wants faster trials.

In my view, an argument about the way Bayesian trials can help to protect the consumer from incorrect regulatory decisions is still lacking. In particular, it is still undecided which is the best design to cope, within a Bayesian framework, with the growing financial pressure exerted by pharmaceutical companies in the conduct of for-profit clinical trials. The KSS admissibility criteria illustrate the sort of practical issues involved in this process. If an expert decides to recommend a treatment independently of the accruing data, patients will not be protected from inferior treatments; thus it is necessary to incorporate a (fourth) admissi-

[52]Food and Drug Administration, *Innovation or stagnation? Challenge and opportunity on the critical path to new medical products* (2004) and *Providing clinical evidence of effectiveness for human drug and biological products. Guidance for industry* (1998), both available at http://www.fda.gov (accessed in July 2009).

bility principle in order to prevent such situations.[53] *Mutatis mutandis*, a similar principle should be applied to the selection of priors in a trial conducted for regulatory purposes, so that pharmaceutical companies do not make abusive use of exaggeratedly optimistic priors. That is, this should occur unless, as happened in the ASTIN trial, we use priors with minimal information in order not to influence the trial data, thus diminishing the potential to exploit the information available before the trial.

I think Steven Goodman is right in pointing out the necessity of a middle ground between the potential flexibility of Bayesian approaches and the necessity of standardised Bayesian procedures that secure good (and quick) regulatory decisions [Berry, 2005, p. 304]. Once these procedures are agreed, their ethical superiority to standard RCTs may not be as outstanding as it currently appears in the examples discussed in the previous section, but this should not be the crucial consideration in our choice of a design for regulatory purposes. Even if it is an imperative to conduct clinical trials with the highest ethical standards, in the current regulatory regime most of them are conducted for the sake of consumer protection. In my view, this latter goal should prevail, as long as our societies deem it necessary to have regulatory agencies overseeing pharmaceutical markets.

BIBLIOGRAPHY

[Abraham, 1995] J. Abraham. *Science, Politics and the Pharmaceutical Industry*. N. York: St. Martin's Press, 1995.
[Ashby, 2006] D. Ashby. Bayesian Statistics in Medicine: A 25 Year Review, *Statistics in Medicine* 25: 3589–3631, 2006.
[Basu, 1980] D. Basu. Randomization Analysis of Experimental Data: The Fisher Randomization Test, *Journal of the American Statistical Association* 75: 585-581, 1980.
[Baum et al., 1994] M. Baum, J. Houghton and K. Abrams. Early Stopping Rules–Clinical Perspectives and Ethical Considerations, *Statistics in Medicine* 13: 1459-1472, 1994.
[Beauchamp and Childress, 2001] T. L. Beauchamp and J. F. Childress. *Principles of Biomedical Ethics*. New York: Oxford University Press, 2001.
[Berry, 1993] D. Berry. A Case for Bayesianism in Clinical Trials (with Discussion), *Statistics in Medicine* 12: 1377-1404, 1993.
[Berry, 2004] D. Berry. Bayesian Statistics and the Efficiency and Ethics of Clinical Trials, *Statistical Science* 19: 175-187, 2004.
[Berry, 2005] D. Berry. Clinical Trials: Is the Bayesian Approach Ready for Prime Time? Yes!, *Stroke* 36: 1621-1622, 2005.
[Berry, 2006] D. Berry. Bayesian Statistics, *Medical Decision Making* 26: 429-430, 2006.
[Berry et al., 2002] D. Berry, P. Müller, A. P. Grieve, M. Smith, T. Parke, R. Blazek, et al. Adaptive Bayesian Designs for Dose-Ranging Drug Trials, in C. Gatsonis et. al. (eds.), *Case Studies in Bayesian Statistics Vol. V*. New York, NY: Springer, pp. 99-181, 2002.
[Berry et al., 2005] D. Berry, S. N. Goodman and T. Louis. Floor Discussion, *Clinical Trials* 2: 301-304, 2005.
[Berry and Kadane, 1997] S. M. Berry and J. B. Kadane. Optimal Bayesian Randomization, *Journal of the Royal Statistical Society, Series B: Methodological* 59: 813-819, 1997.
[Biswas et al., 2009] S. Biswas, D. Liu, J. Lee and D. Berry. Bayesian Clinical Trials at the University of Texas M. D. Anderson Cancer Center, *Clinical Trials* 6: 205-216, 2009.

[53]The principle goes as follows: "At the outset, no experimental treatment is guaranteed perpetual or even very long-term admissibility" [Sedransk, 1996, p. 77].

[Buchanan and Miller, 2005] D. Buchanan and F. Miller. Principles of Early Stopping of Randomized Trials for Efficacy: A Critique of Equipoise and an Alternative Nonexploitation Ethical Framework, *Kennedy Institute of Ethics Journal. Je* 15: 161-178, 2005.

[Campbell, 2005] G. Campbell. The Experience in the FDA's Center for Devices and Radiological Health with Bayesian Strategies, *Clinical Trials* 2: 359-363, 2005.

[Cannistra, 2004] S. A. Cannistra. The Ethics of Early Stopping Rules: Who Is Protecting Whom?, *Journal of Clinical Oncology* 22: 1542-1545, 2004.

[Carpenter, 2004] D. Carpenter. The Political Economy of FDA Drug Review: Processing, Politics, and Lessons for Policy, *Health Affairs* 23: 52-63, 2004.

[Carpenter and Moore, 2007] D. Carpenter and C. Moore. Robust Action and the Strategic Use of Ambiguity in a Bureaucratic Cohort: FDA Scientists and the Investigational New Drug Regulations of 1963, in S. Skowronek and M. Glassman (eds.), *Formative Acts: American Politics in the Making*. Philadelphia: University of Pennsylvania Press, pp. 340-362, 2007.

[Cartwright, 2006] N. Cartwright. Well-Ordered Science: Evidence for Use, *Philosophy of Science*. 73: 981-990, 2006.

[Cartwright, 2007] N. Cartwright. Are RCTs the Gold Standard?, *Biosocieties* 2: 11-20, 2007.

[Ceccoli, 1998] S. J. Ceccoli. *The Politics of New Drug Approvals in the United States and Great Britain*. Unpublished Thesis (Ph. D.), Washington University, 1998.

[Chalmers, 2005] I. Chalmers. Statistical Theory Was Not the Reason That Randomization Was Used in the British Medical Research Council's Clinical Trial of Streptomycin for Pulmonary Tuberculosis, in G. Jorland, G. Weisz and A. Opinel (eds.), *Body Counts: Medical Quantification in Historical and Sociological Perspective*. Montreal: McGill-Queen's Press, pp. 309-334, 2005.

[Comanor, 1986] W. Comanor. The Political Economy of the Pharmaceutical Industry, *Journal of Economic Literature* 24: 1178-1217, 1986.

[Council, 1948] Medical Research Council. Streptomycin Treatment of Pulmonary Tuberculosis, *British Medical Journal* 2: 769-782, 1948.

[Couzin, 2004] J. Couzin. The New Math of Clinical Trials, *Science* 303: 784-786, 2004.

[Cowles and Davis, 1982] M. Cowles and C. Davis. On the Origins of the .05 Level of Statistical Significance, *American Psychologist* 37: 553-558, 1982.

[Cox-Maksimov, 1997] D. Cox-Maksimov. *The Making of the Clinical Trial in Britain, 1910-1945: Expertise, the State and the Public*. Cambridge University, Cambridge, 1997.

[Daemmrich, 2004] A. A. Daemmrich. *Pharmacopolitics: Drug Regulation in the United States and Germany*. Chapel Hill: University of North Carolina Press, 2004.

[Edwards, 2007] M. N. Edwards. *Control and the Therapeutic Trial: Rhetoric and Experimentation in Britain, 1918-48*. Amsterdam: Rodopi, 2007.

[Edwards et al., 1998] S. Edwards, R. J. Lilford and J. Hewison. The Ethics of Randomised Controlled Trials from the Perspectives of Patients, the Public, and Healthcare Professionals, *British Medical Journal* 317: 1209-1212, 1998.

[Emrich and Sedransk, 1996] L. Emrich and N. Sedransk. Whether to Participate in a Clinical Trial: The Patient's View, in J. B. Kadane (ed.), *Bayesian Methods and Ethics in Clinical Trial Design*. New York: Wiley, pp. 267-305,1996.

[Epstein, 1996] S. Epstein. *Impure Science. Aids and the Politics of Knowledge*. Berkeley-Los Angeles: University of California Press, 1996.

[Evans et al., 2006] I. Evans, H. Thornton and I. Chalmers. *Testing Treatments. Better Research for Better Healthcare*. London: The British Library, 2006.

[Featherstone and Donovan, 1998] K. Featherstone and J. L. Donovan. Random Allocation or Allocation at Random? Patients' Perspectives of Participation in a Randomised Controlled Trial, *BMJ* 317: 1177-1180, 1998.

[Flory and Emanuel, 2004] J. Flory and E. Emanuel. Interventions to Improve Research Participants' Understanding in Informed Consent for Research: A Systematic Review, *JAMA* 292: 1593-1601, 2004.

[Gillies, 1973] D. Gillies. *An objective theory of probability*. London: Methuen, 1973.

[Gifford, 1986] F. Gifford. The Conflict between Randomized Clinical Trials and the Therapeutic Obligation, *Journal of Medicine and Philosophy*. 86: 347-366, 1986.

[Gifford, 1995] F. Gifford. Community-Equipoise and the Ethics of Randomized Clinical Trials, *Bioethics*. 9: 127-148, 1995.

[Gifford, 2000] F. Gifford. Freedman's 'Clinical Equipoise' and Sliding-Scale All Dimensions Considered Equipoise. *Journal of Medicine and Philosophy* v. 25, n. 4, 399-426, 2000.

[Gigerenzer, 1989] G. Gigerenzer *et al. The Empire of Chance: How Probability Changed Science and Everyday Life.* Cambridge University Press, UK, 1989.

[Goodman, 1999a] S. N. Goodman. Toward Evidence-Based Medical Statistics. 1: The P Value Fallacy, *Annals of Internal Medicine* 130: 995-1004, 1999.

[Goodman, 1999b] S. N. Goodman. Toward Evidence-Based Medical Statistics. 2: The Bayes Factor, *Annals of Internal Medicine* 130: 1005-1013, 1999.

[Goodman, 2007] S. N. Goodman. Stopping at Nothing? Some Dilemmas of Data Monitoring in Clinical Trials, *Ann Intern Med* 146: 882-887, 2007.

[Grieve and Krams, 2005] A. Grieve and M. Krams. ASTIN: A Bayesian Adaptive Dose–Response Trial in Acute Stroke, *Clinical Trials* 5: 340-351, 2005.

[Hackshaw, 2009] A. Hackshaw. *A Concise Guide to Clinical Trials.* London: Wiley-Blackwell, 2009.

[Hartnett, 2000] T. Hartnett (ed.). *The Complete Guide to Informed Consent in Clinical Trials.* Springfield (VA): PharmSource Information Services, 2000.

[Heitmiller *et al.*, 1996] E. Heitmiller, J. B. Kadane, N. Sedransk and T. Blanck. Verapamil Versus Nitroprusside: Results of the Clinical Trial II, in J. B. Kadane (ed.), *Bayesian Methods and Ethics in Clinical Trial Design.* New York: Wiley, pp. 211-219,1996.

[Hennekens *et al.*, 2004] C. H. Hennekens, F. M. Sacks, A. Tonkin, J. W. Jukema, R. P. Byington, B. Pitt, *et al.* Additive Benefits of Pravastatin and Aspirin to Decrease Risks of Cardiovascular Disease: Randomized and Observational Comparisons of Secondary Prevention Trials and Their Meta-Analyses., *Archives of Internal Medicine* 164: 40-44, 2004.

[Inoue *et al.*, 2005] L. Y. T. Inoue, D. Berry and G. Parmigiani. Relationship between Bayesian and Frequentist Sample Size Determination, *The American Statistician* 59: 79-87, 2005.

[Jain, 2007] S. Jain. *Understanding Physician-Pharmaceutical Industry Interactions.* Cambridge University Press, UK, 2007.

[Kadane, 1994] J. B. Kadane. An Application of Robust Bayesian Analysis to a Medical Experiment, *Journal of Statistical Planning and Inference* 40: 221-232, 1994.

[Kadane, 1996] J. B. Kadane. *Bayesian Methods and Ethics in a Clinical Trial Design.* New York: Wiley, 1996.

[Kadane *et al.*, 1999] J. B. Kadane, M. J. Schervish and T. Seidenfeld. *Rethinking the Foundations of Statistics.* Cambridge University Press, UK, 1999.

[Kadane and Sedransk, 1996] J. B. Kadane and N. Sedransk. Verapamil Versus Nitroprusside: Results of the Clinical Trial I, in J. B. Kadane (ed.), *Bayesian Methods and Ethics in Clinical Trial Design.* New York: Wiley, pp. 177-210,1996.

[Kadane and Seidenfeld, 1990] J. B. Kadane and T. Seidenfeld. Randomization in a Bayesian Perspective, *Journal of Statistical Planning and Inference* 25: 329-345, 1990.

[Kadane and Seidenfeld, 1996] J. B. Kadane and T. Seidenfeld. Statistical Issues in the Analysis of Data Gathered in the New Designs, in J. B. Kadane (ed.), *Bayesian Methods and Ethics in Clinical Trial Design.* New York: Wiley, pp. 115-125,1996.

[Krams *et al.*, 2005] M. Krams, K. R. Lees and D. A. Berry. The Past Is the Future: Innovative Designs in Acute Stroke Therapy Trials, *Stroke* 36: 1341-1347, 2005.

[Krams *et al.*, 2003] M. Krams, K. R. Lees, W. Hacke, A. P. Grieve, J.-M. Orgogozo, G. A. Ford, *et al.* Acute Stroke Therapy by Inhibition of Neutrophils (Astin): An Adaptive Dose-Response Study of Uk-279,276 in Acute Ischemic Stroke. See Comment, *Stroke* 34: 2543-2548, 2003.

[Krimsky, 2003] S. Krimsky. *Science in the Private Interest: Has the Lure of Profits Corrupted Biomedical Research?* Lanham: Rowman & Littlefield Publishers, 2003.

[Lehmann, 1993] E. L. Lehmann. The Fisher, Neyman-Pearson Theories of Testing Hypotheses: One Theory or Two?, *Journal of the American Statistical Association* 88: 1242-1249, 1993.

[Levi, 1982] I. Levi. Direct Inference and Randomization, *PSA: Proceedings of the Biennial Meeting of the Philosophy of Science Association* 2: 447-463, 1982.

[Levine, 1988] R. J. Levine. *Ethics and Regulation of Clinical Research.* New Haven-London: Yale University Press, 1988.

[Lexchin *et al.*, 2003] J. Lexchin, L. Bero, B. Djulbegovic and O. Clark. Pharmaceutical Industry Sponsorship and Research Outcome and Quality: Systematic Review, *British Medical Journal* 326: 1167-1170, 2003.

[Macklin, 2004] R. Macklin. *Double Standards in Medical Research in Developing Countries.* Cambridge: Cambridge University Press, 2004.

[Mainland, 1960] D. Mainland. The Use and Misuse of Statistics in Medical Publications, *Clin. Pharmacol. Ther.* 1: 411-422, 1960.

[Marks, 1997] H. M. Marks. *The Progress of Experiment. Science and Therapeutic Reform in the United States, 1900-1990.* N. York: Cambridge University Press, 1997.

[Marks, 2000] H. M. Marks. Trust and Mistrust in the Marketplace: Statistics and Clinical Research, 1945-1960, *History of Science* 38: 343-355, 2000.

[Montori et al., 2005] V. M. Montori, P. J. Devereaux, N. K. J. Adhikari, K. E. A. Burns, C. H. Eggert, M. Briel, *et al.* Randomized Trials Stopped Early for Benefit: A Systematic Review, *JAMA* 294: 2203-2209, 2005.

[Mueller et al., 2007] P. S. Mueller, V. M. Montori, D. Bassler, B. A. Koenig and G. H. Guyatt. Ethical Issues in Stopping Randomized Trials Early Because of Apparent Benefit, *Annals of Internal Medicine* 146: 878-881, 2007.

[Neyman, 1957] J. Neyman. 'Inductive Behavior' as a Basic Concept of Philosophy of Science, *Review of the International Statistical Institute* 25: 7-22, 1957.

[Papineau, 1994] D. Papineau. The Virtues of Randomization, *British Journal for the Philosophy of Science* 45: 437-450, 1994.

[Piantadosi, 2005] S. Piantadosi. *Clinical Trials. A Methodological Approach.* Hoboken (NJ): Wiley, 2005.

[Pocock, 1983] S. J. Pocock. *Clinical Trials: A Practical Approach.* Wiley, Chichester, UK, 1983.

[Porter, 1995] T. M. Porter. *Trust in Numbers: The Pursuit of Objectivity in Science and Public Life.* Princeton, N.J.: Princeton University Press, 1995.

[Seidenfeld, 1979] T. Seidenfeld. *Philosophical Problems of Statistical Inference: Learning from R.A. Fisher.* Dordrecht-London: Reidel, 1979.

[Sedransk, 1996] N. Sedransk. Admissibility of Treatments, in J. B. Kadane (ed.), *Bayesian Methods and Ethics in Clinical Trial Design.* New York: Wiley, pp. 65-113,1996.

[Sismondo, 2009] S. Sismondo. Ghosts in the Machine: Publication Planning in the Medical Sciences, *Social Studies of Science* 39: 171-198, 2009.

[Spiegelhalter et al., 2004] D. J. Spiegelhalter, K. Abrams and J. Myles. *Bayesian Approaches to Clinical Trials and Health-Care Evaluation.* Chichester: John Wiley, 2004.

[Spiegelhalter et al., 1994] D. J. Spiegelhalter, L. S. Freedman and M. K. B. Parmar. Bayesian Approaches to Randomized Trials, *Journal of the Royal Statistical Society. Series A (Statistics in Society)* 157: 357-416, 1994.

[Sterne and Smith, 2001] J. A. C. Sterne and G. D. Smith. Sifting the Evidence—What's Wrong with Significance Tests?, *British Medical Journal* 322: 226–231, 2001.

[Stone, 2007] P. Stone. Why Lotteries Are Just, *The Journal of Political Philosophy* 15: 276-295, 2007.

[Taylor et al., 1984] K. Taylor, R. Margolese and C. Soskolne. Physicians' Reasons for Not Entering Eligible Patients in a Randomized Clinical Trial of Surgery for Breast Cancer, *N. Engl. J. Med.* 310: 1363-1367, 1984.

[Toth, 1998] B. Toth. *Clinical Trials in British Medicine 1858-1948, with Special Reference to the Development of the Randomised Controlled Trial.* University of Bristol, Bristol, 1998.

[Urbach, 1985] P. Urbach. Randomization and the Design of Experiments, *Philosophy of Science.* JE 85: 256-273, 1985.

[Urbach, 1993] P. Urbach. The Value of Randomization and Control in Clinical Trials (with Discussion), *Statistical Science* 12: 1421-1431, 1993.

[Vandenbroucke, 2004] J. P. Vandenbroucke. When Are Observational Studies as Credible as Randomised Trials?, *Lancet* 363: 1728-1731, 2004.

[Walton et al., 2005] M. Walton, R. Simon, F. Rockhold, W. DuMouchel, G. Koch and R. O'Neill. Panel Discussion of Case Study 3, *Clinical Trials* 2: 352-358, 2005.

[Whitehead, 1993] J. Whitehead. The Case for Frequentism in Clinical Trials (with Discussion), *Statistical Science* 12: 1405-1419, 1993.

[Worrall, 2007] J. Worrall. Evidence in Medicine and Evidence-Based Medicine, *Philosophy Compass* 2: 981-1022, 2007.

[Worrall, 2008] J. Worrall. Evidence and Ethics and Medicine, *Perspectives in Biology and Medicine* 51: 418-431, 2008.

[Yank et al., 2007] V. Yank, D. Rennie and L. Bero. Financial Ties and Concordance between Results and Conclusions in Meta-Analyses: Retrospective Cohort Study, *British Medical Journal* 335: 1202-1205, 2007.

UNCERTAINTY IN CLINICAL MEDICINE

Benjamin Djulbegovic, Iztok Hozo and Sander Greenland

1 INTRODUCTION

It is often said that clinical research and the practice of medicine are fraught with uncertainties. But what do we mean by uncertainty? Where does uncertainty come from? How do we measure uncertainty? Is there a single theory of uncertainty that applies across all scientific domains, including the science and practice of medicine? To answer these questions, we first review the existing theories of uncertainties. We then attempt to bring the enormous literature to bear from other disciplines to address the issue of uncertainty in clinical research and medical practice. Our main and overarching goal is to review and classify uncertainties in clinical medicine.

To appreciate and understand multiple sources of uncertainty in medicine, consider that clinical practice sits at the intersection of several great branches of learning [Wilson, 1998] where the sciences meet humanities. It is at a crossroads of basic natural sciences (i.e., biology, chemistry, physics) and technological applications (i.e., relying on the application of numerous diagnostic and therapeutic devices to diagnose or treat a particular disorder). It occurs in a specific economic and social setting (each with its own resources, social policies, and cultural values). It essentially involves a human encounter, typically between a physician and a patient, that results in the subsequent attempt for rational and ethical decision-making to create a framework for action in order to do more good than harm for individuals and societies (and consistent with individual or societal values and preferences). This encounter can occur in the setting of clinical practice or clinical research. It is then no wonder that medicine is an enormously complex enterprise where there are more questions than answers and where definitive knowledge is rare and doubts reign.

The analysis of uncertainty has only been recently explored in clinical medicine, but has a long tradition in philosophy, mathematics, statistics, economics, decision theory, engineering and psychology. Hence, any treatise on uncertainty should start with a review of the concepts previously developed in these fields. We illustrate the application of these concepts to the major types of uncertainties encountered in medicine. We have structured this text so that as we review a particular scientific theory of uncertainty, we illustrate its relevance to one of the key types of uncertainties encountered in medicine. We then summarize our views on uncertainty in medicine, both in clinical practice and in clinical research. We finish by providing some thoughts on ethics of uncertainty and training for uncertainty.

Handbook of the Philosophy of Science. Volume 16: Philosophy of Medicine.
Volume editor: Fred Gifford. General editors: Dov M. Gabbay, Paul Thagard and John Woods.

2 DEFINITIONS OF UNCERTAINTY

The term "uncertainty" subsumes multiple concepts and has different meanings with respect to various activities that are performed in medical research and practice [Morgan and Henrion, 1990]. Table 1 presents some common definitions. The literature distinguishes two approaches to uncertainty: (1) the study of the relationship between the unknown and existing knowledge and (2) the quantification of unpredictability and risk, given existing knowledge by employing concepts of probability. The latter approach is often narrowed to statistical methods to calculate and report estimates of random and systematic errors in observations.

Table 1. Definitions of Uncertainty

Definitions of Uncertainty in Relation to Knowledge

1. "The state of being indefinite, indeterminate, unreliable, unknown beyond doubt. Not clearly identified or defined, and/or not constant." [Merriam-Webster]
2. "Cognitive state created when an event cannot be adequately defined or categorized due to lack of information." [Mishel, 1990]
3. "The inability to determine the meaning of illness-related events" resulting from the ambiguity, complexity, unpredictability of illness, deficiency of information about one's illness and its consequences. [Politi *et al.*, 2007]
4. "The difference of 'knowing' and the concept of 'being certain' is not of any great importance, except when 'I know' is meant to mean 'I cannot be wrong.'" [Wittgenstein, 1969]
5. "The lack of information which quantitatively or qualitatively can describe, prescribe or predict deterministically and numerically a system, its behavior or other characteristics." [Zimmerman, 2000]

Statistical Definitions of Uncertainty

6. "A parameter, associated with the result of a measurement (e.g., calibration or test) that defines the range of values that could reasonably be attributed to the measured quantity. When uncertainty is evaluated and reported in a specified way, it indicates the level of confidence that the value actually lies within the range defined by the uncertainty interval." [UKAS Service]
7. "Standard deviation of the collection of data samples approximating the measurand, the quantity being measured." [Taylor and Kuyatt, 1994]
8. "A parameter associated with measurement that characterizes the dispersion of the values that could reasonably be attributed to measurand. The parameter may be a standard deviation or the width of a confidence interval..." "Uncertainty represents the range of all determination, while error refers to the difference between an individual result and the true value of measurand." [Ellison *et al.*, 2000]

2.1 *Philosophical views: knowledge and certainty*

Philosophers have long been preoccupied with uncertainty. They were first to highlight the connection between knowledge and certainty, or between the lack of

knowledge and uncertainty and judgments that are derived from such statements. This connection was captured by Socrates with "All I know is that I know nothing" and by Lao Tzu with "To know one's ignorance is the best part of knowledge" [Morgan and Henrion, 1990]. Later writers distinguished two broad categories of uncertainties [Colyvan, 2008; Regan *et al.*, 2002]: (1) epistemic uncertainty, which is related to our knowledge of the state of a system, about some underlying fact of the matter, typically due to lack of useful or complete information, and (2) linguistic uncertainty, which arises because of uncertainty and ambiguity in the language we use to describe the phenomena of interest — in this case, there is *no fact of the matter* under consideration.

Epistemic uncertainty can be subdivided with respect to whether *something is known* or whether some *particular agent knows something* [Djulbegovic *et al.*, 2009; Audi, 2003]. Do we, as a scientific/medical community, know that "treatment A" is superior to "treatment B"? Do I (as an individual subject) know it? Addressing the first question leads us to examine the justification of scientific and medical theories and the evaluation of the reliability of different sorts of evidence. To address the second question, we need to understand the nature of beliefs agents hold and the different ways these agents acquire beliefs [Djulbegovic *et al.*, 2009; Audi, 2003]. However, these two types of inquiries (knowledge about something vs. who knows it) are not clearly demarcated and often overlap. As stated, there may not be uncertainty about the effects of a particular treatment, which, however, may not be administered to patients in need because a doctor seeing these patients may not know about it. Similarly, doctors may have strong beliefs about the effects of the treatments, even though medical science has not resolved all unknowns about benefits and harms related to the particular treatment. Because of this, (uncertainty about) the nature of medical practice often interacts with (uncertainty about) the nature and scope of medical research.

Epistemic uncertainty is intimately linked to the relationship between theory, evidence, and knowledge [Djulbegovic *et al.*, 2009]. If we want to test a hypothesis in medicine (for example, that aspirin will prevent myocardial infarction), we must carry out a series of observations, but inevitably we will conduct only a finite number of observations to test a hypothesis that is supposed to be generalizable to future practice. Thus, we go beyond the observations we are able to collect as we are testing a claim about a feature of reality we cannot observe directly (in part, the claim that a physiological mechanism exists for aspirin to prevent heart attack). [Djulbegovic *et al.*, 2009] The relationships among observed, observable, and unobservable realities express uncertainties that can be characterized as a lack of knowledge about what is known (unknown knowns), what is known to be unknown (known unknowns), and not knowing what is unknown (unknown unknowns) [Murray, 2003]. This classification extends to methods for dealing with uncertainties.

Intimately linked with this classification of uncertainty is the psychological taxonomy that categorizes uncertainty based on knowledge of the external world and on our own state of knowledge [Schwartz and Bergus, 2008] (see below). Wittgen-

stein [1969] emphasized both the imprecision of our language and the link between
knowledge and certainty. His notion of "a language game" points to the impor-
tance of the context for understanding the meaning of a particular expression — a
view held by contemporary scholars of uncertainty [Wittgenstein, 1969; Zimmer-
man, 2000; Colyvan, 2008; Regan *et al.*, 2002]. In his posthumously published
text titled "On Certainty," Wittgenstein remarked that "the difference of 'know-
ing' and the concept of 'being certain' is not of any great importance, except when
'I know' is meant to mean 'I cannot be wrong.'" [Wittgenstein, 1969]. Modern
applied scientists consider uncertainty as "the gap between certainty and present
state of knowledge" [Nikolaidis *et al.*, 2005] or "the lack of information that quan-
titatively or qualitatively can describe, prescribe, or predict deterministically and
numerically a system, its behavior, or other characteristics" [Zimmerman, 2000].
In this view, the role of information is to reduce epistemic uncertainty. Figure
1 illustrates a conceptual relationship between knowledge and uncertainty. The
figure also illustrates that perfect knowledge is impossible-there will always be
irreducible uncertainty.

Figure 1. Relationship between knowledge and uncertainty

2.2 *Research and resolution of uncertainty*

Uncertainty can be considered within a broader context of scientific knowledge,
which evolved from application of scientific methods. Scientific methodology, in
turn, evolved as the primary means to address and reduce uncertainty [Matthews,

1995]. An essential distinction from religion is that scientific and medical knowledge is admittedly fallible. Most of it will be revised eventually to some degree, and thus it should be regarded as only approximately true and should not be treated as absolutely certain [Audi, 2003].

Raw material for knowing is supplied in justified (or warranted) beliefs. Knowledge can be regarded as the right kind of reliably grounded (propositionally but not necessarily conclusively certain) justified true beliefs [Audi, 2003]. Therefore, we can still know something, or something can be made knowable, even if it cannot be known for certain. Although it can be argued that in our subjective experiences of convictions we can be "absolutely certain," every scientific statement remains tentative and, therefore, uncertain forever [Popper, 1959]. Nevertheless, this does not mean that we cannot define the optimal or rational course of action under shrouds of uncertainty. Although errors are unavoidable, [Hozo *et al.*,2008; Djulbegovic and Hozo, 2007] a hallmark of science is belief that scientific methods are the best means we have to address uncertainties about general and specific propositions.

3 THEORIES OF UNCERTAINTY

Is there a single theory that can model all types of uncertainties? One school of thought is that the language of probability is sufficient to describe all uncertainty [Edwards *et al.*,2007; Lindley, 1985]. Others maintain, however, that probability is not the only coherent approach to uncertainty, as in cases where the logical principle of excluded middle fails when uncertainty is due to vagueness (see below) [Colyvan, 2008; Zimmerman, 2000]. A related question is: should our approach to uncertainty be context-free, or should we develop a taxonomy of uncertainties, which is context and domain-specific Zimmerman, 2000; Regan *et al.*, 2002; Djulbegovic, 2007]?

3.1 *Taxonomy and sources of uncertainty*

Several attempts have been made to characterize different kinds of uncertainties [Morgan and Henrion, 1990; Colyvan, 2008; Regan *et al.*, Colyvan, 2002; Zimmerman, 2000]. Table 2 summarizes one such scheme. It also suggests methods to address the particular uncertainty as a function of its type and source, and it provides examples from clinical medicine. In this section we discuss probabilistic and nonprobabilistic theories of uncertainty [Hajek, 2001; Hayek, 2007]. We also illustrate an application of all these theories in medicine.

3.2 *Measurement of uncertainty: interpretations of probability*

As discussed above, our understanding is always based on incomplete knowledge. The completeness of knowledge can be expressed via probabilities: "a statement is probable if our knowledge concerning its content is deficient" [von Mises, 1957].

Table 2. Types and Sources of Uncertainty[1]

TYPE OF UNCERTAINTY	SOURCE	CLINICAL EXAMPLES	COMMENTS/METHODS TO ADDRESS (REDUCE) UNCERTAINTY
Epistemic uncertainty			
Measurement error: This type of uncertainty includes [in]accuracy of the equipment (instrument error), variation among measurements, and operator error (training and skills of observer) and may also include analytical validity (e.g. ability of diagnostic test to accurately and reliably measure the entity of interest) (see text).	Instrument, random variation in the measurement, and operator (observer). This type of uncertainty may be manifested differently with different types of data (i.e., measurements that are nominal, ordinal, interval, or on a ratio scale).	(1) Coefficients of variation (CV) for common hematologic tests vary. For example, for MCV (mean corpuscular volume), CV = 13.2%.[Djulbegovic 1992] Most physicians act on the results of MCV if it is below 80.[Djulbegovic 1992] This means that under some circumstances physicians can order a diagnostic workup or even administer treatment solely based on random variation in measurement. (2) Detection of colorectal cancer by colonoscopy is a direct function of physicians' training, skills, and the time they take to perform a procedure.[Barclay et al. 2006]	This type of uncertainty is reduced by clear operationalization of terms of measurements and by the application of statistical techniques to report the estimates and the confidence in these estimates (e.g., mean + confidence intervals; median + range; CV) or physical constraints of the equipment used. Establishing training standards and quality control criteria can help reduce uncertainty due to variation in training and skills of operators such as physicians and lab technicians.
Systematic error (bias): (1) In generating, disseminating, and reporting evidence. (2) Observer variation/observational bias. (3) Heuristics and biases in interpretation of evidence. (#4)	**Clinical research:** Numerous biases have been described that decrease confidence and increase uncertainty about particular finding (see text). **Clinical practice:** Availability and representative heuristics (Table 3). **Theory-ladenness:** In both clinical research and practices, we observe what our theories instruct us to observe.[Popper 1959]	(1) Observational studies [as opposed to randomized controlled trials (RCTs) are typically associated with lower confidence and thus higher uncertainty about the true value of the particular result. However, the efficacy of homeopathy has been rejected due to lack of plausible theoretical reasons that it can work despite the fact that its effects were supported by RCTs. (2) There are well documented variations in inter- and intra-observer agreement for all skills that physicians use in clinical practice such as history taking, performing a physical examination, reading X-rays, analyzing lab samples, and reading pathological specimens (see text).	**Clinical research:** The evidence-based medicine (EBM) movement was born out of attempt to strengthen our methods in designing, conducting, analyzing, and reporting clinical research (see text). **Clinical practice:** Develop awareness of heuristics and biases. Utilize EBM methods of critical appraisal to identify and defend against plausible false claims. Ideally, a catalog of reliability and accuracy of all signs, symptoms, labs X-rays, and pathologic results would be helpful, which would include data on inter-and intra-agreement, test sensitivity and specificity, statistical estimates of uncertainty, etc.
Random error/natural variations	**Clinical research:** "Chance results" due to any number of factors (e.g., small trial, few events of	Many research studies are not confirmed by future research.[Ioannidis 2005] In clinical	**Clinical research:** Reproducibility of research (e.g., FDA typically requires two

[1] Based on [Regan *et al.*, 2002; Zimmerman, 2000; Morgan and Henrion, 1990]. Numbers indicate estimated ranks in terms of how common the causes of uncertainty are in clinical medicine (e.g., #1 = most common source of uncertainty, #2 = second leading cause of uncertainty, etc.).

·	interest, short or incomplete outcomes). **Clinical practice:** Regression toward mean; most diseases are fairly rare and hence vulnerable to large statistical errors; the small number of patients that any physician can see in his/her personal practice. [Eddy 1984]	practice, it is common to note an abnormal result due to chance phenomena. In fact, for a routinely performed chemistry testing that includes 20 analytes, there is a $(1-0.95^{20}) = 64\%$ probability that one of the results will be abnormal. [Sox 1990] Since most diseases are relatively rare, sufficiently large clinical trials to address a given uncertainty may never be possible on logistical grounds.	clinical trials of consistent results before approving a new drug). **Clinical practice:** Repetition of lab results typically results in fewer extreme results; awareness of imprecision of the available data/experience and large credibility intervals. Some authors also point to inherent randomness of natural phenomena. This type of uncertainty refers to inherently irreducible uncertainty that cannot be minimized by future research (famously illustrated by Heisenberg's uncertainty principle [Zeilinger 2005]). In medicine, it refers to the central problem with respect to natural variation in the course of any patient's disease and the way people respond to any medical intervention (see text).
Uncertainty about applying class probability to case probability (#2)	This is the classic problem known as "the problem of the single case" or "the gambler's fallacy." It has been argued that since many natural events are not repeatable, the knowledge of class probability cannot tell us anything about a particular case (see text)	Use any trial data ("group averages") at bedside (Table 4)	Classic problem of induction doubting the possibility of whether inferences from repeated observations can be applied to yet unobserved cases. Although not solvable on theoretical grounds, in practice the case is typically made about exchangeability of the past and future events permitting application of trial data to individual patients (see text). Paying attention to PICO (i.e., any difference between trial patients, interventions and comparator used, outcome obtained) as well as setting and circumstances under which a trial was performed or a procedure applied may help generalize results in an individual patient.

Subjective uncertainty			
(1) Lack of information about the effects of treatments, the accuracy of diagnostic tests, long- and short-term outcomes, etc. (≈1a)	This is the most frequent cause of uncertainty. It relates either to something that is not known in the scientific/medical community or to the decision-making agent. Depending on the question (treatment vs. diagnosis vs. prognosis), the information need may vary. For example, in the domain of diagnostic testing, physicians need information on clinical validity such as the test's sensitivity, specificity, and positive/negative predictive values (the ability of the test to detect or predict the associated disorder) and the clinical utility (e.g., if a patient has been diagnosed with disease or is at risk of disease, what can be done about it? What are the benefits and risks of prospective treatments that may be given? (See text.)	For the most part, data are lacking on the effects of many treatments or accuracy of prognostic or diagnostic information. It is estimated that reliable evidence exists to support only about 25% of decisions in medicine (see text).	This type of uncertainty is addressed by obtaining more or better evidence. This can be achieved by conducting research (when the entire medical community needs information) or making existing evidence available when needed, as advocated by the EBM movement.
(2) Abundance of information (information overload, complexity) (≈1b)	This type of uncertainty is due to the limited ability of humans to process simultaneously large amounts of data	It is estimated that [Djulbegovic et al.]: - physicians cannot handle more than seven (diagnostic) hypotheses at a time. - if evidence is provided when needed, decisions can be different 30% to 60% of the time (see text) - more than 20,000 periodicals are currently published - a typical practitioner is required to instantaneously recall more than 2 million facts - second-year medical students are given, on average, 11,000 pages to read	The information is best used when it is needed, and this type of uncertainty is best addressed by developing information technology structures to improve connectivity between data, information, and knowledge (see text). Development of clinical decision support systems (CDSS) is considered particularly helpful to reduce this type of uncertainty.
(3) Conflicting evidence (≈1c)	This type of uncertainty arises either because one evidence contradicts another or because the evidence is inconclusive (e.g., results obtained in a trial testing the effects of two treatments can be consistent with the possibility that either or their effects treatments is superior to the other or their effects do not differ)	Even highly cited clinical research is frequently contradicted [Ioannidis, 2005a]. Likewise, trials testing similar interventions by industry can produce the opposite results from those of trials sponsored by public entities	Developing reliable, unbiased, and up-to-date sources of evidence and ensuring its delivery at the right place, for the right patient, at the right time via CDSS is considered to be the optimal way to address this type of uncertainty.
(4) Degree of beliefs, values, and preferences (≈3)	(1) Uncertainty due to subjective judgments occurs as a result of interpretation of data, particularly when data are sparse and prone to bias and error.	(1) When evidence is lacking, many recommendations for the practice of medicine are based on the consensus of experts [Winn et al., 1996]. (2) Because of multiple outcomes that typically	This type of uncertainty is best addressed by explicit measurements of the degree of beliefs of experts' and patients' preferences. The problem is that best methods on how to do this in a medical context have yet to be identified (see text).

	Source / description	Examples	How it can be addressed
	(2) Another source of this uncertainty is related to the lack of reliable data to inform scientific conclusions or medical decisions (see above). (3) When outcomes are value-dependent, individual preferences and values become decisive in shaping this kind of uncertainty. This is because any single medical procedure results in multiple outcomes — some good and some bad — such as quality of life vs. survival, pain vs. costs. There is probably an infinite number of variations, and hence huge uncertainty, regarding how different people value pain, anxiety, disability, operative risk, life expectancy, hospitalization, societal priorities, etc.	go in opposite directions (for example, adjuvant treatment for breast cancer employing trastuzumab is more effective but more expensive [Hillner and Smith, 2007]), tradeoffs that inevitably involve values have to be made. Therefore, both individual decisions and cost-effectiveness models are impacted to a large extent by the need to consider patients' values and preferences (see text).	
(5) Disagreement	This type of uncertainty relates to different perspectives, beliefs, and biases (competing interests)	Industry-sponsored research often generates results that, on average, inflate findings by a factor of 4 [Lexchin et al., 2003].	This can be addressed by recognizing biases and by managing competing interests in both clinical research and clinical practice.
Model (decision) uncertainty (approximation)	This type of uncertainty arises because models represent only simplified versions of the real world that is being modeled. It can relate to uncertainties about the model parameters or the structure of the model itself.	Physicians are sometimes not sure how to articulate the question and frame uncertainties or they don't know how effective their model works in a particular patient (e.g., use of Framingham equation to predict the probability of heart disease in a 65-year-old patient) [Collins and Altman 2009] or which test or procedure to select out of many diagnostic or therapeutic options available for a given condition. For example, which test (of a dozen available) should be used to screen for colon cancer: occult blood test, rectosigmoidoscopy, colonoscopy, or virtual colonoscopy? Perhaps a series of two or more tests? Which of many antihypertensive drugs available at the market should be administered to the patient with hypertension?	Model uncertainty is difficult to quantify and impossible to eliminate. The model should be based on supporting evidence and explicit and transparent clinical logic. Ultimately, it should be tested against prediction by performing validation studies. However, it is impossible to empirically test every combination and permutation of tens of diagnostic tests and treatment interventions that are available for the management of a single condition. The uncertainty further increases when the patient has multiple medical conditions.

Benjamin Djulbegovic, Iztok Hozo and Sander Greenland

Linguistic uncertainty			
-- Numerical vagueness (Sorites paradox) (#6) -- Nonnumerical vagueness	Borderline cases result in different classifications based on a single individual or small differences in the quantities of interest. Vague predicates such as "aggressive behavior," "affluent," etc.	Borderline cases are common in medicine (see Table 4. For example, if obesity is classified as BMI (body mass index) > 30, what about BMI = 29.9? Nonnumerical vagueness: e.g., severe kidney failure	Nonclassical logic such as fuzzy theory, three-valued logic, supervaluation, paraconsistent, and modal logic are all proposed to help deal with vagueness. Uncertainty due to nonnumerical vagueness is typically treated by converting it into multidimensional measures (e.g., ordering severity of kidney failure by creatinine level at a point where it can be dealt with numerically).
-- Ambiguity (#5)	This type of uncertainty arises due to the fact that words can have more than one meaning and it is often not clear which is intended.	In medicine this often occurs when qualitative terms (e.g., rare, unlikely, likely) are used to communicate risk instead quantitative expressions. This type of uncertainty is a common cause of medical error (see text). Errors resulting in preventable adverse drug events occur most often at the stages of ordering and monitoring, which are dominated by ambiguity. In one study, 51% of adverse drug events were judged to be preventable, including 171 (72%) of the 238 fatal, life-threatening, or serious events [Gurwitz et al. 2000]	This type of uncertainty is best addressed by making clear what is meant, although it has been noted that in practice, this is often easier said than done.
-- Context dependence	This uncertainty is due to failure to specify the context in which a proposition is to be understood.	Neutropenia (low white blood cell count) has different meanings in the context of a patient who was treated with chemotherapy as opposed to a patient who was not treated with chemotherapy.	This is dealt with by specifying context. In clinical medicine, this has been long understood through time-honored training in taking a history of the patient.
-- Underspecificity	This involves uncertainty due to a lack of specificity in the statement.	Terms that lack specificity such as "shortness of breath" or "loss of appetite" need further qualification, such as "Do you need several pillows to prop you up during sleep?" "Have you lost any weight?" "How much?"	This is best addressed by providing all available information at hand to ensure that statements are as specific as possible. (NB: the word "vagueness" is reserved for the borderline cases and should not be confused with underspecificity.)
-- Indeterminacy (of theoretical concepts)	Uncertainty related to indeterminacy in our theoretical terms.	One example is the classification of myelodysplastic syndrome (MDS) based on morphological features vs. cytogenetic abnormalities.	Uncertainty due to theoretical indeterminacy is typically addressed via scientific developments, which should make conscious decisions to adopt past theoretical construct within a framework of new developments.

Probabilities can range from 0 to 1, where 0 is equated with the impossibility of the event, and 1 is equated with absolute certainty. Values between 0 and 1 reflect various degrees of uncertainties.

The literature is replete with ways to analyze and interpret probability, but typically the interpretation and discussion of the probability is approached from two main points of view: "objective" and "subjective" [Greenland, 1998; Haack, 1995; Hajek, 2001; Hajek, 2007]. The main difference between these two approaches to interpretation of probability is as follows: "objective probability" is believed to reflect the characteristics of the real world, i.e., the probability somehow relates to the physical property of the world or a mechanism generating sequences of events [Greenland,1998; Hajek, 2007]. On the other hand, "subjective probability" is believed to represent a state of mind and not a state of objects [Edwards et al., 2007]. "Objective probability" includes many subtypes, such as the classic interpretation of probability as the way to express the notion of probability as a degree-of-certainty measure of a random phenomenon, as well as logical probability, which provides the framework for inductive reasoning, and propensity theory, which considers probability a physical property, disposition, or tendency of a particular physical situation to yield an outcome of a certain kind [Popper, 1959; Hajek, 2001; 2007]. Our view is that only two types of probability are broadly relevant to health sciences and medical practice today,: "objective" frequentist and subjective Bayesian.

3.2.1 "Objective probability": the frequentist interpretation of probability

In frequentism, probability is defined as the limit of the proportion, as n increases without bound, of

$$f = \frac{k}{n}$$

where f is the frequency of occurrence of the relevant event, k is the number of times the event occurs in n repetitions of the experiment [De Sa, 2008]. This approach to probability is effectively summarized by Venn who stated, "probability is nothing but [a] proportion" [Hajek, 2001; 2007].

> *Application in medicine:* Frequentism has been widely embraced in clinical medicine, particularly in the design of clinical studies and the interpretation of results. For example, one may see statements such as: "in a series of 100 patients seen in a particular clinic (n), 20 patients had hypertension (k) indicating that there is a 1 in 5 (20%) chance that one of the patients will have high blood pressure." However, if we repeat the determination of the number of patients with hypertension in a series of the next 100 patients, it is unlikely that we will obtain the same estimate (20%) as in the first study. To better articulate our confidence in research findings, a number of additional measures for uncertainties have been devised and widely popularized. One such measure is the confidence interval demarcated by confidence level. For example, in

> our case, we can calculate a 95% confidence interval ranging from 12
> to 28 patients. This does not mean that this is a "true" assessment
> about this particular interval. Frequentism says only that if we repeat
> our survey thousands of times, 95% of the intervals we computed will
> contain the true percentages of patients with high blood pressure. It
> does not say the true percentage is between 12% and 28%; instead, the
> frequency with which this single computed 95% CI contains the true
> value is either 100% or 0% [Greenland 1998]

Orthodox frequentism concerns only class probability (frequency within a class of events or patients), as opposed to case (singular) probability [von Mises, 1957]. Since many natural events are not repeatable, the knowledge of class probability cannot tell us anything about a particular case and therefore would leave a physician presented with a single patient in a quandary. The usual practice is simply to identify single-case probability with the frequency in the smallest identified class ("reference set") in which the patient can be placed. This act is sometimes called "the gambler's fallacy" [von Mises, 1957] (see below).

3.2.2 Subjective Bayesian interpretation of probability

Many modern interpretations consider probability a measure of "degree of belief" [Savage, 1954; Greenland, 2006; Greenland, 2008; Hajek, 2007] rather than a frequency or other property of the world. Accordingly, probabilities are states of mind and not states of objects [Edwards *et al.*, 2007]. There is no such thing as an objective probability: a probability reflects a person's knowledge or, equivalently ignorance, about some uncertain distinction" [Edwards *et al.*,2007; Howard 1988].

As argued by de Finetti, [DeFinetti, 1974] "The only relevant thing is uncertainty — the extent of our knowledge and ignorance. The actual fact of whether or not the events considered are in some sense *determined*, or known by other people, is of no consequence". Since there is no such thing as an objective probability, using a term like "subjective probability" only creates confusion. "Probabilities describing uncertainties have no need of adjectives" [Howard, 2007].

Subjective notions of probability have been traditionally captured through Bayes' theorem, named after 18th-century British minister Thomas Bayes [1764]. He derived the following theorem, which allows updating probabilities as new evidence emerges [DeFinetti, 1974; Greenland, 1998]:

$$p(H+|E) = \frac{p(H+) \cdot p(E|H+)}{p(E)} = \frac{p(H+) \cdot p(E|H+)}{p(H+) \cdot p(E|H+) + p(H-) \cdot p(E|H-)}$$

where $p(H\pm)$ = prior probability that hypothesis is true $(H+)$ or false $(H-)$ (i.e., before new evidence is collected) and $p(E)$ = probability of the evidence; $p(E|H\pm)$ = the probability of evidence given that the hypothesis is true $(H+)$ or false $(H-)$, $p(H+|E)$ = the probability of hypothesis being true given the evidence (posterior probability).

Application in medicine: Bayes' theorem has been widely popularized in clinical medicine, particularly as a means to make more rational diagnosis [Sackett *et al.*, 2000]. For example, assume that a patient with rheumatoid arthritis who has been taking nonsteroidal agents for many years sees you for the workup of anemia. Completed blood count confirms a hemoglobin level of 10 g/dL, with a mean corpuscular volume (MCV) of 75. Both bleeding (iron deficiency anemia) and rheumatoid arthritis (anemia of chronic disease) can explain the findings, but you are completely uncertain (50:50) which of these is the culprit. Knowing from the literature that low MCV is truly low ("true positive") in iron deficiency anemia 90% of the time but only 25% of the time in anemia of chronic disease, you can use Bayes' theorem to calculate that the probability that your patient has iron deficiency anemia is 78%.

Figure 2 illustrates the role of Bayes' theorem in updating the probability of diagnosis after the diagnostic test was performed.

Figure 2. A role of Bayes' theorem (from Sox *et al.* [1988])

Modern research in decision-making using brain imagery suggests that humans appear to be natural Bayesians [Kording, 2007]; the same is claimed for clinicians [Gill *et al.*, 2005]. However, there are problems with the Bayesian approach. Two

types of critiques are usually offered. The first is that the assessment of priors can dramatically vary between different observers [Eddy, 1984]. Therefore, even if the probability calculus is not formally violated (see discussion below of the psychological account of uncertainty), the calculation of posterior probability is bound to be spectacularly different between different parties. However, this problem merely reflects the reality that people often disagree, sometimes spectacularly. Second, and more serious, in order to derive a logically credible calculus, the probabilities of all possible hypotheses should be represented exhaustively and mutually exclusively. This represents an insurmountable challenge since there are an almost infinite number of ways to claim that a hypothesis is false $[p(H - |E)]$. This is a problem with the so called "catch-all hypothesis" [Kasser, 2006]. In practice, however, doctors and scientists do not worry about the "catch-all hypothesis" problem since they typically believe that they have exhausted all the serious possibilities when they assess the $p(H + |E)$, whether in the context of accurate diagnosis or in that of clinical research findings [Kasser, 2006]. While this approach often serves well, the history of both science and medicine has shown that rare events can occur and that it is hazardous to ignore the problem of "catch-all hypothesis" [Goodman, 1999a; 1999b].

The Bayesian approach has been most often advanced within the field of decision theory, which established a relationship between desirability of outcomes (utilities), their probabilities and rational preferences [Edwards et al, 2007]. Applied decision theory, decision analysis, has been increasingly used in clinical medicine [Edwards et al., 2007; Hunink and Glasziou, 2001]. It provides a logical structure for balancing of the factors that influence decisions under uncertainty [Edwards et al., 2007]. At its most basic level, decision analysis distinguishes between the actions (choices), probabilities of events, and their relative values (payoffs, outcomes, consequences) [Hunink and Glasziou, 2001; Djulbegovic et al., 2000]. Decision scientists distinguish between decisions under risks (when probabilities of events are known, typically in the objective sense of the probability or unwanted events that may or may not occur) and decisions under uncertainty (when probabilities of events are either not known or not available to a decision maker) [Hansson, 2007; Knight, 1921]. Since, in medicine, most estimates of risks are not accurate, almost all decisions are "under uncertainty." To derive most optimal decision, decision analysis proposed that rational decision-making should employ the expected utility calculus (the average of all possible results weighted by their corresponding probabilities) [Edwards et al., 2007; Hunink and Glasziou 2001; Sox et al., 1988].

Maximization of expected utility is widely considered to be a normative criterion of rationality, according to which a rational decision-maker should act (e.g., select one treatment over another) [Edwards, et al., 2007; Hunink and Glasziou, 2001; Sox et al., 1988; Bell et al.,1988; Hastie and Dawes, 2001]. Mathematically, this can be expressed as:

$$EU = \sum p_i \cdot u(x_i)$$

where p_i is the probability and $u(x_i)$ is the value (utility) associated with each

outcome x_i.

Empirical violations of this criterion [Allais, 1953; Wakker, 2008] led to the development of subjective expected utility (SEU), [Savage, 1954] which assumes that probabilities are not necessarily objectively known. In the SEU framework, the distinction between known and unknown probabilities becomes meaningless since subjective probabilities are never unknown [Camerer and Weber, 1992].

> *Application in medicine:* A 60-year-old man presents to his orthopedist surgeon with severe back pain due to a herniated disk. The surgeon recommends an operation to correct the hernia and help the patient to lead a pain-free life again. However, there is a risk associated with surgery: about 1% of patients die during or immediately after this type of surgery. Is it rational for the patient to undergo surgery? According to the SEU criterion for any outcome of X (= back pain), which is preferable to L (= death) but not as good as H (= cure, pain-free), there is some probability (p) such that the decision-maker is indifferent (the expected utilities are equal) between X for sure (= 1) and the gamble of giving a chance (p) of getting H (= cure) and $(1 - p)$ of getting L (= death) [Watson and Buede 1987]. If we assume that, on a scale of 0 to 1, the patient rates the utility of pain-free state (H) as 1, the utility of death (L) as 0, and the utility of living with back pain as 0.95, then we can determine that:
>
> $$u(X) = p \cdot u(H) + (1 - p) \cdot u(L)$$
> $$0.95 = p \cdot 1 + (1 - p) \cdot 0 \Rightarrow p = 0.95$$
>
> Thus, as long as the probability of successful surgery is above 95%, the rational choice would be to undergo surgery.

However, humans appear to constantly violate the expected utility criterion, which is probably one of the major factors underlying uncertainty in contemporary medical practice as evidenced by tremendous practice variation [Hozo and Djulbegovic, 2008; 2009; Eddy, 1984]. Before we return to the question of uncertainty and variation in medical practice, we also need to review nonprobabilistic and psychological theories of uncertainty.

4 NONPROBABILISTIC THEORIES OF UNCERTAINTY

Probability theory has been criticized as being insufficient as a model for all types of uncertainties [Zimmerman, 2000; Colyvan, 2008; Curley, 2007; Shaffer, 1976]. Many competing theories, each with its own axioms, have been proposed as alternative theories to model uncertainty. Most of these theories have been developed in the fields of engineering and computer sciences, and their relevance to clinical medicine is not clear at this time [Nikolaidis *et al.*, 2005; Goble, 2001]. Therefore,

we will only briefly list these theories and selectively point out the possible clinical values of some of these theories.

Information theory has advanced the concept of entropy as the optimal measure of uncertainty [Shannon and Weaver, 1962] Mathematically, entropy is equal to:

$$H = -\sum_i p_i log(p_i)$$

This equation states that we obtain maximum uncertainty when events are equally probable. In the views of information theorists, higher entropy (uncertainty) is associated with higher information load and more freedom of choice: when the probabilities of the various choices are equal, one has maximum freedom in making a choice. Conversely, when H = 0, one is heavily influenced toward one particular choice and has little freedom of choice (i.e., the information, the uncertainty, the freedom of choice is low) [Shannon and Weaver, 1962]. Interestingly, within the concept of "classical probability," the notion of "equally possible" is meant to be interpreted as "equally probable" [Hajek, 2001, 2007]. This led Keynes to define the "principle of indifference," which states that whenever there is no evidence favoring one possibility over another, they should be assigned equal probability [Hajek, 2001; 2007].

> *Application in medicine:* The concept of entropy, which relates to uncertainty about choice, has been likened to the concept of equipoise — a state of reasoned epistemic uncertainty in clinical research [Mann and Djulbegovic, 2003, 2004]. It has been contended that when equipoise exists (i.e. the effects of competing treatment alternatives are considered equiprobable), uncertainty about (treatment) choice becomes maximum, and the most rational (and ethical) way to resolve such uncertainty is to select treatment at random as through randomized controlled trials (RCTs) [Djulbegovic, 2007] (see below).

Fuzzy theory (many-valued logic) [Zimmerman, 1996] has been developed to address the problem that not all statements must be considered to be "true" or "false" as the classical logic "law of the excluded middle" supposes. The probabilistic analog of the "law of excluded middle" can be stated as [Colyvan, 2008]:

$$Pr(P \vee \sim P) = 1$$

where \vee is read as "or" and \sim as "not". The expression states that the proposition $(P \vee \sim P)$ is certain $(= 1)]$ and that the possibility of neither P nor $\sim P$ is excluded. However, it has been argued that in vague, borderline cases, the law of excluded middle fails and is not the appropriate tool for representing uncertainty (see below) [Colyvan, 2008]. This is more evident in medicine, where classification of individuals according to particular (diagnostic or prognostic) categories is rarely precise, as shown in the following example:

Application in medicine The U.S. National Institutes of Health define obesity as having a BMI (body mass index) of 30 or above [Vickers *et al.*, 2008]. This means that anyone with a BMI of ≤ 29.9 is not considered obese and that anyone with a BMI of ≥ 30.1 is classified as obese. However, it is difficult to claim that there is any medical significance in a BMI of 29.9 vs. a BMI of 30.1. By allowing partial membership in the categories of interest (e.g., we may allow that all individuals with a BMI of 25 to 35 are assigned the value 0.5 on scale 0 to 1), fuzzy theory can effectively deal with these borderline cases. [Zimmerman, 1996]

Many other nonprobabilistic theories can deal with uncertainties associated with vagueness in our language. A partial and nonexhaustive list includes supervaluations, intuitionistic logic, paraconsistent logic, modal logic, possibility theory, and rough sets theory [Goble, 2001] as well as the Dempster-Shafer (D-S) theory of evidence, which is a generalization of the Bayesian theory of subjective probability.

To date, all these theories have seldom been used in medical domains. Therefore, it is difficult to assess their usefulness in clinical medicine despite their potential theoretical appeal, and so they will not be discussed further here.

Probability theory, with its modifications from the insights gained from psychological research, remains the dominant theory of uncertainty in clinical medicine today. We now turn to a brief account of psychological theories of uncertainties.

5 PSYCHOLOGICAL THEORIES OF PROBABILITIES AND UNCERTAINTY: PSYCHOLOGY OF JUDGMENTS UNDER UNCERTAINTY

Are human beings "intuitive statisticians" capable of correctly employing the probability calculus, or are they "pragmatic rule-makers" who bend and distort the normative probability rules depending on the context [Howell and Burnett, 1978]? Although there are laboratory studies that confirm both views, [Howell and Burnett, 1978] research during the last 30 to 40 years has convincingly demonstrated that people rarely make decisions in accordance with normative expected utility (EU) theory [Baron, 2000; Bell *et al.*, 1988; Hastie and Dawes, 2001]. Ample evidence has accumulated that the precepts of the EU theory are often violated during the actual decision-making process [Baron, 2000; Bell *et al.*, 1988; Hastie and Dawes, 2001]. Descriptive theories of decision-making focusing on the question of how people actually make decisions suggest that the major reason for violation of EU is that people violate laws of the probability calculus. For example, humans are prone to overweight small probabilities and underweight moderate and large ones. [Kahneman and Tversky, 1979; 1982; Kahneman, 2003; Tversky and Kahneman, 1974; 1986; 1992]. The result is such that a change from impossible to possible has a stronger impact than an equal change from possible to more possible. This is known as the possibility effect [Kahneman and Tversky, 1979; Tversky

and Kahneman, 1992; Tversky and Wakker, 1995]. Similarly, a change from possible to certain effect has more impact than an equal change from possible to more likely. This is known as the certainty effect [Kahneman and Tversky, 1979; Tversky and Kahneman, 1992; Tversky and Wakker, 1995]. In addition, many other violations of the axioms of probability [Birnbaum, 2008] have been described in the literature, although mostly in decision-making and economic literature [Birnbaum *et al.*, 1999a; Hastie 2001; Birnbaum and Navarrete, 1998; Birnbaum, 1999b]. Instead of using formal probability calculus, people typically use heuristics ("rules of thumb") [Brandstatter and Gigerenzer, 2006; Gigerenzer and Todd, 1999]. These heuristics are resource-conserving means for problem-solving and dealing with uncertainty, but they are suboptimal and often can produce biased assessments of the phenomenon that is being judged [Tversky and Kahneman, 1974]. Table 3 shows representative heuristics and biases that are based on a distortion of judgments about event frequencies and coherence in probability assignments.

Furthermore, people consistently make choices as if utilities or consequences of our actions were a nonlinear function of outcomes of interest [Birnbaum, 1999c; 2008] This explains, for example, why a gain of $100 is valued more by a pauper than by a millionaire. Descriptive theories of choice, such as the prospect theory, predict that risk behavior depends on whether outcomes are perceived as gains or losses, relative to some reference point [Kahneman and Tversky, 1979, 1982; Kahneman, 2003; Tversky and Kahneman, 1974; 1986; 1992]. As a result, a decision-maker is characteristically being risk-averse when relative gains are considered, while a relative loss is accompanied by risk-seeking behavior [Kahneman and Tversky, 1979; 1982; Kahneman, 2003; Tversky and Kahneman, 1974; 1986; 1992].

These phenomena that are empirically well documented have a profound impact on the decision-making under uncertainty, including clinical medicine.

> *Application in medicine:* People are generally risk-averse when the baseline probability of winning is high, but risk-seeking when it is low [Kahneman and Tversky, 1979; 1982]. This can explain why patients may enroll in risky phase I cancer trials: they believe that the success of the standard treatment is so low that it is worth undergoing the risk of experimental therapy for potential, albeit uncertain, benefits [Meropol *et al.*, 2003; Weinfurt, 2007]. People are also risk-averse when the baseline probability of losing is low, but they are risk-seeking when it is high [Kahneman and Tversky, 1979; 1982; Weinfurt, 2007]. This can explain why people undergo invasive screening tests such as colonoscopy for the detection of colorectal cancer; the risk of complications is relatively low, but the prospect of detecting cancer at an early curative stage is appealing [Kahneman and Tversky, 1979; Tversky and Kahneman, 1992; Hastie and Dawes, 2001].

The insights discussed above have been used in attempts to develop a cognitive taxonomy of uncertainties. Kahneman and Tversky [1982] proposed four proto-

typical variants of uncertainty: two based on knowledge of the external world and two on our own state of knowledge. External uncertainty (also known as aleatory uncertainty) refers to the assessment of the frequency of similar events (class probability) compared with the assessment of the propensity (probability) of the singular cases at hand (case probability) [von Mises, 1957]. These types of uncertainties closely match the formal presentation of uncertainties discussed above. Internal uncertainty refers to our own ignorance, which would roughly correspond to the subjective interpretation of probability, except that the axioms of formal probability calculus are often violated [Kahneman and Tversky, 2000; Kahneman, 2003]. We can reason through our ignorance either by appealing to reasoned arguments in our knowledge base or by expressing confidence in our answer by the strength of associations provided by our introspective judgments. However, the uncertainty related to any given problem can be attributed to the combination of these two pairs of factors.

In an attempt to develop a cognitive taxonomy of uncertainty, Howell and Burnett [1978] distinguished four general tasks related to measurement of uncertainty: (1) direct frequency estimation (class probability, past-oriented), (2) probability estimation (future-oriented, applying to both frequentist and nonfrequentist events but typically in assessing probability of single events), (3) prediction (relating to true/false prediction of future events), and (4) choice (requiring both prediction of future events and the choice of alternatives). Uncertainty related to choice differs from that related to prediction only by the fact that it also involves utility considerations. Uncertainty judgments related to these tasks that can occur over shorter or longer time spans are the product of four cognitive processes: prior knowledge, stored data (typically data on the frequency of events), heuristics, and selective and confidence bias [Howell and Burnett, 1978; Tversky and Kahneman, 1986]. These factors can predictably be combined, depending on the contextual factors and ease of encoding, to assess the uncertainty related to each of these tasks [Kahneman and Tversky, 1982; Kahneman and Frederick, 2006; Lichenstein and Slovic, 2006].

Despite some views that humans may be inherently Bayesian [Gill et al., 2005; Kording, 2007; Gigerenzer and Hoffrage, 1995] (see above), the current prevailing view is that people do not systematically update the prior knowledge gradually and systematically [Kahneman, 2003]. Rather, collection of new evidence is cognitively distinct from the existing knowledge. The existing knowledge often biases acquisition of the new evidence [Kahneman and Tversky, 2000; Howell and Burnett, 1978]. This view has important implications for understanding medical uncertainty (Tables 2 and 3).

There are many psychological theories of uncertainty, typically related to choice and judgments under uncertainty. These include prospect theory, [Kahneman and Tversky, 1979; Tversky and Kahneman, 1979; 1992] potential/aspiration theory, [Lopes, 1987] transfer-of-attention exchange model, [Birnbaum and Navarrete, 1998; Birnbaum, 1999a; 2008] support theory, [Tversky and Koehler, 1994] and regret theory [Bell, 1982; Djulbegovic, et al., 1999; Hozo and Djulbegovic, 2008;

Loomes and Sugden, 1982]. In addition, many heuristics have been proposed to explain how humans manipulate probabilities and make choices under uncertainty [Brandstatter *et al.*, 2006]. Although these theories have rarely been tested in medical domains, they provide important insights for understanding decision-making in medicine.

> *Application in medicine*: Support theory [Tversky and Koehler, 1994] postulates that subjective estimates of the probability of an event are affected by the detailed description of a given event. This has important implications for clinical medicine since longer, more detailed descriptions of cases will increase the suspicion of a disease more than will a brief presentation [Schwartz and Bergus, 2008]. Similarly, informed consent that lists a large number of adverse events unlikely to occur may lead to overestimation of the risks of drugs [Schwartz and Bergus, 2008].

> Both regret and prospect theory can explain why some 40-year-old women undergo annual screening mammography (SM) while others do not. Since SM is associated both with benefits (it can help avoid death due to breast cancer if cancer is detected at an early stage) and harms (it can lead to increased risk of dying from radiation-induced breast cancer), some women may regret more the act of commission (undergoing SM) than the act of omission (failure to undergo SM) [Djulbegovic and Lyman, 2006]. We do not, however, know of empirical studies that show how women consider SM probabilities (if they do at all), or how they make their choice under uncertain estimates of SM benefits and risks.

Although at the moment, there is no agreed-upon a single, unifying psychological theory of judgments under uncertainty, these examples illustrate that any attempt to develop a comprehensive treatise of uncertainty in clinical medicine must take into account the insights obtained from psychological research on uncertainty.

6 UNCERTAINTY ABOUT PROBABILITIES

Empirical evidence suggests that people's knowledge or perceived knowledge about the probability of events influences their decision-making. This introduces the concept of uncertainties about probabilities [Ellsberg, 1961; Camerer and Weber, 1992] relating to the reliability, credibility, or adequacy of information, which can possibly be understood in two or more different ways. Although some theorists dispute the validity of this concept [Howard, 1988; 2007], uncertainty about the probability appears to influence how risk and uncertainty are communicated in medical practice (as discussed below). Some authors refer to uncertainty about probabilities as "ambiguity" [Camerer and Weber, 1992], which differs from ambiguity

related to the use of unclear words and meanings (Table 2). Uncertainty about probability is typically represented by frequentist confidence intervals or Bayesian posterior intervals. Diamond and Forrester [1983] expressed these uncertainties through connection of beliefs, degree of confidence, and information.

"I figure there's a 60% chance of heart disease and a 15% chance we know what we're talking about."

Figure 3. Uncertainty about uncertainty (adapted from Diamond and Forrester [1983]).

Application in medicine: Diamond and Forrester [1983] presented the case of a 55-year-old patient undergoing a heart stress test to diagnose coronary heart disease, and attempted to answer three fundamental questions (Figure 3):

1. *What do we know?* "Your positive stress test result implies that there is a 30% chance that you have coronary disease." (The authors calculated this probability using Bayes theorem.)

2. *How sure are we?* Three physicians (A, B, C) add different provisos, as follows:

Physician A adds that "there is a 2% chance that we are certain about you having 30% chance of coronary heart disease" This is because only 2% of the curve lies within the 1% posterior credibility interval around the 30%.

Physician B adds that "there could be less than a 28% chance of disease and a 50% chance that we are certain that you have less than a 28% of chance of coronary heart disease". This is because 28% represents the median of the probability distribution of heart disease, with 50% being the area under curve below the median.

Physician C adds that "there is between a 5% and a 64% chance of disease, with a 90% chance that we are correct about these chances" because the 90% posterior credibility interval for the probability of heart disease ranges from 5% to 64%.

3. *Why can't you all agree?* "There is precisely a 30% chance that you have coronary disease, and a 2% chance that we are correct about these chances." Don't be surprised if someone else feels differently since the stress test can provide only 23% of the information we need to be certain.

This example illustrates how even simple clinical assessments such as the use of stress tests in diagnosis of coronary heart disease, far from yielding certainty, raise several levels of questions about the uncertainty that we have. This is a key reason why more attention needs to be given to uncertainty and why understanding uncertainty is so important for the clinical practice and research as further outlined below.

7 THE IMPACT OF UNCERTAINTY IN MEDICINE: PRACTICE VARIATION

Dramatic practice variations in the management of seemingly similar patients and their conditions are well documented [Wennberg, 1986; Dartmouth Atlas of Health Care, 2009]. These variations occur across large and small areas, among physicians within the same medical settings, in test and treatment use, and in hospital admissions, referral rates, and surgical rates [Sirovich *et al.*, 2006; Wennberg, 1986; Fisher *et al.*, 2003; 2003]. Although many factors — from the structure of local care, the availability of health care technologies, financial incentives to health providers, and costs to patients — have been invoked to explain variations in the practice of medicine [Fisher *et al.*, 2003;], in the final analysis, it has been argued that most of these factors converge on questions about the role of uncertainty and its impact on the practice of medicine [Eddy, 1984; McNeil, 2001; Gerrity *et al.*, 1990]. Indeed, it is our "stubborn quest for diagnostic certainty" [Kassirer, 1989] that has been proposed as a leading cause of excessive and inappropriate testing resulting in ever-increased health care costs.

We will now try to dissect the various sources of uncertainty that help explain the many variations in clinical management. Intuitively, if multiple causes of uncertainty are operating at random, one would expect that variations in practice would average out [Eddy, 1984]. Instead, the variations are regional, occurring due to "herd behavior" in terms of a mistaken consensus, [Hirshleifer and Teoh, 2003; Bikchandani *et al*,1998] often termed the "community standard" [Eddy, 1984]. The "herd behavior" typically occurs due to a lack of reliable information and the poor quality of evidence that inform most medical decisions [Eddy and Billings, 1988; McNeil, 2001; Djulbegovic, 2004].

8 COMMON SOURCES OF UNCERTAINTY IN MEDICINE

Three basic types of uncertainty have been identified by Fox [1957; 1980]. The first result from incomplete or imperfect mastery of the existing knowledge, the second is a consequence of limitation of the current knowledge, and the third is a combination of the first two. More recently, McNeil [2001] classified he major types of uncertainty in clinical medicine: (1) uncertainty due to lack of convincing evidence because of delayed or obsolete data from clinical studies, (2) uncertainty about applicability of evidence from research at the bedside, and (3) uncertainty about interpretation of data. All of these types can be broadly classified as epistemic uncertainty [Morgan and Henrion, 1990; Colyvan, 2008; Regan *et al.*, 2002]. Similar types of uncertainty have been identified in other fields and can be equally well applied in the health care setting. Each of these specific uncertainties is handled differently (see also Tables 2-4). This, in turn, further indicates that that no single theory of uncertainty is sufficient for clinical medicine [Zimmerman, 2000].

Before we can address uncertainty in medicine, we need to define the clinical context: First, we need to distinguish the contexts of clinical research and clinical practice, and second, we need to distinguish the types of uncertainties related to the key activities in medicine (e.g., making diagnoses, administering treatments).

Table 4 details generic sources and types of uncertainty with illustrative examples from medicine. Note that epistemic uncertainty (e.g., measurement errors, bias, natural variation, the lack of information or conflicting evidence, the problem of applying class probability to single cases, issues of values, preferences) and linguistic uncertainty apply equally well to medicine. In fact, the complexity of medicine is such that all uncertainties listed in Table 2 are so pervasive and inherent in practice and research in clinical medicine that they are likely to multiply, with the ultimate effect of creating a "fog of uncertainty in medicine" [Djulbegovic, 2004]. There is no systematic study of types and sources of uncertainties outlined in Tables 2 and 4, but in our view, the following are the most prevalent causes of uncertainty in clinical medicine.

Table 3. Biases and Heuristics: Distortion of Probabilities in Judgments Under Uncertainty

Type of heuristic#/bias	Mechanism	Clinical example	Comments/How to deal with the bias
Representative	Distortion of the probability based on judgments of how events, processes, causes, or people resemble each other.	A young, effeminate-looking male from the inner city is referred for screening. Is he more likely to have increased blood pressure or be positive for HIV? Because of the prevailing stereotype, physicians might assume that he is more representative of an HIV patient. However, data indicate that more patients have hypertension than HIV, even in effeminate patients from the inner city [Schwartz and Bergus, 2008].	The representativeness heuristic is pervasive in the distortion of the probability of events. It is also known as a "stereotype bias" or "conjunction fallacy" (the conjunction or co-occurrence of two events cannot be more likely than the probability of either event). Awareness of this law of probability often helps correct this bias. The opposite side of the coin is "disjunction fallacy": underestimating the probability of disjunctions of events. According to the probability calculus, the events that are disjunctive (the patient has either pneumonia or lung cancer) are more probable than any single event or their conjunction (the patient has pneumonia *and* lung cancer). Judgments by similarity are also typical for errors in assessing base rate probabilities (prevalence). When a certain category or event is assessed automatically via similarity, its base rate typically is not. The evaluation of the base rate should be independent of the (patient's) characteristic under consideration.
Availability	Distortion of the probability due to relying on ease by which an event is brought to mind to assess the probability or the frequency of class. Typically, two types of distortion of the probabilities are empirically documented: (1) *subadditivity*, in which the sum of the mutually exclusive events >1 (as normatively required by the probability theory) (2) *superadditivity*, in which the sum is judged to have greater probability than its mutually exclusive parts.	When physicians were asked to provide the probabilities for the following mutually exclusive events — whether their patients died during present hospitalization, were discharged alive but died within 1 yr, lived >1 yr but <10 yrs, or lived >10 yrs) — the mean estimated probability was 1.64, (which is 64% higher than the probability allotted to a mutually exhaustive set of events of 1)! [Redelmeier et al. 1995] Typically, availability heuristics is seen when the physician is visited by a pharmaceutical	A general theory to explain why some events are easier to remember than others is lacking. Normatively, this type of bias is best handled by adherence to the principles of the probability calculus. Reminding people that the sum of mutually exclusive events must not exceed 1.00 is often a sufficient solution to both availability and representative bias. In addition, making reliable information available at the time of decision-making can minimize the availability biases (e.g., providing the synthesis of the totality of evidence on the subject instead of relying on the recent report).

	representative or reads a recent report in a medical journal about the value of a diagnostic test or the effects of treatment. This increases the ease by which information is recalled, which often distorts the likelihood of a diagnosis or response to treatment.	
Anchoring effect	The effect on estimates of probability due to "anchor," i.e., the starting point for estimation.	The total number of new patients with myeloma in Florida is about 800/yr. Despite that most anchors are completely arbitrary, people's subsequent reactions are typically insufficiently adjusted. In fact, the more egregious claims are made, the fewer adjustments in the estimate typically follow. Since the effects of anchoring tend to be robust, the best "weapon" against it is reliable evidence.
Overconfidence	"Calibration," the degree to which confidence matches accuracy of predictions. Typically, overconfidence is greatest when accuracy is near chance levels.	A group of clinical experts are asked how many new myeloma patients they see in their clinic (in Florida). The first says around 500 new patients. Ten others stated that they are "not sure," but the estimate of the first expert is "about right."
		Physicians generally underappreciate the likelihood that their diagnosis can be wrong. Diagnostic errors are common (up to 15%) and occur more often when physicians are overconfident (particularly when they believe that they are absolutely certain). [Berner and Graber 2008]
		Overconfidence diminishes as accuracy increases from 50%–80%, and once accuracy exceeds 80%, people often become underconfident. Obtaining feedback and debiasing are useful to minimize overconfidence but are rarely done [Plous 1993] . A simple and useful alternative is to stop and reflect on the reasons why our judgments might be wrong. When reasons for and particularly against given estimates are considered, people's calibration becomes substantially improved while they become less confident. [Berner and Graber 2008]
Selective/ confirmation bias	A tendency to select data or selectively process information to support a given hypothesis ("self-fulfilling prophecy"); affects both objective (frequency) and subjective probability estimates.	This is pervasive in both clinical research and clinical practice. It may be generated consciously (e.g., publication/selective reporting bias) or subconsciously (e.g., specialists give more weight to some findings than generalists do in assessing the likelihood of diagnosis or response to treatment).
		Extremely difficult to eradicate. A good science aiming to generate reliable findings and practice aiming to *disconfirm* findings before making decision seems the best strategy we currently have. Inferences and decisions should be based on the "total evidence principle."

8.1 Lack of evidence, conflicting evidence, or "information overload" that can hinder adequate decision-making

These factors are by far the most common causes of uncertainty in medical practice. Evidence is necessary but not sufficient for optimal decision-making [Djulbegovic, 2006]. Today's practice of medicine is dominated by an information paradox. On one hand, we have an exponential growth of information [Djulbegovic *et al.*, 2000] making it difficult to find relevant information at the time of need. On the other hand, most existing evidence is irrelevant or unreliable, resulting in high uncertainty in inferences or decisions [Djulbegovic, 2004]. The unreliability and poor quality of medical evidence are considered to be the key factors that can explain the enormous variation in medical practice [Eddy and Billings, 1988; McNeil, 2001].

If reliable and evidence-based information had been available at the time of care, physicians would have arrived at a different medical decision in approximately 30% to 60% of cases [Covell *et al*, 1985; Ely *et al.*, 1999; Sackett and Strauss, 1998]. Physicians have need for many types of information related to etiology, prognosis, treatment, diagnosis, patient preferences etc. However, about 70% of information requirements sought by physicians focus on diagnosis and/or treatment, but physicians cannot afford to spend more than 2 minutes to search for this information [Jefferson, 2008; Davies, 2007]. In principle, this type of uncertainty can be easily resolved by performing research that would generate reliable evidence for the decision-maker [Djulbegovic, 2004]. Indeed, research in medicine indicates that it is possible to generate better evidence [Higgins and Green, 2008; Guyatt and Rennie, 2002] and deliver better existing evidence. For example, in general medicine it has been shown that the use of filters to identify relevant and valid evidence can reduce the background noise by over 99.9%, resulting in only five to 50 research articles per year that may need to be incorporated in systematic reviews [Haynes *et al.*, 2006]. In oncology, less than 1% of new evidence has been judged to be important for practicing physicians [Vincent and Djulbegovic, 2005]. Therefore, it may be an achievable goal to identify relevant and valid evidence that can be delivered when needed at the point of care and ideally in its totality as a systematic review.

8.2 "The problem of the single case"— uncertainty about the application of trial ("group averages") data to individual patients

This is probably the second most important source of uncertainty in clinical medicine, and it is widely and passionately discussed [Tanenbaum, 1993; 2005; Rothewell, 2007; Glasziou and Irwig, 1995]. It illustrates the epistemological dilemmas better than any other issue. It can be linked to ancient debates about the nature of knowledge, cause and effect, and deterministic vs. probabilistic knowledge [Goodman, 1999a; Matthews 1995]. It is intimately linked with Hume's "problem of induction" [Vickers ,2006; Achinstein, 2004; Achinstein, 2005]. Hume pointed

out more than 200 years ago that there is no logical way to assert the validity of universal statements based on inferences from a number of singular observations [Vickers, 2006]. The problem of induction is further compounded in medicine with eternal debate about the value of deterministic, experimental methods vs. probabilistic, statistical inductive methods.

The application of probabilistic statements based on group averages to individual patients at the bedside remains at the crux of the debate related to the use of frequency probability. As far as back as 1865, this sentiment was first expressed by Claude Bernard, a pioneer of modern experimental medicine, who maintained that

> "A great surgeon performs operations for stone; later he makes a statistical summary ... and concludes from these statistics that the mortality law for this operation is two out of five. Well, I say that this ratio means literally nothing scientifically and gives us no certainty in performing the next operation ... What really should be done, instead of gathering facts empirically, is to study them more accurately, each in its special determinism. We must study cases of death with great care and try to discover in them the cause of mortal accidents so as to master the cause and avoid the accidents... Empiricism precedes science....never have statistics taught anything, and never can they teach anything about the nature of phenomena". [Goodman,1999a]

The fundamental problem is that there is inherent variation in the natural history of diseases or in the way that people respond to medical interventions [Collins and McMahon, 2001; Eddy, 1984]. Even for well described diseases such as a type I diabetes mellitus, where the cause of disease is well established, dramatic variations can occur in the course of illness, the response to insulin therapy, and the short- and long-term outcomes [Collins and McMahon, 2001]. What physicians can know is only the behavior of classes; individual cases remain unique and unrepeatable.

Nonetheless, despite the uniqueness of each particular patient, most authors believe there is simply no better method of addressing uncertainty in individual cases but through using research evidence obtained from groups of people in controlled clinical trials. Despite its problems, such induction remains one of the key methods for generation of knowledge in science and medicine. This is best expressed by one of the "fathers" of clinical trial methodology, Austin Bradford Hill [Hill, 1952]:

> "Our answers from the clinical trial present ... a group reaction. They show that one group fared better than another, that given a certain treatment, patients, on the average, get better more frequently or rapidly, or both. We cannot necessarily, perhaps very rarely, pass from that to stating exactly what effect the treatment will have on a particular patient. But there is, surely, no way and no method of deciding that."

Other authors still contend that the uniqueness of patients, along with their distinctive experiences, requires different modes of resolution of these types of uncertainties, such as the "tacit knowledge" of experts [Tanenbaum, 1993; Matthews, 1995].

Application of trial data to individual patients is permissible as long as we espouse the idea of exchangeability of the past and future events [Greenland, 1998]. In practice, this type of uncertainty is addressed by paying attention to PICO (i.e., whether the differences between the trial's patients (P), interventions (I), comparators (C), and outcome(s) (O) observed in the setting and circumstances of the trials are similar enough to allow application of the trial results to an individual patient) [Rothwell, 2007; 2006]. Or, to put it another way, the characteristics and circumstances of the patients are typically not demonstrably so different that one is easily able to dismiss the relevance of the group data.

8.3 Uncertainty about patient values and preferences

Ethical and normative standards of current medical practice are based on the views that patients are autonomous beings free to reason and exercise their rights to participate in clinical research or in their clinical care [Foster, 2001]. Rationally, people's attitudes will depend on the outcomes that the proposed medical intervention brings about, either in the context of research or medical practice.

The problem is that it is relatively rare that a medical procedure will result in unequivocally (good) outcomes. When it does, a situation known as effective decision-making, [O'Connor et al., 2003] most people will make the same choice regarding the proposed diagnostic or treatment intervention. Unfortunately, most medical interventions are associated with multiple outcomes, some good and some bad [Eddy, 1984]. For example, coronary bypass surgery can improve quality of life and prolong survival, but it is associated with surgical mortality, hospitalization, pain, anxiety, and expense. When outcomes are multiple and go in opposite directions, decisions have to be based on trade-offs, [Eddy, 1984] and trade-offs involve values. This is known as preference-based decision-making [O'Connor et al., 2003]. This might not be a problem if people's beliefs and preferences were well articulated and stable and easy to assess. Unfortunately, this is not the case. Results from research conducted during the last two decades convincingly demonstrates that peoples' preferences vary dramatically as a function of contextual factors including time pressure, task complexity, reference point regarding gains vs. losses, and the manner in which information is presented (framed), processed, and elicited [Lichenstein and Slovic, 2006]. In fact, it has become apparent that preferences are often constructed in the process of elicitation [Lichenstein and Slovic, 2006]. In theory, this type of uncertainty can best be addressed by explicit measurements of the degree of beliefs of experts and patients' preferences. The problem is that good and agreed-upon methods that address how to do this in the medical context have not yet been identified [Lichenstein and Slovic, 2006; Nelson et al., 2007].

8.4 Uncertainty due to bias in generating, observing, disseminating, reporting, and interpreting clinical data

Systematic distortion of the estimated intervention effect that leads away from the "truth" — caused by inadequacies in the design, conduct, data collection, analysis, or reporting of results of clinical research — adds substantially to the uncertainty regarding the use of such information [Juni et al., 2001; Juni and Egger, 2002; Higgins and Green, 2008; Greenland, 2009; Greenland and Lash, 2008]. It has been estimated that bias can exaggerate up to 60% the real effect of a healthcare intervention [Altman, 2002]. It is claimed that most of our research findings are wrong [Ioannidis, 2005] and that most of what we do in practice is not based on evidence but rather is dictated by authority, personal uncontrolled experience, or habit [Taubes, 1996]. Indeed, there are countless more ways that a particular research finding or clinical observation can go wrong than right [Guyatt, et al, 2008]. The unreliability and poor quality of medical evidence are considered to be the key factors explaining the enormous variations in medical practice [Eddy and Billings, 1988; McNeil, 2001].

The rise of the evidence-based medicine movement (EBM) [Hitt, 2001] has exposed systematic flaws in the way research is conceived, performed, analyzed, submitted, published, and cited [Higgins and Green, 2008]. Space prevents a discussion of all the biases described in the literature which can increase uncertainty [Higgins and Green, 2008; Baron, 2007; MacCoun, 1998; Sackett, 1979]. Below we discuss two of the most common types of epistemic uncertainty related to bias in clinical research and practice.

The first — uncertainty about interpreting results — is illustrated by ongoing discussions about the reliability of data obtained in nonrandomized, observational studies vs. experimental, randomized clinical trials [Concato et al., 2000; Benson and Hartz, 2000; Kunz and Oxman, 1998] In general, results that are obtained in RCTs are considered more credible in terms of internal validity (i.e., the extent in which we are confident that an estimate of effect is correct under the circumstances of the study) [Altman et al., 2001]. For example, many observational studies showed that women taking HRT (hormone-replacement therapy) benefited from estrogen replacement [Grodstein et al., 1996]. As a consequence, more than 50 million women were given HRT in recent decades. However, RCTs showed that many women have suffered from serious consequences from this therapy, including avoidable deaths due to exposure to HRT [Heiss et al., 2008]. Nevertheless, observational studies are considered to have better external validity [Altman et al., 2001] (i.e., the extent to which the study findings can be applied to other clinical settings ["the actual patient"— see below]). Not surprisingly, uncertainty about these questions is particularly acute at the personal level [Daley, 1999].

The second — uncertainty about observing outcomes — is pervasive in clinical practice. There are well documented variations in inter- and intra-observer agreement for all the skills that physicians use in clinical practice, such as history taking, performing the physical examination, reading X-rays, analyzing laboratory

samples, and reading pathology specimens [Eddy, 1984; Berner and Graber, 2008]. This is further compounded by biases and heuristics that add to uncertainty, both in practice and in research (Table 3). As a response, the entire science, mostly within the EBM movement, has emerged to strengthen our methods in the design, conduct, analysis, and reporting of clinical research, [Gabbay and le May, 2004; Guyatt, 1991; Guyatt and Rennie, 2002; Guyattt et al., 2008] and it has further raised awareness of heuristics and biases in handling this type of uncertainty. Many checklists and standardized procedures have been developed to both improve the reliability of generating new research evidence and critically assess claims regarding the existing findings [Guyatt and Rennie, 2002]. These methods apply to most types of uncertainty in clinical practice and research. The reader is referred to other sources about bias in research for further details [Guyatt and Rennie, 2002; Higgins and Green, 2008; Altman et al, 2001; Bossuyt et al. , 2003; Boutron et al., 2008; Greenland, 2009].

8.5 Ambiguity: uncertainty due to unclear meanings in terms or words

Ambiguity arises when a word can have several meanings and it is not clear which one is intended [Regan et al, 2002; Zimmerman, 2000]. It is often seen in medicine when verbal expressions are used to communicate risk or probability. For example, a physician might say, "It is unlikely that there will be a risk from the treatment I prescribed." The problem is that there is a great overlap in the meaning of qualitative terms. What is "unlikely" for one person may be "likely" for another [Hunink and Glasziou, 2001; Cutler, 1985].

A common source of ambiguity is the wide usage of abbreviations in medical prescribing, which is one of the major causes of medication errors.[2] This is particularly important since medical errors are one of the leading causes of deaths in hospitals in the United States [Kohn et al, 2000; Leape, 1994]. Many of these deaths are due to uncertainty in interpretation of medical terms or abbreviations. For example, "MS" magnesium sulfate might be confused for morphine sulfate, which may lead to the error in prescribing with life-threatening consequences. Ambiguity is common when there is no precise, operational criteria for diagnosis, study entry, response to treatment, etc. [Ramsden, 2006].

Uncertainty due to ambiguity can be resolved by clarifying terms and conditions. For example, there is now a major effort across the U.S. hospitals to clarify which abbreviations should be permitted. Similarly, when risk is communicated, it is preferable to use quantitative rather then qualitative terms. In research, expert panels try to improve the classification of particular disorders (e.g., World Health Organization on classification of hematologic malignancies [Harris et al., 1999]) or to define standardized criteria for judging responses to treatment (e.g., RECIST [Jaffe, 2006]).

[2]http://www.jointcommission.org/sentinelevents/sentineleventalert/sea_23.htm

8.6 Vagueness — uncertainty due to borderline cases

Uncertainty due to vagueness commonly occurs because of difficulties in classification of borderline cases: a single measurement or very small differences in the quantities of interest may completely change the categorization and consequent actions [Williamson, 1994; Hyde, 2005; Sorenson, 2006]. For example, if a diagnosis of obesity defined by a BMI of ≥ 30 is followed by the administration of a particular health intervention, this would mean that only those individuals classified by a BMI of ≥ 30 would obtain the intervention, while those with a BMI of ≤ 29.9 would not.

Solutions to the vagueness problem include technical approaches such as fuzzy theory [Zimmerman, 1996]. In the example above we may assign individuals with a BMI from 25 to 35 the value of 0.5 on scale of 0 to 1. In the open texture concept, borderline cases are judgment dependent: they become true because the speaker and the audience (of similarly competent individuals sharing similar values) judge them to be true [Sorenson, 2006]. The latter concept is implicit in the consensus approach used in medicine to address ambiguities about classification of diseases. Yet, despite its importance and its roots dating back to the ancient Sorites paradox, [Hyde, 2005] little work has been done on examining the role of vagueness in medicine.

We will further illustrate relevance of these sources in clinical medicine as we discuss the major types of uncertainties in clinical practice [Eddy, 1984; McNeil, 2001; Djulbegovic, 2001; 2007; Schwartz and Bergus, 2008; Hunink and Glasziou, 2001; Sox et al., 1988; Legare, in press] (Table 4).

9 UNCERTAINTY IN CLINICAL PRACTICE

9.1 Uncertainty about defining the disease

Three main sources of uncertainty arise in defining the disease. The first relates to the difficulties in drawing the line between disease ("abnormal") and "normal" [Murphy, 1997; Eddy, 1984]. This difficulty is rooted in vagueness (i.e., the problem of borderline cases) and ambiguity (Table 4). The example given above illustrates the effect of vagueness [Williamson, 1994; Regan et al., 2002] concerning the diagnosis of obesity based on the application of BMI value. Should a person with a BMI of 29.9 be considered obese? If hypertension is defined as having systolic blood pressure ≥ 140 mmHg, does that mean that an individual with blood pressure of 139 mmHg is normotensive? As current guidelines recommend that only patients with systolic blood pressure ≥ 140 mmHg are treated, this would imply that people with blood pressure <140 mmHg are at no risk for cardiovascular complications, while the ones with blood pressure = 140 mmHg presumably are [Vickers et al., 2008]. This type of uncertainty is of greater relevance to disorders that are measured on a continuous scale, cases which indeed comprise leading causes of illness in industrialized countries [Vickers et al., 2008]. These disor-

Table 4. Matching Uncertainty with Context: Common Types of Uncertainty in Clinical Medicine

Clinical practice	Example	Theoretical construct	Possible solution (see text for details)
Uncertainty about defining the disease	1. Obesity is defined as body mass index (BMI) ≥30. How should we classify a person with BMI 29.9? 2. Acute leukemia is classified if the number of leukemic blasts in marrow ≥20%, while the patient with a blasts count of 19% is considered as having MDS (myelodysplastic syndrome).	Linguistic uncertainty: numerical vagueness related to inherent uncertainty (unknowability) of *borderline* cases.	1. Fuzzy theory and other similar nonclassic logic (by allowing partial membership in the categories of interest: e.g., we may allow that all individuals with BMI from 25 to 35 are assigned the value 0.5 on a scale of 0 to 1. 2. Open texture concept: borderline cases are judgment dependent: they come true because the speaker and the audience (of similarly competent individuals sharing similar values) judge them to be true.
Uncertainty about making diagnosis	A 40-year-old woman is noted to have a mass on screening mammogram. What is the probability that she has breast cancer?	Epistemic uncertainty: subjective judgments that are framed by degrees of beliefs (prior probability) and imperfect test accuracy that can classify finding in false-negatives and false-positives.	Bayes theorem; nonprobabilistic theories of uncertainty.
Uncertainty about selecting a diagnostic or treatment procedure	A 60-year-old patient is diagnosed with stage IV B follicular lymphoma. Which treatment should be given: CHOP-R vs. CVP-R vs. FR?	Model uncertainty: does the stipulated course of action truly represent the problem at hand? Epistemic uncertainty: lack of information or conflicting evidence.	Clinical scenario should be based on explicit and transparent representation of the current best science. Evidence-based medicine (EBM): obtain (generate) accurate and unbiased evidence.
Treatment uncertainty	Randomized controlled trials (RCTs) were performed showing that warfarin is an effective treatment in preventing clots in patients with atrial fibrillation but at the risk of small but definitive bleeding. Most trials excluded patients older than 75 years. Should warfarin be prescribed to a 75-year-old patient? How should benefit and harms be integrated?	Epistemic uncertainty: classical problem of induction. Uncertainty about applying treatment from the trial data ("averages") to individual patients. Decision uncertainty: related to the integration of treatment benefits and harms.	Classic problem of induction: doubting the possibility whether inferences from repeated observations can be applied to yet-unobserved cases. Unsolvable on theoretical grounds, but in practice, patients with key similar prognostic characteristics tend to have the same outcomes as those who were treated before them (principle of exchangeability of the past and future events). See below for the best approach to making decisions under uncertainty.

Uncertainty about prognosis	A 60-year-old male has a cholesterol level of 260 mg/dL. How likely is he to develop heart attack?	Epistemic (model) uncertainty: reliability of existing models to accurately predict outcomes in population + predicting outcomes in individual patients.	Validation of models: the induction problem of inferring outcomes in individual patients from the group data (see above, *"the problem of the single cases")*. (see text for details)
Uncertainty about eliciting patients preferences	A patient with acute leukemia is invited to participate in high-risk trial involving allogeneic stem cell transplant. Your colleague consented the patient for the trial. You see the patient afterward and discuss benefits and harms of treatment again. This time the patient refuses treatment.	Linguistic uncertainty: context-dependent uncertainty. People preferences are constructed in the process of elicitation.	Awareness of framing effect, elicitation effects, and other contextual factors in presentation of benefits and harms of medical procedures.
Decision-making under uncertainty	Annual screening mammography in 40- to 50-year-old women is associated with benefits in terms of saving 46 lives per 100,000 at the cost of 30 lives lost per 100,000 women screened.[Djulbegovic, Hozo, and Lyman 2007] Her estimated life term risk of breast cancer is 10%. Should she undergo screening mammography or not?	Decision-making under uncertainty involving multiple outcomes (typically going in the opposite directions); synthesizing the values (regret of commission vs. omission), outcomes (evidence), and probability of events.	Formal expected vs. nonexpected utility theories[Reyna 2008; Hozo and Djulbegovic 2009] Elicitation of patients' preferences and values. Deliberative, time-consuming analytical approach [maximizing] vs. nonformal (intuitive) decision-making [satisficing].

ders include cardiovascular diseases, diabetes, developmental disorders, back pain, arthritis, and cancer [Vickers *et al.*, 2008]. Uncertainty due to vagueness has little effect on conditions that are defined by discrete properties (as someone is either HIV infected or not infected, for example).

Occasionally, uncertainty is related to ambiguity as in cases when scientific community has not clearly distinguished one entity from another. For example, the current definitions of stage IA and smoldering myeloma overlap [International Myeloma Working Group, 2003].

The second source of uncertainty is epistemic, related to the lack of information about disease outcomes, while the third source of uncertainty relates to application of population data to the individual. The latter sources of uncertainty relate to the fact that many "diseases" do not present threats to life or cause pain, suffering, or distress at the time of diagnosis [Vickers *et al.*, 2008; Eddy, 1984; Murphy, 1997]. They are considered "diseases" or "abnormal" conditions because they increase the probability that a target disorder will develop [Murphy, 1997; Eddy, 1984]. For example, people with high cholesterol are at increased risk of myocardial infarction, [Wilson *et al.*, 1998]. but the vast majority of people with increased cholesterol — 90% to 99%, depending on other risk factors such as high blood pressure and smoking status — will not have a myocardial infarction [Wilson *et al.*, 1998]. So, who should be considered a "diseased" person? This uncertainty is further magnified when the definition of disease is linked with intervention, as a typically is the case. Treating a particular condition does not mean that we will prevent a target disorder from occurring. As the hypercholesterolemia case illustrates, people with high cholesterol may never have a myocardial infarction, regardless of treatment, while those who were given treatment may still have it.

As with premorbid conditions, uncertainty due to ambiguity in disease definition *can be resolved* by clarification of the terms and conditions, but uncertainty due to borderline cases will often remain.

9.2 Diagnostic uncertainty

Diagnostic uncertainty refers to determining the true underlying cause of disease: what is wrong with this patient [Hunink and Glasziou, 2001]? In addition to heuristics and biases (Table 3), six major sources of uncertainty affect diagnostic uncertainty.

1. *Uncertainty about defining disease:* when a disease is difficult to classify (see above), there will be a greater problem in diagnosing it. This is particularly true for diseases defined on a continuum, wherein uncertainty due to vagueness becomes critical, leading some authors to argue "against diagnosis" [Vickers *et al.*, 2008].

2. *Measurement error:* relates to analytical validity, such as the ability of diagnostic tests to accurately and reliably measure the entity of interest [Hunter *et al.*, 2008; Knottnerus, 2002].

3. *Lack of evidence:* as it relates to information on clinical validity [Hunter *et al*, 2008; Knottnerus, 2002] (e.g., the test's sensitivity, specificity, and positive and negative predictive values, i.e., the ability of the test to detect or predict the associated disorder) and clinical utility [Hunter *et al.*, 2008; Knottnerus, 2002] (if a patient has a disease or is at risk of a disease, what can be done about it? What are the benefits and risks of the treatments that may be given? Will we regret ordering the diagnostic test?).

4. *Uncertainty about observing outcomes:* poor intra- and inter-observer agreement in elicitation of diagnostic signs and symptoms is well documented in medicine [Eddy, 1984; Berner and Graber, 2008] Disagreement about diagnosis is striking regardless of whether it relates to history taking (e.g., the proportion of patients who answered a simple question such as "Do you have a cough?" varies from 23% to 40% depending on who asked), physical examination (e.g., 26% of physicians stated that cyanosis existed in patients with normal oxygen content), laboratory or radiologic interpretation (the discordance rate typically varies between 2% and 20% for most general radiology readings; 35% of cases of atrial fibrillation were misdiagnosed by ECG; this error was detected by the reviewing physicians only 76% of time), or pathology reports (misclassification of cancer ranged for 2% to 9% for gynecologic cancers and 5% to 12% for nongynecologic cancers [Eddy, 1984; Berner and Graber, 2008]

5. *Uncertainty framed by degrees of beliefs (prior probability)* about diagnostic possibilities among different observers, which may result in different estimates about (posttest) probability of diagnosis. For example, different prior probabilities may help explain the failure to appropriately exclude a clot in the lungs [Sox, 2006]

6. *Failure to include all the diagnostic possibilities (mutually exclusive and exhaustive list of differential diagnosis)* [Redelmeier *et al.*, 1995]: for example, some physicians are able to diagnose a particular disorder simply because they thought of it, while others forget to include it in their differential diagnosis.

Resolving diagnostic uncertainty: Bayes' theorem (discussed above) is widely promoted as the method of choice for dealing with diagnostic uncertainty. Most uses presuppose that data are accurate and free of bias and that all reasonable possibilities have been taken into consideration. In practice, heuristics are taught in order to deal with diagnostic uncertainty (e.g., "Any patient who smokes and has palpable supraclavicular adenopathy has [lung] cancer until proven otherwise") [Djulbegovic and Sullivan, 1997].

9.3 Uncertainty about selecting a diagnostic or treatment procedure

For most conditions, there are many diagnostic and treatment procedures that can be ordered, [Eddy, 1984] and there is tremendous variation among physicians regarding selection of diagnostic or treatment procedures. For example, many drug combinations exist for the treatment of lymphoma, but it is not clear which one physicians should choose. How many courses of treatment should they give before they evaluate response — two, three, or more? Which imaging studies should be employed? When and in which sequence? Even for common tests such as a fecal occult blood test, the problem is not a trivial one: there are different test brands, using different technologies, with different sensitivity and specificity [Eddy, 1984]. Should a fecal occult test be followed by colonoscopy only when the test is positive? Can sigmoidoscopy suffice?

This type of uncertainty is often compounded by measurement uncertainty and low intra- and inter-observational agreement (see above). Much uncertainty about selection of a particular health care intervention nonetheless arises from *model uncertainty* and *lack of evidence* addressing a question of interest.

Model uncertainty refers to what is lost in the simplified picture of the real world used in our decision-making scenarios. Models in clinical medicine are typically based on a limited understanding of the underlying pathophysiology of diseases and the mechanisms of actions of health interventions. The model should be based on supporting evidence and explicit and transparent clinical logic, but often the basis is sketchy. The model is best tested by its predictions in validation studies, but subsequent revisions may remain unvalidated, leaving unresolved model uncertainty.

Lack of direct evidence, possibly the largest source of uncertainty in medicine, refers to the lack of research related to testing of a given diagnostic or treatment procedure on clinical outcomes of interest. The best direct evidence comes from "head-to-head" comparative trials in which the effects of one intervention are directly compared with the effects of another for all important outcomes patients care about (e.g. survival, quality of life etc). Unfortunately, direct evidence to inform our practice is often lacking. For example, it is estimated that in oncology only about 25% of decisions are supported by direct evidence [Djulbegovic *et al,* 1997]. Most decisions are based on indirect research evidence, i.e., evidence that does not directly address a particular question [Glenny *et al.,* 2005].

Uncertainty due to lack of evidence can in principle *be resolved* through empirical research. It is nonetheless impossible to empirically test every permutation of dozens of diagnostic tests and treatment interventions that are available for each condition. Most decisions in medicine will continue to be based on inferences from indirect evidence.

Perhaps the best we can do is to represent clinical or research scenarios based on explicit and transparent understanding of the current best science. Since we cannot test every idea we conceive, we must select what we should study.

This selection, however, leads to *research agenda bias*, a major threat to research integrity [Djulbegovic, 2007]

9.4 Uncertainty about treatment

In addition to the biases that plagues research evidence on therapy, treatment uncertainty arises because, for most disease, the effects of treatments are imperfect or incomplete [Dagli *et al.*, 2003; Djulbegovic *et al.*, 1997; Djulbegovic, 2004; Vincent and Djulbegovic, 2005]. Also, many treatments are associated with both benefits and harms. This all contributes to the incompleteness of our knowledge about treatment effects. Major therapeutic uncertainties include: (1) epistemic uncertainty regarding the accurate assessment of probability of outcomes arising from the fact that the majority of medical evidence is of low quality and unreliable (particularly regarding therapies), [Dagli *et al.*, 2003; Djulbegovic *et al.*, 1997; Djulbegovic, 2004; Vincent and Djulbegovic, 2005]. (2) uncertainty about applying treatment from the trial data ("averages") to individual patients (see above), and (3) integration of trade-offs and patients' preferences related to the choice of treatment (discussed below).

It is not surprising that, as in the case of ordering diagnostic tests, studies show dramatic differences among physicians when they are asked about the appropriateness and necessity of recommending given treatments. For example, when an expert panel was asked about recommending splenectomy for a patient with idiopathic thrombocytopenic purpura with a platelet count of <10,000/ccu, the range of opinions varied dramatically. Some experts would not wait longer than 2 weeks, while others would give steroids for up to 10 weeks [George *et al.*, 1996]. When they were asked how much annual fecal occult blood tests and flexible sigmoidoscopy would decrease colorectal cancer mortality, the answers varied from 0 to 100%!.....[Eddy, 1984]

Resolving therapeutic uncertainty: Therapeutic uncertainty is best resolved by reliable and relevant data. In fact, when evidence is of high quality, disagreement among experts usually disappears [Cruse *et al.*, 2002] However, results from such data must be available in intelligible form when and where it is needed [Djulbegovic 2004; Djulbegovic *et al*, 2006]. Thus, it is essential to have effective presentations of evidence in terms of a balance sheet summarizing benefits and harms of a given treatment. Since different presentations of evidence can result in different decisions, it is recommended that the effects be presented in several formats, as discussed below. Finally, when decisions involve complex trade-offs, therapeutic uncertainty is ideally handled using a formal decision theory approach, but this use may be beyond ordinary practice skills.

9.5 Uncertainty about prognosis

Prognostic uncertainty concerns predicting the future (what will happen to this particular patient?). It is typically expressed as the probability of outcome within

some time frame (e.g., there is a 5% probability that this patient will develop a heart attack within next 10 years). Physicians are generally not good prognosticators. For example, in predicting the course of cancer, they are correct only 10% to 30% of the time [Christakis, 2001].

Major sources of prognostic uncertainty include lack of evidence from which to forecast; biases (such as anchoring), and model uncertainty [McShane et al., 2005]. Another source of prognostic uncertainty relates to applying the "class probability to case probability."

Resolving prognostic uncertainty: When given enough data, statistical models are more accurate than human hunches [Hastie and Dawes, 2001; Dawes et al., 1989]. Hence, formal risk-prediction approaches are increasingly advocated [Vickers et al., 2008]. Model validation, such as using acceptable statistical techniques and testing predictions in external populations of patients, is considered the best way to address prognostic uncertainty [McShane et al., 2005].

9.6 Uncertainty about eliciting patients' values, preferences and risk attitudes

Uncertainty about eliciting patients' values and preferences is another major source of uncertainty in medicine. People hold different values in relation to the benefits, harms and costs of health care interventions. As discussed above, the contemporary psychological research is unanimous in the view that peoples' values and preferences are not stable but rather are often constructed during the process of elicitation [Lichenstein and Slovic, 2006; Kahneman and Tversky, 2000]. In addition, because medical interventions are inherently related to risk, people's attitudes toward risks and decisions in the face of risks and uncertainty also differ [Schwartz and Bergus, 2008] Some people are risk-neutral, while others are risk-averse or even risk-seeking. It is important to realize that there is no such thing as a right or wrong risk attitude. It is now widely accepted that risk attitude based on elicitation of a patient's own preferences should be accepted, even if it may not adhere to normative criteria of rationality or the values of physicians [Douard, 1996; Brock, 1990; Kahneman, 2003].

Resolving uncertainty about patients' preferences: Theoretically, we can address uncertainty about patient preferences by measuring them. Unfortunately, there is no ideal way to do so [Lichenstein and Slovic, 2006]. Elicitation is further complicated by the tendency of physicians to project their own risk attitude onto the elicitation, [Schwartz and Bergus, 2008] especially when expert panels develop guidelines to inform clinical practice based on preferences of "hypothetical patients."

10 DECISION-MAKING UNDER UNCERTAINTY

A core task of clinical medicine is decision-making, which is fraught with uncertainties every step of the way. We summarize this point with a case presentation:

A 60-year-old man presented to his physician in January with short-ness of breath without fever. The physician had already seen a number of patients who presented with similar complaints. He knew that this was a flu season, and he was told that the protective value of flu vac-cine is around 40% to 60%. His assistant reported that the patient's vital signs were normal except "slightly increased pulse" and "a some-what low blood pressure at 100/65 mmHg". The assistant also stated that the patient complained of cough, but when the doctor asked the patient about cough, he denied it. The doctor examined the patient and thought he heard diminished breathing at the right lower side of the lungs. The chest-X ray was read by a radiologist as "suspicious for pneumonia," but when the doctor looked at the X-ray, it looked rather normal to him. In addition, the radiologist made no comment regarding which type of pneumonia was suspected: viral, bacterial, or atypical? The patient had received both flu vaccine and pneumonia vaccine. Five other patients were waiting to see the doctor, and he had to make a quick decision. Should he send the sputum for cultures and a PCR (polymerase chain reaction) test for upper respiratory viruses and wait for the results to make a further decision? Should he prescribe an antibiotic for presumptive bacterial pneumonia? If so, which antibi-otic? Should he hospitalize the patient because of low blood pressure suggesting possible systematic infection? The patient told him that the last time he was at a doctor's office 3 years ago, he was told that he had a low blood pressure but was not told the exact value. The pa-tient stated that he would prefer to be treated at home, but he would do whatever "the doctor thinks is best." The physician successfully treated the last several cases with similar complaints symptomatically without antibiotics. Time was running out; what should the physician do?

Although the case just described appears complex, it is typical and might even be described as relatively easy; many decisions in medicine are considerably more complex. The case illustrates that we do not start with a "blank slate" [Hunink and Glasziou, 2001]: the patient's symptoms and signs represent data items that will be converted into information and actionable knowledge in the context of given clinical circumstances. The process is associated with many uncertainties regarding history (taking accuracy of eliciting information about cough varies from around 20% to 40%), [Eddy, 1984] physical examination (sensitivity and specificity of physical examination in diagnosis of pneumonia is only around 50% to 70% and 60% to 75%, respectively [Wipf et al., 1999]), the positive and negative predictive value of a chest X-ray for diagnosis of bacterial infection (around 75% and 57%, respectively); the choice of treatment vs. further diagnostic tests vs. symptomatic treatment without antibiotics, generalizing previous experience to this particular patient, ambiguity and vagueness (what does "slightly increased pulse" and blood pressure of 100/65 mmHg in the patient's context mean?), and cognitive constraint

due to time-pressure forcing physicians to make a decision and act within the allocated time.

What is the best way to handle this complex decision problem? In theory, the physician could apply decision analysis, which was developed to aid rational choice under uncertainty [Hastie and Dawes, 2001; Hunink and Glasziou, 2001]. He could model the situation as a decision tree that includes all courses of actions he can think of (such as whether to give antibiotics, treat symptomatically, or obtain further tests), assign probabilities to all possible outcomes (e.g., efficacy of antibiotics, probability of adverse events, sensitivity and specificity of test results), and assign consequences to each course of action in terms of morbidities and mortalities. He may even assign costs to each of the proposed alternative courses of action should he be interested in modeling cost-effectiveness. The solution of such a decision-tree model (which employs the expected utility criterion) would provide "optimal" normative advice to our physician [Hunink and Glasziou, 2001].

The typical doctor visit currently lasts 5 to 10 minutes [Jefferson, 2008]. It is impossible for a human mind to create a logically coherent and technically valid model, insert all variable values (even if data were available at one's fingertips, which in today's practice they almost never are), and come up with a sound decision within this time frame. Therefore, it is not surprising that physicians resort to heuristics as the key decision-making strategy [Kahneman et al, 2005]. In fact, psychological research has indicated that humans operate within a framework of bounded rationality [Kahneman, 2003] with a goal of "satisficing" [Simon, 1955; 1979] rather than "optimizing," [Schwartz et al., 2002] as expected utility theory would require. To satisfice is to pursue not the best option but rather a "good enough" (satisfactory) option [Schwartz et al., 2002]. Satisficers evaluate choices until they reach a threshold of acceptability, when making potentially bad decisions would be associated with tolerable, acceptable regret [Hozo and Djulbegovic, 2008; Djulbegovic et al., 2005]. Although it is not clear what theory best describes physicians' decision-making [Birnbaum and Navarrete, 1998; Birnbaum, 2008; Brandstatter and Gigerenzer, 2006], it is clear that physicians rarely use a deliberative, time-consuming analytical approaches (optimizing) [Hozo and Djulbegovic, 2009]. Rather, they rely on informal, intuitive decision-making to address uncertainty during typical clinical encounters [Dijksterhuis et al., 2006].

11 MANAGING UNCERTAINTY

Life under uncertainty is complex, is colored by stress, is fraught with anxiety due to lack of control, but also includes hope that uncertainty allows, as there is always the possibility that outcomes will be more favorable than initially feared. Reduction of uncertainty is essential to the practice of medicine, but elimination of uncertainty is impossible [Djulbegovic, 2004; Hastie and Dawes, 2001; Djulbegovic, 2007]. Rather, uncertainty must be "managed." Below is a brief discussion of the key approaches to management of uncertainty.

11.1 Acknowledgment of uncertainty

There is growing consensus that the first step in managing uncertainty, in the context of either clinical research or practice, is to admit and recognize that it exists [Eddy, 1984; Djulbegovic 2001; 2007; Chalmers, 2004; Legare, in press]. Once uncertainty is explicitly acknowledged, we can recognize the type of uncertainty we are facing, its underlying sources, and the means to reduce it [Djulbegovic, 2001; 2007].

11.2 Strategies to reduce complexities and distress associated with decisions under uncertainty

Figure 4. Conceptual model for factors influencing physicians' reactions to uncertainty (from Gerrity *et al.* [1995])

Physicians do not address uncertainties in the sharp categories listed above. In fact, as Figure 4 illustrates, the uncertainty inherent in clinical encounters is affected not only by physicians' reactions, but also by patients' reactions and by characteristics of where the encounter occurs [Gerrity *et al.*, 1990; 1995]. Nevertheless, it is physicians' reactions to uncertainty that are believed to influence

physicians' problem-solving abilities [Gerrity *et al.*, 1990; 1995]. If that is true, then it would appear that measurement of physicians' reactions to these uncertainties would represent one of the first steps in managing uncertainties. Gerrity *et al.* [1990; 1995] described a scale for measuring physicians' reactions to uncertainty (PRU) in patient care. Their refined PRU scale is composed of four constructs: anxiety due to uncertainty, concern about bad outcomes, reluctance to disclose uncertainty to patients, and reluctance to disclose mistakes to other physicians [Gerrity *et al.*, 1995]. PRU appears to reflect disclosure of uncertainty to patients, resource use, interpretation of diagnostic tests, decisional conflicts, and physicians' willingness to engage in shared decision-making [Gerrity *et al.*, 1995; Legare, in press].

Presumably, alleviating the burden and unpleasantness associated with uncertainty should improve decision-making and patients' outcomes [Legare, in press]. According to this view, uncertainty is an undesirable state. To effectively manage it, one can first screen for decisional conflict [Legare, in press] (defined as the uncertainty about which course of action to take when competing actions involve various trade-offs such as risks, loss, regret, or challenge to personal values) by utilizing instruments such as the 16-item Decision Conflict Scale [O'Connor, 1995; O'Connor, 1997] This scale evaluates the level of certainty and clarifies values and information to assess the perceived state of uncertainty, which in turn may help identify areas for which decision support is needed and may encourage shared decision-making [Legare, in press]

11.3 *Identify relevant and reliable evidence: balance sheet*

Since less than 1% of published evidence is judged to be important for practicing physicians, [Vincent and Djulbegovic, 2005; Haynes *et al.*, 2006] it is crucial to identify the relevant, reliable evidence for the most important clinical decisions [Djulbegovic, 2004]. Such a compilation should present outcomes associated with benefits and harms of therapeutic interventions, sensitivity and specificity of diagnostic tests, validity of risk predictions models, and perhaps costs [Djulbegovic *et al*, 2006; Eddy, 1990]. To make this resource useful, evidence has to be continuously and systematically accumulated in a manner adhering to the principle of total evidence [Chalmers, 2001; 2006; Chalmers *et al.*, 2002; Djulbegovic, 2003]. This type of undertaking is one of the key investments that society must make if dismal outcomes seen in contemporary practice [Commitee on Quality of Health Care in America, 2001] are to improve [McClellan *et al.*, 2008].

11.4 *Clinical practice guidelines and systematic review of the totality of relevant evidence*

Clinical practice guidelines (CPGs) have evolved as a reaction to wide variation in the practice of medicine, which, as argued above, is mostly due to uncertainty. CPGs are defined as systematically developed statements to assist practitioners

and patients choose appropriate health care in specific circumstances [Field and Lohr, 1990]. There are different methods for developing CPGs [Eddy, 1990; Woolf, 1992]. Some are based on informal consensus [Winn *et al*, 1996], while others are based on evidence-driven consensus of the expert panels [Guyatt *et al.*, 2008]. The evidence-based guidelines panels use systematic reviews to inform their recommendations. Systematic reviews employ a specific set of techniques to identify, critically appraise, and synthesize all relevant evidence on a given topic. While CPGs are increasingly popular, and in many respects have revolutionized the practice of medicine, evidence that they have actually improved patient outcomes is lacking [Timmermans and Mauck, 2005; Boyd *et al.*, 2005]. Consensus-based guidelines suffer from the risk of cascade to a mistaken consensus because individual panel members are influenced by the recommendations of other (and often more influential) members of the panels [Hirshleifer and Teoh, 2003]. All guidelines suffer from methodologic difficulties concerning how to incorporate patients' preferences and instead rely on projections of the panel members' preferences as surrogates for patients' preferences [Guyatt *et al.*, 2008].

11.5 *Using probability theory and decision analysis*

While many decisions will not require formal use of probability and decision-modeling, such approaches to decision-making can outperform unaided human judgments [Hastie and Dawes, 2001]. Many obstacles, particularly the time pressure discussed above, must be overcome for widespread use of these models. Nonetheless, further development of information technology will facilitate generic development of decision models, which can be customized for use at the bedside in "real time" (discussed below) [Sim *et al.*, 2001].

11.6 *Communicating the uncertainty*

Communication of uncertainty ("risk communication") is critical for rational decision-making, although best practices for communicating uncertainty about benefits and harms of most medical interventions have yet to be identified [Lipkus, 2007; Politi *et al.*, 2007]. Such communication should occur in the setting of shared decision-making, defined as a joint process shared by the physician and patient. Communication is considered effective when it leads to engagement in recommended behavior, when the target audience pays attention to the message, when it results in improved acquisition in knowledge, acceptable effects on emotions, and accurate judgments of perceived risks and benefits, and when it results in a message that is credible, accurate, useful, relevant, comprehensive, trustful, clear, and easy to understand [Lipkus, 2007]. To achieve these effects, a number of formats have been evaluated: numeric communication of risk and uncertainty presented as the probability or frequency (e.g., "Your lifetime risk of getting breast cancer is 5%" or "5 out of 100 women like you will develop breast cancer during their lifetime") [Gigerenzer and Hoffrage, 1995; Schwartz and Bergus, 2008], verbal

communication ("It is unlikely that you will develop breast cancer"), and visual tools to express risk and uncertainty (e.g., bar charts can compare magnitude of risks of an individual patient getting breast cancer with the "average" risk in general population). All formats can include uncertainty measures such as confidence intervals or crediblity intervals, or can frame information in terms of relative or absolute effect measures, [Covey, 2007] gains (benefits), or losses (risks/harms), and do it so either simultaneously or sequentially [Kahneman and Tversky, 1982; 2000; Kahneman and Frederick, 2006].

The communication format is crucial because, as explained above, people often do not have a priori stable opinions about the magnitude of risks and benefits, and their beliefs and attitudes crystallize during the process of elicitation [Lichenstein and Slovic, 2006; Lipkus, 2007]. It is thus not surprising that when identical treatment effects are presented in terms of relative effect measures (e.g., "screening reduces risk of death due to breast cancer by 33%"), more people opt for screening than when it is communicated as absolute effect measures (e.g., "screening reduces risk of death from breast cancer from 3% to 2%), despite the fact that the two statements are mathematically equivalent [Hall, 1995; Fahey et al., 1995; Covey, 2007]. Decision aids are promoted as the technical device that can improve risk and uncertainty communications [O'Connor et al., 2003]. When used with care, decision aids appear to improve decision quality [O'Connor et al., 2003].

11.7 Clinical decision support systems

As illustrated above, many avoidable shortcomings in health care occur because of uncertainty resulting from not having evidence at the time and place it is needed [Djulbegovic, 2004]. This suggests that major investment should be made in information technology not only to improve connectivity between fragmented aspects of modern health care, but also to enable effective management of data, information, and knowledge using clinical decision support systems (CDSS) [Detmer, 2003]. Electronic medical records (EMRs) are considered one of the prerequisites for effective management of clinical information [Emanuel et al., 2007; Basch, 2005; Carter, 2008]. CDSS is broadly defined as "any automated tool that helps clinicians improve the delivery or management of patient care. Ideally, CDSS is a set of knowledge-based tools that are fully integrated with both the clinician workflow components of an EMR and a repository of complete and accurate clinical data" [Perreault and Metzger, 1999; Carter, 2008]. For example, CDSS is typically used to *alert* help providers (e.g., highlighting critical value of potassium level), *remind* (e.g., annual breast cancer screening for women 50 to 70 years of age), *critique* (e.g., rejecting duplicate orders), *interpret* (e.g., use ECG to interpret/diagnose atrial fibrillation), *predict* (e.g., calculate risk for myocardial infarction), *diagnose* (e.g., list differential diagnosis in the patient with abdominal pain), *assist* (e.g., modify drug dosage in patients with renal failure), *suggest* (e.g,. generate suggestions for mechanical ventilator weaning), [Carter, 2008] *guide decision-making* [Sim et al., 2001] (e.g., provide guidelines for the management of deep venous thrombosis, and

provide a full customized decision-making module for whether to give heparin or order further diagnostic tests, depending on the patient's symptoms and signs).

11.8 Training for uncertainty

It has been asserted that failure to educate physicians about uncertainty is "the greatest deficiency of medical education throughout the twentieth century" [Ludmerer 1999]. Most physicians are trained in technical aspects of clinical care but not in the fundamentals of scientific methodology [Altman, 1994; 2002]. Medical curricula need to provide information on how one can avoid biases in judgments under uncertainty and how clinical research should be approached, which includes not only statistics, but also principles of study design, conduct, data collection, analysis, and interpretation. Training should also include the basics of probability as a method for quantifying uncertainty, along with formal methods of decision-making under uncertainty such as incorporating evidence synthesis (meta-analysis) within decision-analysis and economic analysis. In recent years, there has been widespread promotion of courses on evidence-based medicine, which to some extent have taught these topics. We hope that the 21st century will not repeat the education failure of 20th century.

11.9 Clinical research as a strategy to address clinical uncertainties

It can be argued that the research enterprise has evolved in order to address uncertainties [Hastie and Dawes, 2001; Djulbegovic, 2007]. Clinical research, therefore, has become the main means to address and resolve some of the uncertainties of interest to a decision-maker.

11.9.1 Matching study design with taxonomy of clinical uncertainties

Uncertainties, as discussed throughout the text, come in "grades and shades." These can range from complete uncertainty to simply not having the factual confirmation for what is an otherwise sufficiently clear understanding of what is going on (Figure 1) [Djulbegovic, 2007]. The first step in using (empirical) research to shape our responses to uncertainties is to acknowledge and articulate the existing uncertainties [Djulbegovic, 2007; 2001; Chalmers, 2004]. We can then arrange them according to their perceived magnitude and thus develop a taxonomy of (clinical) research uncertainties [Djulbegovic, 2007]. Figures 5a and 5b show one such taxonomy. Like any taxonomy, the one proposed is somewhat artificial and cannot be precisely quantified. Its main value is to express level of uncertainty in such a way that it can be tailored to specific clinical research designs. According to this view, RCTs are best for resolving uncertainties when alternatives are clearly formulated and when there is no convincing evidence that one treatment is better than the other (i.e., when we are in equipoise) [Djulbegovic, 2007]. On the other hand, when the effects of interventions are convincingly clear from mechanistic

and animal studies, observational studies may suffice for decision-making, [Djulbegovic, 2007; Glasziou *et al.*, 2007] with weaker observational evidence required when stronger odds can be obtained from such studies [Vandenbroucke, 2008]. In the extreme, if a compound is found to kill laboratory rats at dosages comparable to proposed human treatments, we need not even a single case report to justify no further use of the compound.

Hierarchy of study designs according to prior odds for *intended effects in therapy*

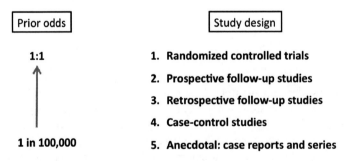

Figure 5. Taxonomy of uncertainties (from Djulbegovic [2007] Behera *et al.* [2007] Vandenbroucke [2008])

11.9.2 *Assessing what is known through research synthesis*

As discussed earlier, there is a fundamental relation between the state of existing knowledge and the perceived level of uncertainty. Therefore, a scientific and ethical

imperative [Djulbegovic, 2001, 2007; Chalmers, 2004] is to assess the quality of the
existing knowledge, i.e., what is known on a particular issue and how good that
knowledge is. As highlighted previously, this imperative is based on the epistemic
principle of total evidence [Good, 1967; Djulbegovic *et al.*, 2009]. The technique of
systematic review has emerged as arguably the best method to synthesize existing
research and assess its reliability. Using such techniques, uncertainties about the
existing knowledge regarding treatment effects can be classified as:

1. *Inevitable or irreducible uncertainty* **of applying class probability
 to individual cases.** "We know sufficiently about the treatment effects
 to inform our choices, but there is inevitable uncertainty about how the
 treatment will affect you." This is similar to arguments made by von Mises
 [von Mises, 1957] that the specific case probability is not open to numerical
 evaluation (see above).

2. *Uncertain certainty (unknown knowns).* We don't know what is known
 about treatment effects. However, this can be known if we perform system-
 atic synthesis of existing evidence (systematic review) [Evans *et al.*, 2006]

3. *Certain uncertainty (known unknowns).* We know that we don't know
 since systematic synthesis of the existing evidence has shown us that what
 we need to know isn't known. According to this view, it is ethical to proceed
 with clinical trials in humans (as a means to address a given uncertainty) only
 if systematic review concluded that there is "certain uncertainty" [Chalmers,
 2001]. Indeed, this view has been espoused by several major research organi-
 zations such as Medical Research Council in England, which will not approve
 a new clinical trial until it is preceded by systematic review to address uncer-
 tainties at hand [Chalmers, 2001]. Only if systematic reviews show that there
 is uncertainty (as, for example, indicated by wide confidence intervals or the
 lack of reliable evidence about the relative effects of two competing treat-
 ments) is a new clinical trial in humans justified to settle these uncertainties
 [Chalmers, 2001; Evans *et al*, 2006; Djulbegovic, 2003]. Once this trial has
 been completed, its results should then be assimilated systematically with
 existing knowledge. Therefore, in this view, uncertainties are being continu-
 ally addressed by systematic accumulation of evidence: research starts and
 finishes with systematic review [Clarke *et al*, 2002; Clarke, 2004].

12 EMBRACING UNCERTAINTY

The views expressed above imply that uncertainty is an undesirable state. Indeed,
most people abhor uncertainty since it makes decisions difficult and it does not
allow control over unpredictable events — in short, it interferes with our life plans.
However, there is a paradox in dealing with uncertainty: imagine a life without
uncertainty, a future that is totally predictable and deterministic, with no choice
to be made, no trade-offs to consider, and nothing to hope for [Djulbegovic, 2004;

Hastie and Dawes, 2001; Schwartz and Bergus, 2008]. In the context of medical decisions, most people might become resigned to the future regardless of how bleak it looks. However, acceptance of uncertainty means we can rationally engage in a decision-making process [Hastie and Dawes, 2001; Nelson *et al.* , 2007] with the hope that we can shrink the domain of the unpredictable and steer it toward favorable outcomes. So, the wisdom is to learn how to live with uncertainty, knowing that it is unavoidable, that it cannot be totally eliminated, but that it can be reduced. In essence, this means knowing when we can affect the future and when we cannot. We need to remember that good decisions can result in bad outcomes and bad decisions can produce good outcomes [Edwards *et al.*, 2007; Hastie and Dawes, 2001]

Outside of being clairvoyant, the best we can do is to scrutinize our decisions and learn how to make good ones. That is the key to decision-making under uncertainty [Edwards *et al.*, 2007; Hastie and Dawes, 2001]. The management of uncertainty revolves around assessing what is uncertain, appreciating the limits of our knowledge, grasping its probabilistic nature, and understanding when uncertainty should be accepted and when it should be addressed using one of the means described above.

13 ETHICS OF UNCERTAINTY

Although uncertainty can be experienced both negatively (e.g., involving fear, anxiety, panic) and positively (e.g., maintaining hope and optimism), [Politi *et al.*, 2007] most commentators maintain that it should be shared with patients and the public [Henry, 2006; Smith, 1992]. In recognition that research is key toward reducing uncertainty, the British General Medical Council states that physicians have a professional responsibility to help address uncertainties about the effects of health care interventions [Chalmers, 2007]:

> You must work with colleagues and patients to maintain and improve
> the quality of your work and promote patient safety. In particular
> you must. . . .help resolve uncertainties about the effects of treatments.
> [General Medical Council, 2007]

Nonetheless, recognition that scientific methods are fallible and that absolute certainty is impossible [Popper, 1959; Audi, 2003; Djulbegovic and Hozo, 2007; Hozo *et al,* 2008] has also led to a manipulation of uncertainties to promote interests of various parties [Michaels, 2005]. The classic example involves uncertainties raised with respect to harmful effects of tobacco [Michaels, 2005]. The lack of "definitive" scientific proof that smoking is harmful to one's health resulted in postponement of tobacco legislation for decades, with the unfortunate consequences of much avoidable disease [Michaels, 2005; Parascandola, 2007]. Most recently, this practice has been adopted by some pharmaceutical companies as well as the manufacturers of substances that are potentially toxic to our environment and to our health [Michaels, 2006].

14 CONCLUSIONS

Uncertainty is inherent in medicine. It occurs at every level of the clinical practice and research. It has multiple causes, with important implications for decision-making, quality of care, and patient management. It will remain a central feature of medical practice. However, uncertainty can be effectively managed by explicitly recognizing its many sources, improving the quality of medical evidence, using better information technology tools, searching for sources of bias, and applying probability and decision theory to decisions under uncertainty.

ACKNOWLEDGEMENT

We wish to thank Drs. Fred Gifford and Iain Chalmers for their invaluable comments and edits, which helped improve the content and the scope of this text. We also thank Dr. Chalmers for sharing his presentation on uncertainty, and in particular on his views on the role of systematic reviews as a means to help resolve clinical uncertainties.

BIBLIOGRAPHY

[Achinstein, 2004] P.E. Achinstein. *Science rules. A historical introduction to scientific methods.* . Baltimore: The John Hopkins University Press, 2004
[Achinstein, 2005] P.E. Achinstein., *Science evidence. Philosophical theories and applications.* . Baltimore: The John Hopkins University Press, 2005.
[Allais, 1953] M. Allais. Le compartment de l'homme rationnel devant le risque. Critque des postulates et axiomes de l'ecole Americaine, *Econometrica* 21:503-546, 1953.
[Altman, 1994] D. Altman. The scandal of poor medical research, *BMJ* 308:283-284, 1994.
[Altman, 2002] D. Altman. Poor-Quality Medical Research: What Can Journals Do?, *JAMA* 287 (21):2765-2767, 2002.
[Altman et al., 2001] D. Altman, K. F. Schultz, and D. Moher, for the CONSORT group.The revised CONSORT statement: explanation and elaboration. *Ann Intern Med* 134:663-694, 2001.
[Audi, 2003] R. Audi. *Epistemology. A contemporary introduction to the theory of knowledge.2nd.* New York: Routledge, 2003.
[Baron, 2000] J. Baron. *Thinking and deciding.3rd ed.* Cambridge: Cambridge University Press, 2000.
[Baron, 2007] J. Baron. *Thinking and deciding.4th ed.* Cambridge: Cambridge University Press, 2007.
[Basch, 2005] P. Basch. Electronic health records and the national health information network: affordable, adoptable, and ready for prime time? *Ann Intern Med* 143 (3):227-228, 2005.
[Bayes, 1764] T. Bayes. An assay toward solving a problem in the doctrine of chances. *Philosphical Transactions of the Royal Society of London* 53:370-418, 1764.
[Behera et al., 2007] M. Behera, A. Kumar, H. P. Soares, L. Sokol, and B. Djulbegovic. Evidence-based medicine for rare diseases: implications for data interpretation and clinical trial design, *Cancer Control* 14 (2):160-166, 2007.
[Bell, 1982] D. Bell. Regret in Decision Making under Uncertainty, *Operations Research* 30:961-981, 1982.
[Bell et al., 1988] D. Bell, H. Raiffa, and A. Tversky. *Decision making. Descriptive, normative, and prescriptive interactions,* Cambridge: Cambridge University Press, 1988.
[Benson and Hartz, 2000] K. Benson and A. J. Hartz. A comparison of observational studies and randomized, controlled trials, *N Engl J Med* 342 (25):1878-1886, 2000.

[Berner and Graber, 2008] E. Berner and M.Graber. Overconfidence as a cause of diagnostic error in medicine, *Am J Med* 121 (5 Suppl):S2-23, 2008.

[Bikchandani *et al.*, 1998] S. Bikchandani, D. Hirshfleifer, and I. Welch. Learning from behavior of others: conformity, fads, and informational cascades, *J Econ Perspectives* 12:151-170, 1998.

[Birnbaum, 1999a] M. Birnbaum . Paradoxes of Allais, stochastic dominance, and decision weights.in B. Shanteau, A. Mellers and D.A. Schum (eds.), *Decision science and technology: Reflections on the contributions of Ward Edwards* Norwell, MA: : Kluwer Academic Publishers., 27-52, 1999.

[Birnbaum, 1999b] M. Birnbaum. Testing critical properties of decision making on the Internet, *Psychological Science* 10:399-407, 1999.

[Birnbaum, 2008] M. Birnbaum. New paradoxes of risky decision making, *Psychological Review* 115:463-501, 2008.

[Birnbaum and Navarrete, 1998] M. Birnbaum and J. Navarrete. Testing descriptive utility theories: Violations of stochastic dominance and cumulative independence, *Journal of Risk and Uncertainty* 17:49-78, 1998.

[Birnbaum *et al.*, 1999] M. Birnbaum, J. Patton and M. Lott. Evidence against Rank-Dependent Utility Theories: Tests of Cumulative Independence, Interval Independence, Stochastic Dominance, and Transitivity, *Organ Behav Hum Decis Process* 77 (1):44-83, 1999.

[Bossuyt *et al.*, 2003] P. Bossuyt, J. Reitsma, D. Bruns, C. Gatsonis, P. Glasziou, L. Irwig, D. Moher, D. Rennie, H. de Vet, and J. Lijmer. The STARD Statement for reporting of studies of diagnostic accuracy: explanation and elaboration, *Clin Chem* 49:7-18, 2003.

[Boutron *et al.*, 2003] I. Boutron, D. Moher, D. Altman, K. Schulz, P. Ravaud and C. G. for the, Extending the CONSORT Statement to Randomized Trials of Nonpharmacologic Treatment: Explanation and Elaboration, *Ann Intern Med* 148 (4):295-309, 2003.

[Boyd *et al.*, 2005] C.Boyd, J. Darer, C. Boult, L. Fried, L. Boult and A. Wu. Clinical Practice Guidelines and Quality of Care for Older Patients With Multiple Comorbid Diseases: Implications for Pay for Performance, *JAMA* 294 (6):716-724, 2005.

[Brandstatter and Gigerenzer, 2006] E. Brandstatter and G. Gigerenzer. The Priority Heuristic: Making Choices Without Trade-Offs, *Psychological Review* 113:409-432, 2006.

[Brock, 1990] D. Brock. When competent patients make irrational choices, *N Engl J Med* 322:1595-1599, 1990.

[Camerer and Weber, 1992] C. Camerer and M. Weber. Recent develpments in modeling preferences:uncertainty and ambiguity, *J Risk Uncertainty* 5:325-370, 1992.

[Carter, 2008] J.Carter. *Electronic Health Records.2nd ed.* Philadelphia: ACP Press, 2008.

[Chalmers, 2001] I. Chalmers. Using systematic reviews and registers of ongoing trials for scientific and ethical trial design, monitoring, and reporting. in M. Egger, G.D. Smith and D.G. Altman (eds.), *Systematic reviews in health care. Meta-analysis in context.*, London: BMJ, 429-443, 2001.

[Chalmers, 2004] I. Chalmers. Well informed uncertainties about the effects of treatments, *BMJ* 328 (7438):475-476, 2004.

[Chalmers, 2004] I. Chalmers. *Why comparisons must address genuine uncertainties.* http://www.jameslindlibrary.org/essays/comparisons/genuine_uncertainties.html, 2004.

[Chalmers, 2006] I. Chalmers.Why fair tests are needed: a brief history, *ACP Journal Club.* Jul-Aug;145:A8-A9, 2006.

[Chalmers, 2007] I. Chalmers. Addressing uncertainties about the effects of treatments offered to NHS patients: whose responsibility? *J R Soc Med* 100 (10):440-441, 2007.

[Chalmers *et al.*, 2002] I. Chalmers, L. V. Hedges and H. Cooper. A brief history of research synthesis, *Eval Health Prof* 25:12-37, 2002.

[Christakis, 2001] N. Christakis. *Death Foretold. Prophecy and prognosis in medical care.* Vol. 11. Chicago: The University of Chicago Press, 2001.

[Clarke, 2004] M. Clarke. Doing new research? Don't forget the old, *PLoS Med* 1 (2):e35, 2004.

[Clarke *et al.*, 2002] M. Clarke, P. Alderson and I. Chalmers. Discussion sections in reports of controlled trials published in general medical journals, *JAMA* 287:2799-2801, 2002.

[Collins and McMahon, 2001] R. Collins, and S. McMahon. Reliable assessment of the effects of treatment on mortality and major morbidity,I: clinical trials, *Lancet* 357:373-380, 2001.

[Colyvan, 2008] M. Colyvan. Is probability the only coherent approach to uncertainty? *Risk Anal* 28 (3):645-652, 2008.

[Committee, 2001] Commitee on Quality of Health Care in America. *Institute of Medicine. Crossing the quality chasm. A New Health System for the 21st Century.* Washington, DC: National Academy Press, 2001.

[Concato et al., 2000] J. Concato, N. Shah and R. I. Horwitz. Randomized, controlled trials, observational studies, and the hierarchy of research designs, *N Engl J Med* 342 (25):1887-1892, 2000.

[Covey, 2007] J. Covey. A meta-analysis of the effects of presenting treatment benefits in different formats, *Med Decis Making* 27 (5):638-654, 2007.

[Cruse et al., 2002] H. Cruse, M. Winiarek, J. Marshburn, O. Clark and B. Djulbegovic. Quality and methods of developing practice guidelines, *BMC Health Service Research* 2002;2:1, 2002. http://www.biomedcentral.com/1472-6963/2/1.

[Curley, 2007] S.Curley. The application of Dempster-Shafer theory demonstrated with justification provided by legal evidence, *Judgment and Decision Making* 5:257-276, 2007.

[Cutler, 1985] P. Cutler. *Problem solving in medicine.* Baltimore: Williams & Wilkins, 1985.

[Dagli et al., 2003] A. Dagli, R. Morse, C. Dalton, J. Owen and G. Hayden. Formulating clinical questions during community preceptorships: a first step in utilizing evidence-based medicine, *Fam Med* 35:619-621, 2003.

[Daley, 1999] J. Daley. Medical uncertainty and practice variation get personal: what should I do about hormone replacement therapy? *Ann Intern Med* 130:602-603, 1999.

[Dartmouth Atlas of Health Care, 2009] Dartmouth *Institute for Health Policy and Clinical Practice. The Dartmouth Atlas of Health Care* cited. Available from http://www.dartmouthatlas.org/.

[Davies, 2007] K. Davies. The information-seeking behavior of doctors: a review of the evidence, *Health Info Libr J* 24 (2):78-94, 2007.

[Dawes et al., 1989] R. Dawes, D. Faust, and P. Meehl. Clinical versus actuarial judgment, *Science* 243 (4899):1668-1674, 1989.

[DeSa, 2008] J. P.M. De SA. *Chance. The life of games and the game of life.* Berlin: Springer, 2008.

[DeFinetti, 1974] B. DeFinetti. *The theory of probability.* New York: Wiley,1974.

[Detmer, 2003] D. Detmer. Building the national health information infrastructure for personal health, health care services, public health, and research, *BMC Med Inform Decis Mak* 3:1, 2003.

[Diamond and Forrester, 1983] G. Diamond, and J. Forrester. Metadiagnosis. An epistemologic model of clinical judgment. *Am J Med.* 75:129-137, 1983.

[Dijksterhuis et al., 2006] A. Dijksterhuis, M. Bos, L. Nordgren and R. van Baaren. On Making the Right Choice: The Deliberation-Without-Attention Effect, *Science* 311 (5763):1005-1007, 2006.

[Djulbegovic, 2001] B. Djulbegovic. Acknowledgment of Uncertainty: A Fundamental Means to Ensure Scientific and Ethical Validity in Clinical Research, *Current Oncology Reports* 3:389-395, 2001.

[Djulbegovic, 2003] B. Djulbegovic. Principles of research synthesis. in M. Perry (ed.), *ASCO Educational Session, 39 Annual Meeting,* Washington, DC: ASCO, 737-750, 2003.

[Djulbegovic, 2004] B. Djulbegovic. Lifting the fog of uncertainty from the practice of medicine, *BMJ* 329 (7480):1419-1420, 2004.

[Djulbegovic, 2004] B. Djulbegovic. Well informed uncertainties about the effects of treatment: Paradox exists in dealing with uncertainty, *BMJ* 328 (7446):1018-, 2004.

[Djulbegovic, 2006] B. Djulbegovic. Evidence and decision-making, *J Eval Clin Practice* 12:248-256, 2006.

[Djulbegovic, 2007] B. Djulbegovic. Articulating and responding to uncertainties in clinical research, *J Med Philosophy* 32:79-98, 2007.

[Djulbegovic et al., 2005] B. Djulbegovic, A. Frohlich and C. Bennett. Acting on Imperfect Evidence: How Much Regret Are We Ready to Accept? *J Clin Oncol* 23 (28):6822-6825, 2005.

[Djulbegovic et al., 2009] B. Djulbegovic, G. Guyatt, and R. Aschroft . Epistemological inquiries in evidence-based medicine, *Cancer Control 16:158-169,2009*

[Djulbegovic and Hozo, 2007] B. Djulbegovic and I. Hozo. When Should Potentially False Research Findings Be Considered Acceptable? *PLoS Medicine* 4 (2):e26, 2008.

[Djulbegovic *et al.*, 2000] B. Djulbegovic, I. Hozo, and G. Lyman. Linking evidence-based medicine therapeutic summary measures to clinical decision analysis, *MedGen-Med* http://www.medscape.com/Medscape/GeneralMedicine/journal/2000/v2002.n2001/mgm0113.djul/mgm0113.djul-2001.html,2000

[Djulbegovic *et al.*, 1999] B. Djulbegovic, I. Hozo, A. Schwartz, and K. McMasters. Acceptable regret in medical decision making, *Med Hypotheses* 53:253-259, 1999.

[Djulbegovic *et al.*, 1999] B. Djulbegovic, T. P. Loughran, Jr., C. A. Hornung, G. Kloecker, E. N. Efthimiadis, T. J.Hadley, J. Englert, M. Hoskins, and G. H. Goldsmith. The quality of medical evidence in hematology-oncology. *The American Journal of Medicine*, 106(2):198-205, 1999.

[Djulbegovic *et al.*, 2006] B. Djulbegovic and G. Lyman. Screening mammography at 40-49 years: regret or no regret? *Lancet* 368 (9552):2035-2037, 2006.

[Djulbegovic *et al.*, 2000] B. Djulbegovic, G. Lyman and J. Ruckdeschel. Why Evidence-based Oncology, *Evidence-based Oncology* 1:2-5, 2000.

[Djulbegovic *et al.*, 2006] B. Djulbegovic, H. Soares and A. Kumar.What kind of evidence do patients and practitioners need: Evidence profiles based on 5 key evidence-based principles to summarize data on benefits and harms, *Cancer Treatment Reviews* 32 (7):572-576.

[Djulbegovic and Sullivan, 1997] B. Djulbegovic, and D. S. Sullivan, eds. (1997), *Decision Making in Oncology. Evidence-based management.* New York: Churchill Livingstone, Inc.

[Douard, 1996] J. Douard. Is risk neutrality rational? *Med Decis Making* 16:10-11, 1996.

[Eddy, 1990] D. Eddy. Comparing benefits and harms: the balance sheet, *JAMA* 263:2493-2505, 1990.

[Eddy, 1990] D. Eddy.Variations in physician practice: the role of uncertainty, *Health Aff* 3 (2):74-89, 1990.

[Eddy, 1990] D. Eddy.Practice polices: guidelines for methods, *JAMA* 263:1839-1841, 1990.

[Eddy and Billings, 1988] D. Eddy and J. Billings. The quality of medical evidence: implications for quality of care, *Health Aff* 7 (1):19-32, 1988.

[Edwards *et al.*, 2007] W. Edwards, R. Miles, Jr. and D. von Winterfeld, *Advances in decision analysis. From foundations to applications.* Edited by. New York: Cambridge University Press, 2007.

[Ellsberg, 1961] D. Ellsberg. Risk, ambiguity, and the Savage axioms, *Quart J Economics* 75:643-669, 1961.

[Emanuel *et al.*, 2007] E. Emanuel, V. Fuchs, and A. Garber. Essential Elements of a Technology and Outcomes Assessment Initiative, *JAMA* 298 (11):1323-1325, 2007.

[Evans *et al.*, 2006] I. Evans, H. Thornton, and I. Chalmers. *Testing Treatments: better research for better healthcare* London: British Library, 2006.

[Fahey *et al.*, 1995] T. Fahey, S. Griffiths and T. J. Peters. Evidence-based purchasing:understanding results of clinical trials and systemetic reviews. *BMJ* 311:1053-1056, 1995.

[Fields and Lohr, 1990] M. Field and K. Lohr, eds. *Clinical practice guidelines:directions for a new agency.* Washigton: Institute of Medicine, National Academy Press, 1990.

[Fisher *et al.*, 2003] E. Fisher, D. Wennberg, T. Stukel, D. Gottlieb, F. Lucas and E. Pinder. The implications of regional variations in Medicare spending. Part 1: the content, quality, and accessibility of care, *Ann Intern Med* 138 (4):273-287, 2003.

[Fisher, 2003] E. Fisher. The implications of regional variations in Medicare spending. Part 2: health outcomes and satisfaction with care, *Ann Intern Med* 138 (4):288-298, 2003.

[Foster, 2001] C. Foster. *The ethics of medical research on humans.* Cambridge: Cambridge University Press, 2001.

[Fox, 1957] R. Fox. Training for uncertainty, in R. Merton, G.C. Reader and P. Kendall (eds.), *The student-physician: introductory studies in the sociology of medical education.*, Cambridge, MA: Harvard University Press, 1957.

[Fox, 1957] R. Fox. The evolution of medical uncertainty, *Milbank Mem Fund Quaterly/Health and Soc* 58:1-49, 1957.

[Gabbay and May, 2004,] J. Gabbay and A. le May. Evidence based guidelines or collectively constructed mindlines? Ethnographic study of knowledge management in primary care, *BMJ* 329 (7473):1013-1010, 2004.

[General Medical Council, 2007] General *Medical Council.Good Medical Practice.* London: GMC, 2007.

[George et al., 1996] J. George, S. Woolf, G. Rakob, and e. al. Idiopathic thrombocytopenic purpura: a practice guideline developed by explicit methods for the American Society of Hematology, *Blood* 88:3-40, 1996.

[Gerrity et al., 1990] M. Gerrity, R. DeVellis and J. Earp. Physicians' reaction to uncertainty in patient care. A new measure and new insights, *Med Care* 28:724-736, 1990.

[Gerrity et al., 1990] M. Gerrity, R. DeVellis and J. Earp. Physicians' reactions to uncertainty in patient care. A new measure and new insights, *Med Care* 28 (8):724-736, 1990.

[Gerrity et al., 1995] M. Gerrity, M. White, R. DeVellis and R. Dittus. Physicians' reaction to uncertainty: refining the constructs and scales, *Motivation and Emotion*. 3:175-191, 1995.

[Gigerenzer and Hoffrage, 1995] G. Gigerenzer and U. Hoffrage. How to improve Bayesian reasoning without instruction: Frequency formats, *Psychology Review* 102:4-704, 1995.

[Gigerenzer and Todd, 1999] G. Gigerenzer and P. Todd, *and the ABC Research Group. Simple Heuristics That Make Us Smart.* New York: Oxford University Press, 1999.

[Gill et al., 2005] C. Gill, L. Sabin, and C. Schmid. Why clinicians are natural bayesians, *Bmj* 330 (7499):1080-1083, 2005.

[Glasziou et al., 2007] P. Glasziou, I. Chalmers, M. Rawlins, and P. McCulloch. When are randomised trials unnecessary? Picking signal from noise, *BMJ* 334 (7589):349-351, 2007.

[Glasziou and Irwig, 1995] P. Glasziou and L. M. Irwig. An evidence based approach to individualising treatment, *BMJ* 311:1356-1359, 1995.

[Glenny et al., 2005] A. Glenny, D. Altman, F. Song, C. Sakarovitch, J. Deeks, R. D'Amico, M. Bradburn, and A. Eastwood. Indirect comparisons of competing interventions, *Health Technol Assess* 9 (26):1-134, iii-iv, 2005.

[Goble, 2001] L. Goble. *The Blackwell Guide to Philosophical Logic*. Oxford: Blackwell Publishing, 2001.

[Good, 1967] I. Good. On the principle of total evidence, *Br J Phil Sci* 17:319-321, 1967.

[Goodman, 1999] S. Goodman. Probability at the bedside: the knowing of chances or the chances of knowing, *Ann Intern Med* 130:604-606, 1999.

[Goodman, 1999] S. Goodman. Toward evidence-based medical statistics. 2: the Bayes factor, *Ann Intern Med* 130:1005-1013, 1999.

[Goodman, 1999] S. Goodman. Toward evidence-based medical statitistics. 1: the p value fallacy, *Ann Intern Med* 130:995-1004, 1999.

[Greenland, 1998] S. Greenland. Probability logic and probabilistic induction, *Epidemiology* 9:322-332, 1998.

[Greenland, 2005] S. Greenland. Multiple-bias modeling for analysis of observational data, *J R Statist Soc* 168 (Part 2(A)):267-306, 2005.

[Greenland, 2006] S. Greenland. Bayesian perspectives for epidemiological research: I. Foundations and basic methods, *Int J Epidemiol* 35 (3):765-775, 2006.

[Greenland, 2007] S. Greenland. Bayesian perspectives for epidemiological research. II. Regression analysis, *Int J Epidemiol* 36 (1):195-202, 2007.

[Greenland, 2008] S. Greenland. Bayesian interpretation and analysis of research results, *Semin Hematol* 45 (3):141-149, 2008.

[Greenland, 2009] S. Greenland. Accounting for uncertainty about investigator bias: disclosure is informative, *J Epidemiol Community Health* 63 (8):593-598, 2009.

[Greenland, 2009] S. Greenland. Bayesian perspectives for epidemiologic research: III. Bias analysis via missing-data methods, *Int J Epidemiol* 38:1662-1673, 2009.

[Greenland and Lash, 2008] S. Greenland and T. L. Lash. Bias analysis in K.J. Rothman, S. Greenland, T.L. Lash and eds. (eds.), *Modern Epidemiology,3rd ed.*, Philadelphia: : Lippincott-Williams-Wilkins, 345-380, 2008.

[Grodstein et al., 1996] F. Grodstein, M. Stampfer, J. Manson, G. Colditz, W. Willett, B. Rosner, F. Speizer, and C. Hennekens. Postmenopausal estrogen and progestin use and the risk of cardiovascular disease, *N Engl J Med* 335 (7):453-461, 1996.

[Guyatt, 1991] G. Guyatt . Evidence-Based Medicine, *ACP J Club* A-16:114, 1991.

[Guyatt and Rennie, 2002] G. Guyatt and D. Rennie *Users' Guidees to the Medical Literature. A Manual for Evidence-based Clinical Practice*. Chicago: American Medical Association.

[Guyatt et al., 2008] G. Guyatt, A. Oxman, R. Kunz, Y. Falck-Ytter, G. Vist, A. Liberati, H. Schunemann, and G. for the Going from evidence to recommendations, *BMJ* 336 (7652):1049-1051, 2008.

[Guyatt et al., 2008] G. Guyatt, A. Oxman, G. Vist, R. Kunz, Y. Falck-Ytter, P. Alonso-Coello, H. Schunemann and G. for the GRADE: an emerging consensus on rating quality of evidence and strength of recommendations, *BMJ* 336 (7650):924-926, 2008.

[Haak, 1995] S. Haack. *Evidence and inquiry.* Oxford: Blackwell.

[Hajek, 2001] A. Hajek. Probability, logic, and probability logic in L. Goble (ed.), *The Blackwell Guide to Philosophical Logic.*, Oxford: Blackwell Publishing.

[Hajek, 2001] A. Hajek. Interpretations of Probability. http://plato.stanford.edu/entries/probability-interpret/.

[Hall, 1995] M. Hall. Perception of risk is affected by presentation, *BMJ* 311:1229, 1995.

[Hansson, 2007] S. O. Hansson *Risk* http://www.science.uva.nl/~seop/entries/risk/, 2007

[Harris et al., 1999] N. Harris, E. Jaffe, J. Diebold, G. Flandrin, H. Muller-Hermelink, J. Vardiman, T. Lister and C. Bloomfield. World Health Organization classification of neoplastic diseases of the hematopoietic and lymphoid tissues: report of the Clinical Advisory Committee meeting-Airlie House, Virginia, November 1997, *J Clin Oncol* 17 (12):3835-3849, 1999.

[Hastie, 2001] R. Hastie. Problems for judgment and decision making, *Annu Rev Psychol* 52:653-683, 2001.

[Hastie and Dawes, 2001] R. Hastie and R. M. Dawes. *Rational choice in an uncertain world.* London: Sage Publications, Inc.

[Haynes et al., 2006] R. Haynes, C. Cotoi, J. Holland, L. Walters, N. Wilczynski, D. Jedraszewski, J. McKinlay, R. Parrish, K. McKibbon, and P. for the McMaster Premium Literature Service (2006), Second-Order Peer Review of the Medical Literature for Clinical Practitioners, *JAMA* 295 (15):1801-1808, 2006.

[Heiss et al., 2008] G. Heiss, R. Wallace, G. L. Anderson, A. Aragaki, S. Beresford, R. Brzyski, R. Chlebowski, M. Gass, A. LaCroix, J. Manson, R. Prentice, J. Rossouw, M. Stefanick, and W. H. I. I. for the Health Risks and Benefits 3 Years After Stopping Randomized Treatment With Estrogen and Progestin, in, 1036-1045, 2008.

[Henry, 2006] M. Henry. Uncertainty, responsibility, and the evolution of the physician/patient relationship, *J Med Ethics* 32 (6):321-323, 2006.

[Higgins and Green, 2008] J. Higgins and S. Green. Cochrane Handbook for Systematic Reviews of Interventions Version 5.0.0 updated February 2008. The Cochrane Collaboration, 2008.

[Hill, 1952] A. Hill. The clinical trial, *N Engl J Med* (247):113-119, 1952.

[Hillner and Smith, 2007] B. E. Hillner and T. J. Smith. Do the Large Benefits Justify the Large Costs of Adjuvant Breast Cancer Trastuzumab? *J Clin Oncol*, 25(6):611-3, 2007.

[Hirshleifer and Teoh, 2003] D. Hirshleifer, and S. Teoh . Herd behaviour and cascading in captial markets: a review and synthesis, *Eur Financial Management* 9:25-66, 2003.

[Hitt, 2001] J. Hitt. The Year in Ideas:A to Z; Evidence-based Medicine, *New York Times, 2001.*

[Howard, 2007] R. Howard. The foundations of decision analysis revisited in W. Edwards, R.F.J. Miles and D. von Winterfeldt (eds.), *Advances in decision analysis: from foundtaions to applications.*, New York: Cambridge University, 32-56, 2007.

[Howard, 1988] R. Howard. Uncertainty about probability: a decision analysis perspective, *Risk Analysis* 8:91-98, 1988.

[Howell and Burnett, 1978] W. Howell and S. Burnett. Uncertainty measurement: a cognitive taxonomy, *Organ Behav Hum Performance* 22:45-68, 1978.

[Hozo and Djulbegovic, 2008] I. Hozo and B. Djulbegovic. When is diagnostic testing inappropriate or irrational? Acceptable regret approach, *Med Decis Making* 28 (4):540-553, 2008.

[Hozo and Djulbegovic, 2009] I. Hozo and B. Djulbegovic. Will insistence on practicing medicine according to expected utility theory lead to an increase in diagnostic testing? *Medical Decision Making* 29:320-324, 2009.

[Hozo et al., 2008] I. Hozo, M. Schell, and B. Djulbegovic. Decision-making when data and inferences are not conclusive: risk-benefit and acceptable regret approach, *Semin Hematol* 45 (3):150-159, 2008.

[Hunink and Glasziou, 2001] M. Hunink and P. Glasziou. *Decision-making in health and medicine. Integrating evidence and values.* Cambridge: Cambridge University Press, 2001.

[Hunter et al., 2008] D. Hunter, M. Khoury and J. Draze. Letting the genome out of the bottle–will we get our wish? *N Engl J Med* 358 (2):105-107, 2008.

[Hyde, 2005] D. Hyde. Sorites Paradox, 2005.

[International, 2003] International Myeloma Working Group. Criteria for the classification of monoclonal gammopathies, multiple myeloma and related disorders: a report of the International Myeloma Working Group, *Br J Haematol* 121:749-757, 2003.

[Ioannides, 2005] J. Ioannidis. Why most published research findings are false, *PLoS Med* 2 (8):e124, 2005.

[Ioannides, 2005a] J. Ioannidis. Contradicted and Initially Stronger Effects in Highly Cited Clinical Research. *JAMA*, 294(2):218-28, 2005.

[Jaffe, 2006] C.Jaffe. Measures of Response: RECIST, WHO, and New Alternatives, *J Clin Oncol* 24 (20):3245-3251, 2006.

[Jefferson, 2008] T. Jefferson. More cases, doctor? Yes please, *Cases J* 2008, 1:38, 2008.

[Join Commission, 2009] `http://www.jointcommission.org/sentinelevents/ sentineleventalert/sea_23.htm`, 2009

[Juni et al., 2001] P. Juni, D. Altman and M. Egger. Assessing the quality of controlled clinical trials, *BMJ* 323:42-46, 2001.

[Juni and Egger, 2002] P. Juni and M. Egger. Allocation concealment in clinical trials, *JAMA* 288:2407 - 2408; discussion 2408-2409., 2002

[Juni and Egger, 2005] P. Juni and M. Egger. Commentary: empirical evidence of attrition bias in clinical trials, *Int J Epidem* 34:87-88, 2005.

[Kahneman, 2003] D. Kahneman. Maps of bounded rationality: psychology for behavioral economics, *American Economic Review* 93:1449-1475, 2003.

[Kahneman, 2006] D. Kahneman. Frames and brains: elicitation and control of response tendencies, *Trends Cogn Sci, 2006.*

[Kahneman et al., 2005] D. Kahneman, P. Slovic and A. Tversky. *Judgement under uncertainty: heuristics and biases.* New York: Cambridge University Press, 2005.

[Kahneman and Tversky, 1979] D. Kahneman and A. Tversky. Prospect theory:an analysis of decion under risk, *Econometrica* 47:263-291, 1979.

[Kahneman and Tversky, 1982] D. Kahneman and A. Tversky. The psychology of preferences, *Sci American* 246:160-173, 1982.

[Kahneman and Tversky, 2000] D. Kahneman and A. Tversky. *Choices, values, and frames.* New York: Cambridge University Press, 2000.

[Kahneman and Tversky, 1982] D. Kahneman and A. Tversky. Variants of uncertainty, *Cognition* 11:143-157, 1982.

[Kasser, 2006] J. Kasser. *Philosophy of science.* Chantily: VA: The Teaching Company, 2006.

[Kasser, 1989] J. Kasser. Our stubborn quest for diagnostic certainty. A cause of excessive testing, *N Engl J Med* 320:1489-1491, 1989.

[Knight, 1921] F. Knight. *Risk, uncertainty, and profit.* Boston: Hart, Schaffner & Mark; Houghton Mifflin Co, 1921.

[Knottnerus, 2002] J. Knottnerus. *The evidence base of clinical diagnosis.* London: BMJ Books, 2002.

[Kohn et al., 2000] L. Kohn, J. Corrigan and M. Donaldosn. *To err is human. Building a safer health system.* Washington,DC: National Academy Press, 2000.

[Kording, 2007] K. Kording. Decision theory: what should the nervous system do? *Science* 318 (5850):606-610, 2007.

[Kunz and Oxman, 1998] R. Kunz and A. Oxman. The unpredictability paradox: review of empirical comparisons of randomized and non-randomized trials, *BMJ* 317:1185-1190, 1998.

[Leape, 1994] L. Leape. Error in medicine, *JAMA* 272:1851-1857, 1994.

[Legare, in press] F. Legare. Managing vriability and uncertainty, *Encyclopedia of decision-making, in press.*

[Lexchin et al., 2003] J. Lexchin, L. A. Bero, B. Djulbegovic, and O. Clark Pharmaceutical industry sponsorship and research outcome and quality: systematic review. *BMJ*, 326(7400):1167-70, 2003.

[Lichenstein and Slovic, 2006] S. Lichenstein and P. Slovic.The Construction of Preference, New York: Cambridge University Press, 2006.

[Lindley, 1985] D. Lindley. *Making decisions, 2nd ed,* New York: Wiley, 2006.

[Lipkus, 2007] I. Lipkus. Numeric, verbal, and visual formats of conveying health risks: suggested best practices and future recommendations, *Med Decis Making* 27 (5):696-713, 2007.

[Loomes and Sugden, 1982] G. Loomes and R. Sugden. Regret theory: an alternative theory of rational choice, *Economic J* 92:805-824, 1982.

[Lopes, 1987] L. Lopes. Between hope and fear: the psychology of risk, *Advances in Experimental and Social Psychology* 20:255-295, 1987.

[Lusmerer, 1999] K. Ludmerer/. *Time to heal.* New York: Oxford Press,1999.

[MacCoun, 1998] R. MacCoun. Biases in the interpretation and use of research results, *Annu Rev Psychol* 49:259-287, 1998.

[Mann and Djulbegovic, 2003] H. Mann, and B. Djulbegovic. Choosing a control intervention for a randomised clinical trial, *BMC Med Res Methodol* 3 (1):7, 2003.

[Mann and Djulbegovic, 2003] H. Mann, and B. Djulbegovic. *Why comparisons must address genuine uncertainties. Comparator bias.* James Lind Library. www.jameslindlibrary.org, 2003

[Matthews, 1995] J. Matthews. *Quantification and Quest for Medical Certainty.* Princeton, NJ: : Princeton University Press, 1995.

[McClellan et al., 2008] M. McClellan, J. McGinnis, E. Nabel and L. Olsen. *Evidence-based medicine and the Changing Nature of Health Care: Workshop Summary (IOM Roundtable on Evidence-Based Medicine)N.* Washington, DC: National Academy of Sciences, 2008.

[McNeil, 2001] B. McNei. Hidden Barriers to Improvement in the Quality of Care, *N Engl J Med* 345 (22):1612-1620, 2001.

[McShane et al., 2005] L. McShane, D. Altman, W. Sauerbrei, S. Taube, M. Gion and G. Clark . Reporting recommendations for tumor marker prognostic studies (REMARK), *J Natl Cancer Inst* 97 (16):1180-1184, 2005.

[Merpol et al., 2003] N. Meropol, K. Weinfurt, C. Burnett, A. Balshem, A. Benson, 3rd, L. Castel, S. Corbett, M. Diefenbach, D. Gaskin, Y. Li, S. Manne, J. Marshall, J. Rowland, E. Slater, D. Sulmasy, D. Van Echo, S. Washington and K. Schulman.Perceptions of patients and physicians regarding phase I cancer clinical trials: implications for physician-patient communication, *J Clin Oncol* 21 (13):2589-2596, 2003.

[Michaels, 2005] D. Michaels. Doubt is their product, *Sci Am* 292 (6):96-101, 2005.

[Michaels, 2005] D. Michaels. Manufactured uncertainty: protecting public health in the age of contested science and product defense, *Ann N Y Acad Sci* 1076:149-162, 2005.

[Morgan and Henrion, 1990] M. Morgan and M. Henrion. *Uncertainty. A guide to dealing with uncertainty in quantitative and policy analysis.* Cambridge: Cambridge University Press, UK, 1990.

[Murphy, 1997] E. Murphy. *Logic of medicine.2nd ed.* Baltimore: John University Press, 1997.

[Murray, 2003] C. Murray. *Human Accomplishment: The Pursuit of Excellence in the Arts and Sciences, 800 B.C. to 1950* New York: HarperCollins, 2003.

[Nelson et al., 2007] W. Nelson, P. Han, A. Fagerlin, M. Stefanek and P. Ubel. Rethinking the Objectives of Decision Aids: A Call for Conceptual Clarity, *Med Decis Making* 27 (5):609-618, 2007.

[Nikolaidis et al., 2005] E. Nikolaidis, D. Ghiocel and S. Singhla. *Engineering design reliability handbook.* Boca Raton, FL: CRC Press, 2005.

[O'Connor, 1997] A. O'Connor. Decisional Conflict Scale. 2nd ed, *Ottawa Civic Hospital, 1997.*

[O'Connor, 1997] A. O'Connor. Validation of a decision conflict scale, *Med Decis Making* 15:25-30,1997.

[O'Connor et al., 2003] A. O'Connor, F. Legare and D. Stacey. Risk communication in practice: the contribution of decision aids, *BMJ* 327 (7417):736-740, 2003.

[O'Connor et al., 2003] A. O'Connor., D. Stacey, V. Entwistle, H. Llewellyn-Thomas, D. Rovner, M. Holmes-Rovner, V. Tait, J. Tetroe, V. Fiset, M. Barry, and J. Jones. Decision aids for people facing health treatment or screening decisions, *Cochrane Database Syst Rev* (2):CD001431, 2003.

[Parascandola, 2007] M. Parascandola. A turning point for conflicts of interest: the controversy over the National Academy of Sciences' first conflicts of interest disclosure policy, *J Clin Oncol* 25 (24):3774-3779, 2007.

[Perreault and Metzger, 1999] L. Perreault and J.Metzger. A pragmatic framework for understanding clinical decision support, *J Healthcare Inform Management System Society* 2:5-21, 1999.

[Politi et al., 2007] M. Politi, P. Han and N. Col. Communicating the uncertainty of harms and benefits of medical interventions, *Med Decis Making* 27 (5):681-695, 2007.

[Popper, 1959] K. Popper. *The logic of scientific discovery.* New York: Harper and Row, 2007.

[Popper, 1959] K. Popper. The propensity interpretation of probability, *Br J Phil Sci* 10:25-42, 1959.

[Ramsden, 2006] C. Ramsden. Geriatric neologism. *British Medical Journal,* 332:451, 2006.

[Redelmeier *et al.*, 1995] D. Redelmeier, D. Koehler, V. Liberman and A. Tversky . Probability judgement in medicine: discounting unspecified alternatives. *Med Decis Making* 15:227-231, 1995.

[Regan *et al.*, 2002] H. Regan, M. Colyvan and M. Burgman. A taxonomy and treatment of uncertainty for ecology and conservation biology, *Ecological Applications* 12:618-628, 2002.

[Rothwell, 2007] P. Rothwell. *Treating individuals: from randomized trials to personalized medicine.* Amsterdam: Elsevier, 2007.

[Rothwell, 2006] P. Rothwell. Factors That Can Affect the External Validity of Randomised Controlled Trials, *PLoS Clinical Trials* 1 (1):e9, 2006.

[Sackett, 1979] D. Sackett. Bias in analytic research. *J Chron Dis* 32:51-63, 1979.

[Sackett *et al.*, 2000] D. Sackett. S. Straus, W. S. Richardson, W. Rosenberg, and B. Haynes. *Evidence-Based Medicine. How to Practice and Teach EBM.2nd ed.* New York: Churchill-Livingstone, 2000.

[Savage, 1954] L. Savage. +*The foundations of statistics.* New York: Wiley, 1954.

[Schwatz and Bergus, 2008] A. Schwartz and G. Bergus. *Medical Decision Making: A Physician's Guide* Cambridge: Cambridge University Press, 2008.

[Shwartz *et al.*, 2002] B. Schwartz, A. Ward, J. Monterosso, S. Lyubomirsky, K. White and D. Lehman. Maximizing versus satisficing: happiness is a matter of choice, *J Pers Soc Psychol* 83 (5):1178-1197, 2002.

[Shaffer, 1976] G. Shaffer. *A mathematical theory of evidence.* Princeton, NJ: Princeton University Press, 1976.

[Shannon and Weaver, 1962] C. Shannon and W. Weaver. *The mathematical theory of communication.* Urbana: The University of Illinois Press, 1962.

[Sim *et al.*, 2001] I. Sim, P. Gorman, R. Greenes, B. Haynes, B. Kaplan, H. Lehmann and P. Tang. White paper: clinical decision support systems for the practice of evidence-based medicine. *J Am Med Inform Assoc* 8:527-534, 2001.

[Simon, 1955] H. Simon. A behavioral model of rational choice, *Quart J Economics* 69 (99-118), 1955.

[Simon, 1955] H. Simon.Information processsing models of cognition, *Ann Review Psychol* 30 (263-96), 1955.

[Sirovich *et al.*, 2006] B. Sirovich, D. Gottlieb, H. Welch and E. Fisher. Regional Variations in Health Care Intensity and Physician Perceptions of Quality of Care, *Ann Intern Med* 144 (9):641-649, 2006.

[Smith, 1992] R. Smith. The ethics of ignorance, *J Med Ethics* 18 (3):117-118, 134, 1992.

[Sorenson, 2006] R. Sorenson. Vagueness, 2006.

[Sox, 2006] H. Sox. Better Care for Patients with Suspected Pulmonary Embolism, *Ann Intern Med* 144 (3):210-212, 2006.

[Sox *et al.*, 1988] H. Sox, M. Blatt, M. Higgins and M. Marton. *Medical Decision Making.* Boston: Butterworths, 1988.

[Tannenbaum, 1993] S. Tanenbaum. What physicians know. *N Engl J Med* 329:1268-1271, 1993.

[Tannenbaum, 1993] S. Tanenbaum. Getting there from here: evidentiary quandaries of the US outcome movement, *J Eval Clin Pract* 1:97-103, 1993.

[Tannenbaum, 2005] S. Tanenbaum. Uncertainty, consultation, and the context of medical care, *BMJ* 330 (7490):515, 2005.

[Taubes, 1996] G. Taubes, Looking for the evidence in medicine, *Science* 272:22-24,1996.

[Timmermans and Mauck, 2005] S. Timmermans and A. Mauck. The Promises And Pitfalls Of Evidence-Based Medicine, *Health Aff* 24 (1):18-28, 2005.

[Tversky and Kahneman, 1974] A. Tversky and D. Kahneman. Judgements under uncertainty: heuristics and biases, *Science* 185:1124-1131, 1974.

[Tversky and Kahneman, 1974] A. Tversky and D. Kahneman. Prospect theory. An analysis of decisions under risk, *Econometrica* 47:263-291, 1974.

[Tversky and Kahneman, 1986] A. Tversky and D. Kahneman. Rational choice and the framing of decisions, *Journal of Bussiness* 59:5251-5278, 1986.

[Tversky and Kahneman, 1992] A. Tversky and D. Kahneman. Advances in Prospect Theory: Cumulative Representation of Uncertainty, *Journal of Risk and Uncertainty* 5:297-323, 1992.

[Tversky and Koehler, 1994] A. Tversky and D. Koehler. Support theory: a nonextensional representation of subjective probability, *Psychol Rev* 101:547-567, 1994.

[Tversky and Wakker, 1995] A. Tversky and P. Wakker . Risk attitudes and decision weights, *Econometrica* 63:297-323, 1995.

[Vandenbrouke, 2008] J. Vandenbroucke. Observational research, randomised trials, and two views of medical science, *PLoS Med* 5 (3):e67, 2008.

[Vickers *et al.*, 2008] A. Vickers, E. Basch and M. Kattan. Against diagnosis, *Ann Intern Med* 149 (3):200-203, 2008.

[Vickers, 2006] J. Vickers. The problem of induction, 2006. `http://plato.stanford.edu/entries/induction-problem/`.

[Vincent and Djulbegovic, 2005] S. Vincent and B. Djulbegovic, Oncology treatment recommendations can be supported only by 1-2% of published high-quality evidence, *Cancer Treat Rev* 314:319-322, 2005.

[von Mises, 1957] R. von Mises. *Probability, Statistics and Truth.2n ed.* New York: Dover, 1957.

[Wakker, 2008] P. Wakker. Uncertainty, in L. Blume and S.N. Durlauf (eds.), *The New Palgrave: A Dictionary of Economics*, London: The MacMillan Press,, 6780-6791, 2008.

[Watson and Buede, 1987] S. Watson and D. Buede. *Decision synthesis. The principles of & practice of decision analysis,*. Cambridge: Cambridge University Press, 1987.

[Weinfurt, 2007] K. Weinfurt. Value of High-Cost Cancer Care: A Behavioral Science Perspective, *J Clin Oncol* 25 (2):223-227, 2007.

[Wennberg, 1986] J. Wennberg. Which rate is right? *N Engl J Med* 314:310-311, 1986.

[Williamson, 1994] T. Williamson. *Vagueness.* London:: Routledge, 1994.

[Wilson, 1998] E. Wilson. *Consilence. The unity of knowledge,* New York: Alfred A. Knopf, 1998.

[Wilson *et al.*, 1998] P. Wilson, R. D'Agostino, D. Levy, A. Belanger, H. Silbershatz and W. Kannel. Prediction of coronary heart disease using risk factor categories, *Circulation* 97:1837-1847, 1998.

[Winn *et al.*, 1996] R. Winn, W. Botnick, and N. Dozier.The NCCN guidelines development program, *Oncology* 10 (supplement):23-28, 1996.

[Wipf *et al.*, 1999] J. Wipf, B. Lipsky, J. Hirschmann, E. Boyko, J. Takasugi, R. Peugeot and C. Davis. Diagnosing pneumonia by physical examination: relevant or relic? *Arch Intern Med* 159 (10):1082-1087, 1999.

[Wittgenstein, 1969] L. Wittgenstein. *On Certainty.* New York: Harper Torchbooks, 1969.

[Woolf, 1992] S. Woolf. Practice guidelines: a new reality in medicine. II. Methods of developing guidelines, *Arch Intern Med* 152:946-952, 1992.

[Zimmerman, 1996] H. Zimmerman. *Fuzzy set theory anf its applications. 3rd ed.* Boston: Kluwer Academic, 1996.

[Zimmerman, 2000] H. Zimmerman. An application-oriented view of modeling uncertainty, *European Journal of Operational Research* 122:190-198, 2000.

THE LOGIC OF DIAGNOSIS*

Kazem Sadegh-Zadeh

1 INTRODUCTION

In contrast to veterinary medicine, historically human medicine has developed as a healing profession. It is oriented toward caring for suffering human beings. This orientation is primarily centered around the healing relationship, a relationship that is usually considered to be of a dyadic structure comprising the physician and the patient. Well-known terms such as "the physician-patient relationship" and "the doctor-patient interaction" reflect this traditional view. As we will see below, however, the healing relationship has a more complex structure than a dyadic one and also contains other components than the patient and the physician.

The healing relationship manifests itself in a process of interaction that is traditionally called clinical practice (from the Greek terms "cline" for *bed, sick-bed*; and "praxis" for *acting, doing*). Clinical practice constitutes the focus of medicine. Since Hippocrates' time five partial, overlapping activities are distinguished in clinical practice that have come to be termed *anamnesis*, i.e. history taking or clinical interview of the patient, *diagnosis*, *prognosis*, *therapy*, and *prevention*. They are the fundamental features of the healing relationship. Diagnosis has been playing a central role for only about two hundred years. In the entire history of medicine prior to this, prognosis was considered more important than diagnosis (see [Hartmann, 1977]).

It is generally believed that diagnosis provides information on 'the true state of the patient' and thereby enables the physician to identify the appropriate treatment. In what follows it is argued that this belief is epistemologically and ontologically problematic. What is usually considered 'the true state of the patient' is a construct of medical knowledge and reasoning methodology applied in clinical decision-making. To substantiate this view we will suggest a theory of the relativity of diagnosis that reveals a complex context producing the diagnosis. The theory also provides an answer to the following question frequently asked in medicine: Is there a logic of diagnosis, and if so, what is the logic of diagnosis?

To handle this question adequately it is advantageous to differentiate between *diagnostics* as an investigation into the patient's health condition, on the one hand, and *diagnosis* as the outcome of this very investigation, on the other. For

* Dedicated to Professor Lotfi A. Zadeh on the occasion of his 90th birthay on February 4, 2011.

Handbook of the Philosophy of Science. Volume 16: Philosophy of Medicine.
Volume editor: Fred Gifford. General editors: Dov M. Gabbay, Paul Thagard and John Woods.

example, the statement "Hilary Ciccione has diabetes" is the outcome of a more or less complex examination of the patient Hilary, i.e. diagnostics, and represents a diagnosis. The subject of the present chapter is the logic of both diagnostics *and* diagnosis. For the sake of simplicity, however, we will talk of the logic of diagnosis.

There are two different approaches we can take to inquire into the subject of our concern, a descriptive and a constructive one. A descriptive approach is concerned with how things are, e.g., "What do physicians understand by the term 'diagnosis' and how do they actually perform diagnostics?" Such an approach can only be based on empirical surveys and thus belongs to empirical linguistics, psychology, and sociology (see, e.g. [Elstein, 1978]). By contrast, a constructive approach reconstructs the existing concepts, methods, knowledge, and theories metatheoretically, e.g. the concepts of disease and diagnosis, so as to improve them by constructing new frameworks and tools for use to enhance the quality of clinical decision-making, medical research, and health care. Our approach belongs to the latter, constructive category. We will not concern ourselves with descriptive-empirical analyses.

We will start our constructive approach by inquiring into the syntax and semantics of diagnosis in Section 2. It will in this way become possible to distinguish different types of diagnosis. An analysis of the *methods* of producing such diagnoses will then follow in Section 3. Among them are the so-called hypothetico-deductive approach, Bayes' Theorem, case-based reasoning, and fuzzy-logical reasoning. The second important device of diagnostic inquiry, i.e. diagnostic *knowledge*, will constitute the subject of our discussion in Section 4. The analysis of the metapractical notions of indication, contra-indication, and differential indication in Section 5 completes our preparatory studies. The results of these studies will enable us to present in Section 6 our theory of the relativity of diagnosis according to which a diagnosis is relative to the context from which it emerges. Section 7 will be concerned with the pragmatics of diagnosis to suggest that clinical diagnoses be viewed as social acts that create social facts. The question of whether there is a logic of producing such social acts and facts is discussed in Section 8. The final Section 9 summarizes our inquiry.

2 THE SYNTAX AND SEMANTICS OF DIAGNOSIS

The analysis of the logic of diagnosis requires a clear concept of diagnosis with specified syntax and semantics. We will therefore introduce such a concept first. For this purpose and for our later inquiries we need some elementary notions from logic. Readers acquainted with logic may skip the following section.

2.1 *Some classical-logical terminology*

The notations of different systems of logic will be employed in what follows. We will successively introduce them in special terminology subsections such as the

present one. Here some elementary notions of predicate logic, modal logic, and probability that we will need are assembled. For details, see [Sadegh-Zadeh, 2011].

A simple subject-predicate statement such as "Hilary has diabetes" will be rewritten as "has-diabetes(Hilary)" by prefixing the bracketed subject with the not bracketed predicate. To generalize this notation, let P be a predicate such as "has-diabetes." We consider a predicate P to apply to n \geq 1 individual objects x_1, \ldots, x_n yielding a subject-predicate sentence of the form $P(x_1, \ldots, x_n)$. According to the number n of the objects $(x_1 \ldots, x_n)$ a predicate P applies to, it is called an n-place or n-ary predicate. We have, for example:

- has-diabetes(Hilary) \equiv $P(a)$ P is a one-place or unary predicate,
- loves(Hilary, Bert) \equiv $Q(a, b)$ Q is a two-place or binary predicate,
- gives(Hilary, Bert, c) \equiv $R(a, b, c)$ R is a three-place or ternary predicate,

where "a" stands for "Hilary" and "b" stands for "Bert." A sentence of the form $P(x_1, \ldots, x_n)$ is referred to as a *predication*. Likewise, let f be an m-place function symbol with $m \geq 1$ such as the unary function symbol "the father of" or the binary function symbol "the sum of ... and $-$"; and let x_1, \ldots, x_m, y be $m + 1$ individual objects; then $f(x_1, \ldots, x_m) = y$ is called an *equality* or identity. Here is an example:

- The sentence "Hilary's blood sugar is 215 mg%" rewritten as "blood-sugar-of(Hilary) = 215" and symbolized by $f(a) = b$ is an equality where the unary function symbol f stands for "the blood sugar of" and "b" stands for "215".

Predications and equalities are referred to as *atomic sentences*. Individual objects, called individuals, will be represented by the symbols "a" "b", "c", ... referred to as individual constants. The symbols "x", "y", "z", ... will be used as individual variables. An individual variable represents any individual and is thus a place-holder for any individual constant. Thus, the atomic sentence $P(x)$ in the present context means that someone, x, has diabetes. We need not know who x is.

The symbols "P", "Q", "R", ... represent n-place predicates as above with $n \geq 1$. And m-place functions with $m \geq 1$ will be represented by "f", "g", and "h". These two types of symbols as well as individual symbols are descriptive signs. There are also so-called logical signs of the language with which we now will briefly concern ourselves. We will sketch sentential connectives, quantifiers, and some modal-logical signs. We symbolize the sentential connectives:

"not"	by	\neg
"and"	by	\wedge
"or"	by	\vee
"if... then $-$"	by	\rightarrow
"... if and only if $-$"	by	\leftrightarrow

Thus we have, for example:

$P(a)$	\equiv	a has diabetes;
$\neg Q(a)$	\equiv	a does not cough;
$P(a) \wedge \neg Q(a)$	\equiv	a has diabetes and a does not cough;
$P(a) \vee \neg P(a)$	\equiv	a has diabetes or a does not have diabetes;
$P(a) \rightarrow f(a) > 160$	\equiv	if a has diabetes then a's blood sugar exceeds 160 (mg%);
$P(a) \leftrightarrow f(a) > 160$	\equiv	a has diabetes if and only if a's blood sugar exceeds 160.

Greek lower case letters $\alpha, \beta, \gamma, \ldots$ will be used as sentential constants representing sentences. For example, let α and β be, respectively, the sentences $P(a)$ and $f(a) = 215$. Then $\alpha \wedge \beta$ means $P(a) \wedge f(a) = 215$, while $\alpha \rightarrow \beta$ symbolizes $P(a) \rightarrow f(a) = 215$.

In natural languages we also encounter additional logical signs called *quantifiers* such as the expressions "there is" and "all" and their synonyms used in sentences like "there is a patient who has diabetes" and "all diabetics have hyperglycemia." The quantifier "there is" is called the "existential quantifier," and the quantifier "all" is referred to as the "universal quantifier." We now introduce symbols for these two quantifiers. We write:

\exists for "there is", "there exists"

\forall for "all", "every", "each", "for all".

Let x be an individual variable and α be a sentence, then both $\exists x \alpha$ and $\forall x \alpha$ are sentences. The first one reads "there is an x such that α," e.g. $\exists x P(x)$; and the second one reads "for all x, α," e.g. $\forall x P(x)$. Examples are:

- the sentence "there is someone who has diabetes and gastritis" may be rewritten as "there is an x such that x has diabetes and x has gastritis" and symbolized by $\exists x P(x) \wedge Q(x)$ where P and Q stand for the predicates "has diabetes" and "has gastritis," respectively;

- the sentence "all diabetics have insulin deficiency" may be rewritten as "for all x, if x has diabetes then x has insulin deficiency" and symbolized by $\forall x(P(x) \rightarrow R(x))$ where R stands for "has insulin deficiency."

A quantified sentence may contain many instances of quantifiers such as, for example, the simple statement "every patient has a doctor." This example may be rewritten as "for every x there is a y such that x is a patient and y is her doctor" and symbolized by $\forall x \exists y(A(x) \rightarrow B(y,x))$ where $A(x)$ stands for "x is a patient" and $B(y,x)$ stands for "y is x's doctor." A statement of the form:

$\neg \alpha$ is called a negation

$\alpha \wedge \beta$	conjunction
$\alpha \vee \beta$	disjunction
$\alpha \rightarrow \beta$	conditional
$\alpha \leftrightarrow \beta$	biconditional
$\exists x \alpha$	existential instantiation
$\forall x \alpha$	universal generalization.

The class of logical symbols introduced above are *predicate-logical* ones. They are dealt with in predicate logic. In addition to predicate-logical notation we will also need some logical terminology beyond predicate logic. Here we mention only some *modal-logical* operators, specifically from alethic-modal logic and epistemic logic. Additional ones will follow in Section 4.1 below.

We distinguish between *extensional* and *intensional* operators. Predicate-logical operators listed above are extensional ones. An extensional operator such as \wedge ("and") operates only on the *truth values* of the sentences α and β which it connects to yield the conjunction $\alpha \wedge \beta$. The operation is independent of the *content* of the sentences it connects. For example, the true sentence "$2 = 2 \wedge$ the Eiffel Tower is in Paris" remains true if we replace any of its two constituent sentences with another true sentence, e.g. "$2 = 2$" with "Jupiter has more than 60 moons." In this way we obtain the sentence "Jupiter has more than 60 moons \wedge the Eiffel Tower is in Paris" that again is true.

An intensional operator, on the other hand, operates on the *content* of the sentences to which it is attached. An example is the operator "to know that" in a sentence like "Hilary knows that $2 = 2$." Whereas this is a true sentence because Hilary in fact knows that $2 = 2$, the replacement of its true constituent sentence "$2 = 2$" with the true sentence "Jupiter has more than 60 moons" yields the false sentence "Hilary knows that Jupiter has more than 60 moons" on the grounds that Hilary lacks this knowledge. This is so because the operator "to know that" does not focus on the extension, i.e. truth or falsity, of the sentence it is attached to, but on its intension, i.e. content, that is either known or unknown to the supposed owner of knowledge.

The most important class of intensional operators are the so-called *modal* operators. They are dealt with in modal logics. A modal operator represents a *modality* such as possibility, necessity, knowledge, belief, etc., and is a constituent part of a *modal sentence* such as "Hilary knows that she has diabetes." Medical knowledge is replete with such modal sentences. Two types of them are alethic modal sentences of the form:

- *it is possible that* α,

- *it is necessary that* α,

where α is any sentence. For example, *it is possible that* Hilary has hepatitis. Here the italic phrases are logical operators of alethic modal logic and represent the modalities of possibility and necessity. They are therefore referred to as alethic

modal operators. Additional operators we should be aware of in the logic of diagnosis are the operators of epistemic logic referred to as epistemic-logical operators. They represent the modalities of knowledge, conviction, belief, and conjecture:

- I *know that* α,

- I *am convinced that* α,

- I *believe that* α,

- I *conjecture that* α,

- I *consider it possible that* α.

The italicized phrases represent the operators. Examples are physician judgments such as "I *know that* Hilary has diabetes" and "I *believe that* she does not have hepatitis." Also the famous concept of probability is a modal expression, specifically, a quantitative one. It transforms the qualitative modality *"it is probable that* α" into a numerical function. The latter is usually symbolized by the one-place probability function "p" in sentences of the form "the probability that X is r," written $p(X) = r$. For example, p(Hilary has diabetes) = 0.7. On the basis of this one-place probability function, p, a two-place probability function is defined that is used in conditional probability sentences of the form "the probability that X conditional on Y is r," e.g. "the probability that a patient has hyperglycemia conditional on untreated diabetes is 0.99." Unfortunately, this binary function is also represented by the same symbol "p" such that our last example reads $p(X, Y) = r$ and is usually written $p(X|Y) = r$. For instance, p(Hilary has hyperglycemia|Hilary has diabetes) = 0.99. For details, see [Sadegh-Zadeh, 2011].

2.2 On the syntax of diagnosis

Let us now consider a simple example at the outset to fix some terminology which we will use throughout.

A particular patient, Hilary, consults her doctor complaining of tiredness, intermittent tachycardia, and loss of weight. After performing a routine examination and some non-routine tests the doctor arrives at the conclusion that Hilary has diabetes.

The *patient data* that Hilary presents at any instant in the diagnostic process, i.e. her problems, complaints, symptoms and signs, are described by a non-empty set D of m \geq 1 singular sentences $\{\delta_1, \ldots, \delta_m\} = D$ where each δ_i is a statement describing a problem, a complaint, a symptom or a sign, e.g. "Hilary has hyperglycemia." The set of judgments on what might be wrong with Hilary that the doctor holds at this instant of the diagnostic process is also a set of $n \geq 1$ sentences, symbolized by $\{\alpha_1, \ldots, \alpha_n\} = \Delta$. It will be referred to as the *diagnosis*, where each α_i is a statement about the patient.

Not every statement about a patient is a diagnosis. Both the structure and the content of the statement, i.e. its syntax and semantics, must be taken into account. To this end we distinguish between categorical and conjectural diagnoses.

2.2.1 Categorical diagnoses

A *categorical diagnosis* is a statement about the patient that the diagnostician considers to be true, and for this reason it is an *idiogram* about the patient. An idiogram in a language L about a particular individual is a conjunction $\alpha_1 \wedge \ldots \wedge \alpha_k$ of $k \geq 1$ statements α_i with $k \geq i \geq 1$ about the individual such that each α_i is an atomic sentence or the negation of an atomic sentence. For example, each of the following statements is an idiogram about Hilary: "Hilary has diabetes," "Hilary does not have hepatitis," "Hilary has diabetes and Hilary does not have hepatitis."

Recall that an atomic sentence is either of the structure $P(x_1, \ldots, x_m)$ or $f(y_1, \ldots, y_n) = z$, where P is an m-place predicate, f is an n-place function symbol, and x_1, \ldots, x_m as well as y_1, \ldots, y_n, z are individual variables or constants. We now define the term "literal." A literal is an atomic sentence or the negation of an atomic sentence. For example, $P(x)$ and $\neg P(x)$ are literals. Thus, an idiogram about an individual a may simply be defined to be a conjunction $\alpha_1 \wedge \ldots \wedge \alpha_k$ of $k \geq 1$ literals α_i about this individual a such that all literals are variable-free and contain the proper name of the individual, i.e. "a". For example, let P, Q and R be unary predicates of a language L such as English or German; let f be a unary function symbol; and let a and b be individual constants of L. The following statements are *literals:*

$$P(a), \neg Q(a), f(a) = b$$

and the following ones are *idiograms* in this language about the individuals a and b:

$$P(a), P(a) \wedge \neg Q(a), P(a) \wedge \neg Q(a) \wedge R(a), P(a) \wedge f(a) = b.$$

Natural language examples are:

Hilary has diabetes $\equiv P(a)$

Hilary has diabetes and she does not have hepatitis $\equiv P(a) \wedge \neg Q(a)$.

Hilary's blood sugar is 215 mg% $\equiv f(a) = b$

Hilary has diabetes and her blood sugar is 215 mg% $\equiv P(a) \wedge f(a) = b$.

Since a fuzzy-set membership function such as μ_A is a function f as above, fuzzy statements such as $\mu_{diabetes}(\text{Hilary}) = 0.66$ and their occurrence in idiograms about a patient are also covered by the concept of categorical diagnosis (see Section 2.3.5 below).

2.2.2 Conjectural diagnoses

Categorical diagnoses are not always attainable in clinical practice. A considerable number of diagnoses are conjectural diagnoses.

A *conjectural diagnosis* is a conjecture about a patient. That means that the diagnostician does not yet consider it to be true, but only a 'hypothesis.' For this reason it may have one or another of a multitude of syntactical structures. For example, it may be a *disjunction* such as 'Hilary has diabetes or she has hepatitis'; or it may be an alethic-*modal* statement such as 'it is possible that Hilary has gastritis.' Also a probabilistic diagnosis is a conjectural diagnosis. It may be either a qualitative-probabilistic diagnosis such as 'it is likely that Hilary has diabetes,' or a quantitative-probabilistic diagnosis such as 'the probability that Hilary has diabetes is 0.7.' The notion of a conjectural diagnosis may be succinctly introduced in the following way.

Let ϕ be the qualitative-probability operator 'it is probable that . . . ' or another modal operator, e.g. an alethic-modal operator such as 'it is possible that . . . ' or an epistemic-modal operator such as 'I consider it possible that . . . ' or 'I believe that . . . ' We may define the notion of a conjectural diagnosis thus:

A statement β about a patient is a conjectural diagnosis if there is a statement α about her such that (i) β is $\phi(\alpha)$, for example:

It is probable that Hilary has diabetes,	\equiv	it is probable that α_1
it is possible that Hilary has appendicitis	\equiv	it is possible that α_2
I believe that Hilary has cystitis	\equiv	I believe that α_3

or (ii) α is a disjunction and β is α such as, for instance:

Hilary has diabetes or Hilary has appendicitis or Hilary has cystitis,

or (iii) β is a quantitative probability statement of the form $p(\alpha) = r$ with $0 < r < 1$. For example, p(Hilary has diabetes) = 0.7, i.e. the probability that Hilary has diabetes is 0.7. For details, see [Sadegh-Zadeh, 1982].

2.2.3 The diagnostic set

Any diagnostic statement attained about a patient in the diagnostic process is a diagnosis. The entirety of these diagnoses constitutes the diagnosis set $\Delta = \{\alpha_1, \ldots, \alpha_n\}$ of all singular diagnoses about a patient at a particular instant in the diagnostic process. The diagnostic set may consist of categorical diagnoses or conjectural diagnoses or both types of diagnoses. For example, a diagnosis set about the patient Hilary may be of the form $\Delta = \{$Hilary has diabetes and she does not have hepatitis; Hilary has retinopathia diabetica; it is possible that she has coronary heart disease; the probability that she has gallstones is 0.6$\}$.

2.3 On the semantics of diagnosis

Not every categorical or conjectural statement about a patient is a medical diagnosis. Examples are the statements "Hilary has fever" and "Hilary is blonde." The

content of the statement is also a critical factor. We must therefore ask *what* it is that a physician is diagnosing. To answer this question we distinguish between the following types of diagnosis: nosological diagnosis, abnormality diagnosis, causal diagnosis, fuzzy diagnosis. We will consider them in turn below. To this end we need to assemble some terminology first.

2.3.1 *Some fuzzy-logical terminology*

The concept of diagnosis has traditionally been closely related with the concept of disease. Although the concept of disease is a fundamental element of medicine, there is as yet no general agreement on what it exactly means. There are many reasons for this deficiency that cannot be discussed here. Nor can we here introduce a concept of disease. For details of this conceptual problem, see [Sadegh-Zadeh, 2000b; 2011].

We must first of all distinguish between *disease* as a general category, on the one hand, and *individual diseases* as its members such as, for example, diabetes mellitus, myocardial infarction and so on, on the other. The concept of disease is concerned with the former. But we are here interested in the latter ones, i.e. individual diseases. They are also called clinical entities, disease entities or nosological entities (from Greek "nosos" for "disease" and "illness"). A linguistic expression such as "diabetes mellitus" and "myocardial infarction" that designates a nosological entity, i.e. an individual disease, is referred to as a *nosological predicate*. We distinguish between the concept of disease that says what *disease* is, on the one hand, and a nosological predicate such as "diabetes mellitus" that says what *diabetes mellitus* is, on the other. A nosological predicate is not *a* concept of disease or *the* concept of disease. It is simply the name of a subcategory of the latter one.

In a series of papers we have suggested a way to reconstruct and represent individual diseases as fuzzy sets (see [Sadegh-Zadeh, 1999; 2000b; 2008]). To consider this approach in our concept of diagnosis requires some acquaintance with fuzzy sets. We will therefore briefly sketch this notion. For details on fuzzy set theory, see [Zadeh, 1965; Klir and Yuan, 1995; 1996; Yager *et al.*, 1987].

In classical set theory a collection of any objects is referred to as a set. Examples are 'the set of even numbers' and 'the set of one's siblings.' The objects that constitute a set are called its elements or members. If a set comprises a *finite* number of $n \geq 1$ members $x_1, ..., x_n$, it is represented by enumerating its members between two braces { } such as $\{x_1, ..., x_n\}$ and is read "the set of objects $x_1, ..., x_n$". One can also assign a name such as A or B or something else to such a set to easily deal with it, e.g. $\{x_1, ..., x_n\} = A$. Sets are represented by Roman capitals. Their members are represented by lower case letters. A set whose members are characterized by a particular property P is represented by $\{x | x is P\}$ to be read as 'the set of all x such that x is P.' For example, the set of healthy people is $\{x | x$ is healthy$\}$.

We write $x \in A$ to say that the object x is a member of set A, while $y \notin A$ means that the object y is not a member of set A. For example, $a \in \{a, b, c, d\}$,

whereas Einstein $\notin \{a, b, c, d\}$. According to this classical view an object either is definitely a member of a set A or it is definitely not a member of set A. A third option does not exist. That is, a *classical set* is a collection with a clear-cut boundary that obeys the all-or-nothing principle. It sharply separates members from non-members and does not allow intermediate members between full members and non-members. This characteristic reduces the practical usability of classical set theory because real-world classes do not have sharp boundaries. For example, there are no clear-cut demarcation lines between the class of trees and the class of bushes. For exactly this reason the former Berkeley computer scientist Lotfi A. Zadeh proposed as an alternative the concept and theory of fuzzy sets [Zadeh, 1965].

A *fuzzy set* is a collection of objects without sharp boundaries. Thus the all-or-nothing principle for membership does not hold. As before, an object may be definitely a member or definitely a non-member of a fuzzy set. But it may also be something intermediate. For example, an individual may be ill or not ill, though she may also be very ill or slightly ill, scarcely ill, and so on. That is, the set of ill people has no sharp boundaries. It is a fuzzy set and allows more than two grades of membership. If we represent full membership by 1, non-membership by 0, and intermediate membership by a number between 0 and 1, we obtain for a fuzzy set A a *membership function*, μ, that assigns to any object x the degree of its membership in A, written $\mu_A(x)$. For instance, if the degree of membership of Hilary in the fuzzy set of ill people is 0.7, then we have $\mu_{ill}(\text{Hilary}) = 0.7$.[1]

After the considerations above we may now intuitively define what a fuzzy set is. A fuzzy set A in, or over, a universe of discourse Ω is a set of $n \geq 1$ pairs of the form $(x, \mu_A(x))$, i.e.:

$$A = \{(x_1, \mu_A(x_1)), (x_2, \mu_A(x_2)), ..., (x_n, \mu_A(x_n))\}$$

such that an x_i in a pair $(x_i, \mu_A(x_i))$ is a member of Ω and $\mu_A(x_i)$ is a real number in the interval $[0, 1]$ denoting x_i's degree of membership in fuzzy set A. For example, let $\Omega = \{\text{Alvin, Bert, Carla, Dirk}\}$ be a family abbreviated by $\{a, b, c, d\}$. The following set YOUNG is a fuzzy set in this family:

$$\text{YOUNG} = \{(a, 1), (b, 0.7), (c, 0.3), (d, 0)\}.$$

It means that:

$$\mu_{young}(a) = 1 \qquad \text{i.e. Alvin is young to the extent 1}$$
$$\mu_{young}(b) = 0.7 \qquad \text{Bert is young to the extent 0.7}$$

[1]The term "fuzzy set" is the basic concept of *Fuzzy Theory* that is popularly known as "fuzzy logic." This theory is a rapidly-developing, multidisciplinary science of vagueness and uncertainty, and as such, best suited for dealing with vague entities like diseases. It was inaugurated by Lotfi A. Zadeh at the UC Berkeley in 1965 (see [Zadeh, 1965; Klir and Yuan, 1996; Yager *et al.*, 1987]). It is more and more becoming the leading methodology in all scientific disciplines and technology, including medicine. See, for example, [Barro and Marin, 2002; Mordeson *et al.*, 2000; Steimann, 2001; Szczepaniak *et al.*, 2000].

$\mu_{young}(c) = 0.3$ Carla is young to the extent 0.3
$\mu_{young}(d) = 0$ Dirk is young to the extent 0.

In any universe of discourse Ω there are infinitely many fuzzy sets because the members of the universe can be mapped to unit interval $[0, 1]$ in infinitely different ways. In closing these introductory notes, consider the following two subsets of our example family $\{a, b, c, d\}$:

MALE $= \{a, b, d\}$

FEMALE $= \{c\}.$

These two sets are classical sets with sharp boundaries. On the one hand, the individuals a, b, and d definitely belong to set MALE, whereas c definitely does not belong to it. On the other hand, the individual c definitely belongs to set FEMALE, whereas the other three individuals are definitely excluded. For exactly these reasons, both sets are also fuzzy sets in $\{a, b, c, d\}$ of the following structure:

MALE $= \{(\text{Alvin}, 1), (\text{Bert}, 1), (\text{Carla}, 0), (\text{Dirk}, 1)\},$

FEMALE $= \{(\text{Alvin}, 0), (\text{Bert}, 0), (\text{Carla}, 1), (\text{Dirk}, 0)\}.$

These examples demonstrate that every classical set is also a fuzzy set, specifically, a limiting one with membership degrees from the two-valued set $\{0, 1\}$ only. The concept of fuzzy set with values from $[0, 1]$ is thus the more general one and includes the classical case. For more details on fuzzy set theory, see [Klir and Yuan, 1995; Ruspini *et al.*, 1998; Dubois and Prade, 1980].

2.3.2 Nosological diagnoses

It is commonly assumed that a diagnosis identifies the disease from which the patient suffers, e.g. "Hilary has diabetes." This traditional notion of diagnosis may be called a *nosological diagnosis*.

A nosological diagnosis would require that every predicate or function symbol occurring in a diagnosis, e.g. in the idiogram $P(a) \wedge \ldots \wedge f(a) = b$, be a nosological term that signifies a disease. However, the actual usage in medicine of the term "diagnosis" strongly deviates from this view. Many physician judgments in clinical practice are handled as diagnoses which are by no means nosological ones. For instance, statements of the type "the patient has an hypercholesterolemia of 280 mg%" identifying an abnormality are also used as diagnoses, whereas nobody would classify such an abnormality as a disease. For this reason a second notion of diagnosis may be useful, i.e. the notion of *abnormality diagnosis*.

2.3.3 Abnormality diagnoses

An abnormality diagnosis is a statement that identifies an abnormality in the patient. According to this notion, any predicate or function symbol contained in a diagnosis would have to be the name of an abnormality, i.e. a malady, be it

a disease, syndrome, disorder, injury, wound, lesion, defect, deformity, disability, and the like. A nosological diagnosis is an abnormality diagnosis, but not vice versa.

2.3.4 Causal diagnoses

For a statement to be a diagnosis it is not enough to be the identification of a disease or abnormality. There needs to be some relationship between the diagnosis and what it is a diagnosis for, i.e. the patient data. It is reasonable to require that this relationship be a *causal* one. That means that if $\Delta = \{\alpha_1, ..., \alpha_m\}$ is a diagnosis for patient data $D = \{\delta_1, ..., \delta_n\}$, there should be a link $\Delta \# D$ between them with $\#$ being a causal relationship that causally relates Δ to D. What does this causal relationship '$\#$' look like?

Usually it is required that the diagnosis *causally explain* patient data. According to this requirement the doctor would have to causally explain, for example, *why* Hilary is suffering from tiredness, intermittent tachycardia, and loss of weight. This apparently reasonable pursuit that sometimes is also referred to as the 'hypothetico-deductive' approach is unrealistic because it is not satisfiable (see Section 3.1 below). It requires causal laws that more often than not are lacking in medicine. For this reason we envisage a weaker relationship than causal explanation. It suffices if the diagnosis describes an event that to some extent is *causally positively relevant* to patient data. The concept of causal relevance that is a prerequisite in this context cannot be introduced here. It may only briefly be noted that an event A in a domain, or population, PO is said to be causally positively relevant to another event B if A precedes B and increases the probability of occurrence of B in PO. It is said to be causally negatively relevant to B if it precedes B and decreases the probability of its occurrence in PO. For details of this probabilistic concept of causality that is advanced by Patrick Suppes, see [Suppes, 1970; Sadegh-Zadeh, 1998, 2011].

Roughly, the degree of causal relevance, cr, of an event A to an event B in a population PO is defined as the difference between the two conditional probabilities $p(B|PO\&A)$ and $p(B|PO)$ thus:

$$cr(A, B, PO) = p(B|PO\&A) - p(B|PO).$$

Thus, it is a real number r in the interval $[-1, 1]$:

(1) $cr(A, B, PO) = r \in [-1, 1]$

and indicates the extent to which the occurrence of A in PO changes the probability of B occurring, given that some additional requirements are satisfied. Accordingly, the relationship may be a positive, a negative or a neutral one:

$$
\begin{aligned}
cr(A, B, PO) &= r > 0 \quad \text{positive,} \\
cr(A, B, PO) &= r < 0 \quad \text{negative,} \\
cr(A, B, PO) &= 0 \qquad\ \ \text{neutral.}
\end{aligned}
$$

For example, we may have these positive causal relevance relationships:

(2) $cr(\text{influenza, cough, smoker}) = 0.7$

$cr(\text{influenza, cough, non-smoker}) = 0.2.$

The former one says that in the population of smokers, influenza is causally positively relevant to cough to the extent 0.7. According to the latter, influenza in the population of non-smokers is causally positively relevant to cough to the extent 0.2.

Let $\Delta = \{\alpha_1, \ldots, \alpha_m\}$ be a diagnosis for patient data $D = \{\delta_1, \ldots, \delta_n\}$. By interpreting the diagnosis as a set of statements that describe the cause event A in a respective population PO, and patient data as another set of statements that describe the effect event B, it becomes apparent how through this interpretation:

$$cr(\Delta, D, PO) = r > 0$$

the concept of positive causal relevance, $cr(A, B, PO) = r > 0$, enters the theory of diagnostics. For instance, with reference to relationships (2) above we may have the following diagnosis for the patient Hilary who coughs and is a smoker:

$$cr(\{\text{Hilary has influenza}\}, \{\text{Hilary coughs}\}, \text{smoker}) = 0.7.$$

It says that influenza is causally positively relevant to her cough to the extent 0.7. As stated above, there are also negative causal relevances such as, for example:

(3) $cr(\text{aspirin, myocardial_infarction, men}) = -0.44$

where 'men' is a shorthand for the population of 'men with elevated C-reactive protein concentration.' A negative causal relevance such as (3) amounts to prevention. Thus, (3) says that in the population mentioned aspirin prevents myocardial infarction to the extent 0.44. In this way, preventive and protective factors are events with negative causal relevance to the effect events they prevent. By contrast, causation is a positive causal relevance such as in (2) above. Examples are diseases, risk factors, and other abnormalities that generate patient data, i.e. problems, complaints, symptoms, and signs.

2.3.5 *Fuzzy diagnoses*

We will introduce two different concepts of fuzzy diagnosis. The first one is a fuzzification of the notion of nosological diagnosis considered in Section 2.3.2 above. To this end we briefly introduce a notion of fuzzy disease. For details, see [Sadegh-Zadeh, 1999; 2000b; 2008].

Traditionally an individual disease is considered to be a set of $n \geq 1$ attributes, e.g. complaints, symptoms, signs, findings or problems. For example, someone may define diabetes mellitus as the presence of "hyperglycemia, glucosuria and polydipsia." This disease is representable in two ways, either as a classical set such as {hyperglycemia, glucosuria, polydipsia} or as a fuzzy set in the following way:

(4) diabetes = {(hyperglycemia, 1), (glucosuria, 1), (polydipsia, 1)}.

A disease represented in this fashion we call a *fuzzy disease*. We have previously suggested the use of this approach in medicine [Sadegh-Zadeh, 2000b].

As is well known, often not all of the defining attributes of a disease are present in a patient, with the effect that it remains uncertain whether the patient does or does not have the disease. Moreover, required attributes may not be present in the required strength. For example, when high body temperature is a required symptom of a disease, the patient's body temperature may be only slightly increased. In such cases the patient's condition cannot be considered a full member of the disease under discussion. The degree of its membership in the disease is less than 1. For example, the patient Hilary with the following data:

(5) {(hyperglycemia, 1), (glucosuria, 0.8), (polydipsia, 0)}

cannot be said to have diabetes to the extent 1 because this data is not in complete agreement with the concept (4) of diabetes above. She cannot be denied to have diabetes either because there is a considerable overlap. It is therefore reasonable to find out to what extent $r < 1$ she can be supposed to have diabetes. This important question may be answered by means of the concept of *similarity* that we will introduce below. We will see that to the extent 0.6 the patient's state (5) resembles the disease (4). We propose using this degree of similarity between the patient's health state and a fuzzy disease as the degree of membership of the patient in the class of those who have that fuzzy disease. In the present example, to the extent 0.6 the patient Hilary is a member of those who have diabetes. That is, $\mu_{\text{has}-\text{diabetes}}(\text{Hilary}) = 0.6$. This statement is a *fuzzy diagnosis* and represents, according to the syntax discussed in Section 2.2.1 above, a categorical diagnosis of the structure $f(a) = b$. We now turn to our second notion of fuzzy diagnosis.

In Section 2.3.4 above a concept of causal diagnosis has been proposed according to which a set $\Delta = \{\alpha_1, \ldots, \alpha_n\}$ of statements is considered a diagnosis for a patient in a population *PO* if it signifies an event that is *causally positively relevant* to patient data $D = \{\delta_1, \ldots, \delta_n\}$ in that population:

$$cr(\Delta, D, PO) = r > 0.$$

Now the following problem arises. In the wake of this concept the diagnosis for patient data D will seldom be unique. Almost always there will exist a large number $n > 1$ of such diagnoses $\Delta_1, \ldots, \Delta_n$ because a lot of different, positive causal relevance relationships of the following type will be available:

$$cr(\Delta_1, D, PO) = r_1,$$
$$\vdots$$
$$cr(\Delta_n, D, PO) = r_n,$$

such that each Δ_i to a particular extent r_i causally accounts for the same patient data D. For example, even at the end of the diagnostic inquiry it may turn out

that as many as twenty different diseases appear to be causally responsible for Hilary's ill health. Since not all of them can be regarded as being of equal weight, it may be useful to search for how to evaluate their diagnostic relevance. This is the well-known problem of *differential diagnosis* in medicine. The novel notion of fuzzy diagnosis that we will now introduce provides a differential-diagnostic reasoning facility.

It is commonly assumed that a statement *is* either a diagnosis or *is not* a diagnosis for a patient. For example, the true statement "Hilary has diabetes" is classified as such a diagnosis for her tiredness and loss of weight, whereas the equally true statement "Hilary is blonde" is viewed as a non-diagnosis for the same data. Thus, the category of diagnoses is handled as a classical set with clear-cut boundaries such that diagnoses definitely reside within the boundaries and non-diagnoses definitely stand outside. The fuzzifying of this clear-cut set boundary will yield a fuzzy set, denoted by *Diag*, such that a collection of statements, $\Delta = \{\alpha_1, \ldots, \alpha_n\}$ with $n \geq 1$, is a member of this set only to a particular extent $r \in [0, 1]$ and thus a diagnosis to that extent. Let μ_{Diag} be the membership function of this fuzzy set *Diag* that we are constructing. We will in this way obtain a notion of fuzzy diagnosis which says that the degree of membership of a statement set Δ in the fuzzy set *Diag* of diagnoses for patient data D in the population PO is $\mu_{\text{Diag}}(\Delta, D, PO) = r \in [0, 1]$. For example, it may be that we have:

$$
\begin{aligned}
&\mu_{\text{Diag}}(\{\text{Hilary has diabetes}\}, D, PO) = 0.6 \\
&\mu_{\text{Diag}}(\{\text{Hilary has hepatitis}\}, D, PO) = 0.3 \\
&\mu_{\text{Diag}}(\{\text{Hilary has diabetes and hepatitis}\}, D, PO) = 1 \\
&\mu_{\text{Diag}}(\{\text{Hilary is blonde}\}, D, PO) = 0,
\end{aligned}
$$

(6)

where the set of patient data, D, in the present case is {tiredness, intermittent tachycardia, loss of weight}. The degree of membership of a statement set Δ in the fuzzy set Diag, μ_{Diag}, will be referred to as the *degree of its diagnostic relevance*, or simply, as its *diagnosticity*. We define the diagnosticity of a statement set simply by the degree of its causal relevance, that is:

DEFINITION 1. $\mu_{\text{Diag}}(\Delta, D, PO) = cr(\Delta, D, PO)$.

We have, for instance, $\mu_{\text{Diag}}(\{\text{Hilary has diabetes}\}, D, PO) = cr(\{\text{Hilary has diabetes}\}, D, PO) = 0.6$. Thus, the diagnosticity of Hilary's diabetes for her data is 0.6. The higher a statement set is causally relevant to patient data, the greater its diagnosticity.

Note that the diagnosticity of a statement set Δ for patient data derives from its causal relevance, but not from its probability, truth or plausibility. Hence, diagnosticity is not a measure of probability, truth, plausibility or any other epistemic quality. It is not an epistemic notion. It is an ontological measure indicating the extent to which something is a diagnosis for something else. In this way, the totality of all possible diagnoses $\Delta_1, \ldots, \Delta_n$ for a particular patient data set D may be arranged in the order of their increasing diagnosticity to suggest an idea of how to plan therapeutic steps. Thus, *diagnosticity* constitutes a quantitative concept of diagnosis.

3 METHODS OF DIAGNOSTICS

What is usually called a 'diagnosis' is something relative to a complex diagnostic context that literally generates the diagnosis as a product. This generative context will be analyzed in Section 5 below. Two important components thereof are the method of diagnostic reasoning and the knowledge used to attain the diagnosis. We will therefore briefly inquire into these two components first to prepare our analysis.

In clinical textbooks and education individual diseases such as diabetes mellitus, myocardial infarction, hepatitis A, B, C, and so on are described and special techniques are presented concerning how to diagnose each of these individual diseases. However, in spite of the honorable age and history of medicine there is as yet no general science of diagnostics that could instruct medical students and young doctors how to diagnose in general, i.e. how to search and find in all cases the best path from a patient's complaints to a diagnosis for this patient by forming diagnostic hypotheses, by testing them, etc. Every individual doctor has her own, idiosyncratic mode of diagnostic reasoning. What is even worse is that only a few physicians are aware of how they achieve their diagnoses. Usually a diagnosis seems to happen to the doctor much as a dream or a headache does. It is therefore not surprising that there are still about 38% misdiagnoses in medicine [Gross and Löffler, 1997; Sadegh-Zadeh, 1981a]. These diagnostic errors will bring with them at least as many wrong treatments. Therefore, as we have already stressed previously, medicine in the 21st century will urgently need to develop a *methodology of clinical practice* to guide the physician's clinical reasoning [Sadegh-Zadeh, 1977; 1994-2000a]. The emerging disciplines of clinical knowledge-based systems research and medical decision-making may be viewed as the advent of such a methodology.

It is generally believed in medicine that the patient suffers from $n \geq 1$ diseases or abnormalities and that the aim of diagnostics is to identify them by searching for a diagnosis. Based on this belief is the assumption that a diagnosis actually informs us about the patient's diseases and abnormalities. We will demonstrate why this assumption is both ontologically and epistemologically problematic. To this end we will point out that diagnosis depends on several components, the most important of them being the medical knowledge and the method of diagnostic reasoning used. In the present section we will be concerned with the role that the method of diagnostic reasoning plays. There are a large number of such methods. Only three examples will be demonstrated here, i.e. the hypothetico-deductive approach, Bayesian reasoning, and similaristic reasoning.

3.1 The hypothetico-deductive approach

It is a rather widely held opinion that the aim of science is to explain natural phenomena and to predict future events. In accord with this traditional dogma, clinical diagnostics is supposed to provide explanations of the patient's suffering. It is therefore important to ask what an explanation is and whether it is true that

clinical diagnostics provides explanations of the patient's suffering.

The most influential theory of scientific explanation today, first proposed by Carl Gustav Hempel and Paul Oppenheim in 1948 [Hempel and Oppenheim 1948; Hempel, 1965], is known as the "covering-law model." Roughly, it says that a scientific explanation is a logical argument whose premises comprise a set of statements that include one or more scientific laws and whose conclusion is a statement that describes the *explanandum*, i.e. the phenomenon, fact or event to be explained. The premises are called the *explanans* because they explain the explanandum. In addition to laws the explanans also contains some other statements describing those particular circumstances, called *antecedent conditions*, which made the occurrence of explanandum possible.

The authors distinguish several subtypes, the main representative of which is the so-called *deductive-nomological* (D-N) explanation. A D-N explanation is a deductive argument such that the explanandum statement follows from the explanans. The explanans consists of $m \geq 1$ universal generalizations, referred to as laws, and $n \geq 1$ statements of antecedent conditions. The explanandum statement describes an event such as, for example, the event that the patient Hilary has suffered myocardial infarction. A D-N argument may be schematically represented in the following way:

$$\left.\begin{array}{l} L_1, \ldots, L_m \\ A_1, \ldots, A_n \end{array}\right\} \text{ Explanans}$$
$$\overline{ E } \quad \text{Explanandum}$$

Here L_1, \ldots, L_m are universal generalizations, i.e. laws; A_1, \ldots, A_n are singular statements of antecedent conditions; and the conclusion E is the explanandum statement implied by the explanans. A simple example may demonstrate. Our explanandum is the event that the patient Hilary has suffered myocardial infarction. Why did this event occur? The following D-N argument explains why:

L: If one of the main coronary arteries of the heart of a human being occludes at time t_1 then she suffers myocardial infarction after a short time;

A_1 Hilary is a human being;

A_2 A main coronary artery of Hilary's heart occluded at time t_1 (e.g. ten minutes ago);

A_3 time t_2 is shortly after time t_1;

E Hilary suffers myocardial infarction at time t_2.

The explanandum statement E deductively follows from the explanans $L \wedge A_1 \wedge A_2 \wedge A_3$. The law statement L in the explanans is a universal generalization of the form $\forall x \forall t_1 \forall t_2 (Px \wedge Qxt_1 \wedge t_2$ is shortly after $t_1 \rightarrow Rxt_2)$ where $Px \equiv$ "x is a human being", $Qxt_1 \equiv$ "one of the main coronary arteries of x's heart occludes at time t_1", and $Rxt_2 \equiv$ "x suffers myocardial infarction at time t_2". In the example

above, the explanandum E is the patient's suffering; and the antecedent statement $A_1 \wedge A_2 \wedge A_3$ suggests a cause of this event and thus a "diagnosis."

We will here not go into the details of the D-N theory. It provides an explication of the so-called hypothetico-deductive approach where the laws in the explanans represent the hypotheses. The idea behind it is that a D-N argument explains an event by demonstrating that this event was nomically expectable ("nomos" ≡ *law*). An extensive analysis, criticism, and evaluation of the theory may be found in [Stegmüller, 1983].

Our aim here is to point out that the D-N theory of explanation has only limited value in medical diagnostics, for the following reason. The universal generalizations required by the explanans, i.e. the so-called deterministic laws as above, are scarcely available in medicine. Most statements in empirical-medical knowledge are statistical statements that do not enable the deduction of the explanandum statement from explanans. That is, only a limited number of diagnoses can be obtained using D-N explanation.

Hempel and Oppenheim's theory also includes as a subtype a method of 'inductive-statistical explanation' (I-S). An explanation of this type, it is said, is an argument whose explanans contains at least one statistical law and inductively implies the explanandum statement [Hempel, 1965, pp. 381 ff.]. We need not speculate about whether inductive-statistical explanations might be used as a device of diagnostic reasoning. It has been shown in the meantime that Hempel and Oppenheim's proposal is objectionable to the effect that there are no inductive-statistical explanations [Stegmüller, 1973, 1983].

3.2 Bayesian reasoning

Strangely enough the existence of universal generalizations in a domain is usually identified with 'certainty' in that domain. Wherever only statistical knowledge or knowledge below the level of 'certainty' is available, reasoning processes are characterized as 'uncertain.' Since the emergence of the concept of probability, and especially since the probabilization of the natural sciences and medicine in the early twentieth century, uncertainty in diagnostics is handled primarily probabilistically by applying the mathematical apparatus of probability theory and statistics. This approach that is characteristic of so-called *medical decision-making* was introduced by Ledley and Lusted in their seminal paper on the reasoning foundations of medical diagnosis in 1959 [Ledley and Lusted, 1959]. Already in that paper they used, for the first time in medicine, the so-called Bayes' Theorem as a method of diagnostic reasoning. This theorem has become an important methodological tool of medical decision-making in the meantime. The theorem was discovered by the eighteenth century English clergyman Thomas Bayes (1702-1761) and published posthumously in 1763 [Bayes, 1763]. After probability theory received its explicit formulation in the twentieth century it was shown that Bayes' Theorem is indeed a theorem of this theory, i.e. derivable from its calculus.

Consider, for instance, a doctor who seeks a diagnosis for a patient, Joseph K.

At the beginning of the patient interview she only weakly believes that Joseph K has coronary heart disease. But one hour later she strongly believes in this hypothesis after she has obtained new evidence by recording and interpreting an ECG of the patient. This is an example of the continuous change of our belief, *belief revision* for short, that takes place throughout the diagnostic process. To 'rationally' manage this diagnostic belief revision the adherents of Bayes' Theorem, the Bayesians, recommend the use of that theorem as a reasoning method that is usually referred to as Bayesian reasoning, Bayesian inference, Bayesian logic, or simply Bayesianism (see [Sadegh-Zadeh, 1980b]).

To assess the role that Bayes' Theorem may play in diagnostics, suppose that before you know whether or not the patient Joseph K has a pathological ECG you only weakly believe that he has coronary heart disease. To what extent should your belief change after observing a pathological ECG in the patient? Bayes' Theorem is a device to calculate just the 'rational' extent of this belief revision, i.e. the belief strength *after*-the-observation given the belief strength *before*-the-observation. That is, it connects the *posterior* probability of an event with its *prior* probability (prior to the new evidence, posterior to the new evidence).

In the theory of probability Bayes' Theorem is derivable from the concept of probability space. It exists in a variety of forms. We will present its simplest version where A and B are two arbitrary events:

$$p(B|A) = \frac{p(A|B) \cdot p(B)}{p(A)}. \qquad \text{(Bayes' Theorem)}$$

The theorem says that the probability of event B conditional on event A equals the product $p(A|B) \times p(B)$ divided by $p(A)$. To illustrate, let us suppose that in the population of patients over 60 years of age, 15% of those who have coronary heart disease show ST segment depression in their resting ECG. We may thus state that in the population mentioned the probability of ST depression occurring in resting ECG on the condition that coronary heart disease is present is 0.15. That is:[2]

(7) $p(ST|CHD) = 0.15.$

The shorthands used in this sentence mean:

ST ≡ ST depression in resting ECG is present,

CHD ≡ coronary heart disease is present.

The patient Joseph K is 63 years old. In a checkup his family physician has recorded a resting ECG and is surprised at observing ST depression on it. She is wondering about whether Joseph K has coronary heart disease. She knows that Bayes' Theorem relates a conditional probability of the form $p(A|B)$ with the inverted conditional probability $p(B|A)$. It enables her to conclude from (7) above that:

[2]The ST segment in ECG connects the S wave and the T wave. When it is below the baseline it is said to be depressed. ST depression is indicative of myocardial ischemia that may cause myocardial infarction.

(8) $p(CHD|ST) = 0.93$.

This conclusion says that the probability that a patient older than 60 years has coronary heart disease conditional on ST depression in his resting ECG is 0.93. Thus the physician has strong reason to believe that Joseph K has coronary heart disease and to act accordingly.

We now will demonstrate how, by means of Bayes' Theorem, (8) follows from (7). To this end the doctor above needs two additional, prior probabilities. She knows that in the population of patients over 60 years of age:

$$p(CHD) = 0.01$$
$$p(ST) = 0.0016.$$

On the basis of this information she can now use Bayes' Theorem to calculate the probability that her patient Joseph K has coronary heart disease on the available evidence that he has ST depression in his resting ECG:

$$p(CHD|ST) = \frac{p(ST|CHD) \cdot p(CHD)}{p(ST)}$$
$$= \frac{0.15 \times 0.01}{0.0016}$$
$$= \frac{0.0015}{0.0016}$$
$$= 0.9375.$$

Thus, the doctor's belief revision has led her to the posterior belief: the probability that the patient Joseph K has coronary heart disease is very high, i.e. 0.93.

3.3 Similaristic reasoning

More often than not there is no sufficient domain knowledge available to understand and manage a particular clinical problem, e.g. a patient's suffering. In such circumstances knowledge of another type is needed. For example, the data at hand may indicate similarities between the current problem and some previous cases that have already been successfully resolved in the past. Using such similarities to reason about, and manage, a present problem by utilizing previous experiences we will refer to as *similaristic reasoning*.

Similaristic reasoning is a salient characteristic of natural human problem solving. It has been known as *casuistry* in the history of ethics and theology, and as *casuistics* in the history of medicine. A sophisticated type of these similaristic methods, the so-called *case-based reasoning*, was born in the early 1980s. It has been attracting research interests in computer science and artificial intelligence since then. This approach will be briefly outlined in the present section to inquire into its diagnostic applicability. To this end we need some terminology, especially a concept of similarity, to be introduced first.

3.3.1 A concept of similarity

The key notion on which case-based reasoning relies is the concept of similarity. The best-known concept of similarity has been the one suggested by Amos Tversky [1977]. Because of its drawbacks, however, we will replace it in this section with a powerful one that we will construct by means of fuzzy-set terminology. To this end, the entities whose similarity is to be assessed, e.g. two diseases or two human beings, are represented as fuzzy sets of attributes that they possess. Similarity will be conceived as a relation between two such fuzzy sets, say A and B, of the syntax "fuzzy set A is similar to fuzzy set B to the extent r" symbolized by $simil(A, B) = r$. The concept we will introduce will enable us to measure, for example, how similar the following two fuzzy sets are that represent the states of two different individuals or of one and the same individual at two different times:

(9) $X = \{(\text{hyperglycemia}, 1), (\text{glucosuria}, 1), (\text{polydipsia}, 1)\}$

$\qquad Y = \{(\text{hyperglycemia}, 1), (\text{glucosuria}, 0.8), (\text{polydipsia}, 0)\}$

An inverse semantic relationship connects the terms "different" and "similar." It says that the less different two objects, the more similar they are and vice versa. This implies that the less different two fuzzy sets, the more similar they are. In complete accord with this precept we will construct our fuzzy set similarity relation as the inverse of fuzzy set difference. So let us first introduce a notion of *fuzzy set difference* as our basic term.

The difference between two fuzzy sets, A and B, will be defined as a relation of the form "fuzzy set A differs from fuzzy set B to the extent r" symbolized by *diff(A, B)* = r. The value r is a real number in the unit interval $[0, 1]$. To define the basic notion *diff*(A, B), we need the following six auxiliary notions that will be introduced in turn:

- the greater of two numbers a and b,

- the lesser of two numbers a and b,

- the absolute value of a real number,

- the size, or count, of a fuzzy set A,

- the intersection of two fuzzy sets A and B,

- the union of two fuzzy sets A and B.

Let a and b be two not necessarily distinct real numbers. The greater of them is called *max(a, b)* and the lesser is called *min(a, b)*. These two functions, *max* and *min*, that we will use below as auxiliary notions, are defined as follows:

$$\begin{aligned}
\max(a,b) \ &= a, \quad \text{if } a \geq b \\
&= b, \quad \text{otherwise} \\
\min(a,b) \ &= a, \quad \text{if } b \geq a \\
&= b, \quad \text{otherwise.}
\end{aligned}$$

For example, $\max(5,3) = 5$ and $\min(5,3) = 3$. Sometimes we need the *absolute value* of a real number r, denoted by $|r|$. The absolute value $|r|$ of a real number r is its size without regard to its sign. Thus, it is defined as follows:

$$\text{If } r \text{ is a real number, then } |r| = \begin{cases} r, & \text{if } r \geq 0 \\ -r, & \text{if } r < 0. \end{cases}$$

Consider the real number $r = 5$ as an example. Then we have $|5| = 5$. And if $r = -5$, we have $|-5| = -(-5) = 5$, too. Thus, $|5| = |-5| = 5$.

The size or *count* of a fuzzy set A, written $c(A)$, is simply the arithmetic sum of the membership degrees of its members. For instance, $c(\{(x,0.2),(y,1)\}) = 0.2 + 1 = 1.2$. Let Ω be a universe of discourse and let A and B be two fuzzy sets in Ω such that:

(10) $$A = \{(x_1, a_1), ..., (x_n, a_n)\},$$
$$B = \{(x_1, b_1), ..., (x_n, b_n)\},$$

where an a_i is the degree of membership of x_i in set A and a b_i is the degree of membership of the same object x_i in set B. Two such fuzzy sets A and B in a universe of discourse Ω may have any relationships with one another. For example, their *intersection*, denoted by $A \cap B$, is a fuzzy set defined by the minima of their joint membership degrees, i.e. by the following membership function $\mu_{A \cap B}$:

$$\mu_{A \cap B}(x) = \min(\mu_A(x), \mu_B(x)).$$

That is, $A \cap B = \{(x, \mu_{A \cap B}(x)) | x \in \Omega \text{ and } \mu_{A \cap B}(x) = \min(\mu_A(x), \mu_B(x))\}$. And their *union*, denoted by $A \cup B$, is a fuzzy set defined by the maxima of their joint membership degrees, i.e. by the following membership function $\mu_{A \cup B}$:

$$\mu_{A \cup B}(x) = \max(\mu_A(x), \mu_B(x)).$$

That is, $A \cup B = \{(x, \mu_{A \cup B}(x)) | x \in \Omega \text{ and } \mu_{A \cup B}(x) = \max(\mu_A(x), \mu_B(x))\}$. This terminology may be illustrated by a few examples. Let:

$$\Omega = \{a, b, c, d\}$$

be our universe of discourse, and let the following two sets be fuzzy sets in Ω:

Proficient doctor $= \{(a,0),(b,0.4),(c,0.8),(d,1)\}$,
Young doctor $= \{(a,0.9),(b,0.5),(c,0.3),(d,0.7)\}$.

Then the following two sets are also fuzzy sets in Ω:

Proficient doctor \cap Young doctor $= \{(a,0),(b,0.4),(c,0.3),(d,0.7)\}$,

Proficient doctor \cup Young doctor $= \{(a,0.9),(b,0.5),(c,0.8),(d,1)\}$.

The intersection $A \cap B$ represents a fuzzy conjunction ('A and B'). The union $A \cup B$ represents a fuzzy disjunction ('A or B'). The fuzzy intersection above, i.e. Proficient doctor \cap Young doctor, is the fuzzy set of those doctors in Ω who are both proficient *and* young, while their fuzzy union, i.e. Proficient doctor \cup Young doctor, is the fuzzy set of those doctors in Ω who are proficient *or* young.

Having the auxiliary notions above at our disposal, we can now define the difference between two fuzzy sets as follows:[3]

DEFINITION 2. Let $A = \{(x_1, a_1), ..., (x_n, a_n)\}$ and $B = \{(x_1, b_1), ..., (x_n, b_n)\}$ be two fuzzy sets, then:

$$diff(A, B) = \frac{\sum_i |a_i - b_i|}{c(A \cup B)}.$$

Here Σ_i means the arithmetic sum of $i \geq 1$ numbers, i.e. the sum $|a_1 - b_1| + \ldots + |a_n - b_n|$ in the present case representing the sum of the absolute differences of membership degrees of our two fuzzy sets A and B. For example, if these fuzzy sets are those displayed in (9) above:

$$X = \{(x, 1), (y, 1), (z, 1)\},$$
$$Y = \{(x, 1), (y, 0.8), (z, 0)\},$$

then we have:

$$
\begin{aligned}
diff(X, Y) &= (|1 - 1| + |1 - 0.8| + |1 - 0|)/(1 + 1 + 1) \\
&= 1.2/3 \\
&= 0.4.
\end{aligned}
$$

This calculation shows that set X differs from set Y to the extent 0.4. After these preparatory remarks we now introduce fuzzy *similarity* as the additive inverse of fuzzy set difference in the following way:

DEFINITION 3. $simil(A, B) = 1 - diff(A, B)$.

For instance, our two example fuzzy sets X and Y above with the difference 0.4 between them are similar to the extent $1 - 0.4 = 0.6$.

A very convenient method of computing similarities that we will use below is provided by the following interesting Similarity Theorem that follows from Definitions 2-3. For details, see [Lin, 1997; Sadegh-Zadeh, 2011]:

THEOREM 4 Similarity. $simil(A, B) = \dfrac{c(A \cap B)}{c(A \cup B)}.$

That is, the degree of similarity between two fuzzy sets equals the count of their intersection divided by the count of their union. For instance, regarding our two example fuzzy sets X and Y above we have:

$$
\begin{aligned}
simil(X, Y) &= 1 + 0.8 + 0/1 + 1 + 1 \\
&= 1.8/3 \\
&= 0.6.
\end{aligned}
$$

[3]The concept is due to [Lin, 1997; Sadegh-Zadeh, 2000c]. Its formal presentation here is overly simplified. For details, see [Sadegh-Zadeh, 2011].

Similarity as defined above is a relationship between fuzzy sets. According to Definition 3 its extent is a real number in the unit interval [0, 1]. The concept introduced is applicable to all fuzzy sets including the patients' health conditions that are being treated as individual *cases* so as to make them amenable to case-based reasoning.

3.3.2 Case-based reasoning

Case-based reasoning, or CBR for short, is a method for solving a current problem by utilizing experience on previous problems. It is increasingly becoming an important subject of research in medical artificial intelligence and clinical decision-making. Although it is often viewed as a recent brainchild of Janet Kolodner [Kolodner, 1993], it does not represent a novel approach. It is rooted in the so-called *casuistry*, a case-based moral judgment, that had its origin in Stoicism and in the writings of Cicero (106-43 BC). Also contemporary bioethics research is devoting attention to casuistry as a method of ethical decision-making (cf. [Boyle, 2004; Strong, 1999]). Casuistry flourished during the fifteenth and sixteenth centuries in the Roman Catholic Church [Jonsen and Toulmin, 1989; Keenan and Shannon, 1995]), and was also used in medicine in the eighteenth and nineteenth centuries giving rise to the well-known *case reports* or casuistics. However, as a moral-philosophical and medical-casuistic approach it lacked a formal methodology. This facility was provided by and after Janet Kolodner's pioneering work on CBR.

As a revival of casuistry, CBR is an empirical approach in that it exploits previous experiences to find solutions for present cases. Previous experiences on individual cases are stored in the memory of a CBR system referred to as its *case base*. Facing a new problem, e.g. a new patient with a particular medical complaint, it retrieves *similar cases* from its case base and adapts them to fit the problem at hand and to provide a solution for it (cf. [Jurisica *et al.*, 1998]). It thus rests on the basic CBR axiom that *similar problems have similar solutions*. This philosophy is reminiscent of homeopathy that relies on Samuel Hahnemann's esoteric *law of similars*, i.e. "similia similibus curentur" (1796), *like cures like*. In order for CBR to be distinguishable from such speculative conceptions, therefore, it may be based on a framework with efficient methods of case representation and a clear notion of case similarity.

Usually CBR is contrasted with the so-called 'model-based reasoning.' The latter term is an inappropriate one and ought to be avoided. It is a misleading name for a knowledge-based, or knowledge-guided, approach that uses general, scientific knowledge in the premises of arguments, e.g. rule-based clinical expert systems such as Mycin and others. CBR does not do so because the knowledge contained in its case base is merely the description of some individual cases without any generalization or statistical analysis. The expertise that is used as 'knowledge' in a CBR system simply consists of narrations on specific problems embodied in a library about single cases, for example, about (i) the patient Hilary who had

had symptoms $A, B,$ and C and had received the drug D to the effect E; (ii) the patient Joseph K who had had symptoms $F, G,$ and H and had received the drug I to the effect J; and so on. A current case is matched against such exemplars in the case base to make a judgment and decision. How is the comparison to be made and the judgment and decision to be attained? Otherwise put, how is information on previous cases to be used so as to manage a present case? This is the central methodological question CBR is concerned with. The first answer it provides is that there must be some similarity between the present case and one or more cases in the case base. Such inter-case similarities are utilized in judging and decision-making by CBR. As an example of CBR we will briefly discuss case-based diagnosis.

3.3.3 Case-based diagnosis

The case base of a CBR system for diagnosis contains records of the making of diagnosis for each individual case in the case base. The records include information of the following type: (i) every individual case's initial data, i.e. initial patient complaints, symptoms, signs, and findings; (ii) the course of diagnostics, i.e. the diagnostic examinations performed at each diagnostic stage and the data gathered; (iii) final patient data; (iv) the set of patient data used in making the diagnosis; (v) the diagnosis; and (vi) whether the diagnosis was confirmed or disconfirmed by biopsy, operation, autopsy or controls of another type.

Suppose there is a particular patient, Hilary, with a set D of initial data. To solve the diagnostic problem for this patient by CBR, set D is matched with all initial data sets in the case base to retrieve a number of sufficiently similar cases, given a similarity threshold of some kind. In order for data set D to be comparable to a data set D' of a case in the case base, both data sets must be represented as fuzzy sets. For example, suppose D and D' are the following fuzzy data sets:

$$D = \{(\text{fever, 1}), (\text{vomiting, 0.7}), (\text{tachycardia, 0.5})\}$$
$$D' = \{(\text{fever, 0.8}), (\text{vomiting, 1}), (\text{tachycardia, 0.5})\}.$$

According to Similarity Theorem 4 in Section 3.3.1 we have the following degree of similarity between these two data sets:

$$simil(D, D') = (0.8 + 0.7 + 0.5) \, / \, (1 + 1 + 0.5) = 0.8.$$

From among the retrieved set of cases the best case is selected in this way, i.e. the case whose initial data set has the maximum similarity to D, and the patient Hilary is examined like that case. The same procedure is followed in making the diagnosis on the basis of the final patient data set. Where more cases than one have been retrieved the solution must be transformed into a solution for the current patient, Hilary. This adaptation process is the most important and difficult step of CBR and cannot be discussed here. For details, see [Hüllemeier, 2007; Pal and Shiu, 2004].

3.4 Fuzzy-logical reasoning

A large number of fuzzy-logical approaches to diagnostics have developed in recent years which deviate considerably from classical-logical and probabilistic ones. However, their discussion would require an introduction to fuzzy logic that we cannot here afford. Among the interesting ones are Adlassnig *et al.*'s CADIAG project where they introduce a new, fuzzy-logical method of medical knowledge representation by fuzzifying frequency notions such as "seldom," "frequently," "never," and others, and temporal notions such as "a few days," "more than four weeks," etc. [Adlassnig, 1980; 1986; Adlassnig and Akhavan-Heidari, 1989; Boegl *et al.*, 2004]). Also the possibilistic approach based on the theory of possibility [Zadeh, 1978; 1981] belongs to this category and seems to be a promising one. For details, see [Sadegh-Zadeh, 2011].

4 THE DIAGNOSTIC KNOWLEDGE

The second component in the diagnostic context which essentially determines the diagnosis is the medical knowledge, especially the clinical knowledge, which is used in the diagnostic process. In inquiring into the logic and philosophy of diagnosis it is therefore useful to be aware of the syntax of all kinds of statements constituting the clinical knowledge and data, and to examine what kind of knowledge plays the central role in making a diagnosis. This issue is briefly discussed in the present section. After introducing some terminology we will first undertake a typology of clinical statements and then analyze the logical deep structure of diagnostic knowledge in the sequel. Our analysis will reveal that clinical decision-making in general and diagnostics in particular belong to the realm of practical ethics. An outstanding contribution to this subject may be found in [Schwarz, 1993].

4.1 Deontic rules and acts

We will reconstruct diagnosis as both social act and fact. To prepare this perspective we will first demonstrate that the making of a diagnosis is a deontic act, and thus the diagnosis itself is the product of a deontic act. To this end we have to explain what we understand by the term "deontic act."

A deontic act is simply an action performed in following a deontic rule. For example, by telling the truth a witness performs a deontic act because she follows the deontic rule "everybody ought to tell the truth." We will now introduce the notion of a deontic rule to show that diagnostic knowledge is not declarative knowledge like, for example, the anatomic description of the body. It consists of deontic rules, and as a consequence, diagnostic decision-making turns out to consist of deontic acts.

The adjective "deontic" derives from the Greek term "deon" meaning *duty*. The class of modal operators that we touched upon in Section 2.1 above also contains three important ones called deontic operators. They represent deontic modalities,

i.e. obligation, prohibition and permission, and are dealt with in deontic logic. In natural languages there are various phrases such as the following to express deontic modalities. For details, see [Åqvist, 1984; McNamara, 2006; Sadegh-Zadeh, 2011]:[4]

> For *obligation*:
>> obligatory, ought to, required, should, must, obliged;
>
> For *prohibition*:
>> forbidden, prohibited, impermissible, must not, wrong, unacceptable;
>
> For *permission*:
>> permitted, permissible, allowed, allowable, may.

Simple examples are:

- Alvin *ought to* tell the truth;

- Bert is *forbidden* to commit murder;

- Carla is *allowed* to drink water.

We will use only the following as their representatives:

- it is obligatory that ... symbolized by OB (obligation operator)

- it is forbidden that ... FO (prohibition operator)

- it is permitted that ... PE (permission operator).

Each of these expressions is an intensional sentential operator. That is, when it is prefixed to a sentence we obtain a new sentence, referred to as a *deontic sentence*. For example, let α be any sentence. Then we have:

- $OB\alpha \equiv$ it is obligatory that α

- $FO\alpha \equiv$ it is forbidden that α

- $PE\alpha \equiv$ it is permitted that α.

The above examples may now be rewritten as follows:

- *it is obligatory that* Alvin tells the truth;

- *it is forbidden that* Bert commits murder;

- *it is permitted that* Carla drinks water.

That means semiformally:

[4]There are in fact five deontic modalities (obligation, prohibition, permission, optionality, gratuitousness). But they are reducible to the above-mentioned three, and these are definable by only one of them. See below.

- OB(Alvin tells the truth),

- FO(Bert commits murder),

- PE(Carla drinks water).

For our studies on the logic of diagnosis in the sequel it is important to note that the three deontic operators sketched above are interdefinable. The obligation operator OB may serve as the undefined, basic one to introduce all other deontic operators as derived ones in the following way ("iff" stands for "if and only if"):

DEFINITION 5.

1. FOα iff OB$\neg\alpha$

2. PEα iff \negFOα.

As a consequence of this definition we obtain: $PE\alpha$ iff $\neg OB\neg\alpha$. Due to the central role that the obligation operator OB obviously plays it may serve as the basic concept to ground a deontic logic thereon. The remaining operators are used as shorthands according to Definition 5. We will therefore use the obligation operator as our main device in our studies below. Moral rules such as "one ought to tell the truth" and legal rules such as "theft is forbidden" are reconstructible as deontic sentences by using deontic operators as above. For details, see [Åqvist, 1984; McNamara, 2006; Sadegh-Zadeh, 2011].

Also diagnostic knowledge consists of deontic sentences, specifically, of deontic rules. To uncover this important feature of diagnostics, we will now introduce the term "deontic rule." To this end we will use the auxiliary notion of an action sentence. A sentence of the form $P(x_1, \ldots, x_n)$ with an n-place predicate P will be called an *action sentence* if P denotes an action such as "tells the truth," "examines the patient," "drinks water," and the like. Thus, sentences such as "Dr. Smith examines the patient Hilary" and "Hilary drinks water" are action sentences. Our aim is to base the notion of a deontic rule on action sentences to prevent vacuous obligations, prohibitions, and permissions such as "it is obligatory that the sky is blue."

DEFINITION 6 Action sentence.

1. If P is an n-ary action predicate, then $P(x_1, \ldots, x_n)$ is an action sentence;

2. If α is an action sentence, then $\neg\alpha$ is an action sentence referred to as the omission of the action;

3. If α and β are action sentences, then $\alpha \wedge \beta$ and $\alpha \vee \beta$ are action sentences;

4. If α is any sentence and β is an action sentence, then $\alpha \rightarrow \beta$ is an action sentence, referred to as a conditional action sentence.

Examples are the action sentences "Hilary tells the truth" and "if Dr. Smith interviews Hilary, then she tells the truth." The latter is a conditional action sentence. We will now introduce the notion of a *deontic rule* in two steps.

DEFINITION 7 Deontic action sentence.

1. If α is an action sentence and ∇ is a deontic operator, then $\nabla\alpha$ is a deontic action sentence;

2. If α and β are deontic action sentences, then $\neg\alpha$, $\alpha\wedge\beta$, and $\alpha\vee\beta$ are deontic action sentences;

3. If $\alpha \rightarrow \beta$ is an action sentence, then $\alpha \rightarrow \nabla\beta$ is a deontic action sentence referred to as a deontic conditional.

For example, "it is obligatory that Hilary tells the truth" is a deontic action sentence. A deontic conditional is the sentence "if Dr. Smith interviews Hilary, then it is permitted that she does not respond."

If α is any sentence and x is an individual variable, $\forall x\alpha$ is also a sentence referred to as the universal generalization of α. We say that the quantifier \forall *binds* the individual variable x. For example, $\forall y P(y)$ is the universal generalization of Py in which the individual variable y is bound by \forall. If α is a sentence with free individual variables x_1, \ldots, x_n, e.g. the sentence $P(x_1, \ldots, x_n)$, its universal generalization $\forall x_1 \ldots \forall x_n \alpha$ is called its closed generalization.

In the same fashion as above, if α is any deontic action sentence with free individual variables x_1, \ldots, x_n, e.g. the sentence $OB(P(x_1, \ldots, x_n))$, its closed generalization is $\forall x_1 \ldots \forall x_n \alpha$, that is, $\forall x_1 \ldots \forall x_n OB(P(x_1, \ldots, x_n))$ in our present example. For instance, the closed generalization of the sentence "it is obligatory that the doctor tells her patient the truth" is: For all x and for all y, if x is a doctor and y is her patient, then it is obligatory that x tells y the truth. That is, $\forall x \forall y (\text{Doctor}(x) \wedge \text{Patient}(y, x) \rightarrow OB(\text{Tells-the-truth}(x, y)))$.

DEFINITION 8 Deontic rule.

1. If α is a deontic action sentence, then its closed generalization is a *deontic rule*, i.e. $\forall x_1 \ldots \forall x_n \alpha$ with $n \geq 1$;

2. A deontic rule of the form $\forall x_1 \ldots \forall x_n (\alpha \rightarrow \nabla\beta)$ is called a conditional obligation if $\nabla \equiv OB$, a conditional prohibition if $\nabla \equiv FO$, and a conditional permission if $\nabla \equiv PE$.

A deontic rule is also called a *deontic norm*. For example, according to clause 1 of Definition 7 the sentence "one ought to tell the truth," i.e.:

1. For everybody x, it is obligatory that x tells the truth

 is a deontic rule because it is the closed generalization of the deontic action sentence "OB(x tells the truth)." Additional examples are:

2. For everybody x, it is forbidden that x steals;

3. For everybody x, if x is a child of age 6, it is obligatory that x starts school.

These three rules may be formalized as follows:

- $\forall x OB(\text{Tells-the-truth}(x))$

- $\forall x FO(\text{Steals}(x))$

- $\forall x(\text{Child-6}(x) \rightarrow OB(\text{Starts-school}(x)))$.

The first two examples are unconditional deontic rules. Example 3 represents a conditional deontic rule, specifically, a conditional obligation. We know from Definition 5 above that the three deontic operators are interdefinable. Specifically, PE is definable by FO, and FO is definable by OB:

$$PE\alpha \equiv \neg FO\alpha$$
$$FO\alpha \equiv OB\neg\alpha \text{ and thus } PE\alpha \equiv \neg OB\neg\alpha.$$

On this account the obligation operator OB may serve as the basic and only deontic operator to formulate both types of deontic rules. That means that all such rules prescribe ought-to-do actions. They may therefore be viewed as *ought-to-do action rules*, *ought-to-do rules*, or *action rules* for short. We will use these terms interchangeably.

4.2 Types of clinical statements

Among the important types of statements constituting clinical knowledge are, in addition to probability statements, the following ones:

- singular statements such as "the patient Hilary has property P," e.g. *Hilary coughs*;

- simple general statements such as "all patients who have property P also have property Q," e.g. *a human being who has bronchitis, coughs*;

- complex general statements such as "all patients who have P, Q, R have also S, T, V," e.g. *a human being with diabetes mellitus and hepatitis has hyperglycemia and icterus*;

and combinations of them by using sentential connectives such as 'not', 'or', 'and', etc. In dealing with statements of this type the classical predicate logic is of course a sufficient and powerful tool.

Medical knowledge also contains several types of *modal* statements that go beyond the facilities of predicate logic. They employ modal operators of different types some of which we have sketched in previous terminology sections. An outstanding example in the present context is diagnostic knowledge. We will show below that it consists of deontic rules. This feature qualifies it as practical knowledge. We will therefore consider the differences between declarative and practical knowledge first.

4.3 Declarative knowledge

Non-clinical knowledge in medicine, i.e. extra- or preclinical knowledge that is usually called 'biomedical knowledge,' is not concerned with clinical subjects such as disease, diagnosis, treatment and other clinical aspects and issues. It deals with the anatomy, physiology, physics, and chemistry of the human organism and some animal species such as mice, rats, cats, and dogs that serve as subjects of biomedical research. The usual label for the production of this type of knowledge in medicine is "animal experimentation." Most of what in preclinical medicine is erroneously called "medical knowledge" or "biomedical knowledge" stems from such animal experimentation. Therefore, it belongs in fact to *zoology* and presents declarative knowledge on its subject. Declarative knowledge states and communicates how things 'are.' It describes objects, structures, behavior, processes, and other entities. Consider, for instance, the following sentences:

> "The replication of a DNA molecule begins at special sites called origins of replication. The bacterial chromosome has a single origin marked by a stretch of DNA having a specific sequence of nucleotides. Proteins that initiate DNA replication recognize this sequence and attach to the DNA, separating the two strands and opening up a replication bubble". [Campbell, 1996, p. 290]

These sentences describe the origins of DNA replication and state how this process develops. In other words, they are constatives. They are therefore considered as *statements* and are said to be true or false. They don't command, don't ask questions, and don't request anything. But practical knowledge does do so: It commands and recommends.

4.4 Practical knowledge

Medicine proper is clinical medicine and not zoology. It produces and uses *clinical knowledge* to attain its goals. This type of knowledge is concerned with human maladies, i.e. pathology, nosology, diagnosis, treatment and other clinical aspects of life and death. It consists of a variety of subtypes, e.g. pathophysiological knowledge on the pathological behavior of cells, tissues, organs, organ systems, and the organism; and phenomenological, 'shallow' knowledge on subjective illness and its symptoms and signs. These knowledge types are also declarative in nature, for example, "symptoms of pneumonia are fever, cough, and dyspnea." The main subtype of clinical knowledge, however, is practical knowledge consisting of diagnostic and therapeutic rules. This is why medicine is to be categorized not as an empirical, experimental or natural science, but as a practical science. We will clarify what practical-medical knowledge is before we proceed to our logic of diagnosis.

It has become customary to contrast practical knowledge with theoretical knowledge. However, this dichotomy is inappropriate. It obscures the nature of practical knowledge because it suggests that practical knowledge is opposed to theoretical

knowledge. A correct dichotomy would be the distinction between *practical* knowledge and non-practical, i.e. *declarative*, knowledge. Declarative knowledge is, in essence, what enables us *to know that* something is the case. By contrast, *to know how* to do something is conveyed by practical knowledge, also called procedural knowledge, for example, know how to diagnose community acquired pneumonia or to treat acute myocardial infarction. To put it in a nutshell, the difference between declarative knowledge and practical knowledge lies between *know-that* and *know-how*. A considerable amount of medical knowledge consists of know-how. The best examples are diagnostic and therapeutic knowledge.

To demonstrate that diagnostic knowledge is practical knowledge it is worth noting that in textbooks and other publications diagnostic knowledge is communicated not by single sentences, but by complex texts. Usually these texts are scattered over different chapters and sub-chapters and do not betray at first glance that they have a nested deep structure consisting of commands and commitments of the form "situation X commits you to Y." Consider as a simple example the following incomplete conditional:

> When a patient has a cough with or without sputum, has an acute or subacute fever and has dyspnea, then if you want to know whether ...

This incomplete sentence can, after the phrase "whether," be continued in numerous different ways, e.g.:

> ... she has disease X_1, then do Y_1
> ... she has disease X_2, then do Y_2
> ... she has disease X_3, then do Y_3

and so on, where each Y_i is an action of arbitrary complexity. Only one of these possible clinical situations may be exemplified. To this end take a clinical textbook in your hand. You will find therein that a chapter on a particular disease or disease group, e.g. community acquired pneumonia, is composed of several sub-chapters each of which is devoted to a special aspect, for example, nosology, diagnosis or treatment of the disease in the following fashion:

- Chapter on nosology: Symptoms of community acquired pneumonia are cough with or without sputum, an acute or subacute onset of fever, dyspnea, etc.

- Chapter on diagnosis: Community acquired pneumonia is diagnosed by chest examination, chest radiography, thoracentesis with pleural fluid analysis, ... etc. In chest examination altered breath sounds and rales are heard. Chest radiography shows that ... etc.

- Chapter on treatment: Antibiotic options for patients with community acquired pneumonia include the following: (1) clarithromycin, 500 mg orally twice a day, (2) etc.

The diagnosis chapter says that the disease "is diagnosed by chest examination, ... etc." Pseudo-declarative formulations of this type are usual in medical textbooks. However, they must not be mistaken for declarative report on how physicians in their practice actually diagnose the disease. Such information would be uninteresting and off the point because practicing physicians may do what they like and may do so out of bad habit. Why should that be binding? Rather, the sentences are to be understood as recommendation and prescription of certain measures that are to be taken to test a diagnostic hypothesis, e.g. the hypothesis that the patient might have the disease described in the nosology sub-chapter, i.e. community acquired pneumonia in the present example. The division into sub-chapters, in a textbook, of nosology, diagnosis, and treatment of the disease in fact comprises artificially isolated parts of a conditional command of the following structure:

> When a patient has a cough with or without sputum, has an acute or subacute fever and has dyspnea, then
>
> - if you want to know whether she has community acquired pneumonia, then
> - *you should*
> 1. examine her chest and
> 2. search for altered breath sounds and
> 3. search for rales and
> 4. perform chest radiography and
> 5. search for opaque areas in both lungs.

A closer look at this example sentence shows that it is a nested conditional obligation of the following form:

> If $\alpha_1 \& \alpha_2 \& \alpha_3$, then (if β, then you-should($\gamma_1 \& \gamma_2 \& \gamma_3 \& \gamma_4 \& \gamma_5$)).

Such a commitment may have the following general structure:

> If $\alpha_1 \& ... \& \alpha_k$, then (if $\beta_1 \& ... \& \beta_m$, then you-should($\gamma_1 \& ... \& \gamma_n$))

with $k, m, n \geq 1$. That is:

(11) $\alpha_1 \wedge ... \wedge \alpha_k \rightarrow (\beta_1 \wedge ... \wedge \beta_m \rightarrow OB(\gamma_1 \wedge ... \wedge \gamma_n))$.

Here the predicate "OB" represents the deontic obligation operator *it-is-obligatory-that* and stands for "you-should." For example,

> it-is-obligatory-that(you examine the patient's chest and
> you search for altered breath sounds and
> you search for rales and
> you perform chest radiography and
> you search for opaque areas in both lungs).

As we can see in sentence (11) above, the operator OB applies to the whole sentence $\gamma_1 \wedge ... \wedge \gamma_n$ in the terminal consequent. This example demonstrates a simplified item of highly complex diagnostic knowledge on how to diagnose respiratory diseases in patients who present the three symptoms listed above, i.e. cough, fever, and dyspnea. Note that its terminal consequent, $OB(\gamma_1 \wedge ... \wedge \gamma_n)$, is an ought-to-do sentence and thus a command that may also be represented by using a command term such as "do action such and such!" Obviously, medical-diagnostic knowledge does not tell us 'what is the case,' but 'what is to be done.' It enables us *to know how* to proceed and is thus practical knowledge rather than declarative knowledge. Similarly, the treatment of the disease is based on a command sentence of the following type that is divided into different chapters on the disease:

> When a patient has a cough with or without sputum, has an acute or subacute fever, and has dyspnea, then
>
> - if she has community acquired pneumonia, then
> - *it is obligatory that* you choose a treatment from among the following options:
> 1. clarithromycin, 500 mg orally twice a day,
> 2. etc.

Also this sentence has the same logical structure as the diagnostic rule (11). We may therefore conclude that diagnostic-therapeutic knowledge consists of, or is reconstructible as, *deontic rules* of the form:

$$\forall x_1...\forall x_n(\alpha \rightarrow (\beta \rightarrow OB(\gamma)))$$

such that γ is an action sentence of arbitrary complexity. With these results at our disposal, we will show in the sequel that diagnostics, as the source of diagnosis, is part of the diagnostic-therapeutic decision-making that we will reconstruct as a deontic process of indication, contra-indication, and differential indication of clinical actions.

5 INDICATION STRUCTURES AND DIAGNOSIS

The following terms will be used as synonyms: clinical decision-making, diagnostic-therapeutic decision-making, clinical reasoning, clinical judgment.

Clinical diagnostics as a part of diagnostic-therapeutic decision-making cannot be neatly separated from the therapeutic part of this process. Both acts are closely intertwined. They are two aspects of one and the same process of clinical reasoning and action planning. The term clinical "action" unites both of them.

It is widely overlooked in the medical community that crucial to an adequate understanding of clinical decision-making and reasoning are the notions of *indication* and *differential indication* of clinical actions. Therefore, it will not be possible

to develop a successful methodology and philosophy of diagnosis without first constructing a logic and methodology of indication and differential indication. The present section suggests a framework for discussing basic problems in handling this task. We will introduce the notions of indication, contra-indication, and differential indication, and will show that on the basis of this terminology clinical decision-making, including the making of a diagnosis, is to be viewed as a computable sequence of selecting the appropriate clinical actions according to clinical ought-to-do rules.

5.1 The clinical goal

To begin with, it should be pointed out that the subjects the physician is dealing with are sick persons and not symptoms, findings, diseases or treatments. Since sick persons are bio-psycho-moral agents governed by moral values and norms, different than physical devices, clinical judgment is not comparable to trouble-shooting in physical devices. Therefore, theories on trouble-shooting in physical devices that are put forward by artificial intelligence researchers and are also spreading in medicine cannot provide appropriate foundations for our task. Raymond Reiter's acclaimed "theory of diagnosis from first principles" is no exception (see [Reiter, 1987; de Kleer *et al.*, 1992]).

The starting-point of clinical judgment is a particular person, denoted 'p', who is ill or believes herself to be ill, and thus presents a non-empty set of initial data consisting of particular problems, complaints, symptoms and signs. Let us call this initial data about the patient that the physician receives, patient data set D_1, such that $D_1 = \{\delta_1, .., \delta_m\}$ with $m \geq 1$. In this data set each δ_i is a sentence providing any information on the patient p. For instance, D_1 may be one of the following sets of sentences:

> {p is a male of about 47, p is complaining of headaches};

> {p is a 12-year-old boy, p is bleeding at the nose};

> {p has just been involved in a car accident, p is unconscious, p's heart rate is 124 per minute, p's blood pressure is 80/60 mm Hg};

> {p has undergone a gastrectomy last year, p is complaining of acute pain in the upper left abdomen}.

It is commonly assumed that in the first place clinical judgment aims at finding a *diagnosis* which will explain why the data set D_1 occurred. For various reasons, however, this widespread opinion must be considered a metapractical misconception about the nature and purpose of clinical practice [Sadegh-Zadeh, 1977; 1979]. A more realistic and fruitful view is provided by treating D_1 as a clinical problem that provokes a problem-solving process, where the solution aimed at is not a diagnosis but a remedial action, including advice and 'wait and watch,' which is meant to ameliorate the patient's present suffering and make her problem disappear. This primary clinical goal may be termed *praxiognosis*, i.e. recognizing 'what

is to be done,' in contradistinction to diagnosis that identifies 'what is wrong' with the patient. That the search for and the optimization of the remedial action often requires additional information on the patient, part of which may be termed diagnosis, is an accidental feature of the praxiognostic process due to the particular course the history of medicine has taken since about 1750. It could have been otherwise (see Section 1).

Our postulate of praxiognosis above becomes plausible by considering the truism that if there were only one unique remedial action for all kinds of patients, no problem-solving and thus no diagnosis would be necessary. Every patient would enjoy that unique remedial measure independent of the nature and causes of her problem. Unfortunately, however, the therapeutic inventory of medicine offers many different therapeutic measures, say $T_1, ..., T_n$ with $n > 1$, including the empty action 'doing nothing.' And each of these numerous therapies may be viewed as a potential remedy for every patient with the initial data set D_1. The problem-solving task is to select from among the therapeutic inventory $\{T_1, ..., T_n\}$ a minimum subset $\{T'_1, ..., T'_m\}$ that is considered the best solution to the problem D_1.[5]

The initial patient data set D_1 provides us with a root problem, and the appropriate minimum remedial set $\{T'_1, ..., T'_m\} \subseteq \{T_1, ..., T_n\}$ we are searching for is the solution goal of the problem-solving process provoked by D_1. The entirety of all possible paths from the root problem to the unknown solution goal $\{T'_1, ..., T'_m\}$ may be conceived of as a *branching clinical questionnaire* whose questions are posed to the patient as a "black box" containing her organism, personality, pathogenetically relevant factors, environment, and history. The questions posed are questions in the proper sense of this term as well as tests, examination of the patient, and the like to gather information.[6] We have the opportunity of asking the box any question, e.g. any physical examination and laboratory test we are allowed to perform, X-ray photographs and NMR images we can take, etc. By providing responses to our questions, the organism in the black box guides us through the labyrinth of the candidate clinical paths to the desired solution goal.

Clinical judgment thus presents itself as a path-searching, or pathfinding, endeavor based on an information-producing inquiry in a question-answering process controlled by the physician and her clinical questionnaire. The process is initiated by the initial patient data set D_1 which provokes the first question and test, i.e. the initial clinical action A_1 the physician takes, and is terminated by her final action, A_n, with $n \geq 1$. To formulate our problem, we will now reconstruct the microstructure of this clinical process [Sadegh-Zadeh, 1977; 1994]:

Any particular instance of clinical judgment is initiated at a particular instant of time, t_1, and is terminated at a later instant of time, t_n. A doctor, d, at t_1

[5]In what follows, "\subseteq" symbolizes the subsethood relation such that "$A \subseteq B$" reads "A is a subset of B."

[6]For the concept and theory of *branching clinical questionnaire*, see [Sadegh-Zadeh, 2011]. In such a questionnaire, the answer to a question Q_i determines what question is to be asked as the next one, Q_{i+1}.

starts inquiring into whether or not the patient p presenting the data set D_1 suffers from any disorder and needs any treatment. The total period of this inquiry, i.e. the time interval $[t_1, t_n]$, can be partitioned into a finite sequence of discrete sub-periods $t_1, t_2, t_3, ..., t_n$. Proceeding from the root data set D_1 at t_1, the physician chooses from among *all possible actions* she might consider, a particular set of actions, A_1, and performs it. This action set A_1 may be any questions she asks the patient, a diagnostic inference she makes, a particular physical examination, laboratory test, treatment or the like. For instance, A_1 may be one of the following action sets:

{how long has this problem been going on?};

{is there any genetic disease in your family?};

{measure p's body temperature, determine her heart rate};

{an ECG should be recorded first, followed by postero-anterior chest radiography and Coomb's test};

{I believe that p suffers from systemic lupus erythematosus};

{give the patient a Nitroglycerin tablet of 0.3 mg}.

The outcome of the action set A_1 the physician performs is some information on the patient she obtains from the black box. This new information changes the original data set D_1 to data set D_2 at t_2, e.g. to the set {p is a male of about 47, p is complaining of severe headaches, p's body temperature is 39 Celsius, p's heart rate is 102 per minute}.

Proceeding from D_2 at t_2, a second set of actions, A_2, is chosen and performed whose result changes the previous data set D_2 to data set D_3 at t_3, and so forth until a final action set A_n is performed at time t_n terminating the process of clinical decision-making.

We have thus partitioned the whole period $[t_1, t_n]$ of clinical decision-making into the discrete sub-periods $t_1, t_2, ..., t_n$ such that the sequence of patient data sets available in these temporal granules is $D_1, D_2, ..., D_n$, and the corresponding action sets performed are $A_1, A_2, ..., A_n$, respectively. Clinical judgment may now be viewed as a linear path of the form displayed in Fig. 1 (a and b).

The path consists of a finite sequence of data-based selection of the actions $A_1, A_2, ..., A_n$, on the one hand, and a successive building of the patient data sets $D_1, D_2, ..., D_n$, on the other, that are used in identifying and selecting the corresponding actions. A double arrow in the figure says that the data set D_i leads the clinical decision-maker to the action set A_i, whereas a simple arrow represents the A_i-mediated acquisition of the data set D_{i+1}. By reconstructing this sequence of data-based action selection in the language of our 'branching clinical questionnaire' theory [Sadegh-Zadeh, 2011] it is easily recognized that the action sets $A_1, A_2, ..., A_{n-1}$ which the physician performs at $t_1, t_2, ..., t_{n-1}$ are the questions she asks the patient, and the data sets $D_2, ..., D_n$ are the respective answers she receives. This question-answering game creates a *clinical path* that

a D_1 D_2 D_3 . . . D_{n-1} D_n

$$\Downarrow \nearrow \Downarrow \nearrow \Downarrow \nearrow \quad \nearrow \Downarrow \nearrow \Downarrow$$

 A_1 A_2 A_3 . . . A_{n-1} A_n

b $D_1 \Rightarrow A_1 \rightarrow D_2 \Rightarrow A_2 \rightarrow \ldots \rightarrow D_n \Rightarrow A_n$

Figure 1. (a and b). The clinical path

represents the route the clinical process in an individual case has actually taken through the jungle of the branching questionnaire.

Let us now formalize the above idea. We will assume that patient data are formulated by statements transformed into ordered pairs of attribute-value type such as, for example:

⟨sex, female⟩	≡ statement δ_1
⟨age, about 50⟩	≡ statement δ_2
⟨cough, severe⟩	≡ statement δ_3
⟨body temperature, high⟩	≡ statement δ_4
⟨heart rate, 102 per minute⟩	≡ statement δ_5

The term "attribute" in this context means either a linguistic variable or a numerical variable in the terminology of fuzzy theory. For instance, the third statement in the list above says "the patient has a severe cough" identifying the value "severe" of the linguistic variable "cough." In special analyses the core data structure above may be supplemented by a variety of additional dimensions, e.g. by adding patient name and time period to yield temporal quadruples of object-time-attribute-value type such as, for example, ⟨Hilary Ciccione, February 20, cough, severe⟩. We will symbolize:

- statements describing singular data by $\delta, \delta_1, \delta_2,$... to connote *data*;

- sets of such data statements by $D_1, D_2, ..., D_n,$... to connote *data set*;

- statements describing actions by $\alpha, \alpha_1, \alpha_2...$ to connote *action*;

- sets of such action statements by $A_1, A_2, ..., A_n,$... to connote *action set*.

The set of *all* data patients may present in the course of clinical decision-making, the *data space*, will be denoted by \mathcal{D}. The physician's *action space* comprising all possible and clinically relevant actions she may consider, will be termed \mathcal{A}. 'Clinically relevant actions' means methods of clinical inquiry in history taking, diagnosis, prognosis, therapy, and prevention. Note that the omission of an action

described by a statement α is also an action, i.e. the negation $\neg\alpha$, and is thus included in the action space \mathcal{A}. The powerset of a set X is written power(X). Thus we have:

$$\mathcal{D} = \{\delta | \delta \text{ is an attribute-value statement about the patient}\}$$
$$\mathcal{A} = \{\alpha | \alpha \text{ is a statement describing an action the physician}$$
$$\text{may consider}\}$$
$$\text{power}(\mathcal{D}) = \{D | D \subseteq \mathcal{D}\}$$
$$\text{power}(\mathcal{A}) = \{A | A \subseteq \mathcal{A}\}.$$

Succinctly stated [Sadegh-Zadeh, 1977], the basic problem in the methodology of clinical reasoning is this: Supposing that the temporal sequence of the decision-making process is $t_1, t_2, ..., t_n$ with $n \geq 1$, is it possible to construct an effective procedure which can be initiated at t_1 such that when the patient data set is $D_i \subseteq \mathcal{D}$ with $1 \leq i \leq n$, the optimal action set $A_i \subseteq \mathcal{A}$ can be selected unambiguously from among the action space \mathcal{A}, the next data set $D_{i+1} \subseteq \mathcal{D}$ can be built as objectively as possible, and the particular doctor d is in principle exchangeable by any doctor x? Put another way, is there a mapping:

$$f\colon \text{power}(\mathcal{D}) \to \text{power}(\mathcal{A})$$
$$f\colon \text{power}(\mathcal{A}) \to \text{power}(\mathcal{D})$$

such that f is a computable function so as to render the process of clinical judgment sketched in Fig. 1 above a computable path-searching with:

$$f(D_i) = A_i$$
$$f(A_i) = D_{i+1}$$

and to unambiguously provide the physician in all possible clinical situations with an optimal guide for her decisions? A computable function of this type will be referred to as a computable clinical decision function, *ccdf* for short.

In what follows, the conceptual apparatus needed for constructing a ccdf is analyzed. To prevent misunderstandings, however, note that the chronologically ordered patient data sets $D_1, D_2, ..., D_n$ above are not supposed to display a monotonic relationship of the type $D_1 \subseteq D_2 \subseteq D_3 \subseteq ... \subseteq D_n$. Such monotonicity is never found in clinical practice. Otherwise, neither healing nor recovery could exist. Patient data change over time by changing their size and the truth values of their single statements. For example, the patient has fever right now, but she has a normal body temperature after two hours.

Note, secondly, that no distinction has been made between patient data and diagnosis. What is usually called diagnosis may be part of any of the patient data sets $D_1, D_2, ..., D_n$. We will in this way be able to avoid both the impracticable partition of clinical decision-making into anamnestic, diagnostic, and therapeutic phases, and the old-fashioned differentiation between anamnestic, diagnostic, and therapeutic actions.

5.2 Indication and differential indication

Traditionally the notion of indication is used in the context of therapeutic decision-making. A treatment that is required in a particular circumstance is said to be 'indicated.' For example, in acute appendicitis the surgical removal of the vermiform appendix is indicated. On the other hand, a treatment that must not be administered in a particular circumstance is said to be contra-indicated, e.g. the application of a drug when the patient has an allergy to that drug. We will in the present section show not only that these two fundamental concepts of clinical practice, *indication* and *contra-indication*, are essentially deontic concepts, but also that all actions the physician performs, i.e. all clinical actions including the diagnostic ones, are *deontic* acts. To this end we have to introduce a few terms.

Let \Box be a variable representing any of the three deontic operators, OB, FO or PE for obligation, prohibition, and permission, respectively. We write $\Box\alpha$ to express any of the propositions $OB(\alpha), FO(\alpha)$, and $PE(\alpha)$. Recall that in Definition 8 in Section 4.1 a closed generalization of the form $\forall x_1 \forall x_2...\forall x_m \beta$ we have called a *deontic rule* if $x_1, ..., x_m$ are the free variables of the sentence β and the sentence satisfies some additional conditions. For the sake of convenience, however, a generalization of the form $\forall x_1 \forall x_2...\forall x_m \beta$ will be shortened to β by omitting the cumbersome quantifier prefix $\forall x_1 \forall x_2...\forall x_m$.

We have already pointed out that clinical reasoning is a knowledge-based endeavor based on knowledge of different types and sources. Examples are anatomical, biochemical, physiological, and pathophysiological knowledge of declarative type. Lastly, however, clinical decisions are made on the base of *clinical-practical* knowledge that according to our analysis consists of deontic rules. We are now in a position to explicate in this section our main, deontic concepts of indication and contra-indication.

We have seen that a piece of diagnostic or therapeutic knowledge as a deontic rule is a commitment stating that:

A: if you are in a clinical situation δ_1, then
B: if you want to reach the goal δ_2, then
C: action α should be performed / is forbidden / is allowed.

That is:

$$\delta_1 \rightarrow (\delta_2 \rightarrow \Box\alpha)$$

or, equivalently:

$$\delta_1 \wedge \delta_2 \rightarrow \Box\alpha.$$

A is the description of the disease or disease state presented in the sub-chapter on symptoms and signs of the disease. B is the physician's goal in that situation, e.g. the goal to confirm or disconfirm a particular differential-diagnostic hypothesis. And C recommends the appropriate action to be taken, e.g. a diagnostic technique described in the sub-chapter on diagnosis or a therapeutic measure described in the sub-chapter on therapy. The artificially separated presentation of A, B, and C in different parts of a chapter in a clinical textbook hides the fact that

a commitment of the following structure is being extended: Situation δ commits you to α. Here, δ is $\delta_1 \wedge \delta_2$. Thus, the commitment is reconstructible as a universal deontic conditional of the form:

(12) $\forall x_1 \forall x_2 ... \forall x_m$ If δ, then $\Box \alpha$

which we will briefly formalize as:

(13) $\delta \rightarrow \Box \alpha$

omitting the quantifier prefix. The antecedent δ is an atomic or compound sentence, i.e. patient data describing symptoms, signs, findings, pathological states, any boundary condition such as patient gender, age, her social environment, the physician's goal, etc. The consequent is a deontic statement, $\Box \alpha$, containing deontic expressions such as 'should be performed,' 'is required,' 'must be applied,' 'is recommended,' 'do!,' 'omit!,' 'may be used,' and the like. Simple examples are the following diagnostic-therapeutic commands, recommendations or rules:

1. If a patient complains of angina pectoris and her ECG is unknown, then an ECG should be recorded.

2. When someone has acute myocardial infarction, taking an exercise ECG is forbidden.

3. In acute myocardial infarction one may administer oxygen to the patient.

These examples demonstrate that depending on the nature of the operator \Box in the consequent of formula (13), we have to distinguish between:

- conditional obligation: $\delta \rightarrow OB\alpha$

- conditional prohibition: $\delta \rightarrow FO\alpha$

- conditional permission: $\delta \rightarrow PE\alpha$.

Example 1 above is a conditional obligation, example 2 is a conditional prohibition, and example 3 is a conditional permission. A clinical indication rule is a more or less complex statement of this type prescribing what actions in a particular situation of the clinical encounter are permitted, forbidden or obligatory, given that the patient data is δ. More specifically, we will see below that any clinical indication rule prescribing particular diagnostic or therapeutic measures may be construed as a *conditional obligation*, $\delta \rightarrow OB\alpha$. A contra-indication rule, on the other hand, may be construed as a conditional prohibition, $\delta \rightarrow FO\alpha$. The propositions δ and α in these rules may be of arbitrary complexity designating a set of data or actions, respectively.[7]

[7]A profound philosophical analysis of this issue may be found in [Schwarz, 1993]. There are considerable disagreements in the literature as to how conditional obligations, prohibitions, and permissions are to be formalized. We have conceived them as conditional sentences as above.

Suppose that a particular clinical knowledge base contains, among other things, the following indication and contra-indication rules:

$$\delta_1 \rightarrow OB\alpha_1$$
$$\delta_2 \rightarrow OB\alpha_2$$
$$\vdots$$
$$\delta_m \rightarrow FO\alpha_m.$$

Given a patient with the data set $\{\delta_1, ..., \delta_m\}$, a deontic-logical inference will yield the conclusion $\{OB\alpha_1, OB\alpha_2, ..., FO\alpha_m\}$ that says action α_1 is indicated and ... and action α_m is forbidden, i.e. contra-indicated.

The preceding preliminaries enable us to reconstruct clinical judgment as a deontic-logical process of pathfinding for indications and contra-indications in the branching clinical questionnaire [Sadegh-Zadeh, 2011]. To enhance the expressive power of the framework, however, we will not confine ourselves to individual deontic conditionals. Let D be a patient data set such that:

$$D = \{\delta_1, ..., \delta_m\}$$

with $m \geq 1$. Then a set function f will identify from among the clinical knowledge base used a bundle of deontic rules whose antecedents match D:

$$\delta_1 \rightarrow \Box\alpha_1$$
$$\delta_2 \rightarrow \Box\alpha_2$$
$$\vdots$$
$$\alpha_m \rightarrow \Box\alpha_m$$

and will infer their consequents, $\{\Box\alpha_1, ..., \Box\alpha_m\}$. This concluded deontic set informs us about the actions $\alpha_1, ..., \alpha_m$ each of which, depending on the prefixed operator \Box, is obligatory, forbidden, or permitted in this situation. Thus, the whole procedure can be simply formalized as a set-functional relationship between the black box's, i.e. the patient's, reactions to the questions asked and the actions that are to be taken accordingly:

$$f(D) = \{\Box\alpha_1, ..., \Box\alpha_m\}.$$

If the operator \Box in $\{\Box\alpha_1, ..., \Box\alpha_m\}$ is exclusively one of the three operators OB, FO, or PE, one may also conveniently write $OB\{\alpha_1, ..., \alpha_m\}, FO\{\alpha_1, ..., \alpha_m\}$, or $PE\{\alpha_1, ..., \alpha_m\}$ to express that the whole action set $\{\alpha_1, ..., \alpha_m\}$ is obligatory, forbidden, or permitted, respectively. That means:

DEFINITION 9. If A is a set of sentences, i.e. $A = \{\alpha_1, ..., \alpha_m\}$, we write

$OB(A)$ instead of $\{OB\alpha_1, ..., OB\alpha_m\}$
$FO(A)$ instead of $\{FO\alpha_1, ..., FO\alpha_m\}$
$PE(A)$ instead of $\{PE\alpha_1, ..., PE\alpha_m\}$.

For the sake of simplicity and convenience, the set-function variable f used in the following frameworks may be supposed to be a triple of this type:

$$f \equiv \{\text{a set } G \text{ of goals; a knowledge base } KB; \text{ a methodology } M$$
$$\text{of applying } KB\}$$

consisting of:

- $G \equiv$ the goals that the decision-maker, e.g. a doctor, pursues in the process of decision-making. These goals play a basic role in determining the course of decision-making;

- $KB \equiv$ a particular system of knowledge that she applies in decision-making, e.g. a cardiological knowledge base;

- $M \equiv$ a set of methods of how to apply the knowledge base KB in decision-making to achieve the goals G, e.g. Bayes' Theorem, hypothetico-deductive approach, etc.

The methods component, M, may also explicitly or implicitly include, or be based upon, any particular system of classical or non-classical logic. We will come back to this point below when analyzing the relativity of diagnosis.

DEFINITION 10. ξ is a *decision-making frame* iff there are $c, d, t, \mathcal{D}, \mathcal{A}, D, A, f$, and \Box such that

1. $\xi = \langle c, d, t, \mathcal{D}, \mathcal{A}, D, A, f, \Box \rangle$,

2. c is a non-empty set of clients, i.e. $c = \{c_1, \ldots, c_m\}$ with $m \geq 1$,

3. d is a non-empty set of decision-makers ('doctors'), i.e. $d = \{d_1, \ldots, d_n\}$ with $n \geq 1$, not necessarily distinct from c,

4. t is a time period,

5. \mathcal{D} is the data space, i.e. a set of statements about c's possible states,

6. \mathcal{A} is d's action space at t, i.e. the set of all possible actions d may take,

7. D is a subset of \mathcal{D} accepted by d at t,

8. A is a subset of \mathcal{A},

9. There are goals G, a knowledge base KB, and a methodology M such that $f \equiv \{G, KB, M\}$ and $f \colon \text{power}(\mathcal{D} \cup \mathcal{A}) \rightarrow \text{power}(\mathcal{D} \cup \mathcal{A})$,

10. \Box is a deontic operator, provided by knowledge base KB or methods M.[8]

[8]A notation of the form "$f : X \rightarrow Y$" means that the function f maps set X to set Y. The symbol "\cup" signifies the union of two sets such that $X \cup Y$ means "the union of sets X and Y."

For example, the client set c may consist of an individual patient such as {Hilary} or a group of patients such as {Hilary, Bert, Carla}, whereas d represents one or more decision-makers, e.g. an individual doctor or a group of doctors or other health providers. The time period of decision-making is indicated by t. The definition above axiomatizes only the frame of a decision-making situation. The function f maps the union of all possible data and actions to this set itself. Thus, it will enable us to choose the appropriate action, given a particular data set D at time t. For this reason, f will be referred to as the *decision function* of the frame. In the following definitions, this decision function is characterized and specialized yielding indication, contra-indication, and differential indication structures.

DEFINITION 11. ξ is a permissive structure if there are $c, d, t, \mathcal{D}, \mathcal{A}, D, A, f$, and PE such that

 1. $\xi = \langle c, d, t, \mathcal{D}, \mathcal{A}, D, A, f, PE \rangle$,

 2. ξ is a decision-making frame,

 3. $f(D) = A$,

 4. $PE(A)$.

Suppose, for example, D is any of the patient data sets $D_1, D_2, ..., D_n$ the physician is successively faced with in the time periods $t_1, t_2, ..., t_n$ during the decision-making process. According to Axioms 3-4, the decision function f will identify the action set $A \subseteq \mathcal{A}$ which is permitted in this situation. A permissive structure may also be termed a weak indication structure. The following definitions in an analogous manner determine indication, contra-indication, and differential indication structures as deontic-logical ones.

DEFINITION 12. ξ is an *indication structure* iff there are $c, d, t, \mathcal{D}, \mathcal{A}, D, A, f$, and OB such that

 1. $\xi = \langle c, d, t, \mathcal{D}, \mathcal{A}, D, A, f, OB \rangle$,

 2. ξ is a decision-making frame,

 3. $f(D) = A$,

 4. $OB(A)$.

DEFINITION 13. ξ is a *contra-indication* structure iff there are $c, d, t, \mathcal{D}, \mathcal{A}, D, A, f$, and FO such that

 1. $\xi = \langle c, d, t, \mathcal{D}, \mathcal{A}, D, A, f, FO \rangle$,

 2. ξ is a decision-making frame,

 3. $f(D) = A$,

4. $FO(A)$.

By interpreting the set D as patient data at time t, and the action set A as a set of diagnostic or therapeutic measures, in Definition 12 the decision function f assigns to D the diagnostic or therapeutic action set A that is obligatory in this situation, i.e. *indicated*. By contrast, in Definition 13 the selected action set A is forbidden, i.e. *contra-indicated*. In this way diagnostic and therapeutic reasoning will become a model of these definitions. We may therefore term the decision function f a *clinical* decision function.

What is particularly important in understanding the deontic nature, and in inquiring into the methodology, of clinical reasoning is the clinical decision function f used in the axiomatizations above. It assigns to a given patient data set a particular set of actions which is permitted, obligatory or forbidden in this situation. Informally, the physician's goals, knowledge, experience, logic, and moral act as a function of this type.

From the definition of the deontic operators FO and PE in Definition 5 we recall the following relationships:

1. $FO\alpha$ iff $OB\neg\alpha$

2. $PE\alpha$ iff $\neg FO\alpha$

3. $PE\alpha$ iff $\neg OB\neg\alpha$.

The first relationship says that a particular action is forbidden if and only if it is obligatory to omit this action. According to the second relationship permission is the negation of prohibition. These two sentences imply the third one which shows that an action is permitted if its omission is not obligatory. Thus, the obligation operator, as used in (1), may be viewed as the basic and single one to represent the other two. Thanks to this fact, every contra-indication turns out to be the indication of the omission of the contra-indicated action as expressed by the following theorem:

THEOREM 14. $\delta \rightarrow OB\neg\alpha$ *is equivalent to* $\delta \rightarrow FO\alpha$.

That means that if an action ('α' at the right-hand side) is contra-indicated, then its omission ('$\neg\alpha$' at the left-hand side) is indicated. In this way, a contra-indication structure:

$$\langle c, d, t, \mathcal{D}, \mathcal{A}, D, \{\alpha_1, ..., \alpha_m\}, f, FO \rangle$$

as defined in Definition 13 above becomes equivalent to an indication structure of the form:

$$\langle c, d, t, \mathcal{D}, \mathcal{A}, D, \{\neg\alpha_1, ..., \neg\alpha_m\}, f, OB \rangle.$$

Here, the action set $\{\neg\alpha_1, ..., \neg\alpha_m\}$ is the omission of the actions $\{\alpha_1, ..., \alpha_m\}$. The relationship is based on the following theorem that follows from Definitions 12–13 and Theorem 15.

THEOREM 15. $\langle c, d, t, \mathcal{D}, \mathcal{A}, D, \{\neg\alpha_1, ..., \neg\alpha_m\}, f, OB\rangle$ *is an indication structure iff* $\langle c, d, t, \mathcal{D}, \mathcal{A}, D, \{\alpha_1, ..., \alpha_m\}, f, FO\rangle$ *is a contra-indication structure.*

For this reason we may integrate contra-indications as *obligatory omissions* into indication structures and thus omit the additional term 'contra-indication.'

When a particular set $A = \{\alpha_1, ..., \alpha_m\}$ of clinical actions is indicated, it is natural to assume that there is a clinical priority ordering \succ that determines the temporal sequence of performing the elements or subsets of A, say in the order $\alpha_1 \succ ... \succ \alpha_m$. A performance order of this kind defined for action set A will be written $\langle A, \succ\rangle$. It renders an indication structure a well-ordered one.

DEFINITION 16. ξ is a *well-ordered* indication structure iff there are $c, d, t, \mathcal{D}, \mathcal{A}$, D, A, f, OB, and \succ such that

1. $\xi = \langle c, d, t, \mathcal{D}, \mathcal{A}, D, A, f, OB, \succ\rangle$,

2. $\langle c, d, t, \mathcal{D}, \mathcal{A}, D, A, f, OB\rangle$ is an indication structure,

3. \succ is a binary relation on power(A),

4. $\langle A, \succ\rangle$ is the performance order induced by f over A.

Considering the circumstance that in clinical situations individual clinical actions may be differently evaluated with respect to their urgency, invasiveness, risk, benefit, cost, etc., one will appreciate the advantages of a performance ordering \succ of the type above which, depending on the degree of its sophistication, may contribute to a well-ordered indication structure. The search for an adequate and acceptable performance ordering \succ is among the central ethical problems of medicine. 'What action A_i must be preferred to what action A_j?'

Well-ordered indication structures are necessary, though they are not sufficient for optimal patient management. There are clinical situations where a patient presents, as a partition of her data D, various data sets $D_1, ..., D_m$ at the same time such that D is their collection, e.g. multiple disorders to be treated or multiple groups of coherent symptoms and signs to be interpreted. Each of these data sets, considered separately, necessitates a particular diagnostic or therapeutic indication set A_i such that an array $A_1, ..., A_m$ of action sets appears to be indicated corresponding to the data sets $D_1, ..., D_m$. For instance, after a kidney operation a patient must be given several drugs, while her postoperative pneumonia requires in addition antibiotics that would increase her current renal insufficiency. In such cases the physician is faced with the problem of whether or not there is any conflict of action among the indication set $\{A_1, ..., A_m\}$, and of how to resolve this conflict and to minimize the action union $A_1 \cup ... \cup A_m$. The solution aimed at is a minimum, proper subset $B \subset A_1 \cup ... \cup A_m$ such that B is indicated due to the present data set $D_1 \cup ... \cup D_m$. A conflict analysis, optimization and resolution of this type is referred to as making a *differential indication* decision.

Note that every patient data set D is the union $D_1 \cup ... \cup D_m$ of its covering subsets $D_1, ..., D_m \subseteq D$. Since these subsets may necessitate a large indication set

$A_1 \cup ... \cup A_m$ as above, it appears reasonable to view every diagnostic-therapeutic setting as one that is best managed by a differential indication decision.

DEFINITION 17. ξ is a *differential indication* structure iff there are $c, d, t, \mathcal{D}, \mathcal{A},$ $D_1, ..., D_m, A_1, ..., A_m, B, f$, and OB such that

1. $\xi = \langle c, d, t, \mathcal{D}, \mathcal{A}, \{D_1, ..., D_m\}, \{A_1, ..., A_m\}, B, f, OB \rangle$,

2. For each pair $\{D_i, A_i\}$, the tuple $\langle c, d, t, \mathcal{D}, \mathcal{A}, D_i, A_i, f, OB \rangle$ is an indication structure,

3. $B \subset A_1 \cup ... \cup A_m$,

4. $\langle c, d, t, \mathcal{D}, A, D_1 \cup ... \cup D_m, B, f, OB \rangle$ is an indication structure.

DEFINITION 18. ξ is a *well-ordered* differential indication structure iff there are $c, d, t, \mathcal{D}, \mathcal{A}, D_1, ..., D_m, A_1, ..., A_m, B, f, OB$, and \succ such that

1. $\xi = \langle c, d, t, \mathcal{D}, \mathcal{A}, \{D_1, ..., D_m\}, \{A_1, ..., A_m\}, B, f, OB, \succ \rangle$,

2. $\langle c, d, t, D, A, \{D_1, ..., D_m\}, \{A_1, ..., A_m\}, B, f, OB \rangle$ is a differential indication structure,

3. \succ is a binary relation on power(B),

4. $\langle B, \succ \rangle$ is the performance order induced by f over B.

The last three definitions imply that every differential indication structure is an indication structure. Differential indication is in Latin what we have in Section 5.1 called praxiognostics in Greek.

A re-examination of the clinical solution path in Fig. 1 above will demonstrate that each of the proposed action steps $D_i \Rightarrow A_i$ in clinical decision-making may be construed as the outcome of a differential indication structure where a clinical decision function f selects, from among the physician's action space A, the action set A_i as the indicated one in this situation. The entirety of the concatenated action steps in that figure may thus be viewed as a trajectory or clinical path of the form $D_1 \Rightarrow A_1 \rightarrow D_2 \Rightarrow A_2 \rightarrow ... \rightarrow D_n \Rightarrow A_n$. The trajectory represents a data-based action planning in a dynamical system of differential indication structures consisting of the following sequence of well-ordered indication structures:

$$\langle c, d, t_1, \mathcal{D}, \mathcal{A}, D_1, A_1, f, OB, \succ \rangle \quad \text{with} \quad \langle D_1, A_1 \rangle \text{ at } t_1$$
$$\langle c, d, t_2, \mathcal{D}, \mathcal{A}, D_2, A_2, f, OB, \succ \rangle \quad \text{with} \quad \langle D_2, A_2 \rangle \text{ at } t_2$$
$$\vdots$$
$$\langle c, d, t_n, \mathcal{D}, \mathcal{A}, D_n, A_n, f, OB, \succ \rangle \quad \text{with} \quad \langle D_n, A_n \rangle \text{ at } t_n.$$

The basic problem that we have formulated in Section 5.1 above ["...is it possible to construct an effective procedure which can be initiated at t_1 such that when the patient data set is $D_i \subseteq \mathcal{D}$ with $1 \leq i \leq n$, the optimal action set $A_i \subseteq \mathcal{A}$

can be selected unambiguously from among the action space \mathcal{A}, the next data set $D_{i+1} \subseteq \mathcal{D}$ can be built as objectively as possible, and the particular doctor d is in principle exchangeable by any doctor x?"] may now be restated as follows: Is it possible to render this data-action path computable? To show that the answer to this question is the affirmative, it will suffice to demonstrate that the clinical decision function f is a computable function.[9]

5.3 The computability of differential indication

There has been much discussion in the philosophy of medicine during the last decades about whether computers are, or will become, able to diagnose diseases or make clinical decisions as doctors do. The standard stance has been, and seems still to remain, NO. A famous position says that computers cannot diagnose on the grounds that "clinical judgment has an essential component [and] cognitive sensibility or style that is required in catching on to a joke," whereas "a computer cannot catch on to a joke" [Wartofsky, 1986, pp. 82 ff.]. However, recent medical expert systems research and practice has turned this position itself into a joke. The research and practice referred to is based on the fundamental notion of computability already introduced in the 1930s by Alan Turing. We will briefly show in the present section that our clinical decision function f above is a computable one, i.e. may be replaced with a computer program. The computability of the decision function f will be demonstrated by constructing two series of computable sub-functions,

$$f_1, f_2, ..., f_n \quad \text{applicable to patient data } D_1, ..., D_n, \text{ respectively}$$
$$g_1, g_2, ..., g_n \quad \text{applicable to action sets } A_1, ..., A_n, \text{ respectively}$$

of which f will be composed. Let there be a series of differential indication structures as listed above with the initial patient data $D_1 = \{\delta_1, ..., \delta_m\}$ at time t_1. Now, it is not hard to design a computable function f_1 such that:

$$f_1(D_1) = A_1,$$
$$OB(A_1),$$
$$\langle A_1, \succ \rangle \text{ is the performance order of the action set } A_1.$$

To this end, just write a definite computer program, Prgr-1, that offers the output $A_1 \subseteq \mathcal{A}$ as an answer to the input D_1 and says "A_1 is obligatory with the performance order $\langle A_1, \succ \rangle$." Thus, Prgr-1 computes a function, f_1, such that $f_1(D_1) = A_1$. Hence, f_1 is a computable function.

Now, write a second definite program, Prgr-2, that proceeds as follows. It asks the doctor (i) to perform A_1 in a particular manner, (ii) to answer a list of specific questions concerning the outcome of the performed action set A_1, and (iii) to

[9]For our purposes here we may understand by a 'computable function' a function that can be represented by an algorithm. Well-known examples are the arithmetic operations of addition, subtraction, multiplication, and division. For details, see [Hermes, 1971; Rogers, 1988].

answer another list of specific questions — regarding the black box *the patient* — so as to update the preceding data set D_1. Based on (i) through (iii), the program then composes the patient data set $D_2 = \{\text{outcome of step (ii)}\} \cup \{\text{outcome of step (iii)}\}$. Thus, Prgr-2 computes a function, g_1, such that $g_1(A_1) = D_2$. Hence, g_1 is a computable function.

Now, write a third definite program, Prgr-3, that provides the output "A_2 is obligatory with the performance order $\langle A_2, \succ \rangle$" as an answer to the input D_2. Thus, Prgr-3 computes a function, f_2, such that $f_2(D_2) = A_2$. Hence, f_2 is a computable function.

And so forth ... until the final action set A_n is recommended by the final program, i.e. Prgr-n at time t_n. We will in this way have available two series of computable functions:

$$f_1, f_2, ..., f_n$$
$$g_1, g_2, ..., g_n$$

such that

$$f_1(D_1) = A_1$$
$$f_2(D_2) = A_2$$
$$\vdots$$
$$f_n(D_n) = A_n = \{\text{terminate decision-making}\},$$

and

$$g_1(A_1) = D_2$$
$$g_2(A_2) = D_3$$
$$\vdots$$
$$g_n(A_n) = \{\text{decision-making terminated}\}.$$

The concatenation of the programs Prgr-1, Prgr-2, ..., Prgr-n will yield a composite program that interlinks the two function series above in the following order:

$$\langle f_1, g_1, f_2, g_2, ..., f_n, g_n \rangle.$$

Thus, it executes a computable function $f = \langle f_1, g_1, f_2, g_2, ..., f_n, g_n \rangle$ which, as successively accomplished above, provides the mapping:

$$f \colon \text{power}(\mathcal{D}) \to \text{power}(\mathcal{A})$$
$$f \colon \text{power}(\mathcal{A}) \to \text{power}(\mathcal{D}),$$

that is:

$$f \colon \text{power}(\mathcal{D} \cup \mathcal{A}) \to \text{power}(\mathcal{D} \cup \mathcal{A})$$

for the management of clinical judgment and acts as required regarding the computability question posed in Section 5.1 above. Hence, *there is a ccdf*, a computable

clinical decision function f, that is defined by cases as follows:

$$
f(x) \begin{cases}
f_1(D_1), & \text{if } X = D_1 \\
g_1(A_1), & \text{if } X = A_1 \\
\vdots & \\
f_n(D_n), & \text{if } X = D_n \\
g_n(A_n), & \text{if } X = A_n
\end{cases}
$$

Sufficient empirical evidence is available in favor of this existence claim. Every clinical expert system designed to provide advice in a particular clinical domain, e.g. cardiology, is a restriction of the ccdf f to that domain. Analogously, a comprehensive clinical expert system covering all of clinical medicine would represent an instance of the total function f, i.e. a particular global ccdf.

The latter statement suggests that one may conceive of a variety of different, competing ccdfs each of which will render clinical judgment computable in a particular manner. The question of how to decide which one of them may be preferred to the rest, is among the core problems of the experimental science of clinical practice that is emerging from the current medical knowledge engineering research.

As is obvious from the design of the sub-function series $g_1, g_2, ..., g_n$ above for performing the indicated actions, the argument of any such function g_i is a set of actions, A_i, having the data set D_{i+1} as its value, $g_i(A_i) = D_{i+1}$. The physician is currently involved in each g_i of the series in that the computation of $g_i(A_i)$ requires her to perform the recommended action set A_i and to assist g_i in gathering data for building the next data set D_{i+1}. Thus, the doctor is physically integrated into the computation of the whole function f. For this reason, one may raise the objection that none of the sub-functions $g_1, g_2, ..., g_n$ is a computable one in the proper sense of this term, and may conclude that there is no ccdf as maintained above.

This objection is based on the assumption that the doctor's involvement in the execution of the sub-functions $g_1, g_2, ..., g_n \in f$ is necessary to this execution. However, this necessity is a mere physical necessity for the time being, but not a logical necessity forever. To prove this claim, replace the doctor with a robot that acts as a mobile peripheral of the machine that computes f. This real 'science fiction' era has already begun in university health centers where a hospital information system in collaboration with Intranets and the Internet acts as a *clinical decision support and control system* using the doctors and other personnel as mere mobile peripherals to feed the machine and to execute its commands. The circumstance that robots are not yet able to match the sensorimotor proficiency of human beings as machine peripherals does not concern the computational aspect of our problem. So, we need not enter into a philosophical discussion on robotics (see [Sadegh-Zadeh, 2001b]).

6 A THEORY OF THE RELATIVITY OF DIAGNOSIS

Within the framework constructed thus far, we will now reconstruct the concept of clinical diagnosis in this and the next section and follow with an inquiry into its logic in Section 8.

6.1 Diagnostic structures

The intuitive idea of diagnosis in medicine is that some phenomenon causally accounts for the patient's complaints and that the diagnosis is just the description of that phenomenon. The appropriate understanding and refinement of this vague idea must be based on the awareness that (1) the patient's complaints have to be something pathological in the medical sense to require a diagnosis at all; (2) a clear concept of causality will be needed; and (3) the diagnosis should be based upon the acquisition and interpretation of specific diagnostic information to exclude doubtful diagnostic methods comparable to tossing a coin. All of these criteria are met by Definition 9 below. To prepare the definition we need the fuzzy-theoretic notion of a *linguistic variable* (see [Zadeh, 1975a; 1975b; 1976]).[10]

We distinguish two types of variables, numerical and linguistic ones. A *numerical* or quantitative variable, such as 'height,' 'length' or 'weight,' is just what a quantitative concept denotes. Such a variable is a function in a mathematical sense and assumes numbers as values. For instance, in the statement "the height of David is 175 cm" the variable *height* has taken the value '175 cm.' It may take another value with respect to the patient Hilary. A *linguistic variable*, on the other hand, assumes linguistic entities such as words or sentences as values. For example, *color* in the statement "the color of this page is white" is a linguistic variable that in the present case has assumed the value *white*. Its possible values are color terms such as 'white,' 'yellow,' 'red,' 'green,' etc. The set of all possible values of a linguistic variable v is referred to as its *term set* and written $T(v)$. In the present example we have $T(\text{color}) = \{$white, yellow, red, green, blue, orange, brown, ... $\}$. Note that a value such as 'white' or 'yellow' that a linguistic variable may assume in a particular case is in fact nothing linguistic, but a property, i.e. a feature or quality, indicating the belonging of the object to a particular class of objects. For instance, "the color of this page is white" means "this page belongs to the class of white objects." Therefore, the name "qualitative variable" or "classificatory variable" would have been a better choice than the label "linguistic variable." But this terminology is well established in fuzzy theory and cannot be changed.

Let the phrase 'normality value,' written nv, be a linguistic variable whose term set, $T(nv)$, may be a set of fuzzy evaluation predicates like {normal, pathological, very pathological, extremely pathological, not very pathological, ... }:

[10]For a detailed discussion of the concept of linguistic variable and its use in medicine, see [Sadegh-Zadeh, 2011].

$T(nv) = \{$normal, pathological, very pathological, extremely pathological, not very pathological, ... $\}$.

Each of these terms can be used to categorize in a particular population, PO, to which the patient belongs, a given patient data δ as normal, pathological, very pathological, etc. The term set $T(nv)$ will therefore be referred to as normality values. In this way, the *normality value*, nv, of a patient data δ with respect to the population PO the patient belongs to may be symbolized by a statement of the form:

$nv(\delta, PO) = y$ where $y \in T(nv)$.

It says that the normality value of δ in PO is y. For example, severe chest pain in the population of men is pathological, that is:

$nv(\langle$chest_pain, severe\rangle, men$) = $ pathological.

Finally, let the following functional statement:

$$cr(X, Y, PO) = z$$

express that the *causal relevance*, cr, of event X to event Y in the population PO equals z. For instance, it may be that cr(smoking, angina_pectoris, diabetics) = 0.3, whereas cr(smoking, angina_pectoris, non_diabetics) = 0.01. This numerical causality function cr has already been introduced in Section 2.3.4 above. Roughly, the causal relevance of an event X to an event Y in a population PO is the extent to which in this population the occurrence of X raises or lowers the probability of the occurrence of Y, given that some additional requirements are satisfied.

A diagnosis does not fall from the heavens. It does not originate in the physician's mind either. It emerges from a more or less complex, social-historical context that includes the medical machinery, i.e. practice or hospital, the diagnostician(s), the assistants, the patient, her family, the laboratory, the medical community, health authorities, and many other components. All of these factors contribute to the diagnosis that attaches to an individual patient.

The following definition axiomatizes the complex structure of the diagnostic context that generates a diagnosis, dg, for a patient p who presents the data set D and is a member of the population PO. See Axiom 14. The other 13 axioms are preparatory ones. They say, in essence, that in the specified context a set of sentences, Δ, is identified as a *diagnosis* for a patient's data D in a particular population PO, i.e. $dg(D, PO) = \Delta$, if in that population Δ is causally relevant to D and some additional conditions are satisfied.

DEFINITION 19. ξ is a *diagnostic structure* iff there are $p, d, t_1, \mathcal{D}, \mathcal{A}, D_1, A, f, OB,$ $t_2, D_2, D, \Delta, PO, nv, T(nv), cr,$ and dg such that

1. $\xi = \langle p, d, t_1, \mathcal{D}, \mathcal{A}, D_1, A, f, OB, t_2, D_2, D, \Delta, PO, nv, T(nv), cr, dg \rangle$,

2. $\langle p, d, t_1, \mathcal{D}, \mathcal{A}, D_1, A, f, OB \rangle$ is an indication structure,

3. t_2 is the same time as or later than t_1

4. $f(A) = D_2$

5. D_2 is a subset of \mathcal{D} accepted by d at t_2

6. D is a subset of $D_1 \cup D_2$, i.e. $D \subseteq D_1 \cup D_2$

7. Also $\Delta \subseteq D_1 \cup D_2$

8. PO is a set such that the patient(s) belong(s) to, i.e. $p \subseteq PO$,

9. nv is a linguistic variable such that its term set $T(nv) = \{$normal, pathological, very pathological, ...$\}$,

10. cr: power(\mathcal{D})\times power(\mathcal{D}) \times $\{PO\} \to [-1, +1]$,

11. dg: power(\mathcal{D}) \times $\{PO\} \to$ power(\mathcal{D}),

12. $nv(\delta, PO) = y \in T(nv)$ and \neq normal, for all $\delta \in D$,

13. $cr(\Delta, D, PO) > 0$,

14. $dg(D, PO) = \Delta$.

The definition requires, first of all, that the base of the structure be an indication structure. This property of being an indication structure, stated in Axiom 2, implies that there is an initial patient data set D_1 and an initial action set A_1 (question, test, examination) that is indicated due to that data. Axioms 3-5 say that a diagnostic inquiry by performing the indicated action set A_1 has updated the information on the patient to yield the data set D_2. Axioms 6-11 characterize the respective ingredients of the diagnostic structure. Axiom 12 states that some part, D, of total patient data is pathological in the reference population PO. Axiom 13 says that to some extent another subset Δ of patient data is positively causally relevant, in the population PO, to the pathological part D of patient data. In Axiom 14, the function dg ('diagnosis') assigns to the pathological part D of patient data in the reference population PO the set Δ as *diagnosis*. Note that due to the time points or periods, t_1 and t_2, the structure is a temporally dynamic one, i.e. a process ('the diagnostic process'). Now, on the basis of the structure above the following Definition 20 introduces a concept of diagnosis as a ternary set-function. The functional relation:

$$\text{diagnosis}(p, D, KB \cup M) = \Delta$$

in the definiendum of Definition 20 reads:

the diagnosis for patient p with data set D and relative to the knowledge base KB and its application methods M is Δ.

Set Δ is, as above, a set of sentences about the patient and a subset of $D_1 \cup D_2$. The knowledge base and the methods of its application, $KB \cup M$, have already been included in our basic Definition 10 (see Axiom 9 of that definition in Section 5.2).

DEFINITION 20. diagnosis$(p, D, KB \cup M) = \Delta$ iff there are $d, t_1, \mathcal{D}, \mathcal{A}, D_1, A, f,$ $OB, t_2, D_2, PO, nv, T(nv), cr,$ and dg such that:

1. $\langle p, d, t_1, \mathcal{D}, \mathcal{A}, D_1, A, f, OB, t_2, D_2, D, \Delta, PO, nv, T(nv), cr, dg \rangle$ is a diagnostic structure,

2. KB is the knowledge base and M is the methodology of the functions f and dg.

The knowledge base and the methods of its application, $KB \cup M$, that we have included in our concept above we will call the *frame of reference* of the respective diagnosis. We will see below that, depending on the frame of reference, one and the same patient may receive different diagnoses. For instance, it may be that a diagnostic examination of our female patient Hilary above, undertaken within a particular frame of reference, say cardiological knowledge and methodology, suggests:

diagnosis({Hilary}, {⟨cough, severe⟩, ⟨body temperature, high⟩, ⟨heart rate,
 102 beats per minute⟩, ⟨heart beats, irregular⟩, ⟨blood pressure,
 low⟩, ⟨substernal chest pain, intermittent⟩}, KB ∪ M)
 = {⟨bronchitis, chronic⟩, ⟨pericarditis, acute⟩}.

Overly simplified, that means that "Hilary has chronic bronchitis and acute pericarditis." The theory of diagnosis we are developing will make it more apparent in what follows that it is of course most realistic to assume that another frame of reference may generate another diagnosis [Sadegh-Zadeh, 1977]. In addition, from Definition 19 it follows that every diagnostic structure is also an indication structure, i.e. a context where individual diagnostic actions are deontically required. And it goes without saying that the computability proof as demonstrated in Section 5.3 above can be extended to the diagnostic function dg sketched in Definition 19, and to the ternary function defined in Definition 20.

6.2 The relativity of diagnosis

As was alluded to in Section 5.2 above, the physician's goals, knowledge, experience, logic, and moral act as part of her *frame of reference* in the sense above. In the current era of clinical knowledge-based or so-called expert systems research and practice we entered in the 1970s, the frame of reference is included in the expert system, i.e. in the computer program that is being applied in a hospital or in a doctor's practice. Such an expert system in its entirety may be conceived of as a computable clinical decision function, *ccdf*, that controls diagnostic and differential indication structures eliminating physicians' confined and biased clinical judgment.

Due to the experimental and technological nature of clinical knowledge-based systems research it seems realistic to view this emerging discipline as an experimental *engineering science of clinical practice* that continually produces different species of computable clinical decision functions: $ccdf_1, ccdf_2, ccdf_3$, and so on [Sadegh-Zadeh, 1990].

The implementation of any such function will be referred to as a 'clinical operator,' *cop* for short. For example, cop_1 may be a MYCIN machine that executes the expert system MYCIN; cop_2 may be a CADUCEUS machine that executes the expert system CADUCEUS; cop_3 may be a QMR machine, and so on.

Let cop_i be a particular type $i \geq 1$ of clinical operator with its domain-specific knowledge base KB_i and its underlying methodology M_i as its frame of reference; and let p be a patient with the data set D and her doctor d using the clinical operator cop_i to get a diagnosis or advice X. Upon receiving this output X, we have that:

(14) $cop_i(p, d, D, KB_i \cup M_i) = X$.

That is, the machine cop_i *operates* as a mathematical operator on the quadruple $\langle p, d, D, KB_i \cup M_i \rangle$ as its argument and produces the value X that may be the recommendation of an indicated action, a diagnosis or something else. The objectivity of an indication or diagnostic structure governed by the operator cop_i is provided by the fact that for all patients p with the same data set D and for all doctors d, the output X in (14) will remain the same guaranteeing the exchangeability of doctors. We can therefore remove the doctor variable d and agree upon the pruned syntax:

(15) $cop_i(p, D, KB_i \cup M_i) = X$

replacing formula 14. The ternary function cop_i in (15) may be construed as a composite operator consisting of at least two parts, a diagnostic operator written $diag_i$, and an indication operator termed $indic_i$, such that:

$$diag_i(p, D, KB_i \cup M_i) = \Delta$$
$$indic_i(p, D, KB_i \cup M_i) = OB(A).$$

The first formula says that relative to the frame of reference $KB_i \cup M_i$ the diagnosis for patient p with data set D is Δ. The second formula says that relative to the frame of reference $KB_i \cup M_i$ action A is obligatory in patient p with the data set D. This syntax may be based and interpreted upon our conceptual apparatus already available, for instance, in the following manner:

DEFINITION 21. $indic(p, D, KB \cup M) = OB(A)$ iff there are d, t, D, A, and f such that:

1. $\langle p, d, t, D, A, D, A, f, OB \rangle$ is an indication structure,

2. $KB \cup M$ is the knowledge base and methodology of the function f.

DEFINITION 22. $\mathrm{diag}(p, D, KB \cup M) = \Delta$ iff there are $d, t_1, D, A, D_1, A, f, OB,$ $t_2, D_2, PO, nv, T(nv), cr,$ and dg such that:

1. $\langle p, d, t_1, \mathcal{D}, \mathcal{A}, D_1, A, f, OB, t_2, D_2, D, \Delta, PO, nv, T(nv), cr, dg \rangle$ is a diagnostic structure,

2. KB is the knowledge base and M is the methodology of the functions f and dg.

Apparently, the diagnostic part of a clinical operator, the function $diag$, is formally identical with our ternary concept of diagnosis, i.e. $diagnosis(p, D, KB \cup M) = \Delta$, that we have introduced in Definition 20 above. They may therefore be used interchangeably. The only difference is that $diag$, executed by a machine, is unbiased as compared to fallible human doctors executing $diagnosis(p, D, KB \cup M) = \Delta$.

A clinical knowledge-based or expert system, reconstructed in this fashion as a composite operator, maps patient data to diagnoses and indications. And it does so always relative to its frame of reference, i.e. its underlying knowledge base and methodology, $KB \cup M$. Any change in the variable $KB \cup M$ will generate changes in diagnoses and action recommendations. This may be exemplified by the behavior of the diagnostic operator. If for a particular patient p with the data set D we have:

$$\mathrm{diag}_i(p, D, KB_i \cup M_i) = \Delta_i$$

and

$$\mathrm{diag}_j(p, D, KB_j \cup M_j) = \Delta_j$$

then

it is almost certain that $\Delta_i \neq \Delta_j$ if $i \neq j$.

That means that the diagnoses produced by different knowledge bases and reasoning methods for the same patient with the same data set are different. Suppose, for example, that KB_1, KB_2, KB_3, and KB_4 are four cardiology knowledge bases. They are used, respectively, with the following four reasoning methods that we have sketched in Section 3 to obtain a diagnosis for the same patient p with the data set D:

$M_1 \equiv$ hypothetico-deductive approach

$M_2 \equiv$ Bayes' Theorem

$M_3 \equiv$ case-based reasoning

$M_4 \equiv$ fuzzy-logical reasoning.

Four different diagnoses will emerge because the contents and the logical structure of the four knowledge bases KB_1–KB_4 as well as the inference strategies of the reasoning methods M_1–M_4 are different from one another. Diagnoses are thus

context dependent in that they are epistemically and methodologically relative. There are no such things as *the patient's disease* and *health* independently of the respective frame of reference, i.e. theories, methodologies, and epistemologies applied. Apart from such frames nothing can be said about a patient's state of health or disease [Sadegh-Zadeh, 1977; 1981b; 1982; 2011].

7 ON THE PRAGMATICS OF DIAGNOSIS

Independently of its syntax, semantics, origin, and context-relativity, a diagnosis has additional characteristics that are usually overlooked. They are perhaps even more important than those we have already considered thus far since the diagnosis lends both to the patient and the physician a social role that develops a remarkable impact on the populations they belong to. In the present section this focal *pragmatic* dimension of diagnosis will be briefly discussed. We will interpret diagnosis as something social that has both social sources and effects. Specifically, we will propose viewing it, in light of John Austin's speech act theory [Austin, 1962, 1979], as a speech act that generates social facts. To this end we need to introduce some terminology first.

7.1 *Speech acts*

It is usually believed that as human beings we perform actions only by our extremities and sense organs in that, for example, we enter our study by using our legs, we take the present book from the shelf by using our arms, we read it by using our eyes, and so on. Surprisingly, the Oxford philosopher John Langshaw Austin (1911-1960) presented in a paper in 1946 and in his lectures during 1950s an intriguing theory built around his discovery which says that also by speaking we can perform actions. The actions we may perform in this way he therefore called *speech acts*, and his theory has come to be known as *speech act theory* [Austin, 1946; 1956; 1962; 1979].[11]

A simple example of speech acts is the act that I perform when I say "I promise," e.g. when I say to a patient "I promise to examine you tomorrow." By uttering this sentence I do not describe anything existent or non-existent. I do not make a statement about myself and my behavior, e.g. I do not say that I was making a promise. Rather, I am actually *making* a promise. Thus, I do not report on the act of my doing. I just *do it*. I perform the action, specifically, the act of promising. My utterance *is* my promise that I make.

John Austin discovered that declarative sentences consist of two types, *constatives* and *performatives*. As far as a declarative sentence such as "the Eiffel Tower is in Paris" states that something is, was, or will be the case it is called a statement, assertion or *constative* (from the Latin "constare" = to stand firm, be fixed). A

[11]In the context of discussions on speech act theory it has become common to use the term "act" instead of "action."

constative makes a validity claim and may turn out true or false. For example, the constative "you are 47 years old" that is told the patient Hilary may turn out true if a thorough examination confirms that she was born 47 years ago. However, it is also possible that the constative will turn out false. A majority of declarative sentences we speak look like such constatives, though they state nothing. For instance, it was already pointed out above that the declarative sentence "I promise to examine you tomorrow" that I utter to the patient Hilary is not a description of something in my mind or in the world out there. It is an act of promising that I *perform* by my very utterance itself. Thus, it is a performative utterance, or a *performative* for short. While Hilary can reasonably tell me "You said that you promised," her claim "You stated that you promised" would be self-defeating. Speech acts are performatives and not constatives.

A performative is a first person declarative sentence in the singular or plural, present indicative tense, e.g. "I promise to examine you tomorrow." There is a fundamental difference between such a performative and a constative. In contrast to constatives a performative does not communicate truth or falsehood. It is an action performed by the speaker. So, it cannot be true or false, but only successful or unsuccessful.

It is also worth noting that a performative is a self-referring and self-verifying sentence. First, a performative utterance such as "I promise to examine you tomorrow" refers to itself and to nothing else in so far as it announces what it does, i.e. promising; it tells that it is doing the promising by using the phrase "I promise ..." Second, it verifies itself; although it is not true of an antecedent fact prior to the utterance, it becomes true of the fact that it creates itself, i.e. the fact of promising.

A speech act thus comprises three actions called locution, illocution, and perlocution. The *locutionary act* is the phonetic act of saying something, e.g. the speaking of the six-word sentence "I promise to examine you tomorrow." This partial act is only a physical occurrence and serves as the vehicle of performing the mission of the speech act, i.e. the *illocutionary act*. The illocutioanary act is the performative speech act proper, e.g. the act of promising, welcoming, apologizing, and the like:

I promise to examine you tomorrow	≡	promising
I welcome you	≡	welcoming
I apologize	≡	apologizing
I swear	≡	swearing
I name this baby 'David'	≡	naming, baptizing, christening.

The locutionary and illocutionary acts always develop some side-effects 'in the world out there.' For example, my act of promising may please, disappoint, annoy or frighten other people and make them take any action. This impact of a speech act on others constitutes the *perlocutionary act*.

To summarize, in a speech act the locutionary act is the act *of* saying something. The illocutionary act is the act of performance *in* saying something. The perlocutionary act is an act done *through* the former two acts. Illocutionary acts

are the core of speech acts. Just as we do things by using our hands and feet, we do other things by using our mouth in that we utter performative sentences and do illocutionary acts thereby.

A *performative verb* is a verb that in a performative names its illocutionary act, e.g. the verb "to promise" in the performative "I promise to examine you tomorrow." Other performative verbs are: to welcome, to apologize, to swear, to request, to warn, etc. We may thus distinguish between explicit and implicit performatives. An explicit performative contains a performative verb, e.g. "I promise to examine you tomorrow." In an implicit performative the verb is omitted. For example, a sentence such as "you have coronary heart disease" may at first glance appear as a constative. However, it is an implicit performative. It can be revealed as an explicit performative by inserting the missing performative verb: "*I assert that* you have a coronary heart disease." This example shows that there are actually no sharp boundaries between constatives and performatives because most constatives can be transformed into performatives. This finding has important philosophical consequences both in general and particularly in medicine [Sadegh-Zadeh, 2011].

7.2 Diagnosis as speech act

Clinical diagnoses are *speech acts*. In this capacity they establish social realities and roles independently of whether they are true or not and state or communicate any facts. What does that mean?

Syntactically and semantically, a diagnosis such as "Hilary has diabetes" or "to the extent 0.8 Hilary has diabetes" resembles a constative statement such as "it is raining" and "to the extent 0.8 it is raining." Since constative statements are usually viewed as truth-evaluable assertions of facts, a physician who considers her diagnoses as constatives believes they report facts. Because of its far-reaching consequences, however, this superficial view merits critical examination [Sadegh-Zadeh, 1976].

The *diagnostic context* that we have called a 'diagnostic structure' has been axiomatized in Definition 9 in Section 6.1 above. It includes the patient, the doctor, her practice, the hospital, the patient's family, medical knowledge, and all other components from which a diagnosis emerges. The whole context may metaphorically be characterized as a *machinery* that like a Turing machine consists of a tape and a control unit. An individual tape is assigned to any individual patient throughout the clinical encounter and contains any information we obtain and learn about the patient. It is an infinite sequence of cells, with each cell containing a particular sentence about the patient. The control unit of the machinery has a tape head that moves over the tape and successively reads the contents of its cells. Sometimes the tape head attaches the label 'diagnosis' to a sentence after it has read the sentence in the cell. Thus, the machinery selects from among the set S of all possible sentences about the patient a finite subset that it calls 'diagnosis.' So the question arises how the machinery generates and justifies its diagnoses. *Why* does it label sentence $\alpha \in S$ a diagnosis, e.g. the sentence "Hilary

has AIDS," but not another sentence $\beta \in S$, e.g. "Hilary is blonde"?

The real-world context or 'machinery' of diagnostics is a highly complex one with regard to the genesis of diagnoses. For example, a diagnosis such as "Hilary has AIDS" emerging from a molecular-biological context of the 21st century would never emerge from a context of the Hippocratic humoral pathology that produced, or produces, diagnoses such as "Hilary has black fever" instead. If we consider this aspect, i.e. the context of genesis of a diagnosis, as a base variable on which the diagnosis depends, it will become obvious that the diagnosticity of a sentence (see Section 2.3.5) is a construct of the context of its genesis in the 'machinery.' The sentence "Hilary has black fever" gets the label 'diagnosis' attached in a Hippocratic context, but not in a molecular-biological one. This context sensitivity of diagnosis may be called its *contextuality*. The contextuality of diagnosis may of course be viewed and analyzed from different perspectives, e.g. from a technological, social, scientific, economic or historical one.

The epistemic and ontological import of diagnosis as an alleged *constative* that purportedly reveals truth or some truth about the patient is called into question by its contextuality. The adherents of the Hippocratic school considered their diagnoses true. In our view today they are not false, but simply meaningless. In a future system of health care our current diagnoses will earn a comparable judgment. Notwithstanding the quarrel about whether or not a diagnosis narrates facts, it *generates* facts in that it triggers individual, group and organizational behavior. Specifically, the patient assumes the role her doctor's diagnosis suggests; her family members, relatives, and the hospital personnel do what the diagnosis implies; the health insurance pays for what the diagnosis costs; and so on. The doctor's utterance "you have diabetes" or "you have myocardial infarction" makes it appear so in the real-world context. The patient behaves, and is treated, as if she had diabetes or she had myocardial infarction even though the doctor's diagnosis may in fact be a misdiagnosis. That means that a diagnosis belongs to the second type of declarative sentences. Rather than being a constative, it is a performative. And its impact on the patient, her family, the hospital and community referred to above is the perlocutionary act of the diagnostician (see Section 7.1).

The diagnosis proper, e.g. the supposed 'fact' and the induced social belief and role that the patient has diabetes, is the *illocutionary act* of the physician. This will become apparent by reconstructing the context of its communication in clinical encounter. Let $\Delta = \{\alpha_1, \ldots, \alpha_n\}$ be the diagnosis set the physician has arrived at. She usually discloses it by communicating the implicit performative "you have Δ," e.g. "you have diabetes". We have seen above that such an implicit performative may be transformed into an explicit one, i.e. into the following *explicit performative* in the present case:

(16) I diagnose you as having Δ.

Examples are "I diagnose you as having diabetes mellitus" or "I diagnose you as having diabetes mellitus, hepatitis A, and no coronary heart disease." It can easily be observed that the verb "to diagnose" is a performative verb like "to promise"

and "to swear."

A clinical diagnosis as a speech act belongs to the following, particular category of speech acts.[12] Like a judicial verdict, it is a *verdictive*. As a verdictive it imposes a social status on the patient (see below), a status that is made by the physician or a group of decision-makers on behalf of the society and is regulated by:

- the state: health care laws, physician duties, patient rights,

- professional community: taxonomies, terminologies, oaths,

- medical sciences: medical language, medical knowledge, diagnostic rules.

The decision says that "you have the malady X and must therefore do Y." The supplement *"and must therefore do Y"* we have added to the diagnosis (16) in the narrow sense because the diagnostic judgment of the physician in a wider sense also includes her recommendation as to *what must be done* in this situation, i.e. treatment and advice.

7.3 Diagnosis as a social act

Diagnosis as a verdictive imposes a social status on the patient, the well-known 'sick role,' in that the patient becomes the client of a care group that cares for her: medically, psychologically, socially, financially, spiritually, etc. This collective action of caring for the sick is not a natural, but a *social fact*.

A communal or *social fact* is a man-made fact that involves a community, i.e. a group of at least two individuals, and whose description by these individuals irreducibly contains "we" as its grammatical subject. Examples are facts that may be communicated by sentences of the type "we X," e.g. we transplant a heart; we diagnose; we care for this patient; we work together; we love each other; we are just leaving for a trip to Berlin; and the like. The verb X characterizing the fact is an intentional we-verb like the verbs in "we transplant," "we diagnose," "we work," "we love," "we believe," or "we X" in general. Therefore, collective acts of this type are called "we-intentions" or "we-acts." For details, see [Searle, 1995; Tuomela, 2002; Sadegh-Zadeh, 2011].

Although diagnosis as a verdictive is usually enacted by the doctor, it is brought about by a collective action of a group that participates in the diagnostic process. This collective action, i.e. diagnostics, is a recurrent one that takes place daily in numerous practices and hospitals.

[12]John Austin, the founder of the speech act theory, has distinguished the following five types of speech acts (see [Austin, 1962], lecture 12): 1. *Verdictives* are speech acts giving a verdict, e.g. court decisions; 2. *Exercitives* are speech acts exercising power, rights, and influence, e.g. orders and requests; 3. *Commissives* are speech acts that commit the speaker to a course of action, e.g. promises and guarantees; 4. *Behabitives* are speech acts concerning social behavior and interaction, e.g. apologies and congratulations; and 5. *Expositives* are a heterogeneous group of speech acts expounding views on how utterances fit into a present discourse, e.g. arguing, replying, and conceding.

A recurrent collective action characterized by "we X" as above we call a *social practice*. Examples are collective rituals, rites, greeting by shaking hands, the relatively uniform course of scientific conferences, and the mode of patient management in hospitals. Also diagnostics as a recurrent collective we-act turns out to be a social practice.

Social practices are generative of social facts. Such facts are referred to as *institutional facts* because they emerge, through social practices, from and within *social institutions*. An example is a chant sung in a mass. It is an institutional fact generated by the institution of religion. Also the sick role imposed by diagnosis is an institutional fact that is generated, through the social practice of diagnostics, by the institution of medicine and supporting state authorities. It is not a natural fact such as raining.

A *social institution* is a set of $n \geq 1$ rules or norms that are constitutive of a social practice. Thus the institution creates this social practice. For example, the rules of chess are constitutive of the chess game. Without those rules there would exist no chess game. Analogously, diagnostic rules as ought-to-do rules may be viewed as a social institution that constitutes the social practice of diagnostics. Thus, the sick role as a social fact is an institutional fact brought about by the social institution of diagnostic ought-to-do rules.

8 ON THE LOGIC OF DIAGNOSTICS

From the previous discussions we can conclude that, first, there is no "logic of diagnostics," and second, medical diagnostics will need a variety of logics. Thus, logical pluralism is the most realistic and appropriate stance in medicine. This will be explained.

By the term "logic" in the narrow sense we understand any system of formalized reasoning with which the science of logic is concerned. We have seen above that viewed from the descriptive perspective, medical diagnostics may be categorized as a human social practice. Therefore, it cannot have a logic because human beings and the actions they perform to manage expected and unexpected social situations are inherently illogical. Viewed from a normative perspective, however, it is of course possible to regulate the diagnostic process by algorithms that may guide and control the clinical pathfinding so as to render clinical decision-making computable. We have discussed this possibility in Section 5.3.

So far as diagnostic reasoning is concerned, logic will automatically come into play whenever a diagnostician is acquainted with logic to examine whether or not a particular diagnosis is justified on the basis of the available patient data and diagnostic knowledge used. Unfortunately, however, most physicians are ignorant of logic. Medical data and knowledge engineering such as medical knowledge-based systems, decision support systems, and hospital information systems research have been ameliorating this deficiency since about the 1970s. They are transforming clinical decision-making into an *engineering science and technology of clinical reasoning*, ESTCR for short. The price one will have to pay for this transformation

in the long run is the successive elimination of the doctor from clinical judgment. She will assume the role of a mobile peripheral of the machine to gather patient data. This transformation is unavoidable for two reasons: the information explosion and globalization of knowledge, on the one hand, and the inability of the doctor's natural intelligence to cope with it, on the other [Sadegh-Zadeh, 2001b, p. IX].

For the reasons above the application of logic in diagnostics is, and will remain, the task of the emerging ESTCR. As we have seen in Section 6.2, a clinical operator constructed and executed by ESTCR has a diagnostic component of the following form:

$$\text{diag}(p, D, KB \cup M) = \Delta$$

such that Δ is the diagnostic set $\{\alpha_1, \ldots, \alpha_n\}$ consisting of $n \geq 1$ statements about the patient such as {Hilary has diabetes, she does not have coronary heart disease}. There are a variety of different logics that can be used by the methods component, M, of such a diagnostic operator to draw diagnostic conclusions from the union of patient data and knowledge base, $D \cup KB$, and to produce the diagnostic set Δ. Which one of them will actually be used depends on the syntax and semantics of $D \cup KB$ because it has to be syntactically and semantically capable of dealing with $D \cup KB$. For example, we will need:

predicate logic	if	$D \cup KB$ satisfies the syntax of predicate logic,
probability theory	if	$D \cup KB$ contains probability sentences,
alethic modal logic	if	$D \cup KB$ talks of possibility and necessity,
temporal logic	if	$D \cup KB$ is dealing with time periods and time series,
deontic logic	if	$D \cup KB$ contains deontic sentences,

and so on. Our analyses in the previous sections have demonstrated that for diagnostic purposes at least deontic logic is required because diagnostic knowledge in fact consists of deontic rules. However, many additional logics will also be necessary on the grounds that a variety of knowledge types from anatomy to biochemistry to surgery to epidemiology are used in diagnostic reasoning. Each one of them uses sentences of different syntax and semantics, e.g. probability sentences, temporal sentences, and others.

In discussions on the role and usefulness of logic in medicine what people usually have in mind is the traditional, classical, bivalent logic. However, apart from the above aspects, there are two additional problems that reduce the applicability of classical logic in medicine. The first one is the inconsistency of medical knowledge and data. To demonstrate, consider the following example.

The traditional representation of medical knowledge in textbooks does not betray that its application by a physician to an individual patient requires a particular logic that is capable of dealing with the syntax of that knowledge. Some physicians may believe that it is enough to possess that knowledge and to try to use it according to one's liking. The naivety of this attitude becomes obvious by considering the precise formal representation of the same textbook knowledge in the medical knowledge base of an expert system.

Like the content of a textbook, medical knowledge bases used in medical expert or decision support systems, e.g. in cardiology, stem from various knowledge sources such as handbooks, journals, and domain experts. Domain experts, for instance, are interviewed by different programmers to elicit their expert knowledge. Since different experts have different experiences during their career and often disagree with each other about states of affairs, it is conceivable that a particular medical expert system contains knowledge items, elicited from different experts, which contradict each other and thereby render the knowledge base inconsistent in terms of classical logic. It is practically difficult and sometimes even impossible to localize and detect such inconsistencies in a large knowledge base or in a hospital database that is used by the expert system. Suppose now that the reasoning method operative in the expert system, usually called its *inference engine*, is based on classical logic. The concept of inference of classical logic is explosive, i.e. it infers from inconsistent knowledge *everything* because a contradiction $\{\alpha, \neg\alpha\}$ classical-logically implies every statement β ("ex falso quod libet"). That means that when set KB is the inconsistent knowledge base of the expert system and D is the set of data of an individual patient for whom a diagnosis is sought, the inference engine will infer from the inconsistent set $KB \cup D$ arbitrary statements about the patient, including false ones. By implying all statements of the world the expert system becomes trivialized because it says everything and nothing about the patient. Such trivializations of knowledge bases can be prevented by using, instead of classical logic, a *paraconsistent* logic as the underlying logic of the inference engine. See, for example [da Costa and Subrahmanian, 1989; Blair and Subrahmanian, 1987; 1989; Grant and Subrahmanian, 1995].[13]

The second problem that makes classical logic almost useless in medicine is the fuzzy nature of medical language. Most terms of medical language, especially nosological terms such as "pneumonia" and "myocardial infarction," and symptom names such as "pain," "icterus," and so on denote fuzzy categories and are thus fuzzy predicates. As fuzzy predicates they violate central principles of classical, two-valued logic (specifically, the principles of excluded middle and non-contradiction), rendering clinical knowledge classical-logically inconsistent. Consequently, classical logic cannot be the appropriate logic to use in diagnostic reasoning. Fuzzy logic will be indispensable (see [Barro and Marin, 2002; Mordeson *et al.*, 2000; Steimann, 2001; Szczepaniak *et al.*, 2000; Sadegh-Zadeh, 2001a]).

[13]Paraconsistent logics are inconsistency tolerant systems of logic which do not contain a principle of non-contradiction. They originated around 1910 with the Russian physician Nikolaj A. Vasiliev (1880-1940) who at the beginning of the 20th century taught philosophy at the University of Kazan, Russia. Inspired by Nikolaj Lobachevski's non-Euclidean geometries in which the Euclidean parallel postulate is not valid, he attempted to construct new, 'Imaginary Logics' by discarding some of the basic laws of classical logic [Arruda, 1977]. These logics would enable us to study a large class of 'imaginary worlds' which are impossible to classical logic, but nevertheless quite well imaginable. Following Stanislaw Jaskowski's contribution [Jaskowski, 1948], specific research in this new field of non-classical logics was initiated by the significant work of the Brazilian logician and philosopher Newton C.A. da Costa [1963; 1974]. The term 'paraconsistent logic' was coined by the Peruvian philosopher F. Miro Quesada in 1976. For a comprehensive account of the subject, see [Priest *et al.*, 1989; Grana, 1983; da Costa *et al.*, 2007].

Thus far there is convincing evidence that, on the one hand, clinical diagnostics has no inherent logic, and on the other hand, it needs a variety of different logics to manage the diagnostic reasoning. No particular system of logic will suffice. This is comparable to the use of mathematics in medicine. A large number of mathematical theories from arithmetic to algebra to ergodic theory to non-Euclidean geometry are needed and used. Like this mathematical pluralism, logical pluralism is the only solution to diagnostic-logical problems (cf. [Sadegh-Zadeh, 1980a, p. 7]).

9 SUMMARY

We have reconstructed the concept of medical diagnosis and have sketched its syntax, semantics, and pragmatics. Concepts of indication, contra-indication and differential indication have been introduced to demonstrate that the making of diagnosis is both a deontic act and computable. Thus, as a deontic act the making of diagnosis belongs to the realm of practical ethics. The core of a theory of the relativity of diagnosis has been outlined according to which a diagnosis is relative to a complex diagnostic context. Among the constituents of this context are the patient, the diagnostician, the method of diagnostic reasoning, M, and the particular medical-diagnostic knowledge used. Method M may also contain one or more logics for use in diagnostic reasoning. Due to the deontic-logical structure of diagnostic knowledge used, the logics in M must also include a deontic logic, presumably a fuzzy-deontic logic or another type of paraconsistent deontic logic (see, e.g. [da Costa and Carnielli, 1986; Grana, 1990; Sadegh-Zadeh, 2002]). We have distinguished between diagnosis and diagnostics, and have shown that medical diagnosis is a social construct because the process of diagnostics that produces the diagnosis is a human social practice based on the social institution of deontic rules.

BIBLIOGRAPHY

[Adlassnig, 1980] K.-P. Adlassnig. A fuzzy logical model of computer-assisted medical diagnosis, *Methods of Information in Medicine*, 19, 141-148, 1980.

[Adlassnig, 1986] K.-P. Adlassnig. Fuzzy set theory in medical diagnosis, *IEEE Trans Syst Man Cybernet*, 16, 260-265, 1986.

[Adlassnig and Akhavan-Heidari, 1989] K.-P. Adlassnig & M. Akhavan-Heidari. CADIAG-2/GALL: An experimental diagnostic expert system for gallbladder and biliary tract diseases, *Artificial Intelligence in Medicine*, 1, 71-77, 1989.

[Åqvist, 1984] L. Åqvist. Deontic Logic. In D.M. Gabbay & F. Guenthner, eds., *Handbook of Philosophical Logic, Volume II*, D. Reidel Publishing Company, Dordrecht, pp. 605-714, 1984.

[Arruda, 1977] A.I. Arruda. On the imaginary logic of N.A. Vasil'év. In A.I. Arruda, N.C.A. da Costa & R Chuaqui, eds., *Non-Classical Logic, Model Theory and Computability*, North-Holland Publishing Company, Amsterdam, pp. 3-24, 1977.

[Austin, 1946] J.L. Austin. Other minds. In *Proceedings of the Aristotelian Society*, Suppl. Vol. 20, 148-187, 1946. Republished in [Austin, 1979, pp. 76-116].

[Austin, 1956] J.L. Austin. Performative utterances. Talk delivered in the Third Programme of the B.B.C., 1956. Published in [Austin, 1979, pp. 233-252].

[Austin, 1962] J.L. Austin. *How to Do Things with Words*, Harvard University Press, Cambridge, MA. 1962.

[Austin, 1979] J.L. Austin. *Philosophical Papers*. Edited by J.O. Urmson & G.J. Warnock, Oxford University Press, Oxford, 1979.

[Barro and Marin, 2002] S. Barro & R. Marin, eds. *Fuzzy Logic in Medicine*, Physika-Verlag, Heidelberg, 2002.

[Bayes, 1763] T. Bayes. An essay towards solving a problem in the doctrine of chances, *Transactions of the Royal Society of London*, 53, 370-418, 1763.

[Blair and Subrahmanian, 1987] H.A. Blair & V.S. Subrahmanian. Paraconsistent logic programming. In *Proceedings of the Seventh Conference on Foundations of Software Technology and Theoretical Computer Scienc*, in Pune, India, Springer-Verlag, London, pp. 340-360, 1987.

[Blair and Subrahmanian, 1989] H.A. Blair & V.S. Subrahmanian. Paraconsistent logic programming. *Theoretical Computer Science*, 68, 135-154, 1989.

[Boegl et al., 2004] K. Boegl, K.-P. Adlassnig, Y. Hayashi, T. Rothenfluh, & H. Leitich. Knowledge acquisition in the fuzzy knowledge representation framework of a medical consultation system, *Artificial Intelligence in Medicine*, 30, 1-26. 2004.

[Boyle, 2004] J. Boyle. Casuistry. In G. Khushf, ed., *Handbook of Bioethics. Taking Stock of the Field from a Philosophical Perspective*, Kluwer Academic Publishers, Dordrecht, pp. 75-88, 2004.

[Campbell, 1996] N.A. Campbell. Biology, The Benjamin/Cummings Publishing Company, Menlo Park, 1996.

[da Costa, 1963] N.C.A. da Costa. *Sistemas Formais Inconsistentes*, Universidade Federal do Parana, Curitiba, Brazil, 1963.

[da Costa, 1974] N.C.A. da Costa. On the theory of inconsistent formal systems, *Notre Dame Journal of Formal Logic*, 15, 497-510. 1974.

[da Costa and Carnielli, 1986] N.C.A. da Costa & W.A. Carnielli. On paraconsistent deontic logic, *Philosophia*, 16, 293-305, 1986.

[da Costa and Subrahmanian, 1989] N.C.A. da Costa & V.S. Subrahmanian. Paraconsistent logics as a formalism for reasoning about inconsistent knowledge bases, *Artificial Intelligence in Medicine*, 1, 167-174, 1989.

[da Costa et al., 2007] N.C.A. da Costa, D. Krause & O. Bueno. Paraconsistent logics and paraconsistency, In D. Jacquette, ed., *Philosophy of Logic*, Elsevier, Amsterdam, pp. 791-911, 2007.

[de Kleer et al., 1992] J. de Kleer, A.K. Mackworth & R. Reiter. Characterizing diagnoses and systems, *Artificial Intelligence*, 56, 197-222, 1992.

[Dubois and Prade, 1980] D. Dubois and H. Prade. *Fuzzy Sets and Systems. Theory and Application*, Academic Press, New York, 1980.

[Elstein et al., 1978] A.S. Elstein, L.S. Shulman & S.A. Sprafka. *Medical Problem Solving. An Analysis of Clinical Reasoning*, Harvard University Press, Cambridge, 1978.

[Grana, 1983] N. Grana. *Logica paraconsistente*, Loffredo Editore Napoli, Naples, 1983.

[Grana, 1990] N. Grana. *Logica deontica paraconsistente*, Liguori Editore, Naples, 1990.

[Grant and Subrahmanian, 1995] J. Grant & V.S. Subrahmanian. Reasoning in inconsistent knowledge bases. In *IEEE Transactions on Knowledge and Data Engineering*, Volume 7, No. 1, pp. 177-189, 1995.

[Gross and Löffler, 1997] R. Gross & M. Löffler. *Prinzipien der Medizin. Eine Übersicht ihrer Grundlagen und Methoden*, Springer, Berlin, 1997.

[Hartmann, 1977] F. Hartmann. Wandlungen im Stellenwert von Diagnose und Prognose im ärztlichen Denken, *Metamed* , 1, 139-160, 1977.

[Hempel, 1965] C.G. Hempel. *Aspects of Scientific Explanation and other Essays in the Philosophy of Science*, The Free Press, New York, 1965.

[Hempel and Oppenheim, 1948] C.G. Hempel & P. Oppenheim. Studies in the logic of explanation, *Philosophy of Science*, 15, 135-175, 1948.

[Hermes, 1971] H. Hermes. *Aufzählbarkeit, Entscheidbarkeit, Berechenbarkeit. Einführung in die Theorie der rekursiven Funktionen*, Springer-Verlag, Heidelberg, 1971.

[Hüllemeier, 2007] E. Hüllemeier. *Case-Based Approximate Reasoning*, Springer, Dordrecht, 2007.

[Jaskowski, 1948] S. Jaskowski. Propositional calculus for contradictory deductive systems, *Studia Logica*, 24, 143-157, 1969. Originally published in Polish, in *Studia Societatis Scientiarum Torunensis, Sectio A*, I/5, pp. 55-77, 1948.

[Jonsen and Toulmin, 1989] A.R. Jonsen & S. Toulmin. *The Abuse of Casuistry. A History of Moral Reasoning*, University of California Press, Berkeley, 1989.

[Jurisica et al., 1998] I. Jurisica, J. Mylopoulos, J. Glasgow, H. Shapiro & R.F. Casper. Case-based reasoning in IVF: prediction and knowledge mining, *Artificial Intelligence in Medicine*, 12, 1-24, 1998.

[Keenan and Shannon, 1995] J.F. Keenan & T.A. Shannon. The Context of Casuistry, Georgetown University Press, Washington, DC, 1995.

[Klir and Yuan, 1995] G.J. Klir & B. Yuan. *Fuzzy Sets and Fuzzy Logic. Theory and Applications*, Prentice Hall, Upper Saddle River, NJ, 1995.

[Klir and Yuan, 1996] G.J. Klir & B. Yuan, eds. *Fuzzy Sets, Fuzzy Logic, and Fuzzy Systems. Selected Papers by Lotfi A. Zadeh*, World Scientific, Singapore, 1996.

[Kolodner, 1993] J.L. Kolodner. *Case-Based Reasoning*, Morgan Kaufmann Publishers, San Mateo, CA, 1993.

[Ledley and Lusted, 1959] R.S. Ledley & L.B. Lusted. Reasoning foundations of medical diagnosis, *Science*, 130, 9-21, 1959.

[Lin, 1997] C.T. Lin. Adaptive subsethood for radial basis fuzzy systems. In B. Kosko, ed., *Fuzzy Engineering, Chapter 13*, Prentice Hall, Upper Saddle River, NJ, pp. 429-464, 1997.

[McNamara, 2006] P. McNamara. Deontic Logic. In D.M. Gabbay & J. Woods, eds., *Handbook of the History of Logic, Volume 7, Logic and the Modalities in the Twentieth Century*, Elsevier, Amsterdam, pp. 197-288, 2006.

[Mordeson et al., 2000] J.N. Mordeson, D.S. Malik & S.C. Cheng, eds. *Fuzzy Mathematics in Medicine*, Physika-Verlag, Heidelberg, 2000.

[Pal and Schiu, 2004] S.K. Pal, & S.C.K. Schiu. *Foundations of Soft Case-Based Reasoning*, John Wiley & Sons, Hoboken, NJ, 2004.

[Priest et al., 1989] G. Priest, R. Routley & J. Norman, eds. *Paraconsistent Logic. Essays on the Inconsistent*, Philosophia Verlag, Munich. 1989.

[Reiter, 1987] R. Reiter. A theory of diagnosis from first principles, *Artificial Intelligence*, 32, 57-95, 1987.

[Rogers, 1988] H. Rogers, Jr. *Theory of Recursive Functions and Effective Computability*, The MIT Press, Cambridge, MA, 1988.

[Ruspini et al., 1998] E.H. Ruspini, P.P. Bonissone & W. Pedrycz, eds. 1998, *Handbook of Fuzzy Computation*, Institute of Physics Publishing, Bristol, 1998.

[Sadegh-Zadeh, 1976] K. Sadegh-Zadeh. Ärztliche Urteile als Performative. Deutsch-Niederländische Medizinhistorikertreffen im Juli 1976 im Haus Wellbergen, Wellbergen bei Münster, Germany, 1976.

[Sadegh-Zadeh, 1977] K. Sadegh-Zadeh. Basic problems in the theory of clinical practice. Part 1: Explication of the concept of medical diagnosis, *Metamed*, 1, 76-102. 1976. (In German.)

[Sadegh-Zadeh, 1979] K. Sadegh-Zadeh. *Problems of Causality in Clinical Practice*, University of Münster Clinicum, Münster, Germany, 1979. (In German.)

[Sadegh-Zadeh, 1980a] K. Sadegh-Zadeh. Toward Metamedicine, *Metamedicine*, 1, 3-10, 1980.

[Sadegh-Zadeh, 1980b] K. Sadegh-Zadeh. Bayesian diagnostics – A bibliography: Part 1, *Metamedicine*, 1, 107-124, 1980.

[Sadegh-Zadeh, 1981a] K. Sadegh-Zadeh. Über die relative Vermeidbarkeit und absolute Unvermeidbarkeit von Fehldiagnosen, *Wissenschaftliche Information*, 7, 33-43, 1981.

[Sadegh-Zadeh, 1981b] K. Sadegh-Zadeh. Foundations of clinical praxiology. Part I: The relativity of medical diagnosis, *Metamedicine*, 2, 183-196, 1981.

[Sadegh-Zadeh, 1982] K. Sadegh-Zadeh. Foundations of clinical praxiology. Part II: Categorical and conjectural diagnoses, *Metamedicine*, 3, 101-114, 1982.

[Sadegh-Zadeh, 1983] K. Sadegh-Zadeh. *Medicine as Ethic and Constructive Utopia: 1*, Burgverlag, Tecklenburg, 1983. (In German.)

[Sadegh-Zadeh, 1990] K. Sadegh-Zadeh. In dubio pro aegro. *Artificial Intelligence in Medicine*, 2, 1-3, 1990.

[Sadegh-Zadeh, 1994] K. Sadegh-Zadeh,. Fundamentals of clinical methodology: 1. Differential indication, *Artificial Intelligence in Medicine*, 6, 83-102, 1994.

[Sadegh-Zadeh, 1998] K. Sadegh-Zadeh. Fundamentals of clinical methodology: 2. Etiology, *Artificial Intelligence in Medicine*, 12, 227-270, 1998.

[Sadegh-Zadeh, 1999] K. Sadegh-Zadeh. Fundamentals of clinical methodology: 3. Nosology, *Artificial Intelligence in Medicine*, 17, 87-108, 1999.

[Sadegh-Zadeh, 2000a] K. Sadegh-Zadeh. Fundamentals of clinical methodology: 4. Diagnosis. *Artificial Intelligence in Medicine*, 20, 227-241, 2000.

[Sadegh-Zadeh, 2000b] K. Sadegh-Zadeh. Fuzzy health, illness, and disease, *The Journal of Medicine and Philosophy*, 25, 605-638, 2000.

[Sadegh-Zadeh, 2000c] K. Sadegh-Zadeh. Fuzzy genomes, *Artificial Intelligence in Medicine* 18, 1-28, 2000.

[Sadegh-Zadeh, 2001a] K. Sadegh-Zadeh. The Fuzzy Revolution: Goodbye to the Aristotelian Weltanschauung, *Artificial Intelligence in Medicine*, 21, 1-25, 2001.

[Sadegh-Zadeh, 2001b] K. Sadegh-Zadeh. Foreword: Intelligent Systems in Patient Care. In K.-P. Adlassnig, ed., *Intelligent Systems in Patient Care*, Austrian Computer Society, pp. IX-X, 2001.

[Sadegh-Zadeh, 2002] K. Sadegh-Zadeh. Fuzzy Deontik: 1. Der Grundgedanke, University of Münster Clinicum, Germany, 2002.

[Sadegh-Zadeh, 2008] K. Sadegh-Zadeh. The prototype resemblance theory of disease, *The Journal of Medicine and Philosophy*, 33, 106-139, 2008.

[Sadegh-Zadeh, 2011] K. Sadegh-Zadeh. *Analytic Philosophy of Medicine*. Springer-Verlag, Dordrecht, 2011.

[Schwarz, 1993] M.K.L. Schwarz. *Strukturelle und dynamische Aspekte klinischer Indikation*, Med. Diss., Universität Münster, 1993.

[Searle, 1995] J.R. Searle. *The Construction of Social Reality*, The Free Press, New York, 1995.

[Stegmüller, 1973] W. Stegmüller. *Probleme und Resultate der Wissenschaftstheorie und Analytischen Philosophie. Band IV: Personelle und Statistische Wahrscheinlichkeit. Zweiter Halbband: Statistisches Schließen, Statistische Begründung, Statistische Analyse*, Springer-Verlag, Berlin. 1973.

[Stegmüller, 1983] W. Stegmüller. *Probleme und Resultate der Wissenschaftstheorie und Analytischen Philosophie. Band I: Erklärung, Begründung, Kausalität*, Springer-Verlag, Berlin, 1983.

[Steimann, 2001] F. Steimann, ed. *Fuzzy Theory in Medicine*, (Vol. 21 of the journal *Artificial Intelligence in Medicine*. Festschrift for Lotfi A. Zadeh on the occasion of his 80th birthday.), Elsevier, Amsterdam, 2001.

[Strong, 1999] C. Strong. Critiques of casuistry and why they are mistaken, *Theoretical Medicine and Bioethics*, 20, 395-411, 1999.

[Suppes, 1970] P. Suppes. *A Probabilistic Theory of Causality*, North-Holland Publishing Company, Amsterdam, 1970.

[Szczepaniak et al., 2000] P.S. Szczepaniak, P.J.G. Lisboa, & J. Kacprzyk, eds. *Fuzzy Systems in Medicine*, Physika-Verlag, Heidelberg. 2000.

[Tuomela, 2002] R. Tuomela. *The Philosophy of Social Practices. A Collective Acceptance View*, Cambridge University Press, Cambridge, 2002.

[Tversky, 1977] A. Tversky. Features of similarity, *Psychological Review*, 84, 327-352, 1977.

[Wartofsky, 1986] M.A. Wartofsky. Clinical judgment, expert programs, and cognitive style: A counter-essay in the logic of diagnosis, *The Journal of Medicine and Philosophy*, 11, 81-92, 1986.

[Yager et al., 1987] R.R. Yager, S. Ovchinnikov, R.M. Tong & H.T. Nguyen, eds. *Fuzzy Sets and Applications. Selected Papers by L.A. Zadeh*, John Wiley and Sons, New York, 1987.

[Zadeh, 1965] L.A. Zadeh. Fuzzy sets, *Information and Control*, 8, 338-353, 1965.

[Zadeh, 1975a] L.A. Zadeh. The concept of a linguistic variable and its application to approximate reasoning, I, *Information Sciences*, 8, 199-251, 1975.

[Zadeh, 1975b] L.A. Zadeh. The concept of a linguistic variable and its application to approximate reasoning, II, *Information Sciences*, 8, 301-357, 1975.

[Zadeh, 1976] L.A. Zadeh. The concept of a linguistic variable and its application to approximate reasoning, III, *Information Sciences*, 9, 43-80, 1976.

[Zadeh, 1978] L.A. Zadeh. Fuzzy sets as a basis for a theory of possibility, *Fuzzy Sets and Systems*, 1, 3-28, 1978.

[Zadeh, 1981] L.A. Zadeh. Possibility and soft data analysis. In L. Cobb, & R.M. Thrall, eds., *Mathematical Frontiers of the Social and Policy Sciences*, Boulder, Colorado, Westview Press, pp. 69-129, 1981.

CONCEPTUAL FOUNDATIONS OF BIOLOGICAL PSYCHIATRY

Dominic Murphy

INTRODUCTION

Modern Psychiatry has a somewhat uncertain self-image. Most thinkers about psychiatry agree — though they may deplore it — that in recent years psychiatry has embraced "the medical model". The subject has become more biological and more closely affiliated with medicine and the life sciences. But there is confusion about what these developments mean. There are also disputes about the implications of these changes for the classification and explanation of mental illness. In this chapter, I offer one perspective on these issues that starts from seeing psychiatry as an applied branch of the cognitive neurosciences.

I begin by trying to get clear about what it means to say that psychiatry has adopted the "medical model" by distinguishing between stronger and weaker versions of the medical model. The difference between them lies in their conceptions of disease. I'll suggest that the stronger version of the medical model, which sees mental illness as caused by pathological neuropsychological processes, is more suitable to moving psychiatry in the direction of successful and established science. I will then explore the implications of this view, beginning with questions of taxonomy. I will argue that psychiatric classification ought to be based on causal hypotheses. Many biological psychiatrists will agree. But I disagree with many enthusiasts for the medical model when it comes to assessing what the relevant causes might be. It's a familiar point that the causes of mental illness are various and occur at many levels of explanation, and nothing in the commitments of the medical model, properly construed, throws that familiar picture into doubt.

In this paper I distinguish two ways to understand the medical model, which I call the minimal and strong interpretations. A minimal interpretation thinks of diseases as collections of symptoms that occur together and unfold in characteristic ways, but it makes no commitments about the underlying causes of mental illness. A strong interpretation of the medical model, on the other hand, does make commitments about causes. The strong interpretation argues that mental illnesses are caused by distinctive pathophysiological processes in the brain. I then try to show what difference it makes to psychiatry if we choose one or the other.

In section 1 I defend and elaborate on the distinction between the strong and minimal interpretations of the medical model. Then I move on to explanation.

Handbook of the Philosophy of Science. Volume 16: Philosophy of Medicine.
Volume editor: Fred Gifford. General editors: Dov M. Gabbay, Paul Thagard and John Woods.

Some forms of explanation sit comfortably with the minimal interpretation of the medical model, but the strong interpretation makes room for a form of causal explanation. If disease is a pathological process in bodily systems, then there must be a way of understanding how such processes occur in the brain, and how they cause the clinically observable symptoms of mental illness. Hence, most of the paper traces out the implications of the strong interpretation in terms of a causal theory of psychiatric explanation. Section 2 discusses levels of explanation. I deny that the medical model forces us to privilege any one level of explanation – notably, it does not commit us to reductive explanations in terms of molecular biology. In section 3, I ask what it is that we explain when we explain a mental illness. I suggest that we use *models* to explain *exemplars*, which are idealized representations of the symptoms and course of disorders.

1 THE MEDICAL MODEL

1.1 *Introducing The Medical Model*

Thirty years or so it was controversial to say that psychiatry was a branch of medicine, but these days it is a commonplace that the field has adopted the "medical model". On the other hand, it is hard to find out exactly what that means. How do we know, for instance, when a piece of psychiatric theorizing departs from, adheres to, or revises the medical model? What difference does it make to psychiatrists whether they see themselves primarily as doctors or as something else?

Many statements of the medical model provide only vague information. If we consult a typical recent textbook, for instance, we find the medical model introduced at the beginning to set the scene. We are told that the medical model just commits you to the "the consistent application, in psychiatry, of modern medical thinking and methods" [Black, 2005, p.3]. So what are these methods and forms of thought? The textbook (p. 5) lists three core assumptions of the medical model:

> First, the same approach should be used for mental illness as for other illnesses. One corollary of this assumption is that there exist different psychiatric illnesses with different causes, courses and optimal treatments. Second, empiric proof is the best way to test a medical theory. In other words, the scientific method should be medicine's approach to knowledge. A third assumption of medical model psychiatry is that an increased understanding of the physiology of the brain will eventually improve the care of patients with mental illness.

This sets a pro-science mood, and is notable for its attempt to align psychiatry with the biological and medical communities and its complete neglect of humanistic approaches. (Psychiatry is not, on this picture, about understanding people in ways other than the scientific.) But although they may rally the troops for medicine, the three assumptions are very uninformative. Without any guidance

about what they are, it is hard to know how psychiatry can employ "the methods of medicine": does electroshock therapy count as a method, for example, and if so is it medical? or does a method have to be of proven use elsewhere in medicine and then imported into psychiatry?

Similarly, to just claim that theories should be tested empirically hardly distinguishes biological psychiatry from other approaches to the unsound mind. Psychoanalysts believe that their theories have been tested. The disagreements are likely to come about what counts as a test. Much of the controversy surrounding Grunbaum's [1984] hostile assessment of psychoanalysis, for example, concerned the extent to which clinical encounters provide a context in which analytic hypotheses can be tested. Outside psychoanalysis, there are many therapists who believe that the outcomes of different talk therapies can be experimentally assessed by statistical trials, but it is unclear whether such trials belong to medicine in the sense that drug trials do [Dawes, 1994].

And a broad range of opinions could also agree that we will understand mental illness better of we know more about the brain: Louis Sass' phenomenological theory of schizophrenia [Sass, 1992] contains a substantial discussion of the relevant neurophysiology and does not deny that brain science can be informative about the causes of schizophrenia. If you believe that mental illnesses are sometimes real phenomena rather than invariably social constructions, and you are a materialist about the mind, you are likely to think that the brain is important to psychiatry. Again, many psychoanalysts would agree with that claim, for instance, since Freud always intended his theory to be a materialist one. Disagreement between camps is likely to appear when we ask how much illumination will come from neuroscience as opposed to other sciences, and from which parts of neuroscience. Some clinicians regard the medical model as overstressing neurobiological rather than cultural and cognitive variables, but are nonetheless materialists who are fully committed to empirical testing.

It seems, then, that two theorists can endorse all three of the textbook propositions about the medical model that we just looked at but understand them in quite different ways, including some ways that are sometimes thought of anti-medical.

There are, of course, skeptics about the whole idea of psychiatry as a branch of medicine. But even if we stick to professed believers in the medical model who seem to belong to the same biologically motivated area of the subject, we find disagreements about how Black's core commitments should be understood. For instance, Guze [1992, p.129] likewise defines the medical model as "using in psychiatry the intellectual traditions, basic concepts, and clinical as well as research strategies that have evolved in general medicine". And Black's third claim, that the physiology of the brain is important, echoes Guze's insistence that mental illness "represents the manifestations of disturbed function" in the brain [1992, p.44]. So far, Guze is fully in agreement with Black, and so is Nancy Andreasen when she says that psychiatry is a form of neuroscience [1997].

But disagreements emerge when we look closer. Andreasen means that psychiatry is a form of cognitive neuroscience, and thinks that we should aim for causal

explanations of disease in terms of failures of information processing systems in the brain. Kandel [2005] however, seems much more committed to the view that molecular explanations of mental disorders in terms of gene expression are the way to bet, and that higher levels of explanation can be discarded. Kandel does not mean by this that all diseases have genetic causes. He means that all diseases have effects mediated by activities within the cell, so that all we need to do is understand the proximate, molecular causes of symptoms. But this dispute over levels of explanation cross-cuts another dispute over the nature of disease. This second argument gives us a better way to frame the conceptual disagreements over the medical model.

The dispute over disease turns on whether we should see diseases as genuine entities or conventional categories. When Guze [1992] calls psychiatry a branch of medicine all he means is that disorders can be distinguished by their characteristic symptoms and courses. He does not think of diseases as specific pathologies, but as conventional labels for groups of patients. They are associated with biological markers but not identified with causal processes in the brain. Similarly, the *Diagnostic and Statistical Manual of Mental Disorders* ([DSM-IV-TR]; American Psychiatric Association 2000) aims to classify mental illnesses based on course and symptoms but not specific causes. Andreasen [2001, p.172-76], on the other hand, argues that we are presently identifying the specific pathophysiologies that cause mental illnesses. Her account sees the medical model in a different way. It is not just a matter of using empirical methods to understand the nature and treatment of syndromes, but a matter of applying cognitive neuroscience to the causal-explanatory strategies of modern medicine. Disagreements over the correct level of explanation proceed against a background of prior dispute over what is to be explained. I shall therefore begin by discussing the medical model in terms of conceptions of mental illness based on a wider way of thinking about disease, and then go on to address levels of explanation in the next section.

I distinguish two ways of understanding the medical model. A minimal interpretation thinks of diseases as collections of symptoms that occur together and unfold in characteristic ways, but it makes no commitments about the underlying causes of mental illness. A strong interpretation of the medical model, on the other hand, does make commitments about causes. The strong interpretation argues that mental illnesses are caused by distinctive pathophysiological processes in the brain. I will expand on this and then try to show what difference it makes to psychiatry if we choose one or the other.

1.2 The Medical Model and the Nature of Mental Illness

The DSM-IV-TR conceives of mental illnesses as syndromes. Individuals who share a diagnosis share a subset of symptoms from a larger list; in some instances they may have all their symptoms in common, but there may be no overlap in the symptoms at all for some cases. These collections of symptoms are also supposed to unfold over time in more or less the same way, once we make allowances for

a degree of individual variation, and respond similarly to treatment. Each diagnosis is supposed to represent malfunction in some mental, physical or behavioral trait or capacity, but the diagnosis is officially made without worrying about that underlying malfunction might be.

This approach to diagnosis is often called Kraepelinian, to indicate that it stands in the tradition of Emil Kraepelin. He affirmed that *"only the overall picture of a medical case from the beginning to the end of its development* can provide justification for its being linked with other observations of the same kind" [1899, p. 3]. This familiar neo-Krapelinian picture is of mental illnesses as collections of signs and symptoms that doubtless depend on physical processes but are not defined or classified in terms of those physical processes.

This idea of diseases as observable syndromes shies away from any commitment to the underlying reality of disease as a genuine process. It is the hallmark of what I have called the minimal interpretation of the medical model. Unlike someone such as Andreasen, who is a realist about disease, a minimalist thinks of mental illnesses as constructs designed to order inquiry. Guze [1992], for example, is a minimalist: in calling psychiatry a branch of medicine he means only that disorders can be distinguished by their characteristic symptoms and courses. He thinks that the concept of disease is conventional, and stresses our ignorance of most etiologies. McHugh and Slavney seem to agree. They insist that a disease "is a construct that conceptualizes a constellation of signs and symptoms as due to an underlying biological pathology, mechanism and cause [1998, p.302]." To diagnose a patient as suffering from a mental disorder, for McHugh and Slavney, is to label them in a way that (p.48) we judge helpful as a starting point for investigating physical processes.

McHugh and Slavney deny that a disease is a physical process — "its essence is conceptual and inferential" (p.48). As a precursor of this view, they cite Thomas Sydenham, the great seventeenth century English physician who distinguished varieties of pox based on their characteristic courses and outcomes. This way of thinking about diseases prescinds from theorizing about underlying causes of a disease entity in favor of a concentration on observable phenomena, not hidden causes. However, it is diseases understood as destructive processes that make up the taxa of medicine.

Remember our textbook: it argued for a commitment to normal medical methods within psychiatry, and there is certainly nothing within McHugh and Slavney's discussion of mental illness that makes scientific methods inapplicable. For one thing, a conception of diseases as syndromes can underwrite one of the most common explanatory strategies in all of sciences, which I called [Murphy, 2006] causal discrimination, as opposed to causal understanding. (Cooper [2007] calls the same phenomenon natural history explanation.) This involves explaining some particular entity's behavior in terms of the kind of object it is, as when we say that Miffy is afraid of dogs because she is a rabbit. We might prefer to think of this as a sketch or place-holder for a more full explanation, but even in the absence of a clear account of why something behaves as it does, we may get useful information

from knowing which class of objects it belongs to. Different types of plant may need to be put in the ground at different times, or in different seasons, in order to maximize crop yield, for instance, and different patients may respond to different drugs even if the causal basis of these differences remain unknown.

We can also use bare categories, without further causal information, as a basis for epidemiological inquiry. A conventional or syndromic account of disease also permits us to use case studies to draw attention to salient features of different diagnoses, and descriptive psychopathology lets us use even conventional categories as the basis for a richer account of the relevant disorder.

So, a conventional concept of disease, in the manner of the minimal medical model, lets us make use of descriptive and statistical reasoning and offers the hope of accurate prediction and effective control. In the opinion of some philosophers, that is all science ever aspires to.

Other philosophers, though, will tell you that the job of science is to discover the causal structure of the world. From this perspective it looks like dereliction of duty when a scientific discipline decides to isolate itself from inquiry into causes, as the DSM-IV-TR has officially done. If we ask why the conventional view of diseases is successful in organizing prediction and control, the obvious answer is that in sorting entities into classes we are sometimes sorting them into sets with the same casual structure. If it is Miffy's rabbithood that explains why she is afraid of dogs, that is because something about the nature of rabbits disposes them to fear of canines, and we now face the task of going on to find out what that is. The same applies to sorting patients based on the natural history of their conditions, or on differential responses to drugs. We can see these sorts of explanations as opening the way to a fuller inquiry, one that tries to uncover the causal structure of psychopathology.

I noted above that the DSM approach is often called "neo-Kraepelinian". But even Kraepelin saw classification by clinical description as an interim measure designed to satisfy the practical requirements of contemporary physicians and also, more importantly, to provide a fruitful heuristic for subsequent pathological and etiological inquiry: "the value of every diagnosis is thus rated essentially by the extent to which it opens up reliable prospects for the future" [1899, p.4]. Kraepelin's considered position was actually [1899, p.2] that "pathological anatomy promises to provide the safest foundation" for classification of mental illness, and assumed that the correct taxonomy would be one in which clinical description, etiology and pathophysiology coincided: "cases arising from the same causes would always have to present the same symptoms and the same post-mortem result" (p.3).

There is a substantial difference between thinking of clinically-based, syndromic classification in this way and thinking of it in the DSM's way. The DSM classification is designed [DSM-IV-TR, p. xxiii] to improve communication across clinical specialties and underwrite clinical education, but not to serve as a spur to an eventual causally-based system. DSM-IV-TR is certainly intended to reflect and foster extensive empirical investigation, but the investigation is guided by the existing, acausal categories. It is not designed to revise those categories in the direction of

a causal taxonomy, and it defines mental illness (p.xxxi) as a clinically significant syndrome rather than a destructive process. Unlike Kraepelin, the DSM-IV does not even envisage a causal taxonomy as a goal. This reflects a minimal interpretation of the medical model; it can guide empirical research but not uncover causal structure.

As well as this lack of explanatory power, the DSM leaves itself open to the charge of arbitrariness. It is a classification that rests on grouping together observable phenomena. We already know from other areas of medicine that what looks like the same phenomenon — a cough, say, or a sore throat, or chest pain — can reflect different causal pathways on the inside and hence different conditions. Any taxonomy that rests content with surface features risks lumping different conditions together and keeping related ones apart. Indeed, without an account of underlying causal structure, it becomes difficult to give a principled answer to the question why some conditions should be seen as pathological to begin with. Merely saying that members of a class have certain properties does not tell us whether, let alone why, they are mentally ill. To answer that question we need some basis for making the judgment. The DSM, as we have seen, states that we have such a basis; mental disorder is an outward sign of dysfunction. But to make that argument, we need a commitment to finding dysfunction somewhere on the basis of the outward, observable phenomena. No amount of observation alone will uncover the dysfunction without a commitment to the idea that there is a destructive process at work that causes an underlying dysfunction. In other words, the minimal model can only answer questions about the relationship between membership in a taxon and some other variable: it will not explain why the taxon has the nature that it has, or why it should be seen as a kind of disorder.

Let me give an example: Ross *et al.* [2008] point out that the brains of pathologically addicted gamblers resemble the brains of cocaine addicts more closely than either resembles the brains of heroin addicts. This, they suggests, shows both that pathological gambling is a genuine addiction and that its basis is a hijacking of the reward learning machinery in the brain's dopaminergic system. They further argue that the substance disorders should be seen as complications of pathological gambling, since the latter's neurological properties mark it out as the basic form of addiction.

To make this argument it is necessary to distinguish the truly pathological gambler, whose life is dominated (and typically wrecked) by gambling, from merely habitual gamblers. Habitual gamblers might engage in gambling more than they feel they should, or periodically lose more than they can afford, but there is a qualitative difference between this population and the population of genuinely addicted gamblers. This qualitative difference is detected by observing behavior and rating the results of questionnaires. However, if we classify gamblers according to quantitative measures alone, we miss the reason why different groups, separated by statistical measurements, behave differently. The reason is a causal process in which the brain works in a way that it does not work among non-addicts; thinking of addiction merely in terms of habitual behaviors will not let us make

the discriminations among gamblers that Ross et al. detect.

An even stronger version of the same argument was recently made by Horwitz and Wakefield [2007]. Here, the claim is that only a hypothesis about causes can allow us to distinguish a normal population from a disordered one. They begin with the DSM criteria for diagnosing major depression to receive a diagnosis of Major Depressive Episode, one must suffer five of the following nine symptoms over a two week period (including either or both of depressed mood or diminished interest or pleasure in almost all activities):

1. depressed mood

2. diminished interest

3. weight gain or loss (without dieting) or change in appetite

4. insomnia or excessive sleep

5. observable psychomotor agitation or retardation

6. fatigue or loss of energy

7. feeling worthless or excessively guilty

8. diminished ability to think or concentrate, or indecisiveness

9. recurrent thoughts of death or suicide or a planned or attempted suicide

Now, it is clear that, since being alive involves a series of disappointments, many ordinary episodes in a person's life can cause behaviors or feelings from this list. We can be depressed, inattentive, tired and sleepless after losing a loved one, receiving a major professional setback or serious medical diagnosis, or being jilted, along with many other trials. These vicissitudes of life were recognized and allowed for by the traditional concept of melancholy or depression, which has a continuous history going back to classical antiquity [Radden, 2000]: we have always recognized that some people become melancholic because of life's misfortunes whereas others slip into depression without any apparently significant cause. The tradition sees pathology only in the latter case, consistently holding that "pathological depression is an exaggerated form of a normal human emotional response" [Horwitz and Wakefield, 2007, p.71]. All of us are downcast by misfortune (even when we deserve it), but some people become melancholy without any apparent justification.

The DSM, however, ignores this tradition. Anyone who fits the syndrome receives the diagnosis, except only that grief following bereavement does not count towards diagnosis of Major Depressive Disorder. (The bereaved person gets two months to grieve after which time a diagnosis of clinical depression may be made.) Not even that minor qualification, however, is made if one shows depressive symptoms after one's spouse abandons one by emptying the back account and running off with a lover, rather than dying.

Horwitz and Wakefield make a very compelling negative case, to wit that DSM-IV fails to respect common sense or previous psychiatric consensus about depression and is diagnosing many people as depressed when they are just normally miserable. They conclude that the concept of depression defined by this diagnostic syndrome represents a major conceptual break with both past psychiatry and commonsense thought about human nature. This leads to needless alarmism about an epidemic of depression and has unfortunate consequences for many individuals who are diagnosed in error.

Horwitz and Wakefield think that what is really wrong in cases of genuine depression is a failure by a loss-response system built onto our minds by natural selection. The system is adapted to respond to losses that threaten to deprive us of reproductive resources. The operations of this system explain why we get sad in those situations where we expect people to be sad, since sadness is the normal adaptive response to loss (p.25). The distinction between this normal sadness and depression reflects the normal and abnormal workings of the loss-response system, since they believe it is the failure of this system to operate normally that explains major depression. In depressives the system brings about the response it is designed to produce, but in situations where it should not, or to a degree that is not consistent with the degree of loss that the individual has undergone.

None of this is very convincing as a positive account, but the argument that Horwitz and Wakefield make about the conflation of depression and sadness has great intuitive force. The DSM concept of depression, on the face of it, lumps together different psychological and behavioral types in the same category because of observable similarities that may nonetheless reflect diverse etiologies. There is no way to answer this charge, or to arrive at a satisfactory taxonomy that mirrors that of general medicine, unless we adopt a causal foundation for nosology. And to do that involves not just the empirical study of mental disorder, but a strong interpretation of the medical model, with its commitment to a view of disease as not just a syndrome but a destructive process. It is certainly possible to collect data using the DSM concept of depression, especially information about epidemiology and natural history. In that sense normal medical reasoning can indeed be employed, but much medical reasoning is directed at trying to understand causes. It is here that we come to the strong interpretation of the medical model, with its commitment to the idea that a mental disorder, like any other kind of disease, is not just a construct to guide inquiry, but a genuine part of the causal structure of the biological world – a destructive entity with a distinctive pathophysiology that explains the observable patterns that the minimal model trades in.

So let me now turn to the strong interpretation of the medical model. We have seen that theorists like Ross, Horwitz and Wakefield are committed to the view that to understand mental disorders correctly — to make the right distinctions between populations — we need to find the right underlying causal structure. The strong view, then, has adherents among psychiatrists and other thinkers about mental illness, even if its realism about mental illness goes beyond the official self-conception of (at least American) psychiatry.

Historically, the minimal medical model has countenanced great variation in the causes of diseases: what matters is the syndrome, not its causal antecedents, since the latter do not form part of the definition of the disease. Indeed, different instances of the same disease, on this picture, might have radically different etiologies. Carter (2003, p.11) gives examples of this thinking, including the following list of the causes of diabetes, from a medical encyclopedia published in 1845:

> frequent exposure to sudden alterations of heat and cold, indulgence in copious draughts of cold fluid when the system has been over-heated by labour or exercise, intemperate use of spirituous liquors, poor living, sleeping out the whole of the night in the open air in a state of intoxication, checking perspiration suddenly, and mental anxiety and distress [...].

If you understand diseases in terms of their symptoms, you can admit a great variety of causes provided they produce the same effects. Carter suggests that for the early nineteenth century medical profession, the notion of *the* cause of a disease was meaningless.

Carter argues via a series of case histories that this picture was supplanted in the mid-nineteenth century by what he calls the aetiological standpoint. From a literature in which medical writings simply deny that the notion of cause is any use at all, we move to a situation in which experimentalists and epidemiologists look for the cause of a disease. The movement reaches its culmination in Koch's germ theory. The aetiological standpoint, thinks Carter, sees the causes of diseases as phenomena that are natural (ie diseases are not just a matter of transgressing norms), universal (i.e. the cause is common to every instance of the disease) and necessary (the disease does not occur in the absence of the cause) [Carter, 2003, p. 1].

Carter thinks this is a revolutionary break with the whole of prior western medicine. To really make that case we might want to add a fourth condition, which is that the cause is usually categorically different from normal natural processes. This distinguishes the explanation of Pasteur and Koch from the long tradition in classical and Renaissance medicine of seeing disease as caused by unbalanced mixtures of normally occurring humors or temperaments.

Whether or not Carter's larger claims about a scientific revolution are correct, there really was a new conception of cause associated with mid-nineteenth century medicine. For the first time researchers began to think of every disease in terms of a unique cause that was necessary and sufficient for the disease and could explain all the signs and symptoms associated with it. Conceptually, this shift in thinking of causes meant that diseases came to be defined in terms of their causes, and seen not as collections of symptoms but as pathophysiological processes. Thus the same observable phenomena could be seen as belonging to different diseases, since it is the underlying cause, not the outward show, which constitutes the disorder.

Let me pause here to say more about causation. I have argued that the minimal medical model, with its stress on syndromes, departs from a key idea of modern

medicine, which is the idea of disorders as pathological processes defined causally. But what kind of process counts? This is a question about explanation and reduction — how we should think of the processes that constitute diseases. There might seem, though, to be a prior problem. Since lots of mental illnesses have myriad causes, you might think there is an impediment to embracing the medical model, which seems to require that a disease be the sole cause of the observable symptoms. I noted above that the causal explanations of nineteenth century physicians assumed that a disease has a universal and necessary cause. I contrasted this to the earlier view which the etiological program superseded. According to that earlier view, two people could share a diagnosis even though their symptoms had very different causes. But many mental illnesses appear to have numerous causes. This seems to depart from the strong medical model's idea — namely, that each disease has one necessary cause. I will end this first section by taking up these issues.

1.3 Causation and realization in the strong medical model

Donald Gillies raises the objection I just mentioned as a more general problem for Carter's analysis of nineteenth century medicine. Gillies wonders [2007, p.370] whether it is not true that

> the modern concept of causality looks rather like the early 19th century plurivalent approach to causality which Pasteur and Koch rejected. Consider a modern account of heart disease for example. It would be quite legitimate to say that heart disease can be caused by smoking and/or by eating fast food. Yet these two causes are neither necessary nor sufficient. There might well be a patient who gets heart disease from smoking 60 cigarettes a day without consuming even a mouthful of fast food; while another might succumb as a result of eating hamburgers and fries twice a day without smoking even once.

There are two responses one can make to this, both of which are relevant to thinking about causal explanation. Indeed, they complement each other, although it would take a bit more time than I have here to fully explain why. First, as Gillies himself goes on to note (p.371), the modern conception of causation in the life sciences is not really the same as the early nineteenth century one that was elbowed out of the way by the medical revolutionaries. The difference is that modern thinking has incorporated statistical methods to give much greater empirical content to the claim that different risk factors cause the same disease. For instance, Kendler and Prescott [2006, p.148ff] found that "stressful life events" are among the chief causes of depression, and that they are especially depressogenic if they involve experiences of humiliation [Kendler and Prescott, 2006, p. 160]. Constructs like these can be operationalized and their probabilistic relationships to each other studied in order to reach a much clearer understanding of the ways in which different causes interact so as to produce a case of depression.

Second, we can distinguish between more remote and more proximate causes, or talk, as Kraepelin did, of etiology and pathology. Many factors can interact to produce the pathology that is common to all cases of a condition. On this view, all the people who share a diagnosis do so in virtue of having a common destructive process in their mind/brain: indeed, the diagnosis names that process: as Gillies (p.371) says, an example is one variety of heart disease, atherosclerosis, which does have a necessary cause, viz. tangled arterial plaques (atheromata). Such factors as overdoing the fried food and cigarettes are more remote causes, or risk factors, that bear a probabilistic relation to the pathology that is conditioned by other factors.

We might prefer to say that the neuropathology realizes the disease, rather than causes it. A particular destructive process is the way the disease occurs in humans, and it can be brought about in many ways via combinations of risk factors. On this view, atherogenesis *just is* a biochemical process of plaque formation and its sequelae, and it can be caused in many ways. For instance, it can happen in blood vessels whose narrowing is of no physiological consequence, and hence not a disease process. Similarly, one might think that major depression *just is* some, as yet unknown, cognitive and/or neurological process (or, perhaps, a family of specific processes) that can be triggered in diverse ways depending on one's genetic inheritance, acquired psychology and contingent biography.

Let me sum up section 1. I have distinguished *strong* and *minimal* interpretations of the medical model. A minimal interpretation makes no commitments to the underlying physical structure that causes mental illness, whereas a strong interpretation argues that mental illnesses have specific pathophysiologies.

I suggested also that we can think of the conceptual move from minimal to strong interpretations of the medical model as akin to the shift from syndromes to causes in the conception of disease in nineteenth century medicine. I am not arguing for any direct historical influence of these debates, or suggesting that contemporary psychiatrists see themselves as belonging to historically conditioned camps (although we saw above that McHugh and Slavney do see themselves as heirs of Sydenham). I do, however, want to suggest that we can see the strong and minimalist camps as divided over realism about disease.

Last, I suggested in this section that we do better, if we are to be realists about disease categories, to view diseases as realized in biological systems rather than caused by them, and this permits strong medical thinking to acknowledge that a realization which is shared across patients might have a variety of specific, peculiar causes.

I will now move on to explanation, with the strong interpretation of the medical model in mind, although much of what I say is relevant on any view of what the medical model is all about, since minimalists tend to be as interested as anyone else in empirical investigation of the causes of symptoms.

If disease is a pathological process in bodily systems, then there must be a way of understanding how such processes occur in the brain, and how they explain the clinically observable facts about mental illness. The rest of this chapter traces out

the implications of the strong interpretation for the theory of psychiatric explanation. I first deny that the medical model forces us to privilege any one level of explanation. Section 2, therefore, discusses reductionism. I try to block the idea that the medical model forces us in the direction of the "geneticisation" of psychiatry. Then in section 3 I offer a positive account of what we are doing when we seek to explain a mental illness. I suggest that we use *models* to explain *exemplars*, which are idealized representations of the symptoms and course of disorders. In section 4 I look more briefly at the consequences of this view for classifying mental disorders.

2 THE MEDICAL MODEL, REDUCTIONISM AND LEVELS OF EXPLANATION

To find the specific causes of disease we need a background theory of normal function relative to which pathology can be identified. Finding a malfunction does not establish the existence of a disease, since our concept of disease involves not just biological abnormalities but also judgments that such abnormalities impede human flourishing [Boorse, 1976; Engelhardt, 2004; Richman, 2004; Sadler, 2004; Wakefield, 1992]. I am avoiding these broader issues. I am asking how far psychiatry can adopt medical reasoning about pathogenic neurobiological processes, which are necessary but not sufficient for mental illness.

I have argued that the medical model assumes that mental illness is brain disease, but that alone does not give us much guidance about choice of background theory. The brain can be understood at many levels of explanation, so it is to this issue that I now turn. I will claim that the obvious source of background theory is cognitive neuroscience, understood very broadly. My conception of cognitive neuroscience includes not just what we might think of as narrowly cognitive phenomena, but also the systems underlying social cognition, visceral states, and other affective processes [Schulkin, 2004]. I do not mean that all explanations will involve cognitive levels of explanation as opposed to other levels of brain function. Cognitive neuroscience is a background theory in the sense that it provides a general framework for understanding mental life as the upshot of information processing systems in the nervous system at various levels of explanation, just as medicine in general derives from theories of normal organ function. We should think not of a cognitive level of explanation, but as a general orientation towards the brain as a collection of systems that process information. Deficits in that information processing can be understood via a number of theories at different levels.

Other thinkers contend that the background theory for psychiatry is molecular neurobiology [Kandel, 2005, ch.2]. I disagree, on two grounds: first, as a matter of logic the medical model privileges explanations of a certain form — explanations that cite a destructive process in the brain — but not a particular level of explanation; second, there are good reasons for thinking that familiar pictures of reduction do not apply when we are relating causal processes of very different types

both within the organism and outside it, in the environment. A commitment to reductionism, I think, is motivated by a metaphysical prejudice in favor of the very small, plus an overoptimistic generalization from a few cases. Most explanations in the life sciences cross levels [Schaffner, 1993; 1994].

2.1 The explanatory commitments of the strong interpretation

The strong interpretation seeks explanations that cite pathogenic processes in brain systems, just as bodily diseases are explained by processes in other organs. The process at issue need not be destructive, in the sense that it makes the system collapse. Bolton and Hill [2004, p. 252] note that many mental illnesses seem to be the outcome of systems in a poorly regulated state that is stable, albeit suboptimal. But, as they say, the same is true of hypertension and Cushing's disease; the idea of a specific pathogenic process in medicine includes dysregulation.

However, Bolton and Hill are bothered by the thought that the medical model requires explanations in terms of biological rather than intentional phenomena. This, they fear, means that it can only apply when "intentionality has run out" [2004, p. 256]. If true, this rules out using the medical model to explain the many psychopathologies that appear to involve irreducibly intentional processes. Their worry is reasonable if the medical model commits us to a reductive view of biological phenomena, or, more generally, if there is an unbridgeable distinction between understanding a phenomenon in intentional terms and providing a causal explanation of it [Bolton and Hill, 2004, chs. 1 & 2]. But the brain is a cognitive organ — and, indeed, a social one. Many disciplines study the effects of healthy cognition on behavior, and there is no reason to expect that cognition will suddenly become irrelevant to the explanation of behavior when we study mental illness. For instance, as I mentioned above, Kendler and Prescott [2006, p.148ff.] found that "stressful life events", especially episodes of humiliation, are among the chief risk factors for depression (pp. 160). They doubt, as well they should, that humiliation can be understood in reductive terms, as a molecular process (p.350). Yet this anti-reductionism does not stop Kendler and Prescott from calling Major Depression one of the oldest diagnoses in medicine (p.52). And they happily employ "classically mental constructs" (p.350) in their causal models of mental illness.

If mental illness is caused by pathogenic systems we must understand systems in terms of their normal function. Any conception of normal neurological functioning must take information-processing into account, because processing information is what brains are for. Nothing in the strong interpretation of the medical model rules out explanations that cite cognitive processes in brains: Andreasen [1997] argues that schizophrenia and depression are cognitive pathologies and sees psychiatry as both a form of medicine and "the discipline within cognitive neuroscience that integrates information from all these related disciplines in order to develop models that explain the cognitive dysfunctions of psychiatric patients based on knowledge of normal mind/brain function" (p.1586). I share this conception of psychiatry.

It is fully biological but not committed to a particular interpretation of what biological explanation must look like.

So Bolton and Hill's worry about the compatibility of the medical with their "neural encoding" theory [2004, ch.2] seems overstated. They are right to stress that the brain can be seen as a socially situated, cognitive organ, but there are advocates of a strong medical model who are equally attuned to this conception of neuroscience. The medical model sees mental illness as the result of pathogenic processes taking place in brain systems but does not force us to choose reductive explanations as a matter of logic.

Now let me turn to the question of whether reductive explanations are likely to be the norm in psychiatry as a matter of fact. Most mental illnesses are caused by diverse environmental and genetic factors. We have little reason to think that all the relevant causes can be given a reductive analysis, for as Schaffner dryly points out, to specify and measure environmental variables in purely molecular terms "would be a very long-term project" [1994, p.287].

However, you might still think that molecular processes are the root causes of mental illness even if many other contributory factors exist. Kandel [2005, p.39] for example, argues that "all of 'nurture' is ultimately expressed as 'nature'." Of course behavioral and cultural factors influence gene expression — the dynamic processes that cells use to turn gene products on and off — but Kandel seems to have a stronger point to make: he implies that psychiatric explanations need only mention gene expression, which will capture all the effects of prior processes without needing us to state them in higher level terms.

Kandel's genetic reductionism is a metaphysical position, aimed at identifying a privileged level in nature. It is a reasonable metaphysical position to hold that all mental phenomena involve gene expression in the brain. But that does not solve the question we are asking, which is what conception of explanation is needed in a mature psychiatry. In medicine the goal of causal explanation is instrumental [Whitbeck, 1977]. We seek the factors that make a difference in a given case, not a metaphysically privileged level.

In studying eating disorders, for example, we find that social factors may explain particular epidemiological patterns, like different levels of eating disorder across populations. But social factors don't tell us why only one girl in a family gets bulimia. To explain that we can appeal to her membership in a class of people with a particular brain chemistry that puts her at risk [Steiger et al., 2001]. But that does not establish that neurobiology really is fundamental. Rather, nothing is fundamental. Culture or trauma may require biological mediation to have its pathological effect, and vice-versa. Neither one should be considered fundamental, but seen rather as the best way to answer a specific question about what makes a difference in a context.

The reason for this, as Whitbeck [1977, p.630] convincingly argued, is that medicine's interest in causal explanation is driven by instrumental goals. The identification of a cause of a disease often depends on what we want to control. That is why alternative theories of etiology can complement, rather than compete

with, each other, as in Meehl's [1977] example of an elderly man, genetically
somewhat at risk for depression, who develops it after his spouse dies. It seems
wrong to call this a genetically caused episode of depression: the genes needed
an unusual environment, so that in most other circumstances the man would not
be depressed. But he would not have developed clinical depression had his genes
been different. Both factors are causally relevant.

Because of this stress on figuring out what makes a difference in a context,
medicine is a natural home to manipulationist accounts of causation, as Whitbeck
saw [1977, p.627-28]. The basic idea behind the manipulationist approach is that
it puts us in a position to begin explaining a phenomenon "when we have iden-
tified factors or conditions such that manipulations or changes in those factors
or conditions will produce changes in the outcome being explained" [Woodward,
2003, p.10]. This view is silent about the underlying metaphysics.

Reductionism, in contrast, bets that molecular explanation will be successful
because it picks out nature's own preferred level. This requires us to give up a
fruitful approach in favor of a promissory note, which we have little reason to
expect to see fulfilled. (Schaffner [1998] pointed out how hard it is to supply re-
ductive explanations even in simple model organisms.) Existing medical practice
already uses cross-level explanations [Schaffner, 1993], and environmental informa-
tion about stress or other risk factors. There is in principle no objection to adding
an intentional level to the mix. The manipulationist account gives a rigorous way
to do this, since its formal properties are compatible with the identification and
interrelation of variables of any sort, from the molecular to the cultural. In the
next section I consider levels of explanation in more detail.

2.2 Levels of Explanation Again

We should expect explanation in a mature psychiatry to take a model of a normal
psychological capacity and then show how symptoms systematically depend on
disrupted processes within and between components of the model. Models need
to be multi-level, able to use information about cognitive and social processes, as
well as biological ones. I will go over this approach in the rest of this section. I
start by looking at Marr's familiar picture of levels.

Marr [1982, p. 24-5] distinguished three levels of explanation in cognitive sci-
ence. The highest specifies the computational task accomplished by the system
of interest. The middle level describes the particular information processing al-
gorithms the system uses to solve that task. The lowest level tells us how brain
tissue implements the algorithm.

Marr wanted to build machines to do the computational tasks that minds per-
form. This led him to try to specify psychological tasks in the abstract, without
worrying about biology. As he said, we can understand flight as a process with-
out knowing anything about the physiology of a bird's feathers. But if one is
interested in the details of biological cognitive organization in a particular species,
one obviously needs to see how mental processes are actually realized biologically,

just as one would need to investigate feathers if one's focus was the physiology of birdflight. And if one were trying to establish why a bird could not fly, it would be fruitless to look only at some abstract principles of flight that birds share with helicopters or insects. We would need to know the details of the physical set up and why it is dysfunctional in order to understand the breakdown. Further, recent cognitive neuroscience suggests that Marr's approach overstates the degree to which processes can be specified independently of each other at different levels.

Marr's three levels are different representations of the same process. But in psychiatry different levels often represent distinct causal processes. For example, the causes of major depression are a mix of genes and environmental adversity. These levels do not represent, as Marr's did, different perspectives on the same kind of process, but processes of different kinds.

So we must amend the Marrian picture in the light of the two complications I have mentioned. First, then, we should look for physical structures in the brain that carry out information-processing jobs, or "cognitive parts" [Glymour, 1992]. Mental capacities can be distinguished functionally, but the final decomposition of our mental life into cognitive parts — physical structures in the brain that carry out information-processing jobs — should be guided by the interrelation of cognitive hypotheses and physical facts. The decomposition of cognitive activity and the identification of cognitive parts mutually inform each other [Bechtel and Mundale, 1999; Zawidski and Bechtel, 2004]. The result may be a functional specification of a psychological process that is less abstract, and less elegant, than one would expect on engineering grounds. When we understand lower level processes we might discover that they constrain higher level processes. Abstract specifications might lead us to harbor expectations about the system that turn out to be incorrect. Nature does not always hit on the solution that a human engineer might come up with if she started from scratch.

Here's a famous example. Mishkin *et al.* [1983] cited lesion studies of monkey brains to show that visual information is processed along two main routes (my discussion of the philosophical morals of this work draws heavily on [Zawidski and Bechtel, 2004]). One route defines the "What" system: lesions in this system prevent the recognition of familiar objects; this, together with the very large visual receptive fields of the neurons in this system, suggest that those neurons identify the physical qualities of objects, enabling them to be re-identified regardless of their locations in the visual field. This system is defined by the ventral stream, in which visual information moves from prestriate cortex down to areas TEO and TE.

Mishkin argued that the "what" system forgets information about location. That is the province of the dorsal or "Where" pathway. It runs into the posterior parietal cortex. Lesions there prevent monkeys from responding appropriately to an object in ways that are sensitive to the object's spatial position.

The final picture was more complicated than this original proposal. But neither the complications, nor the original separation of "what" and "where" processing, would have been predicted via attempts to reach an abstract task decomposition

of the visual system.

Cognitive neuroscience puts much tighter constraints on the relations between levels than the Marrian engineering project. Our understanding of biological realization feeds back into and constrains our understanding of the abstract structures of cognition. Rather than relating abstract psychological capacities to each other, higher level descriptions of the mind/brain relate capacities understood as functional descriptions of fairly coarse-grained brain areas rather than purely abstract computational task specifications. Theories of the normal system specify the nature and interrelation of cognitive parts. Armed with these assumptions about cognitive parts, psychiatrists can see a disorder as a breakdown in normal functioning within and between cognitive parts.

I have argued that cognitive processes taking place in the brain cannot be understood as abstractly as Marr imagined. I now turn to the second problem I mentioned earlier. Levels-talk is often used to specify processes that operate across different phenomena, not different descriptions of the same phenomena. Most mental illnesses, for example, are caused by a complex interaction of proximal causes, within the organism, and distal, environmental causes.

2.3 Levels within and without

In a classical theory reduction we aim at replacing higher-level generalizations with lower-level ones and bridge laws translate the higher level vocabularies into a common lower one. Something like this is anticipated by Kandel's assumption that facts about higher level processes can be restated in terms of genes. Such a vision may make sense when we are talking about generalizations that apply at different levels to the same structures or processes. But this reductive project is not likely to be even imaginable when we are dealing with processes of radically different kinds. Marr's levels represent the same process in different ways. But suppose that an interaction of genetic endowment and long-term unemployment conspire to make someone depressed. In this case we are dealing with different processes, not the same process realized in different ways.

It is hard enough to imagine a molecular reduction of a psychological construct like humiliation (which, we saw above, is depressogenic). It is even harder to imagine a reductive analysis of socio-cultural factors like unemployment or childhood sexual abuse. They have brain effects, but the brain effects vary across classes of individuals in ways that depend on other environmental and genetic contexts (see [Kendler and Prescott, 2006] for a comprehensive review.)

Schaffner [1993; 1994] suggests this interlevel structure is the norm throughout biology, where we frequently find ourselves relating causes and effects at different levels of explanation. Psychiatric explanations will continue to employ different levels, or (perhaps better) types, of explanation, that combine several different processes in one explanatory structure. I turn now to a logically separate question — what are we trying to explain in this way? I suggest that we are trying to explain exemplars, which are idealized descriptions of mental illnesses at various

levels of explanation. The need for them arises from the confrontation between great variation in clinical reality and the need to simplify in order to render that reality scientifically tractable. That is, we must identify the modal processes — those that occur most frequently in a population.

3 EXPLANATION

3.1 Exemplars

I shall now argue that explanation in psychiatry, *qua* branch of cognitive neuroscience, proceeds via model-based explanation of exemplars. Now, mental disorders manifest themselves differently according to the different biographies, circumstances and psychological properties (including the other psychopathologies) of the people who have them. This is why we need exemplars. An exemplar is not a model, but an idealized description of what we need to explain, whereas a model is used to explain the exemplar.

An exemplar is best thought of as an imaginary patient with the textbook form — the symptoms and natural history — of a disorder, and only that disorder. (Or, we can think of an actual patient as an exemplar of a disorder enriched with a set of real-world facts.) Thus, the exemplar for major depression might include lowered affect, serotonin imbalances, negative (but complicated) self-assessment, disturbed sleep and lethargy and lack of motivation. As well as information about the presentation of a patient at a time, exemplars include information about the course of disorders. Discrimination among conditions via information about their histories is characteristic of theory-building in medicine: Sydenham used information about course to distinguish chicken pox from small pox in the seventeenth century. Contemporary psychiatry still uses this method to disentangle related diagnoses or support a unitary interpretation of a category: the idea that schizophrenia is one disease rather than a bundle of conditions is supported by the similarities in development across patients [Lewis and Levitt, 2002].

The conception of mental illness that I earlier argued was characteristic of the minimal medical model is a natural fit here, and in some ways one can see that approach in the construction of a set of exemplars. What is necessary, though, is to treat the construction of exemplars as setting the causal-explanatory challenge.

We need to identify *robust processes* [Sterelny, 2003, p.131-2, 207-8] that are repeatable or systematic in various ways across individuals, rather than the actual processes that occur as a disorder unfolds in one person. Building an exemplar involves construing a condition according to the minimal medical model; we identify a set of symptoms and a characteristic history that is shared by patients who have the condition, extracting the commonalities from the noise of individual variation. But we do not stop there: the ultimate goal of the strong interpretation is causal understanding of a disease. We build a model to serve this end. It aims to represent the pathogenic process that accounts for the observed phenomena in the exemplar. Then we show how those relations, in their turn, resemble the ones

that exist in the actual condition as realized in particular patients.

It is a recurring theme in the history of psychiatry that we conceive of a disorder as an ideal type that can be realized in individuals in different ways. Charcot [1887-88] distinguished *archetypes,* or the ideal types of a disorder, from *formes frustes*, the imperfect forms in which the ideal type occurs in individual subjects with some of its features missing or altered. Birnbaum [1923] is another example. He argued that a psychosis contains both *pathogenic* features, which define its essential structure, and *pathoplastic* features, which depend on the personal circumstances of a given patient. Neuroscientists who talk about the effect of a tumor, lesion or other pathological process must do something similar, since their task is to distinguish the core deficit that is shared across different patients and then explain it as the result of a lesion in a cognitive part. A different approach, exemplified by Bentall [2005] is to look for the smallest unit of explanation that reliably replicates across patients — Bentall advocates forgetting about diagnoses like depression or schizophrenia and seeing individual cases as mosaics made up of recurring symptoms like hallucinations. In general, the process of idealization seems to me to be more typical of successful science. Bentall's approach is also open to the problem of knowing where to stop when one begins to discriminate into smaller units.

The same process of exemplar construction, though, can, in the spirit of Bentall, be applied recursively to symptoms within the wider structure. For example, a symptom of depression like "hopelessness," might have an exemplar. This could include features like "automatic cognition", which produces persistent, wide-ranging negative self-evaluations ("I got a bad grade because I'm stupid, I've always been stupid and that's why I don't have a girlfriend.")

We might combine diagnostic exemplars of particular diseases, too, into more general categories like mood disorders or addictions. This gives us an initial classification that can be refined as more is learned. If Ross et al. are correct about pathological gambling, for instance, an initial bifurcation of addictions into forms of drug dependency and behavioral addictions might be revised so that addictions to gambling and cocaine come to be seen as disorders of the dopamine reward-based desire/learning system.

The result is a very ecumenical picture, with lots of symptoms at different levels of explanation jostling together in the exemplar. The overall goal is to vindicate the strong interpretation of the medical model by explaining these abnormalities in biology, behavior and cognition in terms of abnormal processes within and between cognitive parts.

Our knowledge of the pathophysiology is typically scantier in psychiatry than in general medicine, in which we have very often developed our models to such an extent that we can think in terms of just a (perhaps partly) completed model that shows how the symptoms depend on unobserved processes. But logically there are (and historically there have been) at least these steps: first, the study of patients; second, the construction of an exemplar by isolating those features which the patients share; third, the explanation of why the exemplar takes the form it

does; fourth, relating the exemplar to its realization in individuals.

My approach to psychiatry derives from a general view about biomedical explanation which shares features with Thagard's [1999, 113-117] account of how medicine explains disease. Thagard argues for seeing diseases as networks of causal factors, with their nodes linked not by conditional probabilities but by causal relations. We discover these relations using epidemiological and experimental methods. Thagard's causal networks provide "a kind of narrative explanation of why a person becomes sick" (p115). (Recall, above, our discussion of what Cooper [2007] calls natural history explanation.) Thagard's narrative explanations resemble what I call exemplars in that they include information about the typical course of a disease as it unfolds over time, including information about typical risk factors for the disease, such as the finding that heavy use of aspirin increases acid secretion, which makes a duodenal ulcer more likely. This is a description, like an exemplar, but not really an explanatory model, since the causal network does not specify how each causal factor produces its effects. He calls the network (p.114-115) a set of "statistically based causal relations".

Thagard (p. 106) also mentions mechanisms as having a role in the explanation, but he leaves the relation between mechanisms and disease networks unclear. We are not told whether the nodes in the network are the output of mechanisms whose nature we understand, whether they are putative outputs of mechanisms, or whether they are just symptoms that need to be explained mechanistically in some way or other. It is necessary to be clearer than Thagard about the relations between an explanatory model and the prior description of a set of observable relations, or, in my terms, the relation between model and exemplar.

Like the exemplars I talk about, Thagard's causal network is what needs explaining. But I do not presume that the relata in the exemplar are causally rather than probabilistically related: exemplars are narratives, but not narrative explanations. The underlying causal relations do the explaining.

Our job is to explain the observed relations by identifying the mechanisms that give rise to them. To do that in medicine, and therefore in medicalized psychiatry, we exploit knowledge of the mechanisms that give rise to the normal forms of the behavior. To do that we need a scientific theory that explains how cognitive parts work and interact, so that we can explain abnormal outcomes as a product of the organism's failure to function normally. We causally explain the abnormal by drawing on our knowledge of the normal.

Exemplar explanation, then, belongs to a tradition that deals with the messiness of reality by first constructing a simplified system and seeing how it behaves and second, by showing how relations among parts of the simple system resemble relations in real-life systems. In the rest of this section I will try to make this idea more precise by locating exemplar explanation in the conceptual vicinity of some theories drawn from the literature on modeling. Then in the last section I will give concrete examples to further illustrate the idea.

3.2 Models

The exemplar, remember, does not explain the disorder. It sets the explanatory task. We get an explanation when we successfully model the condition. Kraepelin did not provide a model of schizophrenia when he distinguished dementia praecox from other forms of dementia. Rather, he described an exemplar — the symptoms and course that characterize the disease. But why the symptoms and course have that form is what we need to explain; and we do that via a model. In this section I will say more about modeling.

I start by borrowing a way of talking about models [Giere, 1988; Godfrey-Smith, 2006; Weisberg, 2007] that distinguishes between the target system, the model, and the description of the model. Weisberg and Godfrey-Smith take this to imply the *indirectness* of modeling, since one is explaining nature by first constructing and explaining something else, the model system, which one treats as an independent object with properties of its own. Having understood the model, one then "co-ordinates", as Weisberg puts it, the properties of the model with real-world phenomena. I'll say more in a moment about how that works. Weisberg calls the alternative strategy *abstract direct representation*, in which one identifies properties of interest in a real world system and represents them directly via, say, an equation (or, in Weisberg's example, the periodic table), rather than first figuring out how a model works and then using that knowledge to understand nature.

Weisberg's language may suggest he thinks that representation in modeling takes an indirect form (as opposed, say, to representation in language, or the representation of age by tree rings) but I take it he does not think that. It is not that there is a funny, indirect kind of representing going on, but that the representation of reality by theory goes in two stages; theory-model, and model-reality.

The basic modeling strategy in biology and biomedicine should be seen as the manipulation of concrete entities. But in some cases these entities are imaginary: they are concrete in that they are individuals with specific features, but sometimes they are manipulated in thought, or on a computer, not in vivo. A disease exemplar is as an imaginary patient who has the syndrome in an idealized form. Similarly, as Wachbroit [1994] argued, when we say that an organ is normal, we employ a biomedical concept of normality that is neither normative nor statistical. Rather, it is an idealized description of a component of a biological system in an unperturbed state that may never be attained in actual systems. But it is the account of the organ that gets into the physiology textbook. This concept of normality is not justified by appeal to a conceptual analysis that aims to capture intuitions about what's normal. It draws all its authority from its predictive and explanatory utility: against the background of assuming normal heart function, for example, we account for variation in actual hearts (a particular rhythm, say), by citing the textbook rhythmic pattern (which may be very unusual statistically) and identifying other patterns as arrhythmic. Likewise, psychiatrists and neuropsychologists assume a theory of normal function of cognitive structures that

is a set of idealizations. Interestingly, Ankeny [2000; 2002] argued that a model organism is a "descriptive model", which is an idealized representation of a particular species, like *C. elegans*. There may be no naturally occurring organism with exactly that set of genes, but differences in behavior or development can be compared against the idealized "wild type" and, in theory, traced back to the differences between types and the genetic differences they depend on.

Godfrey-Smith [2006] also thinks that model-based biological and cognitive science typically involves imagining fictional entities. But he is reluctant to draw too close a parallel between imagining fictional systems and manipulating material entities. I think, though, that the latter should be taken as the basic case; we can see the point of the strategy in its clearest form by reflecting on cases in which actual systems are built.

Model organisms are obviously one case, in which abstract models can be checked against biological reality by making them material. Model-building in the life sciences involves taking a theory of how the world works and testing that theory by manipulating a simple intermediate system, whether in thought or in a lab. We cannot build an exemplary patient as we can construct a genetically engineered vole or sea hare, since the psychiatrist or physician can only *imagine* physical systems — an exemplar and perhaps a set of putative models. But the basic idea is the same. We can imagine what an exemplary patient would be like and try to explain why, by drawing on our knowledge of the actual physical workings of the systems our imaginary patients would contain if they were real people. When we explain a mental disorder, we show that some biological, cognitive or other processes cause the symptoms and course that make up the exemplar, which is the ideal imaginary patient. The exemplar represents the syndrome and course, and the model explains the relations between features of the exemplar. Then we explain real patients by pointing to the resemblance between the model and the world.

The model can be more or less realistically construed, depending on the available information which the model-builders possess and their general intellectual commitments. Data on the nature and location of brain lesions, for example, correlates biological insults with symptoms, but do not show how the disturbed function depends on a cognitive part. So a model that relates lesions to features of the exemplar is not a realistic model of causal structure in the brain, but it has some predictive power. In other cases, the model may depict the actual causal relations responsible for the symptoms. The causes are diverse biological and non-biological factors, often interacting in complicated ways, and typically they raise the probability that something will happen, but they do not make it certain. Modeling exemplars is not a search for laws governing mental phenomena, but a search for the causal relations that explain the presence of exemplary features. The assumption is that those relations in the exemplar resemble relations that obtain in actual humans who meet a diagnosis, but an exemplar itself is a descriptive abstraction.

3.3 Clinical Application

Psychiatric models explain exemplary disorders. The point of it all, though, comes when that understanding lets us help patients. Guze [1992] calls this the move from the biological perspective to the clinical one. In making the move we shift from a general description of a disease process to a specific description of the biology of an individual. The clinician takes the imaginary ideal patient and specifies more real-world detail, so as to produce a description of a smaller set of patients, perhaps even a single case. The scientific project generalizes, whereas the clinical one uses the resources of the science to help individuals.

When we explain a disease, we construct an exemplar and model it. But the causal structure that explains the exemplar resembles real world patients to varying degrees. So when we talk about individuals we explain their symptoms by identifying processes in the patient and showing how they resemble some part of the model. Godfrey-Smith [2006], following Giere, suggests that there may not be a helpful general treatment of these resemblance relations. They are not formal relations but the sort of comparisons between imaginary and real states of affairs that we all perform effortlessly. If there is a general theory, then, it is likely to be found not by philosophers but by cognitive scientists studying analogical thought (e.g. [Hummel and Holyoak, 2005]). And recall that I sided earlier with Whitbeck in arguing that instrumental concerns drive our search for explanations in biomedicine. The clinically significant relations between disease model and patient are likely to be highly context-specific; they will be determined in part by whether they offer opportunities for successful therapeutic interventions, which depend not just on how the world is arranged, but also on what our resources and opportunities are.

In displaying causal relations that give rise to exemplary features, the model presents opportunities for therapeutic action. The model defines a set of relations that differ from those present in a real patient along various dimensions. The degree to which a symptom is present, for example, might need to be specified precisely in a clinical setting, whereas in the exemplar the symptom can be defined as inhabiting some range of values, any one of which might apply in nature. Or we can supply a determinate story that embraces the details of the beliefs and other intentional states of the patient, instead of just citing the fact that a particular information-processing pathway is implicated in patients of that type.

Also, not every patient instantiates every feature of an exemplar, and so not every part of a model will apply to a given patient. Once we understand the resemblance relations that exist between parts of the model and the exemplar, we can try to manipulate the model so as to change or forestall selected outcomes in the real world. Which is, in the end, what gives the whole enterprise its point. To reach that end, though, we may need to adopt a very abstract research perspective: as often happens in science, we understand the complexity of the real world by looking at an imaginary version of it that we first learn to control.

4 CONCLUSIONS

I have distinguished minimal and strong interpretations of the medical model. A minimal interpretation thinks of diseases as collections of symptoms that occur together and unfold in characteristic ways, but it makes no commitments about the underlying causes of mental illness. A strong interpretation of the medical model, on the other hand, does make commitments about causes. The strong interpretation argues that mental illnesses are caused by distinctive pathophysiological processes in the brain. However, I have also argued that there is nothing in the strong interpretation that requires this destructive process to be understood at only one level of explanation. The sciences of the brain recognize many different levels of explanation, including the intentional. I further argued that this approach can underwrite a form of explanation that has a long tradition in psychiatry and is widely used in the life sciences, namely the construction of models of idealized processes that can then be compared to actual systems. This approach can use as many levels of explanation as are needed to produce an idealized representation of a disease process and then relate that ideal type to the specific causal pathways that occur in clinical subjects. This explanatory approach is entirely in keeping with the core insights of the strong medical model, which are that diseases are destructive processes realized in bodily systems that depart from the ideal type of the disease in specific ways. There is nothing in that idea of disease that implies a commitment to reductionism as opposed to a commitment to whatever explanatory resources are needed to construct disease models and specify the ways in which they resemble individuals subjects.

BIBLIOGRAPHY

[American Psychiatric Association, 2000] American Psychiatric Association. *Diagnostic and Statistical Manual of Mental Disorders*, 4^{th} edition, textual revision. Washington, D.C: American Psychiatric Association, 2000.

[Andreasen, 1997] N. C. Andreasen. Linking Mind and Brain in the Study of Mental Illnesses: A Project for a Scientific Psychopathology. *Science*, 275: 1586-93, 1997.

[Andreasen, 2001] N. C. Andreasen. *Brave New Brain*. New York: Oxford University Press, 2001.

[Ankeny, 2000] R. A. Ankeny. Fashioning Descriptive Models in Biology: Of Worms and Wiring Diagrams. *Philosophy of Science*, vol. 67, supplement: S260-S272, 2000.

[Ankeny, 2002] R. A. Ankeny. Reduction Reconceptualized: Cystic Fibrosis As A Paradigm Case For Molecular Medicine. In L.S. Parker and R.A.Ankeny (eds), *Mutating Concepts, Evolving Disciplines: Genetics, Medicine and Society*. Dordrecht: Kluwer: 127-141, 2002.

[Bechtel and Mundale, 1999] W. Bechtel and J. Mundale. Multiple Realizability Revisited: Linking Cognitive and Neural States. *Philosophy of Science*, 66: 175-207, 1999.

[Bentall, 2005] R. Bentall. *Madness Explained*. London: Penguin, 2005.

[Birnbaum, 1923] K. Birnbaum. The Making of a Psychosis. Tr. H. Marshall, in S. R. Hirsch & M Shepherd (eds). *Themes and Variations in European Psychiatry* Bristol, John Wright 1974: 197-238, 1923.

[Black, 2005] K. Black. Psychiatry and the Medical Model. In E. Rubin & C. Zorumski, (eds) *Adult Psychiatry*. 2^{nd} edition. Malden, MA: Blackwell: 3-15, 2005.

[Bolton and Hill, 2005] D. Bolton and J. Hill. *Mind, Meaning and Mental Disorder: the Nature of Causal Explanation in Psychiatry*. 2nd ed. New York: Oxford University Press, 2005.

[Boorse, 1976] C. Boorse. What A Theory of Mental Health Should Be. *Journal for the Theory of Social Behavior*, 6: 61-84, 1976.

[Carter, 2003] K. C. Carter. *The Rise of Causal Concepts of Disease*. Aldershot: Ashgate, 2003.

[Charcot, 1987] J.-M. Charcot. *Charcot, the Clinician: The Tuesday Lessons*. Tr C.G.Goetz. Philadelphia: Lippincott, Williams & Wilkins, 1987.

[Cooper, 2007] R. Cooper. *Psychiatry and the Philosophy of Science*. Stocksfield: Acumen, 2007.

[Dawes, 1994] R. Dawes. *House of Cards*. New York: Free Press, 1994.

[Engelhardt, 2004] H. T. Engelhardt. Mental Illness as a Myth: A Methodological Re-interpretation. In J.A. Schaler (ed) *Szasz Under Fire*. Peru, IL: Open Court 365-375, 2004.

[Giere, 1988] R. Giere. *Explaining Science: A Cognitive Approach*. Chicago: University of Chicago Press, 1988.

[Glymour, 1992] C. Glymour. Freud's Androids. In J. Neu (ed) *The Cambridge Companion to Freud*. Cambridge, Cambridge University Press: 44-85, 1992.

[Godfrey-Smith, 2006] P. Godfrey-Smith. The strategy of model-based science. *Biology and Philosophy*, 21: 725-740, 2006.

[Gillies, 2007] D. Gillies. Review of Carter (2003). *British Journal for the Philosophy of Science* 58: 365-377, 2007.

[Grunbaum, 1984] A. Grunbaum. *The Foundations of Psychoanalysis*. Berkeley: University of California Press, 1984.

[Guze, 1992] S. B. Guze. *Why Psychiatry Is a Branch of Medicine*. New York: Oxford University Press, 1992.

[Hummel and Holyoak, 2005] J. E. Hummel and K. J. Holyoak. Relational reasoning in a neurally-plausible cognitive architecture: An overview of the LISA project. *Current Directions in Cognitive Science*, 14, 153-157, 2005.

[Kandel, 2005] E. Kandel. *Psychiatry, Psychoanalysis and the New Biology of Mind*. Arlington, VA: American Psychiatric Publishing, 2005.

[Kendler and Prescott, 2006] K. S. Kendler and C. A. Prescott. *Genes, Environment, and Psychopathology: Understanding the Causes of Psychiatric and Substance Use Disorders*. New York: The Guilford Press, 2006.

[Kraepelin, 1899] E. Kraepelin. *Psychiatry: A Textbook for Students and Physicians*, vol. 2. trans by S. Ayed. Science History Publications, 1899/1990.

[Lewis and Levitt, 2002] D. A. Lewis and P. Levitt. Schizophrenia as a Disorder of Neurodevelopment. *Annual Review of Neuroscience*, 25: 409-432, 2002.

[Marr, 1982] D. Marr. *Vision*. San Francisco: W.H.Freeman, 1982.

[Meehl, 1977] P. E. Meehl. Specific Etiology and Other Forms of Strong Influence: Some Quantitative Meanings. *Journal of Medicine and Philosophy*, 2: 33-53, 1977.

[Mishkin et al., 1983] M. Mishkin, L. G. Ungerleider, and K. A. Macko. Object vision and spatial vision: Two cortical pathways. *Trends in Neurosciences*, 6, 414-417, 1983.

[Radden, 2000] J. Radden, ed. The *Nature of Melancholy from Aristotle to Kristeva*. New York: Oxford University Press, 2000.

[Richman, 2004] K. Richman. *Ethics and the Metaphysics of Medicine*. Cambridge, MA: MIT Press, 2004.

[Ross et al., 2008] D. Ross, C. Sharp, R. E. Vuchinich, and D. Spurrett. *Midbrain Mutiny: The Picoeconomics and Neuroeconomics of Disordered Gambling*: Cambridge, MA: MIT Press, 2008.

[Sadler, 2004] J. Z. Sadler. *Values in Psychiatric Diagnosis*. New York: Oxford University Press, 2004.

[Sass, 1992] L. Sass. *Madness and Modernism*. Cambridge, MA: Harvard University Press, 1992.

[Schaffner, 1993] K. F. Schaffner. *Discovery and Explanation in Biology and Medicine*. Chicago: University of Chicago Press, 1993.

[Schaffner, 1994] K. F. Schaffner. Reductionistic Approaches to Schizophrenia. In J. Sadler, O. Wiggins & M. Schwartz (eds) *Philosophical Perspectives on Psychiatric Diagnostic Classification*. Baltimore: Johns Hopkins University Press: 279-294, 1994.

[Schaffner, 1998] K. F. Schaffner. Genes, Behavior, and Developmental Emergentism: One Process, Indivisible? *Philosophy of Science* 65: 209-252, 1998.

[Schulkin, 2004] J. Schulkin. *Bodily Sensibility*. New York: Oxford University Press, 2004.

[Steiger *et al.*, 2001] H. Steiger, L. Gauvin, M. Israel, N. Koerner, Ng Ying Kin, J. Paris, and S. N. Young. Association of Serotonin and Cortisol Indices with Childhood Abuse in Bulimia Nervosa. *Archives of General Psychiatry,* 58: 837-843, 2001.
[Sterelny, 2003] K. Sterelny. *The Evolution of Agency and Other Essays.* Cambridge: Cambridge University Press, 2003.
[Thagard, 1999] P. Thagard. *How Scientists Explain Disease.* Princeton: Princeton University Press, 1999.
[Wachbroit, 1994] R. Wachbroit. Normality As A Biological Concept. *Philosophy of Science* 61. 579-591, 1994.
[Wakefield, 1992] J. Wakefield. Disorder As Harmful Dysfunction: A Conceptual Critique of DSM-III-R's Definition of Mental Disorder. *Psychological Review* 99: 232-47, 1992.
[Weisberg, 2007] M. Weisberg. Who is A Modeler? *British Journal for the Philosophy of Science.* 58; 207-233, 2007.
[Whitbeck, 1977] C. Whitbeck. Causation in Medicine: The Disease Entity Model. *Philosophy of Science* 44, 619-637, 1977.
[Woodward, 2003] J. F. Woodward. *Making Things Happen.* Oxford: Oxford University Press, 2003.
[Zawidski and Bechtel, 2004] T. Zawidski and B. Bechtel. Gall's Legacy Revisited. Decomposition and Localization in Cognitive Neuroscience. In C. E. Erneling and D. M. Johnson (eds.), *Mind as a Scientific Object: Between Brain and Culture.* Oxford, Oxford University Press, 2004.

BRAIN DEATH

John P. Lizza

HISTORICAL INTRODUCTION

The modern challenge to articulate a definition and neurological criteria for the determination of death was instigated by advances in medical technology and organ transplantation in the early 1950's and 1960's. In the 1950's the increased use of artificial respirators created clinical situations in which the patient's heart would beat spontaneously, but there was no discernible brain activity and respiration was mechanically sustained. To some, it seemed that these patients were more dead than alive. If so, the traditional criterion for determining death on the basis of cessation of circulation and respiration was inadequate.

In the medical field, the French physicians P. Mollaret and M. Goulon [1959] published a landmark paper in *Revue Neurologique* in which they described and suggested criteria for a condition they called "*le coma dépassé* (irreversible or irretrievable coma)" — a condition now commonly called "brain death." It was characterized by "immobility of the eyeballs in a neutral position, mydriasis, absent light reflex, absent blinking with stimuli, absence of swallowing reflexes, 'dropping of the jaw,' absence of motor responses to any stimuli, muscle hypotonia, tendon areflexia, equivocal plantar reflexes, 'retention of idiomuscular contraction with muscle edema,' absence of 'medullary automatism' and sphincter incontinence, absence of spontaneous respiration after discontinuation of ventilation, immediate cardiovascular collapse as soon as the noradrenaline infusion is stopped, and disturbance of thermoregulation-hypothermia or hyperthermia - depending on the environmental temperature" [Wijdicks, 2001a, p. 3].

In the 1960's, advances in organ transplantation techniques and some unusual legal cases provided additional impetus to rethinking the definition and criteria for determining death. Since organ transplantation requires well-preserved organs and is facilitated by removing organs from the donor as soon as possible, there was interest in declaring death at the earliest possible moment. However, as is still the case today, the law required that donors must be dead before vital organs could be removed for transplantation. Adopting a neurological or brain-based criterion for determining death would thus enable death to be declared earlier in some clinical situations.

The unusual legal cases included one in New York in which a woman was assaulted, became comatose, and required the support of a respirator. When a physician later removed her from the respirator, the person accused of the assault

Handbook of the Philosophy of Science. Volume 16: Philosophy of Medicine.
Volume editor: Fred Gifford. General editors: Dov M. Gabbay, Paul Thagard and John Woods.

argued that the doctor's action, not the assault, caused the woman's death. The physician, on the other hand, argued that the woman was already dead when he shut down the respirator [Beauchamp and Perlin, 1978, p. 3]. A second case in Virginia involved a laborer, Bruce Tucker, who fell and suffered a massive head injury. The patient was clinically saved by electrical shock to the heart, but had a flat electroencephalograph "with occasional artifact." An organ transplantation team removed Tucker's heart and argued that Tucker had died, even though Virginia law at the time defined death as the cessation of all bodily functions. In a suit brought by Tucker's family challenging the surgeon's action, the Virginia court found in favor of the surgeon. This was interpreted as the court's endorsement of a neurological criterion for determining death [Veatch, 1972].

However, it was not until 1967-68, under the leadership of Henry Beecher, that the Ad Hoc Committee of the Harvard Medical School to Examine the Definition of Brain Death [1968] formally proposed "irreversible coma" (a permanently non-functioning brain) as a new criterion for determining death. This committee was extremely influential in promoting adoption of a neurological criterion for death. In 1970 Kansas became the first state to legally adopt the recommendation of the Harvard Committee. Many other states, however, did not adopt the new criterion, and thus there was a problem that someone could be legally dead in Kansas but alive, for example, in the neighboring state of Missouri.

To address this problem, the 1981 President's Commission for the Study of Ethical Problems in Medicine and Biomedical and Behavioral Research was charged with proposing a uniform statutory definition of death that could be adopted by all states in the union. The result of the Commission's efforts was the Uniform Determination of Death Act, which holds, "An individual who has sustained either (1) irreversible cessation of circulatory and respiratory functions, or (2) irreversible cessation of all functions of the entire brain, including the brainstem, is dead" [President's Commission, 1981, p. 2]. By 1994 every U. S. state and the District of Columbia had either judicially or legislatively adopted the provisions of the act.[1] New Jersey is exceptional in having subsequently enacted a "conscience clause" that allows individuals who do not accept any neurological criterion for determining death to have only the traditional criterion of cessation of circulation and respiration apply.[2] Some Orthodox Jews and American Indians, for exam-

[1] For the specific state statutes, regulations, and case law that have recognized the criteria for determining death in the Uniform Determination of Death Act, see Charles M. Kester [1994, pp. 44-46 footnotes).

[2] Section 26:6A-5 of the New Jersey Declaration of Death Act reads:

> Death not declared in violation of individual's religious beliefs. The death of an individual shall not be declared upon the basis of neurological criteria pursuant to sections 3 and 4 of this act when the licensed physician authorized to declare death, has reason to believe, on the basis of information in the individual's available medical records, or information provided by a member of the individual's family or any other person knowledgeable about the individual's personal religious beliefs that such a declaration would violate the personal religious beliefs of the individual. In these cases, death shall be declared, and the time of death fixed, solely upon the basis of cardio-respiratory criteria pursuant to section 2 of this act, L.1991, c90, s5.

ple, reject the neurological criterion on religious grounds. New York allows some discretion, but is less explicit about exceptions to the declaration of death on the basis of neurological criteria. It allows but does not require physicians to accommodate family views on the definition of death [Veatch, 1999, p. 139]. Such legal provisions may provide some early acknowledgment that the definition of death goes beyond strictly biological or medical considerations.

Acceptance of death based on the irreversible loss of all functions of the brain, including the brainstem, has been widely accepted in law and medicine around the world. However, there are some exceptions. Japan, for example, accepts the use of the neurological criterion, but only in cases involving organ transplantation and acceptance by the patient and family [Lock, 2002, p. 181]. In the United Kingdom, the irreversible loss of brainstem function is the accepted criterion for determining death. Since the brainstem includes the ascending reticular activating system, the functioning of which is required for consciousness, the irreversible loss of all brainstem function entails the irreversible loss of consciousness, as well as that of unassisted respiration and circulation [Pallis, 1983; 1999]. The neurological criterion has also been generally accepted by most major religions, including Judaism, Islam, and Christianity. However, there is certainly robust debate among members of these religions about its acceptability. Also, as will be the focus of this article, there continues to be a good deal of philosophical debate about the neurological criterion for determining death. Why should we accept "brain death" as death?

THE BRAIN AND ITS FUNCTIONS

Before examining the justification for and challenges to accepting "brain death" as death, it may be helpful to briefly review some of the basic structure and functions of various parts of the brain and some of the confusion of terminology surrounding the term "brain death."

The brain has three major divisions: (1) the cerebrum and its outer shell called the cortex, (2) the cerebellum, and (3) the brainstem, consisting of the midbrain, the pons, and the medulla oblongata. The cerebrum is sometimes referred to as the "higher brain," because it primarily controls consciousness, thought, memory, and feeling. The brainstem is also sometimes called the "lower brain," because it controls spontaneous, vegetative functions like swallowing, yawning, and sleep-wake cycles. However, these terms are somewhat inaccurate, as "higher brain" functions require interaction between the cerebrum and the ascending reticular activating system in the brainstem. Also, there is evidence [Shewmon et al., 1999] that some infants born with congenital apallia (intact brainstems but no cerebral matter) may demonstrate rudimentary conscious awareness. The cerebellum is responsible for the regulation and coordination of complex voluntary muscular

(http://www.braindeath.org/law/newjersey/htm). See also Orlick [1991]. For an interesting commentary on this conscience clause, see Veatch [1999].

movement.

Respiration is normally controlled in the brainstem by neurons in the medulla
stimulating the diaphragm and intercostal muscles which cause the lungs to fill
with air. The medulla also normally regulates the rate of breathing to maintain
the appropriate levels of oxygen and carbon dioxide. When the respiratory center
in the medulla is destroyed, respiration will cease unless it is maintained artificially
by a respirator or "ventilator." The artificial respirator serves to compensate for
the inability of the thoracic muscles to fill the lungs with air due to the lack of
neural input from the brainstem [President's Commission, 1981, p. 15].

In contrast to the respiratory system, which depends on neural inputs from the
brainstem, the heart can pump blood without external control. Normally, the
brain modulates the rate and force of the heartbeat, but this neural input is not
necessary for the heart to contract adequately to circulate the blood. When an
individual is dependent on a respirator, the heart can continue to beat, even if the
individual has lost all brain functions [President's Commission, 1981, p. 16].

When there is severe injury to the brain and an individual has irreversibly lost
all brain functions, including those of the brainstem, consciousness, sensation, and
affect are no longer possible. In addition, the brainstem mediated reflex to breathe
is also absent. Without an artificial respirator, respiration immediately ceases.[3]
However, when there is less severe injury to the brain, involving major damage to or
destruction of the cerebrum but leaving the brainstem intact, an individual may be
in what is called a "persistent vegetative state." These individuals do not require
an artificial respirator for support, as the respiratory centers in their brainstem
still function. They may also exhibit spontaneous, involuntary movements, such
as yawning, grimacing, and eye opening. However, these individuals exhibit no
conscious awareness of self or the environment.

The widely publicized cases of Karen Ann Quinlan, Nancy Cruzan, and Terri
Schiavo have brought the condition of persistent vegetative state to public aware-
ness. Recent research has also focused on the persistent vegetative state, partic-
ularly on how to distinguish it from what is called a "minimally conscious state"
and whether conscious recovery from the persistent vegetative state is possible.
Some of the main epistemological, metaphysical, and ethical issues concerning the
persistent vegetative state will be addressed in a separate section at the end of
this work. At this point, it is important to note that the persistent vegetative
state is physiologically different from the state of an individual that satisfies the
current "whole-brain" criterion for death. Most significantly, although individuals
in persistent vegetative state require artificial feeding and hydration, they have
intact brainstems, which allow them to breathe on their own. No jurisdiction in
the world currently recognizes individuals in persistent vegetative state as legally

[3]A clinical diagnosis of brain death can be made when the following four conditions are met:
(1) complete, unresponsive coma; (2) a known history of injury that rules out the possibility
of transient causes, such as drug intoxication and hypothermia; (3) absent brainstem reflexes;
and (4) apnea (inability to spontaneously breathe). For a more complete account of the tests
used for these conditions, see, for example, American Academy of Neurology, Quality Standards
Committee [1995], and Wijdicks [2001b].

dead.

Although the neurological criterion for determining death has been widely accepted and governs the normal day-to-day medical practice in declaring death, there has been a good deal of confusion among ordinary people, as well as health professionals, over the use of the term "brain death." It is not uncommon to read newspaper accounts of how someone who satisfies the clinical criteria for "brain death" is being kept "alive." Similar references can also be found in medical writings. Surveys of lay people, as well as health professionals, have continued to reveal confusion over the definition and criteria for death [Arnold *et al.*, 1968; Delmonico and Randolph, 1973; Black and Zervas, 1984; Youngner *et al.*, 1985, 1989; Savaria *et al.*, 1990; Deneffel *et al.*, 1992; Youngner, 1992; Pearson *et al.*, 1995; Joffe and Anton, 2006; Joffe *et al.*, 2007;]. Some of those surveyed considered individuals in persistent vegetative state as satisfying the concept of "brain death," even though individuals in persistent vegetative state retain brainstem functions and thus do not satisfy the legal neurological criterion for determining death. Others in the surveys distinguished the "brain-dead" from those who are really or truly "dead."

Much of this confusion may be attributable to the use of the term "brain death," since it may suggest that there are two kinds of death: brain death and ordinary death. If we take the President's Commission's report as the "received view" in law, death is defined as the "permanent cessation of the integrated functioning of the organism as a whole [President's Commission, 1981, p. 55]." The term "brain death" is then best interpreted as referring to one of two criteria or standards for determining when death occurs. Thus, in addition to the traditional criterion for determining death, i.e., the irreversible cessation of circulatory and respiratory functions, the Commission proposed that "the irreversible cessation of all functions of the brain, including the brain stem" could serve as another criterion for determining when death occurs. This criterion can be used when the single biological phenomenon of death may be masked by the presence of a respirator. On the received view, it is therefore contradictory to say that a person is "brain dead" and yet still alive. Since "brain death" refers to a diagnostic state that serves as a legal criterion for death, the "brain dead" are legally dead. Recently, the President's Council for Bioethics [2008, p. 19] has recommended the use of the term "total and irreversible brain failure," instead of "brain death," to avoid the suggestion that there are two kinds of death.

However, as will be discussed in more detail below, it may be that some of the confusion of terminology in the public and in the minds of some health professionals may be symptomatic of deeper problems with the current neurological criterion for death. Some more sophisticated critics, who reject "brain death" as death and accept only the traditional circulatory and respiratory criterion, argue that individuals who satisfy the whole-brain neurological criterion of death but receive artificial support are still alive [Jonas, 1974; Becker, 1975; Byrne *et al.*, (1982/83) 2000; Quay, 1993; Seifert, 1993; Shewmon, 1997, 1998a, 1998b, 2004a; Taylor, 1997; Potts *et al.*, 2000;]. These critics hold that such patients have not ceased

to function as integrated organisms as a whole, albeit through artificial support and, therefore, are not dead. Other critics of the current whole-brain neurological criterion maintain that all brain functions do not need to cease in order for someone to be dead [Veatch, 1975, 1988, 1993; Engelhardt, 1978; Green and Wikler, 1980; Gervais, 1986; Zaner, 1988; Lizza, 1993, 2006; Wallace, 1995; McMahan, 1995, 2002]. They believe that the irreversible loss of just those brain functions required for conscious experience is sufficient for the death of a person. In their view, "death" should therefore be extended to individuals in a persistent vegetative state, if such individuals have no potential for conscious experience. These critics believe that such a potential is essential to the life of a living human being or person.

JUSTIFICATION FOR ACCEPTING "BRAIN DEATH" AS DEATH

When the 1968 Ad Hoc Committee of the Harvard Medical School formally introduced a neurological criterion for determining death, the Committee proposed "irreversible coma" as a new criterion for death and suggested clinical tests for its determination [Gervais, 1986, pp. 8-10]. The Committee's report, however, says little, if anything, about the *definition* of death for which the criterion was proposed. Also, the Harvard Committee shifted back and forth between endorsing the loss of consciousness, as opposed to the loss of bodily integration, as the conceptual foundation for the whole–brain diagnostic criterion that the Committee eventually proposed [Pernick, 1999, p. 12]. Indeed, the Committee's characterization of the criterion as "irreversible coma" reflected this ambiguity, as the term had been used by some in the past to describe the condition of individuals in deep coma or persistent vegetative state [Joynt, 1984].

It is also worth noting that, although the 1981 President's Commission stated that "the *basic concept* of death is fundamentally a philosophical matter," it cautioned that such "broader formulations would lead down arcane philosophical paths which are at best somewhat removed from practical application in the formulation of law" [President's Commission, 1981, p. 56). Although that Commission [1981, p. 55] considered two alternative definitions of death, i.e., "departure of the animating or vital principle" and "irreversible loss of personhood," it ultimately endorsed "the permanent cessation of the integrated functioning of the organism as a whole" as the definition of death. The Commission wrote:

> On this view, death is that moment at which the body's physiological system ceases to constitute an integrated whole. Even if life continues in individual cells or organs, life of the organism as a whole requires complex integration and without the latter, a person cannot properly be regarded as alive. [President's Commission, 1981, p. 33]

In addition, the President's Commission [1981, p. 41] claimed that its acceptance of the "whole-brain" neurological criterion of death did not introduce a new concept of death, but merely provided another means for determining when death,

as traditionally understood, occurs. The rationale offered by the Commission was that it viewed death, in the traditional sense, to mean the loss of integration of the organism as a whole. Just as the irreversible loss of heart and lung functions marks the loss of integration of the organism as a whole, so too, the Commission argued, the loss of all brain functions marks the loss of organic integration. Death occurs when functions essential to the maintenance of the organism as an organism, as opposed to a collection of organic parts, permanently cease. Thus, the brain is understood as the essential control center for the integration of the organism as a whole. Indeed, some supporters of the whole-brain criterion maintain that the irreversible loss of circulation and respiration is an acceptable criterion for determining death, because it entails the irreversible loss of the critical functions of the brain [Bernat *et al.*, 1982; Bernat, 2002].

The Commission used this definition of death to respond to two problematic classes of individuals that challenged the criteria. The first class, which at the time of the Commission's report was more hypothetical than real, consists of artificially sustained human beings with no brain functions, e.g., artificially sustained, pregnant women who have lost all brain functions but are maintained on "life-support" to allow the fetus to gestate long enough so that it can be removed by Caesarian section [Field *et al.*, 1988; Bernstein *et al.*, 1989; Anstötz, 1993]. This class would also include the extraordinary case reported by D. Alan Shewmon [1998a] in which a male with no brain functions was sustained for over 20 years. Critics of the neurological criterion for death [Jonas, 1974; Becker, 1975; Byrne *et al.*, (1982/83) 2000; Veatch, 1982, 1992; Gervais, 1986; Halevy and Brody, 1993; Seifert, 1993; Wikler, 1995; Shewmon, 1997, 1998a, 1998b, 2004a; Taylor, 1997; Truog, 1997; Brody, 1999] argue that such individuals are still alive, as they retain organic integration and have not lost syntropy. To rule out this class of counterexamples to the proposed criteria, the Commission relied on the strictly biological concept of death as the loss of the integration of the organism as a whole. The Commission argued that such individuals are collections of organic parts, rather than integrated organisms. In defense of the "whole-brain" neurological criterion for death, James Bernat [2002] makes essentially the same argument today.

The second problematic class consists of anencephalics and individuals in permanent vegetative state. Proponents of a consciousness-related definition of death [Veatch, 1975, 1988, 1993; Engelhardt, 1978; Green and Wikler, 1980; Gervais, 1986; Lizza, 1993, 2006; Machado, 1995; McMahan, 1995, 2002) argue that persons or human beings who have sustained an irreversible loss of consciousness and every other mental function are dead. A breathing human body is not itself a person or human being. Lacking the potential or capacity for consciousness and every other mental function, anencephalics and individuals in permanent vegetative state are merely breathing bodies. The person that the anencephalic might have been never lived, and the person who has irreversibly lost consciousness and every other mental function has died. To rule out these individuals as counterexamples to the whole-brain criterion, the Commission relied on the idea that anencephalics and individuals in permanent vegetative state are still integrated

organisms, since brainstem functions in these individuals regulate circulation and respiration to maintain the organism as a whole. In doing so, the Commission rejected consciousness-related or "higher brain" formulations of death, such as the irreversible loss of consciousness, personhood or personal identity.

Proponents of the received view also appeal to the idea that death should mean the same thing for all organisms. Death is thus understood to be the same for a relative, pet dog, other animals, and plants. For example, Gert, Culver, and Clouser [Gert *et al.*, 2006] argue that such a trans-species understanding of death is part of the common, ordinary understanding of death, and that any definition of death must capture this ordinary meaning. They reject defining death as the permanent loss of consciousness, because in their view such a definition:

> actually states what it means to cease to be a person rather than what it means for that person to die. 'Person' is not a biological concept but rather a concept defined in terms of certain kinds of abilities and qualities of awareness but also in terms of the attitudes it is appropriate to take toward it. Because death is a biological concept, 'death,' in a literal sense, applies directly only to biological organisms and not to persons. Of course, it is perfectly ordinary to talk about the 'death of a person,' but this phrase in common usage actually means the death of the organism that was the person. [Gert *et al.*, 2006, p. 295]

For a time, proponents of this received view thought that "the permanent cessation of the organism as a whole" sufficed as a biological definition of death for all organisms. Thus, when a plant, dog, or human being dies, it loses its organic integration and no longer functions as a whole. However, because of experiments in which the heads of monkeys were kept alive after they were severed from their bodies, some proponents of the received view [Gert *et al.*, 2006] now believe that it is necessary to include the irreversible loss of consciousness in the definition of death. In their view, considering the monkeys to be dead when they can respond to sights and sounds would alter the ordinary meaning of death more than claiming that the monkeys are alive [Gert *et al.*, 2006, pp. 292-294]. Thus, they now propose that death be defined as "the permanent cessation of all observable natural functioning of the organism as a whole, and the permanent absence of consciousness in the organism as a whole, and in any part of the organism" [Gert *et al.*, 2006, p. 290]. The amendment is needed to accommodate the fact that the monkeys were alive, even though they had ceased to function as organic wholes. As Gert explains, it is necessary to include the clauses about the absence of consciousness in the definition of death, because "the importance of consciousness to a conscious organism has no counterpart in nonconscious animals or plants" [Gert, 1995, p. 28]. Gert, Culver, and Clouser propose that this amended definition captures what death means for any organism, since organisms that are never naturally conscious can satisfy the definition, as well as those that are.

In this amended definition of death, (1) permanent cessation of all observable natural functioning of the organism as a whole and (2) irreversible loss or absence

of consciousness are jointly necessary and sufficient for death. However, neither is individually sufficient for death. Thus, these authors continue to reject the consciousness related or "higher-brain" formulation of death, because, as Gert [1995, p. 28] explains, "Taking permanent loss of consciousness as sufficient for the death of a human being makes the death of a human being something completely distinct from the death of lower organisms." In addition, Gert [1995, p. 29] thinks that such a definition "does not state what we ordinarily mean when we speak of death." In support of this claim, he states, "We ordinarily regard permanently comatose patients in persistent vegetative states who are sufficiently brain damaged that they have irreversibly lost consciousness as still alive."

Besides adding the clauses about consciousness, this amended definition also explicitly makes reference to "natural" functioning. Thus, presumably, if the functioning of the organism as a whole is maintained artificially (especially if such maintenance involves multiple organ systems) and the organism is no longer or was never conscious, then the organism would by definition be dead. However, this implication may be strongly counterintuitive to the ordinary understanding of death. It is not difficult to imagine artificially sustaining lower-order organisms that are never naturally conscious but that could continue to function in many integrated ways. Isn't artificial support what is done to keep organisms alive? However, by the amended trans-species definition of death, these organisms would have to be considered dead, since their "natural" functioning has ceased.

Recently, the President's Council on Bioethics [2008] revisited the issue of whether individuals who satisfy the currently accepted neurological criterion for death, what the Council now calls "total brain failure," are really dead. A large part of the Council's White Paper, *Controversies in the Determination of Death* [2008], is devoted to addressing the challenges raised by cases in which individuals with total brain failure have been artificially sustained for weeks, months, and, in the one case reported by Shewmon, over twenty years. In contrast to the 1981 President's Commission, the President's Council accepts the fact that these individuals retain internal organic integration and cannot be understood simply as collections of organic parts. The Council avers that the brain is not the integrator of the body's many varied functions and that no single structure in the body plays the role of an indispensable integrator [President's Council, 2008, p. 40]. Nonetheless, the Council maintains that individuals who sustain total brain failure are dead.

In support of its view, the Council holds that the 1981 Commission was correct in relying on the intuition that to be a living organism, any animal must be a *whole*. However, the Council rejects the 1981 Commission's focus on the loss of somatic integration as the critical sign that the organism is no longer a whole. Instead, the Council proposes a novel, alternative account of wholeness that supports the view that after total brain failure, the body is no longer an organismic whole and hence no longer alive. According to the Council,

> All organisms have a *needy* mode of being. Unlike inanimate objects, which continue to exist through inertia and without effort, every organ-

ism persists only thanks to its own exertions. To preserve themselves, organisms *must* — and *can* and *do* — engage in commerce with the surrounding world. Their constant need for oxygenated air and nutrients is matched by their ability to satisfy that need, by engaging in certain activities, reaching out into the surrounding environment to secure the required sustenance. This is the definitive work of the organism *as an organism*. It is what an organism "does" and what distinguishes every organism from non-living things. And it is what distinguishes a *living* organism from non-living things. And it is what distinguishes a *living* organism from the dead body that it becomes when it dies.

The work of the organism, expressed in its commerce with the surrounding world, depends on three fundamental capacities:

1. Openness to the world, that is, receptivity to stimuli and signals from the surrounding environment.

2. The ability to act upon the world to obtain selectively what it needs.

3. The basic felt need that drives the organism to act as it must, to obtain what it needs and what its openness reveals to be available.

Appreciating these capacities as mutually supporting aspects of the organism's vital work will help us understand why an individual with total brain failure should be declared dead, even when ventilator-supported "breathing" masks the presence of death. [President's Council, 2008, pp. 60-61]

The Council goes on to distinguish the spontaneous drive to breathe from the technologically supported, *"passive condition of being ventilated* (i.e., of having one's 'breathing' replaced by a mechanical ventilator) [President's Council, 2008, pp. 62-63]." The Council holds that the former is a vital sign of the activity of the organism as a whole, as it is "an indispensable action of the higher animals" and a manifestation of the organism's "inner experience of need [President's Council, 2008, p. 62]." In contrast, the latter does not signify an activity of the organism as a whole, because it is "not driven by felt need" and "the exchange of gases that it effects is neither an achievement of the organism nor a sign of its genuine vitality [President's Council, 2008, p. 63]."

While spontaneous breathing is thus a sufficient sign of continued life, the Council cautions that the loss of spontaneous breathing is not sufficient for an animal to be considered dead, as other capacities indicative of commerce with the surrounding world might be present. For example, patients with spinal cord injury may be unable to breathe without a ventilator, yet they may be fully conscious. It is only when both consciousness and spontaneous breathing are irreversibly lost, as in the case of total brain failure, that a human being can be considered dead. The

Council thus concludes, "total brain failure can continue to serve as a criterion for death — not because it necessarily indicates a complete loss of integrated somatic functioning, but because it is a sign that this organism can no longer engage in the essential work that defines living things [President's Council, 2008, pp. 63-64]."

Whether this alternative rationale for the neurological criterion for determining death will hold up under critical scrutiny remains to be seen. Critics of the neurological criterion may argue that whether respiration is spontaneous or artificially assisted is trivial, since the artificial support should be seen as a change in the environmental conditions — what we do to keep organisms alive and allow them to continue to function in an integrated way. These critics may also argue that the organic integration that remains in an artificially sustained human being with total brain failure, including the processing of nutrients, elimination of waste, maintenance of body temperature, wound healing, and cardiovascular and hormonal responses to unanethesized incision, are signs of the organism's commerce with the surrounding world and, thus, of life.

CHALLENGES TO ACCEPTING "BRAIN DEATH" AS DEATH

As noted above, the challenges to accepting "brain death," i.e., the irreversible loss of all brain function, as a criterion for death have come from two sides: (1) those who reject any neurological criterion of death and argue for a return to the traditional criterion of the irreversible cessation of circulatory and respiratory functions and (2) those who support a consciousness-related neurological criterion for determining death and argue for expanding the neurological criterion to include individuals in permanent vegetative state, who have no potential for regaining consciousness.

Soon after the President's Commission proposed its uniform statutory definition of death, it was criticized as conceptually incoherent. Stuart Youngner and Edward Bartlett [1983] showed that the rationale behind the biological *definition* of death as the loss of integration of the organism as a whole does not support the whole-brain *criterion* of death that the President's Commission and others endorse. Instead, it only supports adoption of a more limited brainstem criterion, since it is the brainstem, not neocortical structures, that is purportedly responsible for integrating the organism in a life-sustaining way. In addition, because "the permanent cessation of the functioning of the organism as a whole" is supposed to capture the idea that any organism dies when it loses its internal, organic integration, it is unclear why it is necessary that higher-brain functions must cease, since those functions are not essential to the integration of the organism as a whole. Higher-brain functions would appear to be as necessary to the functioning of the organism as a whole as, say, fingernail growth. Indeed, it is precisely because the proponents of the above definition do not regard higher-brain functions as necessary for the integration of the organism as a whole, that they do not regard individuals in permanent vegetative state as dead.

The problem with the definition, however, as Youngner and Bartlett pointed

out, is that it has the absurd implication that certain kinds of patients, whom we think are alive, would be "dead." Consider, for example, patients with locked-in syndrome, who have a fairly specific and limited lesion in the ventral pons, causing disconnection of the upper motor neurons in the brain from lower motor neurons in the spinal cord. A locked-in patient is completely paralyzed below the neck, but retains the ability to blink eyes and thereby communicate in a limited way. The parts of the brain responsible for consciousness and cognition, however, remain intact. Since the brainstem is no longer playing a role in the integration of circulation and respiration, acceptance of spontaneous or natural brainstem functions as necessary for organic integration would entail that this patient has irreversibly lost organic integration and therefore is dead. However, this implication appears patently false, since the individual can continue to communicate albeit requiring artificial support.

A second major challenge to the whole-brain criterion of death has come from those who argue that the human organism as a whole may remain alive despite the loss of all brain function. Cases of post mortem pregnancy [Powner and Berstein, 2003] and the extraordinary case reported by D. Alan Shewmon [1998a] in which a male with no brain function was sustained for over twenty years challenge the claim that brain function is necessary for organic integration. Also, the view that individuals who have lost all brain function but receive artificial life support are not integrated organisms but merely collections of organic parts has been critiqued by many scholars, including Becker [1975], Byrne et al. [(1982/83) 2000], Veatch [1982; 1992], Gervais [1986], Halevy and Brody [1993], Seifert [1993], Wikler [1995], Shewmon [1997; 1998b; 2004a], Taylor [1997], Truog [1997], and Brody [1999]. These critics point to a range of functions indicative of organic integration in artificially sustained whole-brain-dead individuals: homeostasis of fluid balance and electrolytes without frequent monitoring or adjustments based on monitoring, temperature maintenance, proportional growth, wound healing, some autonomic control of blood pressure, coordinated responses to stress, and recovery from various medical crises, including congestive heart failure, hypotensive shock, and pneumonia [Shewmon, 2007]. In sum, these critics argue that individuals who have lost all brain function but continue to function in such biologically integrated ways for such lengthy timeframes are integrated organisms of some sort and cannot be classified as corpses or dead organisms. These critics of the current whole-brain neurological criterion of death agree that the loss of all brain function does not entail the loss of integration of the organism as a whole. Accordingly, they advocate a return to the traditional criterion for determining death, i.e., the permanent cessation of circulatory and respiratory functions. However, some of these critics, e.g., Shewmon [1997], Seifert [1993], and Jones [2000] also hold the religious belief that the continuation of organic integration is evidence that an immaterial soul is still present in the body. They therefore reject brain death as death, because it is inconsistent with their understanding of death as the separation of the soul from the body. Shewmon, for example, holds that the artificially sustained whole-brain dead retain the potential for consciousness, intellect, and will, since he believes

that such potential is not dependent on a functioning brain. According to Shewmon [1997, p. 74], "the potency for these specifically human functions resides - ultimately - in the organism and not the organ." Jones [2000] supports this view by appeal to the Thomistic view that the soul is the principle of life and form of the body. If the body survives as a whole, then the soul is still present in the body.

However, other religiously minded people who believe in the existence of the soul reject this view. William Wallace [1995], for example, maintains that just as Aquinas allowed for delayed hominization, the infusion of the soul into the body at some point during gestation of the fetus, Aquinas's view allows for delayed dehominization in which the rational soul may depart from the body before that body loses all somatic life. Wallace thinks that permanent vegetative state and whole-brain death can be construed on Thomistic grounds as cases of delayed dehominization in which the rational soul has departed from the human body before vegetative functions have ceased. He thus argues for a consciousness related formulation of death.

If an organism is alive in cases such as "post mortem" pregnancy, as critics of the neurological criterion maintain, the question arises: What is alive? It does not automatically follow that the person is alive, as claimed by those who wish to maintain that death is the loss of organic integration but reject the neurological criterion for death. Advocates of a consciousness-related formulation of death do not consider such a being to be a living person. In their view, a person cannot persist through the loss of all brain function or even the loss of just those brain functions required for consciousness and other mental functions. Thus, if an advocate of the consciousness-related formulation of death wishes to maintain that the person dies even though some being is alive in these cases, what remains alive must be a different sort of being. It must either be a human being, as distinct from a person, or a being of another sort, e.g., a "humanoid" or "biological artifact." "Humanoid" or "biological artifact" is taken to refer to a living being that has human characteristics but falls short of being human, a form of life created by medical technology. Whereas a person is normally transformed into a corpse at his or her death, technology has intervened in this natural process and has made it possible for a person to die in new ways. Instead of a person's death being followed by remains in the form of an inanimate corpse, it may now be possible for a person's remains to take the form of an artificially sustained, living organism devoid of the capacity for consciousness and any other mental function.

This distinction between the person and the human organism and the idea that a person may die even though the biological organism that in part constituted it may remain alive may cause some consternation. Aren't persons organisms? How can a person's death be different from that of a human organism? These cases thus raise the issue of whether the death of the person must necessarily coincide with the death of the human organism. As in Locke's [(1694) 1975, Bk. II, Ch. 17, Para 15] hypothetical case of the prince and cobbler switching bodies, in which the life-history of the person could diverge from the life-history of the human organism, some people regard these clinical situations as actual cases in

which the life-histories of the person and human organism diverge. These cases also raise the issue of what it is that literally dies. Do persons, understood as in some sense distinct from human organisms, "die"? Or, as Gert, Culver, Clouser, and Bernat maintain, is death something that can only be literally predicated to organisms or to persons understood as identical to human organisms? Critical methodological questions are also raised: Is death a strictly biological concept and, therefore, within the province of biologists to define? Or is defining death a philosophical matter involving consideration of the nature of persons?

PERSONS AND DEATH

In the history of philosophy and religion, there are a variety of views concerning the relation of the person to the human organism. Three of these views have figured more prominently in the debate over the definition of death. The first has been mainly used to support rejection of any neurological criterion for death and a return to the traditional circulatory and respiratory criterion.[4] Two other views have been invoked to justify acceptance of a consciousness-related formulation of death.

Persons as Human Organisms

Simplifying somewhat, the first view identifies the person with the human organism. To be a person is to be a physical specimen of the human species.[5] In philosophical circles, this view is referred to as "animalism," and is associated with the work of Fred Feldman [1992], Eric Olson [1997], and P. F. Snowdon [1990]. David DeGrazia [2005] relies on the animalist view in his criticism of the current whole-brain neurological criterion of death. Accepting the claims of Shewmon and others that an artificially sustained whole-brain-dead human organism may persist as an integrated whole, DeGrazia argues that the person is still alive. He therefore rejects "brain death" as death and accepts only the irreversible loss of circulation and respiration as a criterion for death. Other critics who reject any neurological criterion for death, such as Hans Jonas [1974], also appear to accept this "species meaning" of person.

The animalist view of the person, however, is also accepted by some proponents of the current whole-brain criterion of death. Alexander Capron [1987], for ex-

[4]Some supporters of the current whole-brain neurological criterion, such as Alexander Capron [1987], have invoked the first view, which identifies the person with the human organism, to support acceptance of that criterion.

[5]While most proponents of this view hold that the organism must be alive, at least one proponent, Fred Feldman [1992], holds that the specimen need not be alive. Just as dead butterflies that are carefully preserved and mounted for display are still members of their respective biological species, Feldman argues that the embalmed Aunt Ethel is still a member of her biological species. The person, Aunt Ethel, is literally the corpse at the wake and the body that is interred. Feldman admits that it is not a very satisfying way in which people continue to exist after their death.

ample, writes that "the accepted criterion for being a person is live birth of the product of human conception." He thus draws no distinction between persons and human organisms. Moreover, since he accepts the current whole-brain neurological criterion for determining death, he must consider the cases of artificially sustained whole-brain-dead bodies as the remains of persons or human beings, rather than actual persons or human beings as DeGrazia does. Accordingly, Capron agrees with the "received view" that an artificially sustained whole-brain-dead human body is not an integrated organism but an artificially sustained collection of organic parts.

A significant objection to the conceptual coherence of the animalist position has been raised by Jeff McMahan. McMahan [2002, p. 429] asks us to consider the possibility of transplanting the brain of someone into anther body, where it would continue to function. Suppose that the original organism (now brainless) were also artificially sustained, and that one accepted the claim, as DeGrazia does, that that organism was still alive. The animalist would thus be committed to holding that the person goes with the brainless organism, rather than with the functioning brain. McMahan finds this implication unacceptable, as he thinks that the person would go with their functioning brain. Moreover, suppose that the original organism eventually died in the traditional sense of losing circulation and respiration. In DeGrazia's view, the person would then have died. But, again, McMahan finds this implication counterintuitive, given the functioning brain in its new body. In McMahan's view, we are essentially functioning brains or embodied minds.

Capron's view may also be subject to this criticism. Since he accepts the whole-brain criterion of death, the loss of all brain function is the death of the person or human organism. However, the removal and transplantation of the brain from a human organism, as in McMahan's hypothetical case, would be one way in which a human organism could lose all brain function and therefore lose its organic integration. However, Capron would then be committed to holding that the person had died, despite the fact that the person's brain would continue to function in another body. Again, McMahan finds this counterintuitive. In his view, the person has survived.

While McMahan's case is hypothetical, there have been actual experiments involving the decapitation of animals in which the severed heads of these animals were artificially sustained and responded to various stimuli. As noted earlier, consideration of these cases has led some of the main proponents of the whole-brain criterion to amend the definition of death to include "the permanent absence of consciousness in the organism as a whole, and in any part of the organism" [Gert et al., 2006, p. 290]. Gert, Culver, and Clouser think that, because consciousness persists in these animals, death has not occurred. This modification to the definition of death suggests that the death of a human organism and other organisms capable of consciousness involves more than the loss of organic integration. The permanent loss of consciousness is also *necessary* for the death of these organisms. The claim that the permanent loss of consciousness may be *sufficient* for the death

of human and perhaps other higher-order organisms will now be examined in the context of the two other concepts of person that have been used to support this claim.

Persons as Qualities of Human Organisms

The second concept of person identifies the person with certain abilities and qualities of awareness. It is a "qualitative" or "functionalist" view of the person. It has its roots in the work of John Locke [(1694) 1975] and David Hume [(1739) 1978], and finds it contemporary expression most clearly in the work of Derek Parfit [1986]. These philosophers treat the person as a set of mental qualities, including consciousness, memory, intentions, and character traits, rather than as a substantive entity or subject. Locke, for example, distinguishes the person from the human animal (organism) and questions of personal identity from those of the identity of the human animal (organism). In his discussion of the hypothetical case of a prince and cobbler swapping bodies, Locke argues that personal identity travels with one's psychological states and memories. Thus, if the body of the cobbler woke up one day with the psychological states and memories of the prince and the body of the prince, with the psychological states and memories of the cobbler, Locke concludes that the prince and cobbler would have swapped bodies. For Locke, personal identity over time consists of the connectedness between psychological states evident in memories, regardless of whatever substance, material or immaterial, may underlie those psychological states over time.

Because the substantive matter underlying the psychological states is irrelevant to personal identity, Locke's view is a precursor to contemporary functionalist theories of the mind and personal identity. Functionalism as a philosophy of mind rejects the idea that the mind is a substantive entity, whether material or immaterial. Instead, the mind is conceived as a function that can be described abstractly by a machine table of inputs, internal states, and outputs. While the function needs to be embodied in some medium, e.g., the neurophysiological processes of the brain, the function can be described independently of whatever underlies or instantiates the function. As K. T. Maslin points out,

> the Lockean-Parfit proposal is analogous to treating you as a function or program run on the hardware of the brain, the material embodiment being strictly irrelevant to your identity and survival. You could go from body and brain to body and brain, just as information on a floppy disc can be transferred intact to another disc if the original becomes damaged. [Maslin, 2001, p. 275]

Michael Green and Daniel Wikler [1980] invoke this kind of Lockean conception of personal identity in order to support a consciousness-related or "higher brain" formulation of death. In their view, if personal identity consists of continuity of consciousness, then when a person irreversibly loses consciousness, as in permanent vegetative state, the person ceases to exist, i.e., the person has died. The human

organism may retain brainstem functions, but those functions are insufficient for personal identity and thus the continuation of the life of the person.

In response to this argument, proponents of the whole-brain criterion of death have claimed that persons in the Lockean sense do not literally die. As noted above, Gert, Culver, and Clouser also define a "person" in terms of "certain abilities and qualities of awareness" and thus accept a Lockean qualitative view of personhood. In their view, however, "death" cannot be applied literally to persons, because death is a biological concept appropriate to biological organisms, not to roles, functions, abilities, or qualities of awareness. Since Gert, Culver, and Clouser believe that individuals in permanent vegetative state have lost all the qualities that they believe define persons, e.g., consciousness, memory, and personality, they hold that a person who suffers an irreversible loss of consciousness has ceased to exist. However, since they claim that a death does no occur with the irreversible loss of consciousness, they maintain that persons do not literally die. In their view, expressions like "people die every day" involve a metaphorical use of "death" or are elliptical for saying that the organism that constituted the person has died [Culver and Gert, 1982, pp. 182-183; Bernat, 2002, p. 330].

Some proponents of a consciousness-related or "higher-brain" formulation of death have also rejected Green and Wikler's argument. Veatch [1993], for example, accepts a qualitative or functionalist view of the person. However, he believes that it is a mistake to try to conceptually ground the definition of death on such a concept, as Green and Wikler have tried to do. Veatch's concern is that the functionalist theory of personal identity may entail that a person no longer exists in cases of dementia in which all traces of rationality and many other cognitive abilities are lost. Veatch believes, however, that a death has not occurred in such cases. In addition, Veatch is specifically critical of Green and Wikler's argument, because their view defines death in terms of the loss of personal identity. Veatch believes that we can conceive of cases in which personal identity in the Lockean sense may be lost, but a death has not occurred. According to Veatch, Green and Wikler's theory would commit them to drawing the absurd conclusion that someone who has lost psychological continuity, for example, by suffering complete amnesia, has necessarily died. However, Veatch asks us to suppose that this human being who has suffered complete amnesia subsequently develops a new set of beliefs, memories, and other psychological characteristics that we associate with personhood. According to Veatch, even though we might regard such a being as a new person, it is counterintuitive to say, as he believes Green and Wikler must say, that a death occurred in such a case.

Thus, like Bernat and Gert, Culver, and Clouser, Veatch assumes that *persons* are functional or qualitative specifications of human beings, rather than substantive entities, and concludes that such a view about persons and personal identity cannot provide the proper grounding for a definition of death. Like Bernat and Gert, Culver, and Clouser, Veatch believes that human beings, not persons, are the kind of thing that dies. However, Veatch [1993] accepts what he says is the traditional Judeo-Christian concept of a *human being* as an essential union of mind

and body. Since such a union may still exist even though someone suffers complete amnesia, the human being would still exist. A death has not occurred. However, since an irreversible loss of consciousness, as in permanent vegetative state, would entail the destruction of the essential union of mind and body, Veatch believes that the traditional Judeo-Christian concept of the human being is consistent with accepting a consciousness-related criterion of death. He regards individuals in permanent vegetative state as dead. The essential union of the mind and body in those individuals has been destroyed.

Karen Gervais [1986, p. 126] has also criticized Green and Wikler's view on grounds similar to Veatch. She argues that as long as the biological substrate for consciousness remains intact, despite the complete loss of memories, a death has not occurred. However, Gervais believes that the same *person* continues to exist. At this point, she is invoking a substantive concept of personhood and rejecting the functionalist view that she attributes to Green and Wikler and assumed by Veatch. In contrast to Veatch, Gervais treats persons as the kind of thing that can literally die. Gervais also reinterprets Veatch's argument in a way that essentially equates her substantive concept of person with Veatch's substantive concept of human being. What is common to Gervais and Veatch is that they both accept the idea that what dies is a substantive entity that is essentially mind and body. Gervais calls such a being a "person," whereas Veatch refers to it as a "human being." Gervais, like Veatch, also accepts a consciousness-related formulation of death that would treat individuals in permanent vegetative state as dead. From Gervais's perspective, Veatch's error thus lies in his assumption that there is no alternative to the qualitative or functionalist view of the person and personal identity. Insofar as Gervais invokes a substantive concept of person, she may put the argument for a consciousness-related formulation of death on more coherent, conceptual grounds.

Persons as Psychological Substances

The third concept of person is the one that has been suggested in Gervais's writings. It is a "substantive" concept that treats the person, not as some qualitative or functional specification of some more basic kind of thing, e.g., a human organism, but as a primitive substance that necessarily has psychological and corporeal characteristics. P. F. Strawson's [(1958) 1991; 1959] definition of a person as an individual to which we can necessarily apply both predicates that ascribe psychological characteristics (P-predicates) and predicates that ascribe corporeal characteristics (M-predicates) is an example of the use of "person" in this substantive sense. In Strawson's view, and even assuming with Bernat and Gert, Culver, and Clouser that death is a biological or corporeal concept, it is neither a category mistake nor a metaphor to predicate death to persons. This view of the person may be what is reflected in common expressions such as "people die every day," and differs from the "species meaning" in that it entails that the person must have the capacity or realistic potential for psychological functions. This cannot be

said about a corpse or about some living members of the biological species *Homo sapiens*, e.g., anencephalics and individuals in permanent vegetative state.

As noted above, Jeff McMahan [1995; 2002] treats persons as essentially minds that are neither identical to human organisms or brains, nor to a set of qualities or functions of human organisms or brains. Instead, minds are substances distinct from organisms and brains, yet dependent or "supervenient" on them. This form of mind-body dualism leads McMahan to treat the death of the person as distinct from the death of the human organism. Whereas the loss of integration of the organism as a whole may be necessary and sufficient for the death of human organisms, it is not necessary for the death of persons. Minds cease to exist and hence persons die "when those parts of the brain in which consciousness and mental activity are realized are destroyed or rendered irreversibly nonfunctional" [McMahan, 1995, p. 120].

John Lizza [2006] takes a similar view in treating persons as substances and distinguishing the death of the person from the death of the human organism. Building on the work of Peter Strawson [(1958) 1991; 1959], David Wiggins [1980; 1987], E. J. Lowe [1991a; 1991b], and Lynne Rudder Baker [1999; 2000; 2002], Lizza holds that human persons are substantive beings constituted by but not reducible to human organisms. He argues that this view provides the best account of our nature as biological, moral, and cultural beings and supports a consciousness-related formulation of death. Since a person is understood to be a living substantive being with minimally, but essentially, the capacity for consciousness, the irreversible loss of this capacity, i.e., the loss of the psychophysical integrity of the person, would mean the death of the person. Accepting the critiques of the received view by Shewmon and others that a human organism does not require a brain in order to remain integrated and alive, Lizza argues that the real reason we have been willing to accept brain death as our death is not because we were sure that the irreversible loss of all brain functions meant the loss of our organic integration, but because we were sure that this loss meant the irreversible loss of our capacity for consciousness and any other mental function.

OTHER CRITICAL ISSUES

Must all brain functions cease for death to occur?

In his critique of the current whole-brain neurological criterion for death, Veatch [1993] has pointed to the fact that patients may retain some brain activity, even though they are declared dead. Thus, although the Uniform Statutory Definition of Death (UDDA) stipulates that *all* brain functions, including those of the brain stem, must irreversibly cease in order for someone to be dead, in actual practice individuals who are declared dead may still have some isolated neurological activity in the brain detected by electroencephalogram [Grigg *et al.*, 1987]. This activity may include hypothalamic functioning, including neurohormonal regulation, which is usually considered to be an integrating function of the brain (Brody, 1999, p.

73). Veatch has argued that, if all brain functions do not technically have to cease for someone to be legally declared dead, then physicians must be discriminating between those brain functions that are significant or essential to the human being and those that are not. However, given Veatch's Judeo-Christian understanding of a human being as a union of mind and body, he thinks that the brain functions responsible for the mind are the ones that are significant or essential for human beings. He thus argues that the irreversible loss of those brain functions required for consciousness would entail the destruction of the essential union of mind and body and therefore the death of the human being.

Proponents of the received view, such as James Bernat, have responded to this criticism by pointing out that, even though the UDDA categorically states that all brain functions must cease for someone to be dead, "the whole-brain formulation in the UDDA does not require the cessation of the functioning of every neuron, but only those which contribute to the critical system subserving the organism as a whole" [Bernat, 2002, p. 337]. Bernat maintains that the 1981 President's Commission intended the term "functions" in the Uniform Determination of Death Act to mean "clinical functions" measurable by bedside examination and not "physiological activities," such as the functioning of isolated groups of cells, whose measurement requires laboratory determination [Bernat, 2002, p. 337, fn 43).

According to Bernat, the brain is the critical system that supports the emergent functions of the organism as a whole. In the case of humans and other higher order organisms, these functions are conscious awareness requiring cerebral hemispheres, thalamus, hypothalamus, and the brain stem; breathing and blood pressure regulation, dependent on the brain stem; and the processing of information to integrate and regulate homeostasis located in the hypothalamus. When the brain no longer functions to support these emergent functions, the organism is dead. Thus, not every brain neuron must cease functioning in order for the critical functions of the organism as a whole to cease. Again, what remains for Bernat after the critical functions of the brain have irreversibly ceased is an artificially sustained collection of organic parts, rather than an integrated organism as a whole. The brain is thus understood as essential to the functioning of the organism as a whole.

The organism "as a whole"

Throughout the debate over the definition of death, the notion of what it means for an organism to cease to function "as a whole" has been at issue. Proponents of the received view, such as Bernat, attempt to interpret this concept in biological terms and understand the brain as the critical integrator for the holistic functioning of a human organism. Critics such as Shewmon and Taylor, in contrast, argue that the brain is not essential for such integrated functioning of the human organism as a whole. Just as other non-conscious organisms may be artificially sustained and continue to function as organic wholes, the same is true of artificially sustained, whole-brain-dead human organisms. Moreover, Shewmon has pointed to the phys-

iological similarity between cases of high spinal cord transection and brain death. In both cases, the brain does not function to integrate the organism. Thus, if the loss of the brain's integrating functions is insufficient to declare patients with high spinal cord transection to be dead, then this same loss is insufficient for a determination of death.

Proponents of a consciousness related formulation of death, who view consciousness as essential to the kind of beings that we are, adopt one of two strategies in interpreting what it means for a person or human organism to function as a whole. Mathews [1979], for example, maintains that the irreversible loss of consciousness and sentience in a human organism, as well as in other higher order organisms, such as a dog, would entail the loss of integration of the organism *as a whole* and hence would mean its death. In this view, an artificially sustained human or dog in permanent vegetative state would not be a human or a dog at all. Instead, it may be the remains of a human or a dog, a different kind of biological organism, or, perhaps more descriptively, a kind of biological artifact.

Alternatively, consciousness-related theorists [Engelhardt, 1978; Gervais, 1986; Lizza, 1993, 2006; McMahan, 1995, 2002] rely on a distinction between persons and organisms, e.g., that persons are constituted by but not identical or reducible to living organisms. In this view, the death of the person is understood as different from the death of an organism. What it means for a person to function as a whole may thus differ from what it means for a human organism to function as a whole. The consciousness-related theorist might thus agree with critics of the neurological criterion, like Taylor and Shewmon, that an artificially sustained whole-brain-dead human organism may continue to function as a whole. However, the consciousness-related theorist would maintain that the person, as distinct from the human organism, would no longer be functioning as a whole. This distinction provides consciousness-related theorists with further options, depending on what they consider to be the necessary and sufficient conditions of persons to function as a whole. For example, if the capacity or potential for consciousness and sentience is necessary and sufficient for being a person but is not a necessary condition for being an organism, then the definition of the death of the person would be different than that of the organism. This particular account of personhood might classify dogs as persons, since they exhibit consciousness and sentience. In this case, the definition of death of a human being *qua* person would be the same as that of the dog *qua* person. Moreover, the definition of death of the human being *qua* organism might be the same as that of the dog *qua* organism. However, if more than consciousness and sentience is required for personhood, e.g., the capacity for language, rationality, or moral responsibility, then the dog would be excluded from the class of persons. The death of the human person would then be different from the death of these other kinds of being.

PERSISTENT AND PERMANENT VEGETATIVE STATE

As noted above, consciousness-related theorists about the definition of death wish to expand the neurological criterion for determining death to include individuals who have irreversibly lost consciousness and every other mental function, i.e., individuals in *permanent* vegetative state. Karen Quinlan, Nancy Cruzan, and Terri Schiavo clearly satisfied the current clinical criteria for such a diagnosis, despite the media attention given to those who challenged it. However, there are diagnostic and prognostic complexities surrounding "persistent" and "permanent" vegetative state, as contrasted with "brain death," that warrant special attention.

Ronald Cranford succinctly summarizes these complexities:

> ... for several reasons, the degree of certainty about diagnosis of this syndrome is less absolute than a diagnosis of brain death ...

> With the persistent vegetative state ... there is no broadly accepted

> set of specific medical criteria with as much clinical detail and certainty as the brain death criteria. Furthermore, even the generally accepted criteria, when properly applied, are not infallible. There have been a few unexpected, but unequivocal and well documented, recoveries of cognitive functions in situations where it was believed that the criteria were correctly applied by several neurologists experienced in the diagnosis of the condition. In cases in New Mexico and Minnesota, the patients recovered full cognitive functioning, although they were left with a severe and permanent paralysis of all extremities and some paralysis of facial and head movements, i.e., locked-in syndrome....

> Presently, there are no specific laboratory studies to confirm the clinical diagnosis of the persistent vegetative state. After a variable period of time (weeks to months), some studies such as MRI and CAT (computerized axial tomography) scanning will show extensive structural damage to the cerebral hemispheres consistent with the clinical diagnosis but these studies are not quantifiable. The most promising test on the horizon that will be of value in confirming a clinical diagnosis of the persistent vegetative state is the PET (positron emission tomography scan)...

> The electroencephalogram (EEG) also does not provide absolute certainty because the degree of abnormality of the EEG will vary widely in individual cases. Some appear remarkably normal considering the extent of damage to the cerebral hemispheres ...

> Prognostic assessments of patients in a persistent vegetative state are not free of controversy. A major problem is attributable to the multiple causes and pathophysiologic changes associated with the syndrome. In brain death, the underlying cause of the brain injury is not so important

once the basic sequence of pathophysiologic events begins and lead inexorably to its conclusion (severe primary injury — brain swelling — marked increase in intracranial pressure — increased intracranial pressure exceeding blood pressure, causing secondary loss of blood flow to the entire brain — infarction of cerebral hemispheres and the brain stem). In the persistent vegetative state, however, there are multiple causes for the syndrome, and no single pathophysiologic sequence of events. Therefore, the prognosis of recovery of neurological function, when the prognosis can be made, and its degree of certainty will vary considerably according to the underlying cause of the brain damage and the specific pathophysiology. [Cranford, 1988, pp. 29-30][6]

In 1994, the Multi-Society Task Force on PVS (MSTF) issued a consensus statement summarizing the current knowledge of the medical aspects of the persistent vegetative state in adults and children. The report of the MSTF was endorsed by the American Academy of Neurology, American Neurological Association, American Association of Neurological Surgeons, and Child Neurology Society. The report states,

> The vegetative state is a clinical condition of complete unawareness of the self and the environment, accompanied by sleep-wake cycles, with either complete or partial preservation of hypothalmic and brain-stem autonomic functions. In addition, patients in a vegetative state show no evidence of sustained, reproducible, purposeful, or voluntary behavioral responses to visual, auditory, tactile, or noxious stimuli; show no evidence of language comprehension or expression; have bowel and bladder incontinence; and have variably preserved cranial-nerve and spinal reflexes. We define persistent vegetative states as a vegetative state present one month after acute traumatic or nontraumatic brain injury or lasting for at least one month in patients with degenerative or metabolic disorders or developmental malformations....
>
> Recovery of consciousness from a posttraumatic persistent vegetative state is unlikely after 12 months in adults and children. Recovery from a nontraumatic persistent vegetative state after three months is exceedingly rare in both adults and children. [Multi-Society Task Force on PVS, 1994, p. 1499]

The Report of the MSTF has been criticized as conceptually confused on two main grounds [Borthwick, 1996; Howsepian, 1996; Shewmon, 1997; 2004b]. First, critics argue that the MSTF mistakenly takes the absence of evidence for consciousness as evidence for the absence of consciousness. Critics argue that this

[6]Cranford's remarks are as true today as when he wrote them. If anything, the diagnostic and prognostic complexities of the persistent vegetative state have increased in light of technological advances. In a recent study, Laureys et al. [2004, p. 236] conclude that "at present, the potential for recovery of awareness from the VS [vegetative state] cannot be predicted reliably by any clinical or neurodiagnostic test."

inference is mistaken. For example, patients in locked-in syndrome are unable to communicate that they are conscious, other than by blinking their eyes in response to questioning. However, suppose that these patients were in a "super-locked-in" state and were unable to signal by blinking their eyes. It would be a mistake to infer that they lacked consciousness. Since there are similarities in the evidence used to diagnose both conditions, critics argue that there is no way to tell for certain whether or not the individual in PVS lacks consciousness. As Shewmon [1997, p. 60] suggests, individuals in PVS may be in a "super-locked-in" state. Howsepian [1994, p. 6] suggests that "there actually may be something that it is like to be comatose."

The second main criticism challenges the warrant for calling some PVS cases "permanent" as the MSTF admits that it is possible, although highly unlikely, that someone in a permanent vegetative state might recover. The possibility of recovery appears to contradict the meaning of "permanent."

There is some merit to these criticisms. The report certainly could have been more careful in its language to avoid some of the conceptual inconsistencies that are pounced upon by its critics, especially Howsepian [1996]. However, the critics may err in what appears to be their demand for *absolute* certainty in the diagnosis of a lack of consciousness in PVS and the prognosis of permanency. Neither demand can be met, but that should not discount the usefulness of PVS and PermanentVS as, respectively, diagnostic and prognostic categories. Clinical certainty is always in the realm of empirical probabilities, rather than absolute certainty. It may be also good to keep in mind Aristotle's advice that we should not expect more precision than the subject matter admits [Aristotle, *Nicomachean Ethics* I, 3, 1094b10-15].

The first criticism essentially relies on a claim about the impossibility of knowing whether another being is conscious, i.e., what in philosophy is called "The Problem of Other Minds."[7] Since we appear to have direct access only to the contents of our own minds, how can we know for sure whether there are any other minds? Moreover, since it is clearly possible that someone might be conscious without exhibiting behavior that indicates their consciousness, e.g., the Spartan may be in severe pain but not exhibit any pain behavior, we cannot infer from the absence of behavioral evidence of consciousness that there is no consciousness [Putnam, 1980]. As Shewmon [2004b, p. 222 (parenthetical remarks added)] states, "the lack of 'behavioral indication' of any awareness of pain or suffering (in cases of PVS) does not *per se* imply a lack of pain or suffering." Alternatively, someone might exhibit what we normally recognize as pain behavior, but not be in pain. Thus, the grunting, grimacing, groaning, avoidance movements, etc. that individuals in PVS sometime exhibit are standardly interpreted as stereotypical, unconscious reflexive responses. However, Shewmon asks, "On what plausible ground can anyone confidently dismiss such behaviors as invariably *not* reflecting discomfort or pain?" [Shewmon, 2004b, p. 225]. Panksepp *et al.* [2007] suggest that such behavior may be indicative of lower level, raw affective feelings that can exist

[7]See, e.g., Ludwig Wittgenstein's "beetle in the box" argument [1953, sect 293].

without cognitive awareness of those feelings.

The diagnostic and prognostic problems associated with PVS certainly argue for a tutoristic approach in declaring that every individual that satisfies the generally accepted criteria for a diagnosis of PVS has irreversibly lost consciousness. However, the critical issue is how tutoristic we should be. Howsepian [1994, p. 735] advocates that "Some purportedly irreversibly comatose humans ought to be kept alive indefinitely." However, he does not indicate where a line should be drawn between this claim and the claim that "*all* comatose humans should be kept alive indefinitely" [Howsepian. 1994, p. 735]. Should the philosophical problem of other minds commit us to keeping all individuals in PVS alive indefinitely, because it cannot be determined with absolute certainty that they have irreversibly lost consciousness?

There are some reasons for answering negatively. Strawson [(1958) 1991; 1959], for example, considers persons to be a primitive kind of substance in our ontology to which we can ascribe mental and physical predicates. His argument, which perhaps can be traced back to Wittgenstein [1953], is that in order to ascribe states of consciousness or mental predicates to ourselves, one must be able to ascribe them to others. However, in order to ascribe them to others, we need to identify other subjects of experience, which is done not by observation of their inner mental states, but by observation of their bodies and behavior. Strawson's argument may thus be a partial solution to the problem of other minds, although his view is not without its difficulties.[8]

What makes the problem of other minds so intolerable is that it challenges whether we can know whether any other being is conscious. This is bad enough. But if we cannot know whether any other being is conscious, then in principle we cannot rule out consciousness in any being. This implication is worse. Clearly, we have more reason for thinking that another normal human being is conscious than a cake of soap or a plant. Thus, acceptance of the implications of the problem of other minds is incompatible with an empirical theory that commits us to the view that some kinds of physical beings are more likely than others to have consciousness. The question whether any being is conscious must therefore be addressed within the context of a theory about the connection between the mind and body. Strawson lays the foundation for such a connection by establishing that we could not identify our own mental states as our own without identifying those of others on the basis of physical criteria. Neurophysiological and behavioral psychology is built upon the assumption that psychology is dependent on, though perhaps not reducible to, the body. Dependency but non-reducibility may prevent Strawson's view from sliding into an untenable form of logical or ontological behaviorism. Further inquiry and theorizing about this dependency also enables us to make

[8] P. F. Strawson's view would have to be defended to show that it does not entail an untenable form of logical or ontological behaviorism, as, for example, Graham [1993, pp. 39-40] and G. Strawson [1994, pp. 223-224] have charged. Also, A. J. Ayer [1963, pp. 105-106] has argued that Strawson's view begs the question by assuming that other people are conscious, which is the very point at issue.

reasonable judgments about when consciousness is present. Thus, the diagnostic and prognostic problems associated with PVS may not support a tutoristic line in all cases of PVS. Cranford's statement, reflected in the report of MSTF, that "the degree of certainty (of the prognosis for neurological recovery) will vary considerably according to the underlying cause of brain damage and the specific pathophysiology" suggests that in some cases the certainly of the prognosis may be quite high or at least higher than in other cases. If we are justified in making such comparative judgments about the presence or absence of consciousness, then the philosophical problem of other minds loses its relevancy. Since the implication of the problem of other minds is that we have no reason to think that another being is conscious or unconscious, comparative judgments about the likelihood of consciousness in different physical beings would also be groundless.

Although Cranford does not elaborate on what specifically affects this degree of certainty, i.e., which causes of brain damage and specific pathophysiology yield a higher degree of prognostic certainty, studies of some PVS patients' EEG activity, cerebral blood circulation, and duration of survival yield a very high degree of prognostic certainty. For example, some long-surviving (up to seventeen years) patients with "apallic syndrome" studied by Ingvar et al. [1978] showed over many years repeated isoelectric EEG's and extremely low supratentorial blood flow (about 10-20 percent of the normal level), indicating the reduced metabolic demand of gliotic scar tissue. While there have been exceptional cases of recovery from PVS and some studies, e.g., Hassler et al. [1969] and Kohadon and Richer [1993], in which comatose patients were aroused to consciousness by deep brain stimulation, there are few, if any, neurologists who would recognize a realistic potential for regaining consciousness in Ingvar's patients. Thus, while further studies of PVS patients are needed in order to arrive at covering laws concerning the diagnosis and prognosis of this class of cases, some individual cases can be diagnosed and prognosticated with a high degree of certainty.[9]

It should be noted, of course, that a consensus among neurologists does not imply that their view is correct. D. Alan Shewmon [2004b] has challenged the widely held assumption in neurology that cortical function is absolutely necessary for consciousness in terms of adaptive interaction with the environment and a subjective awareness of self and environment. Shewmon and two colleagues report having studied several cases of children with congenital apallia (loss of the pallium or gray-matter mantle of the brain) who nonetheless clearly demonstrate conscious awareness. These children were able to hear without an auditory cortex, see without a visual cortex, and feel without a somatosensory cortex. Shewmon concludes that "Cases like these seriously undermine the concept of 'apallic syndrome' or 'neocortical death,' understood as anything beyond neuropathology, because they unequivocally prove that the absence of cortex does not necessarily result in what

[9] Jean-Michel Gurit [2004] maintains that in some extreme cases of post-anoxic coma or vegetative state the absence of all primary components of cortical evoked potentials can be accurately determined and that this irreversible situation is incompatible with any consciousness. See also Ted L. Rothstein [2000].

is generally understood as VS (vegetative state)" [Shewmon, 2004b, p. 218 (parenthetical remarks added)].

Shewmon considers whether these congenital cases imply anything for acquired apallia, such as those studied by Ingvar. He notes that patients with the acquired cases suffer greater motor impairment than the children. However, he believes that this should make us cautious about attributing the difference between the acquired cases and the congenital cases entirely to a difference in the degree of brain-stem plasticity for consciousness, for the difference may be due to a plasticity for motor function. Thus, according to Shewmon,

> What the congenital cases imply about acquired VS in older patients is to suggest a plausible alternative to the cortex-consciousness dogma. It has never been scientifically ruled out (nor can it be), that some (unknowable number of) acquired-apallia patients have a limited form of consciousness but simply cannot manifest it due to extreme motoric disability. [Shewmon, 2004b, p. 218]

Shewmon goes on to note that it is well known that the neuroanatomical pathways of pain sensation involve mainly subcortical areas. Some stroke patients may report the raw sensation of pain but not its affective component, i.e., they still feel the pain "just as before" but it "no longer bothers them" [Shewmon, 2004b, p. 219]. Shewmon reasons that if the necessary and apparently sufficient pathways for the sensation of pain abstracted from the affective component are intact in both congenitally and postnatally acquired apallia,

> there is no reason to assume that apallia precludes all experience of pain and discomfort. The hydranencephalic children described above clearly experienced pain, as do newborns and fetuses with relatively non-functioning cortices. Therefore, when adult or older children with similar acquired lesions withdraw limbs, grimace and cry to noxious stimuli, on what grounds can anyone assert that these responses are '*merely* primitive reflexes,' even if the motor reaction is simple and stereotyped? [Shewmon, 2004b, p. 219]

Shewmon concludes that, if we do not know enough about PVS to rule out the possibility that their inability to express their capacity for consciousness may be due to an extreme motoric disability, rather than a lack of capacity for consciousness, then it is *possible* that individuals in even long-surviving PVS retain the capacity for consciousness.

While Shewmon's conclusion may be correct, it is not clear that this is the most reasonable hypothesis. Even though we may not be able to rule out the possibility that these individuals have some rudimentary consciousness, it is not clear that this is a more plausible explanation than that their behavior is merely reflexive and that the degree of probability of the hypothesis is sufficient to justify treating them tutoristically. Moreover, it is unclear what to make of the reports by some stroke patients that they have the raw sensation of pain minus its affective component.

Without the conscious affective component, it is unclear that we should consider these patients to be "in pain" or suffering. However, if they are not in pain and are not suffering, then it is unclear what ethical weight we should assign to such experiences.

Proponents of a consciousness related definition of death have argued that a realistic potential for consciousness is a minimal necessary condition for something to be a living person. However, it is unclear whether an organism capable of having a "raw sensation" is thereby conscious. The "raw sensation" might be analogous to the kind of pupillary reflex that is discussed in the following exchange between Douglas Walton [1980] and Roland Puccetti [1988]. Walton maintains that feeling and sensation may be possible even in the absence of cortical functions. For example, considering the pupillary reflex mediated by the brainstem, Walton writes,

> The pupillary reflex could, for all we know, indicate the presence of feeling or sensation even if the higher cognitive faculties are absent. Even if we cannot resolve the issue with the precision that we would like and, indeed, just because of that, we should be on the safe side.... Following my tutoristic line of argument, it is clear that we cannot rule out the possibility that brain stem reflexes could indicate some form of sensation or feeling, even if higher mental activity is not present. [Walton, 1980, p. 69]

Puccetti claims that Walton's view

> fairly reeks of superstition. As we all know, when the doctor flashed his penlight on the eye, we do not feel the pupil contract, then expand when he turns the light off. If not, then why in the world does Walton suppose that a deeply comatose patient feels anything in the same testing situation? The whole point of evolving reflexes like this, especially in large brained animals that do little peripheral but lots of central information processing, is to shunt quick-response mechanisms away from the cerebrum so that the animal can make appropriate initial responses to stimuli *before* registering them consciously. If one could keep an excised human eye alive *in vitro* and provoke the pupillary reflex, the way slices of rat hippocampus have been stimulated to threshold for neuronal excitation, would Walton argue that the isolated eye might feel something as the pupil contracts? [Puccetti, 1988, p. 78]

Puccetti thus concludes that it is unreasonable to think that the pupillary reflex involves consciousness. If the raw sensations of the stroke victim and the stereotypical behavior exhibited by some individuals in PVS are similar to the pupillary reflex, then it may be implausible to think that these "sensations" or behavior involve conscious awareness.

Critics of extending the consciousness-related formulation of death to anencephalics and individuals in PVS [Capron, 1987; Shewmon, 1988; 2004b] also raise issues about the diagnostic reliability of these conditions. Shewmon, for example, states,

> In a great majority of cases, the diagnosis of anencephaly is very obvious, and there is little chance of mistaking it for another condition. Nevertheless, not all cases are so straightforward. If anencephaly were clearly distinct from all other congenital brain malformations, it should be possible to give an operational definition of it that includes all cases of anencephaly and excludes cases of everything else, yet such a definition has not been offered by anyone so far. [Shewmon, 1988, pp. 11-12]

Shewmon goes on to give examples of diagnostic ambiguity between anencephaly ("a partial or total absence of the brain") and other less severe congenital malformations: exencephaly ("exposure of the brain"), encephaloceles ("hernias of the brain protruding through a congenital opening of the skull"), meroanencephaly or meroacrania ("a partial absence of brain and calvarium"), and amniotic band syndrome ("a broad continuum of severity that can mimic anencephaly").

Shewmon's point is that these cases constitute a spectrum of neural organization and that in some cases it is impossible to distinguish one condition from another. Individuals that fall on the less developed end of the spectrum, such as anencephalics, clearly have no cerebral tissue and thus no cerebral function. Individuals on the other end of the spectrum, such as meroanencephalics, have some rudimentary cerebral tissue and therefore may have some cerebral function, e.g., they may be capable of suffering. Shewmon concludes,

> These examples are not intended to exaggerate the potential for diagnostic confusion surrounding anencephaly: it is still quite true that in the vast majority of cases the diagnosis can be made easily and without risk of error. Nevertheless, the commonly encountered contention that 'anencephaly' is so well defined and distinct from all other congenital brain malformations that misdiagnosis cannot occur and that organ harvesting policies limited to 'anencephalics' cannot possibly extend to other conditions, is simple false. [Shewmon, 1988, p. 12]

In the case of PVS, the possibility of misdiagnosis is more troublesome. Keith *et al.* [1996] report that in their study of 40 patients referred to as being in a persistent vegetative state, 17 (43%) were misdiagnosed. Seven of these misdiagnosed patients had been presumed to be vegetative for over one year, including three for longer than four years. Similar findings of misdiagnosis (an error rate of 37%) are reported in Childs *et al.* [1993]. Childs *et al.* conclude that the error in diagnosis may result from "confusion in terminology, lack of extended observation of patients, and lack of skill or training in the assessment of neurologically devastated patients" [Childs *et al.*, 1993, p. 1465].

As noted above, the problems associated with the diagnosis of anencephaly and PVS may not challenge the consciousness-related definition of death. They do, however, raise issues about whether we could reliably implement a policy of determining death that would include anencephalics and individuals in PermVS. Shinnar and Arras [1989, p. 730] point out that the diagnosis of anencephaly in the vast majority of cases can be reliably made, and there is little chance of mistaking it for another condition. Shewmon concurs when he states that "in the vast majority of cases the diagnosis can be made easily and without risk of error" [Shewmon, 1988, p. 12]. However, there is a greater risk or error in using anencephaly and PVS as criteria for determining the lack of any potential for consciousness, than there is in using total brain failure. This suggests that further study needs to be done before such diagnoses could be reliably used in practice to determine the lack of the potential for consciousness.

The MSTF [1994, p. 1501] concluded that data on the prognosis for neurologic recovery of patients in PVS, "in conjunction with other relevant factors in an individual patient, can be used by a physician to determine when the persistent vegetative state becomes permanent — that is, when a physician can tell the patient's family or surrogate with a high degree of medical certainty that there is no further hope for recovery of consciousness or that, if consciousness were recovered, the patient would be left severely disabled." It is unfortunate that the MSTF conflates the notion of what it means for the loss of consciousness to be "permanent" with the possibility of recovery of consciousness with severe disability. If the caveat about the "possibility of recovery" is simply an expression of the MSTF's recognition that all diagnoses in medicine are based on probabilities and not certainty, then the qualification is innocuous. If absolute certainty were required before implementing a medical policy for determining death, no medical policy could ever be implemented. As Norman Fost points out in the context of his discussion of anencephaly, "not all clinicians or hospitals would be equally competent at making the diagnosis and errors have occurred with anencephaly, just as they have occurred with the simpler (or easier) diagnosis of brain death" [Fost, 1988, p. 8]. However, if the MSTF were expressing greater reservations about the clinical certainty of the diagnosis of permanent loss of consciousness, then reliance on a diagnosis of permanent vegetative state to satisfy a consciousness-related definition of death would be more problematic. In this case, the diagnostic and prognostic uncertainty about PVS would argue against allowing the diagnosis to satisfy a consciousness-related formulation of death at this time. Although some cases of PermVS reliably satisfy the formulation, e.g., the long-surviving cases studies by Ingvar, further work on PVS is needed to develop finer criteria for distinguishing it from other conditions and to identify more clearly those factors in the syndrome itself and in individual patients that contribute to making the condition permanent and irreversible.

BIBLIOGRAPHY

[Ad Hoc Committee.., 968] Ad Hoc Committee of the Harvard Medical School to Examine the Definition of Brain Death. A Definition of Irreversible Coma. *Journal of the American Medical Association* 205 (6): 337-340, 1968.

[American Academy of Neurology, ..., 1995] American Academy of Neurology, Quality Standards Committee. Practice Parameters for Determining Brain Death in Adults. *Neurology* 45 (5): 1012-1014, 1995.

[Anstötz, 1993] A. Anstötz. Should a Brain-Dead Pregnant Woman Carry Her Child to Full Term? The Case of the 'Erlanger Baby'. *Bioethics* 7 (4): 340-350, 1993.

[Arnold *et al.*, 1968] J. D. Arnold, T. F. Zimmerman, and D. C. Martin. Public Attitudes and the Diagnosis of Death. *Journal of the American Medical Association* 206: 1949-1954, 1968.

[Ayer, 1963] A. J. Ayer. *The Concept of a Person*. London: Macmillan, 1963.

[Baker, 1999] L. R. Baker. What Am I? *Philosophy and Phenomenological Research* 59 (1): 151-159, 1999.

[Baker, 2000] L. R. Baker. *Persons and Bodies*. Cambridge: Cambridge University Press, 2000.

[Baker, 2002] L. R. Baker. The Ontological Status of Persons. *Philosophy and Phenomenological Research* 65 (2): 370-388, 2002.

[Beauchamp and Perlin, 1978] T. L. Beauchamp and S. Perlin, eds. *Ethical Issues in Death and Dying*. Englewood Cliffs, N.J.: Prentice-Hall, 1978.

[Becker, 1975] L. Becker. Human Being: The Boundaries of the Concept. *Philosophy and Public Affairs* 4 (4): 335-359, 1975.

[Bernat, 2002] J. Bernat. The Biophilosophical Basis of Whole-Brain Death. *Social Philosophy and Policy* 19 (2): 324-342, 2002.

[Bernat *et al.*, 1982] J. Bernat, C. Culver, and B. Gert. Defining Death in Theory and Practice. *Hastings Center Report* 12 (1): 5-8, 1982.

[Bernstein *et al.*, 1989] I. Bernstein, M. Watson, G. M. Simmons, M. Catalano, G. Davis, and R. Collins. 1989. Maternal Brain Death and Prolonged Fetal Survival. *Obstetrics and Gynecology* 74 (3): 434-437, 1989.

[Black and Zervas, 1984] P. M. Black and N. T. Zervas. Declaration of Brain Death in Neurosurgical and Neurological Practice. *Neurosurgery* 15: 170-174, 1984.

[Borthwick, 1996] C. Borthwick. The Permanent Vegetative State: Ethical Crux, Medical fiction? *Issues in Law and Medicine* 12 (2): 167-185, 1996.

[Brody, 1999] B. Brody. How Much of the Brain Must Be Dead? in Youngner, Arnold, and Schapiro (eds.), *The Definition of Death: Contemporary Controversies*. Baltimore: Johns Hopkins University Press, pp. 71-82, 1999.

[Byrne *et al.*, (1982/83) 2000] P. A. Byrne, S. O'Reilly, P. Quay, and P. W. Salsich, Jr. Brain Death — The Patient, the Physician, and Society. *Gonzaga Law Review* 18 (3): 429-516, 1982/83. Reprinted in Potts, Byrne, and Nilges (eds.), *Beyond Brain Death: The Case Against Brain Based Criteria for Human Death*. Dordrecht: Kluwer, pp. 21-89, 2000.

[Capron, 1987] A. M. Capron. Anencephalic Donors: Separate the Dead from the Dying. *Hastings Center Report* 17 (1): 5-9, 1987.

[Childs *et al.*, 1993] N. L. Childs, W. N. Mercer, and H. W. Childs. Accuracy of Diagnosis of Persistent Vegetative State. *Neurology* 43: 1465-1467, 1993.

[Cranford, 1988] R. Cranford. The Persistent Vegetative State: The Medical Reality (Getting the Facts Straight). *Hastings Center Report* 18 (1): 27-32, 1988.

[Culver and Gert, 1982] C. Culver and B. Gert. 1982. *Philosophy in Medicine: Conceptual and Ethical Issues in Medicine and Psychiatry*. New York: Oxford University Press, 1982.

[DeGrazia, 2005] D. DeGrazia. *Human Identity and Bioethics*. Cambridge: Cambridge University Press, 2005.

[Delmonico and Randolph, 1973] F. L. Delmonico and J. G. Randolph. Death: A Concept in Transition. *Pediatrics* 51: 234-239, 1973.

[Deneffel *et al.*, 1992] M. B. Deneffel, J. E. Kappes, D. Waltmire, *et al.* Knowledge and Attitudes of Health Care Professionals about Organ Donation. *Journal of Transplant Coordination* 2: 127-130, 1992.

[Engelhardt, 1978] T. Engelhardt, T. Medicine and the Concept of Person in Beauchamp and Perlin (eds.), *Ethical Issues in Death and Dying*. Englewood Cliffs, N.J.: Prentice-Hall, 1978.

[Feldman, 1992] F. Feldman. *Confrontations with the Reaper.* New York: Oxford University Press, 1992.

[Field et al., 1988] D. R. Field, E. A. Gates, R. K. Creasy, K. R. Jonsen, and R. K. Laros. Maternal Brain Death During Pregnancy. *Journal of the American Medical Association* 260 (6): 816-822, 1988.

[Fost, 1988] N. Fost. Organs from Anencephalic Infants: An Idea Whose Time Has Not Yet Come. *Hastings Center Report* 18: 5-10, 1988.

[Gert, 1995] B. Gert. A Complete Definition of Death, in Machado (ed.), *Brain Death.* Amsterdam: Elsevier, pp. 23-30, 1995.

[Gert et al., 2006] B. Gert, C. Culver, and D. K. Clouser. *Bioethics: A Systematic Approach.* Oxford: Oxford University Press, 2006.

[Gervais, 1986] K. Gervais. *Redefining Death.* New Haven: Yale University Press, 1986.

[Graham, 1993] G. Graham. *Philosophy of Mind: An Introduction.* Oxford: Blackwell, 1993.

[Green and Wikler, 1980] M. Green and D. Wikler. Brain Death and Personal Identity. *Philosophy and Public Affairs* 9: 105-133, 1980.

[Grigg et al., 1987] M. M. Grigg, M. A. Kelly, G. Celesia, M. Ghobrial, and E. R. Ross. Electroencephalographic Activity After Brain Death. *Archives of Neurology* 44 (9): 948-954, 1987.

[Guérit, 2004] J-M. Guérit. The Concept of Brain Death, in Machado and Shewmon (eds.), *Brain Death and Disorders of Consciousness.* New York: Kluwer, pp. 15-21, 2004.

[Halevy and Brody, 1993] A. Halevy and B. Brody. Brain Death: Reconciling Definitions, Criteria, and Tests. *Annals of Internal Medicine* 119: 519-25, 1993.

[Hassler et al., 1969] R. Hassler, G. D. Ore, A. Bricolo, G. Dieckmann, and G. Dolce. Behavioral and EEG Arousal Induced by Stimulation of Unspecific Projection Systems in a Patient with Post-Traumatic Apallic Syndrome. *Electroencephalography and Clinical Neurophysiology* 27 (7): 306- 310, 1969.

[Howsepian, 1994] A. A. Howsepian. Philosophical Reflections on Coma. *Review of Metaphysics* 47 (4): 735-755, 1994.

[Howsepian, 1996] A. A. Howsepian. The 1994 Multi-Society Task Force Consensus Statement on the Persistent Vegetative State: A Critical Analysis. *Issues in Law and Medicine* 12 (1): 3-29, 1996.

[Hume, (1739) 1978] D. Hume. *A Treatise of Human Nature*, Selby-Bigge (ed.), 2^{nd} edition revised by Nidditch. Oxford: Clarendon Press, (1739) 1978.

[Ingvar et al., 1978] D. H. Ingvar, A. Brun, L. Johannson, and S. M. Samuelsson. Survival After Severe Cerebral Anoxia with Destruction of the Cerebral Cortex: The Apallic Syndrome. *Annals of the New York Academy of Sciences* 315: 184-208; discussion 208-214, 1978.

[Joffe and Anton, 2006] A. R. Joffe and N. Anton. Brain Death: Understanding of the Conceptual Basis by Pediatric Intensivists in Canada. *Archives of Pediatrics and Adolescent Medicine* 160: 747-752, 2006.

[Joffe et al., 2007] A. R. Joffe, N. Anton, and V. Mehta. A Survey to Determine the Understanding and Conceptual Basis and Diagnostic Tests Used for Brain Death by Neurosurgeons in Canada. *Neurosurgery* 61: 1039-1047, 2007.

[Jonas, 1974] H. Jonas. Against the Stream: Comments on the Definition and Redefinition of Death, in Jonas, *Philosophical Essays: From Ancient Creed to Technological Man.* Englewood Cliffs, N.J.: Prentice-Hall, pp. 132-140, 1974.

[Jones, 2000] D. A. Jones. Metaphysical Misgivings about "Brain Death," in Potts, Byrne, and Nilges (eds.), *Beyond Brain Death: The Case Against Brain Based Criteria for Human Death.* Dordrecht: Kluwer, pp. 91-119, 2000.

[Joynt, 1984] R. J. Joynt. A New Look at Death. *Journal of the American Medical Association* 252: 682, 1984.

[Kohadan and Richer, 1993] F. Kohadon and E. Richer, E. *Stimulation Cerébrale Profonde chez des Patients en Etat Végétatif Post-Traumatique: 25 Observations. Neurochirurgie* 39: 281-92, 1993.

[Keith et al., 1996] A. Keith, L. Murphy, R. Munday, and C. Littlewood. Misdiagnosis of the Vegetative State: Retrospective Study in a Rehabilitation Unit. *British Medical Journal* 313: 13-16, 1996.

[Kester, 1994] C. M. Kester. Is There a Person in That Body? An Argument for the Priority of Persons and the Need for a New Legal Paradigm. *Georgetown Law Journal* 82: 1643-1687, 1994.

[Laureys et al., 2004] S. Laureys, M-E. Faymonville, X. De Tiège, P. Peigneux, J. Berré, G. Moonen, S. Goldman, and P. Maquet. Brain Function in the Vegetative State, in Machado and Shewmon (eds.), *Brain Death and Disorders of Consciousness*. New York: Kluwer, pp. 229-238, 2004.

[Lizza, 1993] J. Lizza. Persons and Death: What's Metaphysically Wrong with Our Current Statutory Definition of Death? *Journal of Medicine and Philosophy* 18: 351-74, 1993.

[Lizza, 2006] . J. Lizza. *Persons, Humanity, and the Definition of Death*. Baltimore: Johns Hopkins University Press, 2006.

[Lock, 2002] M. Lock. *Twice Dead*. Berkeley: University of California Press, 2002.

[Locke, (1694) 1975] J. Locke. *An Essay Concerning Human Understanding*, 2nd edition, Nidditch (ed.). Oxford: Clarendon Press,
[1694,] 1975.

[Lowe, 1991a] E. J. Lowe. Real Selves: Persons as a Substantial Kind, in Cockburn (ed.), *Human Beings*. Cambridge: Cambridge University Press, 1991.

[Lowe, 1991b] E. J. Lowe. Substance and Selfhood. *Philosophy* 66: 81-99, 1991.

[Machado, 1995] C. Machado. A New Definition of Death Based on the Basic Mechanism of Consciousness Generation in Human Beings, in Machado (ed.), *Brain Death: Proceedings of the Second International Symposium on Brain Death*. Amsterdam: Elsevier, pp. 57-66, 1995.

[Maslin, 2001] K. T. Maslin. *An Introduction to the Philosophy of Mind*. Cambridge: Polity Press, 2001.

[Mathews, 1979] G. Matthews. Life and Death as the Arrival and Departure of the Psyche. *American Philosophical Quarterly* 16 (2): 151-157, 1979.

[McMahan, 1995] J. McMahan. The Metaphysics of Brain Death. *Bioethics* 9: 91-126, 1995.

[McMahan, 2002] J. McMahan. *The Ethics of Killing: Problems at the Margins of Life*. Oxford: Oxford University Press, 2002.

[Mollaret and Goulon, 1959] P. Mollaret and M. Goulon. Le coma dépassé. *Revue Neurologique* 101: 3-15, 1959.

[Multi-Society Task Force on PVS, 1994] Multi-Society Task Force on PVS. Medical Aspects of the Persistent Vegetative State: Parts 1 and 2. *New England Journal of Medicine* 330: 1499-1508, 1572-1579, 1994.

[Olson, 1997] E. T. Olson, E. T. *The Human Animal*. Oxford: Oxford University Press, 1997.

[Orlick, 1991] R. S. Orlick. Brain Death, Religious Freedom, and Public Policy: New Jersey's Landmark Legislative Initiative. *Kennedy Institute of Ethics Journal* 1: 275-288, 1991.

[Pallis, 1983] C. Pallis. ABC of Brainstem Death. *British Medical Journal* 286: 284- 287, 1983.

[Pallis, 1999] C. Pallis. On the Brainstem Criterion of Death, in Youngner, Arnold, and Shapiro (eds), *The Definition of Death: Contemporary Controversies*. Baltimore: Johns Hopkins University Press, pp. 93-100, 1999.

[Panksepp et al., 2007] J. Panksepp, T. Fuchs, V. A. Garcia, and A. Lesiak. Does Any Aspect of Mind Survive Brain Damage That Typically Leads to a Persistent Vegetative State? Ethical Considerations. *Philosophy, Ethics, and Medical Humanities* 2: 32, 2007. Available at http://www.peh-med.com/content/2/1/32/.

[Parfit, 1986] D.Parfit. *Reasons and Persons*. Oxford: Oxford University Press, 1986.

[Pearson et al., 1995] I. Y. Pearson, P. Bazeley, T. Spencer-Plane, et al. 1995. A Survey of Families of Brain-Dead Patients: Their Experiences and Attitudes to Organ Donation and Transplantation. *Anaesthesia and Intensive Care* 23 (1): 88-95, 1995.

[Pernick, 1999] M. S. Pernick. Brain Death in a Cultural Context, in Youngner, Arnold, and Schapiro (eds.), *The Definition of Death*. Baltimore: Johns Hopkins University Press, pp. 3-33, 1999.

[Potts et al., 2000] M. Potts, P. A. Byrne, and R. Nilges, eds. *Beyond Brain Death: The Case Against Brain Based Criteria for Human Death*. Dordrecht: Kluwer, 2000.

[Powner and Bernstein, 2003] D. J. Powner and I. M. Bernstein. Extended Somatic Support for Pregnant Women After Brain Death. *Critical Care Medicine* 31 (4): 1241-1249, 2003.

[President's Commission, 1981] President's Commission for the Study of Ethical Problems in Medicine and Biomedical and Behavioral Research. *Defining Death: Medical, Ethical, and Legal Issues in the Determination of Death*. Washington: U. S. Government Printing Office, 1981.

[President's Council, 2008] . President's Council on Bioethics. *Controversies in the Determination of Death*. Washington, D. C.: U. S. Government Printing Office, 2008. www.bioethics. gov.

[Puccetti, 1988] R. Puccetti. Does Anyone Survive Neocortical Death? in Zaner (ed.), *Death: Beyond Whole-Brain Criteria*. Dordrecht: Kluwer, pp. 75-90, 1988.

[Putnam, 1980] H. Putnam. Brains and Behavior, in Block (ed.), *Readings in Philosophy of Psychology*, Vol. 1. Cambridge: Harvard University Press, pp. 24-36, 1980.

[Quay, 1993] P. M. Quay. The Hazards of Brain-Death Statutes. *Ethics and Medics* 18: 6, 1993.

[Rothstein, 2000] T. L. Rothstein. The Role of Evoked Potentials in Anoxic-Ischemic Coma and Severe Brain Trauma. *Journal of Clinical Neurophysiology* 17 (5): 486-497, 2000.

[Savaria et al., 1990] D. T. Savaria, M. A. Rovell, and R. T. Schweizer. Donor Family Surveys Provide Useful Information for Organ Procurement. *Transplantation Proceedings* 2: 316-17, 1990.

[Seifert, 1993] J. Seifert. Is 'Brain Death' Actually Death? *The Monist* 76 (2): 175-202, 1993.

[Shewmon, 1988] D. A. Shewmon. Anencephaly: Selected Medical Aspects. *Hastings Center Report* 18: 11-18, 1988.

[Shewmon, 1997] D. A. Shewmon. Recovery from 'Brain Death': A Neurologist's Apologia. *Linacre Quarterly* 64 (1): 31-96, 1997.

[Shewmon, 1998a] D. A. Shewmon. Chronic 'Brain Death': Meta-analysis and Conceptual Consequences. *Neurology* 51 (6): 1538-1545, 1998.

[Shewmon, 1998b] D. A. Shewmon. 'Brainstem Death,' 'Brain Death,' and Death: A Critical Reevaluation of the Purported Evidence. *Issues in Law and Medicine* 14 (2): 125-146, 1998.

[Shewmon, 2004a] D. A. Shewmon. The 'Critical Organ' for the 'Organism as a Whole': Lessons from the Lowly Spinal Cord, in Machado and Shewmon (eds.), *Brain Death and Disorders of Consciousness*. New York: Kluwer, pp. 23-41, 2004.

[Shewmon, 2004b] D. A. Shewmon. The ABC of PVS: Problems of Definition, in Machado and Shewmon (eds.), *Brain Death and Disorders of Consciousness*. New York: Kluwer, pp. 215-228, 2004.

[Shewmon, 2007] D. A. Shewmon. Transcripts (November 9, 2007): Session 5: Response to the White Paper of the President's Council for Bioethics, *Controversies in the Determination of Death*. http://www.bioethics.gov/transcripts/nov07/session5.html.

[Shewmon et al., 1999] D. A. Shewmon, G. L. Holmes, and P. A. Byrne. Consciousness in Congenitally Decorticate Children: "Developmental Vegetative State" as Self-fulfilling Prophecy. *Developmental Medicine and Child Neurology* 41: 364-374, 1999.

[Shinnar and Arras, 1989] S. Shinar, S. and J. Arras. Ethical Issues in the Use of Anencephalic Infants as Organ Donors. *Neurologic Clinics* 7 (4): 729-743, 1989.

[Snowdon, 1990] P. F. Snowdon. Person, Animals, and Ourselves, in Gill (ed.), *The Person and the Human Mind: Issues in Ancient and Modern Philosophy*. Oxford: Clarendon Press, pp. 83-107, 1990.

[Strawson, 1994] G. Strawson. *Mental Reality*. Cambridge: MIT Press, 1994.

[Strawson, (1958) 1991] P. F. Strawson. Persons, in Feigl, Scriven, and Maxwell (eds.), *Minnesota Studies in the Philosophy of Science*, Vol. 2. Minneapolis: University of Minnesota Press, pp. 330-353,

[1958,] 1991. Reprinted in Rosenthal (ed.), *The Nature of Mind*. New York: Oxford University Press, 1991.

[Strawson, 1959] P. F. Strawson. *Individuals*. London: Methuen, 1959.

[Taylor, 1997] R. M. Taylor. Re-examining the Definition and Criteria of Death. *Seminars in Neurology* 17: 265-270, 1997.

[Truog, 1997] R. D. Truog. Is it Time to Abandon Brain Death? *Hastings Center Report* 27 (1): 29-37, 1997.

[Veatch, 1972] R. M. Veatch. Brain Death: Welcome Definition ... or Dangerous Judgment? *Hastings Center Report* 2 (5): 11-13, 1972.

[Veatch, 1975] R. M. Veatch. The Whole-Brain Oriented Concept of Death: An Outmoded Philosophical Formulation. *Journal of Thanatology* 3 (1): 13-30, 1975.

[Veatch, 1982] R. M. Veatch. Maternal Brain Death: An Ethicist's Thoughts. *Journal of the American Medical Association* 248: 1102-1103, 1982.

[Veatch, 1988] R. M. Veatch. Whole-Brain, Neocortical, and Higher Brain Related Concepts, in Zaner (ed.), *Death: Beyond Whole-Brain Criteria*. Dordrecht: Kluwer, pp. 171-186, 1988.

[Veatch, 1992] R. M. Veatch. Brain Death and Slippery Slopes. *The Journal of Clinical Ethics* 3 (3): 181-87, 1992.

[Veatch, 1993] R. M. Veatch. The Impending Collapse of the Whole-Brain Definition of Death. *Hastings Center Report* 23 (4): 18-24, 1993.

[Veatch, 1999] R. M. Veatch. The Conscience Clause: How Much Individual Choice in Defining Death Can Our Society Tolerate? in Youngner, Arnold, and Schapiro (eds.), *The Definition of Death: Contemporary Controversies*. Baltimore: Johns Hopkins University Press, pp. 137-160, 1999.

[Wallace, 1995] W. A. Wallace. St. Thomas on the Beginning and Ending of Human Life, in Vari (ed.), *Sanctus Thomas de Aquino Doctor Hodiernae Humanitatis. Studi Tomistici, Vol. 58*. Vatican City: Libreria Editrice Vaticana, pp. 394-407, 1995. `http://www.nd.edu/Departments/Maritain/ti/wallace3.htm`.

[Walton, 1980] D. Walton. *Brain Death: Ethical Considerations*. West Lafayette, IN: Purdue University Press, 1980.

[Wiggins, 1980] D. Wiggins. *Sameness and Substance*. Cambridge: Harvard University Press, 1980.

[Wiggins, 1987] D. Wiggins. The Person as Object of Science, as Subject of Experience, and as the Locus of Value, in Peacocke and Gillett (eds.), *Persons and Personality: A Contemporary Inquiry*. Oxford: Oxford University Press, 1987.

[Wijdicks, 2001a] E. F. M. Wijdicks. *Brain Death*. Philadelphia: Lippincott, Williams & Wilkins, 2001.

[Wijdicks, 2001b] E. F. M. Wijdicks. The Diagnosis of Brain Death. *New England Journal of Medicine* 344 (16): 1215-1221, 2001.

[Wikler, 1995] D. Wikler. Who Defines Death? Medical, Legal and Philosophical Perspectives, in Machado (ed.), *Brain Death: Proceedings of the Second International Symposium on Brain Death*. Amsterdam: Elsevier, pp. 13-22, 1995.

[Wittgenstein, 1953] L. Wittgenstein. *Philosophical Investigations*, trans. G. E. M. Anscombe. Oxford: Blackwell, 1953.

[Youngner, 1992] S. J. Youngner. Defining Death: A Superficial and Fragile Consensus. *Archives of Neurology* 49: 570-572, 1992.

[Youngner and Barlett, 1983] S. J. Younger and E. Bartlett. Human Death and High Technology: The Failure of the Whole-Brain Formulations. *Annals of Internal Medicine* 99 (2): 252-58, 1983.

[Youngner et al., 1985] S. J. Youngner, M. Allen, E. Bartlett, H. F. Cascorbi, T. Hau, D. L. Jackson, M. B. Mahowald, and B. J. Martin. Psychosocial and Ethical Implications of Organ Retrieval. *New England Journal of Medicine* 313 (5): 321-324, 1985.

[Youngner et al., 1989] S. J. Youngner, S. Landefeld, C. J. Coulton, B. W. Juknialis, and M. Leary. Brain Death and Organ Retrieval: A Cross Sectional Survey of Knowledge and Concepts among Health Professionals. *Journal of the American Medical Association* 261 (15): 2205-2210, 1989.

[Zaner, 1988] R. M. Zaner (ed.). *Death: Beyond Whole-Brain Criteria*. Dordrecht: Kluwer, 1988.

NURSING SCIENCE

Mark Risjord

1 PHILOSOPHICAL ISSUES IN NURSING SCIENCE

The field of nursing science encompasses the full range of phenomena encountered by nurses. Practicing nurses must manage health issues that focus not only on the patient, but those that focus on the family and broader society. Nurses also have a primary role in patient and family health education. Research into these issues has contributed to our understanding of the emotional response to painful stimuli, aggression and agitation in Alzheimer's patients, urinary incontinence in women, and domestic violence. This research has led to widely used innovations in patient care, such as talking through a painful procedure to reduce distress or the elimination of patient restraints in dementia care. In addition to investigating these issues, nurses have examined themselves, looking at nurse experiences, nurse-patient relationships, and nursing administration. Nursing research thus integrates the biological, psychological, and social levels of scientific inquiry, and nurse scholars have had significant, wide-ranging influence on health care and the health sciences.[1]

Research by, for, and about nurses is a late twentieth century phenomenon, and as they were creating a new field, nurse scholars encountered important philosophical issues. Does nursing science need a distinct kind of theory or a characteristic methodology? If it is to be an independent domain of research, does it need a unique object of study? What is the relationship between nursing theory and nursing practice? As nurse scholars wrote about these issues, they drew on philosophical writing about science. Developments in the philosophy of science have thus influenced nurse scientists' conceptions of their discipline, its goals, and its methodology. It is unfortunate that philosophers of science have been largely unaware of nursing research, because the breadth of nursing phenomena makes it a unique scientific research tradition. This essay will examine both the ways in which philosophical views have influenced nursing science, and ways in which reflection on nursing research might contribute to the philosophy of science.

The philosophical issues about the character of nursing science can be roughly divided into problems of *unity* and problems of *structure*. The problems of unity ask what makes a kind of inquiry *nursing* science. In the discussion below it will become clear that both epistemic issues and social pressures made the problems

[1]For an overview of nursing contributions to the health sciences, see Donaldson [2000].

Handbook of the Philosophy of Science. Volume 16: Philosophy of Medicine.
Volume editor: Fred Gifford. General editors: Dov M. Gabbay, Paul Thagard and John Woods.

of unity vivid for nurses. Epistemologically, nursing science investigates a broad range of phenomena, and it is not obvious why these phenomena should be studied together in a single discipline. What is the distinctive contribution of nursing research? Does nursing science have a special object of knowledge? Does it discover unique laws of health? Socially, nurses compete for scarce institutional resources. The justification of graduate programs and research grants requires nurses to explain what contribution their research will make, and how their contribution differs from the other health sciences.

The problems of structure ask about the different kinds of nursing research and how are they are related. For example, how is research based on social scientific methods related to research based on natural scientific methods? To what extent is it appropriate to borrow theory from other disciplines, and to what extent does nursing theory need to be unique? And, what is the relationship between nursing theory and nursing practice? The problems of knowledge structure and the problems of the unity of nursing knowledge are closely related, and nurse scholars do not discuss the two issues separately. Rather, the broad issues of unity and structure are woven through several more specific debates that have occupied nurse scholars. The sections below will track four of these debates as they developed in the history of nursing research.

The first debate concerns the relative importance of theory borrowed from other disciplines. If nursing is to be a legitimate discipline, must it have its own theories? How should the theories developed within nursing be related to those developed in other fields? Anxiety about this issue arises, at least in part, from the political process of establishing a new academic discipline. To procure funding for programs and research, a case has to be made that the research is new and promising. If nursing relied too heavily on theory borrowed from other disciplines, funding agencies and institutional administrators would wonder why the research is being done in a nursing school, rather than the medical school or school of public health. The questions also have deeper epistemic ramifications. What is the place of nursing knowledge in the overall scheme of human understanding? Is it a basic science, like physics or sociology? Is it an applied science, or perhaps a variety of clinical research?

Many nurse researchers today would say that nursing is a basic science, and this raises a second philosophical issue that nurse scientists have debated: How are nursing theories related to one another? It is common for nurses to think of nursing theories as arranged in a hierarchy, typically called "meta-theory," "grand theory," "middle-range theory," and "micro-range theory" (e.g. [Higgins and Moore, 2000]). This hierarchical conception of theory is strongly reminiscent of the received view of theories, and we will see below that it is indeed the intellectual progeny of logical positivism. Logical positivist views dominated the philosophy of science during nursing science's formative years. It is no surprise that positivist views of science structured nurses' understanding of what it meant to be scientific. In the nineteen eighties, nurse scholars became aware of the demise of logical positivism in the philosophy science. The recent history of philosophical discussion among nursing

scientists has been an attempt to come to grips with "post-positivist" notions of science, and to understand their consequences for nursing.

Applying the received view of theory was a special challenge for nursing because nursing is, in the first instance, a practical discipline. Nursing science must be related to nursing practice, and a number of philosophical problems arise from the struggle to both be scientific and practical. This raises the third set of philosophical issues. Various authors, e.g. Dickoff and James [1968] or Collins and Fielder [1981], have argued that nursing knowledge requires a special kind of theory. Because the special needs of nursing arise from its relation to practice, this sort of theory is sometimes called a "practice theory." Standing behind the call for practice theory is the recognition that professional nurses expect theory to generate prescriptions for practice. If a theory is to entail policy recommendations, it must presuppose some values or goals, such as the value of patient wellbeing. The larger question here concerns the relationship of science to values. Are nursing values external to nursing theory, making the latter neutral and value free? If not, then how are values to be integrated into nursing theory without sacrificing objectivity?

The fourth structural issue discussed by nurse scholars concerns the relationship among different kinds of research methods. In the nineteen eighties, methods drawn from the social sciences, such as interviews, focus groups, and participant observation, became popular in nursing research. These methods did not conform to the conception of scientific research that nursing had inherited from logical positivism. After substantial debate, nurse scholars ultimately proclaimed that there were two "paradigms" of nursing knowledge, qualitative and quantitative. Some researchers have insisted that these two domains of nursing knowledge ought to be independent; others have seen them as integrated. The issue, like the others just canvassed, has a long history in the philosophical literature. In the philosophy of social science, it has been framed as the question of whether or not the social sciences should be modeled on the natural sciences. Nursing research spans the domains traditionally associated with the natural and the social sciences. Philosophical discussion about the relationship between the natural and the social sciences is thus directly relevant to the debate surrounding qualitative and quantitative methods, as well as to the questions about the structure and unity of nursing knowledge.

The four debates unfolded as the discipline of nursing grew, and this essay will present them in their historical and dialectical context. In the early years of nursing research (roughly the nineteen fifties and sixties), questions about the relative importance of borrowed and unique theory and about the structure of nursing knowledge were especially prominent. In the nineteen sixties and seventies, some important views about the relationship of practice to theory were articulated. Qualitative research became important in the nineteen eighties, and arguments about the relationship between qualitative and quantitative methods were prominent. In the late nineteen seventies and early eighties a consensus emerged that continues to dominate the meta-theory of nursing science. Research in nursing has not always followed the tracks laid by nursing's philosophers. Because scientific

practice and the philosophy of science are independent, continuing empirical research has challenged the dominant philosophical narrative. The final sections of this essay will reflect on some of these challenges and the philosophical direction they indicate.

2 NURSING PRACTICE AND THE ORIGINS OF NURSING KNOWLEDGE

Florence Nightingale is a central figure in the history of nursing. By creating a secular, professional role for nurses, she set the framework for modern nursing practice. She also was the first to conceptualize nursing's intellectual domain. *Notes on Nursing: What it is and What it is Not* [Nightingale, 1969 / 1860] is the seminal work in nursing theory because it established a domain of nursing concern that was independent of the physician's domain. Specifically, she oriented nurses toward the environment of the patients, everything from the condition of their bandages to the layout of their sickrooms. Viewed from the perspective of modern scientific disciplines, many of Nightingale's specific concerns look like hygiene and public health issues. It must be remembered, however, that Nightingale was working near the dawn of the germ theory of disease. She rejected the idea that disease might be caused by infectious agents, preferring the notion that the diseased state of humans sometimes arose directly from their environmental conditions [Nightingale, 1969 / 1860, pp. 32-34]. While her preferred theory was ultimately unsuccessful, the practical interventions she recommended were effective. The success of her ideas helped establish nursing's intellectual legitimacy. As a result of her work, nursing had a range of concerns that fell outside of the physician's domain. Moreover, nursing addressed aspects of health that fell squarely within a women's expertise.

While Nightingale is rightly regarded as an important figure in the emancipation of women, her formulation of the role of nurses drew heavily on nineteenth century conceptions of gender. In the Conclusion to *Notes on Nursing*, Nightingale considered the objection that educating women as nurses will lead to "amateur physicking" [Nightingale, 1969/1860, p. 130]. She responded that

> ... to cultivate in things pertaining to health observation and experience in women who are mothers, governesses or nurses, is just the way to do away with amateur physicking, and if the doctors did not know it, to make the nurses obedient to them, — helps to them instead of hindrances. [Nightingale, 1969/1860, p. 132]

The theoretical part of medicine, including, diagnosis, prescription and surgical interventions, was left to men. The practical issues of patient care were within the traditional female sphere. Nightingale's contribution was to portray this sphere as a legitimate domain of knowledge and to argue that educating a professional class who ministered in this domain was conducive to better health care.[2]

[2]Hobbes [1997] provides a very good intellectual biography of Florence Nightingale.

During the next hundred years, the profession of nursing was nurtured in military and civilian hospitals, clinics, public health institutions, and private homes. Nurses proved themselves valuable for both patient care and for the administration of many hospital functions. While nursing required specialized knowledge and nurse education came to be increasingly important, there was little or no research within the profession during the late nineteenth and early twentieth centuries. During this period, scientific essays in nursing journals were often written by non-nurses (typically doctors) with the intention of explaining some useful fact or theory. There was little or no research that focused on or arose from nursing itself.

Nursing research arose in the nineteen fifties, and it developed in response to several pressures. Most important, perhaps, was the movement of nurse training from hospital-based apprenticeships to diploma-granting institutions of higher education. The Goldmark Report [Committee for the Study of Nursing Education, 1923] and the Brown Report [Brown, 1948] both recommended university-based training for nurses. Training within institutions of higher education required nursing faculty and a curriculum for them to teach. Interest and funding by the U.S. government was a second factor that helped promote nursing research. During World War II, American government agencies gathered data on the availability and need for nurses. In 1948, the U.S. Public Health Service created a Division of Nursing Resources. This began a project of research on the education of nurses, on their job satisfaction and turn over, and on nursing functions and activities [Gortner, 2000, p. 61]. Beginning with small grants from the Division of Nursing Resources, which eventually developed into the National Institute for Nursing Research, funds gradually became available for nursing research. In 1952, the journal *Nursing Research* was established, marking the beginning of a self-conscious research enterprise in the nursing profession.

3 EARLY NURSING RESEARCH

The first wave of nursing research fell, broadly, into three categories. The bulk of the work published in *Nursing Research* during its early years continued the tradition of examining nurse education, roles, and job responsibilities. This literature was sociologically oriented and was strongly influenced by mid-century trends in sociology. Gradually, however, studies began to appear that either examined the effectiveness of nursing interventions or proposed a useful way of approaching a nursing problem. By the late 1960s, this second kind of research had an established place in the literature, and it continues to fill the pages of nursing journals. Finally, there were systematic treatises on nursing. Hildegard Peplau's *Interpersonal Relations in Nursing* [1952], Ida Jean Orlando's *The Dynamic Nurse — Patient Relationship: Function, Process, and Principles* [1961], and Virginia Henderson's *The Nature of Nursing* [1966] were among the first of these. These books had several aims. Primarily, they provided an analysis of nurse–patient (and sometimes nurse–family or nurse–nurse) interactions. They divided the pro-

cess of nursing into stages and articulated the roles distinctive of nursing. This conceptual framework was intended to facilitate nursing practice and education. The conceptualization of the nursing process was a valuable aid to making explicit nursing problems and their solution. Finally, these works tried to establish what was special, important, or essential to nursing. They aimed to provide a rationale for the existence of the nursing profession.

During the early years of nursing scholarship, questions about the unity of the nursing discipline became vivid in the literature. Prior to the nineteen fifties, writing by, for, and about nurses had been closely related to the practicalities of patient care or nursing administration. Nurses had a relatively well-defined set of responsibilities, and the nascent discipline of nursing was defined in relation to the issues and challenges that arose from this role. By the nineteen-fifties, however, nurse scholars had become dissatisfied with the idea of a discipline that depended on a socially-defined professional role. Two influential essays during this period were Dorothy Johnson's "A Philosophy of Nursing" [1959] and Rozella Schlotfeld's "Reflections on Nursing Research" [1960]. Both essays began by voicing concerns about the professional role of the nurse. They thought that nurses ought to be direct caregivers. Changes in the profession were putting more nurses in managerial positions and giving care responsibilities to non-nurses. In their essays, Johnson and Schlotfeld were looking for intellectual grounds on which to resist this change in the profession. Up to that point, the research program of nursing had largely been defined by the professional role of the nurse. That role, however, was now being contested, and Johnson and Schlotfeld were looking for grounds on which to justify some changes and resist others. Hence, they needed a conception of nursing knowledge or nursing research that did not depend so heavily on the socially defined role of nurses. Johnson and Schlotfeld thus argued that nursing research and theory should take priority over nursing practice.

Johnson's and Schlotfeld's stance on the relation of theory to practice raised important questions about theory. Johnson's call for a philosophy of nursing was a call for nurses to think about the foundations of their research discipline, and the question of unity was central. It also highlighted some important structural issues in nursing knowledge. In particular, it raised the question of whether nursing should develop theories borrowed from other disciplines, or whether it should have its own, unique body of theory. Johnson and others argued that nursing practice required a theoretical foundation that was specific to its needs (e.g. [Wald and Leonard, 1964; Dickoff and James, 1968; Dickoff, et al., 1968a; Johnson, 1968]). While this later came to be the dominant viewpoint (for reasons to be explored below), there was early opposition. Laurie Gunter [1962] was one of the first to argue that practicing nurses needed sound science on which to base their activities. Hence, nursing research should draw on theories from sociology, psychology, physiology, and pathology. Sensitive to the political need for a body of research unique to nursing, she wrote that "These theories alone will not be unique [to nursing], but the contribution and the special aspects stressed for each will be unique to nursing in such a manner as to distinguish it [nursing] from other functions"

[Gunter, 1962, p. 6]. Rosemary Ellis [1968] developed this idea by suggesting criteria with which to evaluate theories drawn from other scientific domains. The unique circumstances of nursing would require that these theories be developed and modified. Because nursing practice required biological, psychological, and social knowledge, and theories from different domains would have to be combined. While the theories would be drawn from other disciplines, the needs of nursing practice would demand that nurses make these theories their own.

During this first generation of nursing research, the discipline was also under institutional pressure to be "scientific." Nursing, after all, was part of the health sciences, and its research contribution ought to make some difference to our understanding of human health. Logical positivism played an important role in framing nursing's approach to philosophical questions about their science. The nursing literature in the nineteen sixties and seventies was sprinkled with references to Carl Hempel, Hans Reichenbach, Herbert Feigl, and Ernest Nagel. The logical positivists emphasized the importance of theory in science, and their concept of theory required law-like generalizations that entailed testable hypotheses. The work of the logical positivists provided four grounds on which different domains of science were distinguished. The different domains of science (1) generalized over a distinct range of observations and (2) used distinct theoretical vocabularies to explain and unify the observed regularities. Moreover, (3) different sciences might inhabit distinct levels of the hierarchy, the higher level unifying and explaining the regularities of a less general discipline. Finally, the positivists recognized that the generalizations of different sciences might take different forms. For example, biological generalizations often described functional relationships, while disciplines like mechanics use multi-variable equations. Thus, (4) a domain might be distinct because of the logical form of its laws or explanations.

Nurses faced difficulties in applying the logical positivist conception of science to their field. Since professional nursing is a practical enterprise, it was natural for nurses to draw on a variety of social scientific, psychological, and biological theories to facilitate their work. While useful to practicing nurses, the discipline of nursing could not claim such borrowed theories as their own. If there was to be a nursing science — according to the standard philosophical criteria of the nineteen fifties and sixties — it would need to discover the laws that governed its own, unique phenomena. The distinctive phenomena of nursing, however, were primarily nurse-patient interactions. The first generation of nursing theorists, such as Hildegard Peplau, Virginia Henderson, Ernestine Wiedenbach, and Dorethea Orem, had focused on the role of the nurse and the relationship between the nurse and the patient. Their work was primarily prescriptive. It analyzed the needs or deficiencies of a patient and how the nurse should identify and respond to them. This work was useful in nursing education, but these writers were not postulating law-like relationships in order to explain observations. Nonetheless, nursing scholarship insisted on treating this work as "theory" in a roughly logical positivist sense. Textbooks in nursing theory, such as Meleis [2007 / 1985], Fawcett [1999 / 1985], or George [1990 / 1980] continue to apply standard criteria for

the evaluation of a theory, including generalizability and generation of testable hypotheses, to the work of these early theorists.[3]

While the logical positivist picture of science did not easily fit the work of the early nurse scholars, treating their work as "theory" in the positivists' sense had several clear benefits to the emerging discipline of nursing. First, it made nursing science analogous to other, well established scientific domains. As nursing schools established PhD programs in the nineteen sixties and seventies, the analogy between nursing and the "basic sciences" helped make the case that nursing scholarship could contribute to the health sciences. Second, if nursing science discovered its own laws of health, it could effectively guide practice within the domain of expertise that Nightingale identified. It would provide the basis for designing effective nursing procedures and it would help identify the proper role of nurses. Finally, treating the early theoretical writings as a science (again, in the logical positivist' image of science) provided unity to the discipline. According to the logical positivists, scientific fields were unified by their theories and the scope of a theory was determined by the natural laws it postulated. Thus, the field of nursing scholarship would be unified and delimited by the most abstract laws it discovered.

4 PRACTICE THEORY

In the nineteen sixties and early seventies, attempts to distinguish nursing theories from theories in other sciences often were discussed under the rubric of "practice theory." While there were some antecedents, e.g. Wald and Leonard [1964], the most sophisticated view of practice theory was developed by James Dickoff and Patricia James in a series of influential essays [1968; 1968a; 1968b]. Dickoff and James were influenced by John Dewey's pragmatism, and were thus somewhat critical of the logical positivist view of science. They made two crucial contributions to the development of nurses' conceptions of research and theory. First, they gave a definition of theory that was less restrictive than the common, positivistic conception. In a definition that became almost canonical among nurse scholars, they defined a theory as "a conceptual system or framework invented to some purpose" [Dickoff and James, 1968, p. 198]. While overly broad and more than a little vague, it permitted them to assimilate a wide range of nursing research activities within the scope of "theory." Dickoff and James identified four levels of theory, and argued that each had its own purposes and criteria of evaluation. The levels were conceptualized as a hierarchy in the sense that each level of theory presupposed and required the levels below it. The lower levels included the development of taxonomies (second-level theories) and causal models (third-level theories). The highest level of theory was a version of practice theory, which they called "situation-producing theory."

[3]These theories and the philosophical issues they raise are discussed further in Section 7, below.

According to Dickoff and James, the purpose of situation-producing theory is to articulate the goals or aims of the profession. Situation-producing theory was therefore *normative* in the sense that it identified what made certain forms of the activity good or excellent. In addition, a situation-producing theory must say how the goals may be reached. This requires the theory to describe and analyze the relevant parts of the practice, and to show how those activities should be organized so as to achieve the goals of the practice. In this way, a practice theory must use causal generalizations that are hypothesized and tested at the lower level. Because situation-producing theory includes values, Dickoff and James's analysis took a position on the issue of how scientific theories should be related to values. The common view among philosophers of science at this time was that science should be value free.[4] Scientific theories should include no values; at most, scientific theories could describe facts that might be useful for policy makers. Dickoff and James recognized that, since nursing research was fundamentally oriented toward practice, this vision of value-free science did not suit the needs of the discipline.

In spite of their differences from positivism, Dickoff and James's understanding of theory shared several commitments with it. Dickoff and James seemed to accept the logical positivist's account of theories as their third level of theorizing. Like the positivists, they seemed to regard observation and description as relatively independent of theory. Moreover, the theories were arranged in a logical and temporal sequence. The higher levels depended on the existence of the lower levels, and the lower levels needed to be established before the higher levels could be fully developed. Finally, like the logical positivists, Dickoff and James regarded disciplines as unified by their theories. Given their hierarchy of theories, it follows that the discipline of nursing is given its unity and identity by the highest levels of theory. Because of these shared commitments, nurse scholars of the late nineteen sixties and early nineteen seventies were able to synthesize Dickoff and James's view of practice theory with a broadly positivist understanding of science.

Perhaps the most important challenge to Dickoff and James's conception of practice theory arose from the way it integrated science and values. In a series of philosophically informed essays, Jan Beckstrand argued that practice theory was nothing more than the conjunction of scientific theorizing and ethics [1978a; 1978b; 1980]. Her main argument was that there were two possible roles for values in practice theory: as an ethics for the profession or as goals for the practice. In the first role, she argued, empirical science is irrelevant. Professional ethics are subject to philosophical discussion, not scientific research. Moreover, the phrase "goals of the practice" is ambiguous. It may refer to either the goals to be obtained or the best means for obtaining them. Again, choice of goals is a strictly evaluative matter to which science has little to contribute. And once the goals were established, value-free scientific inquiry could determine the best way to achieve them. Beckstrand's view of the role of values in science thus followed Hempel's

[4]It should be pointed out, however, that this view had been challenged within the philosophy of science even during the height of positivism. See the discussion in Rudner [1953], Churchman [1956], Jeffrey [1956], and Levi [1960].

analysis [1965]. On this view, science speaks only to issues of instrumental value. Intrinsic values are extra-scientific, and they are established independently of scientific inquiry. Once the goals have been determined (and presumably the criteria for "best means"), empirical research can determine the best means for achieving the ends. According to Beckstrand, then, practice theory was nothing more than the instrumental use of science to achieve the goals of the profession.

One response to Beckstrand's arguments was that it pulled the evaluative and the empirical parts of nursing too far apart. Rosemarie Collins and John Fielder argued [1981] that Beckstrand's segregation of science and values obscured an important aspect of nursing research. The social and moral mandate for nursing lies in its practice. Reflection on the goals of nursing is an important object of nursing research, and Beckstrand appeared to suggest that moral theory alone will dictate the goals of practice. Collins and Fielder argued that reflection on the goals of nursing practice would be sterile without knowledge of the concrete details of nursing practice. Hence, they concluded, practice theory had an important function in nursing. While Collins and Fielder's argument is sound, it proves too little. In any practical ethical reflection, the details of the case are determinative. Therefore, they showed only that decisions require knowledge of both facts and values. Beckstrand's argument against practice theory is consistent with this conclusion. The deeper issue concerns the relationship between ethical inquiry and scientific inquiry. Collins and Fielder did not call Hempel's separation of science and values into question. Dickoff and James' practice theory was an attempt to do so; they tried to create a kind of empirical theory that had normative import. Hence, by leaving the value-freedom of science intact, Collins and Fielder's argument failed to undermine Beckstrand's critique.

Philosophical work on scientific value-freedom has identified a number of possible roles for values within science. It is common to distinguish *contextual* values from *constitutive* values [Longino, 1990]. Contextual values are extra-scientific commitments. If science has constitutive values, on the other hand, commitment to the values is a necessary or integral part of scientific activity. Contextual values, on the other hand, may influence science, but are not necessary to the enterprise. Using this distinction, we might reframe Beckstrand's position as holding that the values arising from the nursing profession play a contextual role in nursing science. Other nurse scholars held that the professional values of nursing functioned to identify the proper topics for nursing research [Johnson, 1974, Donaldson and Crowley, 1978]. Once those topics were identified, however, the scientific investigation proceeded in a value-free way. Therefore, on this model, the professional values of nursing are contextual to nursing research. Are there any constitutive values in nursing research? In some philosophical writing, "constitutive values" have been treated as equivalent to theoretical virtues (simplicity, accuracy, etc.) or other epistemic values. It is arguable, however, that in nursing there are non-epistemic constitutive values. The concept of health, of course, is the keystone of the field, and there is a long tradition of argument purporting to show that the concept of heath is normative [Margolis, 1976; Engelhardt, 1981; Culver and Gert,

1982; Seedhouse, 2001; Nordenfelt, 2007]. [5] The best argument for value-freedom in this area distinguishes between disease and illness, and argues that disease is value-free [Boorse, 1981]. When conceived as the opposite of disease, the argument goes, the concept of health is value free. "Illness," on the other hand, is the emotional and social response to disease, and it is a value laden concept. The concept of health is value laden only insofar as it includes illness. The question of whether the concept of disease is value-neutral can be sidestepped here, because nursing research must be concerned with illness (as Boorse defines it). The focus of nursing concern is on how the patient is responding to the disease, not just the biological malfunctions. Hence, in nursing research about health, the concept of health must be normative. There are, therefore, at least some constitutive values in nursing research.

Patient autonomy is another candidate for a constitutive value of nursing research. In nursing, the commitment to autonomy means more than informed consent or the right to refuse treatment. It is not just the freedom to choose; it is the ability to actualize those choices. At least since the nineteen fifties, if not before, professional nurses have sought to enable and enhance the agency of the patient. Nurses aim to enable the patients to do as much for themselves as they can, given their condition. This is manifest in practices of patient education, rehabilitation, symptom management, and patient management. Understood in this rich sense, patient autonomy is a core commitment of professional nursing that emerges in the nursing research agenda. For example, a number of lines of nursing research form the basis of contemporary care practices for patients with dementia. Work by Neville Strumpf and Lois Evans documented the negative effects of patient restraints.[6] They then went on to review the existing (non-nursing) literature on the use of patient restraints, making the case that elder restrains were not necessary. Their subsequent clinical research laid the empirical groundwork for practices of patient management that have better emotional and cognitive outcomes for the patients. This research was guided throughout by a clear commitment to patient autonomy, and the value did more than focus the research on a particular topic. It led the researchers to interrogate the existing literature in particular ways, and test particular kinds of restraint-free interventions.

The claim that the professional values of nursing play only a contextual role in nursing research cannot be maintained. The concepts mobilized by nurse research are permeated by evaluative commitments. In Williams's sense, they are "thick" moral concepts, having both evaluative and descriptive dimensions to their meaning [Williams, 1985, p. 140]. And, as the example about dementia care shows, the professional values also influence the way the questions are framed and the kinds of information sought to answer them. Nursing science, then, seems to be a kind of inquiry that has constitutive, non-epistemic values.

[5]For a full discussion of this issue, see the Chapter by Christopher Boorse, *infra*.

[6]This description of the research is drawn from [Donaldson, 2000, p. 528-529]

5 PATTERNS OF KNOWING AND THE STRUCTURE OF THE DISCIPLINE

Barbara Carper's "Fundamental Patterns of Knowing in Nursing" [1978] is one of the most influential essays in nursing's epistemological literature. Carper sought to analyze the kinds of knowledge required by practicing nurses, and thereby show how the domain of nursing inquiry should be analyzed. She divided nursing knowledge into "empirics," "ethics," "aesthetics," and "personal knowledge." This classification of nursing knowledge reinscribed two distinctions that practice theory had tried to erase: (1) Carper, like Beckstrand, separated ethical knowledge from empirical knowledge, and (2) she distinguished theoretical knowledge from practical knowledge.

"Empirics" is the empirical science of nursing. Influenced by the prevailing logical positivist view of science, Carper conceived of empirics in terms of laws, predictions, and causal explanations. By identifying ethics and empirics as distinct patterns of knowing, she was implicitly rejecting the arguments for practice theory. Carper agreed that a practicing nurse needs to know both ethics and science, but she regarded these as independent kinds of knowledge. Nursing knowledge, then, should be partitioned into nursing science and nursing ethics. On this point, her view is criticizable on the grounds canvassed at the end of Section 4.

With respect to the distinction between theoretical and practical knowledge, practice theorists had supposed that the practical needs of nurses demanded a special kind of theory. Carper's analysis undermined this commitment as well. The last two categories, aesthetics and personal knowledge, are both kinds of practical knowledge. The key elements of the aesthetic component in nursing are that it is particular, rather than general, that it is holistic in the sense of understanding particulars in relation to each other, that it involves empathy, and that it resists discursive formulation. Finally, personal knowledge is a kind of self awareness that concerns the relationship of self to other. These features distinguish aesthetics and practical knowledge from the law-like generalizations of empirics. They are forms of "knowing how" and are not theoretical. On Carper's analysis then, the practical ability of a nurse to respond to individual patients is not something that needs a special kind of theory.

Carper's essay was philosophically important because it provided a direct answer to the question of how nursing knowledge is to be structured. She analyzed nursing knowledge into fundamental components, and she provided a picture of how they were to be related. While Carper's essay was primarily an analysis of the knowledge of practicing nurses, it was quickly used as an analysis of the various research programs to be associated with nursing. Maeona Jacobs-Kramer and Peggy Chinn developed Carper's four patterns into a full model of how nursing theory was to be developed, communicated, and evaluated [Jacobs-Kramer and Chinn, 1988, Chinn and Kramer, 1999 / 1983]. Each of the four patterns had its own form of expression and criteria for evaluation. In a recent essay, several prominent nursing theorists suggested that each of the four patterns was based on its own

kind of "evidence" [Fawcett, *et al.*, 2001]. However, these extensions of Carper's analysis are philosophically problematic. Carper herself warned that the Kramer and Chinn extension of her analysis inappropriately treated ethics, aesthetics, and personal knowledge as too much like empirical science [Carper, 1988]. The "art" of nursing, captured by the aesthetic pattern, was supposed to resist theoretical articulation. Moreover, if aesthetics and personal knowledge are forms of knowing how, then it is a category mistake to identify *theories* that encompass this knowledge, or to look for the evidence on which such theories are based [Edwards, 2001, pp. 44f, Paley, 2006].

In the same year that Carper published her seminal essay, another equally influential essay emerged: Sue Donaldson and Dorothy Crowley's "The Discipline of Nursing" [1978]. Like Dickoff and James, they were concerned with the fact that nursing theory had a deep relationship to the professional role of nurses. Rather than focusing on issues of how nursing knowledge should be structured, however, they turned to the question of how a *discipline* should be structured. A discipline, they argued, was a body of knowledge oriented toward particular interests and framed by a related set of concepts. They suggested three themes that were distinctive of the discipline of nursing [Donaldson and Crowley, 1978, p. 113]:

1. Concern with the principles and laws that govern the life processes, well-being, and optimum functioning of human beings — sick or well.

2. Concern with the patterning of human behavior in interaction with the environment in critical life situations.

3. Concern with the processes by which positive changes in health status are affected.

These concerns were specific to the discipline of nursing because of the values implicit in the professional role: "the discipline is defined by social relevance and value orientation, rather than empirical truths" [Donaldson and Crowley, 1978, p. 118]. Donaldson and Crowley thus used the professional practice of nursing to help answer the question of how the discipline of nursing is unified. Yet, while practice helped unify the discipline, it did not define the limits of the discipline. Donaldson and Crowley gave several arguments to support the idea that "the discipline of nursing should be *governing* clinical practice rather than being defined by it" [Donaldson and Crowley, 1978, p. 118]. First, by 1978, there were nurses writing on nursing history, nursing ethics, and nursing philosophy, in addition to the more practical matters of client interventions and nurse management. The discipline thus had a broad scope, and it was plausible to think that more comprehensive, disciplinary knowledge could be applied to more specific, practical nursing problems. Moreover, as Carper emphasized, nursing practice required attention to the particular client. Yet, the particular competencies required for clinical practice presuppose and draw on a broad understanding of health. Therefore, Donaldson and Crowley conclude, the discipline needs to direct practice, not *vice versa*.

The essays by Carper and by Donaldson and Crowley were profoundly important for nursing. Both essays were quickly accepted and widely cited. They were the seeds around which a consensus about nursing knowledge crystallized.[7] That consensus had the following elements:

1. The knowledge required by professional nurses is properly analyzed by Carper's four patterns, and the knowledge base of the discipline should reflect these four patterns.

2. Nursing inquiry is unified by a related set of topics (Donaldson and Crowley's three themes).

3. Nursing knowledge is hierarchically organized, with the metaparadigm at the highest level of abstraction, followed by grand theory, midrange theory, and finally applications (or "micro-range theory").

4. While the ethical and social mandate of nursing set the goals for the discipline, the discipline of nursing governs the practice of the nursing profession.

These basic commitments remain the dominant epistemological view within the discipline of nursing. The consensus was solidified by the publication of several textbooks on how to create nursing theory. While their presentations have evolved in the light of developments to be discussed below, recent editions continue to affirm the outline of the consensus achieved in the early nineteen eighties (cf. [Chinn and Kramer, 1999/1983; Fawcett, 1999/1985; Walker and Avant, 2005/1983; Meleis, 2007/1985]).

While the consensus view of nursing science continued to dominate philosophical thinking by nurse scholars, subsequent developments in nursing scholarship have exposed deep stresses and fault lines. Three developments are especially interesting from the point of view of the philosophy of science. First, research involving interviews, participant observation, and focus groups became popular in the nineteen eighties. These methods and their results were difficult to fit within the positivist model of science that many nurse scholars had adopted, and the issues resonated both with the philosophical critique of positivism and with longstanding debates in the philosophy of the social sciences. The nursing assimilation of and contributions to these issues is the topic of Section 6. The second challenge comes from the rise of middle-range theory. Abstract and general theories, so-called "grand theory," dominated nursing research in the nineteen seventies and early eighties, when the current consensus was formed. In the nineteen nineties, research developing grand theory was gradually eclipsed by research developing middle-range theory. These theories are often drawn from other disciplines, such as sociology, psychology, or physiology. They are more easily tested and applied than the grand theory. As we will see in Section 7, middle-range theory presents challenges to both the structure and unity of nursing science. Finally, the evidence-based medicine

[7]Jacqueline Fawcett's early meta-theoretical essays (e.g., [1978; 1983; 1984]) nicely articulate the consensus that formed during this period.

movement reached nursing in the nineteen nineties. The program's demand for a clear relationship between research and practice resonated with existing concerns among nurses, but the emphasis on clinical trials conflicted with nursing's embrace of qualitative research. As we will see in Section 8, below, it also threatens the consensus conception of a nurse's practical knowledge and its relation to nursing research.

6 QUALITATIVE RESEARCH AND THE PROBLEM OF TRIANGULATION

In the nineteen eighties there was a rapid expansion of research that relied on interviews, focus groups, and participant observation — what nurses called "qualitative" research, in opposition to "quantitative" research.[8] These methods were quite different from those sanctioned by standard philosophical views of science. Their quick adoption within nursing scholarship was the result of philosophical developments both inside and outside of nursing that created a space for the new methods.

From within nursing, the important developments had their source in Patricia Benner's *From Novice to Expert* [1984]. Benner argued that excellence in nursing was a practical skill that could not be expressed or described by a set of rules. Her arguments were strongly influenced by Hubert Dreyfus' readings of Heidegger [Dreyfus, 1979], and his application of those ideas to problems of skill acquisition [Dreyfus and Dreyfus, 1980]. Her work resonated strongly with Carper's aesthetic and personal patterns of knowing, and it gave a deeper philosophical basis for these aspects of nursing knowledge. She also drew important methodological conclusions. Because nursing practice could not be adequately described by natural laws, theories modeled on the natural sciences (especially as those theories had been conceptualized by logical positivism) would not be relevant. The best way to study nursing, Benner argued, did not involve the postulation of laws or natural regularities. Hence, the study of excellence in nursing (and by extension, any aspects of nursing that involved intentional action) should not use methods based on measurement or hypothesis testing. Rather, nursing should use participant observation and interviews; nursing methods should be "phenomenological"[9] rather than positivistic or quantitative.

Outside of nursing, the received view of theories was crumbling, and the echoes of its fall were heard in nursing. Thomas Kuhn's *Structure of Scientific Revolutions*

[8]This pair of terms is problematic in many ways. The terms will be used here because nurse scholars have used them to draw distinctions among their methodological and philosophical commitments.

[9]The term "phenomenology" is often used within the nursing methodological literature. It is partly the result of Benner's use of Heideggerian ideas to support her position. Also, the word was already used in education studies and sociology to characterize a methodology that relied on interviews, and participant observation. The relationship between these various methods and the eponymous philosophical movement are complicated; for a detailed and comprehensive discussion, see Outhwaite [2007]. For the sake of consistency, this essay will use "qualitative."

[Kuhn, 1970 / 1962] and Larry Laudan's *Progress and its Problems* [1977] were commonly cited in the nursing literature of the nineteen eighties. Jean Watson was among the first in nursing to recognize the critique of positivism and notice its consequences. In "Nursing's Scientific Quest" [1981], she bemoaned the failure of nursing science. Not only had adherence to a natural-scientific model of research yielded few results, it had caused nursing to lose sight of its leaders'...

> call for research aimed fundamentally at the solution of human health problems. Such leaders as Nightingale, Henderson, Krueter, and Hall were advocates of an integrated approach to scientific study that would capitalize on nursing's richness and complexity, not separate practice from research, the art from science, the "doing" of nursing from the "knowing," the psychological from the physical, and theory from clinical care. [Watson, 1981, p. 413]

What nursing needed was exactly the kind of science that seemed to be emerging from the critique of the received view in philosophy, a science that rejected the positivist model of objectivity, personal detachment, and value-freedom. Watson's view was developed by other nurse scholars who argued that a "post-positivist" philosophy of science was a good fit for nursing [Tinkle and Beaton, 1983, Silva and Rothbart, 1984, Moccia, 1988, Kim, 1989]. To many nurse researchers in the late nineteen seventies and early eighties, qualitative research seemed to be exactly the new form of science for which Watson was calling. Qualitative research was thus said to be subjective, rather than objective, value-laden rather than value-free, engaged rather than detached, and so on. The nice fit between qualitative methodology and nursing practice promised a form of nursing theory that would be more congruent with the goals and practices of nursing than research modeled on the natural sciences [Leininger, 1985; Duffy, 1986; 1987; Moccia, 1988].

While they recognized that qualitative research ran contrary to the spirit of positivism, the early proponents of qualitative research regarded qualitative and quantitative research as consistent and complementary. They argued that there were clear advantages to qualitative methods. Interviews and participant observation exposed layers of meaning and significance that were invisible to survey or psychometric instruments, thus capturing the richness of nursing phenomena [Klenow, 1981; Swanson and Chenitz, 1982; Patton, 1990/1980]. Qualitative methods were also useful for preliminary research. Survey or psychometric instruments required the researcher to have already conceptualized the domain. If hypotheses were to be formed and tested, the researcher must already have a theory. Qualitative methods allowed the researcher to learn about a new field and form tentative theoretical constructs. Both of these ideas were reiterated by later writers [Duffy, 1987; Sohier, 1988; Morse, 1991] and became part of the common wisdom about qualitative research. Neither of these rationales for using qualitative methods conflicted with the use of quantitative methods. Indeed, when justified in this way, the methods are clearly complementary. Some of the earliest writers about qualitative research thus argued for the joint use of qualitative and quantitative methods,

what became known as "triangulation."

One of the first essays on triangulation in the nursing journals was by Laura and William Goodwin [Goodwin and Goodwin, 1984]. They argued that qualitative methods were useful for more than exploratory research. Using qualitative and quantitative methods together in a single study could make the research more complete. More importantly, they argued that the joint use of different kinds of methods would strengthen a study. Since different methods would have different weaknesses, similar results would serve to confirm that the findings were not the result of error or bias. The idea that the triangulation of quantitative and qualitative methods could help confirm the results of a single study was accepted and developed by a number of writers in the nineteen eighties [Mitchell, 1986; Duffy, 1987; Knafl, *et al.*, 1988]. Adding confirmation to the list of triangulation's virtues was a philosophically significant and contentious move. By the time that Goodwin and Goodwin were writing, Kuhn's concept of a paradigm had already been used within nursing to distinguish qualitative methodology from quantitative methodology. Within a paradigm, methods were tightly bound to the theories they confirmed. Moreover, according to Kuhn, paradigms were incommensurable; they could not be compared. To contend that different methods could support a single study, then, Goodwin and Goodwin had to argue that qualitative and quantitative methods were consistent. They did so, concluding that:

> Trying rigidly to link paradigm with method will inevitably lead to research that is conducted inappropriately and which, therefore, will produce findings that lack credibility. [Goodwin and Goodwin, 1984, pp. 378-379]

This point was vigorously debated within the nursing journals for the next two decades.

The proposal that qualitative and quantitative methods might be blended in a single study provoked a sharp reaction. Bethel Powers argued that Goodwin and Goodwin had ignored the way in which choices of method depended on the underlying purposes of the study. Since a paradigm's fundamental assumptions about the world determine what questions may (and may not) be asked, methodological choices only make sense in the context of a paradigm [Powers, 1987, p. 123]. She also criticized their assumption that "science is a single-paradigm multiple-method type of enterprise" [Powers, 1987, p. 124] and argued that Goodwin and Goodwin were implicitly committed to positivism. Had they recognized the distinctive philosophical commitments of the qualitative paradigm, Powers argued, they would not have been able to draw their conclusions. Powers' arguments were echoed by John Phillips [1988b, 1988a]. He enumerated several differences between qualitative and quantitative research and treated them as dichotomies, *e.g.* holistic vs. particularistic, dynamic reality vs. static reality, meaning vs. causality. Because these pairs were dichotomies, he concluded that combining qualitative and quantitative forms of research was logically incoherent:

> Blended research gives an array of data related to each method. Such

data will not yield information that enhances the validity of the results
because the data are not compatible. The results are invalid because
numerical and textual data cannot be combined in a meaningful anal-
ysis. [Phillips, 1988b, p. 4]

Phillips was thus arguing for the direct contrary to Goodwin and Goodwin's claim
that findings would have credibility only if method and paradigm were tightly
linked.

The notion that good research required exclusive adherence to either the qual-
itative or quantitative "paradigm" was an important change in nurses' thinking.
Following the lead of education, sociology, and anthropology, early writers on qual-
itative research regarded qualitative and quantitative research as compatible. By
the late nineteen eighties, nursing largely abandoned the idea that the two kinds
of method could be fit into a single methodology. This distinctive methodological
stance was the result of the way in which qualitative methodology and arguments
against logical positivism intersected with the goals of the nursing discipline and
the features of nursing practice. Once qualitative research was associated with a
paradigm, and the qualitative paradigm was contrasted with logical positivism,
the issue took on disciplinary significance. Choice between qualitative and quan-
titative paradigms came to be treated as a major choice of direction for the entire
discipline of nursing [Haase and Myers, 1988; Moccia, 1988; Porter, 1989].

In spite of the rather shrill rhetoric among meta-theorists, practicing researchers
found it beneficial to mix qualitative and quantitative research. In the nine-
teen nineties, hundreds of research papers were published that used triangulation.
Methodological commentary on this practice solidified into two groups, largely re-
iterating the arguments of the nineteen eighties. Almost all commentators take
triangulation to be an appropriate means to more complete studies and for stim-
ulating new hypotheses. The disagreement continues to be over confirmation.
One group, sometimes called "building block" theorists, argue that triangulation
could not yield better confirmation. In multi-method research, the qualitative and
quantitative work must remain separate and distinct. Each method provides an
independent body of data, and each kind of evidence supports its own conclusions
and should be evaluated in its own terms. A triangulated study would thus be the
conjunction of two studies; the methods combined like bricks in a wall, not like
salt and water in saline [Morse, 1991; Dootson, 1995; Giddings and Grant, 2007].
"Blending" theorists, by contrast, argue that different methods can produce evi-
dence to support a single conclusion, and that triangulation enhances confirmation
[Knafl, et al., 1988; Breitmayer, et al., 1993; Risjord, et al., 2002].

One advance in the debate has been the recognition (and attempted expulsion)
of remnants of positivism and the adoption of post-positivist philosophy of science.
Through the nineteen nineties, both sides of the debate implicitly held a positivist
view of quantitative research. In particular, quantitative research was supposed
to involve deducing hypotheses from a theory, which in turn was conceived as
a hierarchy of laws. It is not clear how qualitative methods could support this
kind of theory testing. However, this positivistic conception of theory is limited

at best. More recent commentators [Clark, 1998; Risjord, *et al.*, 2001; Racher and Robinson, 2002, Risjord, *et al.*, 2002] have argued that better conceptions of theory structure and confirmation are available. If, for example, a coherence view is adopted, there is no structural difference between theories supported by qualitative research and theories supported by quantitative research [Risjord, *et al.*, 2001; 2002]. Therefore, there is no barrier to multiple methods providing evidence to support (or refute) a single theory. A further ramification of this line of argument is to undermine the qualitative-quantitative distinction entirely. While there are important differences among the various research techniques, there is philosophical room for a unified conception of nursing research that includes all of them [Clark, 1998; Racher and Robinson, 2002; Risjord, 2010]. By treating the dispute between qualitative and quantitative research as a global issue of paradigm conflict within the discipline, nursing scholars have given methodological decisions priority over choice of research question. Arguably, this is backwards: methods should be jointly determined by the questions asked and the topics asked about. When considered in this light, it is clear that some questions are best answered by more than one method [Risjord, *et al.*, 2002; Twinn, 2003; Risjord, 2010].

7 MIDDLE-RANGE THEORY

Like qualitative research, middle-range theory blossomed in the nineteen eighties and nineties because of research initiatives internal to nursing science and because of philosophical critiques of logical positivism. Middle-range theory, however, has a much longer history within nursing. Arguably, the vast bulk of nursing research has been in the middle-range of abstraction, having neither a discipline-wide scope nor a micro-level focus. As discussed in Section 3, some early research in nursing imported middle-range theory from other disciplines, and this led to debates about the relative importance of borrowed versus disciplinary theory. While concerns about the unity of the discipline inclined nurse scholars toward discipline-based theory, researchers continued to explore and adapt theories from related disciplines. The phrase "middle-range theory" did not come into common use until the nineteen eighties, and it became the buzzword of the nineteen nineties. The term was promoted by Frederick Suppe, who imported his critique of logical positivism and his semantic conception of theory into nursing. It was picked up by nurse scholars who used it to distinguish their work from the "grand theory"[10] that had gone before.

Most of the intellectual products that became nursing's grand theories began their life as a part of nursing education. The early treatises by Peplau [1952],

[10]The phrase "grand theory" has a variety of uses in the nursing literature. Some authors (e.g. [Fawcett, 1999/1985]) distinguish between theories and "conceptual models" on grounds of abstractness, others assimilate abstract theories to empirical theory. The grand theories themselves exhibit a range of abstractness and generality. For the purpose of this essay, fine distinctions need not be maintained and relatively unproblematic examples will be deployed. For more detailed discussion of "grand theory" see [Risjord, 2010].

Orlando [1961], Henderson [1966], and Weidenbach [1964] have been introduced
in Section 3. Their primary pedagogical aim was to systematize the actions, envi-
ronment, and professional role of the nurse, and to show how the nurse's area of
concern was distinct from the physician's. These books provided nursing students
with a set of concepts that helped them both analyze their situation and under-
stand its significance. The intent behind these works was not to produce something
analogous to theories of quantum mechanics or natural selection. Nonetheless, un-
der the influence of the positivist philosophy of science and institutional pressures
to articulate the character of their research, these systematic works were treated
as theories of nursing. On the positive side, these works captured many of the
important features of nursing. They articulated the concepts of health, the nurs-
ing process, the nursing client, stressors, responses, and so on. Perhaps their most
important contribution was to identify the phenomena with which a nursing sci-
ence should be concerned. In this respect, they were analogous to the overarching
theories of nineteenth century social science. On the negative side, there was an
awkward mismatch between their original function as pedagogical conceptualiza-
tions and their subsequent treatment as scientific theories in the positivist sense.
First, it was not clear that these theories included laws, and according to the dom-
inant philosophy of science, a theory was a set of laws. Second, it was unclear how
these theories might be tested. The theories were useful: educational programs
and nursing administration used the conceptualizations of the theories to struc-
ture nursing education and the nursing workplace. Such applications were often
treated as tests, but the successful use of a theory is rather weak evidence for its
truth. Indeed, in an analysis of the literature purporting to test nursing theory
between 1952 and 1986, Mary Silva found that a very small minority of the essays
tried put theory to meaningful empirical tests [Silva, 1986].

As the discipline developed in the late nineteen sixties and early seventies,
nursing theorists aimed more directly at providing a "basic science" of nursing.
Martha Roger's "science of unitary human beings" [1970] and Betty Newman's
"systems model" [1982], for example, are more descriptive and less prescriptive
or analytical than earlier theorists. These works look more like theories as the
logical positivists envisioned them. They included fully general propositions re-
lating theoretical terms, and they attempted to provide complete and systematic
accounts of the nursing domain. The most important problem — both practical
and philosophical — with these theories was their relentless abstraction. New-
man conceptualizes the patient and environment in terms of "stressors," "flexible
lines of defense," and "resistance." Rogers is even more abstract, propounding
principles like Helicy: "The continuous, innovative, probabilistic increasing di-
versity of human and environmental field patterns characterized by nonrepeating
rhymicities" [Rogers, 1986, p. 6]. These theorists developed what they regarded
as fundamental theory without attention the bridge laws that would link the theo-
retical terms to an observation vocabulary. Some of this work was done by others,
and in the nineteen seventies and eighties, there was an active research program
of developing these theories.

While the grand theories attracted disciplinary prestige, the majority of nurse researchers continued to work at a much lower level of abstraction. Rather than trying to derive applications from the rather nebulous propositions of grand theory, many nurse researchers tried to get a clearer understanding of more concrete nursing phenomena. The fact that they did so without recourse to more general theories caused some concern among philosophically minded nurse scholars. In an essay where she surveyed some research that purported to be relevant to practice, Fawcett concluded:

> The above protocols are the areas of nursing research that have been identified as directly relevant for nursing practice. While this is certainly encouraging, it is also cause for concern. This concern lies in the fact that few, if any, of these protocols are based on explicit and logically consistent theory. Although the theoretical explanations probably exist, they have not been articulated. Until that is done, nursing will not have a distinctive body of knowledge. [Fawcett, 1983, p. 178]

Fawcett's call for "explicit and logically consistent theory" is, in the context of the essay, a call for higher-level theory to provide the laws and general principles that will justify the lower-level applications. The positivist conception of theories demanded that lower level theories be derived from higher level theories. Fawcett's complaint was that these linkages are not being made explicit. Notice that the concern is not merely a desire to be theoretically tidy. The argument is that until the links with grand theory have been made, "nursing will not have a distinctive body of knowledge." The underlying view is that a discipline is given its unity by the highest-level theories. These implicitly define the primary theoretical terms, and they express the most comprehensive laws. Middle-range theory thus needed to be linked to grand theory in order to give systematic content to the theoretical terms of middle-range theory and to thereby unify the various theories within the discipline of nursing.

Middle-range theory remained surprisingly resistant to the sort of unification that nurse scholars expected. Where research papers did attempt to establish a relationship to grand theory, the links were often weak. Papers that begin by paying homage to one theory or another often proceed to ignore the theory entirely in the substance of the analysis. Through the nineteen nineties, references to grand theorists waned in the literature [DeKeyser and Medoff-Cooper, 2001].[11] Researchers were simply not finding grand theory to be relevant to their concerns or helpful in the conceptualization of their research problems. While this trend was bemoaned by some, it was given philosophical support by post-positivist conceptions of theory that emerged in the nineteen eighties.

[11] A survey (done by the author for this essay) of all research published in *Journal of Advanced Nursing*, *Nursing Research*, *Nursing Science Quarterly*, *Nursing Outlook*, and *Image: The Journal of Nursing Scholarship* since 1980 shows a steady pattern of decline in discussion of, or even reference to, grand theories. *Nursing Science Quarterly* is the only publication that continues to publish work on grand theory, but their editorial policy is to preserve grand theory in nursing scholarship.

In a series of essays, Frederick Suppe and his collaborators articulated a new conception of nursing theory [Suppe and Jacox, 1985; Suppe, 1993, Lenz, *et al.*, 1995; 1997] based on the semantic conception of theories (as developed in [Suppe, 1989]). Suppe rejected the sharp distinction between theoretical and observational vocabularies, and the idea that theoretical terms are implicitly defined by the laws of the theory. Theoretical terms are interpreted, and observation is always theoretical. Where the received view took theories to be linguistic entities (partially interpreted formal systems), the semantic conception took them to be models of phenomena. These models isolate a set of parameters from the phenomenon to be studied, and use the parameters to define a physical system. Transitions among states of the physical system then model, in an idealized way, the behavior of the phenomenon [Suppe, 1989, pp. 83ff]. The observations that epistemically support the theory are thus measurements of the parameters. Suppe spared nursing theorists the technical details of the semantic conception, choosing to focus on the key consequences of his new understanding of theory. In what is perhaps the seminal essay on middle-range theory, Suppe and his collaborators defined middle-range theory as one that "postulated relationships between the (quantitative or objectively coded qualitative) values of its descriptors and... [where] it is possible to measure or objectively code those descriptors" [Lenz, *et al.*, 1995, p. 3]. The distinguishing feature of middle-range theory, then, is not its level of abstraction, but the way in which it is empirically grounded. Middle-range theory must postulate measurable (or similarly determinate) relationships.

Middle-range theory, as conceived by Suppe and his collaborators, was designed to decouple the development of concrete, empirically grounded nursing theory from the grand theories. On Suppe's view, the work of the grand theorists is returned to something like the status intended by the earliest theorists. These works provide a conceptual orientation for the field, analogous to the "research programs" or "research traditions" identified by Laudan [1977] and Lakatos [1970]. A result of separating grand theory from middle-range theory is that nurse researchers were free to develop a variety of theories without having to establish that they were related by more general laws. Moreover, there was no philosophical barrier to using theories developed within other disciplines. If there were useful models of phenomena about which nurses were concerned, then nursing science should develop them. Suppe's version of middle-range theory, then, legitimized the use of borrowed theories in nursing research. This point, as might be expected, is the most controversial aspect of middle-range theory, for it raised again the questions about how the discipline of nursing is to be unified.

In retrospect, it is perhaps unfortunate that Suppe *et al.* chose the phrase "middle-range theory" to describe their conception of theories in nursing. They borrowed the phrase from Merton's *Social Theory and Structure* [1957], where it had clear positivistic implications. For Merton, middle-range theory is the set of laws that are derived from grand theory and linked to observation by bridge laws. Middle-range theories are simply less abstract, and hence more directly testable, consequences of grand theories. Even though Suppe *et al.* explicitly rejected the

idea that "middle-range" denotes a location in the hierarchy of theory [Lenz, *et al.*, 1995, p. 6], many nurse scholars continued to understand it this way [Fawcett, 1999/1985; Liehr and Smith, 1999; Higgins and Moore, 2000]. As a result, the main philosophical dispute about middle-range theory has been whether middle-range theories can be developed independently of grand theories.

The literature on this topic engages two issues. The first is whether middle-range theory requires the abstract conceptual resources of a more general theory. It is common for discussants to say that middle-range theories are or should be "derived" from grand theory [Olson and Hanchett, 1997, p. 73; Cody, 1999, p. 11; Fawcett, 1999/1985, p. 6]. This echoes the positivistic idea that scientific terms get their meaning by implicit definition in the axioms of a theory. This commitment is implausible in contemporary philosophy of science, and if this were the only reason why middle-range theory presupposed grand theory, then the argument would be a non-starter. The literature on middle-range theory, however, does not clearly distinguish between this implausibly strong commitment and the weaker commitment that middle-range theory development takes place in a disciplinary context that includes a basic conceptualization of the field, a range of interests and evaluative commitments, and so on. This weaker commitment is quite plausible, but it is too weak to support a close relationship between specific middle-range and grand theories. Nursing practice already focuses the discipline on a relatively determinate, if broad, range of phenomena, and the grand theories succeeded in articulating the basic conceptual field. However, these resources need not be conceived as determining the content of middle range theory in any significant way.

The second question speaks to the larger issue of how various middle-range theories might be united into a body of specifically nursing knowledge. Proponents of a strong role for grand theory, such as Cody [1999] or Fawcett [1999/1985], argue that it is only through the unifying effect of grand theory that a set of middle-range theories can contribute to the discipline of nursing. Many middle-range theories are drawn from other disciplines. It is thus legitimate to ask of research based on such a theory: what makes this *nursing* research? The same question arises even if the theory is novel and developed by the faculty of a nursing school. Only the conceptual unity that grand theory provides can support a satisfactory answer, or so the proponents of grand theory argue. This is a significant problem for a view, like Suppe's, that decouples middle range theory from grand theory. The looser the relationship between the conceptual background that characterizes the discipline and the concepts of the middle-range theory, the harder it is to explain why the middle-range theory is nursing theory.

8 EVIDENCE-BASED NURSING PRACTICE

Evidence-based practice arose in clinical medicine in the late nineteen eighties,[12] and it was imported into nursing in the nineteen nineties. The application of evidence based medicine to nursing raises many important issues. Some are beyond the scope of this essay, such as practical issues about clinical nurses' access to research databases or ethical issues about how knowledge of outcomes is to be best integrated into a patient's care. The epistemological issues relevant here revolve around the concept of evidence. Evidence based medicine gives priority to randomized clinical trials and meta-analyses. Many nurse scholars have complained that this disvalues qualitative methods, and as we have seen, a substantial number of nurse researchers take nursing to be a humanistic discipline characterized by qualitative research. Therefore, when applied to nursing, evidence based practice needs a broader conception of what is to count as evidence [Kitson, 2002; Geanellos, 2004; Rycroft-Malone, et al., 2004]. Another sort of problem is that there is a lack of fit between what nurses need to know and the results of randomized clinical trials. Nursing practice is based on personal relationships. The nursing encounter is holistic in the sense that it encompasses all aspects of the patent's experience, social context, and medical situation. It is not easily captured by parameters that are neatly measured in a clinical trial. Thus the adoption of evidence based medicine threatens to exacerbate the existing gap between theory and practice [Mitchell, 1999; Upton, 1999; Fawcett, et al., 2001].

In "On Nursing Theories and Evidence" [2001], Jacqueline Fawcett, Jean Watson, Betty Neuman, Patricia Walker, and Joyce Fitzpatrick argue that the foregoing problems can be resolved by reaffirming Carper's four patterns of knowing. Clinical trials are the "gold standard" of evidence based medicine, and this sort of evidence is well suited to Carper's pattern of "empirics." However, it does not fit the other kinds of knowledge that are important for nursing: ethics, personal knowledge, and aesthetics. Each of the patterns, they argue, can be conceived as a kind of theory too: "the content of ethical, personal, and aesthetic theories can be formalized as sets of concepts and propositions, just as the content of many empirical theories has been so formalized" [Fawcett, et al., 2001, p. 117]. By recognizing these patterns as theories, they claim, the unique sources of evidence required by nursing become apparent. Evidence for personal knowledge includes autobiographical stories, and evidence for nursing aesthetics includes "aesthetic criticism and works of art" [Fawcett, et al., 2001, p. 118]. If evidence based practice is expanded to include all four kinds of theory and their respective sources of evidence, they argue, then it will not further alienate theory and practice. Research will bring theory and practice together in just the way nursing needs.

The main problem with the approach of Fawcett et al is that it elides one of Carper's most important insights. Nursing is fundamentally a practical activity, and practice always outruns its description by propositions or prescription

[12]For a more complete discussion of evidence based medicine and evidence based practice, see the essay by Robyn Bluhm and Kirstin Borgerson in this volume.

by rules. Carper's aesthetic and personal knowledge patterns capture aspects of the nurse's practical knowledge. To describe this practical knowledge as a theory that might be supported by evidence is to miss the point that know-how does not require evidence (cf. [Benner, 1984]). This mistake is not limited to Fawcett *et al.* Jo Rycroft-Malone and her collaborators [2004] are more sophisticated about the distinction between propositional and practical knowledge. However, they also call for the development of "processes for articulating and explicating professional craft knowledge" [Rycroft-Malone, *et al.*, 2004, p. 84], and they want to count these processes as sources of evidence for nursing practice. In so doing, they would assimilate the explication of know-how to the evidence for a theory. It is true that sharing stories about practical situations is an important part of developing practical expertise. One way to get better at any practical activity — from fly fishing to psychiatric nursing — is to discuss problems that have arisen and how they were handled. This kind of reflection makes some aspects of the situation vivid and thereby helps the novice practitioner make better decisions in the future. However, the usefulness of stories does not turn them into a special kind of evidence. Practice does not need evidence; it needs experience.

Another source of anxiety about importing evidence based medicine into nursing is that it emphasized methods that nurse scholars regard as "quantitative." As discussed above, qualitative research forms an important part of nursing's research enterprise, and nurse scholars have looked for ways to include qualitative evidence. The problem is that interviews, participant observation, focus groups, and so on do not seem as epistemically robust as clinical trials. In an important critical essay, John Paley argued that the central element of the concept of evidence is that it is gathered by procedures "designed to rule out, or at any rate minimize, the possibility of error" [Paley, 2006, p. 83]. The advantage of methods that rely on measurement is that they are subject to standard statistical analyses for error. Therefore, it is possible to determine, with relative precision, the chance that a given conclusion is erroneous. Many have suggested mechanisms of consensus formation as support for conclusions about effective nursing practice (e.g. [Upton, 1999; Geanellos, 2004; Rycroft-Malone, *et al.*, 2004]). The problem with consensus is that it does not, all by itself, pass epistemic muster. Consensus can form around false beliefs. Indeed, as Miriam Solomon has argued [2001], consensus can impede scientific development. Any attempt to be more inclusive about the evidence will have to satisfy Paley's criterion. In general, while procedures that do not use measurement can be assessed for reliability, qualitative researchers have made few attempts to do so. Hence, the burden is on qualitative researchers to show that their results are reliable, and this burden has not been shouldered.

A deeper issue concerns the relationship between qualitative evidence and nursing practice. Qualitative research has been very useful for nursing. It is good at providing certain kinds of information: pictures of nurse and patient experiences, understanding of health practices and their consequences, and elucidation of the conceptions that nurses and patients use. Nurses find such understanding interesting, but it bears a different relationship to practice than, say, knowledge that

one kind of intervention is better at reducing bed sores than another. The latter kind of knowledge is the aim of evidence based practice, and qualitative research in nursing does not seem well suited to it. The challenge, then, is to understand how qualitative research does support practice. Fawcett *et al.* were thus correct to suggest that because practicing nurses employ different kinds of knowledge (in particular, both practical expertise and scientific knowledge), nursing research might support nursing practice in a variety of ways. Their mistake, as argued above, was to assimilate all these forms of knowledge to knowledge of theory. This shows that even if Carper's patterns of knowing were a correct analysis of the knowledge of a practicing nurse, it is not an adequate analysis of the discipline's knowledge base. The practical abilities of good nurses — captured in the aesthetic and personal knowing patterns — are not directly reflected in a special form of nursing theory.

The call for evidence based nursing is important because it promises to provide a research base that is directly relevant to practice, but it is forcing nurse scholars to reconsider their conception of evidence and the attendant conceptualizations of method, theory, and confirmation. Fully assimilating evidence based practice will therefore require further philosophical reflection on, and development of, nursing science.

9 THE NURSING STANDPOINT AS A FUTURE DIRECTION FOR THE PHILOSOPHY OF NURSING SCIENCE

In the late nineteen seventies, nurse scholars had reached a consensus about the character of nursing science. In Section 5, above, the consensus was expressed in terms of four theses. Subsequent developments in philosophy and in nursing have called all of them into question. Arguments that nursing science includes constitutive values break down the division between Carper's empiric and ethical patterns of knowing. The philosophical demise of the received view of theories has undermined the idea that a discipline must be unified by its most general laws and concepts. It follows that middle-range theory need not be tied to particular grand theories. These philosophical developments have been paralleled by developments in nursing science. Middle-range theory and evidence-based practice represent attempts by nurse scholars to make their science more testable and more clearly relevant to nursing practice. In spite of the calls to link middle-range theory and evidence to the conceptual resources of grand theory, researchers have not found such links illuminating, and have proceeded without them. This challenges the consensus view about the structure of nursing theory, and it raises difficult questions about the unity of the discipline. These difficulties will only become more pressing as middle-range theory and evidence-based practice continue to be developed. As nursing science moves into the twenty-first century, then, several philosophical questions will remain pressing:

1. How are the values of professional nursing related to the research enterprise of the nursing discipline?

2. What is distinctive of nursing science? What unifies it into a field or discipline?

3. How are the topics, research goals, and results of the discipline related to the needs and values of the nursing profession?

4. Does nursing science need a unified methodological or theoretical framework?

The consensus of the seventies had a tidy package of answers to these questions. As the consensus answers have broken down, the questions arise anew.

Nurse scholars have thought since the nineteen sixties that the discipline should govern the professional practice of nursing [Johnson, 1959; Schlotfeld, 1960; Johnson, 1974; Donaldson and Crowley, 1978]. Nurse scholars defended this arrangement on the grounds that the knowledge base provided by an autonomous discipline would provide grounds for articulating and defending the proper role for nursing within the healthcare system. Fifty years of nursing research has fortified both the discipline and the profession in such a way that nurses are now in a political position to reconsider this arrangement. Perhaps different answers to the outstanding philosophical questions might be obtained by inverting the relationship between the discipline and the profession: perhaps the profession should be seen as governing the discipline. The resources of standpoint epistemology, as it has been developed by feminists over the last several decades, make an interesting and novel perspective on these issues possible.

According to standpoint epistemology,[13] some social positions have a kind of epistemic privilege. Race, class, and gender are the standard loci of analysis. Under the right conditions, the occupants of such subordinated roles can achieve a less distorted view of the conditions of their oppression. Standpoints are not just different backgrounds or experiences. It is crucial that there be a pair of roles, one of which subordinates and oppresses the other. The subordinated role supports the dominant role. Their relationship is structured by the needs and interests of the dominant role, and the dominant role can only exist with the support of the oppressed role. The kinds of support are not clearly or fully understood by the dominant group. (And since the subordinated group typically accepts the dominant ideology, they may not understand it either.) The final condition is that, in order to fulfill their role, the occupants of the subordinate role need to be able to see the world both from their own perspective and from the dominant perspective. A black domestic worker, for example, needs to be able to understand the social world both from the perspective of her white employers and from her own. As she empties the trash and cleans the sheets, she is in a position to know things about her employers and the social status they occupy that it is difficult for them to know about themselves. However, this knowledge does not accrue automatically. She must be willing to question the justice of the social arrangement that puts her

[13]There are a variety of ways of articulating "standpoint epistemology," and this one makes no claim to be authoritative. This account is based on [Hartsock, 1983]. For a broader discussion, see the essays collected in [Harding, 2003].

in the subordinate position. She must come to see her position *as* oppressed and seek to valorize and enhance the lives of those in her position. With this political commitment and some hard empirical work, she can come to see her own role from both perspectives, both the privilege that her work makes possible and the realities of her life that are invisible to her employers.

The relationship between nurses and physicians fits the criteria for an epistemic standpoint. Since Nightingale's time, the domain of nursing has been set by the limits of physician interest. The sites of nursing care (hygiene, wound care, patient monitoring, medication, and so on) are all determined by the needs of the patient, *given* the prescribed treatment regime. Even as they have gained autonomy within the health care system, their responsibilities have been harnessed to the physician's treatment regimen. Hence, the role of the nurse in health care is oppressed and marginalized as compared with the role of the physician. Moreover, nursing work is necessary but largely invisible. While it is not true that physicians are ignorant of nursing action, they do not appreciate the ways in which nursing work makes their treatment possible (for an empirical study that strongly supports these claims, see [Coombs, 2004]). By tending to bodily needs, by providing care for pain or insomnia, or by counseling and educating, nursing creates an environment within which the physician's treatment can be effective. Without the nursing care in all of its aspects, no treatment regimen could succeed. In order to support the treatment regimen, nurses need to understand the patient's health from both the physician's perspective and their own. It is necessary for the nurse to understand the physician's language and perspective. However, the nurse's understanding cannot be limited to the knowledge shared with physicians because the health needs to which she responds are more comprehensive. In a literal sense, nurses know what happens to the patient after the physician has left the room.

The relationship between the physicians' and nurses' roles creates a potential for knowledge, but unearthing it takes the right kind of commitment. This is where the nursing role differs from the other, more socially oriented, standpoints. For race, class, and gender, the political commitment is to social justice. In nursing, the commitment is to the core values of nursing practice, including the patient's autonomy (in the rich sense discussed in Section 4), as well as to the valorization of the nursing role itself. These values motivate the empirical project of embedding the medical view of human health as disease and dysfunction into a larger picture that includes the social, psychological, and personal elements of health. This attempt to synthesize physiology, pharmacology, pathology, psychology, and sociology, and to focus them on the patient's experience so that agency is enhanced, is the science of nursing. While the traditional standpoints have the potential to provide a less distorted view of social relationships, the nursing standpoint can provide a less distorted view of health.

Treating nursing knowledge as a standpoint epistemology has profound consequences for the main questions about nursing science.[14] Just as a feminist standpoint epistemology begins "from the perspectives of women's lives" [Harding, 1991,

[14]The arguments here are developed more fully in [Risjord, 2010].

p. 249], a nursing standpoint must begin from the perspectives of nurses lives. In this sense, the profession of nursing should govern the discipline. The fundamental questions, topics, and problems of the discipline must, in the first instance, be problems that arise from nursing practice. And the ultimate value of the nursing discipline should be measured by its ability to ameliorate nursing practice. This does not limit the discipline to low-level problem solving. In most cases, the problems are best solved by more general causal modeling or theorizing. Research on pain, for example, is a multi-disciplinary enterprise to which nurse researchers contribute. Because it is central to a patient's encounter with disease, managing pain is a significant concern of the nursing profession. This makes pain management an important phenomenon for nursing investigation. But pain management cannot be well understood without models of pain. To some extent, these models will be drawn from other disciplines, such as neurology, physiology, or psychology. But nurses have specific interests in pain and its manifestation. This lead Jean Johnson to challenge the 1960's theories about the cognitive processes involved in pain. She showed that the intensity of pain could be decoupled from the distress caused by pain, and that these could be reliably measured on separate scales. This, in turn, led to changes in the clinical assessment of pain.[15] To say that nursing science must begin with the problems of the nursing profession, then, does not limit nursing research to intervention and outcome studies. Rather, it identifies a domain of research and theorizing that is appropriate for the nursing discipline.

When "middle range theory" is made independent of "grand theory," questions arise about the unity of the discipline. What relates Johnson's research on pain to inquiries into caregiver burden, education about sexually transmitted diseases, or social support? What makes these "nursing theories"? The received view of theory emphasized the role of general concepts and laws in unifying disciplines. Critique of the received view has indicated that not all scientific inquiry has this structure. It is a mistake to suppose that a theory is either a nursing theory or a non-nursing theory; disciplines do not own theories. If nursing knowledge is treated as a standpoint epistemology, we can understand its unity as coming from the bottom up, not the top down. Certain kinds of scientific inquiry become appropriate for nursing scholarship when they are responsive to the concerns of professional nursing. Hence, the nursing standpoint gives a clear answer to the questions about unity without appeal to general laws or objects special to nursing.

Explicating nursing science in the terms of standpoint epistemology is one way to systematically address the outstanding philosophical problems of nursing science. It is, of course, not the only way to align late twentieth century philosophy of science with the needs and concerns of nurse scientists. Because nursing has not attracted much attention from philosophers of science, these alternatives have not been developed. They should be: nursing science raises a number of distinctive philosophical issues. Some are of concern primarily to nurse scholars, but many have broad philosophical interest. We have seen in this essay how reflection on

[15]This description of Johnson's work is drawn from the discussion in [Donaldson, 2000, pp. 252-253].

nursing suggests new models of the way values function in scientific inquiry. It opens new ways of thinking about disciplines that do not rely on theory-centric models of scientific inquiry. In so doing, it suggests new ways to think about scientific research in medicine and public health. Nursing, therefore, offers not only a different perspective on health; it offers a different perspective on the philosophy of health care. It is to be hoped that in twenty-first century philosophical reflection on health care, the philosophy of nursing will have a respected place.

BIBLIOGRAPHY

[Beckstrand, 1978a] J. Beckstrand. The Need for a Practice Theory as Indicated by the Knowledge Used in the Conduct of Practice, *Research in Nursing and Health* 1: 175-179, 1978.

[Beckstrand, 1978b] J. Beckstrand. The Notion of a Practice Theory and the Relationship of Scientific and Ethical Knowledge to Practice, *Research in Nursing and Health* 1: 131-136, 1978.

[Beckstrand, 1980] J. Beckstrand. A Critique of Several Conceptions of Practice Theory in Nursing, *Research in Nursing and Health* 3: 69-79, 1980.

[Benner, 1984] P. Benner. *From Novice to Expert.* Menlo Park CA: Addison-Wesley, 1984.

[Boorse, 1981] C. Boorse. On the Distinction between Disease and Illness, in A. L. Caplan, T. Engelhardt and J. J. McCartney (eds.), *Concepts of Health and Disease.* Reading PA: Addison-Wesley, pp. 545-560, 1981.

[Breitmayer, et al., 1993,] B. J. Breitmayer, L. Ayres and K. A. Knafl. Triangulation in qualitative research: Evaluation of completeness and confirmation purposes, *Image: Journal of Nursing Scholarship* 25: 237-243, 1993.

[Brown, 1948] E. L. Brown. *Nursing for the Future: A Report Prepared for the National Nursing Council.* New York: Russell Sage Foundation, 1948.

[Carper, 1978] B. Carper. Fundamental Patterns of Knowing in Nursing, *Advances in Nursing Science* 1: 13-23, 1978.

[Carper, 1988] B. Carper. Response to 'Perspectives on Knowing: A Model of Nursing Knowledge', *Scholarly Inquiry for Nursing Practice: An International Journal* 2: 141-144, 1988.

[Chinn and Kramer, 1999/1983] P. L. Chinn and M. K. Kramer. *Theory and Nursing: Integrated Knowledge Development.* St. Louis: Mosby, 1999.

[Churchman, 1956] C. W. Churchman. Science and Decision Making, *Philosophy of Science* 33: 247-249, 1956.

[Clark, 1998] A. Clark. The Qualitative-Quantitative Debate: Moving from Positivism and Confrontation to Post-Positivism and Reconciliation, *Journal of Advanced Nursing* 27: 1242-1249, 1998.

[Cody, 1999] W. K. Cody. Middle-Range Theories: Do They Foster the Development of Nursing Science?, *Nursing Science Quarterly* 12: 9-14, 1999.

[Collins and Fielder, 1981] R. Collins and J. Fielder. Beckstrand's Concept of Practice Theory: A Critique, *Research in Nursing and Health* 4: 317-321, 1981.

[Committee for the Study of Nursing Education, 1923] Committee for the Study of Nursing Education. *Nursing and Nursing Education in the United States.* New York: Macmillan, 1923.

[Coombs, 2004] M. A. Coombs. *Power and Conflict Between Doctors and Nurses: Breaking Through the Inner Circle in Clinical Care.* London: Routledge, 2004.

[Culver and Gert, 1982] C. M. Culver and B. Gert. *Philosophy in Medicine.* Oxford: Oxford University Press, 1982.

[DeKeyser and Medoff-Cooper, 2001] F. G. DeKeyser and B. Medoff-Cooper. A Non-Theorists Perspective on Nursing Theory: Issues of the 1990s, *Scholarly Inquiry for Nursing Practice: An International Journal* 15: 329-341, 2001.

[Dickoff and James, 1968] J. Dickoff and P. James. A Theory of Theories: A Position Paper, *Nursing Research* 17: 197-203, 1968.

[Dickoff, et al., 1968a] J. Dickoff, P. James and E. Wiedenbach. Theory in a Practice Discipline Part I: Practice Oriented Theory, *Nursing Research* 17: 415-435, 1968.

[Dickoff, *et al.*, 1968b] J. Dickoff, P. James and E. Wiedenbach. Theory in a Practice Discipline Part II: Practice Oriented Research, *Nursing Research* 17: 545-554, 1968.

[Donaldson, 2000] S. K. Donaldson. Breakthroughs in Scientific Research: The Discipline of Nursing, 1960-1999, in J. J. Fitzpatrick and J. Goeppinger (eds.), *Annual Review of Nursing Research*. New York: Springer Publishing Company, pp. 247-311, 2000.

[Donaldson and Crowley, 1978] S. K. Donaldson and D. M. Crowley. The Discipline of Nursing, *Nursing Outlook* 26: 113-120, 1978.

[Dootson, 1995] S. Dootson. An In-Depth Study of Triangulation, *Journal of Advanced Nursing* 22: 183-187, 1995.

[Dreyfus, 1979] H. L. Dreyfus. *What Computers Can't Do: The Limits of Artificial Intelligence.* New York: Harper and Row, 1979.

[Duffy, 1986] M. E. Duffy. Qualitative Research: An Approach Whose Time Has Come, *Nursing and Health Care* 7: 237-239, 1986.

[Duffy, 1987] M. E. Duffy. Quantitative and Qualitative Research: Antagonistic or Complementary?, *Nursing and Health Care* 8: 356-357, 1987.

[Edwards, 2001] S. D. Edwards. *Philosophy of Nursing: An Introduction.* New York: Plagrave Macmillan, 2001.

[Ellis, 1968] R. Ellis. Characteristics of Significant Theories, *Nursing Research* 17: 217-222, 1968.

[Fawcett, 1978] J. Fawcett. The Relationship Between Theory and Research: A Double Helix, *Advances in Nursing Science* 1: 36-39, 1978.

[Fawcett, 1983] J. Fawcett. Contemporary Nursing Research: Its Relevance for Practice, in N. L. Chaska (ed.), *The Nursing Profession: A Time to Speak.* New York: McGraw-Hill, pp. 169-181, 1983.

[Fawcett, 1984] J. Fawcett. The Metaparadigm of Nursing: Future Status and Current Refinements, *IMAGE: Journal of Nursing Scholarship* 16: 84-87, 1984.

[Fawcett, 1999/1985] J. Fawcett. *The Relationship of Theory and Research.* Philadelphia: F.A. Davis Company, 1999.

[Fawcett, *et al.*, 2001] J. Fawcett, J. Watson, B. Neuman, P. Walker and J. Fitzpatrick. On Nursing Theories and Evidence, *Journal of Nursing Scholarship* 33: 115-119, 2001.

[Geanellos, 2004] R. Geanellos. Nursing Based Evidence: Moving Beyond Evidence-Based Practice in Mental Health Nursing, *Journal of Evaluation in Clinical Practice* 10: 177-186, 2004.

[Giddings and Grant, 2007] L. S. Giddings and B. M. Grant. A Trojan Horse for Positivism?, *Advances in Nursing Science* 30: 52-60, 2007.

[Goodwin and Goodwin, 1984] L. D. Goodwin and W. L. Goodwin. Qualitative vs. Quantitative Research or Qualitative and Quantitative Research?, *Nursing Research* 33: 378-380, 1984.

[Gortner, 2000] S. Gortner. Knowledge Development in Nursing: Our Historical Roots and Future Opportunities, *Nursing Outlook* 48: 60-67, 2000.

[Gunter, 1962] L. M. Gunter. Notes on a Theoretical Framework for Nursing Research, *Nursing Research* 11: 219-222, 1962.

[Haase and Myers, 1988] J. E. Haase and S. T. Myers. Reconciling Paradigm Assumptions of Qualitative and Quantitative Research, *Western Journal of Nursing Research* 10: 128-137, 1988.

[Harding, 1991] S. Harding. *Whose Science? Whose Knowledge?* Ithaca: Cornell University Press, 1991.

[Hartsock, 1983] N. C. Hartsock. The Feminist Standpoint: Developing the Ground for a Specifically Feminist Historical Materialism, in S. Harding and M. B. Hintikka (eds.), *Discovering Reality.* Dordrecht: D. Reidel Publishing Company, pp. 283-310, 1983.

[Hempel, 1965] C. Hempel. *Aspects of Scientific Explanation and Other Essays in the Philosophy of Science.* New York: The Free Press, 1965.

[Henderson, 1966] V. Henderson. *The Nature of Nursing.* New York: The Macmillan Company, 1966.

[Higgins and Moore, 2000] P. A. Higgins and S. M. Moore. Levels of Theoretical Thinking in Nursing, *Nursing Outlook* 48: 179-183, 2000.

[Hobbs, 1997] C. A. Hobbs. *Florence Nightingale.* New York: Simon and Schuster Macmillan, 1997.

[Jacobs-Kramer and Chinn, 1988] M. K. Jacobs-Kramer and P. L. Chinn. Perspectives on Knowing: A Model of Nursing Knowledge, *Scholarly Inquiry for Nursing Practice: An International Journal* 2: 129-139, 1988.

[Jeffrey, 1956] R. C. Jeffrey. Valuation and Acceptance of Scientific Hypotheses, *Philosophy of Science* 23: 237-246, 1956.
[Johnson, 1959] D. Johnson. A Philosophy of Nursing, *Nursing Outlook* 7: 198-200, 1959.
[Johnson, 1968] D. Johnson. Theory in Nursing: Borrowed and Unique, *Nursing Research* 17: 206-209, 1968.
[Johnson, 1974] D. Johnson. Development of Theory: A Requisite for Nursing as a Primary Health Profession, *Nursing Research* 23: 372-377, 1974.
[Kim, 1989] H. S. Kim. Theoretical Thinking in Nursing: Problems and Prospects, *Recent Advances in Nursing* 24: 106-122, 1989.
[Kitson, 2002] A. Kitson. Recognizing Relationships: Reflections on Evidence-Based Practice, *Nursing Inquiry* 9: 179-186, 2002.
[Klenow, 1981] D. J. Klenow. Qualitative Methodology: A Neglected Resource in Nursing Research, *Research in Nursing and Health* 4: 281-282, 1981.
[Knafl, et al., 1988] K. A. Knafl, M. M. Pettengill, M. E. Bevis and K. T. Kirchoff. Blending Qualitative and Quantitative Approaches to Instrument Development and Data Collection, *Journal of Professional Nursing* 4: 30-37, 1988.
[Kuhn, 1970/1962] T. Kuhn. *The Structure of Scientific Revolutions.* Chicago: Chicago University Press, 1970.
[Laudan, 1977] L. Laudan. *Progress and its Problems: Toward a Theory of Scientific Growth.* Berkeley: University of California Press, 1977.
[Leininger, 1985] M. M. Leininger. Nature, Rationale, and Importance of Qualitative Research Methods, in M. M. Leininger (ed.), *Qualitative Research Methods in Nursing.* New York: Grune & Stratton, pp. 1-25, 1985.
[Lenz, et al., 1997] E. R. Lenz, L. C. Pugh, R. A. Milligan, A. G. Gift and F. Suppe. The Middle-Range Theory of Unpleasant Symptoms: An Update, *Advances in Nursing Science* 19: 14-27, 1997.
[Lenz, et al., 1995] E. R. Lenz, F. Suppe, A. G. Gift, L. C. Pugh and R. A. Milligan. Collaborative Development of Middle-Range Theories: Toward a Theory of Unpleasant Symptoms, *ANS: Advances in Nursing Science* 17: 1-13, 1995.
[Levi, 1960] I. Levi. Must the Scientist Make Value Judgments?, *Journal of Philosophy* 57: 345-457, 1960.
[Liehr and Smith, 1999] P. Liehr and M. J. Smith. Middle Range Theory: Spinning Research and Practice to Create Knowledge for the New Millennium, *Advances in Nursing Science* 21: 81-91, 1999.
[Longino, 1990] H. Longino. *Science as Social Knowledge: Values and Objectivity in Scientific Inquiry.* Princeton: Princeton University Press., 1990.
[Margolis, 1976] J. Margolis. The Concept of Disease, *The Journal of Medicine and Philosophy* 1: 238-255, 1976.
[Meleis, 2007/1985] A. I. Meleis. *Theoretical Nursing: Development and Progress.* Philadelphia: Lippincott, Williams & Wilkins, 2007.
[Merton, 1957] R. K. Merton. *Social Theory and Social Structure.* Glencoe, IL: Free Press, 1957.
[Mitchell, 1986] E. S. Mitchell. Multiple Triangulation: A Methodology for Nursing Science, *Advances in Nursing Science* 8: 18-26, 1986.
[Mitchell, 1999] G. Mitchell. Evidence-Based Practice: Critique and Alternative View, *Nursing Science Quarterly* 12: 30-35, 1999.
[Moccia, 1988] P. Moccia. A Critique of Compromise: Beyond the Methods Debate, *Advances in Nursing Science* 10: 1-9, 1988.
[Morse, 1991] J. M. Morse. Approaches to Qualitative-Quantitative Methodologicial Triangulation, *Nursing Research* 40: 120-123, 1991.
[Newman, 1982] B. Newman. *The Newman Systems model: Application to Nursing Education and Practice.* Norwalk CT: Appleton-Century-Crofts, 1982.
[Nightingale, 1969/1860] F. Nightingale. *Notes on Nursing: What it is and What it is Not.* New York: Dover Publications, 1969.
[Nordenfelt, 2007] L. Nordenfelt. The Concepts of Health and Illness Revisited, *Medicine, Health Care, and Philosophy* 10: 5-10, 2007.
[Olson and Hanchett, 1997] J. Olson and E. Hanchett. Nurse-Expressed Empathy, Patient Outcomes, and Development of Middle Range Theory, *IMAGE: Journal of Nursing Scholarship* 29: 71-76, 1997.

[Orlando, 1961] I. J. Orlando. *The Dynamic Nurse-Patient Relationship: Function, Process, and Principles.* New York: G. P. Putnam and Sons, 1961.

[Outhwaite, 2007] W. Outhwaite. Phenomenological and Hermeneutic Aproaches, in S. Turner and M. Risjord (eds.), *Philosophy of Anthropology and Sociology.* Amsterdam: Elsevier, pp. 459-484, 2007.

[Paley, 2006] J. Paley. Evidence and Expertise, *Nursing Inquiry* 13: 82-93, 2006.

[Patton, 1990/1980] M. Patton. *Qualitative Evaluation and Research Methods.* Newbury Park, CA: Sage, 1990.

[Peplau, 1952] H. Peplau. *Interpersonal Relations in Nursing.* New York: G. P. Putnam's and Sons, 1952.

[Phillips, 1988a] J. R. Phillips. Diggers of Deeper Holes, *Nursing Science Quarterly* 1: 149-151, 1988.

[Phillips, 1988b] J. R. Phillips. Research Blenders, *Nursing Science Quarterly* 1: 4-5, 1988.

[Porter, 1989] E. J. Porter. The Qualitative-Quantitative Dualism, *IMAGE: Journal of Nursing Scholarship* 21: 98-102, 1989.

[Powers, 1987] B. A. Powers. Taking Sides: A Response to Goodwin and Goodwin, *Nursing Research* 36: 122-126, 1987.

[Racher and Robinson, 2002] F. E. Racher and S. Robinson. Are Phenomenology and Postpositivism Strange Bedfellows?, *Western Journal of Nursing Research* 25: 464-481, 2002.

[Risjord, 2010] M. Risjord. *Nursing Knowledge: Science, Practice, and Philosophy.* London: Wiley-Blackwell, 2010.

[Risjord, et al., 2002] M. Risjord, S. Dunbar and M. Moloney. A New Foundation for Methodological Triangulation, *Journal of Nursing Scholarship* 34: 269-275, 2002.

[Risjord, et al., 2001] M. Risjord, M. Moloney and S. Dunbar. Methodological Triangulation in Nursing Research, *Philosophy of the Social Sciences* 31: 40-59, 2001.

[Rogers, 1970] M. Rogers. *An Introduction to the Theoretical Basis of Nursing.* Philadelphia: F.A. Davis, 1970.

[Rogers, 1986] M. Rogers. Science of Unitary Human Beings, in V. M. Malinski (ed.), *Explorations on Martha Rogers' Science of Unitary Human Beings.* Norwalk CT: Appleton-Century-Crofts, pp. 3-8, 1986.

[Rudner, 1953] R. Rudner. The Scientist *Qua* Scientist Makes Value Judgments, *Philosophy of Science* 20: 1-6, 1953.

[Rycroft-Malone, et al., 2004] J. Rycroft-Malone, K. Seers, A. Titchen, G. Harvey, A. Kitson and B. McCormack. What Counts as Evidence in Evidence-Based Practice?, *Journal of Advanced Nursing* 47: 81-90, 2004.

[Schlotfeld, 1960] R. M. Schlotfeld. Reflections on Nursing Research, *American Journal of Nursing* 60: 492-494, 1960.

[Seedhouse, 2001] D. Seedhouse. *Health: The Foundations for Achievement.* London: John Wiley and Sons, 2001.

[Silva, 1986] M. C. Silva. Research Testing Nursing Theory: State of the Art, *Advances in Nursing Science* 9: 1-11, 1986.

[Silva and Rothbart, 1984] M. C. Silva and D. Rothbart. An Analysis of Changing Trends in Philosophies of Science on Nursing Theory Development and Testing, *Advances in Nursing Science* 6: 1-13, 1984.

[Sohier, 1988] R. Sohier. Multiple Triangulation and Contemporary Nursing Research, *Western Journal of Nursing Research* 10: 732-742, 1988.

[Solomon, 2001] M. Solomon. *Social Empiricism.* Boston: MIT Press, 2001.

[Suppe, 1989] F. Suppe. *The Semantic Conception of Theories and Scientific Realism.* Urbana: University of Illinois Press, 1989.

[Suppe and Jacox, 1985] F. Suppe and A. K. Jacox. Philosophy of Science and the Development of Nursing Theory, in H. H. Werley and J. J. Fitzpatrick (eds.), *Annual Review of Nursing Research.* New York: Springer Publishing Company, pp. 241-267, 1985.

[Swanson and Chenitz, 1982] J. M. Swanson and W. C. Chenitz. Why Qualitative Research in Nursing?, *Nursing Outlook* 30: 241-245, 1982.

[Tinkle and Beaton, 1983] M. B. Tinkle and J. L. Beaton. Toward a New View of Science: Implications for Nursing Research, *Advances in Nursing Science* 5: 27-36, 1983.

[Twinn, 2003] S. Twinn. Status of Mixed Methods Research in Nursing, in A. Tashakkori and C. Teddlie (eds.), *Handbook of Mixed Methods in Social and Behavioral Research.* Thousand Oaks: Sage Publications, pp. 541-556, 2003.

[Upton, 1999] D. Upton. How Can We Achieve Evidence-Based Practice If We Have a Theory-Practice Gap in Nursing Today?, *Journal of Advanced Nursing* 29: 549-555, 1999.

[Wald and Leonard, 1964] F. S. Wald and R. C. Leonard. Towards Development of Nursing Practice Theory, *Nursing Research* 13: 309-313, 1964.

[Walker and Avant, 2005/1983] L. O. Walker and K. C. Avant. *Strategies for Theory Construction in Nursing*. Upper Saddle River, NJ: Pearson Prentice Hall, 2005.

[Watson, 1981] J. Watson. Nursing's Scientific Quest, *Nursing Outlook* 29: 413-416, 1981.

[Wiedenbach, 1964] E. Wiedenbach. *Clinical Nursing: A Helping Art*. New York: Springer-Verlag, 1964.

[Williams, 1985] B. Williams. *Ethics and the Limits of Philosophy*. London: Fontana Press, 1985.

PUBLIC HEALTH

Dean Rickles

1 WHITHER THE PHILOSOPHY OF PUBLIC HEALTH?

Public health concerns the health of *populations* of people, rather than *individual* people, as is the case in clinical medicine (where these individuals are dealt with as 'patients') or in biomedicine more generally (where they are treated as 'subjects').[1] It deals with *aggregates* of measurements of properties of individuals and is therefore a statistical science, facing the many (technical, epistemological, and metaphysical) problems that this inevitably involves. It prizes the *prevention* (of disease, disability, and premature death) over cure, and is therefore rather more difficult to assess than clinical medicine or biomedical science in terms of its success or failure, since one usually has 'counterfactual' successes: e,g, 'if this policy (or intervention) *hadn't* been in place Jones would have perished'.[2] It is a massively interdisciplinary field (perhaps the *most* interdisciplinary subject there is — *cf.* [Afifi and Breslow, 1994, pp. 225–6], incorporating epidemiology, statistics, biology, informatics, sociology, economics, psychology, environmental science, civic planning, architecture, engineering, and more, making public health a rather unwieldy and complex discipline — indeed, there isn't much that public health doesn't (or couldn't) utilize in some way to achieve its aims. What is considered part of the domain of applicability of public health is flexible to the point of near universal inclusivity: almost anything can be viewed as a public health issue. Furthermore, what is included in public health (and therefore the understanding of what public health *is*) has changed over time, adapting to the changing conditions in society that often bring new diseases, and adapting to the time-varying concepts of disease and its determinants. These features make public health an especially challenging field for philosophers of science with various novel issues not to be found in the study of biomedical science.[3] Despite the many conceptually interesting features alluded to above, and despite its age and importance, the field of

[1] The population can be defined in any number of ways, and need not refer to geographical boundaries. For example, the population might be the 'scattered object' that consists of all smokers under the age of eighteen years.

[2] It is in this regard that C. -E. A. Winslow refers to the "silent victories of public health" [Winslow, 1923, p. 65]. Likewise, Bernard Turnock writes that "when public health efforts are successful, nothing happens. Events that don't occur don't attract attention. ... Indeed, the vast majority of those who will ultimately benefit from the efforts of past and present public health workers are yet to be born" [Turnock, 2006, p. 1].

[3] This is not to say that *all* of the issues are novel: for example, since we are dealing with the health and disease of the public we still have to say what we mean by 'health' and 'disease', and

Handbook of the Philosophy of Science. Volume 16: Philosophy of Medicine.
Volume editor: Fred Gifford. General editors: Dov M. Gabbay, Paul Thagard and John Woods.

public health has received virtually no attention from philosophers of science, es-
pecially those belonging to the 'analytical' school. One exception is Douglas Weed
(a professional epidemiologist and 'amateur' philosopher!): he too bemoans the ab-
sence of philosophical work on public health *qua* scientific discipline [Weed, 1999;
Weed, 2004]. Much of the work available tends to follow a 'Continental path',
which has a tendency to ignore the scientific aspects of public health (in favour of
considerations of *power relations*, *à la* Foucault, for example). The work that falls
outside of the continental tradition is primarily located within the fields of science
studies and bioethics, which tend to have different agendas from the philosophy
of science.[4]

My interest is with highlighting issues that are of relevance and importance to
(analytic) philosophers of science. I make no apologies for this lopsided approach;
I think it is necessary to provide balance to the debate as a whole. Here, then, I
attempt to change the imbalance by offering a simple field guide to some philo-
sophical aspects of public health, covering (in a fairly preliminary way) a variety
of topics that really ought to have been better studied (or just studied, *period*)
by philosophers of science. Because public health includes in its domain many
other fields from medicine it treads on the toes of a vast array of issues that are
dealt with by other contributors to this volume. For this reason, when overlap
is an issue I avoid the nitty gritty details and paint the broad picture, showing
how it connects to public health. Further, in order to keep the scale of this chap-
ter manageable I restrict my attention to those issues that are peculiar to public
health.

I begin with a brief historical review of some key elements of public health
with the aim of building up a picture of what public health is and what kinds of
phenomena it deals with (a surprisingly difficult issue). I then consider definitional

many of the same issues are thrown up in this context as are thrown up in biomedicine: there are
broadly 'normativist' (or subjectivist) and broadly 'naturalist' (or objectivist) approaches. This
issue has ramifications for how we measure health and disease which, in turn, has ramifications
on how resources are distributed in health case systems — hence, these are not idle issues of no
practical consequence. There are also issues to do with causal inference, evidence, the nature of
theories, and so on, that are more or less on a par with those from biomedicine. However, even
these issues do take on a very different flavour on account of the fact that the systems of interest
are populations and the quantities of interest belong to these populations.

[4]'Public health ethics' has recently emerged as a specialized sub-discipline of bioethics devoted
to "those ethical issues and perspectives that may be said to be distinctive to public health ...
apart from the perspective of clinical medicine" [Bayer *et al.*, 2006, p. 4] — see [Dawson and
Verweij, 2007] for a nice collection of essays on the subject (many of which are by philosophers).
The ethical implications flow fairly ineluctably and quite obviously: the systems of investigation
in public health are often very large, making it impossible to gain consent for some intervention.
Decisions, over such interventions, are made by external agencies (government agencies, local
boards, etc.). How far should one take this often involuntary enforcement of public health inter-
ventions? To the point of involuntary inoculation *for the greater good*? Involuntary fluoridation
for the common good? This is but one kind of issue; there are many more. Ethics flows into pol-
itics too when we consider that the policies thus imposed often constrain the liberties of people
in some way or other (e.g. the enforcing of seat-belt wearing; the banning of smoking in public
places, etc.). Hence, though related to issues found in clinical medicine, public health throws up
issues that appear to be *sui generis*.

issues, focusing in particular on the possible meanings of 'public' and 'health' —
I briefly discuss the 'demarcation question' too; that is: Is public health a science
at all? This leads in to a discussion of the concepts of 'health' and 'disease'
in the public health (population) context, which in turn leads into a discussion
of the measurement of health states and disease states, and the construction of
population (or summary) measures. I then consider several epistemological issues,
having to do with causality and causal inference (using public health interventions),
and the concept of evidence in public health contexts.

2 THE HISTORICAL DEVELOPMENT OF PUBLIC HEALTH

It is difficult to say exactly when and where public health as a distinctive discipline
began.[5] In order to answer these questions we need to know *what* public health
is. This in itself is very difficult since the nature of public health has evolved
considerably over time. Some prefer to focus on the quantification of properties
(relevant to health) for large groups of people, and their 'surveillance', providing
an evidence-base for informed interventions. Others focus on the particular 'car-
tographic' methodology of finding the determinants of diseases by 'mapping' their
spread and charting their evolution. Both of these understandings overlap signifi-
cantly with epidemiology: in both cases the aim is to identify the causes of health
and disease (given their variation in populations). However, still others view the
connection of health and disease with social and societal issues as the defining
characteristic, so that public health involves social (or community) *action*. Really,
we ought to view all of these as essential components of modern public health, for
it can be viewed as placing epidemiology and statistics in the service of the wider
community (extending as far as the global community).

Let us briefly review some of these ideas in historical context to gain a better feel
for the kinds of conceptual issues that can arise in public health. In the following
historical remarks I do not aim for any kind of completeness, nor do I present the
episodes in chronological sequence. Rather, the remarks are grouped thematically
— note, however, as intimated above, that there are multiple interactions between
the groups.

2.1 *From Vital Statistics to Biostatistics*

Public health concerns large numbers of interacting people and systems. As with
any theory involving systems composed of very many subunits, public health is a
statistical science (or a discipline based on statistical science), dealing with coarse-
grained properties of wholes, rather than specific details of the parts. In this sense

[5]Good general histories of public health (portraying very different aspects) are: [Hamlin, 1998;
Hamlin, 2005; Leavitt and Numbers, 1997; Porter, 1994; Porter, 1999; Rosen, 1993; Rosenberg,
1992; Ward and Warren, 2006]. As the manifold differences in these books reveal, the history
of public health is an exceedingly complex thing to unpack. A superb recent reader, tracing the
development of public health as a discipline, is [Schneider and Lilienfeld, 2008].

public health resembles statistical physics, only now the 'particles' are patients,
health care professionals, institutions, and so on. The population-level nature of
public health, and the necessity to utilize statistics,[6] as well understood by William
Augustus Guy in 1870:

> As hygiene deals with mankind not one by one, but in masses, its
> scientific method can be no other than that numerical method so often
> confounded with its leading application — statistics. [Guy, 1870]

However, the first numerical approach to epidemiology was John Graunt's develop-
ment of 'vital statistics' in the seventeenth century — as laid out in his *Natural
and Political Observations on the Bills of Mortality*. The idea of making records of
deaths ("books of the dead") began with the plague spanning the 14th to the 16th
century. These records were used to identify and track epidemics. Incidentally,
the plague also led to another common public health measure: quarantine. This
is a fine example of a social intervention: by preventing certain interactions from
occurring one modifies the social network and thereby prevents the spread of dis-
ease in a population. Moreover, the death rates were one of the earliest methods
of measuring the health of the public (of populations). That is, vital statistics give
one a (rough) numerical reading of the health of populations. However, the census
affords perhaps the best and most useful overview of the public's health, enabling
stratification by race, social groupings, education, gender, and so on.[7] This pro-
vides a good starting basis for considering interventions to determine whether any
apparent links between properties and categories are causally implicated in health
states.

Graunt's ideas are an integral part of modern epidemiology and public health.
For example, Graunt used statistical data to monitor the health of populations:
using it to identify potential public health problems, to alert the state to such
problems, or else to show that a problem was subsiding.[8] He also pioneered the

[6] An excellent summary of the history of statistical methods in public health is [Stroup and
Berkelman, 1998]. The Wellcome library has a good brief historical overview of the use of
statistics in public health — see: http://library.wellcome.ac.uk/doc_WTL038911.html.

[7] A *census* provides us with a maximal roster of the individuals' properties of interest. They
give us an idea of the state of the population \mathcal{P} and its dynamics $\partial \operatorname{dist}(\mathcal{P})/\partial t$. The census can
provide snapshots that reveal the distribution of properties $\operatorname{dist}(\mathcal{P})$ over the population. Some
quantities will be constant, $d\theta/dt = 0$, and these allow us to parameterize the other varying
quantities. The mean μ and variance σ^2 are constant, and they determine the shape of the
distribution. So: one draws up a census, and from this one extracts the parameters θ, and this
gives us the information we need to assess such things as the 'health state' of a population. Of
course, in reality it will be difficult if not impossible to perform a census for all members of a
population. The statisticians trick is to draw a subset that will, to varying degrees, *represent*
the population as a whole: this is, of course, the sample.

[8] This monitoring was later made a central part of Johann Peter Frank's 'medical police'. Both
are used as tools of the state in some sense. The idea is to have a monitoring system in place at
the heart of the health system, and on whose data one can act: in Frank's era this involved the
quarantining and disinfecting of the 'unclean' elements in order to have a growing, fit population.
In the former case it is in place to alert the health care agencies to public health threats. For
a recent collection of technical articles dealing with aspects of public health surveillance, see
[Teutsch and Churchill, 2000] — see also [Thacker et al., 1989] for a good brief review.

use of the data to monitor variations in health between different populations, a notion central to research on health inequalities (perhaps the most pressing issue facing contemporary population health researchers — see §5). William Petty, a friend of Graunt's, further grounded the basis of modern public health by enjoining public health with political and economic issues — Petty referred to the study of mortality in populations as "political arithmetic".[9]

In the nineteenth century, both William Farr and Edwin Chadwick (see next subsection) were interested in the social interactions of health and society. Farr's interests were grounded more in statistics: like Graunt he viewed statistics as the basis for social action. But, like Chadwick, he viewed the societal conditions as in large part responsible for the health state of a population, and for differences between the health of populations. Farr was statistician to the General Registrar Office, a post which saw him formulate and investigate many basic principles of epidemiology and public health. His basic aim was fundamentally a public health related one: to prevent and control disease (cf. [Adelstein and Susser, 1976, p. iii]).

Francis Galton and Karl Pearson were responsible for the development of the field of biostatistics which replaced vital statistics. Biostatistics deals with data derived from all manner of studies pertaining to medicine and biology. Its lessons were propagated into the epidemiological community, and so applied to public health-related studies, by Major Greenwood, Wade Hampton Frost, Bradford Hill and others. Biostatistics was primarily a clinical affair. However, the introduction of computers and the availability of vast databases, and the potential to simulate complex processes and make forecasts of complex processes, has led to the field of 'public health informatics'. This is an amalgam of public health, engineering and information technology. This technology will continue to increase so as to include more variables of interest. For example, there has recently been an integration of GIS (geographical information systems) technology to allow for more expansive surveillance.[10] The internet too allows for more detailed comparisons of statistics. A substantial component of biostatistics is public health surveillance. See [O'Carroll et al., 2002] for more details on these recent developments.

Another recent development in the use of statistics in public health is in the area of meta-analysis; namely, the statistical synthesis of evidence gathered from multiple independent studies.[11] There are many issues of philosophical interest lurking in the way the evidence is synthesized in these analyses — see §3 of [Worrall, 2007] for a good discussion of the conceptual issues that arise.

[9]Another interesting development was Christian Huygen's' development of 'life tables' to determine the life expectancy of individuals (at any age), for use in computing life annuities. See Chapter 8 of [Hald, 2003] for an excellent account of this history.

[10]See [Cromley and McLafferty, 2002] and [Elliot et al., 2001] for accessible introductions to the applications of GIS to public health. For a historical survey of the 'mapping' of disease, up to and including GIS, see [Koch, 2005].

[11]Note that this is not the same as a systematic review, which does not necessarily involve statistical manipulation: a meta-analysis constitutes a particular kind of systematic review. See [Egger et al., 2001] for the canonical text on systematic reviews (including meta-analyses).

2.2 Social and Environmental Dimensions of Health and Disease

In an early discussion of the role of statistics and statisticians in public health, Edgar Sydenstricker argues that although "medicine" can be viewed as "synonymous with public health", the latter has in addition "a social objective" [Sydenstricker, 1928, p. 116]. The understanding of public health has in very large part been guided by societal issues. Abdelmonem and Breslow refer, in this regard, to the "dynamic nature of public health" [1994, p. 224]. The emergence of certain novel types of behaviour (due to evolving norms) and the development of new technologies can bring with them new threats to health that simply did not previously exist. For example, industrialization brings with it a greater likelihood of certain kinds of epidemic. The invention of new forms of transport will modify epidemiology and public health due to the new types of injury that can occur. Moreover, greater success in healthcare can, ironically, bring with it its own problems, such as an increased aging population (demanding new specialisms such as gerontology) and a population explosion.

Of course, it isn't only changes in society that can cause the emergence of new public health threats. The physical environment is implicated too and can radically alter the distribution of health and disease (famine is an obvious example of this). Moreover, the social and the physical are often bound together, so that changes in one will modify the other. As Geoffrey Rose writes, the "scale and pattern of disease reflect the way that people live and their social, economic, and environmental circumstances, and all of these can change quickly" [Rose, 1992, p. 1]. These elements have been investigated and conceptualized in a variety of ways. For example, the emerging diseases of nineteenth century England were hypothesized to be a result of the insanitary conditions that resulted from overcrowding. Likewise, overwork, malnutrition and other (what we would now think of as) 'social dimensions of disease' were isolated as part of public health in the Chadwick report [Chadwick, 1842] — similar conclusions were made slightly later in the US in the Shattuck report [Shattuck, 1850]. The isolation and analysis of such problems (using primarily epidemiological studies) were intimately linked with a plan of action to intervene for the betterment of society.

Edwin Chadwick is often taken to have been an advocate of social-wide environmental interventions via sanitary reform. In this goal he was aided by the statistical work of William Farr (see §2.1). However, Sylvia Tesh [1995] has argued that that Chadwick was not so disposed, and that his concerns were firmly grounded in 'miasma theory'. This often pointed to interventions that had their location in conditions of poverty, to do with water supply and sewers. The target was miasma producing things, not the social setup *per se*. Tesh's claim is, then, that the miasma theory led to the particular public health prevention measures (many that were, indeed, loaded with societal significance). Hence, though sanitarianism led to what looks like social reform, it was more a technical fix rather than a matter of social justice.[12]

[12]Virginia Berridge [2007] discusses the Health of Towns Association — an environmental

Hamlin [1995] agrees with this general idea, but takes issue with this claim that "aetiological theory drives preventative strategy", arguing that there are plenty of cases of under-determination (in which one theory generates multiple preventative strategies) and over-determination (in which multiple theories correspond to the same strategy). His examples focus on cases whereby miasmatic theory can be dealt with either at the level of social conditions (poverty reduction and so on) or at more direct level of contagion (sanitation upgrades and so on).

Mendelsohn [1995], on the other hand, argues that the whole distinction between 'social' and 'physical' (environmental) is without a real difference, or is, at least, not so easy to support as most discussions suppose. That is, it is easy to assign 'poverty' to either the social side or the physical side; it can be viewed as a social condition, a physiological, or a physical condition. Given this, the distinction cannot do any real work in this context. However, the idea that individuals' health status is connected to the social structures they find themselves in has recently become very fashionable. Social epidemiology, for example, highlights just this 'social embededness' of individuals. The health states of individuals are not *intrinsic* properties, but are determined by the social networks in which the individuals find themselves: transporting an individual to another context would change the health profile of that individual (*cf.* [Galea and Putnam, 2007], p. 7).[13] The key role of public health on this account is, then, to modify the environment (or 'context') in such a way as to benefit the individuals occupying it. The environment itself then becomes the subject of the adjectives 'sick' and 'healthy' — see [Rose, 2001].

Not surprisingly, this modification of the social and physical environment is what those interested in the ethical consequences of public health find objectionable: the modification is enforced, and not to the benefit of all (most often, in fact, for economic reasons). For example, if I stop a shuttle service taking students between campuses, and build a nice connecting footpath, then that will force them to look for alternative methods, with the hope that many will walk or use a bicycle, and therefore reduce the burden of disease for the population as a whole. This amounts to an involuntary modification in the behaviour patterns of individuals. The benefit to the *population as a whole* might be worth the cost (i.e. in health-economic terms), but it might well also be the case that numerous *individuals* are

public health intervention advocacy group — that was formed after the publication of Chadwick's report. This group was instrumental in the promotion of sanitary reform and is often held up as a particularly 'moral' movement. However, as with Chadwick, Berridge argues (following the work of Chris Hamlin), the group was convinced that "the problem was sewers and not deprivation" (p. 22): it was firmly grounded in the (erroneous) miasmatic theory of disease.

[13]There is a whiff of the debate between (semantic) 'externalists' and 'internalists' here. That debate concerns what a speaker means by some word: is it determined by social and physical factors external to the speaker, or is it determined by factors about the speaker? Or, to put it another way: do physical duplicates always mean the same thing by their words regardless of the external social and physical environment? The social epidemiologist is, in this sense, a kind of externalist about health: an individual's health does not supervene on its intrinsic properties. See [Putnam, 1975] for the original source of this debate.

adversely affected — perhaps dropping out of college, and so on.[14]

In many ways, the recent introduction of this 'social epidemiology' harks back to the very earliest public health work of Hippocrates, who also considered the impact of the social and physical environments of health (in his work *Airs, Waters, Places* for example).[15] His evidential basis was observational: certain places, with certain social systems and physical conditions appear to be correlated with quite specific health conditions. Weather, for example, was found to be correlated with specific disease patterns, as was the status of the water supply. Of course, the precise nature of the effects of the natural environment on health (that is, the *mechanisms* responsible) were not known at the time — for that, one requires the integration of this 'social medicine' with biomedicine. Before the idea of local contagion theory (according to which an 'agent' is passed between individuals or from a source to an individual), leading to germ theory, the common view was that 'miasma' was responsible for the spread of disease — simply by inhaling foul air, one would be exposed. Though this was the 'wrong theory', it can nonetheless prove effective in reducing the incidence of disease, since one will tend to cover the airways, and so reduce the risk of infection, and remove the sources of the stench which can simultaneously serve to remove the bacteria (the 'true cause'). Given this, one could be forgiven for thinking that interventions based on the miasmatic theory, being successful, constituted good evidence for the theory (given the state of knowledge at the time) — that is to say, there were good *rational* reasons for believing the theory.

Before leaving this subsection, I briefly note that the so-called 'new public health' bears many similarities to social epidemiology: it is a sociological approach. The basic idea is that threats to health go beyond infectious diseases and lifestyle risks, and can originate in social organization and structures (*cf.* [Baum, 1990]). This belief motivates advocacy of implementing structural social changes in order to improve health. Again, it suggests a kind of externalist conception of health states. The new public health is also characterized by a greater linkage to the state than previously. Legislation in the form of public health acts serve to control risky activities. Risk is also at the root of legislative action in the context of infectious individuals; the state can detain such individuals if they are deemed to pose a sufficient threat to the public's health. In this sense public health is an object in its own right; something to be moulded and altered. However, as we saw, this political connection can be found in the work of Chadwick, who was in fact employed as assistant to the royal commission set up to investigate the Poor Laws. This work unearthed the terrible conditions that England's poor were subject to. However, as mentioned previously, Chadwick's concerns were more economic than social justice ones. But the results were nonetheless consequential in social justice

[14]This is known as 'the prevention paradox', though it isn't really a paradox as such: 'prevention dilemma' would perhaps be a more appropriate label. See §3.5 for more on this matter.

[15]Note, however, that Hippocrates advocated the 'humoral theory of disease', according to which disease comes about when there is an imbalance amongst the four humors, blood, phlegm, yellow bile, and black bile. This theory suggests physiological treatments that restore the balance (*cf.* [Thagard, 2005, p. 48]).

terms: by eliminating the filth that encouraged disease[16] cholera, for one, was brought under control. Squalor, rather than poverty, was thought to be the root of the problem. Disease, rather, was thought to be a cause of poverty. Hence, the various reforms, associated with sanitary engineering, were intended to reduce disease with the aim of stimulating the economy.

2.3 The Germ Theory of Disease

The bacteriological theory of disease, of Pasteur, Koch and others[17], identified the precise biological organisms responsible for the transmission of infectious diseases. Germ theory reduced the spread of disease to the transmission of these bacteria.[18] Hence, the causes of diseases were conceptualized as local biological impingements. A key move was Koch's isolation and culturing of the tuberculosis virus, and his demonstration that tuberculosis could be artificially induced in animals. This engineered *production* of disease (or rather, the fact that it served to establish the germ theory of disease) appears to constitute an instance of Hacking's 'entity realist' stance: causality, manipulability, and reality were bound together — see [Marcum, 2008, pp. 33–48] for more along these lines.

Public health, *qua* non-local theory of the determinants of human health, suffered somewhat at the hands of this new local and individualistic theory of disease and illness.[19] However, public health has been concerned throughout its existence (however blurry the origins might be) with disease (however that might be understood) and advances in microbiology were quickly integrated into public health (again highlighting the latter's adaptability) and used as both a way of identifying disease and as a means of intervening so as to eliminate it. One of the most significant developments along these lines was the establishing of local and government public health departments whose initial role was to keep an eye on the status of populations *vis-à-vis* communicable diseases. The infrastructure cemented for this purpose was quickly expanded for other means, such as screening programmes. The idea of an agency responsible for the control and monitoring of infectious diseases was later, in 1948, implemented at the international level by the United Nations in the form of The World Health Organization [WHO] — of course,

[16]Though not, of course, *caused* disease, as per the theories of disease aetiology at the time — see the next subsection.

[17]I should perhaps point out that Koch was not much impressed with Pasteur's methodology. As Latour points out, Koch thought that Pasteur's generalization from his vaccinated sheep to a "*general* method, applicable to all infectious diseases" was somewhat "hasty" ([Latour, 1988, p. 29]; *cf.* [Guala, 2003, p. 1195]). Koch, of course, developed precise postulates that gave the necessary and sufficient conditions for inferring bacterial causation [Koch, 1882]. [Evans, 1993] gives a good historical survey of the interconnections between theories of disease and theories of causation. For a more 'revisionist' history, see [Worboy, 2000].

[18]As Thagard [2005, p. 48] notes, the germ theory is a class of theories that applies to multiple specific disease types, each with its own specific infectious agents, from protozoa, to fungi, to prions.

[19]As Mervyn Susser [1985] points out, this can be explained in Kuhnian terms: the non-local, population-based ideas (the miasma paradigm) was replaced by a paradigm based on the Henle-Koch postulates involving the determination of disease-causation.

the remit of the WHO now extends far beyond infectious diseases, extending to various demographic issues that are believed to have health impacts.[20]

Epidemiology and public health are concerned with the spread of disease. This has often been done at a more coarse-grained level. Molecular epidemiology links molecular biology to epidemiology and public health by providing transmission mechanisms for the spread of disease and potential responses to stop the transmission. Genetic screening and engineering also offers the promise of greater control over the spread of disease, and even the promise to entirely wipe out certain diseases. Less grandiosely it offers the potential for more targeted intervention strategies. Hence, the local, biomedical model is utilized by public health and can be merged with the more global issues characteristic of the latter's way of operating.

2.4 Epidemiology and Public Health

In their article on the connections between epidemiology and public health, Abraham and David Lilienfeld conclude with the statement that "without public health, there is no epidemiology" [Lilienfeld and Lilienfeld, 1982, p. 148]. They trace this intimate connection largely through the public health movement, which includes figures we have already discussed, notably W. A. Guy. The Lilienfeld's argued that there was an increasing disconnect between the two fields (*ibid.*, p. 147). Milton Terris [1987] ultimately concurs with the Lilienfeld's about the tight relations between epidemiology and public health, but argues that there is an emerging tightening once again in what he calls a "second epidemiologic revolution" (p. 327), in which the domain of epidemiology is expanded to include all manner of non-infectious diseases.

Combining the numerical methods (quantifying cases) with information about the populations from which the cases are drawn is characteristic of modern epidemiology and really began with John Snow's isolation of the Broad Street Pump as the source of a cholera epidemic propagated through human waste. The basic methodological details of this approach were made more rigorous by William Farr, who formulated many more concepts of modern epidemiology — specifically, Snow utilized Farr's tabulations relating cholera mortality to water supply and based his hypothesis — about the nature of cholera and its propagation via an organism passed though human waste — on this data. The hypothesis was tested using the weekly mortality tables supplied by Farr. Of course, as mentioned above, at this stage it was not known that the cholera bacillus was the agent responsible for the disease, but the success of the intervention did not depend on this knowledge.

Though controlled experiments in public health contexts are extraordinarily difficult, for a variety of reasons (e.g. complexity, ethics, etc.), when they are possible they constitute the most reliable way of generating evidence and testing

[20]The WHO has an excellent online historical collection, accessible at: http://www.who.int/ library/collections/historical/en/. This resource has material going back to 1507.

hypotheses — if conducted correctly, that is, with the right number of trial arms and the right experimental subjects (or units). The modern idea of performing trials (or sampling) to test determinants of health and disease was instigated in the scurvy trial of James Lind. Lind gathered a group of sailors stricken with scurvy and split them up in to various pairs, each pair given a different supplement to their usual diet. The pair that was given citrus fruits recovered. This result was used to infer the causal efficacy of citrus fruit in curing scurvy — later biomedical work determined that it was specifically the vitamin C component of citrus fruits that did the work. This evidence could then be used to *prevent* cases of scurvy from occurring, thus demonstrating how a clinical trial can be used in the service of public health.

A similar trial was conducted by Ignaz Semmelweiss (in the 1840s) to test a hypothesis about the causal factor responsible for the difference in the incidence of puerperal fever within maternity wards operated by midwives (in training) and those run by physicians (who also conducted autopsies). Semmelweiss conjectured that there was some infection as a result of the autopsy work (transmitted by 'cadaverous particles'). To test this he simply instigated measures to cleanse hands prior to deliveries. The rates between the wards balanced out. It is worth spelling out the details of this case.

In fact, Hempel considers this case in his *Philosophy of Natural Science* [Hempel, 1966]. Donald Gillies [2005] examines Hempel's analysis, and argues that it needs to be supplemented by elements of Kuhnian philosophy (in order to make sense of Semmelweiss' failure to convince the wider medical community that his ideas were sound). Gillies notes that Semmelweiss' methodology was largely in line with Popper's model of conjectures and refutations: hypotheses were suggested and then tested experimentally by appropriate interventions.[21] The first hypothesis was that "atmospheric-cosmic-terrestrial" factors were responsible — as Gillies notes, this is another way of referring to the miasmatic theory (*ibid.*, pp. 161-162). This was quickly rejected by noting that these would be constant across the wards (given their close proximity), and so could not be called upon to account for the observed differences in death rates. A government commission established to investigate the curious differences came up with the theory that differences in the way the patients were handled were responsible, in one case involving rough student medics (often foreign) and in the other case involving more delicate (non-foreign!) student midwives. The rationale is that this was another difference between the groups, and one needs a difference in the cause to get a difference in the effect. However, Semmelweiss performed a test involving the canceling out of the suggested causal factors (by making the groups comparable), so that the wards were balanced with respect to them, but found no significant reduction.[22]

[21]Peter Lipton also considered Hempel's treatment of Semmelweiss and argued that it constituted an instance of inference to the best explanation [Lipton, 1991, pp, 75–98].

[22]Gillies also notes an even more surprising hypothesis involving a Priest ringing a bell on the way to give the last sacrament to a dying patient (ibid, p. 163). There were differences in the Priest's trajectory to patients brought about by the arrangement of the rooms, that were correlated with the difference in death rates: the experience of the ringing bell was thought to

It was new background evidence — concerning the death of a colleague by an infection from a knife wound during an autopsy resulting in something similar to puerperal fever — that brought about the breakthrough. Semmelweiss surmised that since some of the doctors go from autopsy to clinic they might be transmitting the same material during their examinations. The midwives, on the other hand, do not conduct autopsies. By implementing a trial of thorough disinfection of the hands following autopsies Semmelweiss was finally able to balance out the death rates. The disinfection was generalized from post-autopsy situations to any medical examination involving "ichor" (that is, discharge emanating from a wound). Further generalization to airborne transmission of "ichorous particles" followed other incidents, resulting in the isolation of those presenting with such wounds.

Gillies, as mentioned, views the hypothetico-deductive account espoused by Hempel to be incomplete: it doesn't offer an account of why Semmelweis' theory was not adopted given the strength of evidence. Gillies argues that Kuhn's model can provide an easy answer: "the theory ... was rejected because it contradicted the then dominant paradigm concerning the causation of disease" [Gillies, 2005, p. 171] — it contradicted both the miasmatic theory and the contagion theory, making Semmelweis a revolutionary.

However, both of these trials are rather small-scale, though the Semmelweis trial was carried out at the level of wards (a population of sorts), rather than individuals. Modern day public health trials can involve entire neighbourhoods! In such cases, observational studies and natural experiments (in which one utilizes coincidentally matching systems) are the alternative. In many respects Snow's determination of the Broad Street pump as the source of a cholera epidemic was a perfect natural experiment: that is, a confluence of circumstances that have conspired, naturally (without intervention), to bring about what looks like a controlled experiment, with multiple groups one of which has 'the intervention' and other which doesn't. In this case the groups (the population at risk) are those who subscribed to water from the Southwark and Vauxhall Company (with contaminated water from the Thames) and those subscribing to water from the Lambeth Company (with water fed from further upstream, and without sewage contamination). What's more, the groups appear to be well-matched in other covariates, so that no confounding would seem to be at work — for example, if the Lambeth Company customers had to pay more for that service then they would likely be richer and in better health anyway. The choice of service provider was fairly random.

Indeed, one could not hope for a better experimental setup if one tried, and Snow was well aware of this, writing:

> Now it must be evident that, if the diminution of cholera, in the districts partly supplied with improved water, depended on this supply,

have some deathly psychological effect. Again, Semmelweiss controlled for this and again found no difference.

the houses receiving it would be the houses enjoying the whole benefit of the diminution of the malady, whilst the houses supplied with the [impure] water from Battersea Fields would suffer the same mortality as they would if the improved supply did not exist at all. As there is no difference whatever in the houses or the people receiving the supply of the two Water Companies, or in any of the physical conditions with which they are surrounded, it is obvious that no experiment could have been devised which would more thoroughly test the effect of water supply on the progress of cholera than this, which circumstances placed ready made before the observer. [Snow, 1855, p. 74]

By finding out how many houses each company supplied water to, and then finding out how many deaths occurred in each (Lambeth supplied versus Southwark and Vauxhall supplied) Snow was able to prove that if one took water from Southwark and Vauxhall one was 14 times more likely to suffer a fatal infection. Although no experimental control is exerted here, given the matching (in 'relevant respects'), inferences are well supported. Of course, though an intervention suggests itself, there is no mechanism specified, and no 'low level' underlying theory. Hence, this constitutes a paradigm instance of 'black box' epidemiology (also known as 'risk factor epidemiology'). It is a perfectly legitimate and often very effective way of stopping the transmission of diseases — see [Greenland et al., 2004] for a recent defense. One might not know the exact mechanism underlying the transmission, or what is being transmitted ('the agent'), but if one knows that certain behaviours or events lead to transmission then this is sufficient to be able to put an intervention into operation. Naturally, a 'deeper' micro-account would most likely result in more effective (and more efficient and generalizable) preventative measures, and perhaps eradication of the disease.[23] However, if necessary, black box studies can often point the way to such studies.

2.5 Modern Public Health

The previous discussion highlights the fact that there are two broad, apparently *competing* strands of public health: a biomedical strand and a socio-economic strand. These are woven together by epidemiology, which utilizes results concerning one to impact on the other. Modern public health places more emphasis on the 'macrosocial determinants' of health than was common during the earlier parts of the twentieth century, with its focus tending to be more on the biomedical aspects of health. We saw that the view that the social and physical environment plays a role in determining health has played a crucial role in the development of public health and epidemiology. Writing specifically about the treatment of tuberculosis, Winslow argued that intervening in social aspects, through the education of individuals for example, "has proved almost as far reaching in its results as

[23]However, social epidemiologists, for example, would argue that the best preventative measures come from imposing measures 'upstream' (i.e. focusing on more distal social causes). We shall return to this controversy several times in subsequent sections.

the discovery of the germ theory of disease thirty years before" [Winslow, 1923]. Moreover, new kinds of theories about non-infectious diseases have emerged in the twentieth century, such as lupus, genetic diseases, and cancer. Theories concerning the social causes of diseases have begun to take shape recently too. This suggests that all components, statistics, sociology, bacteriology, and epidemiology, are necessary for the proper functioning of public health. The current trend appears to suggest greater integration of these elements in the future.

3 WHAT IS PUBLIC HEALTH?

In the previous section we got to grips with several key themes in the historical development of public health as a discipline. In this section we consider the question of how to define public health, and what assumptions and implications the proposed definitions involve.

3.1 A Catalogue of Definitions

In the latest edition of *The Oxford Textbook of Public Health*, public health is defined as "*the process of mobilizing and engaging local, state, national, and international resources to assure the conditions in which people can be healthy*" [Detels and Breslow, 2005, p. 3]. This emphasis on social engineering, and community action, points to a notion of 'infrastructure': public health provides some underlying structure necessary to support the health of the overlying public. It is a substructure that enables (amongst other things) the prevention of disease, the support of the sick, and responses to emergencies. The substructure is often more intangible than bricks and mortar: social norms are required to make many public health ventures go.

This definition is more or less identical to that of the US Institute of Medicine, which states that the "mission" of public health involves "fulfilling society's interest in assuring conditions in which people can be healthy" ([U.S. Institute of Medicine, 1988], p. 40). This is clearly intended to be normative as well as descriptive. The mission is implemented through "organized community efforts aimed at the prevention of disease and the promotion of health" (*ibid.*, p. 41). The organizational framework within which this is carried out includes "activities undertaken within the formal structure of government and the associated efforts of private and voluntary organizations and individuals" (*ibid.*, p. 42). Again, the emphasis is on community and action — see [Beauchamp, 1985] for an engaging study of these aspects.

The model for these definitions, and almost all recent definitions, is C. -E. A. Winslow's canonical definition as:

> The science and the art of preventing disease, prolonging life, and promoting physical health and efficiency through organized community efforts for the sanitation of the environment, the control of community

infections, the education of the individual in principles of personal hygiene, the organization of medical and nursing services for the early diagnosis and preventative treatment of disease, and the development of the social machinery which will ensure to every individual in the community a standard of living adequate for the maintenance of health. [Winslow, 1923, p. 1]

The implementation of this vision is aided by informatics and epidemiology. Often there is public health action without identification of the actual causes of some phenomenon. One does not need a mechanism to use epidemiological results in decisions. Public health often proceeds without theory. This much paints an 'aim oriented' picture of public health.

The early WHO definition of health as "a state of complete physical, mental, and social well-being" [1947, p. 1] has been the subject of a lot of criticism. The main objection is that it is too strong to ever be satisfied by actual individuals. However I think this misses the point somewhat. The definition should be viewed as an ideal towards which our public health activities should strive — in this sense it too is aim-oriented. Naturally, any individual's health state will only ever be an approximation of 'complete well-being', but, the idea would seem to be, the state can nonetheless be shifted closer to the ideal. However, understood this way it nonetheless has its problems. For example, it does not give any information on how to achieve (or approximate) this golden state — in short it makes absolutely no reference to the determinants of health and to the methods by which one might intervene. Even as an ideal then, it is useless. Moreover, we might rightly inquire as to what "well-being" is, if not health by a different name. In the next subsections we examine the notion of public health in more detail.

3.2 Narrow Versus Broad Conceptions

Verweij and Dawson [2003] distinguish "broad" versus "narrow" conceptions of public health. Their focus is a demarcation issue: what counts as a public health problem? On the one hand, according to a narrow (or traditional) conception, public health is concerned with such things as the environment's impact on health, screening programmes, infectious diseases, education campaigns, and so on. A broader conception would focus on less direct aspects, such as socioeconomic and cultural factors. I prefer to call these 'local' and 'nonlocal' since they concern factors that act directly on individuals in the former case and more indirectly in the latter case.

As Verweij and Dawson point out, the problem the nonlocalists have with the local account is that the latter fails to capture all possible (reasonable) determinants of health: "[if] public health is primarily about prevention in its widest sense [then] true prevention will have to focus on all of the causes of public health problems" (*ibid.*, p. 16). In other words, according to the nonlocal account, *everything* (no matter how non-proximal) will be included in public health if it does indeed have an impact on the health of individuals. This all-inclusive approach clearly has

its own problems. Verweij and Dawson object that "such a conception of public health could be limitless, as almost all human activities (and many inactivities) may affect health" (*ibid.*, p. 17). This is true, but one might respond by pointing to the fact that not all contributions to public health will be equally weighted. That is, the fact that public health problems are essentially limitless does not mean that they cannot be prioritized. Some factors will play a much lesser role than others, and so one should naturally devote more attention to those. Likewise, some factors may be easier to intervene in than others and so one should focus on those. There are no doubt many other prioritization criteria that one could employ to decide which factors to focus on, and these will most likely be suggested by the context.

3.3 The 'Public' Aspect of Public Health

Verweij and Dawson go on to distinguish two senses of 'public' in 'public health'. Firstly, they follow Geoffrey Rose [2001] who takes 'public' to refer to a population of individuals so that public health refers to the collective health state of the population. In other words, the basic system of public health is the population rather than the individual. This system, like an individual, can have a health state that can be measured, tracked, compared to other systems, and modified. Secondly, they point to the methodology of implementing *interventions* at the population level, or through collective (public) action: "Taken as a whole, we propose that the practice of public health (roughly) consists of *collective interventions that aim to promote the health of the public*" [Verweij and Dawson, 2003, p. 21]. This seems to follow Winslow's lead once again; however, in this case we have implicitly spelt out what is meant by 'public'. The sense so given contrasts with Winslow's idea of ensuring good health for the *individuals* in a community, for here we have what sounds like a more utilitarian notion of collective health in which the individual members are secondary.

This conception of public health seems to map onto Beauchamp's understanding. He argues that public health ought to be an instrument of social justice [Beauchamp, 1976]. His target is the notion of 'market justice' (this should really be *free* market justice), the idea that a system should be left to its own devices to self-organize, and this way individual freedoms are left alone. However, as in the economic sphere, what we find in market justice worlds are (power law) inequalities: most people have very poor health and living conditions while very few (in terms of percentages) have exceptional health. A social justice understanding would seek to lessen this inequality to the point at which inequalities are no longer inequities (minimal conditions necessary for good health). The right to some specified minimal level is fundamental according to social justice approaches.

3.4 The 'Health' Aspect of Public Health

Christopher Boorse treats the problem of defining 'health' in great detail in his chapter; for now we just briefly discuss a few salient points as they relate to the definition of public health — the shift to public health does introduce novel aspects to this much discussed problem. The key issue to consider here, I think, is whether there is a plurality of concepts (of health and disease), depending on whether one is studying health-related phenomena at the individual or population level, or whether these concepts are of the 'one size fits all' variety. We return to this in subsequent sections, for now it will be instructive to see if the standard answers to the question of what health is are equally applicable in public health.

Kitcher distinguishes between two broad conceptions in the understanding of disease (and so, by extension, health):

Objectivism: "there are facts about the human body on which the notion of disease is founded, and that with a clear grasp of those facts we would have no trouble drawing lines, even in challenging cases" [Kitcher, 1997, p. 208].

Constructivism: objectivism "is an illusion ... the disputed cases reveal how the values of different social groups conflict, rather than exposing any ignorance of fact, and that disagreement is sometimes even produced because of universal acceptance of a system of values" (*ibid.*, p. 209).

One can find many (not necessarily equivalent) variations on this distinction in the literature. For example, Lennox [1995] speaks in terms of "reductionists" and "relativists". One can also find a distinction between "naturalists" and "normativists" (see [Amundson, 2000] for example). However, at the root of all of these is the 'fact/value' distinction: does our understanding of disease and health involve value-judgements, and if so do these judgements cloud the objectivity of our talk of health and disease or can fact and value peacefully coexist? Naturalists, objectivists, and reductionists will generally[24] wish to say that the concepts of health and disease are value-free theoretical concepts that occur in the health sciences: they will likely wish to base their philosophical understanding of the concepts on the scientific understanding of them. Normativists, relativists, and constructivists will deny this, taking the concepts of health and disease to be value-laden (with attributions of 'disease' reflecting our disapproval and 'health' reflecting what we find desirable), subject to change, and in no way 'carving nature at its joints'. Does this debate transfer over to the public health context?

Clearly, many of the definitions of health that have been offered in the biomedical realm will not be applicable in the public health context on the grounds that many of them make specific reference to humans and the human body or to the biological function of organisms. One might extend some of the definitions by

[24]Though not always. For example, it is perfectly consistent to argue for objectivism about health and disease (i.e. argue that they point to some matter of fact about the world: a *state* of a subject) while still arguing that we make value judgements about the impact of that state on the subject and its relationship to other such states. I return to this point in later sections.

taking 'body' and 'organism' to mean any organized system involving biological components. However, if taken to be a defining condition of the general concept of disease it threatens to be over-applicable (on the grounds that there are many systems with biological components, not all of which deserve the attributions of health and disease states — for example, an orchestra has biological components, but one doesn't usually speak of the orchestra itself being 'healthy' or 'diseased'). Having said this, depending on our philosophical proclivities, we might wish to generalize the concepts even wider, so that they are applicable to any system whatsoever. For example, we sometimes speak of the health of financial markets. However, this is usually understood to be a metaphor rather than any indication of the nature of the reality of markets.

The idea that health and disease at the population level are value-laden might be considered more appropriate since populations do not seem to be natural kinds in the way that organisms are often taken to be. However, we need not necessarily make reference to natural kinds. According to Boorse's naturalistic theory, for example, disease, is biological disfunction (and health the absence of it). Let us present the four components of his 'Biostatistical Theory' ([Boorse, 1997, p. 7], as presented in [Schwartz, 2007, p. 52]):

1. The *reference class* is a natural of organisms of uniform functional design; specifically, an age group or a sex of a species.

2. A *normal function* of a part or process within members of the reference class is a statistically typical contribution by it to their individual survival and reproduction.

3. A *disease* is a type of internal state, which is either an impairment of normal functional ability, i.e. a reduction of one or more functional abilities below typical efficiency, or a limitation on functional ability caused by environmental agents.

4. *Health* is the absence of disease.

Hence, we get the view that health is simply the absence of disease, where disease is given by statistical subnormality of biological function (defined by reference to survival and reproduction) in a (stratified) reference class of organisms.

The idea that disease is abnormal function (if we consider 'abnormal' to be deviation from a normal curve) might look initially appealing since public health is based on statistics. We might take populations with health properties that are normally distributed to be 'healthy' ones. If we have a skewed distribution or one with fat tails then this points to inequalities and, therefore (perhaps) functional inefficiency. One can consider the distributions of certain properties to be indicators of healthy and unhealthy populations. As we see in §4, something like this forms the basis of so-called 'summary measures of population health', namely measures of health that roll up individual-level health data into a single number taken to be representative of health and disease in the global system.

However, so understood, this proposal faces a simple problem in that the determination of health status is a relative matter: one could have a distribution reflecting very little by way of inequality, and yet in which the individual events making up the distribution are all very low (in the sense of low life expectancy, for example) — or, in other words, the distribution is distributed 'healthily' according to this proposal, but the individual health levels are very low. Conversely, in a society were the majority of people suffer extreme depression (because of some tragic accident perhaps), then this registers itself in the statistics: it is 'normal' to have extreme depression. Those who *don't* suffer are diseased. There is an easy response to such problems: health and disease are independent of our labels. Just because we do and do not choose to call certain patterns and states 'diseased' and 'healthy' does not mean that there is a genuine correspondence. However, Boorse's definition involves the notion of normal *function*, not normality *simpliciter*. Mere statistical normality is not sufficient to determine health; one must look at how some state is linked up with matters of function and efficiency. Lennox points to the fact that one might need to look to the population level in order to determine these latter aspects [1995, p. 508], by looking at correlations between the variable of interest and variables that are directly linked to mortality (for it is the maintenance of life that guides Lennox's approach). However we approach the problem, it is clear that values will enter at some point, if only in the weighting of health states in terms of severity.

A more pragmatic approach, one that I will flesh out later on, would argue that it is nonsense to try to pin down a unique definition of health and disease independently of one's interests and the uses to which the concepts are being put. This filters through into the (operational) construction of population measures of health and disease — that is, the approach maps onto actual scientific practice. Here there are very many such measures, and one can pick and choose according to task: if one is interested in resource allocation then one can focus on an approach to health that is insensitive to many aspects that one could not ignore if one was interested in equity issues, or in whether it was right to intervene in some property. We return to this issue again in the context of health measures in §4.

3.5 *Prevention versus Cure*

A corollary to the individual/population distinction (discussed in §3.3), though not a strictly necessary one, is the distinct aims that are associated with individual and population level approaches to health. There is an epistemic difference embedded in this difference in aims: the preventative measure concentrates as much focus on 'unknowns' as it does on 'knowns'. In the clinical encounter, the focus is on some presentation of disease in an individual with the aim of diagnosing the disease and finding a cure. Public health, on the other hand, will tend to focus on a disease-free population, with the aim of keeping it that way. The notion of prevention in public health overlaps with the issue of aetiology. A public health programme will usually isolate causes in a different way than clinical health practice in the sense

that a more 'distal' cause will be deemed responsible for some health problem so
that interventions (if used) will be applied at different sites.

Furthermore, as Rose points out [Rose, 1992, pp. 12–13], according to the pre-
ventative strategy the benefit to individuals can be very small (and even negative:
say a loss of earnings). As Rose puts it himself: *"a preventative measure that
brings large benefits to the community offers little to each participating individual"*
(p. 12). The gain is at the population level. Rose accepts the tough side of preven-
tion, including the seeming necessity of alteration of norms of behaviour and the
social fabric to achieve the desired effects.[25] Naturally this level of control invites
ethical commentary — but that is not my concern here. Rose's point is that a
truly preventative science must involve a thorough knowledge of the determinants
of what it is one seeks to prevent: disease. And, likewise, of what one seeks to
promote: health. Once these have been isolated then one can intervene so as to get
the optimal situation. In the ideal case one will no longer need such strategies as
screening programmes and such like: the root cause will no longer be in operation.

This seems rather over-optimistic. Even if the causes could be isolated, it isn't
clear that one could persuade a whole population (or even most of a population)
to engage in practices that are often of minimal individual benefit. On the latter
problem Rose suggests that one adopt a "high-risk strategy" involving the specific
targeting "of those individuals who are judged most likely to develop disease"
(*ibid.*, p. 13). The strategy depends then, as one might expect, on the distribution
of risk in a population. If the risk is spread fairly uniformly over a population then
a "population strategy" (a mass strategy) is appropriate. If one can find clusters
of risk, then one can adopt a targeted approach.

Rose adopts (though doesn't argue directly for) a holistic position well opposed
to methodological individualism. This, he says, provides the "sociological basis'
for his idea of a population-level prevention strategy [Rose, 1992, p. 95]. As he
notes, the view has noble ancestry that he traces to Durkheim. In the health
context it involves the thesis that "healthiness is a characteristic of the population
as a whole and not simply of its individual members" (*ibid.*, p. 62). The problem
is, how to turn this from mere talk into a practical framework. How, for example,
does one measure this state if not by measuring the states of the individuals
and aggregating the results? Even in the case of Durkheim's classic analysis of
suicide the measurement and construction of population-level properties is done
'upwardly' via the individual members.

The division common in the social science between methodological individualism
and holism arises in the field of public health, then, and can have a bearing on
practical matters. For example, if one adopts a holistic approach, then one will
focus on the population as the object of investigation, with its own properties to be
measured, intervened in, and evaluated (*cf.* [Weed, 2004, p. 532]). If, on the other
hand, one adopts an individualistic approach, then one will focus on the individual

[25] For example, by altering the social status quo for smoking one does not need the distant
incentive of better health, one can rely on the immediate social disapproval that smoking gener-
ates.

people in a population, and measure and intervene in their properties. This, of course, colours the explanation one gives of the causes of health and disease. A methodological individualist will seek to explain by drawing attention to factors having to do with the behaviour of people; a holist will look to collective factors, or the wider social and physical environment, that drive that individual behaviour.

3.6 Scientific Foundations of Public Health

Epidemiology and Biostatistics form the scientific core of public health, the foundations on which decisions and actions are made. As Detels and Breslow state, epidemiology "is the scientific method used to describe the distribution, dynamics, and determinants of disease and health in human populations" [Detels and Breslow, 2005, p. 10].[26] Epidemiology is the obvious choice for the scientific basis of public health: both take populations as their primary objects.[27] Public health is grounded in statistical methods. Given aggregates of measurements of health-related properties they enable the identification of health problems (bad trends, inequalities, etc.), which in turn allows for evidence-based promotion and intervention, for informing efficient health economic policy, and assessing the impact of interventions. Epidemiology is in the business of inferring conclusions about the distribution of health (and disease) in a population. Part of this involves uncovering the determinants of health and disease. To do this epidemiologists attend to relative frequencies between various patterns (smoking and lung cancer, for example). We can roughly view the epidemiologist as giving us a measure of public health (or at least some components) in the sense that we are able to see how these components are distributed over the individuals in some population (whose members are not necessarily geographically or temporally coincident). As mentioned, one can look at relationships between components, and their trajectories over time and place, and form hypotheses about the connections. It is these hypotheses that can often lead to public health action in the form of interventions (or in the form of analytical studies).

Public health and epidemiology are, then, very tightly woven together. John Last, in his dictionary of epidemiology, broadens the fairly standard definition given above to include *action*, defining it as "the study of the distribution and determinants of health related states or events in specified populations and the application of this study to the control of health problems" [Last, 1995, p. 42]. That closes the gap between public health and epidemiology making them almost identical. It is more common, I think, to view epidemiology as a providing an evidential basis on which public health acts and bases its decisions (concerning

[26]Note that "disease" here is an umbrella term covering all manner of health-related events or phenomena: HIV, smoking, teenage pregnancy, bullying, and so on. In fact, it needn't be a negative event: one might be interested in what is causing some positive trend, such as an increase in exercise amongst young people.

[27]A lovely little book (just 69 pages) that introduces the essentials of epidemiology for the 'uninitiated' is [Coggon *et al.*, 1997].

the management of resources, and so on). Milton Terris makes the 'evidential-basis' role particularly explicit:

1. To discover the agent, host and environmental factors which affect health, in order to provide the scientific basis for the prevention of disease and injury and the promotion of health.

2. To determine the relative importance of causes of illness, disability, and death, in order to establish priorities for research and action.

3. To identify those sections of the population which have the greatest risk from specific causes of ill health, in order that the indicated action may be directed appropriately.

4. To evaluate the effectiveness of health programs and services in improving the health of the population. [Terris, 1993, p. 142]

Put in this way, public health is nothing but applied epidemiology. However, Sander Greenland strongly distinguishes epidemiology from public health, latching on to exactly the action-based component raised by Last:

[P]ublic health is not a science, but a form of social activism, one whose benefits appear profound enough to society that it is institutionalized and heavily subsidized by governments. A public health activist promoting or searching for an action will be concerned with communicating his or her own opinions, evaluating the opinions of colleagues, and influencing the opinions of governmental figures and the public. [Greenland, 1988, p. 96]

Epidemiology, by contrast, is seen as unbiased, objective, and unfettered by any kind of social incursion — thus following Weber's dictum that "it is the duty of the man of science to remain silent ... on value questions" [Weber, 1920, p. 188]. However, this is a rather naive view of how science works, as countless philosophers, historians, and sociologists of science have demonstrated, whether through feminist challenges, Kuhnian challenges, or many others. Epidemiology, more so than many other sciences (given its statistical basis), is very much invested with values. Indeed, if we are persuaded by Donald MacKenzie's [1981] arguments, even the mathematical foundations of epidemiology are infiltrated with 'interests' due to their incursion into the foundations of modern statistical theory.

4 HEALTH MEASUREMENT AND HEALTH MEASURES

Health scientists and professionals want to be able to measure health for a variety of reasons: to track changes in health, to identify problems, to identify causes and risk factors, to check how an intervention has performed, and to perform cross-comparisons between groups. To do this we need to have a clear idea of what we are measuring.

4.1 Measurement and Standardization

Measurement is, as Grigory Barenblatt succinctly puts it, "the direct or indirect comparison of a certain quantity with an appropriate standard, or, to put it another way, with an appropriate *unit of measurement*" [Barenblatt, 2003, p. 12]. If we are talking about measuring the health of the public this must involve comparison with a standard too: a 'unit of health'. It is clear that this is not going to be a *fundamental* unit; rather, it will be a complex derived (by aggregation) from other, more fundamental units. However, it is still a problem to say what this thing to be measured is. The method of definition in the context of public health is to give an operational definition. In order to ensure objectivity (or as near to objectivity as possible) the focus is on the individual, and the wider social context is ignored: health is viewed as what something that happens under the skin. Even the health of populations is to be reduced to the functioning of individual bodies (a form of methodological individualism in the context of the health sciences). That is, ill health (at least according to most measures) is taken to be the reduction in individual human function caused by disability or, alternatively, a reduction in the well-being of individuals.

This a natural position to adopt: one demands standardization in measurement. The environment (be it physical or social) varies considerably, so it is desirable to have a measure that does not take account of that, or that is 'insensitive' to it. This is clearly especially vital if one wishes to conduct comparative work on different populations, to measure health inequalities for example. However, this standardization misses out on the crucial role played by context (see [Allotey *et al.*, 2003]): a broken leg in Canada is a fairly trivial matter, and one expects the health discounting to be minimal. However, a broken leg in a developing country is a far more significant matter: there may be no sickness benefit to draw from, no easily accessible health care services, and so on. In this case the impact ought to involve a weightier discounting. Yet we are dealing with the same event, from the point of view of the measure: a broken leg. The individualistic health measure will treat the cases as the same in terms of their value.

One can come up with more examples that do not involve inter-population comparisons. Consider two individuals from the same population, both with a sprained finger, one of whom is a concert pianist, the other is, say, a teacher. Clearly these individuals will weight the severity in different ways. Severity is not an objective fact of the matter, it depends very much on the individual. Clearly then, one's health measures have to take account of more than the local considerations of individual bodies. However, the determination to restrict health to individuals resulted in the WHO introducing an idealized "uniform environment", and then considering (in the population health case) the "capacities" of individuals within this environment — see [Chatterji *et al.*, 2002, p. 6]. Health is then defined as having the capacity to perform certain tasks within an idealized (though not necessarily non-actual) environment. In other words, the environment is introduced into the definition of health, but it itself is standardized. The idea is to switch off

the role played by the environment. We return to the problems with such measures in §4.4. Before we get to that let us first say some more about the health measures.

4.2 Summary Measures of Health

Health measures aim to give a numerical representation of health, be it in an individual or in a population. A *summary* measure of health will summarize the health states of the individuals in a population. Health status indicators (those features that might go into a health measure) come in various kinds, and can refer to individual or population properties, and such things as waiting times, resources-to-demand, and so on. Aggregate measures might take a number of these and average over them to produce an index akin to the Dow Jones Industrial Average [DJIA].[28] Amongst other things, these measures are used to assess the impact of interventions and policy. Though a little dated, [Bergner, 1985] gives an excellent overview of the measurement of health status.

In public health, then, (or population health, more generally) one does not (thus far) measure a property of some system ('the public'). Rather, one measures properties of individuals and then aggregates the data that result. One is then left with a single number, a statistic, that is intended to provide the requisite ('summary') measure of the more complex system. This can be understood in terms of 'social indicators', i.e. statistics that are intended to be calibrated to the quality of life of the individuals whose relevant properties are aggregated in some way (*cf.* [Michalos, 2006, p. 344]). Vital statistics would be an example of social indicators, as would the various financial indices. They would be examples of *objective* indictors since they rely on facts that are independent of 'internal' states of individuals[29] — whether they are 'value-free' is another matter, one that we return to below. Quality of life indicators might refer to the subjective reports of individuals, such as 'degree of happiness', and in this case they are *subjective* indicators. As we saw, the job of representing (or indicating) the overall health state of a population was, from very early on, carried out by mortality rates. However, this misses a major component: morbidity. Summary measures of population health were devised in the 1960s to take account of both mortality and morbidity.

One unit for measuring health (and so the effectiveness of an interventions) via the notion of quality of life, is the 'quality-adjusted life year' [QALY]. This gives a measure of the quality and quantity of life.[30] These depart from the more

[28]For those not acquainted with the basics of financial markets, the DJIA is an index composed of thirty blue chip stocks. Initially, the value was computed by simply adding together all of the company stock prices and dividing by 30. The number is is then taken to provide a (fairly rough) measure of the economy's state — it is sometimes said to provide a measure of the economy's health! There are many such indices one can use, largely depending upon one's interests.

[29]See [Stouman and Falk, 1937] for a thorough, early review of objective indices of health.

[30]The on-line resource *Bandolier* refers to the QALY as "a slightly mythical creature of dubious parentage" (http://www.medicine.ox.ac.uk/bandolier/ — as with all on-line resources, this

objective measure in terms of life expectancy (alive = 1 or dead = 0) by introducing a continuum of states between 0 and 1, where the value 1 is taken to represent 'perfect health' and 0 still represents death. More precisely, the value 1 is assigned to one year of perfect health-life expectancy. If a year contains less than perfect health-life expectancy, then a value of less than 1 is assigned. Computations are then very straightforward. For example, if we intervene to extend a patients life by 5 years, but the quality of life for those 5 years is half of the perfect quality, then we simply compute the QALYs gained in the intervention as 5 × 0.5. Hence, 2.5 QALYs will have been 'generated' by the intervention. Such medical mathematics informs medical decisions, since one can use the values so computed to work out which interventions will have the greatest 'yield' in terms of QALYs.

In [Murray *et al.*, 2000] a distinction is made between "ideal" and "actual" health. 'Ideal' has two senses here: it signifies the health state we *want* individuals to attain (namely a full life at full health: with full defined appropriately); and it also serves as kind of limiting case of real health. It is ideal in that it doesn't exist in reality, but only as a concept, or perhaps in some other possible world. An aggregate (or summary) population measure can be constructed from measurements of individuals by simply adding all of the differences between the ideal and actual health of individuals. This gives the years of life lost in a population [YLL] and can be used to measure the level of disease. The way of calculating a figure is fairly straightforward in practice, if not philosophically. Given a specified ideal age (80 for males; 80.2 for females), the YLL is the difference between the actual life and the ideal age. Each subsequent year is weighted slightly less than the previous year. This way of speaking (i.e. of ideal states) fits in with the WHO's definition of health as "a state of complete physical, mental, and social well-being and not merely the absence of disease and infirmity". Naturally this is a limiting case: no individual, I presume, could ever hope to attain such a state.

One can also consider a measure involving morbidity (the years lost due to disability) with mortality as a limiting case. In this case one reduces the value assigned to each year for which the individual was disabled (with an ordering of severities of disability corresponding to an ordering of the amount of the reduction). Population health is then computed as the sum of the years lost to premature mortality and to morbidity. For a given population of individuals (including those who are recently deceased), when we sum this figure for all events during a single year then we get the measure known as the DALY: the Disability Adjusted Life Year. One DALY represents the loss of one year's worth of healthy life. The DALY again involves an ideal reference population with life expectancy (at birth) as above. The burden of disease is then computed as the difference between this ideal state and the state of a population's health (recorded in DALYs).[31]

URL might be subject to change).

[31]Note that DALYs are a subclass of the more general measures known as HALYs ('health-adjusted life years'). A nice review of these issues can be found in [Reidpath, 2007]. A compendious volume dealing with a host of issues relating to population health measures is [Murray *et al.*, 2002b].

There are numerous problems with these measures, largely stemming from the lack of an objectively-agreed upon weighting of events. For example, there might well be states of life in which the suffering involved is worse than death. The measures that are constructed are clearly not carving social reality at the joints (although they may serve to define those joints arbitrarily, or rather, by convention). The DALY is most decidedly not a natural kind.[32]

4.3 Classifying and Measuring Health States

Summary measures of population health perform multiple useful roles: they can enable the cross-time or cross-space comparison of health state; they can identify problems, and they can tell us if an intervention worked. Dennis Fryback [1998, p. 43] notes that there are three steps involved in the construction of health measures:

1. decide on the aspects of health that will be included in the (discrete) classification scheme

2. construct a mapping between the health of humans and the states in the classification scheme[33]

3. assign weights to each health state included in the classification to be used to compute population health

The classification scheme is clearly going to involve massive abstraction from 'real' human health states. How much abstraction will be determined by the use to which the measure is put. The earliest measures simply classified health according to two values, 'alive' and 'dead'. This measure will be adequate for any task that requires only mortality rate data. A finer measure will need to differentiate various substates within 'alive' — clearly 'dead' has no relevant fine structure! Again, the amount of differentiation will be a choice determined by the level of detail one needs for the use.[34] If one wants to know the best way to deliver some mental health intervention, then one will demand a measure that takes account of this. Health, in other words, is multi-dimensional. There are different perspectives that one can adopt towards the health of a system. Given this pragmatic way of conceptualizing health, I don't see that it makes much sense to try to adopt a single definition, as is the trend in the majority of philosophical discussions. Biological disfunction, for example, is but one aspect of health. In some cases it might be an appropriate definition or measure of health, in others it will not be.

[32]Of course, ethical issues loom large; however, I want to steer clear from these in this chapter. For an excellent review of the moral implications of summary measures, see [Brock, 1998].

[33]Given that the classification system results in a measurement system, we then get an operationalization of our health concept.

[34]For example, the (summary) health measure known as 'HUI-Mark III' (where 'HUI' = 'Health Utility Index') has the ability to distinguish between 972,000 distinct health states pertaining to the physical, mental and social dimensions of health. For many purposes this amount of complexity would be simply unnecessary.

A genuinely naturalistic approach to the question of what health is ought to follow what our best science has to say on the matter, and it appears that this pragmatic multifaceted approach is the answer given by that science.[35]

One can usefully view this situation through the lens of Ronald Giere's scientific perspectivism [Giere, 2006]. The idea is to view the various measures as so many scientific instruments restricted to 'viewing' only certain aspects of the systems they are directed at. Here too, I think, "one's theoretical perspective ... depends on the kind of problem one faces" (ibid., p. 34). Different problems demand different perspectives.

The old problems, however, do set in when it comes to weighting the various health states separated by the classification system. There is no objective way of doing this, and an infinite variety is clearly possible. But I think it is best to run the same argument just given: how one assigns health state weights depends on what problem one has in mind. For example, if one is concerned with the 'productivity' of the population, then physical disabilities will presumably be more heavily weighted than self-esteem, say. If one wants a measure that will appear the most democratic, then one might wish to base the weightings on average values assigned to various health states as taken from a survey. The QALY discussed above is based on cost-effectiveness issues and so naturally it bases health state weights on utility. If one is happy to say that there is a plurality of health systems (i.e. that there is no classification system that is the most objectively true) then the values that inevitably go into the weightings do not cause the kinds of problems they cause for other so-called naturalistic accounts: one is not privileging one system as 'fact' in the first place.

4.4 The Inadequacy of Aggregative Measures

As we have seen, aggregate measures are based on the view that the health of a system is determined solely by the health of its individual parts; if one knows the latter then one knows the former. Daniel Reidpath [2005] argues that aggregate measures of public health are inadequate on the grounds that the aggregate does not provide any information on how health is spread out over the population. To work this out one needs to look at the shape of the probability distribution of health states over the individuals. Presumably we would consider a population in which 5 % of the population have enormously high health values (relative to some measure, life expectancy, say) and the remaining 95 % have relatively poor health

[35]Sander Greenland [2002] argues that health's multidimensional nature ought to be reflected in the scrapping of scalar measures in favour of multidimensional measures (vectors whose components represent the different aspects of health). Hausman [2002] argues that while there might be some theoretical attractiveness to this proposal, it is not practical and would most likely be ignored by health policy makers. That is probably correct; however, such a measure would have many uses not covered by unidimensional measures. Unless we wish to fall under the philosopher's spell of the one unique measure that *best* represents the *true* health state, then we ought to accept these measures as providing a perfectly acceptable additional perspective on the health state of a population.

(giving a very skewed, fat-tailed distribution) to warrant a lower health value
than one in which there is a relatively high and even (or normal) distribution
of health. However, one can construct all manner of distributions of health of a
population of individuals many of which will be grossly iniquitous (in terms of the
way health is distributed *over* the individuals), yet that correspond to one and
the same aggregate value, on account of possessing the same average. That is to
say, the value assigned to a summary measure of health is multiply realizable by
(infinitely) many 'spreadings' of health and disease over the population, (infinitely)
many of which are grossly iniquitous. An individual asked to choose which of the
populations they would like to belong to would not be indifferent. Therefore,
argues Reidpath, the distribution is relevant to the way we go about measuring
the health of a population.

Take a simple toy example. Suppose we have two populations with the same
number of people in each. Suppose that we aggregate the health of the individuals
and come up with figures of 100 QALYs as the aggregate measure in both cases.
Now, if we were to use this to determine which population were healthier we would
have to say that they were equal. The measure is not sensitive enough to detect
finer details. However, the finer details are all important. In one population 80% of
the QALYs might be generated by 20% of the people (so that most people are very
unhealthy), whereas in the other population the situation is more balanced, with,
say, 80% of the QALYs generated by 80% of the people. Rather more visually,
we might consider two populations, one of which was composed of two types of
human, giants and dwarfs, and the other with a broader range of heights. We
could set this up so that the average heights of the populations were identical,
and yet the average figure is not giving us the kind of information we want from a
measure of, say, what the sizes of the people are like in the respective populations.

The problem, then, has to do with the aggregative methodology which involves
simply taking the individual level data and summarizing it. The methodology is
individualistic: population-level phenomena are seen as nothing but the synthesis
of individual-level data. The business of the distribution of health and disease is
then seen as a quite separate issue. Reasons given for this separability of level
of health and distribution of health, by those who construct the measures range
from 'tradition' (i.e. the health statistics tradition stemming from mortality rates
— see [Murray *et al.*, 2002a, p. 752]) to 'communicability' (in the sense that it is
easily assimilated by the general public — *ibid.*).

Reidpath argues that this is the wrong way to conceptualize health at the pop-
ulation level. He does not suggest a holistic approach as such, but instead one
based on development economics, that blends population level data about the dis-
tribution of health (or, rather, well-being) with the individual level data. That is,
the distribution of socially relevant properties over the individuals in populations
should not be separated from the measurement of that property at the population
level. The implication of this seems to be that aggregate measures miss out on
'emergent' features of population health. As Redipath puts it, "there is informa-
tion relevant to the health of a population that can only be derived from the gestalt

that cannot be ascertained from the sum of its parts" [Reidpath, 2005, p. 879].
More is different in population health, we might say (here following [Anderson,
1972]).

Reidpath is certainly right that the summary measures are not sufficient for
many purposes. However, clearly sufficiency depends on the task to which the
measure is being put. Sometimes a more coarse-grained measure of health might
be all that is needed. Other times, this will be inadequate and the fine structure
of a population's health will need to be incorporated. That is, one cannot, as
Reidpath does, speak of insufficiency *simpliciter*; insufficiency is tied to a specific
goal.

4.5 Cross-Comparison of Heath Categories and the Ranking of Health States

Daniel Hausman draws attention to a problem of the cross-comparison of what
appear to be incommensurable categories of health state. He presents the example
of comparing an individual with a mild learning disability to an individual with
quadriplegia. How is this comparison to be made? As Hausmann puts it: "How
can one compare units of mobility with units of cognitive functioning? How can
one measure the 'distance' of health states from H [complete health]?" [2006, p.
251]. As he points out, the usual way of comparing is via *evaluation*. One makes
a value judgement about *which would be better or worse*. Hausman sees no way
past this state of affairs: "Measurements of population health are measures of how
good or *bad* population health is, and the goodness or badness of health depends
on the physical, technological, and social environment and on the characteristics of
people's activities and objectives as much as they depend on facts about stomachs
or brains" (*ibid.*, p. 252). Indeed, the DALY, and many other health measures,
involve a ranking of disabilities according to the impact on functional capacity (the
capacity to do certain things, like walking a certain distance). That this weighting
is made explicit is touted as an advantage over QALYs since the value judgements
are open to view and modification — see [Murray, 1994].

John Broome argues that the ranking of health states is done according to how
the state contributes "to well-being" [2002, p. 94]. Well-being is a bad basis for
the evaluation of health states since it is too vague. Hausman argues, instead,
that the ranking is, in practice, done according to *preference* (*ibid.*, p. 253).
This is a "faulty" method on account of problems (false beliefs and cognitive
deficiencies) with preference (*ibid.*, p. 264). Preferences are the outcome of some
other reasoning processes: these problems and other processes, Hausman argues,
ought to be investigated by those concerned with the evaluation of health states.
This all points to the fact that measuring and comparing health states is a difficult
enterprise, not just technically and conceptually, but also morally. In the next
section we consider the *comparison* of health states between distinct systems (or
perhaps the same system at different times) such that there is found to be an
imbalance in their respective values.

5 HEALTH INEQUALITIES

Health inequalities refer to differences in health state between units, or the variation in a population of subunits. A large part of public health is devoted to reducing such inequalities. Many of the same problems faced with measuring health *per se* can be found in the context of measuring health inequalities. The WHO's measures use a variation on the Gini coefficient (an index used to measure wealth inequalities) in which the health of every individual in a population is compared to every other from the same population:

$$(1) \quad \mathcal{I}(\alpha, \beta) = \frac{\Sigma_{i=1}^{n} \Sigma_{j=1}^{n} \|y_i - y_j\|}{2n^2 \mu^\beta}$$

Here, the parameters α and β control the contribution of the absolute difference between pairs of individuals and the weight of the mean respectively. The individuals i and j can be people, social groups, or entire populations, as appropriate, and y_k represents a health measurement outcome performed on individual k — the health measure can take a variety of forms, as discussed previously. The term μ represents the average health (or expected health, relative to some measure) of the entire population (or, given very large n, some well-chosen sample). The value is proportional to the difference between the (area under the) perfect equality curve \mathcal{E} and the (area under the) Lorenz curve \mathcal{L}: $G = 1 - \frac{A_\mathcal{L}}{A_\mathcal{E}}$. A value $G = 0$ represents a situation with perfect equality and the value $G = 1$ represents perfect inequality.

Inequality, formally, concerns the distribution of a property over a population of individual units or between populations. What measure one chooses will to a large extent depend on the units in question: individual people, cities, social groups, gender, countries, etc. So the health measure will be guided by context: if one wishes to compare countries, and search for inequalities at this level, then one might use an index built by averaging over a bunch of health related properties of countries. In this case one is treating the countries as individuals with their own properties. One is then concerned with the distribution of the values of this property over a domain of countries. Hausman *et al.* point out that focusing on "contrasts between social groups ... hides inequalities within groups" [Hausman *et al.*, 2002, p. 184]. The point here is that one could have a pair of countries with the same value relative to our chosen measure, but which have radically different distributions of individual health *within* the population.[36] (We have been here before, of course: this is essentially the same objection raised by Reidpath in §4.4). Writing on the subject of economic inequalities, Charles Wheelan writes: "If the pie is growing, how much should we care about the size of the pieces?" [Wheelan, 2003, p. 115]. In other words, if the economy is steadily growing, so that everyone is becoming 'better off' in an absolute sense, then does it matter

[36]Here they are following the analysis of Murray *et al.* [1999] according to which "health inequality should be defined in terms of inequality across individuals" (p. 541). I say we should take 'individual' as applying to people, groups, and populations in general according to ones interests and goals — this seems to be implied in the way the WHO measure is constructed.

that the *spread* between rich and poor is simultaneously increasing? There are many things one can say about this: one might argue that the reason the economy is growing steadily is precisely because of those at the top earning more: they are the companies and individuals who are investing more, in research, technology, and enterprise. On the other hand, you could argue that the more people that are earning more pushes prices of items up that lie out of the range of those poorer people, thus making the inequalities even more extreme. Either way, the challenge of Reidpath and Hausman *et al.* needs to be answered.

Beyond these issues of distribution, the key philosophical problems with the research on health inequalities have to do with the level of support the data give to the possible explanations of the inequalities. There seems to be some genuine underdetermination going on. This seems to be what underlies virtually all of the objections raised by Forbes and Wainwright [2001] in their philosophical investigation of health inequality explanations: the data does not uniquely determine one explanation. Nor, they imply, can one give, on methodological grounds, an inference to the best explanation. Forbes and Wainwright further contend that a latent positivism underlies much of the health inequality literature. They argue that the extant explanations of health inequalities are too data-dependent. They claim to argue for a 'realist' position in [Wainwright and Forbes, 2000]. However, the fact that they deny the links between the mathematical representations used by health scientists and the reality it is supposed to be representing does not appear to match any of the standard brands of scientific realism. They seem to confuse realism with a belief in unobservables that have no observable effect whatsoever, direct or indirect. Of course, realist positions are committed to the reality of unobservables, however, they will usually only be committed to such things when they generate some kinds of effect or are necessary to explain some observable phenomenon. Completely detaching from data is a dangerous position to espouse in any science, let alone in health research. For this reason, philosophers would do well to scrutinize these arguments more closely.

6 HEALTH MEASURES AND NATURAL KINDS

In his classic discussion of the problem of defining health and disease Lester King wrote that "Science, in studying relations within the total environment, cares not a whit about 'health'" [1954, p. 193]. What he meant by this is that the data alone do not represent a state of disease until we have given it that interpretation:

> Disease is the aggregate of those conditions which, judged by the prevailing culture, are deemed painful, or disabling, and which, at the same time, deviate from either the statistical norm or from some idealized status. Health, the opposite, is the state of well-being conforming to the ideals of the prevailing culture, or to the statistical norm. The ideal itself is derived in part from the statistical norm, and in part from the ab-normal which seems particularly desirable. [King, 1954, p. 197]

The problem of how to measure health (or disease) is intimately connected with what we take health (or disease) to be. Even if we can agree on the definition of individual health, it is a further difficulty to figure out how to aggregate health to get a handle on the health of a population. Furthermore, the debate between normativists and naturalists reasserts itself at this level. Naturalists will claim that the aggregate measures satisfy value-free construction methods, whereas normativists will disagree. An important and interesting task for philosophers to take on would be the investigation of the links between one's position with respect to individual health and disease and health and disease and the aggregate level. Intuitively one would expect that if one adopts the position that the definition of health and disease at the individual level is value-laden then this would be transmitted to the aggregate definition. However, given the fact that the measures involve weightings of specific diseases and disabilities, one might expect that the transmission must fail. The weightings and measures, as I argued above, are not themselves stalking out natural kinds, they are bound to the use to which they will be put.

Daniel Sulmasy [2005] argues, in any case, that disease itself is not a natural kind, but that it involves *reference* to natural kinds. Humans, for example, are natural kinds and disease "is a classification of a certain state of affairs that can occur in members" of this kind (p. 496). Although Sulmasy argues that one must refer to multiple individuals in order to infer that some phenomenon (some illness) is a disease, the account is nonetheless an individuals-based account. It is not easy to see how this could be extended to public health. The only way I can see how it would be possible would be to argue that certain populations are natural kinds, and then one might identify certain patterns than arise repeatedly in such populations as diseases.

Beyond this, it has been argued that population-level features can have a direct bearing on the way we conceive of these notions:

> Characteristics of populations also influence our very definitions of what is health and what is disease. Rose notes that what we consider normal is influenced by what is prevalent. 'What is common is all right, we presume.' One implication of this is that social facts may also influence disease incidence in the broadest sense, by determining what we consider to be a disease. Social facts influence our expectations of how many aches and pains are normal, how long we expect to live and what we expect our bodies to look like and our minds to accomplish. Bodily aberrations and biological variants can come to be defined as diseases or redefined as normal. Obesity, intersexed conditions, senility, acne, post-traumatic stress and gender identity disorder are just a few examples. [Schwartz and Diez-Roux, 2001, p. 439]

In other words, since values are linked to the population, we cannot escape considerations of population in the debate over the nature and definition of health and disease.

I have been hinting at a pragmatic response to the debate in much of the preceding discussion. This would involve a rejection of the distinction between facts and values on which the debate rests. An earlier attempt at a pragmatic definition was made by Fanshel [1972]. However, his approach puts the pressure on the notion of functional states (and dysfunctional states) and then weights these, using a notion of ideal function (thus bringing in the old debate once again). The philosophical debate over the ontological status of disease and health involves the extremes of realism and relativism. I think the work on population measures of health and disease suggests a pluralistic approach that avoids the excesses of these extremes. The approach is well-stated by Giere[37] (here in the context of modeling water):

> consider the simple case of water. If one is studying diffusion or Brownian motion, one adopts a molecular perspective in which water is regarded as a collection of particles. But the situation is far too complex to adopt a Newtonian perspective for individual particles. Instead, one adopts a statistical perspective in which the primary variables are things like mean free path (the average distance a particle travels between collisions). However, if ones concern is the behavior of water flowing through pipes, the best fitting models are generated within a perspective that models water as a continuous fluid. Thus, ones theoretical perspective on the nature of water depends on the kind of problem one faces. Here employing a plurality of perspectives has a solid *pragmatic* justification. There are different problems to be solved and neither perspective by itself provides adequate resources for solving all the problems. [Giere, 2006, pp. 33–34]

There are multifarious uses to which health measures are put: cross comparison of health, determination of healthcare expenditure, targeting of interventions, etc. I advocate a transferal of this way of thinking about health measures to the philosophical problem of understanding what health and disease are. There is no reason

[37]There are, of course, many forms of pluralism. For instance, Dupré [Dupre, 1993, p. 7] usefully distinguishes between two flavours of pluralism: on the one hand, there is the kind of pluralism that denies the elimination of some 'level' (i.e. via reduction of one thing to another); on the other hand there is the kind of pluralism that denies the unique carving of the world into things. This latter flavour is what I have in mind, and what the practice of public health scientists appears best to cohere with. The way we carve up medical reality is in no small way determined by the purpose for which we are doing the carving in the first place. Reductionism is, however, an independent issue — Daniel Steel [Steel, 2004b] argues this particular case well using the example of H.I.V. replication as a case-study. Alternatively, Kitcher [Kitcher, 2002, p. 570] spells out four claims that characterise his version of pluralism: (1) there exist multiple systems of scientific representation for understanding systems in nature; (2) there is no coherent ideal of a complete account of nature; (3) the multiple representations of nature are jointly consistent; (4) the representations we *accept* at any stage might not be jointly consistent. (1)-(3) all seem to be applicable in the case of public/population health measures. (4) seems not to apply: the various representations do not conflict, but rather amount to different levels of coarse-graining. However, Giere's perspectivism does, I think, provide the most useful illustration.

to think that the measure used in each case need be the same in all cases. To think this would be to suppose that there is some 'One True Health State' in the world that these measures are trying to latch on to.

7 CAUSALITY IN PUBLIC HEALTH

Public health, even more so than medicine, is fundamentally concerned with finding the causes of those phenomena that cause disease and impact on health.[38] Such phenomena can be singular or general. That is, one might wish to ascertain the cause of a particular outbreak of SARS or one might want to understand the general mechanism by which SARS outbreaks occur and propagate themselves. The population-level focus alters the causation debate's compass somewhat. In the public health context, as Maxwell Parkin and Bray put it:

> "Cause" is a relative concept, that only has meaning [in] terms of its removal being associated with diminished risk of the disease, and, in this context, it is just as relevant to improve educational levels in a population as a means of reducing infection by HIV as it is to identify the mechanisms by which the virus enters the host cell. [Maxwell Parkin and Bray, 2005, pp. 58–9]

Nancy Cartwright makes a similar point, stating that "although causes may not be universally conjoined with their effects, at least they should increase their frequency" [Cartwright, 1989, p. 55]. This is, of course, the hallmark of a *probabilistic* conception of causality. The approach to causation in the context of health intervention research is certainly probabilistic (or *statistical*): one often works 'backwards' from data, containing patterns of association between variables over a sample (e.g. joint distributions), to causes. As Holland explains, the emphasis in statistical models of causation is on "*measuring the effects of causes*" rather than "the causes of effects" ([Holland, 1986, p. 945], emphasis in original).

However, as Judea Pearl points out, the data isn't sufficient, by itself, to permit causal inferences:

> There is nothing in the joint distribution of symptoms and diseases to tell us that curing the former would or would not cure the latter. [Moreover,] there is nothing in a distribution function to tell us how that distribution would differ if external conditions were to change ... because the laws of probability theory do not dictate how one property of a distribution ought to change when another property is modified. [Pearl, 2001, p. 191]

It is clearly crucial that we know the direction of an association, and how the association would change given different background conditions: the success of

[38]I say 'even more so than medicine' because medicine is generally more concerned with treatment than prevention.

intervention research *depends* on such information. Hence, some extra piece needs to be added to the puzzle in order to allow for the extraction of valid causal inferences from mere statistical data. In *The Oxford Dictionary of Statistical Terms* 'causality' is defined as follows:

> Philosophically difficult notion of relation between an explanatory variable and a response. Older discussions were non-statistical and involved some notion of necessary and sufficient condition for the response. There are a number of variants of a statistical definition of causality (Holland, 1986 ["Statistics and Causal Inference", *Journal of the American Statistical Association* **81**: pp. 945-960]). In one the cause must be in some sense prior to the response and alternative allowable explanations of the statistical independence involved must be excluded. In another there is a notion that the possible cause can conceptually be manipulated with a consequent systematic effect on the response. [Dodge, 2003, p. 59]

The latter aspect, pertaining to manipulability, has formed the basis of many contemporary accounts of causation, philosophical and otherwise and gives us the "extra piece" alluded to above. For example, Woodward and Hausmann write:

> [M]anipulation is crucial to our conception of causation and to the contrast between causation and mere correlation. When X and Y are correlated and X does not cause Y, one expects that when one manipulates X, the correlation will break down. By contrast, if X causes Y, one expects that for some range of values of X, if one is able to manipulate those values, one can thereby control the value of Y. [Hausman and Woodward, 2004, p. 847]

Following Glymour and his team, Woodward and Hausmann understand interventions as processes that (directly) manipulate some variable (the response variable) so as to 'detach' the manipulated variable from its other causes (i.e. its 'parents') — i.e. the response variable is rendered *probabilistically* independent of any other causes. This condition they call 'modularity', and, along with its close relative the 'causal Markov condition', it has been the subject of much recent controversy (primarily having to do with whether real systems of interest are themselves modular).

This manipulationist account is not new, however. In their popular epidemiology textbook, MacMahon and Pugh define a causal association as one in which "an alteration in the frequency or quality of one category is followed by a change in the other" ([MacMahon and Pugh, 1970, pp. 17–18]; cited in [Schaffner, 1991, p. 206]). Likewise, Rubin [1986, p. 962] holds up the motto "no causation without manipulation" as a "critical guideline for clear thinking in empirical studies for causal effects". The manipulationist account has also been central to the study of experimental design. For example, Cook and Campbell [1979, p. 36] write that a

"paradigmatic assertion" regarding causal relationships is that by *manipulating* a cause we will manipulate the effect: "Causation implies that by varying one factor I can make another vary".[39]

In the context of public health research, at least, when causes get more indirect or 'distal', they are labeled 'risk factors' — *cf.* Schaffner [1991, p. 206]. In other words, many health researchers are reluctant to use the term 'cause' when the association is probabilistic. For example, Kleinbaum *et al.* write that:

> Because of the lack of certainty in our results, epidemiologists generally use the term risk factor instead of cause to indicate a variable that is believed to be related to the probability of an individual's developing the disease prior to the point of irreversibility. ([Kleinbaum *et al.*, 1982, p. 29]; quoted in Schaffner [1991, p. 206])

This attitude continues to be seen in many areas of health research. In the context of public health, however, it has transformed into the concept of a *determinant*. In this wider context the determinants are often social, which greatly increases the complexity of issues to do with causality, and *prima facie* decreases the applicability of the manipulationist account. Public health focuses primarily on these social determinants of health, and, inasmuch as manipulability is involved at all, the approach to interventions that it underwrites is one that seeks to manipulate the very fabric of society — that is, to shift the *patterns* of disease and their distributions in the population as a whole. Often, however, direct manipulation (i.e. control) is not possible, and so one has to resort to observational studies. Furthermore manipulability accounts might face problems concerning certain important factors that cannot be controlled: gender and ethnicity, for example. These are called 'categorical properties' in the literature of statistical theories of causality. In fact I think when merged with the counterfactual account we can make good sense of manipulating categorical properties too. That is, we can imagine (or give state descriptions of) worlds in which gender is swapped, and so on. Even in the case where one *can* manipulate, the evidence that it was one's manipulations that caused some outcome, and not some other factor, is not easy to assess because of the complexity of the systems involved. Understanding this latter aspect is the task of 'evaluation'. A very serious problem with evaluation in this context is just such 'fat hand' intervention features — see [Scheines, 2005] for more on fat hand interventions.

There is an old debate, as we have seen, over whether a social or biomedical (natural) cause is responsible for some disease. Causation in public health looks

[39] In his lecture "The Environment and Disease: Association or Causation", Sir Austin Bradford Hill considered some rules of thumb that might enable causal inference in difficult situations. Hill did the wise thing and tried to avoid a philosophical discussion of causality. Of course, one can't really engage in a discussion of causality without slipping into philosophical issues. In laying out his view of causality, he clearly intended a probabilistic, manipulationist account. This can be discerned in his claim that the decisive question in causality research is "whether the frequency of the undesirable event B would be influenced by a change in the environmental feature A" [Bradford Hill, 1965, p. 295].

at the determinants of disease and health at the level of the population. The incidence of disease in a population is given by the averaging out of individual cases over the population. However, in doing this we can see patterns that can point to causes for the incidence of disease than cannot be gleaned from measuring the individual cases themselves. Social epidemiologists often use this to argue that the biomedical model of disease causation ought to be replaced by a socio-medical one involving what they call "upstream" or "distal" causes. That is, if we want to have causal explanations of disease, then the place to look for the fundamental causes is not at the level of local biological phenomena but at the level society and the social networks in which individuals find themselves, because it is only there that manipulation will lead to elimination of the mechanisms that lead to disease — see, for example, Link and Phelan [1995].

Michael Root moves this debate into an interesting direction, linking it up with the issue of natural and artificial kinds and classifications that we discussed earlier. Root notes that there are clear disparities in the health states of black and white people: "blacks are seven times more likely to die of tuberculosis than whites, three times more likely to die of H.I.V.-A.I.D.S and twice as likely to die of diabetes" [Root, 2000, p. S629]. The diseases themselves, Root argues, are biological while the racial differences are social; and yet a social factor here appears to be determining biological factors: racial factors appear to be resulting in differences in the rates of disease. A possible sociological explanation, then, for the health inequalities between blacks and whites suggests itself: it is known that high stress levels can suppress the immune system, and being black is stressful (at least in the U.S.). This is an explanation of disease distribution, and health inequality, that is broadly in line with those given by social epidemiologists. The idea is that it is social factors, rather than biological factors or mechanisms, that are ultimately responsible for the distribution of disease (despite the fact that some biological explanation can be given for the disease occurrence in some individual). However, Root assumes that the explanation is the correct one without argument or evidence, relying on plausibility alone. Clearly more work needs to be done here to strengthen his account.

Albert Mosley attempts to deflate the 'biomedical versus social' debate by drawing attention to the distinction between the distribution of disease in a population and the occurrence of disease in an individual. He argues — in the context of the debate over whether HIV or poverty causes AIDS — that the answer one gives "is relative to whether the inquirer is interested in the disease or the epidemic, with a focus on individuals or populations" [2004, p. 412]. In other words, in a sense *both* cause AIDS, but the notion of 'cause' and the notion of the disease are different in each case: "HIV and poverty are different kinds of causes that operate on different levels of inquiry" (p. 413). This approach is more or less equivalent to that of Stallones, who argues that we should understand causation of health and disease in "two modes", both in terms of the production of illness in individuals

and in terms of the generation of patterns illness in populations [1980, p. 73].[40]
I think this kind of pluralism offers a good way to cut through some of the dense
and seemingly interminable debate over social or biological causation. However,
though I think the distinction is needed, it leaves us no better off in terms of our
understanding of causation at either the individual or the population level.

8 STUDY DESIGN AND EVIDENCE-BASED MEDICINE

Study designs are intended to get the best evidence for a given context, with the
ultimate hope of enabling good causal inferences to be made (or at least to suggest
causal hypotheses).[41] That is, one designs a study to investigate correlations
between variables ('exposure variables' on the one hand, and variables associated
with disease on the other). There are two broad categories of study: 'experimental'
and 'observational'.

Experimental Studies. Experimental studies or 'intervention trials' involve the
active intervention into the system of interest; this is often compared with a
control which does not receive an intervention (but may receive a placebo).
The reasoning is that if the incidence of some disease is reduced following
the intervention (or if there is a difference between the intervention and con-
trol groups) then, adopting probabilistic causal reasoning, there is a causal
relationship between the intervention and the outcome of interest.

The best form of intervention is the RCT in which the treatment allocation
is randomized. In public health these will most often take the form of 'pre-
ventative trials' (the most prevalent of which is the population or group-level
community intervention trial). Of course, given the nature of many of the
hypotheses relevant in public health (involving the gender or race of individ-
uals, or involving children, for example), experimental studies are rare.[42]

[40]Note, however, that Russo et al. [2006] argue that the fact that one speaks about "two levels
of causation" does not thereby commit one to saying that causation acts differently at these two
levels. Russo and Williamson argue that while causal monism is false, causal pluralism is not
right either, since it involves a conflation "the *evidence* from which causal relations are drawn
with the very notion of cause" [2007, p. 169]. In this case, however, it is clear that evidence is
not at issue: it is the *level* at which causality is being considered.

[41]Weed identifies as his "keystone" issue for a philosophy of public health the question: "What
justifies the decision to implement a preventative intervention, to move, in other words, from
scientific evidence to public health action?" [Weed, 2004, p. 531]. This is essentially a policy
issue: how does evidence get translated into a concrete result?

[42]The units of intervention in public health contexts are often, as mentioned, higher-level
entities, such as schools, hospitals, and other large groups of individuals (including entire com-
munities in the case of community intervention trials). It is clear that if it is needed at the
level of individual people randomization is also needed at this level too, for confounding will be
just as possible here. For example, an intervention to reduce the incidence of skin cancer in a
community by the application of a new sun lotion might be confounded by a number of factors:
behaviour modification resulting in less frequent exposure to the sun (perhaps as a result of the
idea of risk of skin cancer suggested by the trial itself) and a mild summer are two possibilities.
To avoid confounding at this level one randomizes 'clusters' of individuals — hence, this study

Observational Studies. An observational study is broadly descriptive, aiming to find out how health and disease are distributed over a population. The data can often reveal correlations between variables which can in turn point the way to testing of causal hypotheses (either statistically or experimentally). Observational studies split into two broad types: descriptive and analytic.

1. *Descriptive Studies*:

 - Cross-Sectional Studies: 'Health Statics'. Cross-sectional studies (otherwise known as cross-sectional field surveys) are descriptive studies intended to give an instantaneous picture (or a 'thin-sandwich' picture) of some system (specifically of the *prevalence* of disease) by investigating survey data for the members of the population of interest. Though the study is considered too weak (for making causal inferences) by modern standards, it can lead to the development of such hypotheses. Note that it also led to the development of both case-control and cohort designs (*qua* repeated cross-sectional surveys) — *cf.* [Susser, 1985, pp. 28–31].

 - Ecological Study. An ecological study is a descriptive study taking populations as its units of analysis. It looks for correlations at the population level that might pave the way to more detailed causal investigations.

2. *Analytic Studies*:

 - Case-Control Studies. Case-control studies (also known as 'retrospective' or 'case-referent' studies) focus on individuals who develop a disease (the "cases" in question), after which one examines their past histories in order to seek out relevant differences between their histories and the histories of individuals without the disease — that is, one looks for a greater frequency in the presence of some risk factor. This method is a fairly effective way of discovering causes of rare diseases. But it is clearly restricted to small scales. Moreover, it is highly fallible due to the fact that the histories most often involve the individual patient's memory recall.

 - Longitudinal Studies: 'Health Dynamics'. In a longitudinal study the aim is to build up a picture of the evolution of some system over time.[43] Hence, one gathers information about the system (usually via the sample members) at multiple times. In other words, a longitudinal study works by piecing together the snapshots from cross-sectional studies. One can use such studies to identify seasonal effects in health, and to get a firmer grip on potential corre-

design is known as "cluster randomization".

[43] Strictly speaking, of course, longitudinal studies are not restricted to observational studies: one could perform repeated experimental studies to determine the dynamics of a population too. However, in practice, given the expense required, they are most often conducted observationally.

lations between variables. They are the obvious tool to assess the health impact of interventions. Longitudinal studies also enable one to chart the history of phenomena of interest, say the spread of a disease.

A *cohort study* (also called 'follow-up' or 'prospective' studies) is the most well-known longitudinal study design, focusing on a group (or 'cohort') of individuals who do not have the disease, but in which there are both exposed and non-exposed members.[44] If there is an increase in the incidence in the exposed subset then this is taken to be indicative of a causal relationship. The major problem with this method is that of confounding factors. In order to draw solid causal conclusions about the exposure, the exposure must be the sole difference between the members. Clearly this is never the case in real-world situations. One needs to supplement the account with some other factors.

Quasi-Experimental Studies. Quasi-experiments or 'natural experiments' rely on natural variation with respect to exposure (and matching in all other relevant respects) in and across populations. However, this means that there is no experimental control over who is exposed.

As with clinical medicine, there is believed to be a 'hierarchy' of evidence, with RCTs (randomized controlled trials) at the top — in fact, the systematic review is seen as being at the top of the evidential hierarchy, since this synthesizes the results from multiple RCTs. Many novel problems emerge when one considers large-scale public health interventions. For example, there is a serious difficulty in external validity (or generalizability from one context to another) on account of the complexity of the environment and the problem of shielding the study from interference effects (between groups) and attrition.

In his analysis of the (in-) efficiency of the NHS (the UK's national health service) — in his lecture series in 1971 entitled *Effectiveness and Efficiency: Random Reflections on Health Services* — the epidemiologist A. L. Cochrane identified the use of ineffective treatments as one of the primary sources of inefficiency in the health system. In response he argued that the treatments ought to be evaluated scientifically, using the best available evidence. In particular, they ought to be run as randomized controlled trials [RCTs] as a matter of course since these trials eliminate bias and are the most systematic method available. We can trace the evidence-based medicine movement back to this point.[45] In both cases there

[44]Snow's investigation of the cholera epidemic (discussed in §2.4) has elements of a cohort study: Snow divided his units (households) into two groups according to their exposure to water from either one or the other water companies. Grouped in this way the data revealed a clear connection between the water supply and cholera mortality.

[45]The canonical definition of evidence-based medicine is: "the conscientious, explicit and judicious use of current best evidence in making decisions about the care of individual patients" [Sackett et al., 1996, p. 71]. Though well known in the context of clinical medicine, it has only recently been expanded into public health, where "the patient" transforms into "the public".

is an underlying ethical imperative to minimize harm, in this case by subjecting treatments to better evaluation. In the context of evidence-based medicine there is a notion of a 'hierarchy of evidence' which (qualitatively) ranks various forms of evidential support for hypotheses by their level of susceptibility to bias and confounding more generally.[46] As John Worrall points out, RCTs are not always deemed necessary; sometimes the efficacy of a treatment will be obvious, such as when it prevents otherwise fatal conditions [Worrall, 2000, p. S319].[47]

Cochrane, however, was concerned as much with the efficiency (i.e. the real benefit of an an intervention outside the confines of the RCT) aspect as he was with efficacy (i.e. the maximum possible effect) of treatments. In other words, health economics was given equal weight. Efficiency and efficacy go hand in hand: in getting rid of ineffective 'treatments', the burden on the system is reduced. Thus, health and economics go hand in hand. Cochrane's early advocacy of RCTs, an axiom of evidence-based medicine, was encapsulated in the development of an international database of RCT evidence: *The Cochrane Collaboration*. Multiple RCTs on the same hypothesis are statistically analysed via meta-analysis. This can strengthen or weaken the level of evidence. The evidence is graded according to 'quality', and often, if there are multiple studies of 'higher quality' any studies of 'lower quality' will be ignored (*cf.* [Doyle *et al.*, 2008, p. 214]. This privileging of RCTs has been widely questioned, and there is some lively debate in the philosophical literature: e.g. [Worrall, 2000; Worrall, 2007] and [Grossman and Mackenzie, 2005]. Grossman and Mackenzie argue that insufficient caution is used in assessing RCTs, as compared to the excessive caution used when assessing observational studies. The case hasn't been made, they argue, for the *general* superiority of RCTs over other study designs, and that observational studies are sometimes better, as in the context of public health interventions, for example. Rather, the study design should be matched to the research question, and this will sometimes mean that RCTs are most appropriate, but not always. Worrall argues that the idea that RCTs control for all factors is a "will-o'-the-wisp": without supplementing an inference with background knowledge, about plausible mechanisms and so on, there will be the potential for (plausible) alternative causal factors underlying any evidence.

The notion of a controlled population-level experiment to intervene in all but the simplest health-states is fraught with difficulties. For example, extremely large samples are needed to detect even very small effects. Even when one can implement such an experiment, drawing causal inferences from them is incredibly difficult. For instance, if one wants to alter the distribution of weight, so that there are fewer anorexic and obese individuals, then one can see how to go about designing an intervention to do this, and then measure the effect. Weight is a

[46]See [Ashcroft, 2004] for a good review of several epistemological issues concerning evidence-based medicine (and RCTs).

[47]Worrall (*ibid.*, p. S328) also notes a curious inconsistency in the reasoning for the high status of RCTs, namely their *reliability*. In meta-analyses of RCTs there is significant divergence over the effectiveness of treatments.

simple additive factor so one can weigh a sample to see if there is a reduction following the intervention (as compared to data gathered before the intervention). However, one simply will not have the ability to control elements of the social and physical environment to test whether the intervention worked — one major problem along these lines is that one cannot ensure perfect compliance with the randomization.[48] That is, even if there are significant differences in the weight distribution after the intervention has been implemented one cannot be sure that it was the intervention that was responsible. To assume otherwise is to commit the *post hoc ergo propter hoc* fallacy: there is a strong possibility that some other factor was responsible.[49]

This is, of course, the problem of underdetermination of theory by data. Weed [1997] discusses this problem in the context of a suggested relationship between induced abortion and breast cancer. Another, classic, example is William Farr's study of the possible influence of marriage on mortality [1858]. The underdetermination in this case concerned the issue of whether the observation that married people tend to live longer than unmarried people was due to selection (the fact that healthier people have a tendency to marry) or causation (married life leads to a healthier life: "marriage protection"). Farr argued that it was a selection effect, and recent statistical studies (involving longitudinal rather than cross-sectional techniques) seem to confirm this: see, e.g., [Goldman, 1993]. Of course, for obvious ethical reasons, this is not the kind of thing one can experimentally determine!

Underdetermination can be broken by appealing to other factors external to the data. Such factors may lead us to prefer one theory over another. However, Weed notes that the 'criteria' used by epidemiologists to break the underdetermination are rather weak. The standard method is to invoke Bradford Hill's so-called causal-criteria: specificity, strength of association, consistency, coherence, temporality, dose-response, biological plausibility, experimentation, and analogy. These are not intended to be necessary and sufficient conditions but rules of thumb. With the exception of temporality (assuming the absence of retro-causality), all of the criteria could be violated without ruling out causality — *cf.* [Weed, 1997, p. 113].[50]

[48]See [Kaufman *et al.*, 2003] for a survey of the problems and prospects for conducting RCTs of social interventions in the context of social epidemiology.

[49]A further factor that causes problems when conducting complex social interventions is that there is often no standardization of intervention categories. [Doyle *et al.*, 2008] give the example of differing definitions of 'smoker' 'ex-smoker', 'quitter' and so on, that can lead to complications in comparing results.

[50]Note that Bradford Hill wished explicitly to avoid philosophical issues, and furthermore made no claim that he was presenting criteria for causation. He states that he is presenting aspects of associations that would lead us to conclude that causation "is the most likely interpretation" [Bradford Hill, 1965, p. 295]. This does not imply that meeting all of the aspects is definite evidence of causality at play. Bradford Hill was concerned with grounds for public health action over perfect knowledge: "All scientific work is incomplete — whether it be observational or experimental. All scientific work is liable to be upset or modified by advancing knowledge. That does not confer upon us a freedom to ignore the knowledge we already have, or to postpone the action that it appears to demand at a given time" (*ibid.*, p. 300). It is interesting to speculate on what the health-science landscape might look like had researchers followed this message rather

Daniel Little suggests that the problem posed by confounding variables might be resolved by invoking mechanisms and argues that the notion of a 'plausible mechanism' could rule out some hypotheses:

> We can best exclude the possibility of a spurious correlation between variables by forming a hypothesis about the mechanisms at work in the circumstances. If we conclude that there is no plausible mechanism linking nicotine stains to lung cancer, then we can also conclude that the observed correlation is spurious. [Little, 1991, pp. 24–25]

This approach appears to be more or less in line with Bradford Hill's methodology. I think Steel [2004a] offers a definitive dismissal of the 'plausible mechanism' method of breaking this inferential deadlock, at least concerning 'negative' explanations (i.e. those showing that we can infer that X is *not* a cause of Y when there is no plausible mechanism connecting them). He argues that it is in reality extremely difficult to think up *any* case of a social phenomenon that could not be explained via some plausible mechanism (*ibid.*, p. 65). Moreover, it seems rather odd to think that the inability to imagine a mechanism generating some phenomenon in some ways aids causal inference (*ibid.*, p. 66). We might also point to the looseness in the notion of 'plausibility' here.

9 INTERNAL AND EXTERNAL VALIDITY

The internal validity of a trial concerns the extent to which differences between the trial arms can be attributed to the intervention. As Guala puts it, internal validity "is achieved when the structure and behaviour of a laboratory system (its main causal factors, the ways they interact, and the phenomena they bring about) have been properly understood by the experimenter" [2003, p. 1198]. It is a causal principle: low internal validity means that we can't tell whether some other factors infected the trial and caused the differences. Such methodology makes these trials practically difficult, for one needs a large number of entire groups. Naturally, the group, being composed of individuals, depends on these individuals so that blinding is done at the lower level, and is expected to transfer to the group level. However, the blinding procedure is especially problematic in cluster trials.

The fundamental idea of trials is to generate evidence on which to base or withhold some intervention. In some cases the intervention will be applied at one site only. However, more often the intervention will be applied to multiple subjects, be they individual patients or hospital wards or entire cities. That is, the results of the trial are generalized away from the original test site, despite a host of differences between them. External validity refers to the generality of the results: trials with high external validity are most likely to have their results replicated in diverse contexts.[51]

than Cochrane's.

[51]Meta-analysis is intended to provide a quantitative estimate of the degree of replication or

Guala labels 'radical localism' the view that "Experimental results do not apply to the world out of the laboratory" ([Guala, 2003, p. 1196]; see also [Guala, 1999]) — there is a close resemblance between this view and Nancy Cartwright's idea of a 'dappled world' according to which we do not have grounds for believing that laws of nature transfer from "the highly contrived environments of a laboratory [to] less regulated settings" [Cartwright, 1999, p. 25]. This notion seems particularly appropriate in the context of group-level or population-level health intervention research, of the kind appearing in public health. In such cases the context (the social and physical environment) can interfere with the experiment — so-called "neighbourhood effects" (i.e. the effects of social context, such as a residential community, on health outcomes) constitute one instance of this phenomenon.[52] One way of attempting to correct for neighbourhood effects, so as to separate them out from the ('pure') experimental effects, is to employ multilevel modeling and multilevel analysis, involving the treatment of neighbourhoods as contexts with individuals nested within (see [Diez-Roux, 2000], especially pp. 180–183). However, there are many problems of validity and causal inference that remain to be worked out in this context in order to have applicability in public health: see [Oakes, 2004] for a review of these issues.

10 CONCLUSION

I hope to have shown in this brief guide that the philosophy of public health has many untilled fields ripe for cultivating. The mixture of concepts and techniques (from statistics, epidemiology, demography, and so on) used in public health result in novel philosophical issues not to be found in the study of clinical medicine (or, at least, not in the same form). For this reason it ought to be studied by philosophers alongside clinical medicine, with equal vigour.

BIBLIOGRAPHY

[Adelstein and Susser, 1976] A. Adelstein and M. Susser. An Introduction. In N. A. Humphreys (ed.), *Vital Statistics: A Memorial Volume of Selections from the Reports and Writings of William Farr.* (pp. iii-xiv). Scarecrow Press, 1976.

[Afifi and Breslow, 1994] A. A. Afifi and L. Breslow. The Maturing Paradigm of Public Health. *Annual Reviews of Public Health* 15, 223-235, 1994.

[Allotey et al., 2003] P. Allotey, D. Reidpath, A. Kouame, and R. Cummins. The DALY, Context and the Determinants of the Severity of Disease: An Exploratory Comparison of Paraplegia in Australia and Cameroon. *Social Science and Medicine* 57(5), 949-958, 2003.

[Amundson, 2000] R. Amundson. Against Normal Function. *Studies in History and Philosophy of Biological and Biomedical Sciences* 31(1), 33–53, 2000.

consistency across several trials that aim to test the same hypothesis. More importantly, perhaps, it allows for the investigation of trials that yield *inconsistent* results. Weed [2000] argues that meta-analysis can offer a better estimate of an effect than the usual 'criteria based' rule of thumb employed.

[52]This idea can, perhaps, trace its ancestry back to Durkheim and Weber's studies of the ways in which social forces and factors can influence various behaviours.

[Anderson, 1972] P. W. Anderson. More Is Different. *Science* 177(4047): 393–396, 1972.

[Ashcroft, 2004] R. E. Ashcroft. Current epistemological problems in evidence based medicine. *Journal of Medical Ethics* 30: 131–135, 2004.

[Barenblatt, 2003] G. I. Barenblatt. *Scaling* Cambridge University Press, 2003.

[Bauer, 2006] S. Bauer. The population as a laboratory - Epistemic and visual cultures of epidemiology, 1955-2005. *Årsskrift for Medicinsk Museion*, 3: 24–34, 2006.

[Baum, 1990] F. Baum. The New Public Health: Force for Change or Reaction? *Health Promotion International*, 5(2): 145-150, 1990.

[Bayer et al., 2006] R. Bayer, L. O. Gostin, B. Jennings and B. Steinbock. *Public Health Ethics: Theory, Policy, and Practice.* Oxford University Press, 2006.

[Beauchamp, 1976] D. E. Beauchamp. Public Health and Social Justice. *Inquiry*, 13: 1-14, 1976.

[Beauchamp, 1985] D. E. Beauchamp. Community: The Neglected Tradition of Public Health. *The Hastings Center Report*, 15(6): 28-36, 1985.

[Bergner, 1985] M. Bergner. Measurement of Health Status. *Medical*, 23(5): 696-704, 1985.

[Berridge, 2007] V. Berridge. Public Health Activism. *British Medical Journal*, 335: 22-29, 2007.

[Boorse, 1997] C. Boorse. A Rebuttal on Health. In J. M. Humber and R. F. Almeder (eds.), *What is Disease?* (pp. 1–134). Humana Press.

[Bradford Hill, 1965] A. Bradford Hill. The Environment and Disease: Association or Causation? *Proc R Soc Med.*, **58**(5): 295–300, 1965

[Brock, 1998] D. W. Brock. Ethical Issues in the Development of Summary Measures of Population Health Status. In MJ. J. Field and M. R. Gold (eds.), *Summarizing Population Health: Directions for the Development and Application of Population Metrics* (pp. 73–81). The National Academic Press, 1998.

[Broome, 2002] J. Broome. Measuring the burden of disease by aggregating wellbeing. In C. J. L. Murray, J. A. Salomon, C. Mathers and A. D. Lopez (eds), *Summary Measures of Population Health: Concepts, Ethics, Measurement and Applications* (pp. 91–113). Geneva: World Health Organization, 2002.

[Cartwright, 1999] N. Cartwright. *The Dappled World.* Cambridge University Press, 1989.

[Cartwright, 1989] N. Cartwright. *Nature's Capacities and their Measurements.* Cambridge University Press, 1989.

[Chadwick, 1842] E. Chadwick. *Report on the Sanitary Conditions of the Labouring Population of Great Britain by Edwin Chadwick.* Edited by M. W. Flinn. Edinburgh University Press, 1965.

[Chatterji et al., 2002] S. Chatterji and B. L. Ustün and R. Sadana and J. A. Salomon and C. D. Mathers and C. J. L. Murray. The Conceptual Basis for Measuring and Reporting on Health. *Global Programme on Evidence for Health Policy Discussion Paper No. 45.* World Health Organization, 2002.

[Coggon et al., 1997] D. Coggon and G. Rose and D. J. P. Barker. *Epidemiology for the Uninitiated* (4th Edition). BMJ Publishing Group, 1997.

[Cook and Campbell, 1979] T. D. Cook and D. T. Campbell. *Quasi Experimentation: Design and Analysis Issues for Field Settings.* Chicago: Rand McNally, 1979.

[Cromley and McLafferty, 2002] E. K. Cromley and S. L. McLafferty. *GIS and Public Health.* The Guilford Press, 2002.

[Dawson and Verweij, 2007] A. Dawson and M. Verweij (eds.). *Ethics, Prevention, and Public Health.* Oxford University Press, 2007.

[Detels and Breslow, 2005] R. Detels and L. Breslow. Current Scope and Concerns in Public Health. In R. Detels, J. McEwen, R. Beaglehole, and H. Tanaka (eds.), *Oxford Textbook of Public Health 4th Ed. Vol. l. The Scope of Public Health* (pp. 3-20). Oxford University Press, 2005.

[Dodge, 2003] Y. Dodge (ed.) *The Oxford Dictionary of Statistical Terms.* Oxford University Press, 2003.

[Doyle et al., 2008] J. Doyle, R. Armstrong, and E. Waters. Issues Raised in Systematic Reviews of Complex Multisectoral and Community Based Interventions. *Journal of Public Health*, 30(2): 213–215, 2008.

[Dupre, 1993] J. Dupré. *The Disorder of Things.* Harvard University Press, 1993.

[Egger et al., 2001] M. Egger, G. D. Smith, and D. Altman (eds.) *Systematic Reviews in Health Care: Meta-Analysis in Context .* BMJ Books, 2001.

[Elliot et al., 2001] P. Elliott, J. Wakefield, N. Best, D. Briggs (eds.). *Spatial Epidemiology: Methods and Applications*. Oxford University Press, 2001.

[Evans, 1993] A. S. Evans. *Causation and Disease: A Chronological Journey*. Plenum Press, 1993.

[Fanshel, 1972] S. Fanshel. A Meaningful Measure of Health for Epidemiology. *International Journal of Epidemiology*, 1(4): 319–337, 1972.

[Farr, 1858] W. Farr. The Influence of Marriage on the Mortality of the French People. In G. W. Hastings (ed.), *Transactions of the National Association for the Promotion of Social Science* (pp. 504–513). London: John W. Parker.

[Forbes and Wainwright, 2001] A. Forbes and S. P. Wainwright. On the Methodological, Theoretical and Philosophical Context of Health Inequality Research: A Critique. *Social Science and Medicine*, 53: 801–816, 2001.

[Fryback, 1998] D. G. Fryback. Methodological Issues in Measuring Health Status and Health-Related Quality of Life for Population Health Measures. In MJ. J. Field and M. R. Gold (eds.), *Summarizing Population Health: Directions for the Development and Application of Population Metrics* (pp. 39–57). The National Academic Press, 1998.

[Galea and Putnam, 2007] S. Galea and S. Putnam. The Role of Macrosocial Determinants in Shaping the Health of Populations. In S. Galea (ed.), *Macrosocial Determinants of Population Health* (pp. 3-12). Springer, 2007.

[Giere, 2006] R. N. Giere. Perspectival Pluralism. In S. H. Kellert, H. E. Longino, and C. K. Waters (eds.), *Scientific Pluralism* (pp. 26-41). University of Minnesota Press, 2006.

[Gillies, 2005] D. Gillies. Hempelian and Kuhnian Approaches in the Philosophy of Science: The Semmelweis Case. *Studies in the History and Philosophy of Biology and the Biomedical Sciences*, 36: 159–181, 2005.

[Goldman, 1993] N. Goldman. Marriage Selection and Mortality Patterns: Inferences and Fallacies. *Demography*, 30(2): 189–208, 1993.

[Greenland, 1988] S. Greenland. Probability Versus Popper: An Elaboration of the Insufficiency of Current Popperian Approaches for Epidemiologic Analysis. In K. Rothman (ed.), *Causal Inference* (pp. 95-104). Epidemiology Resources Inc., 1988.

[Greenland, 2002] S. Greenland. Causality Theory for Policy Uses of Epidemiological Measures. In C. J. L. Murray, J. A. Salomon, C. Mathers and A. D. Lopez (eds), *Summary Measures of Population Health: Concepts, Ethics, Measurement and Applications* (pp. 291–301). Geneva: World Health Organization, 2002.

[Greenland et al., 2004] S. Greenland, M. Gago-Dominguez, and J. E. Castelao. The Value of Risk-Factor (Black-Box) Epidemiology. *Epidemiology*, 15(5): 529–535, 2004.

[Grossman and Mackenzie, 2005] J. Grossman and F. Mackenzie. The Randomized Controlled Trial: Gold Standard, or merely Standard?. *Perspectives in Biology and Medicine*, 48(4): 516–34, 2005.

[Guala, 1999] F. Guala. The Problem of External Validity (or Parallelism) in Experimental Economics. *Social Science Information*, 38: 555–573, 1999.

[Guala, 2003] F. Guala. Experimental Localism and External Validity. *Philosophy of Science*, 70: 1195–1205, 2003.

[Guy, 1870] W. A. Guy. *Public Health* Renshaw Press, 1870.

[Hald, 2003] A. Hald. *A History of Probability and Statistics and Their Applications before 1750*. Wiley-Interscience, 2003.

[Hamlin, 1995] C. Hamlin. Finding a Function for Public Health: Disease Theory or Political Philosophy? *Journal of Health Politics, Policy and Law*, 20(4): 1025–1031, 1995.

[Hamlin, 1998] C. Hamlin. *Public Health and Social Justice in the Age of Chadwick: Britain, 1800-1854*. Cambridge University Press, 1998.

[Hamlin, 2005] C. Hamlin. The History and Development of Public Health in Developed Countries. In R. Detels, J. McEwen, R. Beaglehole, and H. Tanaka (eds.), *Oxford Textbook of Public Health 4th Ed. Vol. l. The Scope of Public Health* (pp. 21-37). Oxford University Press, 2005.

[Hausman and Woodward, 2004] D. M. Hausman and J. Woodward. Manipulation and the Causal Markov Condition. *Philosophy of Science*, 71: 846-856, 1995.

[Hausman, 2006] D. M. Hausman. Valuing Health. *Philosophy & Public Affairs*, 34(3): 246–274, 2006.

[Hausman et al., 2002] D. M. Hausman, Y. Asada and T. Hedemann. Health Inequalities and Why They Matter. *Health Care Analysis*, 10: 177-191, 2002.

[Hausman, 2002] D. Hausman. Causality and Counterfactual Analysis. In C. J. L. Murray, J. A. Salomon, C. Mathers and A. D. Lopez (eds), *Summary Measures of Population Health: Concepts, Ethics, Measurement and Applications* (pp. 309–313). Geneva: World Health Organization, 2002.

[Hempel, 1966] C. G. Hempel. *Philosophy of Natural Science*. Englewood Cliffs, NJ: Prentice-Hall, 1966.

[Holland, 1986] P. W. Holland. Statistics and Causal Inference. *Journal of the American Statistical Association*, 81: 945-960, 1986.

[Kaufman et al., 2003] J. S. Kaufman, S. Kaufman, and C. Poole. Causal Inference from Randomized Trials in Social Epidemiology. *Social Science and Medicine*, 57: 2397-2409, 2003.

[King, 1954] L. S. King. What is Disease? *Philosophy of Science*, 21(3): 193–203, 1954.

[Kitcher, 1997] P Kitcher. *The Lives to Come: The Genetic Revolution and Human Possibilities*. Simon and Schuster, 1997.

[Kitcher, 2002] P Kitcher. Reply to Helen Longino. *Philosophy of Science*, 69: 569–572, 2002.

[Kleinbaum et al., 1982] D. G. Kleinbaum, L. L. Kupper, and H. Morgerstern. *Epidemiologic Research*. Belmont, CA: Lifetime Learning, 1982.

[Koch, 2005] T. Koch. *Cartographies of Disease: Maps, Mapping, and Medicine*. ESRI Press, 2005.

[Koch, 1882] R. Koch. Die Aetiologie der Tuberculose. *Berl. klin. Wchnschr.*, 19: 221–230, 1882.

[Last, 1995] J.M. Last (ed.) *A Dictionary of Epidemiology*. Oxford University Press, 1995.

[Latour, 1988] B. Latour (ed.) *The Pasteurisation of France*. Harvard University Press, 1988.

[Leavitt and Numbers, 1997] J. W. Leavitt and R. L. Numbers (eds.) *Sickness and Health in America: Readings in the History of Medicine and Public Health*. University of Wisconsin Press, 1997.

[Lennox, 1995] J. Lennox. Health as an Objective Value. *Journal of Medicine and Philosophy*, 20(5): 499–511, 1995.

[Lilienfeld and Lilienfeld, 1982] A. M. Lilienfeld and D. E. Lilienfeld. Epidemiology and the Public Health Movement: A Historical Perspective. *Journal of Public Health Policy*, 3(2): 140–149, 1982.

[Link and Phelan, 1995] B. G. Link and J. Phelan. Social Conditions as Fundamental Causes of Diseases. *Journal of Health and Social Behaviour*, 35: 80–94, 1995.

[Lipton, 1991] P. Lipton. *Inference to the Best Explanation*. Routledge, 1991.

[Little, 1991] D. Little. *Varieties of Social Explanation*. Westview Press, 1991.

[MacMahon and Pugh, 1970] T. F. MacMahon and B. Pugh (eds.) *Epidemiology: Principles and Methods*. Boston: Little Brown & Co., 1970.

[Mackenzie, 1981] D. Mackenzie *Statistics in Britain, 1865-1930: The Social Construction of Scientific Knowledge*. Edinburgh University Press, 1981.

[Marcum, 2008] J. A. Marcum. *An Introductory Philosophy of Medicine. Humanizing Modern Medicine*. Springer, 2008.

[Maxwell Parkin and Bray, 2005] D. Maxwell Parkin and F. Bray. Descriptive Studies. In W. Ahrens and I. Pigeot (eds.), *Handbook of Epidemiology* (pp. 157–230). Springer, 2005.

[Mendelsohn, 1995] J. Andrew Mendelsohn. 'Typhoid Mary' Strikes Again: The Social and the Scientific in the Making of Modern Public Health. *Isis*, 86(2): 268–277, 1995.

[Michalos, 2006] A. C. Michalos. The Quality-Of-Life (QOL) Research Movement: Past, Present, and Future. Conceptual and Philosophical Foundations. *Social Indicators Research*, 76: 343–363, 2006.

[Mosley, 2004] A. Mosley. Does HIV or Poverty Cause AIDS? Biomedical and Epidemiological Perspectives. *Theoretical Medicine*, 25: 399-421, 2004.

[Murray, 1994] C. J. L. Murray. Quantifying the Burden of Disease: The Technical Basis for Disability-Adjusted Life Years. *Bulletin of the World Health Organization*, 72: 429–424, 1994.

[Murray et al., 1999] C. J. L. Murray, E. E. Gakidou and J. Frenk. Health Inequalities and Social Group Differences: What Should we Measure? *Bulletin of the World Health Organization*, 77(7): 537-543, 1999.

[Murray et al., 2000] C. J. L. Murray, J. A. Salomon and C. Mathers. A critical examination of summary measures of population health. *Bulletin of the World Health Organization*, 78(8): 981-994, 2000.

[Murray et al., 2002a] C. J. L. Murray, J. A. Salomon, C. Mathers and A. D. Lopez. Summary Measures of Population Health: Conclusions and Recommendations. In C. J. L. Murray, J. A. Salomon, C. Mathers and A. D. Lopez (eds), *Summary Measures of Population Health: Concepts, Ethics, Measurement and Applications* (pp. 731–756). Geneva: World Health Organization, 2002.

[Murray et al., 2002b] C. J. L. Murray, J. A. Salomon, C. Mathers and A. D. Lopez (eds). *Public Health Informatics and Information Systems*. Geneva: World Health Organization, 2002.

[Oakes, 2004] J. M. Oakes. The (Mis)Estimation of Neighborhood Effects: Causal Inference for a Practicable Social Epidemiology. *Social Science and Medicine*, 58: 1929–1952, 2004.

[O'Carroll et al., 2002] P. W. O'Carroll, W. A. Yasnoff, M. E Ward, L. H. Ripp, and E. L. Martin (eds). *Summary Measures of Population Health: Concepts, Ethics, Measurement and Applications*. Springer, 2002.

[Pearl, 2001] J. Pearl. Causal Inference in the Health Sciences: A Conceptual Introduction. Health Services and Outcomes Research Methodology, 2(3/4): 189–220, 2001.

[Porter, 1994] D. Porter (ed.). *The History of Public Health and the Modern State*. Editions Rodopi, 1994.

[Porter, 1999] D. Porter. *Health, Civilization and the State: A History of Public Health from Ancient to Modern Times*. Taylor & Francis, 1999.

[Powers and Faden, 2006] M. Powers and R. Faden (ed.). *Social Justice: The Moral Foundations of Public Health and Health Policy*. Oxford University Press, 2006.

[Putnam, 1975] H. Putnam. The Meaning of 'Meaning'. In H. Putnam (ed.), *Mind, Language and Reality: Philosophical Papers, Volume 2* (pp. 215–71). Cambridge University Press, 1975.

[Reidpath, 2005] D. D. Reidpath. Population Health: More than the Sum of the Parts? *Journal of Epidemiology and Community Health*, 59: 877–880, 2005.

[Reidpath, 2007] D. D. Reidpath. Summary Measures of Population Health: Controversies and New Directions. In I. Kawachi and S. Wamala (eds.), *Globalization and Health* (pp. 187-200). Oxford University Press, 2007.

[Root, 2000] M. Root How we Divide the World. *Philosophy of Science, Vol. 67, Supplement. Proceedings of the 1998 Biennial Meetings of the Philosophy of Science Association. Part II: Symposia Papers*. 2000: S628–S639.

[Rose, 2001] G. Rose. Sick individuals and sick populations. *International Journal of Epidemiology*, 30: 427–432, 2001.

[Rose, 1992] G. Rose. *The Strategy of Preventive Medicine*. Oxford University Press, 1992.

[Rosen, 1993] G. Rosen. *A History of Public Health*. The Johns Hopkins University Press, 1993.

[Rosenberg, 1992] C. E. Rosenberg. *Explaining Epidemics and Other Studies in the History of Medicine*. Cambridge University Press, 1992.

[Diez-Roux, 2000] A. V. Diez-Roux. Multilevel Analysis in Public Health Research. *Annual Review of Public Health*, 21: 171-92, 2000.

[Rusnock, 2002] A. A. Rusnock. *Vital Accounts: Quantifying Health and Population in Eighteenth-Century England and France*. Cambridge University Press, 2002.

[Rubin, 1986] D. B. Rubin Statistics and Causal Inference: Comment: Which Ifs Have Causal Answers. *Journal of the American Statistical Association*, 81(396): 961-962, 1986.

[Russo et al., 2006] F. Russo, M. Mouchart, M. Ghins, and G. Wunsch. Statistical Modelling and Causality in the Social Sciences. *Institute de Statistique Discussion Paper* 0601, 2006.

[Russo and Williamson, 2007] F. Russo and J. Williamson. Interpreting Causality in the Health Sciences. *International Studies in the Philosophy of Science*, 21(2): 157–170, 2007.

[Rychetnik et al., 2004] L. Rychetnik, P. Hawe, E. Waters, A. Barratt, and M. Frommer. A Glossary for Evidence Based Public Health *Journal of Epidemiology and Community Health*, 58: 538–545, 2004.

[Sackett et al., 1996] D. L. Sackett, W. M. C. Rosenberg, J. A. Muir Gray, R. Brian Haynes, W. Scott Richardson. Evidence based medicine: what it is and what it isn't *British Medical Journal*, 312(7023): 71–72, 1996.

[Schaffner, 1991] K. F. Schaffner. Causing Harm: Epidemiological and Physiological Concepts of Causation. In D. G. Mayo and R. D. Hollander (eds.), *Acceptable Evidence: Science and Values in Risk Management* (pp. 204-217). New York: Oxford University Press, 1991.

[Scheines, 2005] R. Scheines. The Similarity of Causal Inference in Experimental and Non-experimental Studies. *Philosophy of Science*, 72: 927–40, 2005.

[Schneider and Lilienfeld, 2008] Schneider, D. and D. E. Lilienfeld (eds). *Public Health: The Development of a Discipline*. Rutgers University Press, 2008.

[Schwartz, 2007] P. H. Schwartz. Decision and Discovery in Defining 'Disease'. In H. Kincaid and J. McKitrick (eds.), *Establishing Medical Reality* (pp. 47–63). Springer, 2007.

[Schwartz and Diez-Roux, 2001] S. Schwartz and R. Diez-Roux. Commentary: Causes of Incidence and Causes of Cases–A Durkheimian Perspective on Rose. *International Journal of Epidemiology*, 30: 435–439, 2001.

[Shattuck, 1850] L. Shattuck. *Report on a General Plan for the Promotion of Public and Personal Health*. Boston: Dutton & Wentworth, 1850.

[Snow, 1855] J. Snow. *On the Mode of Communication of Cholera*. New York: Hafner, 1965.

[Stallones, 1980] R. A. Stallones. To Advance Epidemiology. *Annual Review of Public Health*, 1: 69–82, 1980.

[Steel, 2004a] D. Steel. Social Mechanisms and Causal Inference. *Philosophy of the Social Sciences*, 34: 55–78, 2004.

[Steel, 2004b] D. Steel. Can a Reductionist be a Pluralist? *Biology and Philosophy*, 19: 55–73, 2004.

[Stigler, 1994] S. M. Stigler. Some Correspondence on Methodology Between Milton Friedman and Edwin B. Wilson; November-December 1946. *Journal of Economic Literature*, 32(3): 1197-1203, 1994.

[Stouman and Falk, 1937] K. Stouman and I. S. Falk. (1937). Health Indices: A Study of Objective Indices of Health in Relation to Environment and Sanitation. *The Milbank Memorial Fund Quarterly*, 15(2): 173–195. 1937.

[Stroup and Berkelman, 1998] D. F. Stroup and R. L. Berkelman. History of Statistical Methods in Public Health. In D. F. Stroup and S. M. Teutsch (eds.), *Statistics in Public Health: Qualitative Approaches to Public Health Problems* (pp. 1-18). Oxford University Press, 1998.

[Sulmasy, 2005] D. P. Sulmasy. Diseases and Natural Kinds. *Theoretical Medicine and Bioethics*, 26: 487–513, 2005.

[Susser, 1985] M. Susser. Epidemiology in the United States after World War II: The Evolution of Technique. *Epidemiologic Review* (1985) 7: 147–77. Reprinted in his *Epidemiology, Health, and Society: Selected Papers* (pp. 22–49). Oxford University Press, 1987.

[Sydenstricker, 1928] E. Sydenstricker. The Statistician's Place in Public Health Work. *Journal of of the American Statistical Association*, 23(162): 115–1203, 1928.

[Tesh, 1995] S. N. Tesh. Miasma and 'Social Factors' in Disease Causality: Lessons from the Nineteenth Century. *Journal of Health Politics, Policy and Law*, 20(4): 1001–1024, 1995.

[Terris, 1985] M. Terris. The Changing Relationships of Epidemiology and Society. *Journal of Public Health Policy*, 6: 15–34, 1985.

[Terris, 1987] M. Terris. Epidemiology and the Public Health Movement. *Journal of Public Health Policy*, 8(3): 315–329, 1987.

[Terris, 1993] M. Terris. The Society for Epidemiological Research and the Future of Epidemiology. *Journal of Public Health Policy*, 14(2): 137-148, 1993.

[Teutsch and Churchill, 2000] S. M. Teutsch and R. E. Churchill. *Principles and Practice of Public Health Surveillance, 2nd Edition*. Oxford University Press, 2000.

[Thacker et al., 1989] S. B. Thacker, R. L. Berkelman, and D. F. Stroup. The Science of Public Health Surveillance. *Journal of Public Health Policy*, 10(2): 187–203, 1989.

[Thagard, 2005] Thagard, P. What is a Medical Theory? In L. McNamara (ed.), *Multidisciplinary Approaches to Theory in Medicine, Vol. 3* (pp. 47–62). Elsevier, 2005.

[Turnock, 2006] B. J. Turnock. *Public Health*. Jones and Bartlett Publishers, 2006.

[U.S. Institute of Medicine, 1988] U.S. Institute of Medicine, Committee for the Study of the Future of Public Health. *The Future of Public Health*. National Academy Press, 1988.

[Verweij and Dawson, 2003] M. Verweij and A. Dawson. The Meaning of 'Public' in 'Public Health'. In A. Dawson and M. Verweij (eds.), *Ethics, Prevention, and Public Health* (pp. 13-29). Oxford University Press, 2007.

[Wainwright and Forbes, 2000] S. P. Wainwright and A. Forbes. Philosophical Problems with Social Research on Health Inequalities. *Health Care Analysis*, 8: 259–277, 2000.

[Ward and Warren, 2006] J. W. Ward and C. Warren. *Silent Victories: The History and Practice of Public Health in Twentieth-Century America*. Oxford University Press, 2006.

[Weber, 1920] M. Weber Die Protestantische Ethik und der Geist des Kapitalismus. In *Gesammelte Aufsätze zur Religionnsoziologie*. Tübingen, 1920.

[Weed, 1997] D. L. Weed. Underdetermination and Incommensurability in Contemporary Epidemiology. *Kennedy Institute of Ethics Journal*, 7(2): 107-124. 1997.

[Weed, 1999] D. L. Weed. Towards a Philosophy of Public Health. *Journal of Epidemiology and Community Health*, 53: 99-104. 1999.

[Weed, 2000] D. L. Weed. Interpreting Epidemiological Evidence: How Meta-analysis and Causal Inference Methods are Related. *International Journal of Epidemiology*, 29(3): 387–390, 2000.

[Weed, 2004] D. L. Weed. Ethics and Philosophy of Public Health. In G. Khushf (eds.), *Handbook of Bioethics* (pp. 525-547). Kluwer Academic Publishers, 2004.

[Wheelan, 2003] C. Wheelan. *Naked Economics: Undressing the Dismal Science*. W. W. Norton & Company, 2003.

[WHO, 1947] World Health Organisation. *The constitution of the World Health Organisation*. WHO Chronicle, 1947.

[WHO, 2000] World Health Organisation. *The World Health Report, 2000*. Geneva: WHO, 2000.

[Worrall, 2000] J. Worrall. *What* Evidence in Evidence-Based Medicine? *Philosophy of Science*, 69: S316–S330, 2000.

[Worrall, 2007] J. Worrall. Evidence in Medicine and Evidence-Based Medicine? *Philosophy Compass*, 2(6): 981–1022. 2007.

[Winslow, 1923] C. -E. A. Winslow. *The Evolution and Significance of the Modern Public Health Campaign*. Yale University Press, 1923.

[Winslow, 1929] C. -E. A. Winslow. The Contribution of Hermann Biggs to Public Health: The 1928 Biggs Memorial Lecture. *The American Review of Tuberculosis*, 20: 1-28, 1929.

[Worboy, 2000] M. Worboy. *Spreading Germs: Disease Theories and Medical Practice in Britain, 18651900*. Cambridge University Press, 2000.

INDEX

574

588